GARDNER'S

ART THROUGH THE AGES

GARDNER'S

ART THROUGHTHE AGES

A CONCISE GLOBAL HISTORY

FOURTH EDITION

FRED S. KLEINER

© 2017, 2013, 2009 Cengage Learning

written permission of the publisher.

WCN: 01-100-101

ALL RIGHTS RESERVED. No part of this work covered by the copyright herein may be reproduced, transmitted, stored, or used in any form or by any means graphic, electronic, or mechanical, including but not limited to photocopying, recording, scanning, digitizing, taping, web distribution, information networks, or information storage and retrieval systems, except as permitted under or information storage and retrieval systems, except as permitted under Section 107 or 108 of the 1976 United States Copyright Act, without the prior

For product information and technology assistance, contact us at Cengage Learning Customer & Sales Support, 1-800-354-9706

For permission to use material from this text or product, submit all requests online at www.cengage.com/permissions. Further permissions questions can be emailed to permissionrequest@cengage.com.

Library of Congress Control Number: 2015940837

Student Edition: ISBN: 978-1-305-57780-0

Loose-leaf Edition: ISBN: 978-1-305-87254-7

Cengage Learning 20 Channel Center Street Boston, MA O2210

AZV.
Cengage Learning is a leading provider of customized learning solutions mor

Cengage Learning is a leading provider of customized rearning solutions with employees residing in nearly 40 different countries and sales in more than 125 countries around the world. Find your local representative at

.moɔ.əgagaəɔ.www

Cengage Learning products are represented in Canada by Nelson Education, Ltd.

To learn more about Cengage Learning Solutions, visit www.cengage.com. Purchase any of our products at your local college store or at our preferred online store www.cengagebrain.com.

Gardner's Art through the Ages: A Concise Global History, Fourth Edition Fred S. Kleiner

Cover Designer: Cate Rickard Barr Text Designer: tani hasegawa Compositor: Cenveo® Publisher Services Joan Keyes, Dovetail Publishing Services Production Service and Layout: IP Project Manager: Farah J. Fard IP Analyst: Jessica Elias Manufacturing Planner: Julio Esperas Senior Art Director: Cate Rickard Barr Senior Content Project Manager: Lianne Ames Marketing Manager: Jillian Borden Media Developer: Chad Kirchner Product Assistant: Rachael Bailey Associate Content Developer: Erika Hayden Content Developer: Rachel Harbour Product Manager: Sharon Adams Poore Product Director: Monica Eckman

Cover Image: Summer Trees, Heritage Images,

© The British Museum

Printed in the United States of America Print Number: 01 Print Year: 2015

Song Su-Nam, Summer Trees, 1983. Ink on paper, 2' 15" high. British Museum, London.

Song Su-nam (b. 1938), a Korean artist who was one of the founders of the Oriental Ink Movement of the 1980s, has very successfully combined native Asian and Western traditions in his paintings. Song's Summer Trees, painted in 1983, owes a great deal to the Post-Painterly Abstraction movement of mid-20th-century America and to the work of painters such as Helen Frankenthaler (1928–2011) and especially Morris Louis (1912–1962). But in place of those painters' acrylic resin on canvas, Song used ink on paper, the centuries-old preferred medium of East Asian *literati* (scholar-artists). He forsook, however, the traditional emphasis on brushstrokes to explore the subtle tonal variations that broad stretches of ink wash make possible. Nonetheless, the painting's name recalls the landscapes of earlier Korean and Chinese masters. This simultaneous respect for tradition and innovation has been a hallmark of art from both China and Korea throughout their long histories. The fruitful exchange between Western and non-Western artistic traditions is one of the chief characteristics of the global art scene today.

Song's distinctive personal approach to painting characterizes the art of the modern era in general, but it is not typical of many periods of the history of art when artists toiled in anonymity to fulfill the wishes of their patrons, whether Egyptian pharaohs, Roman emperors, or medieval monks. Art through the Ages: A Concise Global History surveys the art of all periods from prehistory to the present, and worldwide, and examines how artworks of all kinds have always reflected the historical contexts in which they were created.

Brief Contents

Romanticism, Realism, and Photography, 1800

to 1870 330

Preface xv **CHAPTER 13** Impressionism, Post-Impressionism, and Symbolism, INTRODUCTION 1870 to 1900 356 What Is Art History? 1 **CHAPTER 14** CHAPTER 1 Modernism in Europe and America, 1900 to Prehistory and the First Civilizations 1945 376 CHAPTER 2 **CHAPTER 15** Ancient Greece 44 Modernism and Postmodernism in Europe and America, 1945 to 1980 410 CHAPTER 3 The Roman Empire 82 CHAPTER 16 Contemporary Art Worldwide 438 CHAPTER 4 Early Christianity and Byzantium 116 **CHAPTER 17** South and Southeast Asia 460 CHAPTER 5 The Islamic World 142 CHAPTER 18 China and Korea 482 CHAPTER 6 Early Medieval and Romanesque Europe 156 CHAPTER 19 CHAPTER 7 Japan 506 Gothic and Late Medieval Europe 186 CHAPTER 20 CHAPTER 8 Native Americas and Oceania 526 The Early Renaissance in Europe 216 CHAPTER 21 CHAPTER 9 Africa 554 High Renaissance and Mannerism in Europe 250 Notes 573 **CHAPTER 10** Glossary 575 Baroque Europe Bibliography 591 **CHAPTER 11** Credits 603 Rococo to Neoclassicism in Europe and America 312 Index 607 CHAPTER 12

Contents

Preface xv

INTRODUCTION

What Is Art History?

Art History in the 21st Century 2

Different Ways of Seeing 13

Prehistory and the First Civilizations 14

FRAMING THE ERA Pictorial Narration in Ancient

Sumer 15

TIMELINE 16

Prehistory 16

Ancient Mesopotamia and Persia 22

Ancient Egypt 30

- PROBLEMS AND SOLUTIONS: How to Represent an Animal 17
- ART AND SOCIETY: Why Is There Art in Paleolithic Caves? 18
- PROBLEMS AND SOLUTIONS: How Many Legs Does a Lamassu Have? 27
- ART AND SOCIETY: Mummification and Immortality 32
- PROBLEMS AND SOLUTIONS: Building the Pyramids of Gizeh 34

MAP 1-1 Stone Age sites in western Europe 16

MAP 1-2 Ancient Mesopotamia and Persia 22

MAP 1-3 Ancient Egypt 30

THE BIG PICTURE 43

2 Ancient Greece 44

FRAMING THE ERA The Perfect Temple 45
TIMELINE 46

The Greeks and Their Gods 46

Prehistoric Aegean 47

Greece 53

- RELIGION AND MYTHOLOGY: The Gods and Goddesses of Mount Olympus 47
- ARCHITECTURAL BASICS: Doric and Ionic Temples 57
- MATERIALS AND TECHNIQUES: Hollow-Casting Life-Size Bronze Statues 64
- PROBLEMS AND SOLUTIONS: Polykleitos's Prescription for the Perfect Statue 65
- MATERIALS AND TECHNIQUES: White-Ground Painting 72

MAP 2-1 The Greek world 46

THE BIG PICTURE 81

The Roman Empire 82

FRAMING THE ERA Roman Art as Historical Fiction 83

TIMELINE 84

Rome, Caput Mundi 84

Etruscan Art 85

Roman Art 88

- ART AND SOCIETY: Who's Who in the Roman World 90
- ARCHITECTURAL BASICS: Roman Concrete Construction 92
- ARCHITECTURAL BASICS: The Roman House 93
- PROBLEMS AND SOLUTIONS: The Spiral Frieze of the Column of Trajan 104
- PROBLEMS AND SOLUTIONS: The Ancient World's Largest Dome 106
- PROBLEMS AND SOLUTIONS: Tetrarchic Portraiture 112

MAP 3-1 The Roman Empire at the death of Trajan in 117 CE 84

THE BIG PICTURE 115

Early Christianity and Byzantium 116

FRAMING THE ERA Romans, Jews,

LIWELINE 118

Early Christianity 118

Byzantium 124

Christian Art 119

■ PROBLEMS AND SOLUTIONS: Picturing the Spiritual

■ ART AND SOCIETY: Icons and Iconoclasm 134

MAP 4-1 The Byzantine Empire at the death of Justinian

811 292 ni

THE BIG PICTURE

The Islamic World

FRAMING THE ERA The Rise and Spread

and Islam 145

Muhammad and Islam

THE BIG PICTURE

Luxury Arts 151

Architecture 144

TIMELINE 144

FRAMING THE ERA The Door to Salvation 157

Early Medieval and Romanesque

ef Islam 143

■ ART AND SOCIETY: Gothic Book Production 199

■ MATERIALS AND TECHNIQUES: Stained-Glass

■ PROBLEMS AND SOLUTIONS: Building a High Gothic

■ MATERIALS AND TECHNIQUES: Fresco Painting 208

Cathedral 193

■ ARCHITECTURAL BASICS: The Gothic Rib Vault 190

Italy 205

Holy Roman Empire 202

261 swodniW

Italy 229

France 224

LIMELINE 218

and Saint Luke 217

THE BIG PICTURE

MAP 7-1 Europe around 1200 188

Holy Roman Empire 226

Burgundy and Flanders 219

The Early Renaissance in Europe 218

FRAMING THE ERA Rogier van der Weyden

The Early Renaissance in Europe

917

England 201

France 189

"Gothic" Europe 188

LIMELINE 188

the Gothic Age 187

FRAMING THE ERA "Modern Architecture" in

Gothic and Late Medieval Europe

THE BIG PICTURE

MAP 6-1 Western Europe around 1100 158

■ THE PATRON'S VOICE: Terrifying the Faithful at Autun 175

Portal 173 ■ ARCHITECTURAL BASICS: The Romanesque Church

Kelics 170

■ ART AND SOCIETY: Pilgrimages and the Veneration of

and Benedictine Rule 165 ■ RELIGION AND MYTHOLOGY: Medieval Monasteries

Words 161 ■ PROBLEMS AND SOLUTIONS: Beautifying God's

141

Square 128

■ PROBLEMS AND SOLUTIONS: Placing a Dome over a

World 125

■ MATERIALS AND TECHNIQUES: Mosaics 124

■ RELIGION AND MYTHOLOGY: The Life of Jesus in Art 120

■ RELIGION AND MYTHOLOGY: Jewish Subjects in

and Christians 117

Romanesque Europe 169 Early Medieval Europe

951

MAP 5-1 The Islamic world around 1500 144

■ ARCHITECTURAL BASICS: The Mosque 147

■ RELIGION AND MYTHOLOGY: Muhammad

LIWELINE 158

Europe

- MATERIALS AND TECHNIQUES: Tempera and Oil Painting 220
- MATERIALS AND TECHNIQUES: Woodcuts, Engravings, and Etchings 228
- PROBLEMS AND SOLUTIONS: Linear and Atmospheric Perspective 232

MAP 8-1 France, the duchy of Burgundy, and the Holy Roman Empire in 1477 218

MAP 8-2 Italy around 1400 229

THE BIG PICTURE 249

High Renaissance and Mannerism in Europe 250

FRAMING THE ERA Michelangelo in the Service of Julius II 251

TIMELINE 252

Italy 252

Holy Roman Empire 272

France 277

The Netherlands 277

Spain 281

■ PROBLEMS AND SOLUTIONS: Rethinking the Basilican Church 264

MAP 9-1 Europe in the early 16th century 252

THE BIG PICTURE 283

Baroque Europe 284

FRAMING THE ERA Baroque Art and Spectacle 285

TIMELINE 286

Europe in the 17th Century 286

Italy 287

Spain 295

Flanders 298

Dutch Republic 300

France 306

England 310

■ PROBLEMS AND SOLUTIONS: Completing Saint Peter's 288

- PROBLEMS AND SOLUTIONS: Rethinking the Church Facade 291
- ARTISTS ON ART: The Letters of Artemisia Gentileschi 294
- PROBLEMS AND SOLUTIONS: How to Make a Ceiling Disappear 295
- PROBLEMS AND SOLUTIONS: Franz Hals's Group Portraits 300
- ARTISTS ON ART: Poussin's Notes for a Treatise on Painting 307

MAP 10-1 Europe in 1648 after the Treaty of Westphalia 286

THE BIG PICTURE 311

Rococo to Neoclassicism in Europe and America 312

FRAMING THE ERA The Enlightenment, Angelica Kauffman, and Neoclassicism 313

TIMELINE 314

A Century of Revolutions 314

Rococo 314

The Enlightenment 316

Neoclassicism 323

- ART AND SOCIETY: Joseph Wright of Derby and the Industrial Revolution 317
- PROBLEMS AND SOLUTIONS: Grand Manner Portraiture 320
- ART AND SOCIETY: The Grand Tour and Veduta Painting 322
- ARTISTS ON ART: Jacques-Louis David on Greek Style and Public Art 324

THE BIG PICTURE 329

Romanticism, Realism, and Photography, 1800 to 1870 330

FRAMING THE ERA The Horror—and Romance—of Death at Sea 331

TIMELINE 332

Art under Napoleon 332

Romanticism 334

Realism 341

Architecture 348

Photography 351

хi

TIMELINE

Global Upheaval and Artistic Revolution

Europe, 1900 to 1920 378

United States, 1900 to 1930

Europe, 1920 to 1945 393

United States and Mexico, 1930 to 1945 668

Architecture 405

■ ARTISTS ON ART: Henri Matisse on Color 379

■ ARTISTS ON ART: Futurist Manifestos 387

■ ART AND SOCIETY: The Armory Show 391

■ WRITTEN SOURCES: André Breton's First Surrealist

■ ART AND SOCIETY: Jacob Lawrence's Migration of Manifesto 395

the Negro 402

MAP 14-1 Europe at the end of World War I 380

THE BIG PICTURE

in Europe and America, 1945 to 1980 410 Modernism and Postmodernism

modernist Architecture FRAMING THE ERA After Modernism: Post-

TIMELINE 412

The Aftermath of World War II 412

Painting, Sculpture, and Photography 412

Architecture and Site-Specific Art 429

Performance and Conceptual Art and New Media

■ ARTISTS ON ART: Jackson Pollock on Action Painting

Painting 417 ■ ARTISTS ON ART: Helen Frankenthaler on Color-Field

■ ART AND SOCIETY: Pop Art and Consumer Culture

■ ARTISTS ON ART: Judy Chicago on The Dinner Party

THE BIG PICTURE 18F

Contemporary Art Worldwide

438

FRAMING THE ERA Art as Sociopolitical

Message 439

TIMELINE 0440

Art Today

■ ART AND SOCIETY: The Romantic Spirit in Art, Music,

and Literature 335

■ ARTISTS ON ART: Delacroix on David and

Neoclassicism 337

■ PROBLEMS AND SOLUTIONS: Unleashing the Emotive

Power of Color 340

■ ARTISTS ON ART: Gustave Courbet on Realism 342

■ MATERIALS AND TECHNIQUES: Lithography 345

■ ART AND SOCIETY: Edmonia Lewis, an African American

Sculptor in Rome 347

■ PROBLEMS AND SOLUTIONS: Prefabricated

Architecture 350

■ MATERIALS AND TECHNIQUES: Daguerreotypes,

Calotypes, and Wet-Plate Photography 352

MAP 12-1 Europe around 1850 332

THE BIG PICTURE

and Symbolism, 1870 to 1900 Impressionism, Post-Impressionism,

FRAMING THE ERA Modernism at the Folies-

Bergère 357

LIMELINE 358

Marxism, Darwinism, Modernism 358

1mpressionism 360

Post-Impressionism 364

078 msilodmy2

Sculpture 372

Architecture 373

■ PROBLEMS AND SOLUTIONS: Painting Impressions

of Light and Color 359

Solid and Enduring 369

■ ART AND SOCIETY: Women Impressionists 363

■ ARTISTS ON ART: The Letters of Vincent van Gogh 366

■ PROBLEMS AND SOLUTIONS: Making Impressionism

MAP 13-1 France around 1870 with towns along the Seine 358

THE BIG PICTURE

Modernism in Europe and America,

St61 01 0061

Pictorial Tradition 377 FRAMING THE ERA Picasso Disrupts the Western Personal and Group Identity 440

Political and Social Commentary 445

Representation and Abstraction 448

Architecture and Site-Specific Art 451

New Media 456

- ART AND SOCIETY: Public Funding of Controversial Art 443
- PROBLEMS AND SOLUTIONS: Rethinking the Shape of Painting 450
- ART AND SOCIETY: Maya Lin's Vietnam Veterans Memorial 454
- ART AND SOCIETY: Richard Serra's Tilted Arc 455

THE BIG PICTURE 459

South and Southeast Asia 460

FRAMING THE ERA The Great Stupa at Sanchi 461

TIMELINE 462

South Asia 462

Southeast Asia 477

- ARCHITECTURAL BASICS: The Stupa 465
- RELIGION AND MYTHOLOGY: Buddhism and Buddhist Iconography 466
- RELIGION AND MYTHOLOGY: Hinduism and Hindu Iconography 469
- ARCHITECTURAL BASICS: Hindu Temples 471
- MATERIALS AND TECHNIQUES: Indian Miniature Painting 474

MAP 17-1 South and Southeast Asia 462

THE BIG PICTURE 481

18 China and Korea 482

FRAMING THE ERA The Forbidden City 483
TIMELINE 484

China 484

Korea 501

- ART AND SOCIETY: The First Emperor's Army in the Afterlife 486
- RELIGION AND MYTHOLOGY: Daoism and Confucianism 488

- MATERIALS AND TECHNIQUES: Chinese Painting Materials and Formats 491
- MATERIALS AND TECHNIQUES: Calligraphy and Inscriptions on Chinese Paintings 493
- ARCHITECTURAL BASICS: Chinese Wood Construction 494
- MATERIALS AND TECHNIQUES: Chinese Porcelain 497
- PROBLEMS AND SOLUTIONS: Planning an Unplanned Garden 498

MAP 18-1 China during the Ming dynasty 484

THE BIG PICTURE 505

19 **Japan** 506

FRAMING THE ERA The Floating World of Edo 507

TIMELINE 508

Japan before Buddhism 508

Buddhist Japan 509

Japan under the Shoguns 513

Modern Japan 523

- RELIGION AND MYTHOLOGY: Zen Buddhism 515
- ART AND SOCIETY: The Japanese Tea Ceremony 518
- MATERIALS AND TECHNIQUES: Japanese Woodblock Prints 522

MAP 19-1 Japan 508

THE BIG PICTURE 525

Native Americas and Oceania 526

FRAMING THE ERA War and Human Sacrifice in Ancient Mexico 527

TIMELINE 528

Native Americas 528

Oceania 546

- ART AND SOCIETY: The Mesoamerican Ball Game 532
- PROBLEMS AND SOLUTIONS: The Underworld, the Sun, and Mesoamerican Pyramid Design 534
- RELIGION AND MYTHOLOGY: Aztec Religion 537
- ART AND SOCIETY: Nasca Lines 539
- ART AND SOCIETY: Tattoo in Polynesia 549

MAP 20-1 Mesoamerica 528

xiii

20th Century 566

THE BIG PICTURE

MAP 21-1 Africa 556

ILS

■ ART AND SOCIETY: African Artists and Apprentices 567

■ ART AND SOCIETY: Art and Leadership in Africa 559

■ ART AND SOCIETY: African Masquerades 568

MAP 20-2 Andean South America 538

southern Canada 542 MAP 20-3 Native American sites in the United States and

MAP 20-4 Oceania 547

THE BIG PICTURE

Africa

Prehistory and Early Cultures 557

Motes 573

Glossary 575

Bibliography 591

Credits 603

700 xəbnl

FRAMING THE ERA The Royal Arts of Benin 555

LIMELINE 226

African Peoples and Art Forms 556

11th to 18th Centuries 558

19th Century 562

Preface

I take great pleasure in introducing the extensively revised and expanded 4th edition of *Gardner's Art through the Ages: A Concise Global History*, which for the first time is, like the unabridged 15th edition published last year, a hybrid textbook—the only introductory survey of the history of art and architecture of its kind. This innovative new type of "Gardner" retains all of the best features of traditional books on paper while harnessing 21st-century technology to increase the number of works and themes discussed without enlarging the size of the printed book—and at negligible additional cost to the reader.

When Helen Gardner published the first edition of *Art through the Ages* in 1926, she could not have imagined that nearly a century later instructors all over the world would still be using her textbook in their classrooms. (The book has even been translated into Mandarin Chinese.) Nor could Professor Gardner have foreseen that a new publisher would make her text available in special editions corresponding to a wide variety of introductory art history courses ranging from yearlong global surveys to Western- and non-Western-only surveys to the one-semester course for which this concise edition was designed. Indeed, if Helen Gardner were alive today, she would not recognize the book that long ago became—and remains—the world's most widely read introduction to the history of art and architecture. I hope that instructors and students alike will agree that this new edition lives up to that venerable tradition and, in fact, exceeds their high expectations.

KEY FEATURES OF THE 4TH EDITION

For the 4th concise edition of Art through the Ages, in addition to updating the text of every chapter to incorporate the latest research, I have added several important new features while retaining the basic format and scope of the previous edition. The new edition boasts more photographs, plans, and drawings than the previous three versions of the book, nearly all in color and reproduced according to the highest standards of clarity and color fidelity. The illustrations include a new set of maps and scores of new images, among them a series of superb photographs taken by Jonathan Poore exclusively for Art through the Ages in Germany and Italy (following similar forays into France and Italy in 2009–2011). The online MindTap® component also includes custom videos made by Sharon Adams Poore during those five photo campaigns. This extraordinary new archive of visual material ranges from ancient temples in Rome; to medieval, Renaissance, and Baroque churches in France, Germany, and Italy; to such modern masterpieces as Notre-Dame-du-Haut in Ronchamp, France, and the Bauhaus in Dessau, Germany. The 4th edition also features an expanded number of the highly acclaimed architectural drawings of John Burge. Together, these exclusive photographs, videos, maps, and drawings provide readers with a visual feast unavailable anywhere else.

Once again, scales accompany the photograph of every painting, statue, or other artwork discussed—another distinctive feature

of the Gardner text. The scales provide students with a quick and effective way to visualize how big or small a given artwork is and its relative size compared with other objects in the same chapter and throughout the book—especially important given that the illustrated works vary in size from tiny to colossal.

Also retained in this edition are the Quick-Review Captions (brief synopses of the most significant aspects of each artwork or building illustrated) that students have found invaluable when preparing for examinations. These extended captions accompany not only every image in the printed book but also all the digital images in the MindTap version of the text. Each chapter also again ends with the highly popular full-page feature called *The Big Picture*, which sets forth in bullet-point format the most important characteristics of each period or artistic movement discussed in the chapter. Also retained from the third edition are the timelines summarizing the major artistic and architectural developments during the era treated (again in bullet-point format for easy review) and the chapter-opening essays called *Framing the Era* discussing a characteristic painting, sculpture, or building and illustrated by four photographs.

Boxed essays on special topics again appear throughout the book as well. These essays fall under eight broad categories, three of which are new to the fourth edition:

Architectural Basics boxes provide students with a sound foundation for the understanding of architecture. These discussions are concise explanations, with drawings and diagrams, of the major aspects of design and construction. The information included is essential to an understanding of architectural technology and terminology.

Materials and Techniques essays explain the various media that artists have employed from prehistoric to modern times. Since materials and techniques often influence the character of artworks, these discussions contain important information on why many monuments appear as they do.

Religion and Mythology boxes introduce students to the principal elements of the world's great religions, past and present, and to the representation of religious and mythological themes in painting and sculpture of all periods and places. These discussions of belief systems and iconography give readers a richer understanding of some of the greatest artworks ever created.

Art and Society essays treat the historical, social, political, cultural, and religious context of art and architecture. In some instances, specific monuments are the basis for a discussion of broader themes.

In the *Artists on Art* boxes, artists and architects throughout history discuss both their theories and individual works.

New to the 4th edition are three new categories of boxed essays: Written Sources, The Patron's Voice, and Problems and Solutions. The first category presents and discusses key historical documents illuminating major monuments of art and architecture throughout the world. The passages quoted permit voices from the past to speak directly to the reader, providing vivid insights into the creation of artworks in all media. The Patron's Voice essays underscore the important

James M. Saslow, Queens College, City University of New York; South Bend; Bridget Sandhoff, University of Nebraska at Omaha; University of Rhode Island; Andrea Rusnock, Indiana University Romita Ray, Syracuse University; Wendy Wassyng Roworth, The University of Delaware; Holly Pittman, University of Pennsylvania; liam H. Peck, University of Michigan-Dearborn; Lauren Peterson, University; Allison Lee Palmer, The University of Oklahoma; Wilerine Pagani, The University of Alabama; Anna Pagnucci, Ashtord University; Micheline Nilsen, Indiana University South Bend; Cath-Petersburg College-Seminole; Johanna D. Movassat, San Jose State Nicolas Morrissey, The University of Georgia; Basil Moutsatsos, St. University; Erin Morris, Estrella Mountain Community College; McNaughton, Indiana University Bloomington; Mary Miller, Yale Jennifer Ann McLerran, Northern Arizona University; Patrick R. University of Iowa; Susan McCombs, Michigan State University; Buckingham Browne & Nichols School; Brenda Longfellow, The sity of New York; Nancy Lee-Jones, Endicott College; Rob Leith, County College; Paul H.D. Kaplan, Purchase College, State Universon, The University of Texas at San Antonio; Molly Johnson, Ocean of Iowa; Hiroko Johnson, San Diego State University; Julie John-Ho, George Mason University; Julie Hochstrasser, The University versity of Denver; Shannen Hill, University of Maryland; Angela K. Glazer, Nazareth College of Rochester; Annabeth Headrick, Uni-Pacific University; Maria Gindhart, Georgia State University; Tracie College; Verena Drake, Hotchkiss School; Jerome Feldman, Hawai'i Auburn University; Scott Douglass, Chattanooga State Community ida; Thomas B. F. Cummins, Harvard University; Joyce De Vries, The University of Kansas; Gina Cestaro, University of West Flor-Susan H. Caldwell, The University of Oklahoma; David C. Catetoris, Amy R. Bloch, University at Albany, State University of New York; North Texas; Nicole Bensoussan, University of Michigan-Dearborn; Fort Wayne; Paul Bahn, Hull; Denise Amy Baxter, University of der; Jenny Kirsten Ataoguz, Indiana University-Purdue University Jose State University; Kirk Ambrose, University of Colorado Bouledition on which the shorter version is based: Patricia Albers, San tributions to the 4th concise edition and to the unabridged 15th in acknowledging here those individuals who made important conreputation for accuracy as well as readability. I take great pleasure the Ages in order to ensure that the text lives up to the Gardner than a hundred art historians to review every chapter of Art through art. As with previous editions, Cengage Learning has enlisted more or completed without the counsel of experts in all areas of world A work as extensive as a global history of art could not be undertaken

ACKNOWLEDGMENTS

enumerated on page xxi.

location. The host of state-of-the-art MindTap online resources are housed online only, listing all illustrated artworks by their present text and MindTap essays; and a complete museum index, now ing definitions of all italicized terms introduced in both the printed the (updated) bibliography of books in English; a glossary contain-Other noteworthy features retained from the 3rd edition are

fronted, and the solutions that they devised to resolve them. developed, the problems that painters, sculptors, and architects conent. These essays address questions of how and why various forms painting, sculpture, and building from the Old Stone Age to the presthink critically about the decisions that went into the making of every The new Problems and Solutions boxes are designed to make students of the artworks and buildings that they commissioned and paid for. roles that individuals and groups played in determining the character

in 1975, especially my research assistant, Angelica Bradley, From of teaching fellows in my art history courses since I began teaching at Boston University and to the thousands of students and the scores acknowledgments with an expression of gratitude to my colleagues of Western art. I conclude this long (but no doubt incomplete) list of my own, especially with regard to the later chapters on the history but the history of art in general. Her thinking continues to influence had innumerable conversations not only about Art through the Ages Mamiya of the University of Nebraska-Lincoln, with whom I have former co-author and longtime friend and colleague, Christin J. publishing and whose continuing friendship I value highly, and my distinguished career, from whom I learned much about textbook Baxter, who retired from Cengage in 2013 at the end of a long and with this book but who loomed large in my life for many years: Clark I also owe thanks to two individuals not currently associated

Burge, for their superb photos and architectural drawings. Lidrbauch, art log preparer; and, of course, Jonathan Poore and John vices; Jay and John Crowley, Jay's Publishing Services; Mary Ann Indexer; PreMediaGlobal, photo researchers; Cenveo Publisher Ser-Michele Jones, copy editor; Susan Gall, proofreader; Pat Rimmer, entire production process, Joan Keyes, Dovetail Publishing Services; utors to the 4th concise edition: the incomparable quarterback of the

I am also deeply grateful to the following out-of-house contribthe hundreds of instructors they speak to daily.

nationwide who have passed on to me the welcome advice offered by I owe my gratitude to the incomparable group of learning consultants tion of the new e-reader featured in this edition's MindTap. Finally, fully here, who had a hand in the design, creation, and implementadeveloper; and the entire team of professionals, too numerous to list Erika Hayden, associate content developer; Chad Kirchner, content Borden, marketing manager; Rachel Harbour, content developer; Cate Barr, senior art director and cover designer of this edition; Jillian content project manager; Rachael Bailey, senior product assistant; manager (as well as videographer extraordinaire); Lianne Ames, senior dedicated professionals, especially Sharon Adams Poore, product no small part on the expertise and unflagging commitment of these cess of the Gardner series in all of its various permutations depends in two decades and feel privileged to count among my friends. The suc-Some of them I have now worked with on various projects for nearly with the editing, production, and distribution of Art through the Ages. to the extraordinary group of people at Cengage Learning involved I am also happy to have this opportunity to express my gratitude

us better understand your needs in our print and digital products. in surveys, focus groups, design sprints, and advisory boards to help thank the more than 150 instructors and students who participated and Camille Serchuk, Southern Connecticut State University. I also Nebraska Omaha; Erika Schneider, Framingham State University; nan, Portland State University; Amy M. Morris, The University of (retired), The University of Alabama at Birmingham; Anne McClaper, Southern Illinois University Edwardsville; Patricia D. Cosper instructor and student materials for the 4th edition: Ivy Coo-I am especially indebted to the following for creating the

versity; and Benjamin C. Withers, University of Kentucky. Waugh, University of Tennessee; Gregory H. Williams, Boston Uni-Austin; Ying Wang, University of Wisconsin-Milwaukee; Lindsey Community College; Louis A. Waldman, The University of Texas at Venit, University of Maryland; Shirley Tokash Verrico, Genesee University; Lee Ann Turner, Boise State University; Marjorie S. Timmermann, University of Michigan; David Turley, Weber State versity of Missouri; Suzanne Thomas, Rose State College; Achim James Slauson, Carroll University; Anne Rudolph Stanton, Unithem I have learned much that has helped determine the form and content of *Art through the Ages* and made it a much better book than it otherwise might have been.

Fred S. Kleiner

CHAPTER-BY-CHAPTER CHANGES IN THE FOURTH EDITION

All chapters include changes in the text reflecting new research and discoveries, new maps, revised timelines and The Big Picture, and online bonus images, essays, videos, and other features included within the MindTap version of the text, an integral part of the complete learning package for this 4th edition of *Art through the Ages: A Concise Global History*.

A chapter-by-chapter enumeration of the most important revisions follows.

Introduction: What Is Art History?: New chapter-opening illustration of Claude Lorrain's *Embarkation of the Queen of Sheba* with new details. Added 18th-century Benin altar to the hand.

- 1: Prehistory and the First Civilizations: New Framing the Era essay "Pictorial Narration in Ancient Sumer." New Problems and Solutions boxes "How to Represent an Animal" and "How Many Legs Does a Lamassu Have?" Added the Apollo 11 Cave in Namibia, the head of Inanna from Uruk, the seated scribe from Saqqara, and the *Judgment of Hunefer*. New photographs of the *Warka Vase*, Stonehenge, the lamassu from the citadel of Sargon II, a model of the Gizeh pyramids, the Great Sphinx and pyramid of Khafre, and the temple of Amen-Re at Karnak.
- **2: Ancient Greece:** New Art and Society box "Archaeology, Art History, and the Art Market." New Problems and Solutions box "Polykleitos's Prescription for the Perfect Statue." New Materials and Techniques box "White-Ground Painting." New Architectural Basics box "The Corinthian Capital." Added the calf bearer from the Athenian Acropolis, the *Charioteer of Delphi*, the *Massacre of the Niobids* by the Niobid Painter, the tholos at Delphi, and the Hellenistic bronze boxer. New photographs of the Parthenon (general view, Doric columns, and the cavalcade and seated gods of the frieze), the Lion Gate and exterior and interior of the Treasury of Atreus at Mycenae, the Erechtheion and Temple of Athena Nike on the Athenian Acropolis, the theater at Epidauros, and the *Barberini Faun*. New reconstruction drawing of the palace at Knossos.
- 3: The Roman Empire: New Framing the Era essay "Roman Art as Historical Fiction." New Art and Society boxes "The 'Audacity' of Etruscan Women" and "Spectacles in the Colosseum." New Written Sources box "Vitruvius's Ten Books on Architecture." New Problems and Solutions boxes "The Spiral Frieze of the Column of Trajan," "The Ancient World's Largest Dome," and "Tetrarchic Portraiture." Added Apotheosis of Antoninus Pius, Banditaccia necropolis tumuli, the Maison Carrée at Nîmes, and third-century sarcophagus of a philosopher. New photographs of the Tomb of the Leopards at Tarquinia, the Tomb of the Reliefs at Cerveteri, the brawl in the Pompeii amphitheater, the Third Style cubiculum from Boscotrecase, and, in Rome, the Ara Pacis Augustae, the facade of the Colosseum, the Arch of Titus (general view and two reliefs), the Column of Trajan (general view and three details), the interior of the Markets of Trajan, the exterior of the Pantheon, the colossal portrait head of Constantine, the Basilica Nova, and the Arch of Constantine (general view and Constantinian frieze).

- 4: Early Christianity and Byzantium: New Religion and Mythology box "Jewish Subjects in Christian Art." New Art and Society box "Medieval Books." New Problems and Solutions boxes "Picturing the Spiritual World" and "Placing a Dome over a Square." Added an Early Christian statuette of the Good Shepherd, and images of Santa Sabina in Rome and of the *Rabbula Gospels*. New photographs of Santa Costanza in Rome, of Hagia Sophia in Constantinople, and of the Katholikon at Hosios Loukas.
- **5: The Islamic World:** New Art and Society box "Major Muslim Dynasties." Added the ivory pyxis of al-Mughira, the *Baptistère de Saint Louis*, and Sultan-Muhammad's *Court of Gayumars*. New photographs of the exterior and interior of the Dome of the Rock in Jerusalem and the Great Mosque at Kairouan.
- 6: Early Medieval and Romanesque Europe: New Framing the Era essay "The Door to Salvation." New Problems and Solutions box "Beautifying God's Words." New The Patron's Voice box "Terrifying the Faithful at Autun." New Written Sources boxes "The Burning of Canterbury Cathedral" and "Bernard of Clairvaux on Cloister Sculpture." New Religion and Mythology box "The Crusades." Added two Merovingian looped fibulae, the abbey church at Corvey, the Gospel Book of Otto III, and the Morgan Madonna. New photographs of the Palatine Chapel at Aachen and the south portal and cloister of Saint-Pierre at Moissac, and a new restored cutaway view of the Aachen chapel.
- 7: Gothic and Late Medieval Europe: New Framing the Era essay "Modern Architecture' in the Gothic Age." New Art and Society boxes "Paris, the New Center of Medieval Learning" and "Gothic Book Production." New The Patron's Voice boxes "Abbot Suger and the Rebuilding of Saint-Denis" and "Artists' Guilds, Artistic Commissions, and Artists' Contracts." Added Nicholas of Verdun's Shrine of the Three Kings, Pietro Cavallini's Last Jugdment, and the Doge's Palace, Venice. New photographs or drawings of Gothic rib vaults, the facade and rose window of Reims Cathedral, plan and elevation of Chartres Cathedral, elevation of Amiens Cathedral, aerial view and interior of Salisbury Cathedral, Death of the Virgin tympanum of Strasbourg Cathedral, the Naumburg Master's Ekkehard and Uta, and the Pisa baptistery pulpit by Nicola Pisano.
- 8: The Early Renaissance in Europe: New Framing the Era essay "Rogier van der Weyden and Saint Luke." New Art and Society box "The Artist's Profession during the Renaissance." New Written Sources box "The Commentarii of Lorenzo Ghiberti." New Artists on Art box "Leon Battista Alberti's On the Art of Building." Added Memling's diptych of Martin van Nieuwenhove, the Buxheim Saint Christopher, Brunelleschi's San Lorenzo and Pazzi Chapel, and Alberti's Palazzo Rucellai. New photographs of Riemenschneider's Creglingen Altarpiece and Donatello's Gattamelata.
- 9: High Renaissance and Mannerism in Europe: New Framing the Era essay "Michelangelo in the Service of Julius II." New Artists on Art box "Leonardo and Michelangelo on Painting versus Sculpture." New Written Sources box "Giorgio Vasari's Lives." New The Patron's Voice box "The Council of Trent." New Problems and Solutions box "Rethinking the Basilican Church." New Religion and Mythology box "Catholic versus Protestant Views of Salvation." Added Michelangelo's Fall of Man, the facade and plan of Il Gesú in Rome, Giulio Romano's Fall of the Giants from Mount Olympus, and Lucas Cranach the Elder's Law and Gospel. New photographs of the Sistine Chapel and Bramante's Tempietto in Rome.
- **10: Baroque Europe:** New Problems and Solutions boxes "Completing Saint Peter's," "Rethinking the Church Facade," "How to

No. 2, Schnabel's The Walk Home, Song's Summer Trees, Murray's Can You Hear Me?, Anatsui's Bleeding Takari II, Behnisch's Hysolar Institute in Stuttgart, Hadid's Signature Towers project in Dubai, Serra's Tilted Arc, Kapoor's Cloud Gate, and Suh's Bridging Home. New Artists on Art box "Shirin Neshat on Iran after the Revolution." New Problems and Solutions box "Rethinking the Shape of Painting." New Art and Solutions box "Rethinking the Shape of Painting." New Art and Society box "Richard Serra's Tilted Arc." New photographs of Christo and Jeanne-Claude's Surrounded Islands and Gehry's Guggenheim Museo in Bilbao.

I7: South and Southeast Asia: New Framing the Era essay "The Great Stupa at Sanchi." New The Patron's Voice box "Ashoka's Sponsorship of Buddhism." New Materials and Techniques box "Indian Miniature Painting." New Written Sources box "Abd al-Hamid Lahori on the Taj Puram relief of Durga slaying Mahisha, Shiva as Nataraja from Tamilaburam relief of Durga slaying Mahisha, Shiva as Nataraja from Tamil Nadu, and the Bayon temple and towers at Angkor. New photographs of the Great Stupa at Sanchi and its east torana; Bodhisattva Padmapani in Ajanta cave I; the Vishnu Temple at Deogarh and its Ananta panel; the Vishvanatha Temple at Khajuraho and its mithuna reliefs; and the pietra dura stonework of the Taj Mahal.

18: China and Korea: New Materials and Techniques boxes "Chinese Jade," "Silk and the Silk Road," and "Chinese Porcelain." New Art and Society box "The First Emperor's Army in the Afterlife." New Artists on Art box "Xie He's Six Canons." New Problems and Solutions box "Planning an Unplanned Garden." Added Eastern Zhou bi disk; Lingering Garden, Suzhou; Shang Xi's Guan Yu Captures General Pang De; Ming lacquered table with drawers; Shitao's Riding the Clouds; and Jeong Seon's Geumgangsan Mountains. New photothe Clouds; and Jeong Seon's Geumgangsan Mountains. New photothe Clouds; and Jeong Seon's Grumgangsan Mountains. New photothe Clouds; and Jeong Seor's Grumgangsan Mountains and Streams; the Yuan David Vases; the Garden of the Master of the Fishing Nets, Suzhou; Ye Yushan's Rent Gallection Courtyard; and the Buddhist cave temple at Seokguram.

19: Japan: New Framing the Era essay "The Floating World of Edo." New Meligion and Mythology box "Shinto." New Written Sources box "Woman Writers and Calligraphers at the Heian Imperial Court." New Art and Society box "The Japanese Tea Ceremony." Added the honden of the Ise Jingu in Ise, the Daibutsuden and Unkei's Agyo of Todaiji in Nara, the karesansui garden of Ryoanji in Kyoto, and the White Heron Castle of Himeji. New photographs of the Phoenix Hall at Uji, a tea ceremony Kogan in Cleveland, and a large plate by Hamada Shoji.

20: Native Americas and Oceania: New Framing the Era essay "War and Human Sacrifice in Ancient Mexico." New Problems and Solutions box "The Underworld, the Sun, and Mesoamerican Pyramid Design." New Art and Society box "Nasca Lines." New general view and details of the watercolor copy of the Lord Chan Muwan mural tobe as well as a new section on Oceania, including the Ambum Stone, the mosi of Rapa Mui, a Chuuk prow ornament, the Hawaiian Gather cloak of Kamehameha III, an engraving of a tattooed Marteather cloak of Kamehameha III, an engraving of a tattooed Marquesan warrior, the Maori Mataatua meeting house, a Rarotonga quesan warrior, the Maori Mataatua meeting house, a Rarotonga staff god, an Australian Dreaming bark painting, a New Ireland malanggan mask, and an Art and Society box "Tattoo in Polynesia."

21: Africa: New Framing the Era essay "The Royal Arts of Benin." New Art and Society box "African Artists and Apprentices." Added the Tassili n'Ajjer rock painting of a running woman, a I6th-century brass plaque portraying a Benin king on horseback, a Fang bieri reliquary figure, the Kuba ndop portrait of King Shyaam aMbul aNgoong, and a Baga d'mba mask.

Make a Ceiling Disappear," and "Frans Hals's Group Portraits." Added Bernini's Apollo and Daphne, Gentileschi's Judith Slaying Holofernes, Gaulli's Triumph of the Name of Jesus, Vermeer's Woman Holding a Balance, and Girardon and Regnaudin's Apollo Attended by the Nymphs of Thetis. New photographs of Saint Peter's, Bernini's Ecstasy of Saint Teresa, Borromini's San Carlo alle Quattro Fontane (exterior and dome), and Rembrandt's Night Watch.

II: Rococo to Neoclassicism in Europe and America: New Framing the Era essay "The Enlightenment, Angelica Kauffman, and Meoclassicism." New Written Sources box "Femmes Savantes and Rococo Salon Culture." New Art and Society boxes "Joseph Wright of Derby and the Industrial Revolution" and "Vigée-Lebrun, Labille-Guiard, and the French Royal Academy." New Problems and Solutions box "Grand Manner Portraiture." New The Patron's Voice box "Thomas Jefferson, Patron and Practitioner." Added Labillebox "Thomas Jefferson, Patron and Practitioner." Added Labillebox and "Thomas Jefferson, Patron and Practitioner." Added Labillebox "Thomas Jefferson, Patron and Practitioner." Added Labillebox "Thomas Jefferson, Patron and Practitioner." Added Labillebox "Thomas Jefferson, Patron and Jefferson's Monticello.

12: Romanticism, Realism, and Photography, 1800 to 1870: New Framing the Era essay "The Horror—and Romance—of Death at Sea." New Problems and Solutions boxes "Unleashing the Emotive Power of Color" and "Prefabricated Architecture." New Artists and Society box "Edmonia Lewis, an African American Sculptor in Rome." Added Vignon's La Madeleine in Paris, Daumier's Nadar in Rome." Added Vignon's La Madeleine in Paris, Daumier's Nadar Raising Photography to the Height of Art, and Muybridge's Horse Galloping. New photographs of Daumier's Rue Transnonain and the Houses of Parliament, London.

13: Impressionism, Post-Impressionism, and Symbolism, 1870 to 1900: New Framing the Era essay "Modernism at the Folies-Bergère:" New Problems and Solutions boxes "Painting Impressions of Light and Color" and "Making Impressionism Solid and Enduring." New Art and Society box "Women Impressionists." Added Manet's A Bar at the Folies-Bergère and Claude Monet in His Studio Boat, Monet's Saint-Lazare Train Station, Morisot's Summer's Day, Rodin's Burghers of Calais, Gaudi's Casa Milà in Barcelona, and Sullivan's Carson, Pirie, Scott Building in Chicago. New photographs of Livan's Eiffel Tower and a detail of Seurat's A Sunday on La Grande Jatte.

14: Modernism in Europe and America, 1900 to 1945: New Framing the Era essay "Picasso Disrupts the Western Pictorial Tradition." New Art and Society boxes "The Armory Show" and "Jacob Lawrence's Migration of the Negro." New Written Sources box "André Breton's First Surrealist Manifesto." New Written Sources box "André Léger's The City, Dove's Nature Symbolized No. 2, Lam's The Jungle, Moore's Reclining Figure, and Orozco's Hispano-America 16. New photograph of the Bauhaus, Dessau.

15: Modernism and Postmodernism in Europe and America, 1945 to 1980: New Framing the Era essay "After Modernism: Postmodernist Architecture." New Artists on Art boxes "David Smith on Outdoor Sculpture," "Roy Lichtenstein on Pop Art and Comic Books," and "Chuck Close on Photorealist Portrait Painting." Added Moore's Piazza d'Italia, Krasner's The Seasons, Noguchi's Shodo Shima Stone Study, Warhol's Marilyn Diptych, Freud's Maked Portrait, and White's Moencopi Strafa. New photographs of the interior of Le Corbusier's Notre-Dame-du-Haut and of Graves's Portland Building. Corbusier's Notre-Dame-du-Haut and of Graves's Portland Building.

16: Contemporary Art Worldwide: Major reorganization and expansion of the text with the addition of many new artists, architects, artworks, and buildings: Burtynsky's Densified Scrap Metal #3A, Rosler's Gladiators, Botero's Abu Ghraib 46, Zhang's Big Family

ABOUT THE AUTHOR

Fred S. Kleiner

FRED S. KLEINER (Ph.D., Columbia University) has been the author or coauthor of *Gardner's Art through the Ages* beginning with the 10th edition in 1995. He has also published more than a hundred books, articles, and reviews on Greek and Roman art and architecture, including *A History of Roman Art*, also published by Cengage Learning. Both *Art through the Ages* and the book on Roman art have been awarded Texty prizes as the outstanding college textbook of the year in the humanities and social sciences, in 2001 and 2007, respectively. Professor Kleiner has taught the art history survey course since 1975, first at the University of Virginia and, since 1978, at Boston University, where he is currently professor of the history of art and architecture and classical archaeology and has served as department chair for five terms, most recently from 2005 to 2014. From 1985 to 1998, he was editor-in-chief of the *American Journal of Archaeology*.

Long acclaimed for his inspiring lectures and devotion to students, Professor Kleiner won Boston University's Metcalf Award for Excellence in Teaching as well as the College Prize for Undergraduate Advising in the Humanities in 2002, and he is a two-time winner of the Distinguished Teaching Prize in the College of Arts & Sciences Honors Program. In 2007, he was elected a Fellow of the Society of Antiquaries of London, and, in 2009, in recognition of lifetime achievement in publication and teaching, a Fellow of the Text and Academic Authors Association.

Also by Fred Kleiner: A History of Roman Art, Enhanced Edition (Wadsworth/Cengage Learning 2010; ISBN 9780495909873), winner of the 2007 Texty Prize for a new college textbook in the humanities and social sciences. In this authoritative and lavishly illustrated volume, Professor Kleiner traces the development of Roman art and architecture from Romulus's foundation of Rome in the eighth century bee to the death of Constantine in the fourth century ce, with special chapters devoted to Pompeii and Herculaneum, Ostia, funerary and provincial art and architecture, and the earliest Christian art. The enhanced edition also includes a new introductory chapter on the art and architecture of the Etruscans and of the Greeks of South Italy and Sicily.

Resources

FOR FACULTY

MindTap® for Instructors

Leverage the tools in MindTap for *Gardner's Art through the Ages: A Concise Global History*, 4th edition, to enhance and personalize your course. Add your own images, videos, web links, readings, projects, and more either in the course Learning Path or right in the chapter reading. Set project due dates, specify whether assignments are for practice or a grade, and control when your students see these activities in their Learning Path. MindTap can be purchased as a stand-alone product or bundled with the print text. Connect with your Learning Consultant for more details via www.cengage.com/repfinder/.

Instructor Companion Site

Access the Instructor Companion Website to find resources to help you teach your course and engage your students. Here you will find the Instructor's Manual; Cengage Learning Testing, powered by Cognero; and Microsoft PowerPoint slides with lecture outlines and images that can be used as offered or customized by importing personal lecture slides or other material.

Digital Image library

Display digital images in the classroom with this powerful tool. This one-stop lecture and class presentation resource makes it easy to assemble, edit, and present customized lectures for your course. Available on flash drive, the Digital Image Library provides high-resolution images (maps, diagrams, and the fine art images from the text) for lecture presentations and allows you to easily add your own images to supplement those provided. A zoom feature allows you to magnify selected portions of an image for more detailed display in class, or you can display images side-by-side for comparison.

Google EarthTM

Take your students on a virtual tour of art through the ages! Resources for the 4th edition include Google Earth coordinates for all works, monuments, and sites featured in the text, enabling students to make geographical connections between places and sites. Use these coordinates to start your lectures with a virtual journey to locations all over the globe, or take aerial screenshots of important sites to incorporate in your lecture materials.

FOR STUDENTS

MindTap for Art through the Ages

MindTap for *Gardner's Art through the Ages: A Concise Global History*, 4th edition, helps you engage with your course content and achieve greater comprehension. Highly personalized and fully online, the MindTap learning platform presents authoritative Cengage Learning content, assignments, and services offering you a tailored presentation of course curriculum created by your instructor.

MindTap guides you through the course curriculum via an innovative Learning Path Navigator where you will complete reading assignments, annotate your readings, complete homework, and engage with quizzes and assessments. This new edition features a two-pane e-reader, designed to make your online reading experience easier. Images discussed in the text appear in the left pane, while the accompanying text scrolls on the right. Highly accessible and interactive, this new e-reader pairs videos, Google Map links, and 360-degree panoramas with the matching figure in the text. Artworks are further brought to life through zoom capability right in the e-reader. Numerous study tools are included, such as image flashcards; glossary complete with an audio pronunciation guide; downloadable Image Guide (a note taking template with all chapter images); and the ability to synchronize your eBook notes with your personal EverNote account.

New Flashcard App

The new and improved Flashcard App in MindTap gives you more flexibility and features than ever before. Study from the preexisting card decks with all the images from the text, or create your own cards with new images from your collection or those shared by your instructor. Create your own custom study deck by combining cards from separate chapters or those you've created. Once you've compiled your flashcard deck, you can save it for later use or print it for on-the-go studying.

GARDNER'S

ART THROUGH THE AGES

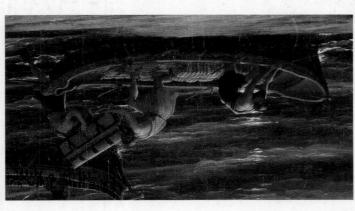

 \blacktriangle I-1b Why is the small boat in the foreground much larger than the sailing ship in the distance? What devices did Western artists develop to produce the illusion of deep space in a two-dimensional painting?

■ I-1a Among the questions art historians ask is why artists chose the subjects they represented. Why would a 17th-century French painter set a biblical story in a confemporary harbor with a Roman ruin?

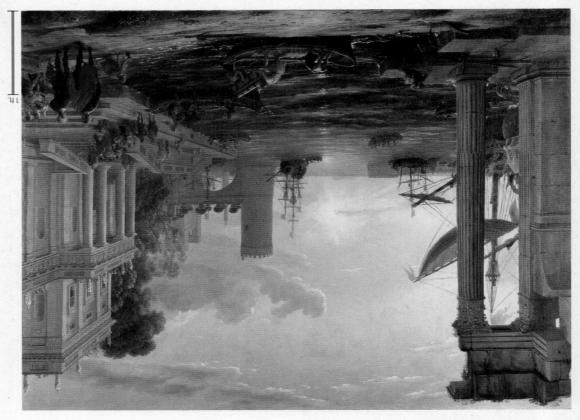

CLAUDE LORRAIN, Embarkation of the Queen of Sheba, 1648. Oil on canvas, 4' $10'' \times 6$ ' 4". National Gallery, London.

► I-1c Why does the large port building at the right edge of this painting seem normal to the eye when the top and bottom of the structure are not parallel horizontal lines, as they are in a real building?

What Is Art History?

What is art history? Except when referring to the modern academic discipline, people do not often juxtapose the words *art* and *history*. They tend to think of history as the record and interpretation of past human actions, particularly social and political events. In contrast, most think of art, quite correctly, as part of the present—as something that people can see and touch. Of course, people cannot see or touch history's vanished human events, but a visible, tangible artwork is a kind of persisting event. One or more artists made it at a certain time and in a specific place, even if no one now knows who, when, where, or why. Although created in the past, an artwork continues to exist in the present, long surviving its times. The first painters and sculptors died at least 30,000 years ago, but their works remain, some of them exhibited in glass cases in museums built only during the past few years.

Modern museum visitors can admire these objects from the remote past and countless others produced over the millennia—whether a large painting on canvas by a 17th-century French artist (FIG. I-1), a wood portrait from an ancient Egyptian tomb (FIG. I-12), or an 18th-century bronze altar glorifying an African king (FIG. I-13)—without any knowledge of the circumstances leading to the creation of those works. The beauty or sheer size of an object can impress people, the artist's virtuosity in the handling of ordinary or costly materials can dazzle them, or the subject depicted can move them emotionally. Viewers can react to what they see, interpret the work in the light of their own experience, and judge it a success or a failure. These are all valid responses to a work of art. But the enjoyment and appreciation of artworks in museum settings are relatively recent phenomena, as is the creation of artworks solely for museum-going audiences to view.

Today, it is common for artists to work in private studios and to create paintings, sculptures, and other objects for sale by commercial art galleries. This is what American artist CLYFFORD STILL (1904–1980) did when he produced his series of paintings (FIG. I-2) of pure color titled simply with the year of their creation. Usually, someone the artist has never met will purchase the artwork and display it in a setting the artist has never seen. This practice is not a new phenomenon in the history of art—an ancient potter decorating a vase for sale at a village market stall probably did not know who would buy the pot or where it would be housed—but it is not at all typical. In fact, it is exceptional. Throughout history, most artists created paintings, sculptures, and other objects for specific patrons and settings and to fulfill a specific purpose, even if today no one knows the original contexts of those artworks. Museum visitors can appreciate the visual and tactile qualities of these objects, but they cannot understand why they were made or why they appear as they do without knowing the circumstances of their creation. Art appreciation does not require knowledge of the historical context of an artwork (or a building). Art history does.

ART HISTORY IN THE 21ST CENTURY

Art historians study the visual and tangible objects that humans make and the structures that they build. Beginning with the earliest Greco-Roman art critics, scholars have studied objects that their makers consciously manufactured as "art" and to which the artists assigned formal titles. But today's art historians also study a multitude of objects that their creators and owners almost certainly did not consider to be "works of art." Few ancient Romans, for example, would have regarded a coin bearing their emperor's portrait as anything but money. Today, an art museum may exhibit that coin in a locked case in a climate-controlled room, and scholars may subject it to the same kind of art historical analysis as a portrait by an acclaimed Renaissance or modern sculptor or painter.

The range of objects that art historians study is constantly expanding and now includes, for example, computer-generated images, whereas in the past almost anything produced using a machine would not have been regarded as art. Most people still consider the performing arts—music, drama, and dance—as outside art history's realm because these arts are fleeting, impermanent media. But during the past few decades even this distinction between "fine art" and "performance art" has become blurred. Art historians, however, generally ask the same kinds of questions about what they study, ever, generally ask the same kinds of questions about what they study, whether they employ a restrictive or expansive definition of art.

The Questions Art Historians Ask

HOW OLD IS IT? Before art historians can write a history of art, they must be sure they know the date of each work they study. Thus an indispensable subject of art historical inquiry is chronology, the dating of art objects and buildings. If researchers cannot determine a monument's age, they cannot place the work in its historical context. Art historians have developed many ways to establish, or at least approximate, the date of an artwork.

Physical evidence often reliably indicates an object's age. The material used for a statue or painting—bronze, plastic, or oil-based pigment, to name only a few—may not have been invented before a certain time, indicating the earliest possible date (the terminus post quem: Latin, "point after which") someone could have fashioned the specific kinds of inks and papers for drawings—at a known time, providing the latest possible date (the terminus ante quem: Latin, "point before which") for objects made of those materials. Sometimes the material (or the manufacturing technique) of an object or a building can establish a very precise date of production or construction. The study of tree rings, for instance, usually can determine within a narrow range the date of a wood statue or a timber roof beam.

Documentary evidence can help pinpoint the date of an object or building when a dated written document mentions the work. For example, archival records may note when church officials commissioned a new altarpiece—and how much they paid to which artist. Integral evidence can play a significant role in dating an artist.

Internal evidence can play a significant role in dating an artwork. A painter or sculptor might have depicted an identifiable person or a kind of hairstyle or clothing fashionable only at a certain time. If so, the art historian can assign a more accurate date to that painting or sculpture.

Stylistic evidence is also very important. The analysis of style—an artist's distinctive manner of producing an object—is the art

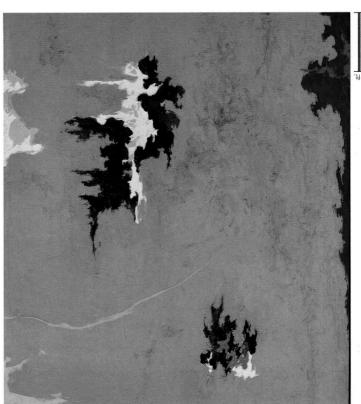

l-2 CLYFFORD STILL, 1948-C, 1948. Oil on canvas, 6' $8\frac{7}{8}$ " \times 5' $8\frac{3}{4}$ ". Hirshhorn Museum and Sculpture Garden, Smithsonian Institution, Washington, D.C. (purchased with funds of Joseph H. Hirshhorn, 1992).

Clyfford Still painted this abstract composition without knowing who would purchase it or where it would be displayed, but throughout history, most artists created works for specific patrons and settings.

Thus a central aim of art historiy is to determine the original context of artworks. Art historians seek to achieve a full understanding not only of why these "persisting events" of human history look the way they do but also of why the artistic events happened at all. What unique set of circumstances gave rise to the construction of a particular building or led an individual patron to commission a certain artist to fashion a singular artwork for a specific place? The study of history is therefore vital to art history. And art history is that other historical documents may not, art objects and buildings that other historical documents may not, art objects and buildings can shed light on the peoples who made them and on the times of their creation. Furthermore, artists and architects can affect history by reinforcing or challenging cultural values and practices through the objects they create and the structures they build. Although the two odisciplines are not the same, the history of art and architecture two disciplines are not the same, the history of art and architecture

The following pages introduce some of the distinctive subjects that art historians address and the kinds of questions they ask, and explain some of the basic terminology they use when answering these questions. Readers armed with this arsenal of questions and terms will be ready to explore the multifaceted world of art through

the ages.

is inseparable from the study of history.

historian's special sphere. Unfortunately, because it is a subjective assessment, stylistic evidence is by far the most unreliable chronological criterion. Still, art historians sometimes find style a very useful tool for establishing chronology.

WHAT IS ITS STYLE? Defining artistic style is one of the key elements of art historical inquiry, although the analysis of artworks solely in terms of style no longer dominates the field the way it once did. Art historians speak of several different kinds of artistic styles.

Period style refers to the characteristic artistic manner of a specific time, usually within a distinct culture, such as "Archaic Greek." But many periods do not display any stylistic unity at all. How would someone define the artistic style of the second decade of the third millennium in North America? Far too many crosscurrents exist in contemporary art for anyone to describe a period style of the early 21st century—even in a single city such as New York.

Regional style is the term that art historians use to describe variations in style tied to geography. Like an object's date, its *provenance*, or place of origin, can significantly determine its character.

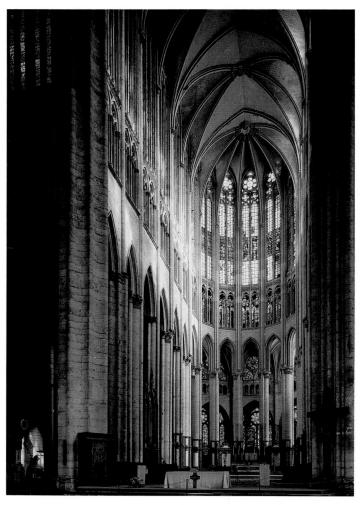

I-3 Choir of Beauvais Cathedral (looking east), Beauvais, France, rebuilt after 1284.

The style of an object or building often varies from region to region. This cathedral has towering stone vaults and large stained-glass windows typical of 13th-century French architecture.

Very often two artworks from the same place made centuries apart are more similar than contemporaneous works from two different regions. To cite one example, usually only an expert can distinguish between an Egyptian statue carved in 2500 BCE and one made in 500 BCE. But no one would mistake an Egyptian statue of 500 BCE for one of the same date made in Greece or Mexico.

Considerable variations in a given area's style are possible, however, even during a single historical period. In late medieval Europe, French architecture differed significantly from Italian architecture. The interiors of Beauvais Cathedral (FIG. 1-3) and the church of Santa Croce (Holy Cross, FIG. 1-4) in Florence typify the architectural styles of France and Italy, respectively, at the end of the 13th century. The rebuilding of the east end of Beauvais Cathedral began in 1284. Construction commenced on Santa Croce only 10 years later. Both structures employ the *pointed arch* characteristic of this era, yet the two churches differ strikingly. The French church has towering stone ceilings and large expanses of colored-glass windows, whereas the Italian building has a low timber roof and small, widely separated windows. Because the two contemporaneous churches served similar purposes, regional style mainly explains their differing appearance.

Personal style, the distinctive manner of individual artists or architects, often decisively explains stylistic discrepancies among artworks and buildings of the same time and place. For example, in

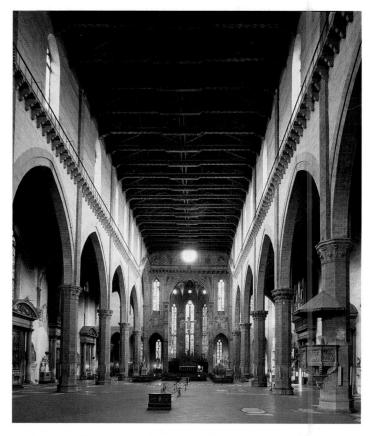

1-4 Interior of Santa Croce (looking east), Florence, Italy, begun 1294.

In contrast to Beauvais Cathedral (FIG. I-3), this contemporaneous Florentine church conforms to the quite different regional style of Italy. The building has a low timber roof and small windows.

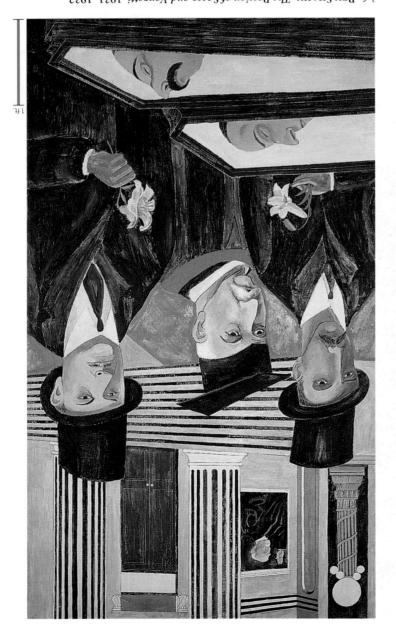

1-6 BEN SHAHN, The Passion of Sacco and Vanzetti, 1931–1932. Tempera on canvas, $7'\frac{1}{2}'' \times 4'$. Whitney Museum of American Art, New York (gift of Edith and Milton Lowenthal in memory of Juliana Force).

O'Keeffe's contemporary, Shahn developed a style markedly different from hers. His paintings are often social commentaries on recent events and incorporate readily identifiable people.

of the very different subjects the artists chose. But even when two artists depict the same subject, the results can vary widely. The way O'Keeffe painted flowers and the way Shahn painted faces are distinctive and unlike the styles of their contemporaries. (See the "Who Made It?" discussion on page 5.)

The different kinds of artistic styles are not mutually exclusive. For example, an artist's personal style may change dramatically during a long career. Art historians then must distinguish among the different period styles of a particular artist, such as the "Blue Period" and the "Cubist Period" of the prolific 20th-century artist Pablo Picasso.

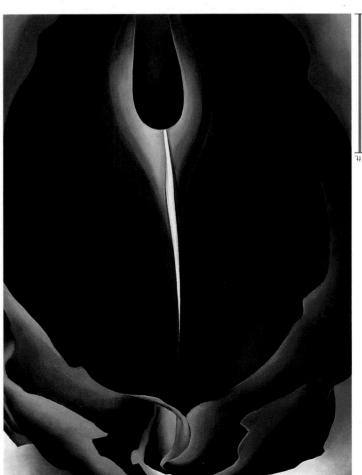

|-5 GEORGIA O'KEEFFE, Jack-in-the-Pulpit No. 4, 1930. Oil on canvas, 3' 4" x 2' 6". National Gallery of Art, Washington, D.C. (Alfred Stieglitz Collection, bequest of Georgia O'Keeffe).

O'Keeffe's paintings feature close-up views of petals and leaves in which the organic forms become powerful abstract compositions. This approach to painting typifies the artist's distinctive personal style.

canvas apart from O'Keeffe's. The contrast is extreme here because sentence. Personal style, not period or regional style, sets Shahn's hangs the framed portrait of the judge who pronounced the initial executions. Behind, on the wall of a stately government building, who declared the original trial fair and cleared the way for the (headed by a college president wearing academic cap and gown) fins. Presiding over them are the three members of the commission the trial and its aftermath. The two executed men lie in their cof-Shahn's painting compresses time in a symbolic representation of had been unjustly convicted of killing two men in a robbery in 1920. Bartolomeo Vanzetti. Many people believed that Sacco and Vanzetti the trial and execution of two Italian anarchists, Nicola Sacco and (FIG. 1-6), a stinging commentary on social injustice inspired by SHAHN (1898-1969), painted The Passion of Sacco and Vanzetti in the next section). Only a year later, another American artist, Ben shapes, and colors (see the discussion of art historical vocabulary converting the plant into a powerful abstract composition of lines, O'Keeffe captured the growing plant's slow, controlled motion while No. 4 (FIG. 1-5), a sharply focused close-up view of petals and leaves. 1930, GEORGIA O'KEEFFE (1887–1986) painted Jack-in-the-Pulpit

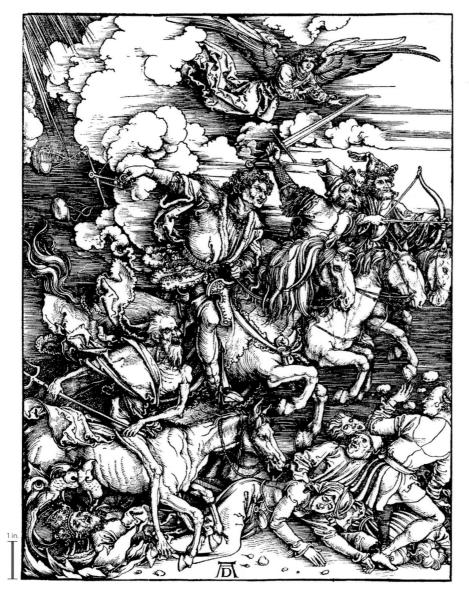

WHAT IS ITS SUBJECT? Another major concern of art historians is, of course, subject matter. Some artworks, such as modern *abstract* paintings (FIG. I-2), have no subject, not even a setting. But when artists represent people, places, or actions, viewers must identify these features to achieve complete understanding of the work. Art historians traditionally separate pictorial subjects into various categories, such as religious, historical, mythological, *genre* (daily life), portraiture, *landscape* (a depiction of a place), *still life* (an arrangement of inanimate objects), and their numerous subdivisions and combinations.

Iconography—literally, the "writing of images"—refers both to the content, or subject, of an artwork, and to the study of content in art. By extension, it also includes the study of *symbols*, images that stand for other images or encapsulate ideas. In Christian art, two intersecting lines of unequal length or a simple geometric cross can serve as an emblem of the religion as a whole, symbolizing the cross of Jesus Christ's crucifixion. A symbol also can be a familiar object that an artist has imbued with greater meaning. A balance or scale, for example, may symbolize justice or the weighing of souls on judgment day.

1-7 ALBRECHT DÜRER, The Four Horsemen of the Apocalypse, ca. 1498. Woodcut, 1' $3\frac{1}{4}$ " × 11". Metropolitan Museum of Art, New York (gift of Junius S. Morgan, 1919).

Personifications are abstract ideas codified in human form. Here, Albrecht Dürer represented Death, Famine, War, and Pestilence as four men on charging horses, each man carrying an identifying attribute.

Artists may depict figures with unique *attributes* identifying them. In Christian art, for example, each of the authors of the biblical gospel books, the four evangelists, has a distinctive attribute. People can recognize Saint Matthew by the winged man associated with him, John by his eagle, Mark by his lion, and Luke by his ox.

Throughout the history of art, artists have also used personifications—abstract ideas codified in human form. Because of the fame of the colossal statue set up in New York City's harbor in 1886, people everywhere visualize Liberty as a robed woman wearing a rayed crown and holding a torch. Four different personifications appear in The Four Horsemen of the Apocalypse (FIG. 1-7) by German artist Albrecht Dürer (1471-1528). The print is a terrifying depiction of the fateful day at the end of time when, according to the Bible's last book, Death, Famine, War, and Pestilence will annihilate the human race. Dürer personified Death as an emaciated old man with a pitchfork. Famine swings the scales for weighing human souls, War wields a sword, and Pestilence draws a bow.

Even without considering style and without knowing a work's maker, informed viewers can determine much about the work's period and provenance by iconographical and subject analysis alone. In *The Passion of Sacco and Vanzetti* (FIG. I-6), for example, the two coffins, the trio headed by an aca-

demic, and the robed judge in the background are all pictorial clues revealing the painting's subject. The work's date must be after the trial and execution, probably while the event was still newsworthy. And because the two men's deaths caused the greatest outrage in the United States, the painter–social critic was probably American.

WHO MADE IT? If Ben Shahn had not signed his painting of Sacco and Vanzetti, an art historian could still assign, or attribute, the work to him based on knowledge of the artist's personal style. Although signing (and dating) works is quite common (but by no means universal) today, in the history of art countless works exist whose artists remain unknown. Because personal style can play a major role in determining the character of an artwork, art historians often try to attribute anonymous works to known artists. Sometimes they assemble a group of works all thought to be by the same person, even though none of the objects in the group is the known work of an artist with a recorded name. Art historians thus reconstruct the careers of artists such as "the Achilles Painter," the anonymous ancient Greek artist whose masterwork is a depiction of the hero Achilles. Scholars base their attributions on internal

personal style is of paramount importance. But in many times and places, artists had little to say about what form their work would take. They toiled in obscurity, doing the bidding of their patrons, those who paid them to make individual works or employed them on a continuing basis. The role of patrons in dictating the content and shaping the form of artworks is also an important subject of art historical inquiry.

In the art of portraiture, to name only one category of painting and sculpture, the patron has often played a dominant role in deciding how the artist represented the subject, whether that patron or another individual, such as a spouse, son, or mother. Many Egyptian pharaohs and some Roman emperors, for example, insisted that artists depict them with unlined faces and perfect youthful bodies no matter how old they were when portrayed. In these cases, the state employed the sculptors and painters, and the artists had no choice but to portray their patrons in the officially approved manchoice but to portray their patrons in the officially approved manners. This is why Augustus, who lived to age 76, looks so young in ner. This is why Augustus, who lived to age 76, looks so young in years, Augustus demanded that artists always represent him as a young, godlike head of state.

All modes of artistic production reveal the impact of patronage. Learned monks provided the themes for the sculptural decoration of medieval church portals. Renaissance princes and popes dictated the subject, size, and materials of artworks destined for display in buildings also constructed according to their specifications. An art historian could make a very long list of commissioned works, and it would indicate that patrons have had diverse tastes and needs throughout history and consequently demanded different kinds of art. Whenever a patron contracts an artist or architect to paint, sculpt, or build in a prescribed manner, personal style often becomes a very minor factor in the ultimate appearance of the painting, statue, or building. In these cases, the identity of the patron reveals more to art historians than does the identity of the artist or school.

The Words Art Historians Use

As in all fields of study, art history has its own specialized vocabulary consisting of hundreds of words, but certain basic terms are indispensable for describing artworks and buildings of any time and place. They make up the essential vocabulary of *Jormal analysis*, the visual analysis of artistic form. Definitions and discussions of the most important art historical terms follow.

FORM AND COMPOSITION Form refers to an object's shape and structure, either in two dimensions (for example, a figure painted on a wall) or in three dimensions (such as a statue carved from a stone block). Two forms may take the same shape but differ in their color, texture, and other qualities. Composition refers to how an artist organizes (composes) forms in an artwork, either by placing shapes on a flat surface or by arranging forms in space.

MATERIAL AND TECHNIQUE To create art forms, artists shape materials (pigment, clay, marble, gold, and many more) with tools (pens, brushes, chisels, and so forth). Each of the materials and tools available has its own potentialities and limitations. Part of all artists' creative activity is to select the *medium* and instrument most suitable to the purpose—or to develop new media and tools, such as bronze and concrete in antiquity and cameras and computers in modern times. The processes that artists employ, such as applying paint to canvas with a brush, and the distinctive, personal ways they

1-8 Bust of Augustus wearing the corona civica (civic wreath), early first century CE. Marble, I' 5" high. Glyptothek, Munich.

Patrons frequently dictate the form their portraits will take. The Roman emperor Augustus demanded that he always be portrayed as a young, godlike head of state even though he lived to age 76.

evidence, such as the distinctive way an artist draws or carves drapery folds, earlobes, or flowers. It requires a keen, highly trained eye and long experience to become a connoisseur, an expert in assigning artworks to "the hand" of one artist rather than another.

Sometimes a group of artists works in the same style at the same time and place. Art historians designate such a group as a school. "School" does not mean an educational institution. The term connotes only shared chronology, style, and geography. Art historians speak, for example, of the Dutch school of the 17th century and, within it, of subschools such as those of the cities of Haarlem, Utrecht, and Leyden.

WHO PAID FOR IT? The interest that many art historians show in attribution reflects their conviction that the identity of an artwork's maker is the major reason the object looks the way it does. For them,

handle materials constitute their *technique*. Form, material, and technique interrelate and are central to analyzing any work of art.

LINE Among the most important elements defining an artwork's shape or form is *line*. A line can be understood as the path of a point moving in space, an invisible line of sight. More commonly, however, artists and architects make a line visible by drawing (or chiseling) it on a *plane*, a flat surface. A line may be very thin, wirelike, and delicate. It may be thick and heavy. Or it may alternate quickly from broad to narrow, the strokes jagged or the outline broken. When a continuous line defines an object's outer shape, art historians call it a *contour line*. All of these line qualities are present in Dürer's *Four Horsemen of the Apocalypse* (FIG. I-7). Contour lines define the basic shapes of clouds, human and animal limbs, and weapons. Within the forms, series of short broken lines create shadows and textures. An overall pattern of long parallel strokes suggests the dark sky on the frightening day when the world is about to end.

COLOR Light reveals all colors. Light in the world of the painter and other artists differs from natural light. Natural light, or sunlight, is whole or *additive light*. As the sum of all the wavelengths composing the visible *spectrum*, it may be disassembled or fragmented into the individual colors of the spectral band. The painter's light in art—the light reflected from pigments and objects—is *subtractive light*. Paint pigments produce their individual colors by reflecting a segment of the spectrum while absorbing all the rest. Green pigment, for example, subtracts or absorbs all the light in the spectrum except that seen as green.

Artists call the three basic colors or *hues*—red, yellow, and blue—the *primary colors*. The *secondary colors* result from mixing pairs of primaries: orange (red and yellow), purple (red and blue),

and green (yellow and blue). *Complementary colors*—red and green, yellow and purple, and blue and orange—complete, or "complement," each other, one absorbing colors the other reflects.

Painters can manipulate the appearance of colors, however. One artist who made a systematic investigation of the formal aspects of art, especially color, was Joseph Albers (1888-1976), a German-born artist who emigrated to the United States in 1933. In Homage to the Square: "Ascending" (FIG. 1-9)—one of hundreds of color variations on the same composition of concentric squares— Albers demonstrated "the discrepancy between physical fact and psychic effect." Because the composition remains constant, the Homage series succeeds in revealing the relativity and instability of color perception. Albers varied the saturation (a color's brightness or dullness) and tonality (lightness or darkness) of each square in each painting. As a result, the sizes of the squares from painting to painting appear to vary (although they remain the same), and the sensations emanating from the paintings range from clashing dissonance to delicate serenity. In this way, Albers proved that "we see colors almost never unrelated to each other."2

TEXTURE The term *texture* refers to the quality of a surface, such as rough or shiny. Art historians distinguish between true texture—that is, the tactile quality of the surface—and represented texture, as when painters depict an object as having a certain texture, even though the pigment is the true texture. Texture is, of course, a key determinant of any sculpture's character. People's first impulse is usually to handle a work of sculpture—even though museum signs often warn "Do not touch!" Sculptors plan for this natural human response, using surfaces varying in texture from rugged coarseness to polished smoothness. Textures are often intrinsic to a material, influencing the type of stone, wood, plastic, clay, or metal that a sculptor selects.

SPACE AND PERSPECTIVE *Space* is the bounded or boundless "container" of objects. For art historians, space can be the real three-dimensional space occupied by a statue or a vase or contained within a room or courtyard. Or space can be *illusionistic*, as when painters depict an image (or illusion) of the three-dimensional spatial world on a two-dimensional surface.

Perspective is one of the most important pictorial devices for organizing forms in space. Throughout history, artists have used various types of perspective to create an illusion of depth or space on a two-dimensional surface. The French painter Claude Lorrain (1600–1682) employed several perspective devices in *Embarkation of the Queen of Sheba* (Fig. I-1), a painting of a biblical episode set in a 17th-century European harbor with an ancient Roman ruin in the left foreground, an irrationally anachronistic combination that can be

l-9 Josef Albers, *Homage to the Square: "Ascending,*" 1953. Oil on composition board, $3' 7\frac{1}{2}" \times 3' 7\frac{1}{2}"$. Whitney Museum of American Art, New York.

Albers painted hundreds of canvases using the same composition but employing variations in color saturation and tonality in order to reveal the relativity and instability of color perception.

POGATA KORIN, Waves at Matsushima, Edo period, ca. 1700-1716. Six-panel folding screen, ink, colors, and gold leaf on paper, $4^{\circ}11\frac{1}{8}^{\circ}\times12^{\circ}\frac{7}{8}^{\circ}$. Museum of Fine Arts, Boston (Fenollosa-Weld Collection).

Asian artists rarely employed Western perspective (Fig. 1-1). Korin was more concerned with creating an intriguing composition of shapes on a surface than with locating boulders, waves, and clouds in space.

 $\label{eq:canya} \mbox{$|-||$} \mbox{$|$ Peter Paul Rubens, Lion Hunt, $1617-1618$. Oil on canvas, $8'$ $2"$ $\times 12'$ $5"$. Alte Pinakothek, Munich. }$

Foreshortening—the representation of a figure or object at an angle to the picture plane—is a common device in Western art for creating the illusion of depth. Foreshortening is a kind of perspective.

explained only in the context of the cultural values of the artist's time and place. In the painting, the figures and boats on the shore-line are much larger than those in the distance, because decreasing an object's size makes it appear farther away. The top and bottom of the port building are not parallel horizontal lines, as they are in a real building. Instead, the lines converge beyond the structure, leading the viewer's eye toward the hazy, indistinct sun on the horizon. These perspective devices—the reduction of figure size, the convergence of diagonal lines, and the blurring of distant forms—have been familiar features of Western art since they were first employed by the ancient Greeks. It is important to state, however, that all kinds of perspective are only pictorial conventions, even when one or more types of perspective may be so common in a given culture that people accept them as "natural" or as "true" means of representing the natural world.

In Waves at Matsushima (FIG. 1-10), a Japanese seascape painting on a six-part folding screen, OGATA KORIN (1658-1716) ignored these Western perspective conventions. A Western viewer might interpret the left half of Korin's composition as depicting the distant horizon, as in the French painting, but the sky is an unnatural gold, and the clouds which fill that sky are almost indistinguishable from the waves below. The rocky outcroppings decrease in size with distance, but all are in sharp focus, and there are no shadows. The Japanese artist was less concerned with locating the boulders, waves, and clouds in space than with composing shapes on a surface, playing the swelling curves of waves and clouds against the jagged contours of the rocks. Neither the French nor the Japanese painting can be said to project "correctly" what viewers "in fact" see. One painting is not a "better" picture of the world than the other. The European and Asian artists simply approached the problem of picture making differently.

FORESHORTENING Artists also represent single figures in space in varying ways. When Flemish artist Peter Paul Rubens (1577–1640) painted *Lion Hunt* (Fig. 1-11), he used *foreshortening* for all the hunters and animals—that is, he represented their bodies at angles to the picture plane. When in life someone views a figure at an angle, the body appears to contract as it extends back in space. Foreshortening is a kind of perspective. It produces the illusion that one part of the body is farther away than another, even though all the painted forms are on the same surface. Especially noteworthy in *Lion Hunt* are the gray horse at the left, seen from behind with the bottom of its left rear hoof facing the viewer and most of its head hidden by its rider's shield, and the fallen hunter at the painting's lower right corner, whose barely visible legs and feet recede into the distance.

The artist who carved the portrait of the ancient Egyptian official Hesire (FIG. 1-12) did not employ foreshortening. That artist's purpose was to present the various human body parts as clearly as possible, without overlapping. The lower part of Hesire's body is in profile to give the most complete view of the legs, with both the heels and toes of each foot visible. The frontal torso, although unnaturally twisted 90 degrees, presents its full shape, including both shoulders, equal in size, as in nature. (Compare the shoulders of the hunter on the gray horse or those of the fallen hunter in *Lion Hunt*'s left foreground.) Rubens and the Egyptian sculptor used very different means of depicting forms in space. Once again, neither is the "correct" manner.

PROPORTION AND SCALE *Proportion* concerns the relationships (in terms of size) of the parts of persons, buildings, or objects. People

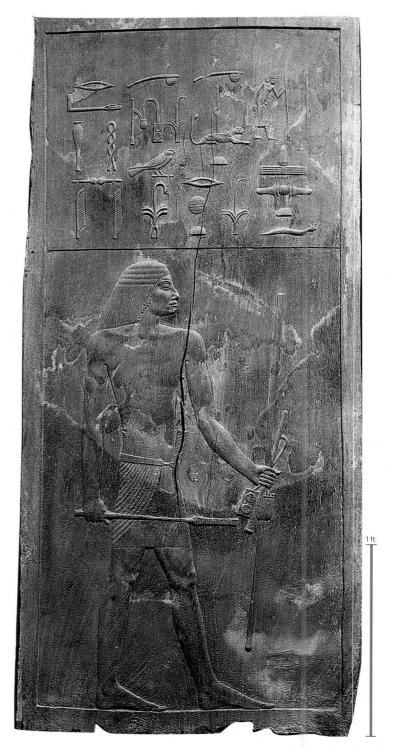

1-12 Hesire, relief from his tomb at Saqqara, Egypt, Third Dynasty, ca. 2650 BCE. Wood, 3' 9" high. Egyptian Museum, Cairo.

Egyptian artists combined frontal and profile views to give a precise picture of the parts of the human body, as opposed to depicting how an individual body appears from a specific viewpoint.

can judge "correct proportions" intuitively ("that statue's head seems the right size for the body"). Or proportion can be a mathematical relationship between the size of one part of an artwork or building and the other parts within the work. Proportion in art implies using a *module*, or basic unit of measure. When an artist or architect

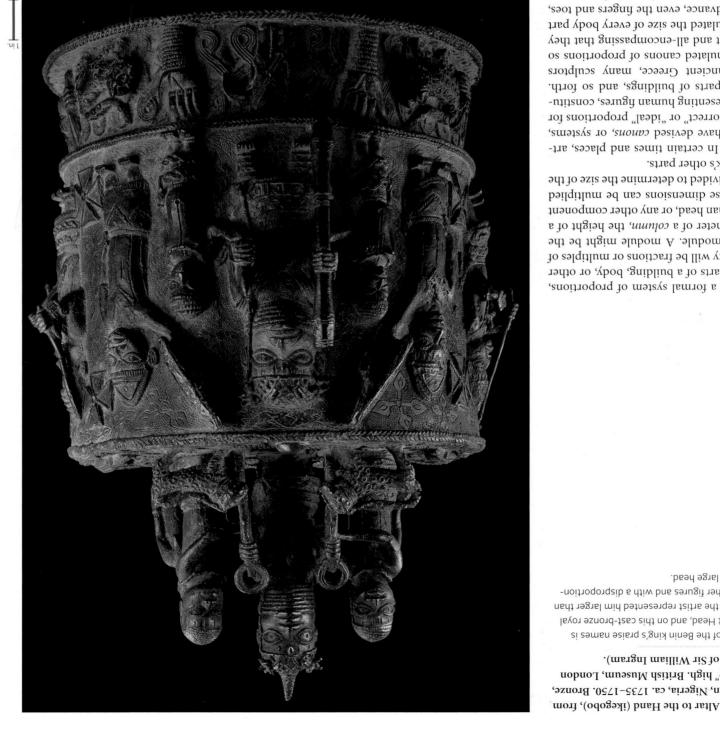

(mergnI mailliw ris to fig) I' $5\frac{1}{2}$ " high. British Museum, London Benin, Nigeria, ca. 1735-1750. Bronze, I-13 Altar to the Hand (ikegobo), from

ately large head. all other figures and with a disproportionaltar, the artist represented him larger than Great Head, and on this cast-bronze royal One of the Benin king's praise names is

work's other parts. or divided to determine the size of the whose dimensions can be multiplied human head, or any other component diameter of a column, the height of a the module. A module might be the entity will be fractions or multiples of all parts of a building, body, or other uses a formal system of proportions,

in advance, even the fingers and toes, calculated the size of every body part strict and all-encompassing that they formulated canons of proportions so In ancient Greece, many sculptors ent parts of buildings, and so forth. representing human figures, constituof "correct" or "ideal" proportions for ists have devised canons, or systems,

Proportional systems can differ according to mathematical ratios.

precisely as the artist intended.

sharply from period to period, cul-

distortion distinguish him from all the other figures in the work, bones, and his limbs are distorted and stretched. Disproportion and expressive effect. Dürer's Death (FIG. I-7) has hardly any flesh on his many artists have used disproportion and distortion deliberately for students face is to perceive and adjust to these differences. In fact, ture to culture, and artist to artist. Part of the task that art history

In other cases, artists have used disproportion to focus atten-

of scale, the enlarging of elements considered the most important. ancies in proportion constitute what art historians call hierarchy member (usually the leader). These intentional "unnatural" discreption on one body part (often the head) or to single out a group

body, consistent with one of the Benin ruler's praise names: Great

The king's head is also disproportionately large compared to his king, depicted twice, each time flanked by two smaller attendants.

social status. Largest, and therefore most important, is the Benin the sculptor varied the size of each figure according to the person's

On the bronze altar from Benin, Nigeria, illustrated here (FIG. 1-13),

One problem that students of art history—and professional

l-14 MICHELANGELO BUONARROTI, unfinished captive, 1527–1528. Marble, 8' $7\frac{1}{2}$ " high. Galleria dell'Accademia, Florence.

Carving a freestanding figure from stone or wood is a subtractive process. Italian master sculptor Michelangelo thought of sculpture as a process of "liberating" the statue within the block of marble.

all are printed at approximately the same size on the page. Readers of *Art through the Ages* can learn the exact size of all artworks from the dimensions given in the captions and, more intuitively, from the scales positioned at the lower left or right corner of each illustration.

CARVING AND CASTING Sculptural technique falls into two basic categories, *subtractive* and *additive*. *Carving* is a subtractive technique. The final form is a reduction of the original mass of a block of stone, a piece of wood, or another material. Wood statues were once tree trunks, and stone statues began as blocks pried from mountains. The unfinished marble statue illustrated here (FIG. 1-14) by

I-15 Head of a warrior, detail of a statue (FIG. 2-34A) from the sea off Riace, Italy, ca. 460–450 BCE. Bronze, full statue 6' 6" high. Museo Archeologico Nazionale, Reggio Calabria.

The sculptor of this life-size statue of a bearded Greek warrior cast the head, limbs, torso, hands, and feet in separate molds, then welded the pieces together and added the eyes in a different material.

renowned Italian artist MICHELANGELO BUONARROTI (1475–1564) clearly reveals the original shape of the stone block. Michelangelo thought of sculpture as a process of "liberating" the statue within the block. All sculptors of stone or wood cut away (subtract) "excess material." When they finish, they "leave behind" the statue—in this example, a twisting nude male form whose head Michelangelo never freed from the stone block.

In additive sculpture, the artist builds up the forms, usually in clay around a framework, or *armature*. Or a sculptor may fashion a *mold*, a hollow form for shaping, or *casting*, a fluid substance such as bronze. The ancient Greek sculptor who made the bronze statue of a warrior found in the sea near Riace, Italy, cast the head (FIG. I-15) as well as the limbs, torso, hands, and feet (FIG. 2-34A 🖅) in separate molds and then *welded* them together (joined them by heating). Finally, the artist added features, such as the pupils of the eyes (now missing), in other materials. The warrior's teeth are silver, and his lower lip is copper.

italicized terms. hensive glossary at the end of the book contains definitions of all new terms appear in italics when they first appear. The compredescribed in distinct vocabularies. As in this introductory chapter, ous other arts. All of them involve highly specialized techniques photography, and computer graphics are just some of the numer-

Art History and Other Disciplines

discipline of art history. Art historical research in the 21st century art historians of previous generations considered the specialized go beyond the boundaries of what the public and even professional but also in the social and natural sciences. Today, art historians must of others in many fields of knowledge, not only in the humanities By its very nature, the work of art historians intersects with the work

At other times, rather than attempting to master many discithe documents provide. philosophy, sociology, and gender studies to weigh the evidence that also use methodologies developed in fields such as literary criticism, observers with their own biases and agendas, the art historian may the written documents often were not objective recorders of fact but and a host of other questions. Realizing, however, that the authors of when, where it originally stood, how people of the time reacted to it, shedding light on who paid for the work and why, who made it and might conduct archival research hoping to uncover new documents effort to unlock the secrets of a particular statue, an art historian is typically interdisciplinary in nature. To cite one example, in an

solution of problems in other disciplines. A historian, for example, art historians often reciprocate by contributing their expertise to the an attempt to establish whether a painting is a forgery. Of course, stone for a particular statue. X-ray technicians might be enlisted in or might ask geologists to determine which quarry furnished the to date an artwork based on the composition of the materials used, in multidisciplinary inquiries. Art historians might call in chemists plines at once, art historians band together with other specialists

Beauvais, France, rebuilt after 1284. 1-16 Plan (left) and lateral section (right) of Beauvais Cathedral,

visually and by moving through and around them, so they perceive ARCHITECTURAL DRAWINGS People experience buildings both the projection is slight. project boldly and may even cast shadows. In low reliefs (FIG. I-12), ground but remain part of it. In high reliefs (FIG. I-13), the images in the round. In relief sculpture, the subjects project from the backviewers can walk around are freestanding sculptures, or sculptures that exist independent of any architectural frame or setting and that RELIEF SCULPTURE Statues and busts (head, shoulders, and chest)

ing vault ribs. The lateral section shows not only the interior of the supporting the vaults above, as well as the pattern of the crisscrosschoir's shape and the location of the piers dividing the aisles and the photograph of the church's choir (FIG. I-3). The plan shows the (FIG. 1-16) of Beauvais Cathedral, which readers can compare with gitudinal sections. Illustrated here are the plan and lateral section lateral sections. Those cutting through a building's length are lon-Drawings showing a theoretical slice across a structure's width are the masses as if someone cut through the building along a plane.

enclose. A section, a kind of vertical plan, depicts the placement of

structure's masses and, therefore, the spaces they circumscribe and A plan, essentially a map of a floor, shows the placement of a

these spaces and masses graphically in several ways, including as

architectural space and mass together. Architects can represent

plans, sections, elevations, and cutaway drawings.

book. An elevation drawing is a head-on view of an external or Other types of architectural drawings appear throughout this vaults in place. of the roof and the form of the exterior flying buttresses holding the

choir with its vaults and stained-glass windows but also the structure

internal wall. A cutaway combines in a single drawing an exterior

This overview of the art historian's vocabulary is not exhausview with an interior view of part of a building.

architecture as media over the millennia. Ceramics, jewelry, textiles, tive, nor have artists used only painting, drawing, sculpture, and

"slices," across either a building's width or length. Plans are maps of floors, recording the structure's masses. Sections are vertical Architectural drawings are indispensable aids for the analysis of buildings. might ask an art historian to determine—based on style, material, iconography, and other criteria—if any of the portraits of a certain king date after his death. Such information would help establish the ruler's continuing prestige during the reigns of his successors. For example, some portraits of Augustus (FIG. I-8), the founder of the Roman Empire, postdate his death by decades, even centuries.

DIFFERENT WAYS OF SEEING

The history of art can be a history of artists and their works, of styles and stylistic change, of materials and techniques, of images and themes and their meanings, and of contexts and cultures and patrons. The best art historians analyze artworks from many viewpoints. But no art historian (or scholar in any other field), no matter how broad-minded in approach and no matter how experienced, can be truly objective. Like the artists who made the works illustrated and discussed in this book, art historians are members of a society, participants in its culture. How can scholars (and museum visitors and travelers to foreign locales) comprehend cultures unlike their own? They can try to reconstruct the original cultural contexts of artworks, but they are limited by their distance from the thought patterns of the cultures they study and by the obstructions to understanding—the assumptions, presuppositions, and prejudices peculiar to their own culture—that their own thought patterns raise. Art historians may reconstruct a distorted picture of the past because of culture-bound blindness.

A single instance underscores how differently people of diverse cultures view the world and how various ways of seeing can result in sharp differences in how artists depict the world. Illustrated here are two contemporaneous portraits of a 19th-century Maori chieftain (FIG. I-17)—one by an Englishman, John Sylvester (active early 19th century), and the other by the New Zealand chieftain himself, Te Pehi Kupe (d. 1829). Both reproduce the chieftain's facial *tattoo*. The European artist (FIG. I-17, *left*) included the head and shoulders and downplayed the tattooing. The tattoo pattern is one aspect of the likeness among many, no more or less important than the chieftain's European attire. Sylvester also recorded his subject's momentary glance toward the right and the play of light on his hair, fleeting aspects having nothing to do with the figure's identity.

In contrast, Te Pehi Kupe's self-portrait (FIG. I-17, right)—made during a trip to Liverpool, England, to obtain European arms to take back to New Zealand—is not a picture of a man situated in space and bathed in light. Rather, it is the chieftain's statement of the supreme importance of the tattoo design announcing his rank among his people. Remarkably, Te Pehi Kupe created the tattoo patterns from memory, without the aid of a mirror. The splendidly composed insignia, presented as a flat design separated from the body and even from the head, is the Maori chieftain's image of himself. Only by understanding the cultural context of each portrait can art historians hope to understand why either representation appears as it does.

As noted at the outset, the study of the context of artworks and buildings is one of the central concerns of art historians. *Art through the Ages* seeks to present a history of art and architecture that will help readers understand not only the subjects, styles, and techniques of paintings, sculptures, buildings, and other art forms created in all parts of the world during 30 millennia but also their cultural and historical contexts. That story now begins.

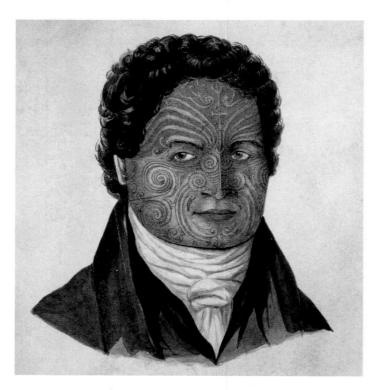

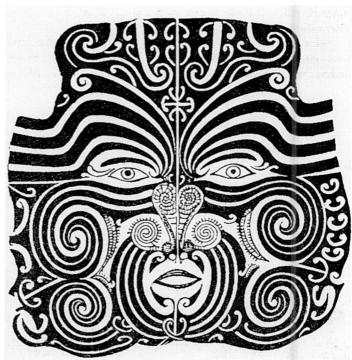

I-17 Left: John Henry Sylvester, Portrait of Te Pehi Kupe, 1826. Watercolor, $8\frac{1}{4}$ " × $6\frac{1}{4}$ ". National Library of Australia, Canberra (Rex Nan Kivell Collection). Right: Te Pehi Kupe, Self-Portrait, 1826. From Leo Frobenius, The Childhood of Man: A Popular Account of the Lives, Customs and Thoughts of the Primitive Races (Philadelphia: J. B. Lippincott, 1909), 35, fig. 28.

These strikingly different portraits of the same Maori chief reveal the different ways of seeing of a European artist and an Oceanic one. Understanding the cultural context of artworks is vital to art history.

✓ 1-1a The Worka Vase is the first great work of narrative relief sculpture known. It represents a ceremony in honor of the goddess Inanna in which a priest-king brings votive offerings shrine.

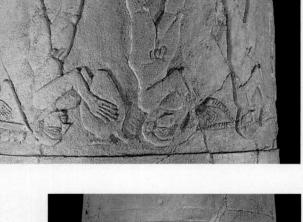

▲ 1-1b The Sumerians were the first to use pictures to tell coherent stories. This sculptor placed the figures in three registers. In each band, all the humans and animals stand on a common ground line.

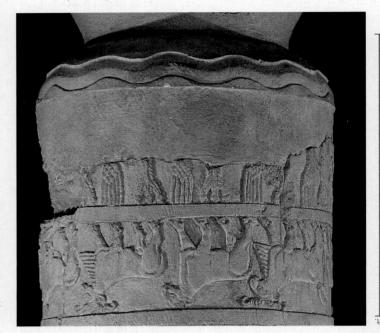

▲ 1-1c The two lowest registers show ewes, rams, and crops above a wavy line representing water. The animals and food are Inanna's blessings to the inhabitants of the city-state.

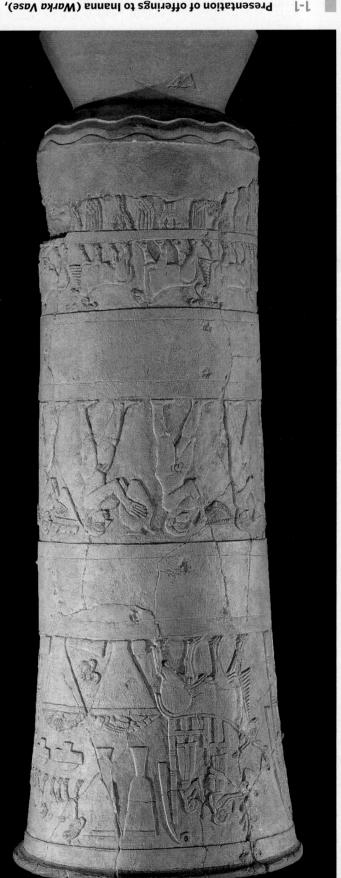

Presentation of offerings to Inanna (Warka Vase), from the Inanna temple complex, Uruk (modern Warka), Iraq, ca. 3200–3000 BCE. Alabaster, $\frac{1}{4}$ " high. National Museum of Iraq, Baghdad.

Prehistory and the First Civilizations

PICTORIAL NARRATION IN ANCIENT SUMER

Mesopotamia—a Greek word meaning "the land between the [Tigris and Euphrates] rivers"—is the core of the region often called the Fertile Crescent, where humans first learned how to use the wheel and plow and how to control floods and construct irrigation canals. In the fourth millennium BCE, the inhabitants of ancient Sumer, "the cradle of civilization," established the earliest complex urban societies, called *city-states*. The Sumerians also invented writing and were the first to use pictures to tell coherent stories, far surpassing all earlier artists' tentative efforts at pictorial narration.

The Warka Vase (FIG. 1-1) from Uruk (modern Warka) is the first great work of narrative relief sculpture known. Its depiction of a religious ceremony honoring the Sumerian goddess Inanna (FIG. 1-1A 1) incorporates all of the pictorial conventions that would dominate narrative art for the next 2,000 years. The artist divided the pictorial field into three bands (called registers or friezes) and placed all the figures on a common ground line, a format that marks a significant break with the haphazard figure placement of Stone Age art (FIGS. 1-4 to 1-6). The lowest band shows crops above a wavy line representing water. Then comes a register with alternating ewes and rams. Agriculture and animal husbandry were the staples of the Sumerian economy, but the produce and the female and male animals are also fertility symbols. They underscore that Inanna blessed Uruk's inhabitants with good crops and increased herds.

A procession of naked men moving in the opposite direction of the animals fills the band at the center of the vase. The men carry baskets and jars overflowing with the earth's abundance. They will present their bounty to the goddess as a *votive offering* (gift of gratitude to a deity usually made in fulfillment of a vow). In the uppermost band of the *Warka Vase* is Inanna wearing a tall horned headdress. Facing her is a nude male figure bringing a large vessel brimming with offerings to be deposited in the goddess's shrine, and behind her (not visible in FIG. 1-1), a man wearing a tasseled skirt and an attendant carrying his long train. Near the man is the *pictograph* for the Sumerian official that scholars ambiguously refer to as a "priest-king"—that is, both a religious and secular leader. Some art historians interpret the scene as a symbolic marriage between the priest-king and the goddess, ensuring her continued goodwill—and reaffirming the leader's exalted position in society. The greater height of the priest-king and Inanna compared with the offering bearers indicates their greater importance, a convention called *hierarchy of scale*, which the Sumerians also pioneered.

ingly varied. They range from simple shell necklaces to human and animal forms in ivory, clay, and stone to life-size paintings, engravings, and relief sculptures covering the walls and ceilings of

VENUS OF WILLENDORF One of the oldest sculptures discovered to date, carved using simple stone tools, is the tiny limestone figurine (Fig. 1-2) of a woman nicknamed the *Venus of Willendorf* after its findspot in Austria (MAP 1-1). Art historians can only speculate on the function and meaning of this and similar objects because they date to a time before writing, before (or pre-) history. Yet the preponderance of female over male figures in the art of the Old Stone Age seems to indicate a preoccupation with women, whose childbearing capabilities ensured the survival of the species. The

Humankind originated in Africa in the very remote past. Yet it was not until millions of years later that ancient hunters began to represent (literally, "to present again"—in different and substitute form) the world around them and to fashion the first examples of what people generally call "art." The immensity of this intellectual achievement cannot be exaggerated.

Paleolithic Age

PREHISTORY

The earliest preserved art objects date to around 40,000 to 30,000 BCE, during the Old Stone Age or Paleolithic period (from the Greek paleo, "old," and lithos, "stone"). Paleolithic artworks are astonish-

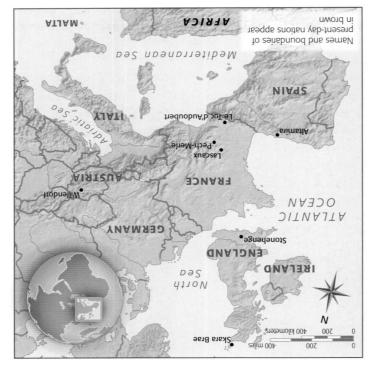

MAP 1-1 Stone Age sites in western Europe.

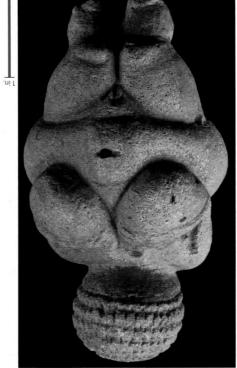

from Willendorf, Austria, ca. 28,000–25,000

BCE. Limestone, 4 1"
high. Naturhistorisches Museum,
Vienna.

The anatomical exaggerations in this tiny figurine—one of the oldest

(Venus of Willendorf),

1-2 Nude woman

The anatomical exagegerations in this tiny figurine—one of the oldest sculptures known—are typical of Paleolithic representations of women, whose child-bearing capabilities ensured the survival of the species.

PREHISTORY AND THE FIRST CIVILIZATIONS

3200-5120 BCE

900-330 BCE Assyria, Achaemenid Persia

Assyrians (900-612 BCE)
construct fortified citadels
guarded by lamassu, and carve
large-scale reliefs celebrating
their prowess in warfare and
hunting.
(559-330 BcE) build an
immense palace complex at

(SS9-330 BCE) build an immerace palace complex at Persepolis featuring an audience hall that could accommodate 10,000 guests.

1070-900 BCE

S150-1070 BCE Babylonia, New Kingdom

Hammurabi, the greatest Babylonian king (r. 1792-1750 BcE), sets up a stele recording his comprehensive laws.
 Egyptian New Kingdom (1550-1070 BcE) architects construct grandiose pylon construct grandiose pylon temples. Akhenaton intro-

duces a new religion and new

art forms.

Sumer, Akkad, Old Kingdom Sumerians (3500-2332 BcE) Sumerians (3500-2332 BcE) establish the first city-states, lonian king (r. 1792)

mud-brick platforms, and adopt the register format for narrative art.

Akkadians (2322-2150 BcE) produce the earliest known life-size hollow-cast metal sculptures.

construct temples on lotty

Old Kingdom (2575–2734)

BCE) Egyptian sculptors create statuary types expressing the eternal nature of divine kingship. The Fourth Dynasty kings build three colossal pyramids at Gizeh.

40,000-3500 BCE

Paleolithic (40,000-9000 BCE)
humans create the first sculptures and paintings. The
works range in scale from tiny
figurines to life-size paintings
on cave walls.

In the Neolithic (8000-3500
BCE) age, the first settled communities appear in Anatolia
and Mesopotamia. Artists
and Mesopotamia. Artists
produce the first large-scale

sculptures and earliest paintings with coherent narratives.

PROBLEMS AND SOLUTIONS

How to Represent an Animal

Like every artist in every age in every medium, the sculptor of the pair of bison (FIG. 1-3) in the cave at Le Tuc d'Audoubert had to answer two questions before beginning work: What shall be my subject? How as in Europe, the almost universal answer to the first question was

an animal. In fact, Paleolithic painters and sculptors depicted humans infrequently, and men almost never. In equally stark contrast to today's world, there was also agreement on the best answer to the second question. During the Old Stone Age and for thousands of years thereafter, artists represented virtually every animal in every painting in the same manner: in strict profile. Why?

The profile is the only view of an animal in which the head, body, tail, and all four legs are visible. The frontal view conceals most of the body, and a three-quarter view shows

1-3 Two bison, reliefs in the cave at Le Tuc d'Audoubert, France, ca. 15,000-10,000 BCE. Clay, right bison $2'\frac{7}{8}$ " long.

Animals are far more common subjects in Paleolithic art than are humans. In both relief sculpture and painting, animals always appear in profile, the only view completely informative about their shape.

neither the front nor side fully. Only the profile view is completely informative about the animal's shape, and that is why Paleolithic painters and relief sculptors universally chose it.

A very long time passed before artists placed any premium on "variety" or "originality" either in subject choice or in representational manner. These are quite modern notions in the history of art. The aim of the earliest artists was to create a convincing image of their subject, a kind of pictorial definition of the animal capturing its very essence, and only the profile view met their needs.

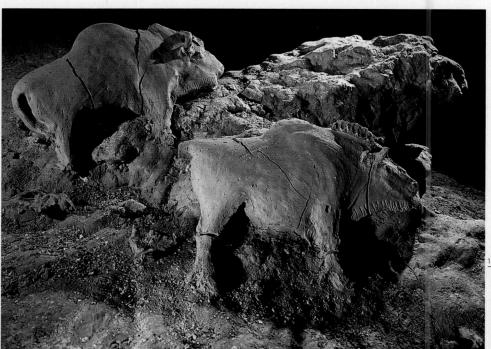

anatomical exaggeration of the Willendorf figurine has suggested to many scholars that this and other prehistoric statuettes of women served as fertility images. The breasts of the Willendorf woman are enormous, far larger in proportion than the tiny forearms and hands resting on them. In addition to using a stone chisel, the sculptor also used a burin to incise (scratch) into the stone the outline of the pubic triangle. Sculptors often omitted this detail in other Paleolithic female figurines, however, and many of the women also have far more slender proportions than the Willendorf woman, leading some scholars to question the nature of these figures as fertility images. In any case, it seems clear that the makers' intent was not to represent a specific woman but the female form.

LE TUC D'AUDOUBERT Far more common than Paleolithic representations of humans are sculptures and paintings of animals (see "How to Represent an Animal," above). An early example of animal sculpture is the pair of clay bison reliefs (FIG. 1-3) in the cave at Le Tuc d'Audoubert, France. The sculptor modeled the forms by pressing the clay against the surface of a large boulder at the back of the cave. After using both hands to form the overall shape of the animals, the artist smoothed the surfaces with a spatula-like tool and used fingers to shape the eyes, nostrils, mouths, and manes.

CAVE PAINTING The bison of Le Tuc d'Audoubert are among the largest sculptures of the Paleolithic period, but they are dwarfed by the "herds" of painted animals that roam the cave walls of southern France and northern Spain. Examples of Paleolithic painting now have been found at more than 200 European sites. Nonetheless, archaeologists still regard painted caves as rare occurrences, because even though the cave images number in the hundreds, prehistoric artists created them over a period of some 10,000 to 20,000 years.

Paleolithic painters drew their subjects using chunks of red and yellow ocher. For painting, they ground these same ochers into powders that they mixed with water before applying. Large flat stones served as palettes to hold the pigment. The painters made brushes from reeds, bristles, or twigs, and may have used a blowpipe of reed or hollow bone to spray pigments on out-of-reach surfaces. Some caves have natural ledges on the rock walls, on which the painters could have stood in order to reach the upper surfaces of the naturally formed chambers and corridors. To illuminate their work, the painters used stone lamps filled with marrow or fat, perhaps with a wick of moss. Despite the difficulty of making the tools and pigments, modern attempts at replicating the techniques of Paleolithic painting have demonstrated that skilled workers could cover large surfaces with images in less than a day.

Old Stone Age diets did not include the species most frequently creation theories is that the animals that were the staple foods of their clothing. A central problem for both the hunting-magic and foodon which Paleolithic peoples depended for their food supply and for sculptors created animal images to assure the survival of the herds tion of animal species. Instead, they believe that the first painters and purpose of the paintings and reliefs was not to facilitate the destruc-In contrast, some prehistorians have argued that the magical

postulated various meanings for the abstract signs that sometimes have equated certain species with men and others with women and Paleolithic humans believed they had animal ancestors. Still others mythology based on the cave paintings and sculptures, suggesting that Other researchers have sought to reconstruct an elaborate

before the invention of writing, no contemporaneous explanations of these works remains an unsolved mystery—and always will, because arranged on the surface), is unlikely to apply universally. The meaning even ones similar in subject, style, and composition (how the motifs are unknown. In fact, a single explanation for all Paleolithic animal images, most prehistorians admit that the intent of these representations is Almost all of these theories have been discredited over time, and

images served as targets for spears. acter of the various species they would encounter or even that the have served as teaching tools to instruct new hunters about the charanimals. Others have speculated that the animal representations may these rites served to improve hunters' luck in tracking and killing the that rituals or dances were performed in front of the images and that the beasts under their control. Some scholars have even hypothesized their cave walls, Paleolithic communities believed they were bringing According to this argument, by confining animals to the surfaces of attributed magical properties to the images they painted and sculpted. precisely why many experts have suggested that prehistoric peoples the images, and indications that the caves were in use for centuries, are of many of the representations. In fact, the remote locations of many of cannot account for the narrow range of subjects or the inaccessibility including that the animals were mere decoration, but this explanation images (Figs. 1-3 to 1-6). Researchers have proposed various theories, Old Stone Age decided to cover the walls of dark caverns with animal western Spain in 1879, scholars have wondered why the hunters of the Ever since the discovery of the first cave paintings at Altamira in north-

Why Is There Art in Paleolithic Caves?

ART AND SOCIETY

individual painters. members or, less likely, of tures" of cult or community painted hands are "signathink that the Pech-Merle handprints. Some scholars include abstract signs and Many Paleolithic paintings

11' 2" long.

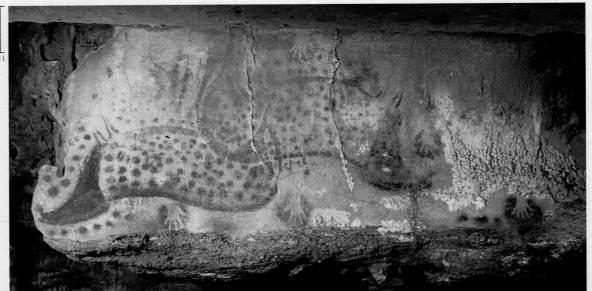

could be recorded.

accompany the images.

portrayed.

Art in Paleolithic Caves?" above). in Paleolithic art—their meaning is unknown (see "Why Is There a primitive form of writing, but like the hands—and everything else stones or signs. Several observers think that these various signs are not have spots. The "spots" also surround the horses and may be Paleolithic caves. In fact, the "spotted horses" of Pech-Merle may and other abstract signs appear near the painted animals in other bers or, less likely, of individual painters. Checks, dots, squares, have considered them "signatures" of cult or community mem-

Montignac, France, which features a large circular gallery called LASCAUX The best-known Paleolithic cave is that at Lascaux, near imprint. These handprints must have had a purpose. Some scholars pigment and then pressed it against the wall, leaving a "positive" pigment around it. Occasionally, the painter dipped a hand in the placed one hand against the wall and then brushed or blew or spat of painted hands at other sites are "negative"-that is, the painter however, painted hands accompany them. These and the majority Tuc d'Audoubert, the Pech-Merle horses are in strict profile. Here, face resembling a horse's head and neck. Like the clay bison at Le right may have been inspired by the rock formation in the wall surists chose certain subjects for specific locations. The horse at the Merle, France, provides some insight into the reason Stone Age art-PECH-MERLE A mural (wall) painting (FIG. 1-4) in a cave at Pech-

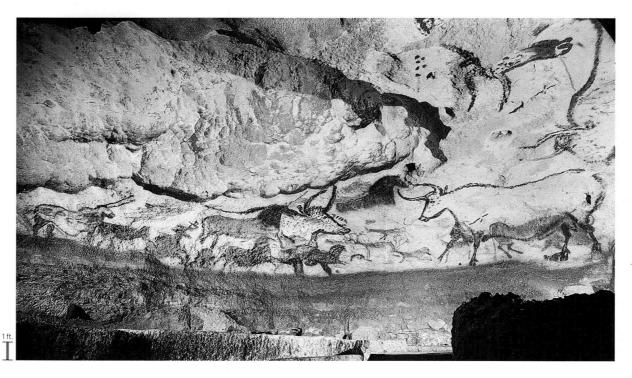

1-5 Left wall of the Hall of the Bulls in the cave at Lascaux, France, ca. 16,000–14,000 BCE. Largest bull 11' 6" long.

The purpose and meaning of Paleolithic cave paintings are unknown, but it is clear that the painters' sole concern was representing the animals, not locating them in a specific place or on a common ground line.

the Hall of the Bulls (FIG. 1-5). Not all of the painted animals are bulls, despite the modern nickname. Some of the animals, such as the great bull at the right in FIG. 1-5, were represented using outline alone, but others are colored silhouettes. These are the two basic approaches to drawing and painting in the history of art. Here, they appear side by side, suggesting that different artists painted the animals at various times. The impression that a modern viewer gets of a rapidly moving herd is therefore almost certainly false. The "herd" consists of several different species of animals of disparate sizes moving in different directions. Although most share a common ground line, some—for example, those in the upper right corner of FIG. 1-5—seem to float above the viewer's head, like clouds in the sky. The painting has no setting, no background, no indication of place. The Paleolithic painter's sole concern was representing the animals, not locating them in a specific place.

Another feature of the Lascaux paintings deserves attention. The bulls show a convention of representing horns that art historians call *twisted perspective*, or *composite view*, because viewers see the heads in profile but the horns from the front. Thus the painter's approach is not consistently optical (seen from a fixed viewpoint). Rather, the approach is descriptive of the fact that cattle have two horns. Two horns are part of the concept "bull." In strict profile, only one horn would be visible, but painting the animal in that way would be an incomplete picture of it.

Perhaps the most perplexing painting in any Paleolithic cave is the mural (FIG. 1-6) deep in the well shaft at Lascaux, where man (as opposed to woman) makes one of his earliest appearances in the history of art. At the left, and moving to the left, is a rhinoceros. Beneath its tail are two rows of three dots of uncertain significance. At the right is a bison, with less realistic proportions, probably the

work of someone else. The second painter none-theless successfully suggested the bristling rage of the animal, whose bowels hang from its belly in a heavy coil. Between the two beasts is a bird-faced (masked?) man with outstretched arms and hands having only four fingers. The painter depicted the man with far less care and detail than either animal, but made the hunter's gender explicit by the prominent penis. The position of the man is ambiguous. Is he wounded or dead or merely tilted back and unharmed? Do the staff(?) with

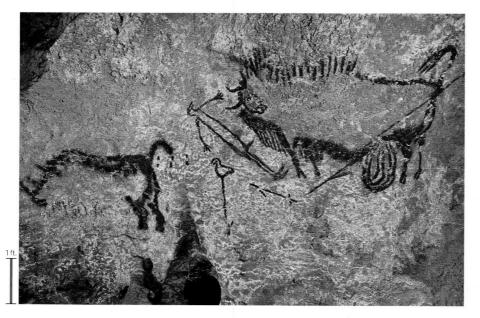

1-6 Rhinoceros, wounded man, and disemboweled bison, painting in the well of the cave at Lascaux, France, ca. 16,000-14,000 BCE. Bison 3' $4\frac{1}{2}"$ long.

If these paintings of two animals and a bird-faced (masked?) man, deep in a well shaft in the Lascaux cave, depict a hunting scene, they constitute the earliest example of narrative art ever discovered.

timber frames, varied in size but repeated the same basic plan. The rooms have plastered and painted floors and walls, with platforms along the walls that served as sites for sleeping, working, and eating. The living buried the dead beneath the floors.

The excavators have found many rooms decorated with mural paintings and plaster reliefs. These "shrines" had an uncertain function, but their number indicates that the rooms played an important role in the life of the Neolithic settlement. On the wall of one room, archaeologists discovered a painted representation of a deer that the hunters of the Paleolithic period produced. Perhaps what is most strikingly new about the Çatal Höyük painting and similar Neolithic examples is the regular appearance of the human figure—not only singly but also in large, coherent groups with a wide variety of poses, subjects, and settings. As noted earlier, humans rarely figured in Paleolithic paintings. As noted earlier, humans rarely unknown. Even the Lascaux "hunting scene" (Fig. 1-6) is doubtful as a narrative. In Neolithic art, scenes with humans dominating aniunknown. Even the Lascaux "hunting scene" (Fig. 1-6) is doubtful as a narrative. In Neolithic art, scenes with humans dominating aniunknown.

In the Çatal Höyük hunt, the group of hunters—and no one doubts that it is, indeed, an organized hunting party, not a series of individual figures—is a rhythmic repetition of basic shapes, but the painter took care to distinguish important descriptive details (bows, arrows, and garments), and the heads have clearly defined noses, mouths, chins, and hair. The Neolithic painter placed all the choses the profile for the same reason Paleolithic painters universally view of the human head shows all its shapes clearly. However, at Catal Höyük the painter presented the torsos from the front—again, the most informative viewpoint—whereas the profile view was the choice for the legs and arms. This composite view of the human body is as artificial as the twisted horns of the Lascaux bulls (Fig. 1-5) because the human body cannot make an abrupt 90-degree shift at the hips. But it well describes the parts of a human body, as opposed the hips. But it well describes the parts of a human body, as opposed the hips. But it well describes the parts of a human body, as opposed the hips. But it well describes the parts of a human body, as opposed the hips. But it well describes the parts of a human body, as opposed the hips. But it well describes the parts of a human body, as opposed the hips. But it well describes the parts of a human body, as opposed the hips.

The technique of painting also changed dramatically from the Paleolithic to the Neolithic Age. The Çatal Höyük painters used

to how a body appears from a particular viewpoint.

mals are central subjects.

the bird on top and the spear belong to him? Is it he or the rhinoceros that gravely wounded the bison—or neither? Which animal, if either, has knocked the man down, if indeed he is on the ground? Are these three images related at all? Modern viewers can be sure to tell a story, this is evidence for the creation of narrative compositions involving humans and animals at a much earlier date than anyone had imagined only a few generations ago. Yet it is important to remember that even if the painter(s) intended to tell a story, very few people would have been able to "read" it. The mural, in a deep shaft, is very difficult to reach and could have been viewed only in flickering lamplight. Like all Paleolithic art, the scene in the Lascaux

AgA sidtilo9M

well shaft is a puzzle.

Around 9000 BCE, the ice covering much of northern Europe during the Paleolithic period melted as the climate warmed. The sea level rose more than 300 feet, separating England from continental Europe, and Spain from Africa. The Paleolithic gave way to a transitional period, the Mesolithic (Middle Stone Age). Then, for several great new age, the Mesolithic (New Stone Age), dawned. Humans great new age, the Neolithic (New Stone Age), dawned. Humans Degan to domesticate plants and animals and settle in fixed abodes. Their food supply assured, many groups changed from hunters to herders to farmers and finally to townspeople. Wandering hunters by cultivated fields. In addition to agriculture, these Neolithic societies originated weaving, metalworking, pottery, and counting and recording with tokens, and constructed religious shrines as well as recording with tokens, and constructed religious shrines as well as homes.

This traditional sequence may recently have been overturned, however, by excavations at Göbekli Tepe in southeastern Turkey. There, German archaeologists discovered that prehistoric huntergatherers had built stone temples with animal reliefs on T-shaped pillars around 9000 BCE, long before sedentary farmers established permanent village communities at sites such as Çatal Höyük.

ÇATAL HÖYÜK The Neolithic settlement at Çatal Höyük on the central Anatolian plateau flourished between 6500 and 5700 BCE and was one of the world's first experiments in urban living. The regularity of the town's plan suggests that the inhabitants built the settlement to some predetermined scheme. The houses, constructed of mud brick strengthened by sturdy mud brick strengthened by sturdy

1-7 Deer hunt, detail of a wall painting from level III, Çatal Höyük, Turkey, ca. 5750 BCE. Museum of Anatolian Civilization, Ankara.

This Meolithic painter depicted human figures as composites of frontal and profile views, the most descriptive picture of the shape of the human body. This format would become the rule for millennia.

1-8 Human figure, from Ain Ghazal, Jordan, ca. 6500 BCE. Plaster, painted and inlaid with cowrie shell and bitumen, 3' $5\frac{3}{8}$ " high. Musée du Louvre, Paris.

At Ain Ghazal, archaeologists have uncovered dozens of large white plaster Neolithic statuettes with details added in paint and shell. They mark the beginning of large-scale sculpture in the history of art.

brushes to apply their pigments to a background of dry white plaster. The careful preparation of the wall surface is in striking contrast to the direct application of pigment to the irregularly shaped walls and ceilings of Old Stone Age caves.

AIN GHAZAL A second well-excavated Neolithic settlement is Ain Ghazal, near Amman, Jordan. Occupied from around 7200 to 5000 BCE, Ain Ghazal has produced striking finds, including two caches containing three dozen plaster statuettes (FIG. 1-8) datable to around

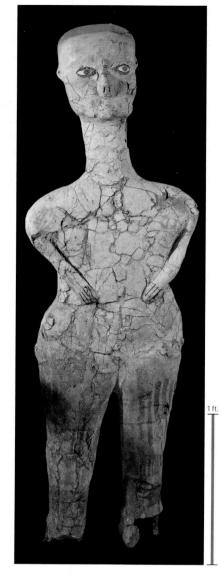

6500 BCE. The sculptures, which appear to have been ritually buried, are white plaster built up over a core of reeds and twine, with black bitumen, a tarlike substance, for the pupils of the eyes. Some of the figures have painted clothing. Only rarely did the sculptors indicate the gender of the figures. Whatever their purpose, the size (as much as 3 feet tall) and sophisticated technique of the Ain Ghazal statuettes sharply differentiate the Neolithic figurines from tiny, faceless Paleolithic sculptures such as the *Venus of Willendorf* (FIG. 1-2). The Ain Ghazal statues mark the beginning of large-scale sculpture in the ancient world.

STONEHENGE In western Europe, where Paleolithic paintings and sculptures abound, no comparably developed towns of the time of Çatal Höyük or Ain Ghazal have been found. However, in succeeding millennia, perhaps as early as 4000 BCE, the local Neolithic populations in several areas developed a monumental architecture employing massive rough-cut stones. The very dimensions of the stones, some as tall as 24 feet and weighing as much as 50 tons, have prompted historians to call them *megaliths* ("great stones") and to designate the culture that produced them *megalithic*.

Although megalithic monuments are plentiful throughout Europe, the arrangement of huge stones in a circle (called a *henge*), often surrounded by a ditch, is almost entirely limited to Britain. The most imposing example is Stonehenge (FIG. 1-9) near Salisbury, a complex of rough-cut sarsen (a form of sandstone) stones and smaller "bluestones" (various volcanic rocks) built in several stages over hundreds of years. In its final form, Stonehenge consists of an outermost ring, 97 feet in diameter, of 24-foot-tall sarsen monoliths (one-piece pillars) supporting lintels (horizontal stone blocks used to span an opening). This simple post-and-lintel system of construction is still in use today. Inside is a ring of bluestones, which in turn encircles a horseshoe (open end facing east) of trilithons (threestone constructions)—five lintel-topped pairs of the largest sarsens, each weighing 45 to 50 tons. Standing apart and to the east (outside the aerial view) is the "heel-stone," which, for a person looking outward from the center of the complex, would have marked the

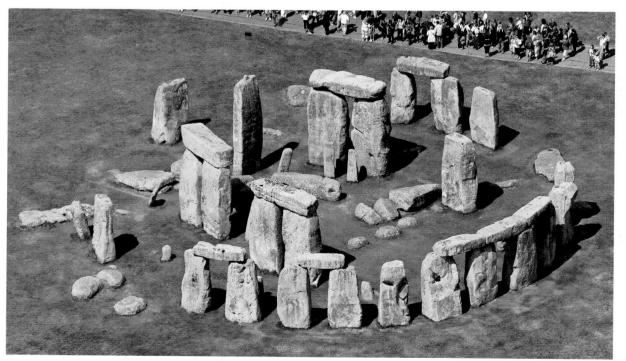

1-9 Aerial view of Stonehenge (looking northwest), Salisbury Plain, Wiltshire, England, ca. 2550–1600 BCE.

One of the earliest examples of monumental stone architecture in Neolithic Europe, the circles of 24-foot-tall trilithons at Stonehenge probably functioned as an astronomical observatory and solar calendar.

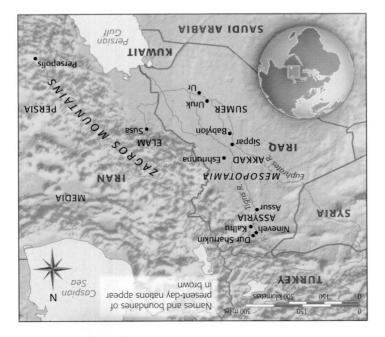

MAP 1-2 Ancient Mesopotamia and Persia.

WHITE TEMPLE, URUK The layout of Sumerian cities reflected the central role of the gods in daily life. The main temple to each state's chief god formed the city's nucleus. In fact, the temple complex was a kind of city within a city, where priests and scribes carried on official administrative and commercial business as well as oversaw all religious functions. The outstanding preserved example of early Sumerian temple architecture is the 5,000-year-old White Temple (Fig. 1-10) at Uruk, a city with a population of about 40,000 that not have access to stone quarries and instead formed mulders did for the superstructures of their temples and other buildings. Mud bricks is a durable building material, but unlike stone, it deteriorates with exposure to water. The Sumerians nonetheless erected towerwith exposure to water. The Sumerians nonetheless erected towerming works, such as the Uruk temple, several centuries before the ing works, built their stone pyramids (Figs. 1-25 to 1-27). This says a

point where the sun rose at the summer solstice. Perhaps originally a burial site, Stonehenge in its latest phase seems to have been a kind of astronomical observatory and a remarkably accurate solar calendar that may also have served as a center of healing, attracting the sick and dying from throughout the region. Whatever function Stonehenge served in Neolithic Britain, it is an enduring testament to the rapidly developing intellectual powers of humans as well as to their capacity for heroic physical effort.

ANCIENT MESOPOTAMIA AND PERSIA

The fundamental change in human society from the dangerous and uncertain life of the hunter and gatherer to the more predictable and stable life of the farmer and herder first occurred in Mesopotamia, the land mass that forms a huge "fertile crescent" from the mountainous border between Turkey and Syria through Iraq to Iran's Zagros Mountain range (MAP 1-2). There, in present-day southern Iraq, the world's first great civilization—Sumer (Fig. 1-1)—arose in the valley between the Tigris and Euphrates Rivers.

Sumer

state was one of the many Sumerian inventions. as protection from enemy attack and the whims of nature. The citychosen from among the leading families, assumed functions such time. The community, whether ruled by a single person or a council had been individually initiated became institutionalized for the first rian city-states of the fourth millennium BCE, activities that once is the hallmark of the first complex urban societies. In the Sumemanufacturing, trade, and administration. Specialization of labor the community were free to specialize in other activities, including portion of the population had to produce food, some members of the Sumerians developed agriculture to such an extent that only a canal construction, crop collection, and food distribution. Because The rulers and priests directed all communal activities, including representatives on earth and the stewards of their earthly treasure. ferent Mesopotamian deities. The Sumerian rulers were the gods' dozen or so independent city-states under the protection of dif-Ancient Sumer was not a unified nation. Rather, it comprised a

1-10 White Temple, Uruk (modern Warka), Iraq, ca. 3200-3000 BCE.

Using only mud bricks, the Sumerians erected temples on lofty platforms several centuries before the Egyptians built stone pyramids. This temple was probably dedicated to Anu, the sky god.

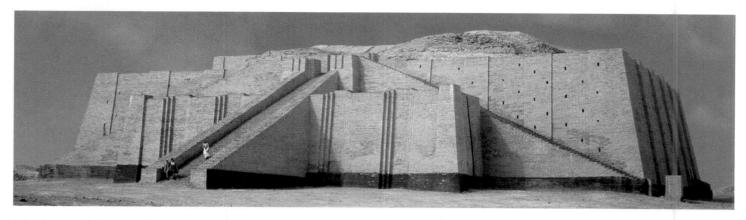

1-11 Ziggurat (looking southwest), Ur (modern Tell Muqayyar), Iraq, ca. 2100 BCE.

The 50-foot-tall Ur ziggurat is one of the largest in Mesopotamia. It has three (restored) ramplike stairways of 100 steps each that originally ended at a gateway to a brick temple, which does not survive.

great deal about the Sumerians' desire to provide grandiose settings for the worship of their deities.

The Uruk temple (whose whitewashed walls suggested its modern nickname) stands atop a platform 40 feet above street level. A stairway leads to the temple at the top. As in other Sumerian temples, the corners of the White Temple are oriented to the cardinal points of the compass. The building, probably dedicated to Anu, the sky god, is of modest proportions (61 by 16 feet). By design, Sumerian temples did not accommodate large throngs of worshipers but only a select few, the priests and perhaps the leading community members. The White Temple had several chambers. The central hall, or *cella*, was the divinity's room and housed a stepped altar. The Sumerians referred to their temples as "waiting rooms," a reflection of their belief that the deity would descend from the heavens to appear before the priests in the cella. It is unclear whether the Uruk temple had a roof.

ZIGGURAT, UR Eroded temples on mud-brick platforms still dominate most of the ruined cities of Sumer. The best preserved is the *ziggurat* (tiered Mesopotamian temple platform) at Ur (FIG. 1-11), the home of the biblical Abraham. Built about a millennium after Uruk's White Temple and much grander, the Ur ziggurat is a solid mass of mud brick 50 feet high, faced with baked bricks laid in bitumen. Three (restored) ramplike stairways of a hundred steps each converge on a tower-flanked gateway. From there another flight of steps (which has not been rebuilt) probably led to the temple that once crowned the ziggurat.

The loftiness of the Sumerian temple platforms made a profound impression on the peoples of ancient Mesopotamia. The tallest, at Babylon, was about 270 feet high. Known to the Hebrews as the Tower of Babel, it became the centerpiece of a cautionary biblical tale (Gen. 11:1–9) about arrogance. Humankind's desire to build a tower to Heaven angered God. The Lord caused the workers to speak different languages, preventing them from communicating with one another and bringing construction of the ziggurat to a halt.

ESHNUNNA STATUETTES The *Warka Vase* (FIG. 1-1), discussed in the introduction to this chapter, provides priceless information about the rituals that took place in Sumerian temples. Further insight into Sumerian religion comes from a cache of gypsum statuettes inlaid with shell and black limestone found in a temple at Eshnunna (modern Tell Asmar). The two largest figures (FIG. 1-12), like all the others, represent mortals rather than deities. They hold the small beakers

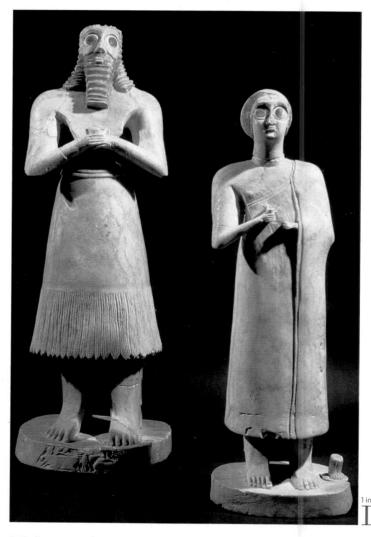

1-12 Statuettes of two worshipers, from the Square Temple at Eshnunna (modern Tell Asmar), Iraq, ca. 2700 BCE. Gypsum, shell, and black limestone. Man 2' $4\frac{1}{4}$ " high, woman 1' $11\frac{1}{4}$ " high. National Museum of Iraq, Baghdad.

The oversized eyes probably symbolize the perpetual wakefulness of these substitute worshipers offering prayers to the deity. The beakers that the figures hold were used to pour libations in honor of the gods.

donors' behalf, the open-eyed stares most likely symbolize the eternal wakefulness necessary to fulfill their duty.

STANDARD OF UR Agriculture, trade, and the spoils of war brought considerable wealth to some of the city-states of ancient Sumer. Nowhere is this clearer than in the so-called Royal Cemetery at Ur. Archaeologists debate whether those buried in this cemetery were true kings and queens or simply aristocrats, priests, and priest-esses, but their tombs were regal in character. They contained gold helmets and daggers with handles of lapis lazuli (a rich azure-blue stone imported from Afghanistan), gold beakers and bowls, jewelry stone imported from Afghanistan), gold beakers and bowls, jewelry

that the Sumerians used for *libations* (ritual pouring of liquid) in honor of the gods. The men wear belts and fringed skirts. Most have beards and shoulder-length hair. The women wear long robes, with the right shoulder bare. Similar figurines from other sites bear inscriptions with the name of the donor and the god or even specific prayers to the deity on the owner's behalf. With their heads tilted upward, the figures wait in the Sumerian "waiting room" for the divinity to appear. Most striking is the disproportionate relationship between the inlaid oversized eyes and the tiny hands. Scholars have explained the exaggeration of the eye size in various ways. Because the purpose of these votive figures was to offer constant prayers to the gods on their

1-13 War side of the Standard of Ur, from tomb 779, Royal Cemetery, Ur (modern Tell Muqayyar), Iraq, ca. 2600-2400 BCE. Wood, lapis lazuli, shell, and red limestone, $8" \times 1' 7"$. British Museum, London.

In this early example of historical narrative, a Sumerian artist depicted a battlefield victory in three registers, reading from bottom to top. The size of the figures varies with their importance in society.

1-14 Peace side of the Standard of Ur, from tomb 779, Royal Cemetery, Ur (modern Tell Muqayyar), Iraq, ca. 2600-2400 BCE. Wood, lapis lazuli, shell, and red limestone, $8" \times 1' 7"$. British Museum, London.

Entertaining the Sumerian nobility at this banquet are a harp player and a singer. The artist represented all of the standing and seated humans in composite views and all the animals in strict profile.

of gold and lapis, musical instruments, chariots, and other luxurious items. Not the costliest object found in the "royal" graves, but the most significant for the history of art, is the so-called *Standard of Ur* (FIGS. 1-13 and 1-14), the sloping sides of which are inlaid with shell, lapis lazuli, and red limestone. The excavator who discovered this box-shaped object thought the Sumerians mounted it on a pole as a kind of military standard, hence its nickname. The "standard" may have been the sound box of a musical instrument.

Art historians usually refer to the two long sides of the box as the "war side" (FIG. 1-13) and "peace side" (FIG. 1-14). On the war side, four ass-drawn four-wheeled war chariots crush enemies, whose bodies appear on the ground in front of and beneath the animals. Above, foot soldiers gather up and lead away captured foes. In the uppermost register, soldiers present bound captives (whom the victors have stripped naked to degrade them) to a kinglike figure, who has stepped out of his chariot. His central place in the composition and his greater stature (his head breaks through the border at the top) set him apart from all the other figures.

In the lowest band on the peace side, men carry provisions, possibly war booty, on their backs. Above, attendants transport animals, perhaps also spoils of war, and fish for the great banquet depicted in the uppermost register. There, seated dignitaries and a largerthan-life personage (third from the left; probably a king, whose head interrupts the upper border) attend a feast. A harp player and a longhaired bare-chested singer (a court eunuch) entertain the group. Some art historians have interpreted the scene as a celebration after the victory in warfare represented on the other side of the box. But the two sides may be independent narratives illustrating the two principal roles of a Sumerian ruler—the mighty warrior who defeats enemies of his city-state and the chief administrator who, with the blessing of the gods, assures the bountifulness of the land in peacetime (compare FIG. 1-1). The absence of an inscription prevents connecting the scenes with a specific event or person, but, like the Warka Vase, the Standard of Ur undoubtedly is another early example of historical narrative, even if only of a generic kind.

Akkad

In 2334 BCE, the loosely linked group of cities known as Sumer came under the domination of a great ruler, Sargon of Akkad (r. 2332–2279 BCE). Archaeologists have yet to locate Akkad, but the city was in the vicinity of Babylon. Under Sargon (whose name means "true king") and his successors, the Akkadians introduced a new concept of royal power based on unswerving loyalty to the king rather than to the city-state. Naram-Sin (r. 2254–2218 BCE), Sargon's grandson, regarded the governors of his cities as mere royal servants, and called himself King of the Four Quarters—in effect, ruler of the earth, akin to a god.

AKKADIAN PORTRAITURE A magnificent copper head (FIG. 1-15) portraying an Akkadian king embodies this new concept of absolute monarchy. The head is all that survives of a statue knocked over in antiquity, perhaps during the sack of Nineveh in 612 BCE. To make a political statement, the enemy forces not only toppled the Akkadian royal portrait but gouged out the eyes (once inlaid with precious or semiprecious stones), broke off the lower part of the beard, and slashed the ears. Nonetheless, the king's majestic serenity, dignity, and authority are evident. So, too, is the masterful way the sculptor balanced *naturalism* and *abstract* patterning. The artist carefully observed and recorded the distinctive profile of the king's nose and

long, curly beard, and brilliantly communicated the differing textures of flesh and hair, even the contrasting textures of the mustache, beard, and braided hair on the top of the head. The coiffure's triangles, lozenges, and overlapping disks of hair and the great arching eyebrows that give such character to the portrait reveal that the artist was also sensitive to formal pattern. No less remarkable is the fact that this is the oldest extant life-size, hollow-cast metal sculpture (see "Hollow-Casting Life-Size Bronze Statues," page 64). The head demonstrates the sculptor's skill in casting and polishing copper and in engraving the details.

NARAM-SIN The godlike sovereignty the kings of Akkad claimed is also evident in the victory stele that Naram-Sin set up at Sippar. A *stele* is a carved stone slab erected to commemorate a historical event or, in some other cultures, to mark a grave (FIG. 2-45). Naram-Sin's

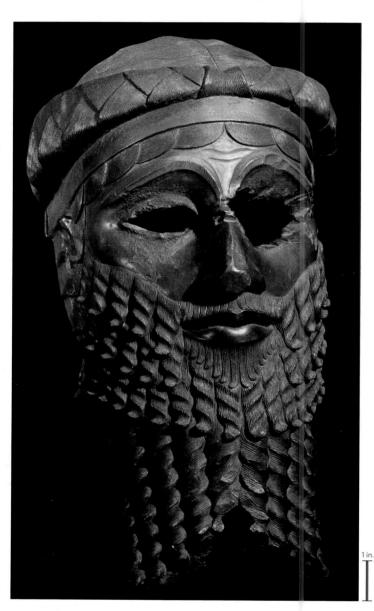

1-15 Head of an Akkadian ruler, from Nineveh (modern Kuyunjik), Iraq, ca. 2250–2200 BCE. Copper, 1' $2\frac{3}{8}$ " high. National Museum of Iraq, Baghdad.

The sculptor of this oldest known life-size hollow-cast head captured the distinctive features of the ruler while also displaying a keen sense of abstract pattern. Vandals defaced the head in antiquity.

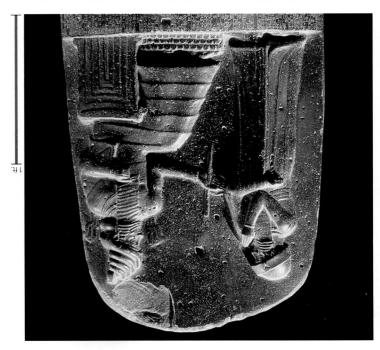

7' 4" high, detail 2' high. Musée du Louvre, Paris. set up at Babylon, Iraq, found at Susa, Iran, ca. 1780 BCE. Basalt, stele 1-17 Hammurabi and Shamash, detail of the law stele of Hammurabi,

senting a figure or object from an angle (foreshortening). shouldered sun god Shamash, one of the first examples of an artist repre-Crowning Hammurabi's law stele is a relief of the king and the flame-

tional formula of telling a story in a series of horizontal registers. levels. This was a bold rejection of the millennium-old composilandscape setting for the story and placing the figures on staggered head. But the sculptor showed daring innovation in creating a

Babylon

Mesopotamia in the 18th and 17th centuries BCE. ceeded in establishing a centralized government that ruled southern reemerged and persisted until one of those cities, Babylon, succal pattern of several independent city-states existing side by side the following two centuries, the traditional Mesopotamian politiof the Elamites, who ruled the territory east of the Tigris River. In resurgence was short lived. The last of the Ur kings fell at the hands then that the Ur ziggurat (FIG. 1-11) was constructed, but Sumer's of Ur. Historians call this period the Third Dynasty of Ur. It was tamia, and established a Neo-Sumerian state ruled by the kings response to the alien presence, drove the Gutians out of Mesopoto Akkadian power. The cities of Sumer, however, soon united in Around 2150 BCE, a mountain people, the Gutians, brought an end

The symbols are builders' tools—measuring rods and coiled rope. extends to Hammurabi the rod and ring that symbolize authority. shouldered sun god. The king raises his hand in respect. The god the top (FIG. 1-17), Hammurabi stands before Shamash, the flametall black-basalt stele (FIG. 1-16A (1)) discovered at Susa in Iran. At down of a neighbor's trees. Hammurabi's laws are inscribed on a penalties for everything from adultery and murder to the cutting is best known today for his comprehensive laws, which prescribed (r. 1792-1750 BCE). Famous in his own time for his conquests, he HAMMURABI Babylon's most powerful king was Hammurabi

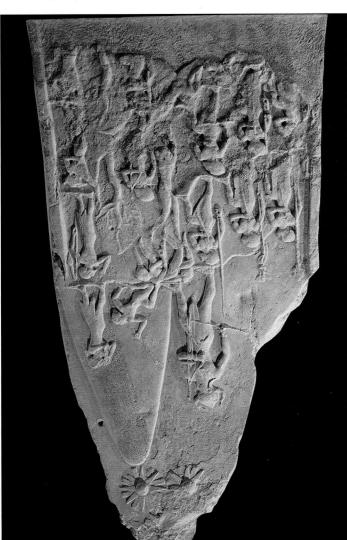

Iran, ca. 2254-2218 BCE. Pink sandstone, 6' 7" high. Musée du Louvre, 1-16 Victory stele of Naram-Sin, set up at Sippar, Iraq, found at Susa,

figures, abandoning the traditional register format. showing him leading his army up a mountain. The sculptor staggered the To commemorate his conquest of the Lullubi, Naram-Sin set up this stele

By storming the mountain, Naram-Sin seems also to be scalfavorable stars (the stele is damaged at the top) shine on his triumph. first time a king appears as a god in Mesopotamian art. At least three fallen Lullubi. He wears the horned helmet signifying divinity—the alone, far taller than his men, treading on the bodies of two of the His routed enemies fall, flee, die, or beg for mercy. The king stands son of Sargon leading his army up the slopes of a wooded mountain. the Iranian mountains to the east. The sculptor depicted the grandstele (FIG. 1-16) commemorates his defeat of the Lullubi, a people of

and by placing a frontal two-horned helmet on Naram-Sin's profile cially by portraying the king and his soldiers in composite views Akkadian artist adhered to older conventions in many details, espevariety of postures. One falls headlong down the mountainside. The forces. In contrast, the Lullubi are in disarray, depicted in a great orderly files, suggesting the discipline and organization of the king's potamian ziggurats. His troops march up the slope behind him in ing the ladder to the heavens, the same idea that lies behind Meso-

PROBLEMS AND SOLUTIONS

How Many Legs Does a Lamassu Have?

Guarding the gate to Sargon II's palace at Dur Sharrukin and many of the other Assyrian royal complexes were colossal limestone monsters (FIG. 1-18), which the Assyrians probably called *lamassu*. These winged, man-headed bulls (or lions in some instances) served to ward off the king's enemies.

The task of moving and installing these immense stone sculptures was so difficult that several reliefs in the palace of Sargon's successor, Sennacherib (r. 705–681 BCE), celebrate the feat, showing scores of men dragging lamassu figures with the aid of ropes and sledges.

The two lamassu guarding the gateway of Sargon's Dur Sharrukin palace are nearly 14 feet tall. But transporting these mammoth blocks from the quarry to the building site was not the only problem the Assyrian sculptors had to confront. The artists also had to find a satisfactory way to represent a composite beast no one had ever seen, and they had to make the monster's unfamiliar form intelligible from every angle. They came up with a solution that may seem strange to modern eyes, but one consistent with the pictorial conventions of the age and perfectly suited to the problem.

The Assyrian lamassu sculptures are partly in the round, but the sculptors nonetheless conceived them as high reliefs on adjacent sides of a corner. They combine the front view of the animal at rest with the side view of it in motion. Seeking to present a complete picture of the lamassu from both the front and the side, the sculptors of all the extant Assyrian guardian statues gave each of the monsters five legs—two seen from the front, four seen from the side.

The Assyrian lamassu sculptures, therefore, are yet another case of early artists providing a *conceptual representation* of an animal or person and all its important parts, as opposed to an *optical representation* of the composite monster as it would stand in the real, versus the pictorial, world.

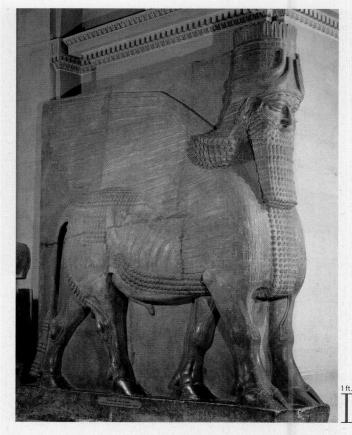

1-18 Lamassu (man-headed winged bull), from the citadel of Sargon II, Dur Sharrukin (modern Khorsabad), Iraq, ca. 720–705 BCE. Limestone, 13' 10" high. Musée du Louvre, Paris.

Ancient sculptors insisted on showing complete views of animals. This four-legged composite monster that guarded an Assyrian palace has five legs—two when seen from the front and four in profile view.

They connote Hammurabi's capacity to build the social order and to measure people's lives—that is, to render judgments and enforce laws. The sculptor depicted Shamash in the familiar convention of combined front and side views, but with two important exceptions. The god's great headdress with its four pairs of horns is in true profile so that only four, not all eight, of the horns are visible. Also, the artist seems to have tentatively explored the notion of foreshortening-a means of suggesting depth by representing a figure or object at an angle, instead of frontally or in profile. Shamash's beard is a series of diagonal rather than horizontal lines, suggesting its recession from the picture plane. The sculptor also depicted the god's throne at an angle, further enhancing the illusion of spatial recession. Innovations such as these and the bold abandonment of the register format in favor of a tiered landscape on the Naram-Sin stele were exceptional in early eras of the history of art. These occasional departures from conventional representational modes testify to the creativity of Mesopotamian artists, but they did not displace the age-old formulas.

Assyria

The Babylonian Empire toppled in the face of an onslaught by the Hittites, an Anatolian people who conquered and sacked Babylon around 1595 BCE. They then retired to their homeland, leaving

Babylon in the hands of the Kassites. By around 900 BCE, however, the Assyrians had overtaken Mesopotamia. The new conquerors took their name from Assur, the city in northern Iraq dedicated to the god Ashur. At the height of their power, the Assyrians ruled an empire that extended from the Tigris to the Nile and from the Persian Gulf to Asia Minor.

DUR SHARRUKIN The royal citadel of Sargon II (r. 721–705 BCE) at Dur Sharrukin is the most completely excavated of the many Assyrian palaces. The citadel measured about a square mile in area and included a great ziggurat and six sanctuaries for six different gods. The palace, elevated on a mound 50 feet high, covered some 25 acres and had more than 200 courtyards and timber-roofed rooms. The ambitious layout reveals the confidence of the Assyrian kings in their all-conquering might, but its strong defensive walls and gateway guarded by monstrous beasts (see "How Many Legs Does a Lamassu Have?" above, and FIG. 1-18) also reflect a society ever fearful of attack during a period of almost constant warfare.

KALHU Sheathing the mud-brick walls of the Assyrian palaces were extensive series of painted gypsum reliefs exalting royal power and piety. The sculptures record official ceremonies, religious rituals, battlefield victories, and the slaying of wild animals. (The Assyrians,

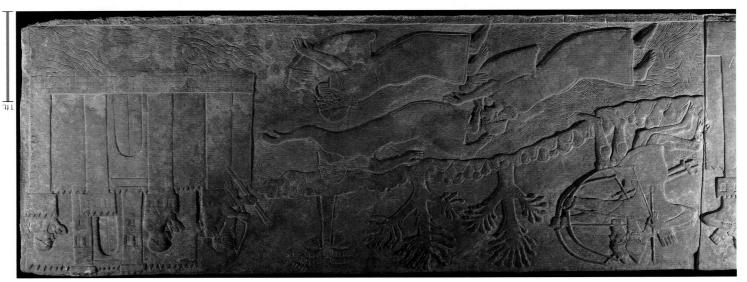

Assyrian archers pursuing enemies, relief from the northwest palace of Ashurnasirpal II, Kalhu (modern Nimrud), Iraq, ca. 875-860 BCE. Gypsum, 2' $10\frac{5}{8}$ " high. British Museum, London.

Extensive reliefs exalting the king and recounting his great deeds adorned the walls of Assyrian palaces. This one depicts Ashurnasirpal II's archers driving the enemy into the Euphrates River.

Tower of Babel—dedicated to Mardulk, the chief god of the Babylonians. Throughout the city, the most important monuments were faced with dazzling blue glazed bricks. Some of the buildings, such as the Ishtar Gate (Fig. 1-20), with its imposing arcuated (archablapped) opening flanked by towers, featured glazed bricks with molded reliefs of animals, real and imaginary. The Babylonian proper sequence on the wall. On the Ishtar Gate, profile figures of Mardulk's dragon and Adad's bull alternate. (Ishtar was the Babylonian proper sequence on the wall. On the Ishtar Gate, profile figures of mian equivalent of Inanna; Adad was the Babylonian god of storms.) Lining the processional way leading up to the gate were reliefs of Ishtar's sacred lion, glazed in yellow, brown, and red against a blue Jackground.

Achaemenid Persia

Although Nebuchadnezzar—the "king of kings" in the book of Daniel (2:37)—had boasted that he "caused a mighty wall to circumscribe Babylon . . . so that the enemy who would do evil would not threaten," Cyrus of Persia (r. 559–529 BCE) captured the city in that the sacestry back to a mythical King Achaemene. Babylon was but one of the Persians' conquests. Egypt fell to them in 525 BCE, and by 480 BCE the Persian Empire was the largest the world had yet known, extending from the Indus River in South Asia to the Danube River in northeastern Europe. If the Greeks had not turned back the Persians in 479 BCE, the Achaemenids would have taken control of southeastern Europe as well (see page 63). The Achaemenance in did line ended with the death of Darius III in 330 BCE, after his defeat at the hands of Alexander the Great (Fig. 2-50).

PERSEPOLIS The most important source of knowledge about Persian art and architecture is the ceremonial and administrative complex within the citadel at Persepolis (FIG. 1-21), which the successors of Cyrus, Darius I (r. 522–486 BCE) and Xerxes (r. 486–465 BCE), built between 521 and 465 BCE. Situated on a high plateau, the

like many other societies before and after, regarded prowess in hunting as a manly virtue on a par with success in warfare.) One of the most extensive cycles of Assyrian narrative reliefs comes from the northwest palace of Ashurnasirpal II (r. 883–859 BCE) at Kalhu.

All these liberties with optical reality, however, result in a vivid and will snare their heads in their bows when they launch their arrows.) but behind their heads in order not to hide their faces. (The men ments for clarity. The archers' bowstrings are in front of their bodies men, trees, and fort from the side. The artist also made other adjustcomposition. The spectator views the river from above, and the Assyrian sculptor also combined different viewpoints in the same would stand out from their environment (compare FIG. 1-16). The compressed distances and enlarged the human actors so that they land, perhaps at some distance from the battle. Ancient artists often fort as if it were in the middle of the river, but it was, of course, on is a fort where their compatriots await them. The artist showed the attempt to float to safety by inflating animal skins. Their destination fleeing foes. One swims with an arrow in his back. The other two into the Euphrates River. Two Assyrian archers shoot arrows at three 878 BCE battle during which the Assyrians drove the enemy's forces The relief illustrated here (Fig. 1-19) depicts an episode in an

easily legible narrative, which was the sculptor's primary goal.

Neo-Babylonia

The Assyrian Empire was never very secure, and in the mid-seventh century BCE it began to disintegrate, eventually collapsing from the simultaneous onslaught of the Medes from the east and the resurgent Babylonians from the south. For almost a century beginning in 612 BCE, Meo-Babylonian kings held sway over the former Assyrian Empire.

ISHTAR GATE The most renowned Neo-Babylonian king was Nebuchadnezzar II (r. 604–562 BCE), who restored Babylon to its rank as one of the great cities of antiquity. The centerpiece of Nebuchadnezzar's vast mud-brick city was an enormous ziggurat—the

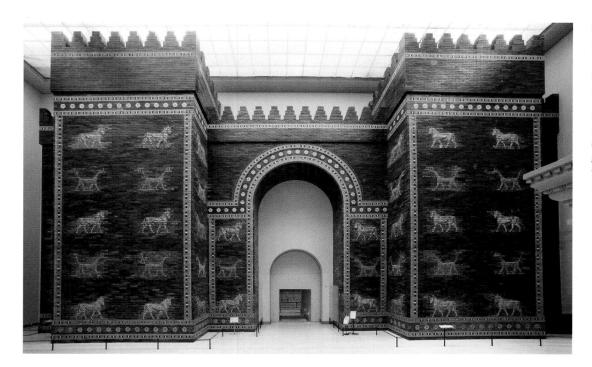

1-20 Ishtar Gate (restored), Babylon, Iraq, ca. 575 BCE. Vorderasiatisches Museum, Staatliche Museen zu Berlin, Berlin.

Babylon under King Nebuchadnezzar II was one of the greatest cities of the ancient world. Its gigantic arcuated Ishtar Gate featured glazed-brick reliefs of Marduk's dragon and Adad's bull.

heavily fortified complex of royal buildings stood on a wide platform overlooking the plain. Alexander the Great razed the site in a gesture symbolizing the destruction of Persian imperial power. Even in ruins, the Persepolis citadel is impressive. The approach to the citadel led through a monumental gateway called the Gate of All Lands, a reference to the harmony among the peoples of the vast Persian Empire. Assyrian-inspired colossal man-headed winged bulls flanked the great entrance. Broad ceremonial stairways provided access to the platform and the huge royal audience hall, or *apadana*, in which 10,000 guests could stand at one time amid 36 colossal *columns* with 57-foot *shafts* topped by sculpted animals.

The reliefs decorating the walls of the terrace and staircases leading to the apadana represent processions of royal guards, Persian nobles and dignitaries, and representatives from 23 subject nations bringing tribute to the king. Every emissary wears a characteristic costume and carries a typical regional gift for the conqueror. Traces of paint prove that the reliefs were brightly colored. Although Assyrian palace reliefs may have inspired those at Persepolis, the

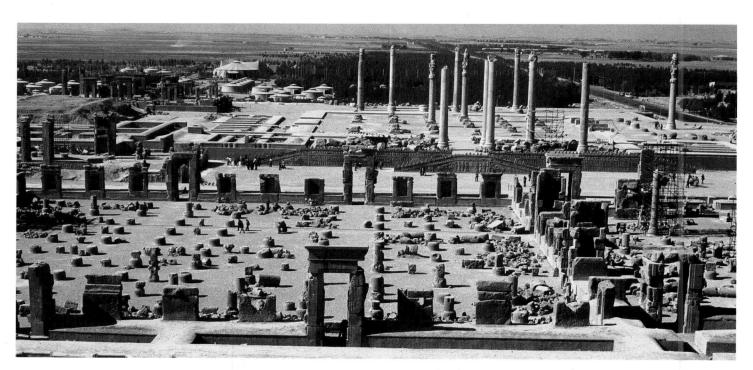

1-21 Aerial view of Persepolis (looking west with the apadana in the background), Iran, ca. 521-465 BCE.

The Persian capital at Persepolis boasted a grandiose column-filled royal audience hall capable of housing 10,000 guests. The terraces featured reliefs of subject nations bringing tribute to the king.

culture on the banks of the Nile around 3500 BCE. In Predynastic times, Egypt was divided geographically and politically into Upper Egypt (the southern, upstream part of the Nile Valley) and Lower (northern) Egypt. The ancient Egyptians began the history of their kingdom with the unification of the two lands, which until recently historians thought occurred during the First Dynasty kingship of

PALETTE OF KING NARMER Many Egyptologists have identified Menes with King Narmer, whose image and name appear on both sides of a ceremonial palette (stone slab with a circular depression) found at Hierakonpolis. The palette (FIGS. 1-22 and 1-23) is an in the Predynastic period to prepare eye makeup, which Egyptians object commonly used in the Predynastic period to prepare eye makeup, which Egyptians palette is the earliest extant labeled work of historical art. Although palette is the earliest extant labeled work of historical art. Although of the first of Egypt's 31 dynastics around 2920 BCE (the last ended in 332 BCE), 1 it does record the unification of Upper and Lower that this unification occurred over several centuries, but the palette presents the creation occurred over several centuries, but the palette resents the creation occurred over several centuries, but the palette presents the creation occurred over several centuries, but the palette presents the creation occurred over several centuries, but the palette presents the creation of the "Kingdom of the Two Lands" as a single present the creation of the "Kingdom of the Two Lands" as a single present the creation of the "Kingdom of the Two Lands" as a single of the resent the creation of the "Kingdom of the Two Lands" as a single of the resent the creation of the "Kingdom of the Two Lands" as a single of the resent the creation of the "Kingdom of the Two Lands" as a single of the resent the creation of the palette of the p

King Narmer's palette is important not only as a document marking the transition from the prehistorical to the historical period in ancient Egypt but also as a kind of early blueprint of the formula for figure representation that characterized most Egyptian art for 3,000 years. At the top of each side of the palette are two heads of a cow with a woman's face, whom scholars usually identify as Hathor.

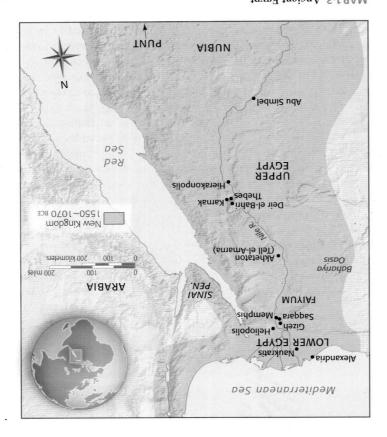

MAP 1-3 Ancient Egypt.

Persian sculptures differ in style. The forms are more rounded, and they project more from the background. Some of the details, notably the treatment of drapery folds, echo forms characteristic of contemporaneous Greek sculpture. Achaemenid art testifies to the active exchange of ideas and artists among Mediterranean, Mesopotamian, and Persian civilizations at this date. A building inscription at Susa, for example, names Ionian Greeks, Medes (who occupied the land north of Persia), Egyptians, and Babylonians among those who built and decorated the palace.

of Islam (see Chapter 5). greatest artists and architects of Mesopotamia worked in the service in 636, just four years after the death of Muhammad. Thereafter, the 400 years, until the Arabs drove the Sasanians out of Mesopotamia (in modern Turkey). The New Persian Empire endured more than pur I was able to capture the Roman emperor Valerian near Edessa territory. So powerful was the Sasanian army that in 260 CE, Sha-Shapur I (r. 241-272), succeeded in further extending Sasanian of Rome's eastern enemies). The son and successor of Artaxerxes, Persian Empire in 224 CE after he defeated the Parthians (another first Sasanian king, Artaxerxes I (r. 211-241), founded the New Sasan, said to be a direct descendant of the Achaemenid kings. The Sasanians. They traced their lineage to a legendary figure named to force them out of the region. The new rulers called themselves new power rose up in Persia that challenged the Romans and sought then Roman rule in western Asia. In the third century CE, however, a 330 BCE marked the beginning of a long period of first Greek and THE SASANIANS Alexander the Great's conquest of Persia in

ANCIENT EGYPT

Blessed with ample sources of stone of different hues suitable for carving statues and fashioning building blocks, the ancient Egyptians left to posterity a profusion of spectacular monuments spanning three millennia. Many of them, as in Mesopotamia, glorify gods and were set up by kings, whom the Egyptians believed were also divine. Indeed, the Egyptians devoted enormous resources to erecting countless monuments and statues to honor their god-kings durenntless monuments and statues to honor their god-kings during their lifetimes and to constructing and furnishing magnificent

The backbone of Egypt was, and still is, the Nile River, which, through its annual floods, supported all life in that ancient land (MAP 1-3). Even more so than the Tigris and the Euphrates Rivers of Mesopotamia, the Nile defined the cultures that developed along its banks. Originating deep in Africa, the world's longest river flows through regions that may not receive a single drop of rainfall in a decade. Yet crops thrive from the rich soil that the Nile brings thousands of miles from the African hills. In antiquity, the land bordering the Nile consisted of marshes dotted with island ridges. Amphibious animals swarmed in the marshes, where the Egyptians hunted them through tall forests of papyrus and rushes (Fig. 1-30). Egypt's fertility was famous. When the Kingdom of the Nile became a province of the Roman Empire after the death of Queen Cleopatra a province of the Roman Empire after the death of Queen Cleopatra (r. 51–30 BCE), it served as the granary of the Mediterranean world.

Predynastic and Early Dynastic Periods

The Predynastic, or prehistoric, beginnings of Egyptian civilization are obscure. Nevertheless, tantalizing remains of tombs, paintings, pottery, and other artifacts attest to the existence of a sophisticated

1-22 Back of the palette of King Narmer, from Hierakonpolis, Egypt, Predynastic, ca. 3000–2920 BCE. Slate, 2' 1" high. Egyptian Museum, Cairo.

Narmer's palette is the earliest surviving labeled work of historical art. The king, the largest figure in the composition, wears the crown of Upper Egypt and slays a captured enemy as his attendant looks on.

the divine mother of all Egyptian kings, but who may instead be the sky goddess Bat. Between the goddess heads is a *hieroglyph* giving Narmer's name (catfish = nar; chisel = mer) within a frame representing the royal palace. Below, the story of the unification of Egypt unfolds in registers.

On the back of the palette (FIG. 1-22), the king, wearing the high, white, conical crown of Upper Egypt and accompanied by a much smaller attendant carrying his sandals, slays a captured enemy. Above and to the right, the king appears again in his role as the "Living Horus"—here as a falcon with one human arm. The falcon-king takes captive a man-headed pictograph with a papyrus plant growing from it that stands for the land of Lower Egypt. Below the king are two fallen enemies. On the front (FIG. 1-23), the elongated necks of two felines form the circular depression that would have held eye makeup in an ordinary palette not made for display. The intertwined necks of the animals may be a pictorial reference to Egypt's unification. In the uppermost register, Narmer, now wearing Lower Egypt's distinctive crown, reviews the beheaded bodies of the enemy. The artist depicted each body with its severed head neatly placed between its legs. In the lowest band, a great bull symbolizing

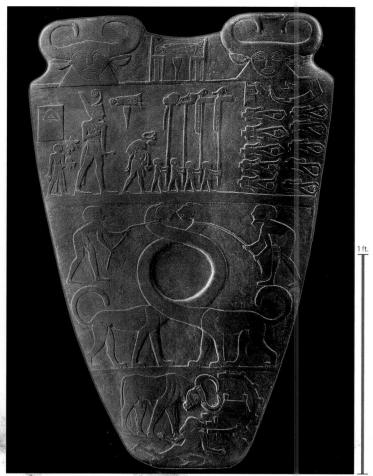

1-23 Front of the palette of King Narmer, from Hierakonpolis, Egypt, Predynastic, ca. 3000–2920 BCE. Slate, 2' 1" high. Egyptian Museum, Cairo.

Narmer, now wearing the crown of Lower Egypt, reviews the beheaded enemy bodies. At the center of the palette, the intertwined animal necks may symbolize the unification of the two kingdoms.

the king's superhuman strength knocks down the fortress walls of a rebellious city.

On both sides of the palette, the god-king performs his ritual task alone and, by virtue of his superior rank, towers over his own men and the enemy. Specific historical narrative was not the artist's goal in this work. What was important was the characterization of the king as supreme, isolated from and larger than all ordinary men and solely responsible for the triumph over the enemy. These pictorial and ideological conventions endured in Egyptian art for millennia.

TOMBS AND THE AFTERLIFE Narmer's palette is exceptional among surviving Egyptian artworks because it is commemorative rather than funerary in nature. The majority of monuments the Egyptians left behind were dedicated to ensuring safety and happiness in the next life (see "Mummification and Immortality," page 32). In fact, the contents of tombs provide the principal evidence for the historical reconstruction of Egyptian civilization.

The standard tomb type in early Egypt was the *mastaba* (Arabic, "bench"), a rectangular brick or stone structure with sloping sides

by providing substitute dwelling places for the ka in case the mummy disintegrated. Wall paintings and reliefs recorded the recurring round of human activities. The Egyptians hoped and expected that the images and inventory of life, collected and set up within the protective stone walls of the tomb, would ensure immortality.

1. Chapel
2. False door
3. Shaft into burial chamber for statue of deceased)
5. Burial chamber
5. Burial chamber

1-24 Section (top), plan (center), and restored view (bottom) of typical Egyptian mastaba tombs.

Egyptian mastabas had underground chambers, which housed the mummified body, portrait statues, and offerings to the deceased. Scenes of daily life often decorated the interior walls.

another. The tomb's dual function was to protect the mummified

posed of a series of mastabas of diminishing size, stacked one atop

shape. About 200 feet high, the stepped pyramid seems to be com-

the tomb was enlarged at least twice before assuming its ultimate

grandiose royal tomb. Begun as a large mastaba with each of its faces oriented toward one of the cardinal points of the compass,

est stone structures in Egypt and, in its final form, the first truly

connected with the Jubilee Festival, the event that perpetually reat-

daily rituals in celebration of the divine king, and several structures

precinct also enclosed a funerary temple, where priests performed

a wall of white limestone 34 feet high and 5,400 feet long. The huge

piece of an immense (37-acre) rectangular enclosure surrounded by

Memphis, Egypt's capital at the time. The pyramid was the center-

designed Djoser's stepped pyramid (FIG. 1-25) at Saqqara, near

probably inflated the list of his achievements, but he undoubtedly

god Re. After his death, the Egyptians deified Imhotep and in time

firmed the royal existence in the hereafter.

Built before 2600 BCE, Djoser's pyramid is one of the old-

ART AND SOCIETY Mummification and Immortality

The Egyptians did not make the sharp distinction between body and soul that is basic to many religions. Rather, they believed that from birth a person had a kind of other self—the ka—which, on the death of the body, could inhabit the corpse and live on. For the ka to live securely, however, the body had to remain as nearly intact as possible. To ensure that it did, the Egyptians developed the technique of embalming (mummification) to a high art.

Embalming generally lasted 70 days. The first step was the surgical removal of the lungs, liver, stomach, and intestines through an incision in the left flank. The Egyptians thought that these organs were most subject to decay, and wrapped them individually and placed them in four jars for eventual deposit in the burial chamber with the corpsecisy surgeons extracted the brain through the nostrils and then discarded it because they did not attach any special significance to that organ. But they left in place the heart, necessary for life and also regarded as the seat of intelligence.

Next, the body was treated for 40 days with natron, a naturally occurring salt compound that dehydrated the body. Then the embalmers filled the corpse with resin-soaked linens, and closed and covered the incision with a representation of Horus's eye, a powerful amulet (a device to ward off evil and promote rebirth). Finally, they treated the body with lotions and resins and wrapped it tightly with hundreds of yards of linen bandages to maintain its shape. The Egyptians often placed other amulets within or on the resulting mummy. Masks (Fig. 138) covered the linen-wrapped faces of the wealthy.

Preserving the deceased's body by mummification was only the first requirement for immortality. Food and drink also had to be provided, as did clothing, utensils, and furniture. Often, Egyptian tombs contained papyrus scrolls with collections of spells and prayers needed to secure a happy afterlife (FIG. 1-23A A). Nothing that had been enjoyed on earth was to be lacking in the tomb (FIG. 1-24). Statuettes called ushabtis ("answerers") performed any labor the deceased equired in the afterlife, answering whenever his or her name was required in the afterlife, answering whenever his or her name was called ushabtis ("answering whenever his or her name was required in the afterlife, answering whenever his or her name was required in the afterlife.

probably developed from earthen mounds that had covered even probably developed from earthen mounds that had covered even earlier tombs. Although mastabas originally housed single burials, as in Pig. 1-24, they later became increasingly complex in order to accommodate many members of the same or several families. The main feature of these tombs, other than the burial chamber itself, was the chapel, which had a false door through which the ka could join the world of the living and partake in the meals placed on an offering table. Some mastabas also had a serdab, a small room housing a statue of the deceased. Adorning the chapel's interior walls and the ancillary rooms were paintings and reliefs depicting scenes from the ancillary rooms were paintings and reliefs depicting scenes from daily life with symbolic overtones (Fig. 1-30).

IMHOTEP AND DIOSER One of the most renowned figures in Egyptian history was IMHOTEP, master builder for King Djoser (r. 2630–2611 BCE) of the Third Dynasty. Imhotep's is the first recorded name of an artist. A man of legendary talent, he also served as Djoser's official seal bearer and as high priest of the sun

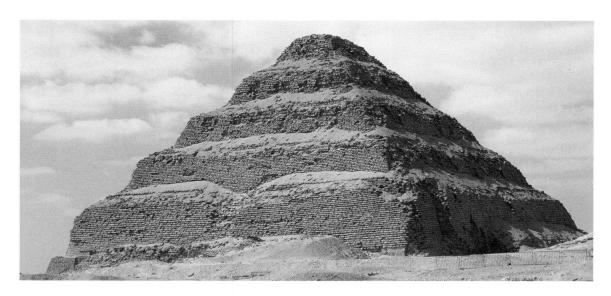

1-25 IMHOTEP, stepped pyramid (looking northwest) of Djoser, Saqqara, Egypt, Third Dynasty, ca. 2630–2611 BCE.

Djoser's tomb, the first pyramid, resembles a series of stacked mastabas. It was the centerpiece of an immense funerary complex glorifying the god-king and his eternal existence in the hereafter.

king and his possessions and to symbolize, by its gigantic presence, his absolute and godlike power. Beneath the pyramid was a network of several hundred underground rooms and galleries, resembling a palace. It was to be Djoser's new home in the afterlife.

Old Kingdom

The Old Kingdom is the first of the three great periods of Egyptian history, called the Old, Middle, and New Kingdoms, respectively. Many Egyptologists now begin the Old Kingdom with Sneferu

(r. 2575–2551 BCE), the first king of the Fourth Dynasty, although the traditional division of kingdoms places Djoser and the Third Dynasty in the Old Kingdom. It ended with the breakup of the Eighth Dynasty around 2134 BCE.

GIZEH PYRAMIDS At Gizeh stand the three Fourth Dynasty pyramids (FIG. 1-26) that are the oldest of the Seven Wonders of the ancient world. The prerequisites for membership in this elite club were colossal size and enormous cost. The Gizeh pyramids testify to the wealth and pretensions of three kings: Khufu (r. 2551–2528 BCE),

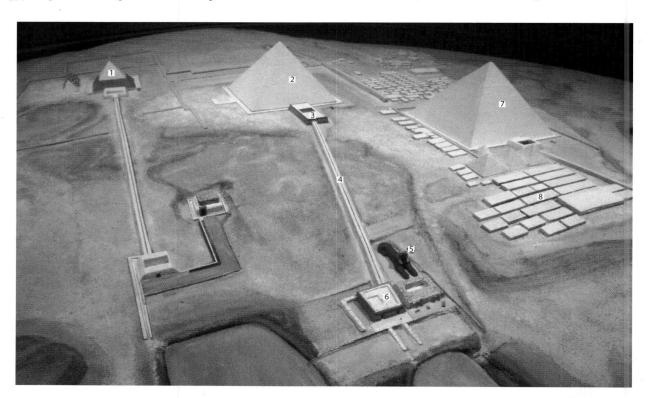

1-26 Model of the Fourth Dynasty pyramid complex, Gizeh, Egypt. Harvard University Semitic Museum, Cambridge.
(1) pyramid of Menkaure, ca. 2490–2472 BCE; (2) pyramid of Khafre, ca. 2520–2494 BCE; (3) mortuary temple of Khafre;
(4) causeway; (5) Great Sphinx, ca. 2520–2494 BCE; (6) valley temple of Khafre; (7) Great Pyramid of Khufu, ca. 2551–2528 BCE;
(8) pyramids of the royal family and mastabas of nobles.

The three pyramids of Gizeh took the shape of the ben-ben, the emblem of the sun god, Re. The sun's rays were the ladder that the Egyptian kings used to ascend to the heavens after their death and rebirth.

torians call this kind of construction ashlar masonry—carefully cut and regularly shaped blocks of stone piled in successive rows, or courses.

To set the ashlar blocks in place, workers erected great rubble ramps against the core of the pyramid. They adjusted the ramps' size and slope as work progressed and the tomb grew in height. Scholars debate whether the Egyptians used simple linear ramps inclined at a right angle to one face of the pyramid, or zigzag or spiral ramps akin to staircases. Linear ramps would have had the advantage of simplicity and would have left three sides of the pyramid unobstructed. But zigzag ramps placed against one side of the structure or spiral ramps winding around the pyramid would have greatly reduced the slope of the incline and would have made dragging the blocks easier. Some scholars also have suggested a combination of straight and spiral ramps, and one recent theory posits a combination of straight and spiral ramps, and one recent theory posits a combination of straight and spiral ramps, and one recent theory posits a

system of spiral ramps within, instead of outside, the pyramid. The Egyptians used ropes and levers both to lift and to lower the stones, guiding each block into its designated place. Finally, the pyramid received a casing of white limestone cut so precisely that the eye could scarcely detect the joints. Some casing stones are still in place at the peak of the pyramid of Khafre (FIG. 1-27).

The Gizeh pyramids attest not only to Egyptian builders' mastery of masonry construction but also their ability to mobilize, direct, house, and feed a huge workforce engaged in one of the most labor-intensive enterprises ever undertaken.

PROBLEMS AND SOLUTIONS Building the Pyramids of Gizeh

The Fourth Dynasty pyramids (Fig. 1-26) across the Nile from modern Cairo are on every list of the Wonders of the ancient world. How did the Egyptians solve the myriad problems they encountered in constructing these colossal tombs?

Like all building projects of this type, the process of erecting the pyramids began with leveling the building site and quarrying the stone, in this case primarily the limestone of the Gizeh plateau itself. Teams of workers had to cut into the rock and remove large blocks of roughly equal size using stone or copper chisels and wood mallets and wedges. Often, the artisans had to cut deep tunnels to find high-quality stone free of cracks and other flaws. To remove a block, the stonemasons cut channels on all sides and partly underneath. Then they pried the stones channels on all sides and partly underneath. Then they pried the stones

After workers liberated the stones, the rough blocks had to be transported to the building site on wood sleds. There, the stonemasons shaped the blocks to the exact dimensions required, with smooth faces (dressed masonry) for a perfect fit. The Egyptians dressed the blocks by chiseling and pounding the surfaces and, in the last stage, by rubbing and grinding the surfaces with fine polishing stones. Architectural his-

Carved out of the Gizeh quarry, the Great Sphinx is of colossal size. Sphinxes have the body of a lion and the head of a man, in this case a king (probably Khafre) wearing the royal headdress and false beard.

7-27 Great Sphinx (with pyramid of Khafre in Egypt, Fourth Dynasty, ca. 2520-2494 BCE. Sand-

free from the bedrock with wood levers.

stone, 65' high.

stepped pyramid may also have been conceived as a giant stairway.) The pyramids were where Egyptian kings were reborn in the afterlife, just as the sun is reborn each day at dawn. As with Djoser's tomb, the four sides of each of the Gizeh pyramids are oriented to the cardinal points of the compass. But the funerary temples associated with the Gizeh pyramids are not on the north side, facing the stars of the northern sky, as was Djoser's temple. The temples are on the east side, facing the rising sun and underscoring their connection with Refecing the rising sun and underscoring their connection with Re.

The tomb of Khufu, known as the Great Pyramid, is the oldest and largest. At the base, the pyramid covers some 13 acres, and

Khafre (r. 2520–2494 BCE), and Menkaure (r. 2490–2472 BCE). Built in the course of about 75 years, these colossal tombs represent the culmination of an architectural evolution that began with the mastaba. The classic pyramid form, however, is not simply a refinement of the stepped pyramid (Fig. 1-25). The new tomb shape probably reflects the influence of Heliopolis, the seat of the powerful cult of Re, whose emblem was a pyramidal stone, the ben-ben. The pyramid nids are symbols of the sun. The Pyramid Texts, inscribed on the burial chamber walls of many royal tombs, refer to the sun's rays as the ladder that the god-king uses to ascend to the heavens. (Djoser's

the length of each side is approximately 775 feet. Its present height is about 450 feet (originally 480 feet). Except for the galleries and burial chamber, the Great Pyramid is an almost solid mass of limestone masonry comprising roughly 2.3 million blocks of stone, each weighing an average of 2.5 tons (see "Building the Pyramids of Gizeh," page 34).

From the remains surrounding the pyramid of Khafre, archaeologists have been able to reconstruct an entire funerary complex consisting of the pyramid itself with the burial chamber; the *mortuary temple* (FIG. 1-26, no. 3) adjoining the pyramid on the east side, where priests made offerings to the god-king; the roofed *causeway* (raised road; no. 4) leading to the mortuary temple; and the *valley temple* (no. 6) at the edge of the floodplain. Many Egyptologists believe that the complex served not only as the king's tomb and temple but also as his palace in the afterlife.

GREAT SPHINX Beside the causeway and dominating the valley temple of Khafre rises the Great Sphinx (FIGS. 1-26, no. 5, and 1-27). Carved from a spur of rock in the Gizeh quarry, the colossal statue is probably an image of Khafre (originally complete with the royal ceremonial beard and *uraeus* cobra headdress), although some scholars believe that it portrays Khufu and antedates Khafre's complex. Whomever it portrays, the *sphinx*—a lion with a human head—was an appropriate royal image. The composite form suggests that the king combines human intelligence with the fearsome strength and authority of the king of beasts.

KHAFRE ENTHRONED Although the Egyptians used wood, clay, and other materials, mostly for images of those not of the royal or noble classes, the primary material for funerary statuary was stone to ensure a permanent substitute home for the ka if the deceased's mummy was destroyed (see "Mummification and Immortality," page 32). The seated statue of Khafre illustrated here (FIG. 1-28) comes from the pharaoh's valley temple (FIG. 1-26, no. 6) near the Great Sphinx. The stone is diorite, an exceptionally hard dark stone brought some 400 miles down the Nile from royal quarries in the south. Khafre wears a simple kilt and sits rigidly upright on a throne formed of two stylized lions' bodies. Between the legs of the throne are intertwined lotus and papyrus plants—symbolic of the united Egypt. Khafre has the royal false beard fastened to his chin and wears the royal linen nemes headdress with uraeus cobra. The headdress covers his forehead and falls in pleated folds over his shoulders. Behind Khafre's head is the falcon that identifies the king as the "Living Horus." As befitting a divine ruler, the sculptor portrayed Khafre with a well-developed, flawless body and a perfect face, regardless of his real age and appearance. Because Egyptians considered ideal proportions appropriate for representing their god-kings, the statue of Khafre is not a true likeness and was not intended to be. The purpose of Egyptian royal portraiture (in vivid contrast to nonroyal portraiture; FIG. 1-28A (1) was not to record individual features or the distinctive shapes of bodies, but rather to proclaim the divine nature of Egyptian kingship.

The enthroned Khafre radiates serenity. The sculptor created this effect in part by giving the figure great compactness and solidity, with few projecting, breakable parts. The form of the statue expresses its purpose: to last for eternity. Khafre's body is one with the simple slab that forms the back of the king's throne. His arms follow the bend of his body and rest on his thighs, and his legs are close together. Part of the original stone block still connects the king's legs to his chair. Khafre's pose is frontal and, except for the

1-28 Khafre enthroned, from Gizeh, Egypt, Fourth Dynasty, ca. 2520–2494 BCE. Diorite, 5' 6" high. Egyptian Museum, Cairo.

This portrait from his pyramid complex depicts Khafre as an enthroned divine ruler with a perfect body. The formality of the pose creates an aura of eternal stillness, appropriate for the timeless afterlife.

hands, *bilaterally symmetrical* (the same on either side of an axis, in this case the vertical axis). The sculptor suppressed all movement and with it the notion of time, creating an aura of eternal stillness.

To produce Khafre's statue, the Egyptian artist first drew the front, back, and two profile views of the enthroned king on the four vertical faces of the stone block. Next, apprentices chiseled away the excess stone on each side. Finally, the workshop head sculpted the parts of Khafre's body, the falcon, and so forth. The polished surface was achieved by *abrasion* (rubbing or grinding). This subtractive method accounts in large part for the blocklike look of the standard Egyptian statue. Nevertheless, other sculptors, both ancient and modern, with different aims, have transformed stone blocks into dynamic, twisting human forms (for example, FIGS. I-14 and 2-57).

Egyptians associated these activities with providing nourishment for the ka in the hereafter, but the subjects also had powerful symbolic overtones. In ancient Egypt, success in the hunt, for example, was a metaphor for triumph over the forces of evil.

pression of the anecdotal (that is, of the time-bound) from their that Egyptian artists could be close observers of daily life. The supsive observer of life, like his ka. Scenes such as this one demonstrate do anything. He simply is—a figure apart from time and an impasimmobility implies that he is not an actor in the hunt. He does not carved and painted birds and animals among the papyrus buds. Ti's rendered activities of his tiny servants and with the naturalistically appearance. Ti's conventional pose contrasts with the realistically emphasizes the essential nature of the deceased, not his accidental representation was well suited for Egyptian funerary art because it parts clearly. This conceptual (as opposed to optical) approach to bined frontal and profile views of Ti's body to show its characteristic the artist exaggerated the size of Ti to announce his rank, and compalette (FIG. 1-22)—appear again here. As in the Predynastic work, representation—used a half millennium earlier for King Narmer's their size, stands aloof. The basic conventions of Egyptian figure are frantically busy with their spears, whereas Ti, depicted twice tern of wavy lines, is crowded with hippopotami and fish. Ti's men and stalking foxes. The water beneath the boats, signified by a patfan out gracefully at the top into a commotion of frightened birds eated the reedy stems of the plants with repeated fine grooves that and birds in a dense growth of towering papyrus. The sculptor delinboats move slowly through the Nile marshes, hunting hippopotami In the relief illustrated here (FIG. 1-30), Ti, his men, and his

activities while alive.

The idealized image of Ti is typical of Egyptian relief sculpture. Egyptian artists regularly ignored the endless variations in body types of real human beings. Painters and sculptors did not sketch their subjects from life but applied a strict canon, or system of proportions, to the human figure. They first drew a grid on the wall. Then they placed various human body parts at specific points on the network of squares. The height of a figure, for example, was a fixed number of squares, and the head, shoulders, waist, knees, and other parts of the body also had a predetermined size and place within the scheme. This approach to design lasted for more than 2,500 years. Specific proportions might vary from workshop to workshop and Specific proportions might vary from workshop to workshop and

representations of the deceased both in relief and in the round was a deliberate choice. Egyptian artists' primary purpose was to suggest the deceased's eternal existence in the afterlife, not to portray his

change over time, but the principle of the canon persisted.

New Kingdom

About 2150 BCE, the Egyptians challenged the weak kings of the Sixth Dynasty, and for more than a century the land was in a state of civil unrest and near anarchy. But in 2040 BCE, the king of Upper of civil unrest and near anarchy. But in 2040 BCE, the king of Upper Egypt, Mentuhotep II (r. 2050–1998 BCE), managed to unite Egypt

About 2150 BCE, the Egyptians challenged the weak kings of the Sixth Dynasty, and for more than a century the land was in a state of civil unrest and near anarchy. But in 2040 BCE, the king of Upper Egypt, Mentuhotep II (r. 2050–1998 BCE), managed to unite Egypt again under the rule of a single king and established the Middle Kingdom (11th to 14th Dynasties), which brought stability to Egypt for four centuries. In the 17th century BCE, it too disintegrated. Power passed to the Hyksos (Shepherd Kings) who descended on Egypt from the Syrian and Mesopotamian uplands. But in the 16th century, native Egyptian kings of the 17th Dynasty rose up in revolt. Ahmose I (r. 1550–1525 BCE), final conqueror of the Hyksos and first king of the 18th Dynasty, ushered in the 16th are leth stated in the 18th Dynasty, ushered in the Wew Kingdom, the first king of the 18th Dynasty, ushered in the New Kingdom, the first king of the 18th Dynasty, ushered in the New Kingdom, the first king of the 18th Dynasty, ushered in the New Kingdom, the

The statue of Menkaure and his wife (or Hathor?) displays the conventional postures used for Egyptian statues designed as substitute homes for the denotes the close association of the two figures.

Arts, Boston.

4' 6 $\frac{1}{2}$ " high.

Museum of Fine

все. Стаумаске,

Fourth Dynasty, ca. 2490-2472

Gizeh, Egypt,

nebty(?), from

and Khamerer-

1-29 Menkaure

two figures.

MENKAURE

The seated statue is one of only a small number of basic formulaic types that Old Kingdom sculptors employed to represent the human figure. Another is the image of a person or deity standing, either alone or in a group—for example, the pair

ing places. Depictions of agriculture and hunting fill Ti's tomb. The

Old Kingdom patrons favored for the adornment of their final rest-

mastaba of a Fifth Dynasty official named Ti typify the subjects that

times singly (FIG. I-12), sometimes in a narrative context. The painted limestone relief scenes decorating the walls of the Saqqara

frequently appear in relief sculpture and in mural painting, some-

TOMB OF TI In Old Kingdom tombs, images of the deceased also

dess, their shared divinity. The two figures show no other sign of affection or emotion and look not at each other but out into space.

reotypical gesture indicates their marital status or, if king and god-

similar position. Her right arm, however, circles around the king's waist, and her left hand gently rests on his left arm. This frozen ste-

to the uneven distribution of weight. Khamerernebty(?) stands in a

ing straight down and close to his well-built body. He clenches his hands into fists with the thumbs forward and advances his left leg slightly, but no shift occurs in the angle of the hips to correspond

less other Egyptian statues—is rigidly frontal with the arms hang-

wedded to the stone block. Menkaure's pose-duplicated in count-

Khamerernebty, or the goddess Hathor. The statue once stood in Menkaure's valley temple at Gizeh. Here, too, the figures remain

(FIG. 1-29) of Menkaure and either one of his wives, probably

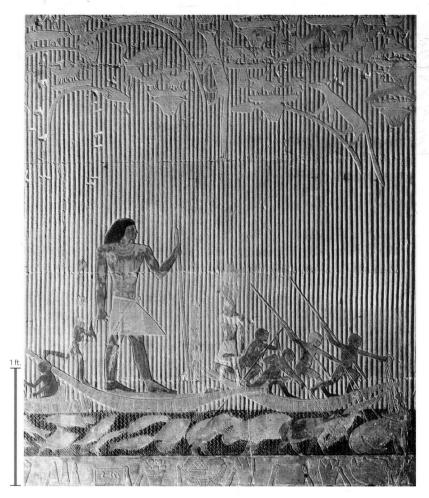

extended its borders by conquest from the Euphrates River in the east deep into Nubia to the south (MAP 1-3). A new capital—Thebes, in Upper Egypt—became a great metropolis with magnificent palaces, tombs, and temples along both banks of the Nile. The Egyptian kings began to call themselves *pharaohs*.

1-30 Ti watching a hippopotamus hunt, relief in the mastaba of Ti, Saqqara, Egypt, Fifth Dynasty, ca. 2450–2350 BCE. Painted limestone, 4' high.

In Egypt, a successful hunt was a metaphor for triumph over evil. In this painted tomb relief, the deceased stands aloof from the hunters busily spearing hippopotami. Ti's size reflects his high rank.

HATSHEPSUT One of the most intriguing figures in ancient history was the New Kingdom pharaoh Hatshepsut (r. 1473-1458 BCE). In 1479 BCE, Thutmose II (r. 1492-1479 BCE), the fourth pharaoh of the 18th Dynasty, died. Hatshepsut, his principal wife (and half sister), had not given birth to any sons who survived, so the title of king went to the 12-year-old Thutmose III, son of Thutmose II by a minor wife. Hatshepsut became regent for the boy-king. Within a few years, however, the queen proclaimed herself pharaoh and insisted that her father, Thutmose I, had chosen her as his successor during his lifetime. Hatshepsut is the first great female monarch whose name has been recorded. For two decades, she ruled what was then the most powerful and prosperous empire in the world. As always, Egyptian sculptors produced statues of their pharaoh in great numbers for display throughout the kingdom. Hatshepsut uniformly wears the costume of the male pharaohs, with royal headdress and kilt, and in some cases even a false ceremonial beard. Many inscriptions refer to Hatshepsut as "His Majesty."

One of the most impressive of the many grandiose monuments that the New Kingdom pharaohs built is Hatshepsut's mortuary temple (FIG. 1-31) on the Nile at Deir el-Bahri. The temple rises from the valley floor in three terraces connected by ramps on the central axis. It is striking

how visually well suited the structure is to its natural setting. The long horizontals and verticals of the *colonnades* of the terraces repeat the pattern of the limestone cliffs above. In Hatshepsut's day, the terraces were not the barren places they are now but gardens with frankincense trees and rare plants that the pharaoh brought from the

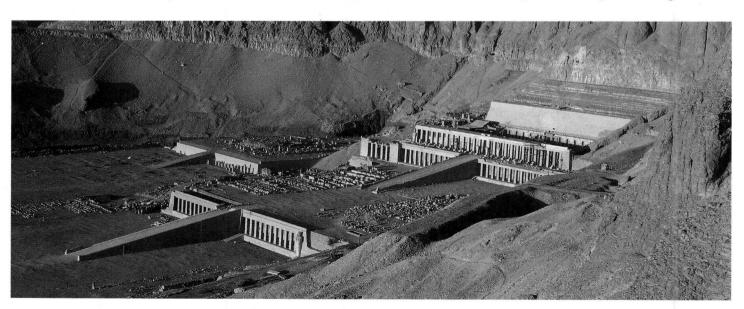

1-31 Mortuary temple of Hatshepsut (looking southwest), Deir el-Bahri, Egypt, 18th Dynasty, ca. 1473-1458 BCE.

Hatshepsut was the first great female monarch in history. Her immense terraced funerary temple featured an extensive series of painted reliefs recounting her divine birth, coronation, and great deeds.

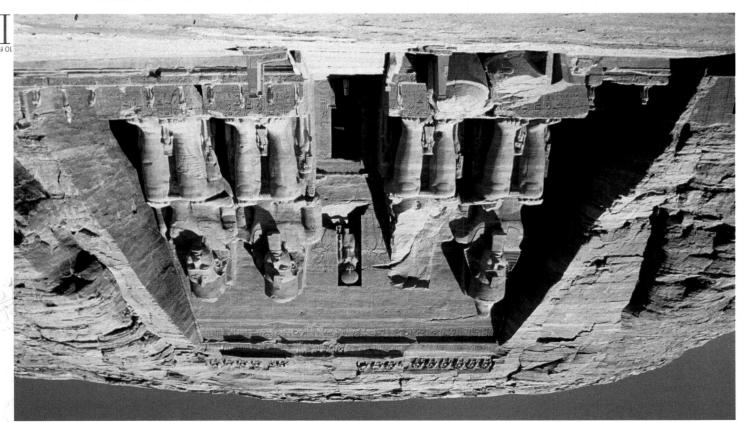

1-32 Facade of the temple of Ramses II, Abu Simbel, Egypt, 19th Dynasty, ca. 1290-1224 BCE. Sandstone, seated portraits 65' high.

depict him as Osiris, god of the dead and giver of eternal life.

begun during the Middle Kingdom, was largely the work of the I8th Dynasty pharaohs, including Hatshepsut, but Ramses II (19th Dynasty) and others also contributed sections. Parts of the complex date as late as the 26th Dynasty.

el-Bahri also conform to the Egyptian preference for axial plans. to the multilevel mortuary temple of Hatshepsut (Fig. 1-31) at Deir approaches to the Old Kingdom pyramids (FIG. 1-26) of Gizeh and the complex—characterizes much of Egyptian architecture. The Kingdom pylon temple plan-a narrow axial passageway through ceed only as far as the open court. The central feature of the New ted to the great columnar hall. The majority of the people could proand the priests could enter the sanctuary. A chosen tew were admitnaded court and hall into a dimly lit sanctuary. Only the pharaohs single axis that runs from an approaching avenue through a colonple design. A typical pylon temple is bilaterally symmetrical along a sloping walls) that are characteristic features of New Kingdom temname derives from the simple and massive pylons (gateways with ple is a typical, if especially large, New Kingdom pylon temple. The waters at the beginning of time. In other respects, however, the temrises from the earth as the original sacred mound rose from the cinct, a reference to the primeval waters before creation. The temple The Karnak temple has an artificial sacred lake within its pre-

In the Karnak plan, the hall (Fig. 1-34) between the court and sanctuary has its long axis placed at right angles to the corridor of the entire building complex. Inside this 58,000-square-foot hypo-style hall (one in which columns support the roof) are 134 massive sandstone columns, which support a roof of stone slabs carried on

faraway "land of Punt" on the Red Sea. Her expedition to Punt figures prominently in the once brightly painted low reliefs that cover many walls of the complex. In addition to representing great deeds, the reliefs also show Hatshepsut's divine birth and coronation. She was said to be the daughter of the sun god Amen, whose sanctuary was on the temple's uppermost level. The reliefs of Hatshepsut's mortuary temple, unfortunately defaced after her death, constitute the first great tribute to a woman's achievements in the history of art.

RAMSES II Perhaps the greatest pharaoh of the New Kingdom was Ramses II (r. 1290–1224 BCE), who ruled Egypt for two-thirds of a century, an extraordinary accomplishment in an era when life expectancy was far less than it is today. Four colossal images of Ramses never fail to impress visitors to the pharaoh's mortuary temple (Fig. 1-32) at Abu Simbel. The 65-foot-tall portraits, carved directly into the cliff face, are almost a dozen times an ancient Egyptian's height, even though the pharaoh is seated. The grand scale of the facade statues extends inside the temple also, where gigantic (32-foot-tall) figures of the king, carved as one with the pillars, face each other across the narrow corridor. Ramses appears in his atlantials (statue-columns) in the guise of Osiris, god of the dead and king of the underworld, as well as giver of eternal life.

KARNAK Colossal scale also characterizes the temples that the New Kingdom pharaohs built to honor one or more of the gods. Successive kings often added to them until they reached enormous size. The temple of Amen-Re (Fig. 1-33) at Karnak, for example,

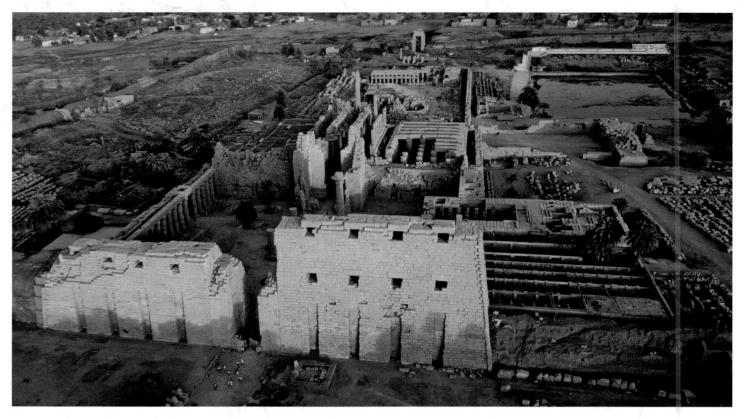

1-33 Aerial view of the temple of Amen-Re (looking east), Karnak, Egypt, major construction 15th to 13th centuries BCE.

The vast Karnak temple complex contains a pylon temple with a bilaterally symmetrical axial plan and an artificial lake associated with the primeval waters of the Egyptian creation myth.

stone lintels. The columns have bud-cluster or bell-shaped *capitals* (heads) resembling lotus or papyrus (the plants symbolizing Upper and Lower Egypt). The 12 central columns are 75 feet tall, and their capitals are 22 feet in diameter at the top, large enough for a hundred people to stand on them. The Egyptians, who used no cement,

depended on precise cutting of the joints and the weight of the huge stone blocks to hold the columns in place.

In the Amen-Re temple at Karnak and in many other Egyptian hypostyle halls, the two central rows of columns are taller than those at the sides. Raising the roof's central section created a

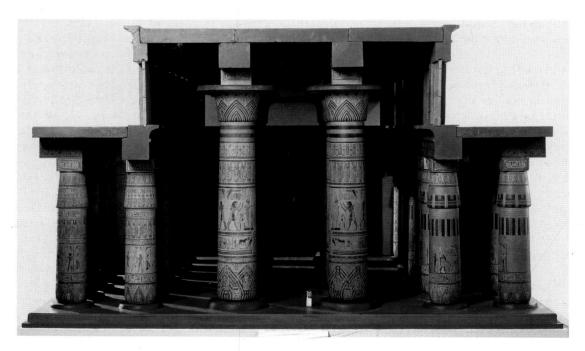

1-34 Model of the hypostyle hall, temple of Amen-Re, Karnak, Egypt, 19th Dynasty, ca. 1290–1224 BCE. Metropolitan Museum of Art, New York.

The two central rows of columns of Karnak's hypostyle hall are 75 feet high, with capitals 22 feet in diameter. The columns support a clerestory that admitted sunlight to illuminate the hall's interior.

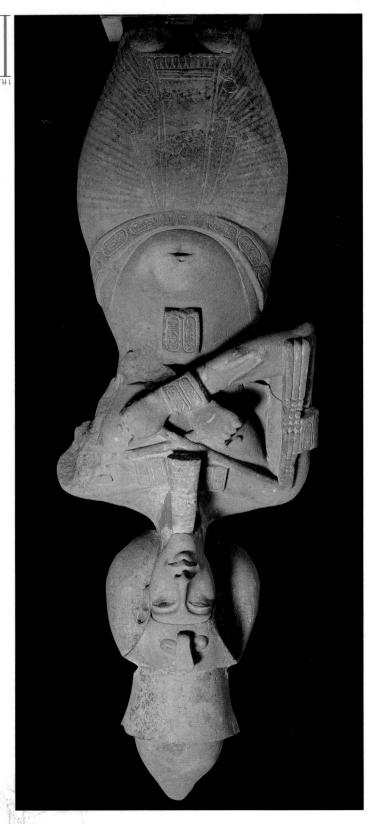

1-35 Akhenaton, colossal statue from the temple of Aton, Karnak, Egypt, 18th Dynasty, ca. 1353–1335 BCE. Sandstone, 13' high.

Akhenaton initiated both religious and artistic revolutions. This androgynous figure is a deliberate reaction against tradition. It may be an attempt to portray the pharaoh as Aton, the sexless sun disk.

clerestory. Openings in the clerestory enabled sunlight to filter into the interior, although the stone grilles would have blocked much of the light. This method of construction appeared in primitive form in the Old Kingdom valley temple of Khafre at Gizeh. The clerestory is evidently an Egyptian innovation, and its significance cannot be overstated. Before the invention of the electric light bulb, illuminating a building's interior was always a challenge for architects. The clerestory played a key role in the history of architecture until very clerestory played a key role in the history of architecture until very

recently.

largely abandoned. Akhenaton's religious revolution was soon undone, and his new city priesthood of Amen and restored the temples and the inscriptions. The pharaohs who followed Akhenaton reestablished the cult and human form but simply as the sun disk emitting life-giving rays. tice, artists represented Akhenaton's god neither in animal nor in sole prophet of Aton. Moreover, in stark contrast to earlier prac-(Horizon of Aton). The pharaoh claimed to be both the son and from Thebes to present-day Amarna, a site he named Akhetaton great temples, enraged the priests, and moved his capital downriver of his father, Amenhotep III (r. 1390-1353 BCE). He emptied the Amen from all inscriptions and even from his own name and that to be the universal and only god. Akhenaton deleted the name of of Aton, identified with the sun disk, whom the pharaoh declared BCE), abandoned the worship of most of the Egyptian gods in favor tury BCE, Amenhotep IV, later known as Akhenaton (r. 1353-1335 a corresponding revolution in Egyptian art. In the mid-14th cena period of religious upheaval during the New Kingdom and for AKHENATON The Karnak sanctuary also provides evidence for

that the style was revolutionary and short-lived. tion of Aton, the sexless sun disk. But no consensus exists other than mulate a new androgynous image of the pharach as the manifestatraditional religion. They argue that Akhenaton's artists tried to forreaction against the established style, paralleling the suppression of historians think that Akhenaton's portrait is a deliberate artistic rate depiction of a physical deformity—is probably faulty. Some art agree on a diagnosis, and their premise—that the statue is an accuby attributing a variety of illnesses to the pharach. They cannot fatty thighs. Modern physicians have tried to explain his physique with weak arms, a narrow waist, protruding belly, wide hips, and pharaoh's predecessors. Akhenaton's body is curiously misshapen, alized faces and heroically proportioned bodies (FIG. 1-29) of the full lips and heavy-lidded eyes are a far cry indeed from the ideeffeminate body, with its curving contours, and the long face with retains the standard frontal pose of Egyptian royal portraits. But the of Akhenaton from Karnak, toppled and buried after his death, changes also occurred in Egyptian art. A colossal statue (FIG. 1-35) During the brief heretical episode of Akhenaton, profound

NEFERTITI A painted limestone bust (FIG. 1-36) of Akhenston's queen, Nefertiti (her name means "the beautiful one has come"), also breaks with the past. The portrait exhibits an expression of entranced musing and an almost mannered sensitivity and delicacy of curving contour. Nefertiti was an influential woman during her husband's kingship. She frequently appears in the decoration of the husband in size but also sometimes wears pharaonic headgear. Excavators discovered the portrait illustrated here in the workshop of the sculptor ered the portrait illustrated here in the workshop of the sculptor and the portrait illustrated here in the workshop of the sculptor or the portrait illustrated here in the workshop of the sculptor and the portrait illustrated here in the workshop of the sculptor or the portrait illustrated here in the workshop of the sculptor and the portrait illustrated here in the workshop of the sculptor and the portrait illustrated here in the workshop of the sculptor and the portrait illustrated here in the workshop of the sculptor and the portrait illustrated here in the workshop of the sculptor and the portrait illustrated here.

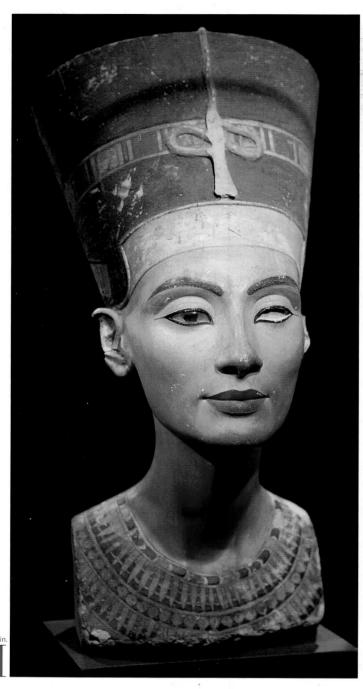

1-36 Thutmose, bust of Nefertiti, from Amarna, Egypt, 18th Dynasty, ca. 1353–1335 BCE. Painted limestone, 1' 8" high. Ägyptisches Museum, Staatliche Museen zu Berlin, Berlin.

Found in the workshop of the master sculptor Thutmose, this unfinished bust portrait of Nefertiti depicts Akhenaton's influential wife with a thoughtful expression and a long, delicately curved neck.

master's own hand. The left eye socket still lacks the inlaid eyeball, making the portrait a kind of before-and-after demonstration piece. With this elegant bust, Thutmose may have been alluding to a heavy flower on its slender stalk by exaggerating the weight of the crowned head and the length of the almost serpentine neck. The sculptor seems to have adjusted the likeness of his subject to meet the era's standard of spiritual beauty.

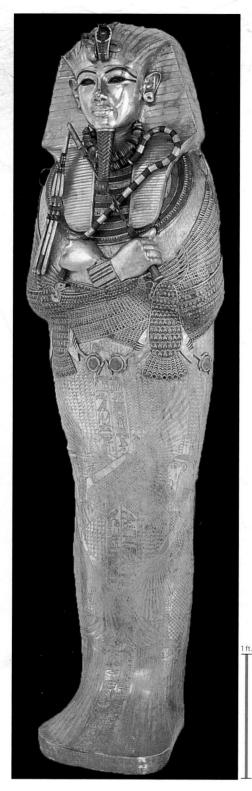

1-37 Innermost coffin of Tutankhamen, from his tomb at Thebes, Egypt, 18th Dynasty, ca. 1323 BCE. Gold with inlay of enamel and semiprecious stones, 6' 1" long. Egyptian Museum, Cairo.

The boy-king Tutankhamen owes his fame to the discovery of his treasure-filled tomb. His mummy was encased in three nested coffins. The innermost one, made of gold, portrays the pharaoh as Osiris.

TUTANKHAMEN Probably Akhenaton's son by a minor wife, Tutankhamen (r. 1333–1323 BCE) ruled Egypt for a decade and died at age 18. Although a minor figure in Egyptian history, Tutankhamen is famous today because of the fabulously rich treasure of sculpture, furniture, and jewelry discovered in 1922 in his tomb at Thebes. The principal find was the enshrined body of the pharaoh himself (FIG. 1-37). The royal mummy reposed in the innermost of three

Egyptian Museum, Cairo. with inlay of semiprecious stones, $1'9^{\frac{1}{4}}$ high. Thebes, Egypt, 18th Dynasty, ca. 1323 BCE. Gold innermost coffin (Fig. 1-37) in his tomb at 1-38 Death mask of Tutankhamen, from the

tional false beard and uraeus cobra headdress. portrayal of the teenaged pharaoh featuring the tradimummy radiates grandeur and richness. It is a sensitive The gold mask that covered the head of Tutankhamen's

the land of the Vile. Many of the formal traditions of Egyptian art

Mediterranean, artistic change was the only common denominator. maintained for millennia, whereas everywhere else in the ancient to a way of making pictures and statues so satisfactory that it was tian artistic style is one of the marvels of the history of art. It attests endured, however. Indeed, the exceptional longevity of the Egyp-

following additional subjects: buildings, Google Earth™ coordinates, and essays by the author on the Explore the era further in MindTap with videos of major artworks and

- Head of Inanna(?), from Uruk (FIG. 1-1A)
- * Apollo 11 Cave, Namibia (FIG. 1-3A)
- Law stele of Hammurabi (FIG. 1-16A)
- Judgment of Hunefer, from Thebes (FIG. 1-23A)
- Seated scribe, from Saggara (FIG. 1-28A)

expressive of Egyptian power, pride, and limitless wealth. and of the tomb treasures as a whole is one of grandeur and richness the nemes headdress and false beard. The general effect of the mask the serene adolescent king dressed in his official regalia, including of gold with inlaid semiprecious stones. It is a sensitive portrayal of portrait mask (FIG. 1-38), which covered the king's face, is also made is a supreme monument to the sculptor's and goldsmith's crafts. The semiprecious stones such as lapis lazuli, turquoise, and carnelian, it three. Made of beaten gold (about a quarter ton of it) and inlaid with Tutankhamen in the guise of Osiris and is the most luxurious of the coffins, nested one within the other. The innermost coffin shows

successors and, eventually, the emperors of Rome took control of ruled the land, until Alexander the Great of Macedon and his Greek empire dwindled away, and foreign powers invaded, occupied, and the commanding role it once had played in the ancient world. The EGYPT IN DECLINE During the first millennium BCE, Egypt lost

PREHISTORY AND THE FIRST CIVILIZATIONS

Prehistory

- The first sculptures and paintings antedate the invention of writing by tens of thousands of years. No one knows why humans began to paint and carve images or what role those images played in the lives of Paleolithic hunters. Women were far more common subjects than men, but animals, not humans, dominate Paleolithic art (ca. 40,000-9000 BCE). Surviving works range in size from tiny figurines to painted walls and ceilings covered with over-life-size animals. Animals always appear in profile in order to show clearly the head, body, tail, and all four legs.
- The Neolithic Age (ca. 8000–3500 BCE) revolutionized human life with the beginning of agriculture and the formation of the first settled communities. The earliest known large-scale sculptures date to the seventh millennium BCE. In painting, coherent narratives became common, and artists began to represent human figures as composites of frontal and profile views.

Hall of the Bulls, Lascaux, ca. 16,000–14,000 BCE

Ancient Mesopotamia and Persia

- The Sumerians (ca. 3500–2332 BCE) founded the world's first city-states and invented writing in the fourth millennium BCE. They were also the first to build towering mud-brick temple platforms and to tell coherent stories in pictures by placing figures in superposed registers.
- The Akkadians (ca. 2332–2150 BCE) were the first Mesopotamian rulers to call themselves kings of the world and to assume divine attributes. Akkadian artists may have been the first to cast hollow life-size metal sculptures and to place relief figures at different levels in a landscape setting.
- During the Third Dynasty of Ur (ca. 2150–1800 BCE) and under the kings of Babylon (ca. 1800–1600 BCE), the Neo-Sumerians constructed one of the largest Mesopotamian ziggurats at Ur. Babylonian artists were among the first to experiment with foreshortening.
- At the height of their power, the Assyrians (ca. 900–612 BCE) ruled an empire extending from the Persian Gulf to the Nile and Asia Minor. Assyrian palaces were fortified citadels with gates guarded by monstrous lamassu. Painted reliefs glorifying the king decorated the ceremonial halls.
- The Neo-Babylonian kings (612-559 BCE) erected the biblical Tower of Babel and the Ishtar Gate.
- The capital of the Achaemenid Empire (559–330 BCE) was Persepolis, where the Persians built a huge palace complex with an audience hall that could accommodate 10,000 people.

Warka Vase, Uruk, ca. 3200-3000 BCE

Persepolis, ca. 521-465 BCE

Ancient Egypt

- The palette of King Narmer, which commemorates the unification of Upper and Lower Egypt around 3000–2920 BCE, established the basic principles of Egyptian representational art for 3,000 years.
- Imhotep, architect of the funerary complex of King Djoser (r. 2630–2611 BCE) at Saqqara, is the first artist in history whose name was recorded.
- During the Old Kingdom (ca. 2575–2134 BCE), the Egyptians built three colossal pyramids at Gizeh, emblems of the sun on whose rays the pharaohs ascended to the heavens after their death. Old Kingdom artists established the statuary types that would dominate Egyptian art for 2,000 years. Egyptian artists suppressed all movement in their statues to express the eternal nature of divine kingship.
- During the New Kingdom (ca. 1550–1070 BCE), the most significant architectural innovation was the axially planned pylon temple incorporating an immense gateway, columnar courtyards, and a hypostyle hall with clerestory windows. Powerful pharaohs such as Hatshepsut (r. 1473–1458 BCE) and Ramses II (r. 1290–1224 BCE) constructed gigantic temples in honor of their patron gods and, after their deaths, for their own worship. Akhenaton (r. 1353–1335 BCE) abandoned the traditional Egyptian religion in favor of Aton, the sun disk, and initiated a short-lived artistic revolution in which physical deformities and undulating curves replaced the idealized physiques and cubic forms of earlier Egyptian art.

Khafre enthroned, ca. 2520–2494 BCE

Mortuary temple of Hatshepsut, Deir el-Bahri, ca. 1473–1458 BCE

and of the Greek defeat of the Persians in 479 BCE. human centaurs are allegories of the triumph of civil-▲ 2-1b The reliefs depicting Greeks battling semi-

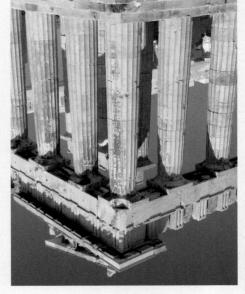

diameter of each column. for example, the height and ratios, which determined, using harmonic numerical of every part of the building calculated the dimensions architect of the Parthenon, ✓ 2-1a Iktinos, the

Athens, Greece, 447-438 BCE. Іктімоз, Раґthenon (looking southeast), Acropolis,

Athens. the personification of Victory to statue depicting Athena presenting Phidias's colossal gold-and-ivory program was inside the temple— Parthenon's lavish sculptural ▶ 2-1c The costliest part of the

Ancient Greece

THE PERFECT TEMPLE

Although the Greeks borrowed many ideas from the artists and architects of Mesopotamia and Egypt, they quickly developed an independent artistic identity. Their many innovations in painting, sculpture, and architecture became the foundation of the Western tradition in the history of art. Indeed, no building type has ever had a longer and more profound impact on the later history of architecture than the Greek temple, which was itself a multimedia monument, richly adorned with painted statues and reliefs.

The greatest Greek temple was the Parthenon (FIG. 2-1), the shrine dedicated to the patron goddess of Athens—Athena, the *parthenos* ("the virgin"). Erected on the Athenian Acropolis in the mid-fifth century BCE, it represents the culmination of a century-long effort by Greek architects to design a building having perfect proportions. The architect Iktinos calculated the dimensions of every part of the Parthenon in terms of a fixed proportional scheme, consistent with the thinking of the philosopher and mathematician Pythagoras of Samos, who believed that beauty resides in harmonic numerical ratios. (An important geometric theorem still bears Pythagoras's name.) Consequently, in the Parthenon, the ratio of the length to the width of the building, the number of columns on the long versus the short sides, and even the relationship between the diameter of a column and the space between neighboring columns conformed to the all-encompassing mathematical formula used by Iktinos. The result was a "perfect temple."

The Athenians did not, however, construct the Parthenon to solve a purely formal problem of architectural design. Nor did this shrine honor Athena alone. The Parthenon also celebrated the Athenian people, who a generation earlier had led the Greeks to victory over the Persians after they had sacked the Acropolis in 480 BCE. Under the direction of Phidias, a team of gifted sculptors lavishly decorated the building with statues and reliefs that in many cases alluded to the Persian defeat. For example, the sculptural program included reliefs depicting nude Greek warriors battling with the parthorse, part-human *centaurs*—an allegory of the triumph of civilization (that is, Greek civilization) over barbarism (in this case, the Persians). The statues on the front of the building told the story of the birth of Athena, who emerged from the head of her father, Zeus, king of the gods, fully armed and ready to protect her people. The costliest sculpture, and most prestigious of all, however, Phidias reserved for himself: the colossal gold-and-ivory statue of Athena inside, which depicted the warrior goddess presenting the Athenians with the winged personification of Victory—an unmistakable reference to the Greek victory over the Persians.

surrounding "barbarians" who did not speak Greek. Greeks regarded themselves as citizens of Hellas, distinct from the Olympia. From then on, despite their differences and rivalries, the

to make seminal contributions in the fields of art, literature, and create the concept of democracy (rule by the demos, the people) and humans into gods. This humanistic worldview led the Greeks to immortal. The Greeks made their gods into humans and their the Greek gods and goddesses differed from humans only in being boring civilizations. Unlike Mesopotamian and Egyptian deities, of Mount Olympus," page 47) were distinct from those of neigh-Even the gods of the Greeks (see "The Gods and Goddesses

not, however, obscure the enormous debt the Greeks owed to the The distinctiveness and originality of Greek civilization should

THE GREEKS AND THEIR GODS

nated in Greece 2,500 years ago. of mind that most people are scarcely aware that the concepts origifact, these ideas are so completely part of modern Western habits remain fundamental principles of Western civilization today. In cially the exaltation of humanity as "the measure of all things," through the ages. Many of the cultural values of the Greeks, espe-Ancient Greek art occupies a special place in the history of art

and on the western coast of Asia Minor (MAP 2-1). In 776 BCE, the states on the Greek mainland, on the islands of the Aegean Sea, formed a single nation but instead established independent city-The Greeks, or Hellenes, as they called themselves, never

separate Greek states held their first athletic games in common at

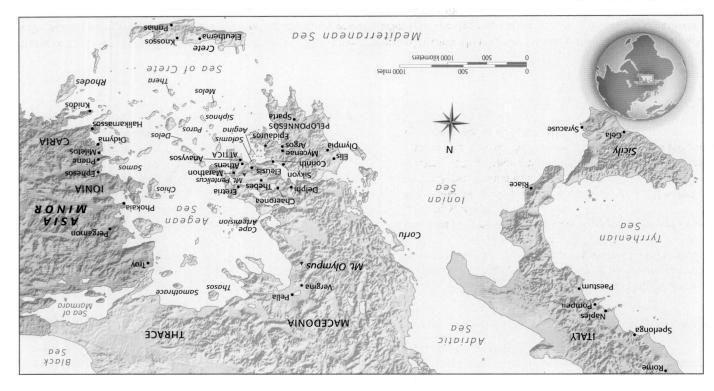

MAP 2-1 The Greek world.

Hellenistic 323-30 BCE

and painting. subjects in sculpture Artists explore new ing cultural centers. replace Athens as lead-■ Hellenistic kingdoms

Classical 480-353 BCE

the Greek gods and Praxiteles humanizes the Persian sack. Athenian Acropolis after Pericles rebuilds the his canon of proportions. Polykleitos tormulates statuary. contrapposto in Greek Sculptors introduce

goddesses.

Geometric and Archaic 900-480 BCE

with "Archaic smiles." life-size stone statues Greek sculptors carve and lonic temples. the first peripteral Doric Greek architects erect Geometric period. ure painting during the Greek artists revive fig-

figure vase painting.

plack- and, later, red-

Greek ceramists perfect

1200-900 BCE

Head in deep shaft Mycenaeans bury their ca. 1628 BCE. destroys Thera, Volcanic eruption with trescoed walls. major palaces on Crete Minoans construct Minoan and Mycenaean

build tombs featuring fortified citadels and Mycenaeans construct graves with gold masks.

corbeled domes.

Early Cycladic sculptors Early Cycladic 3000-2000 BCE

ANCIENT GREECE

afterlife. pany the dead into the for graves to accomcreate marble figurines

RELIGION AND MYTHOLOGY

The Gods and Goddesses of Mount Olympus

The Greek deities most often represented in art—not only in antiquity but also in the Middle Ages, the Renaissance, and up to the present—are the 12 gods and goddesses of Mount Olympus. Listed here are those Olympian gods (and their Roman equivalents).

- Zeus (Jupiter) was king of the gods and ruled the sky. His weapon was the thunderbolt, and with it he led the other gods to victory over the giants, who had challenged the Olympians for control of the world.
- Hera (Juno), the wife and sister of Zeus, was the goddess of marriage.
- Poseidon (Neptune), Zeus's brother, was lord of the sea. He controlled waves, storms, and earthquakes with his three-pronged pitchfork (trident).
- Hestia (Vesta), sister of Zeus, Poseidon, and Hera, was goddess of the hearth.
- Demeter (Ceres), Zeus's third sister, was the goddess of grain and agriculture.
- Ares (Mars), the god of war, was the son of Zeus and Hera and the lover of Aphrodite. His Roman counterpart, Mars, was the father of the twin founders of Rome.
- Athena (Minerva), the goddess of wisdom and warfare, was a virgin (parthenos), born not from a woman's womb but from the head of her father, Zeus.
- Hephaistos (Vulcan), the son of Zeus and Hera, was the god of fire and of metalworking. He provided Zeus his scepter and Poseidon his trident, and fashioned the armor that Achilles wore in battle against Troy. He was also the "surgeon" who split open

- Zeus's head to facilitate the birth of Athena. Hephaistos was lame and, uncharacteristically for a god, ugly. His wife, Aphrodite, was unfaithful to him.
- Apollo (Apollo) was the god of light and music, and a great archer. He was the son of Zeus with Leto (Latona), daughter of one of the Titans who preceded the Olympians. His epithet, phoibos, means "radiant," and the young, beautiful Apollo was sometimes identified with the sun, Helios (Sol).
- Artemis (Diana), the sister of Apollo, was the goddess of the hunt and of wild animals. As Apollo's twin, she was occasionally regarded as the moon, Selene (Luna).
- Aphrodite (Venus), the daughter of Zeus and Dione (one of the nymphs—the goddesses of springs, caves, and woods), was the goddess of love and beauty. She was the mother of the Trojan hero Aeneas by a mortal named Anchises.
- Hermes (Mercury), the son of Zeus and another nymph, was the fleet-footed messenger of the gods and possessed winged sandals. He was also the guide of travelers and carried the caduceus, a magical herald's rod.

Several non-Olympian deities also appear frequently in ancient and later art.

- Hades (Pluto), Zeus's other brother, was equal in stature to the Olympian deities but never resided on Mount Olympus. He was the god of the dead and lord of the Underworld (also called Hades).
- **Dionysos** (**Bacchus**) was the god of wine and the son of Zeus and a mortal woman.
- **Eros** (**Amor** or **Cupid**) was the winged child-god of love and the son of Aphrodite and Ares.
- Asklepios (Aesculapius), the son of Apollo and a mortal woman, was the healing god whose serpent-entwined staff is the emblem of modern medicine.

cultures of Mesopotamia and Egypt. The ancient Greeks themselves readily acknowledged borrowing ideas, motifs, conventions, and skills from those older civilizations. Nor should a high estimation of Greek art and culture blind anyone to the realities of Hellenic life and society. Even "democracy" was a political reality for only one segment of the demos. Slavery was a universal institution among the Greeks, and Greek women were in no way the equals of Greek men. Well-born women normally remained secluded in their homes, emerging usually only for weddings, funerals, and religious festivals, in which they had a prominent role. Otherwise, they played little part in public or political life.

The story of art in Greece does not begin with the Greeks, however, but with their prehistoric predecessors in the Aegean world the people who would later become the heroes of Greek mythology.

PREHISTORIC AEGEAN

Historians, art historians, and archaeologists alike divide the prehistoric Aegean into three geographic areas. Each has a distinctive artistic identity. *Cycladic* art is the art of the Cycladic Islands (so named because they "circle" around Delos), as well as of the adjacent islands in the Aegean, excluding Crete. *Minoan* art, named for the legendary King Minos, encompasses the art of Crete. *Mycenaean* art, which takes its name from the great citadel of Mycenae celebrated in Homer's *Iliad*, the epic tale of the Trojan War, is the art of the Greek mainland.

Cycladic Art

Archaeologists have uncovered evidence that humans inhabited Greece as far back as the Paleolithic period and that village life was firmly established in Neolithic times. However, the earliest distinctive Aegean artworks date to the third millennium BCE and come from the Cyclades.

STATUETTES Marble was abundantly available in the Aegean Islands, and many Cycladic marble sculptures survive. Most of these, like many of their Stone Age predecessors (FIG. 1-2), represent nude women with their arms folded across their abdomens. One example, about a foot-and-a-half tall—but only about a half-inch

of the Syros woman may suggest pregnancy. the breasts as well as the pubic area. The slight swelling of the belly figures or goddesses. In any case, the artist took pains to emphasize and similar Cycladic statuettes represent dead women or fertility down, like the deceased. Archaeologists debate whether the Syros upright and must have been placed on its back in the grave—lying feet have the toes pointed downward, so the figurine cannot stand

number of the surviving figurines. lets, as well as painted dots on the cheeks and necks, characterize a addition to the sculpted noses. Red and blue necklaces and bracealmost featureless faces would have had painted eyes and mouths in cate that at least parts of these sculptures were colored. The now Traces of paint found on some of the Cycladic figurines indi-

Minoan Art

yielded, attest to the power and prosperity of the Minoans. size and number of the "palaces," as well as the rich finds they have nies and games, and dozens of offices, shrines, and storerooms. The mercial, and religious centers with a central courtyard for ceremonot have served as royal residences. They were administrative, comemerged. The Cretan buildings, conventionally called palaces, may prehistoric Aegean, the era when the first great Western civilization architectural complexes on Crete. This was the golden age of the centuries of the second millennium BCE is the construction of major such as the Syros statuette. In contrast, the hallmark of the opening only of simple buildings. Rarely did graves contain costly offerings the Greek mainland, most settlements were small and consisted During the third millennium BCE, both on the Aegean Islands and

steps. The Knossos palace was indeed mazelike in plan. The central thread to mark his path through the labyrinth and safely retrace his aid of Minos's daughter, Ariadne. She had given Theseus a spindle of the monster, he was able to find his way out of the maze only with the ited a vast labyrinth, and when the Athenian king Theseus defeated half man and half bull. According to the myth, the minotaur inhabthe legendary home of King Minos and of the minotaur, a creature KNOSSOS The largest Cretan palace—at Knossos (Fig. 2-3)—was

as a series of triangles. female body schematically The sculptor rendered the the deceased is uncertain. but whether it represents one comes from a grave, depict nude women. This

Most Cycladic statuettes

cal Museum, Athens.

Marble, 1' 6" high.

ся. 5600-2300 все.

(Cyclades), Greece,

woman, from Syros

2-2 Figurine of a

National Archaeologi-

broad shoulders to tiny feet), and the incised triangular pubis. The form—the head, the body itself (which tapers from exceptionally History, and the Art Market" (1). Large simple triangles dominate the larity of Cycladic statuettes among collectors (see "Archaeology, Art many modern abstract sculptures, which accounts for the popudered the human body in a highly schematic manner, not unlike thick—comes from a grave on Syros (FIG. 2-2). The sculptor ren-

The Knossos palace, (John Burge). са. 1700-1370 все sos (Crete), Greece,

of the palace, Knos-(looking northwest) 2-3 Restored view

in the labyrinth. myth of the minotaur plan gave rise to the The palace's mazelike rounded a large court. Scores of rooms surhome of King Minos. was the legendary the largest on Crete,

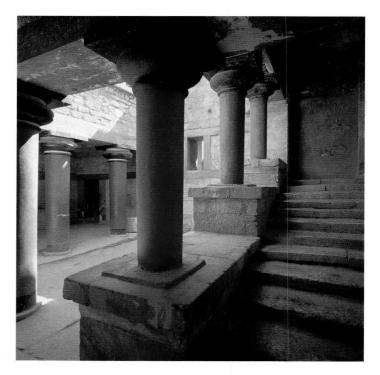

2-4 Stairwell in the residential quarter of the palace, Knossos (Crete), Greece, ca. 1700–1370 BCE.

The Knossos palace was complex in elevation as well as plan. It had at least three stories on all sides of the court. Minoan columns taper from top to bottom, the opposite of Egyptian and Greek columns.

feature of the rambling complex was its large rectangular court. The builders arranged the other palace units around this primary space. The palace was complex in *elevation* as well as plan. Around the central court, there were as many as three stories, and on the south and east sides, where the terrain sloped off sharply, up to five stories. Interior light and air wells (FIG. 2-4), some with staircases,

provided necessary illumination and ventilation. The Minoans fashioned their columns of wood and usually painted the shafts red. The columns had black, bulbous, cushionlike capitals resembling those of the later Greek Doric order (Fig. 2-20, *left*), but the shafts taper from a wide top to a narrower base, the opposite of both Egyptian and later Greek columns.

Mural paintings liberally adorned the Knossos palace, constituting one of its most striking features. The paintings depict many aspects of Minoan life (bull-leaping, processions) and of nature (birds, animals, flowers, marine life). Unlike the Egyptians, who painted in *fresco secco* (dry fresco), the Minoans coated the rough fabric of their rubble walls with a fine white lime plaster and applied the pigments while the plaster was still wet (see "Fresco Painting," page 208). The Minoan frescoes required rapid execution and great skill.

The most famous fresco (FIG. 2-5) from the palace at Knossos depicts Minoan bull-leaping, in which young men grasped the horns of a bull and vaulted onto its back—a perilous and extremely difficult acrobatic maneuver. The young women have fair skin and the leaping youth has dark skin in accord with the widely accepted ancient convention for distinguishing male and female. The painter brilliantly suggested the powerful charge of the bull (which has all four legs off the ground) by elongating the animal's shape and using sweeping lines to form a funnel of energy, beginning at the very narrow hindquarters of the bull and culminating in its large, sharp horns. The human figures also have stylized shapes, with typically Minoan pinched waists. The elegant, elastic, highly animated Cretan figures, with their long curly hair and proud and self-confident bearing, are easy to distinguish from Mesopotamian and Egyptian figures.

THERA Much better preserved than the Knossos frescoes are the mural paintings discovered in the excavations of Akrotiri on the island of Thera in the Cyclades, some 60 miles north of Crete. The excellent condition of the Akrotiri paintings is due to an enormous volcanic eruption on the island that buried the site in pumice

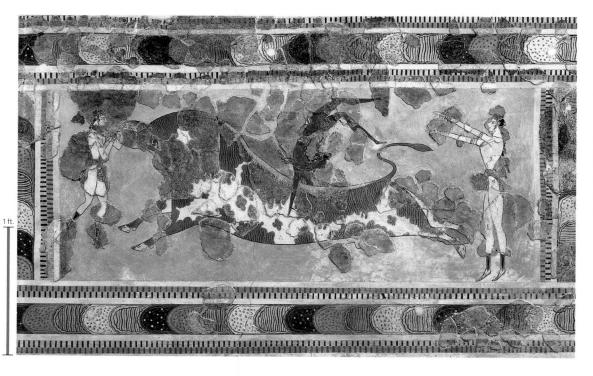

2-5 Bull-leaping, from the palace, Knossos (Crete), Greece, ca. 1500 BCE. Fresco, 2' 8" high, including border. Archaeological Museum, Iraklion.

Frescoes decorated the Knossos palace walls. The Minoan men and women have stylized bodies with narrow waists. The skin color varies with gender, a common convention in ancient paintings.

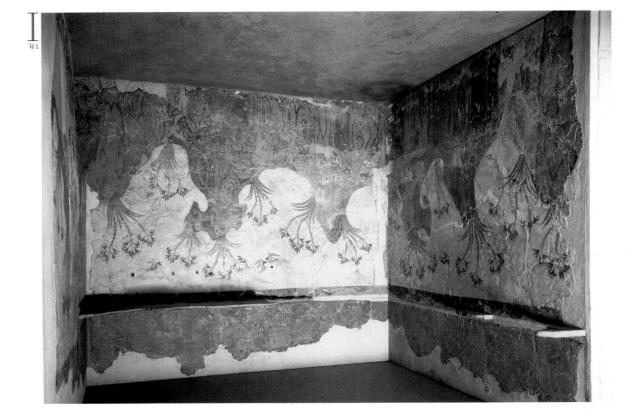

2-6 Landscape with swallows (Spring Fresco), south and west walls of room Delta 2, Akrotiri, Thera (Cyclades), Greece, ca. 1650–1625 BCE.
Fresco, 7'6" high. Reconstructed in National structed in National Archaeological Museum, Athens.

Aegean muralists painted in wet fresco, which required rapid execution. In this wraparound landscape, the painter used vivid colors and undulating lines to capture the essence of nature.

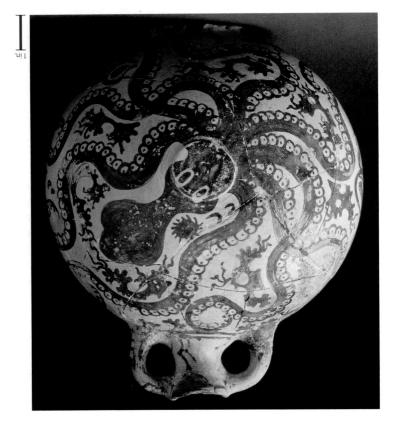

2-7 Octopus flask, from Palaikastro (Crete), Greece, ca. 1500 BCE. 11 high. Archaeological Museum, Iraklion.

The sea figures prominently in Minoan art. Here, the painter perfectly matched the octopus motif to the shape of the flask by spreading the sea creature's tentacles over the curving surface of the vessel.

irrationally undulating and vividly colored rocks, the graceful lilies swaying in the cool island breezes, and the darting swallows express the vigor of growth, the delicacy of flowering, and the lightness of birdsong and flight. In the lyrical language of curving line, the Theran muralist celebrated the rhythms of nature. The Spring Fresco represents the polar opposite of the first efforts at painting in the caves of Paleolithic Europe, where animals (and occasionally humans) appeared as isolated figures with no indication of setting.

MINOAN POTTERY Minoan painters also decorated small objects, especially ceramic pots, usually employing dark silhouettes against as cream-colored background. On a flask (Fig. 2-7) found at Palaisarcelored background. On a flask (Fig. 2-7) found at Palaisarcelored management of the cave of Palaiser of the cave of packground. On a flask (Fig. 2-7) found at Palaisarcelored background.

and ash around 1628 BCE. One almost perfectly preserved mural painting, known as the *Spring Fresco* (FIG. 2-6), is the largest prehistoric example of a pure *landscape*—a picture of a place without humans or animals. The artist's aim, however, was not to render the rocky island terrain realistically but to capture its essence. The

MINOAN POTTERY Minoan painters also decorated small objects, especially ceramic pots, usually employing dark silhouettes against a cream-colored background. On a flask (Fig. 2-7) found at Palaikastro on Crete, the tentacles of an octopus reach out over the curving surface of the vessel, embracing the piece and emphasizing its volume. The flask is a masterful realization of the relationship between the vessel's decoration and its shape, always an issue for the vase painter.

SNAKE GODDESS In contrast to Mesopotamia and Egypt, Minoan Crete has yielded no trace of temples or life-size statues of gods, kings, or monsters, although large wood images may once have existed. What remains of Minoan sculpture is uniformly small in scale, such as the faience (low-fired opaque glasslike silicate) statuette found in the palace at Knossos and popularly known as the Snake Goddess (FIG. 2-8). Reconstructed from many fragments and in large part modern in its present form, it is one of several similar

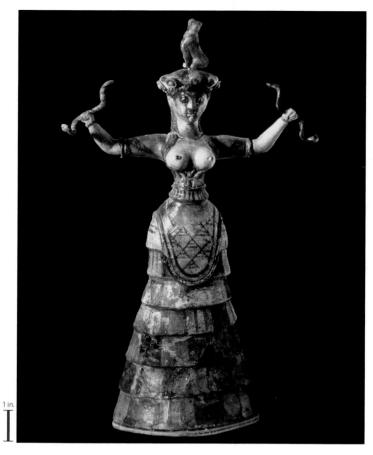

2-8 *Snake Goddess*, from the palace, Knossos (Crete), Greece, ca. 1600 BCE. Faience, 1' $1\frac{1}{2}$ " high. Archaeological Museum, Iraklion.

This Minoan figurine may represent a priestess, but she is more likely a barebreasted goddess. The snakes in her hands and the feline on her head imply that she wields power over the animal world.

figurines that some scholars believe may represent mortal priestesses rather than a deity. The prominently exposed breasts suggest, however, that these figurines stand in the long line of prehistoric fertility images usually considered divinities. The Knossos woman holds snakes in her hands and, as reconstructed, supports a tamed leopardlike feline on her head. If the feline was part of the statuette, the implied power over the animal world would be appropriate for a deity. The frontality of the figure is reminiscent of Mesopotamian and Egyptian statuary, but the costume, with its open bodice and flounced skirt, is distinctly Minoan.

MINOAN DECLINE Scholars dispute the circumstances ending the Minoan civilization, although most now believe that Mycenaeans had already moved onto Crete and established themselves at Knossos in the 15th century BCE. Parts of the palace continued to be occupied until its final destruction around 1200 BCE, but its importance as a cultural center faded soon after 1400 BCE, as the focus of Aegean civilization shifted to the Greek mainland.

Mycenaean Art

The origin of the Mycenaeans is also a subject of continuing debate. The only certainty is the presence of these forerunners of the Greeks on the mainland at the beginning of the second millennium BCE. Some scholars believe that the mainland was a Minoan economic dependency for a long time, but by 1500 BCE a distinctive Mycenaean culture was flourishing in Greece.

TIRYNS The destruction of the Cretan palaces left the mainland culture supreme. Although historians refer to this civilization as Mycenaean, Mycenae was but one of several large sites. The bestpreserved and most impressive Mycenaean remains are those of the citadels at Tiryns and Mycenae. Construction of both complexes began about 1400 BCE. Homer, writing in the mid-eighth century BCE, called the citadel of Tiryns (FIG. 2-9), located about 10 miles from Mycenae, "Tiryns of the Great Walls." In the second century CE, when Pausanias, author of an invaluable guidebook to Greece, visited the long-abandoned site, he marveled at the imposing fortifications and considered the walls of Tiryns to be as spectacular as the pyramids of Egypt. Indeed, the Greeks of the historical age did not believe that mere humans could have built such a fortress. They attributed the construction of the great Mycenaean citadels to the mythical Cyclopes, a race of one-eyed giants. Architectural historians still employ the term Cyclopean masonry to refer to the huge, roughly cut stone blocks forming the massive fortification walls of Tiryns and other Mycenaean sites. The Tiryns walls average about 20 feet in thickness and incorporate blocks often weighing several tons each. The heavily fortified Mycenaean palaces contrast sharply with the open Cretan palaces (FIG. 2-3) and clearly reveal their defensive character.

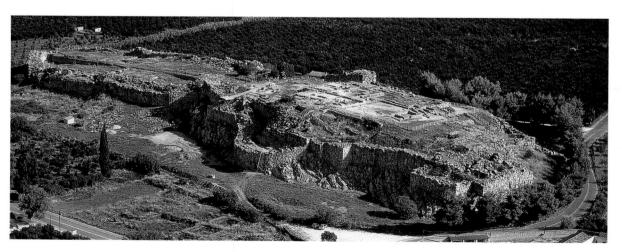

2-9 Aerial view of the citadel (looking east), Tiryns, Greece, ca. 1400–1200 BCE.

In the *Iliad*, Homer called the fortified citadel of Tiryns the city "of the great walls." Its huge, roughly cut stone blocks are examples of Cyclopean masonry, named after the mythical one-eyed giants.

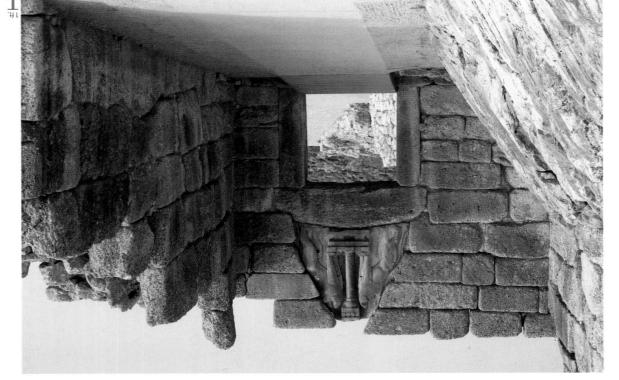

possibly sphinxes.

ca. 1300–1250 BCE.
Limestone, relief panel
9' 6" high.
The largest sculpture in
the prehistoric Aegean is
the prehistoric Aegean is

2-10 Lion Gate (looking

The largest sculpture in the prehistoric Aegean is the prehistoric Aegean is the relief of confronting ing triangle of Mycenae's main gate. The gate itself consists of two great monolithic posts and a huge lintel.

groups appear in miniature on Cretan seals, but the concept of scale with the massive stones forming the walls and gate. Similar matches its triangular shape, harmonizing in dignity, strength, and ing a central Minoan-type column. The whole design admirably triangle is a great limestone slab with two lions in high relief facing that lightens the weight the lintel carries. Filling this relieving then cantilevering them inward until they meet, leaving an openarch, constructed by placing the blocks in horizontal courses and FIG. 1-9). Above the lintel, the masonry courses form a corbeled monolithic posts capped with a huge lintel (compare Stonehenge, ers above them on both sides. The gate itself consists of two great had to enter this 20-foot-wide channel and face Mycenaean defending bastion of large blocks. Any approaching enemies would have built on a natural rock outcropping and on the right by a projectthe so-called Lion Gate (FIG. 2-10), protected on the left by a wall LION GATE, MYCENAE The gateway to the citadel at Mycenae is

placing monstrous guardian figures at the entrances to palaces,

and the adjoining fortification wall circuit a few generations before the presumed date of the Trojan War. At that time, elite families buried their dead outside the citadel walls in beebive-shaped tholos tombs covered by enormous earthen mounds. The best preserved is mistakenly believed was the repository of the treasure of Atreus, father of King Agamemnon, who waged war against Troy. A long passageway leads to a doorway surmounted by a relieving triangle similar to that in the roughly contemporaneous Lion Gate. Comsimilar to that in the courses laid on a circular base, the tholos posed of a series of stone courses laid on a circular base, the tholos

have speculated that the "lions" may have been composite beasts,

mals' heads separately. Because those heads are lost, some scholars

(FIGS. 1-18 and 1-27). At Mycenae, the sculptors fashioned the ani-

tombs, and sacred places has its origin in Mesopotamia and Egypt

The best-preserved Mycenaean tholos tomb is named after Homer's King Atreus. An earthen mound covers the burial chamber, reached through a doorway at the end of a long passageway.

2-11 Exterior of the Treasury of Atreus (looking west), Mycenae, Greece, ca. 1300–1250 BCE.

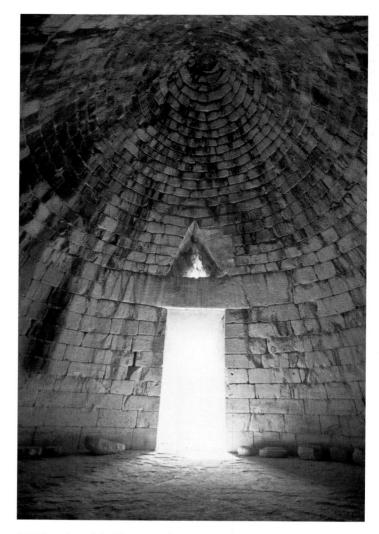

2-12 Interior of the Treasury of Atreus (looking east toward the entrance), Mycenae, Greece, ca. 1300–1250 BCE.

The beehive-shaped tholos of the Treasury of Atreus consists of corbeled courses of stone blocks laid on a circular base. The 43-foot-high dome was the largest in the ancient world for almost 1,500 years.

has a lofty pointed *corbeled dome* (FIG. 2-12). The principle involved is no different from a corbeled arch. The builders probably constructed the dome using cantilevered rough-hewn blocks. After the masons set the stones in place, they had to finish the surfaces with great precision to make them conform to both the horizontal and vertical curvature of the wall. About 43 feet high, this Mycenaean domed chamber was the largest *vault*-covered space without interior supports ever built before the Roman Empire.

ROYAL SHAFT GRAVES The Treasury of Atreus was thoroughly looted long before its modern rediscovery, but archaeologists have unearthed spectacular grave goods elsewhere at Mycenae. Just inside the Lion Gate, but predating it by some three centuries, is the burial area designated as Grave Circle A. Here, at a site protected within the circuit of the later walls, six deep shafts served as tombs for kings and their families. The excavation of the royal shaft graves yielded many gold artifacts, including beaten (*repoussé*) gold masks. (Homer described the Mycenaeans as "rich in gold.") Art historians have often compared the Mycenaean mask illustrated here (FIG. 2-13) to Tutankhamen's gold mummy mask (FIG. 1-38).

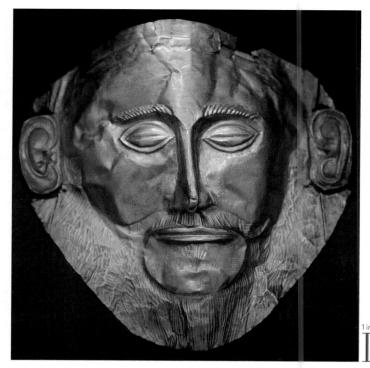

2-13 Funerary mask, from Grave Circle A, Mycenae, Greece, ca. 1600–1500 BCE. Beaten gold, 1' high. National Archaeological Museum, Athens.

Homer described the Mycenaeans as "rich in gold." This beaten-gold (repoussé) mask of a bearded man comes from a royal shaft grave. It is one of the first attempts at life-size sculpture in Greece.

The treatment of the human face is, of course, more primitive in the Mycenaean mask. But this is one of the first known attempts in Greece to render the human face at life-size, whereas the Egyptian mask stands in a long line of large-scale sculptures going back more than a millennium. No one knows whether the Mycenaean masks were intended as portraits, but the goldsmiths took care to record different physical types. The illustrated mask, with its full beard, must depict a mature man, perhaps a king—although not Agamemnon, as its 19th-century discoverer wished. If Agamemnon was a real king, he lived some 300 years after the death of the man buried in Grave Circle A.

THE END OF MYCENAE Despite their mighty walls, the citadels of Mycenae and Tiryns were burned between 1250 and 1200 BCE, when the Mycenaeans seem to have been overrun by northern invaders or to have fallen victim to internal warfare. By Homer's time, the greatest days of Aegean civilization were but a distant memory, and the men and women of Crete and Mycenae had assumed the stature of heroes from a lost golden age.

GREECE

The destruction of the Mycenaean palaces had a profound impact on both Aegean society and art. The disappearance of powerful kings and their retinues led to the loss of the knowledge of how to construct fortified citadels and vaulted tombs, to paint frescoes, and to sculpt in stone. Depopulation, poverty, and an almost total loss of contact with the outside world characterized the succeeding centuries, sometimes called the Dark Age of Greece.

chariots. Befitting the vase's funerary function, the scenes depict the mourning for a man laid out on his bier and a chariot procession in his honor. The painter filled every empty space around the figures with circles and M-shaped ornaments, negating any sense that the mourners or soldiers inhabit open space. The human figures, animals, chariots, and furniture are as two-dimensional as the geometmals, chariots, and furniture are as two-dimensional as the geomet-

point in the history of Greek art. Not only did the human figure manner of representation, this krater marks a significant turning is no sense of depth. Despite the highly stylized and conventional of heads and legs but seem to share a common body, so that there the chariots appear side by side. The horses have the correct number Below, the warriors look like walking shields, and the two wheels of the artist's concern was specifying gender, not anatomical accuracy. breasts rendered as simple lines beneath their armpits. In both cases thigh. The mourning women, who tear their hair out in grief, have female, the painter added a penis growing out of the deceased's right center), following the age-old convention. To distinguish male from profile arms, legs, and heads (with a single large frontal eye in the ettes constructed of triangular (that is, frontal) torsos with attached an abstract checkerboard-like backdrop. The figures are silhou-In the upper band, the shroud, raised to reveal the corpse, is ric shapes elsewhere on the vessel.

reenter the painter's repertoire, but Geometric artists also revived the art of storytelling in pictures.

LADY OF AUXERRE During the seventh century BCE, the first stone sculptures since the Mycenaean Lion Gate (FIG. 2-10) began to appear in Greece. One of the earliest, probably originally from Crete, is a limestone statuette of a goddess or maiden (kore; goddess or maiden (kore; plural, korai) popularly

2-15 Lady of Auxerre, from Crete, probably Eleutherna, Greece, ca. 650–625 BCE. Limestone, 2' $1\frac{1}{2}$ " high. Musée du Louvre, Paris.

One of the earliest Greek stone sculptures, this kore (maiden) typifies the Daedalic style of the seventh century BCE with its triangular face and hair and lingering Geometric fondness for abstract pattern.

Geometric and Archaic Art Only in the eighth century BCE did economic

Only in the eighth century BCE did economic conditions improve and the population begin to grow again. This era was in its own way a heroic age, a time when the Greeks established the Olympic Games, wrote down Homer's epic poems (formerly passed orally from bard to bard), and began to trade with their neighbors to both the east and the west.

GEOMETRIC KRATER This formative period, which art historians call the Geometric age, because Greek vase painting of the time consisted primarily of abstract motifs, also marked the return of the human figure to Greek art. One of the earliest examples of Greek figure painting is the huge krater (Fig. 2-14), or bowl for mixing wine and water, that stood atop the grave of a man buried around 740 BCE in the Dipylon Cemetery in Athens. At well over 3 feet tall, this vase in the Dipylon Cemetery in Athens. At well over 3 feet tall, this vase the krater's surface with precisely painted abstract angular motifs in horizontal bands. Especially prominent is the meander, or key, pattern around the rim. But the Geometric painter reserved the widest tern around the trim. But the Geometric painter reserved the widest part of the krater for two bands of human figures and horse-drawn part of the krater for two bands of human figures and horse-drawn

2-14 Geometric krater, from the Dipylon cemetery, Athens, Greece, ca. 740 bce. 3' $4\frac{1}{2}$ " high. Metropolitan Museum of Art, New York.

Figure painting returned to Greek art in the Geometric period, named for the abstract motifs on vessels such as this funerary krater featuring a mourning scene and procession in honor of the deceased.

known as the *Lady of Auxerre* (FIG. 2-15) after the French town that is her oldest recorded location. Because she does not wear a headdress, as early Greek goddesses frequently do, and the placement of her right hand across the chest is probably a gesture of prayer, the *Lady of Auxerre* is most likely a kore. The style is characteristic of the early *Archaic* period (ca. 700–480 BCE). The flat-topped head takes the form of a triangle framed by complementary triangles of four long strands of hair each. Also typical are the small belted waist and a fondness for pattern, seen, for example, in the almost Geometric treatment of the long skirt with its incised concentric squares, once brightly painted.

Art historians refer to this early Greek style as *Daedalic*, after the legendary artist Daedalus, whose name means "the skillful one." In addition to his stature as a great sculptor, Daedalus reputedly built the labyrinth of Knossos (FIG. 2-3) and designed a temple at Memphis in Egypt. The historical Greeks attributed to him almost all the great achievements in early sculpture and architecture. The story that Daedalus worked in Egypt reflects the enormous influence of Egyptian art and architecture on the Greeks.

NEW YORK KOUROS One of the earliest Greek examples of lifesize statuary (Fig. 2-16) is the marble *kouros* ("youth"; plural, *kou*-

roi) now in New York, which emulates the stance of Egyptian statues (FIG. 1-29). In both Egypt and Greece, the figure is rigidly frontal with the left foot advanced slightly. The arms are held beside the body, and the fists are clenched with the thumbs forward. Nevertheless, Greek kouros statues differ from their Egyptian models in two important ways. First, the Greek sculptors liberated the figures from the stone block. The Egyptian obsession with permanence was alien to the Greeks, who

are formally indistinguishable from Greek statues of deities. The New York kouros shares many traits with the Lady of Auxerre (FIG. 2-15), especially the triangular shape of head and hair and the flatness of the face—the hallmarks of the Daedalic style. The eyes, nose, and mouth all sit on the front of the head, and the ears on the sides. The long hair forms a flat backdrop behind the head. This is the result of the sculptor's having drawn these features on the four vertical sides of the marble block, following the same workshop procedure used in Egypt for millennia. The kouros also has the slim waist of earlier Greek statues and exhibits the same love of pattern. The pointed arch of the rib cage, for example, echoes the V-shaped ridge of the hips, which suggests but does not accurately reproduce the rounded flesh and muscle of the human body. **KROISOS** Sometime around 530 BCE, a young man named Kroisos died a hero's death in battle, and his family erected a kouros statue (FIG. 2-17) over his grave at Anavysos, not far from Athens. Although the Egyptian-inspired stance is the same as in the earlier New York

were preoccupied with finding ways to represent motion rather

than stability in their sculpted figures. Second, the kouroi are nude,

just as Greek athletes competed nude in the Olympic Games. In the

absence of identifying attributes, Greek youths as well as maidens

kouros, this sculptor rendered the human body in a far more naturalistic manner. The head is no longer too large for the body, and the face is more rounded, with swelling cheeks replacing the flat planes of the earlier work. The long hair does not form a stiff backdrop to the head but falls naturally over the back. The V-shaped ridges of the New York kouros have become rounded, fleshy hips. Also new is that Kroisos smiles—or seems

2-16 Kouros, from Attica, possibly Anavysos, Greece, ca. 600 BCE. Marble, 6' ½" high. Metropolitan Museum of Art, New York.

The sculptors of the earliest lifesize statues of kouroi (young men) adopted the Egyptian pose for standing figures (FIG. 1-29), but the kouroi are nude and freestanding, liberated from the stone block.

2-17 Kroisos, from Anavysos, Greece, ca. 530 BCE. Marble, 6' 4" high. National Archaeological Museum, Athens.

This later kouros displays increased naturalism in its proportions and more rounded modeling of face, torso, and limbs. Kroisos also smiles—the Archaic sculptor's way of indicating that a person is alive.

before applying it to the statue. encaustic, a technique in which the pigment is mixed with hot wax and polished. Artists painted the eyes, lips, hair, and drapery in

hard, muscular bodies. flesh also sharply differentiates later korai from kouroi, which have soft female form much more naturally. This softer treatment of the head, arms, and feet, the sixth-century BCE sculptor rendered the Although in both cases the drapery conceals the entire body save for she is, the contrast with the Lady of Auxerre (FIG. 2-15) is striking. missing left hand would have identified her. Whichever goddess which only goddesses wore. The attribute the goddess held in her belted garment. She wears four different garments, however, one of recently scholars thought she wore a peplos, a simple, long, wool paint, is the smiling Peplos Kore (FIG. 2-18), so called because until PEPLOS KORE A stylistic "sister" to Kroisos, also with preserved

columnar halls clearly inspired Greek architects. with Egyptian temples (for example, Fig. 1-33), New Kingdom Mycenaean kingdoms. Although Greek temples cannot be confused builders began to erect the first stone edifices since the fall of the lished a trading colony at Naukratis (MAP 1-3). Soon after, Greek Archaic Greek architecture. Around 650-630 BCE, the Greeks estabest Greek stone statues, Egypt also influenced the development of GREEK TEMPLES In addition to providing models for the earli-

architects was to find the most perfect proportions for each part cosmic order. A primary goal of sixth- and fifth-century BCE Greek harmony in music. Both were reflections and embodiments of the mind, proportion in architecture and sculpture was comparable to tended to be a little longer than twice their width. To the Greek roughly expressible as 1:3. From the sixth century BCE on, temples be long and narrow, with the proportion of the ends to the sides relationships and geometric rules. The earliest temples tended to tion and their effort to achieve ideal forms in terms of numerical pactness, and symmetry that reflect the Greeks' sense of propor-Temples," page 57, and FIGS. 2-19 and 2-20) reveals an order, com-The basic plan of all Greek temples (see "Doric and Ionic

The Greeks gathered to worship outside, not inside, their tem-Temple, page 45). of the building and for the structure as a whole (see "The Perfect

was the house of the god or goddess, not of his or her followers. ings. Both in its early and mature manifestations, the Greek temple the deity—the cult statue (FIG. 2-1c), the grandest of all votive offerrising sun. The temple proper housed a life-size or larger image of ples. The altar stood outside the temple-at the east end, facing the

ent than their gleaming white, if ruined, state today. The original appearance of Greek temples was therefore quite differdecorative moldings, and other architectural elements (FIG. 2-28). (caryatids; FIG. 2-42). The Greeks also often painted the capitals, frieze. Occasionally, they replaced their columns with female figures less severe in this respect as well, were willing to decorate the entire only in the "voids" of the metopes and pediment. Ionic builders, ticularly of the Doric order, in which decorative sculpture appears the building parts that had no structural function. This is true partectural sculptures and usually placed statues and reliefs only in the Greek temple from early times. The Greeks painted their archi-Figural sculpture played a major role in the exterior program of

temple design is not in Greece but in Italy, at Paestum. The huge PAESTUM The premier example of early Greek efforts at Doric

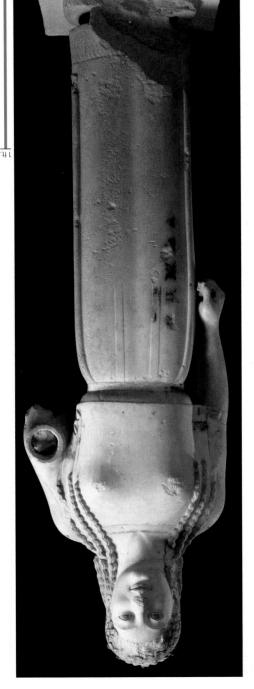

this convention, Greek artists signaled that their intentions were sculptors indicated that the person portrayed is alive. By adopting should not be taken literally. Rather, the smile is the way Archaic this so-called Archaic smile in various ways, but the happy face inappropriate contexts (Fig. 2-29). Art historians have interpreted 2-17A (1), Archaic Greek statues always smile—even in the most to. Beginning around 560 BCE with the statue of a calf bearer (FIG.

left the flesh in the natural color of the stone, which they waxed The Greeks did not color their statues garishly, however. They modern notion that Greek statuary was pure white is mistaken. the sense of life. Greek artists painted all their stone statues. The Traces of paint remain on the Kroisos statue, enhancing

very different from those of their Egyptian counterparts.

.bnsd 1991 gnissim

ing attribute in her She held her identify-

wearing four garments.

smiling kore is a votive

Archaic statuary. This

are always clothed in

Unlike men, women

Museum, Athens. 4' high. Acropolis

ca. 530 BCE. Marble, Athens, Greece,

from the Acropolis,

2-18 Peplos Kore,

statue of a goddess

ARCHITECTURAL BASICS

Doric and Ionic Temples

The plan and elevation of Greek temples varied with date, geography, and the requirements of individual projects, but all Greek temples share defining elements that set them apart from both the religious shrines of other civilizations and other kinds of Greek buildings.

■ **Plan** (FIG. 2-19) The core of a Greek temple was the *naos*, or *cella*, a windowless room that housed a statue of the deity. In front was a *pronaos*, or porch, often with two columns between the *antae*, or extended walls (columns *in antis*—that is, between the antae). A smaller second room might be placed behind the cella, but more frequently the Greek temple had a porch at the rear (*opisthodomos*) set against the blank back wall of the cella. The second porch served only a decorative purpose, satisfying the Greek passion for balance and symmetry. Around this core, Greek builders might erect a colonnade across the front of the temple (*prostyle*; FIG. 2-42), across both front and back (*amphiprostyle*; FIG. 2-43),

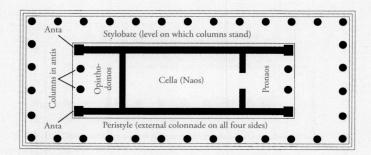

2-19 Plan of a typical Greek peripteral temple.

Greek temples had peripteral colonnades and housed cult statues of the gods in the central room, or cella. Worshipers gathered outside the temples, where priests made offerings at open-air altars.

or, more commonly, all around the cella and its porch(es) to form the *peristyle* of a *peripteral* temple (FIGS. 2-1, 2-19, 2-21, and 2-37).

Elevation (Fig. 2-20) The elevation of a Greek temple consists of the platform, the colonnade, and the superstructure (*entablature*). In the Archaic period, two basic systems, or *orders*, evolved for articulating the three units. The Greek architectural orders differ both in the nature of the details and in the relative proportions of the parts. The names of the orders derive from the Greek regions where they were most commonly employed. The *Doric*, formulated on the mainland (Fig. 2-1), remained the preferred manner there and in the Greeks' western colonies (Fig. 2-21). The *lonic* was the order of choice in the Aegean Islands and on the western coast of Asia Minor. The geographical distinctions are by no means absolute. The lonic order, for example, was often used in Athens (Figs. 2-42 and 2-43).

In both orders, the columns rest on the *stylobate*, the uppermost course of the platform. The columns have two or three parts, depending on the order: the *shaft*, usually marked with vertical channels (*flutes*); the *capital*; and, in the lonic order, the *base*. Greek column shafts, in contrast to their Minoan and Mycenaean forebears, taper gradually from bottom to top. Greek capitals have two elements. The lower part (the *echinus*) varies with the order. In the Doric, it is convex and cushionlike, similar to the echinus of Minoan (Fig. 2-4) and Mycenaean (Fig. 2-10) capitals. In the lonic, it is small and supports a bolster ending in scroll-like spirals (the *volutes*). The upper element, present in both orders, is a flat square block (the *abacus*), which provides the immediate support for the entablature.

The entablature has three parts: the *architrave*, the main weight-bearing and weight-distributing element; the *frieze*; and the *cornice*, a molded horizontal projection that together with two *raking* (sloping) *cornices* forms a triangle framing the *pediment*. In the lonic order, the architrave is usually subdivided into three horizontal bands. Doric architects subdivided the frieze into *triglyphs* and *metopes*, whereas lonic builders left the frieze open to provide a continuous field for relief sculpture.

Raking cornice
Pediment

Cornice

Frieze Triglyph
Metope

Architrave

Capital Echinus

Stylobate

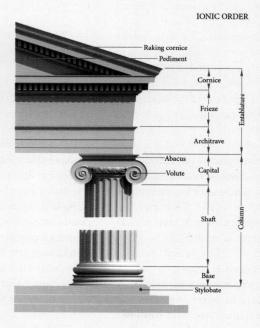

The Doric order is massive in appearance, its sturdy columns firmly planted on the stylobate. Compared with the weighty and severe Doric, the lonic order seems light, airy, and much more decorative. Its columns are more slender and rise from molded bases. The most obvious differences between the two orders are, of course, in the capitals—the Doric, severely plain, and the lonic, highly ornamental.

2-20 Elevations of the Doric and Ionic orders (John Burge).

The major orders of Greek architecture awere the Doric and Ionic. They differ primarily in the form of the capitals and the treatment of the frieze. The Doric frieze is subdivided into triglyphs and metopes.

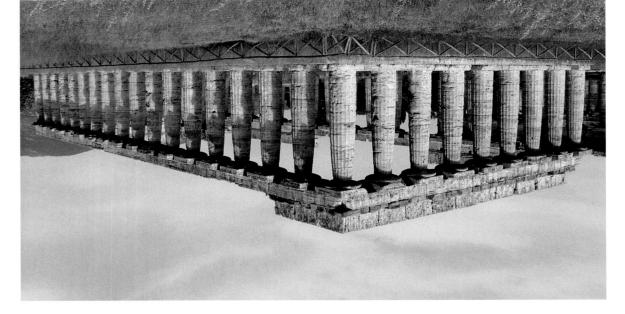

architecture. of Archaic Greek characteristic features pancakelike capitals, columns with bulky, spaced cigar-shaped consists of heavy, closely huge early Doric temple The peristyle of this

> ся. 550 все. Paestum, Italy, (looking northeast), 2-21 Temple of Hera

each side of the temple.

1:2 ratio of facade and flank columns by erecting 18 columns on viewing the statue. However, the architect still achieved a simple of the standard two, which in turn ruled out a central doorway for this case). At Paestum, there are also three columns in antis instead the temple's facade required an odd number of columns (nine in central cult statue. Further, in order to correspond with the interior, tages. The row of columns on the cella's axis allowed no place for a internal support for the roof structure, but it had several disadvanthe peak of the gabled roof) might seem the logical way to provide ridgepole (the timber beam running the length of the building below teristic only of Archaic temples. Placing columns underneath the columns dividing the cella into two aisles—is unusual and characvanished. The building's plan (FIG. 2-22)—with a central row of entablature, including the frieze, pediment, and all of the roof, has 550 BCE retains its entire peripteral colonnade, but most of the (80-by-170-foot) Temple of Hera (FIG. 2-21) erected there around

Another early aspect of the Paestum temple is the shape of its

and the entablature lighter. shafts became more slender, the entasis subtler, the capitals smaller, (FIG. 2-1), the builders placed the columns farther apart, and the would result in the superstructure's collapse. In later Doric temples builders feared that thinner and more widely spaced columns rowness of the spans between the columns might be that the Archaic function. One reason for the heaviness of the design and the narand capitals thus express in a vivid manner their weight-bearing the shafts, giving them a profile akin to that of a cigar. The columns The columns have a pronounced swelling (entasis) at the middle of bearing weight of what probably was a high, massive entablature. pancakelike Doric capitals, which seem compressed by the overheavy, closely spaced columns (FIG. 2-21) with their large, bulky,

gular shape. The central figures had to be of great size (more than for the Greek sculptor because of the pediment's awkward trian-Designing figural decoration for a pediment was never an easy task the sculpture that embellished its pediments (FIG. 2-23) survives. in Greece. The building is unfortunately in ruins, but most of of Artemis at Corfu, one of the first stone peripteral temples built CORFU Even older than the Paestum temple is the Doric temple

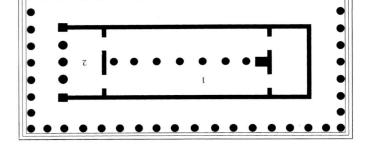

2-22 Plan of the Temple of Hera, Paestum, Italy, ca. 550 BCE.

leaving no place for a central cult statue. number of columns on the facade and a single row of columns in the cella, The Hera temple's plan also reveals its early date. The building has an odd

the available area became increasingly cramped. 9 feet tall at Corfu), but as the pediment tapered toward the corners,

by depicting her offspring. Narration was, however, the purpose not in telling a coherent story but in identifying the central figure fore a chronological impossibility. The Archaic artist's interest was with his sword. Their presence here with the living Medusa is theresprang from her head when the Greek hero Perseus decapitated her legs remain). Chrysaor and Pegasus were Medusa's children. They her left and the winged horse Pegasus at her right (only the rear the great beasts are two smaller figures—the human Chrysaor at enemies from the sanctuary of the goddess. Between Medusa and great felines. Together they serve as temple guardians, repulsing all or, for a winged creature, flying. To Medusa's left and right are two bent-leg, bent-arm, pinwheel-like posture that signifies running into stone. The sculptor depicted her in the conventional Archaic a hideous face and snake hair, and anyone who gazed at her turned demon with a woman's body and a bird's wings. Medusa also had At the center of the Corfu pediment is the gorgon Medusa, a

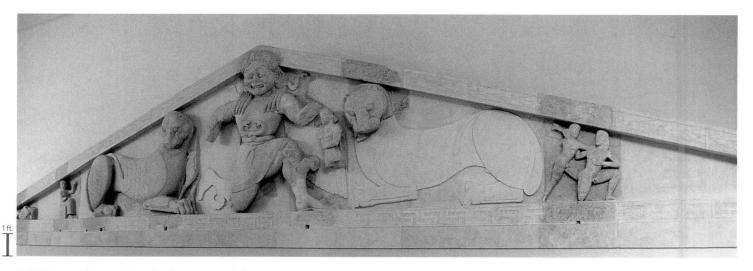

2-23 West pediment, Temple of Artemis, Corfu, Greece, ca. 600–580 BCE. Limestone, greatest height 9' 4". Archaeological Museum, Corfu.

The hideous Medusa and two panthers at the center of this early pediment served as temple guardians. To either side, and much smaller, are scenes from the Trojan War and the battle of gods and giants.

of the much smaller groups situated in the pediment corners. To the viewer's right is Zeus, brandishing his thunderbolt and slaying a kneeling giant. In the extreme corner was a dead giant. The *gigantomachy* (battle of gods and giants) was a popular Greek theme that was a metaphor for the triumph of reason and order over chaos. In the pediment's left corner is one of the Trojan War's climactic events: Achilles's son Neoptolemos kills the enthroned King Priam. The fallen figure to the left of this group may be a dead Trojan.

The master responsible for the Corfu pediments was a pioneer, and the composition shows all the signs of experimentation. The lack of narrative unity in the Corfu pediment and the figures' extraordinary diversity of scale eventually gave way to pediment designs in which all the figures are the same size and act out a single event. But the Corfu designer already had shown the way by realizing, for example, that the area beneath the raking cornice could

be filled with gods and heroes of similar size by employing a combination of standing, leaning, kneeling, seated, and lying figures. The Corfu master also discovered that animals could be very useful space fillers because, unlike humans, they have one end taller than the other.

BLACK-FIGURE PAINTING During the Archaic period, Greek vase painters replaced the simple silhouettes of the Geometric style with much more detailed representations using a new ceramic painting technique that art historians call *black-figure painting*. Black-figure painters still applied black silhouettes to the clay surface, but then used a sharp, pointed instrument to incise linear details in the black *glaze* forms, usually adding highlights in purplish red or white before firing the vessel. The combination of the weighty black silhouettes with the delicate detailing and the bright polychrome

overlay proved to be irresistible, and painters throughout Greece quickly adopted the new technique.

EXEKIAS The acknowledged master of the black-figure technique was an Athenian named EXEKIAS. An *amphora*, or two-handled storage jar (FIG. 2-24), bears his signature as both painter and potter. Such signatures,

2-24 EXEKIAS, Achilles and Ajax playing a dice game (detail of an Athenian black-figure amphora), from Vulci, Italy, ca. 540–530 BCE. Amphora 2' high; detail $8\frac{1}{2}$ " high. Musei Vaticani, Rome.

The dramatic tension, coordination of figural poses with vase shape, and intricacy of the engraved patterns of the cloaks are hallmarks of Exekias, the greatest master of black-figure painting.

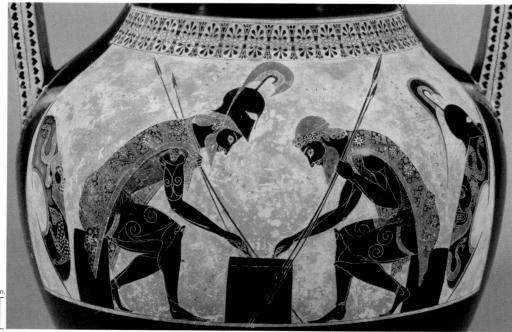

EUPHRONIOS One of the most admired red-figure painters was Euphronios, whose krater depicting the struggle between Herakles (Roman Hercules), the greatest Greek hero, and the giant Antaios (Fig. 2-25) reveals the exciting possibilities of the new technique. Antaios was a son of Earth, and he derived his power from contact with the ground. To defeat him, Herakles had to lift him into the air and strangle him while no part of the giant's body touched the earth. Here, the two wreatle on the ground, and Antaios still possesses enormous strength. Nonetheless, Herakles has the upper hand. The giant's face is a mask of pain. His eyes roll, and he bares his teeth. His right arm is paralyzed, with the fingers limp.

posed to be. space—a revolutionary new conception of what a picture is supmythological world with protagonists moving in three-dimensional the upper leg and the foot. Euphronios's panel is a window onto a is visible. The viewer must mentally make the connection between lower leg disappears behind the giant, and only part of the right foot not only Antaios's torso but also his right thigh from the front. The how a particular human body is seen. He presented, for example, posture for the human figure and attempted instead to reproduce occupy space. He deliberately rejected the conventional composite his only interest. Euphronios also wished to show that his figures les. But rendering human anatomy and hair convincingly was not coiffure and carefully trimmed beard of the emotionless Herakintentionally contrasting the giant's unkempt hair with the neat figures and to produce a golden brown hue for Antaios's hair— Euphronios used diluted glaze to delineate the muscles of both

EUTHYMIDES A preoccupation with the art of drawing per se is evident in a remarkable amphora (FIG. 2-26) painted by EUTHYMIDES, a rival of Euphronios's. The subject is appropriate for a wine storange jar—three tipsy revelers. But the theme was little more than an excuse for the artist to experiment with the representation of unusual positions of the human form. It is no coincidence that the bodies do not overlap, for each is an independent figure study. Euthymides cast aside the conventional frontal and profile composite views. Instead, he painted torsos that are not two-dimensional ite views. Instead, he painted torsos that are not two-dimensional

common on Greek vases, reveal the artists' pride in their work but also served as "brand names," ensuring a higher price for the products of the most famous ceramists. Unlike his Geometric predecessors, Exekias did not divide the surface of his vases with bands filled with small figures and abstract ornament. Instead, he placed large figures in a single framed panel. In the illustrated example, Achilles, fully armed, is at the left. He plays a dice game with his comrade Ajax during a lull in the Trojan War. Ajax has taken off his helmet, but both men hold their spears. Their shields are nearby, and each man is ready for action at a moment's notice. The gravity and tension that characterize this composition are rare in Archaic art.

Exekias had no equal as a black-figure painter. This is evident in such details as the extraordinarily intricate engraving of the patterns on the heroes' cloaks (highlighted with delicate touches of white) and in the masterful composition. The arch formed by the backs of the two warriors echoes the shape of the rounded shoulders of the amphora. The shape of the vessel (compare Fig. 2-26) is echoed again in the void between the heads and spears of Achilles and Ajax. Exekias also used the spears to lead the viewer's eye toward the thrown dice, where the heroes' gazes are fixed. Of course, their eyes do not really look down at the table but stare out from the profile heads. For all his brilliance, Exekias was still wedded to many of the old conventions. Real innovation in figure drawing would have to await the invention of a new ceramic painting technique of greater versatility than black-figure.

RED-FIGURE PAINTING The birth of this new technique, called red-figure painting, occurred around 530 BCE. Red-figure is the opposite of black-figure. What was previously black became red, and vice versa. The artist used the same black glaze for the figures, but instead of creating silhouettes, the painter outlined the figures and then colored the background black, reserving the red clay for the figures themselves. For the interior details, the artist used a soft brush in place of a metal graver. The painter could now vary the thickness of the lines and even build up the glaze to give relief to curly hair or dilute it to create brown shades, thereby expanding the curly hair or dilute it to create brown shades, thereby expanding the color range of the Greek vase painter's craft.

2-25 EUPHRONIOS, Herakles wrestling Antaios (detail of an Athenian red-figure calyx krater), from Cerveteri, Italy, ca. 510 BCE. Krater I' 7" high; detail $7\frac{3}{4}$ " high. Musée du Louvre, Paris.

The early red-figure master Euphronios rejected the age-old composite view for painted figures and instead attempted to reproduce the way the human body appears from a specific viewpoint.

CHAPTER 2 Ancient Greece

2-26 EUTHYMIDES, three revelers (Athenian red-figure amphora), from Vulci, Italy, ca. 510 BCE. 2' high. Staatliche Antikensammlungen, Munich.

Euthymides chose this theme as an excuse to represent bodies in unusual positions, including a foreshortened three-quarter rear view. He claimed to have surpassed Euphronios as a draftsman.

surface patterns but are *foreshortened*—that is, drawn in a three-quarter view. Most noteworthy is the central figure, shown from the rear with a twisting spinal column and buttocks in three-quarter view. Earlier artists had no interest in attempting to depict figures seen from behind or at an angle because those postures not only are incomplete but also do not show the "main" side of the human body. For Euthymides, however, the challenge of drawing a figure from this unusual viewpoint was a reward in itself. With understandable pride he proclaimed his achievement by adding to the formulaic signature "Euthymides painted me" the phrase "as never Euphronios [could do!]"

AEGINA The years just before and after 500 BCE were also a time of dynamic transition in architecture and architectural sculpture. The key monument is the temple (FIGS. 2-27 and 2-28) dedicated to Aphaia, a local nymph, at Aegina. The colonnade consists of 6 Doric columns on the facade and 12 on the flanks. This is a much more compact structure than Paestum's impressive but ungainly Hera temple (FIGS. 2-21 and 2-22), even though the ratio of width to length is similar. Doric architects had learned a great deal in the half-century that elapsed between construction of the two temples.

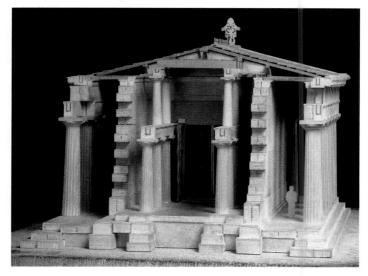

2-27 Model showing internal elevation (*top*) and plan (*bottom*) of the Temple of Aphaia, Aegina, Greece, ca. 500–490 BCE. Model: Glyptothek, Munich.

In this refined Doric design, the columns are more slender and widely spaced, there are only six columns on the facade, and the cella has two colonnades of two stories each framing the cult statue.

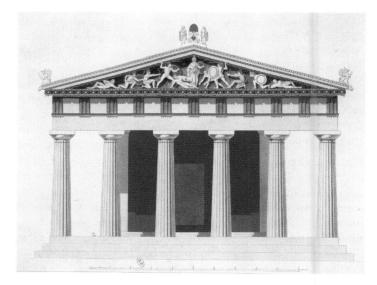

2-28 GUILLAUME-ABEL BLOUET, restored view (1828) of the facade of the Temple of Aphaia, Aegina, Greece, ca. 500–490 BCE.

The Aegina designer solved the problem of composing figures in a pediment by using the whole range of body postures from standing to lying. The restored view suggests how colorful Greek temples were.

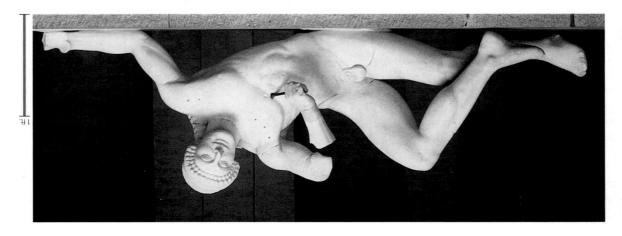

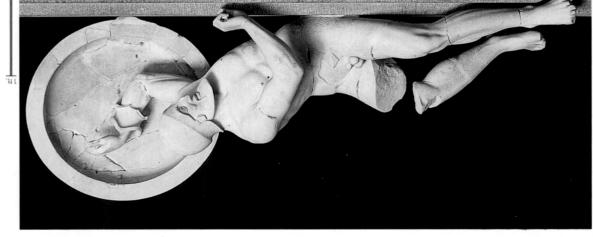

2-29 Dying warrior, from the west pediment of the Temple of Aphaia, Aegina, Greece, ca. 490 BCE. Marble, 5' $\Sigma \frac{1}{2}$ " long. Glyptothek, Munich.

The two sets of Aegina pediment statues date about a decade apart. The earlier statues exhibit Archaic features. This fallen warrior still has a rigidly frontal torso and an Archaic smile on his face.

2-30 Dying warrior, from the east pediment of the Temple of Aphaia, Aegina, Greece, ca. 480 BCE. Marble, 6' I" long. Glyptothek, Munich.

This later dying warrior already belongs to the Classical era. His posture is more natural, and he exhibits a new self-consciousness. Concerned with his own pain, he does not face the viewer.

chest. He is like a mannequin in a store window whose arms and legs have been arranged by someone else for effective display.

The comparable figure (Fig. 2-30) in the east pediment is fundamentally different. This warrior's posture is more natural and more complex, with the torso placed at an angle to the viewer (compare Fig. 2-25). Moreover, he reacts to his wound. He knows that death is inevitable, but still struggles to rise once again, using his shield for support. He does not look out at the viewer. This dying warrior is concerned with his plight, not with the viewer.

The two statues belong to different eras. The eastern warrior is not a creation of the Archaic world, when sculptors imposed anatomical patterns (and smiles) on statues. This statue belongs to the Classical world, where statues move as humans move and possess the self-consciousness of real men and women. This constitutes a radical change in the conception of the nature of statuary. In sculpture, as in painting, the Classical revolution had occurred.

Early and High Classical Art

Art historians mark the beginning of the Classical* age from a historical event: the defeat of the Persian invaders of Greece by the allied Hellenic city-states. Shortly after the sack of Athens in 480 BCE, the Greeks won a decisive naval victory over the Persians at Salamis.

*In Art through the Ages, the adjective "Classical," with uppercase C, refers specifically to the Classical period of ancient Greece, 480–323 BCE. Lowercase "classical" refers to Greece-Roman antiquity in general—that is, the period treated in Chapters 2 and 3.

The columns of the Aegina temple are more widely spaced and more slender. The capitals create a smooth transition from the vertical shafts below to the horizontal architrave above. Gone are the Archaic flattened echinuses and bulging shafts of the Paestum columns. The Aegina architect also refined the internal elevation and plan. In place of a single row of columns down the center of the cella is a double colonnade of two stories each. This arrangement enabled a statue to be placed on the central axis and also gave those gathered in front of the building an unobstructed view through the pair of columns in the pronaos.

The theme of both statuary groups was the war between the Greeks and Trojans, and the compositions differed only slightly. In both pediments, Athena stands at the center. She is larger than all the other figures because she is superhuman, but all the mortal heroes are the same size, regardless of their position in the pediment. Unlike the experimental design at Corfu (Fig. 2-23), the Aegina pediments feature a unified theme and consistent scale. The designer achieved the latter by using the whole range of body postures from upright (Athena) to leaning, falling, kneeling, and lying (Greeks and upright (Athena) to leaning, falling, kneeling, and lying (Greeks and

The sculptures of the west pediment were set in place upon completion of the building around 490 BCE. The eastern statues are a decade later. It is instructive to compare the earlier and later figures. The sculptor of the west pediment's dying warrior (FIG. 2-29) still conceived the statue in the Archaic mode. The warrior's torso is rigidly frontal, and he looks out directly at the spectator—with his face set in an Archaic smile despite the bronze arrow puncturing his

It had been a difficult war, and at times it appeared that Asia would swallow up Greece and that the Persian king Xerxes (see page 28) would rule over all. The narrow escape of the Greeks from domination by Asian "barbarians" nurtured a sense of Hellenic identity so strong that from then on, European civilization would be distinct from Asian civilization. Historians universally consider the decades following the removal of the Persian threat the high point of Greek civilization. This is the era of the dramatists Aeschylus, Sophocles, and Euripides; the historian Herodotus; the statesman Pericles; the philosopher Socrates; and many of the most famous Greek architects, sculptors, and painters.

KRITIOS BOY The sculptures of the Early Classical period (ca. 480–450 BCE) display a seriousness that contrasts sharply with the smiling figures of the Archaic period. But a more fundamental and significant break from the Archaic style was the abandonment of the rigid and unnatural Egyptian-inspired pose of Archaic statuary. The earliest example of the new approach is the marble statue known as the *Kritios Boy* (FIG. 2-31)—because art historians once thought it was the work of the sculptor Kritios. Never before had a sculptor been concerned with portraying how a human being (as opposed

to a stone image) truly stands. Real people do not stand in the stifflegged pose of the kouroi and korai or their Egyptian predecessors. Humans shift their weight and the position of the torso around the vertical (but flexible) axis of the spine. The sculptor of the Kritios Boy was among the first to grasp this anatomical fact and to represent it in statuary. The youth dips his right hip slightly, indicating the shifting of weight onto his left leg. His right leg is bent, at ease. The head, which no longer exhibits an Archaic smile, also

2-31 *Kritios Boy*, from the Acropolis, Athens, Greece, ca. 480 BCE. Marble, 2' 10" high. Acropolis Museum, Athens.

This is the first statue to show how a person naturally stands. The sculptor depicted the weight shift from one leg to the other (contrapposto). The head also turns slightly, and the youth no longer smiles.

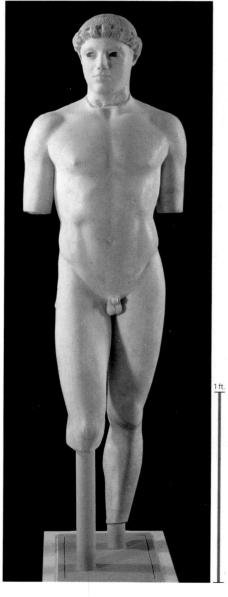

turns slightly to the right and tilts, breaking the unwritten rule of frontality that dictated the form of virtually all earlier statues. This weight shift, called *contrapposto* ("counterbalance"), separates Classical from Archaic Greek statuary.

MYRON Early Classical Greek sculptors also explored the problem of representing figures engaged in vigorous action. The famous *Diskobolos* (*Discus Thrower*; FIG. 2-32) by MYRON, with its arms boldly extended, body twisted, and right heel raised off the ground, is such a statue. Nothing comparable survives from the Archaic period. The pose suggests the motion of a pendulum clock. The athlete's right arm has reached the apex of its arc but has not yet begun to swing down again. Myron froze the action and arranged the body and limbs to form two intersecting arcs, creating the impression of a tightly stretched bow a moment before the archer releases the string.

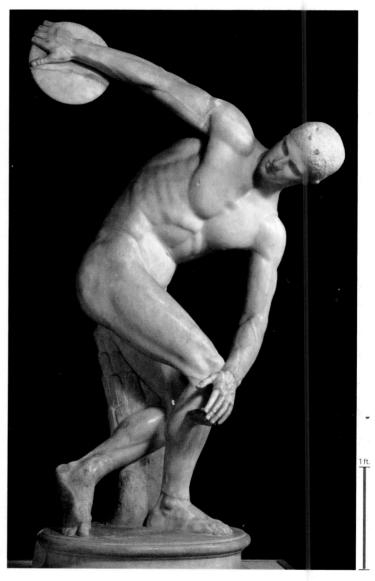

2-32 Myron, *Diskobolos* (*Discus Thrower*). Roman copy from the Esquiline hill, Rome, Italy, of a bronze statue of ca. 450 BCE. Marble, 5' 1" high. Palazzo Massimo alle Terme, Museo Nazionale Romano, Rome

This marble copy of Myron's lost bronze statue captures how the sculptor froze the action of discus throwing and arranged the nude athlete's body and limbs so that they form two intersecting arcs.

2-34 Charioteer (Charioteer (Charioteer of Delphi), from a group dedicated by Polyzalos of Gela in the Sanctuary of Apollo, Delphi, Greece, ca. 470 BCE. Bronze, 5' II" high. Archaeological Museum, Delphi.

The Charloteer of Delphi was part of a large bronze group that also included a charlot, a team of horses, and a groom. The assemblage required hundreds of individually cast pieces soldered together.

In the next stage, an assistant applied a final clay mold (investment) to the exterior of the wax model and poured liquid clay inside the model. Apprentices then hammered metal pins (chaplets) through the new mold to connect the investment with the clay core (Fig. 2-33a). Mext, the wax was melted out ("lost") and molten bronze poured into the mold in its place (Fig. 2-33b). When the bronze hardened and assumed the shape of the wax model, the sculptor removed the investment and as much of the core as possible. The last step was to fit together and solder the individually cast pieces, smooth the joins and any surface imperfections, inlay the eyes, and add teeth, eyelashes, and any surface imperfections, inlay the eyes, and add teeth, eyelashes, and accessories such as swords and wreaths.

MATERIALS AND TECHNIQUES Hollow-Casting Life-Size Bronze Statues

Large-scale bronze statues such as Myron's Diskobolos (known only through marble copies; Fig. 2-32) could not be manufactured using a single mold, as could simpler small-scale figures. Weight, cost, and the tendency of large masses of bronze to distort when cooling made lifesize castings in solid bronze impractical. Instead, the Greeks holloweast large statues using the cire perdue (lost-wax) method (Fig. 2-33). The process entailed several steps and had to be repeated many times, because sculptors typically cast life-size statues such as the Charioteer

of Delphi (FIG. 2-34) in parts—head, arms, hands, feet, and so forth. First, the sculptor fashioned a full-size clay model of the intended statue. Then an assistant formed a clay master mold around the model and removed the mold in sections. When dry, the various pieces of the master mold were reassembled for each separate body part. Next, assistants applied a layer of beeswax to the inside of each mold. When the wax cooled, the sculptor removed the mold, revealing a hollow wax model in the shape of the original clay model. The artist could then correct or refine details—for example, engrave fingernails on the wax correct or refine details—for example, engrave fingernails on the wax

hands or individual locks of hair in a beard.

2-33 Two stages of the lost-wax method of bronze-casting (after Sean A. Hemingway).

Drawing a shows a clay mold (investment), wax model, and clay core connected by chaplets. Drawing b shows the wax melted out and the molten bronze poured into the mold to form the cast bronze head.

are indispensable today. Without them it would be impossible to reconstruct the history of Greek sculpture after the Archaic period.

CHARIOTEER OF DELPHI Two rare extant Early Classical bronze statues are the Charioteer of Delphi (Fig. 2-34) and a warrior from Riace, Italy (Fig. 2-34A). The former was the centerpiece of a chariot group set up by the tyrant Polyzalos of Gela (Sicily) to commemorate his brother Hieron's victory in the Delphic Pythian Games. The group originally comprised the Sicilian driver, the chariot, the team of horses, and a young groom. The charioteer stands in iot, the team of horses, but the turn of the head and feet in opposite an almost Archaic pose, but the turn of the head and feet in opposite

The illustrated marble statue, however, is not Myron's, which was bronze (see "Hollow-Casting Life-Size Bronze Statues," above). It is a copy made in Roman times, when demand so far exceeded the supply of Greek statues that a veritable industry was born to meet the call for replicas of famous works to display in public places and private villas alike. Usually, the copies were of less costly painted marble, which presented a very different appearance from shiny bronze. In most cases, the copyist also had to add an intrusive tree trunk to support the great weight of the stone statue, and to place struts between arms and body to strengthen weak points. The replicas rarely approach the quality of the originals, but the Roman statues

PROBLEMS AND SOLUTIONS

Polykleitos's Prescription for the Perfect Statue

In his treatise simply called the *Canon*, Polykleitos of Argos sought to define what constituted a perfect statue, one that could serve as the standard by which all other statues might be judged. How does one make a "perfect statue"? What principles guided the Greek master in formulating his canon?

One of the most influential philosophers and mathematicians of the ancient world was Pythagoras of Samos, who lived during the latter part of the sixth century BCE (see page 45). Pythagoras discovered that harmonic chords in music are produced on the strings of a lyre at regular intervals that may be expressed as ratios of whole numbers—for example, 2:1, 3:2, 4:3. He believed more generally that underlying harmonic proportions could be found in all of nature, determining the form of the cosmos as well as of things on earth, and that beauty resided in harmonious numerical ratios.

Following this reasoning, Polykleitos concluded that the way to create a perfect statue would be to design it according to an all-encompassing mathematical formula. That is what Polykleitos achieved in his *Doryphoros*. Galen, a physician who lived during the second century CE, summarized the sculptor's philosophy as follows:

[Beauty arises from] the commensurability of the parts, such as that of finger to finger, and of all the fingers to the palm and the wrist, and of these to the forearm, and of the forearm to the upper arm, and, in fact, of everything to everything else, just as it is written in the *Canon* of Polykleitos. . . . Polykleitos supported his treatise [by making] a statue according to the tenets of his treatise, and called the statue, like the work, the *Canon*.*

This is why Pliny the Elder, writing in the first century CE, maintained that Polykleitos "alone of men is deemed to have rendered art itself [that is, the theoretical basis of art] in a work of art."

* Galen, De placitis Hippocratis et Platonis, 5. Translated by J. J. Pollitt, The Art of Ancient Greece: Sources and Documents (New York: Cambridge University Press, 1990), 76.

† Pliny the Elder, Natural History, 34.55. Translated by Pollitt, 75.

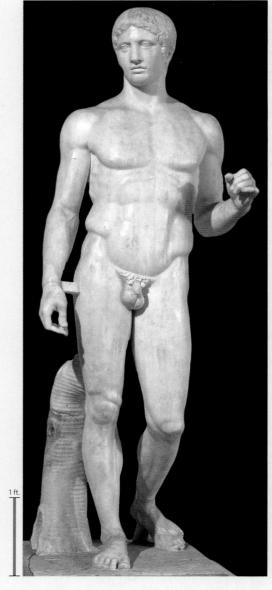

2-35
POLYKLEITOS,
Doryphoros
(Spear Bearer).
Roman copy
from the palaestra, Pompeii,
Italy, of a bronze
statue of ca.
450–440 BCE.
Marble, 6' 11"
high. Museo
Archeologico
Nazionale,
Naples.

Polykleitos sought to portray the perfect man and to impose order on human movement. He achieved his goals through harmonic proportions and a system of cross balancing for all parts of the body.

directions as well as a slight twist at the waist are in keeping with the Early Classical manner. The moment the sculptor chose for depiction was not during the frenetic race but after, when the charioteer modestly held his horses quietly in the winner's circle. He grasps the reins in his outstretched right hand (the lower left arm, cast separately, is missing), and he wears the standard charioteer's garment, girdled high and held in at the shoulders and the back to keep it from flapping. The folds emphasize both the verticality and calm of the figure and recall the flutes of a Greek column. The fillet that holds the charioteer's hair in place is inlaid with silver. The eyes are glass paste, shaded by delicate lashes individually cut from a sheet of bronze and soldered to the head.

POLYKLEITOS One of the most frequently copied Greek statues was the *Doryphoros* (FIG. 2-35), or *Spear Bearer*, by POLYKLEITOS, the sculptor whose work exemplifies the intellectual rigor of High Classical (ca. 450–400 BCE) statuary design. Polykleitos created the *Doryphoros* as a demonstration piece to accompany a treatise on

the ideal statue of a nude male warrior or athlete. *Spear Bearer* is a modern descriptive title for the statue. The name that the artist assigned to it was *Canon* (see "Polykleitos's Prescription for the Perfect Statue," above).

The *Doryphoros* is the culmination of the evolution in Greek statuary from the Archaic kouros (FIGS. 2-16 and 2-17) to the *Kritios Boy* (FIG. 2-31) to the Riace warrior (FIG. 2-34A). The contrapposto is more pronounced than ever before in a standing statue, but Polykleitos was not content with simply rendering a figure that stands naturally. His aim was to impose order on human movement, to make it "beautiful," to "perfect" it. He achieved this through a system of cross balance of the figure's various parts. Note, for instance, how the straight-hanging arm echoes the rigid supporting leg, providing the figure's right side with the columnar stability needed to anchor the left side's dynamically flexed limbs. The tensed and relaxed limbs oppose each other diagonally. The right arm and the left leg are relaxed, and the tensed supporting leg opposes the flexed arm, which held a spear. In like manner, the head turns to the right

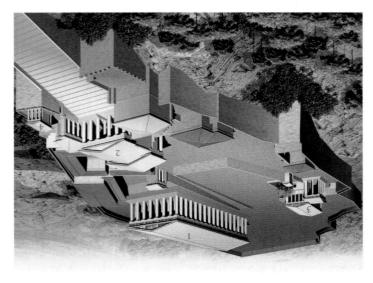

2-36 Restored view of the Acropolis, Athens, Greece (John Burge).
(1) Parthenon, (2) Propylaia, (3) Erechtheion, (4) Temple of Athena Nike

Under Pericles, the Athenians undertook one of history's most ambitious building projects—the reconstruction of the Acropolis after the Persian sack. The funds came from the Delian League treasury.

length to width is 9:4, because $9 = (2 \times 4) + 1$. I? on the long sides, because $17 = (2 \times 8) + 1$. The stylobate's ratio of temple's plan (Fig. 2-37) called for 8 columns on the short ends and may be expressed algebraically as x = 2y + 1. Thus, for example, the in beautiful proportions. For the Parthenon, the controlling ratio belief that strict adherence to harmonious numerical ratios resulted Parthenon architects and Polykleitos were kindred spirits in their in Doric temple design (see "The Perfect Temple," page 45). The ideal solution to the Greek architect's quest for perfect proportions of the human body, so, too, the Parthenon may be viewed as the nation of nearly two centuries of searching for the ideal proportions Just as the contemporaneous Doryphoros may be seen as the culmiof Pericles that Phidias was in charge of the entire Acropolis project. ple's sculptural decoration. In fact, Plutarch stated in his biography cella was the work of Phidias, who was also the overseer of the temsources, by Kallikrates. The statue of Athena (Fig. 2-1c) in the

while the hips twist slightly to the left. And although the Doryphoros seems to take a step forward, he does not move. This dynamic asymmetrical balance, this motion while at rest, and the resulting harmony of opposites are the essence of the Polykleitan style.

and architectural historians do not ask how an art or building project but the by-product of tyranny and the abuse of power. Too often art not the glorious fruit of Athenian democracy, as commonly thought, Acropolis (FIG. 2-36). The Periclean building program was therefore Greek states. Instead, he expropriated the money to resurrect the did not spend the surplus reserves for the common good of the allied sibly for security reasons. Tribute continued to be paid, but Pericles 454 BCE, the league transferred the Delian treasury to Athens, ostenthe alliance intact, but Athens gradually assumed a dominant role. In to the treasury at Delos. Continued fighting against the Persians kept were to furnish ships and which were instead to pay an annual tribute providing the allied fleet commander and determining which cities league member had an equal vote, Athens was "first among equals," were on the Cycladic island of Delos. Although at the outset each acy came to be known as the Delian League, because its headquarters tection against any renewed threat from the East. The new confederof the Persian defeat, the Greeks formed an alliance for mutual promeans "high city") after the Persian sack. In 478 BCE, in the aftermath ever undertaken—the reconstruction of the Acropolis (acropolis 495-429 BCE), initiated one of the most ambitious building projects Canon in Argos, the Athenians, under the leadership of Pericles (ca. ATHENIAN ACROPOLIS While Polykleitos was formulating his

was financed. The answer can be very revealing.

The centerpiece of the Periclean Acropolis was the Parthenon (Figs. 2-1 and 2-36, no. 1), erected in the remarkably short period between 447 and 438 BCE. (Work on the temple's ambitious sculptural ornamentation continued until 432 BCE.) In 437 BCE, continued until 432 BCE.) In 437 BCE, continued until 432 BCE, In 437 BCE, and 438 BCE, and 2-36, no. 3, and 2-36, no. 3, and 2-45), built after Pericles died, were probably also 2-36, no. 4, and 2-43), built after Pericles died, were probably also

PARTHENON: ARCHITECTURE Most of the peripteral colonnade of the Parthenon (Fig. 2-1) still stands (or has been reerected), and art historians know a great deal about the building and its sculptural program. The architect was Iktinos, assisted, according to some

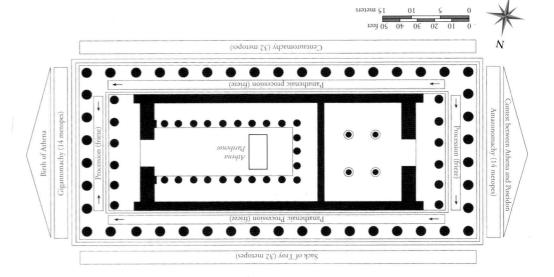

2-37 Plan of the Parthenon, Acropolis, Athens, Greece, with diagram of the sculptural program (after Andrew Stewart), 447–432 BCE.

part of the original project.

The Parthenon was lavishly decorated. Statues filled both pediments, and reliefs adorned all 92 Doric metopes as well as the 524-foot lonic frieze. In the cella was Phidias's colossal gold-and-ivory Athena.

The Parthenon's harmonious design and the mathematical precision of the sizes of its constituent elements obscure the fact that throughout the building are pronounced deviations from the strictly horizontal and vertical lines assumed to be the basis of all Greek temples. The stylobate, for example, curves upward at the center on all four sides, forming a kind of shallow dome, and this curvature carries up into the entablature. Moreover, the peristyle columns (FIG. 2-1a) lean inward slightly. Those at the corners have a diagonal inclination and are also about 2 inches thicker than the rest. If their lines continued, they would meet about 1.5 miles above the temple. These deviations from the norm meant that virtually every Parthenon block had to be carved according to the special set of specifications dictated by its unique place in the structure. Vitruvius, a Roman architect of the late first century BCE, explained these adjustments as compensations for optical illusions. Vitruvius noted, for example, that if a stylobate is laid out on a level surface, it will appear to sag at the center. He also recommended that the corner columns of a building should be thicker because they are surrounded by light and would otherwise appear thinner than their neighbors (see "Vitruvius's Ten Books on Architecture" 1.

One of the ironies of the Parthenon, the world's most famous Doric temple, is that it incorporates major Ionic elements. Although the cella (FIG. 2-37) had a two-story Doric colonnade, the back room (which housed the goddess's treasury and the tribute collected from the Delian League) had four tall and slender Ionic columns as sole supports for the superstructure. And whereas the temple's exterior had a standard Doric frieze, the inner frieze (FIG. 2-41) running around the top of the cella wall was Ionic. Perhaps this fusion of Doric and Ionic elements reflects the Athenians' belief that the Ionians of the Aegean Islands and Asia Minor were

descendants of Athenian settlers and were therefore their kin. Or it may be Pericles and Iktinos's way of suggesting that Athens was the leader of *all* the Greeks. In any case, a mix of Doric and Ionic features characterizes the fifth-century BCE buildings of the Acropolis as a whole.

ATHENA PARTHENOS The Parthenon was more lavishly decorated than any Greek temple before it, Doric or Ionic. A mythological scene appears in every one of the 92 Doric metopes (FIGS. 2-37 and 2-38), and a cavalcade and procession unfold along the 524-footlong Ionic frieze (FIG. 2-41). Dozens of larger-than-life-size statues filled both pediments (FIGS. 2-39 and 2-40). And inside was the most expensive item of all—Phidias's gold-and-ivory 38-foot-tall chryselephantine (gold-and-ivory) Athena Parthenos (FIG. 2-1c). Fully armed, the goddess held Nike (the winged female personification of victory) in her extended right hand. No one doubts that this Nike referred to the victory of 479 BCE. The memory of the Persian sack of the Acropolis was still vivid, and the Athenians were intensely conscious that by driving back the Persians, they were saving their civilization from the "barbarians" who had committed atrocities against the Greeks of Asia Minor. In fact, Phidias incorporated multiple allusions to the Persian defeat in his colossal statue. On the thick soles of Athena's sandals was a representation of a centauromachy. Emblazoned on the exterior of her shield were high reliefs depicting the battle of Greeks and Amazons (Amazonomachy), in which Theseus drove the Amazons (female warriors) out of Athens. On the shield's interior, Phidias painted a gigantomachy. Each of these mythological contests was a metaphor for the triumph of order over chaos, of civilization over barbarism, and of Athens over Persia.

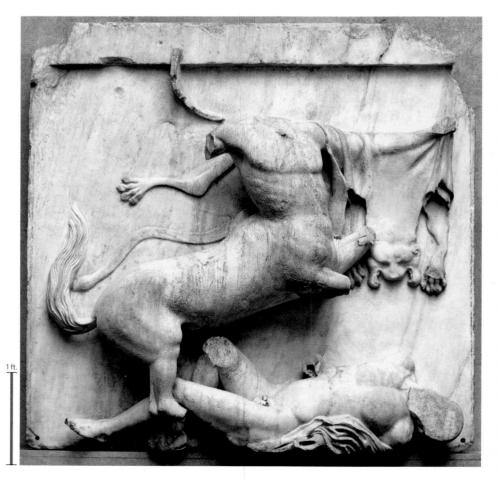

PARTHENON: METOPES Phidias took up these same themes again in the Parthenon's metopes (FIG. 2-37). The south metopes, for example, depicted the battle of Lapiths (a northern Greek people) and centaurs, a combat in which Theseus of Athens played a major role. On one extraordinary slab (FIG. 2-38), a triumphant centaur rises up on its hind legs, exulting over the crumpled body of the Greek whom the horse-man has defeated. The relief is so high that parts are fully in the round. Some have broken off. The sculptor brilliantly distinguished the vibrant, powerful form of the living beast from the lifeless corpse on the ground. In other metopes, the Greeks have the upper hand, but the full set suggests that the battle was a difficult one against a dangerous enemy and that losses as well as victories occurred. The same was true of the war against the Persians.

2-38 *Centauromachy*, metope from the south frieze of the Parthenon, Acropolis, Athens, Greece, ca. 447–438 BCE. Marble, 4' 8" high. British Museum, London.

The Parthenon's centauromachy metopes allude to the Greek defeat of the Persians. Here the High Classical sculptor brilliantly distinguished the vibrant living centaur from the lifeless Greek corpse.

dawn, are weary. day, are energetic. Those of the Moon or Night, having labored until liantly characterized. The horses of the Sun, at the beginning of the light and shade. Moreover, all the figures, even the animals, are brilof the bodies produce a wonderful variation of surface and play of tide that subtly unifies the figures. The articulation and integration

consideration. is another instance of how the builders took optical effects into is as legible from the ground as the lower part of the trieze. This lower part so that the more distant and more shaded upper zone (FIG. 2-37). The upper part of the frieze is in higher relief than the east frieze, over the doorway to the cella housing Phidias's statue north and south sides of the building and ends at the center of the way to the Acropolis. It then moves in parallel lines down the long begins on the west side—that is, at the temple's rear, facing the gateeve of the Persian attack. On the Parthenon frieze, the procession temple that the Persians razed, but the Athenians removed it on the the Lady of Auxerre, FIG. 2-15) had been housed in the Archaic of Athena. That statue (probably similar in general appearance to where the Athenians placed a new peplos on an ancient wood statue began at the Dipylon Gate to the city and ended on the Acropolis, cession that took place every four years in Athens. The procession frieze (FIG. 2-41), which represents the Panathenaic Festival proable part of the Parthenon's sculptural decoration is the inner Ionic PARTHENON: IONIC FRIEZE In many ways, the most remark-

(FIG. 2-41, top), the momentum of the cavalcade picks up. On the and youths mount their horses. In the north and south triezes and deceleration. At the outset, on the west side, marshals gather The frieze vividly communicates the procession's acceleration

> same arrogance that led to the use of Delian League funds to rebuild tive merits of the two gods. The selection of this theme reflects the story and in the pediment, the Athenians are the judges of the relagiving her name to the city and its people. It is significant that in the mine which one would become the city's patron deity. Athena won, At the west was the contest between Athena and Poseidon to deterthe Athenians. The east pediment depicted the birth of the goddess. were especially appropriate for a temple celebrating Athena—and PARTHENON: PEDIMENTS The subjects of the two pediments

> is the horizon line, and charioteers and their horses move through to deal with the awkward triangular frame of the pediment. Its floor the pediment's floor. Here, Phidias discovered an entirely new way (Moon) or Myx (Night) and more horses, this time sinking below desses, probably Hestia, Dione, and Aphrodite, and either Selene pleted 12 impossible labors. At the right (FIG. 2-40) are three godpossibly Herakles, who entered the realm of the gods after he comto them is a powerful male figure usually identified as Dionysos or (Sun) and his chariot horses rising from the pediment floor. Next Olympus. At the far left (FIG. 2-39) are the head and arms of Helios tors to the left and right who witnessed Athena's birth on Mount All that remains of the east pediment's statues are the specta-

> the main and lesser body masses while swirling in a compositional thin and heavy tolds of the garments afternately reveal and conceal clothed forms as well. In the Dione-Aphrodite group (FIG. 2-40), the bodies move. The Athenian sculptors mastered the rendition of anatomy but also the mechanics of how muscles and bones make understood not only the surface appearance of human and animal Phidias and his assistants were master sculptors. They fully

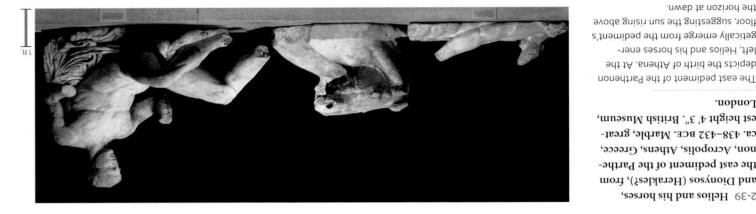

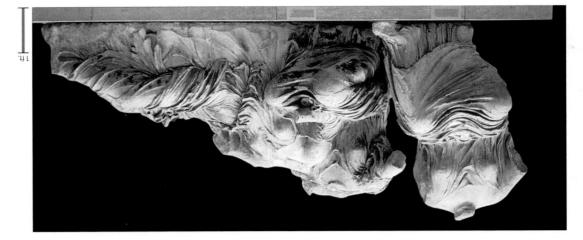

the horizon at dawn. floor, suggesting the sun rising above getically emerge from the pediment's left, Helios and his horses enerdepicts the birth of Athena. At the The east pediment of the Parthenon

ca. 438-432 BCE. Marble, greatnon, Acropolis, Athens, Greece, the east pediment of the Partheand Dionysos (Herakles?), from 2-39 Helios and his horses,

it effortlessly.

the Acropolis.

London. est height 4' 5". British Museum, ca. 438-432 BCE. Marble, greatnon, Acropolis, Athens, Greece, the east pediment of the Parthe-Dione, and Aphrodite?), from 2-40 Three goddesses (Hestia,

conceal the body forms. the garments alternately reveal and pediment. The thin and heavy tolds of ing right side of the Parthenon's east desses conform perfectly to the slop-These statues representing three godeast side, seated gods and goddesses (FIG. 2-41, *center*), the invited guests, watch the procession slow to a halt (FIG. 2-41, *bottom*). The role assigned to the Olympian deities is extraordinary. They do not take part in the festival or determine its outcome. They are merely

spectators, admiring the Athenian people, the new masters of a new Aegean empire who considered themselves worthy of depiction on a temple. The Parthenon celebrated the greatness of Athens and the Athenians as much as it honored Athena.

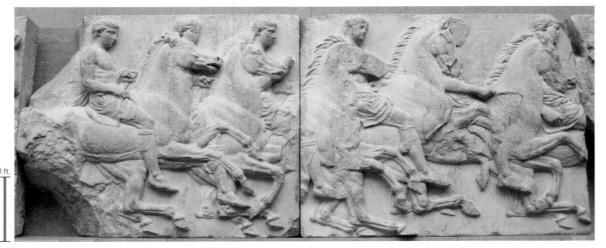

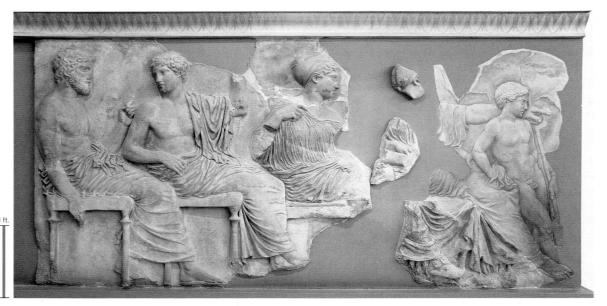

The Parthenon's lonic frieze represents the Panathenaic procession of citizens on horseback and on foot under the gods' watchful eyes. The Parthenon celebrated the Athenians as much as the goddess Athena.

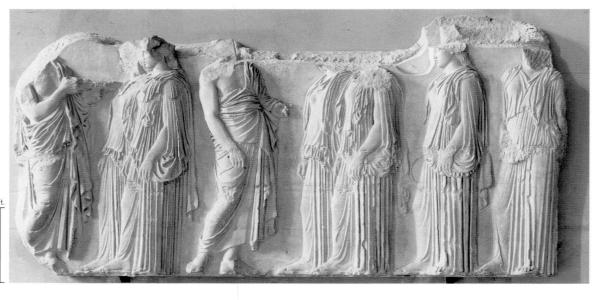

11

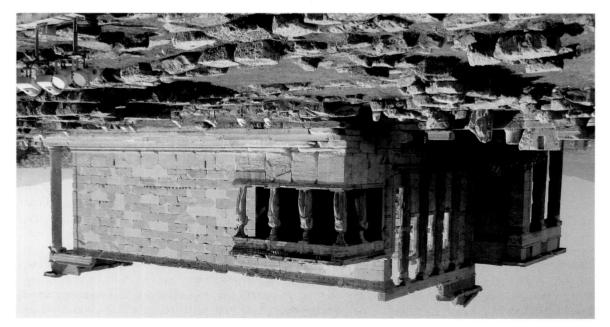

2-42 Erechtheion (looking northeast), Acropolis, Athens, Greece, ca. 421-405 BCE.

The asymmetrical form of the Erechtheion is unique for a Greek temple. It reflects the need to incorporate preexisting shrines into the plan. The decorative details are perhaps the tinest in Greek architecture.

TEMPLE OF ATHENA NIKE Another lonic building on the Athennian Acropolis is the small Temple of Athena Nike (FIG. 2-43), designed by Kallikrates, who may have been responsible for the Parthenon's lonic elements. The temple stands on what was once a Mycenaean bastion and greets all visitors entering Athena's great sanctuary. Like the Parthenon, the Athena Nike temple commemorated the victory over the Persians—and not just in its name. Part of the frieze represented the battle of Marathon in 490 BCE, a turning point in the war against the Persians—a human event, as in the Parthenon's Panathenaic Festival procession frieze. But on the later temple, the sculptors chronicled a specific occasion, not a recurring event involving anonymous citizens.

Around the building, at the bastion's edge, was a parapet decorated with exquisite reliefs. The theme matched that of the

 $2\text{-43}\,$ Kallikrates, Temple of Athens Nike (after restoration, 2012; looking southwest), Acropolis, Athens, Greece, ca. 427-424 BCE.

The small lonic temple at the entrance to the Acropolis celebrates Athena as bringer of victory. One of its friezes depicts the Greek defeat of the Persian forces at Marathon in 490 BCE.

olive tree to grow. producing a salt-water spring. Athena had miraculously caused an claim to Athens by striking the Acropolis rock with his trident and the very spot where that contest occurred. Poseidon had staked his Athena and Poseidon. In fact, the site chosen for the new temple was another king of Athens, who served as judge of the contest between whose reign the Athena idol fell from the heavens, and Kekrops, past. Among these were Erechtheus, an early king of Athens, during other gods and demigods who loomed large in the city's legendary naic Festival procession. But it also incorporated shrines to a host of ancient wood image of the goddess that was the goal of the Panathehowever. It honored Athena and became the new home of the the north of the old temple's remains, was to be a multiple shrine, destroyed. The new structure, the Erechtheion (Fig. 2-42), built to was to replace the Archaic Athena temple that the Persians had ERECHTHEION In 421 BCE, work finally began on the temple that

The asymmetrical plan of the lonic Erechtheion is unique for a Greek temple and the antithesis of the simple and harmoniously balanced plan of the Doric Parthenon across the way. Its irregular form reflected the need to incorporate the tomb of Kekrops and other preexisting shrines, the trident mark, and the olive tree into a single complex. The unknown architect responsible for the building also had to struggle with the problem of uneven terrain. The area could not be leveled by terracing because that would disturb the sacred sites. As a result, the Erechtheion has four sides of very different character, and each side rests on a different ground level. Perhaps to compensate for the awkward character of the build-

ing as a whole, the architect took great care with the Erechtheion's decorative details. The Ionic capitals were inlaid with gold, rock crystal, and colored glass, and the frieze received special treatment. The stone chosen was grey-blue limestone to contrast with the white marble relief figures attached to the dark frieze and the white walls and columns. The temple's most striking and famous feature is its south porch, where caryatids replaced Ionic columns. Although the caryatids exhibit the weight shift that was standard for the era, the flutelike drapery folds concealing their stiff, weight-bearing legs underscore their role as architectural supports. The figures have enough rigidity to suggest the structural column and just the degree enough rigidity to suggest the structural column and just the degree

of flexibility needed to suggest the living body.

temple proper—victory. Dozens of images of Nike adorned the parapet, always in different attitudes. Sometimes she erects trophies bedecked with Persian spoils. Other times she brings forward sacrificial bulls for Athena. One relief (FIG. 2-44) shows Nike adjusting her sandal—an awkward posture rendered elegant and graceful by a sculptor who carried the style of the Parthenon pediments (FIG. 2-40) even further and created a figure whose garments cling so tightly to the body that they seem almost transparent, as if drenched with water. The drapery folds form intricate linear patterns unrelated to the body's anatomical structure and have a life of their own as abstract designs.

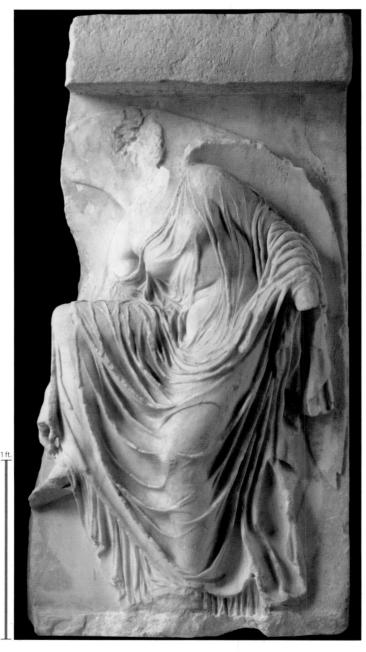

2-44 Nike adjusting her sandal, from the south side of the parapet of the Temple of Athena Nike, Acropolis, Athens, Greece, ca. 410 BCE. Marble, 3' 6" high. Acropolis Museum, Athens.

Dozens of images of winged Victory adorned the parapet on three sides of the Acropolis's Athena Nike temple. The sculptor carved this Nike with garments that appear almost transparent.

HEGESO STELE Decorating temples was not the only job available to sculptors in fifth-century BCE Athens. Around 400 BCE, the family of a young woman named Hegeso, daughter of Proxenos, set up a grave stele (FIG. 2-45) in her memory in the Dipylon cemetery, where, centuries earlier, Athenians had marked graves with enormous vases (FIG. 2-14). Hegeso is the well-dressed woman seated on an elegant chair (with footstool). She examines a piece of jewelry (once rendered in paint, not now visible) selected from a box a servant girl brings to her. The maid's simple unbelted *chiton* contrasts sharply with the more elaborate attire of her mistress. The garments of both women reveal the body forms beneath them, as on the parapet reliefs of the Athena Nike temple. The faces are serene, without a trace of sadness. Indeed, the sculptor depicted both mistress and maid during a characteristic shared moment out of daily life. Only the epitaph reveals that Hegeso is the one who has departed.

The simplicity of the scene on the Hegeso stele is deceptive, however. This is not merely a bittersweet scene of tranquil domestic life before an untimely death. The setting itself is significant—the secluded women's quarters of a Greek house, from which Hegeso rarely would have emerged. Contemporaneous grave stelae of men regularly show them in the public domain, often as warriors. The servant girl is not so much the faithful companion of the deceased in life

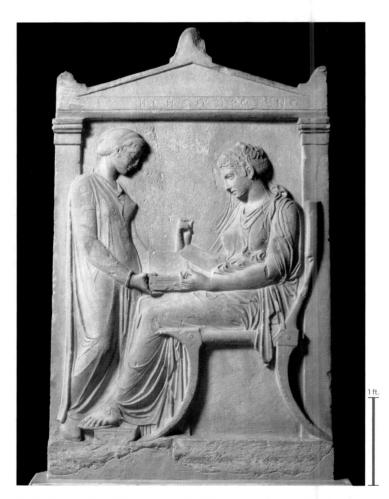

2-45 Grave stele of Hegeso, from the Dipylon cemetery, Athens, Greece, ca. 400 BCE. Marble, 5' 2" high. National Archaeological Museum, Athens.

On her tombstone, Hegeso examines jewelry from a box that her servant girl holds. Mistress and maid share a serene moment out of daily life. Only the epitaph reveals that Hegeso is the one who died.

2-46 ACHILLES
PAINTER, WAITIOT
taking leave of his
wife (Athenian whitefrom Eretria, Greece,
from Eretria, Greece,
Autional Archaeologica. 440 BCE. 1' 5" high.
Cal Museum, Athens.

White-ground painters applied the colors after firing because most colored glazes could not withstand the kiln's heat. The Achilles Painter here displayed his mastery at drawing an eye in profile.

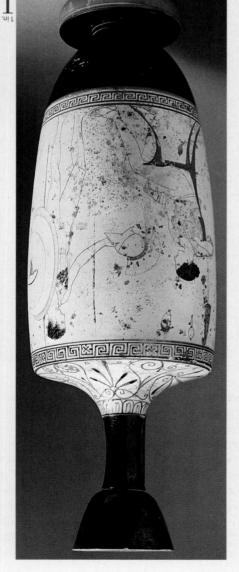

MATERIALS AND TECHNIQUES White-Ground Painting

White-ground painting takes its name from the chalky white slip (liquefied clay) used to provide a background for the painted figures. One of the best examples is the lekythos (Fig. 2-46)—a flask to hold perfumed oil—painted around 440 BEE by the Achilles Painter. White-ground is essentially a variation of the red-figure technique. First the painter covered the pot with a slip of very fine white clay, then applied black glaze to outline the figures, and diluted brown, purple, red, and white to color them. The artist could use other colors—for example, the yellow the Achilles Painter chose for the garments of both figures on this lekythos—but these had to be applied after firing because the Greeks did not know how to make them withstand the intense heat of the kiln.

Despite the obvious attractions of the technique, the impermanence of the expanded range of colors discourseed white-ground paintnence of the expanded range of colors discourseed white-ground paintnence of the expanded range of colors discourseed white-ground paintnence of the expanded range of colors discourseed white-ground paintnence of the expanded range of colors discourseed white-ground paintnence of the expanded range of colors discourseed white-ground paintnence of the expanded range of colors discourseed white-ground paintnence of the expanded range of colors discourseed white-ground paintnence of the expanded range of colors discourseed white-ground paintnence of the expanded range of colors discoursed white-ground paintnence of the expanded range of colors discoursed white-ground paintnence of the expanded range of colors discoursed white-ground paintnence of the expanded range of colors discoursed white-ground paintnence of the expanded range of colors discoursed white-ground paintnence of the expanded range of colors discoursed white-ground paintnence of the expanded range of colors discoursed white-ground paintnenced the color of the

nence of the expanded range of colors discouraged white-ground painting on everyday vessels, such as amphoras and kraters. In fact, Greek artists explored the full polychrome possibilities of the white-ground technique almost exclusively on lekythoi, which families commonly placed in graves as offerings to the deceased. For vessels designed for short-term use, the fragile nature of white-ground painting was of little

The subject of the illustrated lekythos is appropriate for the vase's funerary purpose. A youthful warrior takes leave of his wife. The red scart, mirror, and jug hanging on the wall behind the woman indicate that the setting is the interior of their home. The motif of the seated woman is strikingly similar to that of Hegeso on her grave stele (Fig. 2-45), but here the woman is the survivor. It is her husband, preparing to go to war, who will depart, never to return. On his shield is a large painted sa the horrific face of Medusa, intended to ward off evil spirits and frighten the enemy. This eye recalls that tradition, but for the Achilles Painter it was little more than an excuse to display his superior drawing skills. Since the late sixth century BCE, Greek painters had abandoned the Archaic habit of placing frontal eyes on profile faces and attempted to render the eyes in profile. The Achilles Painter's mastery of this diftorender the eyes in profile. The Achilles Painter's mastery of this diftorender the eyes in profile. The Achilles Painter's mastery of this diftorely problem in foreshortening is on exhibit here.

Late Classical Art

The Peloponnesian War, which began in 431 BCE, ended in 404 BCE with the defeat of a plague-weakened Athens. The victor, Sparta, and then Thebes undertook the leadership of Greece, both unsuccessfully. In the middle of the fourth century BCE, a threat from without caused the rival Greek states to put aside their animosities and unite for their common defense, as they had earlier against the Persians. But at the battle of Chaeronea in 338 BCE, the Greek cities suffered a devastating loss and had to relinquish their independence to the Macedonian king, Philip II (r. 359–336 BCE). After Philip's assassination, his son Alexander III, better known as Alexander the Great (r. 336–323 BCE), succeeded him. Alexander led a powerful army on an extraordinary campaign that overthrew the Persian Empire (the ultimate revenge for the Persian invasion of Greece), wrested control of Egypt, and even reached India.

The fourth century BCE was thus a time of political upheaval, which had a profound impact on the psyche of the Greeks and on the art they produced. In the fifth century BCE, Greeks had generally

as she is Hegeso's possession, like the jewelry box. The slave girl may look at her mistress, awaiting her next command, but Hegeso has eyes only for her ornaments. Both slave and jewelry attest to the wealth of Hegeso's father, unseen but prominently cited in the epitaph. (It is noteworthy that there is no mention of the mother's name.) Indeed, even the jewelry box carries a deeper significance, for it probably represents the dowry Proxenos would have provided to his daughter's husband when she left her father's home to enter her husband's home. In the patriarchal society of ancient Greece, the dominant position of men is manifest even when only women are depicted.

WHITE-GROUND PAINTING All the masterpieces of Classical painting have vanished because they were on wood panels, but Greek vases of this period—for example, a red-figure krater by the so-called Viobid Paintrer (FIG. 2-45A) and especially those painted using the white-ground painting technique (see "White-Ground Painting," above)—give some idea of the lost panel paintings. One of the masters of white-ground painting was the Achilles ings. One of the masters of white-ground painting was the Achilles Paintings.

believed that rational human beings could impose order on their environment, create "perfect" statues such as Polykleitos's *Canon* (FIG. 2-35), and discover the "correct" mathematical formulas for constructing temples such as the Parthenon (FIG. 2-1). The Parthenon frieze (FIG. 2-41) celebrated the Athenians as a community of citizens with shared values. The Peloponnesian War and the unceasing strife of the fourth century BCE brought an end to the serene idealism of the previous century. Disillusionment and alienation followed. Greek thought and Greek art began to focus more on the individual and on the real world of appearances instead of on the community and the ideal world of perfect beings and perfect temples.

PRAXITELES The new approach to art is immediately apparent in the work of Praxiteles, one of the great masters of the Late Classical period (ca. 400–323 BCE). Praxiteles did not reject the favored statuary themes of the High Classical period, and his Olympian gods and goddesses retained their superhuman beauty. But in his hands, those deities lost some of their solemn grandeur and took on a worldly sensuousness. Nowhere is this new humanizing spirit plainer than in the statue of Aphrodite (FIG. 2-47) that Praxiteles sold to the Knidians after another city had rejected it. The lost marble original is known only through copies of Roman date, but Pliny considered it "superior to all the works, not only of Praxiteles, but indeed in the whole world." The statue made Knidos famous, and Pliny reported that many people sailed there just to

see it. The *Aphrodite of Knidos* caused such a sensation in its time because Praxiteles took the unprecedented step of representing the goddess of love completely nude. Female nudity was rare in earlier Greek art and had been confined almost exclusively to paintings on vases designed for household use. The women so depicted also were usually not noblewomen or goddesses but courtesans or slave girls, and no one had ever dared fashion a life-size statue of an undressed goddess. Moreover, Praxiteles's Aphrodite is not a cold and remote image. In fact, the goddess engages in a trivial act out of everyday life. She has removed her garment and draped it over a large *hydria* (water pitcher), and is about to step into the bath.

Although shocking in its day, the *Aphrodite of Knidos* is not openly erotic (the goddess modestly shields her pelvis with her right hand), but she is quite sensuous. Lucian, writing in the second century CE, noted that she had a "welcoming look," a "slight smile," and "dewy eyes," and that Praxiteles was renowned for his ability to transform marble into soft and radiant flesh.

Unfortunately, the rather mechanical Roman copies do not capture the quality of Praxiteles's modeling of the stone, but the statue of Hermes and the infant Dionysos (FIG. 2-48) found in the Temple of Hera at Olympia provides a good idea of the Praxitelean "touch." The statue was once thought to be by the master himself, but is now generally considered a copy of the highest quality or an original work by a son or grandson with the same name. The statue depicts Hermes resting in a forest during his journey to deliver Dionysos to

2-47
PRAXITELES,
Aphrodite of
Knidos. Roman
copy of a marble
statue of ca.
350–340 BCE.
Marble, 6' 8"
high. Musei
Vaticani, Rome.

This first nude statue of a Greek goddess caused a sensation. But Praxiteles was also famous for his ability to transform marble into soft and radiant flesh. His Aphrodite had "dewy eyes."

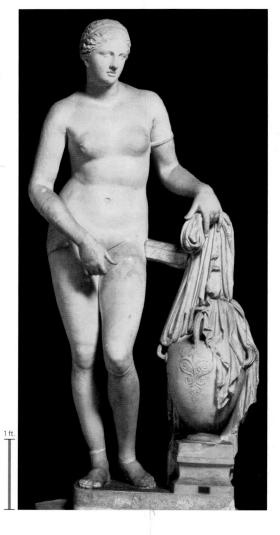

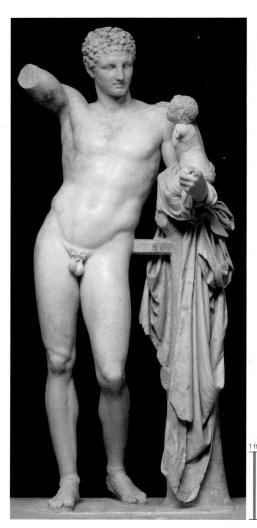

2-48 PRAXITELES(?), Hermes and the infant Dionysos, from the Temple of Hera, Olympia, Greece. Copy of a marble statue of ca. 340 BCE or an original work of са. 330-270 все by a son or grandson. Marble, 7' 1" high. Archaeological Museum, Olympia.

Praxiteles humanized the Olympian deities. This Hermes is as sensuous as the sculptor's Aphrodite. The god gazes dreamily into space while he dangles grapes to tempt the infant wine god.

2-49 Lysippos, Apoxyomenos (Scraper). Roman copy from Trastevere, Rome, Italy, of a bronze statue of ca. 330 BCE. Marble, Vaticani, Rome.

Lysippos introduced a new canon of proportions and a nervous energy to his statues. He also broke down the dominance of the frontal view and encouraged looking at his statues from multiple angles.

around 310 BCE by PHILOXENOS OF ERETRIA. The subject is the great battle in southeastern Turkey between the armies of Alexander the Great and the Achaemenid Persian king Darius III (r. 336–330 BCE), who fled from the Macedonian forces in humiliating defeat.

Pattle of Issue is postable for the artist's tachnical mastery of

not only with figures, trees, and sky but also with light. ground. Philoxenos here truly opened a window into a world filled clear presentation of weighty figures seen against a blank backstands in sharp contrast to earlier painters' preoccupation with the tial light on a shiny surface, and in the absence of light (shadows), shadows on the ground. This interest in the reflection of insubstanshield. Everywhere in the scene, men, animals, and weapons cast reflection of the man's terrified face on the polished surface of the to protect himself from being trampled. Philoxenos recorded the to the ground and raises, backward, a dropped Macedonian shield impressive. The Persian to the right of the rearing horse has fallen vase painter (FIG. 2-46) ever attempted. Other details are even more browns and yellows goes far beyond anything even a white-ground The subtle modulation of the horse's rump through shading in the rearing horse seen in a three-quarter rear view below Darius. des (FIG. 2-26) would have marveled at Philoxenos's depiction of problems that had long fascinated Greek painters. Even Euthymi-Battle of Issus is notable for the artist's technical mastery of

Perhaps most impressive, however, about Battle of Issus is the psychological intensity of the drama unfolding before the viewer's eyes. Alexander leads his army into battle without even a helmet to

the satyr Papposilenos and the nymphs, who assumed responsibility for raising the child. Hermes leans on a tree trunk (here it is an integral part of the composition and not the copyist's addition), and his slender body forms a sinuous, shallow 5-curve that is the hallmark of many of Praxiteles's statues. Hermes gazes dreamily into space while he dangles a bunch of grapes (now missing) to tempt the infant who is to become the Greek god of the vine. This is the kind of tender human interaction between an adult and a child that one encounters frequently in real life but that had been absent from one encounters frequently in real life but that had been absent from Greek statuary before the fourth century BCE.

The quality of the carving is superb. The modeling is deliberately smooth and subtle, producing soft shadows that follow the planes as they flow almost imperceptibly one into another. The delicacy of the marble facial features stands in sharp contrast to the metallic precision of Polykleitos's bronze Doryphoros (PiG. 2-35). The High Classion of Polykleitos's bronze Doryphoros (PiG. 2-35). The High Classion of Polykleitos's bronze Doryphoros (PiG. 2-35). The High Classion of these two statues reveals the skeeping changes in artistic attitude and intent that took place from the fifth to the fourth century BCE. In the statues of Praxiteles, the Olympian deities still artistic attitude and intent that took place from the fifth to the fourth century BCE. In the statues of Praxiteles, the Olympian deities still artistic attitude and intent that took place from the fifth to the fourth possess a beauty mortals can aspire to, although not achieve, but they are no longer aloof. Praxiteles's gods have stepped off their pedestals and entered the world of human experience.

three-quarter angle or in full profile. the observer must move to the side and view Lysippos's work at a defined the boundaries of earlier statues. To comprehend the action, forward, the figure breaks out of the shallow rectangular box that pos represented the apoxyomenos with his right arm boldly thrust observer to view his athlete from multiple angles. Because Lysipthe dominance of the frontal view in statuary and encouraged the reverse the positions of his legs. Lysippos also began to break down can scrape his left arm. At the same time, he will shift his weight and at any moment the athlete will switch it to the other hand so that he strigil (scraping tool) is about to reach the end of the right arm, and form of the Doryphoros, runs through Lysippos's Apoxyomenos. The in physique, however. A nervous energy, lacking in the balanced with Polykleitos's Doryphoros (FIG. 2-35) reveals more than a change in marble (Fig. 2-49)—exhibits the new proportions. A comparison body after exercising)—known, as usual, only from Roman copies bronze statue of an apoxyomenos (an athlete scraping oil from his as in the previous century. One of Lysippos's most famous works, a roughly one-eighth the height of the body rather than one-seventh, bodies were more slender than those of Polykleitos and the heads Lysippos introduced a new canon of proportions in which the ing thinker of his age, Aristotle, as the young Alexander's tutor.) could afford to employ the best. His father, Philip II, hired the leadander the Great selected to create his official portrait. (Alexander LYSIPPOS Equal in stature to Praxiteles was Lysippos, whom Alex-

BATTLE OF ISSUS. The life of Alexander the Great very much resembled an epic saga, full of heroic battles, exotic locales, and unceasing drama. Alexander was a man of singular character, an inspired leader with boundless energy and an almost foolhardy courage, who always personally led his army into battle. A Roman mosaic captures the extraordinary character of the Macedonian king. It also provides a welcome glimpse at the lost art of Greek panel painting during Alexander's time. In the so-called Alexander Mosaic (Pig. 2-50) the mosaicist employed tesserae (cubical pieces of glass or tiny stones cut to the desired size and shape) to "paint" what art historians believe to the desired size and shape) to "paint" what art historians believe is a reasonably faithful copy of Battle of Issus, a famous painting of is a reasonably faithful copy of Battle of Issus, a famous painting of

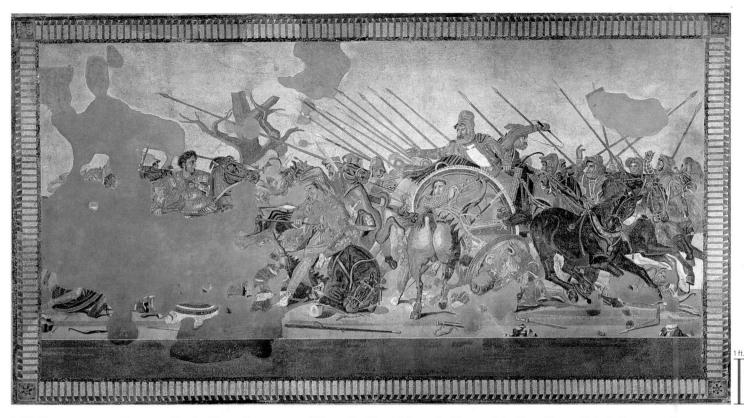

2-50 PHILOXENOS OF ERETRIA, *Battle of Issus*. Roman copy (*Alexander Mosaic*) from the House of the Faun, Pompeii, Italy, late second or early first century BCE, of a panel painting of ca. 310 BCE. Tessera mosaic, 8' 10" × 16' 9". Museo Archeologico Nazionale, Naples.

Battle of Issus reveals Philoxenos's mastery of foreshortening, of modeling figures in color, and of depicting reflections and shadows, as well as his ability to capture the psychological intensity of warfare.

protect him. He drives his spear through one of Darius's bodyguards while the Persian's horse collapses beneath him. The Macedonian king is only a few yards away from Darius, and Alexander directs his gaze at the king, not at the man impaled on his now-useless spear. Darius has called for retreat. In fact, his charioteer is already whipping the horses and speeding the king to safety. Before he escapes, Darius looks back at Alexander and in a pathetic gesture reaches out toward his brash foe. But the victory has slipped from his hands. In Pliny's opinion, Philoxenos's painting of the battle between Alexander and Darius was "inferior to none."

EPIDAUROS In ancient Greece, actors did not perform plays repeatedly over months or years as they do today, but only during sacred festivals. Greek drama was closely associated with religious rites and was not pure entertainment. In the fifth century BCE, for example, the Athenians staged performances of the great tragedies of Aeschylus, Sophocles, and Euripides during the Dionysos festival in the theater dedicated to the god on the southern slope of the Acropolis. Yet it is Epidauros that boasts the finest theater (FIG. 2-51) in Greece. The architect was Polykleitos the Younger.

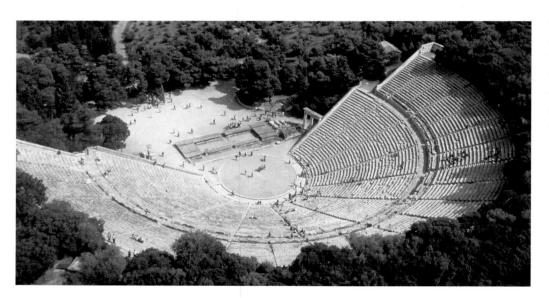

2-51 POLYKLEITOS THE YOUNGER, aerial view of the theater (looking southwest), Epidauros, Greece, ca. 350 BCE.

The Greeks always situated theaters on hillsides to support the cavea of stone seats overlooking the circular orchestra. The Epidauros theater is the finest in Greece. It accommodated 12,000 spectators.

in 323 BCE and lasted nearly three centuries, until the double suicide of Queen Cleopatra of Egypt and her Roman consort, Mark Antony, in 30 BCE, after their decisive defeat at the battle of Actium by Antony's rival, Augustus (see page 97). That year, Augustus made Egypt a province of the Roman Empire.

The cultural centers of the Hellenistic period were the court cities of the Greek kings who succeeded Alexander and divided his far-flung empire among themselves. Chief among them were Antioch in Syria, Alexandria in Egypt (named after Alexander), and Pergamon in Asia Minor. An international culture united the Hellenistic world, and its language was Greek. Hellenistic kings became enormously rich, and prided themselves on their libraries, art collections, and scientific enterprises, as well as on the learned men they could assemble at their courts. The world of the small, austere, and heroic city-state passed away, as did the power and prestige of its center, Athens. A cosmopolitan ("citizen of the world," in Greek) civilization, much like today's, replaced it.

PERGAMON The kingdom of Pergamon, founded in the early third century BCE after the breakup of Alexander's empire, embraced almost all of western and southern Asia Minor. The Pergamene kings enjoyed immense wealth and expended much of it on embellishing their capital. The Altar of Zeus, erected about 175 BCE, is the most famous Hellenistic sculptural ensemble. The monument's west front (Fig. 2-52) has been reconstructed in Berlin. The altar proper front (Fig. 2-52) has been reconstructed in Berlin. The altar proper was on an elevated platform, framed by an Ionic colonnade with was on an elevated platform, framed by an Ionic colonnade with

projecting wings on either side of a broad central staircase.

All around the altar platform was a sculpted frieze almost 400 feet long, populated by about a hundred larger-than-life-size figures. The Pergamene frieze is the most extensive representation giants. The Pergamene frieze is the most extensive representation of the World. The gigantomachy also appeared on the shield of Phidias's Athena Parthenos and on some of the Parthenon metopes, because the Athenians wished to draw a parallel between the defeat of the giants and the defeat of the Persians. The Pergamene king Attalos I (r. 241–197 BCE) had successfully turned back an invasion of the Gauls in Asia Minor. The gigantomachy of the Altar of Zeus alluded to his victory over those barbarians. It also established a connection to his victory over those barbarians. It also established a connection

of the seats would have had a poor view of the skene, all had unobthe harmony of its proportions. Although spectators sitting in some its function. Even in antiquity, the Epidauros theater was famous for a backdrop for the plays. The design is simple but perfectly suited to (skene), which housed dressing rooms for the actors and also formed via a passageway between the seating area and the scene building accommodated about 12,000 spectators. They entered the theater plan. The auditorium is 387 feet in diameter, and its 55 rows of seats benches separated by stairs, is somewhat greater than a semicircle in The cavea at Epidauros, composed of wedge-shaped sections of stone the auditorium (cavea, Latin for "hollow place, cavity") on a hillside. Greek theater took architectural shape, the builders always situated ing," and watched the actors and chorus in the orchestra. When the a slope overlooking the orchestra—the theatron, or "place for seeto Dionysos stood at the center of the circle. The spectators sat on The actors and chorus performed there, and at Epidauros, an altar This area later became the orchestra ("dancing place") of the theater. of earth where actors performed sacred rites, songs, and dances. The precursor of the formal Greek theater was a circular piece

The theater at Epidauros is about 500 yards southeast of the sanctuary of Asklepios, and Polykleitos the Younger worked there as well. He was the architect of the tholos, the circular shrine that probably housed the sacred snakes of the healing god. That building lies in ruins today, but the Greek archaeological service is in the process of reconstructing it. One can get an approximate idea of the Epidauros tholos's original appearance from the somewhat earlier and already partially rebuilt tholos (Fig. 2-51A A) at Delphi, designed by Theodoros of Phokaia. Both tholoi had an exterior colonnade of Doric columns, but the interior columns had molded bases and of Doric columns, but the interior columns had molded bases and invention of the second half of the fifth century BCE.

structed views of the orchestra. Because of the excellent acoustics of

Hellenistic Art

Alexander the Great's conquest of Mesopotamia and Egypt ushered in a new cultural age that historians and art historians alike call *Hellenistic*. The Hellenistic period opened with the death of Alexander

2-52 Reconstructed west front of the Altar of Zeus, Pergamon, Turkey, ca. 175 BCE. Pergamonmuseum, Staatliche Museen zu Berlin, Berlin.

The gigantomachy frieze of Pergamon's monumental Altar of Zeus is almost 400 feet long. The battle of gods and giants alluded to the victory of King Attalos I over the Gauls of Asia Minor.

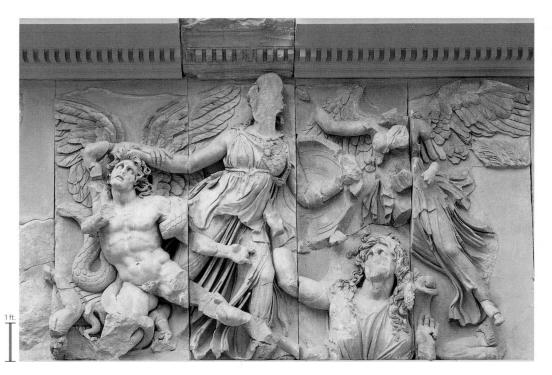

2-53 Athena battling Alkyoneos, detail of the gigantomachy frieze of the Altar of Zeus, Pergamon, Turkey, ca. 175 BCE. Marble, 7' 6" high. Pergamonmuseum, Staatliche Museen zu Berlin, Berlin.

The tumultuous battle scenes of the Pergamon altar have an emotional power unparalleled in earlier Greek art. Violent movement, swirling draperies, and vivid depictions of suffering fill the frieze.

with Athens, whose earlier defeat of the Persians was by then legendary, and with the Parthenon, which the Hellenistic Greeks already recognized as a Classical monument—in both senses of the word. The figure of Athena (FIG. 2-53), for example, who grabs the hair of the giant Alkyoneos as Nike flies in to crown her, resembles Athena in the Parthenon's east pediment.

The Pergamene frieze is not a dry series of borrowed motifs, however. On the contrary, its tumultuous narrative has an emotional intensity that has no parallel in earlier sculpture. The battle rages everywhere, even up and down the steps leading to Zeus's altar (FIG. 2-52). Violent movement, swirling draperies, and vivid depictions of death and suffering fill the frieze. Wounded figures writhe in pain, and their faces reveal their anguish. Deep carving creates dark shadows. The figures project from the background like bursts of light.

DYING GAUL The Altar of Zeus was not the only Pergamene monument to celebrate the victory of Attalos I over the Gauls. An earlier Pergamene statuary group had explicitly represented the defeat of the barbarians, instead of cloaking it in mythological disguise. The Pergamene victors were apparently not part of this group, however. The viewer saw only their Gallic foes and their noble and moving response to defeat. Roman copies of some of these figures survive, including a trumpeter (FIG. 2-54) who collapses on his large oval

> shield as blood pours out of the gash in his chest. If this figure is the tubicen ("trumpeter") that Pliny mentions in his Natural History, then the sculptor's name was Epigonos. In any case, the sculptor carefully studied and reproduced the distinctive features of the foreign Gauls, most notably their long, bushy hair and mustaches and the torques (neck bands) they frequently wore. The artist also closely observed male

2-54 Epigonos(?), dying Gaul. Roman copy of a bronze statue of ca. 230–220 BCE. Marble, $3'\frac{1}{2}''$ high. Museo Capitolino, Rome.

The defeat of the Gauls was also the subject of Pergamene statuary groups. The barbaric Gauls have bushy hair, mustaches, and neck bands, but the sculptor portrayed them as powerful and noble foes

acts with its environment and appears as a living, breathing, and self-contained entity on a bare pedestal. The Hellenistic statue interthe Polykleitan conception of a statue as an ideally proportioned, tic sculptor combined art and nature, and resoundingly rejected added another dimension to the visual drama. Here, the Hellenisthe sense of lightness and movement. The sound of splashing water The statue's reflection in the shimmering water below accentuated created the illusion of rushing waves hitting the prow of the ship. the lower basin were large boulders. The fountain's flowing water set the war galley in the upper basin of a two-tiered fountain. In The statue's setting amplified this theatrical effect. The sculptor

2-56 Alexandros right leg, and her linen chiton is pulled tightly across her abdomen ery. Her himation (wool mantle) bunches in thick folds around her Samothracian Nike's wings still beat, and the wind sweeps her drap-But the Pergamene relief figure seems calm by comparison. The places a wreath on Athena's head on the Altar of Zeus (FIG. 2-53). raises her (missing) right arm to crown the naval victor, just as Nike intensely emotive presence. (FIG. 2-55) has just alighted on the prow of a Greek warship. She

thrace, Greece, ca. 190 BCE. Marble, Nike 8' 1" high. Musée du Louvre, 2-55 Nike alighting on a warship (Nike of Samothrace), from Samo-

water heightened the dramatic visual effect. the wind sweeps her drapery. The statue's placement in a fountain of splashing Victory lands on a ship's prow to crown a naval victor. Her wings still beat, and

by the sculptor Alexandros of Antioch-on-the-Meander. In found on Melos together with its inscribed base (now lost) signed (FIG. 2-56) is a larger-than-life-size marble statue of Aphrodite explored the eroticism of the nude female form. The Venus de Milo lowed Praxiteles's lead in undressing Aphrodite, but they also openly VENUS DE MILO In the Hellenistic period, sculptors regularly fol-

the spectator. sessest frammerg gniqqils (FIG. 2-47). The goddess's the Knidian Aphrodite more overtly sexual than ues, this Aphrodite is of many Hellenistic stat-Displaying the eroticism

Paris.

Musée du Louvre, Marble, 6' 7" high. ся. 150-125 все. from Melos, Greece, rodite (Venus de Milo), тне-Мелирев, Арһ-OF ANTIOCH-ON-

Great Gods on the island of Samothrace. The Nike of Samothrace

ture is the statue of winged Victory set up in the Sanctuary of the

NIKE OF SAMOTHRACE Another masterpiece of Hellenistic sculp-

Aegina (FIG. 2-30), but the pathos and drama of the suffering Gaul

dying warrior from the east pediment of the Temple of Aphaia at dinarily powerful man. The Hellenistic figure is reminiscent of the

struck down this noble and savage foe must have been an extraor-

ing veins of his left leg-implying that the unseen Greek hero who

anatomy. Note the tautness of the fallen Gaul's chest and the bulg-

CHAPTER 2 Ancient Greece

and left leg.

are far more pronounced.

this statue, the goddess of love is more modestly draped than the Aphrodite of Knidos (FIG. 2-47), but is more overtly sexual. Her left hand (separately preserved) holds the apple that the Trojan hero Paris awarded her when he judged her the most beautiful goddess. Her right hand may have lightly grasped the edge of her drapery near the left hip in a halfhearted attempt to keep it from slipping farther down her body. The sculptor intentionally designed the work to tease the spectator, instilling this partially draped Aphrodite with a sexuality absent from Praxiteles's entirely nude image of the goddess.

when Classical statues look away, they are always awake and alert. Hellenistic sculptors often portrayed sleep. The suspension of consciousness and the entrance into the fantasy world of dreams-the antithesis of the Classical ideals of rationality and discipline—had great appeal for them. This newfound interest is evident in a marble statue (FIG. 2-57) of a drunken, restlessly sleeping satyr known as the Barberini Faun after the Italian cardinal who once owned it. The satyr has consumed too much wine and has thrown down his panther skin on a convenient rock, then fallen into a disturbed, intoxicated sleep. His brows are furrowed, and one can almost hear him

Eroticism also comes to the fore in this statue. Although men had been represented naked in Greek art for hundreds of years,

It is not surprising that when Hellenistic sculptors began to explore the sexuality of the human body, they turned their attention to both men and women. BARBERINI FAUN Archaic statues smile at the viewer, and even **OLD MARKET WOMAN** Hellenistic sculpture stands in contrast to Classical sculpture in other ways too. Many Hellenistic sculptors had a deep interest in exploring realism—the very opposite of the Classical period's idealism. This realistic mode is evident in a Hellenistic bronze statue of a defeated boxer (FIG. 2-57A →) and above all in Hellenistic statues of old men and women from the lowest rungs of the social order. Shepherds, fishermen, and drunken beggars are common—the kinds of people pictured earlier on red-figure vases but never before thought worthy of life-size statuary. One statue of this type depicts a haggard old woman (FIG. 2-58) bringing chick-

2-57 Sleeping satyr (Barberini Faun), from Rome, Italy, ca. 230-200 BCE. Marble, 7' 1" high. Glyptothek, Munich.

Here, a Hellenistic sculptor represented a restlessly sleeping, drunken satyr, a semihuman in a suspended state of consciousness—the antithesis of the Classical ideals of rationality and discipline.

Archaic kouroi and Classical athletes and gods do not exude sexual-

ity. Sensuality surfaced in the works of Praxiteles and his followers

in the fourth century BCE. But the dreamy and supremely beauti-

ful Hermes playfully dangling grapes before the infant Dionysos

(FIG. 2-48) has nothing of the blatant sexuality of the Barberini

Faun, whose wantonly spread legs focus attention on his genitals.

Homosexuality was common in the man's world of ancient Greece.

ens and a basket of fruits and vegetables to sell in the market or,

according to a recent interpretation suggested by the ivy wreath in her hair, bringing gifts to Dionysos at one of the god's festivals. In

either case, the woman's face is wrinkled and her body bent with

2-58 Old woman. Roman copy(?) of a marble statue of ca. 150-100 BCE. Marble, 4' $1\frac{5}{8}$ " high. Metropolitan Museum of Art, New York.

Consistent with the realism of much Hellenistic art, many statues portray the elderly of the lowest rungs of society. Earlier Greek artists did not consider them suitable subjects for statuary.

on to the medieval and modern worlds. If Greece was the inventor the Greek artistic legacy. What Rome adopted from Greece it passed inherited the Pergamene kingdom in 133 BCE, it also became heir to on long after Greece ceased to be a political force. When Rome At Tiberius's villa and in Titus's palace, Hellenistic sculpture lived creators of the Laocoon group signed one of the Sperlonga groups. 60 miles south of Rome. The same three sculptors Pliny cited as the of the Roman emperor Tiberius (r. 14-37 cE) at Sperlonga, some served as the picturesque summer banquet hall of the seaside villa groups illustrating scenes from Homer's Odyssey in a grotto that in 1957 by the discovery of fragments of several Hellenistic-style ums today was made for Romans rather than Greeks was confirmed That the work seen by Pliny and displayed in the Vatican Muse-

of the European spirit, Rome was its propagator and amplifier.

expanding Roman Empire. Nonetheless, Greek politically it was merely another city in the everlier prestige as a center of culture and learning, ter, although Athens retained some of its eargeneral Sulla crushed the Athenians. Thereaf-(r. 120-63 BCE) in his war against Rome, the later sided with King Mithridates VI of Pontus province in 146 BCE. When Athens 60 years mer glory, however. Greece became a Roman again. The Greek cities never regained their forthe old city-states of Classical Greece free once defeated the Macedonian army and declared century BCE, the Roman general Flamininus LAOCOON In the opening years of the second absent in earlier Greek statuary. statues, they attest to an interest in social realism

three Rhodian sculptors. statuary group of the second century BCE was the inspiration for the Athena's opponent. In fact, many scholars believe that a Pergamene and Laocoon himself is strikingly similar to Alkyoneos (FIG. 2-53), the suffering giants of the frieze of the Altar of Zeus at Pergamon, priest lets out a ferocious cry. The serpent-entwined figures recall death grip of the serpents. One bites into Laocoon's left hip as the Trojans writhe in pain as they struggle to free themselves from the his sons in a spectacular fashion in this marble group. The three The Rhodian sculptors communicated the torment of the priest and city. In Vergil's graphic account, Laocoon suffered in terrible agony. danger of bringing the Greeks' wood horse within the walls of their punish Laocoön, who had tried to warn his compatriots about the favored the Greeks in the war against Troy had sent the serpents to two sons by sea serpents while sacrificing at an altar. The gods who Aeneid. Vergil vividly described the strangling of Laocoön and his two figures) to conform with the Roman poet Vergil's account in the coon's left (note the greater compositional integration of the other only one son. Their variation on the original added the son at Laotheir group on a Hellenistic masterpiece depicting Laocoon and worked in the early first century CE. These artists probably based and Polydoros of Rhodes—who most art historians now think uted the statue to three sculptors—Athanadoros, Hagesandros, the palace of the emperor Titus (r. 79-81 CE) in Rome. Pliny attribbelieved to be an original of the second century BCE, was found in priest Laocoon and his sons (FIG. 2-59). The marble group, long The most famous work of this type is the statue of the Trojan

following additional subjects: buildings, Google Earth $^{\text{\tiny TM}}$ coordinates, and essays by the author on the Explore the era further in Mind Tap with videos of major artworks and

- ART AND SOCIETY: Archaeology, Art History, and the Art Market
- Calf bearer, from the Athenian Acropolis (FIG. 2-17A)
- Warrior, from Riace (FIG. 2-34A)
- WRITTEN SOURCES: Vitruvius's Ten Books on Architecture
- Miobid Painter: Massacre of the Niobids (FIG. 2-45A)
- ARCHITECTURAL BASICS: The Corinthian Capital
- Theodoros of Phokaia: Tholos, Delphi (FIG. Z-51A)
- Polykleitos the Younger: Corinthian capital, Epidauros (FIG. Z-57B)
- Seated boxer, from Rome (FIG. Z-57A)

Roman patrons.

and to create new statues in Greek style for copies of Classical and Hellenistic masterpieces furnish the Romans with an endless stream of artists continued to be in great demand, both to

age. Whatever the purpose of this and similar

matches the account given only in the Aeneid. of sea serpents attacking Laocoön and his two sons akin to Pergamene sculpture (Fig. 2-53), this statue Hellenistic style lived on in Rome. Although stylistically

 7^{1} 10 $\frac{1}{2}$ " high. Musei Vaticani, Rome.

from Rome, Italy, early first century CE. Marble, POLYDOROS OF RHODES, Laocoon and his sons, 2-59 Атнамаровоз, Насезаиркоз, and

ANCIENT GREECE

Prehistoric Aegean

- The major surviving artworks of the third millennium BCE in Greece are Cycladic marble statuettes. Most come from graves and may represent the deceased.
- The golden age of Crete was the Late Minoan period (ca. 1600–1200 BCE). The palace at Knossos was a vast multistory structure so complex in plan that it gave rise to the myth of the minotaur in the labyrinth of King Minos. Large fresco paintings adorned the walls, but all surviving Minoan sculptures are of small scale
- The Mycenaeans (ca. 1600–1200 BCE) constructed great citadels at Mycenae, Tiryns, and elsewhere with "Cyclopean" walls of huge irregularly shaped stone blocks. Masters of corbel vaulting, the Mycenaeans also built beehive-shaped tholos tombs such as the Treasury of Atreus, which boasted the largest dome before the Roman Empire. The graves of the kings of Mycenae have yielded gold masks and other luxury items.

Palace, Knossos, ca. 1700-1370 BCE

Gold funerary mask, Mycenae, ca. 1600–1500 все

Geometric and Archaic Art

- The human figure returned to Greek art during the Geometric period (ca. 900-700 BCE) in the form of simple silhouettes amid other abstract motifs on vases.
- Around 600 BCE, during the Archaic period (ca. 700–480 BCE), the first life-size stone statues appeared in Greece. The earliest kouroi emulated the frontal poses of Egyptian statues, but artists depicted the young men nude, the way Greek athletes competed in the Olympic Games. During the course of the sixth century BCE, Greek sculptors refined the proportions and added "Archaic smiles" to the faces of their statues to make them seem more lifelike. The Archaic age also saw the construction of the first stone temples with peripteral colonnades and the codification of the Doric and Ionic orders. Vase painters developed in turn the black- and red-figure techniques. Euphronios and Euthymides rejected the age-old composite view for the human figure and experimented with foreshortening.

Euthymides, three revelers, ca. 510 BCE

Classical Art

- The fifth century BCE was the golden age of Greece, when Aeschylus, Sophocles, and Euripides wrote their plays, and Herodotus, the "father of history," lived. During the Early Classical period (480–450 BCE), which opened with the Greek victory over the Persians, sculptors revolutionized statuary by introducing contrapposto (weight shift) to their figures.
- In the High Classical period (450–400 BCE), under the patronage of Pericles and the artistic directorship of Phidias, the Athenians rebuilt the Acropolis after 447 BCE. Polykleitos developed a canon of proportions for the perfect statue, and Iktinos applied mathematical formulas to temple design in the belief that beauty resulted from the use of harmonic numbers.
- In the aftermath of the Peloponnesian War, which ended in 404 BCE, Greek artists began to focus more on the real world of appearances than on the ideal world of perfect beings. During the Late Classical period (400–323 BCE), sculptors humanized the remote deities and athletes of the fifth century BCE. Praxiteles, for example, caused a sensation when he portrayed Aphrodite undressed.

Praxiteles, Aphrodite of Knidos, ca. 350-340 BCE

Hellenistic Art

The Hellenistic age (323–30 BCE) extended from the death of Alexander the Great until the death of Cleopatra, when Egypt became a province of the Roman Empire. The great cultural centers of the era were no longer the city-states of Archaic and Classical Greece, but royal capitals such as Pergamon in Asia Minor. Hellenistic sculptors explored new subjects—for example, Gauls with mustaches and necklaces, and impoverished old women—and treated traditional subjects in new ways. Hellenistic artists delighted in depicting violent movement and unbridled emotion.

Epigonos(?), dying Gaul, ca. 230–220 BCE

important local landmark. ing the Egyptian obelisk that was an haired, seminude young man holdhere personified by a reclining longapotheosis is the Campus Martius, s'suninotnA to gnittes etT df-€ ►

before her husband.

Faustina. The empress, however, died 20 years ascends to the realm of the gods with his wife, column erected in his honor, Antoninus Pius ▼ 3-1a On the pedestal of the memorial

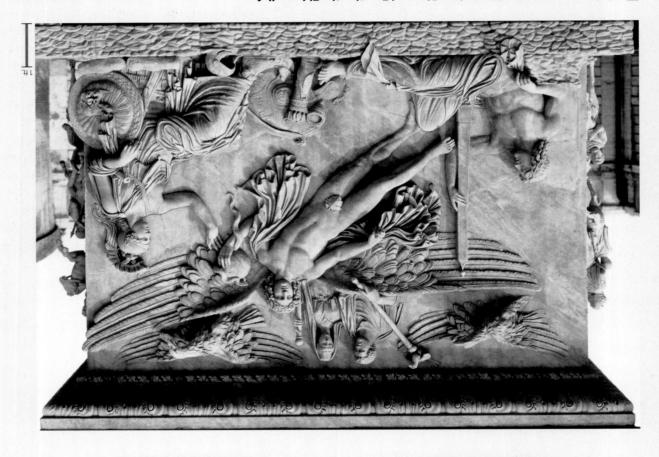

Italy, ca. 161 ce. Marble, 8' $1\frac{1}{2}$ " high. Musei Vaticani, Rome. on the pedestal of the Column of Antoninus Pius, Rome, Apotheosis of Antoninus Pius and Faustina the Elder, relief

Romulus and Remus. suckling Rome's two founders, decorated with the she-wolf personified), leaning on a shield seated goddess Roma (Rome emperor and empress is the ▶ 3-1c Bidding farewell to the

The Roman Empire

ROMAN ART AS HISTORICAL FICTION

The name "Rome" almost invariably conjures images of power and grandeur, of mighty armies and fearsome gladiators, of marble cities and far-flung roads. Indeed, at the death of Emperor Trajan in 117 CE, the "eternal city" was the capital of the greatest empire the world had ever known. For the first time in history, a single government ruled territories extending from the Strait of Gibraltar to the Nile, from the Tigris and Euphrates to the Rhine, Danube, Thames, and beyond (MAP 3-1). The Romans presided over prosperous cities and frontier outposts on three continents, ruling virtually all of Europe, North Africa, and West Asia.

No government, before or after, ever used art more effectively as a political tool. Indeed, the Romans were masters at creating pictorial fictions to glorify their emperors and advance their political agendas. For example, after the death of Antoninus Pius (r. 138–161 CE) in 161, the emperor's two adopted sons, Marcus Aurelius (r. 161–180 CE) and Lucius Verus (r. 161–169 CE), erected a memorial column in his honor. Atop the column was a gilded-bronze portrait statue of Antoninus. On the pedestal were a dedicatory inscription and three narrative reliefs. The subject of one of them was a central theme of Roman imperial ideology—the *apotheosis* (FIG. 3-1), or ascent to Heaven, of the emperor after his death, when he takes his place among the other gods. Empresses could also become goddesses.

The setting of Antoninus's apotheosis is the Campus Martius (Field of Mars) in Rome, here personified by a reclining long-haired, seminude young man holding the Egyptian obelisk that was an important local landmark. Opposite him is the seated goddess Roma (Rome personified), leaning on a shield decorated with the she-wolf suckling Rome's founder, Romulus, and his brother, Remus. Roma waves farewell to Antoninus and his wife, Faustina the Elder (ca. 100–141 CE), whom a winged youthful male personification of uncertain identity lifts into the realm of the gods.

The representation of the apotheosis of Antoninus and Faustina is an example of what art historians generally call "Roman historical reliefs," but there is nothing historical about this scene. Not only is the very notion of apotheosis historical fiction, but this joint apotheosis is doubly so. Faustina died 20 years before Antoninus. By depicting the emperor and empress ascending to Heaven together, the Roman artist wished to suggest not only the divinity of the deceased rulers but also that Antoninus, who by all accounts had been devoted to his wife, would now be reunited with her in the afterlife.

ROME, CAPUT MUNDI

the calendar—even in the coins used daily. Western world in concepts of law and government, in languages, in

today. But in 753 BCE, when according to legend, Romulus founded concrete construction began an architectural revolution still felt Art as Historical Fiction," page 83). And the Roman invention of crafted imagery of contemporary political campaigns (see "Roman tive reliefs, to manipulate public opinion is similar to the carefully ern world. The Roman use of art, especially portraits and narraand eclecticism of Roman art foreshadowed the art of the mod-Western viewer today can readily understand. Indeed, the diversity The art of the ancient Romans speaks a language almost every

lows the routes of Roman roads. Ancient Rome also lives on in the Roman ports, and Western Europe's highway system still closely folare staged in Roman amphitheaters. Ships dock in what were once and museums. Bullfights, sports events, operas, and rock concerts ings form the cores of modern houses, stores, restaurants, factories, as churches. The powerful concrete vaults of ancient Roman build-North Africa today, Roman temples and basilicas have an afterlife ous of any ancient civilization. In Europe, the Middle East, and ments of art and architecture are the most conspicuous and numer-The Roman Empire spanned three continents, and Roman monu-

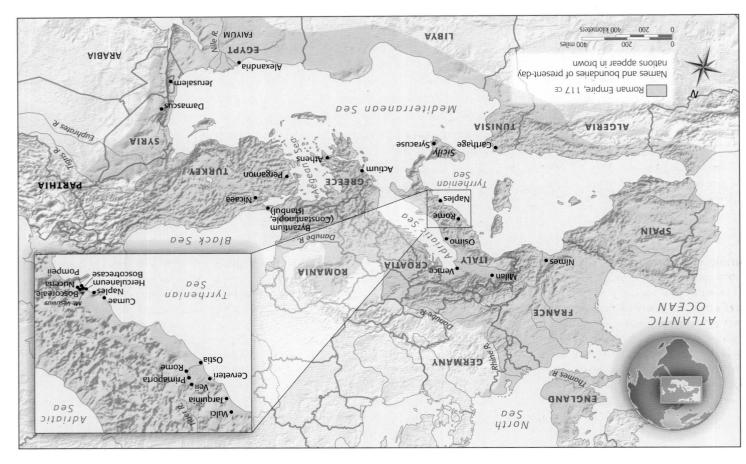

MAP 3-1 The Roman Empire at the death of Trajan in 117 CE.

Late Empire 193-337 CE

Constantinople.

rule and founds a New Rome at Constantine reestablishes one-man Diocletian establishes the tetrarchy. reveal the insecurity of the age. Portraits of the soldier emperors style takes root under the Severans. A new non-Classical Late Antique

- High Empire 30 Z6L-96
- The domination of the Classical style crete technology. temple of all gods), a triumph of con-Hadrian builds the Pantheon (the of two wars against the Dacians. a new forum in Rome from the spoils Trajan extends the Empire and builds

begins to erode under the Antonines.

of concrete construction in buildings Architects realize the full potential style in art and architecture.

and Fourth Styles of mural decoration.

Roman painters introduce the Third

world's largest amphitheater.

Early Empire

such as the Colosseum, the ancient Augustan artists revive the Classical

27 BCE-96 CE THE ROMAN EMPIRE

At Cerveteri, the Etruscans bury statues on the roof. and stairs only on the front and with mud-brick temples with columns The Etruscans build wood and

Etruscan and Republican

\00-7\ BCE

- can architecture and decorate walls Republican builders Hellenize Etrustombs feature fresco paintings. tombs resembling houses. Tarquinian their dead beneath earthen tumuli in
- (superrealistic) portraits. Republican sculptors produce veristic in the First and Second Styles.

what would become the *caput mundi*—the "head [capital] of the world"—Rome was neither the most powerful nor the most sophisticated city even in central Italy. In fact, in the sixth century BCE, the rulers of Rome were Etruscan kings.

ETRUSCAN ART

The heartland of the Etruscans was the territory between the Arno and Tiber rivers of central Italy. During the eighth and seventh centuries BCE, the Etruscans, as highly skilled seafarers, enriched themselves through trade abroad. By the sixth century BCE, they controlled most of northern and central Italy. Their most powerful cities included Tarquinia, Cerveteri, Vulci, and Veii. The Etruscan cities never united to form a state, however. Any semblance of unity among the independent cities was based primarily on common linguistic ties and religious beliefs and practices. This lack of political cohesion eventually made the Etruscans relatively easy prey for the Romans.

ETRUSCAN TEMPLES In the sixth century BCE, the most innovative artists and architects in the Mediterranean were the Greeks. Still, however eager Etruscan artists may have been to emulate Greek works, their distinctive Etruscan temperament always manifested itself. In religious architecture, for example, the differences between Etruscan temples and their Greek prototypes outweigh the similarities. Because of the materials that Etruscan builders employed, usually only the foundations of their temples have survived. Supplementing the archaeological record is the Roman architect Vitruvius's treatise on architecture written near the end of the first century BCE (see "Vitruvius's Ten Books on Architecture" 1. In it, Vitruvius provided an invaluable chapter on Etruscan temple design.

The typical Archaic Etruscan temple (FIG. 3-2) resembled Greek stone gable-roofed temples (FIG. 2-1), but it had wood columns, a tile-covered timber roof, and walls of sun-dried mud brick. Entrance was via a narrow staircase at the center of the front of the temple, which sat on a high podium, the only part of the building

3-2 Model of a typical Etruscan temple of the sixth century BCE, as described by Vitruvius. Istituto di Etruscologia e di Antichità Italiche, Università di Roma, Rome.

Etruscan temples resembled Greek temples but had widely spaced, unfluted wood columns placed only at the front, walls of sun-dried mud brick, and a narrow staircase at the center of the facade.

made of stone. Columns were placed only at the front of the building, creating a deep porch occupying roughly half the podium and setting off one side of the structure as the main side. In contrast, the front and rear of Greek temples were indistinguishable, and their builders placed steps and columns on all sides (Fig. 2-19). Furthermore, although the columns of Etruscan temples resembled Greek Doric columns (Fig. 2-20, left), Tuscan columns were made of wood, were unfluted, and had bases. Also, because of the lightness of the superstructure, fewer, more widely spaced columns were the rule in Etruscan temples. Unlike their Greek counterparts, Etruscan temples also frequently had three cellas—one for each of their chief gods: Tinia (Greek Zeus/Roman Jupiter), Uni (Hera/Juno), and Menrva (Athena/Minerva). Pediment statuary was also rare in Etruria. The Etruscans normally placed statues—made of terracotta instead of stone—on the roofs of their temples.

APOLLO OF VEII The finest surviving Etruscan rooftop statue is the life-size image of Apulu (FIG. 3-3)—the Greco-Roman Apollo—from the Portonaccio sanctuary at Veii. The *Apollo of Veii* was one of a group of at least four painted terracotta figures that stood atop the ridgepole of the Portonaccio temple. Apulu confronted Hercle (Hercules/Herakles) for possession of the Ceryneian hind, a wondrous gold-horned beast sacred to the god's sister Artumes (Diana/Artemis). The bright paint and the rippling folds of the god's garment immediately distinguish the statue from the nude images of the Greek gods. Apulu's vigorous striding motion, gesticulating arms, fanlike calf muscles, and animated face are also distinctly Etruscan.

3-3 Apulu (Apollo of Veii), from the roof of the Portonaccio temple, Veii, Italy, ca. 510–500 BCE. Painted terracotta, 5' 11" high. Museo Nazionale di Villa Giulia, Rome.

This statue of Apulu was part of a group depicting a Greek myth. Distinctly Etruscan, however, are the god's vigorous motion and gesticulating arms and the placement of the statue on a temple roof.

for the shrines of their gods, but only rarely built monumental tombs values of the Etruscans and the Greeks. The Greeks employed stone word necropolis). The Cerveteri tumuli highlight the very different was a veritable city of the dead (the literal meaning of the Greek orderly manner along a network of streets, the Cerveteri cemetery in diameter and reaching nearly 50 feet in height. Arranged in an est Banditaccia mounds are truly of colossal size, exceeding 130 feet bered tombs cut out of the dark local limestone called tufa. The larg-Etruscan tumulus covered one or more underground multichammasonry blocks and then encased them in earthen mounds, each But whereas the Mycenaeans constructed their tholos tombs with (Fig. 3-5), not unlike the Mycenaean Treasury of Atreus (Fig. 2-11). teri's Banditaccia necropolis took the form of a mound, or tumulus can sarcophagi is well documented. The typical tomb in Cervesarcophagus is not known, but the kind of tomb that housed Etrus-BANDITACCIA NECROPOLIS The exact findspot of the Cerveteri

3-4 Sarcophagus with reclining couple, from the Banditaccia necropolis, Cerveteri, Italy, ca. 520 BCE. Painted terracotta, 3' $9\frac{1}{2}$ " × 6' 7". Museo Vazionale di Villa Giulia, Rome.

Sarcophagi in the form of a husband and wife on a dining couch have no parallels in Greece. The artist's focus on the upper half of the figures and the emphatic gestures are Etruscan hallmarks.

of terracotta, the favored medium for lifesize statuary in Etruria, is a sarcophagus size statuary in Etruria, is a sarcophagus (PiG. 3-4) that comes from a tomb at Cerveteri. Sarcophagus literally means "flesh-eater," and most ancient sarcophagi contained the bodies of the deceased, but this one, which takes the form of a husband and wife reclining on a banqueting couch, contained only ashes. Cremation was the most common means of disposing of the dead in Etruscan means of disposing of the dead in Etruscan opprailel at this date in Greece, where there no parallel at this date in Greece, where there mo parallel at this date in Greece, where there

sarcophagi. The Greeks buried their dead in simple graves marked by a large vase (Fig. 2-14), a statue (Fig. 2-17), or a stele (Fig. 2-45). Moreover, only men dined at Greek banquets. Their wives remained at home, excluded from most aspects of public life. The image of a husband and wife sharing the same banqueting couch is uniquely between (see "The 'Audacity' of Etruscan Women" (3)).

The man and woman on the Cerveteri sarcophagus are as ani-

The man and woman on the Cerveteri sarcophagus are as animated as the Apollo of Veii (Fig. 3-3), even though they are at rest. The woman may have held a perfume flask and a pomegranate in her hands, the man an egg, a symbol of regeneration (compare Fig. 3-7). They are the antithesis of the stiff and formal figures encountered in Egyptian funerary sculpture (Fig. 1-29). Also typically Etruscan, and in sharp contrast to contemporaneous Greek statues with their emphasis on proportion and balance, is the manner in which the Cerveteri sculptor rendered the upper and lower parts of each body. The artist shaped the legs only summarily, and parts of each body. The artist shaped the legs only summarily, and

the transition to the torso at the waist is unnatural. The sculptor's interest focused on the upper half of the figures, especially on the vibrant faces and gesticulating arms. The Cerveteri banqueters and the Veii Apulu speak to the viewer in a way that Greek statues of similar date never do.

3-5 Tumuli in the Banditaccia necropolis, Cerveteri, Italy, seventh to second centuries BCE.

In the Banditaccia necropolis at Cerveteri, the Etruscans buried several generations of families in multichambered rock-cut underground tombs covered by great earthen mounds (tumuli).

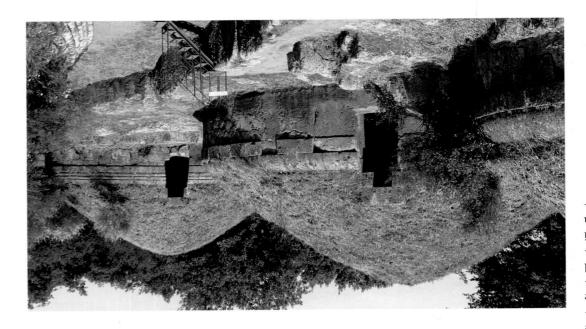

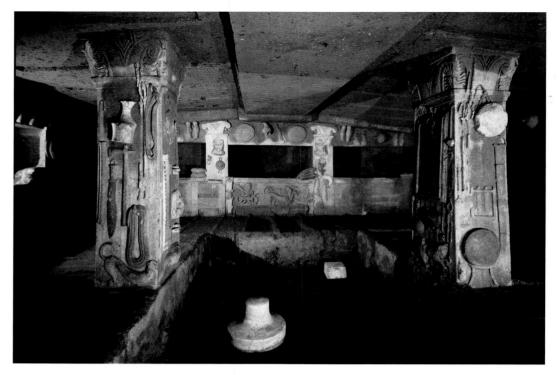

3-6 Interior of the Tomb of the Reliefs, Banditaccia necropolis, Cerveteri, Italy, late fourth or early third century BCE.

The Tomb of the Reliefs takes its name from the painted stucco reliefs of domestic items that cover its walls and piers. The interior was intended to mimic the appearance of an Etruscan house.

for their dead. The Etruscans' temples no longer stand because they were constructed of wood and mud brick, but Etruscan tombs are as permanent as the bedrock itself.

The most elaborately decorated Cerveteri tomb is the so-called Tomb of the Reliefs (FIG. 3-6), which accommodated the remains of several generations of a single family. The walls, ceiling beams, piers, and funerary couches of this tomb were, as in other Cerveteri tombs, gouged out of the tufa bedrock, but in this instance brightly painted stucco reliefs cover the stone. The stools, mirrors, drinking cups, pitchers, and knives effectively suggest a domestic context, underscoring the visual and conceptual connection between Etruscan houses of the dead and those of the living.

Etruscans also decorated their underground burial chambers with mural paintings. Painted tombs are statistically rare, the privilege of only the wealthiest Etruscan families. Most have been found in the Monterozzi necropolis at Tarquinia. A well-preserved example is the Tomb for the beasts guarding the tomb

TOMB OF THE LEOPARDS The

of the Leopards (FIG. 3-7), named for the beasts guarding the tomb from their perch within the pediment of the rear wall. The leopards recall the panthers on each side of Medusa in the pediment (FIG. 2-23) of the Artemis temple at Corfu. But mythological figures, whether Greek or Etruscan, are uncommon in Tarquinian murals. Instead, the Tomb of the Leopards features banqueting couples (the men with dark skin, the women with light skin, in conformity with the age-old convention; compare FIG. 2-5). They are the painted counterparts of the husband and wife on the terracotta sarcophagus (FIG. 3-4) from Cerveteri. Pitcher- and cup-bearers serve the guests, and musicians entertain them. The banquet takes place in the open air or perhaps in a tent set up for the occasion. In characteristic

Etruscan fashion, the banqueters, servants, and entertainers all make exaggerated gestures with unnaturally enlarged hands. The man on the couch at the far right on the rear wall holds up an egg. The tone is joyful—a celebration of the good life of the Etruscan elite, rather than a somber contemplation of death.

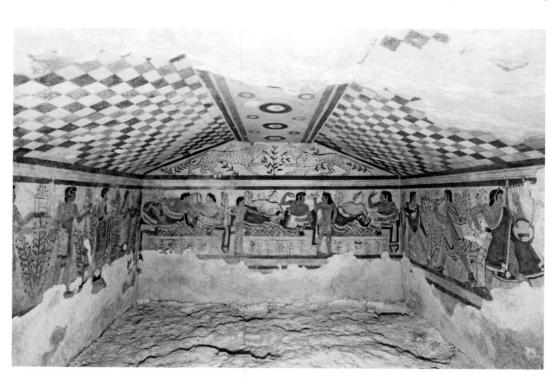

3-7 Interior of the Tomb of the Leopards, Monterozzi necropolis, Tarquinia, Italy, ca. 480 BCE.

Mural paintings adorn many Tarquinian tombs. Here, beneath two guardian leopards, banqueting couples celebrate the good life, attended by servants and musicians. The men have dark skin, the women fair skin.

Although the sculptor inscribed the man's Etruscan name and the names of both of his Etruscan parents on the hem of his garment, the orator wears the short toga and high, laced boots of a Roman magistrate. His head also resembles contemporaneous Roman portraits. Aule Metele is Etruscan in name only. If the origin of the Etruscans remains the subject of debate, the question of their demise has a ready answer. Aule Metele and his compatriots became Romans, and Etruscan art became Romans, and Etruscan art became Romans, and Etruscan art became

TAA NAMOA

Imperial Rome (FIG. 3-9) was a densely populated metropolis crowded with temples, fora (singular, forum), theaters, bathing complexes, and triumphal arches. But the Rome of King Romulus in the eighth century BCE consisted only of small huts clustered together on the Palatine Hill overlooking what was then uninhabited marshland. In the Archaic period, Rome was essentially an Etruscan city, both politically and culturally. Its greatest shrine, the late-sixth-century BCE Temple of Jupiter on the Capitoline Hill, was built by an Etruscan king, designed by an Etruscan architect, made of wood and mud brick in the Etruscan manner, and decorated with terracotta statuary fashioned by an Etruscan sculptor. When, in 509 BCE, the Romans overthrew Tarquinius Superbus, the last of Rome's Etruscan kings (see "Who's Who in the Roman World," Rome's Etruscan kings (see "Who's who in the Roman World," Page 90), they established a constitutional government, or republic.

Republic

The new Roman Republic vested power mainly in a senate (literally, "a council of elders," senior citizens) and in two elected consuls. Under extraordinary circumstances, a dictator could be appointed for a limited term and a specific purpose, such as commanding the army during a crisis. Before long, the Republican descendants of Romulus conquered Rome's neighbors one by one: the Etruscans to the north, the Samnites and the Greek colonists to the south. Even the Carthaginians of North Africa, who under Hannibal's dynamic leadership had destroyed some of Rome's legions and almost brought down the Republic, fell before the mighty Roman armies.

The year 211 BCE was a turning point both for Rome and for Roman art. Breaking with precedent, Marcellus, conqueror of the fabulously wealthy Sicilian Greek city of Syracuse, brought back to Rome not only the usual spoils of war—captured arms and armor, and so the usual spoils of war—captured arms and armor, gold and silver coins, and the like—but also the city's artistic pattor works of Greek art." Exposure to Greek sculpture and painting and to the splendid marble temples of the Greek gods increased as the Romans expanded their conquests beyond Italy. Greece became a Roman province in 146 BCE, and in 133 BCE the last king of Pergamon willed his kingdom in Asia Minor to Rome. Nevertheless, although the Romans developed a virtually insatiable taste for Greek "antiques," the influence of Etruscan art and architecture persisted. The artists and architects of the Roman Republic drew on both Greek and Etruscan traditions.

TEMPLE OF PORTUNUS The mixing of Greek and Etruscan forms is the primary characteristic of the temple dedicated to Portunus (FIGS. 3-9, no. I, and 3-10), the Roman god of harbors. Its plan

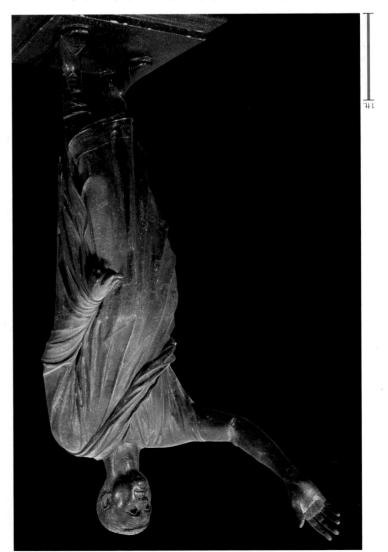

3-8 Aule Metele (Arringatore), from Cortona, Italy, early first century BCE. Bronze, 5' 7" high. Museo Archeologico Nazionale, Florence.

Inscribed in Etruscan, this bronze statue of an orator is Etruscan in name only. Aule Metele wears the short toga and high boots of a Roman magistrate, and the portrait style is Roman as well.

ETRUSCAN DECLINE The fifth century BCE was a golden age in Greece, but not in Etruria. In 509 BCE, the Romans expelled the last of their Etruscan kings and replaced the monarchy with a republican form of government. In 474 BCE, the allied Greek forces of Cumae, and Syracuse defeated the Etruscan fleet off Cumae, effectively ending Etruscan dominance of the seas. Veii fell to the Romans in 396 BCE, after a terrible 10-year siege. Rome concluded peace with Romans had annexed Tarquinia too, and they conquered Cerveteri in 273 BCE. By the first century BCE, Roman control of century, the Boesme had annexed Tarquinia too, and they conquered Cerveteri in 273 BCE. By the first century BCE, Roman control of central Italy became total.

AULE METELE A life-size bronze portrait statue (FIG. 3-8) dating to the early first century BCE is an eloquent symbol of the Roman absorption of the Etruscans. Known as the Arringatore (Orator), the statue portrays Aule Metele raising his arm to address an assembly.

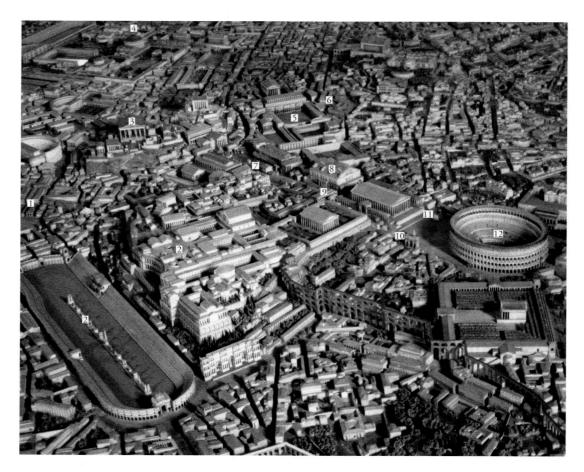

3-9 Model of the city of Rome during the early fourth century CE. Museo della Civiltà Romana, Rome. (1) Temple of Portunus, (2) Palatine Hill, (3) Capitoline Hill, (4) Pantheon, (5) Forum of Trajan, (6) Markets of Trajan, (7) Forum Romanum, (8) Basilica Nova, (9) Arch of Titus, (10) Arch of Constantine, (11) Colossus of Nero,

At the height of its power, Rome was the capital of the greatest empire in the ancient world. The Romans ruled from the Tigris and Euphrates to the Thames and beyond, from the Nile to the Rhine and Danube.

(12) Colosseum.

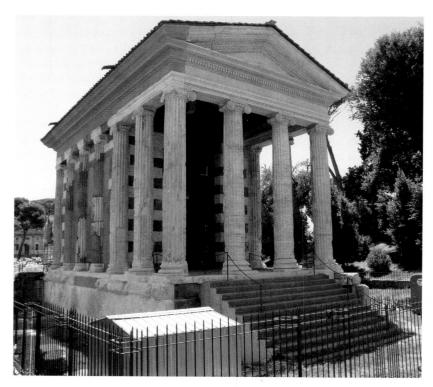

3-10 Temple of Portunus (looking south, after restoration, 2013), Rome, Italy, ca. 75 BCE.

Republican temples combined Etruscan plans and Greek elevations. This pseudoperipteral stone temple employs the lonic order, but it has a staircase and freestanding columns only at the front.

follows the Etruscan pattern with a high podium, a flight of steps at the front, and freestanding columns only in the deep porch. But the builders constructed the temple of stone (local tufa and travertine), overlaid originally with *stucco* in imitation of Greek marble. The columns are not Tuscan but Ionic, complete with flutes and bases, and there is a matching Ionic frieze. Moreover, in an effort to approximate a peripteral Greek temple yet maintain the basic Etruscan plan, the architect added a series of Ionic *engaged columns* (attached half-columns) to the sides and back of the cella. Although the design combines Etruscan and Greek elements, the resultant mix—a *pseudoperipteral* temple—is distinctively Roman.

VERISM The patrons of Republican religious and civic buildings were in almost all cases men from old and distinguished families, often generals who used the spoils of war to finance public works. These aristocratic *patricians* were fiercely proud of their lineage. They kept likenesses (*imagines*) of their ancestors in wood cupboards in their homes and paraded them at the funerals of prominent relatives. Ancestral portraiture was one way that the patrician class celebrated its elevated position in society. The subjects of these portraits were almost exclusively men of advanced age, for generally only elders held power in the Republic. These patricians did not ask sculptors to idealize them. Instead, they requested brutally realistic images immortalizing their distinctive features, in the tradition of the treasured household imagines.

ART AND SOCIETY

Who's Who in the Roman World

HICH EWPIRE (96-192 CE)

of the Antonine dynasty. The emperors of this period were Spanish emperors, Trajan and Hadrian, and ended with the last emperor The High Empire began with the death of Domitian and the rule of the

Trajan, r. 98-117 (FIG. 3-36B 🖪)

Domitian, r. 81-96

Vespasian, r. 69-79

Titus, r. 79-81 (FIG. 3-34)

- Antoninus Pius, r. 138-161 (FIG. 3-1) Hadrian, r. 117-138
- Marcus Aurelius, r. 161-180 (FIG. 3-41)
- Lucius Verus (r. 161-169)
- Commodus (r. 180-192)

LATE EMPIRE (192-337 CE)

Constantine, the first Christian emperor. Among these emperors were so-called soldier emperors of the third century, the tetrarchs, and The Late Empire began with the Severan dynasty and included the

- Caracalla, r. 211-217 (FIGS. 3-43 and 3-44) Septimius Severus, r. 193-277 (FIG. 3-43)
- Constantine I, r. 306-337 (Figs. 3-51 and 3-54) Diocletian, r. 284-305 (Fig. 3-50) Trajan Decius, r. 249-251 (FIG. 3-47)

MONARCHY (753-509 BCE)

king, Tarquinius Superbus (exact dates of rule unreliable). lus on April 21, 753 BCE, until the revolt in 509 BCE against Rome's last Latin and Etruscan kings ruled Rome from the city's founding by Romu-

BEPUBLIC (509-27 BCE)

major figures were victor over Mark Antony in the civil war that ended the Republic. Some title of Augustus on Octavian, the grandnephew of Julius Caesar and The Republic lasted almost 500 years, until the Senate bestowed the

- Marcellus, b. 268(?), d. 208 BCE, consul
- Sulla, b. 138, d. 79 BCE, consul and dictator
- Julius Caesar, b. 100, d. 44 BCE, consul and dictator
- Mark Antony, b. 83, d. 30 BCE, consul

EARLY EMPIRE (27 BCE-96 CE)

The emperors discussed in this chapter were Claudian successors and continued until the end of the Flavian dynasty. The Early Empire began with the rule of Augustus and his Julio-

- Augustus, r. 27 BCE-14 CE (FIGS. I-8 and 3-25)
- Nero, r. 54-68

and state—the most admired virtues during the Republic. about personality: serious, experienced, determined, loyal to family vidual features or exaggerated types designed to make a statement whether Republican veristic portraits are truly blunt records of indi-

Pompeii and the Cities of Vesuvius

Republic and Early Empire to a degree impossible anywhere else. a reconstruction of the art and life of Roman towns of the Late for the region's inhabitants but a boon for archaeologists, enabling of Naples, among them Pompeii. The eruption was a catastrophe suddenly erupted, burying many prosperous towns around the Bay On August 24, 79 ce, Mount Vesuvius, a long-dormant volcano,

and 15,000 when Mount Vesuvius buried Pompeii in volcanic ash. language. The colony's population had grown to between 10,000 founded a new Roman colony on the site, with Latin as its official War that ended in 89 BCE, and in 80 BCE, the Roman consul Sulla ian cities on the losing side against Rome in the so-called Social shape to the city center (FIG. 3-12). Pompeii fought with other Italgreatly expanded the original settlement and gave monumental town. Under the influence of their Greek neighbors, the Samnites toward the end of the fifth century BCE, the Samnites took over the the peak of Etruscan power, were the first to settle at Pompeii, but The Oscans, one of the many Italian population groups during

porticos (colonnades) on three sides of the long and narrow plaza. At town. In the second century BCE, the Samnites constructed two-story corner of the expanded Roman city but at the heart of the original public square. Pompeii's forum (FIG. 3-12, no. 1) lies in the southwest FORUM The center of civic life in any Roman town was its forum, or

> want to miss the slightest detail of surface change. Scholars debate bulge and fold, of the facial surface, like a mapmaker who did not Osimo. The sculptor painstakingly recorded each rise and fall, each tic) portraits is the head (FIG. 3-71) of an unidentified patrician from One of the most striking of these so-called veristic (superrealis-

cipio, Osimo. Palazzo del Muni-Marble, life-size. first century BCE. -bim omisO morì elderly patrician, 3-11 Head of an

man's face. detail of the elderly recorded every head painstakingly The sculptor of this during the Republic. lies were the norm -imeł badziugnitzib of old men from realistic) portraits Veristic (super-

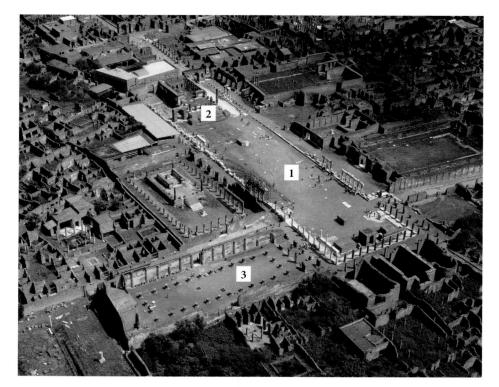

the north end, they built a temple of Jupiter (FIG. 3-12, no. 2). When Pompeii became a Roman colony, the Romans converted the temple into a *Capitolium*—a triple shrine to Jupiter, Juno, and Minerva. The temple is of standard Republican type, constructed of tufa covered with fine white stucco and combining an Etruscan plan with Corinthian columns. It faces into the civic square, dominating the area. This contrasts with the siting of Greek temples (FIG. 2-36), which stood in isolation and could be approached and viewed from all sides, like colossal statues on giant stepped pedestals. The Roman forum, like the Etrusco-Roman temple, had a chief side, a focus of attention.

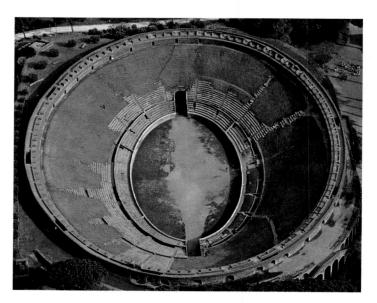

3-13 Aerial view of the amphitheater (looking northeast), Pompeii, Italy, ca. 70 BCE.

Pompeii's amphitheater is the oldest known and an early example of Roman concrete technology. In the arena, bloody gladiatorial combats and wild animal hunts took place before 20,000 spectators.

3-12 Aerial view of the forum (looking northeast), Pompeii, Italy, second century BCE and later. (1) forum, (2) Temple of Jupiter (Capitolium), (3) basilica.

The center of Roman civic life was the forum. At Pompeii, colonnades frame a rectangular plaza with the city's main temple at the north end and the basilica (law court) at the southwest corner.

All around the square, behind the colonnades, were secular and religious structures, including the town's administrative offices. Most important was the *basilica* at the southwest corner (FIG. 3-12, no. 3). It is the earliest well-preserved building of its kind. Constructed during the late second century BCE, the basilica was Pompeii's law court and chief administrative center. In plan it resembled the forum itself: long and narrow, with colonnades dividing the central *nave* from the flanking *aisles*.

AMPHITHEATER Shortly after the Romans took control of Pompeii, two of the town's wealthiest officials used their own funds to erect a large amphitheater (FIGS. 3-13 and 3-14)

at the southeastern end of town. The earliest amphitheater known, it could seat some 20,000 spectators—more than the entire population of the town even a century and a half after its construction. The word *amphitheater* means "double theater," and Roman amphitheaters resemble two Greek theaters put together. Amphitheaters nonetheless stand in sharp contrast, both architecturally and functionally, to Greco-Roman theaters, where actors performed comedies

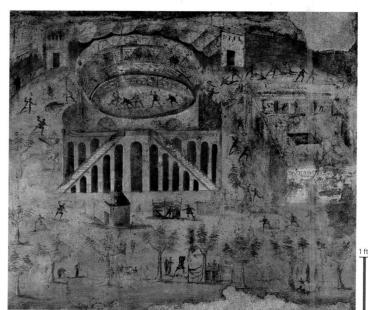

3-14 Brawl in the Pompeii amphitheater, wall painting from House I,3,23, Pompeii, Italy, ca. 60–79 CE. Fresco, 5' $7'' \times 6'$ 1". Museo Archeologico Nazionale, Naples.

This wall painting records a brawl that broke out in the Pompeii amphitheater in 59 ce. The painter included the awning (velarium) that could be rolled down to shield the spectators from sun and rain.

"artificial stone" in which the openings do not lessen the vault's structural integrity. Whether made of stone or concrete, barrel vaults require buttressing (lateral support) of the walls below the vaults to counteract their downward and outward thrust.

Groin Vaults A groin (or cross) vault (Fig. 3-15b) is formed by

Groin Yaults to countersect their downward and outward tinust.

Groin Yaults A groin (or cross) vault (Fie. 3-15b) is formed by the intersection at right angles of two barrel vaults of equal size. Besides appearing lighter than the barrel vault, the groin vault inceds less buttressing. Whereas the barrel vault's thrust is concentrated along the groins, the lines at the vault's thrust is concentrated along the groins, the lines at the juncture of the two barrel vaults. Buttressing is needed only at juncture of the two barrel vaults. Buttressing is needed only at juncture of the two barrel vaults. Buttressing is needed only at enabling light to enter the groins meet the vault's vertical supports, enabling light to enter. Builders can construct groin vaults as well as barrel vaults using stone blocks, but stone groin vaults have the same structural limitations as stone barrel vaults do compared to their concrete counterparts.

When a series of groin vaults covers an interior hall (FIE. 3-15c; compare FIG. 3-37), the open lateral arches of the vaults form the equivalent of a clerestory of a traditional timber-roofed structure (FIG. 4-3). A fenestrated (with openings or windows) sequence of groin vaults has a major advantage over a timber clerestory: concrete vaults are relatively fireproof.

Hemispherical Domes If a barrel vault is a round arch extended in a line, then a hemispherical dome (Fie. 3-154) is a round arch rotated around the full circumference of a circle. Masonry domes (Fie. 2-12), like masonry vaults, cannot accommodate windows without threat to their stability. Concrete domes can be opened up even at their apex with a circular oculus ("eye"), enabling light to reach the sometimes vast spaces beneath (Fies. 3-39 and 3-40). Hemispherical domes usually rest on concrete cylindrical drums.

The history of Roman architecture would be very different had the Romans been content to use the same building materials that the Greeks, Etruscans, and other ancient peoples did. Instead, the Romans developed concrete construction, which revolutionized architectural design. Roman builders mixed concrete according to a changing recipe of lime mortar, volcanic sand, water, and small stones (coementa, from which the English word "cement" derives). Workers poured the mixture into wood frames and left it to dry. When the concrete hardened, they removed the wood molds, revealing a solid mass of great strength, though rough in appearance. The Romans often covered the coarse concrete with stucco or with marble revetment (facing). Despite this lengthy procedure, concrete walls were much less costly to construct than walls of imported Greek marble or even local tuts and travertine.

Roman Concrete Construction

ARCHITECTURAL BASICS

The advantages of concrete went well beyond cost, however. It is possible to fashion concrete shapes unachievable in masonry construction, especially huge vaulted and domed rooms without internal supports. The new medium became a vehicle for shaping architectural space and enabled Roman architects to design buildings in unprecedance and enabled Roman architects.

dented ways.

The most common types of Roman concrete vaults and domes are

Barrel Vaults Also called the tunnel vault, the barrel vault (FIE. 3-15a) is an extension of a simple arch, creating a semicylindrical ceiling over parallel walls. Pre-Roman builders constructed barrel vaults using traditional ashlar masonry (FIE. 1-20), but those earlier vaults were less stable than concrete barrel vaults. If even a single block of a cut-stone vault comes loose, the whole vault may collapse. Also, masonry barrel vaults can be illuminated only by light entering at either end of the tunnel. Using concrete, Roman builders could place windows at any point in a barrel vault, because once the concrete hardens, it forms a seamless sheet of

3-15 Roman concrete construction. (a) barrel vault, (b) groin vault, (c) fenestrated sequence of groin vaults, (d) hemispherical dome with oculus (John Burge).

Concrete domes and vaults of varying designs enabled Roman builders to revolutionize the history of architecture by shaping interior spaces in novel ways.

ARCHITECTURAL BASICS

The Roman House

The entrance to a typical Roman *domus* ("private house") was through a narrow foyer (*fauces*, the "jaws" of the house), which led to a large central reception area, the *atrium*. The rooms flanking the fauces could open onto the atrium, as in FIG. 3-16, or onto the street, in which case the owner could operate or rent them as shops. The roof over the atrium (FIG. 3-17) was partially open to the sky, not only to admit light but also to channel rainwater into a basin (*impluvium*) to be stored in cisterns for household use. Opening onto the atrium were small bedrooms called *cubicula* ("cubicles"). At the back were two recessed areas (*alae*, "wings") and the owner's *tablinum*, or home office; one or more *triclinia* ("dining rooms"); a kitchen; and sometimes a small garden. Extant houses display endless variations of the same basic plan, dictated by the owners' personal tastes and means, the size and shape of the lot, and so forth, but all Roman houses of this type were inward-looking in nature. The design shut off the street's noise and dust, and all

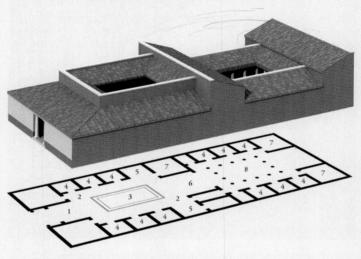

3-16 Restored view and plan of a typical Roman house of the Late Republic and Early Empire (John Burge). (1) fauces, (2) atrium, (3) impluvium, (4) cubiculum, (5) ala, (6) tablinum, (7) triclinium, (8) peristyle.

Roman houses were inward-looking, with a central atrium open to the sky and an impluvium to collect rainwater. A visitor standing in the fauces had an axial view through to the peristyle garden.

internal activity focused on the brightly illuminated atrium at the center of the residence (where patricians displayed their family imagines).

During the second century BCE, the Roman house took on Greek airs. Builders added a *peristyle* (colonnaded) garden at the rear, as in FIG. 3-16, providing a second internal source of illumination as well as a pleasant setting for meals served in a summer triclinium. The axial symmetry of the plan meant that on entering the fauces of the house, a visitor had a view through the atrium directly into the colonnaded garden (as in FIG. 3-17), which often boasted a fountain or pool, marble statuary, mural paintings, and mosaic floors.

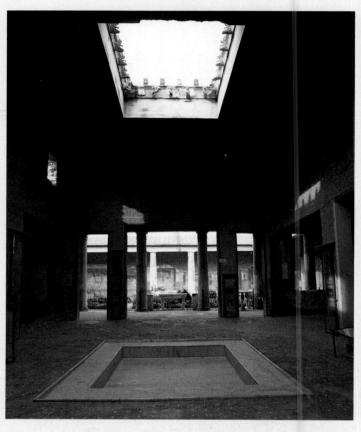

3-17 Atrium of the House of the Vettii, Pompeii, Italy, second century BCE, rebuilt 62-79 CE.

Older Roman houses had a small garden behind the atrium, but beginning in the second century BCE, builders added peristyles with Greek columns at the rear, as in the House of the Vettii.

and tragedies. Amphitheaters were where the Romans staged violent games (see "Spectacles in the Colosseum" (1). Greek theaters (FIG. 2-51) were always on natural hillsides, but supporting an amphitheater's continuous elliptical *cavea* (seating area) required building an artificial mountain. Only concrete, unknown to the Greeks, could easily meet that challenge (see "Roman Concrete Construction," page 92, and FIG. 3-15). In the Pompeii amphitheater, shallow concrete *barrel vaults* form a giant retaining wall holding up the earthen mound and stone seats. Barrel vaults running all the way through the elliptical mountain of earth form the tunnels leading to the *arena*, the central area where the violent contests took place. (*Arena* is Latin for "sand," which soaked up the blood of the wounded and killed.)

A painting (FIG. 3-14) found in one of Pompeii's houses records a brawl that occurred in the amphitheater during a gladiatorial contest

in 59 ce. The fighting—between the Pompeians and their neighbors, the Nucerians—left many seriously wounded and led to the banning of games in the amphitheater for a decade. The painting holds further interest because it shows the awning (*velarium*) destroyed in the Vesuvian eruption. The velarium could be rolled down from the top of the cavea to shield spectators from sun and rain.

HOUSE OF THE VETTII The evidence from Pompeii regarding Roman domestic architecture (see "The Roman House," above, and FIG. 3-16) is unparalleled anywhere else. One of the best-preserved houses at Pompeii is the House of the Vettii. A photograph (FIG. 3-17) taken in the *fauces* shows the *impluvium* in the center of the *atrium*, the opening in the roof above, and, in the background, the *peristyle* garden. Of course, only the wealthy—whether patricians

3-18 First Style wall painting in the fauces of the Samnite House, Herculaneum, Italy, late second century BCE.

In First Style murals, the aim was to imitate costly marble panels using painted stucco relief. The style is Greek in origin and another example of the Hellenization of Republican architecture.

or former slaves like the Vettius brothers, who made their fortune as merchants—could own large private houses. The masses, especially in expensive cities like Rome, lived in multistory apartment houses.

bave also yielded the most complete record of the changing fashions in mural painting anywhere in the ancient world. Art historians divide the various Roman mural types into four "Pompeian Styles." In the First Style, the decorator's aim was to imitate costly marble panels (compare Fig. 3-40) using painted stucco relief. The fauces a stunning illusion of walls faced with marbles imported from quarties all over the Mediterranean. This approach to wall decoration is comparable to the modern practice of using inexpensive manufactomparable to the modern practice of using inexpensive manufactomparable to the modern practice of using inexpensive manufactored materials to approximate the look and shape of genuine wood paneling. The practice is not, however, uniquely Roman. First Style walls are well documented in Greece from the late fourth century Bee on. The use of the First Style in Italian houses is yet another example of the Hellenization of Republican architecture.

VILLA OF THE MYSTERIES In contrast, the Second Style, introduced around 80 BCE, seems to be a Roman innovation and is in most respects the antithesis of the First Style. Second Style painters aimed to dissolve a room's confining walls and replace them with the illusion of an imaginary three-dimensional world. An early example of the new style is the room (Fig. 3-19) that gives its name to the this chamber was used to celebrate, in private, the rites of the Greek god Dionysos (Roman Bacchus). Dionysos was the focus of an unofficial mystery religion popular among women in Italy at this time. The precise nature of the Dionysiac rites is unknown, but the figural cycle in the Villa of the Dionysiac rites is unknown, but the figural provides evidence of the cult's initiation rites. In these rites, probably provides evidence of the cult's initiation rites. In these rites, young women symbolically united in marriage with Dionysos.

The Second Style painter created the illusion of a shallow ledge on which the human and divine actors move around the room. Especially striking is the way some of the figures interact across the corners of the room. For example, a seminude winged woman at the far right of the rear wall lashes out with her whip across the space

3-19 Dionysiac mystery frieze, Second Style wall paintings in room 5 of the Villa of the Mysteries, Pompeii, Italy, ca. 60–50 BCE. Frieze, 5' 4" high.

Second 5tyle painters created the illusion of an imaginary threedimensional world on the walls of Roman houses. The figures in this room are acting out the initiation rites of the Dionysiac mysteries.

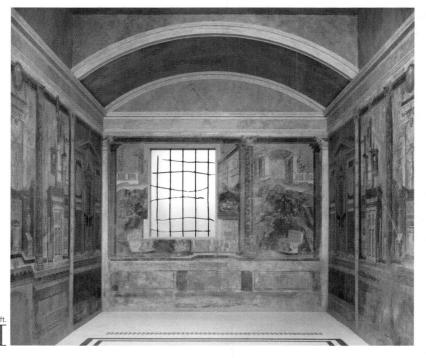

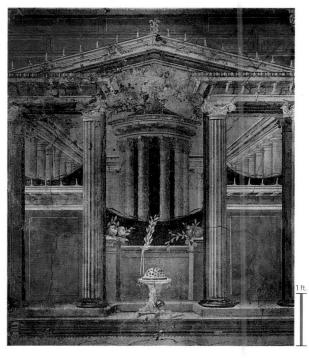

3-20 Second Style wall paintings (general view, *left*, and detail of tholos, *right*) from cubiculum M of the Villa of Publius Fannius Synistor, Boscoreale, Italy, ca. 50–40 BCE. Fresco, 8' 9" high. Metropolitan Museum of Art, New York.

In this Second Style bedroom, the painter opened up the walls with vistas of towns, temples, and colonnaded courtyards. The convincing illusionism is due in part to the artist's use of linear perspective.

of the room at a kneeling woman with a bare back (the initiate and bride-to-be of Dionysos) on the left end of the right wall.

BOSCOREALE In later Second Style designs, painters created a three-dimensional setting that also extends beyond the wall, as in cubiculum M (FIG. 3-20) of the Villa of Publius Fannius Synistor at Boscoreale. All around the room, the painter opened up the walls with vistas of Italian towns, marble tholos temples, and colonnaded courtyards. Painted doors and gates invite the viewer to walk through the wall into the magnificent world the painter created. Familiarity with *linear perspective* (see "Linear and Atmospheric Perspective," page 232) explains in large part the Boscoreale muralist's success in suggesting depth. In this kind of perspective, all the

receding lines in a composition converge on a single point along the painting's central axis. Ancient writers state that Greek painters of the fifth century BCE first used linear perspective for the design of Athenian stage sets (hence its Greek name, *skenographia*, "scene painting"). In the Boscoreale cubiculum, the painter most successfully used linear perspective in the far corners, where a low gate leads to a peristyle framing a round temple (FIG. 3-20, *right*).

PRIMAPORTA The ultimate example of a Second Style picture-window mural is the gardenscape (FIG. 3-21) in the Villa of Livia, wife of the emperor Augustus, at Primaporta, just north of Rome. To suggest recession, the painter employed another kind of perspective—atmospheric perspective—in which the illusion of depth

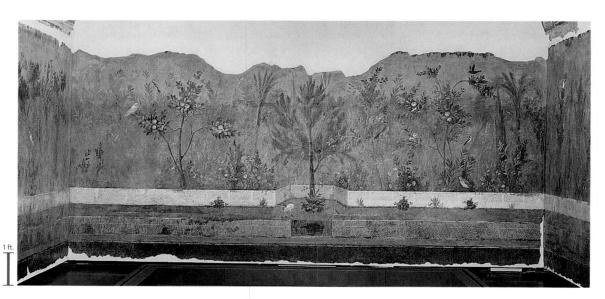

3-21 Gardenscape, Second Style wall paintings, from the Villa of Livia, Primaporta, Italy, ca. 30–20 BCE. Fresco, 6' 7" high. Palazzo Massimo alle Terme, Museo Nazionale Romano, Rome.

The ultimate example of a Second Style "picture window" wall is this gardenscape in Livia's villa. To suggest recession, the painter used atmospheric perspective, intentionally blurring the distant forms.

frames and floating central motifs, would fit naturally into the most elegant Third Style design. Unmistakábly Fourth Style, however, are the fragmentary architectural vistas of the central and upper zones of the walls. They are unrelated to one another and do not constitute a unified cityscape beyond the wall. Moreover, the figures depicted would tumble into the room if they took a single step forward.

The Ixion Room takes its name from the mythological painting at the center of the rear wall. Ixion had attempted to seduce Hera, and Zeus punished him by binding him to a perpetually spinning wheel. The panels on the two adjacent walls also have Greek myths as subjects. The Ixion Room is a kind of private art gallery. Many art historians believe that lost Greek panel paintings were the models for the many mythological paintings on Third and Fourth Style walls. Although few, if any, of the Pompeiian paintings can be described as true copies of famous Greek works, they attest to the Romans' continuing admiration for Greek art.

STILL LIFE Another important genre of Roman mural painting was the still life (a painting of inanimate objects, artfully arranged). A still life with peaches and a carafe (Fig. 3-24), a detail of a Fourth Style wall from Herculaneum, is one of the finest extant examples. The painter was a master of illusionism who devoted as much attention to the shadows and highlights on the fruit, the stem and leaves, and the glass jar as to the objects themselves.

Early Empire

The murder of Julius Caesar on the Ides of March, 44 BCE, plunged the Roman world into a bloody civil war. The fighting lasted until 31 BCE, when Octavian, Caesar's grandnephew and adopted son, crushed the naval forces of Mark Antony and Queen Cleopatra

3-22 Third Style wall painting, from cubiculum 15 of the Villa of Agrippa Postumus, Boscotrecase, Italy, ca. 10 BCE. Fresco, 7' 8" high. Metropolitan Museum of Art, New York.

In the Third Style, Roman painters decorated walls with delicate linear fantasies sketched on monochromatic backgrounds. Here, a tiny floating landscape on a black ground is the central motif.

is achieved by the increasingly blurred appearance of objects in the distance. At Primaporta, the Second Style muralist precisely painted the fence, trees, and birds in the foreground, whereas the details of the dense foliage in the background are indistinct.

BOSCOTRECASE The Primaporta gardenscape is the notation of the foreground are indistinct.

BOSCOTRECASE The Primaporta gardenscape is the polar opposite of First Style designs, which reinforce, rather than deny, the heavy presence of confining walls. But tastes changed rapidly in the Roman world, as in society today. Not long after Livia had her villa decorated, Roman patrons began to favor mural designs that reasserted the primacy of the wall surface. In the Third Style of Pompeian painting, popular from about 15 BCE to 60 CE, artists no longer attempted to replace to 60 CE, artists no longer attempted to replace walls with three-dimensional worlds of their own creation. Nor did they seek to imitate the

appearance of the marble walls of Hellenistic palaces. Instead they adorned walls with delicate linear fantasies sketched on predominantly monochromatic (one-color) backgrounds.

One of the earliest and also the finest examples of the new style is cubiculum 15 (FIG. 3-22) in the Villa of Agrippa Postumus at Boscotrecase. Nowhere did the artist use illusionistic painting to penetrate the wall. In place of the stately columns of the Second Style are insubstantial and impossibly thin colonnettes supporting featherweight canopies barely reminiscent of pediments. In the center of this delicate and elegant architectural frame is a tiny floating landscape painted directly on the jet-black ground. It is hard to imagine a sharper contrast with the panoramic gardenscape at Livia's villa. Third Style walls can never be mistaken for windows opening onto a world beyond the room. Not everyone approved of the new Roman mural fashion, however. One of those who disliked the Third Style was the Augustan architect Vitruvius, author of the most important extant ancient treatise on architecture (see "Vitru-most important extant ancient treatise on architecture (see "Vitru-

FOURTH Style, which was the most popular way to decorate walls during the last two decades of the life of Pompeii. The style is characterized by crowded and confused compositions mixing fragmentary architectural vistas, framed panel paintings, and motifs favored in the First and Third Styles. The Ixion Room (Fig. 3-23), a triclinium opening onto the peristyle of the House of the Vettii (Fig. 3-17), features a Fourth Style design that dates just before 79 ce. The mural scheme is a kind of summation of all the previous Pompeiian styles. The lowest zone, for example, is one of the most successful imitations anywhere of costly multicolored imported marbles. The large tions anywhere of costly multicolored imported marbles. The large white panels in the corners of the room, with their delicate floral

vius's Ten Books on Architecture" (1).

3-23 Fourth Style wall paintings in the Ixion Room (triclinium P) of the House of the Vettii (FIG. 3-17), Pompeii, Italy, ca. 70–79 CE.

Fourth Style murals are often multicolored, crowded, and confused compositions with a mixture of fragmentary architectural views, mythological paintings, and First and Third Style motifs.

of Egypt at Actium in northwestern Greece. Antony and Cleopatra committed suicide, and in 30 BCE, Egypt, once the wealthiest and most powerful kingdom of the ancient world, became another province in the ever-expanding Roman Empire.

AUGUSTUS Historians mark the passage from the Roman Republic to the Roman Empire from the day in 27 BCE when the Senate conferred the title of *Augustus* (the Majestic, or Exalted, One; r. 27 BCE–14 CE) on Octavian. The Empire was ostensibly a continuation of the Republic, with the same constitutional offices, but in fact Augustus, as *princeps* ("first citizen"), occupied all the key positions. He was consul and *imperator* (commander in chief; root of the word "emperor") and even, after 12 BCE, *pontifex maximus* ("chief priest" of the state religion). These offices gave Augustus control of all aspects of Roman public life.

With powerful armies keeping order on the Empire's frontiers and no opposition at home, Augustus brought peace and prosperity to a war-weary Mediterranean world. Known in his day as the *Pax Augusta* (Augustan Peace), the peace Augustus established prevailed for two centuries. It came to be called simply the *Pax Romana*. During this time, the emperors com-

missioned a huge number of public works throughout the Empire, all on an unprecedented scale. Imperial portraits and monuments covered with reliefs recounting the emperors' great deeds reminded people everywhere that the emperors were the source of peace and prosperity. These portraits and reliefs, however, often presented a picture of the emperors and their achievements bearing little resemblance to historical fact (see "Roman Art as Historical Fiction," page 83). Their purpose was not to provide an objective record but to mold public opinion.

When Augustus vanquished Antony and Cleopatra and became undisputed master of the Mediterranean world, he was not yet 32 years old. The rule by elders that had characterized the Roman Republic for nearly 500 years came to an abrupt end. Suddenly,

3-24 Still life with peaches, detail of a Fourth Style wall painting, from the House of the Stags, Herculaneum, Italy, ca. 62–79 CE. Fresco, $1' 2'' \times 1' 1\frac{1}{2}''$. Museo Archeologico Nazionale, Naples.

The Roman interest in illusionism explains the popularity of still-life paintings. This painter paid scrupulous attention to the play of light and shadow on different shapes and textures.

3-26 Portrait bust of Livia, from Arsinoe, Egypt, early first century ce. Marble, I' $1\frac{1}{2}$ " high. My Carlsberg Glyptotek, Copenhagen.

sharply defined features derive from images of Greek goddesses. She died at 87, but, like Augustus, never aged in her portraits.

Although Livia sports the latest Roman coiffure, her youthful appearance and

the statue carry political messages. The reliefs on his cuirass (breast-plate) celebrate a victory over the Parthians, Rome's enemies to the east. The Cupid at Augustus's feet refers to his divine descent from Venus through Julius Caesar.

LIVIA A marble portrait (FIG. 3-26) of Livia shows that the imperial women of the Augustan age shared the emperor's perpetual youthfulness. Although the empress sports the latest Roman coiffure, with the hair rolled over the forehead and knotted at the nape of the ineck, her blemish-free skin and sharply defined features derive from images of Classical Greek goddesses. Livia outlived Augustus by 15 years, dying at age 87. In her portraits, the coiffure changed with the introduction of each new fashion, but her face remained ever young, befitting her exalted position in the Roman state.

ARA PACIS AUGUSTAE On Livia's birthday in 9 BCE, Augustus dedicated the Ara Pacis Augustae (Altar of Augustan Peace; FIG. 3-27), the monument celebrating his most important achievement, the establishment of peace. Acanthus tendrils adorn the lower zone of the altar's marble precinct walls. The rich botanical ornament of panels on the east and west ends of the Ara Pacis depict carefully selected mythological subjects, including (at the right in Fig. 3-27) a relief of Aeneas making a sacrifice. Aeneas was the son of Venus and relief of Augustus's forefathers. The connection between the emperor

3-25 Portrait of Augustus as imperator (general), from Primaporta, Italy, early-first-century CE copy of a bronze original of ca. 20 BCE. Marble, 6' 8" high. Musei Vaticani, Rome.

The models for Augustus's idealized portraits, which depict him as a neveraging youth, were Classical Greek statues (Fig. 2-35). This statue portrays the armor-clad emperor as commander in chief.

Roman portraitists had to produce images of a youthful head of state. But Augustus was not merely young. The Senate had declared Caesar a god after his death, and Augustus, though never claiming to be a god himself, widely advertised himself as the son of a god. His portraits (Fig. I-8) were designed to present the image of a god-like leader who miraculously never aged.

The models for Augustus's idealized portraits were Classical Greek statues. In the portrait of Augustus as imperator (FIG. 3-25), but the emperor's pose recalls Polykleitos's Doryphoros (FIG. 2-35), but Augustus raises his right arm to address his troops in the manner of the orator Aule Metele (FIG. 3-8). Augustus's head, although depicting a recognizable individual, also emulates the Polykleitan youth's head in its overall shape, the sharp ridges of the brows, and the tight cap of layered hair. Augustus is not nude, however, and the details of cap of layered hair. Augustus is not nude, however, and the details of

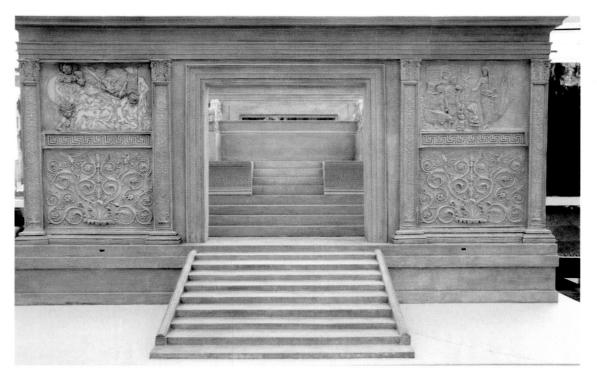

3-27 West facade of the Ara Pacis Augustae (Altar of Augustan Peace), Rome, Italy, 13–9 BCE.

Augustus sought to present his new order as a Golden Age equaling that of Athens under Pericles. The Ara Pacis celebrates the emperor's most important achievement, the establishment of peace.

and Aeneas was a key element of Augustus's political ideology. It is no coincidence that Vergil wrote the *Aeneid* during the rule of Augustus. The epic poem glorified the young emperor by celebrating the founder of the Julian line.

Processions of the imperial family (FIG. 3-28) and other important dignitaries appear on the long north and south sides of the Ara Pacis. The inspiration for these parallel friezes was very likely the Panathenaic procession frieze (FIG. 2-41, *bottom*) of the Parthenon. Augustus sought to present his new order as a Golden Age equaling that of Athens under Pericles, and he consciously revived the Classical style in both architecture (see "Vitruvius's *Ten Books on Architecture*" and FIG. 3-28A ③) and sculpture. The emulation of Classical models thus

made a political as well as an artistic statement. Even so, the Roman and Greek processions are very different in character. On the Parthenon, anonymous figures act out an event that recurred every four years. The frieze stands for all Panathenaic Festival processions. The Ara Pacis depicts a specific event—probably the inaugural ceremony of 13 BCE—and recognizable historical figures. Among those portrayed are children, who restlessly tug on their elders' garments and talk to one another when they should be quiet on a solemn occasion. Augustus was concerned about a decline in the birthrate among the Roman nobility, and he enacted a series of laws designed to promote marriage, marital fidelity, and raising children. The portrayal of men with their families on the Altar of Peace served as a moral exemplar.

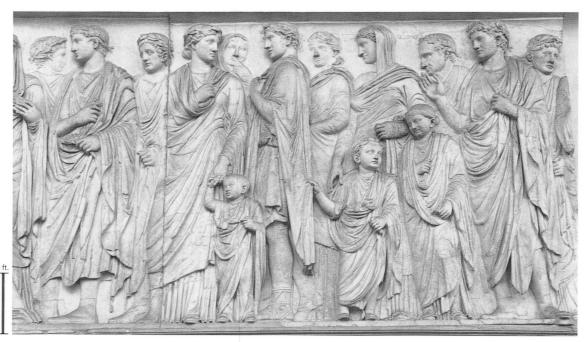

3-28 Procession of the imperial family, detail of the south frieze of the Ara Pacis Augustae, Rome, Italy, 13-9 BCE. Marble, 5' 3" high.

Although inspired by the lonic frieze (Fig. 2-41, bottom) of the Parthenon, the Ara Pacis procession depicts recognizable individuals, including children. Augustus promoted marriage and childbearing.

3-29 Pont-du-Gard (looking northeast), Nîmes, France, ca. 16 BCE.

Roman engineers constructed roads and bridges throughout the empire. This aqueduct-bridge brought water from a distant mountain spring to Nimes—about 100 gallons a day for each inhabitant.

Claudians. But the outrageous behavior of Neto (r. 54–68 CE) produced a powerful backlash. Facing assassination, Nero committed suicide in 68 CE, bringing the Julio-Claudian dynasty to an end. A year of renewed civil strife followed. The man who emerged triumphant in this brief but bloody conflict was Vespasian (r. 69–79 CE), a general who had served under Nero. Vespasian, whose family name was Flavius, had two sons, Titus (r. 79–81 CE) and Domitian name was Flavius, had two sons, Titus (r. 79–81 CE) and Domitian quarter century.

COLOSSEUM The Flavian Amphitheater, or Colosseum (FIGS. 3-9, no. 12, and 3-30), was one of Vespasian's first undertakings after becoming emperor. The decision to build the Colosseum was politically shrewd. The site chosen was on the property that Nero had confiscated from the Roman people after a great fire in 64 CE in order to build a private villa for himself. By constructing the new amphitheater there, Vespasian reclaimed the land for the public and also provided Romans with the largest arena for gladiatorial comalso provided Romans with the largest arena for gladiatorial combats and other lavish spectacles ever constructed (see "Spectacles in

who designed the aqueduct also had a keen aesthetic sense. larger and smaller arches reveals that the Roman hydraulic engineer channel itself. The harmonious proportional relationship between the three above each of the large openings below. They carry the water two tons each. The bridge's uppermost level is a row of smaller arches, large arch spans some 82 feet and consists of blocks weighing up to of the water channel where the water crossed the Gard River. Each source to city. The three-story Pont-du-Gard maintained the height built with a continuous gradual decline over the entire route from the considerable distance by gravity alone, which required channels from a mountain spring some 30 miles away. The water flowed over vided about 100 gallons of water a day for each inhabitant of Nîmes known as the Pont-du-Gard (FIG. 3-29) still stands. The aqueduct proempire. In southern France, outside Nîmes, the aqueduct-bridge to construct roads, bridges, and aqueducts throughout its far-flung PONT-DU-GARD During the Pax Romana, Rome sent engineers

THE FLAVIANS For a half century after Augustus's death, Rome's emperors all came from his family, the Julians, or his wife Livia's, the

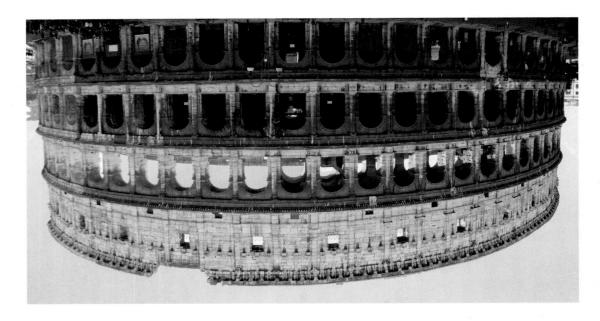

3-30 Facade of the Colosseum (Flavian Amphitheater; looking south), Rome, Italy, ca. 70-80 ce.

Vespasian began construction of the Flavian Amphitheater on land that Nero had confiscated from the public. The Colosseum's facade mixes Roman arches and Tuscan, lonic, and Corinthian engaged columns.

the Colosseum" and Fig. 3-30A ①). To mark the opening of the Colosseum, the Flavians staged games for 100 days. Some later writers reported that the highlight was the flooding of the arena to stage a complete naval battle with more than 3,000 participants.

The Colosseum, like the much earlier Pompeian amphitheater (FIGS. 3-13 and 3-14), could not have been built without concrete. A complex system of barrel-vaulted corridors holds up the enormous oval seating area. This concrete "skeleton" is exposed today because the amphitheater's marble seats were hauled away during the Middle Ages and Renaissance. Originally, there were seats for more than 50,000 spectators. (The Colosseum takes its name, however, not from its enormous size but from its location beside the Colossus of Nero [FIG. 3-9, no. 11], a 120-foot-tall statue of the emperor in the guise of the sun god.) Also visible now are the arena substructures, which housed waiting rooms for the gladiators, animal cages, and machinery for raising and lowering stage sets as well as animals and humans.

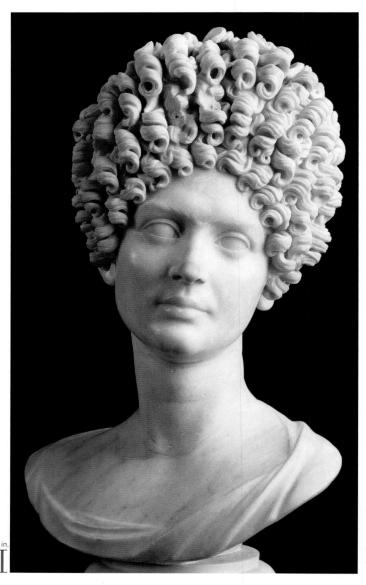

3-31 Portrait bust of a Flavian woman, from Rome, Italy, ca. 90 CE. Marble, 2' 1" high. Museo Capitolino, Musei Capitolini, Rome.

The Flavian sculptor reproduced the elaborate coiffure of this elegant woman by drilling deep holes for the corkscrew curls. The rest of the hair and the face were carved with a hammer and chisel.

The exterior travertine shell (FIG. 3-30) is approximately 160 feet high, the height of a modern 16-story building. The architect divided the facade into four bands, with large arched openings piercing the lower three. Ornamental Greek orders frame the arches in the standard Roman sequence for multistory buildings: from the ground up, Tuscan, Ionic, and then Corinthian. The use of engaged columns and a lintel to frame the openings in the Colosseum's facade is a common motif on Roman buildings. Like the pseudoperipteral temple (FIGS. 3-10 and 3-28A), which combines Greek orders and Etruscan plan, this way of decorating a building's facade mixed Greek orders with an architectural form foreign to Greek post-and-lintel architecture—the arch. The Roman practice of framing an arch with Greek engaged columns had no structural purpose, but it added variety to the surface and unified the towering facade by casting a net of verticals and horizontals over it.

FLAVIAN PORTRAITURE Flavian portraits survive in large numbers, but a marble bust (FIG. 3-31) of a young woman, probably a Flavian princess, is of special interest. The portrait is notable for its elegance and delicacy and for the virtuoso way the sculptor rendered the differing textures of hair and flesh. The elaborate Flavian coiffure, with its corkscrew curls picked out using a drill instead of a chisel, is a dense mass of light and shadow set off boldly from the softly modeled and highly polished skin of the face and swanlike neck.

ARCH OF TITUS When Titus died in 81 CE, his younger brother, Domitian, succeeded him. The new emperor set up a *triumphal arch* (FIGS. 3-9, no. 9, and 3-32) in Titus's honor on the road leading into the Forum Romanum (FIG. 3-9, no. 7). The Arch of Titus is a typical

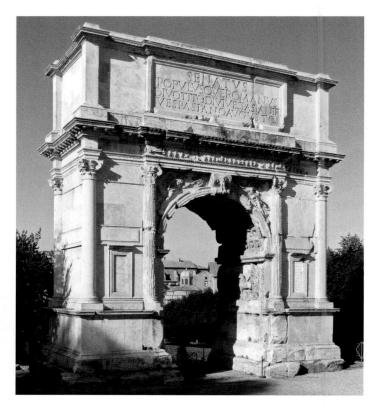

3-32 East facade of the Arch of Titus, Rome, Italy, after 81 CE.

Domitian built this arch on the road leading into the Forum Romanum to honor his brother, the emperor Titus, who became a god after his death. Victories fill the spandrels of the arcuated passageway.

heads in low relief, which are intact. The play of light and shade emphasized their different placement in space compared with the broken off because they stood free from the block. Their high relief produces strong shadows. The heads of the foreground figures have the Ara Pacis (FIG. 3-28) in favor of extremely deep carving, which rapid march. The sculptor rejected the Classical low-relief style of ground. The energy and swing of the column of soldiers suggest a and disappears through the obliquely placed arch in the right backparade emerges from the left background into the center foreground damage to the relief, the illusion of movement is convincing. The spoils from the Jewish temple in Jerusalem. Despite considerable One of the reliefs (FIG. 3-33) depicts Roman soldiers carrying the from the conquest of Judaea at the end of the Jewish War in 70 CE.

names were erased from public inscriptions. This was Nero's fate. of those who suffered damnatio memoriae were toppled, and their unless they ran afoul of the senators and were damned. The statues after they died (see "Roman Art as Historical Fiction," page 83), pasian. The Senate normally proclaimed Roman emperors gods Senate erected the arch to honor the god Titus, son of the god Vesentablature). The dedicatory inscription on the attic states that the (the area between the arch's curve and the framing columns and opening. Reliefs depicting personified Victories fill the spandrels osseum, engaged columns frame the arcuated (curved or arched) early triumphal arch in having only one passageway. As on the Col-

panels. They represent the triumphal parade of Titus after his return Inside the passageway of the Arch of Titus are two great relief

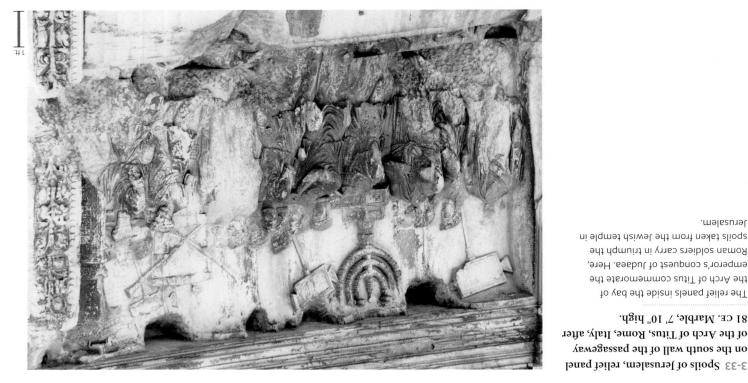

of the Arch of Titus, Rome, Italy, after on the north wall of the passageway 3-34 Triumph of Titus, relief panel

spoils taken from the Jewish temple in Roman soldiers carry in triumph the emperor's conquest of Judaea. Here, the Arch of Titus commemorate the The relief panels inside the bay of

on the south wall of the passageway 3-33 Spoils of Jerusalem, relief panel

81 CE. Marble, 7' 10" high.

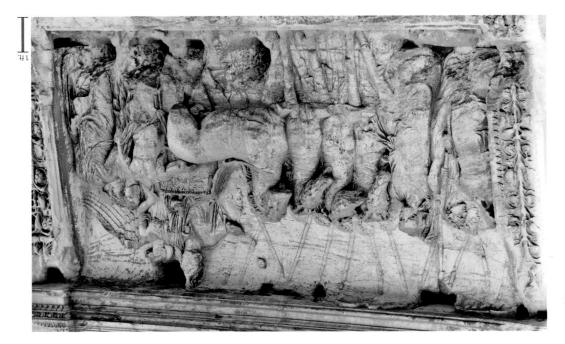

and divine figures in a Roman historical instance of the intermingling of human of Honor and Valor in this first known chariot. Also present are personifications Victory crowns Titus in his triumphal

81 ce. Marble, 7' 10" high.

Jerusalem.

across the protruding foreground and receding background figures enhances the sense of movement.

On the other side of the passageway, the panel (FIG. 3-34) shows Titus in his triumphal chariot. Victory rides with the emperor and places a wreath on his head. Below her is a bare-chested youth who is probably a personification of Honor (Honos). A female personification of Valor (Virtus) leads the horses. These allegorical figures transform the relief from a record of Titus's battlefield success into a celebration of imperial virtues. A comparable intermingling of divine and human figures characterized the Dionysiac mysteries frieze (FIG. 3-19) at Pompeii, but the Arch of Titus panel is the first known instance of divine beings interacting with humans on an official Roman historical relief. (On the Ara Pacis, FIG. 3-27, the gods, heroes, and personifications appear in separate framed panels, carefully segregated from the procession of living Romans.) The Arch of Titus, however, does not honor the living emperor but the deified Titus, who has entered the realm of the Roman gods. But soon afterward, this kind of interaction between mortals and immortals became a staple of Roman narrative relief sculpture, even on monuments erected in honor of living emperors.

High Empire

Domitian's extravagant lifestyle and ego resembled Nero's. He so angered the senators that he was assassinated in 96 ce. The first emperor of the second century, chosen with the consent of the Senate, was Trajan (r. 98–117 ce), a popular general. Born in Spain, Trajan was the first non-Italian to rule Rome. During his reign, the Roman Empire reached its greatest extent (MAP 3-1), and the imperial government took on ever greater responsibility for its people's welfare by instituting a number of farsighted social programs.

FORUM OF TRAJAN Trajan's major building project in Rome was a huge new forum (FIGS. 3-9, no. 5, and 3-35), which glorified his victories in two wars against Dacia, in present-day Romania. The architect was Apollodorus of Damascus, Trajan's chief military engineer, who during the first Dacian campaign had constructed a world-famous bridge across the Danube River. Apollodorus's plan incorporated the main features of most early fora (FIG. 3-12), except that a huge basilica, not a temple, dominated the colonnaded open square. The temple (completed after the emperor's death and dedicated to the newest god in the Roman pantheon, Trajan himself) stood instead behind the basilica facing two libraries and a giant commemorative column (FIG. 3-36). Entry to Trajan's forum was through an impressive gateway resembling a triumphal arch. Inside the forum were other reminders of Trajan's military prowess. A larger-than-life-size gilded-bronze statue of the emperor on horseback, trampling a terrified Dacian, stood at the center of the great court in front of the basilica. Statues of captive Dacians stood above the columns of the forum porticos.

The Basilica Ulpia (Trajan's family name was Ulpius) was a much larger and far more ornate version of the basilica adjoining the forum of Pompeii (FIG. 3-12, no. 3). As shown in FIG. 3-35, no. 4, it had *apses*, or semicircular recesses, on each short end. Two aisles flanked the nave on each side. The building was vast: about 400 feet long (without the apses) and 200 feet wide. Light entered through clerestory windows, made possible by elevating the timberroofed nave above the colonnaded aisles. In the Republican basilica at Pompeii, light reached the nave only indirectly through aisle windows. The clerestory (used already at Karnak in Egypt; FIG. 1-34) was a much better solution.

3-35 APOLLODORUS OF DAMASCUS, Forum of Trajan (restored view), Rome, Italy, dedicated 112 CE (James E. Packer and John Burge). (1) Temple of Trajan, (2) Column of Trajan, (3) libraries, (4) Basilica Ulpia, (5) forum, (6) equestrian statue of Trajan.

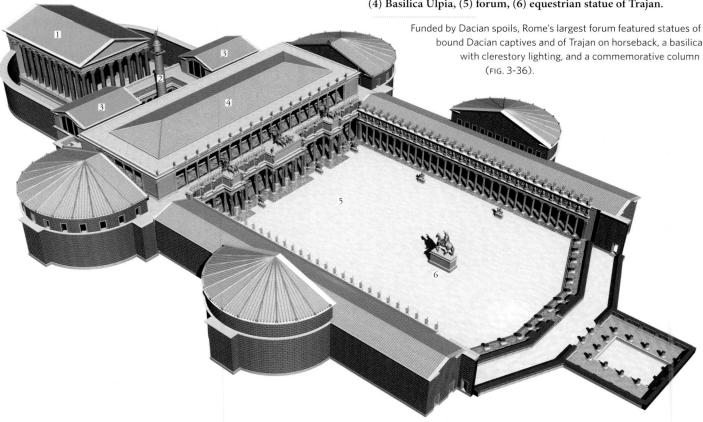

3-36 Column of Trajan (looking west), Forum of Trajan, Rome, Italy, dedicated 112 CE.

The spiral frieze of Trajan's Column tells the story of the Dacian wars in 150 episodes. The reliefs depict all aspects of the campaigns, from battles to sacrifices to road and fort construction.

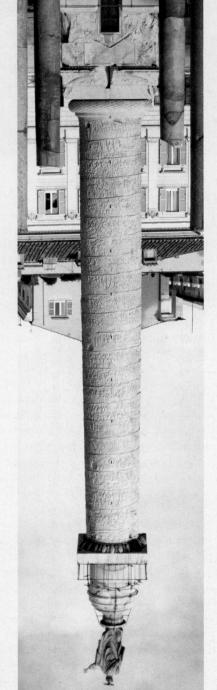

PROBLEMS AND SOLUTIONS The Spiral Frieze of the Column of Trajan

The 128-foot-tall Column of Trajan (Fie. 3-36), which celebrates Trajan's successes in Dacia and once had a heroically nude statue of the emperor at the top, was probably the brainchild of Apollodorus of Jamascus, Trajan's official architect and designer of the emperor's forum (Fie. 3-35) and markets (Fie. 3-37). The problem that Apollodorus faced was how to incorporate a pictorial record of the emperor's military campaigns in a monument—a freestanding column—ill-suited for narrative relief sculpture except on its pedestal. Apollodorus's solution was to invent a new artistic mode: a 625-foot frieze winding solution was to invent a new artistic mode: a 625-foot frieze winding 23 times around the shaft of Trajan's Column from bottom to top. A measure of his success is that the column was widely imitated, not only in antiquity but in the Middle Ages and as late as the 19th century (by Napoleon in Paris).

Carving the frieze was a complex process. First, the stonemasons had to fashion enormous marble column drums, hollowed out to accommodate an internal spiral staircase running the entire length of the column shaft. The sculptors carved the relief scenes after the drums were in place to ensure that the figures and buildings lined up perfectly. The sculptors carved the last scenes in the narrative first, working from the sculptors carved the last scenes in the narrative first, working from the collection of the shaft so that falling marble chips or a dropped top to the bottom of the shaft so that falling marble chips or a dropped

hammer or chisel would not damage the reliefs below.

Art historians have likened the sculptured frieze winding around the column to an illustrated scroll of the type housed in the neighboring libraries (Fig. 3-35, no. 3) of the Forum of Trajan. The reliefs (Figs. 3-36A, 3-36B, and 3-36C () recount Trajan's two successful campaigns against the Dacians in more than 150 episodes, in which some Dacians in more than 150 episodes, in which some 2,500 figures appear. The band increases in width as it winds to the top of the column in order to make the upper portions easier to see. Throughout, the relief is very low so as not to distort the contours of the shaft. Paint enhanced the legibility of the figures, but it still would have been very difficult for anyone to follow the narrative from beginning to end.

Easily recognizable compositions such as those found on coin reverses and on historical relief panels—Trajan addressing his troops, sacrificing to the gods, and so on—fill most of the frieze. The narrative is not a reliable chronological account of the Dacian wars, as once thought. The sculptors nonetheless accurately recorded the general character of the campaigns. Notably, battle scenes (Fig. 3-36A ③) take up only about a quarter of the frieze. As is true of modern military opertransporting men and equipment, and preparing forts (Fig. 3-36C ④), transporting men and equipment, and preparing for battle than fighting. The focus is always on the emperor, who appears repeatedly in the frieze (Fig. 3-36B ④). From every vantage point, Trajan can be seen directing the military operation. His involvement in all aspects of the directing the military operation. His involvement in all aspects of the Dacian campaigns—and in expanding Rome's empire on all fronts—is one of the central messages of the Column of Trajan.

MARKETS OF TRAJAN On the Quirinal Hill overlooking the forum, Apollodorus built the Markets of Trajan (Fig. 3-9, no. 6) to house both shops and administrative offices. Concrete made possible the transformation of the hill into a multilevel complex. The basic unit was the *taberna*, a single-room shop covered by a barrel vault. The tabernae were on several levels. They opened either onto a concave semicircular facade winding around one of the large exedense (semicircular recessed areas) of Trajan's forum, onto a paved

COLUMN OF TRAJAN Behind the ruins of the Basilica Ulpia still stands the almost perfectly preserved Column of Trajan (FIG. 3-36). The column's large pedestal, decorated with captured Dacian arms and armor, encloses a chamber that originally served as Trajan's frieze recounting the defeat of the Dacians (see "The Spiral Frieze of the Column of Trajan," above, and FIGS. 3-36A, 3-36B, and of the Column of Trajan," above, and FIGS. 3-36A, 3-36B, and

CHAPTER 3 The Roman Empire

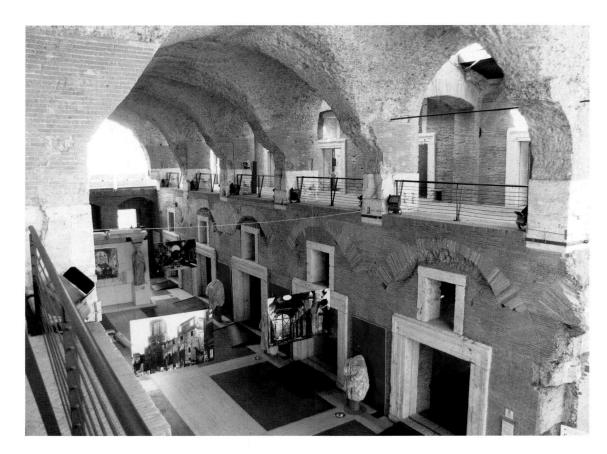

3-37 APOLLODORUS OF DAMASCUS, interior of the great hall (looking southwest), Markets of Trajan, Rome, Italy, ca. 100-112 CE.

The great hall of Trajan's markets resembles a modern shopping mall. It housed two floors of shops, with the upper ones set back and lit by skylights. Concrete groin vaults cover the central space.

street higher up the hill, or onto a great indoor market hall (FIG. 3-37) resembling a modern shopping mall. The hall housed two floors of tabernae, with the upper shops set back on each side and lit by skylights. Light from the same sources reached the ground-floor shops through arches beneath the great umbrella-like groin vaults (FIG. 3-15c) covering the hall.

PANTHEON Upon Trajan's death, Hadrian (r. 117–138 CE), also a Spaniard and a relative of Trajan's, succeeded him as emperor. Almost immediately, Hadrian began work on the Pantheon (FIGS. 3-9, no. 4, and 3-38), the temple of all the gods. The Pantheon reveals the full potential of concrete, both as a building material and as a means for shaping architectural space. The approach to the temple

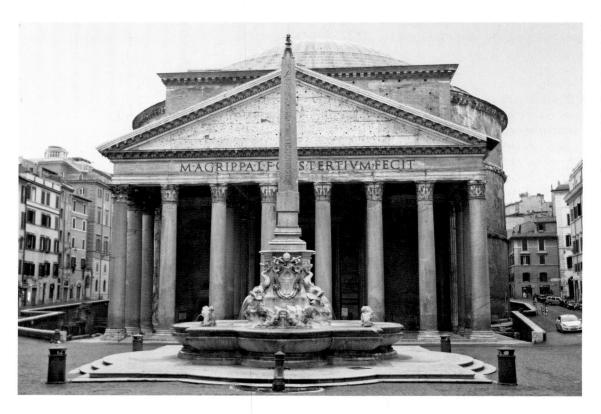

3-38 Pantheon (looking south), Rome, Italy, 118–125 CE.

The Pantheon's traditional facade masked its revolutionary cylindrical drum and its huge hemispherical dome. The interior symbolized both the orb of the earth and the vault of the heavens.

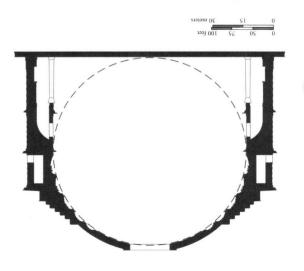

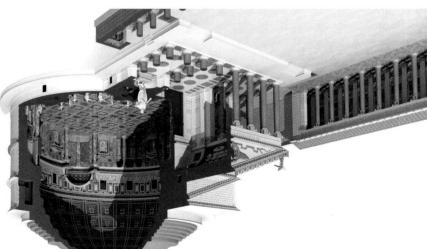

3-39 Restored cutaway view (left) and lateral section (right) of the Pantheon, Rome, Italy, 118-125 CE (John Burge).

Originally, the approach to Hadrian's "temple of all gods" was from a columnar courtyard. Like a temple in a Roman forum (Fig. 3-12), the Pantheon stood at one narrow end of the enclosure.

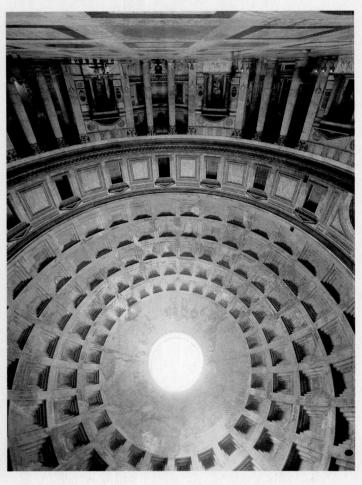

3-40 Interior of the Pantheon (looking south), Rome, Italy, 118-125 CE.

The coffered dome of the Pantheon is 142 feet in diameter and 142 feet high. The light entering through its oculus forms a circular beam that moves across the dome as the sun moves across the sky.

PROBLEMS AND SOLUTIONS The Ancient World's Largest Dome

Below the dome, much of the original marble veneer of the walls, its center, enhancing the symbolism of the dome as the starry heavens. suggest that each coffer once had a glistening gilded-bronze rosette at some pattern of squares within the vast circle. Renaissance drawings ening its structure, further reduced its mass, and even provided a hand-(sunken decorative panels) lessened the dome's weight without weakdiameter that is the only light source for the interior. The use of coffers also decreases as it nears the oculus, the circular opening 30 feet in pumice replaced stones to lighten the load. The dome's thickness recipe gradually changed until, at the top of the dome, featherweight hard and durable basalt went into the mix for the foundations, and the drum level by level using concrete of varied composition. Extremely until the 16th century. Their solution was to build up the cylindrical bassedrus fon feaf e-emif that of qu blow aft ni amob feagral and gni an's engineers. The builders were faced with the problem of constructfloor are equal), executing that design took all the ingenuity of Hadri-3-40) is simplicity itself (a dome whose diameter and height from the If the design of the dome of Hadrian's Pantheon (FIGS. 3-38, 3-39, and

niches, and floor has survived. In the Pantheon, visitors can appreciate, as almost nowhere else (compare Fig. 3-46), how magnificent the interiors of Roman concrete buildings could be. But despite the luxurious skin of the Pantheon's interior, on first entering the structure, visitors do not sense the weight of the walls but the vastness of the space they enclose. In pre-Roman architecture, the form of the enclosed space as determined by the placement of the solids, which did not so much shape space as interrupt it. Roman architects were the first to conceive of architecture in terms of units of space that could be shaped by the enclosures. The Pantheon's interior is a single unified, self-sufficient whole, uninterrupted by supporting solids. It encloses people without imprisoning them, opening through the oculus to the drifting clouds, imprisoning them, opening through the oculus to the drifting clouds, imprisoning them, opening through the oculus to the drifting clouds,

the blue sky, the sun, and the gods.

was from a columnar courtyard, and, like a temple in a Roman forum, the Pantheon stood at one narrow end of the enclosure (FIG. 3-39, left). Its facade of eight Corinthian columns was a bow to tradition. Everything else about the Pantheon was revolutionary. Behind the columnar porch is an immense concrete cylinder covered by a huge hemispherical dome (FIG. 3-40) 142 feet in diameter (see "The Ancient World's Largest Dome," page 106). The dome's top is also 142 feet from the floor (FIG. 3-39, right). The design is thus based on the intersection of two circles (one horizontal, the other vertical). The interior space can be imagined as the orb of the earth, and the dome as the vault of the heavens. The unknown architect enhanced this impression by using light not merely to illuminate the darkness but to create drama and underscore the symbolism of the building's shape. On a sunny day, the light passing through the oculus forms a circular beam, a disk of light that moves across the coffered dome in the course of the day as the sun moves across the sky itself. Escaping from the noise and heat of a Roman summer

3-41 Equestrian statue of Marcus Aurelius, from Rome, Italy, ca. 175 CE. Bronze, 11' 6" high. Palazzo dei Conservatori, Musei Capitolini, Rome.

In this majestic portrait of Marcus Aurelius on horseback, the emperor stretches out his arm in a gesture of clemency. An enemy once cowered beneath the horse's raised foreleg.

day into the Pantheon's cool, calm, and mystical immensity is an experience not to be missed.

MARCUS AURELIUS Early in 138 CE, Hadrian adopted the 51-yearold Antoninus Pius. At the same time, he required Antoninus to adopt Marcus Aurelius and Lucius Verus (see page 83), thereby assuring a peaceful succession for at least another generation. Perhaps the most majestic surviving portrait of a Roman emperor is the larger-than-life-size gilded-bronze equestrian statue (FIG. 3-41) of Marcus Aurelius. The emperor possesses a superhuman grandeur and is much larger than any normal human would be in relation to his horse. Marcus stretches out his right arm in a gesture that is both a greeting and an offer of clemency. Beneath the horse's raised right foreleg, an enemy once cowered, begging the emperor for mercy, underscoring the Roman emperor's role as ruler of the whole world. This message of supreme confidence is not, however, conveyed by the emperor's head, with its long, curly hair and full beard, consistent with the latest fashion. Marcus's forehead is lined, and he seems weary, saddened, and even worried. For the first time, the strain of constant warfare on the frontiers and the burden of ruling a worldwide empire show in the emperor's face. The Antonine sculptor ventured beyond Republican verism, exposing the ruler's character, his thoughts, and his soul for all to see, as Marcus revealed them himself in his Meditations, a deeply moving philosophical treatise setting forth the emperor's personal worldview. This kind of introspective portraiture was a profound change from classical idealism. It marks a major turning point in the history of ancient art.

MUMMY PORTRAITS Painted portraits were common in the Roman Empire, but most have perished. In Roman Egypt, however, large numbers have been found because the Egyptians continued to bury their dead in mummy cases (see "Mummification," page 32), with painted wood panels depicting the deceased replacing the traditional stylized portrait masks (FIG. 1-37). One example (FIG. 3-42)

3-42 Mummy portrait of a priest of Serapis, from Hawara (Faiyum), Egypt, ca. 140–160 CE. Encaustic on wood, $1'4\frac{3}{4}''\times8\frac{3}{4}''$. British Museum, London.

In Roman times, the Egyptians continued to bury their dead in mummy cases, but painted portraits replaced the traditional masks. The painting medium is encaustic—colors mixed with hot wax.

portrait of an emperor (Fig. 3-43) depicts Severus and his family—his wife, Julia Domna, and their two sons, Caracalla and Geta. The tondo (circular) portrait is of special interest for two reasons beyond its aurvival. Severus's hair is tinged with gray, suggesting that his marble portraits also may have revealed his advancing age in this way. Also noteworthy is the erasure of Geta's face. When Caracalla (r. 211-217 CE) succeeded his father as emperor, he had his younger brother murdered, and ordered the Senate to damn Geta's memory. The Severan family portrait is an eloquent testimony to the long arm of Roman authority, which reached all the way to Egypt in this case. This kind of defacement of a rival's image is not unique to ancient sea a political tool more often and more systematically than any other civilization.

CARACALLA In the Severan family portrait, the artist portrayed Caracalla as a boy with long, curly Antonine hair. The portraits of Caracalla as emperor are very different. In a bust (FIG. 3-44) in Berlin, Caracalla appears in heroic nudity save for a mantle over much shorter than his father's—initiating a new fashion in male coiffure during the third century CE. More remarkable, however, is the moving characterization of Caracalla's personality, a further development from the groundbreaking introspection of Marcus Aurelius's likenesses. Caracalla's brow is knotted, and he abruptly turns his head over his left shoulder. The sculptor probably intended the facial expression and the dramatic movement to suggest energy and strength, but it appears to modern viewers as if the emperor suspects danger from behind. Caracalla had reason to be fearful. An suspects danger from behind. Caracalla had reason to be fearful. An suspects danger from behind. Caracalla had reason to be fearful. An suspects danger felled him in the sixth year of his rule.

3-44 Portrait bust of Caracalla, ca. 211–217 ce. Marble, I' $10\frac{4}{4}$ " high. Altesmuseum, Staatliche Museen zu Berlin, Berlin.

Caracalla's portraits introduced a new fashion in male coiffure, but are more remarkable for the dramatic turn of the emperor's head and the moving characterization of his personality.

depicts a priest of the Egyptian god Serapis. The technique is encaustic, in which the painter mixes colors with hot wax and then uses a spatula to apply the wax pigment. The priest's portrait exhibits the painter's masterful use of the brush and spatula to depict different textures and the play of light over the soft and delicately modeled face. Artists also applied encaustic to stone, and the mummy portraits give some idea of the original appearance of Roman marble portraits. According to Pliny, when Praxiteles (Figs. 2-47 and 2-48), perhaps the greatest marble sculptor of the ancient world, was asked which of his statues he preferred, the master replied, "Those that Wikias painted." This anecdote underscores the importance of col-

Late Empire

oration in ancient statuary.

By the time of Marcus Aurelius, two centuries after Augustus established the Pax Romana, Roman power was beginning to erode. It was increasingly difficult to keep order on the frontiers, and even within the Empire, many challenged the authority of Rome. The assassination of Marcus's son Commodus (r. 180–192 cE) brought the Antonine dynasty to an end. The economy was in decline, and the efficient imperial bureaucracy was disintegrating. Even the official state religion was losing ground to Eastern cults, Christianity among them. The Late Empire was a pivotal era in world history during which the polytheistic ancient world gradually gave way to the Christian Middle Ages.

THE SEVERANS Civil conflict followed Commodus's death. When it ended, an African-born general named Septimius Severus (r. 193–211 ce) was master of the Roman world. The only preserved painted

3-43 Painted portrait of Septimius Severus and his family, from Egypt, ca. 200 ce. Tempera on wood, I' 2" diameter. Altesmuseum, Staatliche Museen zu Berlin, Berlin.

This only known painted portrait of an emperor shows Septimius Severus with gray hair. With him are his wife, Julia Domna, and their two sons, but Geta's head was removed after his damnatio memoriae.

3-45 Plan of the Baths of Caracalla, Rome, Italy, 212–216 CE. (1) natatio, (2) frigidarium, (3) tepidarium, (4) caldarium, (5) palaestra.

Caracalla's baths could accommodate 1,600 bathers. They resembled a modern health spa and included libraries, lecture halls, and exercise courts in addition to bathing rooms and a swimming pool.

BATHS OF CARACALLA The Severans were active builders in the capital, and even during his short reign, Caracalla built the greatest in a long line of imperial bathing and recreational complexes intended to win the public's favor. The Baths of Caracalla (FIG. 3-45) covered an area of almost 50 acres. All the rooms had thick brick-faced concrete walls up to 140 feet high, covered by enormous concrete vaults. The design was symmetrical along a central axis, facilitating the Roman custom of taking sequential plunges in warm-, hot-, and cold-water baths in, respectively, the tepidarium, caldarium, and frigidarium. There were stucco-covered vaults, mosaic floors, marble-faced walls, and colossal statuary throughout the complex, which also had landscaped gardens, lecture halls, libraries, colonnaded exercise courts (palaestras), and a giant swimming pool (natatio). Archaeologists estimate that up to 1,600 bathers at a time could enjoy this Roman equivalent of a modern health spa. A branch of one of the city's major aqueducts supplied water, and furnaces circulated hot air through hollow floors and walls throughout the bathing rooms.

The concrete vaults of the Baths of Caracalla collapsed long ago, but a good idea of the original appearance of the central bathing hall can be gleaned from the nave (FIG. 3-46) of Santa Maria degli Angeli in Rome, which was once the frigidarium of the later Baths of Diocletian. Although the interior of that Renaissance church has many new features foreign to a Roman bath, its rich wall treatment, colossal columns, immense groin vaults, and clerestory lighting provide a better sense of what it was like to be in a Roman imperial bathing complex than does any other building in the world.

3-46 Frigidarium, Baths of Diocletian, Rome, ca. 298–306 CE (remodeled by MICHELANGELO BUONARROTI as the nave of Santa Maria degli Angeli, 1563).

The groin-vaulted nave of the church of Santa Maria degli Angeli in Rome was once the frigidarium of the Baths of Diocletian. It gives an idea of the lavish adornment of imperial Roman baths.

popular Eastern mystery religions. On the youth's forehead is the emblem of Mithras, the Persian god of light, truth, and victory over death.

PHILOSOPHER SARCOPHAGUS The insecurity of the times led some Romans to seek solace in philosophy. On the sarcophagus illustrated here (FIG. 3-49), the deceased assumed the role of the learned intellectual, posing as a seated Roman philosopher holding a scroll. Two standing women (also with portrait features) gaze at him from left and right, confirming his importance. In the background are other philosophers, students or colleagues of the central ground are other philosophers, students or colleagues of the central daughter, two sisters, or some other combination of family members. The composition, with a frontal central figure and two subordinate flanking figures, is typical of what art historians call the Late dinate flanking figures, is typical of what art historians call the Late popular for Christian burials. Sculptors used the wise-man motif to portray not only the deceased but also Christ flanked by saints to portray not only the deceased but also Christ flanked by saints (FIG. 4-1b).

portrait reveals the anguished soul of the man—and of the times. and chiseling deep lines in the forehead and around the mouth. The at the level of the eyes, incising the hair and beard into the stone, the marble as if it were pliant clay, compressing the sides of the head to restore order to an out-of-control world. The sculptor modeled directly, revealing the anxiety of a man who knows he can do little The eyes glance away nervously rather than engage the viewer tians as an old man with bags under his eyes and a sad expression. for example, show the emperor best known for persecuting Chrisnical virtuosity. Portraits (FIG. 3-47) of Trajan Decius (r. 249-251), are as notable for their emotional content as they are for their techportraits, artists fashioned likenesses of the soldier emperors that lowing the lead of the sculptors of the Marcus Aurelius and Caracalla duced some of the most moving portraits in the history of art. Folunstable times of the so-called soldier emperors nonetheless proturn by another general a few years or even a few months later. The emperor one general after another, only to have each murdered in tury of almost continuous civil war. The Roman legions declared as TRAJAN DECIUS The assassination of Caracalla opened a half cen-

ists felt with the Classical style. the increasing dissatisfaction that third-century CE artan emphatic rejection of perspective, and underscores illusion of space behind them. This piling of figures is emotive figures evenly across the entire relief, with no the Goths. The sculptor spread the writhing and highly Romans battling one of their northern foes, probably tury is decorated on the front with a chaotic scene of Sarcophagus (FIG. 3-48)—dating to the mid-third cen-An unusually large sarcophagus—the Ludovisi Battle the imperial family practiced it in place of cremation. burial of the dead had become so widespread that even sudden demand for sarcophagi. By the third century CE, Whatever the explanation, the shift to burial led to a adherents believed in an afterlife for the human body. ence of Christianity and other Eastern religions, whose This reversal of funerary practices may reflect the influnines, Romans began to favor burial over cremation. Hadrian and especially during the rule of the Anto-LUDOVISI BATTLE SARCOPHAGUS Under Trajan and

Within the dense mass of intertwined bodies, the central horseman stands out vividly. He wears no helmet and thrusts out his open right hand to demonstrate that he holds no weapon. Several scholars have identified him as one of the sons of Trajan Decius. In an age when the Roman army was far from invincible and emperors were constantly assassinated by other Romans, this young general boasts that he is a fearless commander assured of victory. His self-assurance may stem from his having embraced one of the increasingly stem from his having embraced one of the increasingly

3-47 Portrait bust of Trajan Decius, 249–251 CE. Marble, full bust 2' 7" high; detail 1' 7" high. Museo Capitolino, Musei Capitolini, Rome.

This portrait of a short-lived soldier emperor depicts an older man with bags under his eyes and a sad expression. The eyes glance away nervously, reflecting the anxiety of an insecure ruler.

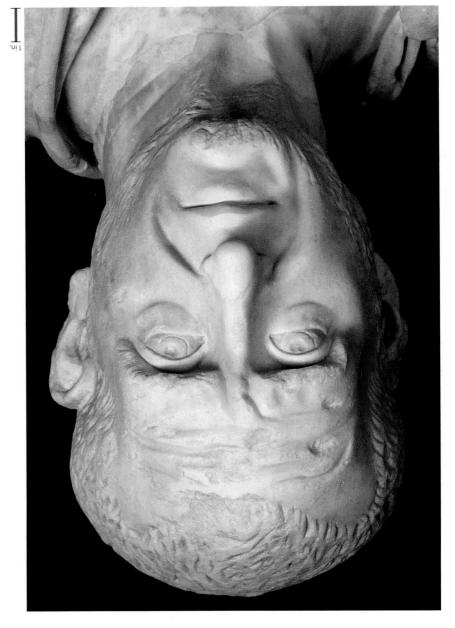

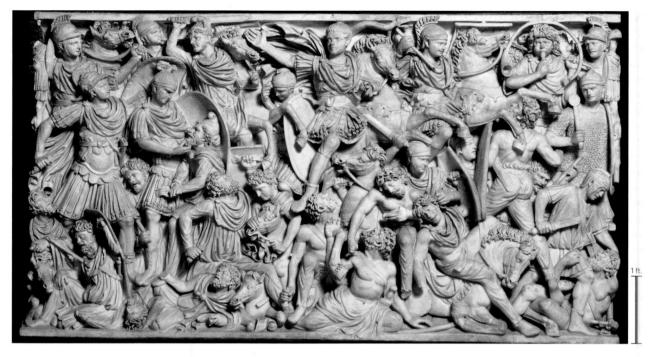

3-48 Sarcophagus with battle of Romans and barbarians (Ludovisi Battle Sarcophagus), from Rome, Italy, ca. 250-260 CE. Marble, 5' high. Palazzo Altemps, Museo Nazionale Romano, Rome.

A chaotic scene of battle between Romans and barbarians decorates the front of this sarcophagus. The sculptor piled up the writhing, emotive figures in an emphatic rejection of classical perspective.

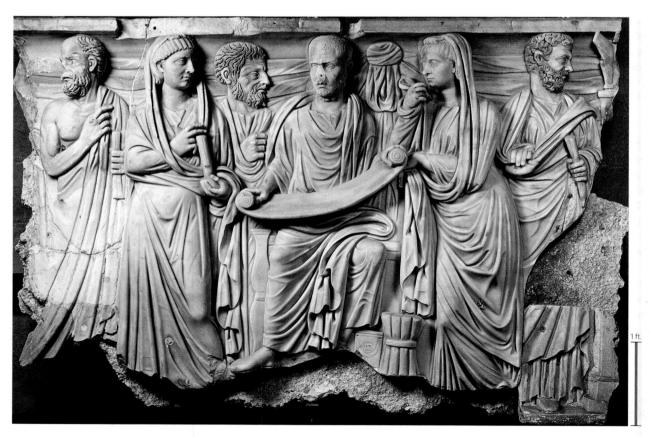

3-49 Sarcophagus of a philosopher, ca. 270-280 CE. Marble, 4' 11" high. Musei Vaticani, Rome.

On many third-century CE sarcophagi, the deceased appears as a learned intellectual. Here, the seated philosopher is the central frontal figure. His two female muses also have portrait features.

PROBLEMS AND SOLUTIONS Tetrarchic Portraiture

With the establishment of the tetrarchy in 293 cE, the sculptors in the emperors' employ suddenly had to grapple with a new problem—namely, how to represent four individuals who oversaw different regions of a vast empire but were equal partners in power. Although in life the four tetrarchs were rarely in the same place, in art they usu-

The finest extant tetrarchic portraits are the two pairs of porphyry (purple marble) statues (Fig. 3-50) that have since medieval times adorned the southwestern corner of the great church dedicated to Saint Mark in Venice. In this and similar tetrarchic group portraits, it is impossible to name the rulers. Each of the four emperors has lost the tetrarchy. All the tetrarchs are identically clad in cuirass and cloak. Each greaps a sheathed sword in his left hand. With their right arms, the corulers embrace one another in an overt display of concord. The figures have large cubical heads and squat bodies. The drapery is schetigures have large cubical heads and squat bodies. The drapery is schedistinguished only by the beards of two of the tetrarchs (probably the older Augusti, differentiating them from the younger Caesars). Other older Augusti, differentiating them from the younger Caesars). Other than the presence or absence of facial hair, each pair is as alike as freethan the presence or absence of facial hair, each pair is as alike as freethan the presence or absence of facial hair, each pair is as alike as freethan the presence or absence of facial hair, each pair is as alike as freethan the presence or absence of facial hair, each pair is as alike as freethan the presence or absence of facial hair, each pair is as alike as freethan the presence or absence of facial hair, each pair is as alike as freethan the presence or absence of facial hair, each pair is as alike as freethan the presence or absence of facial hair, each pair is as all ke as freethan the same and appear as all the as all the as freethan the same and appear as all the as all the appear and appear as all the appear and appear and appear and appear as all the appear appear and appear and appear and appear appear appear appear and appear appear appear and appear appea

ally appeared together, both on coins and in statues. Artists did not try to capture their individual appearances and personalities—the norm in portraiture of the preceding soldier emperors (Fig. 3-47)—but sought

In this group portrait, carved eight centuries after Greek sculptors first freed the human form from the rigidity of the Egyptian-inspired kouros stance, an artist or artists once again conceived the human figure in iconic terms. Idealism, naturalism, individuality, and personality have disappeared, replaced by a new approach to representing the human figure that was perfectly suited to the portrayal of four corulers.

hand carving can achieve.

3-50 Portraits of the four tetrarchs, from Constantinople, ca. 305 CE. Porphyry, 4' 3" high. Saint Mark's, Venice.

Diocletian established the tetrarchy to bring order to the Roman world. In group portraits, artists always depicted the four rulers as nearly identical partners in power, not as distinct individuals.

East, issued the Edict of Milan, ending persecution of Christians. In time, Constantine and Licinius became foes, and in 324 Constantine defeated and executed Licinius near Byzantium (modern Istanbul, Turkey). Constantine, now unchallenged ruler of the whole Roman Empire, founded a "New Rome" at the site of Byzantium and named it Constantinople (City of Constantine). In 325, at the Council of Nicaea, Christianity became the de facto official religion of the Roman Empire. From this point on, the ancient cults declined rapidly. Constantine dedicated Constantinople on May 11, 330, "by the commandment of God," and in 337 the emperor was baptized on his deathbed.

For many scholars, the transfer of the seat of power from Rome to Constantinople and the recognition of Christianity mark the beginning of the Middle Ages. Constantinian art is a mirror of this transition from the classical to the medieval world. In Rome, for example, Constantine was a builder in the grand tradition of the emperors of the first, second, and early third centuries, constructing public baths, a basilica in the Forum Romanum, and a triumphal arch. But he was also the patron of the city's first churches (see phal arch. But he was also the patron of the city's first churches (see page 120).

TETRARCHY In an attempt to restore order to the Roman Empire, Diocletian (r. 284–305 cE), whose troops proclaimed him emperor, decided to share power with his potential rivals. In 293, he established the tetrarchy (rule by four) and adopted the title of Augustus of the East. The other three tetrarchs were a corresponding Augustus of the West, and Eastern and Western Caesars (whose allegiance to the two Augusti was cemented by marriage to their daughters). The four coemperors often appeared together in group portraits (Fig. 3-50) to underscore their harmonious partnership (see "Tetrarchic Portraiture," above).

among the tetrarchs ended with Diocletian's retirement in 305 CE. An all-too-familiar period of conflict among rival Roman armies followed. The eventual victor was Constantine (r. 306–337 CE), son of Constantius Chlorus, Diocletian's Caesar of the West. After the death of his father, Constantine invaded Italy in 312 and took control of Rome. Constantine attributed his decisive victory at the Miltrol of Rome. Constantine attributed his decisive victory at the Miltrol of Rome. Constantine attributed his decisive victory at the Miltrol of Rome. Constantine attributed his decisive victory at the Miltrol of Rome. Constantine attributed his decisive victory at the Miltrol of Rome. Constantine attributed his decisive victory at the Miltrol of Rome. Constantine and Licinius, Constantine's coemperor in the god. The next year, he and Licinius, Constantine's coemperor in the

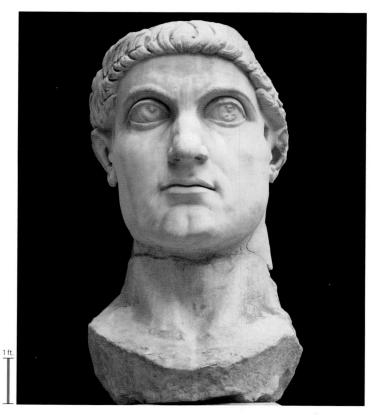

3-51 Portrait of Constantine, from the Basilica Nova (Fig. 3-52), Rome, Italy, ca. 315–330 CE. Marble, 8' 6" high. Palazzo dei Conservatori, Musei Capitolini, Rome.

Constantine's portraits revive the Augustan image of a perpetually youthful ruler. This colossal head is one fragment of an enthroned Jupiter-like statue of the emperor holding the orb of world power.

COLOSSUS OF CONSTANTINE The most impressive of Constantine's preserved portraits is an eight-and-one-half-foot-tall head (FIG. 3-51), one of several fragments of a colossal enthroned statue of the emperor composed of a brick core, a wood torso covered with bronze, and a head and limbs of marble. Constantine's artist modeled the seminude seated portrait on Roman images of Jupiter, but also resuscitated the Augustan image of a perpetually youthful head of state. The emperor held an orb (possibly surmounted by the cross of Christ), the symbol of global power, in his extended left hand. The colossal size, the likening of the emperor to Jupiter, the eyes directed at no person or thing of this world—all combine to produce a formula of overwhelming authority appropriate to Constantine's exalted position as absolute ruler.

BASILICA NOVA Constantine's gigantic portrait sat in the western apse of the Basilica Nova (New Basilica; FIGS. 3-9, no. 8, and 3-52) in Rome. From its position in the apse, the emperor's image dominated the interior of the basilica in much the same way that enthroned statues of Greco-Roman divinities loomed over awestruck mortals in temple cellas. The Basilica Nova ruins never fail to impress tourists with their size and mass. The original structure was 300 feet long and 215 feet wide. Brick-faced concrete walls 20 feet thick supported coffered barrel vaults in the aisles. These vaults also buttressed the groin vaults of the nave, which was 115 feet high. Marble slabs and stuccoes covered the walls and floors. The restored view (FIG. 3-52) effectively suggests the immensity of the interior, where the great vaults dwarf even the emperor's colossal portrait. The drawing also clearly reveals the fenestrated groin vaults, a lighting system akin to the clerestory of a traditional stone-and-timber basilica (FIG. 3-35, no. 4). The architect here applied to basilica design the lessons learned in the construction of buildings such as Trajan's great market hall (FIG. 3-37) and the Baths of Caracalla and Diocletian (FIG. 3-46).

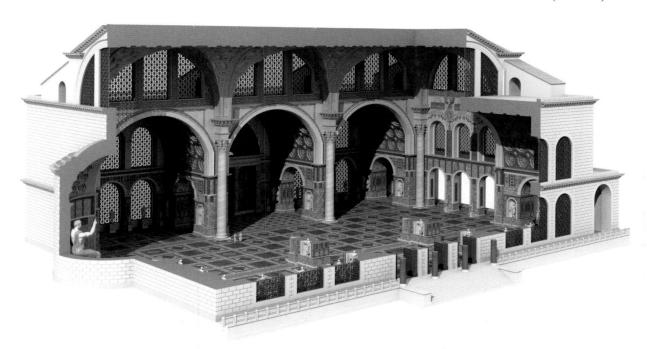

3-52 Restored cutaway view of the Basilica Nova, Rome, Italy, ca. 306-312 CE (John Burge).

Roman builders applied the lessons learned constructing baths and market halls to the Basilica Nova, in which fenestrated concrete groin vaults replaced the clerestory of a stone-and-timber basilica.

113

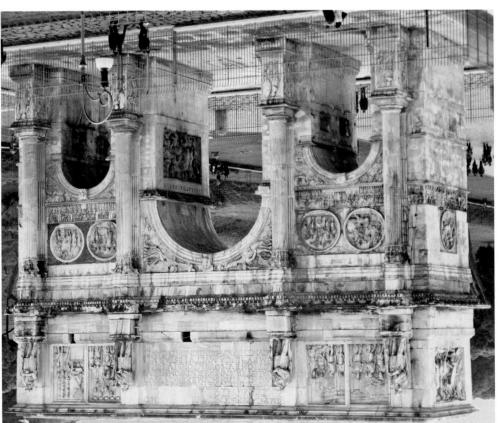

tine's arch came from monuments of Trajan, Much of the sculptural decoration of Constanwest), Rome, Italy, 312-315 CE.

Constantine's features. the heads of the earlier emperors to substitute Hadrian, and Marcus Aurelius. Sculptors recut

3-53 Arch of Constantine (looking south-

to associate Constantine with famous reused sculptures were carefully selected part deserved, it ignores the fact that the Empire. Although such a judgment is in and technical skill in the Late Roman as evidence of a decline in creativity ans have cited the Arch of Constantine ors with his features. Some art historirecutting the heads of the earlier empersecond-century reliefs to honor him by Constantine's sculptors refashioned the Trajan, Hadrian, and Marcus Aurelius. decoration from earlier monuments of however, took much of the sculptural end of the Severan dynasty. The builders, was the largest set up in Rome since the erected next to the Colosseum. The arch 3-9, no. 10, and 3-53) that Constantine ose is the triple-passageway arch (FIGS. -ibnstg oela Also grandi-

statues of Hadrian and Marcus Aurelius. stantine on the speaker's platform in the Forum Romanum between ian reliefs (not illustrated) underscores that message. It shows Conemperors of the second century. One of the arch's few Constantin-

mechanical and repeated stances and gestures of puppets. The relief to any Classical principle of naturalistic motion, but rather with the proportion, like the tetrarchs (FIG. 3-50). They move, not according throne above the recipients of his generosity. The figures are squat in and left. Constantine is a frontal and majestic presence, elevated on a tributes largesse to grateful citizens, who approach him from right In another Constantinian relief (FIG. 3-54), the emperor dis-

Constantine, Rome, Italy, 312-315 CE. Marble, 3' 4" high. 3-54 Distribution of largesse, detail of the north frieze of the Arch of

would come to dominate medieval art. frozen in time. The composition's rigid formality reflects the new values that This Constantinian frieze is less a narrative of action than a picture of actors

An eminent art historian once characterized this approach to gesse (below), both of smaller stature than the emperor. attendants (to the left and right above) and the recipients of the larimperial donor (the largest figure, enthroned at the center) from his frozen in time so that the viewer can distinguish the all-important incised. The frieze is less a narrative of action than a picture of actors

is very shallow, the forms are not fully modeled, and the details are

and thereby paving the way for the iconic art of the Middle Ages. sculptures while rejecting the norms of Classical design in its frieze era, exhibiting a respect for the past in its reuse of second-century art. The Arch of Constantine is the quintessential monument of its ent from, but not "better" or "worse" than, those of Greco-Roman Antique style are those of early medieval art. They were very differicon (FIG. 4-20) reveals that the compositional principles of the Late dotal action. Comparing this Constantinian relief with a Byzantine the Classical notion that a picture is a window onto a world of aneca new set of values. It soon became the preferred mode, supplanting ity, determined by the rank of those portrayed, was consistent with standards of Classical art, it was. But the composition's rigid formalpictorial narrative as a "decline of form," and when judged by the

following additional subjects: buildings, Google Earth $^{\text{\tiny TM}}$ coordinates, and essays by the author on the ■ Explore the era further in MindTap with videos of major artworks and

■ WRITTEN SOURCES: Vitruvius's Ten Books on Architecture ■ ART AND SOCIETY: The "Audacity" of Etruscan Women

- Maison Carrée, Mîmes (FIG. 3-28A)
- ART AND SOCIETY: Spectacles in the Colosseum
- Aerial view of the Colosseum, Rome (FIG. 3-30A)
- Three details of the Column of Trajan, Rome (FIGS. 3-36A, 3-36B, and

THE ROMAN EMPIRE

Etruscan Art

The Etruscans admired Greek art and architecture but did not copy Greek works. They constructed their temples of wood and mud brick instead of stone and placed the columns and stairs only at the front. Terracotta statuary decorated the roof. Most surviving Etruscan artworks come from underground tomb chambers. At Cerveteri, earthen mounds (tumuli) covered tombs with interiors sculptured to imitate the houses of the living. At Tarquinia, painters adorned tomb walls with frescoes, usually depicting funerary banquets.

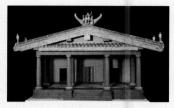

Model of a typical Etruscan temple, sixth century BCE

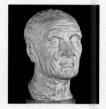

Head of a patrician, mid-first century BCE

Republican Art

In the centuries following the establishment of the Republic (509–27 BCE), Rome conquered its neighbors in Italy and then moved into Greece, bringing exposure to Greek art and architecture. Republican temples combined Etruscan plans with the Greek orders, and houses boasted peristyles with Greek columns. The Romans, however, pioneered the use of concrete as a building material. The First Style of mural painting derived from Greece, but the illusionism of the Second Style is distinctly Roman. Republican portraits were usually superrealistic likenesses of elderly patricians.

Early Imperial Art

- Augustus (r. 27 BCE-14 CE) established the Roman Empire after defeating Antony and Cleopatra. The Early Empire (27 BCE-96 CE) extends from Augustus to the Flavian emperors (r. 68-96 CE).
- Augustan art celebrated the emperor's establishment of peace and revived the Classical style with frequent references to Periclean Athens. Augustus's portraits always depict him as an idealized youth. Under the Flavians, architects exploited the full potential of concrete in buildings such as the Colosseum, the largest amphitheater in the Roman world. The eruption of Mount Vesuvius in 79 cE buried Pompeii and Herculaneum, preserving Early Imperial murals of the Third and Fourth Styles.

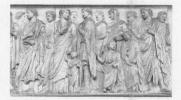

Ara Pacis Augustae, Rome, 13-9 BCE

High Imperial Art

- During the High Empire (96-192 cE), beginning with Trajan (r. 98-117 cE), the Roman Empire reached its greatest extent.
- Trajan's new forum and markets transformed the center of Rome. The Column of Trajan commemorated his Dacian campaigns in a spiral frieze with some 2,500 figures. Hadrian (r. 117–138 cE) built the Pantheon, the temple to all the gods, incorporating in its design the forms of the orb of the earth and the dome of the heavens. Under the Antonines (r. 138–192 cE), imperial artists introduced a psychological element in portraiture.

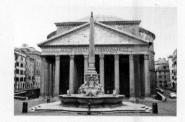

Pantheon, Rome, 118-125 CE

Late Imperial Art

- The Late Empire (193–337 cE) opened with the Severans (r. 193–235 cE) and closed with Constantine (r. 306–336 cE), who ended persecution of the Christians and transferred the imperial capital from Rome to Constantinople in 330.
- During the chaotic era of the soldier emperors (r. 235–284 cE), artists revealed the anxiety and insecurity of the emperors in moving portraits. Diocletian (r. 284–305 cE) reestablished order by sharing power. Statues of the tetrarchs portray the four emperors as identical and equal rulers, not as individuals. Constantine restored one-man rule. The abstract formality of Constantinian art paved the way for the iconic art of the Middle Ages.

Arch of Constantine, Rome, 312–315 ce

enthroned Christ is long-haired and youthful in the Early Christian tradition. Below him is the personified Roman sky god. Flanking the new ruler of the universe are Saints beter and Paul.

▲4-1a Episodes from the Hebrew scriptures, including Abraham's sacrifice of Isaac, appear beside scenes from the life of Iesus on the sarcophagus of Junius Bassus, a recent convert to Christianity.

Sarcophagus of Junius Bassus, from Rome, Italy, ca. 359. Marble, 3' 10 $\frac{1}{2}$ " × 8'. Museo Storico del Tesoro della Basilica di San Pietro, Rome.

► 4-1c The Jewish scenes on this mid-fourth-century sarcophagus had special significance for Christians. Adam and Eve's original sin of eating the apple in the Garden of Eden necessitated Christ's sacrifice.

L-b

Early Christianity and Byzantium

ROMANS, JEWS, AND CHRISTIANS

During the third and fourth centuries, a rapidly growing number of Romans rejected *polytheism* (belief in multiple gods) in favor of *monotheism* (the worship of a single all-powerful god)—but they did not stop commissioning works of art picturing the divine. A prominent example is Junius Bassus, the midfourth-century city prefect of Rome who converted to Christianity and, according to the inscription on his sarcophagus (FIG. 4-1), was baptized just before his death in 359. He grew up immersed in traditional Roman culture and initially paid homage to the old Roman gods, but when he died, he chose to be buried in a sarcophagus decorated with episodes from the Hebrew scriptures and the life of Jesus.

The sculptor of Junius Bassus's sarcophagus decorated the front with 10 figural scenes in two rows of five compartments, each framed by columns, a well-established format for Roman sarcophagi. However, the deceased does not appear in any of those compartments. Instead, Jewish and Christian biblical stories fill the niches. Jesus has pride of place and appears in the central compartment of each row: enthroned between Saints Peter and Paul (FIG. 4-1b), and entering Jerusalem on a donkey. Both compositions derive from official Roman art. In the upper zone, Jesus, like an enthroned Roman emperor, sits above the sky god, who holds a billowing mantle over his head, indicating that Christ is ruler of the cosmos. The scene below is based on portrayals of Roman emperors entering conquered cities on horseback, but Jesus's steed and the absence of imperial attributes break sharply with the imperial models that the sculptor used as compositional sources.

The Jewish scenes on the Junius Bassus sarcophagus include the stories of Adam and Eve (FIG. 4-1c) and Abraham and Isaac (FIG. 4-1a), which took on added significance for Christians as foretelling events in the life of their savior (see "Jewish Subjects in Christian Art," page 119). Christians believe that Adam and Eve's original sin of eating the apple in the Garden of Eden ultimately necessitated Christ's sacrifice for the salvation of humankind. Christians view the Genesis story of Abraham's willingness to sacrifice his son as a parallel to God's sacrifice of his son, Jesus.

The crucifixion, however, does not appear on this sarcophagus and was rarely depicted in Early Christian art. Artists emphasized Jesus's exemplary life as teacher and miracle worker, not his suffering and death at the hands of the Romans (see "The Life of Jesus in Art," pages 120–121). Nonetheless, this sculptor alluded to the crucifixion in the scenes in the two compartments at the upper right depicting Jesus being led before Pontius Pilate for judgment. The Romans condemned and executed Jesus, but he triumphantly overcame death. Junius Bassus hoped for a similar salvation.

lished Christianity as a legal religion with equal or superior standing it (see page 112). In 313, he issued the Edict of Milan, which estabthe Christian god as the source of his power rather than a threat to tion ended only when Constantine (r. 306-337; FIG. 3-51) embraced as well as the traditional pantheon of gods and goddesses). Persecuto the Roman state's official gods (which included deified emperors

Catacombs

to the traditional Roman cults.

their tomb chambers beneath earthen tumuli (FIGS. 3-5 and 3-6). catacombs out of the tufa bedrock, much as the Etruscans excavated means "in the hollows." The Christian community tunneled the cemeteries. The name derives from the Latin ad catacumbas, which vast underground networks of galleries and chambers that served as Most of the Early Christian art in Rome is found in the catacombs-

EARLY CHRISTIANITY

authority, because the Christians refused to pay even token homage appeal grew, so too did the Roman state's fear of weakening imperial tions under Trajan Decius (r. 249–251; FIG. 3-47). As Christianity's cutions in 303 to 305, a half century after the last great persecuin the Roman army ranks that he ordered a fresh round of persebecame so concerned by the growing popularity of Christianity Empire. For example, the emperor Diocletian (r. 284–305; FIG. 3-50) the time when Christians were a persecuted minority in the Roman dated before the late third and early fourth centuries*—that is, to art of Christians at the time of Jesus. Few Christian artworks can be the earliest preserved artworks having Christian subjects, not the historians speak about "Early Christian art," they are referring to Very little is known about the art of the first Christians. When art

*From this point on, all dates are CE unless otherwise indicated.

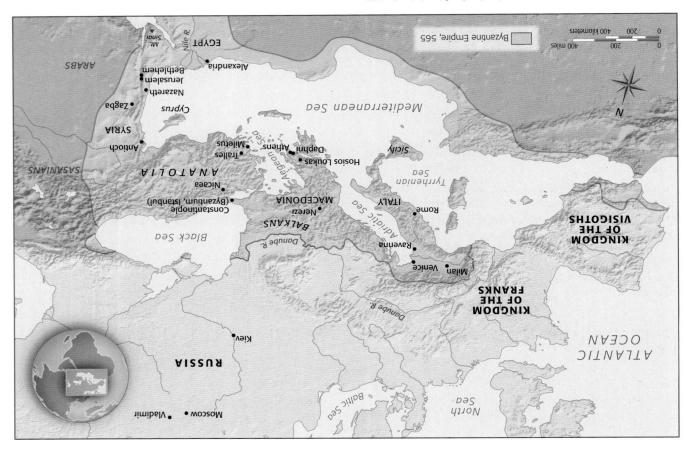

MAP 4-1 The Byzantine Empire at the death of Justinian in 565.

EARLY CHRISTIANITY AND BYZANTIUM

Middle and Late Byzantine

Iconoclasm

726-843

- Theodora repeals iconoclasm in 843.
- decorative patterning, Greek-cross plans, Churches feature exterior walls with
- Ivory triptychs for personal prayer become and domes on drums.
- Michael VIII recaptures Constantinople
- after the Crusader sack of 1204.
- in 1453. Constantinople falls to the Ottoman Turks

bendentives. with a 180-foot-high dome resting on Justinian (r. 527-565) builds Hagia Sophia

nestinian to Iconoclasm

- at Ravenna with its rich mosaic program in Bishop Maximianus dedicates San Vitale
- Leo III bans picturing the divine in 726. Icon painting flourishes at Mount Sinai until

Earliest Christian catacomb paintings and Early Christian

- first churches in Rome and founds Constantine (r. 306-337) constructs the sarcophagi appear in the third century.
- Mosaics become the primary medium for Constantinople as the New Rome.

1-257

RELIGION AND MYTHOLOGY Jewish Subjects in Christian Art

When the Christians codified the Bible in its familiar form, they incorporated the Hebrew Torah and other writings, and designated the Jewish books as the "Old Testament" in contrast to the Christian books of the "New Testament." From the beginning, the Hebrew scriptures played an important role in Christian life and Christian art, in part because Jesus was a Jew and so many of the first Christians were converted Jews, but also because Christians came to view many of the persons and events of the Old Testament as prefigurations of New Testament persons and events. Christ himself established the pattern for this kind of biblical interpretation when he compared Jonah's spending three days in the belly of the sea dragon (usually translated as "whale" in English) to the comparable time he would be entombed in the earth before his resurrection (Matt. 12:40). In the fourth century, Saint Augustine (354-430) confirmed the validity of this reading of the Old Testament when he stated that "the New Testament is hidden in the Old; the Old is clarified by the New."*

The following are three of the most popular Jewish biblical stories depicted in Early Christian art:

- Adam and Eve (FIG. 4-1c) Eve, the first woman, tempted by a serpent, ate the forbidden fruit of the tree of knowledge and fed some to Adam, the first man. As punishment, God expelled Adam and Eve from Paradise. This "original sin" ultimately led to Christ's sacrifice on the cross so that all humankind could be saved. Christian theologians often consider Christ the new Adam and his mother, Mary, the new Eve.
- Sacrifice of Isaac (FIG. 4-1a) God instructed Abraham, the father of the Hebrew nation, to sacrifice his son Isaac as proof of his faith. When it became clear that Abraham would obey, the Lord sent an angel to restrain him and provided a ram for sacrifice in Isaac's place. Christians view this episode as a prefiguration of the sacrifice of God's son, Jesus.
- Jonah (FIGS. 4-2) The Old Testament prophet Jonah had disobeyed God's command. In his wrath, the Lord caused a storm

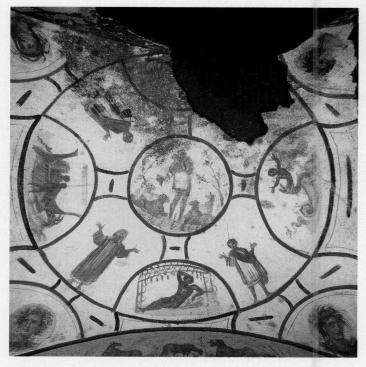

4-2 The Good Shepherd, the story of Jonah, and orants, frescoed ceiling of a cubiculum in the Catacomb of Saints Peter and Marcellinus, Rome, Italy, early fourth century.

Christian catacomb paintings often mixed Old and New Testament themes. Jonah was a popular subject because he emerged safely from a sea monster after three days, prefiguring Christ's resurrection.

while Jonah was at sea. Jonah asked the sailors to throw him overboard, and the storm subsided. A sea dragon then swallowed Jonah, but God answered his prayers, and the monster spat Jonah out after three days, foretelling Christ's resurrection (see "The Life of Jesus in Art," pages 120-121).

*Augustine, City of God, 16.26.

The catacombs are less elaborate than the Etruscan tombs, but much more extensive. The known catacombs on the outskirts of Rome run for 60 to 90 miles and housed as many as four million bodies.

PETER AND MARCELLINUS Often, the Christians carved out small rooms, called cubicula (as in Roman houses), to serve as mortuary chapels opening off the catacomb galleries. The painted ceiling (FIG. 4-2) of a cubiculum in the Catacomb of Saints Peter and Marcellinus in Rome features a large circle enclosing the symbol of the Christian faith, the cross. The arms of the cross end in four lunettes (semicircular frames) illustrating the key episodes from the biblical story of Jonah. Sailors throw Jonah from his ship on the left. He emerges on the right from the sea dragon that swallowed him. At the bottom, safe on land, Jonah contemplates the miracle of his salvation and the mercy of God. Jonah was a popular figure in Early Christian painting and sculpture because Christians regard him as a

prefiguration (prophetic forerunner) of Christ (see "Jewish Subjects in Christian Art," above).

A man, a woman, and at least one child occupy the compartments between the Jonah lunettes. They are orants (praying figures), raising their arms in the ancient attitude of prayer. Together they make up a cross-section of the Christian family seeking a heavenly afterlife. The central medallion shows Christ as the Good Shepherd (compare FIG. 4-2A 1), whose powers of salvation the painter underscored by placing the four episodes of the Jonah story around him. In Early Christian art, Jesus often appears as the youthful and loyal protector of the Christian flock who said to his disciples, "I am the good shepherd; the good shepherd gives his life for the sheep" (John 10:11). Only after Christianity became the Roman Empire's official religion in 380 did Christ take on in art such imperial attributes as the halo, the purple robe, and the throne, which denoted rulership (see "The Life of Jesus in Art," pages 120-121).

the prophesied savior of humankind. would not die until he had seen the Messiah, recognizes Jesus as

- all infants in Bethlehem, but an angel warns the holy family, and fearful that a rival king has been born, orders the massacre of Massacre of the Innocents and Flight into Egypt King Herod,
- scholars in the temple, foretelling his ministry. at the time, engages in learned debate with astonished Jewish from bondage to the pharaohs of Egypt). Jesus, only 12 years old the feast of Passover (the celebration of the release of the Jews Dispute in the Temple Joseph and Mary travel to Jerusalem for they escape to Egypt.

PUBLIC MINISTRY

The public-ministry cycle comprises the teachings of Jesus and the

by John the Baptist in the Jordan River. The Holy Spirit appears, Baptism lesus's public ministry begins with his baptism at age 30 miracles he performed.

- fish into enough food to feed several thousand people. example, Jesus transforms a few loaves of bread and a handful of ing on water. In the miracle of loaves and fishes (Fig. 4-8), for healing and raising the dead, turning water into wine, and walkmany miracles, revealing his divine nature. These include acts of Peter and the tax collector Matthew (Fig. 10-9). Jesus performs Jesus enlists 12 disciples, or apostles, including the fisherman Apostles and Miracles In the course of his teaching and travels, and God's voice proclaims Jesus as his son.
- that Peter is the rock on which his church will be built, and sym-Peter (whose name means "rock") as his successor. He declares Delivery of the Keys to Peter (FIG. 8-34) Jesus chooses the apostle
- gelist, transforms into radiant light. God, speaking from a cloud, ence of Peter and two other disciples, James and John the Evan-Transfiguration Jesus scales a high mountain and, in the presbolically delivers to Peter the keys to the kingdom of Heaven.
- He rebukes them and drives them out of the sacred precinct. moneychangers and merchants conducting business in the temple. Cleansing of the Temple lesus returns to lerusalem, where he finds discloses that Jesus is his son.

The plan and elevation of the immense church, capable of hous-

this rock [in Greek, petra] I will build my church" (Matt. 16:18).

fulfilled Jesus's prophecy when he said, "Thou art Peter, and upon

the Christian martyr at his reputed grave. Old Saint Peter's therefore

have in fact revealed a second-century memorial erected in honor of

buried. Excavations in the Roman cemetery beneath the church

Rome, its first pope, and one of the first Christian saints—had been

believed that Peter-the founder of the Christian community in

on the spot where the emperor and Pope Sylvester (r. 314-335)

replacement for the Constantinian structure. Old Saint Peter's stood

as early as 319. The present-day church (FIGS. 10-2 and 10-3) is a Rome was Old Saint Peter's (FIGS. 4-3 and 4-4), probably begun

OLD SAINT PETER'S The greatest of Constantine's churches in

The Life of Jesus in Art RELIGION AND MYTHOLOGY

artworks.

rize at the outset the entire cycle of events as they usually appear in depicted many of the events of Jesus's life, it is useful to summathe present day. Although during certain periods artists rarely, if ever, been the subject of countless artworks from Roman times through his execution by the Romans and subsequent ascent to Heaven—has from the womb of a virgin mother, his preaching and miracle working, esied Messiah (Savior, Christ) of the Jews. His life—his miraculous birth Christians believe that Jesus of Nazareth is the son of God, the proph-

INCARNATION AND CHILDHOOD

tion (incarnation), birth, infancy, and childhood. The first "cycle" of the life of Jesus consists of the events of his concep-

- God's presence at the incarnation by a dove, the symbol of the Holy and give birth to God's son, Jesus. Artists sometimes indicated announces to the Virgin Mary that she will miraculously conceive Annunciation to Mary (FIGS. 7-35 and 8-23) The archangel Gabriel
- Elizabeth is the first to recognize that the baby in Mary's womb is older cousin, who is pregnant with the future John the Baptist. Visitation (FIG. 7-15) The pregnant Mary visits Elizabeth, her Spirit, the third "person" of the Trinity with God the Father and Jesus.
- shepherds in the field. the newborn, while an angel announces the birth of the Savior to and placed in a basket. Mary and her husband, Joseph, marvel at of the Shepherds (Fig. 8-8) Jesus is born at night in Bethlehem Nativity (FIG. 7-28), Annunciation to the Shepherds, and Adoration the son of God.
- gifts to the infant Jesus. They travel 12 days to find the holy family and present precious men (magi) in the East that the King of the Jews has been born. Adoration of the Magi (FIG. 8-20) A bright star alerts three wise
- the temple in Jerusalem, where the aged Simeon, who God said Presentation in the Temple Mary and Joseph bring their son to

Architecture and Mosaics

modate only a small community.

worship were usually remodeled private houses that could accoming number of worshipers. Prior to Constantine, Christian places of tian liturgy (the ritual of public worship) to house a rapidly growbuildings designed specifically to meet the requirements of Chrisof his crucifixion (MAP 4-1). And he also built Rome's first churches, notably Bethlehem, the birthplace of Jesus, and Jerusalem, the site "New Rome" in the East, and at sites sacred to Christianity, most Christian shrines not only in Rome but also in Constantinople, his major patron of Christian architecture. He constructed elaborate the city (FIGS. 3-52 and 3-53). But Constantine also was the first and he was (for his time) a builder on a grand scale in the heart of safeguard the ancient Roman religion, traditions, and monuments, ity throughout the Empire. As emperor, he was, of course, obliged to tory, and in lifelong gratitude he protected and advanced Christian-Constantine believed that the Christian god had guided him to vic-

of polytheistic shrines, but practical considerations also contributed standably, did not want their houses of worship to mimic the form than the design of any Greco-Roman temple. The Christians, underbasilicas, such as Trajan's Basilica Ulpia (FIG. 3-35, no. 4), rather ing 3,000 to 4,000 worshipers at one time, resemble those of Roman

PASSION

The passion (from Latin *passio*, "suffering") cycle includes the episodes leading to Jesus's death, resurrection, and ascent to Heaven.

- **Entry into Jerusalem** (FIG. 4-1, bottom center) On the Sunday before his crucifixion (Palm Sunday), Jesus rides triumphantly into Jerusalem on a donkey, accompanied by disciples. People place palm fronds in his path.
- Last Supper (FIGS. 8-24 and 9-3) In Jerusalem, Jesus celebrates Passover with his disciples. During this last supper, Jesus foretells his imminent betrayal, arrest, and death and invites the disciples to remember him when they eat bread (symbol of his body) and drink wine (his blood). This ritual became the celebration of Mass (Eucharist).
- Agony in the Garden Jesus goes to the Mount of Olives in the Garden of Gethsemane, where he struggles to overcome his human fear of death by praying for divine strength.
- Betrayal and Arrest One of the disciples, Judas Iscariot, agrees to betray Jesus to the Jewish authorities in return for 30 pieces of silver. Judas identifies Jesus to the soldiers by kissing him, whereupon the soldiers arrest Jesus.
- Trials of Jesus (FIG. 4-1, top right) The soldiers bring Jesus before Caiaphas, the Jewish high priest, who interrogates Jesus about his claim to be the Messiah. Jesus is then brought before the Roman governor of Judaea, Pontius Pilate, on the charge of treason because he had proclaimed himself as the Jews' king. Pilate asks the crowd to choose between freeing Jesus or Barabbas, a murderer. The people select Barabbas, and the judge condemns Jesus to death. Pilate washes his hands, symbolically relieving himself of responsibility for the mob's decision.
- Flagellation and Mocking The Roman soldiers who hold Jesus captive whip (flagellate) him and mock him by dressing him as king of the Jews and placing a crown of thorns on his head.
- Carrying of the Cross, Raising of the Cross (FIG. 10-15), and Crucifixion (FIGS. 4-23 and 6-15) The Romans force Jesus to carry the cross on which he will be crucified from Jerusalem to Mount Calvary (Golgotha, the Place of the Skull, Adam's burial place). Jesus falls three times, and his robe is stripped along the way. Soldiers

- erect the cross and nail his hands and feet to it. Jesus's mother, John the Evangelist, and Mary Magdalene mourn at the foot of the cross, while the Roman soldiers torment Jesus. One of them (Longinus) stabs Jesus in the side with a spear. After suffering great pain, Jesus dies. The crucifixion occurred on a Friday, and Christians celebrate the day each year as Good Friday.
- **Deposition** (FIG. 8-7), **Lamentation** (FIG. 7-32), and **Entombment** Joseph of Arimathea and Nicodemus remove Jesus's body from the cross (the deposition) and take him to the tomb that Joseph had purchased for himself. Joseph, Nicodemus, the Virgin Mary, John the Evangelist, and Mary Magdalene mourn over the dead Jesus (the lamentation). (When in art the isolated figure of the Virgin Mary cradles her dead son in her lap, it is called a *Pietà* (FIGS. 7-27 and 9-7)—Italian for "pity.") In portrayals of the entombment, Jesus's followers lower his body into a sarcophagus in the tomb.
- Descent into Limbo During the three days he spends in the tomb, Jesus descends into Hell, or Limbo, and triumphantly frees the souls of the righteous, including Adam, Eve, Moses, David, Solomon, and John the Baptist.
- Resurrection (FIG. 8-34A 🕖) and Three Marys at the Tomb

 On the third day (Easter Sunday), Jesus rises from the dead and leaves the tomb while the Roman guards sleep. The Virgin Mary, Mary Magdalene, and Mary, the mother of James, visit the tomb but find it empty. An angel informs them of Jesus's resurrection.
- Noli Me Tangere and Doubting of Thomas During the 40 days between Jesus's resurrection and his ascent to Heaven, he appears on several occasions to his followers. Christ warns Mary Magdalene, weeping at his tomb, with the words "Don't touch me" (Noli me tangere in Latin), but he tells her to inform the apostles of his return. Later, he invites Thomas, who cannot believe that Jesus has risen, to touch the wound in his side received at his crucifixion.
- **Ascension** (FIG. 4-18A 🗹) On the 40th day, on the Mount of Olives, with his mother and some followers as witnesses, Christ gloriously ascends to Heaven in a cloud.

to their rejection of the classical temple type. Greco-Roman temples housed only the cult statue of the deity. All rituals took place outside at open-air altars. Therefore, architects would have found it difficult to adapt the classical temple to accommodate large numbers of people within it. The Roman basilica, in contrast, was ideally suited as a place for congregation, and Early Christian builders readily selected the basilica as the standard format for the first churches.

Like Roman basilicas, Old Saint Peter's had a wide central *nave* with flanking *aisles* and an *apse* at the end (FIG. 4-4). Worshipers entered the 300-foot-long nave through a *narthex*, or vestibule, whereupon they had an uninterrupted view of the altar and the officiating priest in the apse. In front of the building proper was an open colonnaded courtyard, very much like the forum proper in the Forum of Trajan (FIG. 3-35, no. 5) but called an *atrium*, like the central room in a private house. A special feature of the Constantinian basilica was the *transept*, or transverse aisle, an area perpendicular to the nave between the nave and apse. It housed Saint Peter's *relics* (the body parts, clothing, or any object associated with a saint or Christ;

see "Pilgrimages and the Veneration of Relics," page 170), which hordes of pilgrims came to see. The transept became a standard element of church design in the West only much later, when it also took on, with the nave and apse, the symbolism of the Christian cross.

Compared with Roman temples, which usually displayed statuary in pediments on their facades, most Early Christian basilicas were quite austere on the exterior. Inside, however, were frescoes and mosaics, marble columns, grandiose chandeliers, and gold and silver vessels on jeweled altar cloths for use in the Mass. In Saint Peter's, a huge marble *baldacchino* (domical canopy over an altar), supported by four spiral porphyry columns, stood at the *crossing* of the nave and transept, marking the location of Saint Peter's tomb. Some idea of the character of the interior and exterior of Old Saint Peter's can be gleaned from the restored view (FIG. 4-3) of the church and from the century-later basilica of Santa Sabina (FIGS. 4-4A and 4-4B) in Rome. The columns of both *nave arcades* produce a steady rhythm that focuses all attention on the apse, which frames the altar. In Santa Sabina, as in Old Saint Peter's, the

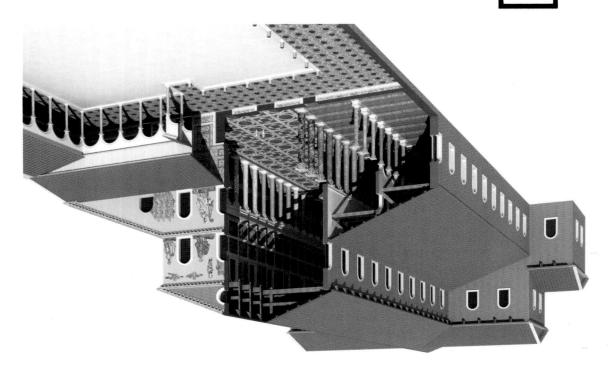

Built by Constantine, the first imperial patron of Christianity, this huge church stood over Saint Peter's grave. The building's plan and elevation resemble those of Roman pasilicas, not temples.

4-3 Restored cutaway view of Old Saint Peter's (looking northwest, with later mosaics decorating the east facade), Rome, Italy, begun ca. 319 (John Burge).

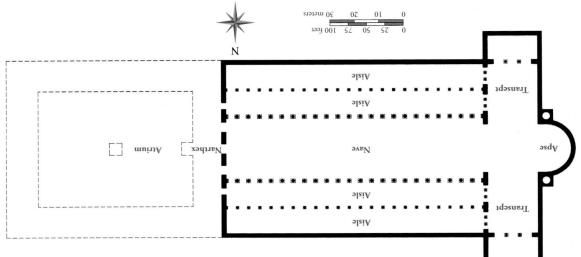

4-4 Restored plan of Old Saint Peter's, Rome, Italy, begun ca. 319.

Old Saint Peter's closely followed the plan of a Roman basilica and had a 300-footlong nave with flanking aisles leading to an apse, but unlike other early churches, it also other early churches, it also

A highly refined example of the central-plan design is Santa Costanza (Figs. 4-5 and 4-6) in Rome, built in the mid-fourth century, possibly as the mausoleum for Constantina, Constantine's daughter. Recent excavations have called the traditional identification into question, but the building housed Constantina's monumental porphyry sarcophagus, even if the structure was not originally her tomb. The mausoleum, later converted into a church, stood next to the basilica of Saint Agnes, erected over the catacomb in which she was buried.

Santa Costanza's design derives from the domed structures of the Romans, such as the Pantheon (Figs. 3-38 to 3-40), but the architect introduced an ambulatory, a ringlike barrel-vaulted corridor separated from the central domed cylinder by 12 pairs of columns. Like most Early Christian basilicas, Santa Costanza has a severe brick exterior, but its interior was very richly adorned with mostaics, although most are lost.

featuring a longitudinal plan was long the favorite of the Western Christian world. But Early Christian architects also adopted another classical architectural type: the central-plan building, a structure in which the parts are of equal or almost equal dimensions around the center. Roman central-plan buildings were usually round or polygonal domed atructures. Byzantine architects developed this form in numerous ingenious variations (FIGS. 4-12, 4-22, and 4-24). In the West, builders generally used the central plan for structures adjacent to the main basilicas, such as mausoleums, baptisteries, and pricent to the main basilicas, such as mausoleums, baptisteries, and pricent to the main basilicas, such as mausoleums, baptisteries, and pricent to the main basilicas, such as mausoleums, baptisteries, and pricent to the main basilicas, such as mausoleums, baptisteries, and pri-

essential for illuminating the mosaics and frescoes that commonly

the thin upper wall beneath the timber roof. Clerestory lighting was

nave is drenched with light from the clerestory windows piercing

vate chapels, rather than for churches, as in the East.

adorned the nave and apse of Early Christian churches.

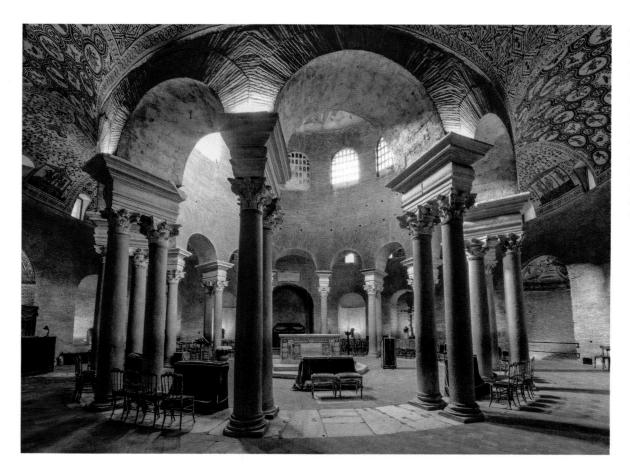

4-5 Interior of Santa Costanza (looking southwest), Rome, Italy, ca. 337–351.

Possibly built as the mausoleum of Constantine's daughter, Santa Costanza later became a church. Its central plan, featuring a domed interior, would become the preferred form for Byzantine churches.

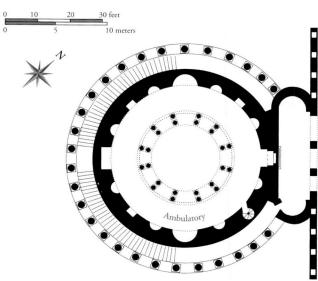

4-6 Plan of Santa Costanza, Rome, Italy, ca. 337-351.

Santa Costanza has antecedents in the domed temples (FIG. 3-40) and mausoleums of the Romans, but its plan, which features a circle of 12 pairs of columns and a vaulted ambulatory, is new.

MAUSOLEUM OF GALLA PLACIDIA Mosaic decoration (see "Mosaics," page 124) played an important role in the interiors of Early Christian buildings of all types. Mosaics not only provided a beautiful setting for Christian rituals but also were vehicles for instructing

the congregation about biblical stories and Christian dogma, especially in an age of widespread illiteracy. The so-called Mausoleum of Galla Placidia in Ravenna is a rare example of a virtually intact Early Christian mosaic program. Galla Placidia was the half sister of the emperor Honorius (r. 395–423), who had moved the capital of his crumbling Western Roman Empire from Milan to Ravenna in 404. Built shortly after 425, almost a quarter century before Galla Placidia's death in 450, the "mausoleum" was probably originally a chapel honoring the martyred Saint Lawrence. The building has a characteristically unadorned brick exterior. Inside, however, mosaics cover every square inch above the marble-faced walls.

Christ in his role as Good Shepherd is the subject of the lunette (FIG. 4-7) above the entrance. No earlier version of the Good Shepherd is as regal as this one. Instead of carrying a lamb on his shoulders (FIGS. 4-2 and 4-2A), Jesus sits among his flock, haloed and robed in gold and purple. To his left and right, the sheep are distributed evenly in groups of three. But their arrangement is rather loose and informal, and they occupy a carefully described landscape extending from foreground to background beneath a blue sky. All the forms have three-dimensional bulk, and the shadows they cast reveal that this representation is still deeply rooted in the classical tradition.

SANT'APOLLINARE NUOVO In 476, Ravenna fell to Odoacer, the first Germanic king of Italy, whom Theodoric, king of the Ostrogoths, overthrew in turn. Theodoric established his capital at Ravenna in 493. The mosaics in his palace church, Sant'Apollinare Nuovo, date from different periods, but those that Theodoric commissioned reveal a new, much more abstract and formal, style (see "Picturing the Spiritual World," page 125).

became possible (FIG. 2-50), and mosaicists finally could aspire to rival the achievements of painters. In Early Christian mosaics (FIGS. 4-7) and 4-8), the tesserae are usually made of glass, which reflects light and makes the surfaces sparkle. Ancient mosaicists occasionally used glass tesserae, but the Romans preferred opaque marble pieces.

catch and reflect the light. mosaicists also set the cubes unevenly so that their surfaces could to be seen from a distance, usually consisted of larger tesserae. The floor mosaics, would be pointless. Early Christian mosaics, designed observer's head, the painstaking use of tiny tesserae seen in Roman apse or ambulatory vault or over the nave colonnade, far above the simplified pattern, became the rule. For mosaics situated high in an blended, colors. Bright, hard, glittering texture, set within a rigorously ralistic painter's approach would require. Artists "placed," rather than were not meant to incorporate the subtle tonal changes that a natucomposition's central, most relevant features. Early Christian mosaics contrasts and concentrations of color that could focus attention on a flooding through the windows in vibrant reflection, producing sharp mural paintings were more common. The mosaics caught the light rating walls and vaults in Early Christian buildings, although less costly Mosaics quickly became a popular, if expensive, means of deco-

MATERIALS AND TECHNIQUES
Mosaics

As an art form, mosaic had a rather simple and utilitarian beginning, seemingly invented primarily to provide inexpensive and durable flooring. Originally, mosaicists set small beach pebbles, unaltered from their natural form and color, into a thick coat of cement. Artisans soon discovered, however, that the stones could be arranged in decorative patterns. At first, these pebble mosaics were uncomplicated and confined to geometric shapes. Generally, the artists used only black and white stones. The earliest examples of this type date to the eighth century BCE. Eventually, mosaicists arranged the stones to form more complex prictorial designs, and by the fourth century BCE, artists depicted elaborate figural scenes using a broad range of colors—red, yellow, and brown, in addition to black, white, and gray—and shaded the figures, clothing, and setting to suggest volume.

By the middle of the third century BCE, Greek artists had invented a new kind of mosaic employing tesserae (Latin, "cubes" or "dice"). These tiny cut stones gave mosaicists much greater flexibility because their size and shape could be adjusted. More gradual gradations of color also

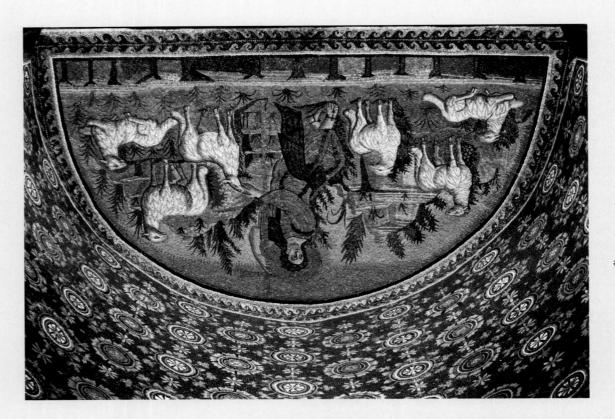

4-7 Christ as Good
Shepherd, mosaic on
the interior entrance
wall of the Mausoleum of
Galla Placidia, Ravenna,
Italy, ca. 425.

Jesus sits among his flock, haloed and robed in gold and purple. The landscape and the figures, with their cast shadows, are the work of a mosaicist still deeply rooted in the naturalistic classical tradition.

Theodosius died in 395, and imperial power passed to his two sons, Arcadius, who became emperor of the East, and Honorius, emperor of the West. Though not formally codified, this division of the Roman Empire became permanent. In the western half, the Visigoths, under their king Alaric, sacked Rome in 410. The Western Roman Empire soon collapsed, replaced by warring kingdoms that, during the Middle Ages, formed the foundations of the modern nations of Europe (see page 158). The Eastern Roman Empire, only loosely connected by religion to the West and with only minor territorial holdings there,

MUITNASY8

In the decades following the foundation in 324 of Constantinople—the New Rome in the East, on the site of the Greek city of Byzantium—the pace of Christianization of the Roman Empire quickened. In 380, Theodosius I (r. 379–395) issued an edict finally establishing Christianity as the state religion. In 391, he enacted a ban against worshiping the old gods, and in 394, the emperor abolished the Olympiping the old gods, and in 394, the emperor abolished the Olympic Games, the enduring symbol of the classical world and its values.

PROBLEMS AND SOLUTIONS

Picturing the Spiritual World

The early-sixth-century mosaics of Sant'Apollinare Nuovo in Ravenna depict scenes from Jesus's life (see "The Life of Jesus in Art," pages 120–121)—for example, *Miracle of the Loaves and Fishes* (FIG. 4-8). The mosaic stands in sharp contrast to the 80-year-earlier *Christ as Good Shepherd* mosaic (FIG. 4-7) in the Mausoleum of Galla Placidia. Jesus, again beardless but now wearing the imperial dress of gold and purple and distinguished by the cross-inscribed *nimbus* (halo) that signifies his divinity, faces directly toward the viewer. With extended arms, he directs his disciples to distribute to the great crowd the miraculously increased supply of bread and fish he has produced. The mosaicist told the story with the least number of figures necessary to make its meaning explicit, aligning the figures laterally, moving them close to the foreground, and placing them in a shallow picture box. The

landscape setting, which the artist who worked for Galla Placidia so explicitly described, is here merely a few rocks and bushes enclosing the figure group like parentheses. The blue sky of the physical world has given way to the otherworldly splendor of heavenly gold. This represents a major stylistic shift away from classical illusionism toward a more abstract style.

Why did Early Christian artists begin to depict the sky as golden instead of blue? The answer is clear. These artists were seeking a means to conjure a spiritual world before the eyes of the faithful, not to represent the everyday world outside the sacred space of the church. A new aesthetic is on exhibit in the Sant'Apollinare Nuovo mosaic, one quite foreign to classical art, with its worldly themes, naturalism, perspective illusionism, and modeling in light and shade. Indeed, the ethereal golden background suggests that the holy figures exist not on earth but in the palatial kingdom of Heaven far above the heads of the Christian worshipers below. This is precisely the impression the Christian mosaicist wished to create.

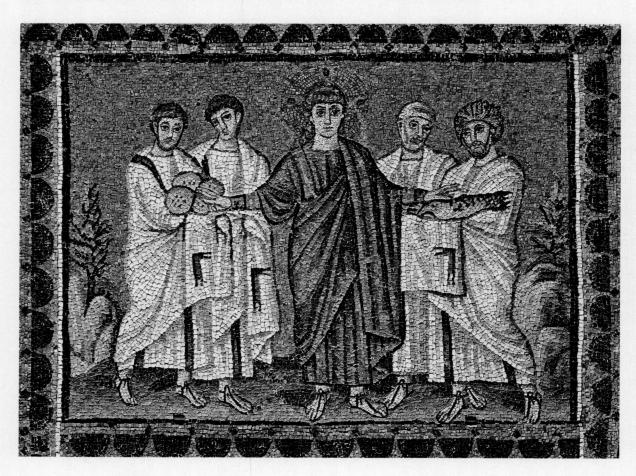

4-8 Miracle of the Loaves and Fishes, mosaic in the top register of the nave wall above the clerestory windows of Sant'Apollinare Nuovo, Ravenna, Italy, ca. 504.

In contrast to FIG. 4-7, Jesus here faces directly toward the viewer. Blue sky has given way to the otherworldly splendor of heavenly gold, the standard background color for medieval mosaics.

had a long and complex history of its own. Centered at New Rome, the Eastern Roman Empire remained a cultural and political entity for a millennium, until the last of a long line of emperors, ironically named Constantine XI, died at Constantinople in 1453, in a futile attempt to defend the city against the Muslim Ottoman Turks (see page 140).

Historians refer to that eastern empire as Byzantium, employing Constantinople's original name, and use the term *Byzantine* to identify whatever pertains to Byzantium—its territory, its history,

and its culture. The Byzantine emperors, however, did not use that term to define themselves. They called their empire Rome and themselves Romans. Though they spoke Greek and not Latin, the Eastern Roman emperors never relinquished their claim as the legitimate successors to the ancient Roman emperors.

The Byzantine emperors considered themselves the earthly vicars of Jesus Christ. Their will was God's will, and they exercised the ultimate spiritual as well as temporal authority. As sole executives for Church and State, the emperors shared power with neither senate nor

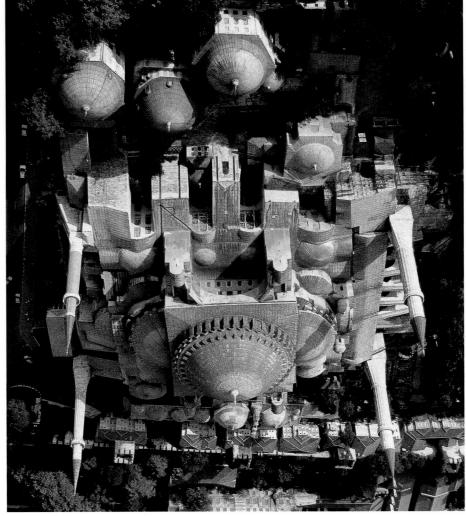

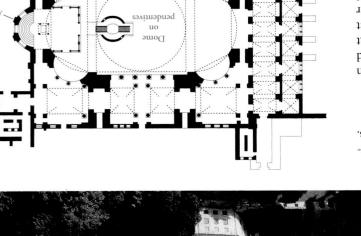

A-10 Anthemius of Tralles and Isidorus of Miletus, plan of Hagia Sophia, Constantinople (Istanbul), Turkey, 532-537.

In Hagia Sophia, Justinian's architects succeeded in fusing two previously independent architectural traditions: the vertically oriented central-plan building and the longitudinally oriented basilica.

4-9 ANTHEMUS OF TRALLES and ISIDORUS OF MILETUS, aerial view of Hagia Sophia (looking north), Constantinople (Istanbul), Turkey, 532–537.

Justinian's reign was the first golden age of Byzantine art and architecture. Hagia Sophia was the most magnificent of the more than 30 churches Justinian built or restored in Constantinople alone.

Church council. They reigned supreme, combining the functions of both pope and Caesar, which the Christian West would keep strictly separate. The Byzantine emperors' exalted position made them quasi-divine. The imperial court was an image of the kingdom of Heaven.

Art historians divide the history of Byzantine and statements of the history of Byzantine and statements.

antine art into three periods. The first, Early Byzantine, extends from the founding of Constantinople in 324 to the onset of iconoclasm (the destruction of images used in religious worship) in 726 under Emperor Leo III. The Middle Byzantine period begins with the renunciation of iconoclasm in 843 and ends with Western Crusaders' occupation of ends with Western Crusaders' occupation of Constantinople in 1204. Late Byzantine cor-

responds to the two centuries after the Byzantines recaptured Constantinople in 1261 until its final loss in 1453 to the Ottoman Turks.

Early Byzantine Art

The first golden age of Byzantine art is the reign of Justinian (r. 527–565), during which the Eastern Roman Empire briefly rivaled the old united Roman Empire in power and extent (MAP 4-1). At this time, Byzantine art emerged as a recognizable style distinct from Early Christian art. In Constantinople alone, Justinian built or restored more than 30 churches, and his activities as builder extended throughout his empire. Procopius of Caesarea (ca. 500–565), the official chronicler of Justinian's reign, admitted that the emperor's extravagant building program was an obsession that cost his subjects dearly in taxation. But Justinian's monuments defined the Byzantine style in architecture forever after.

HAGIA SOPHIA The emperor's most important project was the construction of Hagia Sophia (FIGS. 4-9 to 4-12), the Church of Holy Wisdom, in Constantinople. Anythemius of Tralinian Isidorus of Miletus designed and built the church for Justinian between 532 and 537. It is Byzantium's grandest building and one of the supreme accomplishments of world architecture. Hagia Sophia's dimensions are formidable: about 270 feet long and 240 feet wide.

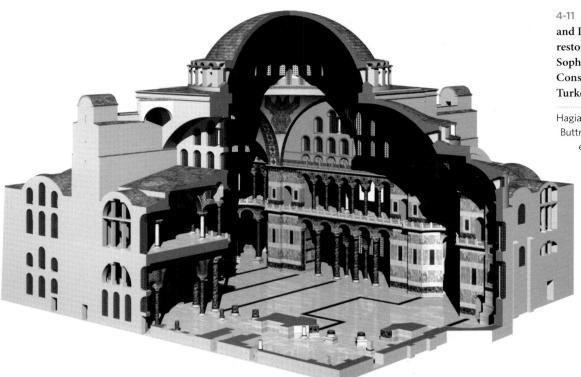

4-11 Anthemius of Tralles and Isidorus of Miletus, restored cutaway view of Hagia Sophia (looking northwest), Constantinople (Istanbul), Turkey, 532–537 (John Burge).

Hagia Sophia is a domed basilica.

Buttressing the great dome are eastern and western halfdomes whose thrusts descend, in turn, into smaller halfdomes surmounting columned exedrae.

The church's dome is 108 feet in diameter, and its crown rises some 180 feet above the pavement. In exterior view (FIG. 4-9), the great dome dominates the structure, but the building's external aspects today are much changed from their original appearance. The huge buttresses are later additions to the Justinianic design, as are the four towering *minarets* that the Turks constructed after their conquest of 1453 and conversion of Hagia Sophia into a *mosque* (see page 147).

The characteristic Byzantine plainness and unpretentiousness of the exterior (FIG. 4-9) scarcely prepare visitors for the building's interior (FIG. 4-12), which was once richly appointed. Colored stones from throughout the known world covered the walls and floors. But the feature that distinguishes Hagia Sophia from equally lavishly revetted Roman buildings such as the Pantheon (FIG. 3-40) is the special mystical quality of the light flooding the interior. The soaring canopy-like dome that dominates the inside as well as the outside of the church rides on a halo of light from 40 windows in the dome's base, which creates the illusion that the dome rests on light, not masonry. Procopius observed that the dome looked as if it were suspended by "a golden chain from Heaven" and that "the space is not illuminated by the sun from the outside, but the radiance is generated within, so great an abundance of light bathes this shrine all around."

A Justinianic poet and *silentiary* (an usher responsible for maintaining silence), Paulus Silentiarius, compared the dome to "the firmament which rests on air" and described the vaulting as covered with "gilded tesserae from which a glittering stream of golden rays pours abundantly and strikes men's eyes with irresistible force. It is as if one were gazing at the midday sun in spring." Thus Hagia Sophia has a vastness of space shot through with light, and a central dome that appears to be supported by the light it admits. Light is the mystic element—light that glitters in the mosaics, shines forth from the marbles, and pervades and defines spaces that escape definition. Light seems to dissolve material substance and transform it into an abstract spiritual vision.

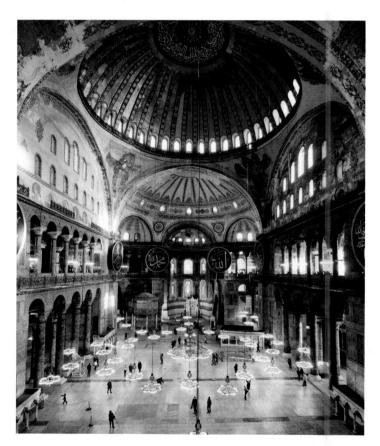

4-12 Anthemius of Tralles and Isidorus of Miletus, interior of Hagia Sophia (looking southwest), Constantinople (Istanbul), Turkey, 532-537.

Pendentive construction made possible Hagia Sophia's lofty dome, which seems to ride on a halo of light. A contemporary said that the dome seemed to be suspended by "a golden chain from Heaven."

The pendentive system is a dynamic solution to the problem of setting a round dome over a square, making possible a union of centralized and longitudinal (basilican) attructures. A similar effect can be achieved using squinches (FIG. 4-13, right)—arches, corbels, or lintels—that bridge the corners of the supporting walls and form an octagon inscribed within a square. To achieve even greater height, a builder can rest a dome on a cylindrical drum that in turn rests on either pendentives or squinches, as cylindrical drum that in turn rests on either pendentives or squinches, as in the 11th-century Church of the Dormition (FIG. 4-22) at Daphni, but the

principle of supporting a dome over a square is the same.

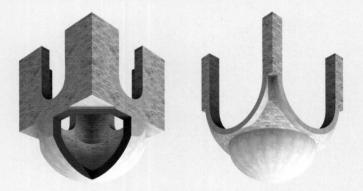

A-73 Dome on pendentives (left); dome on squinches (right) (John Burge).

Pendentives (triangular sections of a sphere) make it possible to place a dome on a ring over a square. Squinches achieve the same goal by bridging the corners of the square to form an octagonal base.

PROBLEMS AND SOLUTIONS Placing a Dome over a Square

Perhaps the most characteristic feature of Byzantine architecture is the use of a dome, which is circular at its base, over an interior space that is square in plan, as in the Justinianic church of Hagia Sophia (Figs. 4-10 to 4-12) and countless later structures (for example, Figs. 4-22 and 4-24). Unlike other engineering marvels that the Byzantine Empire inherited from imperial Rome, the placement of a dome over a square was a problem that Byzantine builders had to solve themselves. Two innovative structural devices that became hallmarks of Byzalves. Two innovative structural devices that became hallmarks of Byzantine engineering made this feat possible: pendentives and squinches. In pendentive construction (from the Latin pendere, "to hang"), a long that sets on what is, in effect a second larger dome (Eig. A-13 left).

In pendentive construction (from the Latin pendere, "to hang"), a dome rests on what is, in effect, a second, larger dome (Fie. 4-13, left). The builders omit the top portion and four segments around the rim of the larger dome, producing four curved triangles, or pendentives. The pendentives and arches transfer the weight of the dome not to the walls but to the four piers from which the arches spring. The first use of pendentives on a monumental scale was in Hagia Sophia in the mid-sixth century, although Mesopotamian architects had experimented with pendentives earlier. In Roman and Early Christian centralmented with pendentives earlier. In Roman and Early Christian centralmented with pendentives earlier. In Roman and Early Christian centralmented with pendentives earlier in Roman and Early Christian centralmented with pendentives earlier in Roman and Early Christian centralmented with pendentives earlier. In Roman and Early Christian centralmented with pendentives earlier in Roman and Early Christian centralmented with pendentives earlier. In Roman and Early Christian centralmented with pendentives earlier in Roman and Early Christian centralmented with pendentives earlier. In Roman and Early Christian centralmented with pendentives earlier in Roman and Early Christian centralmented with pendentives earlier. In Roman and Early Christian centralmented with pendentives earlier in Roman and Early Christian centralmented with pendentives earlier in Roman and Early Christian centralmented with pendented with pende

a cylinder (FIG. 3-15d).

The diverse vistas and screenlike ornamented surfaces mask the structural lines. The columnar arcades of the nave and second-story galleries have no real structural function. Like the walls they pierce, they are only part of a fragile "fill" between the huge piers. Structurally, although Hagia Sophia may seem Roman in its great scale and majesty, the organization of its masses is not Roman. The very fact piers indicates that the architects sought Roman monumentality as an effect and did not design the building according to Roman principles. Hagia Sophia's eight great supporting piers are ashlar masonry, but the screen walls are brick, as are the vaults of the aisles and galleries and the dome and semicircular half-domes. Using brick in place of concrete was a further departure from Roman practice and marks of concrete was a further departure from Roman practice and marks of concrete was a further as a distinctive structural style.

The ingenious design of Hagia Sophia provided the illumination and the setting for the solemn liturgy of the Eastern Christian Orthodox faith (as opposed to the Catholicism of the Roman Church). The large windows along the rim of the great dome poured light down upon the interior's jeweled splendor, where priests staged the sacred spectacle. Sung by clerical choirs, the Orthodox rist at the altar in the apsidal sanctuary, in spiritual reenactment of Jesus's crucifixion. Processions of chanting priests, accompanying the patriarch (archbishop) of Constantinople, moved slowly to and from the sanctuary and the vast nave. The gorgeous array of their from the sanctuary and the vast nave. The gorgeous array of their from the sanctuary and the vast nave. The gorgeous array of their westments rivaled the interior's polychrome marbles and mosaics vestments rivaled the interior's polychrome marbles and mosaics

PENDENTIVES To achieve this illusion of a floating "dome of Heaven," Anthemius and Isidorus used pendentives (see "Placing a Dome over a Square," above, and Fig. 4-13) to transfer the weight from the great dome to the piers beneath rather than to the walls. With pendentives, not only could the space beneath the dome be unobstructed, but scores of windows could puncture the walls. The pendentives created the impression of a dome suspended above, not only walls. Experts today can explain the technical virtuosity of Justinian's builders, but it remained a mystery to their contemporaries. Procopius communicated the sense of wonderment experienced by those who entered Hagia Sophia: "No matter how much they concentrate... they are unable to understand the craftsmanship and always depart from there amazed by the perplexing spectacle." By placing a hemispherical dome on a square base instead of on a circular base, Anthemius and Isidorus succeeded in fusing two on a circular base, Anthemius and Isidorus succeeded in fusing two

on a circular base, Anthemius and Isidorus succeeded in fusing two previously independent and seemingly mutually exclusive architectural traditions: the vertically oriented central-plan building and the longitudinally oriented basilica. Hagia Sophia is, in essence, a several centuries of experimentation in Christian church architecture. However, the thrusts of the pendentive construction at Hagia Sophia made external buttresses necessary, as well as huge internal northern and southern wall piers and eastern and western half-domes (Fig. 4-9). The semidomes' thrusts descend, in turn, into atill smaller half-domes surmounting columned exedrac that give a still smaller half-domes surmounting columned exedrac that give a

curving flow to the design (FIG. 4-12).

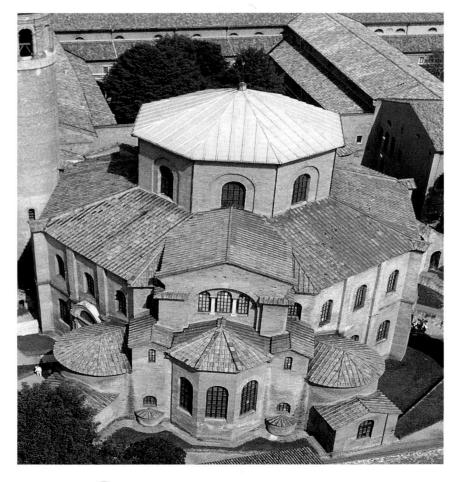

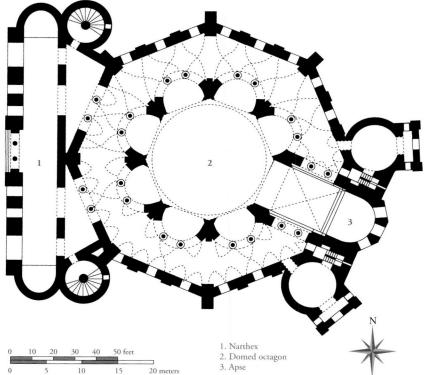

4-15 Plan of San Vitale, Ravenna, Italy, 526-547.

Centrally planned like Justinian's churches in Constantinople, San Vitale is unlike any other church in Italy. The design features two concentric octagons. A dome crowns the taller, inner octagon.

4-14 Aerial view of San Vitale (looking northwest), Ravenna, Italy, 526–547.

Justinian's general Belisarius captured Ravenna from the Ostrogoths. The city became the seat of Byzantine dominion in Italy. San Vitale honored Saint Vitalis, a second-century Ravenna martyr.

and the gold and silver candlesticks and candelabras, all glowing in shafts of light from the dome.

The nave of Hagia Sophia was reserved for the clergy, not the congregation. The laity, segregated by sex, had only partial views of the brilliant ceremony, the men from the shadows of the aisles and galleries, the women from the galleries. The emperor was the only layperson privileged to enter the sanctuary. When he participated with the patriarch in the liturgical drama, standing at the pulpit beneath the great dome, his rule was sanctified and his person exalted. Church and State were symbolically made one. Hagia Sophia was the earthly image of the court of Heaven, its light the image of God and God's holy wisdom. At Hagia Sophia, the ambitious scale of imperial Rome and the religious mysticism of the Orthodox Christian faith combined to create a monument that is at once a summation of antiquity and a positive assertion of the triumph of Christianity.

SAN VITALE In 539, Justinian's general Belisarius captured Ravenna from the Ostrogoths. As the Eastern Roman Empire's foothold in Italy, Ravenna enjoyed great prosperity, and its culture became an extension of Constantinople's. Its art, even more than that of the Byzantine capital (where relatively little outside of architecture has survived), clearly reveals the transition from the Early Christian to the Byzantine style.

Dedicated by Bishop Maximianus (r. 546–556) in 547 in honor of Saint Vitalis, a second-century martyr, San Vitale (FIGS. 4-14 and 4-15) is the most spectacular building in Ravenna. Work on the church began under Bishop Ecclesius (r. 522–532) shortly after Theodoric's death in 526 and was made possible by Julianus Argentarius (Julian the Banker), who provided the enormous sum of 26,000 *solidi* (gold coins), weighing in excess of 350 pounds, required to proceed with the work. San Vitale is unlike any of the Early Christian churches of Ravenna. It is not a basilica. Rather, it is centrally planned, like Justinian's churches in Constantinople.

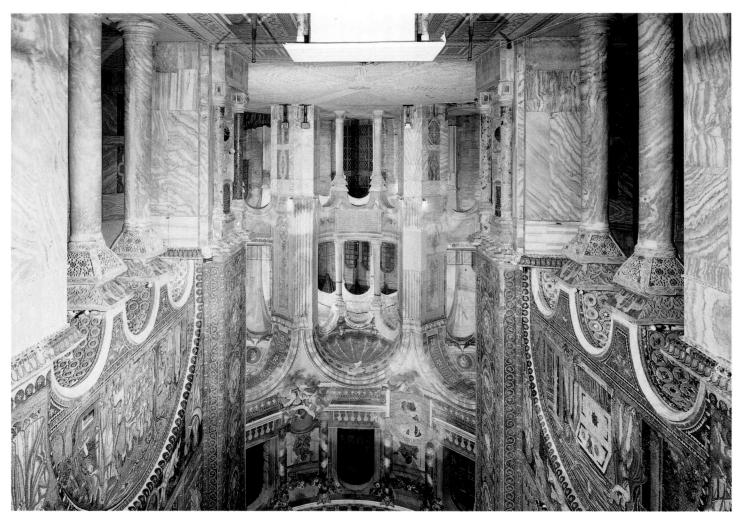

4-16 Interior of San Vitale (looking west from the apse), Ravenna, Italy, 526-547.

Natural light, filtered through alabaster-paned windows, plays over the glittering mosaics and glowing marbles sheathing San Vitale's complex wall and vault shapes, producing a splendid effect.

mosaics and glowing marbles that cover the building's complex surfaces, producing a splendid effect.

The mosaics in San Vitale's choir and apse, like the building itself, must be regarded as one of the greatest achievements of Byzantine art. Completed less than a decade after the Ostrogoths surrendered Ravenna, the apse and choir decorations form a unified composition, whose theme is the holy ratification of Justinian's right to rule. In the apse vault is Christ, who extends the golden martyr's wreath to Saint Vitalis. Beside him is Bishop Ecclesius, who offers a model of San Vitale to Christ. On the choir wall to the left of the apse mosaic appears Justinian (Fig. 4-17). Uniting the Savior and the emperor visually and symbolically are the imperial purple they wear and their halos. A dozen attendants accompany Justinian, paralleling Christ's 12 apostles. Thus the mosaic program underscores the dual political and religious role of the Byzantine emperor.

In the mosaic panel representing Justinian and his retinue, the emperor is at the center. At his left is Bishop Maximianus. The mosaicist stressed the bishop's importance by labeling his figure with the only identifying inscription in the composition. The artist divided the figures into three groups: the emperor and his staff;

The design features two concentric octagons. The dome-covered inner octagon rises above the surrounding octagon to provide the interior (PIG. 4-16) with clerestory lighting. Eight large rectilinear piers alternate with curved, columned exedrae, pushing outward into the surrounding two-story ambulatory and creating an intrincate eight-leafed plan (PIG. 4-15). The exedrae closely integrate the inner and outer spaces that otherwise would have existed simply side by side as independent units. A cross-vaulted choir preceding the appearance of the ambulatory and gives the plan some axial stability. Weakening this effect, however, is the off-axis placement of the narthex, whose odd angle never has been explained. (The atrium, which no longer exists, may have paralleled a street running in the same direction as the angle of the narthex.)

San Vitale's intricate plan and elevation combine to produce an effect of great complexity. The exterior's octagonal regularity is not readily apparent inside. A rich diversity of ever-changing perspectives greets visitors walking through the building. Arches looping over arches, curving and flattened spaces, and wall and vault shapes seem to change constantly with the viewer's position. Natural light, filtered through alabaster-paned windows, plays over the glittering filtered through alabaster-paned windows, plays over the glittering

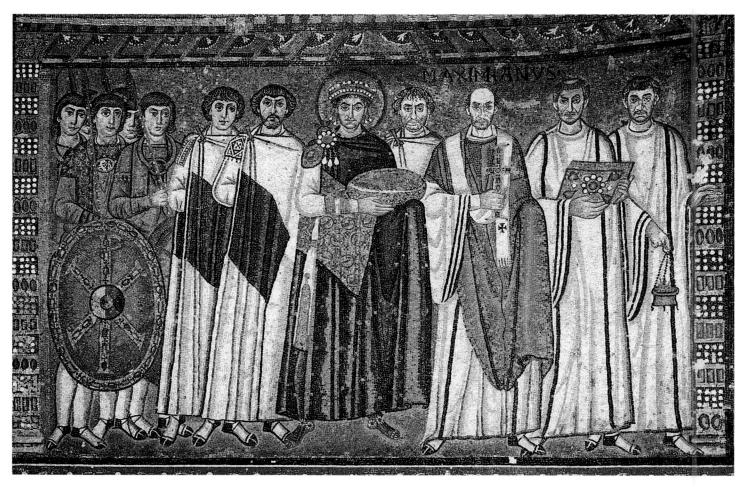

4-17 Justinian, Bishop Maximianus, and attendants, mosaic on the north wall of the apse, San Vitale, Ravenna, Italy, ca. 547.

San Vitale's mosaics reveal the new Byzantine aesthetic. Justinian is foremost among the weightless and speechless frontal figures hovering before the viewer, their positions in space uncertain.

the clergy; and the imperial guard, bearing a shield with the Christogram, the monogram made up of chi (X), rho (P), and iota (I), the initial letters of Christ's name in Greek. Each group has a leader whose feet precede (by one foot overlapping) the feet of those who follow. The positions of Justinian and Maximianus are curiously ambiguous. Although the emperor appears to be slightly behind the bishop, the golden paten (large shallow bowl for the Eucharist bread) he carries overlaps the bishop's arm. Thus, symbolized by place and gesture, the imperial and churchly powers are in balance. The emperor's paten, the bishop's cross, and the attendant clerics' book and censer produce a slow forward movement that strikingly modifies the scene's rigid formality. The artist placed nothing in the background, wishing the observer to understand the procession as taking place in this very sanctuary. Thus the emperor appears forever as a participant in the sacred rites and as the proprietor of this royal church and the ruler of the western territories of the Eastern Roman Empire.

The procession at San Vitale recalls but contrasts with that of Augustus and his entourage on the Ara Pacis (FIG. 3-28), carved more than a half millennium earlier in Rome. There, the fully modeled marble figures have their feet planted firmly on the ground. The Romans talk among themselves, unaware of the viewer's presence.

All is anecdote, all very human and of this world, even if the figures themselves conform to a classical ideal of beauty that cannot be achieved in reality. The frontal figures of the Byzantine mosaic hover before viewers, weightless and speechless, their positions in space uncertain. Tall, spare, angular, and elegant, the figures have lost the rather squat proportions characteristic of much Early Christian figural art. The garments fall straight, stiff, and thin from the narrow shoulders. The organic body has dematerialized, and, except for the heads, some of which seem to be true portraits, viewers see a procession of solemn spirits gliding silently in the presence of the sacrament. Indeed, the theological basis for this approach to representation was the idea that the divine was invisible and that the purpose of religious art was to stimulate spiritual seeing (see "Picturing the Spiritual World," page 125). Theodulf of Orleans summed up this idea around 790: "God is beheld not with the eyes of the flesh but only with the eye of the mind." The mosaics of San Vitale reveal this new Byzantine aesthetic, one very different from that of the classical world but equally compelling. Byzantine art disparages matter and material values. It is an art in which blue sky has given way to heavenly gold, an art without solid bodies or cast shadows, and with the perspective of Paradise, which is nowhere and everywhere.

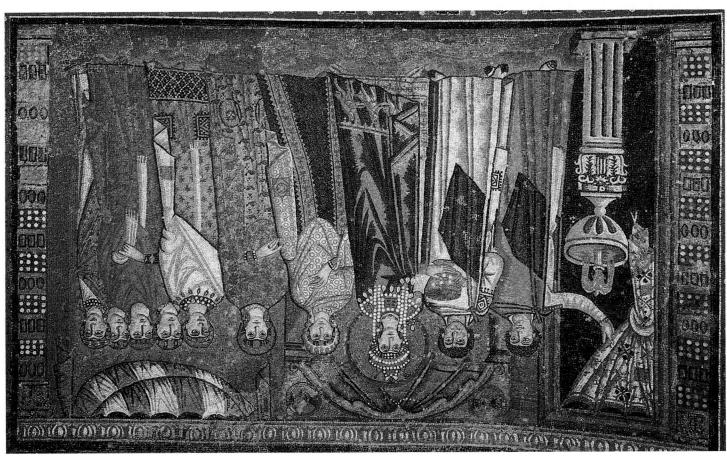

4-18 Theodora and attendants, mosaic on the south wall of the apse, San Vitale, Ravenna, Italy, ca. 547.

Justinian's counterpart on the opposite wall is the Empress Theodora, Justinian's influential consort. Neither of them ever visited Ravenna. San Vitale's mosaics are proxies for the absent sovereigns.

magi on the border of her robe suggests that the empress belongs in the elevated company of the three monarchs bearing gifts who approached the newborn Jesus.

of the time and expense involved in producing handwritten and illuminare, meaning "to adorn, ornament, or brighten." Because tion of the printing press as illuminated manuscripts, from the Latin Art historians refer to the painted books produced before the inven-As a result, luxuriousness of ornament became increasingly typical. replaced the comparatively brittle papyrus used for ancient scrolls. (lambskin), which provided better surfaces for painting, also FIG. 3-49.) Much more durable vellum (calfskin) and parchment Romans. (Jesus holds a rotulus in his left hand in Fig. 4-1b; compare script scroll (rotulus) of the Egyptians, Greeks, Etruscans, and with a front (recto) and back (verso), superseded the long manucover and bound together at one side. The new format, with pages ern books, composed of separate leaves (folios) enclosed within a scripts as well as their preservation. Codices are much like mod-(plural, codices), which greatly aided the dissemination of manuimportant invention during the Early Roman Empire was the codex (FIG. 1-23A A). Illustrated ancient books are rare, however. An long tradition of placing pictures in manuscripts began in Egypt scripts (handwritten books, from the Latin manu scriptus). The less importance for the history of medieval art are painted manu-MANUSCRIPTS Of much smaller scale than mosaics but of no by extension, at Ravenna. In fact, the representation of the three San Vitale is proof of the power she wielded at Constantinople and, as his spouse. Theodora's prominent role in the mosaic program of Justinian's court. She was the emperor's most trusted adviser as well trayal is more surprising and testifies to her unique position in authority extends over his territories in Italy. But Theodora's porhis inclusion in the decoration of the church underscores that his ian is present because he was the head of the Byzantine state, and fiction. The mosaics are proxies for the absent sovereigns. Justin-Ravenna. Their participation in the liturgy at San Vitale is pictorial at San Vitale is significant. Neither she nor Justinian ever visited not quite equal to her consort's. But the very presence of Theodora about to enter attests that, in the ceremonial protocol, her rank was she is outside the sanctuary in a courtyard with a fountain and only attendant beckons her to pass through the curtained doorway. That an imperial canopy, waiting to follow the emperor's procession. An haps the atrium of San Vitale. The empress stands in state beneath the artist represented the women within a definite architecture, perexhibit the same stylistic traits as those in the Justinian mosaic, but the golden cup with the wine. The portraits in the Theodora mosaic Eucharist. Justinian carries the paten containing the bread, Theodora to right and Theodora from right to left, in order to take part in the Both processions move into the apse, Justinian proceeding from left empress, Theodora (Fig. 4-18), with her corresponding retinue. Justinian's counterpart on the opposite wall of the apse is his

hand-painted books, complete Bibles and other very lengthy texts are exceptional. Usually, medieval codices consist of sections of the Bible, such as a single book (for example, Genesis) or the set of four Gospel books (see "Medieval Books" and Fig. 4-18A 🗐).

VIENNA GENESIS The oldest well-preserved painted manuscript containing biblical scenes is the early-sixth-century Vienna Genesis, so called because of its present location. The book was probably produced in Constantinople. The pages are fine vellum dyed with rich purple, the same dye used to give imperial cloth its distinctive color. The Greek text is in silver ink. The front of folio 7 (FIG. 4-19) combines the biblical text with the corresponding illustration of the story of Rebecca and Eliezer at the well (Gen. 24:15-61). When Isaac, Abraham's son, was 40 years old, his parents sent their servant Eliezer to find a wife for him. Eliezer chose Rebecca, because when he stopped at a well, she was the first woman to draw water for him and his camels. The Vienna Genesis illustration presents two episodes of the story within a single frame. In the first episode, at the left, Rebecca leaves the city of Nahor to fetch water from the well. In the second episode, she offers water to Eliezer and his camels, while one of them already laps water from the well. The artist painted Nahor as a walled city seen from above, like the cityscapes of the

Column of Trajan frieze (FIG. 3-36C ①). Rebecca walks to the well along the colonnaded avenue of a Roman city. A seminude female personification of a spring is the source of the well water. These are further reminders of the persistence of classical motifs and stylistic modes in Early Christian and Byzantine art even while other artists (FIG. 4-8) were rejecting classical norms in favor of a style better suited for a focus on the spiritual instead of the natural world.

MOUNT SINAI During Justinian's reign, almost continuous building activity took place, not only in Constantinople and Ravenna but throughout the Byzantine Empire. Between 548 and 565, Justinian rebuilt an important early *monastery* (monks' compound) at Mount Sinai in Egypt where Moses received the Ten Commandments from God. Now called Saint Catherine's, the monastery marked the spot at the foot of the mountain where the Bible says that God first spoke to the Hebrew prophet from a burning bush.

Monasticism began in Egypt in the third century and spread rapidly to Palestine and Syria in the East and as far as Ireland in the West (see page 159). It began as a migration to the wilderness by those who sought a more spiritual way of life, far from the burdens, distractions, and temptations of town and city. In desert places, these refuge seekers lived austerely as hermits, in contempla-

tive isolation, cultivating the soul's perfection. So many thousands fled the cities that the authorities became alarmed—noting the effect on the tax base, military recruitment, and business in general. The origins of the monastic movement are associated with Saints Anthony and Pachomius in Egypt in the fourth century. By the fifth century, many of the formerly isolated monks had begun to live together within a common enclosure and formulate regulations governing communal life under the direction of an abbot (see "Medieval Monasteries and Benedictine Rule," page 165). The monks typically lived in a walled monastery, an architectural complex that included the monks' residence (an alignment of single sleeping cells), an oratory (monastic church), a refectory (dining hall), a kitchen, storage and service quarters, and a guesthouse for pilgrims (FIG. 6-10). Mount Sinai had been an important pilgrimage destination since the fourth century, and Justinian's fortress protected not only the monks but also the lay pilgrims during their visits. The Mount Sinai church was dedicated to the Virgin Mary, whom the Orthodox Church had officially recognized in the mid-fifth century as the Mother of God (Theotokos, "she who bore God" in Greek).

THE ASSESSMENT OF THE PROPERTY OF THE PROPERTY

4-19 Rebecca and Eliezer at the Well, folio 7 recto of the Vienna Genesis, early sixth century. Tempera, gold, and silver on purple vellum, $1'\frac{1}{4}" \times 9\frac{1}{4}"$. Österreichische Nationalbibliothek, Vienna.

This luxuriously dyed vellum book is the oldest wellpreserved manuscript containing biblical scenes. Two episodes of the Rebecca story appear in a single setting filled with classical motifs.

ART AND SOCIETY Icons and Iconoclasm

Icons were by no means universally accepted, however. From the beginning, many Christians were deeply suspicious of the practice of imaging the divine, whether on portable panels, on the walls of churches, or especially as statues that reminded them of ancient idols. The opponents of Christian figural art had in mind the prohibition of images that the Lord dictated to Moses in the Second Commandment: "Thou shalt not make unto thee any graven image or any likeness of anything that is in heaven above, or that is in the earth beneath, or that is in the water under the earth. Thou shalt not bow down thyself to the water under the earth. Thou shalt not bow down thyself to the water under the earth. Thou shalt not bow down thyself to

Opposition to icons became especially strong in the eighth century, when the faithful often burned incense and knelt before the icons in prayer to seek protection or a cure for illness. Although their purpose was only to evoke the presence of the holy figures addressed in prayer, for many, the icons became identified with the personages represented. Icon veneration became confused with idol worship, and this brought about an imperial ban on all sacred images, as well as edicts ordering the destruction of existing images (iconoclasm).

The consequences of iconoclasm for the study of Early Byzantine art are difficult to overstate. For more than a century, not only did the portrayal of Christ, the Virgin, and the saints cease, but the iconoclasts ("breakers of images") also destroyed countless works from the first several centuries of Christendom.

4-20 Virgin (Theotokos) and Child between Saints Theodore and George, icon, sixth or early seventh century. Encaustic on wood, 2' $3"\times 1'\,7\frac{3}{8}"$. Monastery of Saint Catherine, Mount Sinai, Egypt.

Byzantine icons are the heirs to the Roman tradition of portrait painting on small wood panels (Fie. 3-42), but their Christian subjects and function as devotional objects broke sharply from classical models.

solemn demeanor. Background details are few. The shallow forward plane of the picture dominates. Traces of Greco-Roman illusionism remain in the Virgin's rather personalized features, in her sideways glance, and in the posing of the angels' heads. But the painter rendered the saints' bodies in the new Byzantine manner.

ICONOCLASM The preservation of Early Byzantine icons at the Mount Sinai monastery is surprising because in the seventh century, a series of calamities erupted in Egypt and Syria that indirectly caused the imperial ban on images. The Sasanians, chronically at war with Rome, swept into the Eastern provinces, and between 611 and 617 they captured the great cities of Antioch, Jerusalem, and

icons (see "Icons and Iconoclasm," above). Unfortunately, few early icons survive because of the wholesale destruction of images that icons survive because of the wholesale destruction of images that occurred in the eighth century. One of the finest early examples (Fig. 4-20) comes from Mount Sinai. The medium is encaustic on wood, continuing a tradition of panel painting in Egypt that, like so much else in the Byzantine world, dates to the Roman Empire (Figs. 3-42 and 3-43). The icon depicts the enthroned Theotokos and Child with Saints Theodore and George. The two guardian saints intercede with the Virgin on the worshiper's behalf. Behind them, two angels gaze upward at a shaft of light where the hand of God appears. The foreground figures are strictly frontal and have a God appears. The foreground figures are strictly frontal and have a

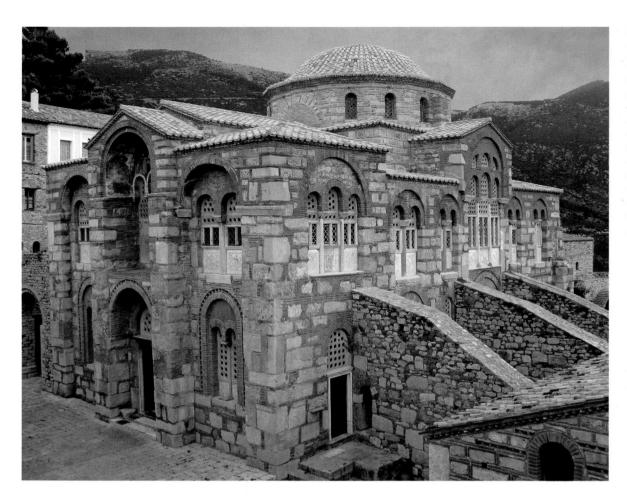

4-21 Katholikon (looking northeast), Hosios Loukas, Greece, first quarter of 11th century.

Middle Byzantine churches typically are small and high-shouldered, with a central dome on a drum, and exterior wall surfaces with decorative patterns, probably reflecting Islamic architecture.

Alexandria. The Byzantine emperor Heraclius (r. 610–641) had hardly defeated them in 627 when a new and overwhelming power appeared unexpectedly on the stage of history. The Arabs, under the banner of the new Islamic religion, conquered not only Byzantium's eastern provinces but also Persia itself, replacing the Sasanians in the age-old balance of power with the Christian West (see page 30). In a few years the Arabs were launching attacks on Constantinople, and Byzantium was fighting for its life.

These were catastrophic years for the Eastern Roman Empire. They terminated once and for all the long story of imperial Rome, closed the Early Byzantine period, and inaugurated the medieval era of Byzantine history. The Byzantine Empire lost almost two-thirds of its territory—many cities and much of its population, wealth, and material resources. The shock of these events persuaded Emperor Leo III (r. 717–741) that God was punishing Byzantium for its idolatrous worship of icons by setting upon it the merciless armies of the infidel—an enemy that, moreover, shunned the representation not only of God but of all living things in holy places (see page 152). In 726, he formally prohibited the use of images, and for more than a century, Byzantine artists produced little new religious figurative art.

Middle Byzantine Art

In the late eighth and ninth centuries, a powerful reaction against iconoclasm set in. Two empresses in particular led the movement to restore image-making in the Byzantine Empire: Irene in 780 and

Theodora in 843. The destruction of images was condemned as a heresy, and under a new line of *iconophile* ("image-loving") Byzantine rulers, known as the Macedonian dynasty, lavish commissions of religious art resumed. Basil I (r. 867–886), founder of the new dynasty, regarded himself as the restorer of the Roman Empire. He denounced as usurpers the Carolingian monarchs of the West who, since 800, had claimed the title "Roman Empire" for their realm (see page 161). Basil bluntly reminded their emissary that the only true emperor of Rome reigned in Constantinople. They were not Roman emperors but merely "kings of the Germans."

HOSIOS LOUKAS Although the Macedonian emperors did not wait long to redecorate the churches of their predecessors, they undertook little new church construction in the decades after the renunciation of iconoclasm. But in the 10th century and through the 12th, a number of monastic churches arose that are the flowers of Middle Byzantine architecture. They feature a brilliant series of variations on the domed central plan. From the exterior, the typical later Byzantine church building is a domed cube, with the dome rising above the square on a cylindrical drum. The churches are small, vertical, and high shouldered, and, unlike earlier Byzantine buildings, they have exterior wall surfaces decorated with vivid patterns, probably reflecting Islamic architecture.

The *katholikon* (FIG. 4-21), the main church in the monastery at Hosios Loukas (Saint Luke) in Greece, dates to the early 11th century and exemplifies church design during this second golden age of Byzantine art and architecture. Light stones framed by dark red

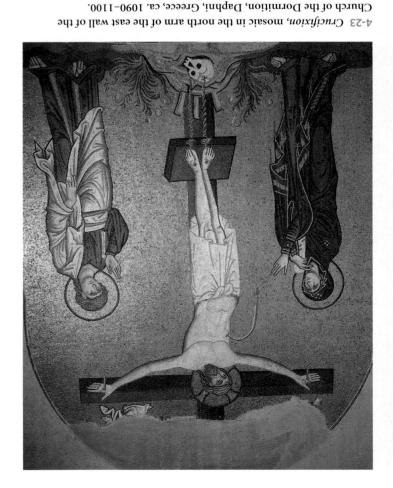

The Daphni Crucifixion is a subtle blend of classical naturalism and the more abstract Byzantine style. The Virgin Mary and Saint John point to Christ on the

cross as if to a devotional object.

space. The image serves to connect the awestruck worshiper in the church below with Heaven through Christ.

Below the Greek cross, is a mosaic (FIG. 4-23) depicting Christ's death on the Greek cross, is a mosaic (FIG. 4-23) depicting Christ's death on the cross. Like the dome mosaic, the Daphni Crucifixion is a subtle blend of the painterly, naturalistic style of classical and Early Christian art and the later, more abstract and formalistic Byzantine style. The Byzantine artist fully assimilated classicism's simplicity, and grace into a perfect synthesis with Byzantine piety and pathos. The figures have regained classical organic structure to a surprising degree, particularly compared to figures from the Justinianic period (compare FIGS. 4-17 and 4-18). The style is a masterful adaptation of classical statuesque qualities to the linear Byzantine manner.

In quiet sorrow and resignation, the Virgin and Saint John flank the crucified Christ. A skull at the foot of the cross indicates Golgotha, the Place of the Skull. The artist needed nothing else to set the scene. The picture is not a narrative of the historical event of Jesus's execution, although it contains anecdotal details. Christ has a tilted head and sagging body, and although the Savior is not overtly in pain, blood spurts from the wound that Longinus inflicted on him. The Virgin and John point to the figure on the cross as it to

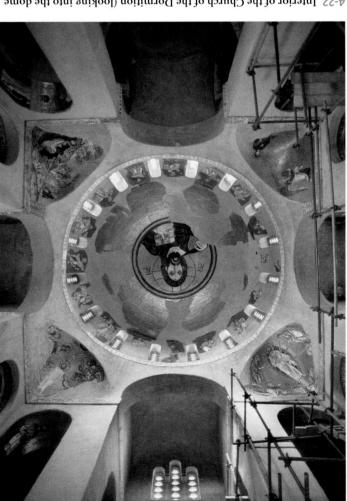

4-22 Interior of the Church of the Dormition (looking into the dome with mosaic of Christ as Pantokrator), Daphni, Greece, ca. 1090–1100.

The Daphni dome rests on an octagon formed by squinches. In the dome, the fearsome image of Christ as Pantokrator (ruler of all) is like a gigantic icon hovering above the awestruck worshiper below.

bricks make up the walls. The interplay of arcuated windows, projecting apses, and varying rooflines further enhances this surface dynamism. The plan is in the form of a domed cross in square with four equal-length, vaulted cross arms (the Greek cross).

Byzantine churches. Some of the best-preserved examples are in the monastic churches. Some of the best-preserved examples are in the monastic church of the Dormition (from the Latin for "sleep," referring to Christ's receiving the soul of the Virgin Mary at the moment of her death), at Daphni, near Athens. The church has a typical Middle Byzantine plan with a dome supported by a drum resting on squinches (Fig. 4-22). The main elements of the late-11th-century pictorial program are intact, although the mosaics underwent restoration in the 19th century. Gazing down from on high is the feartoration in the 19th century. Gazing down from on high is the feartoration in the 19th century. Gazing down from on high is the feartoration in the 19th century. Gazing down from on high is the feartoration in the 19th century. Gazing down from on high is the feartoration in the 19th century. Gazing down from on high is the feartoration in the 19th century. Gazing down from on high is the feartoration in the 19th century are produced to Christ in his role as last judge of humankind). The dome mosaic is the climax of an elaborate hierarchical mosaic program including several New Testament episodes below. The Daphni Pantokrator is like a gigantic icon hovering dramatically in Daphni Pantokrator is like a gigantic icon hovering dramatically in

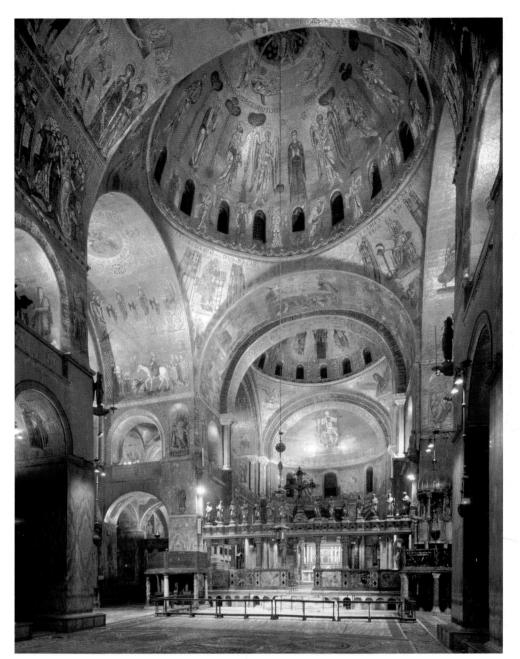

4-24 Interior of Saint Mark's (looking east), Venice, Italy, begun 1063.

Modeled on a church in Constantinople, Saint Mark's has a dome over the crossing, four other domes over the arms of the Greek cross, and 40,000 square feet of Byzantine-style mosaics.

a devotional object. They act as intercessors between the viewer below and Christ, who, in the dome, appears as the last judge of all humans.

SAINT MARK'S, VENICE The revival on a grand scale of church building and of figural mosaics extended beyond the Greek-speaking Byzantine East in the 10th to 12th centuries, especially in areas of the former Western Roman Empire where the ties with Constantinople were the strongest. In the Early Byzantine period, Venice, about 80 miles north of Ravenna on the eastern coast of Italy, was a dependency of that Byzantine stronghold. In 751, Ravenna fell to the Lombards, who wrested control of most of northern Italy from Constantinople. Venice, however, became an independent power. Its *doges* (dukes) enriched themselves and the city through seaborne commerce, serving as the crucial link between Byzantium and the West.

Venice had obtained the relics of Saint Mark from Alexandria in Egypt in 829, and shortly thereafter, the doges constructed the first Venetian shrine dedicated to the saint. In 1063, Doge Domenico Contarini (r. 1043–1071) began construction of the present Saint Mark's, modeled on the Church of the

Holy Apostles at Constantinople, built in Justinian's time. That shrine no longer exists, but its key elements were a *cruciform* (cross-shaped) plan with a central dome over the crossing and four other domes over the four equal arms of the Greek cross, as at Saint Mark's.

The interior (FIG. 4-24) of Saint Mark's is, like its plan, Byzantine in effect. Light enters through a row of windows at the bases of all five domes, vividly illuminating a rich cycle of mosaics. Both Byzantine and local artists worked on the project over the course of several centuries. Most of the mosaics date to the 12th and 13th centuries. Cleaning and restoration have returned the mosaics to their original splendor, enabling visitors to experience the full radiance of 40,000 square feet of mosaics covering all the walls, arches, vaults, and domes, like a gold-brocaded and figured fabric.

In the vast central dome, 80 feet above the floor and 42 feet in diameter, Christ ascends to Heaven in the presence of the Virgin Mary and the 12 apostles. In the great arch framing the crossing

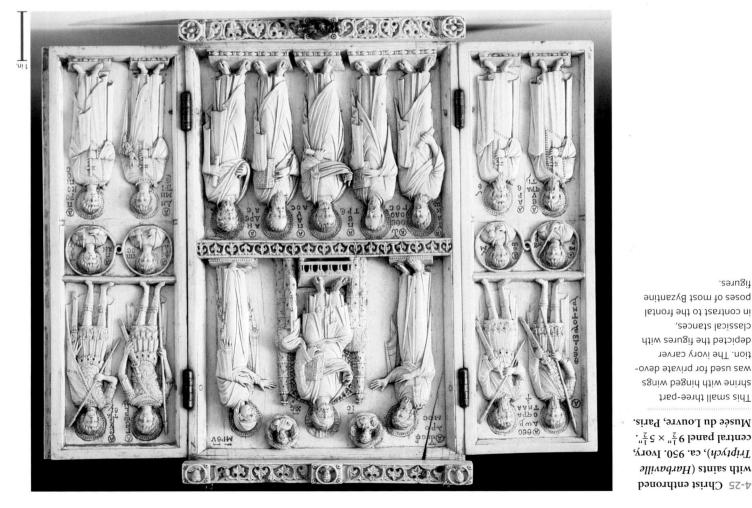

figures. poses of most Byzantine in contrast to the frontal classical stances, depicted the figures with tion. The ivory carver was used for private devoshrine with hinged wings This small three-part

with saints (Harbaville 4-25 Christ enthroned

on the world of matter, of solids, of light and shade, or of space. ters above them. As in other Byzantine mosaics, nothing here reflects no farther from their flat field than the elegant Latin and Greek leton the walls, vaults, and domes appear weightless, and they project ern Christendom in the later Middle Ages. The insubstantial figures reflecting Venice's position as the key link between Eastern and West-Christ. The mosaics have explanatory labels in both Latin and Greek, of Adam and Eve, John the Baptist, and other biblical figures by are the Crucifixion and Resurrection and the liberating from death

of Deësis (supplication). John the Baptist and the Theotokos appear the back of the triptych (not illustrated). On the inside is a scene medallions depicting saints. A cross dominates the central panel on inside and out, are four pairs of full-length figures and two pairs of sonal prayer. Carved on the wings of the Harbaville Triptych, both such luxurious items—and they often replaced icons for use in per-Ivory triptychs were very popular—among those who could afford portable shrine with two hinged wings used for private devotion. terpiece of ivory carving is the Harbaville Triptych (FIG. 4-25), a eled icons, illuminated manuscripts, and carved ivories. A masin the production of costly small-scale artworks, including bejew-HARBAVILLE TRIPTYCH Middle Byzantine artists also excelled

art yielded here to a softer, more fluid style. The figures may lack The formality and solemnity usually associated with Byzantine viewer. Below them are five apostles.

as intercessors, praying to the enthroned Savior on behalf of the

stylistic current of the Middle Byzantine period. This more natural, classical spirit was a second, equally important the heads relieve the hard austerity of the customary frontal pose. bases, like freestanding statues) and three-quarter views of many of true classical contrapposto, but the looser stances (most stand on

death. tine art, intensified for the viewer the emotional impact of Christ's ment of Christ. Their inclusion here, as elsewhere in Middle Byzan-In the Gospels, neither Mary nor John was present at the entombagainst her dead son's face. Saint John clings to Christ's left hand. the disciple Nicodemus kneel at his feet. Mary presses her cheek gestures of quite human bereavement. Joseph of Arimathea and The artist captured Christ's followers in attitudes, expressions, and (FIG. 4-26), is an image of passionate grief over the dead Christ. with murals of great emotional power. One of these, Lamentation ers, possibly brought from Constantinople, embellished the church construction of the church of Saint Pantaleimon. Byzantine paintdonia, a member of the Comnenian imperial family sponsored the ment figures and events was universal. In 1164, at Nerezi in Maceregion, but a renewed enthusiasm for picturing the key New Testathe impact was felt far and wide. The style varied from region to ages and again encouraged religious painting at Constantinople, NEREZI When the emperors lifted the ban against religious im-

sky—a striking contrast to the abstract golden world of the mosaics The setting for this lamentation is a hilly landscape below a blue

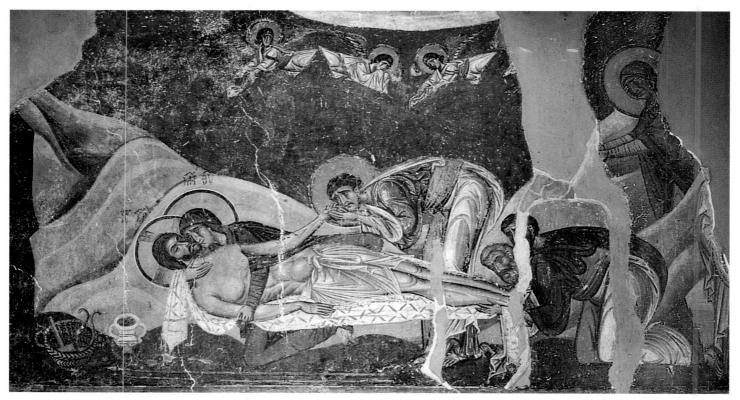

4-26 Lamentation, wall painting, Saint Pantaleimon, Nerezi, Macedonia, 1164.

Working in an alternate Byzantine mode, this Middle Byzantine painter staged the emotional lamentation over the dead Christ in a hilly landscape below a blue sky and peopled it with fully modeled figures.

favored for church walls throughout the Byzantine Empire. In order to make utterly convincing an emotionally charged realization of the theme, this artist instead staged the mourning scene in a more natural setting and peopled it with fully modeled actors. This alternate representational mode is no less Byzantine than the frontal, flatter figures more commonly associated with Byzantine art. In time, artists in Italy (FIG. 7-32) would emulate this more naturalistic style, giving birth to Renaissance art.

PARIS PSALTER Another example of this classical-revival style is the so-called Paris Psalter. (A psalter is a book containing King David's Psalms; see "Medieval Books" (A). Art historians believe that the manuscript dates from the mid-10th century—the Macedonian Renaissance, a time of humanistic reverence for the classical past and of enthusiastic and careful study of the language and literature of ancient Greece. In the illustrated page (FIG. 4-27), David, surrounded by sheep, goats, and his faithful dog, plays his harp in a rocky landscape with a town in the background. Similar settings are common in Pompeian murals. Also present are several allegorical figures. Melody looks over David's shoulder, while Echo peers from behind a column. A reclining male figure points to a Greek inscription identifying him as representing the mountain of Bethlehem. These personifications do not appear in the Bible. They are

4-27 David Composing the Psalms, folio 1 verso of the Paris Psalter, ca. 950–970. Tempera on vellum, 1' $2\frac{1}{8}$ " × $10\frac{1}{4}$ ". Bibliothèque Nationale, Paris.

During the Macedonian Renaissance, Byzantine artists revived the classical style. This painter portrayed David as if he were a Greek hero, accompanied by personifications of Melody, Echo, and Bethlehem.

4-28 Virgin of Compassion icon (Viadimir Virgin), late 11th or early 12th century, with later repainting. Tempera on wood, 2' $6\frac{1}{2}$ " \times 1' 9". Tretyakov Gallery, Moscow.

In this Middle Byzantine icon, the painter depicted Mary as the Virgin of Compassion, who presses her cheek against her son's as she contemplates his future. The reverse side shows the instruments of Christ's passion.

small states. The Palaeologans ruled one of these, the kingdom of Micaea. In 1261, Michael VIII Palaeologus (r. 1259–1282) succeeded in recapturing Constantinople. But his empire was no more than a fragment, and even that disintegrated during the next two centuries. Isolated from the Christian West by Muslim conquests in the Balkans and besieged by Muslim Turks to the east, Byzantium sought help from the West. It was not forthcoming. In 1453, the Ottoman help from the Mest, It was not forthcoming. In 1453, the Ottoman Turks, then a formidable power, took Constantinople and brought to an end the long history of Byzantium.

the stock population of Greco-Roman painting. Apparently, the artist translated a classical model into a Byzantine pictorial idiom. In works such as this, Byzantine artists kept the classical style alive in the Middle Ages.

VLADIMIR VIRGIN Nothing in Middle Byzantine art better demonstrates the rejection of the iconoclastic viewpoint than the painted icon's return to prominence. After the restoration of images, icons multiplied by the thousands to meet public and private demand. In the 11th century, the clergy began to display icons in hierarchical order (Christ, the Theotokos, John the Baptist, and then other saints, as on the Harbaville Triptych) in tiers on the templon, the columnar screen separating the sanctuary from the main body of a columnar church.

passion.) (The back of the icon bears images of the instruments of Christ's the image as Mary contemplates the future sacrifice of her son. an intimate portrayal of mother and child. A deep pathos infuses Virgin of Compassion, who presses her cheek against her son's in of the Virgin than that in the Mount Sinai icon. Here, Mary is the ground. But this is a much more tender and personalized image encloses the two figures; and the flat silhouette against the golden rays in the infant's drapery; the sweep of the unbroken contour that icons: the Virgin's long, straight nose and small mouth; the golden displays all the characteristic traits of Byzantine Virgin and Child ably the work of a Constantinopolitan painter, the Vladimir Virgin centuries of working and reworking the conventional image. Prob-Russian icon clearly reveals the stylized abstraction resulting from Descended from works such as the Mount Sinai icon (FIG. 4-20), the One example is the renowned Vladimir Virgin (FIG. 4-28).

The Vladimir icon has seen hard service. Placed before or above altars in churches or private chapels, it became blackened by the incense and the smoke from candles that burned before or below it. It was taken to Kiev (Ukraine) in 1131, then to Vladimir (Russia) in 1155 (hence its name), and in 1395, as a wonder-working image, to Moscow to protect that city from the Mongols. The Russians believed that the sacred picture saved the city of Kazan from later Tartar invasions and all of Russia from the Poles in the 17th century. The Vladimir Virgin is a historical symbol of Byzantium's religious and cultural mission to the Slavic world.

Byzantium after 1204

When rule passed from the Macedonian to the Comnenian dynasty in the later 11th and the 12th centuries, three events of fateful significance changed Byzantium's fortunes for the worse. The Seljuk Turks conquered most of Anatolia. The Byzantine Orthodox Church broke finally from the Church of Rome. And the Crusades brought the Latins (a generic term for the peoples of the West) into Byzantine lands on their way to fight for the Christian cross against the Saracens (Muslims) in the Holy Land (see "The Crusades A").

Crusaders had passed through Constantinople many times en route to "smite the infidel" and had marveled at its wealth and magnificence. Envy, greed, religious fanaticism (the Latins called the Greeks "heretics"), and even ethnic enmity motivated the Crusaders when, during the Pourth Crusade in 1203 and 1204, the Venetians persuaded them to divert their expedition against the Muslims in Palestine and to attack Constantinople instead. They took the city

and sacked it.

The Latins set up kingdoms within Byzantium, notably in Constantinople itself. What remained of Byzantium split into three

Explore the era further in MindTap with videos of major artworks and buildings, Google EarthTM coordinates, and essays by the author on the following additional subjects:

[■] Good Shepherd statuette (FIG. 4-2A)

Santa Sabina, Rome (FIGS. 4-4A and 4-4B)

[■] ART AND SOCIETY: Medieval Books

Ascension of Christ, Rabbula Gospels (FIG. 4-18A)

CHAPTER 4 Early Christianity and Byzantium

EARLY CHRISTIANITY AND BYZANTIUM

Early Christianity

- Very little Christian art or architecture survives from the first centuries of Christianity. "Early Christian art" means the earliest art having Christian subjects, not the art of Christians at the time of Jesus. The major surviving examples are frescoes in the catacombs of Rome and marble sarcophagi depicting Old and New Testament stories.
- Constantine (r. 306-337) issued the Edict of Milan in 313, granting Christianity legal status equal or superior to the traditional Roman cults. The emperor was the first great patron of Christian art and built the first churches in Rome, including Old Saint Peter's. In 330, he moved the capital of the Roman Empire to Constantinople (Greek Byzantium).
- The emperor Theodosius I (r. 379–395) proclaimed Christianity the official religion of the Roman Empire in 380 and banned worship of the old Roman gods in 391. Honorius (r. 395–423) moved the capital of his Western Roman Empire to Ravenna in 404. Rome fell to the Visigoth king Alaric in 410.
- Mosaics became a major vehicle for the depiction of Christian themes in the naves and apses of churches, which closely resembled Roman basilicas in both plan and elevation.

Catacomb of Saints Peter and Marcellinus, Rome, early fourth century

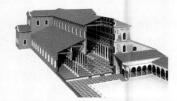

Old Saint Peter's, Rome, begun ca. 319

Byzantium

- The reign of Justinian (r. 527–565) opened the first golden age of Byzantine art (527–726). Justinian was a great patron of the arts, and in Constantinople alone he built or restored more than 30 churches, including Hagia Sophia. A brilliant fusion of central and longitudinal plans, the church featured a 180-foot-high dome resting on pendentives, rivaling the architectural wonders of Rome.
- The seat of Byzantine power in Italy was Ravenna, which also prospered under Justinian. San Vitale is Ravenna's greatest church. Its mosaics, with their weightless, hovering, frontal figures against a gold background, reveal the new Byzantine aesthetic.
- Justinian also rebuilt the monastery at Mount Sinai in Egypt, which boasts the finest surviving Early Byzantine icons. The first manuscripts with biblical illustrations also date to the early sixth century. In 726, however, Leo III (r. 717-741) enacted a ban against picturing the divine, initiating the era of iconoclasm (726-843).
- Middle Byzantine (843–1204) churches, such as those at Hosios Loukas and Daphni, have highly decorative exterior walls, and feature domes resting on drums above the center of a Greek cross. The climax of the interior mosaic programs was often an image of Christ as Pantokrator in the dome. Middle Byzantine artists also excelled in ivory carving and manuscript illumination. The Paris Psalter is noteworthy for its revival of classical naturalism.
- In 1204, Latin Crusaders sacked Constantinople, bringing to an end the second golden age of Byzantine art. In 1261, Michael VIII Palaeologus (r. 1259–1282) succeeded in recapturing the city. Constantinople remained in Byzantine hands until it was taken in 1453 by the Ottoman Turks.

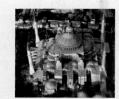

Hagia Sophia, Constantinople, 532-537

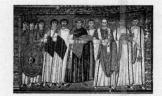

San Vitale, Ravenna, ca. 547

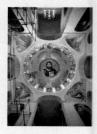

Church of the Dormition, Daphni, ca. 1090–1100

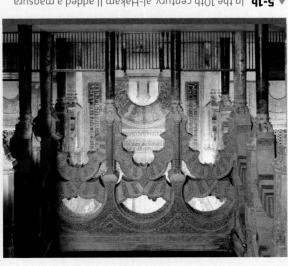

■ **5-1b** In the 10th century, al-Hakam II added a magsura to the Córdoba mosque. The hall highlights Muslim architects' bold experimentation with curvilinear shapes and different kinds of arches.

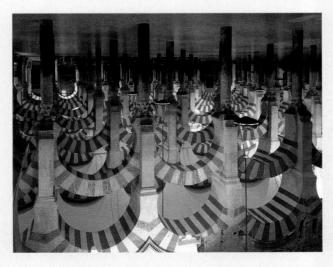

■ 5-1a Islamic architecture draws on diverse sources. The horseshoe arches of the Córdoba mosque's prayer hall may derive from Visigothic architecture. The Arabs overthrew that Christian kingdom in 711.

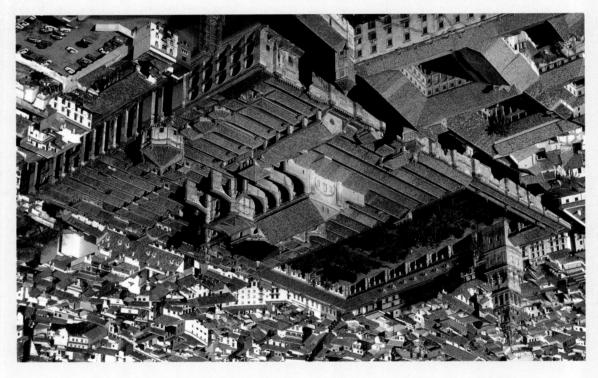

Aerial view of the Great Mosque (looking east), Córdoba, Spain, 8th to 10th centuries; rededicated as the Cathedral of Saint Mary, 1236.

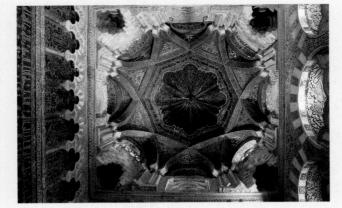

► 5-1c Byzantine artists installed the mosaics in the dome of the Córdoba mosque's mihrab, but the decorative patterns formed by the crisscrossing ribs and the multipleed arches are distinctly Islamic.

I-C

The Islamic World

THE RISE AND SPREAD OF ISLAM

At the time of Muhammad's birth around 570, the Arabian peninsula was peripheral to the Byzantine and Sasanian Empires. The Arabs, nomadic herders and caravan merchants who worshiped many gods, resisted the Prophet's teachings of Islam, an Arabic word meaning "submission to the one God (Allah in Arabic)." Within a decade of Mohammad's death in 632, however, Muslims ("those who submit") ruled Arabia, Palestine, Syria, Iraq, and northern Egypt. From there, the new religion spread rapidly both eastward and westward.

With the rise of Islam also came the birth of a compelling new worldwide tradition of art and architecture. In the Middle East and North Africa, Islamic art largely replaced Late Roman, Early Christian, and Byzantine art. In India, the establishment of Muslim rule at Delhi in the early 13th century brought Islamic art and architecture to South Asia (see page 473). In fact, perhaps the most famous building in Asia, the Taj Mahal (FIG. 17-19) at Agra, is an Islamic mausoleum. At the opposite end of the then-known world, in Spain, Abd al-Rahman I (r. 756–788) founded a Muslim dynasty at Córdoba, which became the center of a brilliant court culture that profoundly influenced medieval Europe.

The jewel of the capital at Córdoba was its Great Mosque (FIG. 5-1), begun in 784 and enlarged several times during the 9th and 10th centuries until it eventually became one of the largest *mosques* in the Islamic West (see "The Mosque," page 147). In 1236, the Christians converted the shrine into a church (the tallest part of the complex, at the center of the aerial view) after they captured the city from the Muslims.

A visual feast greets all visitors to the remodeled mosque of al-Hakam II (r. 961–976), whose designers used horseshoe-shaped arches (which became synonymous with Islamic architecture in Europe) to crown the more than 500 columns in the mosque's huge prayer hall. Even more elaborate multilobed arches on slender columns form dazzling frames for other areas of the mosque, especially in the *maqsura*, the hall reserved for the ruler, which at Córdoba connects the mosque to the palace. Crisscrossing ribs form intricate decorative patterns in the complex's largest dome.

The Córdoba *mezquita* (Spanish, "mosque") typifies Islamic architecture both in its conformity to the basic principles of mosque design and in its incorporation of distinctive regional forms.

ARCHITECTURE

MAJSI DNA DAMMAHUM

builders on a grand scale. Like other potentates before and after, the Muslim caliphs were in Spain and the Abbasids in Iraq (see "Major Muslim Dynasties" (1). territories and provinces, most notably the Umayyads in Syria and ally gained relative independence by setting up dynasties in various to rule the vast territories they controlled. These governors eventu-Syria) and Baghdad (capital of Iraq) appointed provincial governors opotamia (see page 22). The caliphs of Damascus (capital of modern political and cultural center was the Fertile Crescent of ancient Mes-During the early centuries of Islamic history, the Muslim world's

sacred to both Jews and Christians. It stands on the spot where the coming of the new religion to the city that had been, and still is, tribute to the triumph of Islam. The Dome of the Rock marked the shrine is not a mosque, as popularly thought, but an architectural the Umayyad caliph Abd al-Malik (r. 685-705). The monumental of the Rock (FIG. 5-2)—was erected there between 687 and 692 by Byzantines in 638, and the first great Islamic building—the Dome DOME OF THE ROCK The Muslims captured Jerusalem from the

The Ottomans capture Byzantine Constantinople in

Manuscript painting flourishes at the Timurid and

Satavid courts.

1453-1924

collapse in 1453. sure against the shrinking Byzantine Empire eventually caused its reached the Indus River by 751. In Anatolia, relentless Muslim pres-Islamic influence and power end in Iberia. In the East, the Muslims of Córdoba (FIG. 5-1) flourished until 1031, and not until 1492 did Franks turned them back. In Spain, in contrast, the Muslim rulers they had advanced north to Poitiers in France. There, however, the 711 seemed to open all of western Europe to the Muslims. By 732, was under Muslim control by 710. A victory in southern Spain in more than 400 years of Sasanian rule in Iran. All of North Africa Muslim conquest of northern Egypt. In 651, Islamic forces ended In 642, the Byzantine army abandoned Alexandria, marking the ders of history. By 640, Muslims ruled Syria, Palestine, and Iraq. (MAP 5-1). The swiffness of the Islamic advance is among the wonthe followers of Muhammad controlled much of the Mediterranean than a century, Muslim armies had subdued the Middle East, and were not major players on the world stage. Yet within little more (see "Muhammad and Islam," page 145). At that time, the Arabs The religion of Islam arose in Arabia early in the seventh century

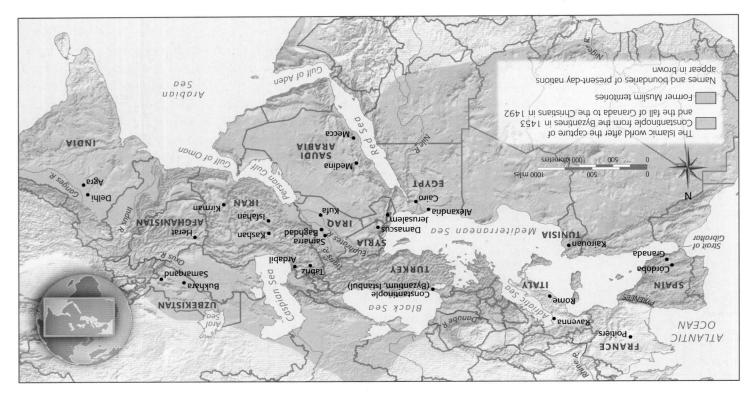

MAP 5-1 The Islamic World around 1500.

The Abbasids produce the earliest Korans with 226-1453

Kufic calligraphy.

in Jerusalem. Dome of the Rock to celebrate the triumph of Islam The Umayyads, the first Islamic dynasty, build the Muhammad abandons Mecca for Medina in 722.

954-279

Mosque in their capital at Córdoba. The Spanish Umayyad dynasty builds the Great

Alhambra. The Nasrids construct magnificent palaces in the

architecture. In Egypt, the Mamluks are great patrons of art and

RELIGION AND MYTHOLOGY Muhammad and Islam

Muhammad, revered by Muslims as the Final Prophet in the line including Abraham, Moses, and Jesus, was a native of Mecca on the west coast of Arabia. Born around 570 into a family of merchants, Muhammad was critical of the polytheistic religion of his fellow Arabs. In 610, he began to receive the revelations of God through the archangel Gabriel. Opposition to Muhammad's message among the Arabs was strong, and in 622, the Prophet and his followers abandoned Mecca for a desert oasis eventually called Medina ("City of the Prophet"). Islam dates its beginning from this flight—known as the Hijra (Arabic, "emigration"). Barely eight years later, in 630, Muhammad returned to Mecca with 10,000 soldiers. He took control of the city, converted the population to Islam, and destroyed all the idols. But he preserved as the Islamic world's symbolic center the small cubical building that had housed the idols, the Kaaba (from the Arabic for "cube"). The Arabs associated the Kaaba with the era of Abraham and Ishmael, the common ancestors of Jews and Arabs. Muhammad died in Medina in 632.

The essential tenet of Islam is acceptance of and submission to God's will. Muslims must live according to the rules laid down in the collected revelations communicated through Muhammad during his lifetime and recorded in the Koran, Islam's sacred book. The word *Koran* means "recitations"—a reference to Gabriel's instructions to Muhammad in 610 to "recite in the name of God."

The profession of faith in the one God is the first of the Five Pillars binding all Muslims. In addition, the faithful must worship five times daily facing Mecca, give alms to the poor, fast during the month of Ramadan, and once in a lifetime—if possible—make a pilgrimage to Mecca. The revelations in the Koran are not the only guide for Muslims. Muhammad's words and exemplary ways and customs, the *Hadith*, recorded in the *Sunnah*, offer models to all Muslims on ethical problems of everyday life. The reward for the faithful is Paradise.

Islam has much in common with Judaism and Christianity. Muslims think of their religion as a continuation, completion, and in some sense a reformation of those other great monotheisms. Islam, for example, incorporates many Hebrew biblical teachings, with their sober ethical standards and rejection of idol worship. But, unlike Jesus, Muhammad did not claim to be divine. Rather, he was God's messenger, the Final Prophet, who purified and perfected the common faith of Jews, Christians, and Muslims in one God. Islam also differs from Judaism and Christianity in its simpler organization. Muslims worship God directly, without a hierarchy of rabbis, priests, or saints acting as intermediaries.

In Islam, as Muhammad defined it in the seventh century, the union of religious and secular authority was even more complete than in Byzantium. Muhammad established a new social order and took complete charge of his community's temporal as well as spiritual affairs. After Muhammad's death, the *caliphs* (from the Arabic for "successor") continued this practice of uniting religious and political leadership in one ruler.

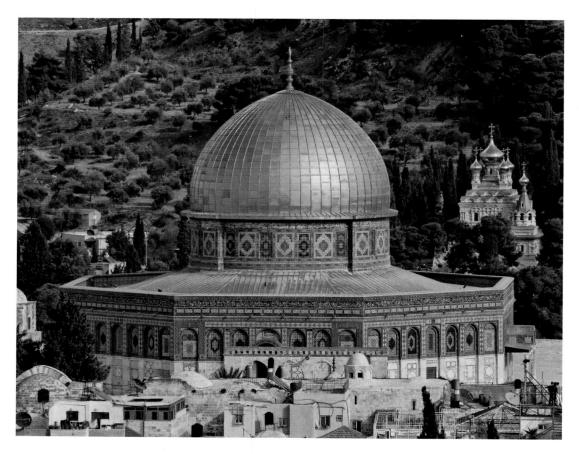

5-2 Dome of the Rock (looking east), Jerusalem, 687–692.

Abd al-Malik erected the Dome of the Rock to mark the triumph of Islam in Jerusalem on a site sacred to Muslims, Christians, and Jews. The shrine takes the form of an octagon with a towering dome.

in its basic design. A neighboring Christian monument, Constantine's Church of the Holy Sepulchre, seems to have been the immediate model. That fourth-century domed rotunda bore a family resemblance to the roughly contemporaneous Santa Costanza (FIG. 4-5) in Rome. Crowning the Islamic shrine is a 75-foot-tall double-shelled wood dome, which so dominates the elevation as to reduce the octagon to functioning visually merely as its base. This soaring, majestic unit creates a decidedly more commanding effect than that of similar Late Roman and Byzantine domical structures (for example, FIG. 4-10). The silhouettes of those domes are comparatively insignificant when seen from the outside.

The Dome of the Rock's exterior has been much restored. Tiling from the 16th century and later has replaced the original mosaic. Yet the vivid, colorful patterning wrapping the walls like a textile is typical of Islamic ornamentation. It contrasts markedly with Byzantine brickwork and Greco-Roman sculptured decoration. The rich mosaic ornamentation ringing the base of the dome (Pic. 5-4) is largely intact and suggests the original appearance of the exterior walls. Against a lush vegetal background, Abd al-Malik's mosaicists depicted crowns, jewels, chalices, and other royal motifs—probably as reference to the triumph of Islam over the Byzantine and Persian are the superior new monotheism, superseding both Judaism and Christianity in Jerusalem.

KAIROUAN The Dome of the Rock is a unique monument. Throughout the Islamic world, the most important buildings were mosques (see "The Mosque," page 147). Of all the variations, the hypostyle mosque most closely reflects the mosque's supposed precursor, Muhammad's house in Medina. One of the oldest well-preserved hypostyle mosques is the mid-eighth-century Great Mosque (FIG. 5-5) at Kairouan in Tunisia. Like the Dome of the

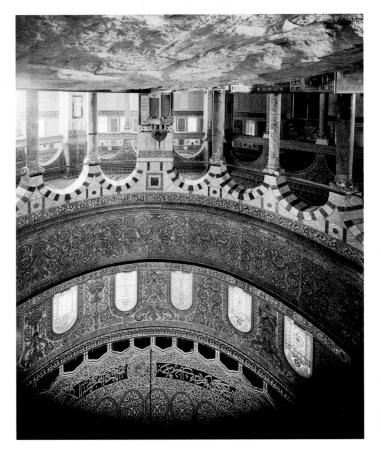

5-3 Interior of the Dome of the Rock, Jerusalem, 687-692.

The Dome of the Rock is a domed central-plan rotunda. At the center of the rotunda, below the dome, is the rocky outcropping later associated with Adam, Abraham, and Muhammad.

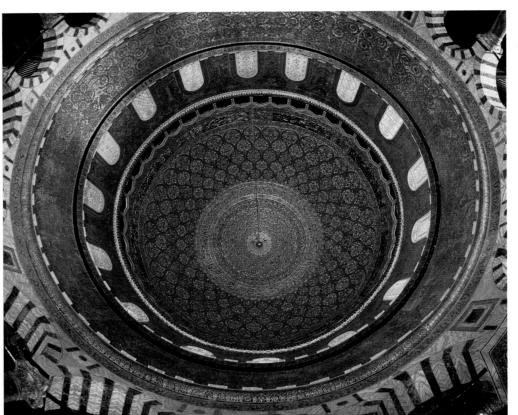

Abraham, and Muhammad.

Hebrews built the Temple of Solomon, which the Roman emperor Titus destroyed in the year 70 (see page 102). Eventually, the site acquired additional significance as the reputed location of Adam's grave and the spot where Abraham prepared to sacrifice Isaac. It houses the rock (FIG. 5-3) that later came to be identified with the place where Muhammad began his miraculous journey to Heaven (the Miraj) and then, in the same night, returned to his home in Mecca.

In its form, construction, and decoration, the Dome of the Rock is firmly in the Late Roman/Byzantine tradition. It is a domed octagon resembling San Vitale (FIG. 4-14) in Ravenna

5-4 View into the dome of the Dome of the Rock, Jerusalem, 687--692.

The mosaics ringing the base of the dome inside the Dome of the Rock are largely intact and suggest the original appearance of the exterior walls, today covered with Jeth-century ceramic tiles.

ARCHITECTURAL BASICS

The Mosque

Islamic religious architecture is closely related to Muslim prayer. In Islam, worshiping can be a private act and requires neither prescribed ceremony nor a special locale. Only the gibla—the direction (toward Mecca) that Muslims face while praying—is important. But worship also became a communal act when the first Muslim community established a simple ritual for it. To celebrate the Muslim sabbath, which occurs on Friday, the community convened each Friday at noon, probably in the Prophet's house in Medina. The main feature of Muhammad's house was a large, square court with rows of palm trunks supporting thatched roofs along the north and south sides. The southern side, which faced Mecca, was wider and had a double row of trunks. The imam, or leader of collective worship, stood on a stepped pulpit, or minbar, set up in front of the southern (qibla) wall.

These features became standard in the Islamic house of worship, the mosque (from Arabic masjid, "a place of prostration"), where the faithful gather for the five daily prayers. The congregational mosque (also called the Friday mosque or great mosque) was ideally large enough

to accommodate a community's entire population for the Friday noon prayer. An important feature both of ordinary and of congregational mosques is the mihrab (FIGS. 5-5, no. 2, and 5-12), a semicircular niche set into the gibla wall. Often a dome over the bay in front of the mihrab marked its position (FIGS. 5-5, no. 3, and 5-8). The niche—a common feature in Roman buildings, generally enclosing a statue-may honor the place where the Prophet stood in his house at Medina when he led communal worship.

In some mosques, a magsura precedes the mihrab. The magsura is the area reserved for the ruler or his representative. Mosques may also have one or more minarets (FIGS. 5-5, no. 8, and 5-6), towers used to call Muslims to worship. Early mosques were generally hypostyle halls, communal worship halls with roofs held up by a multitude of columns (FIGS. 5-5, no. 4, and 5-7). An important later variation is the mosque with four iwans (vaulted rectangular recesses), one on each side of a courtyard (FIG. 5-11).

Today, despite many variations in design and detail and the employment of building techniques and materials unknown in Muhammad's day, the mosque's essential features remain unchanged. The orientation of all mosques everywhere, whatever their plan, is Mecca, and the faithful worship facing the qibla wall.

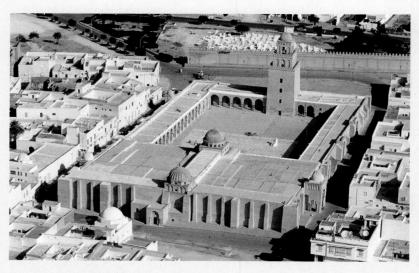

5-5 Aerial view (looking north; left) and plan (right) of the Great Mosque, Kairouan, Tunisia, ca. 836-875.

Kairouan's Great Mosque is an early hypostyle mosque with forecourt and columnar prayer hall (with two domes). The plan most closely resembles the layout of Muhammad's house in Medina

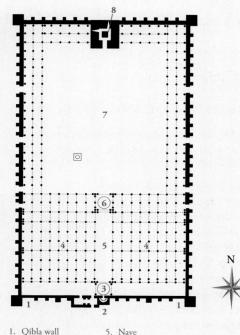

- 1. Qibla wall
- Mihrab 3. Mihrab dome
- Entrance dome 6.

4. Hypostyle prayer hall 8. Minaret

- 7. Forecourt
- 100 feet 30 meters

Rock, the Kairouan mosque owes much to Greco-Roman and Early Christian architecture. The huge precinct is some 450 by 260 feet. Lateral entrances on the east and west lead to an arcaded forecourt (FIG. 5-5, no. 7) resembling a Roman forum (FIG. 3-35) or the atrium of an Early Christian basilica (FIGS. 4-3 and 4-4). The courtyard is oriented north-south on axis with the mosque's minaret (no. 8) and the two domes (nos. 3 and 6) of the hypostyle prayer hall (no. 4). The first dome (no. 6) is over the entrance bay, the second (no. 3) over the bay that fronts the mihrab (no. 2) set into the qibla

wall (no. 1). A raised nave (no. 5) connects the domed spaces and prolongs the north-south axis of the minaret and courtyard. Eight columned aisles flank the nave on either side, providing space for a large congregation. The hypostyle mosque synthesizes elements received from other cultures into a novel architectural unity.

SAMARRA The three-story minaret of the Kairouan mosque is square in plan and believed to be a near copy of a Roman lighthouse. Minarets can take a variety of forms, however. Perhaps

announce the presence of Islam in the Tigris Valley. from a considerable distance in the flat plain around Samarra, to prayer, the Abbasids probably intended the tower, which is visible Malwiya Minaret is too tall to have been used to call Muslims to tom to top in order to keep each stage the same height. Because the tower is its stepped spiral ramp, which increases in slope from botthe minaret to the mosque. The distinguishing feature of the brick

ing major influence on the civilization of the Christian West. brilliant culture rivaling that of the Abbasids at Baghdad and exertdynasty. Their capital was Córdoba, which became the center of a the fugitive as their overlord, and he founded the Spanish Umayyad the Christian kingdom of the Visigoths in 711. The Arabs accepted clan in Syria, fled to Spain in 750, where the Arabs had overthrown the only Umayyad notable to escape the Abbasid massacre of his capital from Damascus to Baghdad. Abd-al-Rahman I (r. 756-788), 750, they had overthrown the Umayyad caliphs and moved the mosque (FIG. 5-5), the Abbasids ruled much of North Africa. In CÓRDOBA At the time that the Umayyads built the Kairouan

airy effect of the Córdoba mosque's interior. out like windblown sails, and they contribute greatly to the light and ated with Muslim architecture. Visually, these arches seem to billow the West, the horseshoe-shaped arch quickly became closely associfrom earlier Mesopotamian architecture or of Visigothic origin. In The lower arches are horseshoe shaped, a form perhaps adapted employed earlier in other structures, both Visigothic and Roman. the roof to an acceptable height using short columns that had been The two-story system was the builders' response to the need to raise that originally supported a timber roof (later replaced by vaults). and 514 columns topped by a unique system of double-tiered arches style prayer hall (FIG. 5-7), remodeled several times, has 36 piers Mosque (FIG. 5-1)—begun in 784 by Abd al-Rahman I. The hypo-The centerpiece of Umayyad Córdoba was its Mezquita—Great

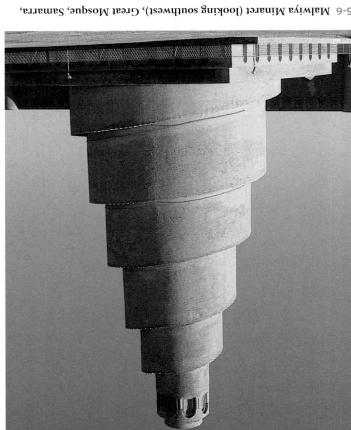

5-6 Malwiya Minaret (looking southwest), Great Mosque, Samarra,

presence of Islam in the Tigris Valley. is more than 165 feet tall and can be seen from afar. It served to announce the The unique spiral Malwiya (snail shell) Minaret of Samarra's Great Mosque

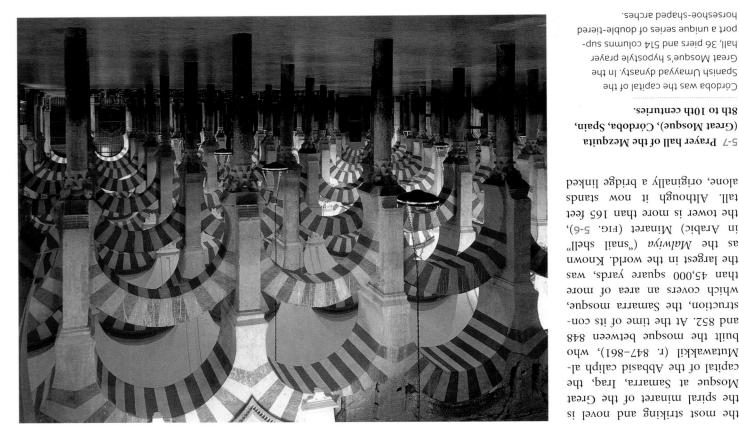

Iraq, 848-852.

8th to 10th centuries. (Great Mosque), Córdoba, Spain, 5-7 Prayer hall of the Mezquita

horseshoe-shaped arches. port a unique series of double-tiered hall, 36 piers and 514 columns sup-Great Mosque's hypostyle prayer Spanish Umayyad dynasty. In the Córdoba was the capital of the

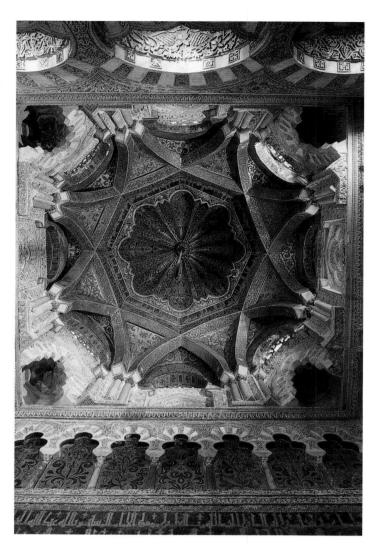

5-8 Dome in front of the mihrab of the Mezquita (Great Mosque), Córdoba, Spain, 961–965.

The dome in front of the Córdoba mihrab rests on an octagonal base of arcuated squinches. The crisscrossing ribs and multilobed arches exemplify Islamic experimentation with abstract patterning.

In 961, al-Hakam II (r. 961–976) became caliph and immediately undertook major renovations to Córdoba's Mezquita, including the addition of a series of domes in the prayer hall to emphasize the axis leading to the mihrab. The dome (FIG. 5-8) covering the area in front of the mihrab rests on an octagonal base crisscrossed by ribs that form an intricate pattern centered on two squares set at 45-degree angles to each other. It is a prime example of Islamic experimentation with highly decorative multilobed arches. The Muslim builders created rich and varied abstract patterns and further enhanced the magnificent effect of the complex arches by sheathing the surfaces with mosaics. Al-Hakam II brought the mosaicists and even the tesserae to Spain from Constantinople.

ALHAMBRA In the early years of the 11th century, the Umayyad caliphs' power in Spain unraveled, and their palaces fell prey to Berber soldiers from North Africa. The Berbers ruled southern Spain for several generations, but could not resist the pressure of Christian forces from the north. Córdoba fell to the Christians in 1236. From then until the final Christian triumph in 1492, the Nasrids, an Arab dynasty that had established its capital at Granada in 1232, ruled the remaining Muslim territories in Spain. On a rocky spur at Granada, the Nasrids constructed a huge palace-fortress called the Alhambra ("the Red" in Arabic), named for the rose color of the stone used for its walls and 23 towers. By the end of the 14th century, the complex was home to 40,000 and included at least a half dozen royal residences.

The Palace of the Lions takes its name from its courtyard (FIG. 5-9), which contains a fountain with 12 marble lions carrying

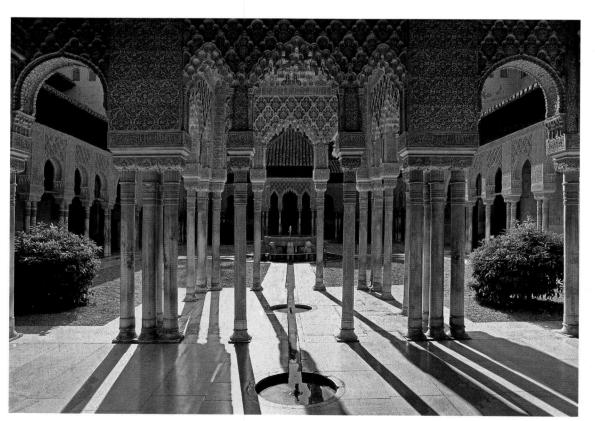

5-9 Court of the Lions (looking east), Palace of the Lions, Alhambra, Granada, Spain, 1354–1391.

The Nasrid Palace of the Lions takes its name from the fountain in this courtyard, a rare Islamic example of stone sculpture. Interwoven abstract ornamentation and Arabic calligraphy cover the stucco walls.

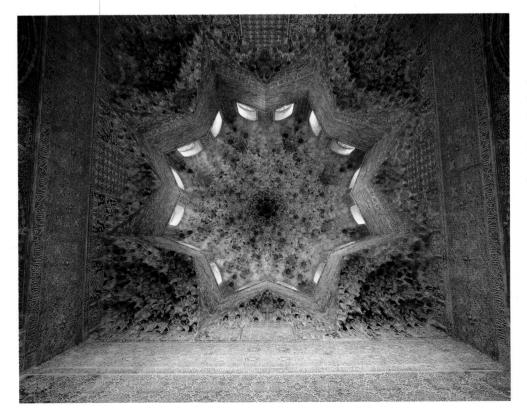

lofty vault in this hall and others in the palace symbolize the dome and reflect sunlight as well as form beautiful abstract patterns. The ing the structure's solidity—cover the ceiling. The mugarnas catch after tier of stalactite-like prismatic forms that seem aimed at deny-

> Alhambra, Granada, Spain, 1354-1391. Abencerrajes, Palace of the Lions, 5-10 Mugarnas dome, Hall of the

starry sky. forms reflect sunlight, creating the effect of a cately carved stucco mugarnas. The prismatic drum is difficult to discern because of the intri-The structure of this dome on an octagonal

conjure the image of Paradise. carpets and other furnishings served to courtyards, lush gardens, and luxurious of Muhammad V (r. 1354-1391), and its tal writing). The palace was the residence motifs and Arabic calligraphy (ornamenstucco walls with interwoven abstract multilobed pointed arches and carved is distinctly Islamic and features many setting. But the design of the courtyard Islamic world, unthinkable in a sacred of freestanding stone sculpture in the bra's lion fountain is an unusual instance a water basin on their backs. The Alham-

5-10) of the so-called Hall of the Aben-A spectacular example is the dome (FIG. thy also for its elaborate stucco ceilings. The Palace of the Lions is notewor-

the intricate carved stucco decoration. Some 5,000 mugarnas—tier pairs of windows, but its structure is difficult to discern because of drum supported by squinches (FIG. 4-13, right) and pierced by eight cerrajes (a leading Spanish family). The dome rests on an octagonal

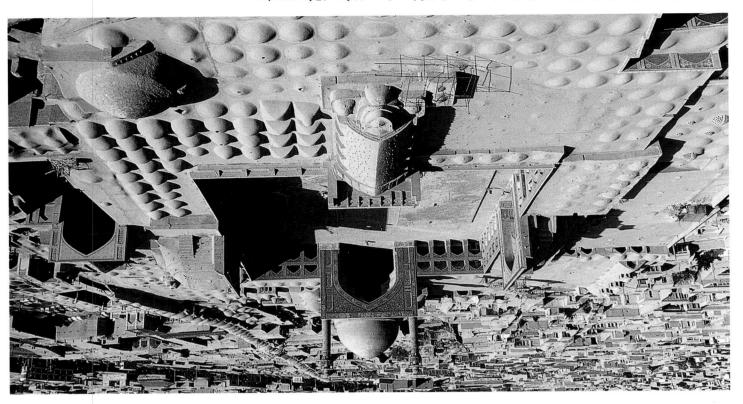

5-11 Aerial view of the Friday Mosque (looking southwest), Isfahan, Iran, 11th to 17th centuries.

iwan leads into a dome-covered magsura in front of the mihrab. Mosques take a variety of forms. In Iran, the standard type of mosque has four vaulted iwans opening onto a courtyard. The largest (qibla) of Heaven. The flickering light and shadows create the effect of a starry sky as the sun's rays glide from window to window during the day. To underscore the symbolism, the palace walls were inscribed with verses by the court poet Ibn Zamrak (1333–1393), who compared the Alhambra's lacelike muqarnas ceilings to "the heavenly spheres whose orbits revolve."

ISFAHAN In the Middle Eastern core of the Islamic world, in Iran, successive dynasties erected a series of mosques at Isfahan. The first and largest is the Friday Mosque (FIG. 5-11), constructed by the Abbasids during the eighth century. In the late 11th century, the Seljuk sultan (ruler) Malik Shah I (r. 1072-1092) transformed the Abbasid hypostyle structure into a distinctly Iranian mosque with a large courtyard bordered by an arcade on each side. Four vaulted iwans open onto the courtyard, one at the center of each side. The southwestern iwan leads into a dome-covered room in front of the mihrab that functioned as a maqsura reserved for the sultan and his attendants. It is uncertain whether Isfahan's Friday Mosque is the earliest example of a four-iwan mosque, but that plan became standard in Iranian religious architecture. In this type of mosque, the qibla iwan is always the largest. Its size (and the dome that often accompanied it) immediately indicated to worshipers the proper direction for prayer.

MADRASA IMAMI The iwans of the Isfahan mosque feature soaring pointed arches framing tile-sheathed muqarnas vaults. The muqarnas ceilings probably date to the 14th century. The ceramictile revetment on the walls and vaults is the work of the 17th-century Safavid dynasty (r. 1501–1732) of Iran. The use of glazed tiles has a long history in Mesopotamia (FIG. 1-20) and Persia. The golden age of Islamic ceramic tilework was the 16th and 17th centuries in Iran and Turkey. Employed as a veneer over a brick core, tiles could sheathe entire buildings (FIG. 5-2), including domes and minarets.

One of the masterworks of Iranian tilework is the 14th-century mihrab (FIG. 5-12) from the Madrasa Imami in Isfahan. (A madrasa is an Islamic theological college, often incorporating a mosque.) It is also a splendid example of Arabic calligraphy. The Islamic world held the art of calligraphy in high esteem, and the walls of buildings often displayed the sacred words of the Koran. Quotations from the Koran appear, for example, in a mosaic band above the outer ring of columns inside the Dome of the Rock (FIG. 5-4). The Isfahan mihrab exemplifies the perfect aesthetic union between calligraphy and abstract ornamentation. The pointed arch framing the mihrab niche bears an inscription from the Koran in an early stately rectilinear script called Kufic, after the city of Kufah, one of the renowned centers of Arabic calligraphy. A cursive style, Muhaqqaq, fills the mihrab's outer rectangular frame. The tile decoration on the curving surface of the niche and the area above the pointed arch consists of tighter and looser networks of geometric and abstract floral motifs. The tilework technique used here is the most difficult of all the varieties Islamic artisans practiced: mosaic tilework. Every piece had to be cut to fit its specific place in the mihrab—even the tile inscriptions. The ceramist smoothly integrated the subtly varied decorative patterns with the framed inscription in the center of the niche proclaiming that the mosque is the domicile of the pious believer. The mihrab's outermost inscription—detailing the Five Pillars of Islamic faith-serves as a fringelike extension, as well as a boundary, for the entire design. The unification of calligraphic and geometric elements is so complete that only the practiced eye can distinguish them.

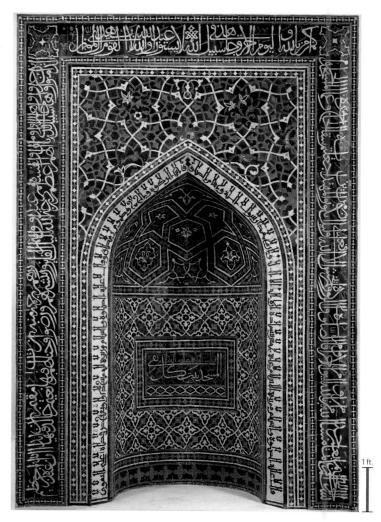

5-12 Mihrab, from the Madrasa Imami, Isfahan, Iran, ca. 1354. Glazed mosaic tilework, 11' $3'' \times 7'$ 6". Metropolitan Museum of Art, New York.

This Iranian mihrab is a masterpiece of Iranian tilework, but it is also a splendid example of Arabic calligraphy. In the Islamic world, the walls of buildings often displayed the sacred words of the Koran.

LUXURY ARTS

In the smaller-scale, and often private, realm of the luxury arts, often referred to as *minor arts*, Muslim artists also excelled. In the Islamic world, the term *minor arts* is especially inappropriate. Although of modest size, the manuscripts, ivories, textiles, colored glass, and metalwork that Muslim artists produced in great quantities are among the finest works of any age. From the vast array of Islamic luxury arts, a selection of several masterpieces may serve to suggest both the range and quality of small-scale Islamic art.

KORANS The earliest preserved Korans date to the ninth century, and the finest of them are masterpieces of Arabic calligraphy. Muslim scribes wanted to reproduce the Koran's sacred words in a script as beautiful as human hands could contrive. Koran pages were either bound into books or stored as loose sheets in boxes. Most of the early examples feature the angular Kufic script used in the central panel of the Madrasa Imami mihrab (FIG. 5-12). Arabic is written from right to left, with certain characters connected by a baseline. In Kufic script, the uprights usually form right angles with

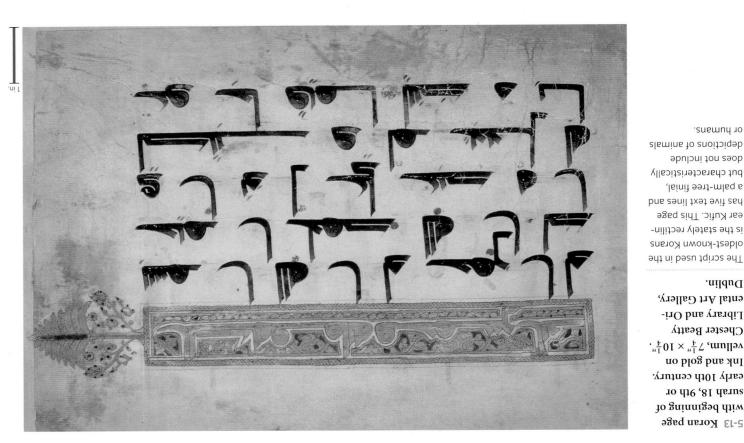

or humans. depictions of animals abuloni ton saob but characteristically a palm-tree finial, has five text lines and ear Kufic. This page is the stately rectilinoldest-known Korans The script used in the

ental Art Gallery, Library and Ori-Chester Beatty

Ink and gold on early 10th century. surah 18, 9th or vith beginning of 5-13 Koran page

Dublin.

featured motifs symbolic of royal power and privilege, including (singular, pyxis; a cylindrical box with a hemispherical lid) usually Befitting their prospective owners, Spanish Umayyad ivory pyxides and for use as diplomatic gifts, including richly carved ivory boxes. workshops for the production of luxury items for the caliph's family

(not visible in Fig. 5-14), the prince himself appears, serenaded by figural medallions. In one medallion, lions attack bulls. In another and hunters amid lush vine scrolls surrounding four eight-lobed mous ivory carver decorated the pyxis with a rich array of animals God have mercy upon him, in the year 357 [968 CE]. The anonycommander of the faithful [the standard epithet for caliphs], may "God's blessing, favors, and happiness to al-Mughira, son of the base of the lid is a prayer for the 18-year-old prince's well-being: younger son of Abd al-Rahman III. The inscription carved at the The pyxis shown here (FIG. 5-14) belonged to al-Mughira, the hunting scenes and musical entertainments.

of the mosque, during the reign of Shah Tahmasp (r. 1524-1576). carpets date to 1540, however—two centuries after the construction Shaykh Safi al-Din (1252-1334), the founder of the Safavid line. The is a pair of carpets from the funerary mosque in Ardabil, Iran, of been preserved. Perhaps the best later example of the weaver's art carpets endure, only a few fragmentary early Islamic textiles have tunately, because of their fragile nature and the heavy wear that and cushions. Textiles are among the glories of Islamic art. Unforsleeping, for example) can change simply by rearranging the carpets chairs—are rare in Muslim buildings. A room's function (eating or world, the kinds of furniture used in the West-Deds, tables, and ARDABIL CARPETS Because wood is scarce in most of the Islamic

> bols above or below the line. of the Koran, scribes often indicated vowels by red or yellow sympractice was to write in consonants only. But to facilitate recitation the baseline. As with Hebrew and other Semitic languages, the usual

> and Byzantium. sharply apart from both the classical world and Christian Europe absence of figural ornament in mosques, setting the Islamic world of fauna of any kind in sacred contexts. This also explains the total never appear in Korans. Islamic tradition shuns the representation ized human and animal forms that populate those Christian books and ornamentation were similarly united (FIG. 6-4). But the stylearly medieval manuscripts of Britain and Ireland, where text ing ornament). This approach to page design has parallels in the the chapter title in gold and ending in a palm-tree finial (a crownin black ink with red vowels, below a decorative band incorporating and opening five text lines of surah (chapter) 18. The text lines are Koran page (FIG. 5-13) now in Dublin, which carries the heading All of these features are present in a 9th- or early 10th-century

> about five miles from Córdoba. The palace complex housed royal ish new palace for himself and his successors at Medina al-Zahra, Medina. During his nearly 50-year reign, he constructed a lavto the Muslim rulers who controlled the holy cities of Mecca and 22. In 929, he declared himself caliph, a title previously restricted of the Umayyad dynasty in Spain, became emir (ruler) when he was 5-8). Abd al-Rahman III (r. 912-961), a descendant of the founder Muslim caliphs and sultans. One was Córdoba (FIGS. 5-1, 5-7, and with gold and silver (FIG. 5-14A A), were usually the courts of the from more costly materials, such as ivory (FIG. 5-14) or brass inlaid IVORY CARVING The centers of production for objects fashioned

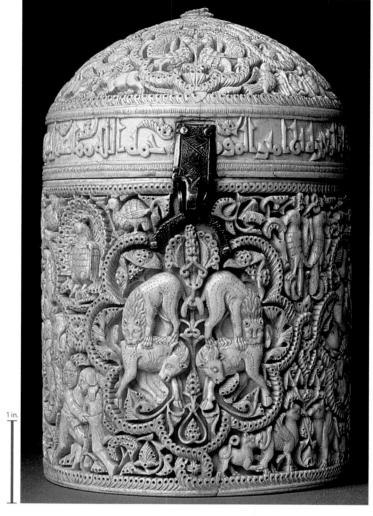

5-14 Pyxis of al-Mughira, from Medina al-Zahra, near Córdoba, Spain, 968. Ivory, $5\frac{7}{8}$ " high. Musée du Louvre, Paris.

The royal workshops of Abd al-Rahman III produced luxurious objects such as this ivory pyxis decorated with hunting motifs and vine scrolls. It belonged to al-Mughira, the caliph's younger son.

Tahmasp elevated carpet weaving to a national industry and set up royal factories at Isfahan, Kashan, Kirman, and Tabriz. The name of Maqsud of Kashan appears as part of the design of the Ardabil carpet illustrated here (fig. 5-15). Maqsud must have been the artist who supplied the master pattern to two teams of royal weavers (one for each of the two carpets). The almost 35-by-18-foot carpet consists of roughly 25 million knots, some 340 to the square inch. (Its twin has even more knots.)

The design consists of a central sunburst medallion, representing the inside of a dome, surrounded by 16 pendants. Mosque lamps (compare FIG. 5-15A (1))—appropriate motifs for the Ardabil funerary mosque—hang from two pendants on the long axis of the carpet. The lamps are of different sizes. This may be an optical device to make the two appear equal in size when viewed from the end of the carpet at the room's threshold (the bottom end in FIG. 5-15). Covering the rich blue background are leaves and flowers attached to delicate stems that spread over the whole field. The entire composition presents the illusion of a heavenly dome with lamps reflected in a pool of water full of floating lotus blossoms.

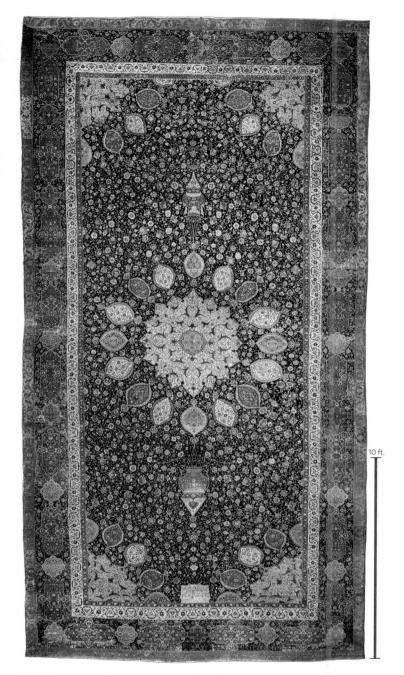

5-15 MAQSUD OF KASHAN, carpet from the funerary mosque of Shaykh Safi al-Din, Ardabil, Iran, 1540. Knotted pile of wool and silk, $34'6'' \times 17'7''$. Victoria & Albert Museum, London.

Textiles are among the glories of Islamic art. This carpet required roughly 25 million knots. It presents the illusion of a heavenly dome with mosque lamps reflected in a lotus-blossom-filled pool of water.

TIMURIDS In the late 14th century, a new Islamic empire arose in Central Asia under the leadership of Timur (r. 1370–1405), known in the Western world as Tamerlane. Timur, a successor of the Mongol conqueror Genghis Khan (see page 495), quickly extended his dominions to include Iran and parts of Anatolia. The Timurids, who ruled until 1501, were great patrons of art and architecture in Herat, Bukhara, Samarqand, and other cities. Herat in particular became a leading center for the production of luxurious books under the patronage of the Timurid sultan Husayn Mayqara (r. 1470–1506).

5-16 SULTAN-MUHAMMAD, Court of Gayumars, folio 20 verso of the Shahnama of Shah Tahmasp, from Tabriz, Iran, ca. 1525–1535. Ink, watercolor, and gold on paper, I'I" × 9". Prince Sadruddin Aga Khan Collection, Geneva.

Sultan-Muhammad painted the legend of King Gayumars for the Safavid ruler Shah Tahmasp.
The off-center placement on the page enhances the sense of lightness permeating the painting.

In contrast to Korans (FIG. 5-13), Timurid secular books—for example, the Bustan (FIG. 5-158 ♠), with paintings by BIHZAD—often featured full-page narrative paintings with human and animal figures.

SAFAVID SHAHNAMA The successors of the Timurids in Iran were the Safavids. Shah Tahmasp, the Safavid ruler who commissioned the Ardabil carpets (Fig. 5-15), was also a great patron of books. Around 1525, he commissioned an ambitious trated 742-page copy of the Shahnama (Book of Kings). The Shahnama, the Persian national epic poem by Firdawsi (940–1025), recounts the history of Iran from creation until the Muslim conquest. Tahmasp's Shahnama contains 258 illustrations by many artists, including some trations by many artists, including some of the most admired painters of the day.

The page reproduced here (FIG. 5-16) is the work of SULTAN-MUHAMMAD and depicts Gayumars, the legendary first king of Iran, and his court. According to tradition, Gayumars ruled from a mountaintop when humans first learned to cook food and clothe themselves in leopard skins. In Sultan-Muhammad's representation of the story, Gayumars presides over his court from his mountain throne. The king is surtounded by light amid a golden sky. His son and grandson perch on multicolored rocky outcroppings to the viewer's left and rocky outcroppings to the viewer's left and right, respectively. The court encircles the ruler and his heirs. All of the figures wear ruler and his heirs. All of the figures wear

leopard skins. Dozens of human faces appear among the rocks, and many species of animals populate the lush landscape. According to the *Shahnama*, wild beasts became instantly tame in the presence of Gayumars. Sultan-Muhammad rendered the figures, animals, trees, rocks, and sky with an extraordinarily delicate touch. The sense of lightness and airiness permeating the painting is enhanced by its placement on the page—floating, off center, on a speckled background of gold leaf. The painter gave his royal patron a singular vision of Iran's fabled past.

ISLAM IN ASIA Islamic artists and architects also brought their distinctive style to South Asia, where a Muslim sultanate was established

at Delhi in India in the early 13th century. These important Islamic works are an integral part of the history of Asian art and are treated in Chapter 17.

Explore the era further in MindTap with videos of major artworks and buildings, Google EarthTM coordinates, and essays by the author on the following additional subjects:

■ ART AND SOCIETY: Major Muslim Dynasties

ANT AIND SOCIETT: INIGIOI INIGINITI DYTIGGE

Baptistère de Saint Louis (FIG. 5-14A)

 $^{\rm e}$ Mosque lamp of Sayf al-Din Tuquztimur (FIG. 5-15A)

(871-7 and the fact of driving the services of the services of

Bihzad, Seduction of Yusuf (FIG. 5-15B)

THE ISLAMIC WORLD

Architecture

- The Umayyads (r. 661–750) were the first Islamic dynasty. They ruled from their capital at Damascus (Syria) until the Abbasids (r. 750–1258) overthrew them and established a new capital at Baghdad (Iraq).
- The first great Islamic building was the Dome of the Rock, a domed octagon commemorating the triumph of Islam in Jerusalem, which the Muslims captured from the Byzantines in 638. It was intended to rival and surpass the Christian Church of the Holy Sepulchre.
- The earliest mosques—for example, the Great Mosque that the Abbasids erected at Kairouan (Tunisia) in the mid-9th century—were of the hypostyle-hall type and incorporated arcaded courtyards and minarets. Inside mosques, Muslims pray facing Mecca.
- The Umayyad capital in Spain was at Córdoba, where the caliphs (r. 756-1031) constructed and expanded the Great Mosque between the 8th and 10th centuries. The mosque features horseshoe and multilobed arches and mosaic-covered domes resting on arcuated squinches.
- The last Spanish Muslim dynasty was the Nasrid (r. 1230–1492), whose capital was at Granada. The Alhambra is the best surviving example of Islamic palace architecture. It is famous for its carved stucco walls, muqarnas decoration on vaults and domes, and the Court of the Lions and its fountain, which is a rare example of Islamic stone sculpture.
- The Timurid (r. 1370–1501) and Safavid (r. 1501–1732) dynasties ruled Iran and Central Asia for almost four centuries and were great patrons of art and architecture. The art of tilework reached its peak under the patronage of the Safavid dynasty. Builders of the time frequently used mosaic tiles to cover the walls and vaults of mosques and madrasas.

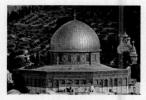

Dome of the Rock, Jerusalem, 687-692

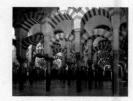

Great Mosque, Córdoba, 8th to 10th centuries

Palace of the Lions, Granada, 1354-1391

Luxury Arts

- The earliest preserved Korans date to the ninth century and feature Kufic calligraphy and decorative motifs but no figural illustrations. Islamic tradition shuns the representation of fauna of any kind in sacred contexts.
- Muslim artists excelled in the art of enamel-decorated glass lamps, which illuminated mosque interiors; carved ivory pyxides; and textiles. In secular contexts, figural decoration was permitted. The ivory pyxis of al-Mughira produced at the Córdoba court features animals and hunters. Some carpets—for example, the pair designed by Maqsud of Kashan for a 16th-century funerary mosque at Ardabil (Iran)—were woven with at least 25 million knots each.
- The Timurid court at Herat (Afghanistan) and the Safavid rulers of Iran employed the most skilled painters of the day, who specialized in illustrating secular books with narrative scenes incorporating people and animals. Among the most famous manuscript painters were Bihzad, who illustrated books for Sultan Husayn Mayqara (r. 1470–1506), and Sultan-Muhammad, who worked for Shah Tahmasp (r. 1524–1576).

Koran page, 9th or early 10th century

Maqsud of Kashan, Ardabil carpet, 1540

ures of crowned ures of crowned musicians in the grand relief above the portal are the 24 elders who accompany Christ as the kings of this world and make music in his praise. Each turns to face the turns to face the enthroned judge.

▲ 6-1a A vision of the second coming of Christ on judgment day greets worshipers entering Saint-Pierre at Moissac. The sculptural program reflects the belief that Christ is the door to salvation.

■ 6-1c On the front of the trumeau, six roaring lions greet worshipers as they enter the church. Lions were the church's ideal protectors. In the Middle Ages, people believed that lions slept with their eyes open.

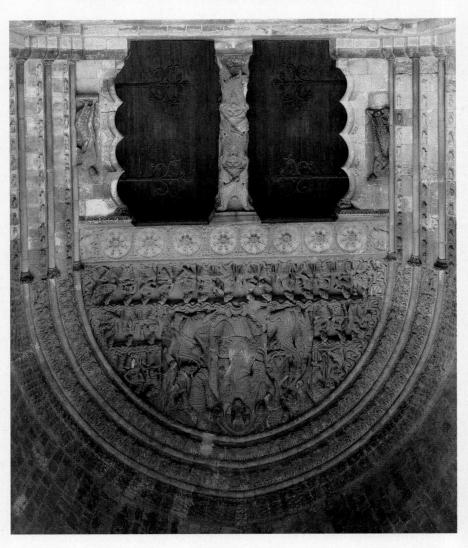

South portal of Saint-Pierre, Moissac, France, ca. 1775-7735.

Early Medieval and Romanesque Europe

THE DOOR TO SALVATION

The church of Saint-Pierre (Saint Peter) at Moissac in southwestern France boasts the most extensive preserved ensemble of 12th-century sculpture in Europe. An important stop along the pilgrimage route to the tomb of Saint James at Santiago de Compostela in northwestern Spain (see "Pilgrimages," page 170, and MAP 6-1), the Moissac abbey had joined the Cluniac order in 1047. Enriched by the gifts of pilgrims and noble benefactors, the monks adorned their church with an elaborate series of relief sculptures, both in the cloister (FIG. 6-20) and especially in the richly decorated south portal (FIG. 6-1) facing the town square.

The jambs and central post (*trumeau*) of the Moissac portal have scalloped contours, a borrowing from Spanish Islamic architecture (FIG. 5-7). Six roaring interlaced lions on the front of the trumeau greet worshipers as they enter the church. The notion of placing fearsome images at the gateways to important places is of very ancient origin (compare FIGs. 1-18, 2-10, 2-23, and 3-7). In the Middle Ages, lions were the church's ideal protectors because people believed that lions slept with their eyes open.

The grand stone relief in the *tympanum* above the portal depicts the second coming of Christ as king and judge of the world in its last days. As befits his majesty, the enthroned Christ is at the center, reflecting a compositional rule followed since Early Christian times. Flanking him are the signs of the four Gospel authors and attendant angels holding scrolls to record human deeds for judgment. Completing the design are 24 figures of crowned musicians. They are the 24 elders who accompany Christ as the kings of this world and make music in his praise. Each turns to face the enthroned judge, much as would the courtiers of a medieval monarch in attendance on their lord. Two courses of wavy lines symbolizing the clouds of Heaven divide the elders into three tiers.

The inclusion of a larger-than-life image of Christ as the central motif of the Moissac tympanum is a common feature of many church portals of this era. These entryways reflect the belief, dating to Early Christian times, that Christ is the door to salvation ("I am the door; who enters through me will be saved"—John 10:9). An inscription on the tympanum of the late-11th-century monastic church of Santa Cruz de la Serós in Spain made this message explicit: "I am the eternal door. Pass through me faithful. I am the source of life."

Moissac's south portal is an early example of the rebirth of the art of large-scale sculpture in the Middle Ages, one hallmark of the age that art historians have dubbed *Romanesque* (Roman-like) because of the extensive use of stone sculpture and stone vaulting in 11th- and 12th-century churches.

Aerovingians and Anglo-Saxons

EARLY MEDIEVAL EUROPE

classical idea that naturalistic representation should be the focus of and abstract ornamentation, and because their makers rejected the "minor arts" because of their small scale, seeming utilitarian nature, who viewed medieval art through a Renaissance lens, ignored these (FIG. 6-1A (4)) discovered in a Merovingian grave. Earlier scholars, bracelets, pendants, belt buckles, and fibulae—for example, the pair tus symbols"-weapons and items of personal adormment such as not fully representative and consists almost exclusively of small "stathese non-Roman cultures produced. What has survived is probably Art historians do not know the full range of art and architecture that

phisticated or inferior. On the contrary, medieval artists produced ever, long ago ceased to regard the art of medieval Europe as unsoto describe this "era in between" and its art. Modern scholars, howin the retention of the noun Middle Ages and the adjective medieval legacy of the humanist scholars of Renaissance Italy, persists today and the beginning of modern Europe. This negative assessment, a Ages. They viewed this period as a blank between classical antiquity and the rebirth (Renaissance) of interest in classical art as the Dark between the dying Roman Empire's official adoption of Christianity Historians once referred to the thousand years (roughly 400 to 1400)

artworks. innovative and beautiful some of the world's most

nations. ally in today's European Empire, resulting eventuwhat had been the Roman order gradually replaced groups merged, and a new the various population anity. Over the centuries, of the Alps, and Christinon-Roman peoples north inces, the cultures of the Rome's northwestern provof the classical heritage of Europe was a unique fusion 500-1000) art in western Early medieval (ca.

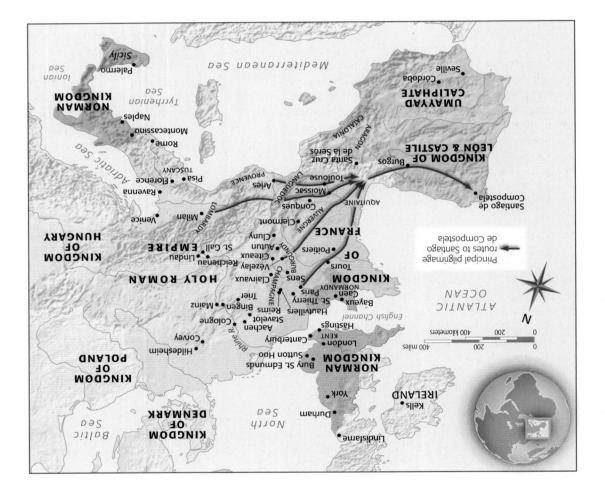

ary in the Gero Crucifix.

naves of churches.

Ottonian

7701-616

revives the art of freestanding statu-

Michael's, and a Cologne sculptor

historiated bronze doors for Saint

alternate-support system into the

Offonian architects introduce the

Hildesheim metalworkers cast huge

around 1100. MAP 6-1 Western Europe

EARLY MEDIEVAL AND ROMANESQUE EUROPE

Komanesque 1024-1200

- Relief sculpture becomes commonthe display of relics. adiating chapels to ambulatories for tribune-clerestory). They also add three-story nave elevation (arcadechurches in conjunction with a stone barrel and groin vaulting in Romanesque architects introduce
- as last judge. ing worshipers with a vision of Christ place in church portals, usually greet-
- the scriptoria of Cluniac monasteries. Manuscript illumination flourishes in

- the art and culture of Early Christian cessors initiate a conscious revival of Charlemagne and his Carolingian suc-Carolingian
- plans for basilican churches. twin-tower westwork and modular Carolingian architects introduce the
- Hiberno-Saxon Merovingian, Anglo-Saxon, 894-014
- In Ireland and Northumbria, Christian patterns. mentation and animal-and-interlace adornment featuring cloisonné ornacostly portable items of personal and Anglo-Saxon artists produce After the fall of Rome, Merovingian
- word of God. pages devoted to embellishing the minated manuscripts featuring full missionaries commission lavish illu-

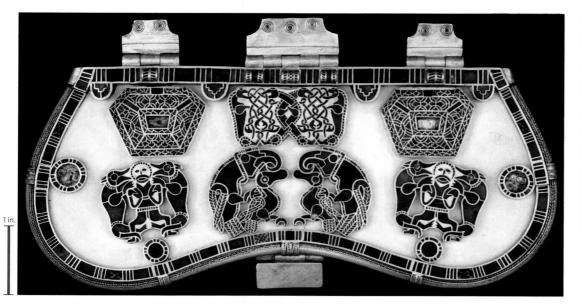

6-2 Purse cover, from the Sutton Hoo ship burial in Suffolk, England, ca. 625. Gold, glass, and enamel cloisonné with garnets and emeralds, $7\frac{1}{2}$ " long. British Museum, London (gift of Mrs. E. M. Pretty).

This purse cover with cloisonné ornamentation comes from a treasure-laden royal burial ship. The combination of abstract interlace with animal figures is the hallmark of early medieval art in western Europe.

artistic endeavor. In the early Middle Ages, people regarded these objects as treasures. The miniature artworks enhanced their owners' prestige and testified to the stature of those buried with them. In the great Anglo-Saxon epic *Beowulf*, after Beowulf dies, his comrades cremate the hero and place his ashes in a huge burial mound overlooking the sea. As an everlasting tribute, they "buried rings and brooches in the barrow, all those adornments that brave men had brought out from the hoard after Beowulf died. They bequeathed the gleaming gold, treasure of men, to the earth."²

SUTTON HOO SHIP BURIAL The *Beowulf* saga also recounts the funeral of the warrior lord Scyld, whom his companions laid to rest in a ship overflowing with arms and armor and costly adornments, which they set adrift in the North Sea. In 1939, archaeologists uncovered a treasure-laden ship in a burial mound at Sutton Hoo, England. Among the many precious finds in the Sutton Hoo ship were a gold belt buckle, 10 silver bowls, 40 gold coins, and 2 silver spoons inscribed "Saulos" and "Paulos" (Saint Paul's names in Greek before and after his baptism). The spoons may allude to a conversion to Christianity. Some historians have associated the ship with the East Anglian king Raedwald (r. 599?–625), who was baptized a Christian before his death in 625.

The most extraordinary Sutton Hoo find was a purse cover (FIG. 6-2) decorated with seven cloisonné plaques. Early medieval metalworkers produced cloisonné jewelry by soldering small metal strips, or cloisons (French, "partitions"), edge-up, to a metal background, and then filling the compartments with semiprecious stones, pieces of colored glass, or glass paste fired to resemble sparkling jewels. On the Sutton Hoo purse cover, four symmetrically arranged groups of cloisonné figures make up the lower row. The end groups consist of a man standing between two beasts. The trio is a pictorial parallel to the epic sagas of the era in which heroes such as Beowulf battle and conquer horrific monsters. The two center groups represent eagles attacking ducks. The convex beaks of the eagles (compare FIG. 6-1A) fit against the concave beaks of the ducks. The two figures fit together so snugly that they seem at first to be a single dense abstract design. This is true also of the manand-animals motif.

Above these figures are three geometric designs. The outer ones are purely linear. The central design is an interlace pattern in which the interlacements evolve into writhing animal figures. Elaborate intertwining linear patterns are characteristic of many times and places, but the combination of interlace with animal figures was uncommon outside the realm of the early medieval warlords. In fact, metalcraft with interlace patterns and other motifs beautifully integrated with animal forms was, without doubt, the premier art of the early Middle Ages in northwestern Europe.

Hiberno-Saxon Art

The Christianization of the British Isles, which began in the fifth century, accelerated in the sixth. In 563, for example, Saint Columba (521–597) founded an important monastery on the Scottish island of Iona, where he successfully converted the native Picts to Christianity. Iona monks in turn established the monastery at Lindisfarne off the northern coast of Britain in 635. Art historians call the art produced in these and other early medieval monasteries in Ireland and Britain *Hiberno-Saxon* (Hibernia was the Roman name of Ireland).

MANUSCRIPT ILLUMINATION The most distinctive products of these monasteries were illuminated Christian books, which brought the word of God to a predominantly illiterate population, who regarded the monks' sumptuous volumes with awe. Books were scarce and jealously guarded treasures of monastic libraries and scriptoria (writing studios). One of the most characteristic features of Hiberno-Saxon book illumination is the inclusion of full pages devoted neither to text nor to illustration but to pure embellishment. Interspersed between the text pages are so-called carpet pages resembling textiles (FIG. 6-3), made up of decorative panels of abstract and animal forms. Many books also contain pages (for example, FIG. 6-4) on which the illuminator enormously enlarged the initial letters of an important passage of sacred text and transformed those letters into elaborate decorative patterns. Such manuscript pages have no precedents in Greco-Roman books. They reveal the striking independence of Hiberno-Saxon artists from the classical tradition.

Gospels, from Northumbria, England, ca. 698–721. Tempera on vellum, 1' $1\frac{1}{2}$ " $\times 9\frac{1}{4}$ ". British Library, London.

The cross-inscribed carpet page of the Lindisforne Gospels exemplifies

6-3 Cross-inscribed carpet page, folio 26 verso of the Lindisfarne

The cross-inscribed carpet page of the Lindisforne Gospels exemplifies the way Hiberno-Saxon illuminators married Christian imagery and the animal-and-interlace style of the early medieval warlords.

detailed symmetries, with inversions, reversals, and repetitions that the viewer must study closely in order to appreciate not only their variety but also their mazelike complexity. The animal forms intermingle with clusters and knots of line, and the whole design vibrates with energy. The color is rich yet cool. The painter skillfully adjusted shape and color to achieve a smooth and perfectly even surface.

BOOK OF KELLS Surpassing the Lindisfarne Gospels in richness is the Book of Kells, which boasts an unprecedented number of full-page illuminations, including carpet pages, symbols of the four Gospel authors, portrayals of the Virgin Mary and of Christ, New Testament narrative scenes, canon tables, and several instances of enlarged and embellished words from the Bible (see "Beautifying God's Words," page 161, and FIG. 6-4).

LINDISFARIE GOSPELS. The marriage between Christian imagery and the animal-and-interlace style of the Anglo-Saxon warlords is evident in the cross-inscribed carpet page (Pie. 6-3) of the Lindisfurne Gospels. The Gospels (see "Medieval Books" (4) tell the story of the life of Christ, but the painter of the Lindisfurne Gospels had little interlacements in narrative. On the page illustrated here, serpentine interlacements of fantastic animals devour one another, curling over and returning on their writhing, elastic shapes. The rhythm of expanding and the painter held it in check by the regularity of the design and by the dominating motif of the inscribed cross. The cross—the all-important dominating motif of the inscribed cross. The cross—the all-important symbol of the imported religion—stabilizes the rhythms of the serpentines and, perhaps by contrast with its heavy immobility, seems to heighten the effect of motion. The illuminator placed the motifs in to heighten the effect of motion. The illuminator placed the motifs in

PROBLEMS AND SOLUTIONS

Beautifying God's Words

The greatest extant Hiberno-Saxon book is the *Book of Kells*, which one commentator described in the *Annals of Ulster* for 1003 as "the chief relic of the western world." The manuscript (named after the abbey in central Ireland that once owned it) was probably the work of scribes and illuminators at the monastery at Iona. The monks kept the *Book of Kells* in an elaborate metalwork box, as befitted a greatly revered "relic," and they most likely displayed it on the church altar (see "Pilgrimages and the Veneration of Relics," page 170).

Impressing the new and largely illiterate Irish Christians with the beauty of God's words was no doubt one of the goals of the monks who were entrusted with illuminating the Book of Kells. They achieved that goal by literally making the words beautiful. The page reproduced here (FIG. 6-4) is the first folio of the account of the nativity of Jesus in the Gospel of Saint Matthew. The initial letters of Christ in Greek (\$\frac{1}{8}\$, chi-rho-iota) occupy nearly the entire page, although two words-autem (abbreviated simply as h) and generatio—appear at the lower right. Together they read: "Now this is how the birth of Christ came about." The illuminator transformed the holy words into extraordinarily intricate, abstract designs recalling metalwork (FIG. 6-2), but the page is not purely embellished script and abstract pattern. The letter rho, for example, ends in a male head, and animals are at the base of rho to the left of h generatio. Half-figures of winged angels appear to the left of chi. Close observation reveals many other figures, human and animal.

When the priest Giraldus Cambrensis visited Ireland in 1185, he described a manuscript he saw that, if not the *Book of Kells* itself, must have been very much like it:

Fine craftsmanship is all about you, but you might not notice it. Look more keenly at it and you ... will make out intricacies, so delicate and subtle, so exact and compact, so full of knots and links, with colors so fresh and vivid, that you might say that all this was the work of an angel, and not of a man. For my part, the oftener I see the

6-4 *Chi-rho-iota* ($\stackrel{\bullet}{X}$) page, folio 34 recto of the *Book of Kells*, probably from Iona, Scotland, late eighth or early ninth century. Tempera on vellum, 1' 1" \times 9 $\frac{1}{2}$ ". Trinity College Library, Dublin.

In this opening page to the Gospel of Saint Matthew, the painter transformed the biblical text into abstract pattern, literally making God's words beautiful. The intricate design recalls early medieval metalwork.

book, the more carefully I study it, the more I am lost in ever fresh amazement, and I see more and more wonders in the book.*

*Translated by Françoise Henry, The Book of Kells (New York: Alfred A. Knopf, 1974), 165.

Carolingian Art

On Christmas Day of the year 800 in Saint Peter's basilica (FIG. 4-3) in Rome, Pope Leo III (r. 795–816) crowned Charles the Great (Charlemagne), king of the Franks since 768, as emperor of Rome

(r. 800–814). In time, Charlemagne came to be seen as the first Holy (that is, Christian) Roman Emperor, a title that his successors in the West did not formally adopt until the 12th century. Born in 742, when northern Europe was still in chaos, Charlemagne consolidated the Frankish kingdom that his father and grandfather bequeathed

6-6 Saint Matthew, folio 18 verso of the Ebbo Gospels (Gospel Book of Archbishop Ebbo of Reims), from the abbey of Saint Peter, Hautvillers, France, ca. 816–835. Ink and tempera on vellum, $10\frac{1}{4}^n \times 8\frac{3}{4}^n$. Bibliothèque municipale, Épernay.

Saint Matthew writes frantically, and the folds of his drapery writhe and vibrate. Even the landscape rears up alive. This painter merged classical illusionism with the northern European linear tradition.

Roman Empire. program to establish Aachen as the capital of a renewed Christian painting style was one of the many components of Charlemagne's Carolingian artist had fully absorbed the classical manner. Classical ist painted the evangelist portraits of the Coronation Gospels, the Matthew. If a Frankish, rather than an Italian or a Byzantine, artworld that could have prepared the way for this portrayal of Saint art. Almost nothing is known in the Hiberno-Saxon or Frankish consists of the kind of acanthus leaves commonly found in Roman terranean model employing classical perspective. Even the frame placement of the book and lectern top at an angle suggests a Medilectern, and the saint's toga are familiar Roman accessories, and the wrapped around the evangelist's body. The cross-legged chair, the of light and shade to create the illusion of massive drapery folds classical style. The Carolingian painter used color and modulation The Matthew of the Coronation Gospels also reveals the legacy of phers or poets writing or reading (FIG. 3-49) abound in ancient art. of Greek and Latin books. Similar representations of seated philosovenerable tradition of author portraits, which were familiar features news"). The page (Fig. 6-5) depicting Saint Matthew follows the

6-5 Saint Matthew, folio 15 recto of the Coronation Gospels (Gospel Book of Charlemagne), from Aachen, Germany, ca. 800-810. Ink and tempera on vellum, $1'\frac{3}{4}''\times 10''$. Schatzkammer, Kunsthistorisches Museum, Vienna.

The books produced for Charlemagne's court reveal the legacy of classical art. The Carolingian painter used light, shade, and perspective to create the illusion of three-dimensional form.

him, and defeated the Lombards in Italy. He thus united Europe and laid claim to reviving the glory of the Roman Empire. (His official seal bore the words renovatio imperii Romani—"renewal of the Roman Empire.") Charlemagne gave his name (Carolus Magnus in Latin) to an entire era, the Carolingian period.

Charlemagne was a sincere admirer of learning, the arts, and classical culture. He could read and speak Latin fluently, in addition to Frankish, his native tongue. Charlemagne also could understand Greek, and placed high value on books, both sacred and secular, importing many and sponsoring the production of far more. He invited to his court at Aachen, Germany, the best minds of his age, among them Alcuin (d. 804), master of the cathedral (bishop's church, from cathedra—Latin, 'throne' or 'seat'') school at York, the center of Northumbrian learning. One of Charlemagne's dearest projects was the recovery of the true text of the Bible, which, through centuries of errors in copying, had become quite corrupted. Alcuin of York's revision of the Bible became the most widely used.

CORONATION GOSPELS The most famous of Charlemagne's books is the Coronation Gospels. The text is in handsome gold letters on purple vellum. The major full-page illuminations show the four Gospel authors at work—Saints Matthew, Mark, Luke, and John, the four evangelists (from the Greek word for "one who announces good

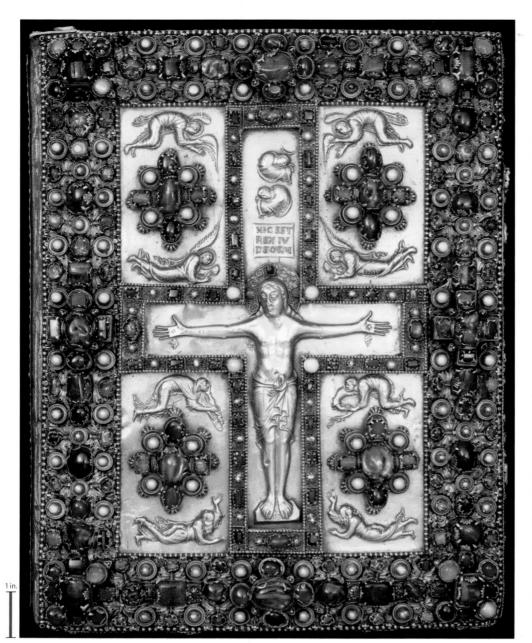

6-7 *Crucifixion*, front cover of the *Lindau Gospels*, from Saint Gall, Switzerland, ca. 870. Gold, precious stones, and pearls, $1' 1\frac{3}{8}'' \times 10\frac{3}{8}''$. Pierpont Morgan Library, New York.

Sacred books with covers of gold and jewels were among the most costly and revered early medieval art objects. This Carolingian cover revives the Early Christian imagery of the youthful Jesus.

EBBO GOSPELS Another Saint Matthew (FIG. 6-6), in a Gospel book made for Archbishop Ebbo of Reims, France, may be an interpretation of an author portrait very similar to the one that the *Coronation Gospels* master used as a model. The *Ebbo Gospels* illuminator, however, replaced the classical calm and solidity of the *Coronation Gospels* evangelist with an energy approaching frenzy. Matthew writes in frantic haste. His hair stands on end, his eyes open wide, the folds of his drapery writhe and vibrate, and the landscape behind him rears up alive. The painter even set the page's leaf border in motion. The *Ebbo Gospels* painter translated a classical prototype into a new Carolingian style, merging classical illusionism and the northern linear tradition.

LINDAU GOSPELS The taste for luxurious portable objects, the hallmark of the art of the early medieval warlords, persisted under Charlemagne and his successors. The Carolingians commissioned numerous works employing costly materials, including book covers made of gold and jewels and sometimes also ivory or pearls. One

of the most opulent Carolingian book covers (FIG. 6-7) is the one later added to the *Lindau Gospels*. The gold cover, fashioned in one of the royal workshops of Charlemagne's grandson, Charles the Bald (r. 840–875), presents a youthful Christ in the Early Christian tradition, nailed to the cross but oblivious to pain. Surrounding Christ are pearls and jewels (raised on golden claw feet so that they can catch and reflect the light even more brilliantly and protect the delicate metal relief from denting). The statu-

esque open-eyed figure, rendered in *repoussé* (hammered relief), is classical both in conception and in execution. In contrast, the four angels and the personifications of the Moon and the Sun above and the crouching figures of the Virgin Mary and Saint John (and two other figures of uncertain identity) in the quadrants below display the vivacity and nervous energy of the *Ebbo Gospels* Saint Matthew (FIG. 6-6). The *Lindau Gospels* cover highlights the stylistic diversity of early medieval art in Europe. Here, however, the translated figural style of the Mediterranean prevailed, in keeping with the classical tastes and imperial aspirations of the Frankish emperors of Rome.

AACHEN In his eagerness to reestablish the imperial past, Charlemagne looked to Rome and Ravenna for architectural models. One was the former heart of the Roman Empire, which he wanted to renew. The other was the western outpost of Byzantine might and splendor, which he wanted to emulate at Aachen. Charlemagne often visited Ravenna, and once brought from there porphyry

6-9 Restored cutaway view of the Palatine Chapel of Charlemagne, Aachen, Germany, 792-805 (John Burge).

Charlemagne's chapel is the first vaulted medieval structure north of the Alps. The architect transformed the complexity of San Vitale's interior (Fig. 4-16) into simple, massive geometric form.

SAINT GALL A major initiative of the Carolingian period was the construction and expansion of monasteries. Around 819, Haito, the abbot of Reichenau and bishop of Basel from 806 to 823, commissioned a schematic plan (Fig. 6-10) for a Benedictine monastic community (see "Medieval Monasteries and Benedictine Rule," page 165) and sent it to Abbot Gozbertus as a guide for rebuilding his monastery at Saint Gall. The design's fundamental purpose was to separate the monks from the laity (nonclergy) who also inhabited the community. The plan provides precious information about Carolingian monasteries. Variations of the scheme may be seen in later monasteries all across western Europe.

Near the center, dominating the complex, was the oratory (monastic church) with its cloister, a colonnaded courtyard (compare Fig. 6-20) not unlike the Early Christian atrium (Fig. 4-3) but situated to the side of the church instead of in front of its main portal. Reserved for monks, the cloister was a kind of earthly paradise removed from the world at large. Clustered around the cloister were the most essential buildings: the dormitory, refectory (dining hall), kitchen, and storage rooms. Other structures, including an infirmary, school, guesthouse, bakery, brewery, and workshops, filled mary, school, guesthouse, bakery, brewery, and workshops, filled

the areas around this central core of church and cloister.

Haito invited the abbot of Saint Gall to adapt the plan as he saw fit, and indeed, the Saint Gall builders did not follow the Reichenau model precisely. Nonetheless, had the abbot wished, Haito's plan could have served as a practical guide for the Saint Gall masons because it was laid out using a module (standard unit) of 2.5 feet.

6-8 West facade of the Palatine Chapel of Charlemagne, Aachen, Germany, 792-805.

The innovative design of Charlemagne's palace chapel features two cylindrical towers with spiral staircases flanking the entrance portal, foreshadowing later medieval dual-tower church facades.

(purple marble, the royal color) columns to adorn his Palatine (palace) Chapel (FIGS. 6-8 and 6-9). The plan of the Aachen chapel resembles that of Ravenna's San Vitale (FIGS. 4-14, 4-15, and 4-16), and a direct relationship very likely exists between the two.

A comparison between the Carolingian chapel, the first vaulted structure of the Middle Ages north of the Alps, and its southern counterpart is instructive. The Aachen plan is simpler. The architect omitted San Vitale's apselike extensions reaching from the central octagon into the ambulatory. At Aachen, the two main units stand in greater independence of each other. This solution may lack the subtle sophistication of the Byzantine building, but the Palatine Chapel gains geometric clarity. A restored view of its interior (FIG. 6-9) shows that Charlemagne's builders converted the lightness and complexity of San Vitale's interior (FIG. 4-16) into massive geometric form.

On the exterior (FIG. 6-8), two cylindrical towers with spiral staircases flank the entrance portal. This was a first step toward the great dual-tower facades of western European churches from the 10th century to the present. Above the portal, Charlemagne could appear in a large framing arch and be seen by those gathered in the atrium in front of the chapel. Directly behind the arch was Charlemagne's marble throne. From there he could peer down at the altar in the apse. The Palatine Chapel's second-story gallery followed the model of the imperial gallery at Hagia Sophia (FIGS. 4-11 lowed the model of the imperial gallery at Hagia Sophia (FIGS. 4-11 lowed the model of the imperial gallery at Hagia Sophia (FIGS. 4-11 lowed the model of the imperial gallery at Hagia Sophia (FIGS. 4-11 lowed the model of the imperial gallery at Hagia Sophia (FIGS. 4-11 lowed the model of the imperial gallery at Hagia Sophia (FIGS. 4-11 lowed the model of the imperial gallery at Hagia Sophia (FIGS. 4-11 lowed the model of the imperial gallery at Hagia Sophia (FIGS. 4-11 lowed the model of the imperial gallery at Hagia Sophia (FIGS. 4-11 lowed the model of the imperial gallery at Hagia Sophia (FIGS. 4-11 lowed the model of the imperial gallery at Hagia Sophia (FIGS. 4-11 lowed the model of the imperial gallery at Hagia Sophia (FIGS. 4-11 lowed the model of the imperial gallery at Hagia Sophia (FIGS. 4-11 lowed the model of the imperial gallery at Hagia Sophia (FIGS. 4-11 lowed the model of the imperial gallery at Hagia Gallery at Hagia for the model of the lowed the model of the province for model of the facade broke and the model of the facade broke at the faca

sharply from Byzantine tradition.

RELIGION AND MYTHOLOGY

Medieval Monasteries and Benedictine Rule

Since Early Christian times, monks who established monasteries also made the rules governing communal life. The most significant of these monks was Benedict of Nursia (Saint Benedict, ca. 480–547), who founded the Benedictine Order in 529. By the ninth century, the "Rule" Benedict wrote (*Regula Sancti Benedicti*) had become standard for all western European monastic communities, in part because Charlemagne had encouraged its adoption throughout the Frankish territories.

Saint Benedict believed that the corruption of the clergy that accompanied the increasing worldliness of the Church had its roots in the lack of firm organization and regulation. As he saw it, idleness and selfishness had led to neglect of the commandments of God and of the Church. The cure for this was communal association in an *abbey* under the absolute rule of an *abbot* whom the monks elected (or an *abbess* chosen by the nuns), who would ensure that the clergy spent each hour of the day in useful work and in sacred reading. The emphasis on work and study and not on meditation and austerity is of great historical significance. Since antiquity, manual labor had been considered unseemly, the business of the lowborn or of slaves. Benedict raised it to the dignity of religion. By thus exalting the virtue of manual labor, Benedict not only rescued it from its age-old association with slavery but also recognized it as the way to self-sufficiency for the entire religious community.

Whereas some of Saint Benedict's followers emphasized spiritual "work" over manual labor, others, most notably the Cistercians (see page 173), put Benedict's teachings about the value of physical work into practice. These monks reached into their surroundings and helped reduce the vast areas of daunting wilderness of early medieval Europe. They cleared dense forest teeming with wolves, bear, and wild boar; drained swamps; cultivated wastelands; and built roads, bridges, and dams as well as monastic churches and their associated living and service quarters.

The ideal monastery (FIG. 6-10) provided all the facilities necessary for the conduct of daily life as well as "the Work of God"—a mill, bakery, infirmary, vegetable garden, and even a brewery—so that the monks felt no need to wander outside its protective walls. Monks were also often scribes and scholars and had a monopoly on the skills of reading and writing in an age of almost universal illiteracy. Consequently, medieval monasteries were centrally important to the revival of learning. The libraries and scriptoria, where the monks and nuns read, copied, illuminated, and bound books with ornamented covers,

6-10 Schematic plan for a monastery, from Saint Gall, Switzerland, ca. 819. Red ink on parchment, 2' $4" \times 3'$ $8\frac{1}{8}"$. Stiftsbibliothek, Saint Gall.

The purpose of this plan for an ideal, self-sufficient Benedictine monastery was to separate the monks from the laity. Near the center is the church with its cloister, the monks' earthly paradise.

became centers of study. Monasteries were almost the sole repositories of what remained of the literary culture of the Greco-Roman world and early Christianity. Saint Benedict's requirements of manual labor and sacred reading came to include writing and copying books, studying music for chanting daily prayers, and—of great significance—teaching. The monasteries were the schools of the early Middle Ages.

The designer consistently employed that module, or multiples or fractions of it, for all elements of the plan. For example, the nave's width, indicated on the plan as 40 feet, is equal to 16 modules. Each monk's bed is 2.5 modules long.

The prototypes carrying the greatest authority for Charlemagne and his builders were those from the time of Constantine. The widespread adoption of the Early Christian basilica, at Saint Gall and elsewhere, rather than the domed central plan of Byzantine churches, was crucial to the subsequent development of western European

church architecture. Unfortunately, no Carolingian basilica has survived in its original form. Nevertheless, it is possible to reconstruct the appearance of some of them with fair accuracy. The oratory at Saint Gall, for example, was essentially a traditional basilica, but it had features not found in any Early Christian church. Most obvious is the addition of a second apse on the west end of the building.

Not quite as evident but much more important to the subsequent development of church architecture in northern Europe was the presence of a *transept* at Saint Gall, a rare feature, but one that

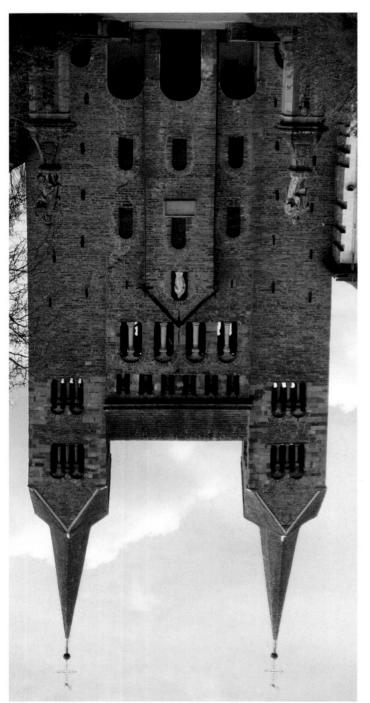

6-71 Westwork of the abbey church, Corvey, Germany, 873-885.

An important new feature of Carolingian church architecture was the west-work, a monumental western facade incorporating two towers. The sole surviving example is the abbey church at Corvey.

Ottonians. In Rome in 962, the pope crowned the first Otto, king of the Germans since 936, as emperor, the title he held until his death in 973. The Ottonians not only preserved but enriched the culture and tradition of the Carolingian period.

HILDESHEIM A great nonimperial patron of Ottonian art and architecture was Bishop Bernward (r. 993–1022) of Hildesheim,

characterized the two greatest Early Christian basilicas in Rome, Saint Peter's (Fig. 4-3) and Saint Paul's. The Saint Gall transept is as wide as the nave on the plan and was probably the same height. Early Christian builders had not been concerned with proportional relationships. On the Saint Gall plan, however, the various parts of the building relate to one another by a geometric scheme that ties them together into a tight and cohesive unit. Equalizing the widths of nave and transept automatically makes the area where they cross (the crossing) a square. Most Carolingian churches shared this feature. But Haito's planner also used the crossing square as the unit of measurement for the remainder of the church plan. The transept arms are equal to one crossing square, the distance between transept and apse is one crossing square, and the nave is 4.5 crossing squares long. In addition, the two aisles are half as wide as the nave, integrating all parts of the church in a rational and orderly plan.

The Saint Gall plan also reveals another important feature of many Carolingian basilicas: towers framing the end(s) of the church. Haito's plan shows only two towers, both cylindrical and on the west side of the church, as at Charlemagne's Palatine Chapel (Pig. 6-8), but they stand apart from the church facade. If a tower existed above the crossing, the silhouette of Saint Gall would have shown three towers, altering the horizontal profile of the traditional basilica and identifying the church even from afar.

in the church's nave. westwork chapel participated from above in the services conducted cial celebrations on major feast days. Boys' choirs stationed in the tioned as churches within churches, housing a second altar for spehowever, served as seats reserved for the emperor. They also funcparticipate in the service below. Not all Carolingian westworks, and from it the visiting emperor and his entourage could watch and lery on three sides. As at Aachen, the chapel opens onto the nave, On the second floor is a two-story chapel with an aisle and a galtechnique). Stairs in each tower provided access to the upper stories. tinguishable from the original westwork by the differing masonry Corvey. The uppermost parts are 12th-century additions (easily dissurviving example is the westwork (FIG. 6-71) of the abbey church at castellum (Latin, "castle" or "fortress") or turris ("tower"). The major ern entrance structure"). Early medieval writers referred to it as a later churches the westwork (from the German Westwerk, "west-Architectural historians call this feature of Carolingian and some diose unified facade greeting all those who entered the church. the fabric of the west end of the building, thereby creating a gran-CORVEY Other Carolingian basilicas had towers incorporated in

Ottonian Art

Charlemagne was buried in the Palatine Chapel at Aachen. His empire survived him by fewer than 30 years. When his son Louis the Pious (r. 814–840) died, Louis's sons—Charles the Bald, Lothair, and Louis the German—divided the Carolingian Empire among themselves. In 843, after bloody conflicts, the brothers signed a treaty partitioning the Frankish lands into western, central, and eastern areas, very roughly foreshadowing the later nations of France and Germany and a third realm corresponding to a long strip of land stretching from the Netherlands and Belgium to Rome. In the midstretching from the Netherlands and Belgium to Rome. In the midstretching from the Sastern part of the former empire consolidated under the rule of a new Saxon line of German emperors called, after the names of the three most illustrious family members, the

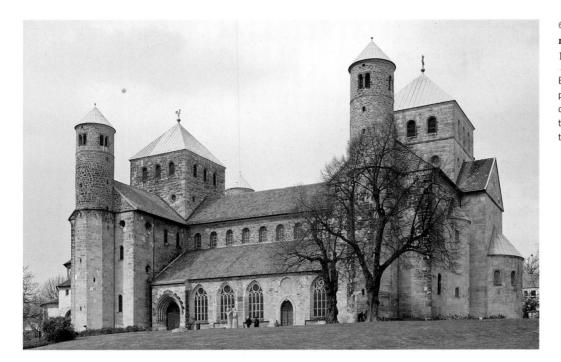

6-12 Saint Michael's (looking northwest), Hildesheim, Germany, 1001–1031.

Built by Bishop Bernward, a great art patron, Saint Michael's is a masterpiece of Ottonian basilica design. The church's two apses, two transepts, and multiple towers give it a distinctive profile.

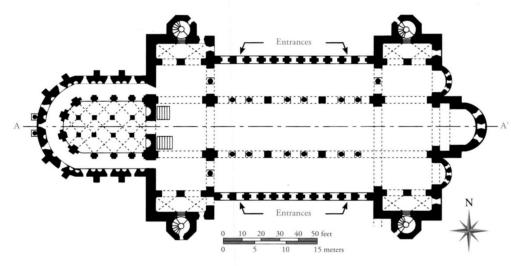

6-13 Plan of the abbey church of Saint Michael's, Hildesheim, Germany, 1001–1031.

Saint Michael's entrances are on the side. Alternating piers and columns divide the space in the nave into vertical units. These features transformed the tunnel-like horizontality of Early Christian basilicas.

Germany. Bernward was an expert craftsman and bronze-caster as well as the scholar who made the Hildesheim abbey an important center of learning. He also served as the tutor of Otto III (r. 983–1002; FIG. 6-11A ③), and in 1001 traveled with the emperor to Rome, where he was able to study at first hand the ancient monuments revered by the Carolingian and Ottonian emperors.

Bernward's major building project as abbot was the construction of the church of Saint Michael (FIGS. 6-12 and 6-13). The work was carried out between 1001 and 1031. The abbey church, which was rebuilt after a bombing raid during World War II, is a characteristic example of Ottonian basilica design. The church features a double-transept plan, two apses, six towers, and a westwork. The two transepts create eastern and western centers of gravity. The nave merely seems to be a hall connecting them. Lateral entrances leading into the aisles from the north and south additionally make for an almost complete loss of the traditional basilican orientation toward the east. Some ancient Roman basilicas, such as the Basilica Ulpia (FIG. 3-35, no. 4) in the Forum of Trajan, also had two apses and

entrances on the side, and Bernward probably was familiar with this variant basilican plan.

At Hildesheim, as in the Saint Gall monastery plan (FIG. 6-10), the builders adopted a modular approach. The crossing squares, for example, are the basis for the nave's dimensions—three crossing squares long and one square wide. The placement of heavy piers at the corners of each square gives visual emphasis to the three units. These piers alternate with pairs of columns to form what architectural historians call the *alternate-support system*. The alternating piers and columns divide the nave into vertical units, breaking the smooth rhythm of the all-column arcade of Early Christian (FIG. 4-4A $\boxed{\hspace{-0.1cm}}$) and Carolingian basilicas and leading the eye upward.

BERNWARD'S DOORS In 1001, when Bishop Bernward was in Rome, he resided in Otto III's palace on the Aventine hill near Santa Sabina (FIGS. 4-4A and 4-4B 🗷), a fifth-century church renowned for its carved wood doors. Those doors, decorated with episodes from both the Old and New Testaments, may have inspired the

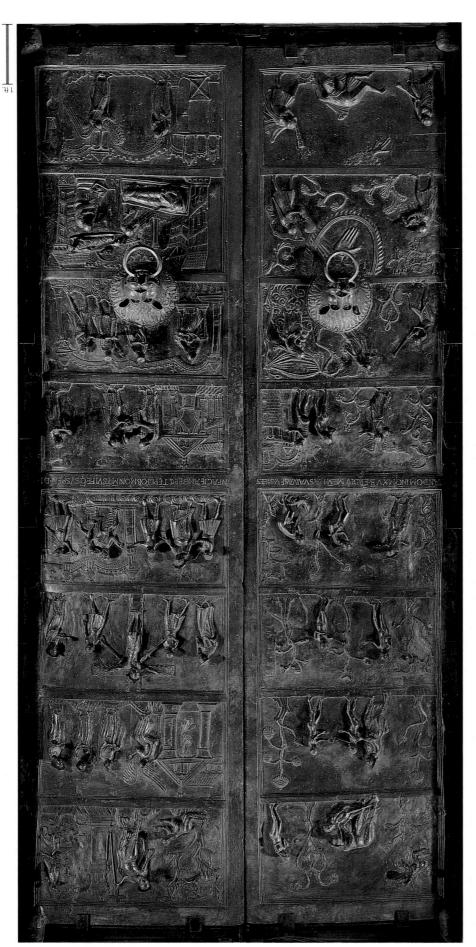

6-14 Doors with relief panels (Genesis, left door; life of Christ, right door), commissioned by Bishop Bernward for Saint Michael's, Hildesheim, Germany, 1015. Bronze, 15' $5\frac{3}{4}$ " high. Römer- und Pelizaeus-Museum, Hildesheim.

Bernward's doors tell the story of original sin and redemption, and draw parallels between the Old and New Testaments, as in the expulsion from Paradise and the infancy and suffering of Christ.

remarkable 15-foot-tall bronze doors (FIG. 6-144) that the bishop had cast for Saint Michael's. They are technological marvels because the Ottonian metalworkers cast each door in a single piece with the figural sculpture. Carolingian sculpture, like most sculpture since the fall of Rome, consisted primarily of small-scale art executed in ivory and precious metals, often for book covers ivory and precious metals, often for book covers (FIG. 6-7). The Hildesheim doors are huge in comparison, but the 16 individual panels stem from this tradition.

Mary with the Christ Child in her lap. cifixion. Eve nursing the intant Cain is opposite of Adam and Eve panel is juxtaposed with the Cru-"Jewish Subjects," page 119). For example, the Fall scripture as prefiguring the New Testament (see times, the Ottonian clergy interpreted Hebrew adise through the Church. As in Early Christian from the Garden of Eden and the path back to Parand ultimate redemption, showing the expulsion Together, the doors tell the story of original sin Tangere (see "The Life of Jesus," pages 120-121). the Annunciation and terminating with Noli Me Jesus (reading from the bottom up), starting with the bottom). The right door recounts the life of Abel, Adam and Eve's son, by his brother Cain (at of Eve (at the top) and ending with the Murder of lights from Genesis, beginning with the Creation The panels of the left door illustrate high-

their unconvincing denials of wrongdoing. newfound embarrassment at their nakedness and gesture, the artist brilliantly communicated their the other. With an instinct for expressive pose and attempting to shield their bodies from view with and Eve both struggle to point with one arm while pointing downward to the deceitful serpent. Adam blame—Adam pointing backward to Eve, and Eve lightning bolt of divine wrath. Each passes the only to hide their shame but also to escape the his whole body. The frightened pair crouch, not grace. He jabs his finger at them with the force of man, accuses Adam and Eve after their fall from the top on the left door, God, portrayed as a detail. For example, in the fourth panel from reveal the Ottonian artist's genius for anecdotal (FIG. 6-6), but the narrative compositions also tion that recalls the Ebbo Gospels Saint Matthew The Hildesheim figures show a vivid anima-

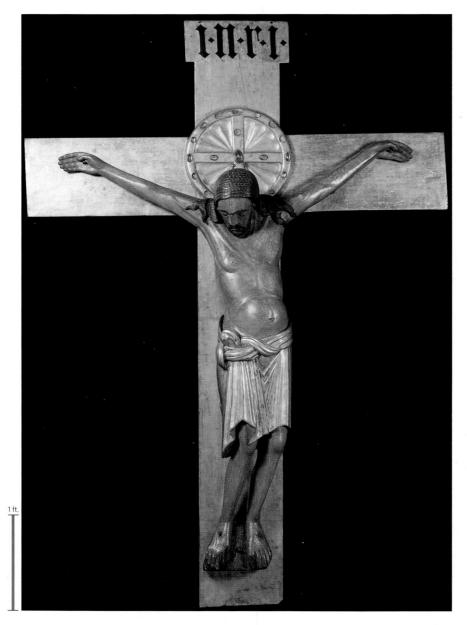

GERO CRUCIFIX The Ottonian period also witnessed a revival of interest in freestanding statuary. The outstanding example is the crucifix (FIG. 6-15) that Archbishop Gero (r. 969-976) commissioned in 970 for display in Cologne Cathedral. Carved in oak, then painted and gilded, the 6-foot-tall image of Christ nailed to the cross presents a conception of the Savior dramatically different from that seen on the Lindau Gospels cover (FIG. 6-7), with its Early Christian imagery of the youthful Christ triumphant over death. The bearded Christ of the Cologne crucifix is more akin to Byzantine representations (FIG. 4-23) of the suffering Jesus, but the emotional power of the Ottonian work is greater still. The sculptor depicted Christ as an all-too-human martyr. Blood streaks down his forehead from the (missing) crown of thorns. His eyelids are closed, his face is contorted in pain, and his body sags under its weight. The muscles stretch to their limit—those of his right shoulder and chest seem almost to rip apart. The halo behind Christ's head may foretell his subsequent resurrection, but the worshiper can sense only his pain. The Gero Crucifix is the most powerful characterization of intense agony of the early Middle Ages.

6-15 Crucifix commissioned by Archbishop Gero (*Gero Crucifix*) for Cologne Cathedral, Germany, ca. 970. Painted wood, height of figure, 6' 2". Cathedral, Cologne.

In this early example of the revival of large-scale sculpture in the Middle Ages, an Ottonian sculptor depicted with unprecedented emotional power the intense agony of Christ's ordeal on the cross.

ROMANESQUE EUROPE

The Romanesque era is the first since Archaic and Classical Greece to take its name from an artistic style rather than from politics or geography. Unlike Carolingian and Ottonian art, named for emperors, or Hiberno-Saxon art, a regional term, Romanesque is a title that art historians invented to describe medieval art and architecture that appeared "Roman-like." Architectural historians first employed the adjective in the early 19th century to describe European architecture of the 11th and 12th centuries. They noted that certain architectural elements of this period, principally barrel and groin vaults based on the round arch, resembled those of ancient Roman architecture. Thus the word distinguished most Romanesque buildings from earlier medieval timber-roofed structures, as well as from later Gothic churches with vaults resting on pointed arches (see "The Gothic Rib Vault," page 190). Scholars in other fields quickly borrowed the term. Today, "Romanesque" broadly designates the history and culture of western Europe between about 1050 and 1200.

During the 11th and 12th centuries, thousands of churches and monasteries were remodeled or newly constructed. This immense building enterprise was in part a natural by-product of the rise of independent towns and the prosperity they enjoyed. But it also was an expression of the widely felt relief and thanksgiving that the conclusion of the first

Christian millennium in the year 1000 had not brought an end to the world, as many had feared. In the Romanesque age, the construction of churches became almost an obsession. As the monk Raoul Glaber (ca. 985–ca. 1046) observed in 1003, "It was as if the whole earth . . . were clothing itself everywhere in the white robe of the church."

PILGRIMS AND RELICS The enormous investment in churches and their furnishings also reflected a significant increase in pilgrimage traffic in Romanesque Europe (see "Pilgrimage and the Veneration of Relics," page 170, and MAP 6-1). Pilgrims were important sources of funding for those monasteries that possessed the *relics* of revered saints. The monks of Sainte-Foy (FIG. 6-15A) at Conques, for example, used pilgrims' donations to pay for a magnificent cameo-and-jewel-encrusted gold-and-silver *reliquary* (FIG. 6-16) to house the skull of Saint Faith. In fact, the clergy of the various monasteries vied with one another to provide the most magnificent settings for the display of their unique relics. They found justification for their lavish expenditures on buildings and furnishings in the Bible

remains at Autun (FIG. 6-23) and Saint Saturninus's at Toulouse (FIG. 6-17). Each of these great shrines was also an important way station en route to the most venerated Christian shrine in western Europe, the tomb of Saint James at Santiago de Compostela in northwestern Spain (MAP 6-1).

Large crowds of pilgrims paying homage to saints placed a great burden on the churches housing their relics, but they also provided significant revenues, making possible the construction of ever grander and more luxuriously appointed shrines. The popularity of pilgrimages and more luxuriously appointed shrines. The popularity of pilgrimages led to changes in church design, principally longer and wider naves and sisles, transepts and ambulatories with additional chapels (FIG. 6-18),

6-16 Reliquary statue of Sainte Foy (Saint Faith), late 10th to early 11th century with later additions. Gold, silver gilt, jewels, and cameos over a wood core, sury, Sainte-Foy, sury, Sainte-Foy, sury, Sainte-Foy,

This enthroned image containing the skull of Saint Faith is one of the most lavish Romanesque reliquaries. The head is an ancient Roman helmet, and the cameos are donations from pilgrims.

Conques.

and second-story galleries (FIG. 6-19).

still largely intact, although the two towers of the west facade (at the

nearly invisible pedestrians. The church's 12th-century exterior is

accommodate them. The grand scale of the building is apparent in the aerial view (FIG. 6-17), which includes automobiles, trucks, and

western French shrines along the pilgrimage routes to Santiago de Compostela, and the unknown architect designed Saint-Sernin to

began in honor of Toulouse's first bishop, Saint Saturninus (Saint Sernin in French). Large congregations gathered at the south-

TOULOUSE Around 1070, construction of a great new church

of the Romans. Some of the most innovative developments in Roman-

esque architecture and architectural sculpture occurred in France.

ART AND SOCIETY Pilgrimages and the Veneration of Relics

The veneration of relics was not new in the Romanesque era. For centuries, Christians had traveled to sacred shrines housing the body parts of, or objects associated with, the holy family or the saints. The faithful had long believed that bones, clothing, instruments of martyrdom, and the like had the power to heal body and soul. The veneration of relics,

the like had the power to heal body and soul. The veneration of relics, however, reached a high point in the 11th and 12th centuries.

The case of the relics of Saint Faith (Sainte Foy, in French), an early-fourth-century child martyr who refused to pay homage to the Roman gods, is a telling example. A monk from the abbey church at Conques (FIG. 6-15A A) stole the saint's skull from the nearby abbey of Agen around 880. The monks justified the act as furta sacra ("holy theft"), claiming that Saint Faith herself wished to move. The reliquary (FIG. 6-16) they provided to house the saint's remains is one of the most lavish ever produced (compare the reliquary of Saint Alexander, FIG. 6-16) they provided to house the reliquary of Saint Alexander, FIG. 6-16 (the most action of the most lavish ever produced (compare the reliquary of Saint Alexander, FIG. 6-16 A). It takes the form of an enthroned statuette of the martyr. 6-16 A). It takes the form of an enthroned statuette of the martyr. FIG. 10 the most sold leaf and silver gilt over a wood core, the reliquary prominently features inset jewels and cameos of various dates—the prominently features inset jewels and cameos of various dates—the accumulated donations of pilgrims and church patrons over many accumulated donations of pilgrims and church patrons over many

parallel between Christ's martyrdom and Saint Faith's.

In the Romanesque era, pilgrimage was the most conspicuous feature of public religious devotion, proclaiming pilgrims' faith in the power of saints and hope for their special favor. The major shrines—Saint Peter's and Saint Paul's in Rome and the Church of the Holy Sepulchre in Jerusalem—drew pilgrims from throughout Europe. Christians braved on innocent travelers—all for the sake of salvation. The journeys could take more than a year to complete—when they were successful. People often undertook pilgrimage as an act of repentance or as a last resort in their search for a cure for some physical disability. Hardship and austertheir search for a cure for some physical disability. Hardship and austerity were means of increasing pilgrims' chances for the remission of sin try were means of increasing pilgrims' chances for the remission of sin or of disease. The distance and peril of the pilgrimage were measures of or or of disease. The distance and peril of the pilgrimage were measures of

martyr's crown to the ancient helmet. The rear of the throne bears an image engraved in rock crystal of Christ on the cross, establishing a

occasions and not part of standard battle dress. The monks added a

helmet—a masklike helmet worn by soldiers on special ceremonial

years. The saint's oversize head is a reworked ancient Roman parade

For those with insufficient time or money to make a pilgrimage to Rome or Jerusalem, holy destinations could be found closer to home. In France, for example, the church at Vézelay (Fig. 6-23A 1) housed the bones of Mary Magdalene. Pilgrims could also view Saint Lazarus's

pilgrims' sincerity of repentance, or of the reward they sought.

itself—for example, in Psalm 26:8, "Lord, I have loved the beauty of your house, and the place where your glory dwells." Pilgrimages were a major economic as well as conceptual catalyst for the art and architecture of the Romanesque period.

France

Although art historians use the adjective "Romanesque" to describe 11th- and 12th-century art and architecture throughout Europe, pronounced regional differences exist. To a certain extent, Romanesque art and architecture can be compared to European Romance languages, which vary regionally but have a common core in Latin, the language

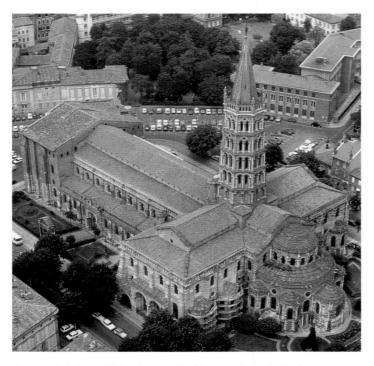

6-17 Aerial view of Saint-Sernin (looking northwest), Toulouse, France, ca. 1070–1120.

Pilgrimages were a major economic catalyst for Romanesque art and architecture. Many churches capable of housing large congregations were constructed along the major routes to the shrine of Saint James.

left in FIG. 6-17) were never completed, and the prominent *crossing tower* dates to the Gothic and later periods.

Saint-Sernin's plan (FIG. 6-18) is extremely regular and geometrically precise. The crossing square, flanked by massive piers

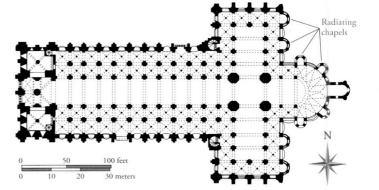

6-18 Plan of Saint-Sernin, Toulouse, France, ca. 1070-1120.

Increased traffic led to changes in church design. "Pilgrimage churches" have longer and wider naves and aisles, as well as transepts and ambulatories with radiating chapels for viewing relics.

and marked off by heavy arches, served as the module for the entire church. Each nave *bay*, for example, measures exactly one-half of the crossing square, and each aisle bay measures exactly one-quarter. The Toulouse design is a highly refined realization of the planning scheme first seen at Saint Gall (FIG. 6-10). But the Toulouse plan differs in significant ways from those of earlier monastic churches. It exemplifies what has come to be called the "pilgrimage church" type. At Toulouse, the builders provided additional space for curious pilgrims, worshipers, and liturgical processions by increasing the length of the nave, doubling the side aisles, and adding a transept and *ambulatory* with *radiating chapels* housing the church's relics so that the faithful could view them without having to enter the choir where the main altar stood.

Saint-Sernin also has upper galleries, or *tribunes*, over the inner aisles opening onto the nave (FIG. 6-19). These tribunes, which

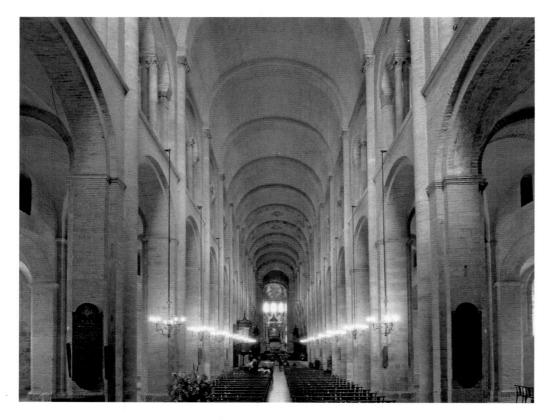

6-19 Interior of Saint-Sernin (looking east), Toulouse, France, ca. 1070–1120.

Saint-Sernin's groin-vaulted tribune galleries housed overflow crowds and buttressed the nave's stone barrel vault, whose transverse arches continue the lines of the compound piers.

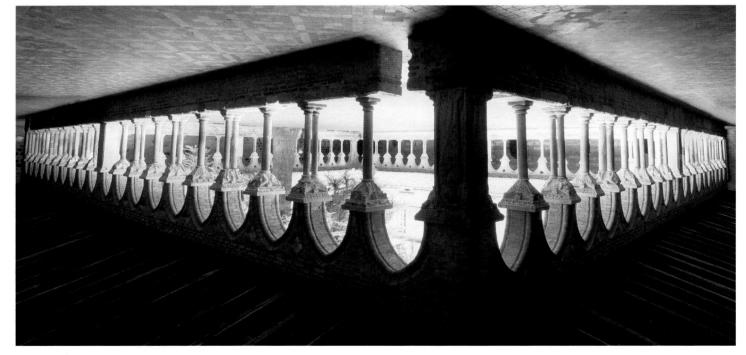

aisles in an age when candles and lamps provided interior illumination, other factors probably played a greater role in the decision to make the enormous investment of time and funds required. The rapid spread of stone vaulting throughout Romanesque Europe was most likely the result of a desire to provide a suitably majestic setting for the display of relics as well as enhanced acoustics for the Christian liturgy and the music accompanying it. Some contemporaneous texts, in fact, communic accompanying it. Some contemporaneous texts, in fact, comment on the "wondrous" visual impact of costly stone vaults.

moissace Saint-Sernin also features a group of seven marble slabs representing angels, apostles, and Christ. Dated to the year 1096, they are among the earliest known examples of large-scale Roman-esque sculpture. Stone sculpture had almost disappeared from the art of western Europe during the early Middle Ages. The revival of stone carving is a hallmark of the Romanesque age—and one of the reasons the period is aptly named. The revived tradition of stone carving seems to have begun with decorating column and stone carving seems to have begun with decorating column and pier capitals with reliefs. The most extensive preserved ensemble of

6-20 General view (top; looking southeast) and historiated capital (bottom) of the cloister of Saint-Pierre, Moissac, France, ca. 1100–1115.

The revived tradition of stonecarving probably began with historiated capitals. The most extensive preserved ensemble of sculptured early Romanesque capitals is in the cloister of the Moissac abbey.

housed overflow crowds on special occasions, played an important role in buttressing the continuous semicircular cut-stone barrel vault that covers Saint-Sernin's nave. Groin vaults (indicated by Xs on the plan, Fig. 6-18; compare Fig. 3-15b) in the tribunes as well as in the ground-floor aisles absorbed the pressure (thrust) exerted by the barrel vault along the entire length of the nave and transferred the main thrust to the thick outer walls.

repeated units decorated and separated by moldings, would have a geometric organization. This rationally integrated scheme, with spatial organization corresponds to and renders visually the plan's ing down the building's length in orderly procession. Saint-Sernin's cal vertical volumes of space placed one behind the other, march-Saint-Sernin nave gives the impression of being numerous identiand continue across the nave as transverse arches. As a result, the compound piers to the vault's springing (the lowest stone of an arch) At Saint-Sernin, the engaged columns rise from the bottom of the or pilasters attached to their rectangular cores as compound piers. (FIG. 6-18). Architectural historians refer to piers with columns ners of the bays, fully reflects the church's geometric floor plan features engaged columns embellishing the piers marking the cormodular plan of the building as a whole. The nave elevation, which vault's design with that of the nave arcade below and with the tress the massive nave vault. They also carefully coordinated the The builders of Saint-Sernin were not content merely to but-

Saint-Sernin's stone vaults provided protection from the devastating conflagrations that regularly destroyed traditional timber-roofed basilicas (see "The Burning of Canterbury Cathedral" (A). But although fireproofing was no doubt one of the attractions of vaulted naves and

long future in later European church architecture.

ARCHITECTURAL BASICS

The Romanesque Church Portal

Sculpture in a variety of materials adorned different areas of Romanesque churches, but the primary location was the grand stone portal through which the faithful had to pass (see "The Door to Salvation," page 157). Sculpture had appeared in church doorways before. For example, Ottonian bronze doors (FIG. 6-14) featuring Old and New Testament scenes marked the entrance from the cloister to Saint Michael's at Hildesheim. But Hildesheim was exceptional, and in the Romanesque era (and during the Gothic period that followed), sculpture usually appeared in the area *around*, rather than *on*, the doors.

Shown in Fig. 6-21 are the parts of church portals that Romanesque sculptors regularly decorated with figural reliefs:

- **Tympanum** (Figs. 6-1a, 6-23, and 6-23A 🗹), the prominent semicircular *lunette* above the doorway proper, comparable in importance to the triangular *pediment* of a Greco-Roman temple (see Fig. 2-20)
- **Voussoirs** (FIG. 6-23A 🗹), the wedge-shaped blocks that together form the *archivolts* of the arch framing the tympanum
- **Lintel** (FIGS. 6-23 and 6-23A **1**), the horizontal beam above the doorway
- **Trumeau** (FIGS. 6-1c and 6-22), the center post supporting the lintel in the middle of the doorway
- Jambs (FIG. 6-1), the side posts of the doorway

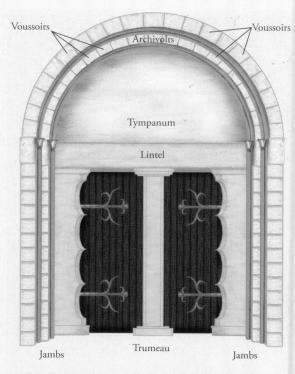

6-21 The Romanesque church portal (John Burge).

The clergy considered the church doorway the beginning of the path to salvation through Christ. The entrance portals of many Romanesque churches feature sculptural reliefs emphasizing that theme.

sculptured early Romanesque capitals is in the cloister (FIG. 6-20) of Saint-Pierre at Moissac (FIG. 6-1) in southwestern France. The monks of the Moissac abbey joined the Cluniac order in 1047, and Moissac quickly became an important stop along the pilgrimage route to Santiago de Compostela.

At Moissac, as elsewhere, the cloister and its garden provided the monks (and nuns) with a foretaste of Paradise. In the cloister, they could read their devotions, pray, meditate, and carry on other activities secluded from the outside world. Moissac's cloister sculpture program consists of large figural reliefs on the piers as well as historiated capitals (capitals ornamented with carved figures) on the columns. The pier reliefs portray the 12 apostles and the monastery's first Cluniac abbot, Durandus (r. 1047-1072), whom the monks buried in the cloister. The 76 capitals alternately crown single and paired column shafts. They are variously decorated, some with abstract patterns, many with biblical scenes or the lives of saints, others with fantastic monsters of all sorts (FIG. 6-20, bottom). Bestiaries—collections of illustrations of real and imaginary animals—became very popular in the Romanesque age. The monstrous forms were reminders of the chaos and deformity of a world without God's order. Medieval artists delighted in inventing composite multiheaded beasts and other fantastic creations.

BERNARD OF CLAIRVAUX Historiated capitals were common in Cluniac monasteries. Many medieval monks, especially those of the Cluniac order, equated piety with the construction of beautiful churches with elegant carvings. But one of the founding principles

of monasticism was the rejection of worldly pleasures in favor of the *vita contemplativa* ("contemplative life"), as opposed to the *vita activa* ("active life") of the lay population. Some monks were appalled by lavish churches and their costly furnishings. One group of Benedictine monks founded a new order at Cîteaux in eastern France in 1098. The Cistercians (from the Latin name for Cîteaux) split from the Cluniac order to return to the strict observance of the Rule of Saint Benedict. The Cistercian movement expanded with astonishing rapidity. Within a half century, more than 500 Cistercian monasteries had been established. The Cistercians rejected figural sculpture as a distraction from their devotions. The most outspoken Cistercian critic was Abbot Bernard of Clairvaux (1090–1153), a fervent supporter of *Crusades* to wrest the Holy Land from Muslim control (see "The Crusades" (**J*), who complained bitterly about the rich outfitting of non-Cistercian churches (see "Bernard of Clairvaux on Cloister Sculpture" (**J*).

During the Romanesque period, stone sculpture also spread to other areas of the church, both inside and out. The proliferation of sculpture reflects the changing role of many churches in western Europe. In the early Middle Ages, most churches served small monastic communities, and the worshipers were primarily or exclusively clergy. With the rise of towns in the Romanesque period, churches, especially those on the major pilgrimage routes, increasingly served the lay public. To reach this new, largely illiterate audience and to draw a wider population into their places of worship, the clergy decided to display Christian symbols and stories throughout their churches, especially in the portals (see "The Romanesque Church Portal," above, and FIG. 6-21) facing onto the

town squares. Stone, rather than painting or mosaic, was the most suitable durable medium for exterior decorative programs.

The focus of the sculptural program of the Moissac portal is the Second Coming of Christ in the tympanum (FIG. 6-1), a subject chosen to underscore the role of the church as the path to Heaven (see "The Door to Salvation," page 157). Variations on this theme adorn the tympans of many Romanesque churches, but the style of these sculptures is quite diverse. The extremely elongated bodies of the angels recording each soul's fate, the cross-legged dancing pose of Saint Matthew's angel, the jerky movement of the elders' heads, the corsos, and the bending back of the hands against the body are all charsos, and the bending back of the hands against the body are all charsoteristic of the anonymous Moissac master's distinctive style. The animation of the individual figures, however, contrasts with the stately monumentality of the composition as a whole, producing a dynamic tension in the tympanum.

Below the tympanum is a richly decorated trumeau with scalloped contours (FIG. 6-1c). On the front are the church's guardian lions. On the trumeau's right face is a prophet (FIG. 6-22) displaying the scroll bearing his prophetic vision. The prophet is tall and thin, and he executes a cross-legged step. The animation of the body reveals the passionate nature of the soul within. The long, serpentine locks of hair and beard frame an arresting image of the dreaming locks of hair and beard frame an arresting image of the dreaming mystic. The prophet seems entranced by his vision of what is to

AUTUM In 1132, the Cluniac bishop Etienne de Bage consecrated the Burgundian cathedral of Saint-Lazare (Saint Lazarus) at Autun. The sculptor he entruated with carving figural reliefs for the church was GISLEBERTUS, who placed his name beneath his dramatic vision of the Last Judgment (FIG. 6-23), the subject of the most important element of the sculptural program. No doubt the bishop permitted Gislebertus to sign his work because the sculptor had so successfully fulfilled his patron's wishes (see "Terrifying the Faithful at Autun," page 175).

MORGAN MADONNA Despite the use of stone relief sculptures to adorn church portals at Moissac (Fig. 6-1), Autun (Fig. 6-23), Vêzelay (Fig. 6-23A 丞), and many other Romanesque sites, resistance to the creation of statues in the round continued in the Romanesque period. The avoidance of anything that might be construed as an idol was still the rule, in Reeping with the Second Commandment. (The Gero Crucifix [Fig. 6-15] is an exception.) The veneration of relics, however, brought with it a demand for small-scale images of the holy family and saints to be placed on the chapel altars of of the holy family and saints to be placed on the chapel altars of of saints or parts of saints (Fig. 6-16 and 6-16A 丞), tabletop crucifixes, and wood devotional figurines began to be produced in great numbers.

6-22 Old Testament prophet (Jeremiah or Isaiah?), right side of the trumeau (FIG. 6-1c) of the south portal of Saint-Pierre, Moissac, France, ca. 1115-1130.

On the trumeau of Moissac's south portal, this Old Testament prophet displays the scroll recounting his vision. The prophet's figure is tall, thin, and animated, like the angels in the tympanum.

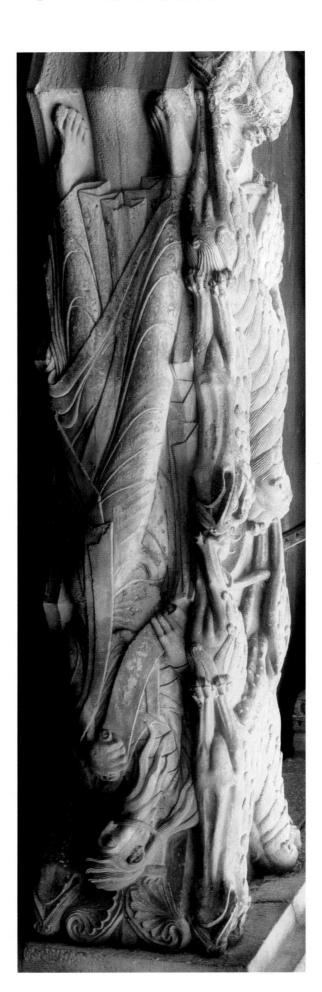

THE PATRON'S VOICE

Terrifying the Faithful at Autun

In the medieval world, as in antiquity, patrons, not artists, chose the subjects to be represented on the monuments they commissioned. In the case of churches, the clergy were responsible for determining the themes of mosaics, frescoes, relief sculptures, and statues. The artists may have had considerable leeway in how to depict the subjects, but not in what to represent. Nonetheless, only in exceptional cases did the church officials append to the representations explanations of their intent. The tympanum (FIG. 6-23) of the Cathedral of Saint-Lazare at Autun is one of those exceptions. There, the clergy asked the sculptor Gislebertus to carve a relief of the Last Judgment that would encourage Christians to seek salvation through the Church by terrifying them with a graphic depiction of the horrors of Hell.

In Gislebertus's vision of the Last Judgment, four trumpet-blowing angels announce the second coming of Christ, who appears at the tympanum's center, far larger than any other figure, enthroned in a *mandorla*. He dispassionately presides over the separation of the blessed from the damned. At the left, an obliging angel boosts one of the blessed into the heavenly city. Below, the souls of the dead line up to await their fate. Two of the men near the center of the lintel carry bags emblazoned with a cross and a shell. These are the symbols of pilgrims to Jerusalem and Santiago de Compostela, respectively. Those who had made the difficult journey would be judged favorably. To their

right, three small figures beg an angel to intercede on their behalf. The angel responds by pointing to the judge above.

On the right side are those who will be condemned to Hell. Giant hands pluck one poor soul from the earth. Directly above is one of the most unforgettable renditions of the weighing of souls in the history of art. Angels and the Devil's agents try to manipulate the balance for or against a soul. Hideous demons guffaw and roar. Their gaunt, lined bodies, with legs ending in sharp claws, writhe and bend like long, loathsome insects. A devilish creature, leaning from the dragon mouth of Hell, drags souls in, while, above him, a howling demon crams souls headfirst into a furnace.

The purpose of the Autun tympanum was to inspire terror in the believers who passed beneath it as they entered the cathedral. Even those who could not read could, in the words of Bernard of Clairvaux, "read in the marble." For the literate, the Autun clergy composed explicit written warnings to reinforce the pictorial message and had the words engraved in Latin on the rim of Christ's mandorla and on the upper edge of the lintel:

I alone arrange all things and crown the deserving. Punishment, with me as judge, holds in check those whom vice stimulates. Whoever is not seduced by an impious life will rise again in this way, and the light of day will shine on him forever. May this terror terrify those whom earthly error binds, for the horror of these images here in this manner truly depicts what will be.*

*Translated by Calvin B. Kendall, *The Allegory of the Church: Romanesque Portals and Their Verse Inscriptions* (Toronto: University of Toronto Press, 1998), 207.

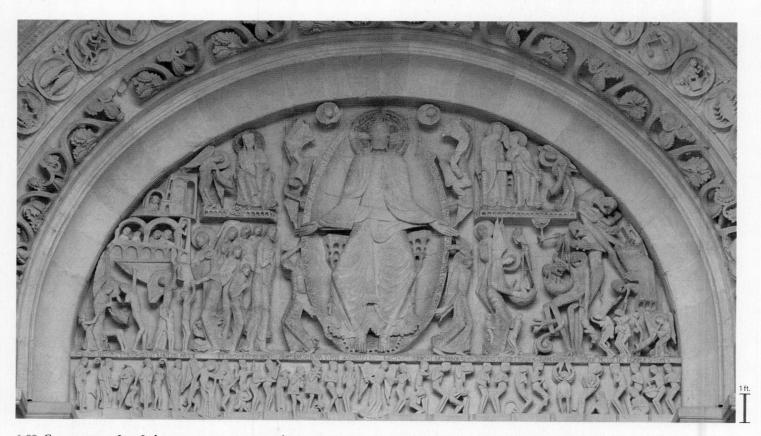

6-23 GISLEBERTUS, Last Judgment, west tympanum of Saint-Lazare, Autun, France, ca. 1120-1135. Marble, 21' wide at base.

The enthroned Christ presides over the separation of the blessed from the damned in Gislebertus's dramatic vision of the Last Judgment, designed to terrify those guilty of sin and beckon them into the church.

6-25 Initial R with knight fighting a dragon, folio 4 verso of the Moralia in Job, from Citeaux, France, ca. 1115–1125. Ink and tempera on vellum, I' $1\frac{3}{4}$ " × $9\frac{1}{4}$ ". Bibliothèque municipale, Dijon.

Ornamented initials date to the Hiberno-Saxon era (FIG. 6-4), but this artist translated the theme into Romanesque terms. The duel between knight and dragons symbolized a monk's spiritual struggle.

(both hands are broken off). His seated mother is in turn the throne of wisdom because her lap is the Christ Child's throne. As in Byzantine art, both Madonna and Child sit rigidly upright and are strictly frontal, emotionless figures. But the intimate scale, the gesture of benediction, the once-bright coloring of the garments, and the soft modeling of the Virgin's face make the mother-and-son pair seem much less remote than its Byzantine counterparts.

MORALIA IN JOB Unlike stone sculpture, the art of painting needed no "revival" in the Romanesque period. Monasteries had been producing large numbers of illuminated manuscripts for centuries. One of the major Romanesque scriptoria was at the abbey of Citeaux, of the major Romanesque scriptoria was at the abbey of Citeaux, mother church of the Cistercian order. Just before Bernard of Clairant Joined the monastery in 1112, the monks completed work on an illuminated copy of Saint Gregory's (Pope Gregory the Great, r. 590–604) Moralia in Job. It is an example of Cistercian illuminated ropy of Saint Gregory's (Pope Gregory the Great, nation that predates Bernard's passionate opposition to monastic figural art, which in 1134 resulted in a Cistercian ban on elaborate paintings in manuscripts as well as sculptural ornamentation in monasteries (see "Bernard of Clairvaux" (A)). After 1134, the Cistercian order prohibited full-page illustrations, and even initial letters had to be nonfigurative and of a single color. The historiated initial reproduced here (Fig. 6-25) clearly would have been in violation reproduced here (Fig. 6-25) clearly would have been in violation

6-24 Virgin and Child (Morgan Madonna), from Auvergne, France, second half of 12th century. Painted wood, 2' 7" high. Metropolitan Museum of Art, New York (gift of J. Pierpont Morgan, 1916).

The veneration of relics created a demand for small-scale images of the holy family and saints to be placed on chapel altars. This painted wood statuette depicts the Virgin as the "throne of wisdom."

One popular type, a specialty of the workshops of Auvergne, France, was a wood statuette depicting the Virgin Mary with the Christ Child in her lap. The Morgan Madonna (Fig. 6-24), so named because it once belonged to the American financier and collector J. Pierpont Morgan, is one example. The type, known as the sedes sapientiae (Latin, "throne of wisdom"), is a western European freestanding version of the Theotokos theme popular in Byzantine icons (Fig. 4-20) and mosaics. Christ, the embodiment of divine wisdom, holds a Bible in his left hand and raises his right arm in blessing holds a Bible in his left hand and raises his right arm in blessing

6-26 Hildegard receives her visions, detail of a facsimile of a lost folio in the Rupertsberger Scivias by Hildegard of Bingen, from Trier or Bingen, Germany, ca. 1150–1179. Abbey of St. Hildegard, Rüdesheim/Eibingen.

Hildegard of Bingen was one of the great religious figures of the Middle Ages. Here, she experiences a divine vision, shown as five tongues of fire emanating from above and entering her brain.

flourish to the swordsman's gesture. The knight, handsomely garbed, cavalierly wears no armor and calmly aims a single stroke, unmoved by the ferocious dragons lunging at him.

Holy Roman Empire and Italy

The Romanesque successors of the Ottonians were the Salians (r. 1027–1125), a dynasty of Franks. They ruled an empire corresponding roughly to present-day Germany and the Lombard region of northern Italy (MAP 6-1). Like their predecessors, the Salian emperors were important patrons of art and architecture, although, as elsewhere in Romanesque Europe, the monasteries remained great centers of artistic production.

HILDEGARD OF BINGEN The most prominent nun of the 12th century and one of the greatest religious figures of the Middle Ages was Hildegard of Bingen (1098–1179). Born into an aristocratic family that owned large estates in the German Rhineland, Hildegard began to have visions at a very early age, and her parents had her study to become a nun. In 1141, God instructed Hildegard to disclose her visions to the world. Bernard of Clairvaux certified in 1147 that those visions were authentic. Archbishop Heinrich of Mainz joined in the endorsement, and in 1148, the Cistercian pope

Eugenius III (r. 1145–1153) formally authorized Hildegard "in the name of Christ and Saint Peter to publish all that she had learned from the Holy Spirit." At this time, Hildegard became the abbess of a new convent built for her near Bingen. As reports of Hildegard's visions spread, kings, popes, barons, and prelates sought her counsel.

Among the most interesting Romanesque books is Hildegard's *Scivias* (*Know the Ways* [*Scite vias*] *of God*). On the opening page (FIG. 6-26), Hildegard sits within a monastery experiencing her divine vision. Five long tongues of fire emanating from above enter her brain, just as she describes the experience in the accompanying text. Using a wax tablet resting on her left knee, Hildegard immediately sets down what has been revealed to her. Nearby, the monk Volmar, Hildegard's confessor, copies into a book everything she wrote. Here, in a singularly dramatic context, is a picture of the essential nature of ancient and medieval book manufacture—individual scribes copying and recopying texts by hand.

of Bernard's ban if it had not been painted before his prohibitions took effect. A knight, his squire, and two roaring dragons form an intricate letter R, the initial letter of the salutation *Reverentissimo*. This page is the opening of Gregory's letter to "the most revered" Leander, bishop of Seville, Spain. The knight is a slender, regal figure who raises his shield and sword against the dragons while the squire, crouching beneath him, runs a lance through one of the monsters. The duel between knight and dragons symbolized the spiritual struggle of monks against the Devil for the salvation of souls.

Ornamented initials date to the Hiberno-Saxon period (FIG. 6-4), but in the *Moralia in Job*, the artist translated the theme into Romanesque terms. The Leander page may be a reliable picture of a medieval baron's costume. The typically French Romanesque banding of the torso and partitioning of the folds are evident, but the master painter deftly avoided stiffness and angularity. The partitioning here accentuates the knight's verticality and elegance and the thrusting action of his servant. The flowing sleeves add a spirited

complements this modualternate-support system to two aisle bays. The иале рау соггеsponds vaults in the nave. Each of the first to use groin Milanese church was one The architect of this

late 11th to early 12th ing east), Milan, Italy, Sant'Ambrogio (look-6-27 Interior of

century.

aisles, but no transept. Above each inner aisle is a tribune gallery. architecture north of the Alps. Sant'Ambrogio has a nave and two tion with different kinds of vaulting that characterizes Romanesque the city's first bishop (d. 397), is an example of the experimentain the late 11th or early 12th century in honor of Saint Ambrose, The Lombard church of Sant'Ambrogio (FIG. 6-27), erected in Milan in central Italy, the Early Christian tradition remained very strong. Lombardy parallel those elsewhere in the Holy Roman Empire, but architecture more readily apparent than in Italy. Developments in MILAN Nowhere is the regional diversity of Romanesque art and

closely resembles Early Pisa's cathedral more **.**₽711 campanile begun baptistery begun 1153; cathedral begun 1063; northeast), Pisa, Italy; complex (looking

6-28 Cathedral

are Italian features. towers and baptisteries churches. Separate bell Lombard Romanesque experimental French and than structurally more Christian basilicas

Each nave bay consists of a full square flanked by two small squares in each aisle, all covered with groin vaults. The technical problems of building groin vaults of cut stone (as opposed to concrete, knowledge of which did not survive the fall of Rome) at first limited their use to the covering of small areas, such as the individual bays of the aisles of Saint-Sernin (FIGS. 6-18 and 6-19) at Toulouse. In Sant'Ambrogio, the nave vaults are slightly domical, rising higher than the transverse arches. The windows in the octagonal dome over the last bay provide the major light source for the otherwise rather dark interior. (The building lacks a clerestory.) The emphatic alternate-support system perfectly reflects the geometric regularity of the plan. The lighter pier moldings stop at the gallery level, and the heavier ones rise to support the nave vaults. The compound piers even continue into the ponderous vaults, which have supporting arches, or ribs, along their groins. This is one of the first instances of rib vaulting, a key characteristic of mature Romanesque and later Gothic architecture (see "The Gothic Rib Vault," page 190).

PISA Although the widespread use of stone vaults in 11th- and 12th-century churches inspired the term *Romanesque*, Italian Romanesque churches outside Lombardy usually retained the timber roofs of their Early Christian predecessors. The cathedral complex (FIG. 6-28) at Pisa dramatically testifies to the regional diversity of Romanesque architecture. The cathedral, its freestanding *campanile* (bell tower), and the baptistery, where infants and converts were initiated into the Christian community, present a rare opportunity to study a coherent group of three Romanesque buildings. Save for the upper portion of the baptistery, with its remodeled Gothic exterior, the three structures are stylistically homogeneous.

Construction of Pisa Cathedral began first—in 1063, the same year work began on Saint Mark's (FIG. 4-24) in Venice, another prosperous maritime city. The spoils of a naval victory over the Muslims off Palermo in Sicily in 1062 funded the Pisan project. Pisa Cathedral is large, with a nave and four aisles, and is one of the most impressive and majestic Romanesque churches. At first glance, the cathedral resembles an Early Christian basilica, but the broadly projecting transept with apses, crossing dome, and multiple arcaded galleries on the facade distinguish it as Romanesque. So too does the rich marble incrustation (wall decoration consisting of bright panels of different colors, as in the Pantheon's interior; FIG. 3-40). The cathedral's campanile, detached in the standard Italian fashion, is Pisa's famous Leaning Tower (FIG. 6-28, right). Graceful arcaded galleries mark the tower's stages and repeat the cathedral's facade motif, effectively relating the round campanile to its mother building. The tilted vertical axis of the tower is the result of a settling foundation. The tower began to "lean" even while under construction, and now inclines some 5.5 degrees out of plumb at the top.

Normandy and England

After their conversion to Christianity in the early 10th century, the Vikings—Scandinavian traders and pirates named after the *viks* ("coves" or "trading places" of the Norwegian coastline)—settled on the northern French coast in present-day Normandy, the home of the Norsemen, or Normans. The Normans quickly developed a distinctive Romanesque architectural style that became the major source of French Gothic architecture.

CAEN Most critics consider the abbey church of Saint-Étienne at Caen the masterpiece of Norman Romanesque architecture. Begun by William of Normandy (William the Conqueror; see page 183) in 1067, work must have advanced rapidly because the Normans buried the duke in the church in 1087. Saint-Étienne's west facade (FIG. 6-29) is a striking design rooted in the tradition of Carolingian and Ottonian westworks, but it reveals a new unified organizational scheme. Four large buttresses divide the facade into three bays that correspond to the nave and aisles. Above the buttresses, the towers also display a triple division and a progressively greater piercing of the walls from lower to upper stages. (The culminating spires are a Gothic addition.) The three-part composition extends throughout the facade, both vertically and horizontally, consistent with the careful and methodical planning of the entire structure.

6-29 West facade of Saint-Étienne, Caen, France, begun 1067.

The division of Saint-Étienne's facade into three parts corresponding to the nave and aisles reflects the methodical planning of the entire structure. The towers also have three sections.

The six-part groin vaults of Saint-Étienne make clerestory windows possible. The three-story elevation with its large arched openings provides ample light and makes the nave appear taller than it is.

6-30 Interior (left; looking east) and plan (right) of Saint-Etienne,

Caen, France, vaulted ca. 1115-1120.

perfectly to the design of the arcade below. Each seven-part nave vault covers two bays (Fig. 6-32), left). Large, simple pillars ornaterns, all originally painted) alternate with compound piers that carry the transverse arches of the vaults. The pier-vault relationship scarcely could be more visible or the building's structural rationale better expressed.

The bold surface patterning of the pillars in the Durham nave is a reminder that the raising of imposing stone buildings such as the Romanesque churches of England and Normandy required more than just the talents of master designers. A corps of expert masons had to transform rough stone blocks into the precise shapes necessary for their specific place in the church's fabric. Although thousands of simple quadrangular blocks make up the great walls of these buildings, the stonecutters also had to produce large numbers of blocks of far more complex shapes. To cover the nave and aisles, the masons had to carve blocks with concave faces to conform to the curve of the vault. Also required were blocks with projecting moldings for the ribs, blocks with convex surfaces for the pillars or with multiple profiles for the compound piers, and so forth. It was an immense undertaking, and it is no wonder that medieval building immense undertaking, and it is no wonder that medieval building immense undertaking, and it is no wonder that medieval building

Durham's builders employed the earliest known example of a rib groin vault placed over a three-story nave. In the nave's western parts, completed before 1130, the rib vaults have pointed arches, bringing together for the first time two key elements that

campaigns often lasted for decades.

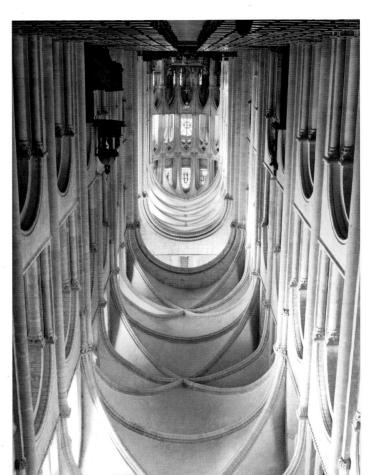

Romanesque period. rior wall surface give the nave a light and airy quality unusual in the the heavy masonry, Saint-Étienne's large windows and reduced intesupports the still fairly massive paneling between them. But despite diagonal and transverse ribs form a structural skeleton that partially Sant'Ambrogio (FIG. 6-27), the Norman building has rib vaults. The the interior. It also makes the nave appear taller than it is. As in elevation, with its large arched openings, allows ample light to reach to provide room for clerestory windows. The resulting three-story into six sections—a sexpartite vault. The vaults rise high enough Their branching ribs divide the large square-vault compartments a good match. Those piers soar all the way to the vaults' springing. vaults around 1115, the existing alternating compound piers proved attached to pilasters. When the Normans decided to install groin engaged half columns alternating with piers with half columns but the Caen nave (FIG. 6-30) had compound piers with simple The original design of Saint-Étienne called for a timber roof,

DURHAM William of Mormandy's conquest of Anglo-Saxon England in 1066 began a new epoch in English history. In architecture, it signaled the importation of Morman Romanesque building and design methods. Construction of Durham Cathedral (Fig. 6-31), on the Scottish frontier of northern England, began around 1093—before the remodeling of Saint-Étienne. Unlike the Caen church, Durham Cathedral was a vaulted structure from the outset. Consequently, the pattern of the ribs of the nave's groin vaults corresponds quently, the pattern of the ribs of the nave's groin vaults corresponds

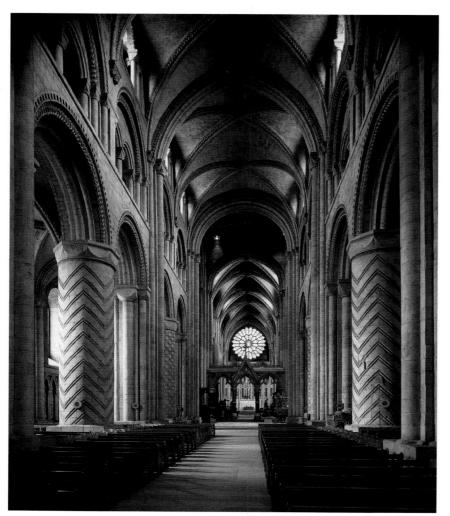

6-31 Interior of Durham Cathedral (looking east), Durham, England, begun ca. 1093.

Durham Cathedral boasts the first examples of rib groin vaults placed over a three-story nave. The builders replaced groin vaults in the tribune with quadrant arches as buttresses of the nave vaults.

determined the structural evolution of Gothic architecture (see "The Gothic Rib Vault," page 190). Also of great significance is the way the English builders buttressed the nave vaults. The lateral section (FIG. 6-32, right) exposes the simple quadrant arches (arches whose curve extends for one-quarter of a circle's circumference) that take the place of groin vaults in the Durham tribune. The structural descendants of these quadrant arches are the flying buttresses that are another hallmark of the mature Gothic solution to church construction (see "Building a High Gothic Cathedral," page 193).

BURY BIBLE Many of the finest illustrated manuscripts of the Romanesque age were the work of monks in English scriptoria, following in the tradition of Hiberno-Saxon books. The *Bury Bible*, produced at the Bury Saint Edmunds abbey in England around 1135, exemplifies the luxurious illumination common to the large Bibles used in wealthy Romanesque abbeys not subject to the Cistercian restrictions

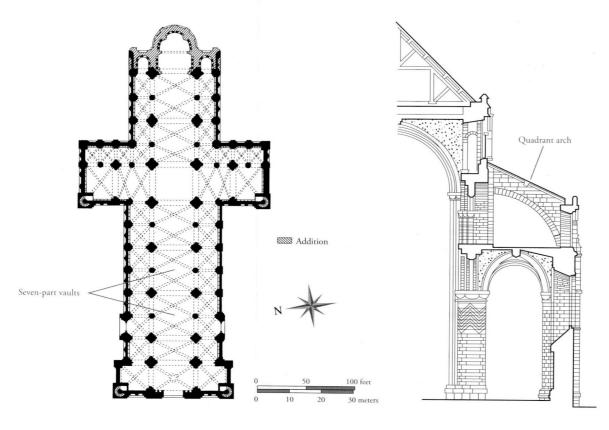

6-32 Plan (*left*) and lateral section (*right*) of Durham Cathedral, Durham, England, begun ca. 1093.

Durham Cathedral is typically English in its long, slender proportions. In the nave, simple pillars alternate with compound piers that support the transverse arches of the seven-part groin vaults.

the exception, however, and most Romanesque scribes and illumiabbey walls, and they traveled frequently to find work. They were teries. These artists resided in towns rather than within secluded for their livelihood on commissions from well-endowed monasemerging class of professional artists and artisans who depended is striking. Hugo apparently was a secular artist, a member of the the contrast of the Romanesque period with the early Middle Ages themselves. Although most medieval artists remained anonymous, recorded. In the 12th century, artists increasingly began to identify

the service of God. nators continued to be monks and nuns working anonymously in

ing typical of many Romanesque painted and sculpted garments the movements of the body beneath it. Here, the abstract patternin the cowl and the thigh), the drapery falls more softly and follows of the Bury Bible, but although the patterning is still firm (notably esque artist at work. The style of the Eadwine portrait resembles that last page (FIG. 6-34), however, presents a rare picture of a Roman-SCRIBE, the Eadwine Psalter contains 165 biblical illustrations. The EADWINE PSALTER Named for the English monk Eadwine The

vellum, 1' $3\frac{1}{2}$ " × 11 $\frac{5}{8}$ ". Trinity College, Cambridge. verso of the Eadwine Psalter, ca. 1160-1170. Ink and tempera on 6-34 Eadwine the Scribe, Eadwine the scribe at work, folio 283

scribes" whose fame would endure forever. Eadwine added an inscription to his portrait declaring himself "the prince of Although he humbly offered his book as a gift to God, the English monk

> ladderlike folds. limbs, the lightly shaded volumes connected with sinuous lines and tures. Yet patterning remains in the multiple divisions of the draped spastic movement of contemporaneous Romanesque relief sculp-This presentation is quite different from the abrupt emphasis and the figures possess a quiet dignity. Moses and Aaron seem to glide. the Hebrew word that also means "rays." The gestures are slow and the prophet has horns, consistent with Saint Jerome's translation of below, he points out the clean and unclean beasts. In both panels, glowing harmonized colors. At the top, Moses expounds the law; from Deuteronomy framed by symmetrical leaf motifs in softly on painted manuscripts. One page (FIG. 6-33) shows two scenes

> Romanesque artists who signed their works or whose names were tus (FIG. 6-23), Hugo was one of the small but growing number of Hugo, who was also a sculptor and metalworker. With Gisleber-The artist responsible for the Bury Bible is known: MASTER

tempera on vellum, I' 8" × I' 2". Corpus Christi College, Cambridge. Bury Bible, from Bury Saint Edmunds, England, ca. 1135. Ink and 6-33 Master Hugo, Moses Expounding the Law, folio 94 recto of the

sions from wealthy monasteries. professional artists and artisans who depended for their livelihood on commis-Master Hugo was a rare Romanesque lay artist, one of the emerging class of yielded slightly, but clearly, to the requirements of more naturalistic representation. The Romanesque artist's instinct for decorating the surface remained, as is apparent in the gown's whorls and spirals. Significantly, however, the artist painted those interior lines very lightly so that they would not conflict with the functional lines containing them.

The "portrait" of Eadwine—it is probably a generic type and not a specific likeness—is in the long tradition of author portraits in ancient and medieval manuscripts, although the true author of the Eadwine Psalter is King David. Eadwine exaggerated his importance by likening himself to an evangelist writing his Gospel (FIGS. 6-5 and 6-6) and by including an inscription within the inner frame giving his name and proclaiming that he is "the prince of scribes." He declares that the excellence of his work will cause his fame to endure forever, and consequently he can offer his book as an acceptable gift to God. Eadwine, like other Romanesque sculptors and painters who signed their works, may have been concerned for his fame, but these artists, whether clergy or laity, were as yet unaware of the concepts of "fine art" and "fine artist." To them, their work existed not for its own sake but for God's. Nonetheless, works such as Eadwine's portrait are an early sign of a new attitude toward the role of the artist in society that presages the reemergence in the Renaissance of the classical notion of individual artistic genius.

BAYEUX TAPESTRY The most famous work of English Romanesque art is neither a book nor Christian in subject. The so-called *Bayeux Tapestry* (FIGS. 6-35 and 6-36) is unique in medieval art. It is not a woven *tapestry* but rather an *embroidery* made of eight colors of wool yarn sewn on linen—two varieties of blue; three shades of green; yellow; buff; and terracotta red. Closely related to

Romanesque manuscript illumination, the Bayeux Tapestry's borders contain the kinds of real and imaginary animals found in contemporaneous books, and an explanatory Latin text sewn in thread accompanies many of the pictures. Some 20 inches high and about 230 feet long, the embroidery is a continuous, friezelike, pictorial narrative of the Norman defeat of the Anglo-Saxons at Hastings in 1066, and of the events leading up to that crucial battle in the history of England. The Norman victory at Hastings united all of England and much of France under one rule. The dukes of Normandy became the kings of England. Commissioned by Bishop Odo, the half brother of the conquering Duke William, the embroidery may have been sewn by women at the Norman court. Many art historians, however, believe that it was the work of English stitchers in Kent, where Odo was earl after the Norman conquest. Odo donated the work to Bayeux Cathedral (hence its nickname), but it is uncertain whether it was originally intended for display in the church's nave, where the theme would have been a curious choice.

The events that precipitated the Norman invasion of England are well documented. In 1066, Edward the Confessor (r. 1042–1066), the Anglo-Saxon king of England, died. The Normans believed that Edward had recognized William of Normandy as his rightful heir. But the crown went to Harold, earl of Wessex, the king's Anglo-Saxon brother-in-law, who had sworn an oath of allegiance to William. The betrayed Normans, descendants of the seafaring Vikings, boarded their ships, crossed the English Channel, and crushed Harold's forces.

Illustrated here are two episodes of the epic tale as represented in the *Bayeux Tapestry*. The first detail (FIG. 6-35) depicts King Edward's funeral procession. The hand of God points the way to the church in London where he was buried—Westminster

6-35 Funeral procession to Westminster Abbey, detail of the *Bayeux Tapestry*, from Bayeux Cathedral, Bayeux, France, ca. 1070–1080. Embroidered wool on linen, 1' 8" high (entire length of fabric, 229' 8" long). Centre Guillaume le Conquérant, Bayeux.

The Bayeux Tapestry is not a tapestry but rather an embroidery. The women needleworkers employed eight colors of dyed wool yarn and sewed the threads onto the linen fabric.

wool on linen, I' 8" high (entire length of fabric, 229' 8" long). Centre Guillaume le Conquérant, Bayeux. 6-36 Battle of Hastings, detail of the Bayeux Tapestry, from Bayeux Cathedral, Bayeux, France, ca. 1070-1080. Embroidered

Roman art, it depicts contemporaneous events in full detail. The Bayeux Topestry is unique in medieval art. Like the scroll-like frieze of Trajan's Column (Fig. 3-36) and other historical narratives in

work of Romanesque art. forth. In this respect, the Bayeux Tapestry is the most Roman-esque ment onto the vessels, the cooking and serving of meals, and so and splitting of trees for ship construction, the loading of equipare the preparations for war, with scenes depicting the felling to battlefield successes. It is a complete chronicle of events. Included national pride. As in the ancient frieze, the narrative is not confined the textile is the conqueror's version of history, a proclamation of

following additional subjects: buildings, Google Earth™ coordinates, and essays by the author on the Explore the era further in MindTap with videos of major artworks and

- Merovingian looped fibulae (FIG. 6-1A)
- Gospel Book of Otto III (FIG. 6-11A)
- Sainte-Foy, Conques (FIG. 6-15A)
- Head reliquary of Saint Alexander (FIG. 6-16A)
- WRITTEN SOURCES: The Burning of Canterbury Cathedral
- WRITTEN SOURCES: Bernard of Clairvaux on Cloister Sculpture
- Mission of the Apostles, Vézelay (FIG. 6-23A)
- KELIGION AND MYTHOLOGY: The Crusades

3-36B, and 3-36C (1). Like the Roman account, the story told on the scroll-like frieze of the Column of Trajan (FIGS. 3-36, 3-36A, The Bayeux Tapestry stands apart from all other Romanesque

art. Art historians have often likened the Norman embroidery to it occurred, recalling the historical narratives of ancient Roman artworks in depicting in full detail an event at a time shortly after volume and modeling in light and dark hues. Linear patterning and flat color replace classical three-dimensional FIG. 2-50)—but rendered the figures in the Romanesque manner. ple, the horses with twisted necks and contorted bodies (compare

characteristic motifs of Greco-Roman battle scenes-for exam-

of the embroidery. The Romanesque artist co-opted some of the although the upper register continues the animal motifs of the rest lish defenders. Filling the lower border are the dead and wounded,

of Hastings in progress. The Norman cavalry cuts down the Eng-

Christmas Day, 1066. The second detail (FIG. 6-36) shows the Battle

nave with tribunes. There, William was crowned king of England on

its main features, including the lofty crossing tower and the long

ings erected in England, and the embroiderers took pains to record

Edward's death. The church was one of the first Romanesque build-

Abbey, consecrated on December 28, 1065, just a few days before

EARLY MEDIEVAL AND ROMANESQUE EUROPE

Early Medieval Art

- The surviving artworks of the period following the fall of Rome in 410 are almost exclusively small-scale status symbols, especially items of personal adornment featuring cloisonné decoration consisting of abstract intertwined animal-and-interlace patterns.
- Art historians call the Christian art of early medieval Ireland and Britain Hiberno-Saxon. The most important extant artworks are the illuminated manuscripts produced in monastic scriptoria. Among the distinctive features of these books are "carpet pages" devoted neither to text nor to illustration but to pure embellishment, as in the Lindisfarne Gospels, and text pages with the initial letters of important passages enlarged and transformed into elaborate decorative patterns.
- In 800, Pope Leo III crowned Charlemagne, king of the Franks since 768, emperor of Rome (r. 800–814). Charlemagne reunited much of western Europe and initiated a conscious revival of the art and culture of Early Christian Rome during the Carolingian period (768–877). Carolingian artists merged the illusionism of classical painting with the northern linear tradition and revived the Early Christian practice of depicting Christ as a statuesque youth. Carolingian architects looked to Ravenna and Early Christian Rome for models, but transformed their sources—introducing the twin-tower west facade (westwork) for basilicas—for example, the abbey church at Corvey—and employing strict modular plans for entire monasteries—for example, Saint Gall—as well as for individual buildings.
- In the 10th century, a new line of emperors, the Ottonians (r. 919–1024), consolidated the eastern part of Charlemagne's former empire and sought to preserve and enrich the culture and tradition of the Carolingian period. Ottonian architects built basilican churches incorporating the towers and westworks of their Carolingian models, but introduced the alternate-support system into the nave. Ottonian sculptors revived the art of large-scale sculpture in works such as the *Gero Crucifix* and the colossal bronze doors of Saint Michael's at Hildesheim.

Lindisfarne Gospels, ca. 698-721

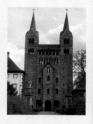

Abbey church, Corvey, 873-885

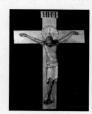

Gero Crucifix, ca. 970

Romanesque Art

- Romanesque takes its name from the Roman-like barrel and groin vaults based on round arches employed in many European churches built between 1050 and 1200. Romanesque vaults, however, are made of stone, not concrete. Numerous churches sprang up along the French pilgrimage roads leading to the shrine of Saint James at Santiago de Compostela in northwestern Spain. These churches were spacious enough to accommodate large crowds of pilgrims who came to view the relics displayed in radiating chapels off the ambulatory and transept. Elsewhere, especially in the Holy Roman Empire and in Normandy (Saint-Étienne, Caen) and England, innovative architects began to use groin vaults in naves and introduced the three-story elevation of nave arcade, tribune, and clerestory.
- The Romanesque period also brought the revival of large-scale stone relief sculpture in cloisters and especially in church portals—for example, Saint-Pierre, Moissac—where scenes of Christ as last judge often greeted the faithful as they entered the doorway to the road to salvation. The sculptor Gislebertus, who worked at the Cathedral of Saint Lazarus at Autun, was one of a growing number of Romanesque artists who signed their works. The names of some Romanesque manuscript painters are also known, including the Englishman Master Hugo, a rare instance of a professional lay artist during the early Middle Ages.

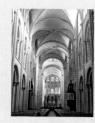

Saint-Étienne, Caen, ca. 1115-1120

Second Coming of Christ, Moissac, ca. 1115–1135

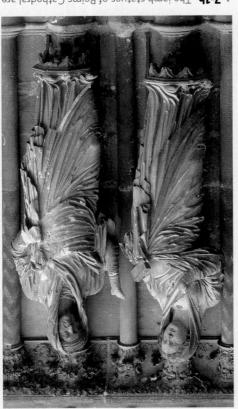

▲ 7-1b The jamb statues of Reims Cathedral are almost fully detached from the walls. They stand in contrapposto poses, turn toward one another, and act out biblical dramas using gestures.

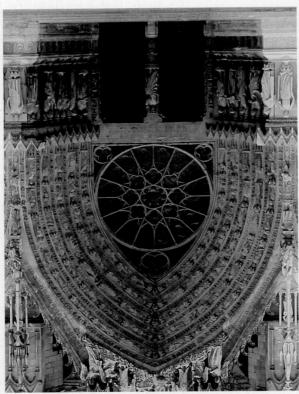

▲ 7-1c Reims Cathedral's facade reveals High Gothic architects' desire to replace heavy masonry with intricately framed voids. Stained-glass windows, not stone reliefs, fill the three tympana.

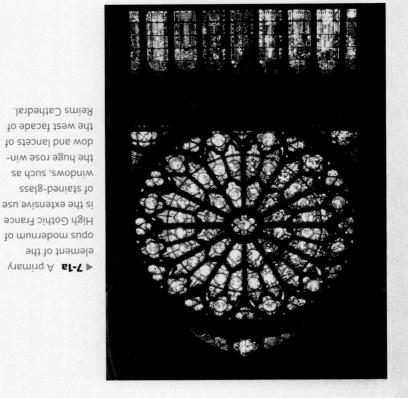

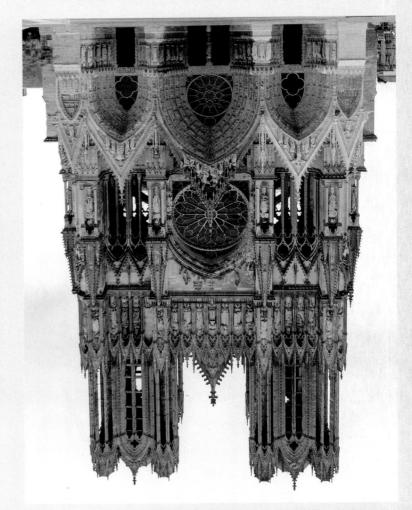

JEAN D'ORBRIS, JEAN LE LOUP, GAUCHER DE REIMS, and BERNARD DE SOISSONS, West facade of Reims Cathedral, Reims, France, ca. 1271-7290.

Gothic and Late Medieval Europe

"MODERN ARCHITECTURE" IN THE GOTHIC AGE

Although the names of very few medieval architects are known today, the identities of quite a few builders of the Gothic age have been recorded for posterity, including Jean d'Orbais, Jean Le Lour, Gaucher de Reims, and Bernard de Soissons, all of whom worked at Reims Cathedral (Fig. 7-1) during its multigeneration construction campaign. The survival of the names of these and other Gothic architects no doubt reflects the enormous prestige that accrued to all associated with the great cathedrals of the Gothic age. Gothic architecture is one of the towering achievements in the history of world architecture, the unique product of an era of peace and widespread economic prosperity, deep spirituality, and extraordinary technological innovation. Born in the region around Paris called the Île-de-France, the Gothic style quickly came to be called *opus francigenum* ("French work") or, more simply, *opus modernum* ("modern work"). Admired throughout Europe, Gothic cathedrals were regarded as stone and glass images of the City of God, the Heavenly Jerusalem.

One of the prime examples of the "modern" Gothic style of architecture is the cathedral dedicated to the Virgin Mary at Reims in the heart of France's Champagne wine district. Reims Cathedral occupies a special place in the history of France as well as in the history of architecture. Since 496 it has been the site of all French kings' coronations. The present church, begun in 1211 and completed in 1290, features a grandiose facade "punctured" with tall and narrow pointed-arch *lancets*, a huge *stained-glass* circular *rose window* above the central portal, and smaller windows in the three tympana where Romanesque designers had placed stone reliefs. Inside, mystical light streaming through tall stained-glass windows illuminates the church. The nave has three stories, including a new Gothic feature called a *triforium* below the clerestory, and huge rib vaults resting on pointed arches. The thin, window-filled walls at Reims and elsewhere are invisibly held in place by external *flying buttresses* (see "Building a High Gothic Cathedral," page 193).

Reims Cathedral is also noteworthy for its sculpture. In contrast to Romanesque churches, whose facades are adorned with reliefs, Reims and similar French Gothic cathedrals have statues that are almost fully detached from the walls. The figures, such as the Virgin Mary and Saint Elizabeth, stand in contrapposto poses, act out biblical dramas (in this instance, the Visitation), and turn toward one another and converse through gestures.

The High Gothic cathedral and the Gothic architectural style in general live on in countless chapels, academic buildings, and dormitories on college campuses throughout the world.

"GOTHIC" EUROPE

Scandinavia. these areas, however, reaching, for example, Eastern Europe and and Italy—in separate sections. The Gothic style spread beyond four major regions—France, England, the Holy Roman Empire, fore, this chapter deals with contemporaneous developments in the tinct regional styles characterized the Romanesque period. Thereexisted within European Gothic art and architecture, just as disbeginning to take shape (MAP 7-1). In fact, many regional variants Muslims, the independent secular nations of modern Europe were of its power, and Christian knights still waged Crusades against the founded the first universities. Although the papacy was at the height homes and formed guilds (professional associations), and scholars sky. In these new urban centers, prosperous merchants made their enormous cathedrals like that at Reims (FIG. 7-1) reaching to the side and pilgrimage churches to rapidly expanding cities with religious life shifted definitively from monasteries in the countrychange in European society. The focus of both intellectual and The 12th through 14th centuries were a time of profound

the history of Western art and architecture. and the modern view of the Gothic era as one of the high points in unavoidable label completely out of sync with both the late medieval it ugly and crude. "Gothic," like "medieval," is an unfortunate if ture. They regarded "Gothic" art with contempt and considered Rome and for the decline of the classical style in art and architecthat the uncouth Goths were responsible both for the downfall of regarded Greco-Roman art as the standard of excellence, believed the Middle Ages was a period of decline. The Italian humanists, who (1378–1455) had already advanced in his Commentarii, namely that all time the notion that the early Renaissance artist Lorenzo Chiberti influential Introduction to the Three Arts of Design, Vasari codified for "monstrous and barbarous." With the publication that year of his and architecture, which he attributed to the Goths and regarded as first used Gothic as a term of ridicule to describe late medieval art In 1550, Giorgio Vasari (1511–1574; see "Giorgio Vasari's Lives" (1)

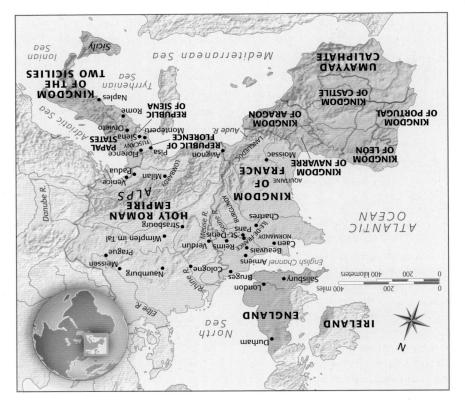

MAP 7-1 Europe around 1200.

GOTHIC AND LATE MEDIEVAL EUROPE

 The Perpendicular style in England emphasizes surface embellishment over structural clarity.
 Giotto, considered the first Renaissance artist, pioneers a naturalistic approach to painting based

Late Gothic

1300-1400

- on observation.

 Duccio softens the Byzantine-inspired maniera greca
- and humanizes religious subject matter.

 Secular themes emerge as important subjects in civit commissions, as in the trescoes of Siena's.
- Civic commissions, as in the frescoes of Siena's Palazzo Pubblico.
- The rebuilt Chartres Cathedral sets the pattern for High Gothic churches: four-part nave vaults braced by external flying buttresses, three-story elevation (arcade, triforium, clerestory), and stained-glass windows in place of heavy masonry.
- At Chartres and Reims in France, at Naumburg in Germany, and elsewhere, statues become more independent of their architectural setting.

 Manuscript illumination moves from monastic

scriptoria to urban lay workshops.

- 1194-1300 High Gothic
- Abbot Suger begins rebuilding the French royal abbey church at Saint-Denis with stained-glass windows and rib vaults on pointed arches.
 Introduced at Saint-Denis, sculpted jamb figures
- Introduced at Saint-Denis, scuipted Jamp figures also adorn all three portals of the west facade of Chartres Cathedral.

FRANCE

About 1130, King Louis VI (r. 1108–1137) moved his official residence to Paris, spurring much commercial activity and a great building boom. Paris soon became the most important city in France, indeed in northern Europe (see "Paris, the New Center of Medieval Learning" (1), and the Île-de-France the leading center of Gothic art and architecture.

Architecture and Architectural Decoration

Architectural historians generally agree that the birthplace of Gothic architecture was the abbey of Saint-Denis, a few miles north of Paris. Dionysius (*Denis* in French) was the legendary saint who brought Christianity to Roman Gaul in the third century.

SUGER AND SAINT-DENIS On June 11, 1144, King Louis VII of France (r. 1137–1180), Queen Eleanor of Aquitaine, and an entourage of court members, together with five French archbishops and

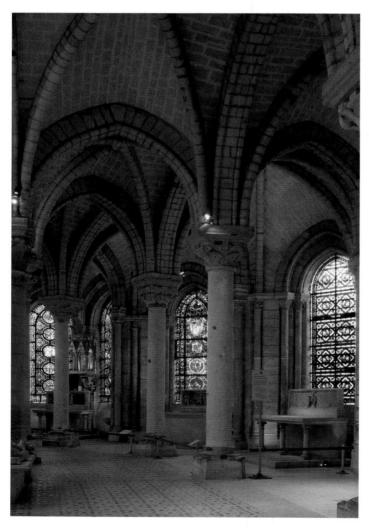

7-2 Ambulatory and radiating chapels (looking northeast), abbey church, Saint-Denis, France, 1140–1144.

Abbot Suger's remodeling of Saint-Denis marked the beginning of Gothic architecture. Rib vaults with pointed arches spring from slender columns. The radiating chapels have stained-glass windows.

other distinguished clergy, converged on the Benedictine abbey church of Saint-Denis for the dedication of its new east end. The original Carolingian basilica housed the tomb of Saint Dionysius and those of nearly all the French kings. The basilica was France's royal church, the very symbol of the monarchy. By the early 12th century, however, the church was in disrepair and had become too small to accommodate the growing number of pilgrims. Its abbot, Suger (ca. 1081–1151), also believed that the Carolingian shrine was of insufficient grandeur to serve as the official church of the French kings. In 1135, he began to rebuild Saint-Denis by erecting a new west facade with sculptured portals (see "Abbot Suger and the Rebuilding of Saint-Denis" (1). Work began on the east end (FIGS. 7-2 and 7-3) in 1140. Suger died before he could remodel the nave, but he attended the 1144 dedication of the new choir, ambulatory, and radiating chapels.

The remodeled portion of Saint-Denis represented a sharp departure from past practice. Innovative rib vaults resting on pointed, or *ogival*, arches (see "The Gothic Rib Vault," page 190, and FIG. 7-4) cover the ambulatory and chapels (FIG. 7-2). These pioneering, exceptionally lightweight vaults spring from slender columns in the ambulatory and from the thin masonry walls framing the chapels. The lightness of the vaults enabled the builders to eliminate the walls between the chapels and open up the outer walls and fill them with stained-glass windows (see "Stained-Glass Windows," page 195). Suger and his contemporaries marveled at the "wonderful and uninterrupted light" that poured in through these "most luminous windows." The abbot called the colored light *lux nova*, "new light." Saint-Denis's pointed-arch vaulting and stained-glass windows became hallmarks of French Gothic architecture.

ROYAL PORTAL, CHARTRES Saint-Denis is also the key monument of Early Gothic (ca. 1140–1194) sculpture. Little of the sculpture that Suger commissioned for the west facade of the abbey church survived the French Revolution of the late 18th century, but originally, statues of Old Testament kings, queens, and prophets

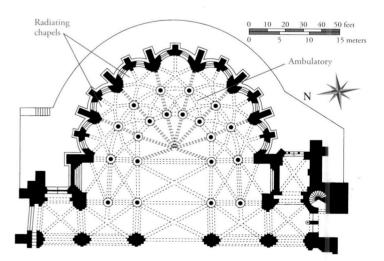

7-3 Plan of the east end, abbey church, Saint-Denis, France, 1140–1144 (after Sumner Crosby).

The innovative plan of the east end of Saint-Denis dates to Abbot Suger's lifetime. By using very light rib vaults, the builders were able to eliminate the walls between the radiating chapels.

ARCHITECTURAL BASICS The Gothic Rib Vault

(AFB, BJC, and DHC), their radii and, therefore, their heights (EF, IJ, and GH) will be different because the width of a semicircular arch determines its height. The result will be a vault (Fig. λ -4b) with higher transverse arches (DHC) than the arcade's arches (CJB). The vault's crown (F) will be still higher. If the builder uses pointed arches (Fig. λ -4c), the transverse (DLC) and arcade (BKC) arches can have the same heights (GL and IK in Fig. λ -4a). The result will be a Gothic rib vault where the points of the arches (L and K) are at the same level as the vault's

A major advantage of the Gothic vault is its flexibility, which enables the vaulting of compartments of varying shapes, as at Saint-Denis (FIGS. 7-2 and 7-3). Pointed arches also channel the weight of the vaults more directly downward than do semicircular arches. The vaults therefore require less buttressing to hold them in place, in turn making it possible to open up the walls and place large windows beneath the arches. Because pointed arches also lead the eye upward, they make the vaults appear taller than they are. In FIG. 7-4, the crown (F) of both the vaults appear taller than they are. In FIG. 7-4, the crown (F) of both the Romanesque (b) and Gothic (c) vaults is the same height from the pavement, but the Gothic vault seems taller. Both the physical and visual properties of rib vaults with pointed arches aided Gothic builders in their quest for soaring height in church interiors (FIG. 7-13).

The ancestors of the Gothic rib vault are the Romanesque vaults found at Caen (Fig. 6-30), Durham (Fig. 6-31), and elsewhere. The rib vault's distinguishing features are the crossed, or diagonal, arches under its groins. The ribs form the armature, or skeletal framework, for constructing the vault. Gothic vaults generally have more thinly vaulted webs (the masonry between the ribs) than found in Romanesque vaults. But the an integral part of the Cothic skeletal armature. French Romanesque archief difference between the two types of rib vaults is the pointed arch, an integral part of the Cothic skeletal armature. French Romanesque architects (Fig. 6-1) borrowed the form from Muslim Spain and passed architects (Fig. 6-1) borrowed the form from Muslim Spain and passed it to their Gothic successors. Pointed arches enabled Gothic builders to make the crowns of all the vaults approximately the same level, regardless of the space to be vaulted. The Romanesque architects could not aschieve this with their semicircular arches.

The drawings in Fig. 7-4 illustrate this key difference. In Fig. 7-4a, the rectangle ABCD is an oblong nave bay to be vaulted. AC and DB are the diagonal ribs; AB and DC, the transverse arches; and AD and BC, the nave arcade's arches. If the architect uses semicircular arches

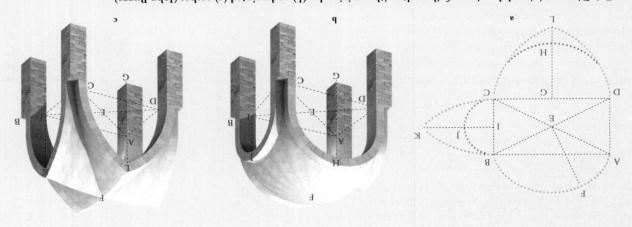

7-4 Diagram (a) and drawings of rib vaults with semicircular (b) and pointed (c) arches (John Burge).

Pointed arches channel the weight of the rib vaults more directly downward than do semicircular arches, requiring less buttressing. Pointed arches also make the vaults appear taller than they are.

of Hell, interceding for all her faithful. Worshipers in the later 12th and 13th centuries sang hymns to the Virgin and dedicated great cathedrals to her. Soldiers carried her image into battle on banners, and Mary's name joined Saint Denis's as part of the French king's battle cry. The Virgin became the spiritual lady of chivalry, and the Christian knight dedicated his life to her. The severity of Romanesque themes atressing the last judgment yielded to the gentleness of Gothic art, in which Mary is the kindly queen of Heaven.

Statues of Old Testament kings and queens (Fig. 7-6) occupy the jambs flanking each doorway of the Royal Portal. They are the royal ancestors of Christ and, both figuratively and literally, support the New Testament figures above the doorways. They wear 12th-century clothes, and medieval observers may have regarded them as images of the kings and queens of France. (This was the motivation for vandalizing the comparable figures at Saint-Denis during tion for vandalizing the comparable figures at Saint-Denis during

attached to columns adorned the jambs of all three doorways. This innovative design appeared immediately afterward in the Royal Portal (Fig. 7-5) of the west facade of Chartres Cathedral, the church dedicated to Our Lady (Notre Dame), the Virgin Mary, and that the Royal Portal—named for the jamb statues of kings and queens—proclaims the majesty and power of Christ. Christ's ascension appears in the tympanum of the left doorway. The second coming is the subject of the center tympanum, as at Moissac (Fig. 6-1). In the tympanum of the right portal, the infant Jesus sits in the lap of the Virgin Mary's prominence on the Chartres facade has no parallel in the sculptural programs of Romanesque church portals. At Chartres, the Virgin assumed a central role, a position she maintained throughout the Gothic period. As the mother of the Savior, Mary's stood compassionately between the last judge and the horrors Mary stood compassionately between the last judge and the horrors

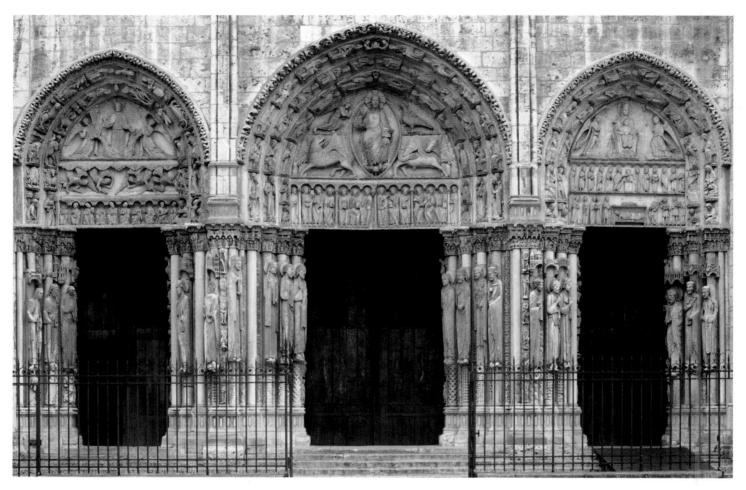

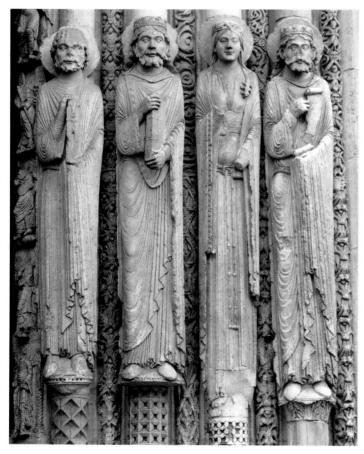

7-5 Royal Portal, west facade, Chartres Cathedral, Chartres, France, ca. 1145–1155.

The sculptures of the Royal Portal proclaim the majesty and power of Christ. The tympana depict, from left to right, Christ's ascension, the second coming, and the infant Jesus in the lap of the Virgin Mary.

the French Revolution.) The figures stand rigidly upright with their elbows held close against their hips. The linear folds of their garments—inherited from the Romanesque style, along with the elongated proportions—generally echo the vertical lines of the columns behind them. In this respect, Gothic *jamb statues* differ significantly from classical *caryatids* (FIG. 2-42). The Gothic figures are *attached* to columns. The classical statues *replaced* the columns. The Chartres jamb statues are therefore technically high reliefs. Nonetheless, the statues of kings and queens stand out from the plane of the wall and display signs of a new interest in naturalism on the part of medieval sculptors, noticeable particularly in the heads, where kindly human faces replace the masklike features of most Romanesque figures. The Royal Portal figures initiate an era of artistic concern with personality and individuality.

7-6 Old Testament kings and queen, jamb statues on the right side of the central doorway of the Royal Portal (FIG. 7-5), Chartres Cathedral, Chartres, France, ca. 1145–1155.

The biblical kings and queens of the Royal Portal are the royal ancestors of Christ. These Early Gothic jamb figures display the first signs of a new naturalism in European sculpture.

7-7 Notre-Dame (looking northwest), Paris, France, begun 1163; nave and flying buttresses, ca. 1180–1200; remodeled after 1225.

Architects first used flying buttresses on a grand scale at the Cathedral of Notre-Dame in Paris. The buttresses countered the outward thrust of the nave vaults and held up the towering nave walls.

buttresses and rib vaults with pointed arches was the ideal solution to the problem of constructing lofty naves with huge windows (see "Building a High Gothic Cathedral," page 193, and FIG. 7-8).

predecessor, making taller naves more practical to build. bay and therefore could be braced more easily than its Early Gothic the norm. The High Gothic four-part nave vault covered only one flanks a single rectangular unit in the nave (FIG. 7-10, left), became in which a single square in each aisle (rather than two, as before) (FIG. 6-30) at Caen and in Early Gothic churches. The new system, part vaults and the alternate-support system used at Saint-Etienne nave bays with four-part vaults replaced the square bays with six-High Gothic building. At Chartres (FIGS. 7-9 and 7-10), rectangular ans generally consider the post-1194 Chartres Cathedral the first west facade took a relatively short 27 years. Architectural historidevastating fire in 1194 that destroyed all but the lower parts of its times centuries. The rebuilding of Chartres Cathedral tollowing a tion histories that frequently extended over decades and someoften could be completed quickly, urban cathedrals had construc-In contrast to monastic churches, which usually were small and often had to raise money unexpectedly for new building campaigns. dle Ages (see "The Burning of Canterbury Cathedral" (◄), and the clergy CHARTRES AFTER 1194 Churches burned frequently in the Mid-

NOTRE-DAME, PARIS Because of the rapid urbanization of Paris under Louis VI and his successors and the accompanying population boom, a new cathedral became a necessity. Notre-Dame (FIG. 7-7) occupies a picturesque site on an island in the Seine River called the Île-de-la-Cité. The Gothic church, which replaced a large Merovingian basilica, has a complicated building history. The choir and transept were in place by 1182, the nave by about 1225, and the facade not until about 1250 to 1260. The original nave elevation had four stories, with a stained-glass oculus (small round window) inserted between the vaulted tribune and clerestory typical of Morman Romanesque churches, such as Saint-Étienne (FIG. 6-30) at Caen. As a result, windows filled two of the four stories, further reducing the masonry area.

To hold the much thinner—and taller—walls of Notre-Dame in place, the unknown architect introduced flying buttresses, external arches that spring from the lower roofs over the aisles and ambulatory (Fig. 7-7) and counter the outward thrust of the nave vaults. Gothic builders had introduced flying buttresses as early as 1150 in a few smaller churches, but at Notre-Dame in Paris, they circle a great urban cathedral. The internal quadrant arches (Fig. 6-32, right) beneath the aisle roofs at Durham Cathedral perform a similar function and may be regarded as precedents for exposed Gothic flying buttresses. The combination of precisely positioned flying hying buttresses. The combination of precisely positioned flying

ARCHITECTURAL BASICS

Building a High Gothic Cathedral

Most of the architectural components of Gothic cathedrals appeared in earlier structures, but Gothic architects combined the elements in new ways. The essential ingredients of their formula for constructing churches in the *opus modernum* style were rib vaults with pointed arches, flying buttresses, and huge colored-glass windows. The cutaway view of a typical Gothic cathedral in FIG. 7-8 illustrates how these and other important Gothic architectural devices worked together.

- Pinnacle (Fig. 7-8, no. 1) A sharply pointed ornament capping the piers or flying buttresses; also used on cathedral facades.
- Flying buttresses (2) Masonry struts that transfer the thrust of the nave vaults across the roofs of the side aisles and ambulatory to a tall pier rising above the church's exterior wall.
- Vaulting web (3) The masonry blocks that fill the area between the ribs of a groin vault.
- Diagonal rib (4) In plan, one of the ribs forming the X of a groin vault. In Fig. 7-4, the diagonal ribs are the lines AC and DB.
- **Transverse rib** (5) A rib crossing the nave or aisle at a 90-degree angle (lines AB and DC in Fig. 7-4).
- Springing (6) The lowest stone of an arch; in Gothic vaulting, the lowest stone of a diagonal or transverse rib.
- Clerestory (7) The windows below the vaults in the nave elevation's uppermost level. By using flying buttresses and rib vaults with pointed arches, Gothic architects could build huge clerestory windows and fill them with stained glass held in place by ornamental stonework called tracery.

7-8 Cutaway view of a typical French Gothic cathedral (John Burge).

The major elements of the Gothic formula for constructing a church in the opus modernum style were rib vaults with pointed arches, flying buttresses, and stained-glass windows.

- Oculus (8) A small, round window.
- Lancet (9) A tall, narrow window crowned by a pointed arch.
- **Triforium** (10) The story in the nave elevation consisting of arcades, usually *blind arcades* but occasionally filled with stained glass
- Nave arcade (11) The series of arches supported by piers separating the nave from the side aisles.
- Compound pier (cluster pier) with shafts (responds) (12) A pier with a group, or cluster, of attached shafts, or responds, extending to the springing of the vaults.

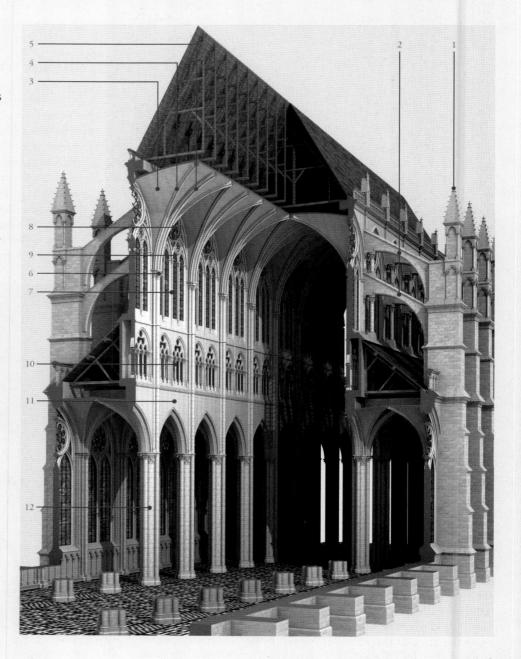

The 1194 Chartres Cathedral was also the first church planned from its inception to have flying buttresses, another key High Gothic feature. The flying buttresses enabled the builders to eliminate the tribune above the aisle, which had partially braced Romanesque

and Early Gothic naves. Taking its place was the *triforium*, the band of arcades between the clerestory and the nave arcade. The triforium occupies the space corresponding to the exterior strip of wall covered by the sloping timber roof above the galleries. The new

7-9 Interior of Chartres Cathedral (looking east), Chartres, France, begun 1194.

Chartres Cathedral established the High Gothic model with its four-part nave vaults and three-story elevation consisting of nave arcade, triforium, and clerestory with tall stained-glass windows.

High Gothic three-story nave elevation consisted of arcade, triforium, and clerestory with greatly enlarged windows (Fig. 7-10, right). The Chartres windows are almost as tall as the main arcade and consist of double lancets with a single crowning oculus. The strategic placement of flying buttresses made possible the construction of nave walls with so many voids that heavy masonry played merely a minor role.

GHARTRES STAINED GLASS Despite the vastly increased size of its clerestory windows, the Chartres nave (Fig. 7-9) is relatively dark. This seeming contradiction is the result of using colored instead of clear glass for the windows. The purpose of the Chartres windows was not to illuminate the interior with bright sunlight but to transform natural light page 195). Chartres Cathedral retains almost the full complement of its original stained glass. Although the tinted windows have a dimming effect, they transform the character of dows have a dimming effect, they transform the character of the church's interior in dramatic fashion. The immense rose the church's interior in dramatic fashion. The immense rose the church's interior in dramatic fashion. The immense rose the church's interior in dramatic fashion. The immense rose window (approximately 43 feet in diameter) and tall lancets window (approximately the in diameter) and tall lancets

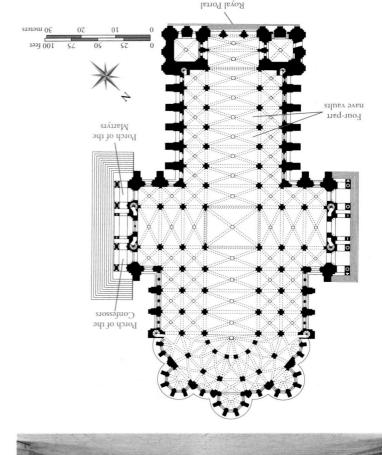

7-10 Plan (left; after Paul Frankl) and elevation (right; John Burge) of Chartres Cathedral, Chartres, France, as rebuilt after the 1194 fire.

The Chartres plan—with one bay in each aisle flanking a four-part vaulted bay in the nave—became the norm for High Gothic architecture. The clerestory windows are almost as tall as the nave arcade.

MATERIALS AND TECHNIQUES

Stained-Glass Windows

Stained-glass windows, although not a Gothic invention, are almost synonymous with Gothic architecture. They differ from the mural paintings and mosaics that adorned earlier churches in one all-important respect. They do not conceal walls. They replace them. Moreover, they transmit rather than reflect light, filtering and transforming the natural sunlight. Abbot Suger called this colored light *lux nova*. Suger's contemporary, Hugh of Saint-Victor (1096–1142), a prominent Parisian theologian, believed that "stained-glass windows are the Holy Scriptures . . . and since their brilliance lets the splendor of the True Light pass into the church, they enlighten those inside.* William Durandus (ca. 1237–1296), bishop of Mende, expressed a similar sentiment at the end of the 13th century: "The glass windows in a church are Holy Scriptures, which expel the wind and the rain, that is, all things hurtful, but transmit the light of the True sun, that is, God, into the hearts of the faithful."

The manufacture of stained-glass windows was costly and laborintensive. A German monk named Theophilus recorded the full process around 1100. First, the master designer drew the exact composition of the planned window on a wood panel, indicating all the linear details and noting the colors for each section. Glassblowers provided flat sheets of glass of different colors to glaziers (glassworkers), who cut the windowpanes to the required size and shape with special iron shears. Glaziers produced an even greater range of colors by flashing (fusing one layer of colored glass to another). Next, painters added details such as faces, hands, hair, and clothing in enamel by tracing the master design on the wood panel through the colored glass. Then they heated the painted glass to fuse the enamel to the surface. At that point, the glaziers "leaded" the various fragments of glass—that is, they joined them by strips of lead called cames. The leading not only held the pieces together but also separated the colors to heighten the effect of the design as a whole. The distinctive character of Gothic stained-glass windows is largely the result of this combination of fine linear details with broad, flat expanses of color framed by black lead. Finally, the glassworkers strengthened the completed window with an armature of iron bands (FIG. 7-11).

The form of the stone frames for the stained-glass windows also evolved. Early rose windows have stained glass held in place by *plate tracery*. The glass fills only the "punched holes" in the heavy ornamental stonework. *Bar tracery* (FIG. 7-11), a later development, used first at Reims (FIG. 7-1a), is much more slender. The stained-glass windows fill almost the entire opening, and the stonework is unobtrusive, resembling delicate leading more than masonry wall.

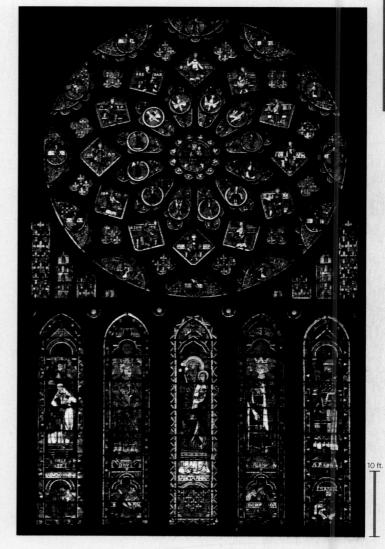

7-11 Rose window and lancets, north transept, Chartres Cathedral, Chartres, France, ca. 1220. Stained glass, rose window 43' in diameter.

Stained-glass windows transformed natural light into Suger's lux nova. This huge rose window with tall lancets fills almost the entire facade wall of the High Gothic north transept of Chartres Cathedral.

*Hugh of Saint-Victor, Speculum de mysteriis ecclesiae, sermon 2.

*William Durandus, Rationale divinorum officiorum, 1.1.24. Translated by John Mason Neale and Benjamin Webb, The Symbolism of Churches and Church Ornaments (Leeds: Green, 1843), 28.

of Castile (see page 199) around 1220. Yellow castles on a red ground and yellow *fleurs-de-lis* (three-petaled iris flowers; the French monarchy's floral emblem) on a blue ground fill the eight narrow windows in the rose's lower *spandrels*. The iconography is also fitting for a queen. The enthroned Virgin and Child appear in the *roundel* at the center of the rose, which resembles a gem-studded book cover or cloisonné brooch. Around her are four doves of the Holy Spirit and eight angels. Twelve square panels contain images of Old Testament kings, including David and Solomon (at the 12 and 1 o'clock positions respectively). These are the royal ancestors of Christ. Isaiah (11:1–3) had prophesized that the Messiah would come from the family of the patriarch Jesse, father of David. The genealogical "tree of Jesse" is a

familiar motif in medieval art. Below, in the central lancet, are Saint Anne and the baby Virgin. Flanking them are four of Christ's Old Testament ancestors—Melchizedek, David, Solomon, and Aaron—echoing the royal genealogy of the rose, but at a larger scale.

Almost the entire mass of wall opens up into stained glass, held in place by an intricate stone armature of *bar tracery* and filling the church with lux nova that changes in hue and intensity with the hours. Here, the Gothic passion for luminous colored light led to a most daring and successful attempt to subtract all superfluous material bulk just short of destabilizing the structure. That this vast, complex fabric of stone-set glass has maintained its structural integrity for almost 800 years attests to the Gothic builders' engineering genius.

skeletal architecture reached full maturity. weight-bearing walls. At Amiens, the concept of a self-sustaining possible the almost complete elimination of heavy masses and thick four-part rib vault, and an external buttressing system that made High Gothic structural vocabulary: the rectangular-bay system, the design reflects the Amiens builders' confident use of the complete windows in both its clerestory and triforium are greater. The whole are more slender, and the number and complexity of the lancet of Chartres (FIG. 7-10, right), but Amiens Cathedral's proportions Amiens elevation (FIG. 7-14) derived from the High Gothic formula by 1247, but work on the choir continued until almost 1270. The The nave (FIG. 7-13) was ready by 1236 and the radiating chapels DE LUZARCHES, THOMAS DE CORMONT, and RENAUD DE CORMONT. work was still in progress at Chartres. The architects were ROBERT the details. Construction of Amiens Cathedral began in 1220, while tern that many other Gothic architects followed, even if they refined AMIENS CATHEDRAL The builders of Chartres Cathedral set a pat-

Those at Amiens are 144 feet above the floor, reflecting the French Gothic obsession with constructing ever taller cathedrals. At Amiens, the vault ribs converge to the colonnettes and speed down the walls the vault ribs converge to the colonnettes and speed down the walls to the compound piers. Almost every part of the superstructure has strength, of a buoyant lightness not normally associated with atone architecture. The light flooding in from the clerestory—and, in the choir, also from the triforium—makes the vaults seem even more insubstantial. The effect recalls another great building, one utterly different from Amiens but where light also plays a defining role: Hagia Sophia (Fig. 4-12) in Constantinople. The designers of Amiens Cathedral, too, reduced the building's physical mass through structural ingenuity and daring, but in the High Gothic basilica, unlike the domed Byzantine church, light further dematerializes what remains domed Byzantine church, light further dematerializes what remains

REIMS CATHEDRAL Construction of Reims Cathedral began only a few years after work commenced at Amiens. Gaucher de Reims and Bernard de Soissons, who were primarily responsible for the west facade (Fig. 7-1), carried the High Gothic style of Amiens still further, both architecturally and sculpturally. Especially striking, as noted in the chapter-opening essay, is the treatment of the tympans over the doorways, where stained-glass windows replaced the stone relief sculpture of earlier facades. The jamb statues that flank the Reims west portals are also more advanced than the comparable figures at Amiens or Chartres (Fig. 7-12). The subjects of the four most prominent statues (Fig. 7-15) are the Annunciation and Visitation—further testimony to the Virgin's central role in Gothic iconography. The statues appear completely detached from their architectural background because the sculptors shrank the supporting columns into insignificance. The columns in no way restrict the free and easy movements of the full-bodied figures.

The Reims statues also vividly illustrate how long it frequently took to complete the sculptured ornamentation of a large Gothic cathedral. Sculptural projects of this magnitude normally required decades to complete and entailed hiring many sculptors, often working in diverse styles. Art historians believe that three different sculptors carved the four statues in Fig. 7-15 at different times during the quarter century from 1230 to 1255. The Visitation figures (Fig. 7-15, right) are the work of an artist who must have studied classical statuary. Reims was an ancient Roman city. The heads of both Mary and stry. Reims was an ancient Roman portraits, and the rich folds of the garments also recall ancient statuary. The Gothic statues closely approximents also recall ancient statuary. The Gothic statues closely approximate the classical naturalistic style and feature contrapposto postures in which the swaying of the hips is much more pronounced than in

be described as a second "Classical revolution." Archaic to the Classical style (see page 63) and could appropriately ary developments in Greek sculpture during the transition from the that occurred in 13th-century Gothic sculpture echo the revolutionposto stance of Polykleitos's Spear Bearer (FIG. 2-35). The changes nounced sway recall ancient Greek statuary, especially the contrapswings out his hip to the right. The body's resulting torsion and proand rests his left hand on his shield. He turns his head to the left and some, long-haired youth holds his spear firmly in his right hand cloak and chain-mail armor of 13th-century Crusaders. The handtrayed Theodore as the ideal Christian knight, clothing him in the (FIG. 7-6) of the mid-12th century. The High Gothic sculptor por-French sculpture had undergone since the Royal Portal jamb figures the south transept around 1230, embodies the great changes that Theodore statue (FIG. 7-12), placed in the Porch of the Martyrs in tectural framework than their Early Gothic predecessors. The Saint on the transept portal jambs are more independent from the archiprime examples of the new High Gothic spirit. The statues of saints tals of the two Chartres transepts erected after the 1194 fire are also CHARTRES SOUTH TRANSEPT The sculptures adorning the por-

of the Martyrs, south transept, Chartres, Cathedral, Chartres, France, ca. 1230.

Although the statue of Theodore is still attached to a column, the setting more of the column, the setting matter at the column transfer of the column trans

portal of the Porch

jamb statue in the left

7-12 Saint Theodore,

Although the statue of Theodore is still attached to a column, the setting no longer determines its pose. The High Gothic sculptor portrayed the saint in a contrapposto stance, as in classical statuary.

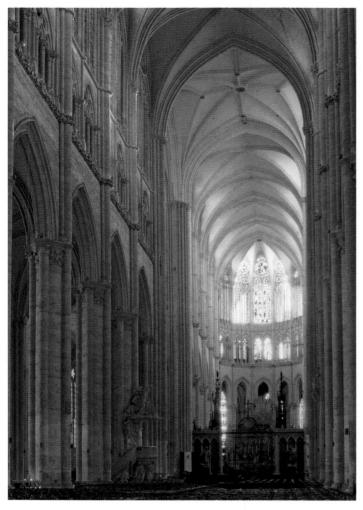

7-13 ROBERT DE LUZARCHES, THOMAS DE CORMONT, and RENAUD-DE CORMONT, interior of Amiens Cathedral (looking east), Amiens, France, begun 1220.

The concept of a self-sustaining skeletal architecture reached full maturity at Amiens Cathedral. The light entering from the clerestory and triforium creates a buoyant lightness rare in stone architecture.

7-14 ROBERT DE LUZARCHES, THOMAS DE CORMONT, and RENAUD DE CORMONT, nave elevation of Amiens Cathedral, Amiens, France, begun 1220 (John Burge).

Amiens Cathedral's four-part vaults on pointed arches rise an astounding 144 feet, three times the width of the nave floor. The Chartres vaults (FIG. 7-10, *right*) are 120 feet tall and 2.64 times the nave width.

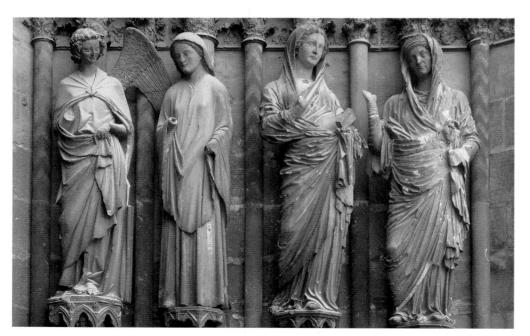

7-15 Annunciation and Visitation, jamb statues on the right side of the central doorway of the west facade, Reims Cathedral (FIG. 7-1), Reims, France, ca. 1230–1255.

Several sculptors working in diverse styles carved the Reims jamb statues, but all the figures resemble freestanding statues, with bodies and arms in motion. The biblical figures speak using gestures.

extreme slenderness of the architectural forms and on linearity in general. Sainte-Chapelle's enormous windows filter the light and fill the interior with an unearthly rose-violet atmosphere. Approximately 49 feet high and 15 feet wide, they were the largest stained-glass windows up to their time.

GUILD HALL, BRUGES One of the many signs of the growing urbanization of life in the late Middle Ages was the erection of large meeting halls and warehouses for the increasing number of craft guilds being formed throughout Europe. An early example is the imposting market and guild hall (FIG. 7-17) of the clothmakers of Bruges, Belgium, begun in 1230. Situated in the city's major square, the hall corner watchtowers with their cremellations) and sacred architecture corner watchtowers with their cremellations) and sacred architecture (lancet windows with crowning oculi). The uppermost, octagonal portion of the tower with its flying buttresses and pinnacles dates to the 15th century, but even the original two-story tower is taller portion of the tower with their cremellations. Lofty towers, a common feature of late medieval guild and town halls, were designed to compete for attention and prestige with the towers of city cathedrals.

the Chartres Saint Theodore (Fig. 7-12). (It is even more exaggerated in the elegant elongated body of the angel Gabriel of the Annunciation [Fig. 7-15, left].) The right legs of the Visitation figures bend, and the knees press through the rippling folds of the garments. The sculptor also set the figures' arms in motion. Mary and Elizabeth look at each other and speak using gestures. In the Reims Visitation, the formerly isolated Gothic jamb statues became actors in a biblical narrative.

SAINTE-CHAPELLE, PARIS The stained-glass windows inserted into the portal tympana of Reims Cathedral (Fig. 7-1c) exemplify the wall-dissolving High Gothic architectural style. The architect of Sainte-Chapelle (Fig. 7-16) in Paris extended this approach to an entire building. Louis IX (Saint Louis, r. 1226–1270) built Sainte-Chapelle near Notre-Dame as a repository for the crown of thorns and other relics of Christ's passion that he had purchased in 1239. The chapel is a masterpiece of the so-called Rayonnant ("radiant") style of the High Gothic age, which was the preferred style of the royal Parisian court of Saint Louis. In Sainte-Chapelle, 6,450 square feet of stained glass make up more than threequarters of the structure. The supporting elements are hardly more quarters of the structure. The supporting elements are hardly more than large mullions (vertical stone bars). The emphasis is on the than large mullions (vertical stone bars). The emphasis is on the

7-17 Hall of the cloth guild (looking south), Bruges, Belgium, begun 1230.

The Bruges cloth guild's meeting hall is an early example of a new type of secular architecture in the late Middle Ages. Its lofty tower competed for attention with the towers of the cathedral.

7-16 Interior of the upper chapel (looking northeast), Sainte-Chapelle, Paris, France, 1243–1248.

At Louis IX's Sainte-Chapelle, the architect succeeded in dissolving the walls to such an extent that 6,450 square feet of stained glass account for more than three-quarters of the Rayonnant Gothic structure.

ART AND SOCIETY

Gothic Book Production

The famous Florentine poet Dante Alighieri (1265–1321) referred to Paris in his *Divine Comedy* (ca. 1310–1320) as the city famed for the art of illumination.* During the Gothic period, book production shifted from monastic scriptoria shut off from the world to urban workshops of professional artists—and Paris boasted the most and best workshops. The owners of these new for-profit secular businesses sold their products to the royal family, scholars, and prosperous merchants. The Parisian shops were the forerunners of modern publishing houses.

Not surprisingly, some of the finest extant Gothic books belonged to the French monarchy, including a moralized Bible now in the Pierpont Morgan Library. Moralized Bibles are heavily illustrated, each page pairing paintings of Old and New Testament episodes with explanations of their moral significance. Blanche of Castile (1188-1252), granddaughter of Eleanor of Aquitaine (queen of France, 1137-1152, and of England, 1152-1189), ordered the Morgan Bible during her regency (1226-1234) for her teenage son, Louis IX, who inherited the throne when he was only 12 years old. The dedication page (FIG. 7-18) has a costly gold background and depicts Blanche and Louis enthroned beneath triple-lobed arches and miniature cityscapes. The latter are comparable to the architectural canopies above the heads of contemporaneous French and German statues (FIG. 7-26). Below Blanche and Louis are a monk and a professional lay scribe. The older clergyman instructs the scribe, who already has divided his page into two columns of four roundels each, a format often used for the paired illustrations of moralized Bibles. The inspirations for such pages were probably the roundels of stained-glass windows such as those of Louis's own later Sainte-Chapelle (FIG. 7-16).

The picture of Gothic book production on the dedication page of Blanche of Castile's Bible is a very abbreviated one. Book manufacture involved many steps and required numerous specialized artists, scribes, and assistants of varying skill levels. The Benedictine abbot Johannes Trithemius (1462–1516) described the way books were still made in his day in his treatise *In Praise of Scribes*:

If you do not know how to write, you still can assist the scribes in various ways. One of you can correct what another has written. Another can add the rubrics [headings] to the corrected text. A third can add initials and signs of division. Still another can arrange the leaves and attach the binding. Another of you can prepare the covers, the leather, the buckles and clasps. All sorts of assistance can be offered the scribe to help him pursue his work without interruption. He needs many things which can be prepared by others: parchment cut, flattened and ruled for script, ready ink and pens. You will always find something with which to help the scribe.

Preparation of the illuminated pages also involved several hands. Some artists, for example, specialized in painting borders or initials.

7-18 Blanche of Castile, Louis IX, a monk, and a scribe, dedication page (folio 8 recto) of a moralized Bible, from Paris, France, 1226–1234. Ink, tempera, and gold leaf on vellum, 1' $3'' \times 10\frac{1}{2}''$. Pierpont Morgan Library, New York.

The dedication page of this royal book depicts Saint Louis, his mother and French regent Blanche of Castile, a monk, and a lay scribe at work on the paired illustrations of a moralized Bible.

Only the workshop head or one of the most advanced assistants would paint the main figural scenes. Given this division of labor and the assembly-line nature of Gothic book production, it is astonishing how uniform the style is on a single page, as well as from page to page, in most illuminated manuscripts.

Inscriptions in some Gothic books state the production costs—the prices paid for materials, especially gold, and for the execution of initials, figures, flowery script, and other embellishments. By this time, however, although the cost of materials was still the major factor determining a book's price, individual skill and "brand name" played a significant role. In the Gothic age, urban workshops of professional scribes and painters ended the centuries-old monopoly of the Church in book production.

*Dante, Divine Comedy, Purgatory, 11.81.

[†]Translated by Roland Behrendt, *Johannes Trithemius, In Praise of Scribes: De laude scriptorum* (Lawrence, Kansas: Coronado Press, 1974), 71.

Book Illumination and Luxury Arts

Paris's claim as the intellectual center of Gothic Europe (see "Paris") did not rest solely on the stature of its university faculty and the reputation of its architects, masons, sculptors, and stained-glass makers. The city was also a renowned center for the

production of fine books, such as the Bible (FIG. 7-18) that once belonged to Blanche of Castille (see "Gothic Book Production," above).

GOD AS CREATOR Another moralized Bible produced in Paris during the 1220s features a magnificent frontispiece, *God as Creator*

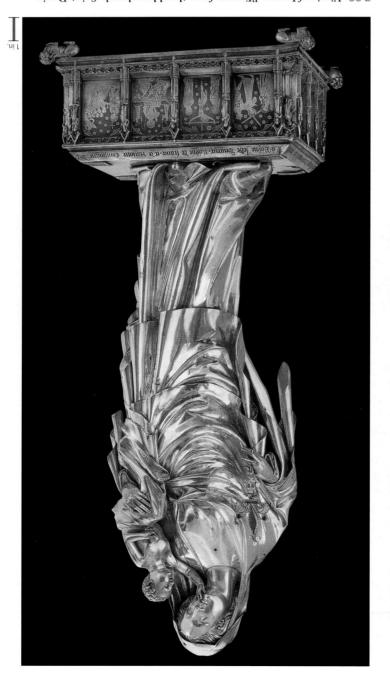

7-20 Virgin of Jeanne d'Evreux, from the abbey church, Saint-Denis, France, 1339. Silver gilt and enamel, 2' $3\frac{1}{2}$ " high. Musée du Louvre, Paris.

Queen Jeanne d'Evreux donated this reliquary-statuette to the royal abbey of Saint-Denis. It exemplifies French Late Gothic style in its swaying pose and the intimate human portrayal of Mary and Jesus.

Child to the royal abbey church of Saint-Denis (FIG. 7-2) in 1339. Mary stands on a rectangular base decorated with enamel scenes of Christ's passion. But no hint of grief appears in the beautiful young Mary's face. The Christ Child, also without a care in the world, playfully reaches for his mother. The elegant proportions of the two figures, Mary's swaying posture, the heavy drapery folds, and the intimate human characterization of mother and son are also features of the roughly contemporaneous Virgin of Paris (FIG. 7-20A). In both instances, Mary appears not only as Christ's mother but as

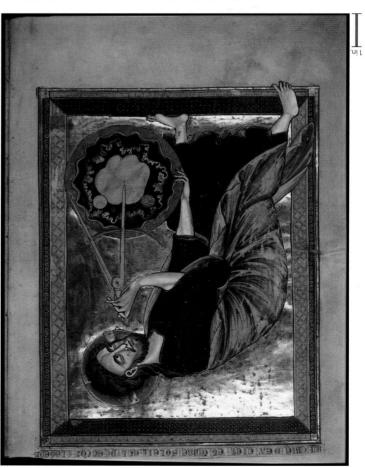

7-19 God as Creator of the World, folio I verso of a moralized Bible, from Paris, France, ca. 1220–1230. Ink, tempera, and gold leaf on vellum, I' $I_2^{1} \times 8_4^{1}$. Österreichische Nationalbibliothek, Vienna.

Paris boasted renowned workshops for the production of illuminated manuscripts. In this book, the artist portrayed God in the process of creating the universe using a Gothic builder's compass.

of the World (Fig. 7-19). Above the illustration, the scribe wrote (in French rather than Latin): "Here God creates heaven and earth, the sun and moon, and all the elements." The painter depicted God in the process of creating the world, shaping the universe with the aid of a compass. Within the perfect circle already created are the spherical sun and moon and the unformed matter that will become the earth once God applies the same geometric principles to it. In contrast to the biblical account of creation, in which God created the sun, moon, and stars after the earth had been formed, and made the world by sheer force of will and a simple "Let there be" command, this Gothic Bible portrays God systematically creating the universe

VIRGIN OF JEANNE D'EVREUX The royal family also patronized goldsmiths, silversmiths, and other artists specializing in the production of luxury works in metal and enamel for churches, palaces, and private homes. Especially popular were statuettes of sacred figures, which the wealthy purchased either for private devotion or as gifts to churches. The Virgin Mary was a favored subject. Perhaps the finest of these costly statuettes is the large silver-gilt figurine known as the Virgin of Jeanne d'Evreux (Fig. 7-20). The French queen, wife of Charles IV (r. 1322–1328), donated this image of the Virgin and of Charles IV (r. 1322–1328), donated this image of the Virgin and

using geometrical principles.

queen of Heaven. The Saint-Denis Mary originally had a crown on her head, and the scepter she holds is in the form of the fleur-de-lis. The statuette also served as a reliquary. The Virgin's scepter contained hairs believed to come from Mary's head.

GOTHIC OUTSIDE FRANCE In 1269, the *prior* (deputy abbot) of the church of Saint Peter at Wimpfen-im-Tal in the German Rhineland hired "a very experienced architect who had recently come from the city of Paris" to rebuild his monastery church. The architect reconstructed the church *opere francigeno* ("in the French manner")—that is, in the opus modernum style of the Île-de-France, which by the second half of the 13th century became dominant throughout Europe. European architecture did not, however, turn Gothic all at once or even uniformly. Almost everywhere, patrons and builders modified the Parisian court style according to local preferences.

ENGLAND

The influence of French style in England began with William the Conqueror and the Norman invasion of 1066 (see page 183), but just as the Romanesque architecture of Normandy and England has a distinctive character, so too do English Gothic buildings.

SALISBURY CATHEDRAL Salisbury Cathedral (FIG. 7-21) embodies the essential characteristics of English Gothic architecture. Begun in 1220, the English church is contemporaneous to the

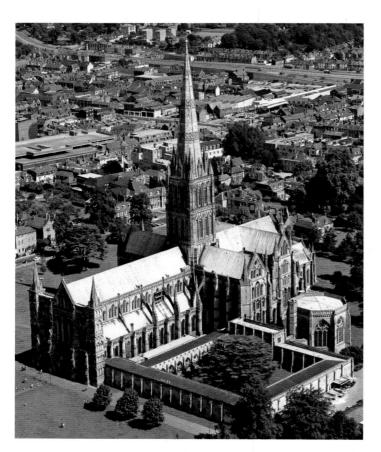

7-21 Aerial view of Salisbury Cathedral (looking northeast), Salisbury, England, 1220–1258; west facade completed 1265; spire ca. 1320–1330.

Exhibiting the distinctive regional features of English Gothic architecture, Salisbury Cathedral has a squat facade that is wider than the building behind it. The architects used flying buttresses sparingly.

cathedrals of Amiens and Reims, and the differences between the French and English buildings are instructive. Although Salisbury's facade incorporates lancet windows and blind arcades with pointed arches as well as statuary, it presents a striking contrast to French High Gothic designs. The English facade is a squat screen in front of the nave, wider than the building behind it. The Salisbury architect did not seek to match the soaring height of the Amiens and Reims (FIGS. 7-1) facades or try to make the facade correspond to the three-part division of the interior (nave and aisles). Different, too, is the emphasis on the great crossing tower (added around 1320–1330), which dominates the church's silhouette. Salisbury's height is modest compared with that of Amiens and Reims. Because height is not a decisive factor in the English building, the architect used the flying buttress sparingly. In short, the English builders adopted some of the superficial motifs of French Gothic architecture but did not embrace its structural logic or emphasis on height.

Salisbury's interior (FIG. 7-22)—although Gothic in its three-story elevation, pointed arches, four-part rib vaults, compound piers, and triforium tracery—conspicuously departs from the French Gothic style of Amiens (FIG. 7-13). The pier colonnettes stop

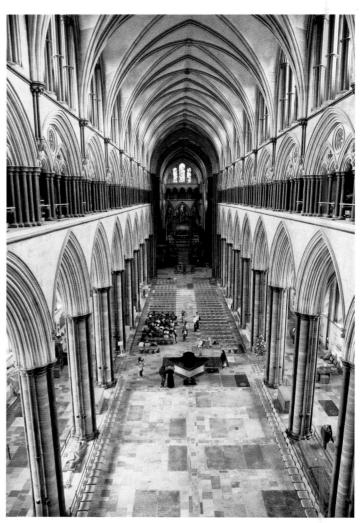

7-22 Interior of Salisbury Cathedral (looking east), Salisbury, England, 1220–1258.

Salisbury Cathedral's interior also differs from contemporaneous French Gothic designs in the strong horizontal emphasis of its three-story elevation and the use of dark Purbeck marble for moldings.

decorative fancy. The architects released the French Gothic style's original lines from their function and multiplied them into the uninhibited architectural virtuosity and theatrics of the English Perpendicular style.

НОГУ ВОМАИ ЕМРІВЕ

As part of his plan to make his new church at Saint-Denis an earthly introduction to the splendors of Paradise (see "Abbot Suger" (3), Suger selected artists from the Meuse River region in present-day Belgium to fashion for the choir a magnificent crucifix on a base decorated with 68 enamel scenes pairing Old and New Testament episodes. The Mosan (Meuse) region long had been famous for the quality of its metalworkers and enamelers (FIG. 6-16A (4)). Indeed, as Suger's treatises demonstrate, in the Middle Ages, the artists who worked at small scale with precious metals, ivory, and jewels produced the most admired objects in a church, far more important in the eyes of contemporaries than the jamb statues and tympanum reliefs that are the focus of modern histories of medieval art.

shrine's two stories. prophets, and New Testament apostles fill the arcuated frames of the Repoussé figures of the Virgin Mary, the three magi, Old Testament considering its size. The shape resembles that of a basilican church. gemstones, is one of the most luxurious ever produced, especially quary, made of silver and bronze with ornamentation in enamel and his successors the right to crown German kings. Nicholas's reliemperor donated to Cologne Cathedral, gave the archbishop and in the conquest of Milan in 1164. The three kings' relics, which the Holy Roman Emperor Frederick Barbarossa (r. 1155–1190) acquired long and almost as tall) to contain the relics of the three magi that Cologne from 1167 to 1191, commissioned the huge shrine (6 feet (FIG. 7-24A (A) around 1190. Philip von Heinsberg, archbishop of the Shrine of the Three Kings (FIG. 7-24) for Cologne Cathedral and early 13th centuries was Micholas of Verdun, who fashioned NICHOLAS OF VERDUN The leading Mosan artist of the late 12th

The Shrine of the Three Kings and Suger's treatises on the furnishings of Saint-Denis are welcome reminders of how magnificantly outfitted medieval church interiors were. The sumptuous small-scale objects exhibited in the choir and chapels, which also housed the church's most precious relics, played a defining role in These Cothic examples continued a tradition dating to the Roman These Gothic examples continued a tradition dating to the Roman emperor Constantine and the first imperial patronage of Christianity (see page 120).

STRASBOURG CATHEDRAL In 1176, work began on a new cathedral for Strasbourg in present-day France, then an important city in the German Rhineland ruled by the successors of the Ottonian dynasty. The apse, choir, and transepts were in place by around 1240. Stylistically, these sections of Strasbourg Cathedral are Romanesque. But the reliefs of the two south-transept portals are fully Gothic and reflect developments in contemporaneous French sculpture. The left tympanum (Fig. 7-25) presents Death of the Virgin. A comparison of the Strasbourg Mary on her deathbed with the Mary of the Reims Visitation (Fig. 7-15, right) shows the stylistic kinship of the Strasbourg and Reims masters. The 12 apostles gather around the Virgin, forming an arc of mourners well suited to the semicircular frame. At the center, Christ receives his mother's soul (the doll-like figure he holds in his left hand). Mary Magdalene, wringing her hands in he holds in his left hand). Mary Magdalene, wringing her hands in

7-23 ROBERT and WILLIAM VERTUE, fan vaults of the chapel of Henry VII, Westminster Abbey, London, England, 1503–1519.

Two hallmarks of the Perpendicular style of English Late Gothic architecture are the multiplication of vault ribs and the use of fan vaults with lacelike tracery pendants resembling stalactites.

at the springing of the nave arches and do not connect with the vault ribs. Instead, the vault ribs rise from corbels in the triforium, producing a strong horizontal emphasis. Underscoring this horizontality is the rich color contrast between the light stone of the walls and vaults and the dark marble (from the Isle of Purbeck in southeastern England) used for the triforium moldings and corbels, compound pier responds, and other details.

CHAPEL OF HENRY VII English Gothic architecture found its native language in the elaboration of architectural pattern for its own sake. The pier, wall, and vault elements, still relatively simple at Salisbury, became increasingly complex and decorative in the 14th century and later. In the early-16th-century ceiling (Fig. 7-23) of the so-called Perpendicular style of English Late Gothic is on display. The style takes its name from the pronounced verticality of its decorative details, in contrast to the horizontal emphasis of Salisbury and English Early Gothic. In Henry's chapel, Robert and William and English Early Gothic. In Henry's chapel, Robert and William and English fan vaults (vaults with radiating ribs forming a fanlike pattern) with large hanging pendants resembling stalactites. Intricate tracery recalling lace overwhelms the cones hanging from the ceiling. The chapel represents the dissolution of structural Gothic into ing. The chapel represents the dissolution of structural Gothic into ing. The chapel represents the dissolution of structural Gothic into

7-24 NICHOLAS OF VERDUN, Shrine of the Three Kings, begun ca. 1190. Silver, bronze, enamel, and gemstones, 5' 8" × 6' × 3' 8". Cologne Cathedral, Cologne.

This huge reliquary in the form of a basilican church is fashioned of silver and bronze with ornamentation in enamel and gemstones. It contains Cologne Cathedral's relics of the three magi.

grief, crouches beside the deathbed. The sorrowing figures express emotion in varying degrees of intensity, from serene resignation to gesturing agitation. The sculptor organized the figures both by dramatic pose and gesture and by the rippling flow of deeply incised drapery that passes among them like a rhythmic electric pulse. The

sculptor's objective was to imbue the sacred figures with human emotions and to stir emotional responses in observers. In Gothic France, as already noted, art became increasingly humanized and natural. In the Holy Roman Empire, artists carried this humanizing trend even further by emphasizing passionate drama.

7-25 Death of the Virgin, tympanum of the left doorway of the south transept, Strasbourg Cathedral, Strasbourg, France, ca. 1230.

Stylistically akin to the Visitation statues (FIG. 7-1B) of Reims Cathedral, the figures in Strasbourg's southtransept tympanum express profound sorrow through dramatic poses and gestures.

be a memorial to the 12 benefactors of the original 11th-century church. Art historians call the nameless sculptor who received the commission to carve portraits of those benefactors the Naumburg Mastrer. Two of the figures (FIG. 7-26) stand out from the group of represent the margrave (German military governor) Ekkehard II of Meissen and his wife, Uta. The statues are attached to columns and stand beneath architectural canopies, following the pattern of French Gothic portal statuary, but they project from the architecture more forcefully and move more freely than contemporaneous French jamb figures. The period costumes and the individualized features and personalities of the margrave and his wife give the French jamb figures. The period costumes and the individualized features and personalities of the margrave and his wife give the jects lived well before the Naumburg Master's time. Ekkehard, the jects lived well before the Naumburg master's time. Ekkehard, the intense knight, contrasts with the beautiful and aloof Uta. With a intense knight, contrasts with the beautiful and aloof Uta. With a intense knight, contrasts with the beautiful and aloof Uta. With a

7-27 Röttgen Pietà, from the Rhineland, Germany, ca. 1300–1325. Painted wood, 2' $10\frac{1}{2}$ " high. Rheinisches Landemuseum, Bonn.

This statuette of the Virgin grieving over the distorted dead body of Christ in her lap reflects the increased interest during the 13th and 14th centuries in the Savior's suffering and the Virgin's grief.

NAUMBURG CATHEDRAL During his tenure as bishop (1244–1272), Dietrich II of Wettin completed the rebuilding of the Romaneseque cathedral of Naumburg in northern Germany. The most distinctive aspect of the project was the west choir, which was to

7-26 NAUMBURG MASTER, Ekkehard and Uta, statues in the west choir of Naumburg Cathedral, Naumburg, Germany, ca. 1249–1255. Painted limestone, Ekkehard 6' 2" high.

The period costumes and individualized features of these donor statues give the impression that Ekkehard and Uta posed for the Naumburg Master, but they lived long before the sculptor's time.

wonderfully graceful gesture, she draws the collar of her cloak partly across her face while she gathers up a soft fold of drapery with a jeweled, delicate hand. The sculptor subtly revealed the shape of Uta's right arm beneath her cloak and rendered the fall of drapery folds with an accuracy suggesting that the Naumburg Master used a living model. The two statues are arresting images of real people, even if they bear the names of aristocrats the artist never met. In the Holy Roman Empire, life-size images of secular personages had found their way into churches by the mid-13th century.

RÖTTGEN PIETÀ The Naumburg choir statues are also noteworthy because, as indoor sculptures, they have retained their color, whereas almost all the statues on church exteriors, exposed to sun and rain for centuries, have lost their original paint. Also retaining its original appearance is a haunting 14th-century German painted wood statuette (FIG. 7-27) of the Virgin Mary holding the dead Christ in her lap. This *Pietà* (Italian, "pity" or "compassion") reflects the increased interest during the 13th and 14th centuries in humanizing biblical figures and in the suffering of Jesus and the grief of his mother and followers. This expressed emotionalism accompanied the shift toward the representation of the human body in motion. As the figures of the church portals began to twist on their columns, then move within their niches, and then stand independently, their details became more outwardly related to the human audience as indicators of recognizable human emotions.

The sculptor of the *Röttgen Pietà* (named after a collector) portrayed Christ as a stunted, distorted human wreck, stiffened in death and covered with streams of blood gushing from a huge wound. The Virgin, who cradles him as if he were a child in her lap, is the very image of maternal anguish, her oversized face twisted in an expression of unbearable grief. This statue expresses nothing of the serenity of Romanesque (FIG. 6-24) and earlier Gothic depictions of Mary (FIG. 7-5, right tympanum). Nor does it have anything in common with the aloof, iconic images of the Theotokos with the infant Jesus in her lap common in Byzantine art (FIG. 4-20). Here the artist forcibly confronts the devout with an appalling icon of agony, death, and sorrow. The work calls out to the horrified believer, "What is your suffering compared to this?"

ITALY

Nowhere is the regional diversity of late medieval art and architecture more evident than in Italy. In fact, art historians debate whether the art of Italy between 1200 and 1400 is the last phase of medieval art or the beginning of the rebirth, or *Renaissance*, of Greco-Roman naturalism, the dawn of a new artistic age when artists broke away from medieval conventions and consciously revived the classical style. Both of these characterizations have merit.

A revived interest in classical cultures—indeed, the veneration of classical antiquity as a model—was central to the notion of a renaissance in Italy. Indeed, the belief that the Renaissance represented the restoration of the glorious past of Greece and Rome gave rise to the concept of the "Middle Ages" as the era falling between antiquity and the Renaissance. This notion of artistic rebirth is the root of Vasari's condescending labeling of medieval art as "Gothic."

A significant development in 14th-century Italy was the blossoming of a vernacular literature (written in the commonly spoken language instead of Latin), which dramatically affected Italy's intellectual and cultural life. Latin remained the official language of church liturgy and state documents. However, the creation of an Italian

vernacular literature was one important sign that the essentially religious view that had dominated medieval Europe was about to change dramatically. Although religion continued to occupy a primary position in the lives of Europeans, a growing concern with the natural world, the individual, and humanity's worldly existence characterized the Renaissance period—the 14th through the 16th centuries.

HUMANISM Fundamental to the development of the Italian Renaissance was *humanism*. Humanism was more a code of civil conduct, a theory of education, and a scholarly discipline than a philosophical system. The chief concerns of Italian humanists were human values and interests as distinct from—but not opposed to—religion's otherworldly values. Humanists pointed to classical cultures as particularly praiseworthy. This enthusiasm for antiquity involved study of Latin literature and a conscious emulation of what proponents believed were the Roman civic virtues. These included self-sacrificing service to the state, participation in government, defense of state institutions (especially the administration of justice), and stoic indifference to personal misfortune in the performance of duty. Classical cultures provided humanists with a model for living in this world, a model primarily of human focus derived not from an authoritative and traditional religious dogma but from reason.

Sculpture and Painting

The Renaissance humanists quickly developed a keen interest in classical art as well as literature. Although the *Visitation* statues (FIG. 7-1b) of Reims Cathedral show a familiarity with Roman statuary in 13th-century France, the emulation of Greco-Roman art was, not surprisingly, far more common in Italy, where Holy Roman Emperor Frederick II (r. 1220–1250) had been king of Sicily since 1197. Frederick's nostalgia for Rome's past grandeur fostered a revival of Roman sculpture in Sicily and southern Italy not unlike the classical *renovatio* that Charlemagne encouraged in Germany and France four centuries earlier (see page 162).

NICOLA PISANO The sculptor known as NICOLA PISANO (Nicola of Pisa, active ca. 1258-1278) received his early training in southern Italy. After Frederick's death in 1250, Nicola traveled northward and eventually settled in Pisa. Then at the height of its political and economic power, the maritime city was a magnet for artists seeking lucrative commissions. Nicola specialized in carving marble reliefs and may have been the inventor of a new kind of church furniture—the monumental pulpit (raised platform from which priests delivered sermons) with supports in the form of freestanding statues and featuring wraparound narrative reliefs depicting biblical themes. He made his first pulpit (FIG. 7-28) in 1260 for Pisa's baptistery (FIG. 6-28, left). Some elements of the pulpit's design carried on medieval traditions—for example, the trefoil (triple-curved) arches (compare FIG. 7-18) and the lions supporting columns—but Nicola also incorporated classical elements. The large, bushy capitals are a Gothic variation of the Corinthian capital. The arches are round, as in ancient Roman architecture, rather than pointed, as in Gothic buildings. Also, each of the large rectangular relief panels resembles the sculptured front of a Roman sarcophagus (FIGS. 3-48 and 3-49). The face types, beards, coiffures, and draperies, as well as the bulk and weight of Nicola's figures, reveal the influence of classical relief sculpture. Art historians have even been able to pinpoint the models for some of the pulpit figures on Roman sarcophagi in Pisa.

7-29 CIMABUE, Madonna Enthroned with Angels and Prophets, from Santa Trinità, Florence, Italy, ca. 1280–1290. Tempera and gold leaf on wood, 12' $7'' \times 7'$ 4". Galleria degli Uffizi, Florence.

Cimabue was one of the first artists to break away from the maniers greca. Although he relied on Byzantine models, the Italian master depicted the Madonna's massive throne as receding into space.

eloTTO Critics from Giorgio Vasari to the present day have regarded Giorto DI Bondone (ca. 1266–1337) as the first Renaissance painter. A pioneer in pursuing a naturalistic approach to representation based on observation, he made a much more radical break with the maniera greea than did Cimabue, whom Vasari idenstyle, although one formative influence must have been Cimabue. Byle, although one formative influence must have been Cimabue. Hig. 7-29A ⑤), French Gothic sculpture, and ancient Roman art must also have impressed the young Giotto. Yet no mere synthesis of these varied sources could have produced the significant shift in artistic approach that has led some scholars to describe Giotto as the father of Western pictorial art.

7-28 Alcola Pisano, pulpit of the baptistery, Pisa, Italy, 1259–1260. Marble, 15' high.

The Pisa baptistery pulpit by Micola Pisano retains many medieval features—for example, trefoil arches—but the sculptor modeled the marble figures on extant ancient Roman relief sculptures.

beneath the throne reinforce the sense of depth. and the half-length prophets who look outward or upward from throne as receding into space. The overlapping bodies of the angels in Byzantine painting, and he convincingly depicted the massive Madonna and the surrounding figures to inhabit than was common background. However, Cimabue constructed a deeper space for the poses of the figures, the gold lines of Mary's garments, and the gold and 4-27) is apparent in the careful structure and symmetry, the ity in Florence, the heritage of Byzantine icon painting (FIGS. 4-20 (nearly 13-foot-tall) panel painted for the church of the Holy Trin-(FIG. 7-29) is perhaps Cimabue's finest work. In this enormous (ca. 1240-1302). Madonna Enthroned with Angels and Prophets style), still characterizes the art of Cenni di Pepo, called CIMABUE The Italo-Byzantine style, or maniera greca ("Greek manner" or style dominated Italian painting throughout the Middle Ages. from the elegant court style popular north of the Alps. Byzantine CIMABUE Late-13th-century Italian painting also differs sharply

7-30 GIOTTO DI BONDONE, Madonna Enthroned (Ognissanti Madonna), from the Chiesa di Ognissanti (All-Saints Church), Florence, Italy, ca. 1310. Tempera and gold leaf on wood, 10° 8" \times 6' 8". Galleria degli Uffizi, Florence.

Giotto displaced the Byzantine style in Italian painting and revived classical naturalism. His figures have substance, dimensionality, and bulk, and give the illusion that they could throw shadows.

MADONNA ENTHRONED On nearly the same great scale as Cimabue's enthroned Madonna (FIG. 7-29) is Giotto's *altarpiece* (FIG. 7-30) depicting the same subject. Giotto's Madonna sits on her Gothic throne with the unshakable stability of an ancient marble goddess. Giotto replaced Cimabue's slender Virgin, fragile beneath the thin ripplings of her drapery, with a weighty, queenly mother. He even showed Mary's breasts pressing through the thin fabric of her white undergarment. Gold highlights have disappeared from her heavy robe. Giotto's aim was to construct a figure with substance, dimensionality, and bulk—qualities suppressed in favor of a spiritual immateriality in Byzantine and Italo-Byzantine art. Works painted in the new style portray statuesque figures projecting into the light and giving the illusion that they could throw shadows. Giotto's *Madonna Enthroned* marks the end of medieval painting in Italy and the beginning of a new naturalism in art.

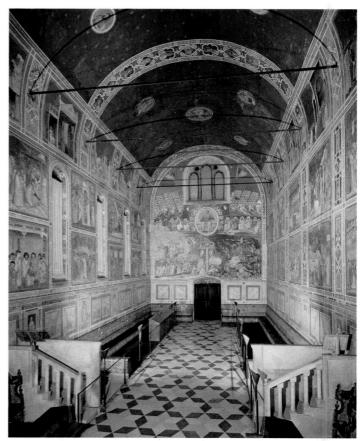

7-31 GIOTTO DI BONDONE, interior of the Arena Chapel (Cappella Scrovegni; looking west), Padua, Italy, 1305–1306.

The frescoes Giotto painted in the Arena Chapel show his art at its finest. In 38 framed panels, he presented the complete cycle of the life of Jesus, culminating in the *Last Judgment* on the entrance wall.

Giotto's restoration of the naturalistic approach to painting that the ancients developed and medieval artists largely abandoned inaugurated an age that some scholars call "early scientific." By stressing the preeminence of sight for gaining knowledge of the world, Giotto and his successors contributed to the foundation of empirical science. Praised in his own and later times for his fidelity to nature, Giotto was more than a mere imitator of it. He showed his generation a new way of seeing. With Giotto, European painters turned away from representing the spiritual world—the focus of medieval artists—and once again made recording the visible world a central, if not the sole, aim of their art.

ARENA CHAPEL Projecting onto a flat surface the illusion of solid bodies moving through space presents a double challenge. Constructing the illusion of a weighty, three-dimensional body also requires constructing the illusion of a space sufficiently ample to contain that body. In his fresco cycles (see "Fresco Painting," page 208), Giotto constantly strove to reconcile these two aspects of illusionistic painting. His murals in the Arena Chapel (Cappella Scrovegni; FIG. 7-31) at Padua show his art at its finest. A banker, Enrico Scrovegni, built the chapel on a site adjacent to his palace in the hope that the shrine would atone for the moneylender's sin of usury. Consecrated in 1305, the chapel takes its name from an adjacent ancient Roman arena (amphitheater).

7-32 Giotto di Bondone, Lamentation, Arena Chapel (Cappella Scrovegni), Padua, Italy, ca. 1305. Fresco, 6' $6\frac{3}{4}$ " \times 6' $\frac{3}{4}$ ".

Giotto painted Lamentation in several sections, each corresponding to one painting session. Artists employing the buon fresco technique must complete each section before the plaster dries.

was the norm in ancient Egypt. Although the finished product visually approximates buon fresco, the plaster wall does not absorb the pigments, which simply adhere to the surface, so fresco secco is not as permanent as buon fresco.

Fresco painting has a long history, particularly in the Mediterranean region, where the Minoans (Fies. 2-5 and 2-6) used it as early as the 13th century BCE. Fresco (Italian for "fresh") is a mural-painting technique involving the application of permanent limeproof pigments, diluted in water, on freshly laid lime plaster. Because the surface of the wall absorbs the pigments as the plaster dries, fresco is one of the most durable painting techniques. The stable condition of the Minoan frescoes and those in the houses of Roman Pompeii (Fies. 3-18 to 3-24) and the Arena Chapel (Fies. 7-31 and 7-32) testify to the longevity of this painting method. The colors have remained vivid because of the chemipainting method. The colors have remained vivid because of the chemipainting method. The colors have remained vivid because of the chemipainting method. The colors have remained vivid because of the chemipainting method.

MATERIALS AND TECHNIQUES

This buon fresco ("good" or true fresco) process is time-consuming and demanding and requires several layers of plaster. Although buon fresco methods vary, generally the artist prepares the wall with a rough layer of lime plaster called the arriccio (brown coat). The artist then arriccio with a burnt-orange pigment called sinopia, or by transferring a arriccio with a burnt-orange pigment called sinopia, or by transferring a cortoon (a full-sized preparatory drawing). Cartoons increased in usage in the 15th and 16th centuries, largely replacing sinopia underdrawings. Finally, the painter lays the intonaco (painting coat) smoothly over the drawing in sections (called giornate—Italian for "days") only as large as the artist expects to complete in that session. (It is easy to distinguish the various giornate in Giotto's Lamentation [Fire. 7-32].) The buon fresco painter must apply the colors fairly quickly, because once the plaster is dry, it will no longer absorb the pigment. Any unpainted areas plaster is dry, it will no longer absorb the pigment. Any unpainted areas of the intonaco after a session must be cut away so that fresh plaster

In addition to the buon fresco technique, artists used fresco secco ("dry" fresco). Fresco secco involves painting on dried lime plaster and

can be applied for the next giornata.

cally inert pigments the artists used.

Fresco Painting

tional complexity, and emotional resonance. achieved, this combination of naturalistic representation, composiin the foreground. Painters before Giotto rarely attempted, let alone ciples at the right and the mute sorrow of the two hooded mourners Magdalene and John to the philosophical resignation of the two dis-Mary's almost fierce despair to the passionate outbursts of Mary tures and gestures convey a broad spectrum of grief, ranging from (compare Fig. 4-26). The figures are sculpturesque, and their posviewer's eye toward the picture's dramatic focal point at the lower left firm visual support for the figures, and the steep slope leads the zontal ledge in the foreground. Though narrow, the ledge provides figures, bounded by a thick diagonal rock incline defining a horihis arms back dramatically. Giotto arranged a shallow stage for the emnly at the wounds in Christ's feet and John the Evangelist throws ment. Mary cradles her son's body, while Mary Magdalene looks solcongregation mourns over the dead Savior just before his entomb-

The way Giotto grouped the figures within the constructed space of the Lamentation, and each contributes to the rhythmic order of the composition. The strong diagonal of the rocky ledge, with its single dead tree (the tree of knowledge of good and evil, which withered after Adam and Eve's original sin), concentrates the

the chapel's entrance. of the cycle of human salvation, covers most of the west wall above paintings) to resemble sculpture. Last Judgment, the climactic event painted in grisaille (monochrome grays, often used for modeling in ration (FIG. 3-40)—alternates with personified Virtues and Vices imitation marble veneer—reminiscent of ancient Roman wall decoin the lowest zone, his passion, crucifixion, and resurrection. Below, Joachim and Anna; in the middle, the life and mission of Christ; and tom: at the top, incidents from the lives of the Virgin and her parents, the north and south walls in three zones, reading from top to bot-Christian pictorial cycles ever rendered. The narrative unfolds on In 38 framed scenes, Giotto presented one of the most complete well-illuminated and almost unbroken surfaces, ideal for painting. windows, all in the south wall (Fig. 7-31, left). The other walls are interior decoration. The rectangular barrel-vaulted hall has only six been the chapel's architect because its design so perfectly suits its Some scholars have suggested that Giotto himself may have

Subtly scaled to the chapel's space, Giotto's stately and slowmoving half-life-size actors present their dramas convincingly and with great restraint. Lamentation (Fig. 7-32) illustrates particularly well the revolutionary nature of Giotto's art. In the presence of boldly foreshortened angels darting about in hysterical grief, a

viewer's attention on the heads of Christ and his mother, which Giotto positioned dynamically off center. The massive bulk of the seated mourner in the painting's left corner arrests and contains all movement beyond Mary and her dead son. The placement of the seated mourner at the right establishes a relation with the center figures, who, by gazes and gestures, draw the viewer's attention back to Christ's head. Figures seen from the back, which are frequent in Giotto's compositions, are the very contradiction of Byzantine frontality. They emphasize the foreground, aiding the visual placement of the intermediate figures farther back in space. This device in effect puts the viewer behind the "observer figures," who, facing the action as spectators, reinforce the sense of stagecraft as a model for painting. Markedly different too from the maniera greca is Giotto's habit of painting incomplete figures cut off by the composition's frame, a feature also of his *Ognissanti Madonna* (Fig. 7-30).

Giotto's innovations in depicting spatial depth and body mass could not, of course, have been possible without his management of light and shade. He shaded his figures to indicate both the direction of the light illuminating their bodies and the shadows (the diminished light), thereby giving the figures volume. In *Lamentation*, light falls on the upper surfaces of the figures (especially the two central bending figures) and passes down to dark in their garments, separating the volumes one from the other and pushing one to the fore, the other to the rear. The gradual transition from light to shade, directed by an even, neutral light from a single steady source—not shown in the picture—was the first step toward the development of *chiaroscuro* (the use of contrasts of dark and light to produce modeling) in Renaissance painting (see page 253).

Giotto's stagelike settings are pictorial counterparts to contemporaneous *mystery plays*, in which actors extended the drama of

the Mass into one- and two-act performances at church portals and in city squares. The great increase in popular sermons to huge city audiences prompted a public taste for narrative, recited as dramatically as possible. The arts of illusionistic painting, of drama, and of sermon rhetoric with all their theatrical flourishes developed simultaneously and were mutually influential. Giotto's art masterfully synthesized dramatic narrative, holy lesson, and truth to human experience in a visual idiom of his own invention, accessible to all.

DUCCIO In 14th-century Italy, the Republics of Siena and Florence were the two most powerful city-states, home to wealthy bankers and merchants and well-endowed churches with ample funds for commissioning artworks (see "Artists' Guilds, Artistic Commissions, and Artists' Contracts"

■). The Sienese were particularly proud of their defeat of the Florentines at the battle of Monteperti in 1260 and believed that the Virgin Mary had brought them victory. To honor the Virgin, the Sienese commissioned Duccio di Buoninsegna (active ca. 1278–1318) in 1308 to paint an immense altarpiece for Siena Cathedral—the *Maestà* (*Virgin Enthroned in Majesty*). He and his assistants completed the ambitious work in 1311. As originally executed, the altarpiece consisted of a 7-foot-high center panel (Fig. 7-33), surmounted by seven pinnacles above, and a *predella*, or raised shelf, of panels at the base, altogether some 13 feet high.

The main panel on the front of the altarpiece represents the Virgin enthroned as queen of Heaven amid choruses of angels and saints. Duccio derived the composition's formality and symmetry, along with the figures and facial types of the principal angels and saints, from Byzantine tradition. But the artist relaxed the strict frontality and rigidity of the figures, who turn to one another in quiet conversation. Further, Duccio individualized the faces of the

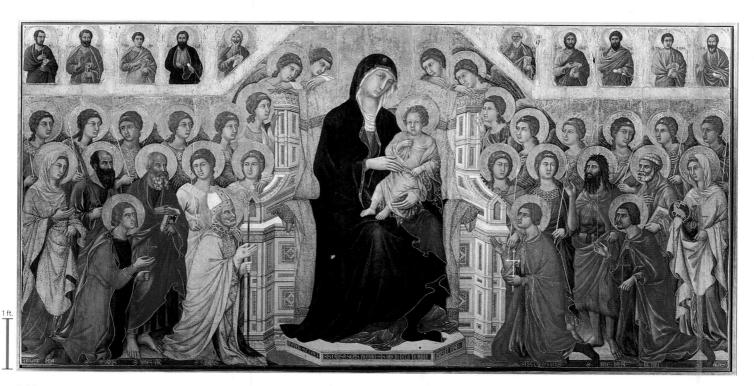

7-33 Duccio di Buoninsegna, *Virgin and Child Enthroned with Saints*, principal panel of the front of the *Maestà* altarpiece, from Siena Cathedral, Siena, Italy, 1308–1311. Tempera and gold leaf on wood, 7' × 13'. Museo dell'Opera del Duomo, Siena.

Duccio derived the formality and symmetry of his composition from Byzantine painting, but relaxed the rigidity and frontality of the figures, softened the drapery, and individualized the faces.

Cathedral, Siena, Italy, 1308-1311. Tempera and gold leaf on wood, 7' × 13'. Museo dell'Opera del Duomo, Siena. 7-34 Duccio di Buoninsegna, Life of Jesus, 14 panels from the dack of the Maestà altarpiece (Fig. 7-33), from Siena

at the lower left, through Noli Me Tangere, at top right. On the back of the Maestà altarpiece, Duccio presented Christ's passion in 24 scenes on 14 panels, beginning with Entry into Jerusalem,

of religious subject matter. passion cycle, Duccio took a decisive step toward the humanization preted in terms of thoroughly human actions and reactions. In this cio's protagonists are actors in a religious drama that the artist interand even facial expression, they display a variety of emotions. Ducway the figures seem to react to events. Through posture, gesture,

ornamentation, and themes involving splendid processions. the aristocratic taste for brilliant colors, lavish costumes, intricate during the late 14th and early 15th centuries because it appealed to the so-called International Gothic style. This new style swept Europe painters with the Sienese style, Martini was instrumental in creating the Gothic style to Sienese art and, in turn, by acquainting French tact with French painters. By adapting the luxuriant patterns of which in the 14th century was at Avignon, where he came in con-Sicily and, in his last years, produced paintings for the papal court, ing the Maestà. Martini worked for the French kings in Vaples and SIMONE MARTINI (ca. 1285-1344), who may have assisted in paint-SIMONE MARTINI Duccio's successors in Siena included his pupil

the tremendous import of Gabriel's message, the scene subordinates befitting the queen of Heaven. Despite Mary's modest reserve and draws about her the deep blue, golden-hemmed mantle, colors reverent bow-an appropriate act in the presence of royalty. Mary ting down her book of devotions, shrinks shyly from the angel's gown signals that he has descended from Heaven. The Virgin, putsage lifting his mantle, his glittering wings still beating. His golden tion of the theme. Gabriel has just alighted, the breeze of his pasthe European chivalric courts probably inspired Martini's presentasetting—all hallmarks of the artist's style. The complex etiquette of color, fluttering lines, and weightless clongated figures in a spaceless assistant Lippo Memmi (active ca. 1317-1350), features radiant Martini's Annunciation altarpiece (FIG. 7-35), painted with his

> logue between Italy and northern Europe in the 14th century. French Gothic works (FIG. 7-20) and is a mark of the artistic diaends of the panel, fall and curve loosely. This is a feature familiar in folds of the garments, particularly those of the female saints at both the usual Byzantine hard body outlines and drapery patterning. The their ceremonial gestures without stiffness. Similarly, he softened four kneeling patron saints of Siena in the foreground, who perform

> Despite these changes revealing Duccio's interest in the new

tive designs in gold leaf (punchwork). frame are the halos of the holy figures, which feature tooled decora-Complementing the luxurious textiles and the (lost) gilded wood of exotic textiles from China, Byzantium, and the Islamic world. the Maestà, Duccio created the glistening and shimmering effects manipulation, unfortunately not fully revealed in photographs. In queen of Heaven panel is a miracle of color composition and texture forms and adjusting their placement in pictorial space. Instead, the and producing illusionistic effects (such as Giotto's) by modeling the altarpiece limited experimentation in depicting narrative action should be an object holy in itself and recognized how the function of and most important church. Duccio understood that the Maestà piece, his Maestà would be the focus of worship in Siena's largest naturalism, he respected the age-old requirement that as an altar-

ies around them convincingly. Even more novel and striking is the a range of tonalities from light to dark, and arranged their draper-Byzantine art. Duccio imbued them with mass, modeled them with the Maestà panel. The bodies are not the flat frontal shapes of Italo-Duccio allowed himself greater latitude for experimentation than in 24 scenes in 14 panels, relates Christ's passion. In these scenes, with Resurrection. The section reproduced here, consisting of sizes and shapes, beginning with Annunciation and culminating piece presents an extensive series of narrative panels of different In contrast to the main panel, the back (Fig. 7-34) of the altar-

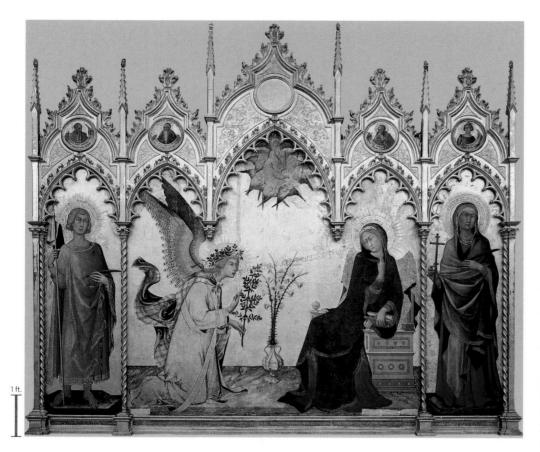

7-35 SIMONE MARTINI and LIPPO MEMMI, Annunciation, from the altar of Saint Ansanus, Siena Cathedral, Siena, Italy, 1333 (frame reconstructed in the 19th century). Tempera and gold leaf on wood; center panel, 10° 1" \times 8' 8 $\frac{1}{4}$ ". Galleria degli Uffizi, Florence.

A pupil of Duccio's, Simone Martini was instrumental in the creation of the International Gothic style. Its hallmarks are radiant colors, fluttering lines, and weightless figures in golden, spaceless settings.

he executed for the Sala della Pace (FIG. 7-36) of Siena's Palazzo Pubblico, Ambrogio Lorenzetti (active 1319–1348) elaborated in spectacular fashion the advances in illusionistic representation made by other Italian painters, while giving visual form to Sienese civic concerns in a series of allegorical paintings: Good Government, Bad Government and the Effects of Bad Government in the City, and Effects of Good Government in the City

and in the Country. The turbulent politics of the Italian cities—the violent party struggles, the overthrow and reinstatement of governments—called for solemn reminders of fair and just administration, and the *palazzo pubblico* ("public palace" or city hall) was the perfect place to display murals contrasting good and bad government. Indeed, the Sienese leaders who commissioned this fresco series had undertaken the "ordering and reformation of the whole city and countryside of Siena."

drama to court ritual, and structural experimentation to surface splendor. The intricate tracery of the richly tooled French Gothic—inspired frame and the elaborate punchwork halos enhance the tactile magnificence of the altarpiece.

AMBROGIO LORENZETTI Another of Duccio's students contributed significantly to the general experiments in pictorial realism taking place in 14th-century Italy. In a vast fresco program

7-36 Ambrogio Lorenzetti, Effects of Good Government in the City and in the Country, north (left) and east (right) walls of the Sala della Pace, Palazzo Pubblico, Siena, Italy, 1338– 1339. Fresco, north wall 25' 3" wide, east wall 46' wide.

In the Hall of Peace of Siena's city hall, Ambrogio Lorenzetti painted an illusionistic panorama of the bustling city. The fresco served as an allegory of good government in the Sienese republic.

resembles a great altar screen. Its single plane is covered with Gothic carved and painted decoration, but in principle, Orvieto Cathedral belongs with Pisa Cathedral (Fig. 6-28) and other Italian buildings, rather than with French Gothic churches (Fig. 7-1). Inside, Orvieto Cathedral has a timber-roofed nave with a two-story elevation (columnar arcade with round arches and a clerestory) in the Early Christian manner.

FLORENCE In the 14th century, the historian Giovanni Villani (ca. 1270–1348) described Florence as "the daughter and the creature of Rome," suggesting a preeminence inherited from the Roman Empire. Florentines were flercely proud of what they perceived as their economic and cultural superiority. Florence controlled the textile industry in Italy, and the republic's gold florin was the standard tile industry in Italy, and the republic's gold florin was the standard

coin of exchange everywhere in Europe. Florentines translated their pride in their predominance into landmark buildings, such as Santa Maria del Fiore (Saint Mary of

In Effects of Good Government in the City and in the Country (FIG. 7-36, right), Lorenzetti depicted the urban and rural effects of good government. One section of the fresco is a panoramic view of Siena, with its palaces, markets, towers, churches, streets, and walls. The city's traffic moves peacefully, guild members ply their trades and crafts, and radiant maidens, clustered hand in hand, perform a graceful circling dance. Dancers were regular features of festive springtime rituals. Here, dancing also serves as a metaphor for a peaceful commonwealth. The artist fondly observed the life of his city, and its architecture gave him an opportunity to apply Sienese city, and its architecture gave him an opportunity to apply Sienese

In the Peaceful Country section of the fresco, Lorenzetti presented a bird's-eye view of the undulating Tuscan terrain—its villas, castles, plowed farmlands, and peasants going about their seasonal occupations. A personification of Security hovers above the hills and fields, unfurling a scroll promising safety to all who live under the rule of law. Although the mural is an allegory, Lorenzetti's Peacethe rule of law. Although the mural is an allegory, Lorenzetti's Peacethe rule of law.

Jul Country is one of the first examples of landscape painting since antiquity.

artists' rapidly growing knowledge of perspective.

Architecture

The picture of Siens in the Sala della Pace could not be confused with a view of a French, German, or English city of the 14th century. Italian architects stood apart from developments north of the Alps.

cathedral in FIG. 7-37 reveals. The facade tradition, as the three-quarter view of the can structure in the Tuscan Romanesque overlay masking a marble-revetted basiliers. Maitani's facade, however, is a Gothic tall northern European west-front towcles serve as miniature substitutes for the facade into three bays. The outer pinnaand the four large pinnacles dividing the and statues in niches in the upper zone, over the three doorways, the rose window teristically French are the pointed gables architectural vocabulary in Italy. Charachighlights the appeal of the French Gothic architecture in Italy. The church's facade dral (FIG. 7-37) is typical of late medieval Maitani (ca. 1255–1330), Orvieto Catheсептигу by the Sienese architect Lовеиzo ORVIETO Designed in the early 14th

7-37 LORENZO MAITANI, Orvieto Cathedral (looking northeast), Orvieto, Italy, begun 1310.

The pointed gables over the doorways, the rose window, and the large pinnacles derive from French Gothic architecture, but the facade of Orvieto Cathedral masks a traditional timberroofed basilica.

7-38 Arnolfo di Cambio and others, aerial view of Santa Maria del Fiore (and the Baptistery of San Giovanni; looking northeast), Florence, Italy, begun 1296. Campanile designed by Giotto di Bondone, 1334.

The Florentine Duomo's marble revetment carries on the Tuscan Romanesque architectural tradition, linking this basilican church more closely to Early Christian Italy than to Gothic France.

the Flower; Fig. 7-38). Arnolfo di Cambio (ca. 1245–1302) began work on the cathedral (*Duomo* in Italian) in 1296. Intended as the "most beautiful and honorable church in Tuscany," the Duomo reveals the competitiveness Florentines felt with such cities as Siena and Pisa (Fig. 6-28). Church authorities planned for the cathedral to hold the city's entire population, and although its capacity is only about 30,000 (Florence's population at the time was slightly less than 100,000), the building seemed so large that even the noted architect Leon Battista Alberti (see page 243) commented that it seemed to cover "all of Tuscany with its shade." The Florentine Duomo is a low, longitudinal basilican church with Tuscan-style marble-revetted walls. A vast gulf separates Santa Maria della Fiore from its towering transalpine counterparts, as is strikingly evident when comparing the Italian church with Reims Cathedral (Fig. 7-1), completed several years before work began in Florence.

Giotto di Bondone designed the Duomo's campanile in 1334. In keeping with Italian tradition (FIG. 6-28), the bell tower stands apart from the church. In fact, it is essentially self-sufficient and

could stand anywhere else in the city without looking out of place. The same cannot be said of northern European bell towers. They are essential elements of the structures behind them, and it would be unthinkable to detach one of them and place it somewhere else. In contrast, not only could Giotto's tower be removed from the building without adverse effects, but also each of the parts—cleanly separated from each other by continuous moldings—seems capable of existing independently as an object of considerable aesthetic appeal. This compartmentalization is reminiscent of the Romanesque style, but it also forecasts the ideals of Renaissance architecture.

VENICE One of the wealthiest cities of late medieval Italy—and of Europe—was Venice, renowned for its streets of water. Situated on a lagoon on the northeastern coast of Italy, Venice was secure from land attack and could rely on a powerful navy for protection against invasion from the sea. Internally, Venice was a tight corporation of powerful families that, for centuries, provided stable rule and fostered economic growth.

7-39 Doge's Palace (looking north), Venice, Italy, begun ca. 1340-1345; expanded and remodeled, 1424-1438.

constitute a Venetian variation of Gothic architecture. The delicate patterning in cream- and rose-colored marbles, the pointed and ogee arches, and the quatrefoil medallions of the Doge's Palace

Italian city that floats between water and air. in appearance, their Venetian palace is ideally suited to the unique ant of Late Gothic architecture. Colorful, decorative, light and airy conducted state business represents a delightful and charming vari-

buildings, Google Earth™ coordinates, and essays by the author on the Explore the era further in MindTap with videos of major artworks and

- ART AND SOCIETY: Paris, the New Center of Medieval Learning
- THE PATRON'S VOICE: Abbot Suger and the Rebuilding of Saint-Denis
- · Virgin of Paris (FIG. 7-20A)

following additional subjects:

- Pietro Cavallini, Last Judgment (FIG. 7-29A) Cologne Cathedral (FIG. 7-24A)
- THE PATRON'S VOICE: Artists' Guilds, Artistic Commissions, and
- Artists' Contracts

makes them appear paper thin. The palace in which Venice's doges delicate patterning in cream- and rose-colored marbles, which plete absence of articulation in the top story and in part to the walls? building does not look top-heavy. This is due in part to the comit, the topmost as high as the two lower arcades combined. Yet the lobed, cloverlike shapes). Each story is taller than the one beneath flamelike tips between medallions pierced with quarrefoils (fourogee arches (made up of double-curving lines), which terminate in doubles in the upper arcades, where more slender columns carry enough to carry the weight of the upper structure. Their rhythm columns support rather severe pointed arches that look strong medieval Italy. In a stately march, the first level's short and heavy 1424, Venice's ducal palace was the most ornate public building in 4-24). Begun around 1340 to 1345 and significantly remodeled after to Venice's most important church, San Marco (Saint Mark's; FIG. (Duke's) Palace (FIG. 7-39), situated on the Grand Canal adjacent The Venetian republic's seat of government was the Doge's

GOTHIC AND LATE MEDIEVAL EUROPE

France

- The birthplace of Gothic art and architecture was Saint-Denis, where Abbot Suger rebuilt the Carolingian royal church using rib vaults with pointed arches and stained-glass windows. The Early Gothic (1140–1194) west facade of Suger's church also introduced sculpted figures on the portal jambs, a feature that appeared shortly later on the Royal Portal of Chartres Cathedral.
- After a fire in 1194, Chartres Cathedral was rebuilt with flying buttresses, four-part nave vaults, and a three-story elevation of nave arcade, triforium, and clerestory, setting the pattern for High Gothic (1194-1300) cathedrals, including Amiens with its 144-foot-high vaults.
- Flying buttresses made possible huge stained-glass windows, which converted natural light into divine colored light (lux nova), dramatically transforming the character of church interiors.
- High Gothic jamb statues differ markedly from their Early Gothic predecessors in their contrapposto stances. The sculpted figures of Reims Cathedral not only move freely but converse with their neighbors.
- In the 13th century, professional lay artists in Parisian workshops were renowned for producing illuminated manuscripts, usurping the role of monastic scriptoria.

Royal Portal, Chartres Cathedral, ca. 1145–1155

Moralized Bible, Paris, 1226-1234

England and the Holy Roman Empire

- English Gothic churches, such as Salisbury Cathedral, differ from their French counterparts in their wider and shorter facades, and sparing use of flying buttresses. Especially characteristic of English Gothic architecture is the elaboration of architectural patterns. A prime example is the chapel of Henry VII in Westminster Abbey in London, which features Perpendicular-style fan vaults.
- In the Holy Roman Empire, architects eagerly embraced the French Gothic architectural style at Cologne Cathedral and elsewhere. German originality manifested itself most clearly in sculptures depicting emotionally charged figures in dramatic poses. The statues of secular historical figures in Naumburg Cathedral signal a revival of interest in portraiture.

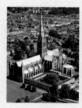

Salisbury Cathedral, London, 1220-1265

Italy

- Nicola Pisano was a master sculptor from southern Italy who carved pulpits incorporating marble panels that, both stylistically and in individual motifs, derive from ancient Roman sarcophagi.
- The leading Italian painter of the late 13th century was Cimabue, who worked in the Italo-Byzantine style, or maniera greca.
- Considered the first Renaissance painter, Giotto di Bondone revived the Greco-Roman naturalistic approach to representation based on observation.
- Duccio di Buoninsegna relaxed the frontality and rigidity of the Italo-Byzantine style and took a decisive step toward humanizing religious subject matter.
- Secular themes also came to the fore in 14th-century Italy. Ambrogio Lorenzetti's frescoes for Siena's Palazzo Pubblico feature one of the first landscapes since antiquity.
- Italian 14th-century architecture underscores the regional character of late medieval art. Orvieto Cathedral's facade incorporates elements of the French Gothic vocabulary, but it is a screen masking a traditional timber-roofed basilica with round arches in the nave arcade.

Nicola Pisano, Pisa baptistery pulpit, 1259-1260

Giotto, Lamentation, ca. 1305

humanity from original sin. the new Adam who will redeem Mary is the new Eve and Jesus serpent reminded viewers that depicting Adam, Eve, and the symbolic meaning. The armrest eral slistab vneW er-8 ■

-iqyt s to waiv s si In the background merchants owned. century Flemish that wealthy 15thhome—the type trait in her elegant to paint her porinvited Saint Luke Virgin Mary has P 8-1p The

cal Flemish town.

Boston (gift of Mr. and Mrs. Henry Lee Higginson). Oil and tempera on wood, 4' $6\frac{1}{8}$ " × 3' $7\frac{5}{8}$ ". Museum of Fine Arts, Rogier van der Weyden, Saint Luke Drawing the Virgin, ca. 1435-1440.

van der Weyden. be a self-portrait of Rogier of painting. Saint Luke may artist and the profession honors the first Christian guild in Brussels, Saint Luke missioned by the painters' ▶ 8-1c Probably com-

The Early Renaissance in Europe

ROGIER VAN DER WEYDEN AND SAINT LUKE

In the 15th-century, Flanders—a region corresponding to what is today Belgium, the Netherlands, Luxembourg, and part of northern France (MAP 8-1)—enjoyed widespread prosperity. Successful merchants and craft *guilds* joined the clergy and royalty in commissioning artists to produce works for both public and private display. Especially popular were paintings by artists using the recently perfected medium of oil-based pigments, which soon became the favored painting medium throughout Europe (see "Tempera and Oil Painting," page 220).

One of the early masters of oil painting was ROGIER VAN DER WEYDEN (ca. 1400–1464) of Tournai in present-day Belgium. Rogier made Brussels his home in 1435 and soon thereafter painted Saint Luke Drawing the Virgin (FIG. 8-1), probably for the city's artists' guild, the Guild of Saint Luke. Luke was the patron saint of artists because legend said that he had painted a portrait of the Virgin Mary (see "Early Christian Saints" (1)). Rogier's subject was therefore perfectly suited for the headquarters of a painters' guild. It shows Luke (his identifying attribute, the ox, is at the right) at work in the kind of private residence that wealthy Flemish merchants of this era owned. Mary has miraculously appeared before Luke and invited him to paint her portrait as she nurses her son. The saint begins the process by making a preliminary drawing using a silverpoint (a sharp stylus that creates a fine line), the same instrument Rogier himself would have used when he began this commission. The painting thus not only honors Luke but also pays tribute to the profession of painting in Flanders (see "The Artist's Profession during the Renaissance" (1)) by documenting the preparatory work required before artists can begin painting the figures and setting.

The subject also draws attention to the venerable history of portrait painting. A rare genre during the Middle Ages, portraiture became a major source of income for Flemish artists, and Rogier van der Weyden was one of the best portrait painters in Flanders. In fact, many scholars believe that Rogier's Saint Luke is a self-portrait, identifying the painter with the first Christian artist and underscoring the holy nature of painting. Saint Luke Drawing the Virgin is also emblematic of 15th-century Flemish painting in aiming to record every detail of a scene with loving fidelity to optical appearance, seen here in the rich fabrics, the patterned floor, and the landscape visible through the window. Also characteristic of Flemish art is the imbuing of many of the painting's details with symbolic significance. For example, the carved armrest of the Virgin's bench depicts Adam, Eve, and the serpent, reminding the viewer that Mary is the new Eve and Jesus the new Adam who will redeem humanity from Adam and Eve's original sin.

acceptable to all. in 1417 of a new Roman pope, Martin V (r. 1417-1431), who was became known as the Great Schism, which lasted until the election Urban VI (r. 1378-1389), who remained in Rome. Thus began what in 1378 of two popes—Clement VII, who resided in Avignon, and

first international commercial stock exchange in Antwerp, which North of the Alps, in 1460 Flemish entrepreneurs established the family members were among the greatest art patrons in history. trading companies, such as that of the Medici of Florence, whose former financed industry. Both were in the hands of international ies. Trade in money accompanied trade in commodifies, and the tems created an economic network of enterprising European citthe financial requirements of trade, new credit and exchange sysevolved—the early stage of European capitalism. In response to Despite the troubles of the age, a new economic system

THE EARLY RENAISSANCE IN EUROPE

conflict between the French and Italians resulted in the election capital of the universal Church, resented the Avignon papacy. The gnon. Understandably, the Italians, who saw Rome as the rightful and the French popes who succeeded him chose to reside in Aviof Cardinals elected a French pope, Clement V (r. 1305-1314). He compounded the period's political instability. In 1305, the College England, the war also involved Flanders. Crisis in the religious realm (1337-1453). Primarily a series of conflicts between France and bilizing—and far longer lasting—was the Hundred Years' War est cities, also spread to much of the rest of Europe. Equally desta-Italy in 1348, killing 50 to 60 percent of the population in the largof plague, war, and social upheaval. The Black Death that ravaged In the 14th and 15th centuries, Europe experienced the calamities

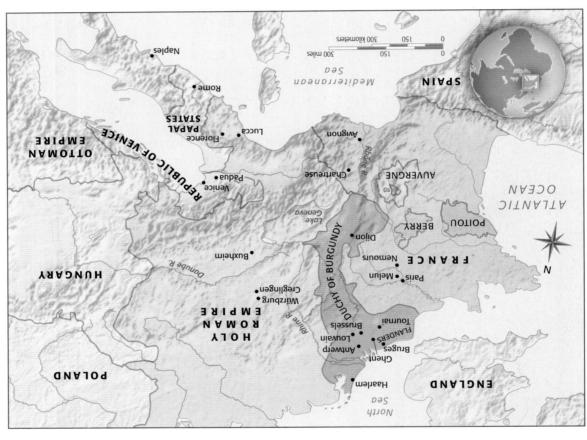

MAP 8-1 France, the duchy of Burgundy, and the Holy Roman Empire in 1477.

THE EARLY RENAISSANCE IN EUROPE

0541-5741

- engraving. first northern European master of Martin Schongauer becomes the of Tilman Riemenschneider. Germany in the large wood retables ■ The Late Gothic style lingers in
- Alberti publishes his treatise on logical allegories for the Medici. Botticelli paints Neo-Platonic mytho-
- and the Medici flee Florence. Savonarola condemns humanism, architecture.
- Sistine Chapel in Rome. Perugino and others decorate the
- della Francesca to the Urbino court. Federico da Montefeltro brings Piero first Bibles on a letterpress. invents moveable type and prints the In Germany, Johannes Gutenberg
- ings for Duke Ludovico Gonzaga of Alberti rebuilds Sant'Andrea and
 - woodcut printing, making art afford-

S/41-0541

- Mantua. Mantegna creates illusionistic paint-
- Donatello revives freestanding nude facing Florence Cathedral. Ghiberti installs the Gates of Paradise spie to the masses.

German graphic artists pioneer

ni striied based-lio to asu art asi

Rogier van der Weyden popular-

Robert Campin, Jan van Eyck, and

- male statuary.
- Michelozzo builds the new Medici
- Alberti publishes his treatise on palace in Florence.
- The Limbourg brothers expand the Burgundy. features for Philip the Bold, duke of of biblical figures with portraitlike Claus Sluter carves life-size statues 5Z71-56EL
- design new doors for Florence's Ghiberti wins the competition to illumination for Jean, duke of Berry. illusionistic capabilities of manuscript
- Masaccio carries Giotto's naturalism papristery.
- tive and designs the Ospedale degli Brunelleschi develops linear perspecfurther in fresco painting.

became pivotal for Europe's integrated economic activity. Thriving commerce, industry, and finance contributed to the evolution of cities, as did the migration of a significant portion of the rural population to urban centers. With successful merchants and bankers joining kings, dukes, and popes as major patrons of painting, sculpture, and architecture, the arts also flourished throughout Europe.

BURGUNDY AND FLANDERS

In the 15th century, Duke Philip the Good (r. 1419-1467) ruled Burgundy, the fertile eastcentral region of France famous for its wines (MAP 8-1). In 1369, one of Philip the Good's predecessors, Philip the Bold (r. 1364-1404), married the daughter of the count of Flanders, and acquired territory in the Netherlands. Thereafter, the major source of Burgundian wealth was Bruges, the city that made Burgundy a dangerous rival of royal France. Bruges initially derived its prosperity from the wool trade, but soon expanded into banking, becoming the financial clearinghouse for all of northern Europe. Indeed, Bruges so dominated Flanders that the duke of Burgundy eventually chose to make the city his capital and moved his court there from Dijon. Due to the expanded territory and the prosperity of the duchy of Burgundy, Philip the Bold and his successors were probably the most powerful northern European rulers during the first three quarters of the 15th century. Although members of the extended French royal family, they usually supported England (on which they relied for the raw materials used in their wool industry) during the Hundred Years' War and, at times, controlled much of northern France, including Paris, the seat of the French monarchy. At the height of Burgundian power, the ducal lands stretched from the Rhône River to the North Sea.

8-2 CLAUS SLUTER, *Well of Moses*, Chartreuse de Champmol, Dijon, France, 1395–1406. Limestone, painted and gilded by JEAN MALOUEL, Moses 6' high.

The Well of Moses, a symbolic fountain of life made for the duke of Burgundy, originally supported a sculpted crucifixion group. Sluter's figures recall French Gothic jamb statues, but are far more realistic.

CHARTREUSE DE CHAMPMOL The great wealth that the dukes of Burgundy amassed enabled them to become significant patrons of the arts. Philip the Bold's largest artistic enterprise was the Chartreuse de Champmol, near Dijon. A *chartreuse* ("charter house" in English) is a Carthusian monastery. The Carthusian order, founded by Saint Bruno (ca. 1030–1101) in the late 11th century at Chartreuse in southeastern France, consisted of monks who devoted their lives to solitary living and prayer. Inspired by Saint-Denis, the French kings' burial site (see page 189), Philip intended the Dijon chartreuse to become a ducal *mausoleum* and serve both as a means of securing salvation in perpetuity for the Burgundian dukes and as a dynastic symbol of Burgundian power.

For the Champmol cloister, Philip the Bold's head sculptor, CLAUS SLUTER (active ca. 1360–1406) of Haarlem (Netherlands), designed a large sculptural fountain located in a well that provided water for the monastery, but water probably did not spout from the fountain because the Carthusian commitment to silence and prayer would have precluded anything producing sound. Sluter's *Well of*

Moses (FIG. 8-2) features statues of Moses and five other prophets (David, Daniel, Isaiah, Jeremiah, and Zachariah) surrounding a base that once supported a 25-foot-tall crucifixion group. The Carthusians called the Well of Moses a fons vitae, a fountain of everlasting life. The blood of the crucified Christ symbolically flowed down over grieving angels and the Old Testament prophets, spilling into the well below, washing over Christ's prophetic predecessors and redeeming anyone who would drink water from the well.

Although the figures recall the jamb statues (FIG. 7-15) of Gothic portals, they are much more realistically rendered. The six prophets have portraitlike features and distinct individual personalities and costumes. Sluter succeeded in sculpting realistic faces and differentiating textures from coarse drapery to smooth flesh and silky hair. Paint, much of which has flaked off, further augmented the naturalism of the figures. (The painter was Jean Malouel [ca. 1365–1415], another Netherlandish master.) This fascination with the specific and tangible in the visible world became one of the chief characteristics of 15th-century Flemish art.

transparent layers, or glazes, over opaque or semiopaque underlayers. In this manner, painters could build up deep tones through repeated glazing. Unlike works in tempera, whose surface dries quickly due to water evaporation, oils dry more uniformly and slowly, giving the artist time to rework areas. This flexibility must have been particularly appealing to artists who worked very deliberately, such as the Flemish masters Robert Campin, Ian van Eyck, and Rogier van der Weyden, and the Italian Leonardo da Vinci. Leonardo also preferred oil paint because its gradual drying process and consistency enabled him to blend the

pigments, thereby creating the impressive sfumato (smoky) effect that

Both tempers and oils can be applied to various surfaces. Through the early 16th century, wood panels served as the foundation for most paintings. Linen canvas became increasingly popular in the late 16th century. Although evidence suggests that artists did not intend permanency for their early images on canvas, the material proved particularly useful in areas such as Venice where high humidity warped wood panels and made fresco unfeasible. Furthermore, until artists began to use els and made tresco unfeasible. Furthermore, until artists began to use wood bars to stretch the canvas to form a taut surface, canvas paintwos could be rolled and were lighter and more easily portable than ings could be rolled and were lighter and more easily portable than

contributed to his fame (see page 255).

MATERIALS AND TECHNIQUES Tempera and Oil Painting

The generic words paint and pigment encompass a wide range of substances that artists have used through the ages. Fresco aside (see "Fresco Painting," page 208), during the 14th century, egg tempera was the material of choice for most painters, both in Italy and northern Europe. Tempera consists of egg combined with a wet paste of ground pigment. Images painted with tempera have a velvety sheen. Artists usually applied tempera to the painting surface with a light touch because thick application of the pigment mixture would result in premature cracking and flaking.

Some artists used oil paints (powdered pigments mixed with linseed oil) as far back as the eighth century, but not until the early 1400s did oil painting become widespread. Flemish artists were among the first to employ oils extensively (often mixing them with tempera), and tablian painters quickly followed suit. The discovery of better drying components in the early 15th century enhanced the settling capabilities of oils. Rather than apply these oils in the light, flecked brushstrokes of oils. As the continue encouraged, artists laid the oils down in that the tempera technique encouraged, artists laid the oils down in

wood panels.

8-3 Robert Campin (Master of Flémalle), Mérode Altarpiece (open), ca. 14.25-14.28. Oil on wood, center panel 2' $1\frac{3}{8}$ " \times 2' $\frac{3}{8}$ ", each wing 2' $1\frac{3}{8}$ " \times 10 $\frac{7}{8}$ ". Metropolitan Museum of Art, New York (The Cloisters Collection, 1956).

Campin, the leading painter of Tournai, was an early master of oil painting. In the Mérode Altarpiece, he used the new medium to reproduce with loving fidelity the interior of a Flemish merchant's home.

over a carefully planned drawing (compare Fig. 8-1) made on a panel prepared with a white ground. With the oil medium, artists could create richer colors than previously possible, giving their paintings an intense tonality, the illusion of glowing light, and glistening surfaces. These traits differed significantly from the high-keyed color, sharp light, and rather matte (dull) surface of tempera. The brilliant

ROBERT CAMPIN One of the earliest important Flemish painters was the man known as the Master of Flémalle, whom many scholars identify as Robert Campin (ca. 1378–1444) of Tournai. Campin was a highly skilled practitioner of the new medium of oil painting (see "Tempera and Oil Painting," above). Flemish painters built up their pictures by superimposing translucent paint layers

and versatile oil medium suited perfectly the formal intentions of 15th-century Flemish painters, who aimed for sharply focused clarity of detail in their representation of objects ranging in scale from large to almost invisible.

Campin's most famous work is the *Mérode Altarpiece* (FIG. 8-3), one of the many small altarpieces of this period produced for private patrons and intended for household prayer. Perhaps the most striking feature of these private devotional images is the integration of religious and secular concerns. For example, artists often presented biblical scenes as taking place in a house (compare FIG. 8-1). Religion was such an integral part of Flemish life that separating the sacred from the secular was almost impossible—and undesirable. Moreover, the presentation in religious art of familiar settings and objects no doubt strengthened the direct bond that the patron or viewer felt with biblical figures.

The *Mérode Altarpiece* is a small *triptych* (three-panel painting) with *Annunciation* as the center panel. Unseen by the Virgin, a tiny figure of Christ carrying the cross enters the room on a ray of light, foreshadowing his incarnation and passion (see "The Life of Jesus in Art," pages 120–121). The archangel Gabriel approaches Mary, who sits reading in a well-kept Flemish home. The view through the window in the right wing, as well as the depicted accessories, furniture, and utensils, confirm the locale as Flanders. However, the objects represented are not merely decorative. They also function as religious symbols. The book, extinguished candle, and lilies on the table; the copper basin in the corner niche; the towels, fire screen, and bench all symbolize the Virgin's purity and her divine mission.

In the right panel, Joseph, apparently unaware of Gabriel's arrival, has constructed two mousetraps, symbolic of the theological concept that Christ is bait set in the trap of the world to catch the Devil. The ax, saw, and rod that Campin painted in the foreground of Joseph's workshop not only are tools of the carpenter's trade but also are mentioned in the account of the Annunciation in Isaiah 10:15. In the left panel, the closed garden is symbolic of Mary's purity, and the flowers Campin included relate to Mary's virtues, especially humility.

The altarpiece's donor, Peter Inghelbrecht, a wealthy merchant, and his wife, Margarete Scrynmakers, kneel in the garden and witness the momentous event through an open door. *Donor portraits*—portraits of the individual(s) who commissioned (or "donated") the work—became very popular in the 15th century. In this instance, in addition to asking to be represented in their altarpiece, the Inghelbrechts probably specified the subject. Inghelbrecht means "angel bringer," a reference to Gabriel's bringing the news of Christ's birth to Mary in the central panel. Scrynmakers means "cabinet- or shrine-makers," and probably inspired the workshop scene in the right panel.

JAN VAN EYCK The first Netherlandish painter to achieve international fame was Jan van Eyck (ca. 1390–1441), who in 1425 became Philip the Good's court painter. In 1431, he moved his studio to Bruges, where the duke maintained his official residence. That same year, he completed the *Ghent Altarpiece* (FIGS. 8-4 and 8-5)—which his older brother, Hubert van Eyck (ca. 1366–1426), had begun—for the church originally dedicated to John the Baptist (since 1540, Saint Bavo Cathedral) in Ghent. One of the most characteristic art forms in 15th-century Flanders was the monumental freestanding altarpiece, and the *Ghent Altarpiece* is one of the largest. Placed behind the altar, these imposing works served as backdrops for the Mass. Given their function, it is not surprising that many altarpieces

8-4 Hubert and Jan van Eyck, *Ghent Altarpiece* (closed), Saint Bavo Cathedral, Ghent, Belgium, completed 1432. Oil on wood, 11' $5" \times 7'$ 6".

Monumental painted altarpieces were popular in Flemish churches. Artists decorated both the interiors and exteriors of these polyptychs, which often, as here, included donor portraits.

depict scenes directly related to Christ's sacrifice. Flemish altarpieces most often took the form of *polyptychs*—hinged multipaneled paintings or relief panels. The hinges enabled the clergy to close the polyptych's side wings over the center panel(s), as in FIG. 8-4. Artists decorated both the exterior and interior of the altarpieces. This multi-panel format provided the opportunity to construct narratives through a sequence of images, somewhat as in manuscript illustration. Although concrete information is lacking about when the clergy opened and closed these altarpieces, the wings probably remained closed on regular days and open on Sundays and feast days. On this schedule, worshipers could have seen both the interior and exterior—diverse imagery at various times according to the liturgical calendar.

Jodocus Vyd, diplomat-retainer of Philip the Good, and his wife, Isabel Borluut, commissioned the *Ghent Altarpiece*. Vyd's largesse contributed to his appointment as the city's *burgomeister* (mayor) shortly after the unveiling of the work. Two of the exterior panels (FIG. 8-4) depict the donors. Husband and wife kneel with their hands clasped in prayer. They gaze piously at illusionistically rendered stone sculptures of Ghent's patron saints, John the Baptist and John the Evangelist. *Annunciation* appears on the upper register, with a careful representation of a Flemish town outside the painted

8-5 Hubert and Jan van Eyck, Ghent Altarpiece (open), Saint Bavo Cathedral, Ghent, Belgium, completed 1432. Oil on wood, 11' 5" × 15' 1".

In this richly colored painting of salvation from the original sin of Adam and Eve (who are shown on the wings), God the Father presides in majesty between the Virgin Mary and John the Baptist.

life, clear as crystal, proceeding out of the throne of God and of the Lamb" (Rev. 22:1). On the right, the 12 apostles and a group of martyrs in red robes advance. On the left appear prophets. In the right background come the virgin martyrs, and in the left background the holy confessors approach. On the lower wings, hermits, pilgrims, knights, and judges arrive from left and right. They symbolize the four cardinal virtues: Temperance, Prudence, Fortitude, and Justice, respectively. The altarpiece celebrates the whole Christian cycle from the fall to the redemption, presenting the Church triumphant in heavenly Jerusalem.

Jan used oil paints to render the entire altarpiece in shimmering oil colors that defy reproduction. No small detail escaped the painter. With pristine specificity, he revealed the beauty of the most insignificant object. He depicted the soft texture of hair, the glitter of gold in the heavy brocades, the luster of pearls, and the flashing of gems, all with loving fidelity to appearance.

GIOVANNI ARNOLFINI Both the Mérode Altarpiece and the Ghent Altarpiece include painted portraits of their donors. These paintings marked a significant revival of portraiture, a genre that had languished since antiquity. The elite wanted to memorialize themselves

window of the center panel. In the uppermost arched panels, Jan depicted the Old Testament prophets Zachariah and Micah, along with sibyls, Greco-Roman mythological female prophets whose writings the Church interpreted as prophesies of Christ.

When open (FIG. 8-5), the altarpiece reveals a richly colored painting of human redemption through Christ. In the upper register, God the Father—wearing the pope's triple tiara, with a worldly crown at his feet and resplendent in a deep-scarlet mantle—presides in majesty. To God's right is the Virgin, represented as the queen of Heaven, with a crown of 12 stars on her head. John the Baptist sits to God's left. To either side is a choir of angels, with an angel playing an organ on the right. Adam and Eve appear in the far panels, amplifying the central theme of salvation. Even though humans, symboling the central theme of salvation. Even though humans, symbolized by Adam and Eve, are sinful, they will be saved because God ised by Adam and Eve, are sinful, they will be saved because God

The panels of the lower register extend the symbolism of the upper. In the center panel, saints arrive from the four corners of the earth through an opulent, flower-spangled landscape. They proceed toward the altar of the lamb and the octagonal fountain of life. The lamb symbolizes the sacrificed son of God, whose heart bleeds into a chalice, while into the fountain spills the "pure river of water of

will sacrifice his own son for this purpose.

8-6 JAN VAN EYCK, Giovanni Arnolfini and His Wife, 1434. Oil on wood, 2' 9" \times 1' $10\frac{1}{2}$ ". National Gallery, London.

Jan van Eyck played a major role in establishing portraiture as an important Flemish art form. In this portrait of an Italian financier and his wife in their home, the painter depicted himself in the mirror.

the couple are taking their marriage vows. As in the Mérode Altarpiece, almost every object carries meaning. For example, the little dog symbolizes fidelity. The finial (crowning ornament) of the marriage bed is a tiny statue of Saint Margaret, patron saint of childbirth. (The bride is not yet pregnant, although the fashionable costume she wears makes her appear so.) From the finial hangs a whiskbroom, symbolic of domestic care. Indeed, even the placement of the two figures is meaningful. The woman stands near the bed and well into the room, whereas the man stands near the open window, symbolic of the outside world.

Many art historians, however, dispute this interpretation because, among other things, the room in which Arnolfini and his wife stand is a public reception area, not a bed-chamber. One scholar has suggested that Arnolfini is conferring legal privileges on his wife to conduct business in his absence. In either case, the artist functions as a witness. In the background is a convex mirror, whose spatial distortion Jan brilliantly recorded. Reflected in the mirror are not only the principals, Arnolfini and his wife, but

also two persons who look into the room through the door. One of these must be the artist himself, as the elegant inscription above the mirror—*Johannes de Eyck fuit hic* ("Jan van Eyck was here")— announces that he was present. The self-portrait also underscores the painter's self-consciousness as a professional artist whose role deserves to be recorded and remembered.

ROGIER VAN DER WEYDEN When Jan van Eyck began work on the *Ghent Altarpiece*, Rogier van der Weyden (FIG. 8-1) was an assistant in the workshop of Robert Campin (FIG. 8-3), but the younger Tournai painter's fame eventually rivaled Jan's. Rogier quickly became renowned for his paintings of Christian themes stressing human action and drama. He concentrated on passion episodes that elicited powerful emotions, moving observers deeply by vividly portraying the suffering of Christ.

in their dynastic lines and to establish their identities, ranks, and stations with images far more concrete than heraldic coats of arms. Portraits also served to represent state officials at events they could not attend. Royalty, nobility, and the very rich would sometimes send artists to paint the likeness of a prospective bride or groom. For example, when young King Charles VI (r. 1380–1422) of France sought a bride, he dispatched a painter to three different royal courts to make portraits of the candidates.

Prosperous merchants also commissioned portraits for their homes. Early examples are Jan van Eyck's *Giovanni Arnolfini and His Wife* (FIG. 8-6) and the *Diptych of Martin van Nieuwenhove* (FIG. 8-6A) by Hans Memling (ca. 1430–1494). Jan depicted the Lucca financier (who had established himself in Bruges as an agent of the Medici family) and his second wife, whose name is not known, in their home. According to the traditional interpretation,

8-7 ROGIER VAN
DEPOSITION, CENTER
Deposition, CENTER
from Motre-Dame
hors-les-murs,
Ca. 1435. Oil on wood,
7' Σ_8^5 " × 8' $7\frac{1}{8}$ ". Museo
del Prado, Madrid.

Deposition resembles a carved ahrine in which the biblical figures act out a drama of passionate sorrow as if on a shallow theatrical stage. The painting atrical stage. The painting makes an unforgettable emotional impact.

The shepherds, with their lined faces, work-worn hands, and uncouth dress and manner, are rendered far more realistically than comparable figures in Italian art, and the Portinari Altarpiece created a considerable stir among Italian artists when it was installed in the patron's family's chapel in Sant'Egidio. Although the painting may have seemed unstructured to the Italians and the varying scale of the figures according to their importance perpetuated medieval conventions, Hugo's masterful technique and incredible realism in representing drapery, flowers, animals, and, above all, human character and emotion made a deep impression on Florentine painters and the publication.

FRANCE

In France, the anarchy of the Hundred Years' War and the weakness of the kings gave rise to a group of powerful duchies. The strongest and wealthiest—the duchy of Burgundy, which controlled Flanders—has already been examined. But the dukes of Berry, Bourbon, and Nemours as well as members of the French royal court were also important art patrons.

LIMBOURG BROTHERS During the 15th century, French artists built on the achievements of Gothic manuscript painters (see "Gothic Book Production," page 199). Among the most significant developments was a new interest in the spatial settings of the subjects depicted. The Limbourge Brothers (Pol., Herman, and Jean)—three nephews of Jean Malouel (Fig. 8-2), the court artist of Philip the Bold—were pioneers in expanding the illusionistic capabilities of manuscript illumination. The Limbourge, Netherlands and Definition of Philip painters who moved to Paris no later than 1402, produced lands and painters who moved to Paris no later than 1402, produced

loss in Deposition makes an unforgettable emotional impact on the in the rendering of passionate sorrow. His depiction of the agony of resemble the shape of a crossbow. Few painters have equaled Rogier same pain at the crucifixion as her son. Their echoing postures also of Christ and his mother reflect the belief that Mary suffered the the sorrowful anguish many of the figures share. The similar poses unity, a formal cohesion that Rogier strengthened by depicting of lateral undulating movements gives the group a compositional senting the deposition instead of the event itself. In any case, a series Indeed, the painting could be a depiction of a carved shrine reprefigures and action onto a shallow stage with a golden back wall. scape setting, as Jan van Eyck might have, Rogier compressed the decorative tracery in the corners. Instead of creating a deep landpatrons by incorporating the crossbow (the guild's symbol) into the sioned by the archers' guild of Louvain. Rogier acknowledged his Deposition (FIG. 8-7) is the center panel of a triptych commis-

HUGO VAN DER GOES By the mid-15th century, Flemish art had achieved renown throughout Europe. The Portinari Altarpiece (Fig. 8-8) is a large-scale Flemish triptych in a family chapel in Florence, Italy. The artist who received the commission was Hugo van DER Goes (ca. 1440–1482) of Ghent. Hugo painted the altarpiece for Tommaso Portinari, an Italian shipowner and agent in Bruges for the With his family and their patron saints. The main panel, Adoration of the with his family and their patron saints. The main panel, Adoration of the angels, and shepherds adoring the infant Savior, who lies on the ground and glows with divine light. Hugo tilted the ground, a compositional device he may have derived from the tilted stage floors of mystery plays.

8-8 HUGO VAN DER GOES, Adoration of the Shepherds (Portinari Altarpiece, open), from Sant'Egidio, Florence, Italy, ca. 1476. Tempera and oil on wood, center panel 8' $3\frac{1}{2}$ " × 10', each wing 8' $3\frac{1}{2}$ " × 4' $7\frac{1}{2}$ ". Galleria degli Uffizi, Florence.

This altarpiece is a rare instance of the awarding of a major commission in Italy to a Flemish painter. The Florentines admired Hugo's realistic details and brilliant portrayal of human character.

a gorgeously illustrated Book of Hours for Jean, the duke of Berry (r. 1360-1416) and brother of Philip the Bold and King Charles V (r. 1364-1380) of France. The duke was an avid art patron and focused on collecting manuscripts, jewels, and rare artifacts. The three brothers worked on Les Très Riches Heures du Duc de Berry (The Very Sumptuous Hours of the Duke of Berry) until their deaths in 1416. A Book of Hours was used for reciting prayers (see "Medieval Books" (1). It contained liturgical passages to be read privately at set times during the day, as well as penitential psalms, devotional prayers, litanies to the saints, and an illustrated calendar containing local religious feast days. Books of Hours became favorite possessions of the northern European aristocracy during the 14th and 15th centuries. Illuminated prayer books eventually became available to affluent merchants and contributed to the decentralization of religious practice that was one factor in the Protestant Reformation in the early 16th century (see page 272).

The calendar pictures of *Les Très Riches Heures* represent the 12 months in terms of the associated seasonal tasks, alternating scenes of nobility and peasantry. Above each picture is a lunette depicting the zodiac signs and the chariot of the sun as it makes its yearly cycle through the heavens. Beyond its function as a religious book, *Les Très Riches Heures* also celebrates the duke and his relationship to the peasants. The illustration for October (FIG. 8-9) focuses on the peasantry. The Limbourgs depicted a sower, a man plowing on horseback, and washerwomen, along with city dwellers, who promenade in front of the Louvre (the French king's residence

8-9 LIMBOURG BROTHERS (POL, HERMAN, JEAN), October, from Les Très Riches Heures du Duc de Berry, 1413–1416. Colors and ink on vellum, $8\frac{7}{8}$ " × $5\frac{3}{8}$ ". Musée Condé, Chantilly.

The Limbourg brothers expanded the illusionistic capabilities of manuscript painting with their care in accurately rendering architectural details and their convincing depiction of cast shadows.

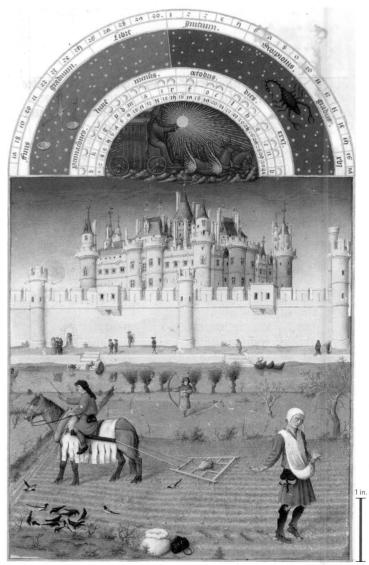

8-10 Jean Fouquet, Melun Diptych, ca. 1451. Left wing: Étienne Chevalier and Saint Stephen. Oil on wood, 3' $\frac{1}{2}$ " \times 2' $9\frac{1}{2}$ ". Koninklijk Gemäldegalerie, Staatliche Museen zu Berlin, Berlin. Right wing: Virgin and Child. Oil on wood, 3' $1\frac{1}{4}$ " \times 2' $9\frac{1}{2}$ ". Koninklijk Museum voor Schone Kunsten, Antwerp.

Fouquet's meticulous representation of a pious kneeling donor with a standing patron saint recalls Flemish painting, as do the three-quarter-view stances and the realism of the donor's portrait head.

the painting medium (oil-based pigment on wood). The artist portrayed Saint Stephen holding the stone of his martyrdom (death by stoning) atop a Bible. Fouquet rendered the entire image in meticulous detail and included a highly ornamented architectural setting. The placement of the figures unites the diptych's two wings. The viewer follows the gaze of Chevalier and Saint Stephen over to the right panel, which depicts the Virgin Mary and Christ Child in a right panel, which depicts the Virgin Mary and Christ Child in a

The placement of the figures unites the diptychs two wings. The viewer follows the gaze of Chevalier and Saint Stephen over to the right panel, which depicts the Virgin Mary and Christ Child in a most unusual way—with marblelike flesh, surrounded by red and blue angels. A straightforward reading of the diptych is complicated, however, by the fact that Agnès Sorel (1421–1450), the mistress of Charles VII, was Fouquet's model for the Virgin Mary. The Madonna's left breast is exposed, presumably to nurse the infant Jesus, but the holy figures look neither at each other nor at the viewer. Chevalier commissioned this painting after Sorel's death, probably by poisoning while pregnant with the king's child. Thus, in addition to the religious interpretation of this diptych, there is surely a personal and political narrative here as well.

HOLY ROMAN EMPIRE

Because the Holy Roman Empire (whose core was Germany) did not participate in the drawn-out saga of the Hundred Years' War, its economy remained stable and prosperous. Without a dominant court to commission artworks, wealthy merchants and clergy near court to commission artworks, wealthy merchants and clergy became the primary German art patrons during the 15th century.

at the time). The peasants do not appear discontented as they go about their tasks. Surely, this imagery flattered the duke's sense of himself as a compassionate master. The growing artistic interest in naturalism is evident in the careful way the painter recorded the architectural details of the Louvre and in the convincing shadows of the people, animals, and objects (such as the archer scarecrow and the horse) in the scene.

As a whole, Les Très Riches Heures reinforced the image of the duke of Berry as a devout man, cultured bibliophile ("lover of books"), sophisticated art patron, and powerful and magnanimous leader. Further, the expanded range of subject matter, especially the prominence of genre subjects in a religious book, reflected the increasing integration of religious and secular concerns in both art and life at the time.

IEAN FOUQUET Images for private devotional use were popular in France, as in Flanders. Among the French artists whose paintings were in demand was JEAN FOUQUET (ca. 1420–1481), who worked for King Charles VII (r. 1422–1461) and for the duke of Memours. Fouquet painted a diptych (two-panel painting; Fig. 8-10) for Étienne Chevalier, the royal treasurer of France. In the left panel, Chevalier appears with his patron saint, Saint Stephen (Étienne in French). Appropriately, Fouquet depicted Chevalier as devout—kneeling, with hands clasped in prayer. The representation of the pious donor with his standing saint recalls Flemish art, as do the pious donor with his standing saint recalls Flemish art, as do the three-quarter stances, the realism of Chevalier's portrait, and

8-11 TILMAN RIEMENSCHNEIDER, Assumption of the Virgin (Creglingen Altarpiece), Herrgottskirche, Creglingen, Germany, ca. 1495– 1499. Lime-wood, 30' 2" high.

Riemenschneider specialized in carving large wood retables. His works feature intricate Gothic tracery and religious figures whose bodies are almost lost within their swirling garments.

TILMAN RIEMENSCHNEIDER

Carved wood retables (altarpieces) were popular commissions for German churches. One prominent sculptor who specialized in producing retables was TILMAN RIEMENSCHNEIDER (ca. 1460-1531) of Würzburg. His 30foot-tall Creglingen Altarpiece (FIG. 8-11) incorporates intricate Gothic forms, especially in the retable's elaborate canopy. In Assumption of the Virgin in the central panel, Riemenschneider succeeded in setting the whole design into fluid motion by employing an endless and restless line running through the garments of the figures. The draperies float and flow around bodies lost within them, serving not as descriptions but as design elements that tie the figures to one another and to the framework. A look of psychic strain, a facial expression common in Riemenschneider's work, heightens the spirituality of the figures.

WOODCUTS A new age blossomed with the invention by Johannes Gutenberg (ca. 1400-1468) of moveable type around 1450 and the development of the printing press. Printing had been known in China centuries before, but had never fostered, as it did in 15th-century Europe, a revolution in written communication and in the generation and management of information. Printing provided new and challenging media for artists, and the earliest form was the woodcut (see "Woodcuts, Engravings, and Etchings," page 228). Artists

and Etchings Woodcuts, Engravings, AND TECHNIQUES MATERIALS

methods of printmaking. ries, artists most commonly used the relief and intaglio plished in several ways. During the 15th and 16th centuink from a printing surface to paper. This can be accomedition. The printmaking process involves the transfer of artist creates from a single block or plate is called an produced in multiple impressions. The set of prints an idly in Europe. A print is an artwork on paper, usually commercial mills, the art of printmaking developed raptury and the new widespread availability of paper from With the invention of moveable type in the 15th cen-

fluid, and closely spaced lines. parts of the material), it is difficult to create very thin, 8-11A (1) through a subtractive process (removing artists produce woodcuts (for example, Figs. I-7 and ist presses the printing block against paper. Because and a correctly oriented image results when the artmaker inks the ridges, the hollow areas remain dry, lines using a gouging instrument. Thus when the print-They then remove the surface areas around the drawn ror image of the intended design on the wood block. their images in reverse—that is, they must draw a mirwood. Relief printing requires artists to conceptualize plest printing method, by carving into a surface, usually Artists produce relief prints, the oldest and sim-

incises (cuts) the lines on a metal plate. The image can intaglio method involves a positive process. The artist In contrast to the production of relief prints, the

"draws" the image onto the plate, intaglio prints differ the remaining ink, creating the print. Because the artist and paper through a roller press, and the paper absorbs into the incisions. Then the printmaker runs the plate of the intaglio plate and wipes it clean, the ink is forced acid-resistant coating. When the artist inks the surface parts of the plate where the artist has drawn through an etching process, an acid bath eats into the exposed or chemically (etching; for example Fig. 10-22). In the ple, Fies. 8-12 and 8-28) using a tool (a burin or stylus), be created on the plate manually (engraving; for exam-

pressure and shifting directions. extent evidence of the artist's touch, the result of the hand's changing ent a wider variety of linear effects. They also often reveal to a greater in character from relief prints. Engravings and etchings generally pres-

of what was called Japan paper (of mulberry fibers) and China paper. paper. As contact with Asia increased, printmakers made greater use thin layer of this pulp to a wire screen and allowed it to dry to create the makers mashed with water into a pulp. The papermakers then applied a makers used papers produced from cotton and linen rags that paperthe printed image. During the 15th and 16th centuries, European print-The paper and inks that artists use also affect the finished look of

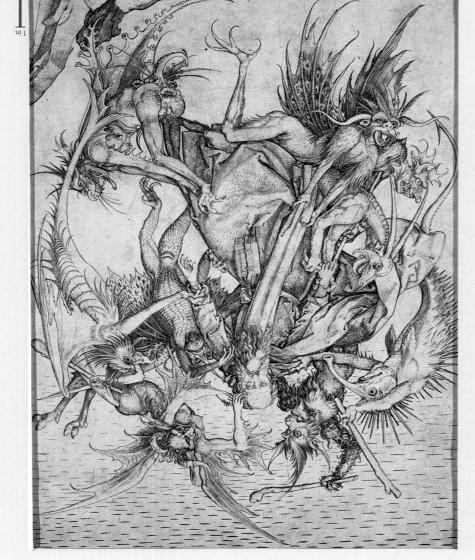

Engraving, 1' $\frac{1}{4}$ " × 9". Fondazione Magnani Rocca, Corte di Mamiano. 8-12 Martin Schongauer, Saint Anthony Tormented by Demons, ca. 1480.

and textures. to incise lines in a copper plate, he was able to create a marvelous variety of tonal values Schongauer was the most skilled of the early masters of metal engraving. By using a burin

oiliness of inks, which various papers absorb differently. and proportion of the ink ingredients affect the consistency, color, and Artists, then as now, could select from a wide variety of inks. The type

European prints attest to the importance of the new print medium. artworks. The number and quality of existing 15th- and 16th-century sequently, prints reached a far wider audience than did one-of-a-kind can be sold at much lower prices than paintings or sculptures. Conmaking attractive to 15th- and 16th-century artists. In addition, prints numerous impressions from the same print surface also made printimportant factor in their appeal to artists. The opportunity to produce Paper is lightweight, and the portability of prints has been an

produced inexpensive woodblock prints such as the Buxheim Saint Christopher (FIG. 8-11A 1) before the development of moveabletype printing. But when the improved economy and a rise in literacy necessitated production of illustrated books on a grand scale, artists met the challenge of bringing the woodcut picture onto the same page as the letterpress.

MARTIN SCHONGAUER The woodcut medium hardly had matured when the technique of engraving, begun in the 1430s and well developed by 1450, proved much more flexible. Predictably, in the second half of the century, engraving began to replace the woodcut process for making both book illustrations and widely popular single prints. The most skilled and subtle early master of metal engraving in northern Europe was MARTIN SCHONGAUER (ca. 1430-1491). His Saint Anthony Tormented by Demons (FIG. 8-12) shows both the versatility of the medium and the artist's mastery of it. The stoic saint is caught in a revolving thornbush of spiky demons, who claw and tear at him furiously. With unsurpassed skill and subtlety, Schongauer created marvelous distinctions of tonal values and textures—from smooth skin to rough cloth, from the furry and feathery to the hairy and scaly—with *hatching*. The use

of cross-hatching (sets of engraved lines at right angles) to describe forms, which Schongauer probably developed, became standard among German graphic artists. The Italians preferred parallel hatching (FIG. 8-28) and rarely adopted the other hatching method, which, in keeping with the general northern European approach to art, tends to describe the surfaces of things rather than their underlying structures.

ITALY

During the 15th century (the '400s, or Quattrocento in Italian), Italy (MAP 8-2) witnessed constant fluctuations in its political and economic spheres, including shifting power relations among the numerous city-states and republics and the rise of princely courts. Condottieri (military leaders) with large numbers of mercenary troops at their disposal played a major role in the ongoing struggle for power. Papal Rome and the courts of Urbino, Mantua, and other cities emerged as cultural and artistic centers alongside the great art centers of the 14th century, especially the Republic of Florence. The association of humanism with education and culture appealed to accomplished individuals of high status, and humanism had its greatest impact among the elite and powerful—the most influential art patrons whether in the republics or the princely courts. As a result, humanist ideas permeate Italian Renaissance art. The intersection of art with humanist doctrines during the Quattrocento is evident in the popularity of subjects selected from classical history or mythology, in the revival of portraiture, and in the increased concern with developing perspective systems and depicting anatomy accurately.

Florence

Because high-level patronage required significant accumulated wealth, those individuals who had managed to prosper came to the fore in artistic circles. The best-known Italian Renaissance art patrons were the Medici, the leading bankers of the Republic of Florence (see page 233), yet the first important artistic commission in Quattrocento Florence was not a Medici project but rather a competition held by the Cathedral of Santa Maria del Fiore and sponsored by the city's guild of wool merchants.

BAPTISTERY COMPETITION In 1401, the Duomo's art directors held a competition to make bronze doors for the east portal of the Baptistery of San Giovanni (FIG. 7-38, left). The commission was prestigious because the baptistery's east entrance faced the cathedral (FIG. 7-38, right). The jurors required each entrant to submit a relief panel depicting the sacrifice of Isaac, a venerable biblical subject (FIG. 4-1, top left). From the many entries submitted, seven semifinalists were selected. Only the panels of the two finalists, FILIPPO Brunelleschi (1377-1446) and Lorenzo Ghiberti (1378-1455), have survived. At 24 and 23 years old respectively, they were also the

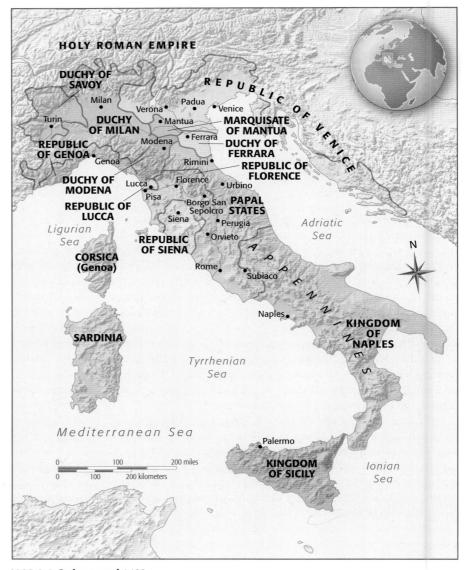

MAP 8-2 Italy around 1400.

8-14 Lorenzo Ghiberti, Sacrifice of Isaac, competition panel for the east doors of the Baptistery of San Giovanni (Fig. 7-38, left), Florence, Italy, I401–I402. Gilded bronze, I'9" × 1' $5\frac{1}{2}$ ". Museo Nazionale del Bargello, Florence.

In contrast to Brunelleschi's panel (Fie. 8-13), Ghiberti's entry in the baptistery competition features gracefully posed figures that recall classical statuary. Even Isaac's altar has a Roman acanthus frieze.

scrolls of a type that commonly adorned Roman buildings. These classical references reflect the increasing influence of humanism. Chiberti's Sacrifice of Isaac is also noteworthy for the artist's interest in spatial illusion. The rocky landscape seems to emerge from the blank panel toward the viewer, as does the strongly foreshortened angel. Brunelleschi's image, in contrast, emphasizes the planar orientation of the surface.

Ghiberti's training included both painting and metalwork. His careful treatment of the gilded bronze surfaces, with their sharply and accurately incised detail, proves his skill as a goldsmith. That Ghiberti cast his panel in only two pieces (thereby reducing the amount of bronze needed) no doubt also impressed the selection committee. Brunelleschi's panel consists of several cast pieces. Thus Ghiberti's doors, as proposed, would be both lighter and significantly less expensive. The younger artist's submission clearly had much to recommend it, both stylistically and technically, and the indeges awarded the commission to him—an achievement that he noted with exceptional pride in his Commendation to Lorenzo Ghiberti' (see "The Commentation of Lorenzo Ghiberti').

GATES OF PARADISE Ghiberti completed the baptistery's east doors in 1424, but church officials moved them to the north entrance so that he could execute another pair of doors for the east entrance. This second project (1425–1452) produced the famous east doors

8-13 Filtippo Brunelleschi, Sacrifice of Isaac, competition panel for the east doors of the Baptistery of San Giovanni (Fig. 7-38, left), Florence, Italy, I401–I402. Gilded bronze, I' 9" \times I' $5\frac{1}{2}$ ". Museo Maxionale del Bargello, Florence.

Brunelleschi's entry in the competition to create new bronze doors for the Florentine baptistery shows a frantic angel about to halt an emotional, lunging Abraham clothed in swirling Gothic robes.

two youngest entrants in the competition. As instructed, both artists used the same French Gothic quatrefoil frames employed earlier for the panels on the baptistery's south doors, and depicted the same moment of the narrative—the angel's halting of Abraham's sacrifice. Brunelleschi's entry (Fig. 8-13) is a vigorous interpretation of the theme and recalls the emotional agitation characteristic of Italian Gothic sculpture. Abraham seems suddenly to have summoned the dreadful courage needed to murder his son at God's command. He lunges forward, robes flying, and exposes the terrified Isaac's throat to the knife. Matching Abraham's energy, the saving angel flies in from the left, grabbing Abraham's arm to stop the killing. Brunelleschi's figures demonstrate his ability to represent faithfully and drachi's figures demonstrate his ability to represent faithfully and dramatically all the elements in the biblical narrative.

Whereas Brunelleschi imbued his image with violent movement and high emotion, Ghiberti emphasized grace and smoothness. In Ghiberti's panel (Fig. 8-14), Abraham appears in a typically Gothic pose with outthrust hip (compare Fig. 7-20) and seems to contemplate the act he is about to perform, even as he draws his arm back to strike. The figure of Isaac, beautifully posed and rendered, recalls Greco-Roman statuary. Unlike his medieval predecessors, Ghiberti revealed a genuine appreciation of the nude male form and a deep interest in how the muscular system and skeletal structure move the human body. Even the altar on which Isaac kneels displays move the human body. Even the altar on which Isaac kneels displays

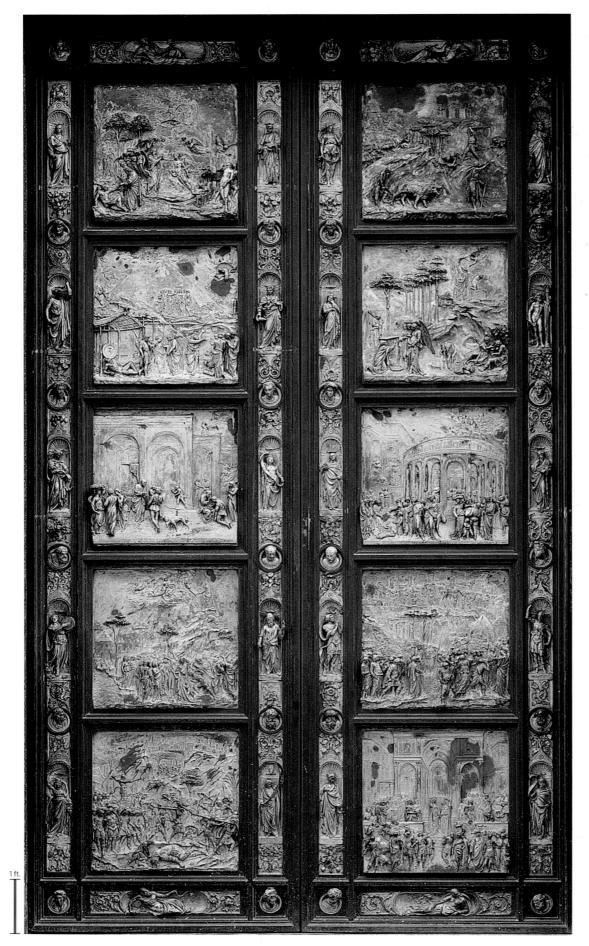

8-15 LORENZO GHIBERTI, east doors (*Gates of Paradise*), Baptistery of San Giovanni (FIG. 7-38, *left*), Florence, Italy, 1425–1452. Gilded bronze, 17' high. Modern replica, 1990. Original panels in Museo dell'Opera del Duomo, Florence.

In Ghiberti's later doors for the Florentine baptistery, the sculptor abandoned Gothic quatrefoil frames for the biblical scenes (compare FIG. 8-14) and employed painterly illusionistic devices.

(FIG. 8-15) that Michelangelo later declared were "so beautiful that they would do well for the gates of Paradise." In the *Gates of Paradise*, Ghiberti abandoned the quatrefoil frames of his earlier doors and reduced the number of panels from 28 to 10. Each panel contains a relief set in a plain molding and depicts an episode from the Old Testament. The complete gilding of the reliefs creates an effect of great splendor and elegance.

The individual panels, such as Isaac and His Sons (FIGS. 8-15, left door, third from top, and 8-16), clearly recall painting techniques in their depiction of space as well as in their treatment of the narrative. Some exemplify more fully than painting many of the principles that the architect and theorist Leon Battista Alberti formulated in his 1435 treatise, On Painting. In his relief, Ghiberti created the illusion of space partly through the use of linear perspective and partly by sculptural means. He represented the pavement on which the figures stand according to a painter's vanishing-point perspective construction, but the figures themselves appear almost fully in the round. In fact, some of their heads stand completely free. As the eye progresses upward, the

79.1

8-16 LORENZO GHIBERTI, Isaac and His Sons (detail of FIG. 8-15, with overlay of perspective orthogonals), east doors (Gates of Paradise) of the Baptistery of San Giovanni, Florence, Italy, 1425–1452. Gilded bronze, 2' $7\frac{1}{2}$ " \times 2' $7\frac{1}{2}$ ". Museo dell'Opera del Duomo, Florence.

All the orthogonals of the floor tiles in this early example of linear perspective converge on a vanishing point on the central axis of the composition, but the orthogonals of the architecture do not.

enormously important, for it made possible what has been called the "rationalization of sight." It brought all random and infinitely various visual sensations under a simple rule that could be expressed matheratically. Indeed, Renaissance artists' interest in linear perspective reflects the emergence at this time of modern science itself. Of course, 15th-century artists were not primarily scientists. They simply found perspective an effective way to order and clarify their compositions. Monetheless, linear perspective, with its new mathematical certifude, by making the picture measurable and exact. The projection of measurable objects on flat surfaces influenced the character of Renaissance able objects on flat surfaces influenced the character of Renaissance and diagrams—means of exact representation that laid the foundation and diagrams—means of exact representation that laid the foundation for modern science and technology.

PROBLEMS AND SOLUTIONS Linear and Atmospheric Perspective

Scholars long have noted the Renaissance fascination with perspective. In essence, portraying perspective involves constructing a convincing illusion of space in two-dimensional imagery while unifying all objects within a single spatial system. Renaissance artists were not the first to focus on depicting illusionistic space. Both the Greeks and the Romans were well versed in perspective rendering (Fig. 3-20, right). However, the Renaissance rediscovery of and interest in perspective contrasted sharply with the portrayal of space during the Middle Ages, when spiritals concerns superseded the desire to depict objects illusionistically. Renaissance knowledge of perspective included both linear

perspective and atmospheric perspective.

on a structured mathematical system, atmospheric perspective Atmospheric perspective. Unlike linear perspective, which relies ing the Keys of the Kingdom to Saint Peter (FIG. 8-34). Masaccio's Holy Trinity (FIG. 8-22), and Perugino's Christ Deliverof linear perspective are Chiberti's Isaac and His Sons (FIG. 8-16), illusionistic space. Among the works that provide clear examples the image and determines the size of objects within the image's vanishing point, the artist creates a structural grid that organizes orthogonals (diagonal lines) from the edges of the picture to the zon line (often located at the exact center of the line). By drawing horizon line). The artist then selects a vanishing point on that horimarks, in the image, the horizon in the distance (hence the term sion into space. The artist first must identify a horizontal line that size of rendered objects to correlate them with the visual recesspective enables artists to determine mathematically the relative Linear perspective Developed by Filippo Brunelleschi, linear per-

spective to great effect, as seen in such works as Madonna of the Rocks (Fig. 9-2) and Mona Lisa (Fig. 9-4).

Earlier Italian artists, such as Giotto, Duccio, and Lorenzetti, had used several devices to indicate distance, but with the development of linear perspective, Quattrocento artists acquired a way to make the illusion of distance certain and consistent. In effect, they conceived the plane as a transparent window through which the observer

detailed it appears. Leonardo da Vinci used atmospheric per-

tive (sometimes called aerial perspective) exploit the principle

that the farther back the object is in space, the blurrier and less

involves optical phenomena. Artists using atmospheric perspec-

looks to see the constructed pictorial world. This discovery was

relief increasingly flattens, concluding with the architecture in the background, which Ghiberti depicted using barely raised lines. In this manner, the artist created a sort of sculptor's atmospheric perspective, with forms appearing less distinct the deeper they are in space (see "Linear and Atmospheric Perspective," above).

In these panels, Ghiberti achieved a greater sense of depth than had previously seemed possible in a relief, but his principal figures do not occupy the architectural space he created for them. Rather, the artist arranged them along a parallel plane in front of the grandiose architecture. (According to Alberti in On the Art of Building, the grandeur of the architecture reflects the dignity of the events shown in the foreground.) Ghiberti's figure style mixes a Gothic shown in the foreground.)

patterning of rhythmic line, classical poses and motifs, and a new realism in characterization, movement, and surface detail. Ghiberti retained the medieval narrative method of presenting several episodes within a single frame. In Isaac and His Sons, the women in the ground. In the central foreground, Isaac sends Esau and his dogs to hunt game. In the right foreground, Isaac blesses the kneeling Jacob as Rebecca looks on. Yet viewers experience little confusion because of Chiberti's careful and subtle placement of each scene. The figures, in varying degrees of projection, gracefully twist and turn, appearing to occupy and move through a convincing stage space, which Ghiberti deepened by showing some figures from behind.

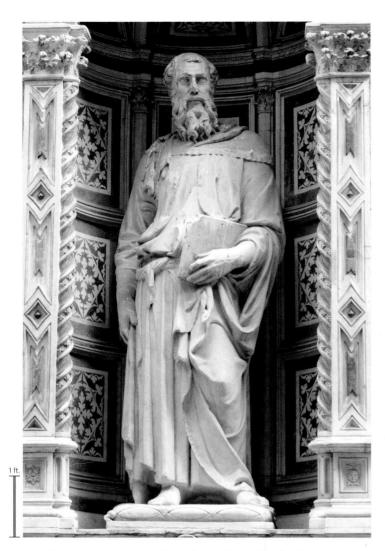

8-17 DONATELLO, *Saint Mark*, niche on the south side of Or San Michele, Florence, Italy, ca. 1411–1413. Marble, figure 7' 9" high. Modern replica. Original statue in the museum on the second floor of Or San Michele, Florence.

In this statue carved for the guild of linen makers and tailors, Donatello introduced classical contrapposto into Renaissance sculpture. The drapery falls naturally and moves with the body.

The classicism derives from the artist's close study of ancient art. Ghiberti admired and collected classical sculpture and coins. Their influence appears throughout the panel, particularly in the figure of Rebecca, which Ghiberti based on a popular Greco-Roman statuary type. The emerging practice of collecting classical art in the 15th century had much to do with the incorporation of classical motifs and the emulation of classical style in Renaissance art.

DONATELLO A former apprentice in Ghiberti's workshop, Donato di Niccolo Bardi, called Donatello (ca. 1386–1466), participated along with other leading sculptors, including Ghiberti, in another major Florentine art program of the early 1400s—the decoration of Or San Michele. At various times, the building housed a church, a granary, and the headquarters of Florence's guilds. City officials had assigned each of the niches on the building's four sides to a specific guild to fill with a statue of its patron saint. Donatello carved *Saint Mark* (FIG. 8-17) for the guild of linen makers and tailors in 1413. In

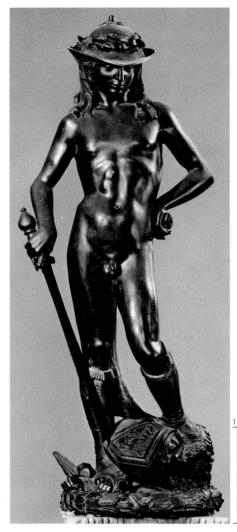

8-18 DONATELLO, *David*, from the Palazzo Medici, Florence, Italy, ca. 1440–1460. Bronze, 5' 2¹/₄" high. Museo Nazionale del Bargello, Florence.

Donatello's *David* possesses both the relaxed contrapposto and the sensuous beauty of nude Greek gods (FIG. 2-48). The revival of classical statuary style appealed to the sculptor's patrons, the Medici.

this sculpture, Donatello introduced the classical principle of weight shift—contrapposto—into Renaissance statuary. As the saint's body moves, his garment moves with it, hanging and folding naturally from and around different body parts so that the viewer senses the figure as a nude human wearing clothing, not as a stone statue with arbitrarily composed drapery folds. Donatello's Saint Mark is the first Renaissance statue whose voluminous robe (the pride of the Florentine guild that paid for the statue) does not conceal but accentuates the movement of the arms, legs, shoulders, and hips. This development further contributed to the sculpted figure's independence from its architectural setting. Saint Mark's stirring limbs, shifting weight, and mobile drapery suggest impending movement out of the niche.

DAVID Donatello was one of many artists in Quattrocento Florence who enjoyed the patronage of the Medici. By the early 15th century, the banker Giovanni di Bicci de' Medici (ca. 1360–1429) had established the family fortune. His son Cosimo (1389–1464) became a great patron of art and of learning in the broadest sense. For example, he founded the first public library since antiquity. Cosimo's grandson Lorenzo (1449–1492), called "the Magnificent," a member of the Platonic Academy of Philosophy, gathered about him artists and gifted men in all fields. Together, the Medici spent lavishly on buildings, paintings, and sculptures.

Sometime between 1440 and 1460, Donatello cast the bronze statue *David* (Fig. 8-18) for display in the courtyard (Fig. 8-32B 🗐)

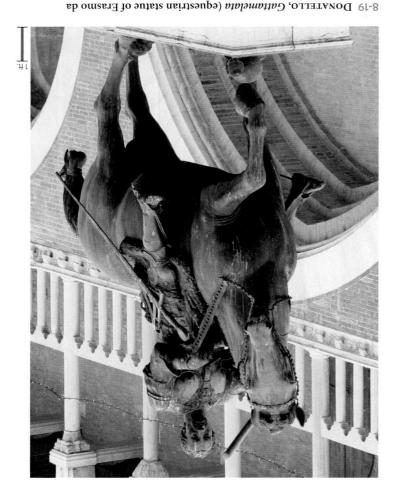

Narni), Piazza del Santo, Padua, Italy, ca. 1445–1453. Bronze, 12' 2" high.

Donatello based his gigantic portrait of a Venetian general on equestrian statues of ancient Roman emperors (Fig. 3-41). Together, man and horse convey an overwhelming image of irresistible strength.

predominantly conservative, Gentile demonstrated that he was not radiant Christ Child-introduced into the picture itself. Although the first nighttime nativity scene with the central light source—the the left panel of the predella, Gentile painted what may have been ing the spurs from the standing magus in the center foreground. In did the same with human figures, such as the kneeling man removthe horse at the far right seen in a three-quarter rear view. Gentile of angles and foreshortened the forms convincingly, most notably tic details. For example, the artist depicted animals from a variety mentally International Gothic, Gentile inserted striking naturaliscentered on the Madonna and Child. Although the style is fundaall the pomp and ceremony of chivalric etiquette in a religious scene a rainbow of color with extensive use of gold. The painting presents menagerie of exotic animals. Gentile portrayed all these elements in tumed kings, courtiers, captains, and retainers accompanied by a too is the painting itself, with its gorgeous surface and richly cosgilded Gothic frame, is testimony to the patron's lavish tastes. So family was the richest in the city. The altarpiece, with its elaborate Trinità in Florence. At the beginning of the 15th century, the Strozzi the family chapel of Palla Strozzi (1372–1462) in the church of Santa 1423 painted Adoration of the Magi (FIG. 8-20) as the altarpiece for Gothic master was Gentile da Fabriano (ca. 1370-1427), who in well into the 15th century. The leading Quattrocento International

> shared Florence's ideals. the family identified themselves with Florence or, at the very least, selection of the same subject for their private residence suggests that a symbol of Florentine strength and independence, and the Medici's sion by King Ladislaus (r. 1399-1414) of Naples. David had become Signoria, which the artist had produced during the threat of inva-Donatello's earlier David in Florence's town hall, the Palazzo della and formats appealed to the humanist Medici, who were aware of ties absent from medieval figures. The invoking of classical poses and sensuous beauty of Greek images of gods (FIG. 2-48), qualiboth the relaxed classical contrapposto stance and the proportions had become the symbol of the Florentine republic. David possesses god, hero, or athlete but the youthful biblical slayer of Goliath who the classical nude. His subject, however, was not a Greco-Roman depictions of sinners in Hell. With David, Donatello reinvented cal or moralizing contexts, such as the story of Adam and Eve or in general appeared only rarely in art—and then only in bibliregarded nude statues as both indecent and idolatrous, and nudity statue since ancient times. During the Middle Ages, the clergy of the Medici palace in Florence. The sculpture was the first nude

> Erasmo da Narni was not an emperor, king, or duke. the world. The imperial imagery is all the more remarkable because on an orb, reviving a venerable ancient symbol for domination of Donatello reinforced visually by placing the left forefoot of the horse image of irresistible strength and unlimited power-an impression tion in the world. Together, man and horse convey an overwhelming resourcefulness and on his own merits, rise to a commanding posiambitious, and frequently of humble origin—could, by his own the Renaissance individualist. Such a man-intelligent, courageous, of dauntless resolution and unshakable will, is the very portrait of ter rather than sheer size. The condottiere, his face set in a mask horse. Gattamelata dominates his mighty steed by force of characcommander as superhuman and disproportionately larger than his Marcus Aurelius statue, Donatello did not represent the Venetian horse bears the armored general easily, for, unlike the sculptor of the Padua, the condottiere's birthplace. Massive and majestic, the great elliptical base in the square in front of the church of Sant'Antonio in ognized this reference to antiquity. The statue stands high on a lotty his horse "with great magnificence like a triumphant Caesar,"2 reccontemporaries, one of whom described Gattamelata as sitting on (FIG. 3-41), which the artist must have seen in Rome. Donatello's Roman imperial mounted portraits, such as that of Marcus Aurelius but Donatello's Gattamelata was the first to rival the grandeur of ues occasionally had been set up in Italy in the late Middle Ages, wordplay on his mother's name, Melania Gattelli). Equestrian statda Narni (1370-1443), nicknamed Gattamelata ("honeyed cat," a in honor of the recently deceased Venetian condottiere Erasmo Venice. His assignment was to create a commemorative monument trian statue (FIG. 8-19) that Donatello produced for the Republic of The grandest portrait of the era is the 11-foot-tall bronze equessurprising that portraiture enjoyed a revival in 15th-century Italy. achievement and recognition that humanism tostered, it is not GATTAMELATA Given the increased emphasis on individual

> **GENTILE DA FABRIANO** In Quattrocento Italy, humanism and the celebration of classical artistic values also largely determined the character of panel and mural painting. The new Renaissance style did not, however, immediately displace all vestiges of the Late Gothic style. In particular, the International Gothic style, the dominant mode in painting around 1400 (see page 210), persisted

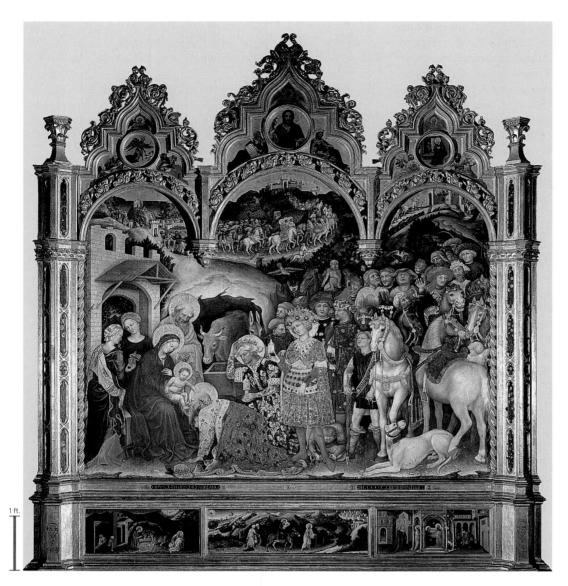

8-20 GENTILE DA FABRIANO, Adoration of the Magi, altarpiece from the Strozzi chapel, Santa Trinità, Florence, Italy, 1423. Tempera on wood, 9' 11" × 9' 3". Galleria degli Uffizi, Florence.

Gentile was the leading Florentine painter working in the International Gothic style. He successfully blended naturalistic details with late medieval splendor in color, costume, and framing ornamentation.

oblivious to Quattrocento experimental trends and could blend naturalistic and inventive elements skillfully and subtly into a traditional composition without sacrificing Late Gothic splendor in color, costume, and framing ornamentation.

MASACCIO The artist who personifies the inventive spirit of early-15th-century Florentine painting was Tommaso di ser Giovanni di Mone Cassai, known as MASACCIO (1401–1428), whose untimely death at age 27 cut short his brilliant career. *Tribute Money* (FIG. 8-21), in the family chapel of Felice Brancacci (1382–1447) in Santa Maria del Carmine in Florence, displays Masaccio's

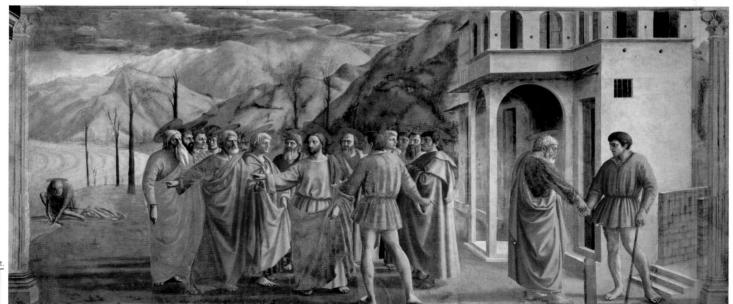

8-21 Masaccio, *Tribute Money*, Brancacci chapel, Santa Maria del Carmine, Florence, Italy, ca. 1424–1427. Fresco, 8' 4 ½" × 19' 7 ½".

Masaccio's figures recall Giotto's in their simple grandeur, but they convey a greater psychological and physical credibility. He modeled his figures with light coming from a source outside the picture.

between viewers and what they see are two parts of the visual expeers (FIG. 3-21), they came to realize that the light and air interposed and his contemporaries rediscovered. As did ancient Roman paintincreases, an aspect of atmospheric perspective, which Masaccio He also diminished the brightness of the colors as the distance vanishing point, where all the orthogonals converge, at Jesus's head. is a building that Masaccio depicted in perspective, locating the

rience called "distance."

coin from the fish, while the tax collector stands in the foreground, Jesus, surrounded by his disciples, tells Saint Peter to retrieve the divided the story into three parts within the fresco. In the center, coin in the mouth of a fish and returns to pay the tax. Massaccio shore of Lake Galilee. There, as Jesus foresaw, Peter finds the tribute to the Roman town of Capernaum, Jesus directs Saint Peter to the thew (17:24–27). As the tax collector confronts Jesus at the entrance innovations. The fresco depicts an episode from the Gospel of Mat-

right, he thrusts the coin into the tax collector's extracts the coin from the fish's mouth, and, at the payment. At the left, in the middle distance, Peter his back to spectators and hand extended, awaiting

Masaccio's figures recall those of Giotto

Masaccio's arrangement of the figures is equally real, and natural."3 day can be said to be painted, while his are living, tion that "the works made before his [Masaccio's] Money provides support for Giorgio Vasari's assercles and the pressures and tensions of joints. Tribute energy, suggesting the movement of bones and mus-Masaccio's figures conveys a maximum of contained body structure, as do Donatello's statues. Each of and weighty, but they also move freely and reveal The individual figures in Tribute Money are solemn some and concealing others, as the artist directs it. of the light, which plays over the forms, revealing visible only because of the direction and intensity works, light has its own nature, and the masses are used light only to model the masses. In Masaccio's the scene in varying degrees. In his frescoes, Giotto a constantly active but fluctuating force highlighting the extremes of light and dark, the light appears as ducing the illusion of deep sculptural relief. Between obstruct its path and leaving the rest in shadow, proat an angle, illuminating the parts of the solids that window in the chapel wall) and strikes the figures the light comes from the right (as if through a real ing from a specific source outside the picture. Here, lacking an identifiable source but with a light combulk through modeling not with a flat, neutral light physical credibility. Masaccio created the figures' deur, but they convey a greater psychological and (FIGS. 7-30, 7-31, and 7-32) in their simple gran-

fined stage space of Giotto's frescoes. At the right in a spacious landscape, rather than in the condepth around Jesus, and he placed the whole group ground. Instead, the artist grouped them in circular inventive. They do not stand in a line in the fore-

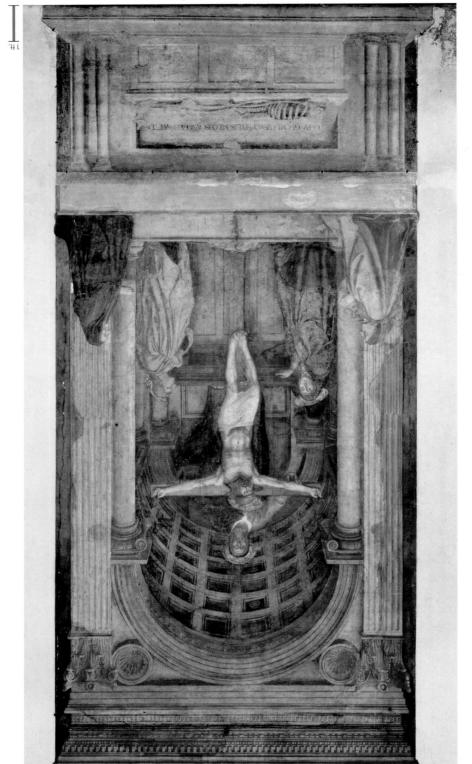

 $\frac{1}{4}$ 10' $\frac{5}{4}$ " × 10' $\frac{5}{4}$ ". Novella, Florence, Italy, ca. 1424-1427. Fresco, 8-22 MASACCIO, Holy Trinity, Santa Maria

of perspective. depiction of space according to Filippo Brunelleschi's system century example of the application of mathematics to the Masaccio's pioneering Holy Trinity is the premier early-15thHOLY TRINITY Masaccio's Holy Trinity (FIG. 8-22) in Santa Maria Novella is the premier early-15th-century example of the application of mathematics to the depiction of space. Masaccio painted the composition on two levels of unequal height. Above, in a coffered barrel-vaulted chapel reminiscent of a Roman triumphal arch (FIG. 3-32), the Virgin Mary and Saint John appear on either side of the crucified Christ. (Mary, unlike in almost all other representations of the crucifixion, appears as an older woman, her true age at the time of her adult son's death.) God the Father emerges from behind Christ, supporting the arms of the cross and presenting his son to the worshiper as a devotional object. Christ's blood runs down the cross onto the painted ledge below-a reference to the symbolic blood of the wine of the Eucharist on the church's altar. The dove of the Holy Spirit hovers between God's head and Christ's head. Masaccio also included portraits of the donors of the painting, Lorenzo Lenzi and his wife, who kneel just in front of the pilasters framing the chapel's entrance. Below, the artist painted a tomb containing a skeleton. An inscription in Italian above the skeleton reminds the spectator, "I was once what you are, and what I am you will become."

The illusionism of *Holy Trinity* is breathtaking, a brilliant demonstration of the principles and potential of Brunelleschi's new science of perspective. Indeed, some art historians have suggested that Brunelleschi may have collaborated with Masaccio on this commission. The vanishing point of the composition is at the foot of the cross. With this point at eye level, spectators look up at the Trinity and down at the tomb. About 5 feet above the floor level, the vanishing point pulls the two views together, creating the illusion of a real structure transecting the wall's vertical plane. Whereas the tomb appears to project forward into the church, the chapel recedes visually behind the wall and appears as an extension of the church's space. This adjustment of the picture's space to the viewer's position was an important innovation in illusionistic painting that other artists of the Renaissance and the later Baroque period would develop further. Masaccio was so exact in his proportions that it is possible to calculate the dimensions of the chapel (for example, the span of the painted vault is 7 feet, and the depth of the chapel is 9 feet). Thus he achieved not only a successful illusion but also a rational measured coherence that is responsible for the unity and harmony of the fresco.

Holy Trinity is, however, much more than an expert application of Brunelleschi's perspective system or a showpiece for the painter's ability to represent fully modeled figures bathed in light. In this painting, Masaccio also powerfully conveyed one of the central tenets of Christian faith. The ascending pyramid of figures leads viewers from the despair of death to the hope of resurrection and eternal life through Christ's crucifixion.

FRA ANGELICO As Masaccio's Holy Trinity clearly demonstrates, humanism and religion were not mutually exclusive, but for many Quattrocento artists, humanist concerns were not a primary consideration. The art of FRA ANGELICO (ca. 1400-1455) focused on serving the Roman Catholic Church. In the late 1430s, the abbot of the Dominican monastery of San Marco (Saint Mark) in Florence asked Fra Angelico to produce a series of frescoes for the monks' compound. The Dominicans had dedicated themselves to lives of prayer and work, and their monastery was quite spare to encourage the monks to immerse themselves in their devotional lives. Annunciation (FIG. 8-23) appears at the top of the stairs leading to the friars' sleeping cells. Appropriately, Fra Angelico presented the scene of the Virgin Mary and the Archangel Gabriel with simplicity and serenity. The pristinely painted figures appear in a well-lit plain loggia (open arcade) resembling the portico of San Marco's cloister, but they do not cast shadows. Although Fra Angelico rendered the setting according to the rules of Renaissance perspective, the unnatural lighting removes the sacred event from the everyday world. Underscoring the devotional function of the image, a small inscription at the base of the fresco reads: "As you venerate, while passing before it, this figure of the intact Virgin, beware lest you omit to say a Hail Mary." Like most of Fra Angelico's paintings, Annunciation, with its simplicity and directness, still has an almost universal appeal and fully reflects the artist's humble character.

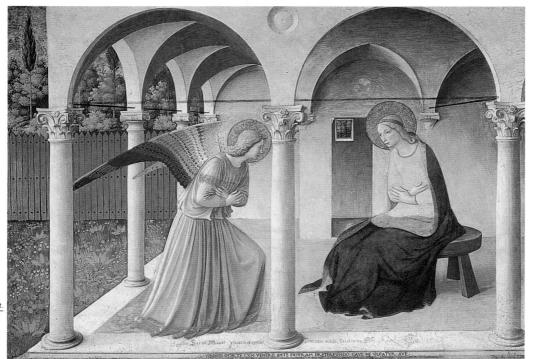

8-23 Fra Angelico, Annunciation, San Marco, Florence, Italy, ca. 1438–1447. Fresco, 7' 1" × 10' 6".

Painted for the Dominican monks of San Marco, Fra Angelico's fresco is simple and direct. Its figures and architecture have a pristine clarity befitting the fresco's function as a devotional image.

8-24 Andrea del Castagno, Last Supper, refectory of the convent of Sant'Apollonia, Florence, Italy, I447. Fresco, 15' $5''\times 32'.$

In this Last Supper on the wall of a nuns' dining room, Judas sits isolated. Castagno's depiction of the setting for the apostles' meal reflects his preoccupation with the new science of perspective.

ANDREA DEL CASTAGNO Fra Angelico's younger contemporary Andrea DEL CASTAGNO (ca. 1421–1457) also accepted a commission to produce a series of frescoes for a religious establishment. Castagno's Last Supper (Fig. 8-24), painted in the refectory (dining faithfully follows the biblical narrative, although the lavish marble-revetted room that Jesus and his 12 disciples occupy has no basis in the Gospels. The setting reflects the artist's absorption with linear perspective, but closer scrutiny reveals inconsistencies. For example, in Brunelleschi's system, it is impossible to see the ceiling from pie, in Brunelleschi's system, it is impossible to see the ceiling from inside and the roof from outside at the same time, as in Castagno's freeco. The two side walls also do not appear parallel.

Castagno chose a conventional compositional format, with the figures seated at a horizontally placed table. He derived the apparent self-absorption of most of the disciples and the menacing features of Judas (who sits alone on the outside of the table) from the Gospel of Saint John, rather than the more familiar version of the Last Supper recounted in Luke's Gospel. Castagno's dramatic and spatially convincing depiction of the event no doubt was a powerful presence for the nuns during their daily meals.

FRA FILIPPO LIPPI (ca. 1406–1469), was also a friar—but there ico, Fra Filippo Lippi (ca. 1406–1469), was also a friar—but there all resemblance ends. Fra Filippo was unsuited for monastic life. He indulged in misdemeanors ranging from forgery and embezzlement to the abduction of a pretty nun, Lucretia, who became his mistress. Only the intervention of the Medici on his behalf at the papal court preserved Fra Filippo from severe punishment and total disgrace.

In Madonna and Child with Angels (FIG. 8-25), the errant friar interpreted his subject in a distinctly worldly manner. The Madonna is a beautiful young mother, albeit with a transparent halo, seated in an elegantly furnished Florentine home. One of the angels

8-25 Fra Filippo Lippi, Madonna and Child with Angels, ca. 1460–1465. Tempera on wood, 2' $111\frac{1}{2}$ " x 2' 1". Galleria degli Uffizi, Florence.

Fra Filippo, a monk guilty of many misdemeanors, represented the Madonna and Child in a distinctly worldly manner, carrying the humanization of the holy further than any artist before him.

holding up the Christ Child sports the mischievous, puckish grin of a boy refusing to behave for the pious occasion. Significantly, all of the figures reflect the use of live models (perhaps Lucretia for the Madonna). Fra Filippo plainly relished the charm of youth and beauty as he found it in this world. He preferred the real in land-scape also. The background, seen through the window, incorporates recognizable features of the Arno River valley. Compared with the earlier Madonnas by Giotto (Fig. 7-30) and Duccio (Fig. 7-33), this work shows how far Quattrocento artists had carried the humanization of this traditional Christian theme. Whatever the ideals of spiritual perfection may have meant to artists in past centuries, Renaissance artists realized those ideals in terms of the sensuous beauty of this world.

SANDRO BOTTICELLI Many 15th-century Florentine artists also received commissions to paint secular subjects for private patrons. The greatest of these were the Medici, and the finest painter they employed was Sandro Botticelli (1444–1510). His work is a testament to the intense interest that the Medici and their circle of humanist scholars had in the art, literature, and mythology of the Greco-Roman world—often interpreted in terms of Christianity according to the philosophical tenets of *Neo-Platonism*. Botticelli painted *Primavera* (*Spring*; FIG. 8-26) for Lorenzo di Pierfrancesco

de' Medici (1463-1503), one of Lorenzo the Magnificent's cousins. The central figure in the composition is Venus, the goddess of love and beauty. Her son Cupid hovers above her head. Botticelli drew attention to Venus by opening the landscape behind her to reveal a portion of sky that forms a kind of halo around the goddess's head. At the left, seemingly the target of Cupid's arrow, are the dancing Three Graces, whom Botticelli based closely on ancient prototypes, but they are clothed, albeit in thin, transparent garments. At the right, the blue ice-cold Zephyrus, the west wind, is about to carry off and marry the nymph Chloris, whom he transforms into Flora, goddess of spring, appropriately shown wearing a rich floral gown. At the far left, Mercury turns away from all the others and reaches up with his distinctive staff, the caduceus, perhaps to dispel storm clouds. The sensuality of the representation, the appearance of Venus in springtime, and the abduction and marriage of Chloris all suggest that the occasion for the painting was young Lorenzo's wedding in May 1482 to Semiramide d'Appiani. But the painting also sums up the Neo-Platonists' view that earthly love is compatible with Christian theology. In their reinterpretation of classical mythology, Venus as the source of love provokes desire through Cupid. Desire can lead either to lust and violence (Zephyr) or, through reason and faith (Mercury), to the love of God. Primavera, read from right to left, served to urge the newlyweds to seek God through love.

8-26 SANDRO BOTTICELLI, Primavera, ca. 1482. Tempera on wood, 6'8" × 10'4". Galleria degli Uffizi, Florence.

In Botticelli's lyrical painting celebrating love in springtime, the blue, ice-cold Zephyrus, the west wind, carries off and marries the nymph Chloris, whom he transforms into Flora, goddess of spring.

8-27 Sandro Botticelli, Birth of Venus, ca. 1484-1486. Tempera on canvas, 5' 9" × 9' 2". Galleria degli Uffizi, Florence.

Inspired by Angelo Poliziano's poem and Greek Aphrodite statues (FIG. 2-47), Botticelli revived the theme of the female nude in this elegant

the scientific knowledge that 15th-century artists had gained in the areas of perspective and anatomy. For example, the seascape in Birth of Venus is a flat backdrop devoid of atmospheric perspective. Botticelli's style paralleled the Florentine allegorical pageants that were chivalric tournaments structured around allusions to classical mythology. The same trend is evident in the poetry of the 1470s and 1480s. Artists and poets at this time did not directly imitate classical antiquity but used the myths, with delicate perception of their charm, in a way still tinged with medieval romance. Ultimately, Bottiselli created a style of visual poetry parallel to the love poetry of ticelli created a style of visual poetry parallel to the love poetry of ticelli created a style of visual poetry parallel to the love poetry of

Lorenzo de' Medici.

POLLATIONIO DEL POLLAIUOLO Another of the many artists who produced sculptures and paintings for the Medici was Antonio del Pollatiuolo (ca. 1431–1498), who took delight in showing human figures in violent action. Masaccio and his contemporaries had dealt usually depicted their figures at rest or in restrained motion. Pollaiuolo conceived the body as a powerful machine and liked to display its mechanisms, such as knotted muscles and taut sinews that activate the skeleton as ropes pull levers. To show this to dest effect, Pollaiuolo developed a figure so lean and muscular that it appears as if it has no skin. His figures also feature strongly accentuated delineations at the wrists, elbows, shoulders, and knees. Battle of Ten Nudes (Fig. 8-28), an early Italian example of the new engraving medium (Fig. 8-28), an early Italian example of the new engraving medium

tual and divine beauty whenever they behold physical beauty. the contemplative life of reason will immediately contemplate spiriceptible to a Neo-Platonic reading, namely that those who embrace unchallenged, in part because Birth of Venus, like Primavera, is susprotection of the powerful Medici, the painter's nude Venus went But in the more accommodating Renaissance culture and under the a large scale—roughly life-size) could have drawn harsh criticism. Ages. Botticelli's depiction of Venus unclothed (especially on such especially the female nude, was exceedingly rare during the Middle the ancient Greek master Praxiteles. As noted earlier, the nude, Primavera, Venus is nude, as in the famous statue (FIG. 2-47) by by rose petals that fall on the whitecaps. In this painting, unlike in out effort. Draperies undulate easily in the gentle gusts, perfumed a brocaded mantle. Zephyrus's breath moves all the figures withisland, Cyprus. There, the nymph Pomona runs to meet her with shell. Zephyrus, carrying Chloris, blows the goddess to her sacred rodite, born of the sea foam—aphros) stands on a floating cockleof Poliziano's version of the Greek myth, Venus (the Greek Apha leading humanist of the day. In Botticelli's lyrical representation (FIG. 8-27) is based on a poem by Angelo Poliziano (1454-1494), BIRTH OF VENUS Painted a few years later, Botticelli's Birth of Venus

and romantic representation of Venus born of sea foam.

Botticelli's paintings stand apart from those of many other Quattrocento artists who sought to comprehend humanity and the natural world through a rational, empirical order. Indeed, Botticelli's elegant and beautiful linear style seems removed from all

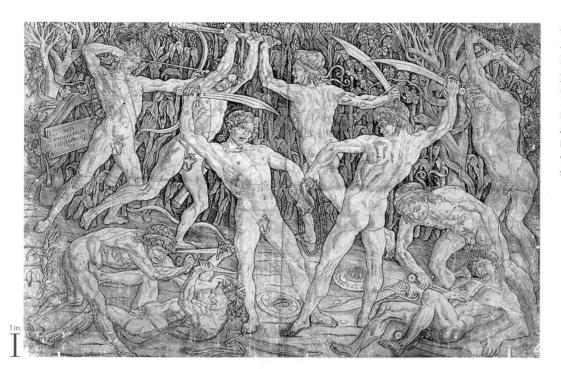

8-28 ANTONIO POLLAIUOLO, Battle of Ten Nudes, ca. 1465. Engraving, 1' $3\frac{1}{8}$ " × 1' $11\frac{1}{4}$ ". Metropolitan Museum of Art, New York (bequest of Joseph Pulitzer, 1917).

Pollaiuolo was fascinated by how muscles and sinews activate the human skeleton. He delighted in showing nude figures in violent action and from numerous foreshortened viewpoints.

that northern European artists (FIG. 8-12) had pioneered, shows this figure type in a variety of poses and from numerous viewpoints. The print has no identifiable subject, but it enabled Pollaiuolo to demonstrate his prowess in rendering the nude male figure. In this, he was a kindred spirit of late-sixth-century BCE Greek vase painters, such as Euthymides (FIG. 2-26), whose experiments with foreshortening also took precedence over narrative content. Even though the figures in *Ten Nudes* hack and slash at each other without mercy, they seem somewhat stiff and frozen because Pollaiuolo depicted *all* the muscle groups at maximum tension. Not until several decades later did an even greater anatomist, Leonardo da Vinci, observe that only some of the body's muscle groups participate in any one action, while the others remain relaxed.

OSPEDALE DEGLI INNOCENTI Filippo Brunelleschi's ability to codify a system of linear perspective derived in part from his skill as an architect. According to his biographer, Antonio Manetti (1423–1497), Brunelleschi turned to architecture out of disappointment over the loss of the commission for the baptistery doors (see page 230). Several trips to Rome (the first in 1402, probably with his friend Donatello), where the ruins of ancient Rome captivated him, heightened his fascination with architecture, a field he would soon reorient. Brunelleschi's close study of Roman monuments and his effort to make an accurate record of what he saw may have been the catalyst that led him to develop his revolutionary system of linear perspective.

Brunelleschi's first major architectural commission was to design the Ospedale degli Innocenti (Hospital of the Innocents, FIG. 8-29), a home for Florentine orphans and foundlings. Most scholars regard Brunelleschi's orphanage as the first building to embody the new Renaissance architectural style. As in earlier similar buildings, the facade is a loggia opening onto the street, a sheltered portico where, in this case, parents could anonymously deliver unwanted children to the care of the foundling hospital. Brunelleschi's arcade consists of a series of round arches on slender Corinthian columns. Each bay is a domed compartment with a pediment-capped window above. Both plan and elevation conform

to a module that embodies the rationality of classical architecture. Each column is 10 *braccia* (approximately 20 feet; 1 braccia, or arm, equals 23 inches) tall. The distance between the columns of the facade and the distance between the columns and the wall are also 10 braccia. Thus each of the bays is a cubical unit 10 braccia

8-29 FILIPPO BRUNELLESCHI, loggia of the Ospedale degli Innocenti (Foundling Hospital; looking northeast), Florence, Italy, begun 1419.

The loggia of Florence's orphanage is an early example of Brunelleschi's work as an architect and the first Renaissance building. It features a classically austere design based on a module of 10 braccia.

The mathematical clarity and austerity of the decor of San Lorenzo are key elements inspired architectural style, which contrasts sharply with the soaring drama of Gothic churches.

Filippo Brunelleschi, interior of San Lorence, (looking east), Florence, Italy, ca. 1421–1469.

wide, deep, and high. The height of the columns also equals the diameter of the arches (except in the two outermost bays, which are slightly wider and serve as framing elements in the overall design). The color scheme, which would become a Brunelleschi hallmark, is austere: white stucco walls with gray pietra serena ("serene stone") columns and moldings.

its faith in reason rather than in the emotions. San Lorenzo fully expresses the new Renaissance spirit that placed nave areades and vaults of Gothic churches (for example, FIG. 7-13). but contrasts sharply with the soaring drama and spirituality of the culated logic of the design echoes that of ancient Roman buildings, one over each chapel opening onto the domed aisle bays. The calarcuated clerestory windows and through oculi in the aisle walls, from which round arches spring. Ample light enters through the with a flat, coffered timber roof. The columns support impost blocks nave has a simple two-story elevation (nave arcade and clerestory) nave columns and the dimensions of their Corinthian capitals. The for the church that extended even to the diameter of the shafts of the building, Brunelleschi adopted an all-encompassing modular design orphanage loggia in its austerity and rationality. As in the earlier Medici, embodies the new Renaissance spirit of the Florentine (Saint Lawrence; FIG. 8-30), financed primarily by Giovanni de' SAN LORENZO Begun around 1421, the church of San Lorenzo

PAZZI CHAPEL Shortly after Brunelleschi began work on San Lorenzo, the Pazzi family commissioned him to design the chapel (FIGS. 8-31 and 8-32) they intended to donate to the Franciscan church of Santa Croce in Florence. The project was not completed, however, until the 1460s, long after Brunelleschi's death, and the exterior probably does not reflect his original design. The loggia, admirable as it is, likely was added as an afterthought, perhaps by the sculptor-architect Giuliano da Maiano (1432–1490). The Pazzi Chapel served as the chapter house (meeting hall) of the local chapter

8-31 Filippo Brunelleschi, west facade of the Pazzi Chapel, Santa Croce, Florence, Italy, begun 1433.

The Pazzi family erected this chapel as a gift to the Franciscan church of Santa Croce. It served as the monks' chapter house and is one of the first independent Renaissance central-plan buildings.

of Franciscan monks. Historians have suggested that the monks needed the expansion to accommodate more of their brethren.

Behind the loggia stands one of the first independent Renaissance buildings conceived basically as a central-plan structure (compare FIGS. 4-5 and 4-6), so called because the various aspects of the interior resemble one another, no matter where an observer stands, in contrast to the longitudinal plan of basilican churches. Although the Pazzi Chapel's plan is rectangular, rather than square or round, Brunelleschi placed all emphasis on the central domecovered space. The short barrel-vaulted sections bracing the dome on two sides appear to be incidental appendages.

Circular medallions (tondi or roundels) in the dome's pendentives (see "Placing a Dome over a Square," page 128) consist of terracotta reliefs representing the four evangelists. The technique for manufacturing these baked clay reliefs was of recent invention. Around 1430, Luca Della Robbia (1400–1482) perfected the application of vitrified (heat-fused) colored potters' glazes to sculpture. Inexpensive, durable, and decorative, these ceramic sculptures became extremely popular and provided the basis for a lucrative family business. Luca's nephew Andrea della Robbia (1435–1525)

8-32 FILIPPO BRUNELLESCHI, interior of the Pazzi Chapel (looking southeast), Santa Croce, Florence, Italy, begun 1433.

Although the Pazzi Chapel is rectangular, rather than square or round, Brunelleschi created a central plan by placing all emphasis on the domecovered space at the heart of the building.

produced roundels of babies in swaddling clothes for Brunelleschi's loggia of the Ospedale degli Innocenti (FIG. 8-29) in 1487 (the only indication on the building's facade of its charitable function), and Andrea's sons, Giovanni della Robbia (1469–1529) and Girolamo della Robbia (1488–1566), carried on this tradition well into the 16th century. Most of the tondi in the Pazzi Chapel are the work of Luca della Robbia himself. Together with the images of the 12 apostles on the pilaster-framed wall panels, they add striking color accents to the tranquil interior.

LEON BATTISTA ALBERTI It seems curious that Brunelleschi, the most renowned architect of his time, did not participate in the upsurge of palace building that Florence experienced in the 1430s and 1440s. The Medici rejected his proposal to build a new palace for them, awarding the commission instead to MICHELOZZO DI BARTOLOMMEO (1396–1472). After the Palazzo Medici (FIGS. 8-32A and 8-32B ①), the most important residential commission in mid-15th-century Florence was the Palazzo Rucellai (FIG. 8-33), designed by LEON BATTISTA ALBERTI (1404–1472) and constructed by his pupil and collaborator, BERNARDO ROSSELLINO (1409–1464) using Alberti's plans and sketches. Alberti entered the profession of architecture rather late in life, but made a major contribution to architectural design (see "Leon Battista Alberti's On the Art of Building" ②). Alberti's architectural style represents a scholarly application of classical elements to Renaissance buildings. In the

8-33 Leon Battista Alberti and Bernardo Rossellino, Palazzo Rucellai (looking northwest), Florence, Italy, ca. 1452–1470.

Alberti was an ardent student of classical architecture. By adapting the Roman use of different orders for each story, he created the illusion that the Palazzo Rucellai becomes lighter toward its top.

however, commissions aplenty for artists elsewhere in Italy. some of their major patrons, at least in the short term. There were, and other wealthy families from Florence, deprived local artists of humanism as heretical nonsense, and his banishing of the Medici siasm for classical antiquity. Certainly, Savonarola's condemnation of spirit that moved Savonarola must have dampened Florentine enthu-Florentine culture at the end of the 15th century. But the puritanical sincere monk deny that his actions played a role in the decline of of Savonarola's brief span of power. Apologists for the undoubtedly and philosophical publications. Scholars still debate the significance urged Florentines to burn their classical texts, scientific treatises, Florence and invited the scourge of foreign invasion. Savonarola Medici family's political, social, and religious power had corrupted a large number of his fellow citizens, Savonarola believed that the of the city and of Italy and assumed absolute control of the state. Like Lorenzo de' Medici died in 1492, the priest prophesied the downfall

The Princely Courts

Although Florentine artists led the way in creating the Renaissance in art and architecture, the arts flourished throughout Italy in the 15th century. The papacy in Rome and the princely courts in Urbino, Mantua, and elsewhere also deserve credit for nurturing Renaissance art.

PERUGINO Between 1481 and 1483, Pope Sixtus IV (r. 1414–1484) summoned a group of artists to Rome, including Sandro Botticelli and Pietro Vannucci of Perugia, known as Perugino (ca. 1450–1523), to adorn the walls of the newly completed Sistine Chapel. Perugino's contribution to the fresco cycle was Christ Delivering the Keys of

qualities. the three levels but also emphasizes the wall's flat, two-dimensional Stretched tightly across the front of his building, it not only unifies project from the wall, Alberti created a large-meshed linear net. ancient model's engaged columns into shallow pilasters that barely mass that is so effective in the Roman structure. By converting his facade, which does not allow the deep penetration of the building's Moreover, Alberti adapted the Colosseum's varied surface to a flat employed are, from the bottom up, Tuscan, Ionic, and Corinthian. slavish copyist. On the ancient amphitheater's facade, the capitals modeled his facade on the Colosseum (FIG. 3-30), but he was no the second story, and Corinthian capitals for the third floor. Alberti own invention with acanthus leaves and palmettes (palm leaves) for left], used also by the Romans) for the ground floor, capitals of his columns (the Etruscan variant of the Greek Doric order [FIG. 2-20, ters of each story. He chose the severe capitals of ancient Tuscan the ancient Roman manner of using different capitals for the pilasthe structure becomes lighter in weight toward its top by adapting subdued and uniform wall surfaces. Alberti created the sense that sical cornice crowns the whole. Between the smooth pilasters are Palazzo Rucellai, pilasters define each story of the facade, and a clas-

GIROLAMO SAVONAROLA In the 1490s, Florence underwent a political, cultural, and religious upheaval. Florentine artists and their fellow citizens responded then not only to humanist ideas but also of the incursion of French armies and especially to the preaching of the Dominican monk Girolamo Savonarola (1452–1498), the reforming priest-dictator who denounced the humanistic secularism of the Medici and their artists, philosophers, and poets. Savonarola appealed to the people of Florence to repent their sins, and when

8-34 Perugino, Christ Delivering the Keys of the Kingdom to Saint Peter, Sistine Chapel, Vatican City, Rome, Italy, 1481-1483. Fresco, $11^{\circ}5\frac{1}{2}^{\circ}\times18^{\circ}8\frac{1}{2}^{\circ}$.

Painted for the Vatican, this fresco depicts the event on which the papacy bases its authority. The converging lines of the pavement connect the action in the foreground with the background.

the Kingdom to Saint Peter (FIG. 8-34). The papacy had, from the beginning, based its claim to infallible and total authority over the Roman Catholic Church on this biblical event. In Perugino's fresco, Christ hands the keys to Saint Peter, who stands amid an imaginary gathering of the 12 apostles and Renaissance contemporaries. These figures occupy the apron of a great stage space that extends into the distance to a point of convergence in the doorway of a central-plan temple. (Perugino used parallel and converging lines in the pavement to mark off the intervening space; compare FIG. 8-16.) The smaller figures in the middle distance enhance the sense of depth and also act out important New Testament stories—for example (at the left), the episode of Jesus, Peter, and the tribute money (compare FIG. 8-21). At the corners of the great plaza, duplicate triumphal arches serve as the base angles of a distant compositional triangle whose apex is in the central building. Perugino modeled the arches very closely on the Arch of Constantine (FIG. 3-53) in Rome. Although they are anachronisms in a painting depicting a scene from Jesus's life, the arches served to underscore the close ties between Saint Peter and Constantine, the first Christian emperor of Rome and builder of the great basilica (FIG. 4-3) over Saint Peter's tomb. Christ and Peter flank the triangle's central axis, which runs through the temple's doorway, the vanishing point of Perugino's perspective scheme. Thus the composition interlocks both twodimensional and three-dimensional space, and the placement of the central actors emphasizes the axial center.

URBINO Under the patronage of Federico da Montefeltro (1422–1482), Urbino, southeast of Florence across the Apennines (MAP 8-2), became an important center of Renaissance art and culture. In fact, the humanist writer Paolo Cortese (1465–1540) described Federico as one of the two greatest artistic patrons of the 15th century (the other was Cosimo de' Medici). Federico was so renowned for his military expertise that he was in demand by popes and kings, and soldiers came from across Europe to study under his direction.

One of the artists who received several commissions from Federico was Piero della Francesca (ca. 1420-1492), who had already established a major reputation in his native Tuscany with works such as Resurrection (FIG. 8-34A 1), a life-size fresco he painted in the town hall of his birthplace, Borgo San Sepolcro. At the Urbino court, Piero produced both religious works and official portraits for Federico, among them a double portrait (FIG. 8-35) of the count and his second wife, Battista Sforza (1446-1472), whom he married in 1460 when she was 14 years old. The daughter of Alessandro Sforza (1409-1473), lord of Pesaro and brother of the duke of Milan, Battista was a well-educated humanist who proved to be an excellent administrator of Federico's territories during his frequent military campaigns. She gave birth to eight daughters in 11 years and finally, on January 25, 1472, to the male heir for which the couple had prayed. When the countess died of pneumonia five months later at age 26, Federico went into mourning for virtually the rest of his life. He never remarried.

Federico commissioned Piero to paint their double portrait shortly after Battista's death to pay tribute to her and to have a memento of their marriage. The present frame is a 19th-century addition. Originally, the two portraits formed a hinged diptych. The format—two bust-length portraits with a landscape background followed Flemish models (FIG. 8-6A 1), as did Piero's use of oil-based pigment. But the Italian artist depicted the Urbino count and countess in profile, in part to emulate the profile portraits on Roman coins, which Renaissance humanists avidly collected, and in part to conceal the disfigured right side of Federico's face. (He lost his right eye and part of the bridge of his nose in a tournament in 1450.) Piero probably based Battista's portrait on her death mask, and the pallor of her skin may be a reference to her death. The backs of the panels also bear paintings. They represent Federico and Battista in triumphal chariots accompanied by personifications of their respective virtues, including Justice, Prudence, and Fortitude (Federico) and Faith, Charity, and Chastity (Battista). The placement of scenes of triumph on the reverse of profile portraits also emulates ancient Roman coinage.

8-35 PIERO DELLA FRANCESCA, Battista Sforza and Federico da Montefeltro, ca. 1472–1474. Oil and tempera on wood in modern frame, each panel 1' $6\frac{1}{2}$ " × 1' 1". Galleria degli Uffizi, Florence.

Piero's portraits of Federico da Montefeltro and his recently deceased wife, Battista Sforza, combine the profile views on Roman coins with the landscape backgrounds of Flemish portraiture (FIG. 8-6A 1).

8-37 Leon Battista Alberti, interior of Sant'Andrea (looking east), Mantua, Italy, designed 1470, begun 1472.

For the nave of Sant'Andrea, Alberti abandoned the traditional columnar arcade. The tremendous vaults suggest that Constantine's Basilica Mova (Fig. 3-52) in Rome may have served as a prototype.

are the same height as those on the nave's interior walls, and the large barrel vault over the central portal, with smaller barrel vault branching off at right angles, introduces on a smaller scale the arrangement of the church's nave and aisles. The facade pilasters, as part of the wall, run uninterrupted through three stories in an early application of the colossal or giant order that became a favorite motif of Michelangelo (FIG. 9-14).

Baroque church planning. a thousand years was extremely influential in later Renaissance and This break with a Christian building tradition that had endured for huge hall with independent chapels branching off at right angles. from the faithful in the aisles. For this reason, he designed a single nave) as impractical because the colonnades conceal the ceremonies ditional basilican plan (with continuous aisles flanking the central Roman temple. In On the Art of Building, Alberti criticized the trati's design because at that time it was erroneously thought to be a Nova (FIG. 3-52), which may have served as a prototype for Albermasses of Roman architecture, especially Constantine's Basilica vaulted interior calls to mind the vast spaces and dense enclosing dome over the crossing, support the huge coffered barrel vault. The walls alternating with vaulted chapels, interrupted by a massive arcade that Brunelleschi still used in San Lorenzo (FIG. 8-30). Thick Inside (FIG. 8-37), Alberti abandoned the medieval columned

ANDREA MANTEGNA Like other princes, Ludovico Gonzaga believed that an impressive palace was an important visual expression of his authority. One of the most spectacular rooms in the Palazzo Ducale (Ducal Palace) in Mantua is the so-called Camera

8-36 Leon Battista Alberti, west facade of Sant'Andrea, Mantua, Italy, designed 1470, begun 1472.

Alberti's design for Sant'Andrea reflects his study of ancient Roman architecture. Employing the colossal order, the architect combined a triumphal archand a Roman temple front with pediment.

MANTUA Marquis Ludovico Gonzaga (1412–1478) ruled Mantua in northeastern Italy (MAP 8-2) during the mid-15th century. A famed condottiere like Federico da Montefeltro, Gonzaga established his reputation as a fierce military leader while general of the Milanese armies. The visit of Pope Pius II (r. 1458–1464) to Mantua in 1459 stimulated the marquis's determination to transform his city into one that all Italy would envy.

dences to the building do exist in Sant'Andrea's facade. The pilasters continuity with the body of the building. Yet structural corresponrelation to the small square in front of it, even at the expense of purely visual proportionality in the facade but also to the facade's sance architects made this concession not only to the demands of a Because of the primary importance of visual appeal, many Renaisfacade, which left it considerably shorter than the church behind it. led him to equalize the vertical and horizontal dimensions of the nious design. The Renaissance architect's concern for proportion there is no close parallel in antiquity for Alberti's eclectic and ingepediment over the arcuated passageway and engaged columns, but Italy. For example, many Roman triumphal arches incorporated a bination was already a feature of Roman buildings still standing in tectural motifs—the temple front and the triumphal arch. The comthat Alberti designed incorporated two major ancient Roman archi-Battista Alberti for this important commission. The facade (FIG. 8-36) ing of Sant'Andrea, an 11th-century church. Gonzaga turned to Leon One of the major projects Gonzaga instituted was the rebuild-

8-38 Andrea Mantegna, interior of the Camera Picta, Palazzo Ducale, Mantua, Italy, 1465–1474. Fresco.

Working for Ludovico Gonzaga, who established Mantua as a great art city, Mantegna produced for the duke's palace the first completely consistent illusionistic decoration of an entire room.

degli Sposi (Room of the Newlyweds), originally the Camera Picta (Painted Room; FIGS. 8-38 and 8-39). Andrea Mantegna (ca. 1431–1506) of Padua took almost nine years to complete the room's extensive fresco program, which celebrates Ludovico Gonzaga and his family. Any viewer standing in the Camera Picta, surrounded by the spectacle and majesty of courtly life, cannot help but be thoroughly impressed by both the commanding presence and elevated status of the patron and the dazzling artistic skills of Mantegna.

In the Camera Picta, Mantegna performed a triumphant feat by producing the first completely consistent illusionistic decoration of an entire room. By integrating real and painted architectural elements, Mantegna illusionistically dissolved the room's walls in a manner foretelling 17th-century Baroque decoration (see page 295). The Camera Picta recalls the efforts more than 15 centuries earlier by Italian painters on the Bay of Naples to integrate mural painting and architecture in frescoes of the Second Style of Roman painting (FIG. 3-20). Mantegna's *trompe l'oeil* (French, "deceives the eye") design, however, went far beyond anything preserved from ancient Italy. The Renaissance painter's daring experimentalism led him to complete the room's decoration with the first perspective of a ceiling

8-39 Andrea Mantegna, ceiling of the Camera Picta, Palazzo Ducale, Mantua, Italy, 1465–1474. Fresco, 8' 9" in diameter.

Inside the Camera Picta, the viewer becomes the viewed as figures gaze into the room from a painted oculus opening onto a blue sky. This is the first perspective view of a ceiling from below.

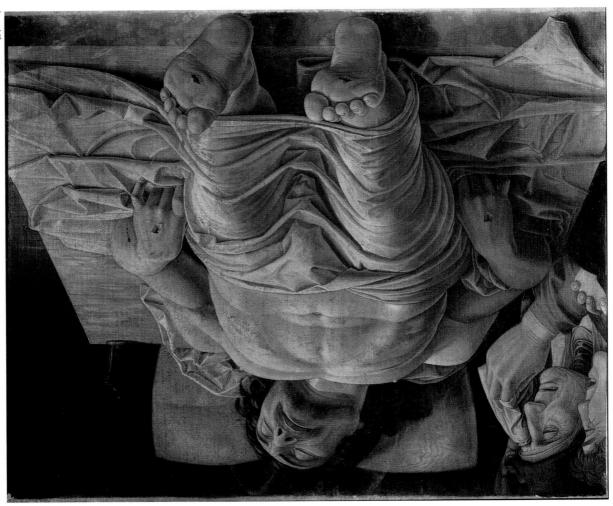

8-40 Andrea Mantegna, Foreshortened Christ, ca. 1500. Tempera on canvas, $2^{1}\sqrt{2}^{3} \times 2^{1}\sqrt{8}^{7}$. Pinacoteca di Brera, Milan.

In this work of overwhelming emotional power, Mantegna presented both a harrowing study of a strongly foreshortened cadaver and an intensely poignant depiction of a biblical tragedy.

MILAN The leading city of northwestern Italy at this time was Milan, ruled by the powerful Sforza family, which also sought to lure the best artists to its court. In 1481, Ludovico Sforza (1451–1508) accepted a proposal from Leonardo da Vinci that the famed artist leave Florence for Milan to work for the Milanese court as military engineer, architect, sculptor, and painter. Several of Leonardo's early masterworks, including his world-famous Last Supper (Fig. 9-3), date to the closing years of the 15th century when he was in Milan. A discussion of Leonardo's Milanese career opens the examination of High Renaissance art in the next chapter.

(FIG. 8-39) seen from below (called, in Italian, di sotto in sui, "from below upward"). Baroque ceiling decorators later broadly developed this technique. Inside the Camera Picta, the viewer becomes the viewed as figures look down into the room from the painted oculus. Seen against the convincing illusion of a cloud-filled blue sky, several putti (cupids), strongly foreshortened, set the amorous mood of the Room of the Newlyweds, as the painted smiling spectators look into the room. The prominent peacock is an attribute of Juno, Jupiter's bride, who oversees lawful matriages. This brilliant feat of illusionism is the climax of decades of experimentation with perspective.

Explore the era further in MindTap with videos of major artworks and

power as well as another example of the artist's mastery of perspec-

FORESHORTENED CHRIST One of Mantegna's later paintings, Foreshortened Christ (Fig. 8-40), is a work of overwhelming emotional

Explore the era further in Mind lab with Mideos of Major altworks and buildings, Google EarthTM coordinates, and essays by the author on the following additional subjects:

[■] ART AND SOCIETY: The Artist's Profession during the Renaissance

Hans Memling, Diptych of Martin van Nieuwenhove (FIG. 8-6A)

Buxheim Saint Christopher (FIG. 8-11A)

[■] WRITTEN SOURCES: The Commentarii of Lovenzo Ghiberti • Michelozzo di Bartolommeo, Palazzo Medici-Riccardi (FIGS. 8-32A and

⁸⁻³²B)

[■] PRTISTS ON ART: Leon Battista Alberti's On the Art of Building Piero della Francesca, Resurrection (FIG. 8-34A)

tive. At first glance, this painting seems to be a strikingly realistic study in foreshortening. However, Mantegna reduced the size of Christ's feet, which, as the painter surely knew, would cover much of the Savior's body if properly represented according to Renaissance perspective rules. Thus, tempering naturalism with artistic license, Mantegna presented both a harrowing study of a strongly foreshortened cadaver and an intensely poignant depiction of a biblical tragened cadaver and an intensely poignant depiction of a biblical tragedy. Remarkably, in the supremely gifted hands of Mantegna, all of Quattrocento science here served the purpose of devotion.

THE EARLY RENAISSANCE IN EUROPE

Burgundy and Flanders

- The most powerful rulers north of the Alps during the first three-quarters of the 15th century were the dukes of Burgundy. Philip the Bold's greatest artistic project was the Chartreuse de Champmol. The head sculptor was Claus Sluter of Haarlem, who carved portraitlike statues of biblical figures.
- Flemish artists popularized the use of oil paints on wood panels. By superimposing translucent glazes, painters could create richer colors than possible using tempera or fresco. An early example is Robert Campin's *Mérode Altarpiece*, in which the everyday objects depicted have symbolic significance.
- Jan van Eyck, Rogier van der Weyden, and Hans Memling established portraiture, a rare genre during the Middle Ages, as an important art form in 15th-century Flanders.

Sluter, Well of Moses, 1395-1406

France and the Holy Roman Empire

- The Limbourg brothers expanded the illusionistic capabilities of manuscript illumination with full-page calendar pictures depicting naturalistic settings in the Book of Hours of Jean, duke of Berry.
- The major German innovation of the 15th century was the development of the printing press, which printers soon used to produce books with woodcut illustrations. Woodcuts are relief prints in which the artist carves out the areas around the lines to be printed. German artists, such as Martin Schongauer, were also the earliest masters of engraving. This intaglio technique enables a wider variety of linear effects because the artist incises the image directly onto a metal plate.

Limbourg brothers, Les Très Riches Heures du Duc de Berry, 1413-1416

Italy

- The fortunate congruence of artistic genius, the spread of humanism, and economic prosperity nourished the flowering of the artistic culture that historians call the Renaissance—the rebirth of classical values in art and life. The greatest center of Quattrocento Renaissance art was Florence, home of the powerful Medici, who were among the most ambitious art patrons in history.
- Some of the earliest examples of the new Renaissance style in sculpture are by Donatello: Saint Mark, which introduced the classical concept of contrapposto into Renaissance statuary; David, the first nude male statue since antiquity; and Gattamelata, modeled on imperial Roman equestrian portraits.
- Masaccio's figures recall Giotto's, but have a greater psychological and physical credibility, and the light shining on them comes from a source outside the picture. His Holy Trinity owes its convincing illusionism to Filippo Brunelleschi's new science of linear perspective. The humanist love of Greco-Roman themes comes to the fore in the paintings of Sandro Botticelli.
- Italian architects also revived the classical style. Brunelleschi's San Lorenzo conforms to a strict modular scheme and showcases the Roman-inspired rationality of Quattrocento Florentine architecture.
- Although Florentine artists led the way in creating the Renaissance in art and architecture, the papacy in Rome and the princely courts in Urbino and Mantua also were major art patrons. Among the important papal commissions of the 15th century was the decoration of the walls of the Sistine Chapel with frescoes, including Perugino's Christ Delivering the Keys of the Kingdom to Saint Peter, a prime example of the application of linear perspective.
- Mantua became an important art center under Marquis Ludovico Gonzaga, who brought leading artists, such as Piero della Francesca, to his court. Gonzaga also commissioned Leon Battista Alberti to rebuild Sant'Andrea, in which the architect applied the principles he developed in his influential 1450 treatise On the Art of Building and freely adapted forms from ancient Roman religious, triumphal, and civic architecture.

Donatello, Gattamelata, ca. 1445-1453

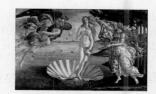

Botticelli, Birth of Venus, ca. 1484-1486

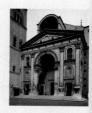

Alberti, Sant'Andrea, Mantua, 1470

■ 9-1a Michelangelo, the Renaissance genius who was primarily a sculptor, reluctantly spent almost four years painting the ceiling of the Sistine Chapel under commission from Pope Commission from Pope Julius II.

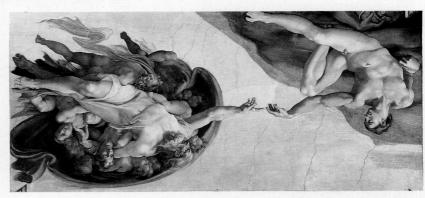

► 9-1b The fresco cycle illustrates the creation and fall of humankind as related in Genesis. Michelangelo always painted with a sculptor's eye. His heroic figures resemble painted statues.

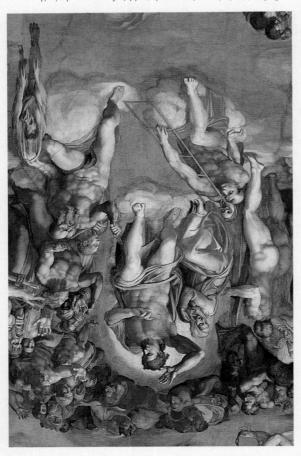

■ **9-1c** Michelangelo completed his freaco cycle in the Sistine Chapel for another pope—Paul III—with this terrifying vision of the fate awaiting sinners. The Last Judgment includes his self-portrait.

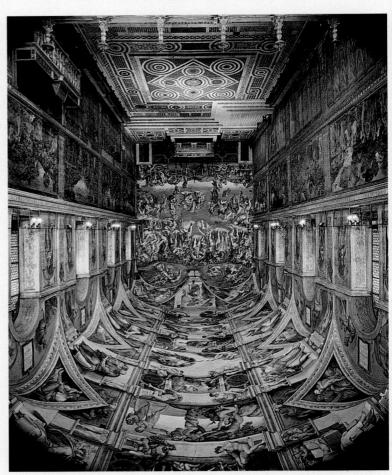

Interior of the Sistine Chapel (looking west), Vatican City, Rome, Italy, built 1473; ceiling and altar wall frescoes by Michele Buonargori, 1508–1512 and 1536–1541, respectively.

High Renaissance and Mannerism in Europe

MICHELANGELO IN THE SERVICE OF JULIUS II

The first artist in history whose exceptional talent and brooding personality matched today's image of the temperamental artistic genius was MICHELANGELO BUONARROTI (1475–1564). The Florentine artist's self-imposed isolation, creative furies, proud independence, and daring innovations led Italians of his era to speak of the charismatic personality of the man and the expressive character of his works in one word—*terribilità*, "the sublime shadowed by the fearful." Yet, unlike most modern artists, who create works in their studios and offer them for sale later, Michelangelo and his contemporaries produced most of their paintings and sculptures under contract for wealthy patrons who dictated the content—and sometimes the form—of their artworks.

In Italy in the 1500s—the *Cinquecento*—the greatest art patron was the Catholic Church, headed by the pope in Rome. Michelangelo's most famous work today—the ceiling of the Sistine Chapel (FIG. 9-1) in the Vatican—was, in fact, a commission he did not want. His patron was Julius II (r. 1503–1513), an immensely ambitious man who sought to extend his spiritual authority into the temporal realm, as other medieval and Renaissance popes had done. Julius selected his name to associate himself with Julius Caesar, and found inspiration in ancient Rome. His enthusiasm for engaging in battle earned Julius the designation "warrior-pope," but his 10-year papacy was most notable for his patronage of the arts. Julius fully appreciated the propagandistic value of visual imagery and, upon his election, immediately commissioned artworks that would present an authoritative image of his rule and reinforce the primacy of the Catholic Church.

When Julius asked Michelangelo to take on the challenge of providing frescoes for the ceiling of the Sistine Chapel, the artist insisted that painting was not his profession—a protest that rings hollow after the fact, but Michelangelo's major works until then had been in sculpture. The artist had no choice, however, but to accept the pope's assignment.

In the Sistine Chapel frescoes, as in his sculptures, Michelangelo relentlessly concentrated his expressive purpose on the human figure. To him, the body was beautiful not only in its natural form but also in its spiritual and philosophical significance. The body was the manifestation of the character of the soul. In the *Creation of Adam* (FIG. 9-1a), *Fall of Man* (FIG. 9-1b), and *Last Judgment* (FIG. 9-1c) frescoes, Michelangelo represented the body in its most elemental aspect—in the nude or simply draped, with almost no background and no ornamental embellishment. He always painted with a sculptor's eye for how light and shadow reveal volume and surface. It is no coincidence that many of the figures in the Sistine Chapel seem to be painted statues.

YJATI

"Michelangelo in the Service of Julius II," page 251). works freely, but had to satisfy the demands of their patrons (see Raphael, and Michelangelo, although even they could not create artthe first time. None achieved greater fame than Leonardo da Vinci, the High Renaissance, artists became international celebrities for celebration of artistic genius originated in Renaissance Italy. During

Leonardo da Vinci

made him a better painter. For example, his in-depth exploration (FIG. 9-1A (A)). Leonardo believed that his scientific investigations making, zoology, military engineering, hydraulics, and anatomy in his notebooks dealing with botany, geology, geography, mapity is evident in the voluminous notes he interspersed with sketches one of Leonardo's innumerable interests. His unquenchable curios-(1452-1519) was the quintessential "Renaissance man." Art was but Born in the small town of Vinci, near Florence, Leonardo da Vinci produced. Indeed, the modern notion of the "fine arts" and the ing quality, both technical and aesthetic, of the art and architecture FIG. 3-40). The one constant in 16th-century Italy is the astound-Raphael had been laid to rest (inside the ancient Roman Pantheon, Mannerism, challenged Renaissance naturalism almost as soon as of the 16th century (the Late Renaissance), but a new style, called tive, proportion, and human anatomy dominated the remainder The Renaissance style and the interest in classical culture, perspecand the deaths of Leonardo da Vinci in 1519 and Raphael in 1520. ans call the High Renaissance—the quarter century between 1495 and Venice. The period opened with the brief era that art historiabounded, especially between central Italy (Florence and Rome) gle artistic style characterized Cinquecento art. Regional differences foundation of the Early Renaissance of the 15th century, but no sin-The art and architecture of 16th-century Italy (MAP 9-1) built on the

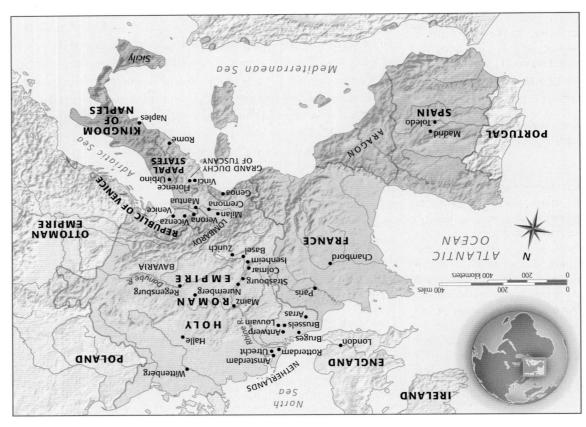

MAP 9-1 Europe in the early 16th century.

HIGH RENAISSANCE AND MANNERISM IN EUROPE

- Mannerist painter. Tintoretto is the leading Venetian
- uniquely personal mix of Byzantine and creates paintings that are a Greek-born El Greco settles in Toledo tions for Mannerist statuary groups. Giambologna uses spiral composi-

hybrid style captures the fervor of

Spanish Catholicism.

- and Italian Mannerist elements. His Architects. Most Eminent Painters, Sculptors, and Giorgio Vasari publishes Lives of the tect of the Venetian Republic. Andrea Palladio becomes chief archi-
- less focus on human activities. masterful landscapes that nonethe-■ Pieter Bruegel the Elder produces

art as part of the Catholic Church's

■ The Council of Trent defends religious

Counter-Reformation.

5/51-0551

- Mannerism emerges as an alternapioneer colorito and poesia in oil ■ In Venice, Giorgione and Titian
- of Pontormo, Parmigianino, Bronzino, painting and architecture in the work tive to the High Renaissance style in
- of everyday life. ing religious messages into paintings Netherlandish painters inject moralizand Giulio Romano.
- Michelangelo. are Leonardo da Vinci, Raphael, and Renaissance in Florence and Rome The leading artists of the High

1495-1520

- classical style in architecture. In Rome, Bramante champions the
- secular to religious themes. Protestant values, art patrons prefer In northern Europe, consistent with
- celebrity outside Italy. becomes the first international art Albrecht Dürer, master printmaker,

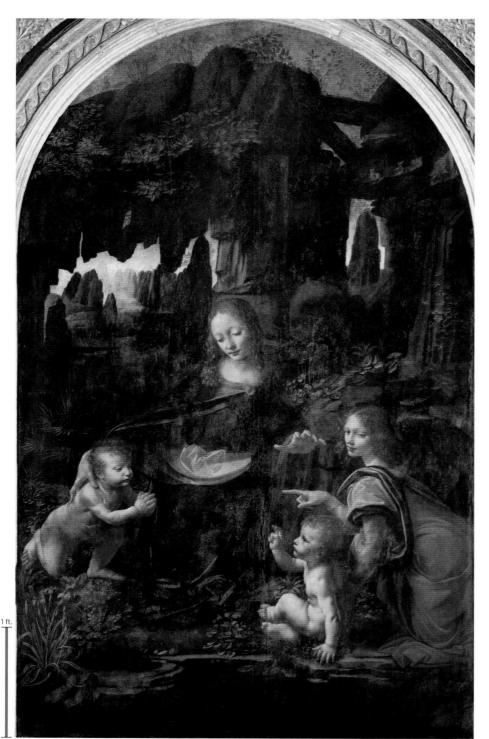

of optics provided him with an understanding of perspective, light, and color. Indeed, Leonardo's scientific drawings (see "Renaissance Drawings" \checkmark) are themselves artworks.

Leonardo's great ambition in both his scientific endeavors and his art was to discover the laws underlying the processes and flux of nature. With this end in mind, he also studied the human body and contributed immeasurably to knowledge of physiology and psychology. Leonardo believed that reality in an absolute sense is inaccessible and that humans can know it only through its changing images. He considered the eyes the most vital organs and sight the most essential function (see "Leonardo and Michelangelo on Painting versus Sculpture" (1).

9-2 LEONARDO DA VINCI, Madonna of the Rocks, from San Francesco Grande, Milan, Italy, 1483–1490. Oil on wood (transferred to canvas), 6' $6\frac{1}{2}$ " × 4'. Musée du Louvre, Paris.

Leonardo used gestures and a pyramidal composition to unite the Virgin, John the Baptist, the Christ Child, and an angel. The figures share the same light-infused environment.

Around 1481, Leonardo left Florence after offering his services to Ludovico Sforza (1451–1508), the son and heir apparent of the ruler of Milan. The political situation in Florence was uncertain, and Leonardo must have felt that his particular skills would be in greater demand at the court of Milan, where he hoped to achieve financial security. The letter that Leonardo wrote to Ludovico seeking employment is revealing. The artist focused on his qualifications as a military engineer, mentioning only at the end his abilities as a painter and sculptor:

And in short, according to the variety of cases, I can contrive various and endless means of offence and defence. . . . In time of peace I believe I can give perfect satisfaction and to the equal of any other in architecture and the composition of buildings, public and private; and in guiding water from one place to another. . . . I can carry out sculpture in marble, bronze, or clay, and also I can do in painting whatever may be done, as well as any other, be he whom he may. I

Ludovico agreed to hire Leonardo, although he did not offer him a salaried position until several years later.

MADONNA OF THE ROCKS Shortly after settling in Milan, Leonardo painted Madonna of the Rocks (FIG. 9-2) as the center panel of an altarpiece in San Francesco Grande. Leonardo presented the Madonna, Christ Child, infant John the Baptist, and angel in a pyramidal grouping. The four figures pray, point, and bless, and these acts and gestures, although

their meanings are uncertain, visually unite the individuals portrayed. The angel points to the infant John and, through his outward glance, involves the viewer in the scene. John prays to the Christ Child, who blesses him in return. The Virgin herself completes the series of interlocking gestures, her left hand reaching toward her son and her right hand resting protectively on John's shoulder. A tender mood suffuses the entire composition. Nonetheless, Leonardo's most notable achievement in *Madonna of the Rocks* was to paint the figures sharing the same light-infused environment, made possible by his deep understanding of *chiaroscuro*. The biblical figures emerge through nuances of light and shade from the half-light of the mysterious cavernous landscape.

architectural framework, and it serves here, along with the diffused light, as a halo. Jesus's head is the focal point of all converging perspective lines in the composition. Thus the still, psychological focus and cause of the action is also the perspective focus, as well as the center of the two-dimensional surface. The two-dimensional, the three-dimensional, and the psychodimensional focuses are the same. Leonardo presented the agitated disciples in four groups of

roles. In this work, as in his other religious paintings, Leonardo fully, and scrupulously cast his actors as the Bible described their type of emotion. Like a stage director, he read the Gospel story carethat he thought of each figure as carrying a particular charge and nardo's numerous preparatory studies—using live models—suggest responses, including fear, doubt, protestation, rage, and love. Leoand intensifies it. The disciples register a broad range of emotional tion, which is more intense closer to Jesus, whose serenity both halts quieter than the others, as if to bracket the energy of the composion the table" (Luke 22:21). The two disciples at the table ends are tion: "But yet behold, the hand of him that betrayeth me is with me his right hand as he reaches his left forward to fulfill Jesus's declararefectory. Judas's face is in shadow, and he clutches a money bag in The light source in the painting corresponds to the windows in the of the table as Jesus and the other disciples (compare FIG. 8-24). torial and dramatic consistency by placing Judas on the same side and postures. The artist sacrificed traditional iconography to picthree, united among and within themselves by the figures' gestures

LAST SUPPER For Ludovico Sforza, Leonardo painted Last Supper (PIG. 9-3) in the refectory of Santa Maria delle Grazie in Milan. The mural—Leonardo's most impressive work, both formally and emotionally—is unfortunately in a poor state, in part because, in a bold experiment, instead of using fresco, which has a matte finish, Leonardo mixed oil and tempera, and he applied the colors a secco (to dried, rather than wet, plaster). Consequently, the paint quickly began to flake. The humidity of Milan further accelerated

the deterioration.

Jesus and his 12 disciples sit at a long table placed parallel to the picture plane in a simple, spacious room. The austere setting amplifies the painting's highly dramatic action. Jesus, with outstretched hands, has just said, "One of you is about to betray me" (Matt. 26:21). A wave of intense excitement passes through the group as each disciple asks himself and, in some cases, his neighbor, "Is it I?" (Matt. 26:22). Leonardo linked Jesus's dramatic statement about betrayal with the initiation of the ancient liturgical ceremony of the Eucharist, when Jesus, blessing bread and wine, said, "This is my body, which is given for you. Do this for a commemoration of me.... This is the chalice, the new testament in my blood, which shall be shed for you" (Luke 22:19–20).

In the center, Jesus appears isolated from the disciples and in perfect repose, the calm eye of the swirling emotion around him. The central window at the back, whose curved pediment arches above his head, frames his figure. The pediment is the only curve in the

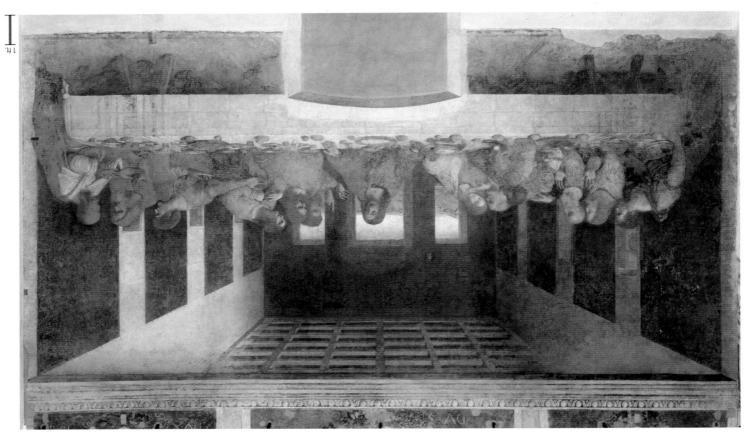

9-3 Leonardo da Vinci, Last Supper, ca. 1495-1498. Oil and tempera on plaster, 13' 9" \times 29' 10". Refectory, Santa Maria delle Grazie, Milan.

Jesus has just announced that one of his disciples will betray him, and each one reacts. He is both the psychological focus of Leonardo's fresco and the focal point of all the converging perspective lines.

revealed his extraordinary ability to apply his voluminous knowledge about the observable world to the pictorial representation of a religious scene, resulting in a psychologically complex and compelling painting.

MONA LISA Leonardo's Mona Lisa (FIG. 9-4) is probably the world's most famous portrait. In his biography of Leonardo, Giorgio Vasari (see "Giorgio Vasari's Lives"

→ identified the woman portrayed as Lisa di Antonio Maria Gherardini, the wife of Francesco del Giocondo, a wealthy Florentine—hence, "Mona (an Italian contraction of ma donna, "my lady") Lisa." Unlike earlier portraits, Leonardo's representation of Gherardini does not serve solely as an icon of status but is a convincing likeness of a specific individual. Indeed,

9-4 Leonardo da Vinci, *Mona Lisa*, ca. 1503–1505. Oil on wood, 2' $6\frac{1}{4}$ " × 1' 9". Musée du Louvre, Paris.

Leonardo's skill with chiaroscuro and atmospheric perspective is on display in this new kind of portrait depicting the sitter as an individual personality who engages the viewer psychologically.

Mona Lisa wears no jewelry and holds no attribute associated with wealth. She sits quietly, her hands folded, her mouth forming a gentle smile, and her gaze directed at the viewer. Renaissance etiquette dictated that a woman should not look directly into a man's eyes. Leonardo's portrayal of this self-assured young woman without the trappings of power but engaging the audience psychologically was unprecedented.

The enduring appeal of *Mona Lisa* also derives in large part from Leonardo's decision to set his subject against the backdrop of a mysterious uninhabited landscape. This setting, with roads and bridges seemingly leading nowhere, recalls that of his *Madonna of the Rocks* (FIG. 9-2). The composition also resembles Fra Filippo Lippi's *Madonna and Child with Angels* (FIG. 8-25) with figures seated in

front of a window through which the viewer glimpses a distant landscape. Originally, the artist represented Gherardini in a loggia. A later owner trimmed the painting, eliminating the columns, but partial column bases remain to the left and right of Mona Lisa's shoulders. The painting is darker today than it was 500 years ago, and the colors are less vivid, but *Mona Lisa* still reveals Leonardo's fascination and skill with chiaroscuro and atmospheric perspective. The portrait is a prime example of Leonardo's famous smoky *sfumato* (misty haziness)—his subtle adjustment of light and blurring of precise planes.

ARCHITECTURE AND SCULPTURE Leonardo also won renown in his time as both architect and sculptor, although no extant building or sculpture can be definitively attributed to him. From his many drawings of central-plan structures, it is evident that he shared the interest of other Renaissance architects in this building type. As for Leonardo's sculptures, numerous drawings of equestrian statues survive, and he made a full-scale model for a monument to Francesco Sforza (1401–1466), Ludovico's father. The French used the statue as a target and shot it to pieces when they occupied Milan in 1499. Leonardo left Milan at that time and served for a while as a military engineer for Cesare Borgia (1476-1507), who, with the support of his father, Pope Alexander VI (r. 1492-1503), tried to conquer the cities of the Romagna region in north-central Italy and create a Borgia duchy. Leonardo eventually returned to Milan in the service of the French. At the invitation of King Francis I (see page 277), he then went to France, where he died at Cloux in 1519.

Raphael

Alexander VI's successor was Julius II (see page 251). In 1508, the new pope called Raffaello Santi (or Sanzio), known as Raphael (1483–1520) in English, to the Vatican, which would soon displace Florence, Urbino, Mantua, and Milan as the leading center of Renaissance art. Born in a small town in Umbria, Raphael probably learned the basics of his art from his father, Giovanni Santi (d. 1494), before entering the studio of Perugino (FIG. 8-34). Although strongly influenced by Perugino and Leonardo, Raphael developed an individual style that embodied the ideals of High Renaissance art.

under the headings Theology, Law (Justice), Poetry, and Philosophy—the learning required of a Renaissance pope. Given Julius II's desire for recognition as both a spiritual and temporal leader, it is appropriate that the Theology and Philosophy frescoes face each other. The two images present a balanced picture of the pope—as a cultured, knowledgeable individual and as a wise, divinely ordained religious authority.

globes, Raphael included his self-portrait. of the astronomers Zoroaster and Ptolemy, both holding mante (FIG. 9-12). At the extreme right, just to the right theorem. Euclid may be a portrait of the architect Brathe right, students surround Euclid, who demonstrates a angelo) broods alone. Diogenes sprawls on the steps. At foreground, Heraclitus (probably a portrait of Michelras writes as a servant holds up the harmonic scale. In the matters, such as mathematics. At the lower left, Pythagothe philosophers and scientists concerned with practical this world, stand on Plato's side. On Aristotle's side are concerned with the ultimate mysteries that transcend reality sprang. Appropriately, ancient philosophers, men tures toward the earth, from which his observations of Aristotle carries his book Nichomachean Ethics and gespoints to Heaven, the source of his inspiration, while arranged the others. Plato holds his book Timaeus and are the central figures around whom Raphael carefully of wisdom, oversee the interactions. Plato and Aristotle ues of Apollo and Athena, patron deities of the arts and rel vaults of the Basilica Nova (FIG. 3-52). Colossal statancient Roman architecture, especially the coffered barting is a vast hall covered by massive vaults that recall and explaining their various theories and ideas. The setwise men, revered by Renaissance humanists, conversing tists of the ancient world. Raphael depicted these famous but a congregation of the great philosophers and scien-School of Athens, FIG. 9-6), the setting is not a "school" In Raphael's Philosophy mural (commonly called

The groups appear to move easily and clearly, with eloquent poses and gestures that symbolize their doctrines and present an engaging variety of figural positions. The self-assurance and natural dignity of the figures convey on, balance, and measure—the qualities that Renaissance on.

calm reason, balance, and measure—the qualities that Renaissance thinkers admired as the heart of philosophy. Significantly, Raphael placed himself among the mathematicians and sciencists in *School of Athens*. Certainly, the evolution of pictorial science approached perfection in this fresco in which Raphael convincingly depicted a vast space on a two-dimensional surface.

School of Athens also reveals Raphael's psychological insight along with his mastery of the problems of physical representation. As in Leonardo's Last Supper (Fig. 9-3), all the characters communicate moods that reflect their beliefs, and the artist's placement of each figure tied these moods together. From the center, where Plato and Aristotle stand, Raphael arranged the groups of figures in an ellipse with a wide opening in the foreground. Moving along the floor's perspective pattern, the viewer's eye penetrates the assembly of philosophers and continues, by way of the reclining Diogenes, up to the here-reconciled leaders of the two great opposing camps of Renaissance philosophy. The vanishing point falls on Plato's left band, drawing attention to Timaeus. In the Stanza della Segnatura, Raphael reconciled and harmonized not only the Platonists and Aristotelians but also classical humanism and Christianity.

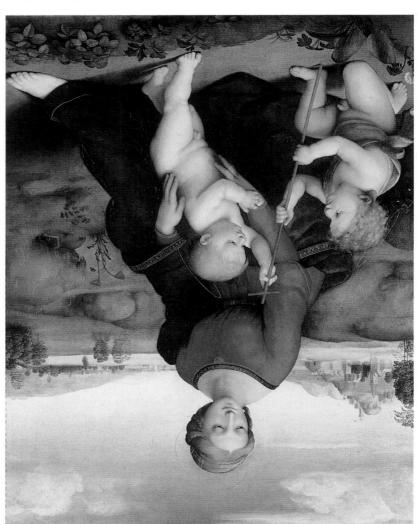

9-5 Raphael, Madonna in the Meadow, 1505–1506. Oil on wood, 3' $8\frac{1}{2}$ " x 2' $10\frac{1}{4}$ ". Kunsthistorisches Museum, Vienna.

Emulating Leonardo's pyramidal composition (FIG. 9-2) but rejecting his dusky modeling and mystery, Raphael set his Madonna in a well-lit landscape and imbued her with grace, dignity, and beauty.

MADONNA IN THE MEADOW Raphael worked in Florence from 1504 to 1508, where he painted Madonna in the Meadow (FIG. 9-5), in which he adopted Leonardo's pyramidal composition and modeling of faces and figures in subtle chiaroscuro. But Raphael retained Perugino's lighter tonalities and blue skies, preferring clarity to obscurity, not fascinated, as Leonardo was, with mystery. Raphael quickly achieved fame for his Madonnas, which depict Mary as a beautiful young mother tenderly interacting with her young son. In Madonna in the Meadow, Mary almost wistfully watches Jesus play with John the Baptist's cross-shaped staff, as if she has a premonition of how her son will die.

SCHOOL OF ATHENS In 1508, Julius II awarded the 25-year-old Raphael with a prestigious commission—the decoration of the papal apartments. Of the suite's several rooms (stanze), Raphael painted two himself, including the Stanza della Segnatura (Room of the Signature—Julius's library, where later popes signed official documents). Pupils completed the others, following Raphael's sketches. On the four walls of the library, Raphael presented images symbolizing the four branches of human knowledge and wisdom symbolizing the four branches of human knowledge and wisdom

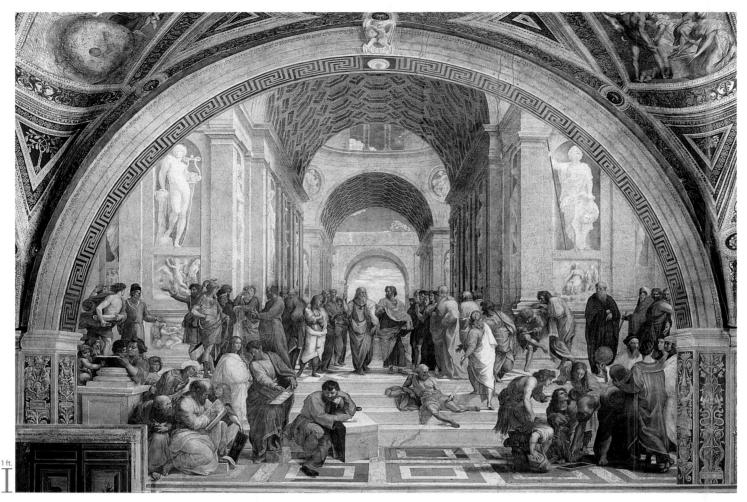

9-6 RAPHAEL, *Philosophy* (*School of Athens*), Stanza della Segnatura, Apostolic Palace, Vatican City, Rome, Italy, 1509–1511. Fresco, $19' \times 27'$.

Raphael included himself in this gathering of great philosophers and scientists whose self-assurance conveys calm reason. The setting recalls the massive vaults of the ancient Basilica Nova (Fig. 3-52).

Michelangelo

Although Michelangelo is most famous today as the painter of the Sistine Chapel (FIG. 9-1), he was also an architect, engineer, poet, and, first and foremost, a sculptor. Michelangelo considered sculpture superior to painting because the sculptor shares in the divine power to "make man" (see "Leonardo and Michelangelo on Painting versus Sculpture" (1). Drawing a conceptual parallel to Plato's ideas, Michelangelo believed that the image which the artist's hand produces must come from the idea in the artist's mind. The idea, then, is the reality that the artist's genius has to bring forth. But artists are not the creators of the ideas they conceive. Rather, they find their ideas in the natural world, reflecting the absolute idea, which, for the artist, is beauty. One of Michelangelo's best-known observations about sculpture is that the artist must proceed by finding the idea—the image—locked in the stone. By removing the excess stone, the sculptor releases the idea from the block (FIG. I-14). The artist, Michelangelo felt, works many years at this unceasing process of revelation and "arrives late at novel and lofty things."2

Michelangelo did indeed arrive at "novel and lofty things," for he broke sharply from his predecessors and contemporaries in one important respect: he mistrusted the application of mathematical methods as guarantees of beauty in proportion. Measure and

proportion, he believed, should be "kept in the eyes." Vasari quoted Michelangelo as declaring that "it was necessary to have the compasses in the eyes and not in the hand, because the hands work and the eye judges." Thus Michelangelo set aside Polykleitos, Vitruvius, Alberti, Leonardo, and others who tirelessly sought the perfect measure, and insisted that the artist's inspired judgment could identify pleasing proportions. In addition, Michelangelo argued that the artist must not be bound, except by the demands made by realizing the idea. This assertion of the artist's authority was typical of Michelangelo and anticipated the modern concept of the right to a self-expression of talent limited only by the artist's own judgment. The artistic license to aspire far beyond the "rules" was, in part, a manifestation of the pursuit of fame and success that humanism fostered. In this context, Michelangelo created works in architecture, sculpture, and painting that departed from High Renaissance regularity. He put in its stead a style of vast, expressive strength conveyed through complex, eccentric, and often titanic forms that loom before the viewer in tragic grandeur.

PIETÀ Michelangelo began his career in Florence, but when the Medici fell in 1494 (see page 244), he fled to Bologna and then moved to Rome. There, still in his early 20s, he produced his first

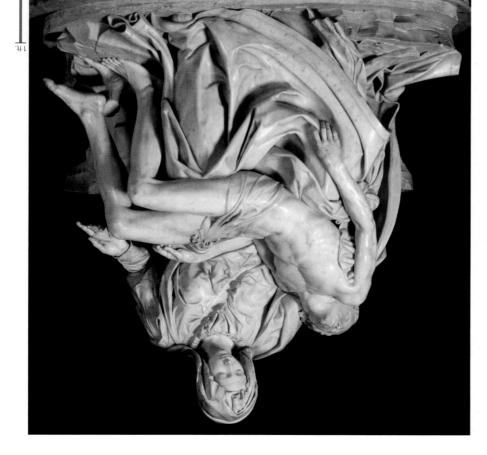

corpse captures the sadness and beauty of the young Michelangelo's representation of Mary cradling Christ's Vatican City, Rome.

ca. 1498–1500. Marble, 5' $8\frac{1}{2}$ " high. Saint Peter's, 9-7 MICHELANGELO BUONARROTI, Pietà,

younger than her son. Virgin, but was controversial because the Madonna seems

of Christ-was a subject of controversy from the her son. In fact, her age-seemingly less than that ful and youthful Mary as she mourns the death of breathtaking is the tender sadness of the beauticiated only in the presence of the original. Also of the exquisite marble surface can be fully apprealmost without parallel. The polish and luminosity flesh, hair, and fabric with a sensitivity for texture manner. Michelangelo transformed marble into the northern European theme in an unforgettable the subject. The Italian sculptor, however, rendered and Michelangelo's French patron doubtless chose repertoire of French and German artists (FIG. 7-27), dead body of Christ in her lap—was a staple in the century basilica.) The theme-Mary cradling the new church [FIG. 10-3] that replaced the fourthwas to be buried. (The work is now on view in the Saint Peter's (not shown in FIG. 4-3) in which he in the rotunda attached to the south transept of Old The cardinal commissioned the statue to be placed Denis and the French king's envoy to the Vatican. hères Lagraulas (1439-1499), Cardinal of Saintmasterpiece—a Pietà (FIG. 9-7)—for Jean de Bil-

maternal arms. His wounds are barely visible. tyr's crucifixion than to have drifted off into peaceful sleep in Mary's too, is the son whom she holds. Christ seems less to have died a marless beauty as an integral part of her purity and virginity. Beautiful, moment the statue was unveiled. Michelangelo explained Mary's age-

doubt the figure has put in the shade every other statue, ancient or talent. Vasari, for example, extolled the work, claiming "without any from that block assured forever his reputation as an extraordinary Florentines referred to it as "the Giant"—that Michelangelo created over from an earlier aborted commission. The colossal statue— David (FIG. 9-8) for the Signoria from a great block of marble left dral building committee to invite Michelangelo to fashion another The importance of David as a civic symbol led the Florence Cathethe Palazzo della Signoria, the seat of the Florentine government. fer of Donatello's David (FIG. 8-18) from the Medici residence to ing the Medici exile, the Florentine Republic had ordered the trans-DAVID Michelangelo returned to Florence in 1501. In 1495, dur-

tightening sinew amplifies the psychological energy of David's pose. feet alert viewers to the triumph to come. Each swelling vein and lude to action. His rugged torso, sturdy limbs, and large hands and The anatomy of David's body plays an important part in this preimbues Michelangelo's figures with the tension of a coiled spring. exhibits the characteristic representation of energy in reserve that encounter, with David sternly watching his approaching foe. David not after his victory, with Goliath's head at his feet, but before the umph, Michelangelo chose to represent the young biblical warrior Despite the traditional association of David with heroic tri-

pent-up emotion rather than calm, ideal beauty. 1501 then, Michelangelo invested his efforts in presenting towering, a feature also of Hellenistic sculpture (FIG. 2-57A (1)). As early as emotionally connected to an unseen presence beyond the statue, toward his gigantic adversary. This David is compositionally and tion of the Quattrocento statue by abruptly turning the hero's head Chapter 2). Michelangelo abandoned the self-contained composi-Hellenistic statues departed from their Classical predecessors (see ary. His David differs from Donatello's in much the same way that and the psychological insight and emotionalism of Hellenistic statutor captured in his David the tension of Lysippan athletes (FIG. 2-49) Without strictly imitating the antique style, the Renaissance sculpin particular the skillful and precise rendering of heroic physique. many of his colleagues, he greatly admired Greco-Roman statues, Michelangelo doubtless had the classical nude in mind. Like

august and solemn themes of all—the creation, fall, and redemption Church doctrine, and his own interests. In depicting the most extraordinary series of frescoes incorporating his patron's agenda, Yet, in fewer than four years, the Florentine sculptor produced an sented—in addition to his inexperience in the fresco technique. cated perspective problems that the vault's height and curve preits height above the pavement (almost 70 feet), and the complithis assignment: the ceiling's dimensions (some 5,800 square feet), page 251). Michelangelo faced enormous difficulties in completing the Sistine Chapel (see "Michelangelo in the Service of Julius II," reluctant Michelangelo to paint the ceiling (FIGS. 9-1 and 9-9) of Raphael to decorate the papal apartments, the pope convinced a SISTINE CHAPEL In 1508, the same year that Julius II asked

modern, Greek or Roman."4

of humankind—Michelangelo succeeded in weaving together more than 300 figures in a grand drama of the human race.

Nine narrative panels describing the creation, as recorded in Genesis, run along the crown of the vault, from *God's Separation of Light and Darkness* (above the altar) to *Drunkenness of Noah* (nearest the entrance to the chapel). Thus as viewers enter the chapel, look up, and walk toward the altar, they review, in reverse order,

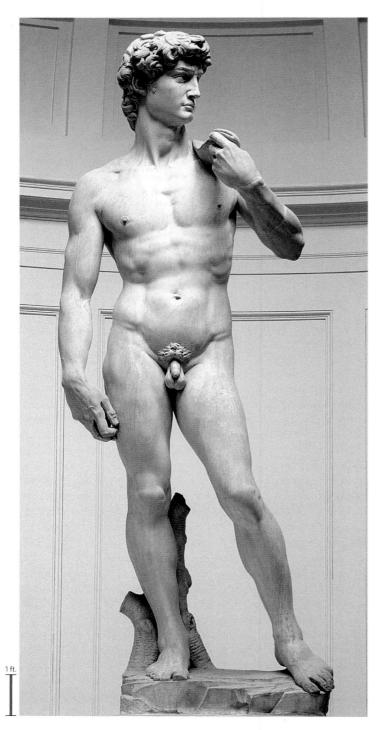

9-8 MICHELANGELO BUONARROTI, *David*, from Piazza della Signoria, Florence, Italy, 1501–1504. Marble, 17' high. Galleria dell'Accademia, Florence.

In this colossal statue, Michelangelo represented David turning his head toward the unseen Goliath, capturing the tension of Lysippos's athletes and the emotionalism of Hellenistic statuary.

the history of the fall of humankind. The Hebrew prophets and ancient *sibyls* who foretold the coming of Christ appear seated in large thrones on both sides of the central row of scenes from Genesis, where the vault curves down. In the four corner pendentives, Michelangelo placed four Old Testament scenes with David, Judith, Haman, and Moses and the Brazen Serpent. Scores of lesser figures also appear. The ancestors of Christ fill the triangular compartments above the windows, nude youths punctuate the corners of the central panels, and small pairs of putti painted in *grisaille* (to imitate sculpture) support the painted cornice surrounding the entire central corridor. The overall conceptualization of the ceiling's design and narrative structure not only presents a sweeping chronology of Christianity but also is in keeping with Renaissance ideas

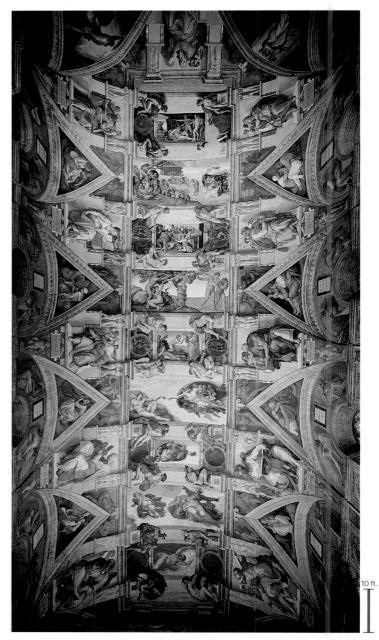

9-9 MICHELANGELO BUONARROTI, ceiling of the Sistine Chapel, Vatican City, Rome, Italy, 1508–1512. Fresco, $128' \times 45'$.

Michelangelo labored almost four years for Pope Julius II on the frescoes for the ceiling of the Sistine Chapel. He painted more than 300 figures illustrating the creation and fall of humankind.

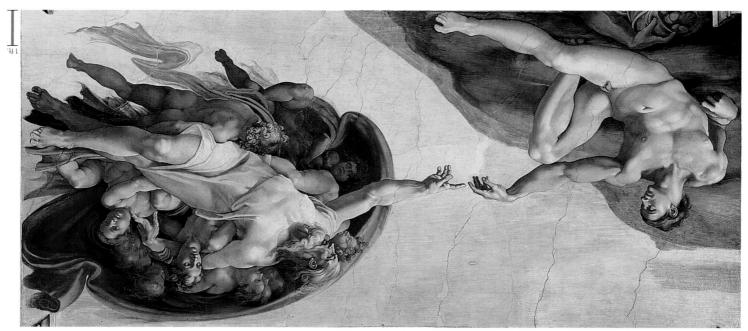

9-10 Michelangelo Buonarrot. Creation of Adam, detail of the ceiling of the Sistine Chapel (fig. 9-9), Vatican City, Rome, Italy, 1511–1512. Freeco, 9' 2" × 18' 8".

Life leaps to Adam like a spark from the extended hand of God in this fresco, which recalls the communication between gods and heroes in the classical myths that Renaissance humanists admired.

sin eventually led to the sacrifice of Christ, which in turn made possible the redemption of all humankind. As God reaches out to Adam, the viewer's eye follows the motion from right to left, but Adam's extended left arm leads the eye back to the right, along the Lord's right arm, shoulders, and left arm to his left forefinger, which points to the Christ Child's face. The focal point of this right-to-left-to-right movement—the fingertips of Adam and the Lord—is dramatically off-center. Michelangelo replaced the straight architectural axes found in Leonardo's compositions with curves and diagonals. For example, the bodies of the two great figures are complementary—the concave body of Adam fitting the convex body and billowing "cloak" of God. Thus motion directs not only the figures but also the whole composition. The reclining positions of the figures but the heavy musculature, and the twisting poses are all intrinsic parts of Michelangelo's style.

exploited this capability. struct and reinforce ideological claims, and the 16th-century popes cials long had been aware of the power of visual imagery to conas an integral part of the Counter-Reformation effort. Church offi-Council of Trent" (A). Many papal art commissions should be viewed also had important consequences for artistic patronage (see "The the defection of its members to Protestantism. The religious schism a full-fledged campaign—the Counter-Reformation—to counteract later (see page 272). The Catholic Church, in response, mounted resulted in the establishment of Protestantism, discussed in detail This Reformation movement, based in the Holy Roman Empire, appointments, and high Church officials pursuing personal wealth. concerns about the sale of pardons for sins, favoritism in church cies of the Roman Catholic Church. Disgruntled Catholics voiced at a time of widespread dissatisfaction with the leadership and poli-COUNTER-REFORMATION Paul III (r. 1534–1549) became pope

about Christian history. These ideas included interest in the conflict between good and evil and between the energy of youth and the wisdom of age. The conception of the entire ceiling was astounding in itself, and the articulation of it in its thousands of details was a superhuman achievement.

sance thought joined classical and Christian traditions. Yet the clas-Heaven in the Olympian sense indicates how easily High Renaismyth, is here concrete. This blunt depiction of the Lord as ruler of communication between gods and heroes, so familiar in classical to Adam like a spark from the extended mighty hand of God. The billowing cloud of drapery and borne up by his powers. Life leaps part, heavy as earth. The Lord transcends the earth, wrapped in a primordial unformed landscape of which Adam is still a material Creation of Adam, God and the first man confront each other in a favor of bold new interpretations of these momentous events. In Michelangelo rejected traditional iconographical convention in Adam (FIG. 9-10) and Fall of Man (FIG. 9-10A A). In both cases, background of the panels. The two central scenes are Creation of lined against the neutral tone of the architectural setting or the plain Rather, the viewer focuses on figure after figure, each sharply outdoes not produce "picture windows" framing illusions within them. marked unifying architectural framework in the Sistine Chapel the Camera Picta (FIGS. 8-38 and 8-39) in Mantua, the strongly CREATION OF ADAM Unlike Andrea Mantegna's decoration of

Beneath the Lord's sheltering left arm is a woman, apprehensively curious but as yet uncreated. Scholars traditionally believed that she is Eve, but many now think she is the Virgin Mary (with the Christ Child at her knee). If the second identification is correct, it suggests that Michelangelo incorporated into his fresco one of the essential tenets of Christian faith—the belief that Adam's original essential tenets of Christian faith—the belief that Adam's original

sical trappings do not obscure the essential Christian message.

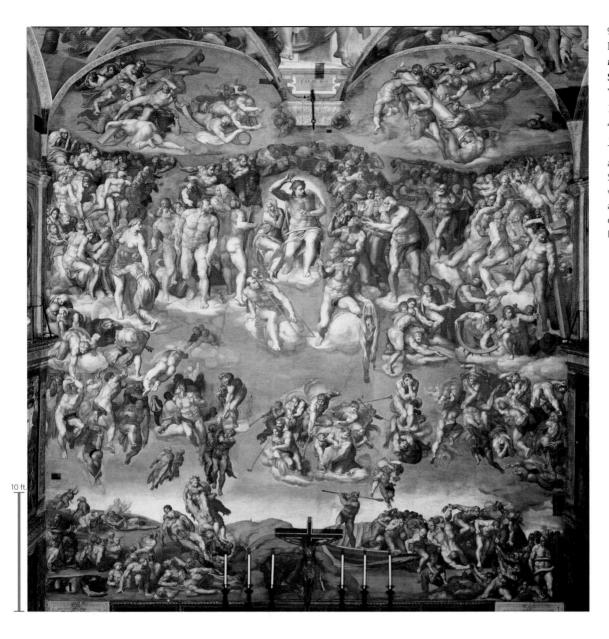

9-11 MICHELANGELO BUONARROTI, Last Judgment, altar wall of the Sistine Chapel (FIG. 9-1), Vatican City, Rome, Italy, 1534–1541. Fresco, 48' × 44'.

The final component of Michelangelo's fresco cycle in the Sistine Chapel is this terrifying vision of judgment day. The artist placed his own portrait on the flayed skin that Saint Bartholomew holds.

LAST JUDGMENT Among Paul III's first papal commissions was Last Judgment (FIG. 9-11), an enormous (48-foot-tall) fresco for the altar wall of the Sistine Chapel (FIG. 9-1). Here, Michelangelo depicted Christ as the stern judge of the world, but—in vivid contrast to medieval traditions—as a twisting, almost nude giant who raises his mighty right arm in a gesture of damnation so broad and universal as to suggest that he will destroy all creation. The choirs of Heaven surrounding the youthful judge pulse with anxiety and awe. Crowded into the spaces below are trumpeting angels, the ascending figures of the saved, and the downward-hurtling figures of the damned. The Virgin is already in Heaven, on Christ's right side, the side of the blessed. On the opposite side, demons, whose gargoyle masks and burning eyes revive the demons of Romanesque tympana (FIG. 6-23), torment the damned.

Michelangelo's terrifying vision of the fate awaiting sinners goes far beyond any previous rendition. Martyrs who suffered especially agonizing deaths crouch below the judge. One of them, Saint Bartholomew, who was skinned alive, holds the flaying knife and the skin, its face a grotesque self-portrait of Michelangelo. The figures are huge and violently twisted, with small heads and contorted features. Yet while this frightening fresco impresses on viewers Christ's

wrath on judgment day, it also holds out hope. A group of saved souls crowds around Christ, and on the far right appears a figure with a cross, most likely the Good Thief (crucified with Christ) or a saint martyred by crucifixion, such as Saint Andrew.

Architecture

During the High Renaissance, consistent with the humanist interest in classical antiquity, architects and patrons alike turned to the buildings of ancient Rome for inspiration. There, they discovered the perfect prototypes for the domed architecture that became the hallmark of the 16th century.

BRAMANTE The leading early Cinquecento proponent of this classical-revival style was Donato D'Angelo Bramante (1444–1514). Born in Urbino and trained as a painter (perhaps by Piero della Francesca), Bramante went to Milan in 1481 and, as Leonardo did, stayed there until the French captured the city in 1499. In Milan, Bramante abandoned painting, and under the influence of Brunelleschi, Alberti, and perhaps Leonardo, developed the High Renaissance form of the central-plan church.

$9\mbox{-}12$ Donato D'Augetto Bramaute, Tempietto, San Pietro in Montorio, Rome, Italy, begun 1502.

Contemporaries celebrated Bramante as the first to revive the classical style in architecture. Roman round temples inspired his "little temple," but Bramante combined the classical parts in new ways.

Bramante's first major project was the architectural gem in Rome known as the Tempietto (Fig. 9-12), so named because, to contemporaries, it had the look of a small ancient temple. In fact, the round temples of Roman Italy provided the direct models for the lower atory of Bramante's "little temple." Standing inside the cloister of San Pietro in Montorio on the Janiculum hill overlooking the Vatican, the Temperto marked the presumed location of Saint Peter's crucifixion. Bramante planned, though never built, a circular colonnaded courtyard to frame the "temple." His intent was to coordinate the Tempietto and its surrounding portico by aligning the columns of the two structures.

The Tempietto design is severely rational and features a stately circular stylobate (stepped temple platform) and austere Tuscan columns. Bramante achieved a wonderful balance and harmony in the relationship of the parts (dome, drum, and base) to one another and to the whole. Conceived as a tall domed cylinder projecting from the lower, wider cylinder of its colonnade, the "temple" is in some respects more a monument than a building. Bramanteès sculptural eye is most evident in the rhythmic pla

te's sculptural eye is most evident in the rhythmic play of light and shadow around the columns and balustrade and across the deep-set rectangular windows, alternating with shallow shell-capped niches in the walls and drum. Although the Tempietto, superficially at least, may resemble a Greco-Roman tholos (circular shrine), and although antique models provided the inspiration for all its details, the combination of parts and details was new and original. (Classical tholos, for instance, were never two-story structures and had neither a drum nor a balustrade.)

One of the main differences between the Early and High Renaissance styles of architecture is the former's emphasis on adorning flat wall surfaces versus the latter's sculptural handling of architectural masses. Bramante's Tempietto initiated the High Renaissance era in architecture. Andrea Palladio, a brilliant theorist as well as a major later Cinquecento architect (Fig. 9-16), included the Tempietto in his survey of ancient temples because Bramante was "the first to bring back to light the good and beautiful architecture that from antiquity to that time had been hidden." Round in plan and elevated on a base that isolates it from its surroundings, the Templetoton and plant and beautiful architecture that solates are surroundings, the Templetoton and plant and baladio's strictest demands for an pietto conforms to Alberti's and Palladio's strictest demands for an pietto conforms to Alberti's and Palladio's strictest demands for an pietto conforms to Alberti's and Palladio's strictest demands for an pietto conforms to Alberti's and Palladio's strictest demands for an

NEW SAINT PETER'S One of the most important artistic projects that Julius II initiated was the replacement of the crumbling basilica of Old Saint Peter's (FIG. 4-3) with a grandiose new church that suited the ambitious pope's vision of the Renaissance papacy. Julius dreamed of gaining control over all Italy and making the Rome of

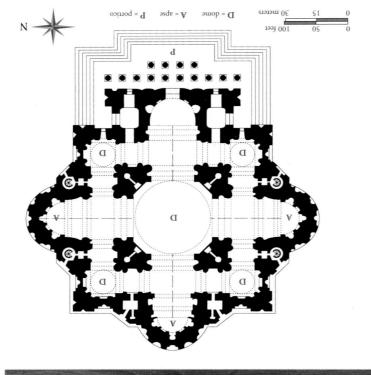

9-13 Michelangelo Buonarrott, plan for Saint Peter's, Vatican City, Rome, Italy, 1546.

Michelangelo's plan for the new Saint Peter's was radically different than that of the original basilica (Fig. 4-3). His central plan called for a domed Greek cross inscribed in a square and fronted by columns.

ideal church.

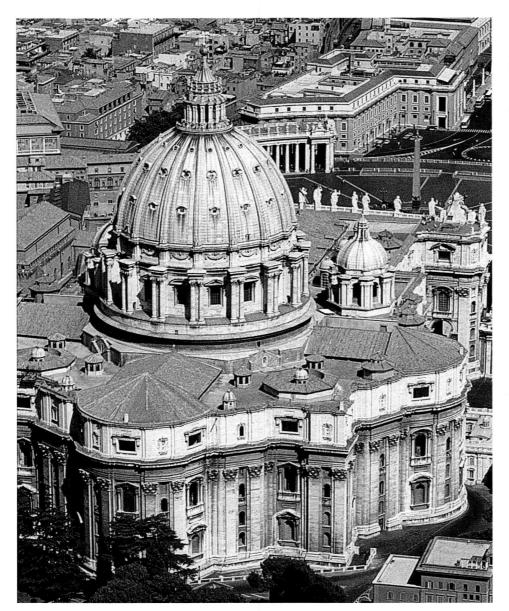

9-14 MICHELANGELO BUONARROTI, Saint Peter's (looking northeast), Vatican City, Rome, Italy, 1546–1564. Dome completed by GIACOMO DELLA PORTA, 1590.

The west end of Saint Peter's offers the best view of Michelangelo's intentions. The giant pilasters of his colossal order march around the undulating wall surfaces of the domed central-plan church.

on Saint Peter's became a long-term show of dedication, thankless and without pay. Among Michelangelo's difficulties was his struggle to preserve Bramante's central-plan design, which he praised. Michelangelo carried his obsession with human form over to architecture and reasoned that buildings should follow the form of the human body. This meant organizing their units symmetrically around a central axis, as the arms relate to the body or the eyes to the nose. "For it is an established fact," he once wrote, "that the members of architecture resemble the members of man. Whoever neither has been nor is a master at figures, and especially at anatomy, cannot really understand architecture."

In his modification of Bramante's plan, Michelangelo replaced the complex interlocking crosses with a compact domed Greek cross inscribed in a square and fronted with a double-columned portico (FIG. 9-13). His treatment of the building's exterior further reveals his interest in creating a unified design. Because of later changes to the front of the church (FIG. 10-3), the west (apse) end (FIG. 9-14) offers the best view of Michelangelo's style and intention. His design incor-

porated the colossal order, the two-story pilasters first used by Alberti at Sant'Andrea (FIG. 8-36) in Mantua. The giant pilasters seem to march around the undulating wall surfaces, confining the movement without interrupting it. The architectural sculpturing here extends up from the ground through the attic stories and into the drum and the dome, unifying the whole building from base to summit.

The domed west end—as majestic as it is today and as influential as it has been on architecture throughout the centuries—is not quite as Michelangelo intended it. Originally, he had planned a dome with an *ogival* section, like the one Brunelleschi had designed for Florence's Duomo (FIG. 7-38). But in his final version, he decided on a hemispherical dome to temper the verticality of the design of the lower stories and to establish a balance between dynamic and static elements. However, when GIACOMO DELLA PORTA (ca. 1533–1602) executed the dome after Michelangelo's death, he restored the earlier high design, ignoring Michelangelo's later version. Giacomo probably believed that an ogival dome would provide greater stability and be easier to construct. The result is that the dome seems to rise from its base, rather than rest firmly on it—an effect Michelangelo might not have approved.

the popes the equal of (if not more splendid than) the Rome of the caesars (see page 251). Like its Constantinian predecessor, the new building was to serve as a *martyrium* to mark the apostle's grave, but Julius also hoped to install his own tomb (designed by Michelangelo) in it. The pope chose Bramante as the architect of the new Saint Peter's.

Bramante's ambitious design consisted of a *Greek cross* with arms of equal length, each terminating in an apse. A large dome would have covered the crossing, and smaller domes over subsidiary chapels would have covered the diagonal axes of the roughly square plan. Bramante's design also called for a boldly sculptural treatment of the walls and piers under the dome. The organization of the interior space was complex in the extreme: nine interlocking crosses, five of them supporting domes. The scale was titanic. The architect boasted that he would place the dome of the Pantheon (Figs. 3-38, 3-39, and 3-40) over the Basilica Nova (Fig. 3-52).

During Bramante's lifetime, construction of the new Saint Peter's did not advance beyond the erection of the crossing piers and the lower choir walls. After his death, the work passed from one architect to another and, in 1546, to Michelangelo, whose work

church building into a single great hall provides an almost theatrical setting for large promenades and processions (which combined social with priestly functions). Above all, the ample space could accommodate the great crowds that gathered to hear the eloquent preaching of

The facade of II Gesù (FIG. 9-15, left) was also not entirely original, but it too had an enormous influence on later church design. The union of the lower and upper stories, achieved by scroll buttresses, harks back to another Alberti design, the Florentine church of Santa Maria Novella (not illustrated). Its classical pediment is also familiar in Alberti's work (FIG. 8-36). The paired pilasters appear in Michelangelo's design for motifs and unified the two stories. The horizontal march of the pilasters and columns builds to a dramatic climax at the central bay, and the bays of the facade snugly fit the nave-chapel system behind them. Many Roman church facades of the 17th century are architectural variations on della Porta's design. Chronologically and stylistically, II Gesù actions on della Porta's design. Chronologically and stylistically, II Gesù belongs to the Late Renaissance, but its enormous influence on later belongs to the Late Renaissance, but its enormous influence on later besilican churches marks it as one of the most significant monuments

for the development of Italian Baroque religious architecture.

PROBLEMS AND SOLUTIONS Rethinking the Basilican Church

As a major participant in the Counter-Reformation, the Jesuit order needed a church appropriate to its new prominence. In 1568, with the financial backing of Cardinal Alessandro Farnese (1520–1589), the order turned to Gircomo DA Vienola (1507–1573), who designed II Gesú's plan (Fie. 9-15, right), and Giacomo della Porta, who was responsible for the facade (Fie. 9-15, left)—and who later designed the dome of Saint Peter's (Fie. 9-14).

The plan of the Church of Jesus in Rome is a monumental expansion of Alberti's scheme for Sant'Andrea (Fig. 8-37) in Mantua. In II Gesù, the nave takes over the main volume of space, making the structure a great hall with side chapels. The transept is no wider than the nave and chapels, and Vignola also eliminated the normal deep choir in front of the altar. Consequently, all worshipers have a clear view of the celebration of the Eucharist. The wide acceptance of Vignola's of the Celebration of the Eucharist. The wide acceptance of Vignola's ability for the performance of Catholic rituals. The opening of the

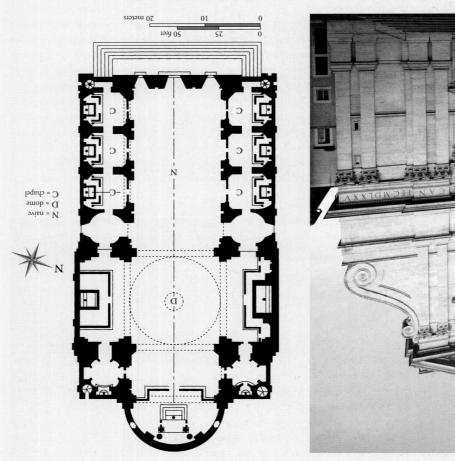

9-15 Il Gesù, Rome, Italy. Lest: Giacomo della Porta, west sacade, degun 1568. Right: Giacomo da Vignola, plan, 1568.

In this Jesuit church's innovative facade, the march of pilasters and columns builds to a climax at the central bay. The wide nave with side chapels instead of aisles won wide acceptance in the Catholic world.

IL GESÙ The activity of the Society of Jesus, known as the Jesuits, was an important component of the Counter-Reformation. Ignatius of Loyola (1491–1556), a Spanish nobleman who dedicated his life to the service of God, founded the Jesuits in 1534 with preaching and missionary work as the key components of their spiritual assignment. In 1540, Paul III formally recognized the Jesuits as a religious order. They soon became the papacy's invaluable allies in the Vatican's quest to reassert the supremacy of the Catholic Church. Particularly successful in the field of education, the Jesuit order established numerous schools. In addition, its members were effective missionaries and carried the message of Catholicism to the Americas, Asia, and Africa.

The Jesuits also made their mark in the history of architecture with the construction of Il Gesù, or Church of Jesus (FIG. 9-15), in Rome. The mother church of the Jesuit order was the most important architectural project of the later 16th century and had an enormous influence on church design in the succeeding Baroque era (see "Rethinking the Basilican Church," page 264).

ANDREA PALLADIO The classical-revival style of High Renaissance architecture in Rome spread far and wide. One of its most accomplished practitioners was Andrea Palladio (1508–1580), the chief architect of the Venetian Republic from 1570 until his death. In order to study the ancient buildings firsthand, Palladio made several trips to Rome. In 1556, he illustrated Daniel Barbaro's edition of Vitruvius's *De architectura* and later wrote his own treatise on architecture, *I quattro libri dell'architettura* (*The Four Books of Architecture*). Originally published in 1570, Palladio's treatise had a wide-ranging influence on succeeding generations of architects throughout Europe, most significantly in England and in colonial America.

Palladio gained his significant reputation from his many designs for *villas*, built on the Venetian mainland, of which 19 still stand. The same spirit that prompted the ancient Romans to build homes in the countryside motivated a similar villa-building boom in 16th-century Venice, which, with its very limited space, was highly congested.

But a longing for a rural setting was not the only motive. Declining fortunes prompted the Venetians to develop their mainland possessions with new land investment and reclamation projects. Citizens who could afford to do so set themselves up as aristocratic farmers and developed swamps into productive agricultural land. The villas were thus aristocratic farms (like the much later American plantations, which frequently emulated Palladio's architectural style). Palladio generally arranged the outbuildings in long, low wings branching out from the main building and enclosing a large rectangular court area.

Palladio's most famous villa, Villa Rotonda (FIG. 9-16), near Vicenza, is exceptional because the architect did not build it for an aspiring gentleman farmer but for a retired monsignor in the papal court in Rome. Paolo Almerico (1514–1589) wanted a villa for social events. Palladio planned and designed Villa Rotonda, located on a hilltop, as a kind of *belvedere* (literally, "beautiful view"; in architecture, a structure with a view of the countryside or the sea), without the usual wings of secondary buildings. It has a central plan featuring four identical facades with projecting porches, each of which resembles a Roman Ionic temple and serves as a platform for enjoying a different view of the surrounding landscape. In placing a traditional temple porch in front of a dome-covered interior, Palladio doubtless had the Pantheon (FIG. 3-38) in his mind as a model.

9-16 Andrea Palladio, Villa Rotonda (looking southwest), near Vicenza, Italy, ca. 1550-1570.

Palladio's Villa Rotonda has four identical facades, each one resembling a Roman temple with a columnar porch. In the center is a great dome-covered rotunda modeled on the Pantheon (Fig. 3-38).

Venetian Painting

In addition to Palladio, Cinquecento Venice boasted some of the most renowned painters of the era, who developed a distinctive Venetian Renaissance style. The Venetians' instrument was color, that of the Florentines and Romans sculpturesque form. Scholars often distill the contrast between these two approaches down to colorito (colored or painted) versus disegno (drawing and design). Whereas most central Italian artists emphasized careful design preparation based on preliminary drawing, Venetian artists focused on color and the process of paint application.

GIORGIONE Giorgio Vasari (see "Vasari's Lives" (1), who held the artists of his native Florence in greater esteem than Venice's, disapprovingly drew attention to the different working methods of the Venetians and attributed them largely to the short-lived Giorgione DA CASTELFRANCO (ca. 1477–1510):

Giorgione of Castelfranco... made use of live and natural objects and copied them as best he knew how with colors, tinting them with the crude and soft colors that Nature displays, without making preliminary drawings since he was firmly convinced that painting alone with its colors, and without any other preliminary study of designs on paper, was the truest and best method of working.

Art historians frequently describe Venetian painting in general, and the work of Giorgione in particular, as "poetic"—a characterization particularly appropriate given the development of poesia, or painting meant to operate in a manner similar to poetry. Both classical and Renaissance poetry inspired Venetian artists, and their paintings focused on the lyrical and sensual. Thus, in many Venetian artworks, discerning concrete narratives or subjects is virtually impossible.

GIORGIONE DA CASTELFRANCO, The Tempest, ca. 1509–1510. Oil on canvas, 2' $8\frac{1}{4}$ " \times 2' $4\frac{3}{4}$ ". Galletia dell'Accademia, Venice.

The subject of Giorgione's painting featuring a nude woman in a lush landscape beneath a stormy sky is uncertain, contributing, perhaps intentionally, to the painting's intriguing air of mystery.

P-18 TITIAN,

Pastoral Symphony,
ca. 1508–1511. Oil on
canvas, 3' 7 ¼" × 4" 6 ¼".

Musée du Louvre,

Paris.

Venetian att conjures

Venetian art conjures poetry. In this painting, Titian so eloquently evoked the pastoral mood that the inability to decipher the picture's meaning is not distressing. The mood and rich color are enough.

That is certainly the case with Giorgione's greatest work, The

Tempest (FIG. 9-17), a painting that continues to defy interpretation. A lush landscape fills most of Giorgione's composition, but stormy skies and lightning in the middle background threaten the tranquility of the pastoral setting. Pushed off to both sides are the few human figures depicted—a young woman nursing a baby in the right foreground and, on the left, a man with a staff. Much scholarly debate has centered on the painting's subject, fueled by X-rays of the canvas, which revealed that Giorgione altered many of the details as work progressed. Most notably, a seated nude woman originally occupied the position where Giorgione subsequently placed the standing man, whose elegant garb is out of place in this rustic setting. The changes that the painter made have led many art historians to believe that Giorgione did not intend the painting to have a definitive narrative, which is appropriate for a Venetian poetic rendering. Other scholars have suggested various mythological and biblical narratives. The uncertainty about the subject contributes to the painting's intriguing air.

TITIAN Giorgione's masterful handling of light and color and his interest in landscape, poetry, and music-Vasari reported that he was an accomplished lutenist and singer-influenced his younger contemporary Tiziano Vecelli, called TITIAN (ca. 1490-1576) in English. Indeed, a masterpiece long attributed to Giorgione— Pastoral Symphony (FIG. 9-18)—is now widely believed to be an early work of Titian. Out of dense shadow emerge the soft forms of figures and landscape. Titian, a supreme colorist and master of the oil medium, cast a mood of tranquil reverie and dreaminess over the

entire scene, evoking the landscape of a lost but never forgotten paradise. As in Giorgione's Tempest, the theme is as enigmatic as the lighting. Two nude women are in the foreground, accompanied by two clothed young men—the lutenist wearing elegant clothes, the other dressed like a shepherd. The four figures occupy a bountiful landscape. In the middle ground is a shepherd and his sheep. In the distance, a villa crowns a hill.

Titian so eloquently evoked the pastoral mood that the viewer does not find the uncertainty about the picture's precise meaning distressing. The mood is enough. The musician symbolizes the poet. The pipes and lute symbolize his poetry. The two women may be thought of as the young men's invisible inspiration, their muses. One turns to lift water from the sacred well of poetic inspiration. Smoky shadow softly models the voluptuous bodies of the women. The fullness of their figures became standard in Venetian art and contributes to their effect as poetic personifications of nature's abundance.

ASSUMPTION OF THE VIRGIN In 1516, Titian became the official painter of the Republic of Venice. Shortly thereafter, he received the commission to paint Assumption of the Virgin (FIG. 9-19) for the main altar of Santa Maria Gloriosa dei Frari. The gigantic altarpiece (nearly 23 feet tall) depicts the ascent of the Virgin to Heaven on a great white cloud borne aloft by putti. Above, golden clouds, so luminous that they seem to glow and radiate light into the church, envelop the Virgin. God the Father appears above, awaiting Mary with open arms. Below, apostles gesticulate wildly as they witness the glorious event. Through vibrant color, Titian infused the image with an intensity that amplifies the drama.

9-19 TITIAN, Assumption of the Virgin, 1515-1518. Oil on wood, 22' $7\frac{1}{2}$ " × 11' 10". Santa Maria Gloriosa dei Frari, Venice.

Titian won renown for his skill in conveying light through color. In this dramatic depiction of the Virgin Mary's ascent to Heaven, the golden clouds seem to glow and radiate light into the church.

female nude, whether divine sentations of the reclining set the standard for reprepreferred painting medium pigment on canvas as the Titian established oil-based

Galleria degli Uffizi, on canvas, $3'11" \times 5'5"$. Urbino, 1536-1538. Oil 9-20 TITIAN, Venus of

Florence.

or mortal. in Western art. Here, he also

Mannerism

mode) is characterized by style (being stylish, cultured, elegant). fashion (someone has "style"). Mannerism's style (or representative (see page 3), but the term can also refer to an absolute quality of acteristic or representative mode, especially of an artist or period ing "style" or "manner." Art historians usually define style as a charand Venice. The term derives from the Italian word maniera, meanstyle in reaction to the High Renaissance style of Florence, Rome, Mannerism emerged in the 1520s in Italy as a distinctive artistic

themes also surface frequently in Mannerist art. from expected conventions, and unique presentations of traditional plexities, both visual and conceptual. Ambiguous space, departures often reveals itself in imbalanced compositions and unusual comately, "mannered." The conscious display of artifice in Mannerism about Mannerism, and why Mannerist works can seem, appropriart production. This is why artifice is a central feature of discussions nerist artists were less inclined to disguise the contrived nature of generally strove to create art that appeared natural, whereas Manconstructed nature of their art. In other words, Renaissance artists natural. In contrast, Mannerist painters consciously revealed the spective and shading to make their representations of the world look Raphael, chose to conceal that artifice by using devices such as perartists, including High Renaissance painters such as Leonardo and "natural"—it is something fashioned by human hands. But many artifice. Of course, all art involves artifice, in the sense that art is not Among the features most closely associated with Mannerism is

familiarity that 16th-century viewers would have had by playing off had frequently depicted this subject, and Pontormo exploited the stylistic features characteristic of Mannerism's early phase. Painters painter JACOPO DA PONTORMO (1494-1557) exhibits almost all the PONTORMO Entombment of Christ (FIG. 9-21) by the Florentine

> sively smaller units. backward into the room and the division of the space into progresopens onto a landscape. Titian masterfully constructed the view for garments to clothe their nude mistress. Beyond them, a window background, two servants bend over a chest, apparently searching ing lapdog—where Cupid would be if this were Venus. In the right foreground from the background. At the woman's feet is a slumberviewer's attention to her left hand and pelvis as well as to divide the vertical edge of the curtain behind her, which serves to direct the pillowed couch. Her softly rounded body contrasts with the sharp tions. This "Venus" reclines on the gentle slope of her luxurious of the reclining female nude, regardless of the many ensuing varialished the compositional elements and the standard for paintings painting of Venus (not illustrated) by Giorgione. Here, Titian estabor mortal, Titian based his version on an earlier (and pioneering) Italian woman in her bedchamber. Whether the subject is divine classical mythology what is probably a representation of a sensual year. The title (given to the painting later) elevates to the status of II, who became the duke of Urbino (r. 1539-1574) the following painted the so-called Venus of Urbino (FIG. 9-20) for Guidobaldo VENUS OF URBINO In 1538, at the height of his powers, Titian

> ance but also to organize his placement of forms. figure. Here, Titian used color not simply to record surface appeartors of an implied diagonal opposed to the real one of the reclining critical role in the composition as a gauge of distance and as indicareds (in the foreground cushions and in the background skirt) play a to realize the subtlety of color planning. For instance, the two deep ivory gold of the flesh. The viewer must study the picture carefully set off against the pale neutral whites of the linen and the warm sleeves and of the kneeling girls gown echo the deep Venetian reds reds of the tapestries against the neutral whites of the matron's Venus of Urbino. The red tones of the matron's skirt and the muted As in other Venetian paintings, color plays a prominent role in

their expectations. For example, he omitted from the painting both the cross and Christ's tomb, and instead of presenting the action as taking place across the perpendicular picture plane, as artists such as Rogier van der Weyden did (FIG. 8-7), Pontormo rotated the conventional figural groups along a vertical axis. Several of the figures seem to float in the air. Those that touch the ground do so on tiptoes, enhancing the sense of weightlessness. Unlike High Renaissance artists, who concentrated their masses in the center of the painting, Pontormo left a void. This emptiness accentuates the grouping of hands filling that hole, calling attention to the void—symbolic of loss and grief. The artist enhanced the painting's ambiguity with the curiously anxious glances that the figures cast in all directions. (The bearded young man at the upper right is probably a self-portrait.) Many of the figures have elastically elongated limbs and undersized heads, and move unnaturally. The contrasting colors, primarily light blues and pinks, add to the dynamism and complexity of the work.

The painting represents a pronounced departure from the balanced, harmoniously structured compositions of the High Renaissance.

PARMIGIANINO The best-known work of Girolamo Francesco Maria Mazzola, known as Parmigianino (1503–1540), is *Madonna with the Long Neck* (FIG. 9-22), which exemplifies the elegant stylishness that was a principal aim of Mannerism. In Parmigianino's hands, this traditional, usually sedate subject became a picture of exquisite grace and precious sweetness. The Madonna's small oval head, her long and slender neck, the otherworldly attenuation and delicacy of her hand, and the sinuous, swaying elongation of her frame—all are marks of the sophisticated courtly taste of Mannerist artists and patrons alike. Parmigianino amplified this elegance by expanding the Madonna's form as viewed from head to toe. On the left stands a bevy of angelic creatures, exuding emotions as soft and smooth as their limbs. On the right, the artist included a line

9-21 Jacopo da Pontormo, *Entombment of Christ*, Capponi chapel, Santa Felicità, Florence, Italy, 1525–1528. Oil on wood, 10' 3" \times 6' 4".

Mannerist paintings such as this one represent a departure from the compositions of the earlier Renaissance. Instead of concentrating masses in the center of the painting, Pontormo left a void.

9-22 PARMIGIANINO, *Madonna with the Long Neck*, from the Baiardi chapel, Santa Maria dei Servi, Parma, Italy, 1534–1540. Oil on wood, 7' 1" \times 4' 4". Galleria degli Uffizi, Florence.

Parmigianino's Madonna displays the stylish elegance that was a principal aim of Mannerism. Mary has a small oval head, a long slender neck, attenuated hands, and a sinuous body.

9-23 Bronzino, Venus, Cupid, Folly, and Time, ca. 1546. Oil on wood, 5' 1" \times 4' $8\frac{4}{4}$ ". National Gallery, London.

In this painting of Cupid fondling his mother, Venus, Bronzino demonstrated a fondness for learned allegories with erotic undertones. As in many Mannerist paintings, the meaning is ambiguous.

a typically Mannerist imbalanced composition and visual complexity. In terms of design, the contrast with Leonardo's Last Supper (Fig. 9-3) is both extreme and instructive. Leonardo's composition, balanced and symmetrical, parallels the picture plane in a

of columns without capitals and a mysterious figure with a scroll, whose distance from the foreground is immeasurable and ambiguous—the antithesis of rational Renaissance perspective diminution of size with distance.

Although the elegance and beauty of the painting are due in large part to the Madonna's attenuated neck and arms, that exaggeration is not solely decorative in purpose. Madonna with the Long Neck takes its subject from a simile in medieval hymns comparing the Virgin's neck with a great ivory tower or column, such as the one Parmigianino inserted to the right of the Madonna.

grace, and the clever depiction of them evidence of artistic skill. feet, for the Mannerists considered the extremities to be carriers of of enamel smoothness. Of special interest are the heads, hands, and block the space. The contours are strong and sculptural, the surfaces placed the figures around the front plane, and they almost entirely and interpretations of the painting vary. Compositionally, Bronzino as in many Mannerist paintings, the meaning here is ambiguous, stancy—is foolish and that lovers will discover its folly in time. But, to suggest that love—accompanied by envy and plagued by inconite device of the Mannerists, symbolize deceit. The picture seems human qualities and emotions, including Envy. The masks, a favorful incest in progress. Other figures in the painting represent other the upper right corner, draws back the curtain to reveal the playprepares to shower them with rose petals. Time, who appears in who has reached puberty—fondling his mother, Venus, while Folly Bronzino depicted Cupid-here not an infant but an adolescent and monumental statements and forms of the High Renaissance. allegories that often had erotic undertones, a shift from the simple ing, Bronzino demonstrated the Mannerists' fondness for learned as a gift for King Francis I of France (see page 277). In this paintthe first grand duke of Tuscany, Cosimo I de' Medici (r. 1537-1534), (1503-1572), painted Venus, Cupid, Folly, and Time (FIG. 9-23) for BRONZINO Pontormo's pupil Agnolo di Cosimo, called Bronzino

TINTORETTO Jacopo Robusti, known as TINTORETTO (1518–1594), claimed to be a student of Titian and aspired to combine Titian's color with Michelangelo's drawing, but he also adopted many Mannerist pictorial devices, which he employed to produce works imbued

with dramatic power, depth of spiritual vision, and glowing Venetian color schemes. Toward the end of Tintoretto's life, his art became spiritual, even visionary, as solid forms dissolved into swirling clouds of dark shot through with fitful light. In Last Supper (FIG. 9-24), the figures—many with shimmering halos—appear in a dark interior illuminated by a single light in the upper left of the image. The huge canvas features

9-24 TINTORETTO, Last Supper, 1594. Oil on canvas, 12' × 18' 8". San Giorgio Maggiore, Venice.

Tintoretto adopted many Mannerist pictorial devices to produce oil paintings imbued with emotional power, depth of spiritual vision, glowing Venetian color schemes, and dramatic lighting.

geometrically organized and closed space. The figure of Jesus is the tranquil center of the drama and the perspective focus. In Tintoretto's painting, Jesus is above and beyond the converging perspective lines racing diagonally away from the picture surface, creating disturbing effects of limitless depth and motion. The viewer locates Tintoretto's Jesus via the light flaring, beaconlike, out of darkness. The contrast of the two pictures reflects the direction Renaissance painting took in the 16th century, as it moved away from architectonic clarity of space and neutral lighting toward the dynamic perspectives and dramatic chiaroscuro of the coming Baroque.

GIAMBOLOGNA Mannerism extended beyond painting. Artists translated its principles into sculpture and architecture as well. The lure of Italy drew a brilliant young Flemish sculptor, Jean de Boulogne, to Florence, where he practiced his art under the equivalent Italian name of Giovanni da Bologna or, in its more common contracted form, Giambologna (1529-1608). His Abduction of the Sabine Women (FIG. 9-25) exemplifies Mannerist principles of figure composition in sculpture. Drawn from the legendary history of Rome, the group received its present title—relating how the early Romans abducted wives for themselves from the neighboring Sabines—only after its exhibition. In fact, the sculptor did not intend to depict any particular subject. His goal was to achieve a dynamic spiral figural composition involving an old man, a young man, and a woman, all nude in the tradition of ancient statues portraying mythological figures. Abduction of the Sabine Women includes references to Laocoön (FIG. 2-59) in the crouching old man and in the woman's up-flung arm. The three bodies interlock on a vertical axis, creating an ascending spiral movement.

To appreciate the sculpture fully, the viewer must walk around it because the work changes radically according to the vantage point. One factor contributing to the shifting imagery is the prominence of open spaces passing through the masses (for example, the space between an arm and a body), which have as great an effect as the solids. This sculpture was the first large-scale group since classical antiquity designed to be seen from multiple viewpoints, although the figures do not break out of the spiral vortex but remain as if contained within a cylinder.

GIULIO ROMANO Mannerist architects used classical architectural elements in a highly personal and unorthodox manner, rejecting the balance, order, and stability that were the hallmarks of the High Renaissance style, and aiming instead to reveal the contrived nature

9-25
GIAMBOLOGNA,
Abduction of the
Sabine Women, Loggia
dei Lanzi, Piazza della
Signoria, Florence,
Italy, 1579–1583.
Marble, 13' $5\frac{1}{2}$ " high.

This sculpture was the first large-scale group since classical antiquity designed to be seen from multiple viewpoints. The three bodies interlock to create a vertical spiral movement.

of architectural design. Applying that approach was the goal of Giulio Romano (ca. 1499–1546) when he designed the Palazzo del Tè (fig. 9-26) in Mantua for Duke Federigo Gonzaga (r. 1530–1540) and also provided frescoes for the building's interior (fig. 9-26A 1). In the facades facing the palace's courtyard, the divergences from architectural convention are pronounced. Indeed, the Palazzo del Tè

9-26 GIULIO ROMANO, courtyard of the Palazzo del Tè (looking southeast), Mantua, Italy, 1525-1535.

The Mannerist divergences from architectural convention—for example, the slipping triglyphs—are so pronounced in the Palazzo del Tè that they constitute a parody of Bramante's classical style.

doctrinal impurities that had collected through the ages. Only the Bible was the word of God—the sole source of all religious truth. The Church's councils, laws, and rituals carried no weight. Luther facilitated the lay public's access to biblical truths by producing the first translation of the Bible in a vernacular language (German).

the important role that art plays in society. reactions dramatically demonstrate the power of art and underscore and other artworks that they perceived as idolatrous. These strong stained-glass windows, smashing statues, and destroying paintings visited Catholic churches in the Netherlands in 1566, shattering In an episode known as the Great Iconoclasm, bands of Calvinists vor swept Basel, Zurich, Strasbourg, and Wittenberg in the 1520s. destruction of religious artworks. Violent waves of iconoclastic ferof religious imagery escalated at times to outright iconoclasm—the churches were relatively bare. The Protestant concern over the role their presence in church—to pray. Because of this belief, Protestant images distracted viewers from focusing on the real reason for Christ, the Virgin, and saints could lead to idolatry. Furthermore, Trent" (A). In contrast, Protestants believed that representations of figures as an aid to communicating with God (see "The Council of of visual imagery in religion. Catholics embraced images of holy ences, Catholics and Protestants took divergent stances on the role ART AND THE REFORMATION In addition to doctrinal differ-

ing of Saints Anthony and Paul and Temptation of Saint Anthony. exposes Hagenauer's interior shrine, flanked by Grünewald's Meet-Child, and Resurrection—appear. Opening this second pair of wings additional scenes-Annunciation, Angelic Concert, Madonna and entation in the predella. When these exterior wings are open, four Sebastian on the left, Saint Anthony Abbot on the right, and Lamas in FIG. 9-27) present four subjects: Crucifixion in the center, Saint Grünewald's exterior panels (visible when the altarpiece is closed, ter. Hinged at the sides, one pair stands directly behind the other. added two pairs of painted moveable wings that open at the cen-Augustine, and Jerome. To Hagenauer's centerpiece, Grünewald turing large painted and gilded statues of Saints Anthony Abbot, (not illustrated) by Nikolaus Hagenauer (active 1493-1538) feaof Isenheim, the altarpiece takes the form of a carved wood shrine ion scene. Created for the monastic hospital order of Saint Anthony of God), whose wound spurts blood into a chalice in the crucifixerences to Catholic doctrines, such as the lamb (symbol of the son polyptych reflecting Catholic beliefs and incorporating several refon the Isenheim Altarpiece (FIG. 9-27), a complex and fascinating tionally as Matthias Grünewald (ca. 1480-1528), began work Roman Empire. Around 1510, Matthias Neithardt, known conventhe Catholic Church was still an important art patron in the Holy however, Luther had not yet posted his Ninety-five Theses, and MATTHIAS GRÜNEWALD At the opening of the 16th century,

The placement of this altarpiece in the choir of a church adjacent to the monastery's hospital dictated much of the imagery. Saints associated with the plague and other diseases and with miraculous cures, such as Saints Anthony and Sebastian, appear prominently in the Isenheim Altarpiece. Grünewald's panels specifically address emphasize the suffering of the order's patron saint, Anthony Abbot. The painted images served as warnings, encouraging increased devotion from monks and hospital patients. They also functioned devotion from monks and hospital patients. They also functioned therapeutically by offering some hope to the afflicted. Indeed, Saint therapeutically by offering some hope to the afflicted. Indeed, Saint

classical architecture. That the duke delighted in Giulio's mannered presupposes a thorough familiarity with the established rules of witticism. Recognizing such quite subtle departures from the norm be sure, only a highly sophisticated observer can appreciate Giulio's down on the head of anyone foolish enough to stand below them. To Ionic Temples," page 57, and FIG. 2-20, left), which threaten to crash weight of the triglyphs of the Doric frieze above (see "Doric and ent structural insufficiency, and they seem unable to support the architraves break midway between the columns stresses their apparing these niches carry incongruously narrow architraves. That these niches, where no arches exist. The massive Tuscan columns flankcally, Giulio placed voussoirs in the pediments over the rectangular or seem to be slipping from the arches—and, even more eccentristones (central voussoirs), for example, either have not fully settled dictions, the courtyard is the most unconventional of all. The keydesign. In a building laden with structural surprises and contratable Mannerist manifesto announcing the artifice of architectural constitutes an enormous parody of Bramante's classical style, a veri-

architectural inventiveness speaks to his cultivated taste.

HOLY ROMAN EMPIRE

The extraordinary flowering of art and architecture in Cinquecento Italy unfolded against the tumultuous backdrop of the split in Christendom between Catholicism and Protestantism. Prominent theologians, most notably Martin Luther (1483–1546) and John Calvin (1509–1564) in the Holy Roman Empire, directly challenged papal authority. Their major concerns were the sale of indulgences (parauth buying one's way into Heaven) and about nepotism (the appointment of relatives to important positions). Particularly damaging was the perception that the Roman popes concerned themselves more with temporal power and material wealth than with the salvation of the faithful. The fact that many 15th-century popes and cardinals came from wealthy families, such as the Medici, intensications of the grown wealthy families, such as the Medici, intensications of the faithful.

PROTESTANTISM Central to both Lutheranism and Calvinism, the two major Protestant sects, was a belief in personal faith rather than adherence to decreed Church practices and doctrines. Because Protestants believed that the only true religious relationship was the personal relationship between individuals and God, they were, in essence, eliminating the need for Church intercession, which is central to Catholicism.

On October 31, 1517, in Wittenberg, Luther posted for discussion his *Ninety-five Theses*, in which he enumerated his objections to Church practices. Luther's goal was significant reform and clarification of major spiritual issues, but his ideas ultimately led to a hundred years of civil war between Protestants and Catholics. According to Luther, the Catholic Church's extensive atructure needed casting out, for it had no basis in the Bible, which alone could serve as the foundation for Christianity. Luther called the pope the Anti-christ (for which Pope Leo X excommunicated him in 1520), and described the Church as the "whore of Babylon." He denounced ordained priests and also rejected most of Catholicism's sacraments other than baptism and communion, decrying them as obstacles to salvation (see "Catholic versus Protestant Views of Salvation" and to salvation (see "Catholic versus Protestant Views of Salvation" and to its original purity, the Catholic Church needed cleansing of all the to its original purity, the Catholic Church needed cleansing of all the

9-27 MATTHIAS GRÜNEWALD, *Isenheim Altarpiece* (closed), from the chapel of the Hospital of Saint Anthony, Isenheim, Germany, ca. 1510–1515. Oil on wood, center panel 9' $9\frac{1}{2}$ " × 10' 9", each wing 8' $2\frac{1}{2}$ " × 3' $\frac{1}{2}$ ", predella 2' $5\frac{1}{2}$ " × 11' 2". Musée d'Unterlinden, Colmar.

Befitting its setting in a monastic hospital, Matthias Grünewald's *Isenheim Altarpiece* includes painted panels depicting suffering and disease but also miraculous healing, hope, and salvation.

Anthony's legend emphasized his dual role as vengeful dispenser of justice (by inflicting disease) and benevolent healer.

In the Temptation of Saint Anthony panel, Grünewald painted a grotesque image of a man whose oozing boils, withered arm, and distended stomach all suggest a horrible disease. Medical experts have connected these symptoms with ergotism (a disease caused by ergot, a fungus that grows especially on rye). Doctors did not discover the cause of ergotism until about 1600. People lived in fear of its recognizable symptoms (convulsions and gangrene) and called the illness "Saint Anthony's Fire." Ergotism was one of the major diseases treated at the Isenheim hospital. Indeed, Grünewald depicted Christ's skin covered with sores. Furthermore, ergotism often compelled amputation. The two moveable halves of the altarpiece's predella, if slid apart, make it appear as if Christ's legs have been amputated. The same observation applies to the two main exterior panels. Due to the off-center placement of the cross, opening the left panel "severs" one arm from the crucified figure.

Thus Grünewald carefully selected and presented his altarpiece's iconography to be particularly meaningful for patients at this hospital. In the interior shrine, the artist balanced the horrors of the disease and the punishments that awaited those who did not repent with scenes such as Meeting of Saints Anthony and Paul, depicting the two saints, healthy and aged, conversing peacefully. Even the exterior panels (the closed altarpiece; FIG. 9-27) convey these same concerns. Crucifixion emphasizes Christ's pain and suffering, but the knowledge that this act redeemed humanity tempers the misery. In addition, Saint Anthony appears in the right wing as a devout follower of Christ who, like Christ, endured intense suffering for his faith. Saint Anthony's appearance on the exterior thus reinforces the themes that Grünewald intertwined throughout this entire work—themes of pain, illness, and death, as well as those of hope, comfort, and salvation. Grünewald also brilliantly used color to enhance the impact of the imagery. He intensified the contrast of horror and hope by playing subtle tones and soft harmonies against shocking dissonances of color.

figures. Yet he tempered this idealization with naturalism. The gnarled bark of the trees and the feathery leaves authenticate the scene, as do the various creatures skulking underfoot. The animals populating the print are symbolic. The choleric cat, the melancholic lity's temperaments based on the "four humors," fluids that were the basis of theories of the body's function developed by the ancient Greek physician Hippocrates and practiced in medieval physiology. The tension between the cat and the mouse in the foreground symbolizes the relation between Adam and Eve at the crucial moment before they commit original sin.

MELENCOLIA1 Dürer took up the theme of the four humors, specifically melancholy, in one of his most famous engravings, *Melencolia I* (Fig. 9-29), which many scholars regard as a kind of self-portrait of Dürer's artistic psyche as well as a masterful example of the artist's ability to produce a wide range of tonal values and textures. (The renowned humanist Erasmus of Rotterdam [1466–1536] praised Dürer as "the Apelles [the most renowned ancient Greek painter]

ALBRECHT DÜRER The dominant artist of the early 16th century in the Holy Roman Empire was ALBRECHT DÜRER (1471–1528) of Muremberg. Dürer was the first artist outside Italy to become an international celebrity. He traveled extensively, visiting and studying in Colmat, Basel, Strasbourg, Venice, Antwerp, and Brussels, among other locales, and became personally acquainted with many of the leading humanists and artists of his time. Dürer achieved his lofty reputation primarily on the quality of his engravings and work he produced. Dürer displayed exceptional business acumen in the marketing of his prints and became a wealthy man from the sale of his work. The lawsuit he brought in 1506 against an Italian artist for copying his prints is thought to be the first in history over intellectual property copyright.

Fascinated with the classical ideas of the Italian Renaissance, Dürer strass among of the classical ideas of the Italian Renaissance, between the property copyright.

Dürer was among the first Northern Renaissance artists to travel to Italy expressly to study Italian art and its underlying theories at their source. After his first journey in 1494–1495 (the second was in 1505–1506), he incorporated many Italian Renaissance developments into his art. Art historians have acclaimed Dürer as the

first artist north of the Alps to understand fully the basic aims of the Renaissance in Italy. Like Leonardo da Vinci, he wrote theoretical treatises on a variety of subjects, such as perspective, fortification, and the ideal in human proportions.

pieces, Fall of Man (Adam and Eve; FIG. 9-28), represents the first distillation of his studies of the Vitruvian theory of human proportions, a theory based on arithmetic ratios. Clearly outlined against the dark background of a northlined against the dark background of a northeory based on arithmetic ratios. Clearly outlined against the dark background of a northeory based forest, the two idealized figures of Adam and Eve stand in poses derived from specific classical statues of Apollo and Venus. Preceded by numerous geometric drawings in which the artist attempted to systematize sets of which the artist attempted to systematize sets of ideal human proportions in balanced contrapposto poses, the final engraving presents Dürect's concept of the "perfect" male and female et's concept of the "perfect" male and female

of black lines."8

9-28 Агвяеснт Dürer, Fall of Man (Adam and Eve), 1504. Engraving, $9\frac{7}{8}$ " $\times 7\frac{5}{8}$ ". Museum of Fine Arts, Boston (centennial gift of Landon T. Clay).

Dürer was the first Northern Renaissance artist to achieve international celebrity. Fall of Man, with two figures based on ancient statues, reflects his studies of the Vitruvian theory of human proportions.

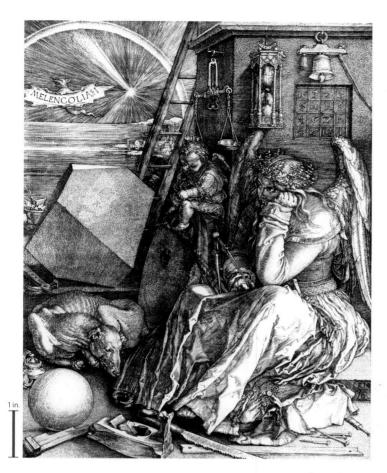

9-29 Albrecht Dürer, *Melencolia I*, 1514. Engraving, $9\frac{3}{8}$ " $\times 7\frac{1}{2}$ ". Victoria & Albert Museum, London.

In this "self-portrait" of his artistic personality, Dürer represented Melancholy as a brooding winged woman surrounded by artists' and builders' tools. A melancholic artist cannot use them, however.

The Italian humanist Marsilio Ficino (1433–1499) had written an influential treatise (*De vita triplici*, 1482–1489) in which he asserted that artists were distinct from the population at large because they were born under the sign of the planet Saturn, named for the ancient Roman god. They shared that deity's melancholic temperament because they had an excess of black bile, one of the four body humors, in their systems. Artists therefore were "saturnine"—eccentric and capable of both inspired artistic frenzy and melancholic depression. Raphael had depicted Michelangelo in the guise of the brooding Heraclitus in his *School of Athens* (FIG. 9-6), and Dürer used a similarly posed female figure for his winged personification of Melancholy in *Melencolia I*.

In 1510, in *De occulta philosophia*, Heinrich Cornelius Agrippa of Nettesheim (1486–1535) identified three levels of melancholy. The first was artistic melancholy, which explains the Roman numeral on the banner carried by the bat—a creature of the dark—in Dürer's engraving. Above the brooding figure of Melancholy is an hourglass with the sands of time running out. All around her are the tools of the artist and builder (compare FIG. 7-19)—compass, hammer, nails, and saw among them. However, those tools are useless to the frustrated artist while suffering from melancholy. Melancholy's face is obscured by shadow, underscoring her state of mind. But Dürer also included a burst of light on the far horizon behind the bat, an

optimistic note suggesting that artists can overcome their depression and produce works of genius—such as this engraving.

FOUR APOSTLES Dürer's impressive technical facility with different media extended also to painting. Four Apostles (FIG. 9-30) is a two-panel oil painting he produced without commission and presented to the city fathers of Nuremberg in 1526 to be hung in the city hall. Saints John and Peter appear on the left panel, Mark and Paul on the right. In addition to showcasing Dürer's mastery of the oil technique, his brilliant use of color and light and shade, and his ability to imbue the four saints with individual personalities and portraitlike features, Four Apostles documents the artist's support for Martin Luther by his positioning of the figures. Dürer relegated Saint Peter (as representative of the pope in Rome) to a secondary role by placing him behind John the Evangelist. John assumed particular prominence for Luther because of the evangelist's focus on Jesus as a person in his Gospel. In addition, Peter and John both read from the Bible, the single authoritative source of religious truth, according to Luther. At the bottom of the panels, Dürer included quotations from the four apostles' books, using Luther's German translation of the New Testament. The excerpts

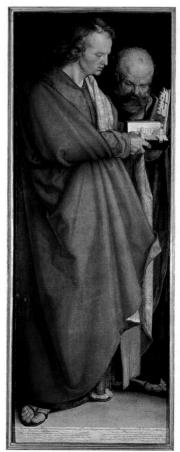

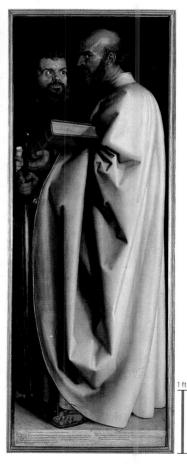

9-30 Albrecht Dürer, *Four Apostles*, from the city hall, Nuremberg, Germany, 1526. Oil on wood, each panel 7' 1" × 2' 6". Alte Pinakothek, Munich.

Dürer's support for Lutheranism surfaces in these portraitlike depictions of four saints on two painted panels. Peter, representative of the pope in Rome, plays a secondary role behind John the Evangelist.

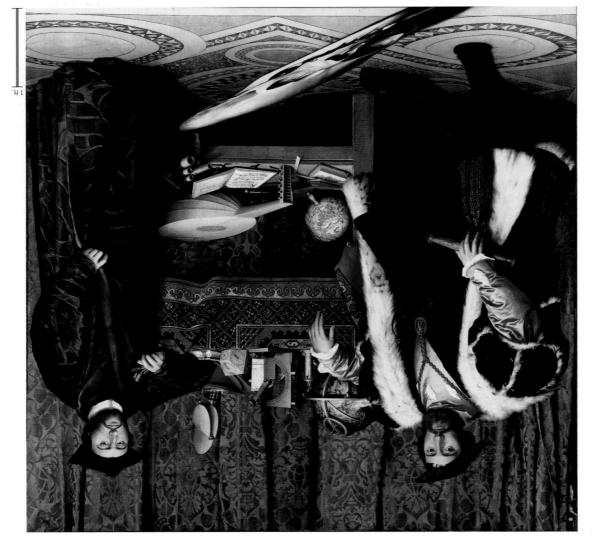

YOUNGER, The French Ambas-Sadovs, 1533. Oil and tempera on wood, 6' 8" \times 6' $9\frac{1}{2}$ ". National Gallery, London.

In this double portrait, Holbein depicted two humanists with a collection of objects reflective of their worldliness and learning, but he also included an anamorphic skull, a reminder of death.

a sundial, flutes, globes, and an open hymnbook with Luther's translation of Veni, Creator Spiritus and of the Ten Commandments.

Of particular interest is the long gray shape that slashes diagonally across the picture plane and interrupts the stable, balanced, and serene composition. This form is an anamorphic image, a distorted image recognizable only when viewed with a special device, such as a cylindrical mirror, or by looking at the painting at an acute angle. In this case, if the viewer stands off to the right, the distorted image becomes a skull. Artists commonly incorporated skulls into paintings as reminders of mortality. Indeed, Holbein depicted a skull on the metal medallion on Jean de Dinteville's hat. Holbein aky have intended the skulls, in conjunction with the crucifix that appears half hidden behind the curtain in the upper left corner, to encourage viewers to ponder death and resurrection.

The French Ambassadors may also allude to the growing tension between secular and religious authorities. Jean de Dinteville was a titled landowner, Georges de Selve a bishop. The inclusion of Luther's translations next to the lute with the broken string (a symbol of discord) may also subtly refer to religious strife. In any case, the painting is a supreme artistic achievement. Holbein rendered the still-life objects with the same meticulous care as the men themselves, the woven design of the deep emerald curtain behind them, and the Italian marble-inlay floor, drawn in perfect perspective.

warn against the coming of perilous times and the preaching of false prophets who will distort God's word.

HANS HOLBEIN The leading artist of the Holy Roman Empire in the generation after Dürer was Hans Holbein the Younger (ca. 1497–1543), who excelled as a portraitist. The surfaces of Holbein's paintings are as lustrous as enamel, and the details are exact and exquisitely drawn, consistent with the tradition of 15th-century Flemish art. Yet he also incorporated Italian ideas about monumental composition and sculptural form.

Holbein began his artistic career in Basel, but because of the immediate threat of a religious civil war, he left for England, where, with Erasmus's recommendation, he became painter to the court of King Henry VIII and produced a double portrait of the French ambassadors to England, Jean de Dinteville (1504–1557) and Georges de Selve (1509–1542). The French Ambassadors (Fig. 9-31) sition, gift for recording likenesses, marvelous sense of composition, gift for recording likenesses, marvelous sensitivity to color, and faultless technique. The two men, both ardent humanists, stand at opposite ends of a side table covered with an oriental rug and a collection of objects reflective of their worldliness and their interest in learning and the arts. These include mathematical and astronomical models and implements, a lute with a broken string, compasses, ical models and implements, a lute with a broken string, compasses,

9-32 Château de Chambord (looking northwest), Chambord, France, begun 1519.

French Renaissance châteaux, which developed from medieval castles, served as country houses for royalty. King Francis I's Château de Chambord reflects Italian palazzo design, but it has a Gothic roof.

FRANCE

As The French Ambassadors illustrates, France in the early 16th century continued its efforts to secure widespread recognition as a political power and cultural force. Under Francis I (r. 1515–1547), the French established a firm foothold in Milan and its environs. Francis waged a campaign (known as the Habsburg-Valois Wars) against Charles V, king of Spain and Holy Roman Emperor (r. 1516-1558). These wars, which occupied Francis for most of his reign, involved disputed territories-southern France, the Netherlands, the Rhineland, northern Spain, and Italy-and reflect France's central role in the shifting geopolitical landscape. Francis also endeavored to elevate his country's cultural profile. To that end, he invited several esteemed Italian artists to his court, Leonardo da Vinci among them. Under Francis, the Church, the primary patron of art and architecture in medieval France, yielded that position to the French monarchy. Francis's art collection became the core of Paris's Musée du Louvre, one of the world's greatest museums.

CHÂTEAU DE CHAMBORD Francis I indulged his passion for building by commissioning several large châteaux, among them the Château de Chambord (FIG. 9-32). These châteaux developed from medieval fortified castles, but, reflecting more peaceful times, served as country houses for royalty, who usually built them near forests for use as hunting lodges. Construction of the Chambord château began in 1519, but Francis never saw its completion. The plan includes a central square block with four corridors in the shape of a cross, and a broad, central staircase that gives access to groups of rooms—ancestors of the modern suite of rooms or apartments. At each of the four corners, a round tower punctuates the square plan, and a moat surrounds the whole. From the exterior, Chambord presents a carefully contrived horizontal accent on three levels, with continuous moldings separating its floors. Windows align precisely, one exactly over another. The Italian Renaissance palazzo (FIG. 8-32A 1 and 8-33) served as the model for this matching of horizontal and vertical features, but above the third level, the structure's lines break chaotically into a jumble of high dormers

(projecting gable-capped windows), chimneys, and turrets that are the heritage of French Gothic architecture.

THE NETHERLANDS

With the demise of the duchy of Burgundy in 1477 and the division of that territory between France and the Holy Roman Empire (MAP 9-1), the Netherlands at the beginning of the 16th century consisted of 17 provinces (corresponding to modern Holland, Belgium, and Luxembourg). The Netherlands was among the most commercially advanced and prosperous countries in Europe. Its extensive network of rivers and easy access to the Atlantic Ocean provided a setting that encouraged overseas trade, and shipbuilding was one of the Netherlands' most profitable enterprises. The region's commercial center shifted toward the end of the 15th century, partly because of buildup of silt in the Bruges estuary. Traffic relocated to Antwerp, which became the hub of economic activity in the Netherlands after 1510. As many as 500 ships a day passed through Antwerp's harbor, and large trading companies from Germany, Italy, Spain, Portugal, and England established themselves in the city.

During the second half of the 16th century, Philip II of Spain (r. 1556–1598) controlled the Netherlands, which he inherited from his father, Charles V. Philip sought to force the entire population to become Catholic. His heavy-handed tactics and repressive measures led in 1579 to revolt and the formation of two federations: the Union of Arras, a Catholic union of southern Netherlandish provinces, which remained under Spanish dominion, and the Union of Utrecht, a Protestant union of northern provinces, which became the Dutch Republic.

Netherlandish artists continued to receive commissions for large-scale altarpieces and other religious works from Catholic churches, but with the rise of Protestantism, most artists in the Netherlands focused on secular subjects. Netherlandish art of this period provides a wonderful glimpse into the lives of various levels of society, from nobility to peasantry, capturing their activities, environment, and values.

9-33 Hieronymus Bosch, Garden of Earthly Delights, 1505–1510. Oil on wood, center panel 7^{\prime} $2\frac{5}{8}^{\prime} \times 6^{\prime}$ $4\frac{3}{4}^{\prime}$, each wing 7^{\prime} $2\frac{5}{8}^{\prime} \times 3^{\prime}$ $2\frac{1}{4}^{\prime\prime}$. Museo del Prado, Madrid.

In the fantastic sunlit landscape that is Bosch's Paradise, scores of nude people in the prime of life blithely cavort. The horrors of Hell include sinners enduring tortures tailored to their conduct while alive.

or turn somersaults. The numerous fruits and birds in the scene are fertility symbols and suggest procreation. Indeed, many of the figures pair off as couples.

In contrast to the orgiastic overtones of the central panel is the terrifying image of Hell in the right wing, where viewers must search through the inky darkness to find all of the fascinating though repulsive details that Bosch recorded. Beastly creatures devour people, while other condemned souls endure tortures tailored to their conduct while alive. A glutton must vomit eternally. A miser squeezes gold coins from his bowels. A spidery monster fondles a promiscuous woman while toads bite her. Scholars have traditionally interpreted Bosch's triptych as a warning about the fate awaiting the sinful, decadent, and immoral, but as a secular work, Garden of Earthly Delights may have been intended for a learned audience fascinated by alchemy—the medieval study of seemingly magical chemical changes. Details throughout the triptych are based on chemical apparatus of the day, which Bosch knew well because on chemical apparatus of the day, which Bosch knew well because his in-laws were pharmacists.

QUINTEN MASSYS Antwerp's growth and prosperity, along with its wealthy merchants' desire to accumulate artworks among other worldly goods, attracted artists to the city. Among them was QUINTEN MASSYS (ca. 1466–1530) of Louvain, who became Antwerp's leading master after 1510. In Money-Changer and His Wife (Fig. 9-34), Massys presented a professional man transacting business. He holds scales, checking the weight of coins on the table. The artist's detailed rendering of the figures, setting, and objects suggests a fidelity to observable fact. But the painting is also a commentary on Netherlandstrable fact. But the painting is also a commentary on Netherlands in Nalues and mores. Money-Changer and His Wife highlights the financial transactions that were an increasingly prominent part of secular life in the Netherlands and that distracted Christians from of secular life in the Netherlands and that distracted Christians from

Surrealism more than 400 years later (see page 394). intrigue—a painted world without close parallel until the advent of and custom, Bosch's image portrays a visionary world of fantasy and depictions of married couples in contemporary Netherlandish life there, however. Whereas Jan and other painters grounded their and His Wife (FIG. 8-6). Any similarity to earlier paintings ends many 15th-century examples is Jan van Eyck's Giovanni Arnolfini riage was a familiar theme in Netherlandish painting. Among the and procreation, the painting may commemorate a wedding. Marscholars have proposed that given the work's central themes of sex suggests that the triptych was a secular commission, and some (r. 1516-1538) no later than seven years after its completion. This was on display in the palace of Count Henry III of Nassau-Breda a religious function as an altarpiece, Garden of Earthly Delights tance. Although the work is a large triptych, which would suggest most puzzling, and no interpretation has ever won universal accepfamous painting, Garden of Earthly Delights (FIG. 9-33), is also his of the most fascinating artistic personalities in history. Bosch's most early 16th century was Hieronymus Bosch (ca. 1450-1516), one HIERONYMUS BOSCH The leading Netherlandish painter of the

In the left panel, God (in the form of Christ) presents Eve to Adam in a landscape, presumably the Garden of Eden. Bosch's wildly imaginative setting includes an odd pink fountainlike structure in a body of water and an array of fanciful and unusual animals, including a giraffe, an elephant, and winged fish. The central panel people, including exotic figures of African descent, who frequently appear in Renaissance paintings (for example, Fig. 8-39), both north and south of the Alps. All those in Paradise are in the prime of youth. They blithely cavort amid bizarre creatures and unidentifuorly of youth.

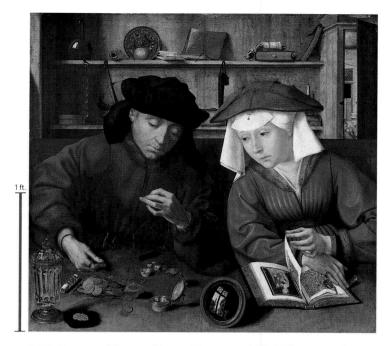

9-34 QUINTEN MASSYS, *Money-Changer and His Wife*, 1514. Oil on wood, 2' $3\frac{3}{4}$ " \times 2' $2\frac{3}{8}$ ". Musée du Louvre, Paris.

Massys's depiction of a secular financial transaction is also a commentary on Netherlandish values. The banker's wife shows more interest in the moneyweighing than in her prayer book.

their religious duties. The banker's wife, for example, shows more interest in watching her husband weigh money than in reading her prayer book. Massys incorporated into his painting numerous references to the importance of a moral, righteous, and spiritual life, including a candlestick and a carafe with water, traditional religious symbols. The couple ignores them, focusing solely on money. On the right, seen through a window, an old man talks with another man,

a reference to idleness and gossip. The reflected image in the convex mirror on the counter offsets this image of sloth and foolish chatter. There, a man reads what is most likely a Bible or prayer book. Behind him is a church steeple. An inscription on the original frame (now lost) read, "Let the balance be just and the weights equal" (Lev. 19:36), an admonition that applies both to the money-changer's professional conduct and eventually to judgment day. Nonetheless, the couple in this painting has tipped the balance in favor of the pursuit of wealth.

PIETER AERTSEN This tendency to inject reminders about spiritual well-being into paintings of everyday life emerges again in Butcher's Stall (FIG. 9-35) by PIETER AERTSEN (ca. 1507–1575), who worked in Antwerp for more than three decades. At first glance, this painting appears to be a descriptive genre scene (one from everyday life). On display is an array of meat products—a side of a hog, chickens, sausages, a stuffed intestine, pig's feet, meat pies, a cow's head, a hog's head, and hanging entrails. Also visible are fish, pretzels, cheese, and butter. But, like Massys, Aertsen embedded strategically placed religious images in his painting. In the background, Joseph leads a donkey carrying Mary and the Christ Child. The holy family stops to offer alms to a beggar and his son, while the people behind the holy family wend their way toward a church. Furthermore, the crossed fishes on the platter and the pretzels and wine in the rafters on the upper left all refer to "spiritual food" (pretzels were often served as bread during Lent). Aertsen accentuated these allusions to salvation through Christ by contrasting them to their opposite a life of gluttony, lust, and sloth. He represented this degeneracy with the oyster and mussel shells (which Netherlanders believed possessed aphrodisiacal properties) scattered on the ground on the painting's right side, along with the people seen eating and carousing nearby under the roof. Underscoring the general theme is the placard at the right advertising land for sale—Aertsen's moralistic reference to a recent scandal involving the transfer of land from an Antwerp charitable institution to a land speculator.

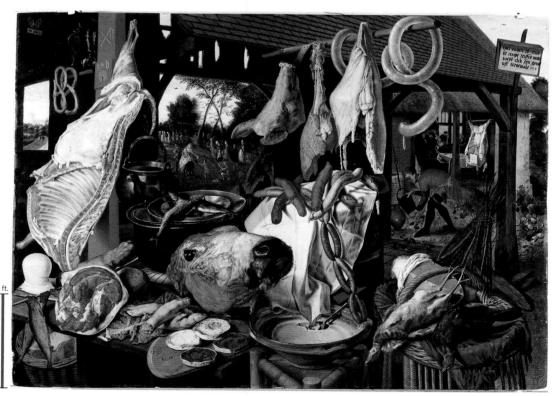

9-35 PIETER AERTSEN, Butcher's Stall, 1551. Oil on wood, $4'\frac{3}{8}'' \times 6'5\frac{3}{4}''$. Uppsala University Art Collection, Uppsala.

Butcher's Stall appears to be a genre painting, but in the background, Joseph leads a donkey carrying Mary and the Christ Child. Aertsen balanced images of gluttony with allusions to salvation.

9-36 Caterina van Hemesera, Self-Portrait, 1548. Oil on wood, $\Gamma^{\frac{3}{4}} \times 9\frac{7}{8}$. Kunstmuseum Basel, Basel.

In this first known northern European self-portrait by a woman, Caterina van Hemessen represented herself as a confident artist momentarily interrupting her work to look out at the viewer.

in the Netherlands, private portraits increased in popularity. The example illustrated here (FIG. 9-36), by CATERINA VAN HEMESSEN (1528-1587), is of special interest because it is the first known northern European self-portrait by a woman. The artist signed the confidently presented herself as a painter who interrupts her work to look toward the viewer. She holds brushes, a palette, and a maulto look toward the viewer. She holds brushes, a palette, and a maulto look toward the viewer. She holds brushes, a palette, and a maulto look toward the viewer. She holds brushes, a palette, and a maulto look toward the viewer. She holds brushes, a palette, and a maulto look toward the viewer. She holds brushes, a palette, and a maulto look toward the viewer. She holds brushes, a palette, and a maulto look toward the viewer. She holds brushes, a palette, and a maulto look toward the viewer. She holds brushes, a palette, and a maulto look toward the viewer. She holds brushes, a palette, and a maulto look toward the viewer. She holds brushes in her left hand, and delicately applies pigment to the canvas with her right hand, in large part because of the difficulty in obtaining formal trainting (see "The Artist's Profession" ♠). Caterina was typical in having been trained by her father, the painter Jan Sanders van Hemessen (ca. 1500-1556).

PIETER BRUEGEL THE ELDER The greatest Netherlandish painter of the mid-16th century was PIETER BRUEGEL THE ELDER (ca. 1528–1569). Like many of his contemporaries, Bruegel traveled to Italy, where between 1551 and 1554 he went as far south as Sicily. However, unlike other artists who visited the ruins of ancient Rome, bruegel chose not to incorporate classical elements into his paintings. Landscapes were among his favorite subjects, but no matter how huge a slice of the world Bruegel depicted, human activities remain the dominant theme.

The setting of Netherlandish Proverbs (FIG. 9-37) is a village populated by a wide range of people, encompassing nobility, peasants, and clerics. Seen from a bird's-eye view is a mesmerizing array of activities reminiscent of the topsy-turvy scenes of Hieronymus Bosch (FIG. 9-33), but the purpose and meaning of Bruegel's anecdotal details are clear. By illustrating more than a hundred proverbe in this one painting, Bruegel indulged his Netherlandish audience's obsession with proverbs, passion for detailed and clever imagery, and interest in human folly—the subject of Erasmus's most famous and interest in human folly—the viewer scrutinizes the myriad vignettes work, In Praise of Folly. As the viewer scrutinizes the myriad vignettes

within the painting, Bruegel's close observation and deep understanding of human nature become apparent. The proverbe depicted include, on the far left, a man in blue gnawing on a pillar. ("He who bites a church pillar" is a religious zealot engaged in folly.) To his right, a man "beats his head against a wall" (a frustrated idiot who has attempted trated idiot who has attempted something impossible). On the roof a man "shoots one arrow

9-37 Ріетев Ввиебец тне Егрев, Netherlandish Proverbs, 1559. Oil on wood, 3' $10" \times 5' 4 \frac{1}{8}"$. Миseen zu Berlin, Berlin.

In this painting of a Metherlandish village, Bruegel indulged his audience's obsession with proverbs and passion for clever imagery, and demonstrated his deep understanding of human nature.

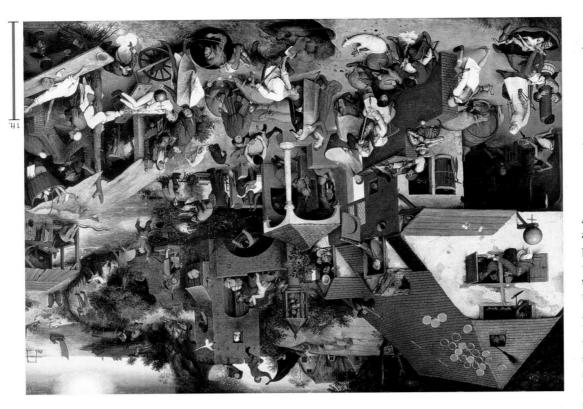

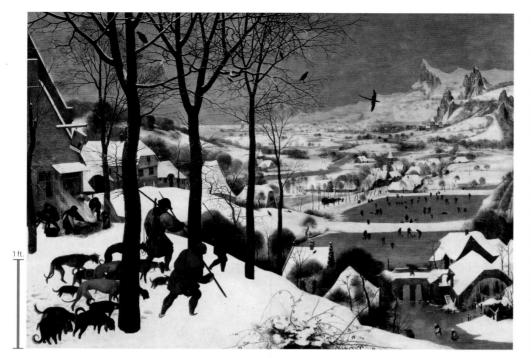

9-38 PIETER BRUEGEL THE ELDER, Hunters in the Snow, 1565. Oil on wood, $3' \cdot 10'' \times 5' \cdot 3^{\frac{3}{4}''}$. Kunsthistorisches Museum, Vienna.

In Hunters in the Snow, one of a series of paintings illustrating different seasons, Bruegel draws the viewer diagonally deep into the landscape by his mastery of line, shape, and composition.

extent than any ever known—a large part of Europe, the western Mediterranean, a strip of North Africa, and vast expanses in the New World. Spain acquired many of its New World colonies through aggressive overseas exploration. Among the most notable conquistadors sailing under the Spanish flag were Christopher Columbus (1451–1506), Vasco Nuñez de Balboa (ca. 1475–1517), Ferdinand Magellan (1480–1521), Hernán Cortés (1485–1547), and Francisco Pizarro (ca. 1470–1541). The Habsburg Empire, enriched by New

World plunder, supported the most powerful military force in Europe. Spain defended and then promoted the interests of the Catholic Church in its battle against the inroads of the Protestant Reformation. In fact, Philip II earned the title "Most Catholic King." Spain's crusading spirit, nourished by centuries of war with Islam (see page 149), prepared the country to assume the role of the most Catholic civilization of Europe and the Americas. In the 16th century, for good or for ill, Spain left the mark of its power, religion, language, and culture on two hemispheres.

EL ESCORIAL Philip II's major building project was El Escorial (FIG. 9-39), designed by Juan de Herrera (ca. 1530–1597) and Juan Bautista de Toledo (d. 1567), principally the former. In his will, Charles V stipulated that a "dynastic pantheon" be built to house the remains of past and future Spanish monarchs. Philip II chose a site some 30 miles northwest of Madrid for the enormous (625-foot-wide and 520-foot-deep) complex, which is not only a royal mausoleum but also a church, a monastery, and a palace. Legend has it that El Escorial's gridlike plan symbolized the gridiron on which Saint Lawrence suffered his martyrdom. The vast structure is in keeping with Philip's austere character, his passionate Catholic

after the other, but hits nothing" (a fool who throws good money after bad). In the far distance, the "blind lead the blind."

Hunters in the Snow (Fig. 9-38), one of six paintings illustrating seasonal changes, is very different in character and illustrates the dynamic variety of Bruegel's work. The series was a private commission for an Antwerp merchant's home and grew out of the tradition of depicting months and peasants in Books of Hours (Fig. 8-9). The painting shows human figures and landscape locked in winter cold. The weary hunters return with their hounds, women build fires, skaters skim the frozen pond, and the town and its church huddle in their mantle of snow. Bruegel rendered the landscape in an optically accurate manner. It develops smoothly from foreground to background and draws the viewer diagonally into its depths. The painter's supreme skill in using line and shape and his subtlety in tonal harmony make this one of the great landscape paintings in Western art.

SPAIN

Spain emerged as the dominant European power at the end of the 16th century. Under the Habsburg ruler Charles V and his son, Philip II, the Spanish Empire encompassed a territory greater in

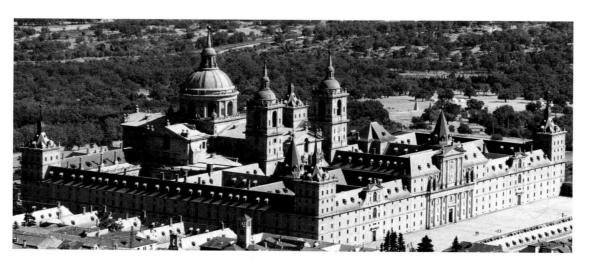

9-39 JUAN DE HERRERA and JUAN BAUTISTA DE TOLEDO, El Escorial (looking southeast), near Madrid, Spain, 1563–1584.

Conceived by Charles V and built by Philip II, El Escorial is a royal mausoleum, church, monastery, and palace in one. The complex is classical in style, with severely plain walls and massive towers.

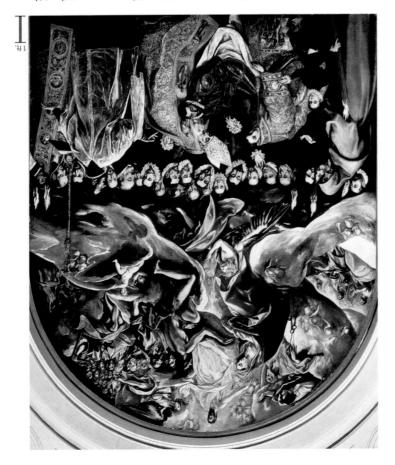

9-40 Et Greco, Burial of Count Orgaz, 1586. Oil on canvas, $16^{i}\times12^{i}$. Santo Tomé, Toledo.

El Greco's art is a blend of Byzantine and Italian Mannerist elements. His intense emotional content captured the fervor of Spanish Catholicism, and his dramatic use of light foreshadowed the Baroque style.

of uncertain origin, explain El Greco's usual classification as a Mannerist, but his art is difficult to classify using conventional labels. Although El Greco used Mannerist formal devices, his primary concerns were conveying emotion and religious fervor and arousing those passions in viewers. The forcefulness of his paintings is the result of his unique, highly developed expressive style, which foreshadowed developments of the Baroque era, examined next in Chapter 10.

 $\overline{\mathbb{A}}$ Explore the era further in MindTap with videos of major artworks and buildings, Google Earth $^{\rm TM}$ coordinates, and essays by the author on the following additional subjects:

- Leonardo da Vinci, The Fetus and Lining of the Uterus (FIG. 9-1A)
- MATERIALS AND TECHNIQUES: Renaissance Drawings
- ARTISTS ON ART: Leonardo and Michelangelo on Painting versus
- Sculpture WRITTEN SOURCES: Giorgio Vasari's Lives
- WRITTEN SOURCES: Giorgio Vasari's Lives

 Michelangelo, Fall of Man (Fig. 9-10A)
- THE PATRON'S VOICE: The Council of Trent
- Giulio Romano, Fall of the Giants from Mount Olympus (FIG. 9-26A)
- RELIGION AND MYTHOLOGY: Catholic versus Protestant Views
- of Salvation Cranach the Elder, Law and Gospel (FIG. 9-26B)

religiosity, his proud reverence for his dynasty, and his stern determination to impose his will worldwide. He insisted that in designing El Escorial, the architects focus on simplicity of form, severity in the whole, nobility without arrogance, and majesty without ostentation. The result is a classicism of Doric severity, ultimately derived from Italian architecture, but without close parallel elsewhere in Europe. Only the three entrances, with the dominant central portal framed by superimposed orders and topped by a pediment in the framed by superimposed orders and topped by a pediment in the

framed by superimposed orders and topped by a pediment in the Italian fashion, break the long sweep of the structure's severely plain walls. Massive square towers punctuate the four corners. Within, the church's imposing granite facade produces an effect of overwhelming strength and weight. El Escorial stands as the overpowering architectural expression of Spain's spirit in its heroic epoch and of the character of Philip II, the extraordinary ruler who directed it.

tured the fervor of Spanish Catholicism. on later Spanish painters. Nevertheless, El Greco's hybrid style capstrictly Spanish, for it had no Spanish antecedents and little effect 16th-century Venetian art and to Mannerism. El Greco's art was not piety, and a great reliance on and mastery of color bound him to emotionalism of his paintings, which naturally appealed to Spanish sonal blending of Byzantine and Mannerist elements. The intense to spend the rest of his life in Toledo. El Greco's art is a strong per-Florentine Mannerism on his work. By 1577, he had left for Spain him. A brief trip to Rome explains the influences of Roman and paintings (FIG. 9-24) seem to have made a stronger impression on to Venice, where he worked in Titian's studio, although Tintoretto's Byzantine frescoes and mosaics. While still young, El Greco went Italy as a young man. In his youth, he absorbed the traditions of Late Theotokopoulos, called EL GRECO (ca. 1547-1614), emigrated to painter of the era was not a Spaniard. Born on Crete, Domenikos European art as well as the mobility of artists, the greatest Spanish EL GRECO Reflecting the increasingly international character of

The upward glances of some of the figures below and the flight figures, El Greco demonstrated that he was also a great portraitist. fills the background. In the carefully individualized features of these solemn chorus of personages (including Philip II) dressed in black painted with all the rich sensuousness of the Venetian school. A ingly lower the count's armor-clad body, the armor and heavy robes draperies, and a visionary swirling cloud. Below, the two saints lovquite personal manner, with elongated undulating figures, fluttering realm with a firm realism, whereas he depicted the celestial, in his nates the earthly scene below. The painter represented the terrestrial into its sepulcher in the church. The radiant Heaven above illumitine miraculously descended from Heaven to lower the count's body Santo Tomé. According to the legend, Saints Stephen and Augusthree centuries before and who had been a great benefactor of painting on the legend of the count of Orgaz, who had died some Tomé in Toledo, vividly expresses that fervor. El Greco based the Burial of Count Orgaz (Fig. 9-40), painted in 1586 for Santo

of an angel above link the painting's lower and upper spheres. The action of the angel, who carries the count's soul in his arms as Saint John and the Virgin intercede for it before the throne of Christ, reinforces this connection. El Greco's deliberate change in style to distinguish between the two levels of reality gives the viewer an opportunity to see the artist's early and late manners in the same work, one below the other. His relatively realistic presentation of the earthly sphere is still strongly rooted in Venetian art, but the abstractions and distortions that El Greco used to show the immaterial nature of the heavenly realm characterize his later style. His elongated figures existing in undefined spaces, bathed in a cool light elongated figures existing in undefined spaces, bathed in a cool light

HIGH RENAISSANCE AND MANNERISM IN EUROPE

Italy

- During the High (1500–1520) and Late (1520–1600) Renaissance, the major Italian artistic centers were Florence, Rome, and Venice. Whereas most Florentine and Roman artists emphasized careful design preparation based on preliminary drawing (disegno), Venetian artists focused on color and the process of paint application (colorito), and took a poetic approach to painting (poesia).
- Leonardo da Vinci was a master of chiaroscuro and atmospheric perspective. He was famous for his sfumato (misty haziness) and for his psychological insight in depicting biblical narrative.
- Raphael favored lighter tonalities than Leonardo, and clarity over obscurity. His sculpturesque figures appear in landscapes under blue skies or in grandiose architectural settings rendered in perfect perspective.
- In both sculpture and painting, Michelangelo won renown for his emotionally charged figures with heroic physiques. He preferred pent-up energy to Raphael's calm, ideal beauty.
- The leading early Cinquecento Italian architect was Bramante, who championed the classical style of the ancients and favored the central plan for churches. In II Gesù, Giacomo della Porta introduced a widely influential plan for basilican churches: a broad nave and side chapels instead of aisles.
- The two greatest masters of the Venetian painting school were Giorgione, a pioneer of poetical painting, and Titian, famed for his rich surface textures and dazzling display of color in all its nuances.
- Mannerism (1520-1600) was a reaction against the High Renaissance style. Mannerist paintings by Pontormo and Parmigianino feature elongated figures, ambiguous space, and intentional departures from expected conventions. The leading Mannerist architect was Giulio Romano, whose designs represent a parody of Bramante's classical style.

Raphael, Madonna in the Meadow, 1505-1506

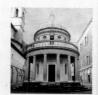

Bramante, Tempietto, Rome begun 1502

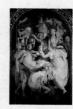

Pontormo, Entombment of Christ, 1525–1528

Northern Europe and Spain

- Dissatisfaction with the Church in Rome led to the Protestant Reformation, which began in the Holy Roman Empire. Protestants objected to the sale of indulgences and rejected most of the sacraments of Catholicism. They also condemned ostentatious church decoration as a form of idolatry. Art, however, especially prints, still played a role in Protestantism. Albrecht Dürer's engravings rival paintings in tonal quality.
- The Netherlands was one of the most prosperous countries in 16th-century Europe. Netherlandish art provides a picture of contemporary life and values. Pieter Aertsen's *Butcher's Stall*, for example, seems to be a straightforward genre scene, but includes the holy family offering alms to a beggar, providing a stark contrast between gluttony and religious piety.
- Landscapes were the specialty of Pieter Bruegel the Elder. His *Hunters in the Snow* is one of a series of paintings depicting seasonal changes and the activities associated with them.
- The leading painter of 16th-century Spain was Greek-born El Greco, whose art combined Byzantine style, Italian Mannerism, and the religious fervor of Catholic Spain.

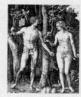

Dürer, Fall of Man, 1504

Aertsen, Butcher's Stall, 1551

▲ 10-1b Each of the four rivers has an identifying attribute. The Ganges (Asia) most closely resembles a Greco-Roman river god. Bernini's personification of that easily navigable river holds an oar.

▲ 10-1c Crowning the grotto is Pope Innocent X's coat of arms, with the Pamphili family's dove symbolizing the Holy Spirit and the triumph of the Catholic Church in all regions of the world.

▲ 10-1a As water flows from a travertine grotto supporting an ancient Egyptian obelisk, Bernini's marble personifications of major rivers of four continents twist and gesticulate emphatically.

GIANLORENZO BERNINI, Fountain of the Four Rivers (looking southwest with Sant'Agnese in Agone, by Francesco Borromini, in the background), Piazza Navona, Rome, Italy, 1648–1651.

Baroque Europe

BAROQUE ART AND SPECTACLE

One of the most popular tourist attractions in Rome is the Fountain of the Four Rivers (FIG. 10-1) in Piazza Navona, by GIANLORENZO BERNINI (1598–1680). Architect, painter, sculptor, playwright, and stage designer, Bernini was one of the most important and imaginative artists of the Baroque era in Italy and its most characteristic and sustaining spirit. Nonetheless, the fountain's patron, Pope Innocent X (r. 1644–1655), did not want Bernini to win this commission. Bernini had been the favorite sculptor of the Pamphili pope's predecessor, Urban VIII (r. 1623–1644), who spent so extravagantly on art and on himself and his family that he nearly bankrupted the Vatican treasury. Innocent emphatically opposed the excesses of the Barberini pope and shunned Bernini, awarding new papal commissions to other sculptors and architects. Bernini was also in disgrace at the time because of his failed attempt to erect bell towers for the new facade of Saint Peter's (FIG. 10-2). When Innocent announced a competition for a fountain in Piazza Navona, site of the Pamphili family's palace and parish church, Sant'Agnese in Agone (FIG. 10-1, rear), he pointedly did not invite Bernini to submit a design. However, the renowned sculptor succeeded in having a model of his proposed fountain placed where the pope would see it. When Innocent examined it, he was so captivated that he declared that the only way anyone could avoid employing Bernini was not to look at his work.

Bernini's bold design, executed in large part by his assistants, called for a sculptured travertine grotto supporting an ancient *obelisk* that Innocent had transferred to Piazza Navona from the *circus* (chariot racecourse) of the Roman emperor Maxentius (r. 305–312) on the Via Appia. Piazza Navona was once the site of the *stadium* of Domitian (r. 81–96), a long and narrow theater-like structure for foot races, which explains the piazza's unusual shape and the church's name (*agone* means "foot race" in Italian). Water rushes from the artificial grotto into a basin filled with marble statues personifying major rivers on four continents—the Danube (Europe), Nile (Africa), Ganges (Asia), and Plata (Americas). The reclining figures twist and gesticulate, consistent with the contemporary taste for movement and drama. The Nile covers his face—Bernini's way of acknowledging that the Nile's source was unknown at the time. The Rio de la Plata has a hoard of coins, signifying the wealth of the New World. The Ganges, easily navigable, holds an oar. The Danube, awestruck, reaches up to the papal coat of arms. A second reference to Innocent X is at the apex of the obelisk, where the Pamphili dove also symbolizes the Holy Spirit and the triumph of Christianity in every region of the world. The scenic effect of the cascading water would have been heightened whenever Piazza Navona was flooded for festival pageants. Bernini's fountain exemplifies the Baroque era's love for uniting art and spectacle.

portraits, and still lifes. Calvinist patrons favor genre scenes,

- In the northern Netherlands, Catholic Flanders.
- Rubens is the leading painter in movement in marble statuary.
- Bernini incorporates drama and oil painting.
- fresco painting.
- Caravaggio pioneers tenebrism in Carracci introduces quadro riportato

3AROQUE EUROPE

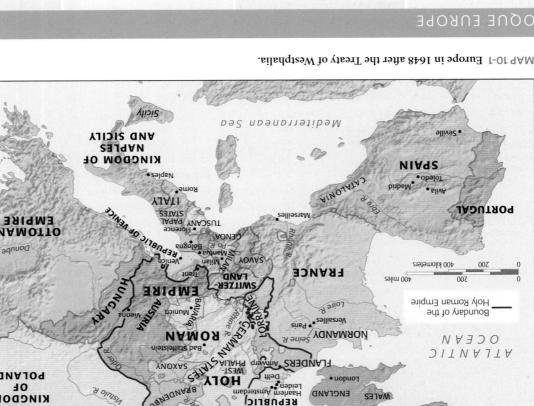

Das MOLLH

Baroque painter and printmaker.

Rembrandt is the foremost Dutch

Hals achieves renown for his group

Zurbarán paints scenes of martyrdom

Centileschi is the leading woman art-

Borromini designs San Carlo alle

in Catholic Spain.

Quattro Fontane.

ist in Europe.

1625-1650

of Spain and the Holy Roman Empire. The war, which concluded were the Bourbon dynasty of France and the Habsburg dynasties political entities vying for expanded power and authority in Europe to secular, dynastic, and nationalistic concerns. Among the major Catholics and militant Protestants, the driving force quickly shifted outbreak of this war had its roots in the conflict between militant the Ottoman Empire, and the Holy Roman Empire. Although the Sweden, Denmark, the Netherlands, Germany, Austria, Poland, the Thirty Years' War (1618–1648), which ensnared Spain, France, peace for a mere four years. The major conflict of this period was and warfare. Indeed, between 1562 and 1721, all of Europe was at nounced political and religious friction resulted in widespread unrest Europe as the fortunes of individual countries rose and fell. Pro-During the 17th century, numerous geopolitical shifts occurred in

RELAND

SCOTLAND

EUROPE IN THE 17TH CENTURY

lifestyles, and trading patterns, along with expanding colonialism, century. In the 17th century, however, changes in financial systems, ing, and advances in shipbuilding—had been laid in the previous extensive voyaging and geographic exploration, improved mapmakto Europe. Much of the foundation for worldwide mercantilism-The 17th century also brought heightened economic competition

KINCDOM OF SWEDEN

POLAND

KINCDOW

states was emphatically under way. realities of secular political systems. The building of today's nationthe idea of a united Christian Europe and accepted the practical throughout Europe. This treaty thus marked the abandonment of Treaty of Westphalia in essence granted freedom of religious choice diminished. In addition to reconfiguring territorial boundaries, the and France expanded their authority. Spanish and Danish power United Provinces of the Netherlands (the Dutch Republic), Sweden, the political restructuring of Europe (MAP 10-1). As a result, the with the Treaty of Westphalia in 1648, was largely responsible for

Christopher Wren designs Saint scaped gardens. palace at Versailles with vast land-Louis XIV, the "Sun King," builds the frescoes in Sant'Ignazio. Pozzo paints illusionistic ceiling

part on French and Italian models.

Paul's Cathedral in London based in

Poussin champions "grand manner"

Philip IV of Spain, paints Las Meninas.

aid in painting domestic interiors.

Velázquez, the chief court painter of

Bernini designs the colonnaded oval

piazza in front of Saint Peter's.

5/91-0591

fueled the creation of a worldwide marketplace. The Dutch founded the Bank of Amsterdam in 1609, which eventually became the center of European transfer banking. By establishing a system in which merchant firms held money on account, the bank relieved traders of having to transport precious metals as payment. Trading practices became more complex. Rather than simple reciprocal trading, triangular trade (trade among three parties) facilitated access to a larger pool of desirable goods. Exposure to an ever-growing array of goods affected European diets and lifestyles. Tea (from China) and, later, coffee (from island colonies) became popular beverages over the course of the 17th century. Equally explosive was the growth of sugar use. Sugar, tobacco, and rice were slave crops, and the slave trade expanded to meet the demand for these goods. The resulting worldwide mercantile system permanently changed the face of Europe. The prosperity generated by international trade affected social and political relationships, necessitating new rules of etiquette and careful diplomacy. With increased disposable income, more of the newly wealthy spent money on art, significantly expanding the market for artworks, especially small-scale paintings for private homes.

"BAROQUE" ART Art historians traditionally describe 17th-century European art as *Baroque*, but the term is problematic because the period encompasses a broad range of styles and genres. Although its origin is unclear, "Baroque" may have come from the Portuguese word *barroco*, meaning an irregularly shaped pearl. Use of the term can be traced to the late 18th century, when critics belittled the Baroque period's artistic production, in large part because of perceived deficiencies in comparison to the art of the Italian Renaissance. Over time, this negative connotation faded, but the term stuck. "Baroque" remains useful to describe the distinctive new style that emerged during the early 1600s—a style of complexity and drama seen especially in Italian art of this period. Whereas Renaissance artists embraced the precise, orderly rationality of classical models, Baroque artists reveled in dynamism, theatricality, and elaborate ornamentation, often on a grandiose scale, as in Bernini's Four Rivers Fountain (FIG. 10-1).

ITALY

Although the Protestant Reformation brought with it fundamental changes in artistic patronage in many northern European countries, in Italy the Catholic Church remained the leading source of artistic commissions. The aim of much of Italian Baroque art was to restore Roman Catholicism's predominance and centrality.

Architecture and Sculpture

Baroque art and architecture in Italy, especially in Rome, embodied the renewed energy of the Counter-Reformation (see "The Council of Trent" (1). At the end of the 16th century, Pope Sixtus V (r. 1585–1590) had augmented the papal treasury and intended to rebuild Rome as an even more magnificent showcase of Church power. Between 1606 and 1667, several strong and ambitious popes—Paul V, Urban VIII, Innocent X, and Alexander VII—made many of Sixtus V's dreams a reality. Rome still bears the marks of their patronage everywhere.

BERNINI'S BALDACCHINO A quarter century before Gianlorenzo Bernini designed the Four Rivers Fountain (FIG. 10-1) for Innocent X, Urban VIII had awarded him the commission to erect a gigantic bronze *baldacchino* (FIG. 10-2) in Saint Peter's directly beneath Giacomo della Porta's dome (FIG. 9-14). Completed between 1624 and 1633, the canopy-like structure (*baldacco* is Italian

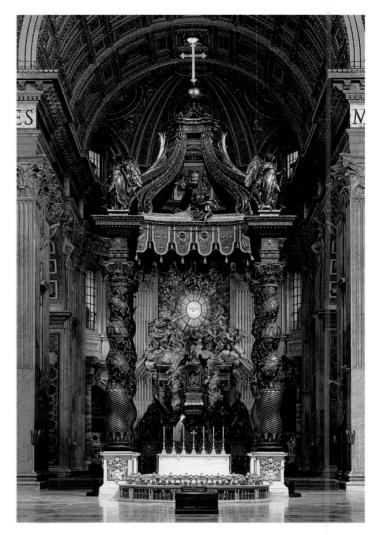

10-2 GIANLORENZO BERNINI, baldacchino (looking west), Saint Peter's, Vatican City, Rome, Italy, 1624–1633.

Bernini's baldacchino serves both functional and symbolic purposes. It marks Saint Peter's tomb and the high altar, and it visually bridges the marble floor and the lofty vaults and dome above.

for "silk from Baghdad," such as for a cloth canopy) stands almost 100 feet high and serves both functional and symbolic purposes. It marks the high altar and the tomb of Saint Peter beneath the basilica, and provides a dramatic presence at the crossing, visually bridging the marble floor to the lofty vaults and dome above. Its columns also serve as a visual frame for the elaborate sculpture representing the throne of Saint Peter (the Cathedra Petri) at the far end of the nave (FIG. 10-2, rear). On a symbolic level, the baldacchino's decorative elements speak to the power of the Catholic Church. Partially fluted and wreathed with vines, the structure's four spiral columns are Baroque versions of those of the ancient baldacchino over the same spot in Old Saint Peter's, thereby invoking the past to reinforce the primacy of the Church of Rome in the 17th century. At the top of the columns, four colossal angels stand guard at the upper corners of the canopy. Forming the canopy's apex are four serpentine brackets that elevate the orb and the cross. Since the time of the emperor Constantine, builder of the original Saint Peter's basilica (FIGS. 4-3 and 4-4), the orb and the cross had served as symbols of the Church's triumph. The baldacchino also features numerous bees, symbols of Urban VIII's family, the Barberini. Bernini's design

make up the two colonnades, which terminate in classical temple fronts. The colonnades extend a dramatic gesture of embrace to all who enter the piazza, symbolizing the welcome that the Roman Catholic Church gave its members during the Counter-Reformation. Bernini himself

referred to his colonnades as the welcoming arms of Saint Peter's. Beyond their symbolic resonance, the colonnades served visually to counteract the natural perspective and bring the facade closer to the viewer. Emphasizing the facade's height in this manner, Bernini subtly and effectively compensated for its extensive width. Thus a Baroque transformation expanded the compact central designs of Bramante and Michelangelo into a dynamic complex of axially ordered elements that reach out and enclose spaces of vast dimension. By its sheer scale and theatricality, the completed Saint Peter's fulfilled the desire of the Counter-Reformation Church to present an awe-inspiring and authori-

PROBLEMS AND SOLUTIONS
Completing Saint Peter's

Old Saint Peter's had a large forecourt, or atrium (Fies. 4-3 and 4-4), in front of the church proper, and in the mid-17th century, Gianlorenzo Bernini (Fie. 10-1) received the prestigious commission to construct a grand colonnade-framed piasza (Fie. 10-3) in front of Maderno's facade. Bernini's design had to incorporate two preexisting structures on the site—an obelisk that the ancient Romans had brought from Egypt (which Pope Sixtus V had moved to its present location in 1585 as part of his vision of Christian triumph in Rome) and a fountain that Maderno had constructed in front of the church. Bernini's solution was to co-opt these features to define the long axis of a vast oval embraced by two colonandes joined to Maderno's facade. Four rows of huge Tuscan columns mades joined to Maderno's facade. Four rows of huge Tuscan columns

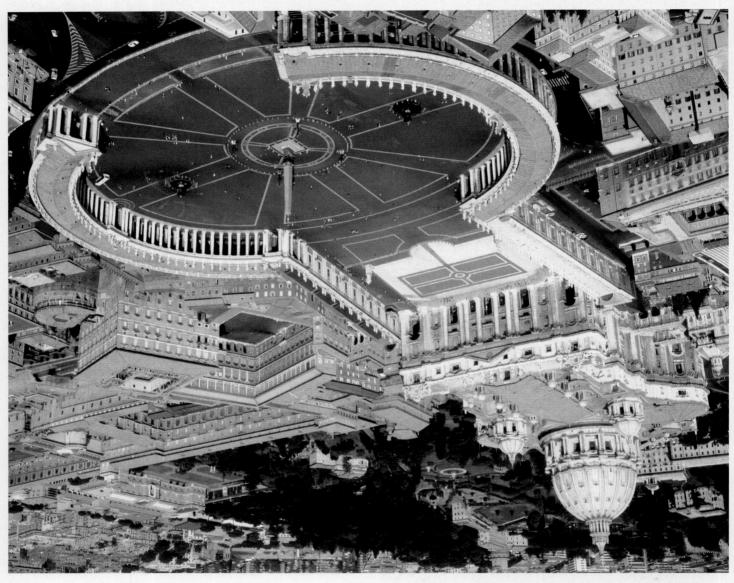

tative vision of itself.

10-3 Aerial view of Saint Peter's (looking northwest), Vatican City, Rome, Italy. Facade by Савьо Маревио, 1606–1612. Piazza by Gianlorenzo Bernini, 1656–1667.

The dramatic gesture of embrace that Bernini's colonnade makes as worshipers enter Saint Peter's piasza symbolizes the welcome the Catholic Church wished to extend during the Counter-Reformation.

thus effectively gives visual form to the triumph of Christianity and to the papal claim to supremacy in formulating Church doctrine.

MADERNO'S SAINT PETER'S The installation of Bernini's baldacchino was the last major transformation of the interior of Saint Peter's after Carlo Maderno (1556-1629) completed the centurylong project to rebuild the Constantinian basilica. Pope Paul V (r. 1605-1621) had asked Maderno to design a new facade (FIG. 10-3, left) for Michelangelo's incomplete building (FIGS. 9-13 and 9-14). Although Maderno did not have the luxury of formulating a totally new concept for Saint Peter's, his facade nonetheless embodies the design principles of early Italian Baroque architecture. The rhythm of vigorously projecting columns and pilasters mounts dramatically toward the emphatically stressed pediment-capped central section. The recessed niches, which contain statues and create pockets of shadow, heighten the sculptural effect. The two outer bays with bell towers were not part of Maderno's original design, however. Had the facade been constructed according to the architect's concept, it would have exhibited greater verticality and visual coherence.

Behind the facade, Maderno's Saint Peter's also departed from the 16th-century plans of Bramante and Michelangelo. At the pope's request, Maderno added three nave bays to the earlier nucleus because Paul V considered the central plan too closely associated with ancient temples, such as the Pantheon (FIG. 3-38). Further, the traditional longitudinal basilica plan reinforced the symbolic distinction between clergy and laity and also was much better suited for large congregations and religious processions. Lengthening the nave, however, pushed the dome farther back from the facade and all but destroyed the effect Michelangelo had planned-a structure pulled together and dominated by its dome (FIG. 9-14). When viewed at close range, the dome barely emerges above the facade's soaring frontal plane. Seen from the great piazza (FIG. 10-3) erected later by Bernini (see "Completing Saint Peter's," page 288), Maderno's dome appears to have no drum. Visitors must move back quite a distance from the front (or fly over the church) to see the dome and drum together.

DAVID Although Bernini won fame as an architect, his international reputation rested primarily on his sculpture. The biographer Filippo Baldinucci (1625–1696) observed: "[No sculptor] manipulated marble with more facility and boldness. He gave his works a marvelous softness . . . making the marble, so to say, flexible." Bernini's sculpture is expansive and theatrical, and the element of time usually plays an important role in it, as in the pronounced movement of the personified rivers—and the cascading water—in his Piazza Navona fountain (FIG. 10-1).

An earlier masterwork is Bernini's *David* (FIG. 10-4), which fundamentally differs from the Renaissance portrayals of the same subject by Donatello (FIG. 8-18) and Michelangelo (FIG. 9-8). Michelangelo portrayed David before his encounter with Goliath. Donatello depicted David after his triumph over the giant. Bernini chose to represent the combat itself and aimed to capture the split-second of maximum action. Bernini's hero, his muscular legs widely and firmly planted, begins the violent, pivoting motion that will launch the stone from his sling. Unlike Myron, the fifth-century BCE Greek sculptor who froze his *Discus Thrower* (FIG. 2-32) at a fleeting moment of inaction, Bernini selected the most dramatic of an implied sequence of poses, requiring the viewer to think simultaneously of the continuum and of this tiny fraction of it. The suggested

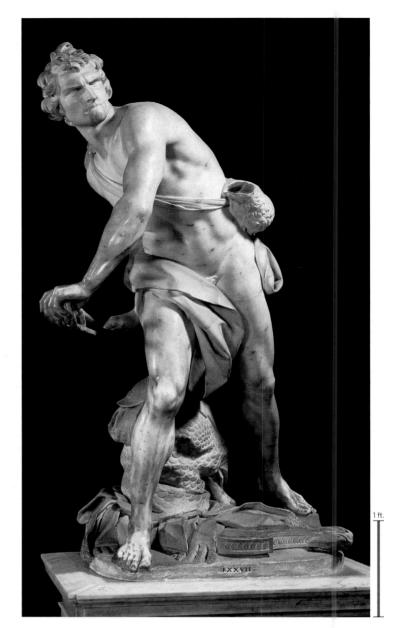

10-4 GIANLORENZO BERNINI, *David*, from the Villa Borghese, Rome, 1623. Marble, 5' 7" high. Galleria Borghese, Rome.

Bernini's sculptures are expansive and theatrical, and the element of time plays an important role in them. His emotion-packed *David* seems to be moving through both time and space.

continuum imparts a dynamic burst of energy. The Baroque statue seems to be moving through time and through space. This kind of sculpture cannot be inscribed in a cylinder or confined in a niche. Its unrestrained action demands space around it. Nor is it self-sufficient in the Renaissance sense, as its pose and attitude direct attention beyond it to the unseen Goliath. Bernini's *David* moves out into the space surrounding it, as do Apollo and Daphne in the marble group (FIG. 10-4A) that he carved for the same patron, Cardinal Scipione Borghese (1576–1633). Further, the expression of intense concentration on David's face contrasts vividly with the classically placid visage of Donatello's biblical hero and is more emotionally charged even than Michelangelo's. The tension in David's face augments the dramatic impact of Bernini's sculpture.

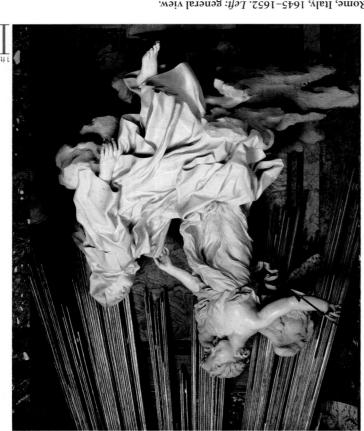

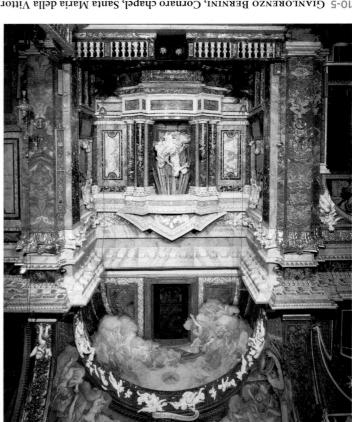

10-5 Gianlorenzo Bernini, Cornaro chapel, Santa Maria della Vittoria, Rome, Italy, 1645–1652. Left: general view. Right: Ecstasy of Saint Teresa. Marble, 11' 6" high.

In the Cornaro chapel, Bernini marshaled the full capabilities of architecture, sculpture, and painting to re-create a spiritual experience for worshipers, consistent with the ideas of Ignatius Loyola.

the visual differentiation in texture among the clouds, rough cloth and gauzy material, smooth flesh, and feathery wings—all carved from the same white marble. Light from a hidden window of yellow glass pours down in golden rays suggesting the radiance of Heaven, whose painted representation covers the vault.

The passionate drama of Bernini's Ecstasy of Saint Teresa correlated with the ideas disseminated earlier by Ignatius Loyola (1491–1556), who founded the Jesuit order in 1534 (see page 265) and whom the Catholic Church canonized as Saint Ignatius in 1622. In his book Spiritual Exercises, Ignatius argued that the re-creation of spiritual experiences in artworks would do much to increase devotion and piety. Thus theatricality and sensory impact were useful of Trent. (3). Bernini was a devout Catholic, which undoubtedly of or achieving Counter-Reformation goals (see "The Council of Trent. (3). Bernini was a devout Catholic, which undoubtedly contributed to his understanding of those goals. His inventiveness, technical skill, sensitivity to his patrons' needs, and energy made them the quintessential Italian Baroque artist.

FRANCESCO BORROMINI (1599–1667) took Italian Baroque architect, FRANCESCO BORROMINI (1599–1667) took Italian Baroque architecture to even greater dramatic heights. In San Carlo alle Quattro Fontane (Saint Charles at the Four Fountains; Fig. 10-6), Borromini in emphasizing a building's sculptural qualities (see "Rethinking the Church Facade," page 291). Inside, San Carlo is a hybrid of a Greek cross and an oval, with a long axis between entrance and apse. Greek cross and an oval, with a long axis between entrance and apse. The side walls move in an undulating flow that reverses the facade's

his arrow. The sculptor's supreme technical virtuosity is evident in passion, swooning back on a cloud, while the smiling angel aims saint in ecstasy, unmistakably a mingling of spiritual and physical enly drama unfold from choice balcony seats. Bernini depicted the dinal Federico Cornaro (1579-1673) and his family watch the heavmarble. On either side of the chapel, sculpted relief portraits of Carcrowned with a broken pediment and ornamented with polychrome as a shallow proscenium (the part of the stage in front of the curtain) tion of this mystical drama. The niche in which it takes place appears hands, the entire Cornaro chapel became a theater for the producexperience as making her swoon in delightful anguish. In Bernini's repeatedly into her heart. In her writings, Saint Teresa described this it to the fire-tipped arrow of divine love that an angel had thrust visions, and heard voices. Feeling a persistent pain, she attributed the death of her father, when she fell into a series of trances, saw of the Spanish Counter-Reformation. Her conversion occurred after Saint Teresa of Avila (1515-1582), one of the great mystical saints sculpture (FIG. 10-5, right) that serves as the chapel's focus depicts ing to charge the entire chapel with palpable tension. The marble marshaled the full capabilities of architecture, sculpture, and paintater that he derived from writing plays and producing stage designs, Baroque master, drawing on the considerable knowledge of the thehis statues to firmly defined spatial settings. For this commission, the Maria della Vittoria. The work exemplifies Bernini's refusal to limit Ecstasy of Saint Teresa in the Cornaro chapel (FIG. 10-5, left) of Santa and emotion that are hallmarks of Italian Baroque art is Bernini's ECSTASY OF SAINT TERESA Another work displaying the motion

PROBLEMS AND SOLUTIONS

Rethinking the Church Facade

Although Carlo Maderno incorporated sculptural elements in his facade of Saint Peter's (FIG. 10-3), the church fronts he designed still develop along relatively lateral planes, the traditional approach to facade design. In contrast, Francesco Borromini rethought the very nature of a church facade. In his design for San Carlo alle Quattro Fontane (FIG. 10-6) in Rome, Borromini set the building's front in undulating motion, creating a dynamic counterpoint of concave and convex elements on two levels (for example, the sway of the cornices). He enhanced the three-dimensional effect with deeply recessed niches. Borromini's facade therefore stands in sharp opposition to the idea, which has its roots in antiquity, that a facade should be a flat frontispiece that defines a building's outer limits. In Borromini's hands, the church facade became a pulsating, engaging screen inserted between interior and exterior space, designed not to separate but to provide a fluid transition between the two.

In fact, San Carlo has not one but two facades, underscoring the functional interrelation of the building and its environment. The second facade, a narrow bay crowned with its own small tower, turns away from the main facade and, following the curve of the street, faces an intersection.

10-6 Francesco Borromini, San Carlo alle Quattro Fontane (looking south), Rome, Italy, 1638–1641.

Borromini rejected the notion that a church should have a flat frontispiece. He set San Carlo's facade in undulating motion, creating a dynamic counterpoint of concave and convex elements.

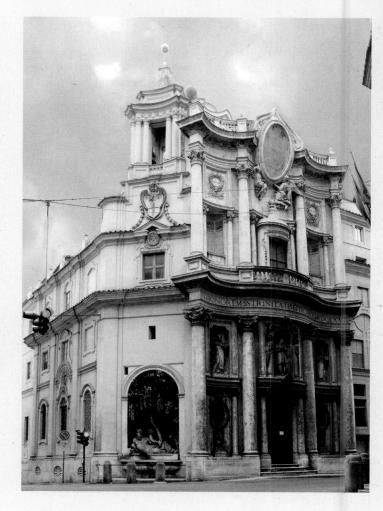

motion. Vigorously projecting columns define the space into which they protrude just as much as they accent the walls to which they are attached. Capping this molded interior space is a deeply coffered oval dome (FIG. 10-7) that seems to float on the light entering

through windows hidden in its base. Rich variations on the basic theme of the oval—dynamic relative to the static circle—create an interior that flows from entrance to altar, unimpeded by the segmentation so characteristic of Renaissance buildings.

10-7 Francesco Borromini, view into the dome of San Carlo alle Quattro Fontane, Rome, Italy, 1638–1641.

Instead of using a traditional round dome, Borromini capped the interior of San Carlo with a deeply coffered oval dome that seems to float on the light entering through windows hidden in its base.

Painting

Although architecture and sculpture provided the most obvious vehicles for manipulating space and creating theatrical effects, painting continued to be an important art form in 17th-century Italy.

PANNIBALE CARRACCI One of the most renowned Italian Baroque painters was ANNIBALE CARRACCI (1560–1609), who received much of his training at an art academy in his native Bologna founded by his extended family, among them his cousin Ludovico Carracci (1555–1619) and brother Agostino Carracci (1557–1602). The Bolognese academy was the first significant institution of its kind in the history of Western art. The Carracci established it on the premthe history of Western art. The Carracci established it on the premtees that art can be taught—the basis of any academic philosophy of art—and that art instruction must include the classical and Renaisati—and that art instruction must include the classical and Renaisatic—and that art instruction must include the classical and Renaisatic—and that art instruction must include the classical and Renaisatic—and that art instruction must include the classical and Renaisatic—and that art instruction must include the classical and Renaisatic—and that art instruction must include the classical and Renaisatic—and that art instruction must include the classical and Renaisatic—art—and that art instruction must include the classical and Renaisatic—art—and that art instruction must include the classical and Renaisatic—art—and that art instruction must include the classical and Renaisatic—art—and that art instruction must include the classical and Renaisatic—art—art can be supplied to the classical and the content of the content of the content of the canada art and the canada art and the content of the con

sance traditions in addition to the study of anatomy and life drawing.

mythology. and divine love in classical tions of the varieties of earthly Loves of the Gods—interpretais mergora pideragonosi priately, the title of the fresco's the cardinal's brother. Approto celebrate the wedding of ceiling of the palace's gallery sioned Carracci to decorate the who built the palace, commisscendant of Pope Paul III, (1573-1626), a wealthy de-Cardinal Odoardo Farnese Palazzo Farnese in Rome. coes (FIG. 10-8) in the notable works are his fres-Annibale Carracci's most

Carracci arranged the scenes in a format resembling framed easel paintings on a wall, but in the Farnese gallery, the paintings cover term for this type of simulation of easel painting for ceiling design is quadro riportato ("transferred framed panel").

10-8 ANNIBALE CARRACCI, Loves of the Gods, ceiling frescoes in the gallery, Palazzo Farnese, Rome, Italy, 1597–1601.

On the shallow curved vault of this large gallery in the Palazzo Farnese, Carracci arranged the mythological scenes in a quadro riportato format resembling easel

tative styles to create something of his own—no easy achievement.

and animated figures. Carracci succeeded in adjusting their authori-

of Raphael's drawing style and lighting and Titian's more sensuous

the vault, the long panel, Triumph of Bacchus, is an ingenious mixture

or statues illuminated by torches in the gallery below. In the crown of

the outside figures, as if they were tangible three-dimensional beings

the panels in an even light. In contrast, light from beneath illuminates

figures surrounding them. Carracci modeled the figures inside

chiaroscuro of the Farnese frescoes differs for the pictures and the

ues. Carracci derived these motifs from the Sistine Chapel ceiling (Fig. 9-9), but he did not copy Michelangelo's figures. Notably, the

them, and standing Atlas figures painted to resemble marble stat-

seated nude youths, who turn their heads to gaze at the scenes around

more than a century. Flanking the framed pictures are polychrome

Carracci made the quadro riportato format fashionable in Italy for

CARAVAGGIO Michelangelo Merisi, known as CARAVAGGIO (1573-1610) after his northern Italian birthplace, developed a distinctive personal style that had tremendous influence throughout Europe. His outspoken disdain for the classical masters (probably more rhetorical than real) drew bitter criticism from many painters, one of whom denounced him as the "anti-Christ of painting." Giovanni Pietro Bellori (1613-1696), the most influential critic of the age and an admirer of Annibale Carracci, believed that Caravaggio's refusal to emulate the models of his distinguished predecessors threatened the whole classical tradition of Italian painting that had reached its zenith in Raphael's work (see "Giovanni Pietro Bellori on Annibale Carracci and Caravaggio" (1). Yet despite this criticism and the problems in Caravaggio's troubled life (police records are an important source of information about the artist), Caravaggio received many commissions, both public and private, and numerous painters paid him the supreme compliment of borrowing from his innovations. His influence on later artists, as much outside Italy as within, was immense. In his art, Caravaggio injected naturalism into the representation of sacred subjects, reducing them to human dramas played out in the harsh and dingy settings of his time and place by unidealized figures that he selected from the fields and the streets.

The setting of Caravaggio's early masterpiece, Calling of Saint Matthew (FIG. 10-9), is a modest tayern with unadorned walls. Into this mundane environment, cloaked in mysterious shadow

and almost unseen, Christ, identifiable initially only by his indistinct halo, enters from the right. With a commanding gesture, he summons Levi, the Roman tax collector, to a higher calling. The astonished Levi-his face illuminated by the beam of light emanating from an unspecified source above Christ's head and outside the picture—points to himself in disbelief. Although Christ's extended arm is reminiscent of the Lord's in Creation of Adam (FIG. 9-10), the position of his hand and wrist is similar to that of Adam's. This reference was highly appropriate because the Church considered Christ the second Adam. Whereas Adam was responsible for the fall of humankind, Christ is the vehicle of its redemption. The conversion of Levi (who became Matthew) brought his salvation.

In Calling of Saint Matthew and Caravaggio's other religious paintings—for example, Conversion of Saint Paul (FIG. 10-9A ◀)—the figures are still heroic, with powerful bodies and clearly delineated contours in the Renaissance tradition, but the stark and dramatic contrast of light and dark, which at first shocked and then fascinated his contemporaries, obscures the more traditional aspects of his style. Art historians call Caravaggio's use of dark settings that envelop their occupants tenebrism, from the Italian word tenebroso, or "shadowy" manner. In Caravaggio's work, tenebrism also contributed greatly to the essential meaning of his pictures. For example, in Calling of Saint Matthew, the beam of light directing the viewer's attention to the seated tax collector is the divine light beckoning him to join the Son of God in his earthly mission.

10-9 CARAVAGGIO. Calling of Saint Matthew, ca. 1597-1601. Oil on canvas, 11' 1" × 11' 5". Contarelli chapel, San Luigi dei Francesi, Rome.

The stark contrast of light and dark is a key feature of Caravaggio's style. Here, Christ, cloaked in mysterious shadow, summons Levi the tax collector (Saint Matthew) to a higher calling.

10-10 Artemisia Gentileschi, Judith Slaying Holofernes, ca. 1614–1620. Oil on canvas, 6' $6\frac{1}{3}$ " \times 5' 4". Galleria degli Uffizi, Florence.

Narratives involving heroic women were a favorite theme of Gentileschi. In Judith Slaying Holofemes, the dramatic lighting of the action in the foreground emulates Caravaggio's tenebrism.

ARTISTS ON ART The Letters of Artemisia Gentileschi

Artemisis Gentileschi (Fies. 10-10 and 10-10A (1)) was the most renowned woman painter in Europe during the first half of the 17th century and the first woman ever admitted to membership in Florence's Accademia del Disegno. In addition to scores of paintings created for wealthy patrons, among them the king of England and the grand duke of Tuscany, Gentileschi left behind 28 letters, some of which reveal that she believed that patrons treated her differently because of her gender. Two 1649 letters written in Naples to Don Antonio Ruffo (1610–1678) in Messina make her feelings explicit.

I fear that before you saw the painting you must have thought me arrogant and presumptuous.... [1]f it were not for Your Most Illustrious Lordship.... I would not have been induced to give it for one hundred and sixty, because everywhere else I have been I was paid one hundred scudi per figure.... You think me pitiful, I was paid one hundred scudi per figure... You think me pitiful, because a woman's name raises doubts until her work is seen.*

As for my doing a drawing and sending it, [tell the gentleman who wishes to know the price for a painting that] I have made a solemn vow never to send my drawings because people have cheated me. In particular, just today I found myself [in the situation] that, having done a drawing of souls in Purgatory for the Bishop of St. Gata, he, in order to spend less, commissioned another painter to do the painting using my work. If I were a man, I can't imagine it would have turned out this way, because when I the concept has been realized and defined with lights and darks, and established by means of planes, the rest is a trifle.

*Letter dated January 30, 1649. Translated by Mary D. Garrard, Artemisia Gentileschi: The Image of the Female Hero in Italian Baroque Art (Princeton, N.J.: Princeton University Press, 1989), 390.

Letter dated November 13, 1649. Ibid., 397-398.

their strength to wield the heavy sword. The tension and strain are palpable. The controlled highlights on the action in the foreground recall Caravaggio's work and heighten the drama here as well.

FRA ANDREA POZZO With the Sistine Chapel (FIG. 9-9) and Farnese Palace (FIG. 10-8) as prestigious models, many Italian Baroque painters created ceiling frescoes for both churches and palaces. One late-17th-century master of ceiling decoration was FRA ANDREA POZZO (1642–1709), a lay brother of the Jesuit order and a master of perspective, on which he wrote an influential treatise. Pozzo designed and executed the huge painting Glorification of Saint Ignatius (FIG. 10-17) for the nave of the church of Sant'Ignazio in Rome (see "How to Make a Ceiling Disappear," page 295). Like II Gesù, which also boasts a vast fresco—Triumph of the Name of Jesus (FIG. 10-17A) by Giovanui Battista Gaulli (1639–1709)—on its nave vault, Sant'Ignazio was a prominent Counter-Reformation church because of its dedication to the founder of the Jesuit order. The Jesuits played a major role in Catholic education and sent legions of missionaries to the New World and Asia.

ARTEMISIA GENTILESCHI Caravaggio's combination of naturalism and drama appealed both to patrons and to artists, and he had many followers. Among them was the most celebrated woman artist of the era, Artemista Gentileschi (ca. 1593–1653; figs. 10-10 and 10-10 № Å), whose father, Orazio (1563–1639), her teacher, was full career, pursued in Florence, Venice, Naples, and Rome (see "The Letters of Artemisia Gentileschi," above), helped disseminate Caravaggio's style throughout the peninsula.

In Judith Slaying Holofernes (FIG. 10-10), Gentileschi adopted the tenebrism and what might be called the "dark" subject matter Caravaggio favored. Significantly, she chose a narrative involving a heroic woman, a favorite theme of hers. The story, from the book of Judith, relates the delivery of Israel from the Assyrians. Having succumbed to Judith's charms, the Assyrian general Holofernes invited her to his tent for the night. When he fell asleep, Judith cut off his head. In this version of the scene (Gentileschi produced more than one painting of the subject), Judith and her maidservant behead Holofernes. Blood spurts everywhere as the two women summon all

PROBLEMS AND SOLUTIONS

How to Make a Ceiling Disappear

The effectiveness of Italian Baroque religious art depended on the drama and theatricality of individual images, as well as on the interaction and fusion of architecture, sculpture, and painting. Sound enhanced this experience. Architects designed churches with acoustical effects in mind, and in an Italian Baroque church filled with music, the power of both image and sound must have been very moving. Through simultaneous stimulation of the senses of both sight and hearing, the faithful might well have been transported into a trancelike state that would, indeed, as the great English poet John Milton (1608–1674) eloquently stated in *Il Penseroso* (1631), "bring all Heaven before [their] eyes."*

Seventeenth-century church officials keenly realized that spectacular paintings high above the ground offered perfect opportunities to impress on worshipers the glory and power of the Catholic Church. Looking up at a painting is different from viewing a painting hanging on a wall, even in the case of quadro riportato ceiling designs. The considerable height and expansive scale of most ceiling frescoes induce a feeling of awe. In conjunction with the theatricality of Italian Baroque architecture and sculpture, grandiose frescoes on church ceilings contributed to creating transcendent spiritual environments well suited to the needs of the Catholic Church in Counter-Reformation Rome.

In his fresco (FIG. 10-11) for the ceiling of the nave of the Roman church honoring Saint Ignatius, Fra Andrea Pozzo created the illusion of Heaven opening up above the congregation. To accomplish this, the artist painted an extension of the church's architecture into the vault so that the roof seems to be lifted off. As Heaven and earth commingle, Christ receives Saint Ignatius in the presence of figures personifying the four corners of the world. A disk in the nave floor marks the spot where the viewer should stand to gain the whole perspective illusion. For worshipers looking up from this point, the vision is complete. They find themselves in the presence of the heavenly and spiritual, the ultimate goal of Italian Baroque church art and architecture.

*John Milton, II Penseroso (1631, published 1645), 166.

10-11 FRA ANDREA POZZO, Glorification of Saint Ignatius, ceiling fresco in the nave of Sant'Ignazio, Rome, Italy, 1691-1694.

By merging real and painted architecture, Pozzo created the illusion that the vaulted ceiling of Sant'Ignazio has been lifted off and the nave opens to Heaven above the worshipers' heads.

SPAIN

During the 16th century, Spain had established itself as an international power. The Habsburg kings had built a dynastic state encompassing Portugal, part of Italy, the Netherlands, and extensive areas of the New World (see page 527). By the beginning of the 17th century, however, the Habsburg Empire was in decline, and although

Spain mounted an aggressive effort during the Thirty Years' War, by 1660 the imperial age of the Spanish Habsburgs was over. In part, the demise of the Habsburg Empire was due to economic woes. The military campaigns of Philip III (r. 1598–1621) and his son Philip IV (r. 1621–1665) waged during the Thirty Years' War were costly and led to higher taxes. The increasing tax burden placed on Spanish subjects in turn incited revolts and civil war in Catalonia and Portugal in

impact of the image. In the background are two barely visible tree branches. A small note next to the saint identifies him. The coarse features of the Spanish monk label him as common (Serapion had not yet been declared a saint at the time Zurbarán portrayed him), no doubt evoking empathy from a wide audience.

DIEGO VELÁZQUEZ The foremost Spanish painter of the Baroque age—and the greatest beneficiary of royal patronage—was DIEGO VELÁZQUEZ (1599–1660). Trained in Seville, Velázquez was quite young when he came to the attention of Philip IV, who, struck by the artist's immense talent, named him chief court painter and palace chamberlain. With the exception of two extended trips to Italy and a few excursions, Velázquez remained in Madrid for the rest of his life. His close relationship with Philip IV and his high office as chamberlain gave him prestige and a rare guaranteed income, although, like Michelangelo in the service of Julius II (see page 251), Velázquez had little opportunity to choose his own subjects.

An early work, Water Carrier of Seville (FIG. 10-13), reveals Velázquez's impressive command of the painter's craft when he was only about 20 years old. In this genre scene that seems to carry a deeper significance, Velázquez rendered the figures with clarity and dignity, and his careful depiction of the water jugs in the foreground, complete with droplets of water, adds to the scene's credibility. As in Zurbarán's Saint Serapion (FIG. 10-12), the commonplace characters

10-13 DIEGO VELÁZQUEZ, Water Carrier of Seville, ca. 1619. Oil on canvas, 3' $5\frac{1}{2}$ " \times 2' $7\frac{1}{2}$ ". Victoria & Albert Museum, London.

In this early work—a genre scene that seems to convey a deeper significance—the contrast of darks and lights and the commonplace characters reveal Velázquez's indebtedness to Caravaggio.

the 1640s, further straining an already fragile economy. Nevertheless, both Philip III and Philip IV continued to spend lavishly on art.

In a country passionately committed to Catholic orthodoxy, Spanish Baroque artists, like their counterparts in Counter-Reformation Italy, sought ways to move viewers and to encourage greater devotion and piety. Scenes of death and suffering had great appeal in Spain. They provided artists with opportunities both to depict extreme emotion and to elicit passionate feelings. Spain prided itself on its saints—Saint Teresa of Avila (Fig. 10-5) and Saint Ignatius Loyola (Fig. 10-11) were both Spanish-born—and martyrdom scenes were staples of Spanish Baroque art.

PERAICISCO DE ZURBRRÀN One prominent Spanish Baroque painter of religious works was Francisco De Zurbraka (1598–1664), whose primary patrons were rich monastic orders. Many of his paintings are quiet and contemplative, appropriate for prayer. Zurbarán paintings are quiet and contemplative, appropriate for prayer. Zurbarán painted Saint Serapion (Fig. 10-12) as a devotional image for the funerary chapel of the monastic Order of Mercy in Seville, which was funerary chapel of the monastic Order of Mercy in Seville, which was martyrdom while preaching the Gospel to Muslims. According to one account, the monk's captors tied him to a tree and then tortured and decapitated him. The Order of Mercy dedicated itself to self-sacrifice, and Serapion's membership in this order amplified the resonance of Surbarán's painting. In Saint Serapion, the monk emerges from a dark background and fills the foreground. The bright light shining on him calls attention to the saint's tragic death and increases the dramatic calls attention to the saint's tragic death and increases the dramatic calls attention to the saint's tragic death and increases the dramatic

10-12 Francisco de Zurbarka, Saint Serapion, 1628. Oil on canvas, 3' $111\frac{1}{2}$ " \times 3' $4\frac{3}{4}$ ". Wadsworth Atheneum Museum of Art, Hartford (Ella Gallup Sumner and Mary Catlin Sumner Collection Fund).

The light shining on Serapion calls attention to his tragic death and increases the painting's dramatic impact. The monk's coarse features label him as common, evoking empathy from a wide audience.

and the contrast of darks and lights reveal the influence of Caravaggio, whose work Velázquez had studied.

LAS MENINAS After an extended visit to Rome from 1648 to 1651, Velázquez returned to Spain and, in 1656, painted his greatest work, *Las Meninas* (*The Maids of Honor*; FIG. 10-14). The setting is the artist's studio in the Alcázar, the royal residence in Madrid. The young Infanta (Princess) Margarita appears in the foreground with her two maids-in-waiting, her favorite dwarfs, and a large dog. In the middle ground are a woman in widow's attire and a male escort. In the background, a chamberlain stands in a brightly lit open doorway. Scholars have been able to identify everyone in the room, including the two meninas and the dwarfs.

Las Meninas is noteworthy for its visual and narrative complexity. Indeed, art historians have yet to agree on any particular reading or interpretation. A central issue has been what, exactly, is taking place in Las Meninas. What is Velázquez depicting on the huge canvas in front of him? He may be painting this very picture—an informal image of the infanta and her entourage. Alternately, Velázquez may be painting a portrait of King Philip IV and Queen Mariana, whose reflections appear in the mirror on the far wall. If so, that would suggest the presence of the king and queen in the viewer's space, outside the confines of the picture. Other scholars have proposed that the mirror image is not a reflection of the royal couple standing in Velázquez's studio but a reflection of the portrait the artist is in the process of painting on the canvas before him.

More generally, *Las Meninas* is Velázquez's attempt to elevate both himself and his profession. Throughout his career, Velázquez

hoped to be ennobled by royal appointment to membership in the ancient and illustrious Order of Santiago (Saint James). Because he lacked a sufficiently noble lineage, he gained entrance only with difficulty at the very end of his life, and then only through the pope's dispensation. In the painting, Velázquez wears the order's red cross on his doublet. In the artist's mind, *Las Meninas* might have embodied the idea of the great king visiting his studio, as Alexander the Great visited the studio of the painter Apelles. The figures in the painting all appear to acknowledge the royal presence. Placed among them in equal dignity is Velázquez, face-to-face with his sovereign.

The location of the completed painting reinforced this act of looking—of seeing and being seen. *Las Meninas* hung in Philip IV's personal office. Thus, although occasional visitors admitted to the king's private quarters may have seen this painting, Philip was the primary audience. Each time he stood before the canvas, he again participated in the work as the probable subject of Velázquez's painting within the painting and as the object of the figures' gazes. In *Las Meninas*, Velázquez elevated the art of painting, in the person of the painter, to the highest status. The king's presence enhanced this status—either in person as the viewer of *Las Meninas* or as a reflected image in the painting itself. The paintings that appear in *Las Meninas* further reinforce this celebration of the painter's craft. On the wall above the doorway and mirror, two canvases depict the immortal gods as the source of art.

Las Meninas is extraordinarily complex visually. Velázquez's optical report of the event, authentic in every detail, pictorially summarizes the various kinds of images in their different levels and degrees of reality. He portrayed the realities of image on canvas, of mirror image, of optical image, and of the two painted images. This

work—with its cunning contrasts of real spaces, mirrored spaces, picture spaces, and pictures within pictures—itself appears to have been taken from a large mirror reflecting the entire scene. This would mean that the artist did not paint the princess and her suite as the main subjects of *Las Meninas* but himself in the process of painting them. *Las Meninas* is a pictorial summary and a commentary on the essential mystery of the visual world, as well as on the ambiguity that results when different states or levels interact or are juxtaposed.

Velázquez employed several devices in order to achieve these results. For example, the extension of the composition's pictorial depth in both directions is noteworthy. The open doorway and its ascending staircase lead the eye beyond the artist's studio, and the mirror and the outward glances of several of the figures incorporate the viewer's space into the picture as well. (Compare how the mirror in Jan van Eyck's *Giovanni Arnolfini and His Wife* [FIG. 8-6] similarly incorporates the area in front of the canvas into the picture, although less obviously and without a comparable extension of space beyond the rear wall of the room.) Velázquez also masterfully

10-14 DIEGO VELAZQUEZ, Las Meninas (The Maids of Honor), 1656. Oil on canvas, 10' 5" \times 9". Museo del Prado, Madrid.

Velázquez intended this huge and complex work, with its cunning contrasts of real, mirrored, and picture spaces, to elevate both himself and the profession of painting in the eyes of Philip IV.

He became court painter to the dukes of Mantua, friend of King Philip IV (r. 1621–1665) of Spain and his adviser on collecting art, painter to Charles I (r. 1625–1649) of England and Marie de' Medici (1573–1642) of France, and permanent court painter to the Spanish governors of Flanders. Rubens also won the confidence of his royal patrons in matters of state, and they often entrusted him with diplomatic missions of the highest importance. To produce a steady atream of paintings for an international clientele, Rubens employed scores of assistants. He also became a highly successful art dealer, buying and selling contemporary artworks and classical antiquities. Subens's many enterprises made him a rich man, able to afford a magnificent townhouse in Antwerp and a castle in the countryside.

departed Flanders for Italy and remained there from 1600 until 1608. During these years, he laid the foundations of his mature style. Shortly after returning home, he painted Elevation of the Cross (Fig. 10-15) for Saint Walburga in Antwerp. The triptych reveals his careful study in Italy of the works of Michelangelo and Carazagegio, as well as ancient statuary. In a treatise he wrote in Latin—De imitatione statuarum (On the Imitation of Statues)—Rubens stated: "I am convinced that in order to achieve the highest perfection one needs a full understanding of the [ancient] statues, indeed a complete absorption in them; but one must make judicious use of them and before all avoid the effect of stone."

Elevation of the Cross provided Rubens with the opportunity to depict heavily muscled men in unusual poses straining to lift the heavy cross with Christ's body nailed to it. Here, as in his Lion Hunt (Fig. I-11), Rubens, deeply impressed by Michelangelo's twisting sculpted and painted figures (Figs. I-14, 9-10, 9-10A), and 9-11), showed his prowess in representing foreshortened anatomy and the contortions of violent action. Rubens placed the body of Christ on the cross as a diagonal that cuts dynamically across the picture while inclining back into it. The whole composition seethes with a power inclining back into it. The whole composition seethes with a power

observed and represented form and shadow. Instead of putting lights abruptly beside darks, following Caravaggio, Velàzquez allowed a great number of intermediate values of gray to come between the two extremes. His matching of tonal gradations approached effects that were later discovered in the age of photography.

FLANDERS

In the 16th century, the Netherlands had come under the crown of Habsburg Spain when Emperor Charles V retired, leaving the Spanish kingdoms, their Italian and American possessions, and the Netherlandish provinces to his only legitimate son, Philip II (r. 1556–1598). (Charles bestowed his imperial title and German lands to his brother.) Philip's repressive measures against Protestants led the northern provinces to break from Spain and establish the Dutch Republic. The southern provinces remained under Spanish control, and they retained Catholicism as their official religion. The political distinction between modern Holland and Belgium more or less reflects this original separation, which in the 17th century signaled not only religious but also artistic differences. The Baroque art of Planders (the Spanish Netherlands) retained close connections to the Baroque art of Catholic Europe, whereas the Dutch schools of the Baroque art of Catholic Europe, whereas the Dutch schools of painting developed their own subjects and styles.

PETER PAUL RUBENS The greatest 17th-century Flemish painter was Peter Paul Rubens (1577–1640), who built on the innovations of the Italian Renaissance and Baroque masters to formulate the first truly pan-European painting style. Rubens's art is an original and powerful synthesis of the manners of many painters, especially Michelangelo, Titian, Carracci, and Caravaggio. His style had wide appeal, and his influence was international. Among the most learned individuals of his time, Rubens possessed an aristocratic education and a courtier's manner, diplomacy, and tact, which, with his facility for language, made him the associate of princes and scholars.

PUBENS, Elevation
BUBENS, Elevation
of the Cross, from
Saint Walburga, Antwerp, 1610. Oil on
wood, center panel
15' 1\frac{7}{8}'' \times 11'' \frac{1}{2}'', each
wing 15' 1\frac{7}{8}'' \times 4'' 11''.
Antwerp Cathedral,
Antwerp Cathedral,
Antwerp.

explored foreshortened explored foreshortened anatomy and violent action. The whole composition seethes with a power that comes from heroic exertion. The tension is emotional as well sion is emotional as well as physical.

that comes from strenuous exertion, from elastic human sinew taut with effort. The tension is emotional as well as physical, as reflected not only in Christ's face but also in the features of his followers. Bright highlights and areas of deep shadow inspired by Caravaggio's tenebrism, hallmarks of Rubens's work at this stage of his career, enhance the drama. He later developed a much subtler coloristic style.

MARIE DE' MEDICI Rubens's interaction with royalty and aristocracy provided him with an understanding of the ostentation and spectacle of Baroque (particularly Italian) art that appealed to the wealthy and privileged. Rubens, the born courtier, reveled in the pomp and majesty of royalty. Likewise, those in power embraced the lavish spectacle that served the Catholic Church so well in Italy. The magnificence and splendor of Baroque imagery reinforced the authority and right to rule of the highborn. Among Rubens's royal patrons was Marie de' Medici, a member of the famous Florentine banking family and widow of Henry IV (r. 1589–1610), the first Bourbon king of France. She commissioned Rubens to paint a series of huge canvases memorializing and glorifying her career. Between 1622 and 1626, Rubens, working with amazing creative energy, produced 21 huge historical-allegorical pictures designed to hang in the queen's new palace, the Luxembourg, in Paris.

In Arrival of Marie de' Medici at Marseilles (FIG. 10-16), Marie disembarks after the sea voyage from Italy. A personification of

10-16 PETER PAUL RUBENS, Arrival of Marie de' Medici at Marseilles, from the Luxembourg Palace, Paris, France, 1622–1625. Oil on canvas, $12' 11\frac{1}{2}'' \times 9' 7''$. Musée du Louvre, Paris.

Rubens painted 21 large canvases glorifying Marie de' Medici's career. In this historical-allegorical picture of robust figures in an opulent setting, the sea and sky rejoice at the queen's arrival in France.

France, draped in a cloak decorated with the royal *fleur-de-lis* (compare FIG. 10-30), welcomes her. The sea and sky rejoice at the queen's safe arrival. Neptune and the Nereids (daughters of the sea god Nereus) salute her, and the winged and trumpeting personified Fame swoops overhead. Conspicuous in the galley's opulently carved stern-castle, under the Medici coat of arms, stands the commander of the vessel, the only immobile figure in the composition. In black and silver, this figure makes a sharp accent amid the swirling tonality of ivory, gold, and red brushstrokes. Rubens enriched the surfaces with a decorative splendor that pulls the whole composition together. The vigorous motion that customarily enlivens the artist's figures, beginning with the monumental, twisting sea creatures, vibrates through the entire design.

ANTHONY VAN DYCK The most famous of Rubens's Flemish successors was Anthony Van Dyck (1599–1641), who was an assistant in the master's studio. Early on, the younger man, unwilling to be overshadowed by Rubens's undisputed stature, left his native Antwerp for Genoa and then London, where he became court portraitist to Charles I. Although Van Dyck created dramatic compositions of high quality, his specialty became the portrait. In one of his finest works, *Charles I at the Hunt* (FIG. 10-17), the ill-fated English king stands on a hillock with the Thames River in the background. The portrait is a stylish image of relaxed authority, as if the king is out for a casual ride in his park, but no one can mistake the regal poise

10-17 Anthony Van Dyck, *Charles I at the Hunt*, ca. 1635. Oil on canvas, 8' $11'' \times 6'$ $11\frac{1}{2}''$. Musée du Louvre, Paris.

Van Dyck specialized in court portraiture. In this painting, he depicted the absolutist monarch Charles I at a sharp angle so that the king, a short man, appears to be looking down at the viewer.

DUTCH REPUBLIC

ingly passed into the hands of a class of wealthy merchants and ity and in the absence of an absolute ruler, political power increasfar away as Japan, Africa, and South America. Due to this prosperthe open seas, which facilitated establishing lucrative trade routes as economy also benefited enormously from the country's expertise on dam emerged as the financial center of the Continent. The Dutch With the founding of the Bank of Amsterdam in 1609, Amster-

portrayed the king turning his back on his attendants and looking seem taller than his attendants and even his horse. The painter also Dyck also managed to make Charles I, who was of short stature, focus of the viewer's attention, whose gaze the king returns. Van against the sky and with the tree branches pointing to him, he is the is exceedingly artful. He stands off center but, as the sole figure seen and was soon to rise against. Van Dyck's placement of the monarch and the air of absolute authority that Charles's Parliament resented

down on the observer, befitting his exalted position.

In Archers of Saint Hadrian, Hals attacked the problem of how to three or four days. These events often included sitting for a group portrait. sometimes lasted an entire week, prompting an ordinance limiting them to uniform for a grand banquet on their saint's feast day. The celebrations from Spain. As did other companies, each year the Archers met in dress

painter" than it is a snapshot of a social gathering. The result is a portrait that is less a record of "sitters posing for the in his mind but not traceable in any preparatory scheme on the canvas. energetic brush appears to have moved instinctively, directed by a plan expression—is, of course, the result of careful planning. Yet Hals's impromptu effect—the preservation of every detail and fleeting facial extending throughout the composition and energizing the portrait. The the work. Indeed, he used those elements to create a lively rhythm ruffs, and sashes—did not deter Hals from injecting spontaneity into recognizable. The uniformity of attire—black military dress, white are stern, others animated. Each archer is equally visible and clearly engage the viewer directly. Others look away or at a companion. Some features. The sitters' movements and moods vary markedly. Some each member is both part of the troop and an individual with unique enliven the depictions. In his portrait of the Saint Hadrian militiamen, erlands were rather ordered and regimented images, Hals sought to ety in the composition. Whereas earlier group portraits in the Nethrepresent each militia member satisfactorily yet retain action and vari-

Frans Hals's Group Portraits PROBLEMS AND SOLUTIONS

expression all seem instantaneously created. The poses of his figures, the highlights on their clothing, and their facial intensified the casualness, immediacy, and intimacy in his paintings. as well. His manner of execution, using light and rapid brushstrokes, taneity into his images and conveyed the individuality of his sitters than traditional formulaic portraiture. He injected an engaging sponthem, Frans Hals produced lively portraits that seem far more relaxed and thus unusable. Despite these difficulties, or perhaps because of or decoration, and the traditional conventions became inappropriate tation, instead wearing subdued and dark clothing with little variation trait painting became more challenging. The Calvinists shunned ostenin life. With the increasing number of Dutch middle-class patrons, porist's goal was to produce an image appropriate to the subject's station such as a pope, king, duchess, condottiere, or wealthy banker, the artthe sitter. Because the subject was usually someone of status or note, specific poses, settings, attire, and furnishings—to convey a sense of Portrait artists traditionally relied heavily on convention—for example,

the Dutch Republic of very large canvases commemorating the participation Hals's most ambitious portraits reflect the widespread popularity in

for liberating the Dutch Republic militia groups that claimed credit ject is one of the many Dutch civic 10-18) is typical in that the sub-His Archers of Saint Hadrian (FIG. cess with this new portrait genre. lenge and achieved great sucsingle sitter. Hals rose to the chalpainter than requests to depict a sented greater difficulties to the zations. These commissions preof Dutch citizens in civic organi-

Frans Halsmuseum, Haarlem. Oil on canvas, $6'9" \times 11'$. of Saint Hadrian, ca. 1633. 10-18 FRANS HALS, Archers

variety in the painting as a whole. portrait while retaining action and portraying each individual in a group succeeded in solving the problem of In this brilliant composition, Hals

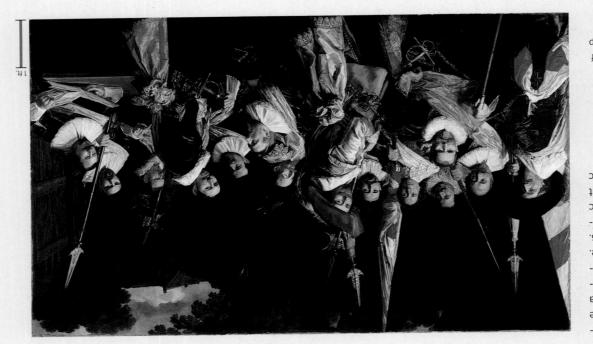

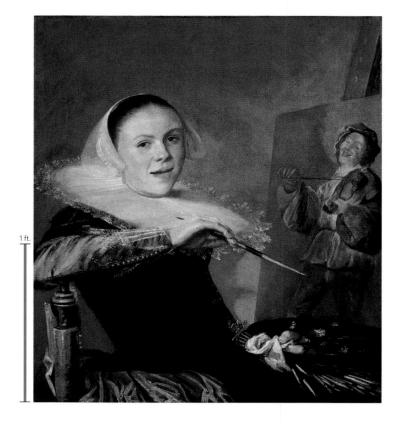

manufacturers, especially in cities such as Amsterdam, Haarlem, and Delft. They in turn emerged as the most important sources of art commissions. As a result of this shift in patronage, and consistent with the Calvinist rejection of most religious art, 17th-century Dutch art centered on genre scenes, landscapes, portraits of middle-class men and women, and still lifes.

FRANS HALS The leading painter in Haarlem was FRANS HALS (ca. 1581–1666), who made portraits his specialty. In addition to

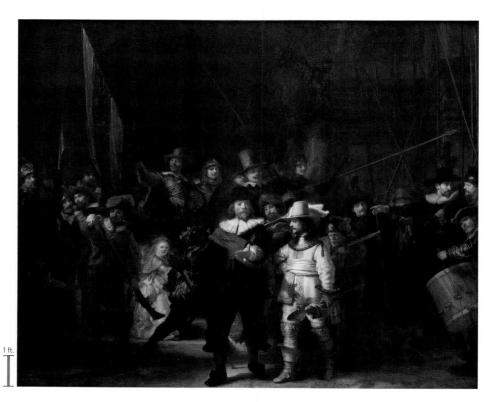

10-19 JUDITH LEYSTER, Self-Portrait, ca. 1630. Oil on canvas, 2' $5\frac{3}{8}$ " \times 2' $1\frac{5}{8}$ ". National Gallery of Art, Washington, D.C. (gift of Mr. and Mrs. Robert Woods Bliss).

Although presenting herself as an artist specializing in genre scenes, Leyster wears elegant attire instead of a painter's smock, placing her socially as a member of a well-to-do family.

individual patrons, groups of Dutch citizens often asked Hals to paint portraits of them. Representing the members of a group, such as the Saint Hadrian militia (FIG. 10-18), rather than separate individuals, presented a special problem for the painter, but Hals quickly became a master of the new genre of group portraiture (see "Frans Hals's Group Portraits," page 300).

JUDITH LEYSTER Some of Hals's followers developed thriving careers of their own as portraitists. One was JUDITH LEYSTER (1609-1660), whose Self-Portrait (FIG. 10-19) is detailed, precise, and accurate, but also exhibits the spontaneity found in Hals's works. In her portrait, Leyster succeeded at communicating a great deal about herself. She depicted herself as an artist, seated in front of a painting resting on an easel. The palette in her left hand and brush in her right announce the painting as her creation. She thus invites the viewer to evaluate her skill, which both the fiddler on the canvas and the image of herself demonstrate as considerable. Although she produced a wide range of paintings, including still lifes and floral pieces, her specialty was genre scenes such as the comic image seen on the easel. Leyster's quick smile and relaxed pose as she stops her work to meet the viewer's gaze reveal her self-assurance. Although presenting herself as an artist, Leyster did not paint herself wearing the traditional artist's smock (compare FIG. 10-21). Her elegant attire distinguishes her socially as a member of a well-to-do family, another important aspect of Leyster's identity.

REMBRANDT VAN RIJN The foremost Dutch artist of the 17th century was Rembrandt Van Rijn (1606–1669), an undisputed genius

and one of the greatest painters and printmakers who ever lived. Born in Leiden, Rembrandt moved to Amsterdam around 1631, where he could attract a more extensive clientele. He quickly gained renown for his portraits, which delve deeply into the psyche and personality of his sitters. Like Hals, Rembrandt also produced memorable group portraits. The most famous is *The Company of Captain Frans Banning Cocq* (FIG. 10-20), better known as *Night Watch*. This more commonly used title is a misnomer, however. The painting is not a nocturnal scene, nor are the figures portrayed posted on a watch in defense of their city. The painting features

10-20 REMBRANDT VAN RIJN, *The Company of Captain Frans Banning Cocq (Night Watch)*, from the Musketeers Hall, Amsterdam, Netherlands, 1642. Oil on canvas, 11' 11" × 14' 4" (trimmed from original size). Rijksmuseum, Amsterdam.

Rembrandt's dramatic use of light contributes to the animation of this militia group portrait in which the artist showed the company rushing to organize themselves for a parade.

10–27 Rembrandt Van Rija, Self-Portrait, ca. 1659–1660. Oil on canvas, 3' $8\frac{3}{4}$ " \times 3' 1". Kenwood House, London (Iveagh Bequest).

In this self-portrait, Rembrandt's interest in revealing the soul is evident in the attention given to his expressive face. The controlled use of light and the nonspecific setting contribute to this focus.

evident, as is the assertive brushwork suggesting his self-assurance. He presented himself as a working artist holding his brushes, palette, and maulstick (compare Fig. 9-36) and wearing his studio garb—a smock and painter's turban. The circles on the wall behind him may allude to a legendary sign of artistic virtuosity—the ability to draw a perfect circle freehand. Rembrandt's abiding interest in revealing the human soul emerges here in his careful focus on his everaling the human soul emerges here in his careful focus on his everaling the human soul emerges here in his careful focus on his everaling the human soul emerges here in his careful focus on his pressive visage. His controlled use of light and the nonspecific setting contribute to drawing the viewer's attention to his face. This is a portrait not just of the artist but of the man as well.

HUNDRED-GUILDER PRINT Rembrandt's virtuosity also extended to the graphic arts, especially etching. Many printmakers adopted etching after its perfection early in the 17th century, because the technique affords greater freedom in drawing the design than engraving does (see "Woodcuts, Engravings, and Etchings," page 228). The etcher covers a copper plate with a layer of wax or varnish, and then incises the design into this surface with a pointed tool, exposing the metal below but not cutting into its surface. Mext, the artist immerses the plate in acid, which etches, or eats away, the exposed parts of the metal, acting in the same way the burin does in engraving. The wax's softness gives etchers greater carving freedom than woodcutters and engraves the cheirs greater carving freedom than wood and metal. If Rembrandt had never painted, he still would be acclaimed, as he principally was in his lifetime, for his prints. Prints were a major source of income for Rembrandt, as they were

dramatic lighting, but its tonality today is the result of the varnish the artist used, which darkened considerably over time.

must have pleased his 18 patrons. ing, firing, and readying the weapon for reloading-details that to record the three most important stages of using a musket—loading the image considerably. At the same time, Rembrandt managed rushing about in the act of organizing themselves, thereby animatin orderly fashion, the younger artist chose to portray the company Dutch group portraits. Rather than present assembled men posed enlivening what was, by then, becoming a conventional format for of Saint Hadrian (FIG. 10-18) reveals Rembrandt's inventiveness in parade. Comparing this militia group portrait with Hals's Archers turing the excitement and frenetic activity of men preparing for a as 2 feet). Even in its truncated form, Night Watch succeeds in cappainting to the town hall, they trimmed it on all sides (by as much fee. Unfortunately, in 1715, when city officials moved Rembrandt's along with 16 members of their militia, contributed to Rembrandt's tain Frans Banning Cocq and Lieutenant Willem van Ruytenburch, information available about the commission, it appears that Capquet hall of Amsterdam's new Musketeers' Hall. From the limited missioned by various groups around 1640 for the assembly and ban-Night Watch was one of six paintings by different artists com-

sometimes are independent of the shapes and figures they modify. values between the two are charged with meanings and feelings that ferences. In the visible world, light, dark, and the wide spectrum of of light and shade, subtly modulated, can be read as emotional difwhole scenes. He discovered for the modern world that variation der subtle nuances of character and mood, both in individuals and varying the surface texture with tactile brushstrokes, he could renthe direction, intensity, and distance of light and shadow, and by or in terms of some ideal. Rembrandt found that by manipulating states. They arrived at these differences optically, not conceptually ences in pose, in the movements of facial features, and in psychic discovered gradations of light and dark as well as degrees of differthan showed how humans perceive light. Artists such as Rembrandt ing is of a standard kind). They represented the idea of light, rather sented forms in a flat, neutral modeling light (even Leonardo's shadbut as always subtly changing. In general, Renaissance artists reprecloser to reality because the eye perceives light and dark not as static those sacrifices. In fact, the recording of light in small gradations is sharp chiaroscuro, a greater fidelity to appearances more than offsets Although both masters sacrificed some of the dramatic effects of the work of artists such as Rembrandt and Velázquez, to gradation. another. Earlier painters' use of abrupt lights and darks gave way, in and dark into finer and finer nuances until they blended with one of light and shade. His pictorial method involved refining light Night Watch is also noteworthy for Rembrandt's masterful use

SELF-PORTRAITS Rembrandt's portraits reveal his complete understanding of what could be called the "psychology of light." Light and dark are not in conflict in his portraits. They are reconciled, merging softly and subtly to produce the visual equivalent of quietness. Their prevailing mood is one of tranquil meditation, of philosophical resignation, of musing recollection—indeed, a whole cluster of emotional tones heard only in silence. In the self-portrait reproduced here (Pig. 10-27), the light source outside the upper left of the painting bathes the artist's face in soft highlights, leaving the lower part of his body in shadow. Rembrandt depicted himself here as possessing dignity and strength, and the portrait serves as a summary of the many stylistic and professional concerns that occupied him throughout his career. Rembrandt's distinctive use of light is him throughout his career. Rembrandt's distinctive use of light is

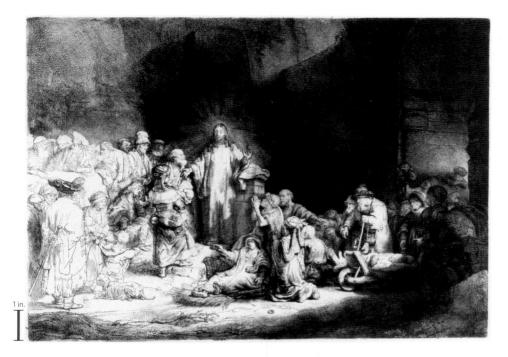

for Albrecht Dürer (see page 274), and he often reworked the plates so that they could be used to produce a new edition.

Christ with the Sick around Him, Receiving the Children (FIG. 10-22) is one of Rembrandt's most celebrated prints. Indeed, the title by which this work has been known since the early 18th century— Hundred-Guilder Print—refers to the high sale price it brought during the artist's lifetime. Rembrandt produced the print using both etching and engraving techniques. As in his other religious works, he suffused Christ with the Sick with a deep and abiding piety, presenting the viewer not the celestial triumph of the Catholic Church but the humanity and humility of Jesus. Christ appears in the center

10-22 REMBRANDT VAN RIJN, Christ with the Sick around Him, Receiving the Children (Hundred-Guilder Print), ca. 1649. Etching, 11" × 1' 3 \frac{1}{4}". Pierpont Morgan Library, New York.

Rembrandt's mastery of the newly perfected medium of etching is evident in his expert use of light and dark to draw attention to Christ as he preaches compassionately to the blind and lame.

preaching compassionately to, and simultaneously blessing, the blind, the lame, and the young, who are spread throughout the composition in a dazzling array of standing, kneeling, and lying positions. Also present is a young man in elegant garments with his head in his hand, lamenting Christ's insistence that the wealthy need to give their possessions to the poor in order to gain entrance to Heaven. The tonal range of the print is remarkable. At the right, the figures near the city gate are in deep shadow. At the left, the figures, some rendered

almost exclusively in outline, are in bright light—not the light of day but the illumination radiating from Christ himself. A second, unseen source of light comes from the right and casts the shadow of the praying man's arms and head onto Christ's tunic. Technically and in terms of its humanity, Rembrandt's *Hundred-Guilder Print* is his supreme achievement as a printmaker.

JACOB VAN RUISDAEL In addition to portraiture, the Dutch avidly collected landscapes, interior scenes, and still lifes. Each of these painting genres dealt directly with the daily lives of the urban mercantile public, accounting for their appeal. Landscape scenes abound

in 17th-century Dutch art. Due to topography and politics, the Dutch had a unique relationship to the land, one that differed from attitudes of people living in other European countries. After gaining independence from Spain, the Dutch undertook an extensive reclamation project lasting almost a century. Dikes and drainage systems cropped up across the countryside, and most Dutch families owned and worked their own farms, cultivating a feeling of closeness to the land.

JACOB VAN RUISDAEL (ca. 1628–1682) became famous for his precise and sensitive depictions of the Dutch landscape. In *View of Haarlem from the Dunes at Overveen* (FIG. 10-23), Ruisdael provided an overarching view of this major Dutch city. The specificity of the artist's image—the Saint Bavo church in the background, the numerous

10-23 JACOB VAN RUISDAEL, View of Haarlem from the Dunes at Overveen, ca. 1670. Oil on canvas, $1'10'' \times 2'1''$. Mauritshuis, The Hague.

In this painting, Ruisdael succeeded in capturing a realistic view of Haarlem, its windmills, and Saint Bavo church, but he also imbued the landscape with a quiet serenity approaching the spiritual.

canvas, I' $3\frac{7}{8}$ " × I' 2". National Gallery of Art, Washington, D.C. (Widener Collection).

Vermeer's woman holding empty scales in perfect balance, ignoring pearls and gold on the table, is probably an allegory of the temperate life. On the wall behind her is a depiction of the Last Judgment.

on the back wall serves as yet another reference to history. As in Woman Holding a Balance, the viewer is outside the space of the action, looking through the drawn curtain, which also separates the artist in his studio from the rest of the house. Some art historians have suggested that the light radiating from an unseen window on alludes to the light of artistic inspiration. Accordingly, many scholars have interpreted this painting as an allegory—a reference to painting inspired by history. Vermeer's mother-in-law confirmed this allegorical reading in 1677 when, after the artist's death, 26 of this works were scheduled to be sold to pay his widow's debts. In her written claim to retain the painting for herself, she described the work as "the piece . . . wherein the Art of Painting is portrayed." Vermeer, like Rembrandt, was a master of pictorial light and yeed it with immense virtuosity. He could render space so convincued it with immense virtuosity. He could render space so convinc-

vermeet, like kembrandt, was a master of pictorial right and used it with immense virtuosity. He could render space so convincingly through his depiction of light that in his works, the picture surface functions as an invisible glass pane through which the viewer looks into the constructed illusion. Art historians believe that Vermeer used as tools both mirrors and the camera obscura, an ancestor of the modern camera based on passing light through a troom. (In later versions, artists projected the image on a groundatom, (In later versions, artists projected the image on a groundlens.) Vermeer did not simply copy the camera's image, however. Instead, the camera obscura and the mirrors helped him obtain results that he reworked compositionally, enabling him to achieve.

windmills that were part of the land reclamation efforts, and the figures in the foreground stretching linen to be bleached (a major industry in Haarlem)—reflects the pride that Dutch painters took in recording their homeland and the activities of their fellow citizens. Monetheless, in this painting the inhabitants and dwellings are so small that they blend into the land itself. Moreover, the horizon line is low, so the sky fills almost three-quarters of the picture space, and the sun illuminates the landscape only in patches, where it has broken through the clouds above. In View of Haarlem, Ruisdael not only captured the appearance of a specific locale but also succeeded in imbutured the work with a quiet serenity that becomes almost spiritual.

sionally children engaging in household tasks or at leisure. Dutch homes featuring women especially but also men and occaand his contemporaries composed neat, quietly opulent interiors of those scenes (for example, FIGS. 8-1 and 8-3). In contrast, Vermeer painted domestic interiors, but sacred personages often occupied of domestic scenes. Flemish artists of the 15th century also had cal themes, but soon abandoned those traditional subjects in favor uted to him. He began his career as a painter of biblical and historicompleted no more than 35 paintings that can be definitively attribof his income from his work as an innkeeper and art dealer, and he inces. Despite his fame as a painter today, Vermeer derived much prosperous, responsible, and cultured citizens of the United Prov-These paintings offer the viewer glimpses into the private lives of scenes, another popular subject among Dutch middle-class patrons. (1632–1675) of Delft made his reputation as a painter of interior JAN VERMEER Although he also painted landscapes, JAN VERMEER

in order to be judged favorably on judgment day. (one free from the temptations of worldly riches) that she must lead woman holds the scales in balance and contemplates the kind of life this serene domestic scene is pregnant with hidden meaning. The golden aureole directly above the young woman's head. Therefore, ing on the back wall in which Christ, weigher of souls, appears in a stering that interpretation is the large framed Last Judgment paintmay also symbolize, as do the pearls and gold, the sin of vanity. Bolbehavior. The mirror on the wall may refer to self-knowledge, but it a temperate, self-aware life and to balance one's sins with virtuous was a Catholic convert in the Protestant Dutch Republic) to lead balance, the way Ignatius of Loyola advised Catholics (Vermeer ance for weighing gold. The scales, however, are empty—in perfect head nor to her treasures but to the hand in which she holds a balorthogonals direct the viewer's attention neither to the woman's an's face and the fingers of her right hand. In fact, the perspective gold coins, which reflect the sunlight that also shines on the womher most precious possessions—pearl necklaces, gold chains, and the scene. The woman stands before a table on which are spread in a room in her home. Light coming from a window illuminates ful young woman wearing a veil and a fur-trimmed jacket stands depiction of the social values of Dutch citizens of his day. A beautiscenes, Woman Holding a Balance (FIG. 10-24), is a highly idealized WOMAN HOLDING A BALANCE One of Vermeer's finest domestic

THE ART OF PAINTING In Vermeer's most complex and intriguing painting, Allegory of the Art of Painting (FIG. 10-25), the artist himself appears with his back to the viewer and dressed in clothing of an earlier era. He is hard at work on a painting of the model standing before him. She wears a laurel wreath and holds a trumpet and book, traditional attributes of Clio, the muse of history. The map of the provinces (an increasingly common feature of Dutch homes)

10-25 JAN Vermeer, Allegory of the Art of Painting, 1670–1675. Oil on canvas, $4' 4'' \times 3' 8''$. Kunsthistorisches Museum, Vienna.

Usually interpreted as an allegory of the art of painting inspired by history, this "domestic scene" shows Vermeer at work depicting a model holding the attributes of Clio, the muse of history.

for example, a beautiful stability of rectilinear shapes by carefully positioning the figures and furniture in a room. Vermeer's compositions evoke a matchless classical serenity.

Enhancing this quality are colors so true to the optical facts and so subtly modulated that they suggest that Vermeer was far ahead of his time in color science. For example, Vermeer realized that shadows are not colorless and dark, that adjoining colors affect each other, and that light is composed of colors (see page 7). Thus he painted reflections off of surfaces in colors modified by others nearby. Some scholars have suggested that Vermeer also perceived the phenomenon that modern photographers call "circles of confusion," which appear on out-of-focus negatives. Vermeer could have seen them in images projected by the camera obscura's primitive lenses. He approximated these effects with light dabs that, in close view, give the impression of an image slightly "out of focus." When the observer draws back a step, however, as if adjusting the lens, the color spots cohere, giving an astonishingly accurate illusion of the third dimension.

PIETER CLAESZ The prosperous Dutch were justifiably proud of their accomplishments, and the popularity of still-life paintings—particularly images of accumulated goods—reflected this pride. These paintings, like Vermeer's interior scenes, are meticulously crafted images both scientific in their optical accuracy and poetic in their beauty and lyricism. One of the best Dutch paintings of this genre is *Vanitas Still Life* (FIG. 10-26) by PIETER CLAESZ (1597–1660), in which the painter presented the material possessions of a prosperous household strewn across a tabletop or dresser. The ever-present morality and humility central to the Calvinist faith tempered Dutch pride in worldly goods, however. Thus, although Claesz fostered the appreciation and enjoyment of the beauty

10-26 PIETER
CLAESZ, Vanitas Still
Life, 1630s. Oil on
panel, 1' 2" × 1' $11\frac{1}{2}$ ".
Germanisches Nationalmuseum, Nuremberg.

Calvinist morality tempered Dutch citizens' delight in worldly possessions and accumulated wealth. In this vanitas still life, the skull and timepiece are mementi mori, reminders of life's transience.

arrangements, but idealized groupings of individually studied flowers, often involving perfect specimens of flowers that bloomed at different times of the year and could never be placed on a table at the same time. Her careful composition of the individual elements in the illustrated example is evident in her arrangement of the flowers to create a diagonal running from the lower left to the upper right corner of the canvas, offsetting the opposing diagonal of the table edge.

FRANCE

In France, monarchical authority had been increasing for centuries, culminating in the reign of Louis XIV (r. 1661–1715), who sought to determine the direction of French society and culture. Although its economy was not as expansive as the Dutch Republic's, France became Europe's largest and most powerful nation in the 17th century. Against this backdrop, the arts of painting, sculpture, and architecture all flourished.

NICOLAS POUSSIN Rome's ancient and Renaissance monuments enticed many French artists to study there. For example, NICOLAS Poussin (1594–1665) of Normandy spent most of his life in Rome, where he produced grandly severe paintings modeled on those of Titian and Raphael. He also carefully formulated a theoretical explanation of his method and was ultimately responsible for establishing classical painting as an important ingredient of 17th-century French art (see "Poussin's Notes for a Treatise on Painting," page 307). Pousin's classical style presents a striking contrast to the contemporaneous Baroque style of his Italian counterparts in Rome, underscoring the multifaceted character of European art of this era.

reserved mood complement Poussin's classical figure types. anced grouping of the figures, the even light, and the thoughtful and the sea god, leaning on his trident. The classically compact and balresting on a boulder derives from Greco-Roman statues of Neptune, the models for this figure, and the posture of the youth with one foot draped female statues surviving in Italy from Roman times supplied in Arcadia, supposedly a spot of paradisiacal bliss. The countless ing these mortals, as does the inscription, that death is found even shoulder of one of them. She may be the spirit of death, remindtomb as a statuesque female figure quietly places her hand on the living in the idyllic land of Arcadia. They study an inscription on a Raphael's paintings. Dominating the foreground are three shepherds in Rome did, Poussin emulated the rational order and stability of movement and intense emotions, as his Italian contemporaries figures based on antique statuary. Rather than depicting dynamic advocated. It features a lofty subject rooted in the classical world and FIG. 10-28) exemplifies the "grand manner" of painting that the artist Poussin's Et in Arcadia Ego (Even in Arcadia, 1 [am present];

CLAUDE LORRAIN Claude Gellée, called CLAUDE LORRAIN (1600–1682) after his birthplace in the duchy of Lorraine, rivaled Poussin in fame. Claude modulated in a softer style Poussin's disciplined rational art, with its sophisticated revelation of the geometry of landscape. Unlike the figures in Poussin's pictures, those in Claude's landscapes tell no dramatic story, point out no moral, and praise no hero. Indeed, they often appear to be added as mere excuses for the radiant landscape itself. For Claude, painting excuses for the radiant landscape itself. For Claude, painting involved essentially one theme—the beauty of a broad sky suffused myth the golden light of dawn or sunset glowing through a hazy atmosphere and reflecting brilliantly off rippling water.

In Landscape with Cattle and Peasants (FIG. 10-29), the figures in the right foreground chat in animated fashion. In the left foreground, cattle relax contentedly. In the middle ground, cattle amble

and value of the objects he depicted, he also reminded the viewer of life's transience by incorporating references to death. Art historians call works of this type vanitas ("vanity") paintings, and each features a memento mori ("reminder of death"). In Vanitas Still Life, references to mortality include the skull, timepiece, tipped glass, and cracked walnut. All suggest the passage of time or someone who was here but has departed. Claesz emphasized this element of time (and demonstrated his skill as a painter) by including a self-portrait, reflected in the glass ball on the left side of the table. He appears to be painting this still life. But in an apparent challenge to the message of inevitable mortality that vanitas paintings convey, the portrait of inevitable mortality that vanitas paintings convey, the portrait serves to immortalize the artist.

RACHEL RUYSCH As living objects that soon die, flowers, particularly cut blossoms, appeared frequently in vanitas paintings. However, floral painting as a distinct genre also enjoyed great popularity in the Dutch Republic because the Dutch were the leading growers and exporters of flowers in 17th-century Europe. One of the major practitioners of flower painting was Rachel Ruysch (1663–1750). Ruysch's father was a professor of botany and anatomy, which may account for her interest in and knowledge of plants and insects. She acquired an international reputation for lush paintings, such as secount for her interest in and knowledge of plants and insects. She acquired an international reputation for lush paintings, such as secount for her interest in and knowledge of plants and insects. Shower Still Life (FIG. 70-27). In this canvas, the floral arrangement is so full that many of the blossoms seem to be spilling out of the is so full that many of the blossoms seem to be expilling out of the is so full that many of the blossoms are not pictures of real floral vase. However, Ruysch's floral still lifes are not pictures of real floral vase.

10-27 Rachel Ruysch, Flower Still Life, after 1700. Oil on canvas, 2' $5\frac{3}{4}$ " × 1' $11\frac{7}{8}$ ". Toledo Museum of Art, Toledo (purchased with funds from the Libbey Endowment, gift of Edward Drummond Libbey).

Flower paintings were very popular in the Dutch Republic. Ruysch achieved international renown for her lush paintings of floral arrangements, noted also for their careful compositions.

ARTISTS ON ART

Poussin's Notes for a Treatise on Painting

As the leading champion of classical painting in 17th-century Rome, Nicolas Poussin outlined the principles of classicism in notes for an intended treatise on painting, left incomplete at his death. In those notes, Poussin described the essential ingredients necessary to produce a beautiful painting in "the grand manner":

The grand manner consists of four things: subject-matter or theme, thought, structure, and style. The first thing that, as the foundation of all others, is required, is that the subject-matter shall be grand, as are battles, heroic actions, and divine things. But assuming that pare

The idea of beauty does not descend into matter unless this is prepared as carefully as possible. This preparation consists of three things: arrangement, measure, and aspect or form. Arrangement means the relative position of the parts; measure refers to their size; and form consists of lines and colors. Arrangement and relative position of the parts and making every limb of the body hold its natural place are not sufficient unless measure is added, which gives to each limb its correct size, proportionate to that of the whole body [compare "Polykleitos's Prescription for the Perfect Statue," page 65], and

unless form joins in, so that the lines will be drawn with grace and with a harmonious juxtaposition of light and shadow. †

Poussin applied these principles in paintings such as *Et in Arcadia Ego* (FIG. 10-28), a work peopled with perfectly proportioned statuesque figures attired in antique garb.

*Translated by Robert Goldwater and Marco Treves, eds., Artists on Art, 3rd ed. (New York: Pantheon Books, 1958), 155. †lbid., 156.

10-28 NICOLAS POUSSIN, *Et in Arcadia Ego*, ca. 1655. Oil on canvas, 2' 10" × 4'. Musée du Louvre, Paris.

Poussin was the leading champion of classicism in 17th-century Rome. His "grand manner" paintings are models of "arrangement and measure" and incorporate figures inspired by ancient statuary.

slowly away. The well-defined foreground, distinct middle ground, and dim background recede in serene orderliness, until all form dissolves in a luminous mist. Atmospheric and linear perspective reinforce each other to turn a vista into a typical Claudian vision, an ideal classical world bathed in sunlight in infinite space (compare FIG. I-1). Claude's formalizing of nature with balanced groups of architectural masses, screens of trees, and sheets of water followed the great tradition of classical landscape.

10-29 CLAUDE LORRAIN, Landscape with Cattle and Peasants, 1629. Oil on canvas, $3' 6'' \times 4' 10^{\frac{1}{2}''}$. Philadelphia Museum of Art, Philadelphia (George W. Elkins Collection).

Claude used atmospheric and linear perspective to transform the rustic Roman countryside filled with peasants and animals into an ideal classical landscape bathed in sunlight in infinite space.

but simultaneously maintaining rigorous control to avoid rebellion. He also ensured subservience by anchoring his rule in divine right (belief in a king's absolute power as God's will) and adopting the title "the Sun King." Like the sun, Louis was the center of the universe. Louis's desire for control extended to all realms of French life, the sun and the sun substantial advisor that the substantial

Louis's desire for control extended to an realistic of trench me, including art. The king and his principal adviser, Jean-Baptiste Colbert (1619–1683), strove to organize art and architecture in the service of the state. They understood well the power of art as propaganda and the value of visual imagery for cultivating a public persona, and they spared no pains to raise monuments to the Sun King's absolute power. Louis and Colbert sought to regularize taste and establish the classical style as the preferred French manner. The founding of the Royal Academy of Painting and Sculpture in 1648 served to advance this goal.

Louis XIV (FIG. 10-30) by HYACINTHE RIGAUD (1659–1743) successfully conveys the image of an absolute monarch. The king, age 63 when he commissioned this portrait, stands with his left hand on his hip and gazes directly at the viewer. His elegant ermine-lined fleur-de-lis coronation robes (compare FIG. 10-16) hang loosely from his left shoulder, suggesting an air of haughtiness. Louis also draws his garment back to expose his legs. (The king was a ballet trait's majesty derives in large part from the composition. The Sun King is the unmistakable focal point, and Rigaud placed him so that he seems to look down on the viewer. (Louis XIV was only 5 feet 4 inches tall—a fact that drove him to invent the red-heeled shoes he wears in this painting.) The carefully detailed environment in which the king stands also contributes to the portrait's stateliness and grandiosity, as does the painting's sheer size (more than 9 feet tall).

through the associated city and park. mile long, is perpendicular to the dominant east-west axis running an official audience chamber. The palace itself, more than a quarter intersected in the king's spacious bedroom, which also served as a symbolic assertion of the ruler's absolute power over his domains, along three radial avenues that converge on the palace. Their axes, in supervision). Le Brun laid out this town to the east of the palace iers, and servants (thereby keeping them all under the king's close and government officials, military and guard detachments, courtpark but also for the construction of a satellite city to house court tic scale, the project called not only for a large palace flanking a vast ose symbol of Louis XIV's power and ambition. Planned on a giganthe age—a defining statement of French Baroque style and a grandi-Versailles (Fig. 10-31) became the greatest architectural project of In their hands, the conversion of a simple lodge into the palace of under the general management of CHARLES LE BRUN (1619-1690). architects, decorators, sculptors, painters, and landscape architects south of Paris, into a great palace. He assembled a veritable army of of his projects was to convert a royal hunting lodge at Versailles, VERSAILLES Louis XIV was also a builder on a grand scale. One

Every detail of the extremely rich decoration of the palace's interior received careful attention. The architects and decorators designed everything from wall paintings to doorknobs in order to reinforce the splendor of Versailles and to exhibit the very finest sense of artisanship. Of the literally hundreds of rooms within the palace, the most famous is the Galerie des Glaces, or Hall of Mirrors (Fig. 10-32), designed by Jules Hardoun-Manarra (1646–1708) and Le Brun. This hall overlooks the park from the second floor and extends along most of the width of the central block. Although deprived of its original furniture, which included gold and silver chairs and bejeweled trees, the 240-foot-long hall retains much of chairs and bejeweled trees, the 240-foot-long hall retains much of

Rome and the mystique of the past. less appeal to the combination of the natural beauty of the outskirts of he infused nature with human feeling. His landscapes owe their timesky or, with their dying glow, set the pensive mood of evening. Thus represented, the sun's rays as they gradually illuminated the morning high-noon sunlight overhead, Claude preferred, and convincingly range of values of outdoor light and shade. Avoiding the problem of value gradations, which imitated, though on a very small scale, the achieved his marvelous effects of light by painstakingly placing tiny ever-present ruins of ancient aqueducts, tombs, and towers. Claude terrain accented by stone-pines, cypresses, and poplars and by the hundreds of sketches the look of the Roman countryside, its gentle nature, making an important contribution. He recorded carefully in the Dutch painters, studied the light and the atmospheric nuances of 9-18) and continued in the art of Poussin (FIG. 10-28). Yet Claude, like It began with the backgrounds of Venetian painting (FIGS. 9-17 and

LOUIS XIV The preeminent French art patron of the 17th century was King Louis XIV. Determined to consolidate and expand his power, Louis was a master of political strategy and propaganda. He established a carefully crafted and nuanced relationship with the nobility, granting them sufficient benefits to keep them pacified

10-30 Hyacinthe Rigaud, Louis XIV, 1701. Oil on canvas, 9' 2" \times 6' 3". Musée du Louvie, Paris.

In this portrait set against a stately backdrop, Rigaud portrayed the 5' 4" Sun King wearing red high-heeled shoes and with his ermine-lined coronation robes thrown over his left shoulder.

10-31 JULES HARDOUIN-MANSART, CHARLES LE BRUN, and ANDRÉ LE NÔTRE, aerial view of the palace and gardens (looking northwest), Versailles, France, begun 1669.

Louis XIV ordered his architects to convert a royal hunting lodge at Versailles into a gigantic palace and park with a satellite city with three radial avenues whose axes intersect in the king's bedroom.

central axis and across terraces, lawns, pools, and lakes toward the horizon. Designed by ANDRÉ LE NÔTRE (1613–1700), the park of Versailles must rank among the world's

greatest artworks in both size and concept. Here, the French architect transformed an entire forest into a park. Although its geometric plan may appear stiff and formal, the park in fact offers an almost unlimited assortment of vistas, as Le Nôtre used not only the multiplicity of natural forms but also the terrain's slightly rolling contours with stunning effectiveness.

The formal gardens near the palace provide a rational transition from the frozen architectural forms to the natural living ones. Here, the elegant shapes of trimmed shrubs and hedges define the tightly designed geometric units. Each unit differs from its neighbor

> and has a focal point in the form of a sculptured group (for example, Apollo Attended by the Nymphs of Thetis [FIG. 10-32A]), a pavilion, a reflecting pool, or a fountain. Farther away from the palace, the design loosens as trees, in shadowy masses, screen or frame views of open countryside. Le Nôtre carefully composed all vistas for maximum effect. Light and shadow, formal and informal, dense growth and open meadows—all play against one another in unending combinations and variations. No photograph or series of photographs can reveal the design's full richness. The park unfolds itself only to those walking through it.

10-32 JULES HARDOUIN-MANSART and CHARLES LE BRUN, Galerie des Glaces (Hall of Mirrors), palace of Versailles, Versailles, France, ca. 1680.

In this grandiose hall overlooking the park of the Sun King's palace at Versailles, hundreds of mirrors illusionistically extend the room's width and once reflected gilded and jeweled furnishings.

its splendor today. Hundreds of mirrors, set into the wall opposite the windows, alleviate the gallery's tunnel-like quality and illusionistically extend its width. The mirror, that ultimate source of illusion, was a favorite element of Baroque interior design. Here, it also enhanced the dazzling extravagance of the great festivals that Louis XIV was so fond of hosting.

The enormous palace might appear unbearably ostentatious were it not for its extraordinary setting in a vast park, which makes the palace seem almost an adjunct. From the Galerie des Glaces, the king and his guests could enjoy a sweeping vista down the park's tree-lined

10-33 SIR Сняізторнек Wren, west facade of Saint Paul's Cathedral, London, England, 1675-1710.

Wren's cathedral replaced an old Gothic church. The facade design owes much to the Italian architects Andrea Palladio and Francesco Borromini. The great dome recalls Saint Peter's in Rome.

ENGLAND

lent maritime capabilities. and powerful navy, as well as excel-Dutch Republic, possessed a large trade offered. England, like the of the opportunities that overseas Dutch Republic) to take advantage was the one country (other than the In the economic realm, England (the English version of Calvinism). ism, Protestantism, and Puritanism included Catholicism, Anglicanreligious affiliations of the English issue it was on the Continent. The religion was not the contentious an important part of English life, other significant ways. Although France (and Europe in general) in check. England also differed from Parliament kept royal power in France, the common law and the In England, in sharp distinction to

In the realm of art, the most important English contributions were in the field of architecture, much of it, as in France, incorporating classical elements.

CHRISTOPHER WREN London's majestic Saint Paul's Cathedral (FIG. 10-33) is the work of England's most renowned architect, Christopher Wren (1632–1723). A mathematical genius and skilled engineer whose work won Isaac Newton's praise, Wren became professor of astronomy in London at age 25. Mathematics led to architecture, and Charles II (r. 1660–1685) asked Wren to prepare a plan for restoring the old Gothic church dedicated to Saint structures. Within a few months, the Great Fire of London, which destroyed the old structure and many churches in the city in 1666, agave Wren his opportunity. The architect had traveled in France, where the splendid palaces and state buildings being created in France, around Paris must have impressed him. Wren also closely studied around Paris must have impressed him. Wren also closely studied prints illustrating Baroque architecture in Italy. In Saint Paul's, he prints illustrating Baroque architecture in Italy. In Saint Paul's, he

In view of its size, the cathedral was built with remarkable speed—in little more than 30 years—and Wren lived to see it completed. The building's form underwent constant refinement during construction, and Wren did not determine the final appearance of the towers until after 1700. In the splendid skyline composition, two foreground towers act effectively as foils to the great dome. Wren must have known similar schemes that Italian architects devised

harmonized Palladian, French, and Italian Baroque features.

was significant and long-lasting, both in England and in colonial America, examined in the next chapter.

London skyline. Saint Paul's dome is the tallest of all. Wren's legacy

Great Fire. Even today, Wren's towers and domes punctuate the

poraneous French architecture. Wren's skillful eclecticism brought

lanterns of the towers. The lower levels owe a debt to Palladio, and the superposed paired columnar porticos have parallels in contem-

romini (FIGS. 10-1, rear, and 10-6) is evident in the upper levels and

relationship between the facade and dome. The influence of Bor-

for Saint Peter's (FIG. 10-2) in Rome to solve the problem of the

all these foreign features into a grand and unified design.

Wren received commissions for many other churches after the

- $\overline{\mathbb{A}}$ Explore the era further in MindTap with videos of major artworks and buildings, Google Earth $^{\mathrm{TM}}$ coordinates, and essays by the author on the following additional subjects:
- Gianlorenzo Bernini, Apollo and Daphne (FIG. 10-4A)
- WRITTEN SOURCES: Giovanni Pietro Bellori on Annibale Carracci and Caravaggio
- Caravaggio, Conversion of Saint Paul (FIG. 10-9A)
- Artemisia Gentileschi, Self-Portrait as the Allegory of Painting
- (A0f-0f.al)
- Giovanni Battista Gaulli, Triumph of the Name of Jesus (Fig. 10-1714)
- François Girardon and Thomas Regnaudin, Apollo Attended by the Nymphs of Thetis (Fig. 10-32A)

BAROQUE EUROPE

Italy and Spain

- In contrast to classical Renaissance architecture, Italian Baroque architecture is dynamic, theatrical, and highly ornate. The facades of Francesco Borromini's churches—for example, San Carlo alle Quattro Fontane—are not flat frontispieces but undulating surfaces that provide a fluid transition from exterior to interior space. The interiors of his buildings pulsate with energy and feature complex domes that grow organically from curving walls.
- The greatest Italian Baroque sculptor was Gianlorenzo Bernini, who was also an important architect. In Ecstasy of Saint Teresa, he marshaled the full capabilities of architecture, sculpture, and painting to create an intensely emotional experience for worshipers, consistent with the Counter-Reformation principle of using artworks to inspire devotion and piety.
- In painting, Caravaggio broke new ground by employing stark and dramatic contrasts of light and dark (tenebrism) and by setting religious scenes, such as Calling of Saint Matthew, in everyday locales filled with rough-looking common people.
- The greatest Spanish Baroque painter was Diego Velázquez, court painter to Philip IV (r. 1621-1665). His masterwork, Las Meninas, is extraordinarily complex and mixes real spaces, mirrored spaces, picture spaces, and pictures within pictures. It is a celebration of the art of painting itself.

Bernini, Ecstasy of Saint Teresa, 1645-1652

Caravaggio, Calling of Saint Matthew, ca. 1597-1601

Flanders and the Dutch Republic

- In the 17th century, Flanders remained Catholic and under Spanish control. Flemish Baroque art is more closely tied to the Baroque art of Italy than is the art of much of the rest of northern Europe. The leading Flemish painter of this era was Peter Paul Rubens, whose works feature robust and foreshortened figures in swirling motion.
- The Dutch Republic received official recognition of its independence from Spain in the Treaty of Westphalia of 1648. Worldwide trade and banking brought prosperity to its predominantly Protestant citizenry, which largely rejected church art in favor of private commissions of portraits, genre scenes, landscapes, and still lifes.
- Frans Hals produced innovative portraits of middle-class patrons in which a lively informality replaced the formulaic patterns of traditional portraiture. Jacob van Ruisdael specialized in landscapes depicting specific places, not idealized Renaissance settings. Peter Claesz painted vanitas still lifes featuring meticulous depictions of worldly goods and reminders of death. Jan Vermeer specialized in painting Dutch families in serenely opulent homes. Vermeer's convincing representation of interior spaces depended in part on his use of the camera obscura.
- Rembrandt van Rijn was the greatest Dutch artist of the age. His oil paintings are notable for their dramatic impact and subtle gradations of light and shade as well as the artist's ability to convey human emotions. Rembrandt was also a master printmaker renowned for his etchings, such as Christ with the Sick, known as the Hundred-Guilder Print.

Rubens, Elevation of the Cross,

Vermeer, Woman Holding a Balance, ca. 1664

France and England

- The major art patron in 17th-century France was Louis XIV, the "Sun King," who built a gigantic palaceand-garden complex at Versailles featuring opulent furnishings and sweeping vistas. Among the architects Louis employed were Charles Le Brun and Jules Hardouin-Mansart, who succeeded in marrying Italian Baroque and French classical styles. The leading French champion of classical painting was Nicolas Poussin, who spent most of his life in Rome and promoted the "grand manner" of painting. This style called for heroic or divine subjects and classical compositions with figures often modeled on ancient statues, as in Et in Arcadia Ego.
- In England, architecture was the most important art form. Christopher Wren harmonized the architectural principles of Palladio with the Italian Baroque and French classical styles.

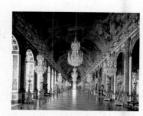

Galerie des Glaces, Versailles, ca. 1680

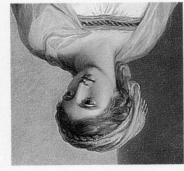

■ 11-1b Kauffman's heroine is Cornelia, mother of Tiberius and Gaius Gracchus, political reformers during the Roman Republic. The portraits of the mother and her sons are based on ancient statusry.

▲ 11-13 The Enlightenment fascination with classical antiquity gave rise to the art called Neoclassiciem. In this painting, Kauffman chose a classical subject and clothed her figures in Roman garb.

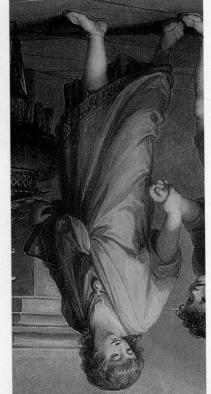

Аибегісь Каиғғмаии, Cornelia Presenting Her Children as Her Treasures, or Mother of the Gracchi, ca. 1785. Oil on canvas, 3' 4" х 4' 2". Virginia Museum of Fine Arts, Richmond (Adolph D. and Wilkins C. Williams Fund).

Rococo to Neoclassicism in Europe and America

THE ENLIGHTENMENT, ANGELICA KAUFFMAN, AND NEOCLASSICISM

The dawn of the *Enlightenment* in the 18th century brought a new way of thinking critically about the world and about men and women, independently of religion, myth, or tradition. Enlightenment thinkers rejected unfounded beliefs in favor of empirical evidence and promoted the questioning of all assertions. This new worldview was a major factor in the revolutionary political, social, and economic changes that swept Europe and America in the mid- to late 1700s. Among these were the wars for independence in America and France, the Industrial Revolution in England, and a renewed admiration in both Europe and America for the art and architecture of classical antiquity. The Enlightenment's emphasis on rationality in part explains this classical focus, because the geometric harmony of classical art and architecture embodied Enlightenment ideals. Moreover, Greece and Rome represented the pinnacle of civilized society—paragons of enlightened political organization. With their traditions of liberty, civic virtue, morality, and sacrifice, these cultures were ideal models during a period of political upheaval.

The Enlightenment interest in classical antiquity in turn gave rise to the artistic movement known as *Neoclassicism*, which incorporated the subjects and styles of Greek and Roman art. One of the pioneers of Neoclassical painting was ANGELICA KAUFFMAN (1741–1807). Born in Switzerland and trained in Italy, Kauffman spent many of her productive years in England. In an era when nearly all successful artists were men, Kauffman enjoyed an enviable reputation and was a founding member of the British Royal Academy of Arts.

Cornelia Presenting Her Children as Her Treasures, or Mother of the Gracchi (FIG. 11-1), is perhaps Kauffman's best-known work. The theme of the painting is the virtue of Cornelia, mother of the future political leaders Tiberius and Gaius Gracchus, who, in the second century BCE, attempted to reform the Roman Republic. Cornelia reveals her character in this scene, which takes place after a visitor has shown off her fine jewelry and then haughtily insists that Cornelia show hers. Instead of taking out her own precious adornments, Cornelia brings her sons forward, presenting them as her jewels. Mother of the Gracchi is a characteristic example of the Enlightenment embrace of the values of the classical world, an exemplum virtutis ("example of virtue") drawn from Greek and Roman history and literature.

To give her retelling of the story an authentic air, Kauffman studied ancient statuary and then clothed her actors in ancient Roman garb and posed them in statuesque attitudes within Roman interiors. The architectural setting is severe, and the composition and drawing have the simplicity and firmness of low-relief carving, qualities that became hallmarks of the Neoclassical style.

A CENTURY OF REVOLUTIONS

technological—came major transformations in the arts. of revolutionary change—social as well as political, economic, and of continental Europe and North America. Against this backdrop tion, which began in England and soon transformed the economies gave birth to a revolution of a different kind—the Industrial Revoludence for the British colonies in America. The 18th century also had overthrown the monarchy in France and achieved independence at Versailles (FIGS. 10-31 and 10-32). By 1800, revolutions presiding over his realm and French culture from his palatial resi-In 1700, Louis XIV still ruled France as the Sun King (see page 308),

ROCOCO

resembling shells were the principal motifs in Rococo ornamentation. stones and shells used to decorate grotto interiors. Shells or forms French word rocaille ("pebble"), but it referred especially to the small was primarily a style of interior design. The term derived from the French elite became the centers of a new style called Rococo, which the hôtels (private townhouses) of Paris. These opulent homes of the gave way to a much more intimate and decentralized culture based in high society. The grandiose palace-based culture of Baroque France The death of Louis XIV in 1715 brought many changes in French

11-2 GERMAIN

into the vault. Irregular painted shapes, topped by sculpture and

French Baroque style into flexible, sinuous curves. The walls melt

Boffrand softened the strong architectural lines and panels of the

(FIG. 10-32) in the Sun King's palace at Versailles reveals how

son between the Salon de la Princesse and the Galerie des Glaces

the sculptor Jean-Baptiste Lemoyne (1704-1778). A compari-

with the painter Charles-Joseph Matoire (1700-1777) and

designed by Germann Boffrand (1667–1754) in collaboration

Salon de la Princesse (FIG. 71-2) in the Hôtel de Soubise in Paris, SALON DE LA PRINCESSE A typical French Rococo room is the

and Satyr Carousing (FIG. 11-1A A) by Clodion (1738-1814) small paintings, and enchanting statuettes—for example, Nymph

mirror frames, delightful ceramics and silver, decorative tapestries,

lively total works of art. Exquisitely wrought furniture, ornamented

enthusiasm or sincerity in bad taste. French Rococo salons were

ing match. Artifice reigned supreme, and participants considered

conversation spiced with wit, repartee as quick and deft as a fenc-Savantes and Rococo Salon Culture" (1). Social gatherings centered on

and the most accomplished people to their salons (see "Femmes

and clever society hostesses competed to attract the most famous

Rococo salon was the center of Parisian society. Wealthy, ambitious,

In the early 1700s, Paris was the social capital of Europe, and the

complemented the architecture and mural paintings.

Rococo rooms such as 1737-1740. Soubise, Paris, France, Lemoyne, Hôtel de by JEAN-BAPTISTE NATOIRE and sculptures ings by Снавсея-Joseph Princesse, with paint-BOFFRAND, Salon de la

intellectual life. center of Parisian social and ornamentation, were the and paintings, and floral mirrors, small sculptures curves, gilded moldings and this one, featuring sinuous

ROCOCO TO NEOCLASSICISM IN EUROPE AND AMERICA

- Manner portraits. Reynolds achieves renown for Grand 0081-5771
- Jefferson promotes Neoclassicism as of the French Revolution. David becomes the painter-ideologist
- new American republic. the official architectural style of the
- n dramatic paintings. Wright celebrates scientific advances During the Industrial Revolution, classical revival in architecture. Greece and Rome prompts a Neo-■ The Enlightenment admiration for
- souvenirs of the Grand Tour of Italy. Canaletto paints views of Venice as painting in favor of "natural" art. ■ Chardin rejects the frivolity of Rococo
- genre—the fête galante. Watteau creates a new painting in the opulent townhouses of Paris. The Rococo style becomes the rage 1700-1725

separated by rocaille shells, replace the hall's cornices. Painting, architecture, and sculpture combine to form a single ensemble. The profusion of curving tendrils and sprays of foliage blend with the shell forms to give an effect of freely growing nature, suggesting that the designer permanently decked the Rococo room for a festival.

ANTOINE WATTEAU The painter most closely associated with French Rococo is Antoine Watteau (1684–1721). He was largely responsible for creating a specific type of Rococo painting genre called a *fête galante* ("amorous festival"). Fête galante paintings depicted the outdoor amusements of French high society. The premier example is Watteau's masterpiece, *Pilgrimage to Cythera* (Fig. 11-3). The painting was the artist's entry for admission to the French Royal Academy of Painting and Sculpture. In 1717, the fête galante was not an acceptable category for submission, but rather than reject Watteau's candidacy, the jurors created a new category to accommodate his entry.

At the turn of the 18th century, two competing doctrines sharply divided the membership of the French Royal Academy. Many members followed Nicolas Poussin (FIG. 10-28) in teaching that form was the most important element in painting, whereas "colors in painting are as allurements for persuading the eyes." Colors, argued

Poussin's admirers, were additions for effect and not really essential. The other group took Peter Paul Rubens (FIGS. 10-15 and 10-16) as its model and proclaimed the supremacy of color. Depending on which doctrine they supported, members of the French Academy were either *Poussinistes* or *Rubénistes*. Watteau was Flemish, and Rubens's coloristic style heavily influenced his work. With Watteau in their ranks, the Rubénistes carried the day, establishing Rococo painting as the preferred style in early-18th-century France.

Pilgrimage to Cythera presents luxuriously costumed lovers who have made a "pilgrimage" to Cythera, the island of eternal youth and love, sacred to Aphrodite. The elegant figures move gracefully from the protective shade of a woodland park filled with playful cupids and voluptuous statuary. Watteau's figural poses blend elegance and sweetness. He prepared his generally quite small paintings using albums of drawings in which he sought to capture slow movement from difficult and unusual angles, searching for the smoothest, most poised, and most refined attitudes. Watteau also strove for the most exquisite shades of color difference, defining in a single stroke the shimmer of silk at a bent knee or the shine appearing on a glossy surface as it emerges from shadow. The haze of color, the subtly modeled shapes, the gliding motion, and the air of suave gentility appealed greatly to Watteau's wealthy patrons.

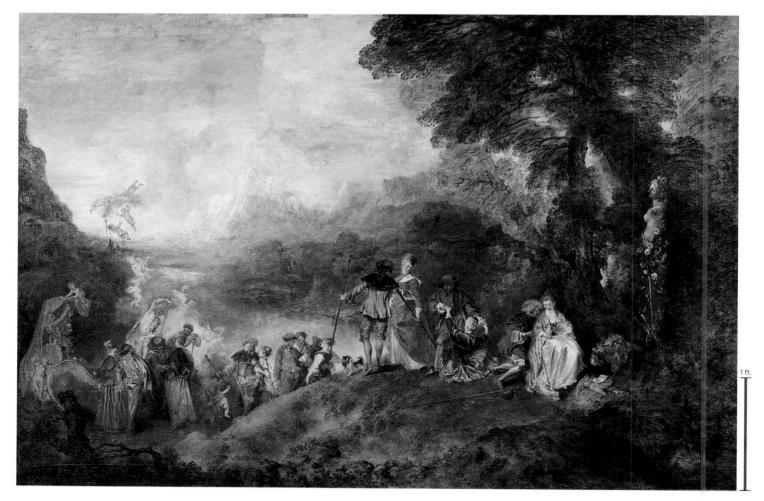

11-3 Antoine Watteau, *Pilgrimage to Cythera*, 1717. Oil on canvas, 4' 3" × 6' 4 ½". Musée du Louvre, Paris.

Watteau's fête galante paintings depict the outdoor amusements of French high society and feature the Rococo taste for hazy color, subtly modeled shapes, gliding motion, and an air of suave gentility.

the I7th century. England and France were the principal centers of the Enlightenment, though its maxims influenced the thinking of intellectuals throughout Europe and in the American colonies. Benjamin Franklin, Thomas Jefferson, and other American notables embraced its principles.

zenry has the further natural right of revolution. these rights. If and when government abuses these rights, the citiconscience. Government is by contract, and its purpose is to protect rights of life, liberty, and property, as well as the right to freedom of cursed by original sin. The laws of nature grant them the natural form ideas. Locke asserted that human beings are born good, not ception of the material world. From these perceptions alone, people "doctrine of empiricism," knowledge comes through sensory perenment gospel, developed these ideas further. According to Locke's ment thought. Locke, whose works acquired the status of Enlightdata and concrete experience became a cornerstone of Enlightenbeyond the natural physical world. This emphasis on both tangible to avoid metaphysics and the supernatural—realms that extended insisted on empirical proof of his theories and encouraged others Locke (1632-1704) in England. In his scientific studies, Newton ment thought was the work of Isaac Newton (1642-1727) and John NEWTON AND LOCKE Of particular importance for Enlighten-

PHILOSOPHES The work of Newton and Locke also inspired many French intellectuals, or philosophes. These thinkers conceived of individuals and societies as parts of physical nature. They shared the conviction that the ills of humanity could be remedied by applying reason and common sense to human problems. They criticized the powers of Church and State as irrational limits placed on political and intellectual freedom. They believed that by accumulating and propagating knowledge, humanity could advance by degrees to a happier state than it had ever known. This conviction matured into the "doctrine of progress" and its corollary doctrine, the "perfectibility of humankind."

Animated by their belief in human progress and perfectibility, the philosophes took on the task of gathering knowledge and making it accessible to all who could read. Their program was, in effect, became editor of the groundbreaking 35-volume Encyclopédie, a compilation of articles written by more than a hundred contributors, including all the leading philosophes. The Encyclopédie was truly comprehensive (its formal title was Systematic Dictionary of truly comprehensive (its formal title was Systematic Dictionary of edge—historical, scientific, and crafts) and included all available knowledge—historical, scientific, and technical, as well as religious and moral—and political theory.

François Marie Arouet, better known as Voltaire (1694–1778), was the most representative figure—almost the personification—of the Enlightenment spirit. Voltaire was instrumental in introducing Mewton and Locke to the French intelligentsia. He hated, and attacked through his writings, the arbitrary despotic rule of kings, the selfish privileges of the nobility and the Church, religious intolerance, and, above all, the injustice of the ancien regime (the "old order"). Voltaire persuaded a whole generation that fundamental changes were necessary, paving the way for revolutions in France changes were necessary, paving the century.

INDUSTRIAL REVOLUTION The Enlightenment emphasis on scientific investigation and technological invention opened up new possibilities for human understanding of the world and for control of its material forces. Research into the phenomena of electricity

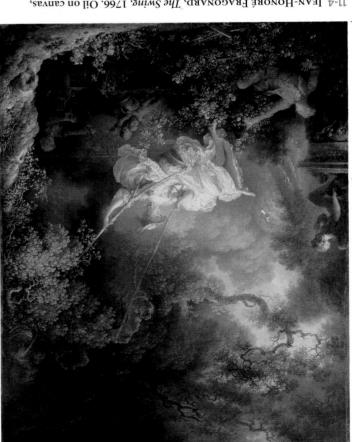

11-4 Jean-Honoré Fragonard, The Swing, 1766. Oil on canvas, 2' 8 $\frac{5}{8}$ " \times 2' 2". Wallace Collection, London.

Fragonard's Swing exemplifies Rococo style. Pastel colors and soft light complement a scene in which a young lady flirtatiously kicks off her shoe at a statue of Cupid while her lover gazes at her.

JEAN-HONORÉ FRAGONARD Watteau died from tuberculosis when he was only 37 years old, but Jean-Honoré Fragonard (1732–1806) and others carried on the Rococo painting manner that Watteau pioneered. In *The Swing* (Fig. 11-4), a young gentleman has convinced an unsuspecting old bishop to swing the young man's pretty sweetheart higher and higher, while her lover (and the work's from a strategic position on the ground. The young lady flirtatiously kicks off her shoe toward the little statue of Cupid. The infant love god holds his finger to his lips. The landscape emulates Watteau's—a luxuriant perfumed bower in a park that very much resembles a stage scene for comic opera. The glowing pastel colors and soft light convey, almost by themselves, the theme's sensuality.

THE ENLIGHTENMENT

In the course of the 18th century, the feudal system that served as the foundation of social and economic life in Europe dissolved, and the rigid social hierarchies that provided the basis for Rococo art and patronage relaxed. A major factor in these societal changes was the Enlightenment (see "The Enlightenment," page 313). Enlightenment edge based on empirical observation and scientific experimentation. Enlightenment-era science had roots in the work of René Descartes, Enlightenment-era science had roots in the work of René Descartes, all space pascal, Isaac Newton, and Gottfried Wilhelm von Leibniz in

ART AND SOCIETY

Joseph Wright of Derby and the Industrial Revolution

The scientific advances of the Enlightenment era affected the lives of everyone, and most people responded enthusiastically to the wonders of the Industrial Revolution such as the steam engine, which gave birth to the modern manufacturing economy and the prospect of a seemingly limitless supply of goods and services.

The fascination that science held for ordinary people as well as for the learned was a favorite subject of the English painter Joseph Wright of Derby. Wright studied painting near Birmingham, the center of the Industrial Revolution, and specialized in dramatically lit scenes show-casing modern scientific instruments and experiments. A characteristic example of Wright's work is *A Philosopher Giving a Lecture on the Orrery* (FIG. 11-5). In this painting, a scholar demonstrates a mechanical model of the solar system called an *orrery*, in which each planet (represented by a metal orb) revolves around the sun (a lamp) at the correct relative velocity. Light from the lamp pours forth from in front of the

boy silhouetted in the foreground to create shadows that heighten the drama of the scene. Curious children crowd close to the tiny orbs representing the planets within the curving bands symbolizing their orbits. An earnest listener makes notes, while the lone woman seated at the left and the two gentlemen at the right pay rapt attention. Scientific knowledge mesmerizes everyone in Wright's painting. The artist visually reinforced the fascination with the orrery by composing his image in a circular fashion, echoing the device's orbital design. The postures and gazes of all the participants and observers focus attention on the cosmic model. Wright scrupulously and accurately rendered every detail of the figures, the mechanisms of the orrery, and even the books and curtain in the shadowy background.

Wright's choice of subjects and realism in depicting them appealed to the great industrialists of his day, including Josiah Wedgwood (1730–1795), who pioneered many techniques of mass-produced pottery, and Sir Richard Arkwright (1732–1792), whose spinning frame revolutionized the textile industry. Both men often purchased paintings by Wright featuring scientific advances. To them, the Derby artist's elevation of the theories and inventions of the Industrial Revolution to the plane of history painting was exciting and appropriately in tune with the new era of Enlightenment.

11-5 JOSEPH WRIGHT
OF DERBY, A Philosopher
Giving a Lecture on the
Orrery, ca. 1763–1765.
Oil on canvas, 4' 10" × 6' 8".
Derby Museums and Art
Gallery, Derby.

Wright specialized in dramatically lit paintings celebrating the modern scientific instruments of the Industrial Revolution. Here, a scholar demonstrates an orrery, a revolving model of the solar system.

and combustion, along with the discovery of oxygen and the power of steam, had enormous consequences. Steam power as an adjunct to, or replacement for, human labor initiated a new era in world history. These and other technological advances—admiringly recorded in the paintings of Joseph Wright of Derby (1734–1797; see "Joseph Wright of Derby and the Industrial Revolution," above, and Fig. 11-5)—exemplified the Enlightenment notion of progress and gave birth to the Industrial Revolution. Most scholars mark the dawn of that technological revolution in the 1740s with the invention in England of steam engines for industrial production.

ROUSSEAU The second key figure of the French Enlightenment, who was also instrumental in preparing the way ideologically for the French Revolution, was Jean-Jacques Rousseau (1712–1778). Voltaire believed that the salvation of humanity lay in the advancement of science and in the rational improvement of society. In contrast, Rousseau argued that the arts, sciences, society, and civilization in general had corrupted "natural man." According to Rousseau, "Man by nature is good . . . he is depraved and perverted by society." He rejected the idea of progress, insisting that "our minds have been corrupted in proportion as the arts and sciences have improved." 2

canvas, 8' 4" x 6' 9". Galleria degli Uffizi, Florence.

Vigée-Lebrun was one of the few women admitted to France's Royal Academy

not contrived and artificial but born of the painter's honesty, insight, and sympathy. Chardin's paintings had wide appeal, even in unexpected places. Louis XV (r. 1723–1774), the royal personification of the Rococo in his life and tastes, once owned Grace.

.(► "ymsbssA and Sculpture (see "Vigée-Lebrun, Labille-Guiard, and the French Royal one of the few women admitted to the Royal Academy of Painting with Adélaïde Labille-Guiard (1749–1803; fig. 11-7A 🗐), was Lebrun was famous for the force and grace of her portraits and, important patron, Queen Marie Antoinette (1755-1793). Vigéeview at work on one of the many portraits she painted of her most dent role in society. She portrayed herself in a close-up, intimate natural stance of a woman whose art has won her an indepen-Vigée-Lebrun's pose appears contrived. Hers is the self-confident, that Rococo artists and wealthy patrons loved, nothing about lighthearted and her costume's details echo the serpentine curve pauses in her work to return their gaze. Although her mood is LEBRUN (1755-1842). The painter looks directly at viewers and fied by the self-portrait (FIG. 11-7) of ELISABETH LOUISE VIGÉEmore personal and less pretentious mode of portraiture, exemplipulse in 18th-century French art was the emergence of a new VIGÉE-LEBRUN Another manifestation of the "naturalistic" im-

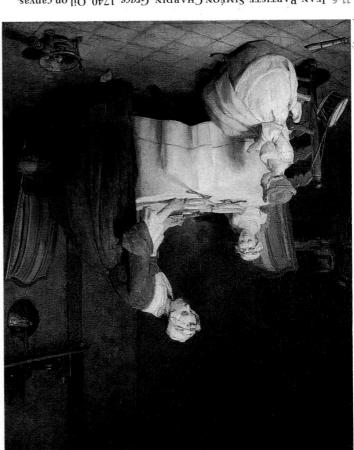

11-6 Jean-Baptiste-Siméon Chardin, Grace, 1740. Oil on canvas, $1'7''\times 1'3''$. Musée du Louvte, Paris.

Consistent with the ideas of Rousseau, Chardin celebrated the simple goodness of ordinary people, especially mothers and children, who lived in a world far from the frivolous Rococo salons of Paris.

Rousseau's elevation of feelings above reason as the most "natural" human expression led him to exalt as the ideal the peasant's simple life, with its honest and unsullied emotions.

nuances. A gentle sentiment prevails in all his pictures, an emotion the Enlightenment's poet of the commonplace and master of its three figures highlighted against the dark background. Chardin was composition reinforces the subdued charm of this scene, with the ritual of giving thanks to God before a meal. The simplicity of the and older sister supervise the younger sister in the simple, pious The viewer witnesses a moment of social instruction, when mother life accessories whose worn surfaces tell their own humble history. hushed lighting and mellow color and with the closely studied stillare about to dine. The mood of quiet attention is at one with the the viewer into a modest room where a mother and her daughters lived far from corrupt society. In Grace (FIG. 11-6), Chardin ushers ers and young children, who in spirit, occupation, and environment praise of the simple goodness of ordinary people, especially moth-CHARDIN (1699-1779) painted quiet scenes of domestic life in and frivolous: Reflecting Rousseau's views, Jean-Baptiste-Siméon the formation of a taste for the "natural," as opposed to the artificial sible for the turning away from the Rococo sensibility in the arts and CHARDIN Rousseau, popular and widely read, was largely respon-

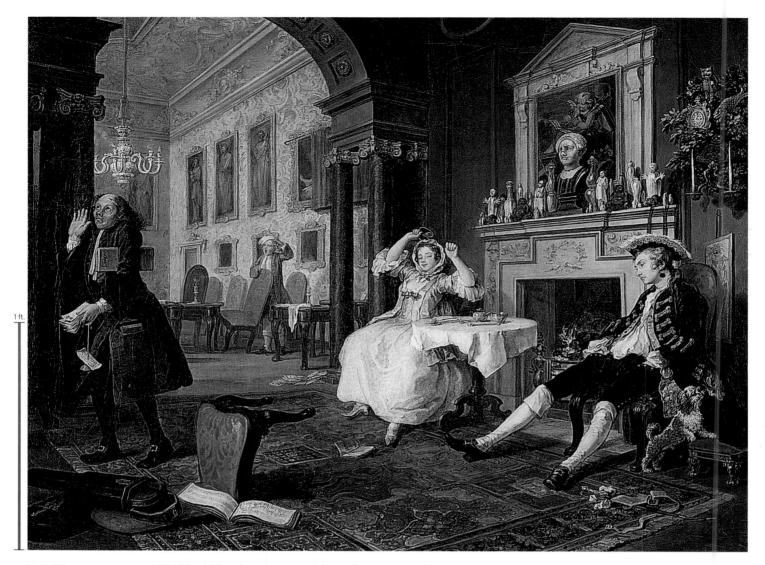

11-8 WILLIAM HOGARTH, The Tête à Tête, from Marriage à la Mode, ca. 1745. Oil on canvas, 2' 4" \times 3'. National Gallery, London.

Hogarth won fame for his paintings and prints satirizing English life with comic zest. This is one of a series of six paintings in which he chronicled the marital immoralities of the moneyed class.

WILLIAM HOGARTH Across the Channel, a truly English style of painting emerged with WILLIAM HOGARTH (1697–1764), who satirized with comic zest the lifestyle of the newly prosperous middle class. Traditionally, the British imported painters from the Continent—Holbein, Rubens, and Van Dyck among them. Throughout his career, Hogarth waged a lively campaign against the English feeling of dependence on, and inferiority to, these artists. Although Hogarth would have been the last to admit it, his own painting owed much to the work of his contemporaries in France, the Rococo artists. Yet his subject matter, frequently moral in tone, was distinctively English. This was the great age of English satirical writing, and Hogarth saw himself as translating satire into the visual arts.

Hogarth's favorite device was to make a series of narrative paintings and prints, in a sequence similar to chapters in a book or scenes in a play, following a character or group of characters in their encounters with some social evil. *The Tête à Tête* (FIG. 11-8), from *Marriage à la Mode*, is one of six paintings satirizing the marital immoralities of the moneyed classes in England. In it, a marriage

is just beginning to founder. The husband and wife are tired after a long night spent in separate pursuits. While the wife stayed at home for an evening of cards and music-making, her young husband had been out on the town with another woman. He thrusts his hands deep into the empty money-pockets of his breeches, while his wife's small dog sniffs inquiringly at a woman's lacy cap protruding from his coat pocket. A steward, his hands full of unpaid bills, raises his eyes in despair at the actions of his noble master and mistress. The couple's home is luxurious, but Hogarth filled it with witty clues to the dubious taste of its occupants. For example, the row of pious religious paintings on the upper wall of the distant room concludes with a curtained canvas undoubtedly depicting an erotic subject. According to the custom of the day, ladies could not view this discretely hidden painting, but at the pull of a cord, the master and his male guests could enjoy a tableau of cavorting figures. In The Tête à Tête, as in all his work, Hogarth proceeded as a novelist might, elaborating on his subject with carefully chosen detail, the discovery of which heightens the comedy.

PROBLEMS AND SOLUTIONS Grand Manner Portraiture

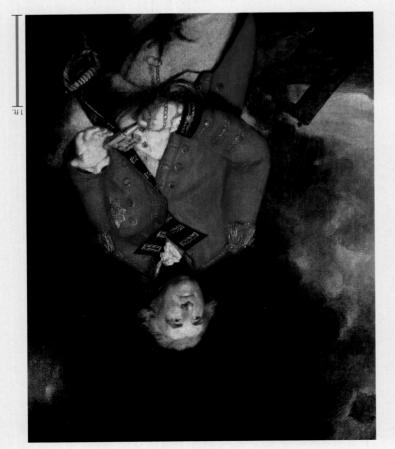

11-9 Sir Joshua Reynolds, Lord Heathfield, 1787. Oil on canvas, $4'8'' \times 3'9''$. National Gallery, London.

In this Grand Manner portrait, Reynolds depicted the English commander who defended Gibraltar. Heathfield stands in a dramatic pose, and his figure takes up most of the canvas.

The Enlightenment concept of "nobility," especially in the view of Rousseau (page 317), referred to character, not to aristocratic birth. In an era of revolutions, the virtues of courage and resolution, patriotism, and self-sacrifice assumed greater importance. Having risen from humble origins, the modern military hero joined the well-born aristocrat as a major patron of portrait painting.

Sir Joshus Reynolds was one of those who often received commissions to paint likenesses of key participants in the great events of the latter part of the 18th century. Indeed, he soon specialized in what became known as Grand Manner portraiture, echoing the term that Nicolas Poussin used in the previous century to describe his paintings of "grand subjects" such as "battles, heroic actions, and divine things" (see "Poussin's Motes for a Treatise on Painting," page 307). Although clearly depicting specific individuals, Grand Manner portraits elevated the sitters by conveying refinement and elegance. Reynolds and other painters communicated a person's grace and class through certain standardized conventions, such as the large scale of the figure relative to the canvas, the controlled pose, as the large scale of the figure relative to the canvas, the controlled pose,

Reynolds painted Lord Heathfield (Fig. 11-9) in 1787. The sitter was Reynolds painted Lord Heathfield (Fig. 11-9) in 1787. The sitter was a perfect subject for a Grand Manner portrait—a burly, ruddy English officer, the commandant of the fortress at Gibraltar. Heathfield had dogardly defended the British stronghold against the Spanish and French, and later received the honorary title Baron Heathfield of Gibraltar. Here, he holds the huge key to the fortress, the symbol of his victory. He stands in front of a curtain of dark smoke rising from the battleground, flanked by one cannon pointing ineffectively downward and another whose tilted barrel indicates that it lies uselessly on its back. Reynolds portrayed the barrel indicates that it lies uselessly on its back. Reynolds portrayed the barrel indicates that it lies uselessly on its back and his uniform with unidealized realism. But Lord Heathfield's posture and the setting dramatically suggest the heroic themes of battle, courage, and patriotism.

composition. His modern hero dies among grieving officers on the field of victorious battle in a way that suggests the death of a saint. (The composition, in fact, derives from paintings of the lamentation over the dead Christ, compare FIG. 8-7.) West wanted to present this religious emotions. His innovative combination of the conventions of traditional heroic painting with a look of modern realism influenced history painting well into the 19th century.

COPLEY (1738–1815) matured as a painter in the Massachusetts Bay Colony. Like West, Copley later settled in England, where he absorbed the fashionable English portrait style. But unlike Grand Manner portraits, Copley's Paul Revere (Fig. 11-11), painted before the artist left Boston, conveys a sense of directness and faithfulness to visual fact that marked the taste for honesty and plainness noted by many late-18th- and early-19th-century visitors to America. When Copley painted his portrait, Revere was not yet the familiar hero of the American Revolution. In this picture, he is a working professional silversmith. The setting is plain, the lighting clear and revealing. Revere sits in his shirtsleeves, bent over a teapot in progrevesling. Revere sits in his shirtsleeves, bent over a teapot in progreves. He pauses and turns his head to look the observer straight in reses. He pauses and turns his head to look the observer straight in

SIR JOSHUA REYNOLDS Quite different in both style and subject is the work of England's greatest painter of the Enlightenment era, SIR JOSHUA REYNOLDS (I723–I792), who achieved renown for his portraits (see "Grand Manner Portraiture," above, and FIG. 11-9).

painting by arranging his figures in a complex, theatrically ordered blended this realism of detail with the grand tradition of history rior, depicted as an exemplary "noble savage." However, West rare glimpse for his English audience of a Native American warclothed his characters in contemporary costumes and included a ada to Great Britain. Because his subject was a recent event, West the French in the decisive battle of Quebec in 1759, which gave Canmortally wounded young English commander just after his defeat of Revolution. In Death of General Wolfe (FIG. 11-10), West depicted the retained that position during the strained period of the American He became official painter to King George III (r. 1760-1801) and Royal Academy of Arts, West succeeded Reynolds as its president. almost immediate success. One of the 36 founding members of the in life to study art and then went to England, where he met with what was then the colonial frontier, traveled on the Continent early in England. Benjamin West (1738–1820), born in Pennsylvania on BENJAMIN WEST Some American artists also became well known

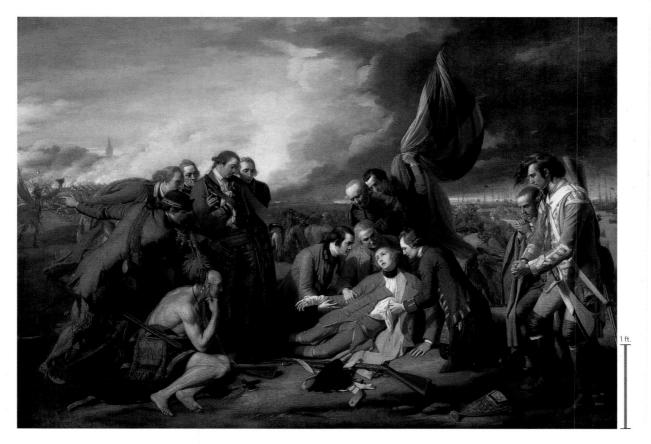

11-10 BENJAMIN WEST, Death of General Wolfe, 1771. Oil on canvas. 4' $11\frac{1}{2}$ " × 7'. National Gallery of Canada, Ottawa (gift of the Duke of Westminster, 1918).

West's great innovation was to blend contemporary subject matter and costumes with the grand tradition of history painting. Here, the painter likened General Wolfe's death to that of a martyred saint.

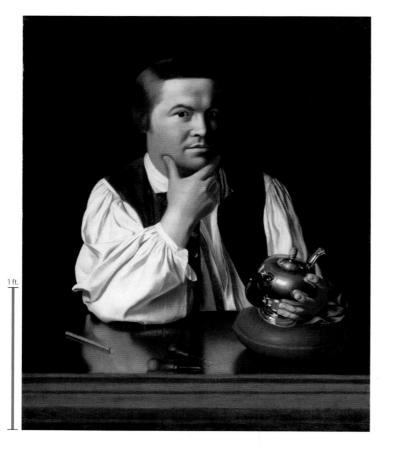

the eyes. The painter treated the reflections in the polished wood of the tabletop with as much care as he did Revere's figure, his tools, and the teapot resting on its leather graver's pillow. The informality and the sense of the moment link this painting to contemporaneous English and Continental portraits. But the spare style and the emphasis on the sitter's down-to-earth character differentiate this American work from its European counterparts.

THE GRAND TOUR The 18th-century public also sought "naturalness" in artists' depictions of landscapes. Documentation of specific places became popular, in part due to growing travel opportunities and expanding colonialism. These depictions of geographic settings also served the needs of the many scientific expeditions mounted during the century and satisfied the desires of genteel tourists for mementos of their journeys. By this time, a "Grand Tour" of the major sites of Europe was an essential part of every well-bred person's education (see "The Grand Tour and Veduta Painting," page 322). Those who embarked on a tour of the Continent wished to return with souvenirs to help them remember their experiences and

11-11 JOHN SINGLETON COPLEY, *Paul Revere*, ca. 1768–1770. Oil on canvas, 2' $11\frac{1}{8}$ " × 2' 4". Museum of Fine Arts, Boston (gift of Joseph W., William B., and Edward H. R. Revere).

In contrast to Grand Manner portraits, Copley's *Paul Revere* emphasizes the subject's down-to-earth character, differentiating this American work from its European counterparts.

ART AND SOCIETY The Grand Tour and Veduta Painting

which to omit to make a coherent and engagingly attractive veduta. tions and exercised great selectivity about which details to include and fact, he presented each site within Renaissance perspective convenings give the impression of capturing every detail, with no "editing." In the variable focus of objects at different distances. Canaletto's paintenabling Canaletto to create convincing representations incorporating a camera obscura, as Vermeer (Figs. 10-24 and 10-25) did before him, paintings. To help make the on-site drawings true to life, he often used drawings "on location" to take back to his studio and use as sources for in scrupulous perspective and minute detail. Canaletto usually made Venetian landmarks, such as the Doge's Palace (Fig. 7-39), painted with its cloud-studded sky, picturesque water traffic, and well-known view such as that in Canaletto's Riva degli Schiavoni, Venice (FIG. 17-12), winter afternoon in England to look up and see a sunny, panoramic views (vedute) of Venice. It must have been very cheering on a gray Tour with a painting by Antonio Canaletto, the leading painter of scenic south as Naples and even Sicily. Many returned home from their Grand destination in Italy, visitors traveled as far north as Venice and as far destinations. Although they designated Rome early on as the primary

Although travel throughout Europe was commonplace in the 18th century, Italy became an especially popular destination. This "pilgrimage" of the wealthy from France, England, Germany, and even the British colonies in America came to be known as the Grand Tour. The Grand Tour was not simply leisure travel. The education available in Italy to the inquisitive mind made the trip an indispensable experience for anyone who wished to make a mark in society. The Enlightenment had made knowledge of ancient Rome imperative, and a steady stream of Europeans and Americans traveled to Italy in the late 18th and early 19th centuries. These tourists aimed to increase their knowledge of literature, the visual arts, architecture, theater, music, and history. Given eastern the visual arts, architecture, theater, music, and history. Given this extensive agends, it is not surprising that a Grand Tour could take a number of years to complete.

The British were the most avid travelers, and they conceived the initial "tour code," including required itineraries and important

II-IZ Antonio Canaletto, Riva degli Schiavoni, Venice, ca. 1735-1740. Oil on canvas, 1' $6\frac{1}{2}$ " \times 2' $\frac{7}{8}$ ". Toledo Museum of Art, Toledo.

Canaletto was the leading painter of Venetian vedute, which were treasured souvenirs for 18th-century travelers visiting Italy on the Grand Tour. He used a camera obscura for his on-site drawings.

British visitors. Chief among those artists was Antonio Canaletto (1697–1768), whose works—for example, Riva degli Schiavoni, Venice (Fig. 11-12)—English tourists avidly acquired as evidence of their visit to Italy's magical city of water.

impress those at home with the wonders they had seen. The English were especially eager collectors of travel pictures. Venetian artists in particular found it profitable to produce paintings of the most characteristic vedute ("scenic views") of their city to sell to

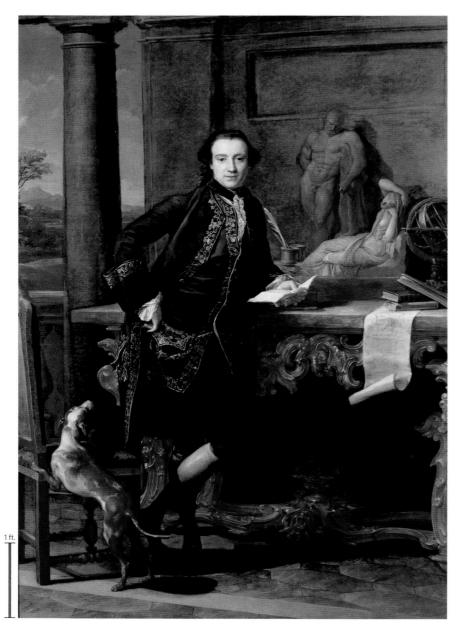

POMPEO BATONI Some of those who embarked on the Grand Tour sought to obtain a more personalized memento of their cultural journey than a portrait of Venice: a portrait of themselves by the leading Italian portrait painter of the day, POMPEO BATONI (1708-1787). Born in Lucca and trained in Rome, where he eventually became curator of the papal art collection, Batoni received commissions for "Grand Tour portraits" from prosperous visitors of various nationalities, but especially from Englishmen. Batoni's portrait (FIG. 11-13) of Charles John Crowle (1738–1811) is a characteristic example. Crowle, a second-generation member of the British Parliament from Yorkshire, stands in a palatial columnar study with a view of the Roman countryside behind him. Attended by his faithful dog, Crowle is surrounded by abundant evidence of his learning and passion for antiquity. Most prominent are copies of reduced size of the much-admired Farnese Hercules in Naples and of a statue of the sleeping Ariadne in the Vatican. On the elegant table on which Crowle leans is an astronomical model (compare FIG. 11-5) and an unrolled plan of Saint Peter's (FIG. 10-2). In 1764, after returning from Rome, Crowle was elected a member of the Society of Dilettanti, a prestigious group of British connoisseur-admirers of Greco-Roman art.

11-13 POMPEO BATONI, Charles John Crowle, ca. 1761–1762. Oil on canvas, 8' $1\frac{5}{8}$ " \times 5' $7\frac{3}{4}$ ". Musée du Louvre, Paris.

Prosperous visitors to Rome on the Grand Tour frequently commissioned Batoni to paint their portraits. Here, an English gentleman poses with items attesting to his learning and passion for antiquity.

NEOCLASSICISM

As Batoni's *Charles John Crowle* vividly illustrates, the popularity of the Grand Tour among the cultural elite of Europe both reflected and contributed to the heightened interest in classical antiquity during the Enlightenment. Exposure to the art treasures of Italy was also a major factor in the rise of Neoclassicism as the leading art movement of the late 18th century (see "The Enlightenment, Angelica Kauffman, and Neoclassicism," page 313) as well as to intensified study of the ancient world in academic circles.

WINCKELMANN In 1755, Johann Joachim Winckelmann (1717–1768), widely recognized as the first modern art historian, published *Reflections on the Imitation of Greek Works in Painting and Sculpture*, in which the German scholar unequivocally designated Greek art as the most perfect to come from human hands. For Winckelmann, classical art was far superior to the "natural" art of his day.

[An enlightened person] will find beauties hitherto seldom revealed when he compares the total structure of Greek figures with most modern ones, especially those modelled more on nature than on Greek taste.³

In his later *History of Ancient Art* (1764), Winckelmann carefully described major works of classical art and positioned each one within a huge inventory organized by subject matter, style, and period. Before Winckelmann, art historians had focused on biogra-

phy, as did Giorgio Vasari and Giovanni Pietro Bellori in the 16th and 17th centuries (see "Vasari" and "Bellori" (1)). Winckelmann thus initiated one modern art historical method thoroughly in accord with Enlightenment ideas of ordering knowledge—a system of description and classification that provided a pioneering model for the understanding of stylistic evolution.

JACQUES-LOUIS DAVID One of the pioneers of Neoclassical painting was the Swiss artist Angelica Kauffman (FIG. 11-1), but Frenchman Jacques-Louis David (1748–1825) is generally considered the greatest Neoclassical master. Although his early paintings were in the Rococo manner, a period of study in Rome of the works of ancient and Renaissance artists converted David to Neoclassicism. He rebelled against the Rococo style as an "artificial taste" and exalted the "perfect form" of Greek art (see "Jacques-Louis David on Greek Style and Public Art," page 324). David, who became the Neoclassical painter-ideologist of the French Revolution, concurred with the Enlightenment idea that the subject of an artwork should have a moral. He believed that paintings representing noble deeds in the past could inspire virtue in the present.

David also strongly believed that paintings depicting noble events in ancient history, such as his Oath of the Horatii (Fig. 11-14), would serve to instill patriotism and civic virtue in the public at large in postrevolutionary France. In November 1793, he wrote:

[The arts] should help to spread the progress of the human spirit, and to propagate and transmit to posterity the striking examples of the efforts of a tremendous people who, guided by reason and philacophy, are bringing back to earth the reign of liberty, equality, and law. The arts must therefore contribute forcefully to the education of the public.... The arts are the imitation of nature in her most beautiful and perfect form....[T]hose marks of heroism and civic virtue offered the eyes of the people [will] electrify the soul, and plant the seeds of glory and devotion to the fatherland.

*Translated by Robert Goldwater and Marco Treves, eds., Artists on Art, 3d ed. (New York: Pantheon Books, 1958), 206.

ARTISTS ON ART Jacques-Louis David on Greek Style and Public Art

Jacques-Louis David was the leading Meoclassical painter in France at the end of the 18th century. He championed a return to Greek style and the painting of inspiring heroic and patriotic subjects. In 1796, he made the following statement to his pupils:

I want to work in a pure Greek style. I feed my eyes on antique statues, I even have the intention of imitating some of them. The Greeks had no scruples about copying a composition, a gesture, a attention and already been accepted and used. They put all their already conceived. They thought, and they were right, that in the arts the way in which an idea is rendered, and the manner in which it is expressed, is much more important than the idea itself. To give it is expressed, is much more important than the idea itself. To give it is expressed, is much more important than the idea itself. To give it is expressed, is much more important than the idea itself. To give it is expressed, is much more important than the idea itself. To give it is expressed, is much more important than the idea itself. To give

11-14 JACQUES-LOUIS DAVID, Oath of the Horatii, 1784. Oil on canvas, 10' 10" × 13' 11". Musée du Louvre, Paris.

David was the Neoclassical painter-ideologist of the French Revolution. This huge canvas celebrating ancient Roman patriotism and sacrifice features statuesque figures and classical architecture.

A milestone painting in David's career, Oath of the Horatii (FIG. 11-14), depicts a story from pre-Republican Rome, the heroic phase of Roman history. The topic was not too obscure for David's audience. Pierre Corneille (1606-1684) had retold this story of conflict between love and patriotism, first recounted by the ancient Roman historian Livy, in a play performed in Paris several years earlier. The leaders of the warring cities of Rome and Alba Longa decided to resolve their conflicts in a series of encounters waged by three representatives from each side. The Romans chose as their champions the three Horatius brothers, who had to face the three sons of the Curatius family from Alba Longa. A sister of the Horatii, Camilla, was the bride-to-be of one of the Curatius sons, and the wife of the youngest Horatius was the sister of the Curatii. David's painting shows the Horatii as they swear on their swords, held high by their father, to win or die for Rome, oblivious to the anguish and sorrow of the Horatius women.

Oath of the Horatii exemplifies the Neoclassical style. The subject is a narrative of patriotism and sacrifice excerpted from Roman history. The action unfolds in a shallow space much like a stage setting, defined by a severely simple architectural framework. David deployed his statuesque and carefully modeled figures across the space, close to the foreground, in a manner recalling ancient relief

sculpture. The rigid, angular, and virile forms of the men on the left effectively contrast with the soft curvilinear shapes of the distraught women on the right. This juxtaposition visually pits virtues that Enlightenment thinkers ascribed to men (such as courage, patriotism, and unwavering loyalty to a cause) against the emotions of love, sorrow, and despair expressed by the women in the painting. The French viewing audience perceived such emotionalism as characteristic of the female nature. The message was clear and of a type readily identifiable to the prerevolutionary French public. The picture created a sensation at its first exhibition in Paris in 1785. Although David had painted it under royal patronage and did not intend the painting as a revolutionary statement, *Oath of the Horatii* aroused his audiences to patriotic zeal. The Neoclassical style soon became the semiofficial voice of the French Revolution.

DEATH OF MARAT When the revolution broke out in 1789, David threw in his lot with the Jacobins, the radical and militant revolutionary faction. He accepted the role of de facto minister of propaganda, organizing political pageants and ceremonies requiring floats, costumes, and sculptural props. David believed that art could play an important role in educating the public and that dramatic paintings emphasizing patriotism and civic virtue would prove

effective as rallying calls. However, rather than continuing to create artworks focused on scenes from antiquity, David began to portray events from the French Revolution itself. He intended Death of Marat (FIG. 11-15) not only to serve as a record of an important episode in the struggle to overthrow the monarchy but also to provide inspiration and encouragement to the revolutionary forces. The painting commemorates the assassination of Jean-Paul Marat (1743-1793), an influential writer who was David's friend. The artist depicted the martyred revolutionary in his medicinal bath after Charlotte Corday (1768-1793), a member of a rival political faction, stabbed him to death. (Marat suffered from a painful skin disease.) The cold neutral space above Marat's figure slumped at his "desk" in the tub produces a chilling oppressiveness. Indeed, the writing stand, which bears the words "To Marat, David" resembles a tombstone, and David vividly placed all narrative details in the foreground—the knife, the wound, the blood, the letter with which Corday gained entrance—to sharpen the sense of pain and outrage. He masterfully composed the painting to present Marat as a tragic martyr who died in the service of the revolution. David based Marat's figure on Christ in Michelangelo's Pietà (FIG. 9-7). The reference

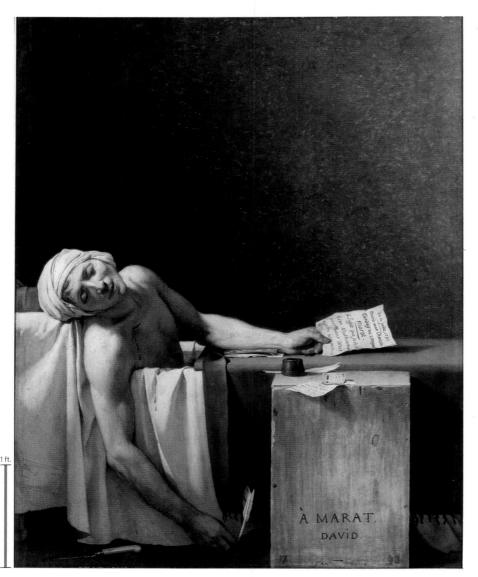

11-15 JACQUES-LOUIS DAVID, Death of Marat, 1793. Oil on canvas, 5' 5" \times 4' $2\frac{1}{2}$ ". Musées royaux des Beaux-Arts de Belgique, Brussels.

David depicted the revolutionary Marat as a tragic martyr, stabbed to death in his bath. Although the painting displays severe Neoclassical spareness, its convincing realism conveys pain and outrage.

11-16 JACQUES-GERMAIN SOUPFLOT, Panthéon (Sainte-Geneviève; looking northeast), Paris, France, 1755–1792.

Soufflot's Panthéon is a testament to the Enlight-enment admiration for Greece and Rome. It combines a portico based on an ancient Roman temple with a colonnaded dome and a Greek-cross plan.

other things, the publication of Colin Campbell's Vitruvius Britanni-(ca. 1686-1748). Paving the way for this shift in style was, among which he built on London's outskirts with the help of WILLIAM KENT style in the new Neoclassical idiom in Chiswick House (FIG. 71-17), RICHARD BOYLE (1695-1753) strongly restated the Palladian in the 15th, 16th, and the 17th centuries, especially Andrea Palladio. Renaissance and Baroque architects who revived the classical style "Vitruvius's Ten Books on Architecture" (A) and more directly from the from the authority of the ancient Roman architect Vitruvius (see ture, the preference for a simple and rational style derived indirectly with the flamboyant rule of absolute monarchy. In English architectrast to the complexity and opulence of Baroque art, then associated its clarity and simplicity. These characteristics provided a stark con-Neoclassicism. In England, Neoclassicism's appeal also was due to parliamentary England joined revolutionary France in embracing ranging from Athenian democracy to Roman imperial rule. Thus

Architect the built on London's outskirts with the help of Williams France (Fig. 71-17), which he built on London's outskirts with the help of William Kent (ca. 1686–1748). Paving the way for this shift in style was, among other things, the publication of Colin Campbell's Vitruvius Britannicus (1715), three volumes of engravings of ancient buildings, prefaced by a denunciation of the Italian Baroque style and high praise for Palladio. Chiswick House is a free variation on the theme of Palladio's Villa Rotonda (Fig. 9-16). The exterior design provided a clear alternative to the colorful splendor of Versailles (Figs. 10-31 and 10-32). In its simple symmetry, unadorned planes, right angles, and precise proportions, Chiswick House looks very classical and rational.

THOMAS JEFFERSON Because the appeal of Neoclassicism was due in part to the values with which it was associated—morality, idealism, patriotism, and civic virtue—it is not surprising that in the new American republic, Thomas Jefferson (1743–1826) spearheaded a movement to adopt Neoclassicism as the national

to Christ's martyrdom made the painting a kind of "altarpiece" for the new civic "religion," inspiring the French people with the saintly dedication of their slain leader.

drals (see "Building a High Gothic Cathedral," page 193) to modern century builders to apply the logical engineering of Gothic catheemployed were essentially Gothic. Soufflot was one of the first 18ththe whole effect, inside and out, is Roman, the structural principles columns, as if the portico's colonnade continued within. Although vaults rest on an interior grid of splendid freestanding Corinthian London, rises above a Greek-cross plan. Both the dome and the (FIGS. 9-14 and 10-2) in Rome and Saint Paul's (FIG. 10-33) in naded dome, a Neoclassical version of the domes of Saint Peter's blank, except for a repeated garland motif near the top. The colonied archaeological precision), stand out from walls that are severely on those of a Roman temple in Lebanon (reproduced with studto the revived interest in classical architecture. The columns, based by JACQUES-GERMAIN SOUFFLOT (1713–1780) stands as testament antique look. Sainte-Geneviève, the Parisian Panthéon (FIG. 11-16), of Baroque and Rococo design and embraced a more streamlined tury, they began to turn away from the theatricality and ostentation admired and emulated Greco-Roman style. Early in the 18th cen-PANTHÉON, PARIS Architects in the Enlightenment era also

CHISWICK HOUSE The appeal of classical architecture extended well beyond French borders. The popularity of Greek and Roman cultures was due not only to their association with morality, rationality, and integrity but also to their connection to political systems

buildings.

11-17 RICHARD BOYLE and WILLIAM KENT, Chiswick House (looking northwest), near London, England, begun 1725.

For this English villa, Boyle and Kent emulated the simple symmetry and unadorned planes of the Palladian architectural style. Chiswick House is a free variation on the Villa Rotonda (Fig. 9-16).

architectural style. Jefferson—economist, educational theorist, and gifted amateur architect, as well as statesman (see "Thomas Jefferson, Patron and Practitioner" (1)—admired Palladio immensely and read carefully the Italian architect's *Four Books of Architecture*. Later, while minister to France, he studied 18th-century French classical architecture and visited the Maison Carrée (FIG. 3-28A (1)),

an ancient Roman temple at Nîmes, which inspired his design for the State House in Richmond, Virginia. Equally influential was the Pantheon (FIG. 3-38) in Rome, which served as the model for the centerpiece of Jefferson's University of Virginia campus (FIG. 11-17A 1). After his European sojourn, Jefferson decided to completely remodel Monticello (FIG. 11-18), his home near Charlottesville, Virginia,

11-18 THOMAS JEFFERSON, Monticello, Charlottesville, Virginia, 1770-1806.

Jefferson led the movement to adopt Neoclassicism as the architectural style of the United States. Although built of local materials, his Palladian Virginia home recalls Chiswick House (Fig. 11-17).

Richmond. 1788-1792. Marble, 6' 2" high. State Capitol, 11-19 JEAN-ANTOINE HOUDON, George Washington,

his farm after his war service. in the statue because Washington similarly had returned to he incorporated the Roman fasces and Cincinnatus's plow Houdon portrayed Washington in contemporary garb, but

author Pliny. by the ones described by the first-century Roman goals—to build for himself a country villa inspired ian.) The setting fulfilled another of Jefferson's ticello means "hillock" or "little mountain" in Italplot of land with mountain vistas all around. (Monment-capped columnar porch. It sits on a wooded above the central drawing room behind a pedi-The single-story home has an octagonal dome set als are the local wood and brick used in Virginia. and of Chiswick House (FIG. 11-17), but its materireminiscent of Palladio's Villa Rotonda (FIG. 9-16) style. The final version of Monticello is somewhat which he originally had designed in a different

a time of war and resigned his position as soon as Roman Republic who was elected dictator during ces alludes to Cincinnatus, a patrician of the early states. The plow behind Washington and the fasof authority. The 13 rods symbolize the 13 original ax attached—the ancient Roman fasces, an emblem which Washington leans is a bundle of rods with an erence to the Roman Republic. The "column" on contemporary garb, the statue makes an overt ref-But although the first American president wears equivalent of a Grand Manner portrait (FIG. 11-9). portrait of Washington (FIG. 11-19) is the sculptural he was America's ambassador to France. Houdon's portrait of Benjamin Franklin (1706-1790) when (1741-1828). Houdon had already carved a bust of the late 18th century, JEAN-ANTOINE HOUDON mission to the leading French Neoclassical sculptor Washington (1732-1799), they awarded the coma life-size marble statue of Virginia-born George members of the Virginia legislature wanted to erect the newly independent United States. When the became the preferred style for public sculpture in JEAN-ANTOINE HOUDON Neoclassicism also

of the Cincinnati (visible beneath the bottom of his waistcoat), an farm. Washington wears the badge of the Society victory had been achieved in order to return to his

longer holds his sword in Houdon's statue. who had resumed their peacetime roles. Tellingly, Washington no association founded in 1783 for officers in the revolutionary army

The Neoclassical style, so closely associated with democracy

of Chapter 12. new styles that eventually displaced Neoclassicism are the subjects decade of the 19th century. Napoleonic art and the revolutionary for promoting the empire of Napoleon Bonaparte in the opening in the late 18th century, ironically also became the ideal vehicle

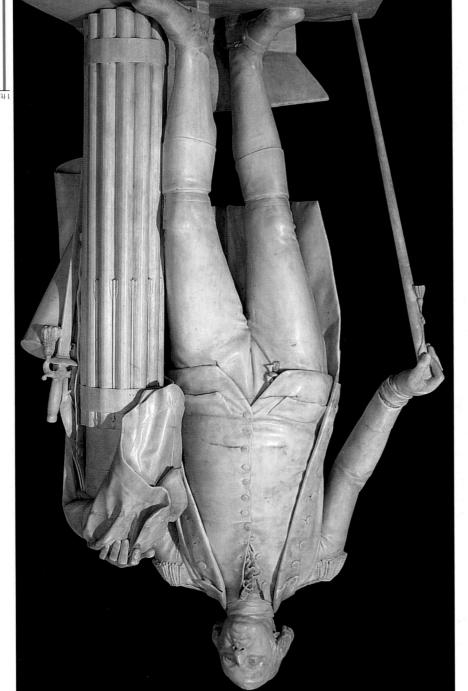

- \mathbb{A} Explore the era further in MindTap with videos of major artworks and
- buildings, Google Earth™ coordinates, and essays by the author on the
- following additional subjects:
- □ Clodion, Nymph and Satyr Carousing (FIG. 11-1A) ■ WRITTEN SOURCES: Femmes Savantes and Rococo Salon Culture
- ART AND SOCIETY: Vigée-Lebrun, Labille-Guiard, and the French Royal
- Adélaïde Labille-Guiard, Self-Portrait with Two Pupils (FIG. 71-7A)
- THE PATRON'S VOICE: Thomas Jefferson, Patron and Practitioner
- Thomas Jefferson, University of Virginia (FIG. 17-77A)

ROCOCO TO NEOCLASSICISM IN EUROPE AND AMERICA

Rococo

- In the early 18th century, the centralized and grandiose palace-based culture of Baroque France gave way to the much more intimate Rococo culture based in the townhouses of Paris. There, aristocrats and intellectuals gathered for witty conversation in salons featuring delicate colors, sinuous lines, gilded mirrors, elegant furniture, and small paintings and sculptures.
- The leading Rococo painter was Antoine Watteau, whose usually small canvases feature light colors and elegant figures in ornate costumes moving gracefully through lush landscapes. Jean-Honoré Fragonard carried on the Rococo style late into the 18th century.

Watteau, Pilgrimage to Cythera, 1717

The Enlightenment

- By the end of the 18th century, revolutions had overthrown the monarchy in France and achieved independence for the British colonies in America. A major factor was the Enlightenment, a new way of thinking critically about the world independently of religion and tradition that also helped foster the Industrial Revolution, which began in England in the 1740s. The paintings of Joseph Wright of Derby celebrated the scientific inventions of the Enlightenment era.
- The Enlightenment also made knowledge of ancient Rome essential for the cultured elite, and Europeans and Americans in large numbers undertook a Grand Tour of Italy. Among the most popular souvenirs of the Grand Tour were Antonio Canaletto's cityscapes of Venice. Other travelers returned with a portrait by Pompeo Batoni of themselves posing with classical antiquities.
- Rejecting the idea of progress, Jean-Jacques Rousseau, one of the leading French intellectuals, argued for a return to natural values and exalted the simple life of peasants. His ideas influenced artists such as Jean-Baptiste-Siméon Chardin, who painted sentimental narratives about rural families.
- The taste for naturalism also led to a reawakening of an interest in realism. Benjamin West represented the protagonists in his history paintings wearing contemporary costumes.

Batoni, Charles John Crowle, ca. 1761-1762

West, Death of General Wolfe, 1771

Neoclassicism

- The Enlightenment revival of interest in Greece and Rome also gave rise in the late 18th century to the artistic movement known as Neoclassicism, which incorporated the subjects and styles of ancient art.
- A pioneer of the new style was Angelica Kauffman, who often chose subjects drawn from Roman history. Jacques-Louis David, who exalted classical art as "the imitation of nature in her most beautiful and perfect form," also favored Roman themes. Painted on the eve of the French Revolution, Oath of the Horatii, set in a severe classical hall, served as an example of patriotism and sacrifice.
- Neoclassicism also became the dominant style in 18th-century architecture. Ancient Roman and Italian Renaissance structures inspired Jacques-Germain Soufflot's Panthéon in Paris. In the United States, Thomas Jefferson championed Neoclassicism as the official architectural style of the new American republic. It represented for him idealism, patriotism, and civic virtue.

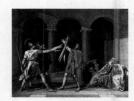

David, Oath of the Horatii, 1784

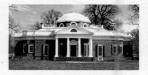

Jefferson, Monticello, 1770-1806

to noitnette adf gni the hope of attracttattered garment in survivors, waves a man, one of the few a seminude black from the lower left, axis stretching lenogeib e ło xege ▶ 12-1b At the

the rescue ship.

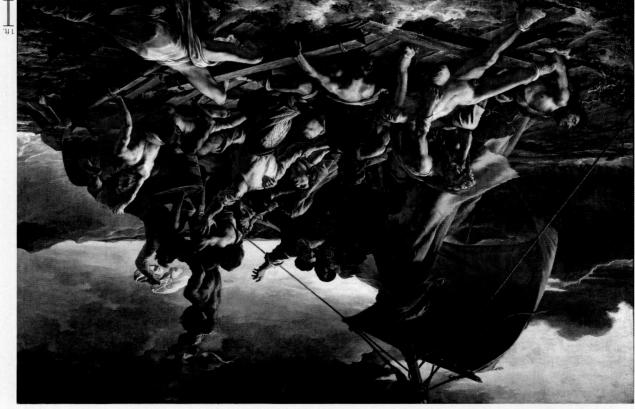

of the raft.

captain's incompetence Géricault the story of the 15 survivors, who told

Argus, which would eventhe distance is the ship ► 12-1c Barely visible in

THÉODORE GÉRICAULT, Raft of the Medusa, 1818-1819.

Oil on canvas, 16' 1" x 23' 6". Musée du Louvre, Paris.

Romanticism, Realism, and Photography, 1800 to 1870

THE HORROR—AND ROMANCE—OF DEATH AT SEA

At the close of the 18th century, Neoclassicism was the dominant artistic style in Europe, but it soon gave way to a movement that historians of art, music, and literature call *Romanticism*. In France, one of the pioneering Romantic painters was Théodore Géricault (1791–1824). Although Géricault retained an interest in the heroic and the epic, and studied drawing in the studio of Neoclassical painter Pierre-Narcisse Guérin (1774–1833), he chafed at the rigidity of the Neoclassical style, instead producing works that captivate viewers with their drama, visual complexity, and emotional force.

Géricault's most ambitious project was *Raft of the Medusa* (FIG. 12-1), an immense (23-foot-wide) canvas with figures larger than life. The painting immortalized the July 2, 1816, shipwreck off the Mauritanian coast of the French frigate *Medusa*, which ran aground on a reef due to the incompetence of its inexperienced captain, a political appointee. The captain and his officers safely abandoned the ship. In an attempt to survive, 147 passengers built a makeshift raft from pieces of the disintegrating frigate. The raft drifted for 13 days, and the starving survivors dwindled to 15, in part because of cannibalism. Finally, the ship *Argus* spotted the raft and rescued those still alive. This horrendous event was political dynamite once it became public knowledge.

In Raft of the Medusa, Géricault chose to represent the moment when some of those still alive summon what little strength they have left to flag down the Argus far on the horizon, not knowing if the ship's crew could see their raft. Géricault sought to capture accurately the horror, chaos, and emotion of the tragedy yet invoke the grandeur and impact of Neoclassical history painting. He visited hospitals and morgues to study the bodies of the dying and dead, interviewed survivors, and had a model of the raft constructed in his studio. The legacy of Neoclassicism is still evident in the incongruously muscular bodies of the starving. But Géricault rejected Neoclassical composition principles and instead presented a jumble of writhing bodies. He arranged the survivors and several corpses in a powerful X-shaped composition, and piled one body on another in every attitude of suffering, despair, and death. One light-filled diagonal axis stretches from the bodies at the lower left up to the black man raised on his comrades' shoulders and waving a tattered garment toward the horizon. Yet the man, seen from the back and faceless, is an anonymous antihero, in striking contrast to the protagonists of the historical and mythological works then in vogue. The cross axis descends from the dark, billowing sail at the upper left to the shadowed upper torso of the body trailing in the open sea. Géricault's bold decision to place the raft at a diagonal so that a corner juts outward makes it seem as though some of the corpses are sliding off the raft into the viewer's space. Raft of the Medusa, like the event itself, caused a sensation. It established Géricault's reputation and reoriented the history of painting.

ART UNDER NAPOLEON

parts of the Continent, facilitating the transportation of both goods population boom in European cities, and railroads spread to many technological and economic. The Industrial Revolution caused a significant changes during the first half of the 19th century were changed dramatically (MAP 12-1), but in many ways, the more After Napoleon's death, the political geography of Europe

into exile on the island of Saint Helena in the South Atlantic, where

Belgium. Forced to abdicate the imperial throne, Napoleon went

on architectural design, and the invention of photography revoluand public alike. New construction techniques had a major impact cism and Realism in turn had captured the imagination of artists opened with Neoclassicism still supreme, but by 1870, Romanti-Transformation also occurred in the art world. The century and people.

tionized picture making of all kinds.

he died six years later.

nation as Emperor of the French. ances, and in 1804 the pope journeyed to Paris for Napoleon's corocontrol of almost all of continental Europe in name or through allipage 88). During the next 15 years, the ambitious general gained clear and intentional links to the ancient Roman Republic (see created position—First Consul of the French Republic, a title with ing in various French army commands, Napoleon assumed a newly ent kind of monarchy with himself at its head. In 1800, after serv-(1769–1821) to exploit the resulting disarray and establish a differthrow of the monarchy also opened the door for Napoleon Bonaparte The revolution of 1789 initiated a new era in France, but the over-

astating defeat at the hands of the British at Waterloo in present-day Russia that ended in retreat, and in 1815 the emperor suffered a dev-In 1812, however, Napoleon launched a disastrous invasion of

MAP 12-1 Europe around 1850.

ROMANTICISM, REALISM, AND PHOTOGRAPHY, 1800 TO 1870

- time are the only valid subjects for art. America insist that people and events of their own ■ Courbet and other Realist painters in Europe and
- of their shocking subject matter and nonillusionistic Manet's paintings get a hostile reception because
- construction in the Crystal Palace. Paxton pioneers prefabricated glass-and-iron
- O'Sullivan makes on-the-spot photographs of the
- featuring unleashed emotion, vibrant color, and bold Delacroix and other painters tavor exotic subjects Romanticism is the leading European art movement.
- Gothic style enjoys a revival in architecture. specialize in painting transcendental landscapes. Friedrich, Turner, Cole, and other Romantic artists prushstrokes.
- Daguerre and Talbot invent photography.
- classical "temple of glory," on ancient Roman Vignon models La Madeleine, Napoleon's Neo-Empire and brings Canova from Rome to Paris. Napoleon appoints David as First Painter of the
- between Neoclassicism and Romanticism. David's students Gros and Ingres form a bridge

2181-0081

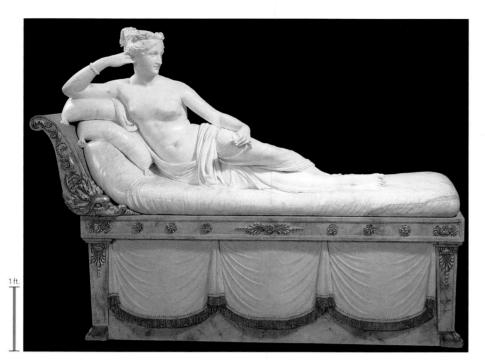

ANTONIO CANOVA Not surprisingly, Napoleon, who aspired to rule an empire that might one day rival ancient Rome's, embraced Neoclassicism as the ideal stylistic vehicle for linking his rule with the classical past and for expressing his imperial authority. He appointed Jacques-Louis David First Painter of the Empire and commissioned Pierre-Alexandre Barthélémy Vignon (1763-1828; FIG. 12-1A (1) and other architects to design buildings and monuments based on ancient Roman models. Napoleon's favorite sculptor was Antonio Canova (1757-1822), who somewhat reluctantly left his native Italy to settle in Paris and serve the emperor. Canova had gained renown for his sculptures of classical gods and heroes. In Paris, he made numerous portraits of the emperor and his family in the Neoclassical style. The most famous is the marble statue of 12-2 Antonio Canova, Pauline Borghese as Venus Victorious, from the Villa Borghese, Rome, Italy, 1808. Marble, 6' 7" long. Galleria Borghese, Rome.

Canova was Napoleon Bonaparte's favorite sculptor. Here, the artist depicted the emperor's sister—at her insistence—as the nude Roman goddess of love in a marble statue inspired by classical models.

Napoleon's sister Pauline Borghese (1780-1825) in the guise of Venus Victorious (FIG. 12-2). Initially, Canova had suggested depicting Pauline as Diana, goddess of the hunt. She demanded, however, that she be portrayed as Venus, the goddess of love. Thus Pauline appears, seminude and reclining on a divan, gracefully holding the golden apple, the symbol of the goddess's triumph in the judgment of Paris. Canova clearly based his work on Greek statuary and on the reclining figures on Roman sarcophagus lids. The French public never got to admire Canova's portrait, however. Napoleon had arranged the marriage of his sister to an heir of the noble Roman Borghese family. Once

Pauline was in Rome, she took several lovers, and the public gossiped extensively about her affairs. Pauline's insistence on being represented as the goddess of love reflected her self-perception. Because of his wife's notoriety, Prince Camillo Borghese (1775-1832), the work's official patron, kept the sculpture hidden in his palatial villa in Rome and allowed relatively few people to see the portrait.

ANTOINE-JEAN GROS David was not the only Neoclassical painter in Napoleon's employ. One of David's best students, Antoine-Jean GROS (1771-1835), also produced paintings that contributed to the emperor's growing mythic status. In Napoleon Visiting the Plague-Stricken in Jaffa (FIG. 12-3), Gros recorded an incident during an outbreak of the bubonic plague in the course of Napoleon's Syr-

ian campaign of 1799. This fear-

12-3 Antoine-Jean Gros, Napoleon Visiting the Plague-Stricken in Jaffa, 1804. Oil on canvas, 17' 5" × 23' 7". Musée du Louvre, Paris.

In his depiction of Napoleon as a Christlike healer, Gros foreshadowed Romanticism by recording the exotic people, costumes, and architecture of Jaffa, including the striped horseshoe arches of the mosque-hospital.

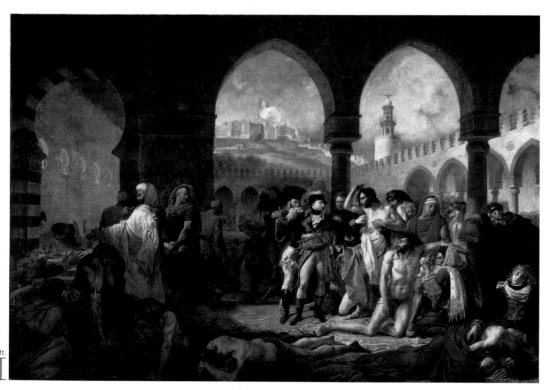

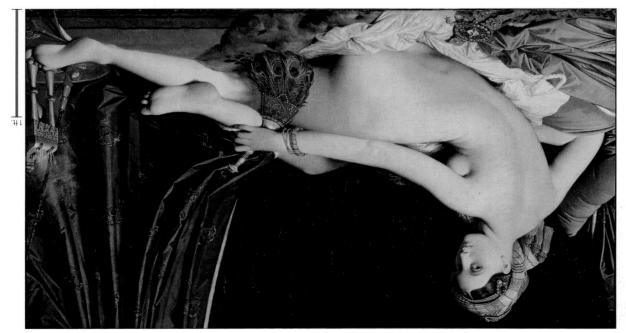

an odalisque in a Turkish Neoclassical figure into Ingres converted his Roman subject, but nude was a Greco-The reclining female du Louvre, Paris. 2' 11 $\frac{7}{8}$ " × 5' 4". Musée

1814. Oil on canvas, Grande Odalisque, DOMINIQUE INGRES, 12-4 JEAN-AUGUSTE-

for the exotic. the new Romantic taste harem, consistent with

(FIG. 12-2), made a strong concession to the burgeoning Romantic an odalisque (woman in a Turkish harem), Ingres, unlike Canova and Giambologna (FIG. 9-25). However, by converting the figure to torso reveal the French painter's debt to Parmigianino (FIG. 9-22) head (FIG. 9-5). The figure's languid pose and elongated limbs and tion for Raphael in his borrowing of that master's type of female Pauline Borghese (FIG. 12-2). The work also shows Ingres's admiraclassical antiquity and the Renaissance (FIG. 9-20), as did Canova's the reclining nude female figure—followed the grand tradition of Caroline Murat (1782-1839), queen of Naples, Ingres's subject ture. In Grande Odalisque (FIG. 12-4), painted for Napoleon's sister ground of his composition, emulating classical low-relief sculp-FIGS. 2-25 and 2-26), and often placed the main figures in the foreapproximating those found in Greek vase painting (for example, Neoclassical manner. The younger artist employed linear forms what he believed to be a truer and purer Greek style than David's Ingres soon broke with his teacher on matters of style and adopted

ROMANTICISM

taste for Orientalist subjects.

from about 1800 to 1840, between Neoclassicism and Realism. term more narrowly to denote an art movement that flourished around 1750 and ended about 1850, but most art historians use the feeling rather than reason. Romanticism as a phenomenon began believed that the path to freedom was through imagination and tics asserted that freedom was the right and property of all. They dom of thought, feeling, action, worship, speech, and taste. Romanfrom a desire for freedom—not only political freedom but also freemarizes a fundamental Romantic premise. Romanticism emerged chains!"—the opening line of his Social Contract (1762)—sum-Rousseau's exclamation, "Man is born free, but is everywhere in owed much to the ideas of Jean-Jacques Rousseau (see page 317). thought, particularly Voltaire's views (see page 316), Romanticism Whereas Neoclassicism's rationality reinforced Enlightenment

nature to subjective emotion. Among the leading manifestations of a shift in emphasis from calculation to intuition, from objective The transition from Neoclassicism to Romanticism represented

> hospital's courtyard (compare FIG. 5-7). On the left are Muslim drop of the horseshoe arches and Moorish arcades of the mosque-The action in Napoleon in Jaffa unfolds against the exotic backhe carved toward the end of his life for his own tomb (not illustrated). right recalls the dead Christ in another Michelangelo work, the Pieta (FIG. 9-11). The kneeling nude Frenchman with extended arm at the parable figure (one of the damned) in Michelangelo's Last Judgment based the despairing seated Arab figure at the lower left on the com-(FIG. 10-22), which Gros certainly knew. The French painter also figure tending to the sick, as in Rembrandt's Hundred-Guilder Print wound. Here, however, Napoleon is not Saint Thomas but a Christlike composition recalls scenes of the doubting Thomas touching Christ's implied that Napoleon possessed the miraculous power to heal. The removed his glove to touch the sores of a French plague victim, Gros ence and authority. Indeed, by depicting the French leader as having trol. He comforts those still alive, who are clearly awed by his preswhereas Napoleon, amid the dead and dying, is fearless and in con-

> core elements of the artistic movement that would soon displace ing, and an emotional rendering of the scene, also foreshadowed of Napoleon in Jaffa, along with Gros's emphasis on death, sufferedly non-Western culture of the East as Orientalism. The setting art historians alike refer to this European curiosity about the decidin large measure by Napoleon's eastern campaigns. Historians and among the French in the Middle East and North Africa, spurred from his teacher's Neoclassicism and reflects a growing interest details of architecture and costume, also represented a departure exoticism of the Muslim world, as is evident in his attention to the and looser brushstrokes. The younger artist's fascination with the lated these features in this painting, but employed brighter colors great effect in his Oath of the Horatii (FIG. 11-14), and Gros emuthis polarized compositional scheme and an arcaded backdrop to his soldiers in their splendid tailored uniforms. David had used in the shadows. On the right, in radiant light, are Napoleon and doctors distributing bread and ministering to plague-stricken Arabs

> INGRES David's greatest pupil was Jean-Auguste-Dominique Neoclassicism—Romanticism.

> INGRES (1780–1867), but his study in David's studio was short-lived.

ART AND SOCIETY

The Romantic Spirit in Art, Music, and Literature

The appeal of Romanticism, with its emphasis on freedom and emotions unrestrained by rational thought (FIG. 12-5), extended well beyond the realm of the visual arts. In European music, literature, and poetry, the Romantic spirit dominated the late 18th and early 19th centuries. Composers and authors as well as painters rejected classicism's structured order in favor of the emotive and expressive. In music, the compositions of Franz Schubert (1797–1828), Franz Liszt (1811–1886), Frédéric Chopin (1810–1849), and Johannes Brahms (1833–1897) emphasized the melodic or lyrical. For these composers, music had the power to express what cannot be expressed with words and to communicate the subtlest and most powerful human emotions.

In literature, Romantic poets such as John Keats (1795–1821), William Wordsworth (1770–1850), and Samuel Taylor Coleridge (1772–1834) published volumes of poetry manifesting the Romantic interest in lyrical drama. *Ozymandias*, by Percy Bysshe Shelley (1792–1822), transported readers to faraway, exotic locales. The setting of *Sardanapalus* (1821) by Lord Byron (1788–1824) is the ancient Assyrian Empire (see page 27). Byron's poem conjures images of eroticism and fury unleashed—images Eugène Delacroix made concrete in his painting *Death of Sardanapalus* (FIG. 12-7).

One of the best examples of the Romantic spirit is the engrossing novel *Frankenstein*, written in 1818 by Shelley's wife, Mary Wollstonecraft Shelley (1797–1851). This fantastic tale of a monstrous creature run amok not only embraced emotionalism but also rejected the rationalism underlying Enlightenment thought. Dr. Frankenstein's monster was a product of science, and the novel is an indictment of the deep belief in science that Voltaire and other Enlightenment thinkers promoted. *Frankenstein* served as a cautionary tale of the havoc that could result from unrestrained scientific experimentation and from the arrogance of scientists.

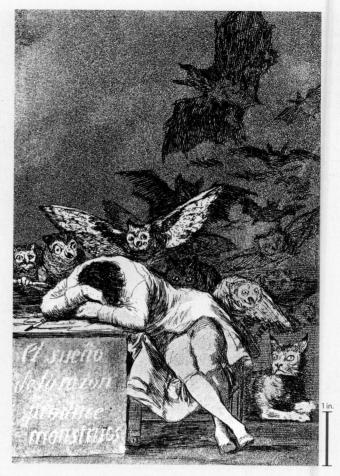

12-5 Francisco Goya, *The Sleep of Reason Produces Monsters*, no. 43 from *Los Caprichos*, ca. 1798. Etching and aquatint, $8\frac{7}{16}$ " $\times 5\frac{7}{8}$ ". Metropolitan Museum of Art, New York (gift of M. Knoedler & Co., 1918).

In this print, Goya depicted himself asleep while threatening creatures converge on him, revealing his embrace of the Romantic spirit—the unleashing of imagination, emotions, and nightmares.

Romanticism was heightened interest in the medieval period and in the sublime. For people living in the 18th century, the Middle Ages were the "dark ages," a time of barbarism, superstition, mystery, and miracle. The Romantic imagination stretched its perception of the Middle Ages into all the worlds of fantasy open to it, including the ghoulish, infernal, terrible, nightmarish, grotesque, sadistic—all the imagery that comes from the chamber of horrors when reason sleeps (FIG. 12-5).

Related to the imaginative sensibility was the period's notion of the sublime. Among the individuals most involved in studying the sublime was the British politician and philosopher Edmund Burke (1729–1797). In *A Philosophical Enquiry into the Origins of Our Ideas of the Sublime and Beautiful* (1757), Burke articulated his definition of the sublime—feelings of awe mixed with terror. Burke observed that pain or fear evoked the most intense human emotions and that these emotions can also be thrilling. Thus raging rivers and great storms at sea could be sublime to their viewers. Accompanying this taste for the sublime was the taste for the fantastic, occult, and macabre—for the adventures of the soul voyaging into the dangerous reaches of the imagination.

FRANCISCO GOYA Although Francisco Jose de Goya Lucientes (1746–1828) was Jacques-Louis David's contemporary, their work has little in common. Both, however, rose to prominence as official court artists. In 1786, Goya entered the employ of Charles IV (r. 1788–1808) of Spain, and in 1799, the king promoted him to First Court Painter. At about that time, Goya produced perhaps his most famous print, *The Sleep of Reason Produces Monsters* (FIG. 12-5), from the series titled *Los Caprichos* (*The Caprices*). *Sleep of Reason* exemplifies Romantic artists' rejection of the Neoclassical penchant for rationality and order.

In the etching, Goya depicted an artist, probably himself, asleep, slumped onto a desk, while threatening creatures converge on him, at least in his dream. Seemingly poised to attack the artist are owls (symbols of folly) and bats (symbols of ignorance). The viewer might read this as a portrayal of what emerges when reason is suppressed and, therefore, as advocating Enlightenment ideals. However, the print should be interpreted as Goya's commitment to the creative process and the Romantic spirit—the unleashing of imagination, emotions, and even nightmares (see "The Romantic Spirit in Art, Music, and Literature," above).

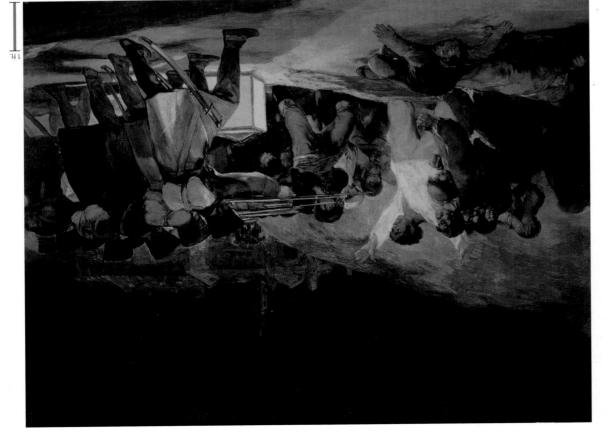

Prado, Madrid.

Goya encouraged empathy for the Spanish peasants massatraying horrified expressions on their faces, endowing them with a humanity lacking in the

12-6 FRANCISCO GOYA, Third of May, 1808, 1814–1815. Oil on canvas, 8' 9" × 13' 4". Museo del

French firing squad.

THIRD OF MAY, 1808 Much of Goya's multifaceted work deals not with Romantic fantasies but with contemporary events. Dissatisfaction with the rule of Charles IV increased dramatically during Goya's tenure at the court, and the Spanish people eventually threw their support behind the king's son, Ferdinand VII, in the hope that he would initiate reform. To overthrow his father, Ferdinand enlisted the aid of Napoleon Bonaparte. Because he had designs on Spain, Napoleon readily agreed to send French troops to Spain. Not surprisingly, as soon as he ousted Charles IV, Napoleon installed his brother Joseph Bonaparte (r. 1808–1813) on the Spanish throne as his surrogate.

of others lying dead on the ground. Still others have been herded one man is about to be executed, he also recorded the bloody bodies frame depicted. Although Goya captured the specific moment when by starkly contrasting darks and lights and by extending the time on the cross. Goya enhanced the emotional drama of the massacre his arms out in a cruciform gesture reminiscent of Christ's position French firing squad. Moreover, the peasant about to be shot throws their faces, endowing them with a humanity lacking in the faceless the Spaniards by portraying horrified expressions and anguish on and terrified Spanish peasants. The artist encouraged empathy for ous wall of Napoleonic soldiers ruthlessly executing the unarmed In emotional fashion, Goya depicted the anonymous murdersubject of Goya's most famous painting, Third of May, 1808 (FIG. 12-6). rounding up and executing Spanish citizens. This tragic event is the ation and as a show of force, the French responded the next day by attacked Napoleon's soldiers in a chaotic and violent clash. In retalisought a way to expel the foreign troops. On May 2, 1808, Spaniards The Spanish people, finally recognizing the French as invaders,

together and will be shot in a few moments.

DEATH OF SARDANAPALUS Delacroix's richly colored and emotionally charged *Death of Sardanapalus* (Fig. 12-7) is perhaps the grandest Romantic pictorial drama ever painted. Although inspired by Lord Byron's 1821 poem *Sardanapalus* (see "The Romantic Delacroix depicted the last hour of the Assyrian king Ashurbanipal (r. 668–627 BCE), whom the Greeks called Sardanapalus. The king has just received news of his army's defeat and the enemy's entry into his city. The setting is much more tempestuous and crowded into his city. The setting is much more tempestuous and crowded into his city. The setting is much more tempestuous and crowded into his city. The setting is much more tempestuous and crowded into his city. The setting is much more tempestuous and crowded into his city. The setting is much more tempestuous and crowded into his city. The setting is much more tempestuous and crowded into his city. The setting is much more tempestuous and crowded into his city. The setting is much more tempestuous and crowded into his city. The setting is much more tempestuous and crowded into his city. The setting is much more tempestuous and crowded into his city. The setting is much more tempestuous and crowded into his city. The setting is much more tempestuous and crowded into his city. The setting is much more tempestuous and crowded into his city. The setting is much more tempestuous and crowded into his city.

ing progressing at once. The fury of his attack matched the fury of

furiously he worked once he had an idea, keeping the whole paint-

execution process. Delacroix's contemporaries commented on how

painting, catching the impression quickly and developing it in the

Neoclassicism," page 337). His work exemplified Romantic colorist

and cold method of the Neoclassicists (see "Delacroix on David and

and definitively as Delacroix. His technique was impetuous, improvisational, and instinctive, in contrast to the deliberate, studious,

explored the domain of Romantic subject and mood as thoroughly

istes and the Rubénistes (see page 315). No other painter of the time

17th century and the beginning of the 18th between the Poussin-

sical draftsman. Their dialogue recalls the quarrel at the end of the

between Delacroix, the Romantic colorist, and Ingres, the Neoclas-

of painting during the first half of the 19th century as a contest

Delacroix (1798-1863). Art historians often present the history

movement, but the leading French Romantic painter was Eugène

was instrumental in the launching of Romanticism as a major art

EUGÈNE DELACROIX In France, Théodore Géricault (FIG. 12-1)

his imagination and his subjects.

ARTISTS ON ART

Delacroix on David and Neoclassicism

Eugène Delacroix (FIGS. 12-7 and 12-8), the leading French Romantic painter of the 19th century, expressed his contempt for the Neoclassical style of Jacques-Louis David (FIGS. 11-14 and 11-15) and others in a series of letters he wrote in 1832 from Morocco. Romantic artists often depicted exotic faraway places they had never seen, but Delacroix journeyed to northern Africa in search of fresh inspiration for his paintings. He discovered in the sun-drenched Moroccan landscape—and in the hardy and colorful Moroccans dressed in robes reminiscent of the Roman toga—new insights into a culture that he believed was more classical than anything European Neoclassicism could conceive. In a letter to his friend Fréderic Villot dated February 29, 1832, he wrote:

This place is made for painters. . . . [B]eauty abounds here; not the over-praised beauty of fashionable paintings. The heroes of David

and Co. with their rose-pink limbs would cut a sorry figure beside these children of the sun, who moreover wear the dress of classical antiquity with a nobler air, I dare assert.*

In a second letter, written June 4, 1832, he reported to Auguste Jal:

I have Romans and Greeks on my doorstep: it makes me laugh heartily at David's Greeks, . . . I know now what they were really like; . . . If painting schools persist in [depicting classical subjects], I am convinced, and you will agree with me, that they would gain far more from being shipped off as cabin boys on the first boat bound for the Barbary coast than from spending any more time wearing out the classical soil of Rome. Rome is no longer to be found in Rome.

*Translated by Jean Stewart, in Charles Harrison, Paul Wood, and Jason Gaiger, eds., Art in Theory 1815–1900: An Anthology of Changing Ideas (Oxford: Blackwell, 1998), 87.

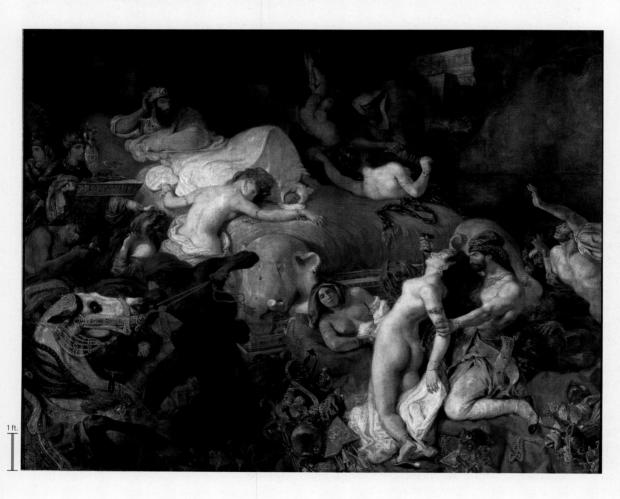

12-7 Eugène Delacroix, Death of Sardanapalus, 1827. Oil on canvas, $12' \frac{1}{2}'' \times 16' \frac{2}{8}''$. Musée du Louvre, Paris.

Inspired by Lord Byron's 1821 poem, Delacroix painted the Romantic spectacle of an Assyrian king on his funeral pyre. The richly colored and emotionally charged canvas is filled with exotic figures.

sacrificial suicide of the poem. Sardanapalus reclines on his funeral pyre, soon to be set alight, and gloomily watches the destruction of all his most precious possessions—his women, slaves, horses, and treasure. The king's favorite concubine throws herself on the bed, determined to go up in flames with her master. The Assyrian presides like a genius of evil over the tragic scene. Most conspicuous are the tortured and dying bodies of the harem women. In

the foreground, a muscular slave plunges his knife into the neck of one woman.

Delacroix filled this awful spectacle of suffering and death with the most daringly difficult and tortuous poses, and chose the richest intensities of hue. With its exotic and erotic overtones and violent Orientalist subject, *Death of Sardanapalus* tapped into the Romantic fantasies of 19th-century viewers.

Charles X. the Parisian uprising against this painting of Liberty leading energy of the 1830 revolution in captured the passion and and poetic allegory, Delacroix In a balanced mix of history

Louvre, Paris.

8' 6" × 10' 8". Musée du 1830. Oil on canvas, Liberty Leading the People, 12-8 EUGÈNE DELACROIX,

translators of nature's transcendent meanings. beheld a landscape but rather participated in its spirit, becoming disguised within visible material things. Artists no longer merely of interpreting the signs, symbols, and emblems of universal spirit mysteriously permeated by "being," landscape artists had the task

world. Wanderer above a Sea of Mist perfectly expresses the Romanan almost religious awe at the beauty and vastness of the natural at the misty landscape. In either case, the painter communicated behind or if he wanted the viewer to contemplate the man gazing Friedrich intended the viewer to identify with the man seen from of mystery that the scene conveys. Art historians dispute whether space behind him—an impossible position that enhances the aura level of the man's head, the viewer has the sensation of hovering in tains, and thick mist. Because Friedrich chose a point of view on the and leans on his cane. He surveys a vast panorama of clouds, mounin attire suggestive of a bygone era stands on a rocky promontory In Wanderer above a Sea of Mist (FIG. 12-9), a solitary man dressed seen from behind gazing at the natural vista dominate the canvas. difficult even to discern. But in other paintings, one or more figures ure plays an insignificant role. Indeed, the human actors are often sees within him." In many of Friedrich's landscapes, the human figshould not only paint what he sees before him, but also what he places filled with a divine presence. "The artist," Friedrich wrote, works demands from the viewer the silence appropriate to sacred understanding of God, nature's creator. The reverential mood of his For Friedrich, the personal experience of nature led to a deeper tal landscape paintings is CASPAR DAVID FRIEDRICH (1774-1840). Among the artists best known for their Romantic transcenden-

tic notion of the sublime in nature.

CASPAR DAVID FRIEDRICH Landscape painting came into its

fies the locale and event, balancing historical fact with poetic allegory. The painter's inclusion of this recognizable Parisian landmark speci-

towers of Notre-Dame (FIG. 7-7) rise through the smoke and haze. (FIG. 12-1), dead bodies lie all around. In the background, the Gothic

in top hat armed with a musket. As in Géricault's Raft of the Medusa

tols, the menacing worker with a cutlass, and the intellectual dandy

Liberty are bold Parisian types—the street boy brandishing his pisantiquity), reinforcing the urgency of this struggle. Arrayed around

on. She wears a scarlet Phrygian cap (the symbol of a freed slave in

ing forth France's tricolor banner as she urges the masses to fight

tion is the bare-breasted personification of Liberty defiantly thrust-

historical record and a Romantic allegory. Dominating the composi-

uprising against Charles X (r. 1824-1830). The painting is at once a

tured the passion and the energy of the July 27-29, 1830, Parisian

ject matter. In Liberty Leading the People (Fig. 12-8), Delacroix cap-

to current events, particularly tragic or sensational ones, for his sub-

a seventh-century BCE drama, Delacroix, like Géricault, also turned

LIBERTY LEADING THE PEOPLE Although Death of Sardanapalus is

theme of the soul unified with the natural world. As all nature was called it—artists found an ideal subject to express the Romantic poet and dramatist Johann Wolfgang von Goethe (1749-1832) and harmony. In nature—"the living garment of God," as German as a "being" that included the totality of existence in organic unity expressed the Romantic view (first extolled by Rousseau) of nature which favored figural composition and history, landscape painting Briefly eclipsed at the century's beginning by the taste for ideal form, own in the 19th century as a fully independent and respected genre.

12-9 CASPAR DAVID FRIEDRICH, Wanderer above a Sea of Mist, 1817–1818. Oil on canvas, 3' $1\frac{3}{4}$ " × 2' $5\frac{3}{8}$ ". Hamburger Kunsthalle, Hamburg.

Friedrich's painting of a solitary man on a rocky promontory gazing at a vast panorama of clouds, mountains, and thick mist perfectly expresses the Romantic notion of the sublime in nature.

JOHN CONSTABLE In England, one of the most momentous developments in history—the Industrial Revolution—had a profound impact on the evolution of Romantic landscape painting. Although discussion of the Industrial Revolution invariably focuses on technological advances, factory development, and growth of urban centers, industrialization had no less pronounced an effect on the countryside and the land itself. The detrimental economic effect that the Industrial Revolution had on prices for agrarian products created significant unrest in the English countryside. In particular, increasing numbers of farmers could no longer afford to farm their small plots and had to abandon their land. JOHN CONSTABLE (1776-1837) addressed this agrarian situation in his landscape paintings. He made countless sketches from nature for each of his canvases, studying nature as a meteorologist. His special gift was for capturing the texture that climate and weather give to landscape. Constable's use of tiny dabs of local color, stippled with white, created a sparkling shimmer of light and hue across the canvas surface—the vibration itself suggestive of movement and process.

The Hay Wain (FIG. 12-10) is a serenely pastoral scene of the countryside. A small cottage is on the left, and in the center foreground, a man leads a horse and a hay-filled wagon (a hay wain) across the Stour River. Billowy clouds float lazily across the sky. The muted greens and golds and the delicacy of Constable's brushstrokes complement the scene's tranquility. The artist portrayed the oneness with nature that the Romantic poets sought. The relaxed figures are not observers but participants in the landscape's "being." The Hay Wain is also significant for precisely what it does not show—the civil unrest of the agrarian working class and the resulting outbreaks of violence and arson. The people inhabiting Constable's landscapes blend into the scenes and become one with nature. Rarely does the viewer see workers engaged in tedious labor. Indeed, this painting has a wistful air to it and reflects Constable's memories of a disappearing rural pastoralism. This nostalgia, presented in such naturalistic terms, renders Constable's works Romantic in tone, although

> they are not sublime. That the painter felt a kindred spirit with the Romantic artists is revealed by his comment, "Painting is with me but another word for feeling."²

12-10 JOHN CONSTABLE, The Hay Wain, 1821. Oil on canvas, 4' $3\frac{1}{4}$ " × 6' 1". National Gallery, London.

The Hay Wain is a nostalgic view of the disappearing English countryside during the Industrial Revolution. Constable had a special gift for capturing the texture that climate and weather give to landscape.

choked with the bodies of slaves sinking to their deaths. The relative scale of the minuscule human forms compared with the vast sea and overarching sky reinforces the sense of the sublime, especially the immense power of nature over humans. The Slave Ship is the polar opposite of Raft of the Medusa, in which heroic, over-life-size bodies fill the canvas and block out most of the ocean. Almost lost in the boiling colors of Turner's painting are the event's particulars, but on close inspection, the viewer can discern the iron shackles and manacles around the wrists and ankles of the drowning slaves, cruelly denying around the wrists and ankles of the drowning slaves, cruelly denying around the predatory fish circling them any chance of saving themselves from the predatory fish circling them any chance of saving themselves from the predatory fish circling

about them. A key ingredient of Turner's highly personal style is the emotive power of pure color. The haziness of the painter's forms and the indistinctness of his compositions intensify the colors and energetic brushstrokes. Turner's innovation in works such as The Slave Ship was to release color from any defining outlines so as to express both the forces of nature and the painter's emotional response to them. In his

paintings, the reality of color is at one with the reality of feeling.

Turner's methods had a profound effect on the later development of painting. His discovery of the aesthetic and emotive power of pure color and his pushing of the medium's fluidity to a point where the paint itself is almost the subject were important ateps toward 20th-century Abstract Expressionist art, which dispensed with identifiable forms altogether (see page 413).

PROBLEMS AND SOLUTIONS
Unleashing the Emotive Power of Color

The passion and energy of Turner's landscapes and seascapes reveal the sensibility that was the foundation for much of the art of the Romantic era, but Turner discovered a new means of capturing in painting Edmund Burke's concept of the sublime—awe mixed with terror.

Turner's The Slave Ship (FIG. 12-11), although strikingly different in form Géricault's Raft of the Medusa (FIG. 12-1), also has as its subject a politically explosive disaster at sea. The Slave Ship depicts a 1781 incident reported in the widely read History of the Abolition of the Slave Incident reported in the widely read History of the Abolition of the Slave Instance of Thomas Clarkson (1760–1846). Clarkson's account, reprinted in 1839, undoubtedly was the reason Turner chose this subject for this 1840 painting. The incident involved the slave ship Zong, en route from Africa to Liverpool. The ship's captain, on realizing that his insurance would reimburse him only for slaves lost at sea but not for those who died en route, ordered more than 50 sick and dying slaves to be thrown overboard. Appropriately, the painting's subtitle is Slavers Throwing overboard the Dead and Dying, Typhoon Coming On.

Turner's frenzied emotional depiction of the dumping of the sick slaves into the sea matches its barbaric nature. The artist transformed the sun into an incandescent comet amid flying scarlet clouds. The slave ship moves into the distance, leaving in its wake a turbulent sea

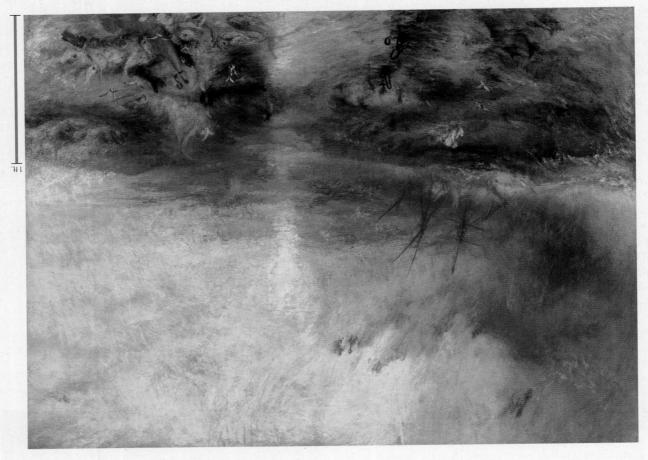

J2-J7 Joseph Mallord William Turner, The Slave Ship (Slavers Throwing Overboard the Dead and Dying, Typhoon Coming On), 1840. Oil on canyas, 2' $11\frac{1}{4}$ " \times 4'. Museum of Fine Arts, Boston (Henry Lillie Pierce Fund).

The essence of Turner's innovative style is the emotive power of color. He released color from any defining outlines to express both the forces of nature and the painter's emotional response to them.

12-12 THOMAS COLE, The Oxbow (View from Mount Holyoke, Northampton, Massachusetts, after a Thunderstorm), 1836. Oil on canvas, $4' 3\frac{1}{2}'' \times 6' 4''$. Metropolitan Museum of Art, New York (gift of Mrs. Russell Sage, 1908).

Cole championed the idea of America having a landscape distinct from Europe's. Here, he contrasted dark wilderness on the left and sunlit civilization on the right, with a minuscule painter at the bottom center.

J.M.W. TURNER Constable's great contemporary in the English school of landscape painting was Joseph Mallord William Turner (1775–1851). Both artists tirelessly sought to raise the prestige of landscape painting in the Royal Academy. However, whereas Constable's canvases are serene and precisely painted, and have as their exclusive subject the rural countryside of his birthplace, Turner's paintings have a much wider range of themes and, as in *The Slave Ship* (Fig. 12-11), feature turbulent swirls of frothy pigment (see "Unleashing the Emotive Power of Color," page 340).

THOMAS COLE In America, landscape painting was the specialty of a group of artists known as the Hudson River School, so named because its members drew their subjects primarily from the uncultivated regions of New York's Hudson River Valley, although many of these painters depicted scenes from across the country. As did the early-19th-century landscape painters in Germany and England, the artists of the Hudson River School not only presented Romantic panoramic landscape views but also participated in the ongoing exploration of the individual's and the country's relationship to the land. American landscape painters frequently focused on identifying qualities that made America unique. Thomas Cole (1801–1848), often referred to as the leader of the Hudson River School, best articulated this idea (see "Thomas Cole on the American Landscape" ◀).

Another issue that surfaced frequently in Hudson River School paintings was the moral question of America's direction as a civilization. Cole addressed this question in *The Oxbow* (FIG. 12-12).

A splendid scene opens before the viewer, dominated by the lazy oxbow-shaped curve of the Connecticut River near Northampton, Massachusetts. Cole divided the composition in two, with the dark, stormy wilderness on the left and the more developed civilization on the right. The minuscule artist wearing a top hat in the bottom center of the painting, dwarfed by the landscape's scale, turns to the viewer as if to ask for input in deciding the country's future course. Cole's depiction of expansive wilderness incorporated reflections and moods romantically appealing to the public.

REALISM

Advances in industrial technology during the early 19th century reinforced Enlightenment faith in the connection between science and progress. Both intellectuals and the general public increasingly embraced *empiricism* and *positivism*. To empiricists, the basis of knowledge is observation and direct experience. Positivists ascribed to the philosophical model developed by Auguste Comte (1798–1857), who believed that scientific laws governed the environment and human activity and could be revealed through careful recording and analysis of observable data. Comte's followers promoted science as the mind's highest achievement and advocated a purely empirical approach to nature and society.

Realism was a movement that developed in France around midcentury against this backdrop of an increasing emphasis on science. Consistent with the philosophical tenets of the empiricists

to prospective students. letter, published a few days later in the Courier du dimanche, addressed Six years later, on Christmas Day, 1861, Courbet wrote an open

"ithin the domain of painting." things . . . An abstract object, not visible, nonexistent, is not and can consist only of the representation of both real and existing I also maintain that painting is an essentially concrete art form its own artists, that is to say, by the artists who have lived in it. tangible to the artist. Every age should be represented only by consist only of the representation of things that are visible and events of the times in which he lives....[A]rt in painting should [An artist must apply] his personal faculties to the ideas and the

ciple of Realist painting: of academic painting, in which he concisely summed up the core prin-Courbet's most famous statement, however, is his blunt dismissal

I have never seen an angel. Show me an angel, and I'll paint one.*

Quoted by Vincent van Gogh in a July 1885 letter to his brother Theo. Ronald de Leeuw, Chicago Press, 1992), 203-204. Translated by Petra ten-Doesschate Chu, Letters of Gustave Courbet (Chicago: University of XX Century (New York: Pantheon, 1958), 295. Translated by Robert Goldwater and Marco Treves, eds., Artists on Art from the XIV to the

The Letters of Vincent van Gogh (New York: Penguin, 1996), 302.

Gustave Courbet on Realism TAA NO STRITAA

movement's manifestos. issued to explain the paintings shown there amounted to the Realist private exhibition of his own work. His pavilion and the statement he his paintings. Courbet was the first artist ever known to have staged a grounds, calling it the Pavilion of Realism, featuring not 14 but 40 of bet withdrew all of his works and set up his own exhibition outside the subjects and figures were too coarse and too large. In response, Cour-Gustave Courbet (Figs. 12-13 and 12-14) submitted, declaring that their sition Universelle in Paris that year) rejected 3 of the 14 paintings that The academic jury selecting work for the 1855 Salon (part of the Expo-

see them—in a word, to create a living art—this has been my aim.* able to translate the customs, ideas, and appearances of my time as I tion the reasoned and free sense of my own individuality. . . . To be I have simply wanted to draw from a thorough knowledge of tradinor have I thought of achieving the idle aim of "art for art's sake." No! I have no more wanted to imitate the former than to copy the latter; moderns, avoiding any preconceived system and without prejudice. be superfluous. . . . I have studied the art of the ancients and the $\ensuremath{\mbox{\sc h}}$ never given a just idea of things; were it otherwise, the work would The title of "realist" has been imposed upon me. . . . Titles have

grays, he conveyed the dreary a palette of dirty browns and in the Realist movement. Using Courbet was the leading figure (5461 Dresden (destroyed in

Formerly Gemäldegalerie, Oil on canvas, 5' 3" \times 8' 6". The Stone Breakers, 1849. 12-13 GUSTAVE COURBET,

France. labor in mid-19th-century and dismal nature of menial

to paint mundane subjects that artists had traditionally deemed Realists' sincerity about scrutinizing their environment led them ing his own works (see "Gustave Courbet on Realism," above). The shunned labels, Courbet used the term "Realism" when exhibit-WAS GUSTAVE COURBET (1819-1877). In fact, even though he GUSTAVE COURBET The leading figure of the Realist movement

real. that they were neither visible nor present and therefore were not and disapproved of historical and fictional subjects on the grounds focused their attention on the people and events of their own time world-what people could see-was "real." Accordingly, Realists and positivists, Realist artists argued that only the contemporary

12-14 GUSTAVE COURBET, Burial at Ornans, 1849. Oil on canvas, 10' $3\frac{1}{2}$ " × 21' $9\frac{1}{2}$ ". Musée d'Orsay, Paris.

Although as monumental in scale as a traditional history painting, *Burial at Ornans* horrified critics because of the ordinary nature of the subject and Courbet's starkly antiheroic composition.

unworthy of depiction—for example, working-class laborers and peasants. Moreover, the Realists depicted these scenes on a scale and with a seriousness that implied parity between contemporary subject matter and historical, mythological, and religious painting.

THE STONE BREAKERS In The Stone Breakers (FIG. 12-13), Courbet represented in a straightforward manner, and nearly at life size, two men—one about 70, the other quite young—in the decidedly nonheroic act of breaking stones to provide paving for roads, traditionally the lot of the lowest members of French society. By juxtaposing youth and age, Courbet suggested that those born to poverty will remain poor their entire lives. The artist neither romanticized nor idealized the men's menial labor but depicted their thankless toil with directness and accuracy. Courbet's palette of dirty browns and grays further conveys the dreary and dismal nature of the task, and the angular positioning of the older stone breaker's limbs suggests a mechanical monotony.

Courbet's portrayal of the working poor had a special resonance for his mid-19th-century French audience. In 1848, laborers rebelled against the bourgeois leaders of the newly formed Second Republic and against the rest of the nation, demanding better working conditions and a redistribution of property. The army quelled the uprising in three days, but not without long-lasting trauma and significant loss of life. The 1848 revolution raised the issue of labor as a national concern. Courbet's depiction of stone breakers in 1849 was thus both timely and populist.

BURIAL AT ORNANS Many art historians regard Courbet's *Burial at Ornans* (FIG. 12-14) as his masterpiece. The huge (10-by-22-foot) canvas depicts a funeral set in a bleak provincial landscape outside the artist's hometown. Attending the funeral are the types of common people that Honoré de Balzac (1799–1850) and Gustave Flaubert (1821–1880) presented in their novels. Although the painting

has the imposing scale of a traditional history painting, the subject's ordinariness and the starkly antiheroic composition horrified critics. (Courbet had the audacity to submit *Burial at Ornans* to the 1851 Salon in the category of history painting.) Arranged in a wavering line extending across the breadth of the canvas are three groups—the somberly clad women at the back right, a semicircle of similarly clad men by the open grave, and assorted churchmen at the left. The seemingly equal stature of all at the funeral also offended the hierarchical social sensibility of the Salon jurors. This wall of figures blocks any view into deep space. Behind and above the figures are bands of overcast sky and barren cliffs. The dark pit of the grave opens into the viewer's space in the center foreground. In place of the heroic, the sublime, and the dramatic, Courbet aggressively presented the viewer with mundane realities. Unlike the theatricality of Romanticism, Realism captured the ordinary rhythms of daily life.

Of great importance for the later history of art, Realism also involved a reconsideration of the painter's primary goals and departed from the established emphasis on illusionism. Accordingly, Realists called attention to painting as a pictorial construction by the ways they applied pigment or manipulated composition. Courbet's intentionally simple and direct methods of expression in composition and technique seemed unbearably crude to many of his more traditional contemporaries, who called him a primitive. Although his bold, somber palette was essentially traditional, Courbet often used the *palette knife* to quickly place and unify large daubs of paint, producing a roughly wrought surface. The public accused him of carelessness, and critics wrote of his "brutalities."

JEAN-FRANÇOIS MILLET Like Courbet, JEAN-FRANÇOIS MILLET (1814–1878) found his subjects in the people and occupations of the everyday world. Millet was the most prominent member of the group of French painters of country life who, to be close to their

12-15 Jean-Prancois Millet, The Gleaners, 1857. Oil on canvas, 2'9" x 3'8". Musée d'Otsay, Paris.

Millet and the Barbizon School painters specialized in depictions of French country life. Here, Millet portrayed three impoverished women gathering the scraps left in the field after a harvest.

Barbizon. This Barbizon School specialised in detailed pictures of forest and countryside. In The Gleaners (FIG. 12-15), Millet depicted three impoverished women—members of the lowest level of peasant society—performing the backbreaking task of gleaning. Landowning nobles traditionally permitted peasants of glean, or collect, the wheat scraps left in the field after the harvest. Millet characteristically placed his large figures in the foreground, against a broad sky in the foreground, against a broad sky in the foreground, against a broad sky.

of haystacks, cottages, trees, and distant workers and a flat horizon, the gleaners quietly doing their tedious and time-consuming work dominate the canvas. It is hard to imagine a sharper contrast with the almost invisible agricultural workers in Constable's Hay Wain (FIG. 12-10).

Although Millet's paintings evoke a sentimentality absent from Courbet's, the French public still reacted to his work with disdain and suspicion. In the aftermath of the 1848 revolution, Millet's investitute of the poor with solemn grandeur did not meet with approval from the prosperous class. Further, the middle class linked the poor with the dangerous, newly defined working class, which was finding outspoken champions in men such as Karl Marx (1818–1883), Friedrich Engels (1820–1895), and the novelists Émile Sola (1840–1902) and Charles Dickens (1812–1870). Socialism was a growing movement, and both its views on property and its call for social justice, even economic equality, threatened the bourgeoisie. Millet's sympathetic portrayal of the poor seemed to much of the Millet's sympathetic portrayal of the poor seemed to much of the

public to be a political manifesto.

HONORÉ DAUMIER Because people widely recognized the power of art to serve political ends, the political and social agitation accompanying the violent revolutions in France and the rest of Europe in the later 18th and early 19th centuries prompted the French people to suspect artists of subversive intention. Realist artist Honore and in his art he boldly confronted authority with social criticism and political protest. In response, the authorities imprisoned him. A painter, sculptor, and one of history's great printmakers, Daumier A painter, sculptor, and one of history's great printmakers, Daumier A painter, sculptor, and one of history's great printmakers, Daumier A painter, sculptor, and one of history's great printmakers, Daumier and political protest in response, the authorities imprisoned him. Produced lithographs (see "Lithography," page 345) that enabled him to create an exceptionally large number of prints. Daumier also contributed satirical lithographs to the widely read, liberal French Republican journal Caricature, in which he mercilessly lampooned the foibles and misbehavior of politicians, lawyers, doctors, and the the foibles and misbehavior of politicians, lawyers, doctors, and the

Daumier's lithograph Rue Transnonain (Fig. 12-16) depicts the atrocity that unfolded on that Parisian street in April 1834 after an

unknown sniper killed a civil guard, part of a government force trying to repress a worker demonstration. Because the fatal shot had come from a workers' housing block, the remaining guards immediately stormed the building and massacred all of its inhabitants. With the power Goya displayed in Third of May, 1808 (Fig. 12-6), Daumier created a view of the slaughter from a sharp angle of vision. But unlike Goya, he depicted not the dramatic moment of execution but the terrible, quiet aftermath. The limp bodies of the workers—and of a child crushed beneath his father's corpse—lie amid violent disorder. Daumier's pictorial manner is rough and spontaneous, and that approach to representation, which is a central characteristic of Realist art, accounts in large measure for its remarkable force.

pastoral scenes, nudes, and even religious scenes. Le Déjeuner sur allusions to many painting genres—history painting, portraiture, painting. The composition contains sophisticated references and wished it to be. In this work, he sought to reassess the nature of truly Realism, because the subject is incomprehensible—as Manet on the grass, although it may be the aftermath of a meal. Nor is this to be looking for something in a pool of water. This is no luncheon what the second man is saying to them. The second woman appears tatiousness. Neither she nor her companion pays any attention to nakedness. She gazes directly at the viewer without shame or fliringly unidealized figure who also seems completely unfazed by her woman-her discarded clothes are on the grass-is a distresstwo men wear fashionable Parisian attire of the 1860s. The nude including Manet's favorite model at the time and his brother. The with Realist principles, Manet based all four figures on real people, men and one nude and one clothed woman at a picnic. Consistent later as a seminal work in the history of art, depicts two clothed l'Herbe (Luncheon on the Grass; Fig. 12-17), widely recognized only Impressionism in the 1870s (see page 357). Manet's Le Déjeuner sur younger artist also played an important role in the development of work too was influential in articulating Realist principles, but the (1832-1883) was a pivotal figure in 19th-century European art. His ÉDOUARD MANET Like Gustave Courbet, Edouard Manet

rich bourgeoisie in general.

MATERIALS AND TECHNIQUES

Lithography

In 1798, the German printmaker Alois Sene-felder (1771-1834) created the first prints using stone instead of metal plates or wood blocks. In contrast to earlier printing techniques (see "Woodcuts, Engravings, and Etchings," page 228), in which the artist applied ink either to a raised or incised surface, in *lithography* (Greek, "stone writing or drawing") the printing and nonprinting areas of the plate are on the same plane.

The chemical phenomenon fundamental to lithography is the repellence of oil and water. The lithographer uses a greasy, oilbased crayon to draw directly on a stone plate, and then wipes water onto the stone, which clings only to the areas the drawing does not cover. Next, the artist rolls oil-based ink onto the stone, which adheres to the drawing but is repelled by the water. When the artist presses the stone against paper, only the inked areas—the drawing—transfer to the paper. Color lithography requires multiple plates, one for each color, and the

printmaker must take special care to make sure that each impression lines up perfectly with the previous one so that each color prints in its proper place.

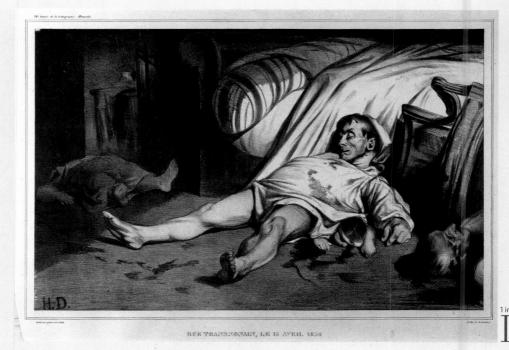

12-16 Honoré Daumier, *Rue Transnonain, April 15, 1834*, 1834. Lithograph, 1' $1\frac{3}{8}$ " × 1' $6\frac{1}{4}$ ". Yale University Art Gallery, New Haven (Everett V. Meeks, B.A. 1901, Fund).

Daumier used the recent invention of lithography to reach a wide audience for his social criticism and political protest. This print records the horrific 1834 massacre in a workers' housing block in Paris.

One of the earliest masters of this new printmaking process was Honoré Daumier, whose lithographs (FIGS. 12-16 and 12-24A 1) in leading French journals reached an audience of unprecedented size.

l'Herbe is Manet's synthesis and critique of the history of painting.

This audacious painting outraged the French public. Rather than depicting a traditional pastoral scene (compare FIG. 9-18), *Le Déjeuner* features ordinary men and promiscuous women in a Parisian park. The negative response to Manet's painting on the part of public and critics alike extended beyond subject matter, however. The painter's technique also elicited severe criticism. Manet rendered the men and women in soft focus

12-17 ÉDOUARD MANET, Le Déjeuner sur l'Herbe (Luncheon on the Grass), 1863. Oil on canvas, 7' × 8' 8". Musée d'Orsay, Paris.

Manet shocked his contemporaries with both his subject matter and manner of painting. Moving away from illusionism, he used colors to flatten form and to draw attention to the painting surface.

strokes and abruptly shifting also faulted his rough brushscandalized the public. Critics carrying a bouquet from a client prostitute and her black maid Aanet's painting of a nude

> Musée d'Orsay, Paris. canvas, 4' 3" \times 6' $2\frac{1}{4}$ ". no liO .£881 ,niqmylO 12-18 ÉDOUARD MANET,

one or two lights or darks. values are summed up in In the main figures, many dark and highlighted areas. strong contrasts between left. The lighting creates and picnic foods at the lower as well as the pile of clothes harshly lit foreground trio with the clear forms of the ner of painting contrasts landscape. The loose manand broadly painted the

ers and their successors to the present day. a core principle of many later 19th-century paintness of the painting surface, which would become edgment of painting's properties, such as the flataway from illusionism toward an open acknowloff sharply from the setting. Manet aimed to move The effect is both to flatten the forms and set them

Olympia with a bouquet of flowers from a client. figure in the painting is a black maid, who presents eye with a look of cool indifference. The only other slippers on her feet, Olympia meets the viewer's her arm, an orchid in her hair, and fashionable black ribbon tied around her neck, a bracelet on titutes) reclining on a bed. Nude except for a thin pia was a common "professional" name for pros-This work depicts a young white prostitute (Olymviewing public was Manet's Olympia (FIG. 12-18). OLYMPIA Even more scandalous to the French

viewers. The depiction of a black woman was also pia and her look verging on defiance shocked of during this period, the shamelessness of Olym-Although images of prostitutes were not unheard Olympia horrified the public and critics alike.

Museum of Art, Philadelphia. vania, 1875. Oil on canvas, $8' \times 6'$ 6". Philadelphia Jefferson Medical College, Philadelphia, Pennsyl-12-19 THOMAS EAKINS, The Gross Clinic, from

America's centennial. rejection from the Philadelphia exhibition celebrating college operating amphitheater caused this painting's The too-brutal realism of Eakins's depiction of a medical

ART AND SOCIETY

Edmonia Lewis, an African American Sculptor in Rome

Sculptor Edmonia Lewis, whose works are stylistically indebted to Neoclassicism but depict contemporary Realist themes, stands apart from all other important 19th-century artists by virtue of the circumstances of her birth. The daughter of a Chippewa mother and African American father in upstate New York, she was given the name Wildfire. Lewis became an orphan when she was four years old and was raised by the Chippewa. She adopted the name Edmonia Lewis in 1859 when she was admitted to Oberlin College (the first American college to grant degrees to women and among the first to admit African Americans). After Oberlin, Lewis became an apprentice in a sculpture studio in Boston. She financed her 1865 trip to Rome, which became her permanent home, with the sale of portrait medallions and marble busts, mostly representing abolitionist leaders. Lewis's success in a field dominated by white European and American men is a testament to both her artistic skill and her determination, but also speaks to the increasing access to training available to women during the 19th century.

Forever Free (FIG. 12-20) is a marble statue that Lewis carved while living in Rome, surrounded by examples of both classical and Renaissance art. It represents two freed African American slaves immediately after President Lincoln's issuance of the Emancipation Proclamation. The man stands triumphantly in a contrapposto stance reminiscent of classical statues. His right hand rests on the shoulder of the kneeling woman with her hands clasped in thankful prayer. The man holds aloft in his left hand a broken manacle and chain as literal and symbolic references to his former servitude. Produced four years after Lincoln's proclamation, Forever Free (originally titled The Morning of Liberty) was widely perceived as an abolitionist statement. ("Forever free" is a phrase that Lincoln used in both his preliminary September 1862 and final January 1863 emancipation proclamations.) Although emancipated, the former slaves still have shackles attached, in contrast to those born free. However, other factors caution against an overly

12-20 EDMONIA
LEWIS, Forever
Free, 1867. Marble,
3' 5 \(\frac{1}{4} \)" high. James A.
Porter Gallery of
Afro-American Art,
Howard University,
Washington, D.C.

African American-Chippewa Lewis's sculptures owe a stylistic debt to Neoclassicism but depict contemporary Realist themes. She carved Forever Free four years after Lincoln's Emancipation Proclamation.

simplistic reading. For example, scholars have debated the degree to which the sculptor attempted to inject a statement about gender relationships into this statue and whether the kneeling position of the woman is a reference to female subordination in the African American community.

not new to painting, but the French public perceived Manet's inclusion of both a black maid and a nude prostitute as evoking moral depravity, inferiority, and animalistic sexuality. The contrast of the black servant with the fair-skinned courtesan also conjured racial divisions. One critic described Olympia as "a courtesan with dirty hands and wrinkled feet . . . her body has the livid tint of a cadaver displayed in the morgue; her outlines are drawn in charcoal and her greenish, bloodshot eyes appear to be provoking the public, protected all the while by a hideous Negress." From this and similar reviews, it is clear that critics were responding not solely to the subject matter but to Manet's artistic style as well. The painter's brush-strokes are much rougher and the shifts in tonality far more abrupt than those found in traditional painting. This departure from accepted practice compounded the audacity of the subject matter.

THOMAS EAKINS Although French artists took the lead in promoting the depiction of the realities of modern life, the Realist movement was neither exclusively French nor confined to Europe. Two of the leading American Realist painters were WINSLOW HOMER (1836–1910; FIG. 12-18A 🗐) of Boston and THOMAS EAKINS (1844–1916) of Philadelphia. The too-brutal Realism of

Eakins's early masterpiece, *The Gross Clinic* (FIG. 12-19), prompted the art jury to reject it for the Philadelphia exhibition celebrating the American independence centennial in 1876. The painting portrays the renowned surgeon Samuel D. Gross (1805–1884) in the operating amphitheater of the Jefferson Medical College in Philadelphia. Dr. Gross, with bloody fingers and scalpel, lectures about his surgery on a young man's leg. Watching the surgeon are several colleagues—all of whom historians have identified—and the patient's mother, who covers her face. The painting is an unsparing description of an unfolding event, with a good deal more reality than many viewers could endure. "It is a picture," one critic said, "that even strong men find difficult to look at long, if they can look at it at all."

JOHN EVERETT MILLAIS Realism also appealed to sculptors, most notably American Edmonia Lewis (ca. 1844–ca. 1911; see "Edmonia Lewis, an African American Sculptor in Rome," above, and Fig. 12-20), but other artists rejected many of the basic premises of Realism. In England, a group of painters who called themselves the *Pre-Raphaelite Brotherhood* refused to be limited to the contemporary scenes that strict Realists portrayed. These artists chose instead to represent fictional and historical subjects, but with

is a Shakespearean subject. trayed. The drowning of Ophelia scenes that strict Realists porlimited to the contemporary whose members refused to be Pre-Raphaelite Brotherhood, Millet was a founder of the

Tate Britain, London. Oil on canvas, 2' $6" \times 3' 8"$. MILLAIS, Ophelia, 1852. 12-21 JOHN EVERETT

esque tower groupings (the Clock Tower, housing Big Ben, at the of Parliament, however, is not genuinely Gothic, despite its picturfelt embodied honesty as well as quality. The design of the Houses believed in the necessity of restoring the old artisanship, which they ties. Machine work was replacing handicraft. Many, Pugin included, flooding the market with cheaply made and ill-designed commodisans who built the great cathedrals. The Industrial Revolution was tecture of the Middle Ages and revered the careful medieval artisaw moral purity and spiritual authenticity in the religious archi-Gothic. Pugin was one of a group of English artists and critics who Pugin successfully influenced him in the direction of English Late styles, but he had designed some earlier Neo-Gothic buildings, and architecture of each place. He preferred the classical Renaissance widely in Europe, Greece, Turkey, Egypt, and Palestine, studying the (FIG. 12-22) for the new government complex. Barry had traveled Моктнмоке Pugin (1812-1852), submitted the winning design BARRY (1795-1860), with the assistance of Augustus Welby

English Gothic] details on a classical body."5

tastic exterior is a conglomeration of Islamic domes, minarets, and China influenced the interior décor of the Royal Pavilion, but the fanseaside resort of Brighton. The architecture of Greece, Egypt, and King George IV) asked him to design a royal pleasure palace in the for Neoclassical buildings in London, when the prince regent (later mix of architectural styles. Nash was an established architect, known ion (FIG. 12-23), designed by Jони Илян (1752-1835), is an eclectic English culture to a broad range of artistic traditions. The Royal Pavil-Britain's forays throughout the world, particularly India, had exposed ism and in part to the Romantic spirit permeating all the arts. Great all manner soon began to appear, due in part to European imperialdominated early-19th-century architecture, exotic new approaches of ROYAL PAVILION Although the Neoclassical and Neo-Gothic styles

Gothic detail. Pugin himself said of it, "All Grecian, Sir. Tudor [late

formal axial plan and a kind of Palladian regularity beneath its Neo-

north end, and the Victoria Tower at the south). The building has a

One of the founders of the Pre-Raphaelite Brotherhood was sanship) of past times, especially the Early Renaissance. appreciated the spirituality and idealism (as well as the art and artiof the contemporary industrializing world. The Pre-Raphaelites also Pre-Raphaelites shared his distaste for the materialism and ugliness enced by the critic, artist, and writer John Ruskin (1819-1900), the the national painting academies by the successors of Raphael. Influwhat they considered the tired and artificial manner promoted in Pre-Raphaelites wished to create fresh and sincere art, free from a significant degree of convincing illusion. Organized in 1848, the

in Surrey. For the figure of Ophelia, Millais had a friend lie in a fact. He painted the background at a spot along the Hogsmill River lais worked diligently to present it with unswerving fidelity to visual worthy of the original poetry. Although the scene is fictitious, Milfeeling witness of its every detail, reconstructing it with a lyricism make the pathos of the scene visible, Millais became a faithful and Shakespeare's Hamlet (4.7.176-179), is the drowning of Ophelia. To at which Courbet set up his Pavilion of Realism. The subject, from ited in the Universal Exposition in Paris in 1855—the exhibition vation of nature is evident in Ophelia (Fig. 12-21), which he exhib-Jони Everett Millais's painstaking obser-

heated bathtub full of water for hours at a time.

ARCHITECTURE

new construction technologies had made possible. same time, architects were exploring the expressive possibilities that architecture of the Napoleonic Empire to the Neo-Gothic. At the most stylistically diverse in history, ranging from the Neoclassical The buildings constructed during the 19th century are among the

don, when the old Houses of Parliament burned in 1834, CHARLES ebrated its medieval heritage with Neo-Gothic buildings. In Lonwas a reflection of nationalistic pride. England, for example, cel-HOUSES OF PARLIAMENT The revival of historical styles often

12-22 Charles Barry and Augustus Welby Northmore Pugin, Houses of Parliament (aerial view looking southwest), London, England, designed 1835.

During the 19th century, architects revived many historical styles, often reflecting nationalistic pride. The Houses of Parliament have an exterior veneer and towers that recall English Late Gothic style.

12-23 John Nash, Royal Pavilion (looking northwest), Brighton, England, 1815–1818.

British territorial expansion brought a familiarity with many exotic styles. This palatial "Indian Gothic" seaside pavilion is a conglomeration of Islamic domes, minarets, and screens.

Prefabricated Architecture

features would not be damaged during transport. This slowed down construction considerably. Paxton's use of prefabricated parts—primarily glass panes in wood frames and cast-iron pillars and beams—for the Crystal Palace enabled workers to build the vast (18-acre) structure in the then unheard-of time of six months and to dismantle it quickly at the exhibition's closing to avoid permanent obstruction of the park. The building was the perfect expression of the new industrial age that the Great Exhibition celebrated.

Paxton's design, nonetheless, borrowed much from traditional architecture, especially Roman and Christian basilicas. The Crystal Palace had a central flat-roofed "nave" and a barrel-vaulted crossing "transept," providing ample interior space to contain displays of huge machines as well as to accommodate decorative touches in the form of large working fountains and giant trees. The public admired the Crystal Palace so much that the workers who dismantled it put up an enlarged version of the glass-and-iron exhibition hall at a new location on the outskirts of London at Sydenham, where it remained until fire destroyed it in 1936. Fortunately, a few old black-and-white photographs and several color lithographs (Fig. 12-24) preserve a record of graphs and several color lithographs (Fig. 12-24) preserve a record of

the Crystal Palace's appearance.

Completely "undraped" construction—that is, the erection of buildings that did not conceal their cast-iron structural skeletons—first became popular in the conservatories (greenhouses) of English country estates. Joseph Paxton built several of these structures for his patron, the duke of Devonshire. In the largest—300 feet long—he used an experimental system of glass-and-metal roof construction. Encouraged by the success of this system, Paxton submitted a winning glass-and-iron building design in the competition for the hall to house the 1851 Great Exhibition of the Works of Industry of All Nations in London.

As innovative as Paxton's use of modern materials in place of stone was his adoption of a new cost-effective way to erect his exhibition building, the Crystal Palace (Fie. 12-24). Paxton was the champion of prefobricated architecture—the use of structural elements manufactured in advance and transported to the construction site ready for assembly. In traditional stone architecture, masons carved the column capitals, moldings, and the like on site to ensure that these delicate

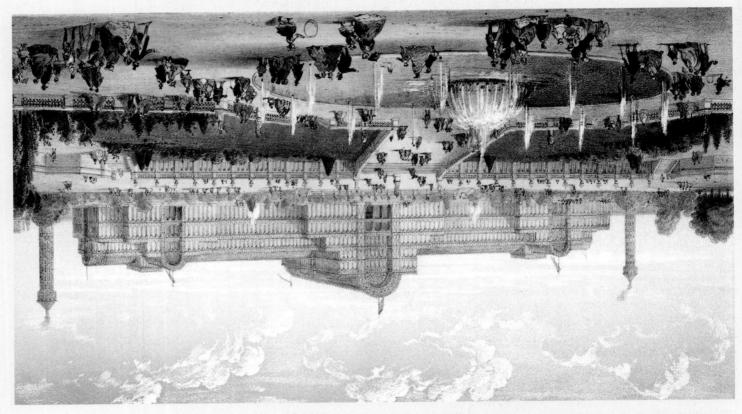

1852-1854. Detail of a color lithograph by Achille-Louis Martiner, ca. 1862. Private collection.

The tensile strength of iron enabled Paxton to experiment with a new system of glass-and-metal roof construction. Constructed of prefabricated parts, the vast Crystal Palace required only six months to build.

CRYSTAL PALACE Other architects abandoned sentimental and Romantic designs from the past. Most utilitarian structures—factories, warehouses, dockyard atructures, mills, bridges, and the like—long had been built simply and without historical ornamentation, often, as in the Royal Pavilion, using cast iron because of its tensile strength

screens that some architectural historians describe as "Indian Gothic." Underlying the exotic facade is a cast-iron skeleton, an early (if hidden) use of this material in noncommercial construction. Nash also put this metal to fanciful use, creating life-size palm-tree columns in cast iron to support the Royal Pavilion's kitchen ceiling.

and resistance to fire. After 1860, steel became available, enabling architects to create new designs involving vast enclosed spaces, as in the great train sheds of railroad stations (FIG. 13-3) and in exposition halls. Joseph Paxton (1801–1865) was the leading proponent of what became known as "undraped" architecture as well as a pioneer in the rapid construction of buildings using parts prepared in advance off-site (see "Prefabricated Architecture," page 350, and FIG. 12-24).

PHOTOGRAPHY

A technological device of immense consequence for the modern experience was invented shortly before the mid-19th century: the camera, with its attendant art of photography. From the time that Frenchman Louis-Jacques-Mandé Daguerre (1789-1851) and Briton William Henry Fox Talbot (1800-1877) announced the first practical photographic processes in 1839, people have celebrated photography's ability to make convincing pictures of humans, animals, places, and things. The relative ease of the process, even in its earliest and most primitive form, seemed a dream come true for 19th-century scientists and artists, who for centuries had grappled with less satisfying methods for capturing accurate images of their subjects. Photography also perfectly suited an age that saw the emergence of Realism as an art movement and a pronounced shift of artistic patronage away from the elite few toward a broader base of support. The growing and increasingly powerful middle class embraced both the comprehensible images of the new medium and their lower cost.

For the traditional artist, photography suggested new answers to the great debate about what is real and how to represent the real in art. Because photography easily and accurately made possible the representation of three-dimensional objects on a two-dimensional surface, the new medium also challenged the place of traditional modes of pictorial representation originating in the Renaissance. Artists as diverse as Ingres, Delacroix, and Courbet welcomed photography as a helpful auxiliary to painting. Other artists, however, feared that the camera was a mechanism that would displace the

painstaking work of skilled painters. From the moment of its invention, photography threatened to expropriate the realistic image, until then the exclusive property of painting. But just as some painters looked to the new medium of photography for answers on how best to render an image in paint, so some photographers looked to painting for suggestions about ways to enhance the photographic image with qualities beyond simple reproduction. Indeed, the first subjects that photographers chose to record were traditional painting themes—for example, still lifes and portraits—in part to establish photography as a legitimate artistic medium on a par with painting. A debate immediately began over whether the photograph was an art form or whether the camera was merely a scientific instrument. An 1862 court case provided the answer: photography was an art, and photographs were entitled to copyright protection, a legal ruling immediately celebrated by Daumier in a memorable lithograph (FIG. 12-24A A).

Artists themselves were instrumental in the development of the new photographic technology. The camera obscura was familiar to 17th- and 18th-century artists (see pages 304 and 322). In 1807, the invention of the *camera lucida* ("lighted room") replaced the enclosed chamber of the camera obscura. Now the photographer aimed a small prism lens, hung on a stand, downward at an object. The lens projected the image of the object onto a sheet of paper. Artists using either of these devices found this process long and arduous, no matter how accurate the resulting work. All yearned for a more direct way to capture a subject's image. Two very different scientific inventions that accomplished this—the *daguerreotype* and the *calotype* (see "Daguerreotypes, Calotypes, and Wet-Plate Photography," page 352)—appeared almost simultaneously in France and England in 1839.

DAGUERREOTYPES The French government presented the new daguerreotype process at the Academy of Science in Paris on January 7, 1839, with the understanding that its details would be made available to all interested parties without charge (although the

inventor received a large annuity in appreciation). Soon, people world-wide began making daguerreotype pictures in a process almost immediately christened "photography," from the Greek *photos* ("light") and *graphos* ("writing or drawing"). Each daguerreotype was a unique work. *Still Life in Studio* (FIG. 12-25) is one of the first successful plates

12-25 LOUIS-JACQUES-MANDÉ DAGUERRE, Still Life in Studio, 1837. Daguerreotype, $6\frac{1}{4}$ " $\times 8\frac{1}{4}$ ". Collection Société Française de Photographie, Paris.

One of the first plates Daguerre produced after perfecting his new photographic process was this still life, in which he was able to capture amazing detail and finely graduated tones of light and shadow.

12-26 Madar, Eugène Delacroix, ca. 1855. Modern print, $8\frac{1}{2}^n \times 6\frac{2}{3}^n$, from the original negative. Bibliothèque nationale, Paris.

Nadar was one of the earliest portrait photographers. His photographs of the leading artists of the day, such as this one of Eugène Delacroix, reveal the sitters' personalities as well as record their features.

detail and a wider range of light and shadow than Talbot's calotype process. The new "wet-plate" technology (so named because the photographic plate was exposed, developed, and fixed while wet) almost at once became the universal way of making negatives until 1880. However, wet-plate photography (Fig. 12-27) had drawbacks. The plates had to be prepared and processed on the spot. Working outdoors meant taking along a portable darkroom—a wagon, tent, or box with lightight sleeves for the photographer's arms.

MATERIALS AND TECHNIQUES Daguerreotypes, Calotypes, and Wet-Plate Photography

The earliest photographic processes were the daguerreotype (FIe. 12-25), named after L.J.M. Daguerre, and the calotype. Daguerre was an architect and theatrical set painter and designer who used a camera obscura in his work. Through a mutual acquaintance, he met Joseph Nicéphore picture of the cityscape outside his upper-story window by exposing, in a picture of the cityscape outside his upper-story window by exposing, in a camera obscura, a metal plate covered with a light-sensitive coating. Niépce's process, however, had the significant drawback that it required an eight-hour exposure time. After Niépce died in 1833, Daguerre continued his work, making two important discoveries. Latent develominant—that is, bringing out the image through treatment in chemical solutions—considerably shortened the length of time needed for exposure. Daguerre also discovered a better way to "fix" the image by chemically stopping the action of light on the photographic plate, which chemically stopping the action of light on the photographic plate, which otherwise would continue to darken until the image turned solid black.

One of the earliest masters of an improved kind of calotype charged for many years after Talbot patented his new process in 1841. adoption of the calotype were the stiff licensing and equipment fees range available with the daguerreotype. Also discouraging widespread blurred, grainy effect very different from the crisp detail and wide tonal images incorporated the texture of the paper. This produced a slightly calotype (from the Greek word kalos, "beautiful"), the photographic duce multiple prints. However, in Talbot's process, which he named the cal development of the negative image. Thus this technique could proimproved the process with more light-sensitive chemicals and a chemieras and, with a second sheet, created "positive" images. He further experiments, Talbot next exposed sensitized papers inside simple camobjects had blocked light from darkening the paper's emulsion. In his colored silhouettes recording the places where opaque or translucent and exposing the arrangement to light. This created a design of light-Talbot made "negative" images by placing objects on sensitized paper genic drawings" to the Royal Institution in London. As early as 1835, in Paris, William Henry Fox Talbot presented a paper on his "photo-31, 1839, less than three weeks after Daguerre unveiled his method the modern negative-print system, eventually replaced it. On January 1850s, but the second major photographic invention, the ancestor of The daguerreotype reigned supreme in photography until the

photography was the multitalented Frenchman known as Madar (Figs. 12-24A lambda and 12-26). He used glass negatives and albumen (prepared with egg white) printing paper, which could record finer

his arrangement to create a stronger image. However, he could suggest a symbolic meaning through his choice of objects. Like the skull and timepiece in Claesz's painting, Daguerre's sculptural and architectural fragments and the framed print of a couple embracing suggest that even art is vanitas and will not endure forever.

NADAR Making portraits was an important economic opportunity for most photographers, and portraiture quickly became one of the most popular early photographic genres. The greatest of the

Daguerre produced after perfecting his method. The process captured every detail—the subtle forms, the varied textures, the finely graduated tones of light and shadow—in Daguerre's carefully constructed tableau. The three-dimensional forms of the sculptures, the basket, and the bits of cloth spring into high relief. The inspiration for the composition came from 17th-century Dutch vanitas still lifes, such as those of Pieter Claesz (Fig. 10-26). Like Claesz, Daguerre arranged his objects to reveal their textures and shapes clearly. Unlike a painter, Daguerre could not alter anything within

early portrait photographers was French novelist, journalist, and caricaturist Gaspar-Félix Tournachon, known simply as NADAR (1828-1910). Photographic studies for his caricatures led Nadar to open a portrait studio. So talented was he at capturing the essence of his subjects that the most important people in France, including Delacroix, Daumier, Courbet, and Manet, flocked to his studio to have their calotype portraits made. Nadar said he sought in his work "that instant of understanding that puts you in touch with the model—helps you sum him up, guides you to his habits, his ideas, and character and enables you to produce . . . a really convincing and sympathetic likeness, an intimate portrait." Nadar's Eugène Dela*croix* (FIG. 12-26) shows the painter at the height of his career. Even in half-length, the painter's gesture and expression create a mood that seems to reveal much about him. Perhaps Delacroix responded to Nadar's famous gift for putting his clients at ease by assuming the pose that best expressed his personality.

TIMOTHY O'SULLIVAN Photographers were quick to realize the documentary power of their new medium. Thus began the story of photography's influence on modern life and of the immense changes it brought to communication and information management. His-

hitorical events could be recorded in permanent form on the spot for the first time. The photographs taken of the American Civil War by Mathew B. Brady (1823–1896), ALEXANDER GARDNER (1821–1882), and TIMOTHY O'SULLIVAN (1840-1882) remain unsurpassed as incisive accounts of military life, unsparing in their truthful detail and poignant as expressions of human experience. The most moving are the inhumanly objective records of combat deaths. Perhaps the most reproduced of these is Gardner's print of O'Sullivan's A Harvest of Death, Gettysburg, Pennsylvania (FIG. 12-27). Although viewers could regard this image as simple news reportage, it also functions to impress on people the high price of war. Corpses litter the battlefield as far as the eye can see. As the photograph modulates from the precise clarity of the bodies of Union soldiers in the foreground, boots stolen and pockets picked, to the indistinct corpses in the distance, the suggestion of innumerable other dead soldiers is unavoidable. This "harvest" is far more sobering and depressing than that in Winslow Homer's Civil War painting, Veteran in a New could reproduce photographs such as this in newspapers, photographers exhibited them publicly. They made an impression that newsprint engravings never could.

12-27 TIMOTHY O'SULLIVAN, A Harvest of Death, Gettysburg, Pennsylvania, 1863. Negative by Timothy O'Sullivan. Albumen print by Alexander Gardner, $6\frac{3}{4}$ " × $8\frac{3}{4}$ ". New York Public Library (Astor, Lenox, and Tilden Foundations, Rare Books and Manuscript Division), New York.

Wet-plate technology enabled photographers to record historical events on the spot—and to comment on the high price of war, as in this photograph of dead Union soldiers at Gettysburg in July 1863.

Nuseum of Photography and Film, Rochester.

Muybridge specialized in photographic studies of the successive stages in human and animal motion—details too quick for the human eye to capture. Modern cinema owes a great deal to his work.

Muybridge presented his work to scientists and general audiences with a device called the zoopraxiscope, which he invented to project his sequences of images (mounted on special glass plates) onto a screen. The result was so lifelike that one viewer said it "threw upon the screen apparently the living, moving animals. Nothing was wanting but the clatter of hoofs upon the turt." The illusion of motion in Muybridge's photographic exhibits was the result of a physical fact of human eyesight called "persistence of vision." Stated simply, it means that the brain retains whatever the eye sees for a fraction of a second after the eye stops seeing it. Thus viewers saw a rapid succession of different images merging one into the next, producing the illusion of continuous change. This illusion lies at the heart of the motion-picture industry that debuted in the 20th century. Thus, with Muybridge's innovations in photography, yet another new art form was born—cinema.

including his contemporary, the painter and sculptor Edgar Degas art. These sequential motion studies influenced many other artists, photographs earned him a place in the history of science, as well as ity through the book Animal Locomotion (1887), and his motion a single action. Muybridge's discoveries received extensive publicies that produced separate photographs of progressive moments in sity of Pennsylvania with a series of multiple-camera motion studto capture. These investigations culminated in 1885 at the Univerin human and animal motion—details too quick for the human eye ning of Muybridge's photographic studies of the successive stages times have all four feet in midair. This experience was the begin-(FIG. 12-28), Muybridge proved that racing horses did in fact at Through his sequential photography, as seen in Horse Galloping all four feet of a horse galloping at top speed are off the ground. assistance in settling a bet about whether, at any point in a stride, California, Leland Stanford (1824-1893), sought Muybridge's tographs of the western United States. In 1872, the governor of he established a prominent international reputation for his phofrom England in the 1850s and settled in San Francisco, where EADWEARD MUYBRIDGE (1830-1904) came to the United States

EADWEARD MUYBRIDGE The Realist photographer and scientist

(Fig. 13-5), and 20th-century artists such as Marcel Duchamp

(FIG. 14-18).

Explore the era further in MindTap with videos of major artworks and buildings, Google Earth $^{\rm TM}$ coordinates, and essays by the author on the following additional subjects:

Pierre-Alexandre Barthélémy Vignon, La Madeleine, Paris (FIG. 12-1A)
 ■ ARTISTS ON ART: Thomas Cole on the American Landscape
 Winslow Homer, Veteran in a New Field (FIG. 12-18A)

Honoré Daumier, Nadar Raising Photography to the Height of Art

⁽FIG. 12-24A)

ROMANTICISM, REALISM, AND PHOTOGRAPHY, 1800 TO 1870

Art under Napoleon

As Emperor of the French from 1804 to 1815, Napoleon embraced the Neoclassical style in order to associate his regime with the empire of ancient Rome. Napoleon chose Jacques-Louis David as First Painter of the Empire. Napoleon's favorite sculptor was Antonio Canova, who carved marble Neoclassical portraits of the imperial family. Antoine-Jean Gros painted a propagandistic portrayal of the emperor seemingly healing the plague-stricken at Jaffa.

Gros, Napoleon Visiting the Plague-Stricken in Jaffa, 1804

Romanticism

The term *Romanticism* denotes the artistic movement that flourished from 1800 to 1840. Romantic artists gave precedence to feeling and imagination over Enlightenment reason, and explored the exotic, erotic, and fantastic. The leading Romantic artist in Spain was Francisco Goya, whose *Sleep of Reason* celebrates the unleashing of imagination, emotions, and even nightmares. In France, Eugène Delacroix led the way in depicting Romantic narratives set in faraway places and distant times—for example, *Death of Sardanapalus*. Romantic painters often chose landscapes as an ideal subject to express the theme of the soul unified with the natural world. Masters of the transcendental landscape include Friedrich in Germany, Constable and Turner in England, and Cole in the United States.

Goya, The Sleep of Reason Produces Monsters, ca. 1798

Realism

Realism developed as an artistic movement in mid-19th-century France. Its leading proponent was Gustave Courbet, whose paintings of ordinary people and everyday events exemplify his belief that painters should depict only their own time and place. Honoré Daumier boldly confronted authority with his satirical lithographs commenting on the plight of the urban working class. Édouard Manet shocked the public with his paintings' subjects—for example, promiscuous women—and his rough brushstrokes, which emphasized the flatness of the painting surface, paving the way for modern abstract art. Among the leading American Realists were Winslow Homer and Thomas Eakins.

Manet, Olympia, 1863

Architecture

Territorial expansion, the Romantic interest in exotic locales and earlier eras, and nationalistic pride led to the revival in the 19th century of older architectural styles, especially the Gothic, exemplified by London's Houses of Parliament. By the middle of the century, many architects had already abandoned sentimental and Romantic designs from the past in favor of exploring the possibilities of cast-iron construction, as in Joseph Paxton's Crystal Palace in London.

Paxton, Crystal Palace, London, 1850-1851

Photography

In 1839, Daguerre in Paris and Talbot in London invented the first practical photographic processes. Many of the earliest photographers, chief among them Nadar in France, specialized in portrait photography, but others, including O'Sullivan in the United States, quickly realized the documentary power of the new medium.

O'Sullivan, Harvest of Death, Gettysburg, 1863

■ 13-1a The FoliesBergère was a popular café and music hall where Parisians enjoyed their leisure—a characteristic Impressionist subject that broke sharply with tradition, as did Manet's sketchy application of paint.

▲ 13-1b The central figure in A Bar at the Folies-Bergère is a young barmaid who looks out from the canvas but seems detached both from the viewer and the gentleman in a top hat who may be propositioning her.

Époυακο Μανετ, Α Βαν αt the Folies-Βergère, 1882. Oil on canvas, 3' 1" × 4' 3". Courtauld Gallery, London.

► 13-1c In accord with modernist principles, Manet called attention to the canvas surface by creating spatial inconsistencies, such as the relation-ship between the barmaid and her apparent reflection in the mirror.

Impressionism, Post-Impressionism, and Symbolism, 1870 to 1900

MODERNISM AT THE FOLIES-BERGÈRE

Between 1800 and 1900, the population of Europe's major cities exploded. In Paris, for example, the number of residents expanded from 500,000 to 2,700,000. It was there that the art movement called *Impressionism* was born, an aesthetic by-product of the sometimes brutal and chaotic transformation of French life, which made the world seem unstable and insubstantial. As the poet and critic Charles Baudelaire (1821–1867) observed in his 1860 essay *The Painter of Modern Life*: "[Modernity is] the ephemeral, the fugitive, the contingent, the half of art whose other half is the eternal and the immutable." Accordingly, Impressionist painters built on the innovations of the Realists in turning away from traditional mythological and religious themes in favor of the daily life of the newly industrialized French capital and its suburbs along the Seine. But, in contrast to the Realists, the Impressionists sought to convey the elusiveness and impermanence of the subjects they portrayed.

One of the most popular Impressionist subjects was Paris's vibrant nightlife. The immensely versatile Édouard Manet (FIGS. 12-17 and 12-18), whose career bridged Realism and Impressionism, painted his last great work—A Bar at the Folies-Bergère (FIG. 13-1)—under the influence of the younger Impressionists. The Folies-Bergère was a popular café with music-hall performances, one of Paris's most fashionable gathering places. At the center of Manet's Folies-Bergère is a barmaid, who looks out from the canvas but seems disinterested or lost in thought, divorced from her patrons as well as from the viewer. In front of her, Manet painted a marvelous still life of bottles, flowers, and fruit—all for sale to the bar's customers. In the mirror is the reflection of a gentleman wearing a dapper top hat and carrying an elegant walking stick. He has approached the barmaid, perhaps to order a drink, but more likely to ask the price of her company after the bar closes. Also visible in the mirror, at the upper left corner of the canvas, are the lower legs of a trapeze artist and a woman in the nightclub's balcony watching some other performance through opera glasses.

What seems at first to be a straightforward representation of the bar, barmaid, and customers quickly fades as visual discrepancies immediately emerge. For example, is the reflection of the woman on the right the barmaid's? If both figures are the same person, it is impossible to reconcile the spatial relationship between the gentleman, the bar, the barmaid, and her seemingly displaced reflection. These visual contradictions complement Manet's blurred brushstrokes and rough application of paint. Together, they draw attention to the tactile surface of the canvas, consistent with late-19th-century artists' emerging insistence on underscoring the artifice of the act of painting, one of the central principles of *modernist* art.

internal to art production, regardless of whether the artist is por-Modernism thus implies certain concerns about art and aesthetics and carried further in his 1882 A Bar at the Folies-Bergère (FIG. 13-1). groundbreaking 1863 painting Le Déjeuner sur l'Herbe (FIG. 12-17) critically examine the premises of art itself, as Manet did in his contemporary world—the goal of Realism. Modernist artists also Modernism in art, however, transcends the simple depiction of the world and the proper subject of a modernist painter (see page 357). Baudelaire insisted was the essential characteristic of the modern world's impermanence and of a constantly shifting reality, which ideas about evolution were consistent with the growing sense of the MODERNISM Marx's emphasis on social conflict and Darwin's

critic, explained: Clement Greenberg (1909-1994), an influential American art traying modern life.

used art to call attention to art. The limitations that constitute the ist art had dissembled the medium, using art to conceal art. Modernism ods of a discipline to criticize the discipline itself. . . . Realistic, illusion-The essence of Modernism lies ... in the use of the characteristic meth-

> steam, and iron, the second focused on steel, electricity, chemicals, lution. Whereas the first Industrial Revolution centered on textiles, the third quarter of the 19th century as the second Industrial Revotorians often refer to the scientific advances that occurred during France (MAP 13-1), the rest of Europe, and the United States that his-The Industrial Revolution, born in England, spread so rapidly to

MARXISM, DARWINISM, MODERNISM

automobile manufacturing, and paved the way for the invention of developments in plastics, machinery, building construction, and and oil. The discoveries in these fields provided the foundation for

the radio, telephone, electric lightbulb, and electric streetcar.

factor in this population shift. Improving health and living conditunities in the cities, especially in the factories, were also a major property owners from their land. The widely available work opporcenters because expanded agricultural enterprises squeezed smaller from the countryside. Farmers in large numbers relocated to urban during the latter part of the 19th century, mainly due to migration ization. The number and size of European cities grew dramatically

Expanding industrialization was closely tied to rapid urban-

explosive growth. tions in the cities further contributed to their

many intellectuals. appeal for the working poor as well as for and destroyed capitalism. Marxism held great state in which the working class seized power Marx advocated the creation of a socialist labor they exploited for their own enrichment. of production conflicted with those whose believed that those who controlled the means to overthrow the capitalist system. Marx rich Engels (1820-1895), called for workers munist Manifesto (1848), written with Friedtheorist Karl Marx (1818-1883), whose Comto the ideas of German political and social the urban working class was fundamental The sir and meinism and meixam

dicted the biblical narrative of creation and by Means of Natural Selection (1859), contraideas, as presented in On the Origin of Species the fittest survived. Darwin's controversial result of a competitive system in which only Darwin argued that evolution was the natural postulated the theory of natural selection. uralist Charles Darwin (1809-1882), who Equally influential was the English nat-

were greeted with hostility by many people.

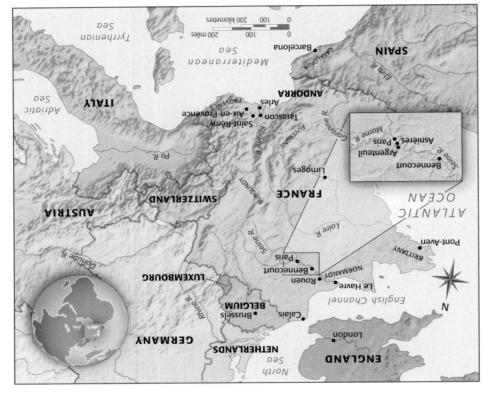

MAP 13-1 France around 1870 with towns along the Seine.

MPRESSIONISM, POST-IMPRESSIONISM, AND SYMBOLISM, 1870 TO 1900

Georges Seurat develops pointillism.

0681-0881

- from nature." Paul Cézanne seeks "to do Poussin over entirely 0061-0681
- and the decorative arts. The Art Nouveau movement emerges in architecture
- Gustav Klimt's paintings reflect fin-de-siècle culture
- scrapers in America. Louis Sullivan builds steel, glass, and stone sky-
- Auguste Rodin receives the commission for The Vincent van Gogh explores the expressive power of
- Gates of Hell.
- Alexandre-Gustave Eiffel builds the Eiffel Tower in
- independent exhibition. and its suburbs on the Seine, and mount their first transitory nature of modern life in urbanized Paris The Impressionists paint subjects that capture the 0881-0781
- in their paintings. porate elements of Japanese style and composition European artists collect Japanese prints and incor-

PROBLEMS AND SOLUTIONS

Painting Impressions of Light and Color

Claude Monet often set up his easel on the banks of the Seine (Fig. 13-2) or in a boat on the river (Fig. 13-2A). Painting en plein air was how the pioneering Impressionist painter was able to meet his goal of capturing an instantaneous representation of atmosphere and climate. Of course, landscape painters had always drawn and made preliminary color studies outdoors and then used those sketches to produce formal paintings in their studios. Finishing as well as beginning his landscapes—for example, Impression: Sunrise (Fig. 13-2)—outdoors sharpened Monet's focus on the roles that light and color play in the way nature appears to the eye. The systematic investigation of light and color and the elimination of the traditional distinction between a sketch and a formal painting enabled Monet to paint images that truly conveyed a sense of the momentary and transitory. Lilla Cabot Perry (1848–1933), a student of Monet's late in his career, gave this description of Monet's approach:

I remember his once saying to me: "When you go out to paint, try to forget what objects you have before you—a tree, a house, a field, or whatever. Merely think, here is a little square of blue, here an oblong of pink, here a streak of yellow, and paint it just as it looks to you, the exact color and shape, until it gives your own naïve impression of the scene before you."*

Another factor encouraging Monet and some of his contemporaries to paint outdoors was the introduction of premixed pigments conveniently sold in easily portable tubes. These readily available oil paints gave artists new colors for their work and heightened their sensitivity to the multiplicity of colors in nature. After scrutinizing the effects of light and color on forms, many late-19th-century painters concluded that local color—an object's color in white light—becomes modified by the quality of the light shining on it, by reflections from other objects, and by the effects that juxtaposed colors produce. Shadows do not appear gray or black, as many earlier painters thought, but seem to be composed of colors modified by reflections or other conditions. If artists use complementary colors side by side over large enough areas, the colors intensify each other, unlike the effect of small quantities of adjoining mixed pigments, which blend into neutral tones. Furthermore, the "mixing" of colors by juxtaposing them directly on a white canvas without any preliminary sketch—also a sharp break from traditional painting practice—produces a more intense hue than the same colors mixed on the palette. Monet achieved remarkably brilliant effects with his characteristically short, choppy brushstrokes, which so accurately catch the vibrating quality of light. The reason for much of the early adverse criticism leveled at Monet's paintings was that they lacked the polished surfaces and sharp contours of academic painting. In Monet's canvases, the forms take on clarity only when the eye fuses the brushstrokes at a certain distance.

*Quoted in Linda Nochlin, Impressionism and Post-Impressionism 1874-1904: Sources and Documents (Englewood Cliffs, N.J.: Prentice Hall, 1966), 35.

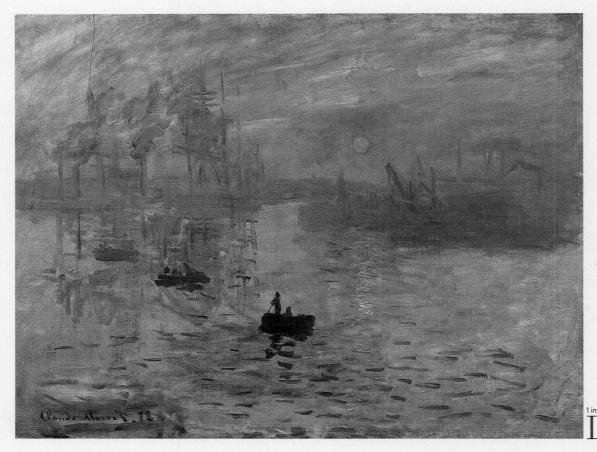

13-2 CLAUDE MONET, Impression: Sunrise, 1872. Oil on canvas, 1' $7\frac{1}{2}$ " × 2' $1\frac{1}{2}$ ". Musée Marmottan, Paris.

Fascinated by reflected sunlight on water, Monet broke with traditional studio practice and painted his "impression" en plein air, using short brushstrokes of pure color on canvas without any preliminary sketch.

.(92£ 9gsq that is, outdoors (see "Painting Impressions of Light and Color," personal responses to nature, formed and recorded en plein airthe two. They were sensations, the Impressionists' subjective and world nor solely subjective responses, but the interaction between paintings were neither purely objective descriptions of the exterior felt. In other words, the "impressions" these artists recorded in their operated at the intersection of what the artists saw and what they of Impressionism. Beyond its affinity with sketches, Impressionism "impressionistic" application of paint is, however, only one aspect ate smooth tonal gradations and an optically accurate scene. The no attempt to disguise the brushstrokes or blend the pigment to cre-Monet, breaking sharply from traditional landscape painting, made (MAP 13-1). Impression: Sunrise is a view of that harbor, in which France at Le Havre, the great seaport at the mouth of the Seine MONET (1840-1926), who grew up on the Normandy coast of CLAUDE MONET The painter of Impression: Sunrise was Claude

SAINT-LAZARE Most of the Impressionists painted scenes in and around Paris, the heart of modern life in France. Monet's Saint-Lazare Train Station (Fig. 13-3) depicts a characteristic aspect of the contemporary urban scene. The expanding railway network had made travel more convenient, bringing large numbers of people into Paris and enabling city dwellers to reach suburban areas, such as Argenteuil (MAP 13-1; Fig. 13-2A A), quickly, In his "impression" of the Saint-Lazare railway terminal, Monet captured the energy and vitality of Paris's modern transportation hub. The train, emerging from the steam and smoke it emits, rumbles into the station. In the background haze are the tall buildings that were becoming a major component of the Parisian landscape. Monet's agitated a major component of the Parisian landscape. Monet's agitated

medium of painting—the flat surface, the shape of the support, the properties of pigment—were treated by the Old Masters as negative factors that could be acknowledged only implicitly or indirectly. Modernist painting has come to regard these same limitations as positive factors that are to be acknowledged openly. Manet's paintings became the first Modernist ones by virtue of the frankness with which they declared the surfaces on which they were painted. The Impressionists, in Manet's wake, abjured underpainting and glaxing, to leave the eye under no doubt as to the fact that the colors used were made of real paint that came from pots or tubes.²

Although the work of Gustave Courbet and the Realists already expressed this modernist viewpoint, modernism emerged even more forcefully in the late-19th-century movements that art historians call Impressionism, Post-Impressionism, and Symbolism.

IWPRESSIONISM

A hostile critic applied the term *Impressionism* in response to *Impression: Sunrise* (Fig. 13-2), one of the paintings exhibited in the first Impressionist show in 1874 (see "Academic Salons and Independent Art Exhibitions" (A). Although the critic intended the label to be derogatory, by the third Impressionist show in 1878, the artists had embraced it and were calling themselves Impressionists. Both artists and critics had used the term before, but only in relation to sketches. Impressionist paintings do incorporate the qualities of sketches—abbreviation, speed, and spontaneity—but the artists considered their sketchlike works to be finished paintings, a radically modernist idea at the time.

Moder, Saint-Lazare Train Station, 1877. Oil on canvas, 2' 5 \frac{3}{4}" \times 3' 5". Musée d'Orsay, Paris. The Impressionists often painted scene

13-3 CLAUDE

of the mipressenses of the mainted scenes Paris, the heart of modern life in France. Monet's agitated application of paint contributes to the sense of energy in this railway terminal.

13-4 PIERRE-AUGUSTE RENOIR, Le Moulin de la Galette, 1876. Oil on canvas, 4' 3" × 5' 8". Musée d'Orsay, Paris.

Renoir's painting of this popular Parisian dance hall is dappled by sunlight and shade, artfully blurred into the figures to produce the effect of floating and fleeting light that many Impressionists cultivated.

paint application contributes to the sense of energy and conveys the atmosphere of urban life.

Georges Rivière (1855–1943), a rare art critic who admired the Impressionists, recorded the essence of what Monet had tried to achieve:

Like a fiery steed, stimulated rather than exhausted by the long trek that it has only just finished, [the locomotive] tosses its mane of smoke, which lashes the glass roof of the main hall.... We see the vast and manic movements at the station where the ground shakes with every turn of the wheel. The platforms are sticky with soot, and the air is full of that bitter scent exuded by burning coal. As we look at this magnificent picture, we are overcome by the same feelings as if we were really there, and these feelings are perhaps even more powerful, because in the picture the artist has conveyed his own feelings as well.³

PIERRE-AUGUSTE RENOIR Modern industrialized Paris provided ample time for leisure activities, and scenes of dining, dancing, caféconcerts, opera, and ballet became mainstays of Impressionism (see "The Folies-Bergère," page 357). *Le Moulin de la Galette* (FIG. 13-4) by PIERRE-AUGUSTE RENOIR (1841–1919) depicts a Parisian dance hall that was popular with ordinary working-class people. Some crowd

the tables and chatter, while others dance energetically. So lively is the atmosphere that the viewer can virtually hear the sounds of music, laughter, and tinkling glasses. The painter dappled the whole scene with sunlight and shade, artfully blurred into the figures to produce precisely the effect of floating and fleeting light that many Impressionists cultivated. The casual poses and asymmetrical placement of the figures and the suggested continuity of space, spreading in all directions and only accidentally limited by the frame, position the viewer as a participant rather than as an outsider. Whereas artists favored by the French Academy sought to express universal and timeless qualities, the Impressionists attempted to depict just the opposite—the incidental and the momentary.

edgas Degas Dancing of a very different kind—ballet—was one of the favorite subjects of Edgar Degas (1834–1917). Although also a "painter of modern life," Degas, unlike Monet and Renoir, was not concerned with light and atmosphere. Indeed, he specialized in indoor subjects and made many preliminary studies for his finished paintings. Degas's interests were primarily with recording body movement and exploring unusual angles of viewing. He was fascinated by the formalized patterns of motion of the performers at the Paris Opéra and its ballet school. In his 1874 canvas—

13-5 EDGAR DEGAS,
The Rehearsal,
1874. Oil on canvas,
I' 11" × 2' 9". Glasgow
Art Galleries and
Museum, Glasgow
(Burrell Collection).

Degas favored subjects, auch as the Paris ballet, that gave him the opportunity to study the human body in motion. The high placement of figures are characteristic aspects of his work.

The Reheavsal (Fig. 13-5)—most of the ballerinas are paradoxically hidden from the viewer by other figures or by the spiral stairway. The painting is the antithesis of a classically balanced composition. The center is empty, and the floor takes up most of the canvas surface. At the margins, Degas arranged the figures in a seemingly random manner. The cutting off of the dancers at the left and right enhances the sense that the viewer is witnessing a fleeting moment. Because of his interest in patterns of movement, Degas became fascinated by photography and often used a camera to make pre-

fascinated by photography and often used a camera to make preliminary studies for his works. Japanese prints, which often depicted figures and places from sharply oblique angles, were another inspirational source for Degas's paintings (see "Japanese Woodblock Prints," page 522). Japanese artists used diverging lines not only to organize the flat shapes of figures but also to direct the viewer's attention into the picture space (compare Fig. 19-1). The Impressionists, acquainted with these prints as early as the 1860s, greatly admired their spatial organization, familiar and intimate themes, and flat, unmodeled color areas.

ORSTAT AND MORISOT The Impressionists were a diverse group of artists, women as well as men, from disparate economic, social, national, and religious backgrounds, united by a shared interest in the modern world that they experienced daily and a distaste for the atylistic constraints and restricted themes of academic art. The two most accomplished Impressionist women were MARY CASSATT (1844–1926), an American, and BERTHE MORISOT (1841–1895), a

13-6 Mary Cassatt, The Child's Bath, 1893. Oil on canvas, 3' $3''\times 2'$ 2'' . At Institute of Chicago, Chicago (Robert A. Walker Fund).

Cassatt's compositions owe much to Degas and Japanese prints, but her subjects differ from those of most Impressionists, in part because, as a woman, she could not frequent cafés with her male friends.

ART AND SOCIETY

Women Impressionists

Two of the best-known Impressionists were women. Although they came from very different backgrounds and their paintings could never be confused, both Mary Cassatt and Berthe Morisot brought a distinctively feminine viewpoint to their work, especially with regard to the subjects they chose and the way they portrayed women.

Cassatt, the daughter of a wealthy Philadelphia banker, was fortunate to live at a time when formerly all-male American colleges and art academies were opening their doors to women. She trained at the Pennsylvania Academy of the Fine Arts and then moved to Europe to study masterworks in France and Italy. Cassatt came to the attention of Degas when he saw a painting of hers in the Salon of 1874. Thereafter, she exhibited regularly with the Impressionists, but as a woman, she could not easily frequent the cafés with her male artist friends. She also had the responsibility of caring for her aging parents, who had moved to Paris to join her. Because of these restrictions, Cassatt's subjects were principally women and children, whom she presented with a combination of objectivity and genuine sentiment.

Cassatt's *The Child's Bath* (FIG. 13-6) owes much to the compositional devices of Degas (FIG. 13-5) as well as to Degas's sources—Japanese prints. But whereas Degas's favorite subjects were professional ballerinas, Cassatt's canvas celebrates the tender relationship between a mother and her child, both of whom gaze at their joint reflection in the tub of water.

In contrast to the expatriate American Cassatt, Morisot was raised in an upper-middle-class home in Paris, and she could not study painting at the École des Beaux-Arts because the European academies were still closed to women. Instead, she and her sister Edma took lessons from a private tutor. Berthe enjoyed some early success exhibiting in the official salons, but after meeting Édouard Manet in late 1867 or 1868 (she married his brother, Eugène, in 1874), she came in contact with the Impressionists and submitted many paintings to their exhibitions.

Morisot's subject matter—the leisure activities of Parisians at resorts along the Seine or in Paris's great park called the Bois de Boulogne—typifies the interests of many of the Impressionists. But the people who inhabit her canvases are almost exclusively women and their children, always well dressed and thoughtful, never frivolous or objects of male desire. Summer's Day (FIG. 13-7) depicts two women in a boat on the Bois de Boulogne lake. It is similar in spirit to some of Claude Monet's paintings of the Seine, but Morisot's focus is the women, not the setting. Morisot herself is in the same boat, unseen, and she represented the women at a sharp angle, with parts of their bodies and most of the boat cut off by the frame, using the compositional format pioneered by Edgar Degas (FIG. 13-5) and adopted also by Cassatt. In Summer's Day, Morisot rejected contour lines in favor of patches of color that define the shapes of her figures. The sketchy brushstrokes used to paint the women merge with those of the water, unifying figure and ground in a striking two-dimensional composition that also captures all the freshness of a brightly lit summer day en plein air.

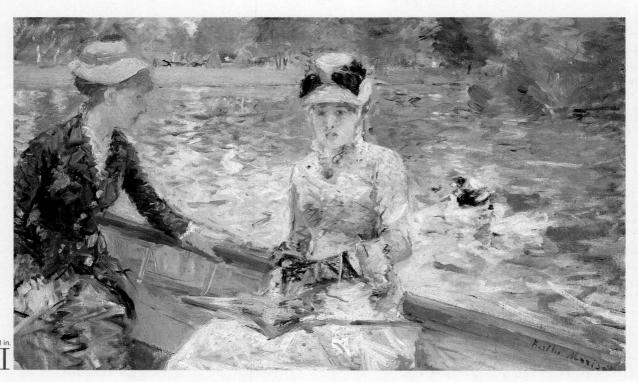

13-7 BERTHE MORISOT, Summer's Day, 1879. Oil on canvas, $1'5\frac{3}{4}" \times 2'5\frac{3}{8}"$. National Gallery, London (Lane Bequest, 1917).

Morisot's subject (Parisians at leisure), bright palette, and sketchy brushstrokes typify Impressionism, but the people who inhabit her paintings are almost exclusively welldressed, thoughtful women.

Frenchwoman, who painted *The Child's Bath* (FIG. 13-6) and *Summer's Day* (FIG. 13-7), respectively. Their works, while having much in common with those of their male colleagues, differed from the paintings of Monet, Renoir, Degas, and the other Impressionists in important ways (see "Women Impressionists," above).

JAMES WHISTLER Like Cassatt, JAMES ABBOTT MCNEILL WHISTLER (1834–1903) was an American expatriate artist in Europe. He spent time in Paris, but eventually settled in London. While in Paris, Whistler met many of the Impressionists, and his art incorporates some of their concerns and his own. Whistler shared the

POST-IMPRESSIONISM

By the mid-1880s, just as the Impressionists' sketchlike paintings of contemporary life were gaining wider acceptance, a group of younger artists came to feel that in attempting to capture momentary sensations of light and color on canvas, too many important elements of traditional painting were being sacrificed. These artists were much more interested in systematically examining the properties and expressive qualities of line, pattern, form, and color. Because their art had its roots in Impressionism, but was not stylistically homogeneous, these artists became known as the Post-Impressionists.

ever before—increased the effect of the images on observers. mal elements—for example, brighter colors and bolder lines than anticipated Expressionism (see page 380), when artists' use of forcousin.) Such distortions by simplification of the figures and faces short man wearing a derby hat accompanying the very tall man, his and masklike faces. (He included himself in the background—the ing artificial light, brassy music, and assortment of corrupt, cruel, 13-4). Toulouse-Lautrec's scene is decadent nightlife, with its glarand casual atmosphere of Renoir's Le Moulin de la Galette (FIG. Compare, for instance, the mood of Moulin Rouge with the relaxed so emphasized or exaggerated each element that the tone is new. line patterns with added dissonant colors. But Toulouse-Lautrec asymmetrical composition, the spatial diagonals, and the strong Degas, of Japanese prints, and of photography in the oblique and outcasts. At the Moulin Rouge (FIG. 13-9) reveals the influences of ing with the underclass of entertainers, prostitutes, and other social to enter. He became a citizen of the night world of Paris, consortfrom the high society that his ancient aristocratic name entitled him Lautrec's growth and partially crippled him, leading to his self-exile often borders on caricature. Genetic defects had stunted Toulouse-(1864–1901). His work, however, has an added satirical edge to it and many ways was the French artist Henri de Toulouse-Lautrec HENRI DE TOULOUSE-LAUTREC Closest to the Impressionists in

GEORGES SEURAT The themes that GEORGES SEURAT (1859–1891) addressed in his paintings were also Impressionist subjects, but he depicted modern life in a strictly intellectual way. Seurat devised a disciplined and painstaking system of painting focused on color analysis. He was less concerned with the recording of immedition into a new kind of pictorial order. Seurat disciplined the free and fluent play of color characterizing Impressionism into a calculated arrangement based on scientific color theory. Seurat's system—pointillism—involves carefully observing color and separating it into its component parts (see "Pointillism and 19th-Century Color the canvas in tiny dots (points) or daubs. Thus the shapes, figures, and spaces in the image become comprehensible only from a disand spaces in the image become comprehensible only from a distance, when the viewer's eye blends the many pigment dots.

Seurat introduced pointillism to the French public at the eighth and last Impressionist exhibition in 1886, where he displayed A Sunand last Impressionist exhibition in 1886, where he displayed A Sunday on La Grande Jatte (Figs. 13-10 and 13-10A), a huge canvas in the tradition of the official Salon. The subject of the painting—Parisans at leisure on an island in the Seine near Asnières—is consistent with Impressionist recreational themes, but Seurat's figures are rigid and remote, unlike the spontaneous representations of Impressionand remote, unlike the spontaneous representations of Impressionation. He played on repeated motifs both to create flat patterns and to suggest spatial depth. Reiterating the profile of the women and to suggest spatial depth. Reiterating the profile of the women and

13-8 James Abbott McNeill Whistler, Nocturne in Black and Gold (The Falling Rocket), ca. 1875. Oil on panel, I' $11\frac{5}{8}$ " x I' $6\frac{1}{2}$ ". Detroit Institute of the Arts, Detroit (gift of Dexter M. Ferry Jr.).

In this painting, Whistler displayed an Impressionist's interest in conveying atmospheric effects of fireworks at night, but he also emphasized the abstract arrangement of shapes and colors.

him financially. and required Whistler to pay all of the court costs, which ruined awarded the artist only one farthing (less than a penny) in damages The judge, showing where his—and the public's—sympathies lay, won the case, his victory had sadly ironic consequences for him. face."4 In reply, Whistler sued Ruskin for libel. Although Whistler review accusing Whistler of "flinging a pot of paint in the public's (see page 348) responded to this painting by writing a scathing 19th-century viewers, however. The British critic John Ruskin 20th-century painters adopted. Whistler's works angered many and colors on the rectangle of his panel, an approach that many Whistler emphasized creating a harmonious arrangement of shapes ing the atmospheric effects than in providing details of the scene, tuating the darkness of the night sky. More interested in conveygold flecks and splatters representing an exploded firework puncand Gold, or The Falling Rocket (FIG. 13-8), is a daring painting with ing his paintings "arrangements" or "nocturnes." Nocturne in Black music. To underscore his artistic intentions, Whistler began calladded a desire to create harmonies paralleling those achieved in sensations that color produces on the eye. To these interests he Impressionists' fondness for recording contemporary life and the

13-9 Henri de Toulouse-Lautrec, At the Moulin Rouge, 1892–1895. Oil on canvas, $4' \times 4'$ 7". Art Institute of Chicago, Chicago (Helen Birch Bartlett Memorial Collection).

Toulouse-Lautrec devoted his brief career to depicting the bohemian lifestyle of Paris at night. The oblique composition, glaring lighting, masklike faces, and dissonant colors of *Moulin Rouge* typify his work.

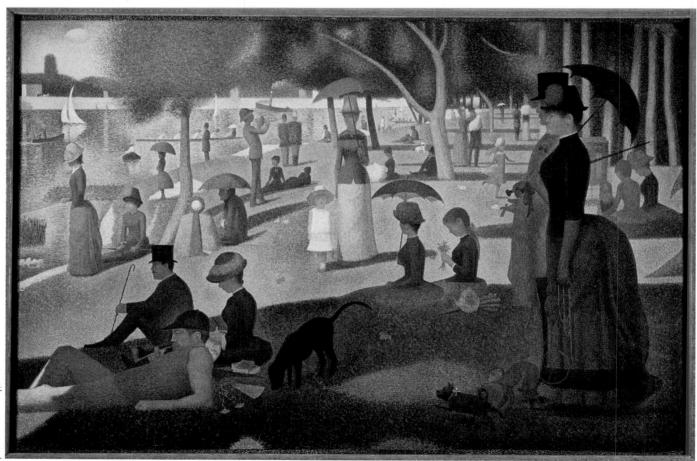

13-10 Georges Seurat, A Sunday on La Grande Jatte, 1884–1886. Oil on canvas, 6' $9'' \times 10'$. Art Institute of Chicago, Chicago (Helen Birch Bartlett Memorial Collection).

Seurat's color system—pointillism—involved dividing colors into their component parts and applying those colors to the canvas in tiny dots. The forms become comprehensible only from a distance.

Some of van Gogh's letters contain vivid descriptions of his paintings. For example, about Night Café (Fig. 13-11), he wrote:

I have tried to express the terrible passions of humanity by means of red and green. The room is blood red and dark yellow with a green billiard table in the middle; there are four citron-yellow lamps with a glow of orange and green. Everywhere there is a clash and contrast of the most disparate reds and greens in the figures of little sleeping hooligans, in the empty, dreary room, in violet and blue. The blood-red and the yellow-green of the billiard table, for instance, contrast with the soft, tender Louis XV green of the counter, on which there is a pink nosegay. The white cost of the landled and the sample in a corner of that furnace, turns citron-yellow, or

"Vincent van Gogh to Theo van Gogh, September 3, 1888, in W. H. Auden, ed., Van Gogh: A Self-Portrait. Letters Revealing His Life as a Painter (New York: Dutton, 1963), 319.

**August 11, 1888. Ibid., 313.

**September 8, 1888. Ibid., 321.

ARTISTS ON ART The Letters of Vincent van Gogh

Throughout his life, Vincent van Gogh wrote letters to his brother Theo van Gogh (1857–1891), a Parisian art dealer, on matters both mundane and philosophical. The letters are precious documents of the ups and downs of the painter's life and reveal his emotional anguish. In many of the letters, van Gogh also forcefully stated his views about art, including his admiration for Japanese prints, which he collected and in some cases copied.

In one letter, Vincent told Theo: "In both my life and in my painting, I can very well do without God but I cannot, ill as I am, do without something which is greater than I, . . . the power to create."* For van Gogh, the power to create involved the expressive use of color. "Instead of trying to reproduce exactly what I have before my eyes, I use color more arbitrarily so as to express myself forcibly."† Color in painting, he argued, is "not locally true from the point of view of the delusive realist, argued, is "not locally true from the point of view of the delusive realist,

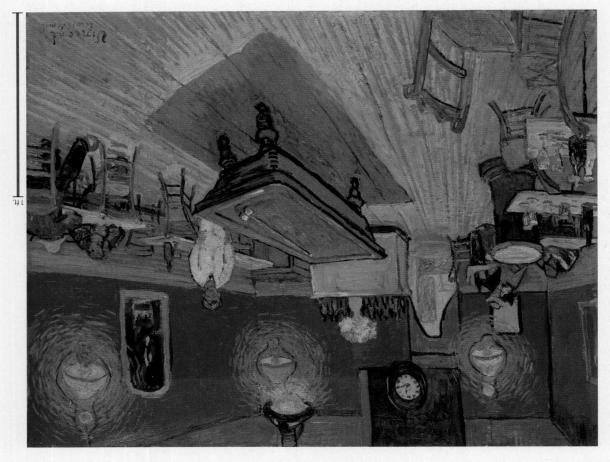

§September 8, 1888. Ibid., 320.

pale luminous green.8

Gooth, Night Café, 1888. Oil on canvas, 2' 4 ½" × 3'. Yale University Art Gallery, New Haven (bequest of Stephen Carlton Clark).

13-11 VINCENT VAN

In Night Cofé, van Gogh explored ways that colors and distorted forms can express emotions. The thickness, shape, and direction of his brushstrokes create a tactile counterpart to the intense colors.

VINCENT VAN GOGH In marked contrast to Seurat, VINCENT VAN GOGH (1853–1890) explored the capabilities of colors and distorted forms to express his emotions. The son of a Dutch Protestant pastor, van Gogh believed he had a religious calling and did missionary work in the coal-mining area of Belgium. Repeated professional and personal failures brought him close to despair. Only after he and personal failures brought him close to despair.

parasols, Seurat placed each form in space to set up a rhythmic movement in depth as well as from side to side. Sunshine fills the picture, but the painter did not break the light into transient patches of color. Light, air, people, and landscape are formal elements in an abstract design in which line, color, value, and shape cohere in a precise and tightly controlled organization.

turned to painting did he find a way to communicate his experiences. When van Gogh died of a self-inflicted gunshot wound at age 37, he considered himself an outcast from society and a failure as an artist. But his work profoundly influenced later artists, especially the Fauves and German Expressionists (see pages 378–382), who built on van Gogh's innovative use of color.

Van Gogh moved to Paris in 1886, and then, in 1888, to Arles in southern France, where he painted Night Café (FIG. 13-11). Although the subject is apparently benign, van Gogh invested it with a charged energy. As he stated in a letter to his brother Theo (see "The Letters of Vincent van Gogh," page 366), he wanted the painting to convey an oppressive atmosphere—"a place where one can ruin oneself, go mad, or commit a crime."5 The room is seen from above, and the floor takes up a large portion of the canvas, as in the paintings of Degas (FIG. 13-5). The ghostly proprietor stands at the edge of the cafe's billiard table, which the painter depicted in such a steeply tilted perspective that it threatens to slide out of the painting into the viewer's space. Van Gogh communicated the "madness" of the place by selecting vivid hues whose juxtaposition augmented their intensity. His insistence on the expressive values of color led him to develop a corresponding expressiveness in his paint application. The thickness, shape, and direction of his brushstrokes created a tactile counterpart to his intense color schemes. He moved the brush vehemently back and forth or at right angles, giving a textilelike effect, or squeezed dots or streaks onto the canvas directly from his paint tubes. This bold, almost slapdash attack enhanced the intensity of his colors.

STARRY NIGHT Similarly illustrative of van Gogh's "expressionist" method is *Starry Night* (FIG. 13-12), which the artist painted in 1889, the year before his death. At this time, van Gogh was living in an asylum in Saint-Rémy, where he had committed himself. In *Starry*

Night, the artist did not represent the sky's appearance. Rather, he communicated his feelings about the electrifying vastness of the universe, filled with whirling and exploding stars, with the earth and humanity huddling beneath it. Given van Gogh's determination to "use color . . . to express [him]self forcibly," the dark, deep blue suffusing the entire painting cannot be overlooked. Together with the turbulent brushstrokes, the color suggests a quiet but pervasive depression. A letter Vincent wrote to his brother reveals his contemplative state of mind at this time:

[L]ooking at the stars always makes me dream, . . . Why, I ask myself, shouldn't the shining dots of the sky be as accessible as the black dots on the map of France? Just as we take the train to get to Tarascon or Rouen, we take death to reach a star.⁶

PAUL GAUGUIN Like van Gogh, with whom he painted in Arles in 1888, PAUL GAUGUIN (1848–1903) rejected objective representation in favor of subjective expression. For Gauguin, the artist's power to determine the colors in a painting was a central element of creativity. However, whereas van Gogh's heavy, thick brushstrokes were an important component of his expressive style, Gauguin's color areas appear flatter, often visually dissolving into abstract patches or patterns.

In 1883, after losing his job as a Parisian stockbroker in the crash of 1882, Gauguin tried to make a living as an artist. Three years later, attracted by Brittany's unspoiled culture, Gauguin moved from Paris to Pont-Aven. Although in the 1870s and 1880s Brittany had been transformed into a profitable market economy focused on tourism, Gauguin still viewed the Bretons as "natural" men and women at ease in their "unspoiled" environment. At Pont-Aven, he painted *Vision after the Sermon*, also called *Jacob Wrestling*

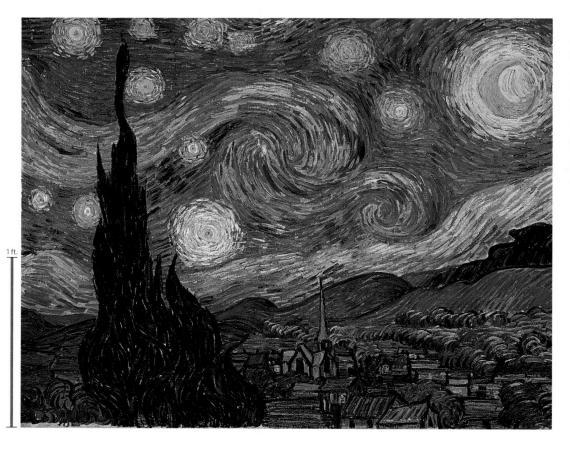

13-12 VINCENT VAN GOGH, Starry Night, 1889. Oil on canvas, 2' $5" \times 3' \frac{1}{4}$ ". Museum of Modern Art, New York (acquired through the Lillie P. Bliss Bequest).

In this late work, van Gogh painted the vast night sky filled with whirling and exploding stars, the earth huddled beneath it. The painting is an almost abstract pattern of expressive line, shape, and color.

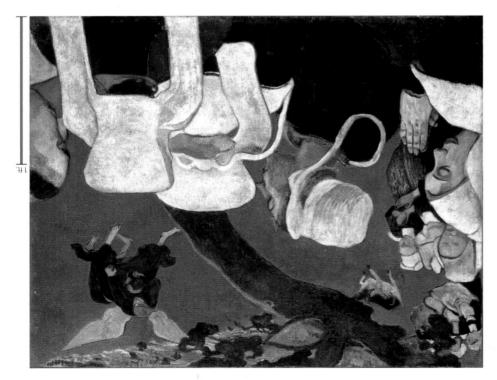

experiment to transform traditional painting and Impressionism into abstract, expressive patterns of line, shape, and pure color.

WHERE DO WE COME FROM? In 1888, Gauguin settled in Tahiti because he believed that it offered him a life far removed from materialistic Europe as well as an opportunity to reconnect with nature. On this arrival, he discovered that the South Pacific island, under French control since 1842, had been extensively colonized. Disappointed, ing to the Tahitian countryside, where he expressed his fascination with primitive life in a series of canvases in which he often based the design on native motifs. The tropical flora of the island inspired the harmonies of lilac, pink, and lemon in his paintings.

13-13 Paul Gauguia, Vision after the Sermon (Jacob Wrestling with the Angel), 1888. Oil on canvas, $\Sigma'4\frac{3}{4}$ " $\times 3'\frac{1}{2}$ ". National Gallery of Scotland, Edinburgh.

Gauguin admired Japanese prints, cloisonné enamels, and stained glass. Their influences are evident in this painting of Breton women, in which firm outlines enclose large areas of unmodulated color.

with the Angel (FIG. 13-13). The painting shows Breton women, wearing their starched white Sunday caps and black dresses, visualizing the sermon they have just heard at church on Jacob's ermon they have just heard at church on Jacob's the far right is a monk who has Gauguin's features. The women and the monk pray devoutly optical realism and composed the picture elements to focus the viewer's attention on the idea and intensify its message. The images are not what the Impressionist eye would have seen and replicated but what Gauguin's memory recalled and his imagination modified. Thus the artist twisted the perspective and allotted most of the twisted the perspective and allotted most of the

space to emphasize the innocent faith of the unquestioning women, and he shrank Jacob and the angel, wrestling in a ring enclosed by a Breton stone fence. Wrestling matches were regular features of the entertainment held after high mass, so Gauguin's women are spectators at a contest that was, for them, a familiar part of their culture.

Gauguin did not unify the picture with a horizon perspective, light and shade, or naturalistic use of color. Instead, he abstracted the scene into a pattern, with the diagonal tree limb symbolically dividing the spiritual from the earthly realm. Pure unmodulated color fills flat planes and shapes bounded by firm lines: white caps, black dresses, and the red field of combat. Gauguin admired Japanese prints and medieval cloisonné metalwork (FIG. 6-2) and stained glass (FIG. 7-11). These art forms contributed to his daring stained glass (FIG. 7-11). These art forms contributed to his daring

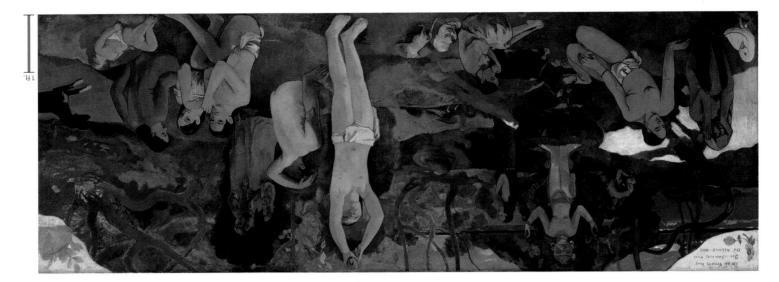

13-14 Paul Gauguin, Where Do We Come From? What Are We? Where Are We Going? 1897. Oil on canvas, $4'6\frac{3}{4}" \times 12'3"$. Museum of Fine Arts, Boston (Tompkins Collection).

In search of a place far removed from European materialism, Gauguin moved to Tahiti, where he used native women and tropical colors to present a pessimistic view of the inevitability of the life cycle.

PROBLEMS AND SOLUTIONS

Making Impressionism Solid and Enduring

Paul Cézanne's desire to "make of Impressionism something solid and enduring" led him to formulate a new approach to the art of painting. whether his subject was landscape (FIG. 13-15), still life (FIG. 13-15A 1), or the human figure. Cézanne's distinctive way of studying nature is evident in Mont Sainte-Victoire (FIG. 13-15), one of many views that he painted of this mountain near his home in Aix-en-Provence. His aim was not truth in appearance, especially not photographic truth, nor was it the "truth" of Impressionism. Cézanne, like Seurat, developed a more analytical style. His goal was to order the lines, planes, and colors of nature, "[to do] Poussin over entirely from nature . . . in the open air, with color and light, instead of one of those works imagined in a studio, where everything has the brown coloring of feeble daylight without reflections from the sky and sun."* He sought to achieve Poussin's effects of distance, depth, structure, and solidity, not by using traditional perspective and chiaroscuro, but rather by recording the color patterns that he deduced from an optical analysis of nature.

Cézanne set out to explore the properties and interrelationships of line, plane, and color. He studied the intrinsic qualities of color and the capacity of lines and planes to create the sensation of depth, as well as the power of colors to modify the direction and depth of lines and planes. To create the illusion of three-dimensional form and space, Cézanne focused on carefully selecting colors. He understood that cool

colors tend to recede, whereas warm ones advance. By applying to the canvas small patches of juxtaposed colors, some advancing and some receding, Cézanne created volume and depth in his works. On occasion, the artist depicted objects chiefly in one hue and achieved convincing solidity by modulating the intensity (or saturation). At other times, he juxtaposed contrasting colors—for example, green, yellow, and red—of similar saturation.

In Mont Sainte-Victoire, Cézanne replaced the transitory visual effects of changing atmospheric conditions, effects that preoccupied Monet, with a more concentrated, lengthier analysis of the colors in large lighted spaces. The main space stretches out behind and beyond the canvas plane and includes numerous small elements, such as roads, fields, houses, and the viaduct at the far right, each seen from a slightly different viewpoint. Above this shifting, receding perspective—so different from traditional Renaissance perspective—the largest mass of all, the mountain, seems simultaneously to be both near and far away, an effect achieved by equally stressing background and foreground contours. Cézanne's rendition of nature approximates the experience that a person has when viewing the forms of nature piecemeal. The relative proportions of objects vary, rather than being fixed by strict linear perspective. Cézanne immobilized the shifting colors of Impressionism into an array of clearly defined planes composing the objects and spaces in his scene. He described his method in a letter to a fellow painter:

[T] reat nature by the cylinder, the sphere, the cone, everything in proper perspective so that each side of an object or a plane is

directed towards a central point. Lines parallel to the horizon give breadth . . . Lines perpendicular to this horizon give depth. But nature for us men is more depth than surface, whence the need of introducing into our light vibrations, represented by reds and yellows, a sufficient amount of blue to give the impression of air.[‡]

*Cézanne to Émile Bernard, March 1904. Quoted in Robert Goldwater and Mario Treves, eds., *Artists on Art, from the XIV* to the XX Century (New York: Pantheon, 1945), 363. †Cézanne to Émile Bernard, April 15, 1904. Ibid., 363.

13-15 PAUL CÉZANNE, Mont Sainte-Victoire, 1902–1904. Oil on canvas, $2' 3\frac{1}{2}" \times 2' 11\frac{1}{4}"$. Philadelphia Museum of Art, Philadelphia (George W. Elkins Collection).

In his landscapes, Cézanne replaced the transitory visual effects of changing atmospheric conditions—the Impressionists' focus—with careful analysis of the lines, planes, and colors of nature.

In 1897, worn down by failing health and the hostile reception of his work, Gauguin tried unsuccessfully to take his own life, but not before painting *Where Do We Come From? What Are We? Where Are We Going?* (FIG. 13-14). Gauguin judged this to be his most important painting. It can be read as a summary of his art and his views on life. The scene is a tropical landscape, populated with

native women and children. Gauguin described the huge canvas in a letter to a friend:

Where are we going? Near to death an old woman.... What are we? Day to day existence.... Where do we come from? Source. Child. Life begins.... Behind a tree two sinister figures, cloaked in garments

appearance revealed. Symbolists cultivated all the resources of imagination, and their subjects became exotic, mysterious, visionarry, dreamlike, and fantastic. Perhaps not coincidentally, at about this time Sigmund Freud (1856–1939), the founder of psychoanalysis, published Interpretations of Dreams (1900), an introduction to the concept and the world of unconscious experience.

HENRI ROUSSEAU Paul Gauguin had journeyed to the South Seas in search of primitive innocence. Henri Rousseau (1844–1910) was a "primitive" without leaving Paris—a self-taught amateur painter. Derided by the critics, Rousseau compensated for his apparent visual, conceptual, and technical naïveté with a natural talent for design and an imagination teeming with exotic images of mysterious tropical landscapes. In Sleeping Gypsy (Fig. 13-16), the recumbent figure occupies a desert world, silent and secret, and dreams beneath a pale, perfectly round moon. In the foreground, a tithe gypsy. The imagery suggests the kind of uneasy encounter a person's vulnerable subconscious self might experience during sleep (the focus of Freud's research). Rousseau's art of drama and fantasy has its own sophistication and, after the artist's death, influenced the development of Surrealism (see page 394).

EDVARD MUNCH Linked in spirit to the Symbolists was the Norwegian artist EDVARD MUNCH (1863–1944). Munch felt deeply the pain of human life and believed that humans were powerless before the great natural forces of death and love. The emotions associated with them—jealousy, loneliness, fear, desire, despair—became the words, to describe the conditions of "modern psychic life," Realist and Impressionist techniques were inappropriate, focusing as they did on the tangible world. Instead, in the spirit of Symbolism, Munch used color, line, and figural distortion for expressive ends.

The Scream (Fig. 13-17) exemplifies Munch's style. The image—aman standing on a bridge—belongs to the real world, but Munch's aman standing on a bridge—belongs to the real world, but Munch's aman standing on a bridge—belongs to the real world, but Munch's

And standing on a bridge—belongs to the real world, but Munch's depiction of the scene departs significantly from visual reality. The Scream evokes a powerful emotional response from the viewer because of the painter's dramatic presentation. The man in the foreground, simplified to almost skeletal form, emits a primal scream.

of somber color, introduce, near the tree of knowledge, their note of anguish caused by that very knowledge in contrast to some simple beings in a virgin nature, which might be paradise as conceived by humanity, who give themselves up to the happiness of living.

Where Do We Come From? is a sobering, pessimistic image of the inevitability of the life cycle. At the center is a Polynesian Eve in the prime of youth. At the left is a crouching old woman contemplating death. Gauguin died a few years later in the Marquesas Islands, his artistic genius still unrecognized.

PAUL CEZANNE Trained as a painter in his native Aix-en-Provence in southern France, PAUL CEZANNE (1839–1906) allied himself early in his career with the Impressionists, accepting their color theories and their faith in subjects chosen from everyday life. But Cézanne's studies of traditional works of Western art in the Louvre persuaded him that Impressionism lacked form and structure. Cézanne declared that he wanted to "make of Impressionism something solid and enduring like the art in the museums." In works such as Mont Sainte-Victoire (FIG. 13-15), he achieved that goal (see such as Mont Sainte-Victoire (FIG. 13-15), he achieved that goal (see such as Mont Sainte-Victoire (FIG. 13-15), he achieved that goal (see

SAMBOLISM

The Impressionists and Post-Impressionists believed that their emotions and sensations were important elements for interpreting the world around them, but the depiction of what they could see remained their primary focus, as it had been for the Realists before them. By the end of the 19th century, many artists turned artists rejected the optical world of daily life in favor of a fantasy world, of forms they conjured in their free imagination. Color, line, and shape, divorced from conformity to the optical image, became symbols of personal emotions in response to the world. Many of the artists following this path adopted an approach to subject and form artists following this path adopted an approach to subject and form strists following this path adopted an approach to subject and form artists following this path adopted an approach to subject and form Symbolism. Symbolists, whether painters or writers, disdained Symbolism as trivial. The task of Symbolist artists was to see through things to a significance and reality far deeper than what superficial things to a significance and reality far deeper than what superficial

13-16 Henri Rousseru, Sleeping Gypsy, 1897. Oil on canvas, 4' $3'' \times 6'$ 7''. Museum of Modern Art, New York (gift of Mrs. Simon Guggenheim).

In Sleeping Gypsy, Rousseau depicted a doll-like but menacing lion sniffing at a recumbent dreaming figure in a mysterious landscape. The painting suggests the vulnerable subconscious during sleep.

13-17 EDVARD MUNCH, *The Scream*, 1893. Tempera and pastels on cardboard, $2' \cdot 11\frac{3}{4}'' \times 2' \cdot 5''$. National Gallery, Oslo.

Although grounded in the real world, *The Scream* departs significantly from visual reality. Munch used color, line, and figural distortion to evoke a strong emotional response from the viewer.

The landscape's sweeping curvilinear lines reiterate the shapes of the man's mouth and head, almost like an echo, as the cry seems to reverberate through the setting. The fiery red and yellow stripes that give the sky an eerie glow also contribute to this work's resonance. Munch wrote a revealing epigraph to accompany the painting:

I was walking along the road with two friends. The sun was setting. I felt a breath of melancholy—Suddenly the sky turned blood-red. I stopped, and leaned against the railing, deathly tired—looking out across the flaming clouds that hung like blood and a sword over the blue-black fjord and town. My friends walked on—I stood there, trembling with fear. And I sensed a great, infinite scream pass through nature.

Appropriately, the original title of this work was Despair.

FIN-DE-SIÈCLE Historians have adopted the term *fin-de-siècle* (French, "end of the century") to describe European culture of the late 1800s. This designation is not merely chronological but also refers to a certain sensibility. At that time, the increasingly large and prosperous middle classes were aspiring to gain the advantages that the aristocracy traditionally enjoyed. The masses, striving to live "the good life," embraced a culture of decadence and indulgence. Char-

acteristic of the fin-de-siècle period was an intense preoccupation with sexual drives, powers, and perversions. People at the end of the century also immersed themselves in an exploration of the unconscious. This culture was unrestrained and freewheeling, but the determination to enjoy life masked an anxiety prompted by significant political upheaval and an uncertain future. The country most closely associated with fin-de-siècle culture was Austria.

GUSTAV KLIMT The Viennese artist Gustav Klimt (1863–1918) captured this period's flamboyance in his work, but tempered it with unsettling undertones. In *The Kiss* (FIG. 13-18), Klimt depicted a kneeling couple locked in an embrace. The setting is ambiguous, perhaps a flower garden, and all the viewer sees of the man and woman is a small segment of each body—and virtually nothing of the man's face. The rest of the

13-18 GUSTAV KLIMT, *The Kiss*, 1907–1908. Oil on canvas, $5' 10\frac{3}{4}" \times 5' 10\frac{3}{4}"$. Österreichische Galerie Belvedere, Vienna.

Klimt's paintings exemplify the Viennese finde-siècle spirit. In *The Kiss*, he revealed only a small segment of each lover's body. The rest of the painting dissolves into shimmering, extravagant flat patterning.

mood and sensuality embody the fin-de-siècle spirit. The swirling composition and emotionalism recall Delacroix's Death of Sardana-palus (Fig. 12-7) and Michelangelo's Last Judgment (Fig. 9-11). But Rodin's work defies easy stylistic classification.

The nearly 200 figures of The Gates of Hell spill over onto the jambs and the lintel. Rodin also included freestanding figures, which, cast separately in multiple versions, are among his best-known works. Above the doors, The Three Shades is a trio of twisted nude male figures, essentially the same figure with elongated arms in three different positions. The Thinker, Rodin's famous seated nude man with a powerful body who rests his chin on his clenched right hand, ponders the fate of the tormented souls on the doors below.

canvas dissolves into shimmering, extravagant flat patterning, evoking the tension between two- and three-dimensionality intrinsic to the work of many other modernists. In The Kiss, however, those patterns also signify gender contrasts—rectangles for the man's garment, circles for the woman's. Yet the patterning also unites the two lovers incles for the woman's, and the patterning their erotic union.

SCULPTURE

The names of the sculptors of the late 19th century are not as familiar as those of the painters of the same era, in part because their work was less revolutionary in nature, in part because their biographies are not as colorful.

ated preliminary versions of his sculptures with coils a model move around in front of him while he crelight on cast bronze. In his studio, he often would have ture, catching the fugitive play of constantly shifting with fingers sensitive to the subtlest variations of texrather than a stone-carver, Rodin worked his surfaces ished planes."10 Primarily a modeler of pliable material hollows and mounds, not of smoothness, or even polsoul, love, passion, life. . . . Sculpture is thus the art of surface, which means all that vibrates on the surface, rior, saying, "The sculptor must learn to reproduce the movement with special attention to the body's extehe joined his profound knowledge of anatomy and sculpted surfaces. When focusing on the human form, in Rodin's abiding concern for the effect of light on his work, the influence of Impressionism is evident vations. Although color was not a significant factor in Rodin was also well aware of the Impressionists' innoand executed his sculptures with a Realist sensibility. eta was Auguste Rodin (1840–1917), who conceived AUGUSTE RODIN The leading French sculptor of the

nects Rodin with the Symbolists, and the pessimistic dreamlike (or rather, the nightmarish) vision conspace in a reflection of their psychic turmoil. The seem to be in flux, moving in and out of an undefined of light on the highly textured surfaces, the figures height of the relief, the complex poses, and the effect circle of Hell for their lust. Because of the varying and women, sinners condemned to Dante's second with a continuous writhing mass of tormented men panels and decided instead to cover each of the doors abandoned the idea of a series of framed narrative Ghiberti's Gates of Paradise (FIG. 8-15), Rodin quickly laire's Flowers of Evil. Originally inspired by Lorenzo theme of his doors from Dante's Inferno and Baudehis still-unfinished doors in bronze. Rodin derived the was not until after the sculptor's death that others cast Paris. The museum was never built, however, and it of doors for a planned Museum of Decorative Arts in 1880, Rodin received the commission to design a pair Burghers of Calais (FIG. 13-19A (A). On August 16, what is perhaps his best-known sculptural group, him for two decades, during which he also produced nearly 21-foot-tall Gates of Hell (FIG. 13-19), occupied THE GATES OF HELL Rodin's most ambitious work, the

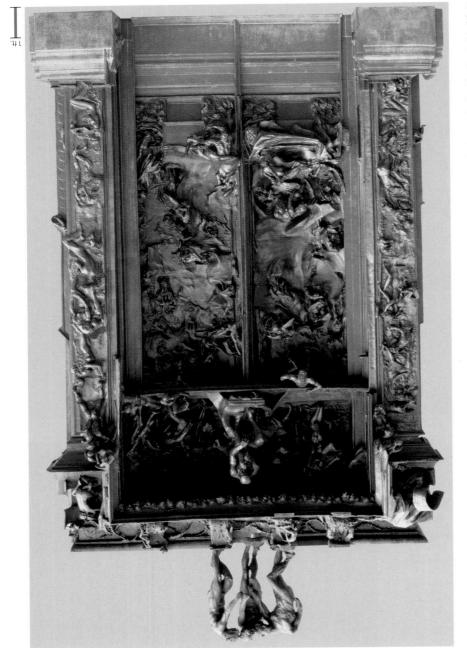

13-19 Auguste Rodin, The Gates of Hell, 1880–1900 (cast in 1917). Bronze, 20° 10° \times 13° 1". Musée Rodin, Paris.

Rodin's most ambitious work, inspired by Dante's Inferno and Ghiberti's Gates of Paradise (FIG. 8-15), presents nearly 200 tormented sinners in relief below The Three Shades and The Thinker.

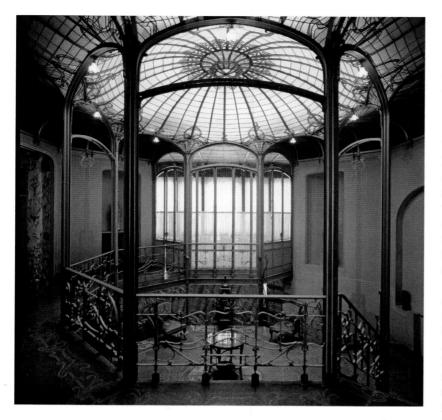

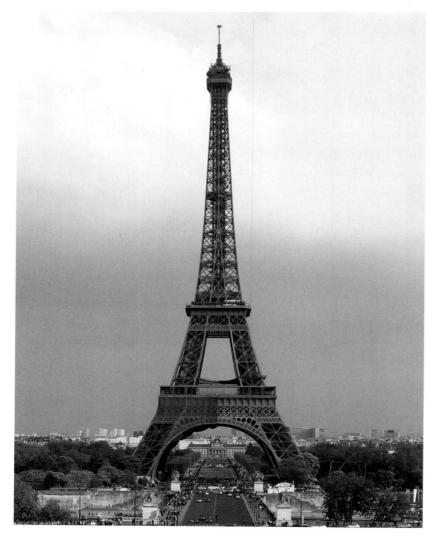

13-20 VICTOR HORTA, staircase in the Van Eetvelde House, Brussels, 1895.

The Art Nouveau movement was an attempt to create art and architecture based on natural forms. Here, every detail conforms to the theme of the twining plant and functions as part of a living whole.

ARCHITECTURE

In the later 19th century, new technologies, the availability of steel, and the changing needs of urbanized, industrialized society affected architecture throughout the Western world. The Realist impulse also encouraged architectural designs that honestly expressed a building's purpose rather than elaborately disguised a building's function. But the taste for elaborate ornamentation also remained strong in an era characterized by stylistic diversity.

ART NOUVEAU An important international architectural and design movement that developed in the closing decades of the 19th century was *Art Nouveau* (New Art), which took its name from a shop in Paris called L'Art Nouveau. Proponents of this movement tried to synthesize all the arts in a determined attempt to create art based on natural forms that could be mass-produced for a large audience. The Art Nouveau style adapted the twining-plant form to the needs of architecture, painting, sculpture, and the decorative arts.

The mature Art Nouveau style is on display in the staircase (FIG. 13-20) of the Van Eetvelde House in Brussels, designed by the Belgian architect VICTOR HORTA (1861–1947). Every detail of the Van Eetvelde interior functions as part of a living whole. Furniture, drapery folds, veining in the lavish stone paneling, and the patterning of the door moldings join with real plants to provide graceful counterpoints for the twining-plant theme. Metallic tendrils curl around the railings and posts, delicate metal tracery fills the glass dome, and floral and leaf motifs spread across the fabric panels of the screen.

Art Nouveau was not solely a French/Belgian phenomenon. The style was also popular in Holland, England, and the United States and, under different names, in Austria and Germany (*Jugendstil*), Italy (*Stile Floreale*), and Spain (*Modernismo*), where Antonio Gaudi (1852–1926; FIG. 13-20A 🗹) was its leading proponent.

ALEXANDRE-GUSTAVE EIFFEL The French engineer-architect who is best known for exploiting new technologies to create larger, stronger, and more fire-resistant structures free of superfluous ornamentation was ALEXANDRE-GUSTAVE EIFFEL (1832–1923). Eiffel created the interior armature for France's anniversary gift to the United States—the *Statue of Liberty*—but he designed his signature work, the Eiffel Tower (FIG. 13-21), for an

13-21 ALEXANDRE-GUSTAVE EIFFEL, Eiffel Tower (looking southeast), Paris, France, 1889.

New materials and technologies and the modernist aesthetic fueled radically new architectural designs in the late 19th century. Eiffel jolted the world with the exposed iron skeleton of his tower.

looking southeast), Chicago, 1899-1904. 13-22 Louis Henry Sullivan Center (formerly Carson, Pirie, Scott Building;

open, well-illuminated display spaces. It has a minimal structural steel skeleton with a glass and Sullivan's motto was "form follows function." This Chicago department store required broad,

modernism as the new cultural orthodoxy of the early 20th century. each in his own way, contributed significantly to the entrenchment of and painters as different as Sullivan, Monet, van Gogh, and Cézanne, modes of expression, often emphatically rejecting the past. Architects century was a period during which artists challenged traditional Thus in architecture as well as in the pictorial arts, the late 19th

following additional subjects: buildings, Google Earth $^{\text{\tiny TM}}$ coordinates, and essays by the author on the Explore the era further in MindTap with videos of major artworks and

■ ART AND SOCIETY: Academic Salons and Independent Art Exhibitions

- Édouard Manet, Claude Monet in His Studio Boat (FIG. 13-2A)
- George Seurat, detail of La Grande Jatte (FIG. 13-10Å)
- MATERIALS AND TECHNIQUES: Pointillism and 19th-Century
- Color Theory
- Auguste Rodin, Burghers of Calais (FIG. 13-19A) Paul Cézanne, Basket of Apples (FIG. 13-15A)
- Antonio Gaudi, Casa Milá, Barcelona (FIG. 13-20A)

tural design. possible a radically innovative approach to architecization that modern materials and processes made Eiffel jolted the architectural profession into a realextent never before achieved or even attempted. distinction between interior and exterior to an the legs. The transparency of the structure blurs the the heavy horizontal girders needed to strengthen open-frame skirts that provide a pleasing mask for four giant supports connected by gracefully arching tion the world's tallest structure. The tower rests on above the city, making it at the time of its construcelegant iron tower thrusts its needle shaft 984 feet diately became the symbol of modern Paris. The as the Roman arch and the Gothic spire, it immepays tribute to traditional architectural forms, such exhibition in Paris in 1889. Although the tower

height, gave birth to the American skyscraper. which could support structures of unprecedented to raise the roof. The new construction materials, increased property values forced architects literally nience required closely grouped buildings, and with the second's fire resistance. In cities, convein masonry, combining the first material's strength ous to fire. This discovery led to encasing the metal strated that cast iron by itself was far from impervi-1870s in New York, Boston, and Chicago demontecture until a series of disastrous fires in the early States enthusiastically developed cast-iron archiespecially commercial ones. Architects in the United and wrought iron for many building programs, reduction in fire hazards, prompted the use of cast speed and economy in building, as well as for a LOUIS HENRY SULLIVAN The desire for greater

spirit of late-19th-century commerce. To achieve and ornamentation that perfectly expressed the 1924) arrived at a synthesis of industrial structure these buildings. Louis Henry Sullivan (1856in 1868, architects refined the visual vocabulary of because of the introduction of elevators beginning As skyscrapers proliferated, in large part

that "form follows function," which became the slogan of many its users. The Sullivan Center illustrates Sullivan's famous dictum ment store's design to meet the functional and symbolic needs of ing of the maturing consumer economy and tailored the depart-In this early skyscraper, Sullivan revealed his profound understandthe display windows as pictures, which merited elaborate frames. invention) made of wildly fantastic motifs. The architect regarded gave over the lowest two levels to an ornament in cast iron (of his ing as a minimal structural steel skeleton with a stone overlay and open, well-illuminated display spaces. Sullivan designed the build-Built between 1899 and 1904, this department store required broad, tics are evident in Sullivan's Sullivan Center (FIG. 13-22) in Chicago. workspaces with a sense of refinement and taste. These characteristo connect commerce and culture, and imbued these white-collar and interiors with ornate embellishments. Such decoration served filled, well-ventilated office buildings and adorned both exteriors this, he used the latest technological developments to create light-

early-20th-century architects.

IMPRESSIONISM, POST-IMPRESSIONISM, AND SYMBOLISM, 1870 TO 1900

Impressionism

A hostile critic applied the term *Impressionism* to the paintings of Claude Monet because of their sketchy quality. The Impressionists—Monet, Pierre-Auguste Renoir, Edgar Degas, and others—were a diverse group. Some strove to capture fleeting moments and transient effects of light and climate on canvas. Others focused on recording the contemporary urban scene in Paris, frequently painting in bars, dance halls, and railroad stations. Many Impressionist compositions feature figures seen at sharply oblique angles and arbitrarily cut off by the frame, reflecting the influence of Japanese prints.

Degas, The Rehearsal, 1874

Post-Impressionism

- Post-Impressionism is not a unified style. The term refers to the group of late-19th-century artists who followed the Impressionists and took painting in new directions.
- Georges Seurat refined the Impressionist approach to color and light into pointillism—the disciplined application of pure color in tiny daubs.
- Vincent van Gogh explored the capabilities of colors and distorted forms to express emotions, as in his dramatic depiction of a billiard parlor in Night Café.
- Paul Gauguin moved away from Impressionism in favor of large areas of flat color bounded by firm lines.
- Paul Cézanne replaced the transitory visual effects of the Impressionists with a rigorous analysis of the lines, planes, and colors that make up landscapes and still lifes.

Van Gogh, Night Café, 1888

Gauguin, Where Do We Come From? 1897

Symbolism

- Henri Rousseau and the Symbolists disdained Realism as trivial and sought to depict a reality beyond that of the everyday world, rejecting materialism and celebrating fantasy and imagination. The subjects of their paintings were often mysterious, exotic, and sensuous, sometimes alluding to the world of the subconscious during sleep.
- The leading sculptor at the end of the 19th century was Auguste Rodin, who explored Realist themes and the representation of movement. His vision of tormented, writhing figures in Hell connects his work with the Symbolists.

Rodin, Gates of Hell, 1880-1900

Architecture

New technologies and the changing needs of urbanized, industrialized society transformed architecture in the late 19th century. The exposed iron skeleton of the Eiffel Tower, which blurs the distinction between interior and exterior, jolted architects into a realization of how modern materials and processes could revolutionize architectural design. In the United States, Louis Sullivan was a pioneer in designing the first metal, stone, and glass skyscrapers.

Sullivan, Sullivan Center, Chicago, 1899-1904

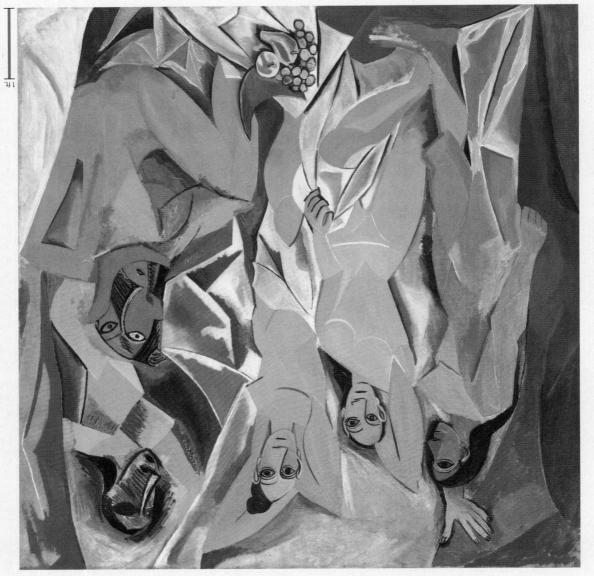

PABLO PICASSO, Les Demoiselles d'Avignon, 1907. Oil on canvas, 8' × 7' 8".

Museum of Modern Art, New York (acquired through the Lillie P. Bliss Bequest).

■ 14-1c By breaking the figures of the demoiselles into ambiguous planes, as if the viewer were seeing them from more than one place in space at once, Picasso disrupted the standards of Western art since the Renaissance.

■ 14-1b The striated features of the distorted heads of the two young Avignon Street prostitutes at the right grew directly from Picasso's increasing fascination with African artworks, which he studied and collected.

▲ 14-1a "Primitive" art helped inspire Picasso's radical break with traditional Western norms of pictorial representation. Ancient Iberian sculptures were the sources of the features of the features of the three young women at the left.

Modernism in Europe and America, 1900 to 1945

PICASSO DISRUPTS THE WESTERN PICTORIAL TRADITION

An artist whose importance to the history of art is uncontested, Pablo Picasso (1881–1973) was blessed with boundless talent and an inquisitive intellect that led him to make groundbreaking contributions to Western pictorial art. In 1907, with *Les Demoiselles d'Avignon (The Young Ladies of Avignon*; Fig. 14-1), he opened the door to a radically new method of representing forms in space. Picasso began the work as a symbolic picture to be titled *Philosophical Bordello*, portraying two male clients (who, based on surviving drawings, had features resembling Picasso's) intermingling with women in the reception room of a brothel on Avignon Street in Barcelona. One was a sailor. The other carried a skull, an obvious reference to death. By the time the artist finished, he had eliminated both men and simplified the room's details to a suggestion of drapery and a schematic foreground still life. Picasso had become wholly absorbed in the problem of finding a new way to represent the five women in their interior space. Instead of depicting the figures as continuous volumes, he fractured their shapes and interwove them with the equally jagged planes representing drapery and empty space. Indeed, the space, so entwined with the bodies, is virtually illegible. The tension between Picasso's representation of three-dimensional space and his modernist conviction that a painting is a two-dimensional design on the surface of a stretched canvas is a tension between representation and abstraction.

Picasso extended the radical nature of *Les Demoiselles d'Avignon* even further by depicting the figures inconsistently. Ancient Iberian sculptures inspired the calm, ideal features of the three prostitutes at the left. The energetic, violently striated features of the heads of the two women at the right emerged late in Picasso's production of the work and grew directly from his increasing fascination with African sculpture. Perhaps responding to the energy of these two new heads, Picasso also revised the women's bodies. He broke them into more ambiguous planes suggesting a combination of views, as if the observer sees the figures from more than one place in space at once. The woman seated at the lower right shows these multiple angles most clearly, seeming to present the observer simultaneously with a three-quarter back view from the left, another from the right, and a front view of the head that suggests seeing the figure frontally as well. Gone is the traditional Renaissance concept of an orderly, constructed, and unified pictorial space mirroring the world. In its place are the rudimentary beginnings of a new approach to representing the world—as a dynamic interplay of time and space. Picasso's *Les Demoiselles d'Avignon* was nothing less than a dramatic departure from and disruption of the Western pictorial tradition. It set the stage for many other artistic revolutions in the 20th century.

(bequest of Elise S. Haas). $2^{\circ} \wedge \frac{3}{4}^{\circ} \times 1^{\circ} \prod_{1}^{1}$. San Francisco Museum of Modern Art, San Francisco 14-2 Henri Matisse, Woman with the Hat, 1905. Oil on canvas,

imitate nature but to produce a reaction in the viewer. seemingly arbitrary colors. He and the other Fauve painters used color not to Matisse's portrayal of his wife, Amélie, features patches and splotches of

and splotches of color juxtaposed in ways that sometimes produce the woman's face, clothes, hat, and background—consists of patches the seemingly arbitrary colors startle the viewer. The entire imagewife, Amélie, in a rather conventional manner compositionally, but page 379). In Woman with the Hat (FIG. 14-2), Matisse depicted his his efforts on developing this notion (see "Henri Matisse on Color," a primary role in conveying meaning, and consequently focused HENRI MATISSE (1869-1954), who believed that color could play HEURI MATISSE The dominant figure of the Fauve group was

AND ARTISTIC REVOLUTION

GLOBAL UPHEAVAL

ing the first half of the last century. explored been as pronounced or as long-lasting as those born durnomic upheaval, but never before had the new directions that artists artistic revolution has often accompanied political, social, and ecoof art and what form an artwork should take. Throughout history, challenged some of the most basic assumptions about the purpose also a time of radical change in the arts when painters and sculptors and Nazism, and suffered the Great Depression. These decades were fought two global wars, witnessed the rise of Communism, Fascism, worldwide. Between 1900 and 1945, the major industrial powers The first half of the 20th century was a period of significant upheaval

ment had challenged artistic conventions with ever-greater intensity. Beginning in the 19th century, each successive modernist movesearched for new definitions of and uses for art in a changed world. from Communism to corporate capitalism, took their places, artists 20th century. As the old social orders collapsed and new ones, the effects of the political and economic disruptions of the early AVANT-GARDE Like other members of society, artists deeply felt

avenues of expression in all artistic media. premises and formal conventions of Western art and explored new Avant-garde artists were likewise trailblazers. They questioned the refers to the French troops that bravely scouted behind enemy lines. of an artistic avant-garde. The term, which means "front guard," This relentless questioning of the status quo gave rise to the notion

EUROPE, 1900 TO 1920

century, beginning with the artistic movement known as Fauvism. Europe (MAP 14-1; page 380) during the opening decades of the 20th Avant-garde artists in all their diversity became a major force in

Fauvism

colors have on emotions. from its descriptive function and exploring the effects that different pages 366-370), the Fauves went even further in liberating color legacy of artists such as Vincent van Gogh and Paul Gauguin (see ing intense color juxtapositions for expressive ends. Building on the develop an art having the directness of Impressionism but employ-Jauves ("wild beasts"). Driving the Fauve movement was a desire to tled critic, Louis Vauxcelles (1870-1943), described the artists as simplified in design and so shockingly bright in color that a star-In 1905, a group of young French painters exhibited canvases so

MODERNISM IN EUROPE AND AMERICA, 1900 TO 1945

1910-1920

- Calder creates abstract sculptures celebrate African American culture. ■ Douglas and Lawrence's paintings
- The Regionalists celebrate life in rural with moving parts.
- Orozco and Rivera paint mural cycles America.
- Lange and Bourke-White achieve of Mexican history.
- fame for their documentary
- Neue Sachlichkeit painters depict the 1920-1930
- the unconscious. ■ The Surrealists represent the world of horrors of war.
- art" using geometric forms and ■ De Stijl artists create "pure plastic
- abstract sculpture. Brancusi and Hepworth promote primary colors.
- tion of all the arts. The Bauhaus advocates the integra-
- motion and modern technology. Italian Futurists celebrate dynamic Picasso and Braque invent Cubism.
- The Armory Show introduces chance in irreverent artworks. The Dadaists explore the role of
- colors and distorted forms. produce paintings featuring bold abstract paintings. Kandinsky produces completely Brücke and Der Blaue Reiter-German Expressionist groups—Die from its descriptive function. Matisse and the Fauves free color
- representation. America to European modernism. reject traditional Western modes of "Primitive" art inspires Picasso to

ARTISTS ON ART

Henri Matisse on Color

In an essay titled "Notes of a Painter," published in the Parisian journal *La Grande Revue* on Christmas Day 1908, Henri Matisse responded to his critics and set forth his principles and goals as a painter. The following excerpts help explain what Matisse was trying to achieve in paintings such as *Red Room* (FIG. 14-3).

What I am after, above all, is expression. . . . Expression, for me, does not reside in passions glowing in a human face or manifested by violent movement. The entire arrangement of my picture is expressive: the place occupied by the figures, the empty spaces around them, the proportions, everything has its share. Composition is the art of arranging in a decorative manner the diverse elements at the painter's command to express his feelings. . . .

Both harmonies and dissonances of color can produce agreeable effects.... Suppose I have to paint an interior. I have before me a cupboard; it gives me a sensation of vivid red, and I put down a red

which satisfies me. A relation is established between this red and the white of the canvas. Let me put a green near the red, and make the floor yellow; and again there will be relationships between the green or yellow and the white of the canvas which will satisfy me. . . . A new combination of colors will succeed the first. . . . From the relationship I have found in all the tones there must result a living harmony of colors, a harmony analogous to that of a musical composition. . . .

The chief function of color should be to serve expression as well as possible. . . . I simply try to put down colors which render my sensation. There is an impelling proportion of tones that may lead me to change the shape of a figure or to transform my composition. Until I have achieved this proportion in all parts of the composition I strive towards it and keep on working. Then a moment comes when all the parts have found their definite relationships, and from then on it would be impossible for me to add a stroke to my picture without having to repaint it entirely.*

*Translated by Jack D. Flam, Matisse on Art (London: Phaidon, 1973), 32-40.

14-3 HENRI MATISSE, Red Room (Harmony in Red), 1908–1909. Oil on canvas, 5' 11" × 8' 1". State Hermitage Museum, Saint Petersburg.

Matisse believed that painters should choose compositions and colors that express their feelings. Here, the table and the wall seem to merge because they are the same color and have identical patterning.

jarring contrasts. Matisse explained his approach: "What characterized Fauvism was that we rejected imitative colors, and that with pure colors we obtained stronger reactions."

Matisse's exploration of the expressive power of color reached maturity in *Red Room* (*Harmony in Red*; FIG. 14-3). The subject is the interior of a comfortable, prosperous household with a maid placing fruit and wine on the table, but Matisse's canvas is radically different from traditional paintings of domestic interiors (compare FIG. 10-24). The Fauve painter depicted objects in simplified

and schematized fashion and flattened out the forms. For example, Matisse eliminated the front edge of the table, rendering the table, with its identical patterning, as flat as the wall behind it. The window at the upper left could also be a painting on the wall, further flattening the space. Everywhere, the colors contrast richly and intensely. Initially, this work was predominantly green. Matisse repainted it blue, but blue also did not seem appropriate to him. Not until he repainted the canvas red did Matisse feel that he had found the right color for the "harmony" he wished to compose.

German Expressionism

Scream (FIG. 13-17). Munch, who made similar expressive use of formal elements in The figures, and color choices reflect the influence of the work of Edvard impact of the image. Kirchner's perspective distortions, disquieting orange, emerald green, chartreuse, and pink-add to the expressive

eliciting intense emotional responses from viewers. paintings that captured the artists' feelings in visual form while also the color blue and in horses. Like Die Brücke, this group produced whimsically selected this name because of their mutual interest in The two founding members, Vassily Kandinsky and Franz Marc, group, Der Blaue Reiter (The Blue Rider), formed in Munich in 1911. VASSILY KANDINSKY The second major German Expressionist

ghoulish, and the garish, clashing colors—juxtapositions of bright

space, much like composers create music out of notes, which do not their innermost feelings by orchestrating color, form, line, and painted Improvisation 28. Artists, Kandinsky believed, must express cerning the Spiritual in Art, published in 1912, the same year that he gible things. He articulated his ideas in an influential treatise, Conhad no real substance, thereby shattering his belief in a world of tan-Early 20th Century" (1), which convinced him that material objects sion the new scientific theories of the era (see "Science and Art in the Kandinsky was one of the few artists to read with some comprehenabstraction, as in Improvisation 28 (FIG. 14-5). A true intellectual, Indeed, Kandinsky was one of the first artists to explore complete Munich in 1896 and soon developed a spontaneous expressive style. Born in Russia, Vassily Kandinsky (1866-1944) moved to

> ERNST LUDWIG KIRCHNER The first group of German Expresdistortions of form, ragged outlines, and agitated brushstrokes. "expressiveness" of many of the images is due as much to wrenching although color plays a prominent role in German Expressionism, the to many artists, especially the German Expressionists. However, Derain (1880-1954; fig. 14-3A A), and the other Fauves appealed The immediacy and boldness of the canvases of Matisse, Andre

> nature. Harshly rendered, the women's features make them appear the women into the viewer's space, increases their confrontational acingly. The steep perspective of the street, which threatens to push women in the foreground loom large, approaching somewhat menscene is jarring and dissonant in both composition and color. The tant, panoramic urban view of the Impressionists, Kirchner's street a bustling German city of that time. Rather than offering the dis-(FIG. 14-4) provides a glimpse into the frenzied urban activity of fostered a mechanized and impersonal society. His Street, Dresden tion, such as the alienation of individuals in cities, which he felt much of his attention on the detrimental effects of industrializaat the opening of the 20th century. Kirchner, in particular, focused their name. The Bridge artists lamented the state of German society for a more perfect age by bridging the old age and the new, hence 1938). The group members thought of themselves as paving the way in 1905 under the leadership of Ernst Ludwig Kirchner (1880– sionists—Die Brücke (The Bridge)—gathered in Dresden (MAP 14-1)

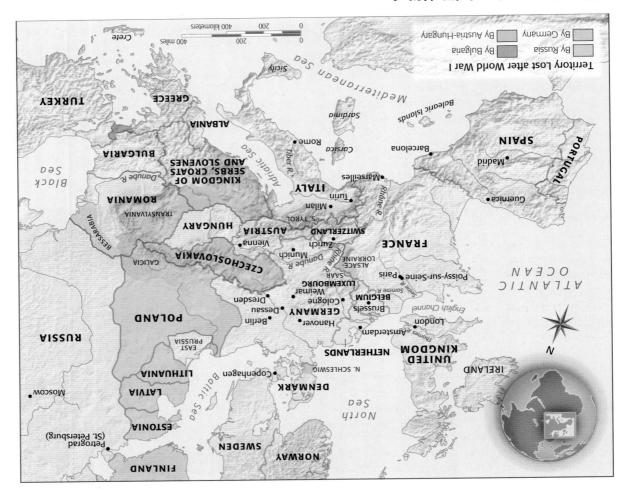

MAP 14-1 Europe at the end of World War I.

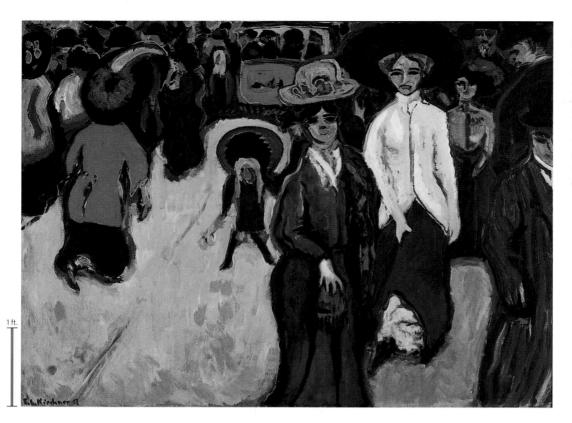

14-4 ERNST LUDWIG KIRCHNER, Street, Dresden, 1908 (dated 1907). Oil on canvas, 4' $11\frac{1}{4}$ " × 6' $6\frac{7}{8}$ ". Museum of Modern Art, New York.

Kirchner's perspective distortions, disquieting figures, and color choices reflect the influence of the Fauves and of Edvard Munch (Fig. 13-17), who made similar expressive use of formal elements.

mimic the sounds of nature. In his *Improvisation* series, Kandinsky sought to convey feelings solely by color juxtapositions, intersecting lines, and implied spatial relationships. Ultimately, Kandinsky saw these abstractions as evolving blueprints for a more enlightened and liberated society emphasizing spirituality.

FRANZ MARC Like many of the other German Expressionists, Franz Marc (1880–1916) grew increasingly pessimistic about the state of humanity, especially as World War I loomed on the horizon.

His perception of human beings as deeply flawed prompted him to turn to the animal world for his subjects. Animals, he believed, were more pure than humans and thus more appropriate vehicles for expressing an inner truth. In his quest to imbue his paintings with greater emotional intensity, Marc focused on color and developed a system of correspondences between specific colors and feelings or ideas. According to Marc, "Blue is the *male* principle, severe and spiritual. Yellow is the *female* principle, gentle, happy and sensual. Red is *matter*, brutal and heavy."²

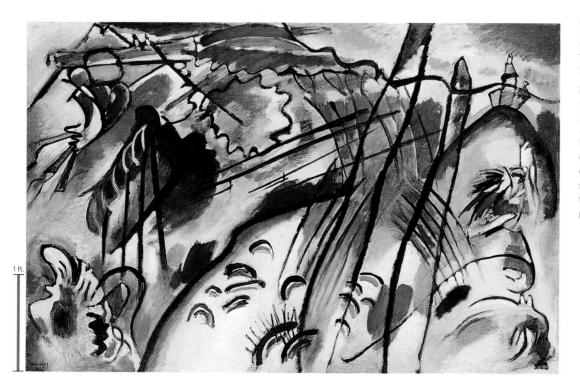

14-5 Vassily Kandinsky, Improvisation 28 (second version), 1912. Oil on canvas, $3' 7\frac{7}{8}" \times 5' 3\frac{7}{8}"$. Solomon R. Guggenheim Museum, New York (gift of Solomon R. Guggenheim, 1937).

Kandinsky believed that artists must express their innermost feelings by orchestrating color, form, line, and space. He was one of the first artists to explore complete abstraction in paintings called *Improvisations*.

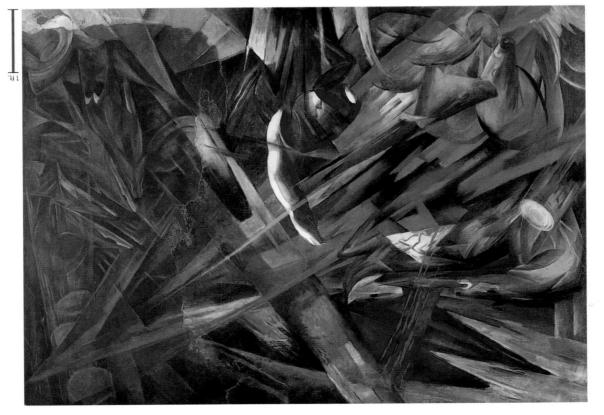

14-6 Franz Marc, Fare of the Animals, 1913. Oil on canvas, 6' $4\frac{1}{4}$ " \times 8' $9\frac{1}{2}$ ". Kunstmuseum Basel, Basel.

Marc developed a system of correspondences between specific colors and feelings or ideas. In this apocalyptic scene of animals trapped in a forest, the colors of severity and brutality dominate.

comparable emotional impact. Because Kollwitz used her son Peter as the model for the dead child, the image was no doubt all the more personal to her. The print stands as a poignant premonition. Peter died fighting in World War I at age 21.

14-7 KÄTHE KOLLWITZ, Woman with Dead Child, 1903. Etching overprinted lithographically with a gold-tone plate, $1'4\frac{5}{8}" \times 1'7\frac{1}{8}"$. British Museum, London.

The theme of the mother mourning over her dead child derives from images of the Pietà in Christian art, but Kollwitz transformed it into a powerful universal statement of maternal loss and grief.

with tragic irony, in his death in action in World War I in 1916. inhumanity and his attempt to express that through his art ended, can hardly conceive that I painted it."3 Marc's contempt for people's mals] is like a premonition of this war-horrible and shattering. I in battle prompted him to tell his wife in a letter: "[Fate of the Aniwhen he ended up at the front the following year. His experiences ered just how well his painting portended war's anguish and tragedy colors of severity and brutality dominate the work. Marc discovcolors—the passive, gentle, and cheerful ones—are absent, and the shattered it into fragments. Significantly, the lighter and brighter animals inhabiting it. The painter distorted the entire scene and trees, some apocalyptic event destroying both the forest and the vaded society, the animals appear trapped in a forest amid falling in 1913, when the horrific tension of impending warfare had per-Marc's efforts to create, in a sense, an iconography of color. Painted Fate of the Animals (FIG. 14-6) represents the culmination of

EXPITES KOLLWITZ The emotional power of postwar German Expressionism is also evident in the graphic work of KÄTHE KOLLWITZ (1867–1945), although she had no formal association with any Expressionist group. Kollwitz explored a range of issues from the overtly political to the deeply personal. One subject that she treated repeatedly was that of a mother with her dead child. Although she initially derived the theme from the Christian Pietà, and grief. In Woman with Dead Child (FIG. 14-7), she replaced the reverence and grace pervading most depictions of Mary holding the dead Christ (FIG. 9-7) with an animalistic passion. The grieving mother ferociously grips the body of her dead child. The prima mother ferociously grips the body of her dead child. The prima mother ferociously grips the body of her dead child. The prima mal nature of the undeniably powerful image is in keeping with the sims of the Expressionists. Not since the Gothic age in Germany aims of the Expressionists. Not since the Gothic age in Germany (FIG. 7-27) had any artist produced a mother-and-son group with a sims of the Expressionists. Not since the Gothic age in Germany (FIG. 7-27) had any artist produced a mother-and-son group with a sims of the Lagrange and any artist produced a mother-and-son group with a

Cubism and Purism

At the same time that the Fauves and German Expressionists were taking painting in new directions, Pablo Picasso was disrupting the history of art in other ways with his revolutionary 1907 *Les Demoiselles d'Avignon* (FIG. 14-1). Although the painting incorporates references to the Western pictorial tradition—for example, a variation on an Archaic Greek *kouros* statue (FIG. 2-17) for the standing woman at the left and a doubtless intentional tribute to Manet's *Déjeuner sur l'Herbe* (FIG. 12-17) for the seated woman at the right—it stands apart from that tradition not only in formal terms but in the representation of nude women as threatening rather than as passive figures on display for the pleasure of male viewers. Picasso's rethinking of the premises of Western art was largely inspired by his fascination with "primitive" art, which he had studied in Paris's Trocadéro ethnography museum and collected and kept in his Paris studio (see "Primitivism and Colonialism" (**).

ANALYTIC CUBISM For many years, Picasso showed Les Demoiselles d'Avignon only to other painters. One of the first to see it was Georges Braque (1882-1963), a Fauve painter who found it so challenging that he began to rethink his own painting style. Using the painting's revolutionary elements as a point of departure, together Braque and Picasso formulated Cubism around 1908 in the belief that the art of painting had to move far beyond the description of visual reality. Cubism represented a radical turning point in the history of art, nothing less than a dismissal of the pictorial illusionism that had dominated Western art since the Renaissance. The Cubists rejected naturalistic depictions, preferring compositions of shapes and forms abstracted from the conventionally perceived world. As Picasso once explained: "I paint forms as I think them, not as I see them."4 Together, Picasso and Braque pursued the analysis of form central to Cézanne's artistic explorations (see "Making Impressionism Solid and Enduring," page 369) by dissecting everything around them into their many constituent features, which they then recomposed, by a new logic of design, into a coherent, independent aesthetic picture.

The new style received its name after Matisse described some of Braque's work to the critic Louis Vauxcelles as having been painted "with little cubes." In his review, Vauxcelles described the new paintings as "cubic oddities." The French writer and theorist Guillaume Apollinaire (1880–1918) summarized well the central concepts of Cubism in 1913:

Authentic cubism [is] the art of depicting new wholes with formal elements borrowed not from the reality of vision, but from that of conception. This tendency leads to a poetic kind of painting which stands outside the world of observation; for, even in a simple cubism, the geometrical surfaces of an object must be opened out in order to give a complete representation of it. . . . Everyone must agree that a chair, from whichever side it is viewed, never ceases to have four legs, a seat and back, and that if it is robbed of one of these elements, it is robbed of an important part. 6

Most art historians refer to the first phase of Cubism, developed jointly by Picasso and Braque, as *Analytic Cubism*. Because Cubists could not achieve the kind of total view Apollinaire described by the traditional method of drawing or painting objects and people from one position, they began to dissect the forms of their subjects and to present their analysis of form across the canvas surface.

14-8 GEORGES BRAQUE, *The Portuguese*, 1911. Oil on canvas, 3' $10\frac{1}{8}$ " \times 2' 8". Kunstmuseum Basel, Basel (gift of Raoul La Roche, 1952).

The Cubists rejected the pictorial illusionism that had dominated Western art for centuries. Here, Braque concentrated on dissecting form and placing it in dynamic interaction with space.

Georges Braque's The Portuguese (FIG. 14-8) is a characteristic Analytic Cubist painting. The subject is a Portuguese musician whom the artist recalled seeing years earlier in a bar in Marseilles. Braque dissected the man and his instrument and placed the resulting forms in dynamic interaction with the space around them. Unlike the Fauves and German Expressionists, who used vibrant colors, the Cubists chose subdued hues—here solely brown tones—in order to focus attention on form. In The Portuguese, Braque carried his analysis so far that the viewer must work diligently to discover clues to the subject. The construction of large intersecting planes suggests the forms of a man and a guitar. Smaller shapes interpenetrate and hover in the large planes. The way that Braque treated light and shadow reveals his departure from conventional artistic practice. Light and dark passages suggest both chiaroscuro modeling and transparent planes that enable the viewer to see through one level to another. Solid forms emerge only to be canceled almost immediately by a different reading of the subject.

The stenciled letters and numbers add to the painting's complexity. Letters and numbers are flat shapes, but as elements of a Cubist painting such as *The Portuguese*, they enable the painter to

14-9 PABLO PICASSO, Still Life with Chair-Caning, 1912. Oil, oilcloth, and rope on canvas, $10\frac{5}{8}$ " × 1' $1\frac{3}{4}$ ". Musée Picasso, Paris.

This painting includes a piece of oilcloth and brushetrobes on top of a

This painting includes a piece of oilcloth and brushstrokes on top of a photolithograph of a cane chair seat. Framed with a piece of rope, the still life challenges the viewer's understanding of reality.

play with the viewer's perception of two- and threedimensional space. The letters and numbers lie flat on the painted canvas surface, yet the shading and shapes of other forms flow behind and underneath the viewing space. Occasionally, they seem attached to the surface of some object within the painting. Ultimately, the constantly shifting imagery makes it impossible to arrive at any definitive reading of the image. Analytical Cubist paintings radically disrupt expectations about the representation of forms, expectations about the representation of forms, space, and time.

SYNTHETIC CUBISM In 1912, Cubism entered a

new phase called *Synthetic Cubism*, in which, instead of dissecting forms, artists constructed paintings and drawings from objects and shapes cut from paper or other materials. The point of departure for this new style was Picasso's *Still Life* with Chair-Caning (Fig. 14-9), a mixed-media work in which the artist graph of a cane chair pasted to the canvas. Framed with rope, this work challenges the viewer's understanding of reality. The photomyork challenges the viewer's understanding or reality replicated chair caning seems so "real" that the chair caning, although optically suggestive of the real, is only an illusion or representation of an object. In contrast, the painted abatract areas do not refer to tangible objects in the real world. Yet the fact that they not refer to tangible objects in the real world. Yet the fact that they

ing. No pretense exists. Picasso extended the visual play by making the letter U escape from the space of the accompanying J and O and partially covering it with a cylindrical shape that pushes across its left side. The letters JOU, which appear in many Cubist paintings, formed part of the masthead of the daily French newspapers (journaux) often found among the objects represented. Picasso and Braque especially delighted in the punning references to jouer and jouir—the French verbs meaning "to play" and "to enjoy."

do not imitate anything makes them more "real" than the chair can-

After Still Life with Chair-Caning, both Picasso and Braque continued to explore the medium of collage introduced into the realm of

14-10 Pablo Picasso, Guernica, 1937. Oil on canvas, 11' $5\frac{1}{2}$ " \times 25' $5\frac{3}{4}$ ". Museo Nacional Centro de Arte Reina Sofia, Madrid.

Picasso used Cubist techniques, especially the fragmentation of objects and dislocation of anatomical features, to expressive effect in this condemnation of the Nazi bombing of the Basque capital.

"high art" (as opposed to unself-conscious "folk art") in that work. From the French verb *coller* ("to stick"), a collage is a composition of bits of objects, such as newspaper or cloth, glued to a surface.

Although most discussions of Cubism and collage focus on the innovations in artistic form they represented, it is important to note that contemporary critics also viewed the revolutionary nature of Cubism in sociopolitical terms. Many considered Cubism's challenge to artistic convention and tradition a subversive attack on 20th-century society. In fact, many modernist artists and writers of the period did ally themselves with various anarchist groups whose social critiques and utopian visions appealed to progressive thinkers. The French press consistently equated Cubism's disdain for tradition with anarchism and revolution.

GUERNICA Picasso continued to experiment with different artistic styles and media right up until his death in 1973. Celebrated primarily for his brilliant formal innovations, in the late 1930s Picasso became openly involved in political issues as he watched his homeland descend into civil war. He declared: "[P]ainting is not made to decorate apartments. It is an instrument for offensive and defensive war against the enemy." In January 1937, the Spanish Republican government-in-exile in Paris asked Picasso to produce a major work for the Spanish Pavilion at the Paris International Exposition that summer. He did not formally accept the invitation, however, until he received word that Guernica, capital of the Basque region in southern France and northern Spain, had been almost totally destroyed in an air raid on April 26. Nazi pilots acting on behalf of the rebel general Francisco Franco (1892-1975) bombed the city at the busiest hour of a market day, killing or wounding many of Guernica's 7,000 citizens. The event jolted Picasso into action. By the end of June, he had completed Guernica (FIG. 14-10), a mural-sized canvas of immense power.

Despite the painting's title, Picasso made no specific reference to the event in *Guernica*. The imagery includes no bombs and no

German planes. It is a universal outcry of human grief. In the center, along the lower edge of the painting, lies a slain warrior clutching a broken and useless sword. A gored horse tramples him and rears back in fright as it dies. On the left, a shrieking woman cradles her dead child (compare FIG. 14-7). On the far right, a woman on fire runs screaming from a burning building, while another woman flees mindlessly. In the upper right corner, a woman, represented by only a head, emerges from the burning building, thrusting forth a light to illuminate the horror. Overlooking the destruction is a bull, which, according to the artist, represents "brutality and darkness."

In *Guernica*, Picasso brilliantly used aspects of his earlier Cubist discoveries to expressive effect, particularly the fragmentation of objects and the dislocation of anatomical features. The dissections and contortions of the human form in Picasso's painting paralleled what happened to the Basque people during the aerial bombardment. To emphasize the scene's severity and starkness, Picasso reduced his palette to black, white, and shades of gray, suppressing color once again, as he had in his Analytic Cubist works.

FERNAND LÉGER AND PURISM Best known today as one of the most important modernist architects, Le Corbusier (FIG. 14-42) was also a painter. In 1918, he founded a movement called *Purism*, which opposed Synthetic Cubism on the grounds that it was becoming merely an esoteric, decorative art out of touch with the machine age. Purists maintained that machinery's clean functional lines and the pure forms of its parts should direct artists' experiments in design, whether in painting, architecture, or industrially produced objects. This "machine aesthetic" inspired Fernand Léger (1881–1955), a French artist who had painted with the Cubists. In his works—for example, *The City* (FIG. 14-11)—Léger brought together meticulous Cubist analysis of form with Purism's broad simplification and machinelike finish of the design components. He retained from his Cubist practice a preference for cylindrical and tube-shaped motifs, suggestive of machined parts such as pistons and cylinders.

Léger's paintings have the sharp precision of the machine, whose beauty and quality he was one of the first artists to appreciate. For example, in his film *Ballet Mécanique* (*Mechanical Ballet*; 1924), Léger contrasted inanimate objects such as functioning machines with humans in dancelike variations. In *The City*, he incorporated the massive effects of modern posters and billboard advertisements, the harsh flashing of electric lights, and the noise of traffic. In a definitive way, Léger depicted the mechanical commotion of urban life.

14-11 FERNAND LÉGER, *The City*, 1919. Oil on canvas, $7' 7'' \times 9' 9\frac{1}{2}''$. Philadelphia Museum of Art, Philadelphia (A. E. Gallatin Collection).

Léger championed the "machine aesthetic." In *The City*, he captured the mechanical commotion of urban life, incorporating the effects of billboard ads, flashing lights, and noisy traffic

Futurism

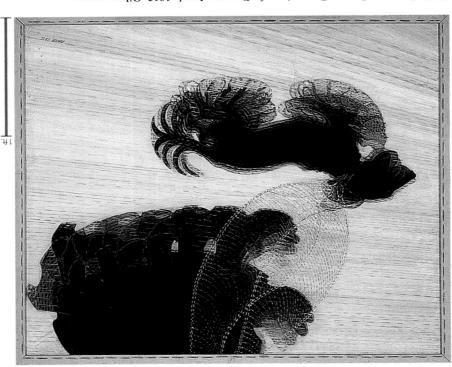

gift of George F. Goodyear, 1964). 2' 11 $\frac{3}{8}$ " \times 3' $7\frac{1}{4}$ ". Albright-Knox Art Gallery, Buffalo (bequest of A. Conger Goodyear, 14-12 Gircomo Balla, Dynamism of a Dog on a Leash, 1912. Oil on canvas,

of a passing dog and its owner. Simultaneity of views was central to the Futurist program. The Futurists' interest in motion and in the Cubist dissection of form is evident in Balla's painting

his ability to capture the sensation of motion in statuary. move. But in the early 20th century, Boccioni was unsurpassed for focused on motion in time and space. past civilizations. Appropriately, Futurist art often century exemplified classicism and the glories of of Samothrace" (FIG. 2-55), which in the early 20th

taneity of views was central to the Futurist program, as it was to ple, the dog's legs and tail and the swinging line of the leash. Simul-Balla achieved the effect of motion by repeating shapes—for exampassing dog and its owner, whose skirts are just within visual range. (Fig. 14-12), in which Gracomo Balla (1871-1958) represented a ist dissection of form is evident in Dynamism of a Dog on a Leash GIACOMO BALLA The Futurists' interest in motion and in the Cub-

sive breath . . . is more beautiful than the Victory

adorned with great pipes like serpents with explo-

ogy. Marinetti insisted that a racing "automobile

were the speed and dynamism of modern technolin the arts. Of particular interest to the Futurists mausoleums. They also called for radical innovation of accumulated culture, which they described as tion of museums, libraries, and similar repositories away the stagnant past, and agitated for the destruc-Futurists championed war as a means of washing launch Italian society toward a glorious future, the "Futurist Manifestos," page 387). In their quest to advocated revolution, both in society and in art (see numerous manifestos in which they aggressively and cultural decline of Italy, the Futurists published music, and architecture. Indignant over the political soon encompassed the visual arts, cinema, theater, 1909, Futurism began as a literary movement but ni (4461-9781) ittenrinetti (1876-1944) in named by the charismatic Italian poet and playdefined sociopolitical agenda. Inaugurated and important to the Futurists, however, was their wellthat the Cubists and Purists explored. Equally movement, Futurism, pursued many of the ideas Artists associated with another early-20th-century

motion only through posture and agitated drapery, not through disto the Nike of Samothrace (FIG. 2-55), the ancient sculptor suggested a highway. Although Boccioni's figure bears a curious resemblance blurred when seen from an automobile traveling at great speed on movement—just as people, buildings, and stationary objects become in plane and contour that it almost disappears behind the blur of its human figure. The figure is so expanded, interrupted, and broken and spatial effects of motion rather than their source, the striding statue, Umberto Boccioni (1882-1916) highlighted the formal is Unique Forms of Continuity in Space (FIG. 14-13). In this bronze UMBERTO BOCCIONI The definitive work of Futurist sculpture

development of kinetic sculpture—sculptures with parts that really several decades later, Alexander Calder (FIG. 14-32) pioneered the FIG. 12-28), produced more convincing illusions of movement. And based on the rapid sequential projection of fixed images (compare tations, however. The eventual development of the motion picture, This Futurist representation of motion in sculpture has its limi-

tortion and fragmentation of the human body.

Dada

eration brought up with the doctrine of progress and a belief in the deaths and mutilations were psychologically devastating for a genthe pounding and shattering of incessant shell fire; and the terrible holed up in trenches. The mud, filth, and blood of the trenches; was suicidal, and warfare became a frustrating stalemate of soldiers and in the sheets of fire from thousands of machine guns, attack artillery hurling millions of tons of high explosives and gas shells age of steel, changed the nature of combat. In the face of massed an extended period. The new technology of armaments, bred of the witnessed such wholesale slaughter on so grand a scale over such flict unleashed horrified other artists. Humanity had never before hoped it would effect, the mass destruction and chaos that the con-Although the Futurists celebrated World War I and the changes they

root in Paris, Berlin, and Cologne, among other cities. Dada was Dada began independently in New York and Zurich, it also took through political anarchy, the irrational, and the intuitive. Although War," and they concluded that the only route to salvation was of collective homicide and global destruction that was the "Great enment reasoning had been responsible for the insane spectacle a movement known as Dada. The Dadaists believed that Enlight-One major consequence in the art world was the emergence of

fundamental values of civilization.

ARTISTS ON ART

Futurist Manifestos

On April 11, 1910, a group of young Italian artists published *Futurist Painting: Technical Manifesto* in Milan in an attempt to apply the writer Filippo Tommaso Marinetti's views on literature to the visual arts. Signed jointly by Giacomo Balla, Umberto Boccioni, and three other artists, the manifesto states in part:

On account of the persistency of an image on the retina, moving objects constantly multiply themselves [and] their form changes. . . . Thus a running horse has not four legs, but twenty. . . .

What was true for the painters of yesterday is but a falsehood today. . . . To paint a human figure you must not paint it; you must render the whole of its surrounding atmosphere. . . . The shadows which we shall paint shall be more luminous than the highlights of our predecessors, and our pictures, next to those of the museums, will shine like blinding daylight compared with deepest night. . . .

We declare . . . that all forms of imitation must be despised, all forms of originality glorified . . . that all subjects previously used must be swept aside in order to express our whirling life of steel, of pride, of fever and of speed . . . that movement and light destroy the materiality of bodies.*

Two years later, Boccioni published *Technical Manifesto of Futurist Sculpture*, in which he argued that traditional sculpture was "a monstrous anachronism" and that modern sculpture should be

a translation, in plaster, bronze, glass, wood or any other material, of those atmospheric planes which bind and intersect things. . . . Let's . . . proclaim the absolute and complete abolition of finite lines and the contained statue. Let's split open our figures and place the environment inside them. We declare that the environment must form part of the plastic whole. †

The paintings of Balla (Fig. 14-12) and the sculptures of Boccioni (Fig. 14-13) are the perfect expressions of these Futurist principles and goals.

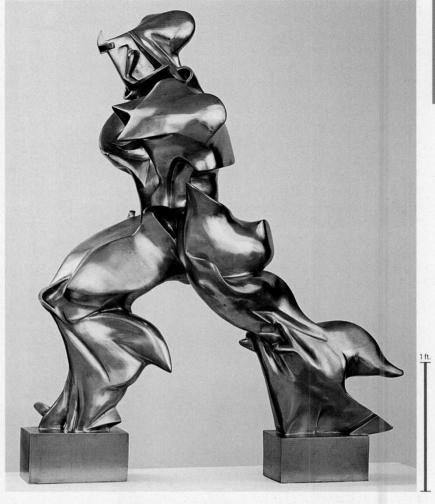

14-13 UMBERTO BOCCIONI, Unique Forms of Continuity in Space, 1913 (cast 1931). Bronze, 3' $7\frac{7}{8}$ " high. Museum of Modern Art, New York (acquired through the Lillie P. Bliss Bequest).

Boccioni's Futurist manifesto for sculpture advocated abolishing the enclosed statue. This running figure's body is so expanded that it almost disappears behind the blur of its movement.

more a mind-set or attitude than a single identifiable style. The Dadaists turned away from logic in favor of the irrational. Thus an element of absurdity is a cornerstone of Dada—reflected in the movement's very name. According to an oft-repeated anecdote, the Dadaists chose "Dada" at random by sticking a knife into a French-German dictionary. Dada is French for a child's hobby horse. The word satisfied the Dadaists' desire for something irrational and nonsensical.

A central goal of the Dadaists was to undermine cherished notions about art. By attacking convention and logic, they unlocked new avenues for creative invention, thereby fostering a more serious examination of the basic premises of art. But the Dadaists could also be lighthearted in their subversion. Although horror and disgust about the war initially prompted Dada, an undercurrent of humor and whimsy runs through much of the art. In its emphasis on the spontaneous and intuitive, Dada paralleled the views of Sigmund

^{*}Futurist Painting: Technical Manifesto (Poesia, April 11, 1910). Translated by Filippo Tommaso Marinetti, in Umbro Apollonio, ed., Futurist Manifestos (Boston: Museum of Fine Arts, 1970), 27-31.

[†]Translated by Robert Brain, in Apollonio, 51-65.

stated, "For us chance was the 'unconscious mind' that Freud had discovered in 1900. . . . Adoption of chance had another purpose, a secret one. This was to restore to the work of art its primeval magic power and to find a way back to the immediacy it had lost through contact with . . . classicism." Arp's renunciation of artistic control and reliance on chance in creating his compositions reinforced the anarchy and subversion inherent in Dada.

object in a new light. conterring the status of art on it and forcing the viewer to see the "artwork" lay in the artist's choice of object, which had the effect of the then-popular comic-strip duo Mutt and Jeff. The "art" of this the Mott plumbing company's name and that of the taller man of "artist's signature" was, in fact, a witty pseudonym derived from nal presented on its back, signed "R. Mutt," and dated (1917). The outrageous readymade was Fountain (Fig. 14-15), a porcelain uriother Dada artists found aesthetically bankrupt. Perhaps his most either good or bad taste, qualities shaped by a society that he and readymades, Duchamp insisted, was free from any consideration of substance or combining them with another object. The creation of the artist selected and sometimes "rectified" by modifying their made" sculptures, which were mass-produced common objects that central artist of New York Dada. In 1913, he exhibited his first "ready-МАВСЕL DUCHAMP (1887-1968), а Frenchman who became the MARCEL DUCHAMP Perhaps the most influential Dadaist was

HANNAH HOCH In Berlin, Dada took on an activist political edge. The Berlin Dadaists pioneered a variation of collage that they called

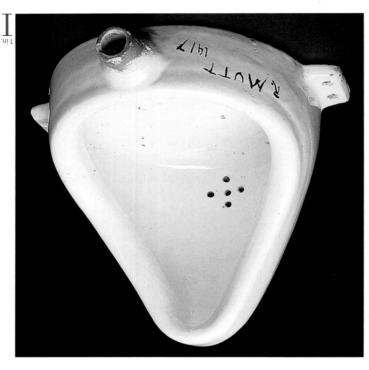

14-15 MARCEL DUCHAMP, Fountain (second version), 1950 (original version produced 1917). Glazed sanitary china with black paint, l'high. Philadelphia Museum of Art, Philadelphia.

Duchamp's "readymade" sculptures were mass-produced objects that the Dada artist modified. In Fountain, he conferred the status of art on a urinal and forced people to see the object in a new light.

Freud (see page 370). In The Interpretation of Dreams, Freud argued that unconscious and inner drives control human behavior. The Dadaists were particularly interested in exploring the unconscious. They believed that art was a powerfully practical means of self-revelation and healing, and that the images arising out of the subconscious mind had a truth of their own, independent of conventional vision.

JEAN ARP The Zurich-based Dadaist JEAN (HANS) ARP (1887–1966) pioneered the use of chance in composing his images. Tiring of the look of some Cubist-related collages he was making, he tore several sheets of paper into roughly shaped squares, haphazardly dropped them onto a sheet of paper on the floor, and glued them into the resulting arrangement. The rectilinearity of the shapes guaranteed a somewhat regular design, but chance had introduced an imbalance that seemed to Arp to restore to his work a special mysterious vitality that he wanted to preserve. Collage Arranged According to the Laws of Chance (Fig. 14-14) is one of the works that Arp created by this method. As the Dada filmmaker Hans Richter (1888–1976)

14-14 Jean (Hans) Arp, Collage Arranged According to the Laws of Chance, 1916–1917. Torn and pasted paper, I' $1\frac{7}{8}$ " × I' $1\frac{5}{8}$ ". Museum of Modern Art, New York.

In this collage, Arp dropped torn paper squares onto a sheet of paper and then glued them where they fell. His reliance on chance in composing images reinforced the anarchy inherent in Dada.

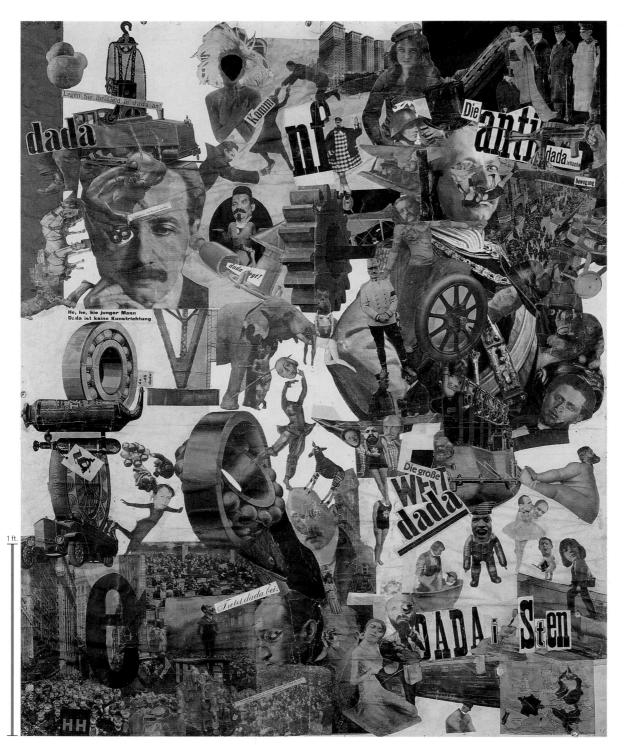

14-16 HANNAH
HÖCH, Cut with the
Kitchen Knife Dada
through the Last Weimar Beer Belly Cultural
Epoch of Germany,
1919–1920. Photomontage, 3' 9" × 2' 11½".
Neue Nationalgalerie,
Staatliche Museen zu
Berlin, Berlin.

Photographs of some of Höch's fellow Dadaists appear among images of Marx and Lenin, and the artist juxtaposed herself with a map of Europe showing the progress of women's right to vote.

photomontage because their assemblages consisted almost entirely of pieces of magazine photographs, usually combined into deliberately antilogical compositions. Collage lent itself well to the Dada desire to use chance when creating art—and antiart. One of the Berlin Dadaists who perfected the photomontage technique was HANNAH HÖCH (1889–1978). Höch's photomontages advanced the absurd illogic of Dada by creating chaotic, contradictory, and satiric compositions. They also provided scathing and insightful commentary on two of the most dramatic developments during the Weimar Republic (1918–1933) in Germany—the redefinition of women's social roles and the explosive growth of mass print media.

Höch, a passionate early feminist, revealed these combined themes in *Cut with the Kitchen Knife Dada through the Last Weimar Beer Belly Cultural Epoch of Germany* (FIG. 14-16). In this work, whose title refers to the story that the name "Dada" resulted from thrusting a knife into a dictionary, Höch arranged an eclectic mixture of cutout photos in seemingly haphazard fashion. Closer inspection, however, reveals the artist's careful selection and placement of the photographs. For example, the key figures in the Weimar Republic are together at the upper right (identified as the "anti-Dada movement"). Some of Höch's fellow Dadaists appear among images of Karl Marx and Vladimir Lenin, aligning Dada with other revolutionary

art—shapes not related to objects in the visible world. Malevich christened his new artistic approach Suprematism, explaining:

Under Suprematism I understand the supremacy of pure feeling in creative art. To the Suprematist, the visual phenomena of the objective world are, in themselves, meaningless; the significant thing is feeling, as such, quite apart from the environment in which it is called forth.

The basic form of Malevich's new Suprematist nonobjective art was the square. Combined with its relatives, the straight line and the rectangle, the square soon filled his paintings, such as Suprematist Composition: Airplane Flying (FIG. 14-17). In this work, the brightly colored shapes float against and within a white space, and the artist placed them in dynamic relationship to one another. Malevirch believed that all peoples would easily understand his new art because of the universality of its symbols. It used the pure language because of the universality of its symbols. It used the pure language of shape and color, to which everyone could respond intuitively.

UNITED STATES, 1900 TO 1930

to modernist art.

Avant-garde experiments in the arts were not limited to Europe. Increasingly common transatlantic travel resulted in a lively exchange of artistic ideas between European and American artists, such as Cassatt (Fig. 13-6), Whistlet (Fig. 13-8), and Arthur Dove (1880–1946; Fig. 14-17A (A)), generally considered America's first abstract painter. However, after 1913, American artists did not have to travel to Europe to become exposed

explosion in a shingle factory,"12 and newspaper cartoonists ity to the Futurists' ideas. One critic described this work as "an ist's interest in depicting the figure in motion reveals an affin-Duchamp's faceted presentation of the human form. The artchromatic palette is reminiscent of Analytic Cubism, as is tics with the work of the Cubists and the Futurists. The mono-14-15), Nude Descending a Staircase shares many characterisof overlaid film stills. Unlike Duchamp's Dadaist work (FIG. ing in a time continuum and suggests the effect of a sequence No. 2 (FIG. 14-18). The painting represents a single figure movmaligned was Marcel Duchamp's Nude Descending a Staircase, response from the press. The work that the journalists most of American modernist art, the exhibition received a hostile later recognized as the foundational event in the development New York City (see "The Armory Show," page 391). Although end on February 17, 1913, when the Armory Show opened in from developments across the Atlantic came to an abrupt ARMORY SHOW The relative isolation of American artists

ARRON DOUGLAS The impact of European modernist art in America is evident in the work of African American artist AARON DOUGLAS (1898–1979), who adapted Synthetic Cubism to represent symbolically the historical and cultural memories of African Americans. Born in Kansas, Douglas spent time in Paris before settling in New York City, where he became a key figure in the Harlem Renaissance. The artists and writers who spearheaded this movement aimed to ists and writers who spearheaded this movement aimed to art that celebrated the cultural history of their race. Douglas art that celebrated the cultural history of their race. Douglas art that celebrated the cultural history of their race. Douglas broadly defined to include ancient Egyptian statues and reliefs,

delighted in lampooning the painting.

forces in what she prominently labeled with cutout lettering Die grosse Welt dada ("the great Dada world"). Certainly, juxtaposing the heads of German military leaders with exotic dancers' bodies provided the wickedly humorous critique central to much of Dada. Höch also positioned herself in the topsy-turvy Dada world that she created. A photograph of her head appears in the lower right corner, juxtaposed with a map of Europe showing which countries had granted women the right to vote—a commentary on the power that both women and Dada had to destabilize society.

Suprematism

Dada was a movement born of pessimism and cynicism. However, not all early-20th-century artists reacted to the profound turmoil of the times by retreating from society. Some promoted utopian ideals, believing staunchly in art's ability to contribute to improving society. These efforts often surfaced in the face of significant political upheaval, as was the case with Suprematism in Russia.

KAZIMIR MALEVICH Russian artist KAZIMIR MALEVICH (1878–1935) developed an abstract style to convey his belief that the supreme reality in the world is "pure feeling," which attaches to no object. Thus this belief called for new, nonobjective forms in

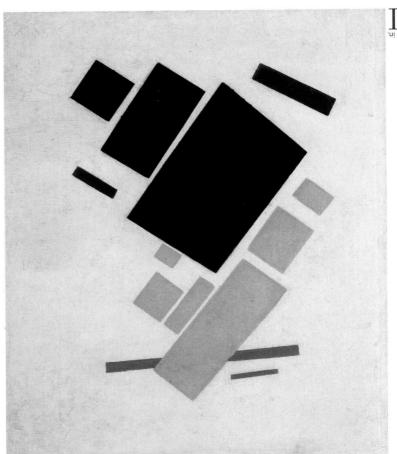

14-17 Kazimir Malevich, Suprematist Composition: Airplane Flying. 1915 (dated 1914). Oil on canvas, 1' 10 $\frac{7}{8}"\times 1'$ 7". Museum of Modern Art, New York.

Malevich developed an abstract style that he called Suprematism to convey that the supreme reality in the world is pure feeling. Here, the brightly colored rectilinear shapes float against white space.

ART AND SOCIETY

The Armory Show

From February 17 to March 15, 1913, the American public flocked in large numbers to view the International Exhibition of Modern Art at the 69th Regiment Armory in New York City. The "Armory Show," as it universally came to be called, was an ambitious endeavor organized primarily by two artists, Walt Kuhn (1877-1949) and Arthur B. Davies (1862-1928). The show included more than 1,600 artworks by American and European artists. Among the European artists represented were Matisse, Derain, Kirchner, Kandinsky, Picasso, Braque, and Duchamp (Fig. 14-18). In addition to exposing American artists and the public to the latest European artistic developments, the Armory Show also provided American artists with a prime showcase for their work. The foreword to the exhibition catalogue spelled out the goals of the organizers:

The American artists exhibiting here consider the exhibition of equal importance for themselves as for the public. The less they find their work showing signs of the developments indicated in the Europeans, the more reason they will have to consider whether or not painters or sculptors here have fallen behind . . . the forces that have manifested themselves on the other side of the Atlantic.*

On its opening, this provocative exhibition served as a lightning rod for commentary, immediately attracting heated controversy. The New York Times described the show as "pathological" and called the modernist artists "cousins to the anarchists," while the magazine Art and Progress compared them to "bomb throwers, lunatics, depravers."† Other critics demanded that the exhibition be closed as a menace to public morality. The New York Herald, for example, asserted: "The United States is invaded by aliens, thousands of whom constitute so many perils to the health of the body politic. Modernism is of precisely the same heterogeneous alien origin and is imperiling the republic of art in the same way."*

Nonetheless, the exhibition was an important milestone in the history of art in the United States. The Armory Show traveled to Chicago and Boston after it closed in New York and was a significant catalyst for the reevaluation of the nature and purpose of American art.

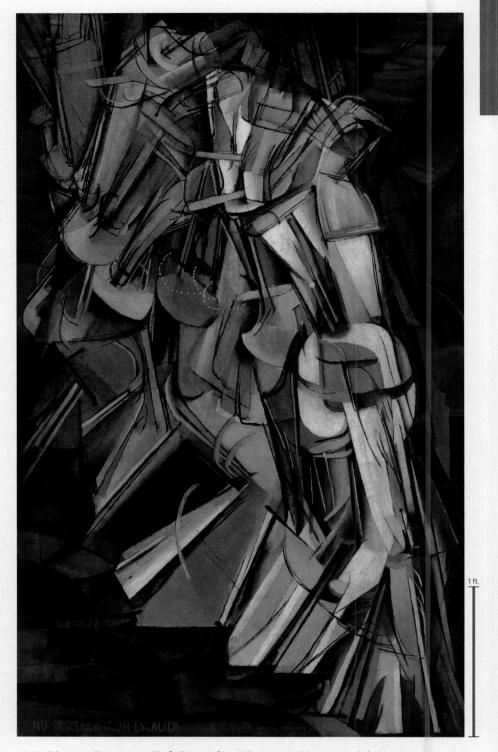

14-18 MARCEL DUCHAMP, *Nude Descending a Staircase*, *No. 2*, 1912. Oil on canvas, 4' 10" × 2' 11". Philadelphia Museum of Art, Philadelphia (Louise and Walter Arensberg Collection).

The Armory Show introduced European modernist art to America. Duchamp's figure moving in a time continuum owes a debt to Cubism and Futurism. The press gave his painting a hostile reception.

^{*}Quoted in Herschel B. Chipp, *Theories of Modern Art: A Source Book by Artists and Critics* (Berkeley and Los Angeles: University of California Press, 1968), 503.

[†]Quoted in Sam Hunter, John Jacobus, and Daniel Wheeler, *Modern Art*, rev. 3d. ed. (Upper Saddle River, N.J.: Prentice Hall, 2005), 250.

[‡]Quoted in Francis K. Pohl, *Framing America: A Social History of American Art*, 2d ed. (New York: Thames & Hudson, 2002), 341.

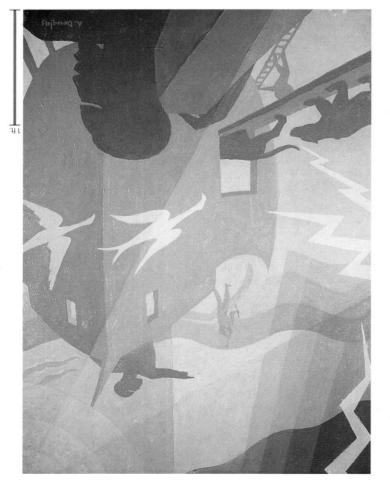

14-19 Алкои Douglas, Noah's Ark, са. 1927. Oil on Masonite, 4' \times 3'. Fisk University Galleries, University of Tennessee, Mashville.

In Noah's Ark and other paintings of the cultural history of African Americans, Douglas incorporated motifs from African sculpture and the transparent angular planes characteristic of Synthetic Cubism.

ing transparent angular planes. Noah's Ark (FIG. 14-19) is one of seven paintings that Douglas based on a book of poems by James Seven paintings that Douglas based on a book of poems by James Weldon Johnson (1871–1938) called God's Trombones: Seven Negro Sermons in Verse. In Noah's Ark, Douglas used flat planes to evoke at sense of mystical space and miraculous happenings. Lightning atrikes and rays of light crisscross the pairs of animals entering the strikes and rays of light crisscross the pairs of animals entering the suggested deep space by differentiating the size of the large human head and shoulders of the worker at the bottom and the small person at work on the far deck of the ship. Yet the composition's unmodulated color shapes create a pattern that cancels any illusion of three-dimensional depth. Here, Douglas used Cubism's formal anguage to express a powerful religious vision.

teatures. the organic reality of the object by strengthening its characteristic growing life. O'Keeffe's painting, in its graceful, quiet poetry, reveals white jetlike streak-in a vision of the slow, controlled motion of planes unfold like undulant petals from a subtly placed axis—the ing the forms almost to the point of complete abstraction. The fluid phony of basic colors, shapes, textures, and vital rhythms, simplifyreduced the curved planes and contours of the flower to a symcolors to heighten their expressive power. In this work, O'Keeffe reveals her interest in stripping subjects to their purest forms and of flowers—for example, Jack-in-the-Pulpit No. 4 (FIG. I-5), which husband. O'Keeffe is best known for her paintings of cow skulls and became one of O'Keeffe's staunchest supporters and, eventually, her her into his circle of avant-garde painters and photographers. He litz had seen and exhibited some of O'Keeffe's work, and he drew wealthy women; see "Art 'Matronage' in the United States" (A.) Stiegchampioning modernist art in America was a remarkable group of through "291," his gallery at 291 Fifth Avenue. (Also significant in a major role in promoting the avant-garde in the United States York City, where she met Alfred Stieglitz (FIG. 14-20), who played (1887–1986) moved from the tiny town of Canyon, Texas, to New GEORGIA O'KEEFFE In 1918, Wisconsin-born Georgia O'Keeffe

ALFRED STIEGLITZ As an artist, ALFRED STIEGLITZ (1864–1946) is best known for his photographs. Taking his camera everywhere he went, Stieglitz photographed whatever he saw around him, from the bustling streets of New York City to cloudscapes in upstate New York to the faces of friends and relatives. He believed in making only "straight, unmanipulated" photographis. Thus he exposed and printed them using basic photographic processes, without resorting to techniques such as double-exposure or double-printing that ing to techniques such as double-exposure or double-printing that

14-20 Alfred Stieglitz, The Steerage, 1907 (print 1915). Photogravute (on tissue), $1^{1/3}$ " \times $10^{1/8}$ ". Amon Carter Museum, Fort Worth.

Stieglitz waged a lifelong campaign to win a place for photography among the fine arts. This 1907 image taken on an ocean liner captures human activity in terms of arrangements of lines and forms.

would add information absent in the subject when he released the shutter. Stieglitz said that he wanted the photographs he made with this direct technique "to hold a moment, to record something so completely that those who see it would relive an equivalent of what has been expressed."¹³

Stieglitz conducted a lifelong campaign to win a place for photography among the fine arts. He founded the Photo-Secession group, which mounted traveling exhibitions in the United States and sent loan collections abroad, and he also published an influential journal titled *Camera Work*. Stieglitz's own work is noteworthy for his insistence on seeing his subjects in terms of arrangements of lines and shapes and of the "colors" of his black-and-white materials. His aesthetic approach crystallized in *The Steerage* (Fig. 14-20), a photograph he took during a voyage to Europe with his first wife and daughter in 1907. Traveling first class, Stieglitz rapidly grew bored with the company of prosperous passengers. From his section of the ship, he could see the lower deck reserved for the steerage passengers whom the government sent back to Europe after refusing them entrance into the United States. Stieglitz described what he saw:

The scene fascinated me: A round hat; the funnel leaning left, the stairway leaning right; the white drawbridge, its railing made of chain; white

14-21 EDWARD WESTON, *Pepper No. 30*, 1930. Gelatin silver print, $9\frac{1}{2}$ " $\times 7\frac{1}{2}$ ". Center for Creative Photography, University of Arizona, Tucson.

Weston "previsualized" his still lifes, choosing the exact angle, lighting, and framing that he desired. His vegetables often resemble human bodies, in this case a seated nude seen from behind.

suspenders crossed on the back of a man below; circular iron machinery; a mast that cut into the sky, completing a triangle. I stood spell-bound. I saw shapes related to one another—a picture of shapes, and underlying it, a new vision that held me: simple people; the feeling of ship, ocean, sky; a sense of release that I was away from the mob called rich. . . . I had only one plate holder with one unexposed plate. Could I catch what I saw and felt? I released the shutter. If I had captured what I wanted, the photograph would go far beyond any of my previous prints. It would be a picture based on related shapes and deepest human feeling—a step in my own evolution, a spontaneous discovery. ¹⁴

EDWARD WESTON Like Alfred Stieglitz, EDWARD WESTON (1886–1958) played a major role in establishing photography as an important artistic medium. But unlike Stieglitz, who worked outdoors and sought to capture transitory moments in his photographs, Weston meticulously composed his subjects in a controlled studio setting, whether he was doing still lifes of peppers, shells, and other natural forms of irregular shape, or figure studies. In the 1930 photograph of a pepper illustrated here (FIG. 14-21), the artificial lighting accentuates the undulating surfaces and crevices of the vegetable. Weston left nothing to chance, choosing the exact angle and play of

light over the object, "previsualizing" the final photographic print before snapping the camera's shutter. Weston frequently chose peppers whose shapes reminded him of human bodies. Pepper No. 30 looks like a seated nude figure seen from behind with raised arms emerging from broad shoulders. Viewers can read the vertical crease down the center of the vegetable as the spinal column leading to the buttocks. Although highly successful as a purely abstract composition of shapes and of light and dark, Weston's still life also conveys mystery and sensuality through its dramatic lighting and rich texture.

EUROPE, 1920 TO 1945

Because World War I was fought entirely in Europe, European artists experienced its devastating effects to a much greater degree than did American artists. The war had a profound impact on Europe's geopolitical terrain (MAP 14-1), on individual and national psyches, and on the art of the 1920s and 1930s.

Neue Sachlichkeit

In Germany, World War I gave rise to an artistic movement called *Neue Sachlichkeit* (New Objectivity). All of the artists associated with Neue Sachlichkeit served, at some point, in the German army. Their military experiences deeply influenced their worldviews and informed their art, which aimed to present an objective image of the world, especially the Great War and its effects.

MAX BECKMANN Because he believed that a better society would emerge from the war, MAX BECKMANN (1884–1950) enlisted in the German army, but over time the massive loss of life and widespread destruction disillusioned him. Soon his work began to emphasize the horrors of war and of a society that he regarded as descending into madness. Beckmann's disturbing view of wartime Germany is evident in

matched his view of the brutality of early-20th-century society. Objects seem dislocated and illogical. torted, and the space appears buckled and illogical.

Beckmann's treatment of forms and space in Night

14-22 Max Beckmann, Night, 1918–1919. Oil on canvas, $4^14_{-8}^3$ " $\times 5^1_{-4}^{1}$ ". Kunstsammlung

Nordrhein-Westfalen, Düsseldorf.

Night (FIG. 14-22), which depicts a cramped room invaded by three intruders. A bound woman, apparently raped, is splayed across the foreground of the painting. At the left, one of the intruders hangs her husband, while another one twists his left arm out of its socket. An unidentified woman cowers in the background. On the far right, the third intruder prepares to flee with the child.

Although this image does not depict a war scene, the wrenching brutality pervading the home is a searing comment on society's condition. Beckmann also injected a personal reference by using himself, his wife, and his son as the models for the three family members. The stilted angularity of the figures and the roughness of the paint

surface contribute to the image's savageness. In addition, the artist's treatment of forms and space reflects the world's violence. Objects are dislocated and contorted, and the space is buckled and illogical. For example, the woman's hands are bound to the window opening from the room's back wall, but her body appears to hang vertically, rather than lying across the plane of the intervening table.

Surrealism

tions, although the imagery sometimes suggests organisms or natu-Biomorphic Surrealism, artists produce largely abstract composiseem to have metamorphosed into a dream or nightmare image. In In Naturalistic Surrealism, artists present recognizable scenes that the vivid world of dreams. Surrealism developed along two lines. the same way that life's seemingly unrelated fragments combine in outer and inner "reality" together into a single position, in much The Surrealists' dominant motivation was to bring the aspects of activating the unconscious forces deep within every human being. methods were important for engaging the elements of lantasy and the Dadaists' improvisational techniques. They believed that these unconscious. Not surprisingly, the Surrealists incorporated many of mined to explore ways to express in art the world of dreams and the First Surrealist Manifesto," page 395). The Surrealists were determent, which had begun as a literary movement (see "André Breton's of the artists associated with Dada had joined the Surrealism movewith the publication in France of the First Surrealist Manifesto, most emerged during World War I lasted for only a short time. By 1924, The exuberantly aggressive momentum of the Dada movement that

GIORGIO DE CHIRICO The widely recognized precursor of Surrealism was the Italian Pittura Metafisica, or Metaphysical Painting, movement led by Gioreio DE CHIRICO (1888–1978). Returning to Italy after studying in Munich, de Chirico found hidden reality

14-23 GIORGIO DE CHIRICO, The Song of Love, 1914. Oil on canvas, $2^{v}4\frac{3}{4}^{w}\times 1^{v}11\frac{3}{8}^{w}$. Museum of Modern Art, New York (Nelson A. Rockefeller bequest).

De Chirico's Metaphysical Painting movement was a precursor of Surrealism. In this dreamlike scene set in a deserted square, a classical head of Apollo floats mysteriously next to a gigantic red glove.

ral forms.

WRITTEN SOURCES

André Breton's First Surrealist Manifesto

A poet, novelist, and critic rather than a visual artist, André Breton (1896–1966) nonetheless played a leading role in the formation of two of the 20th century's most important art movements: Dada and Surrealism. Although it was Guillaume Apollinaire who first proposed the term "Surrealism," the movement did not begin to take firm shape until 1924, when Breton published the *First Surrealist Manifesto* in the inaugural issue of *La revolution surréaliste*.

Some excerpts:

The mere word "freedom" is the only one that still excites me.... We are still living under the reign of logic... The absolute rationalism that is still in vogue allows us to consider only facts relating directly to our experience.... Under the pretense of civilization and

progress, we have managed to banish from the mind everything that may rightly or wrongly be termed superstition, or fancy; forbidden is any kind of search for truth which is not in conformance with accepted practices. . . . [T]hanks to the discoveries of Sigmund Freud . . . [t]he imagination is perhaps on the point of reasserting itself, of reclaiming its rights. . . . Freud very rightly brought his critical faculties to bear upon the dream. . . . I have always been amazed at the way an ordinary observer lends so much more credence and attaches so much more importance to waking events than to those occurring in dreams. . . . I believe in the future resolution of these two states, dream and reality, which are seemingly so contradictory, into a kind of absolute reality, a "surreality," if one may so speak. It is in quest of this surreality that I am going. . . .

Surrealism . . . is [p]sychic automatism in its pure state, by which one proposes to express—verbally . . . or in any other manner—the actual function of thought. . . . Surrealism is based on the belief in

the superior reality of certain forms of previously neglected associations, in the omnipotence of dream, in the disinterested play of thought. It tends to ruin once and for all all other psychic mechanisms and to substitute itself for them in solving all the principal problems of life.*

*Translated by Richard Seaver and Helen R. Lane, *André Breton: Manifestoes of Surrealism* (Ann Arbor: University of Michigan Press, 1969), 3–47.

14-24 SALVADOR DALÍ, The Persistence of Memory, 1931. Oil on canvas, $9\frac{1}{2}$ " \times 1' 1". Museum of Modern Art, New York.

Dalí painted "images of concrete irrationality." In this realistically rendered Surrealist landscape featuring three "decaying" watches, he created a haunting allegory of empty space where time has ended.

revealed through strange juxtapositions, such as those seen on late autumn afternoons in the city of Turin, when the long shadows of the setting sun transformed vast open squares and silent public monuments into what the painter called "metaphysical towns." De Chirico translated this vision into paint in works such as *The Song of* Love (FIG. 14-23), a dreamlike scene set in the deserted piazza of an Italian town. A huge marble head—a fragment of the famous Apollo Belvedere in the Vatican (not illustrated)—is suspended in midair above a green ball. To the right is a gigantic red glove nailed to a wall. The buildings and the three over-life-size objects cast shadows that direct the viewer's eye to the left and to a locomotive puffing smoke—a favorite Futurist motif, here shown in slow motion and incongruously placed near the central square. The choice of the term metaphysical to describe de Chirico's paintings suggests that these images transcend their physical appearances. The Song of Love, for all its clarity and simplicity, takes on a rather sinister air. The sense of strangeness that de Chirico could conjure with familiar

objects and scenes recalls the observation of philosopher Friedrich Nietzsche (1844–1900) that "underneath this reality in which we live and have our being, another and altogether different reality lies concealed." ¹⁵

SALVADOR DALÍ Spaniard Salvador Dalí (1904–1989) was the most famous Naturalistic Surrealist painter. As he described it, in his painting he aimed "to materialize the images of concrete irrationality with the most imperialistic fury of precision . . . in order that the world of imagination and of concrete irrationality may be as objectively evident . . . as that of the exterior world of phenomenal reality." In *The Persistence of Memory* (Fig. 14-24), Dalí created a haunting allegory of empty space where time has ended. An eerie, never-setting sun illuminates the barren landscape. An amorphous creature draped with a limp pocket watch sleeps in the foreground. Another watch hangs from the branch of a dead tree springing unexpectedly from a blocky architectural form. A third watch hangs half

timepiece resting dial-down on the block's surface. Ants swarm mysteriously over the small watch, while a fly walks along the face of its large neighbor, almost as if this assembly of watches were decaying organic life—soft and sticky. Dalí rendered every detail of this dreamscape with precise control, striving to make the world of his paintings convincingly real—in his words, to make the irrational concrete.

RENÉ MAGRITTE The Belgian painter RENÉ MAGRITTE (1898–1967 moved to Paris in 1927 and joined the intellectual circle of Andi moved to Paris in 1927 and joined the intellectual circle of Andi Deton. In 1929, Magritte published an important essay in the Su

over the edge of the rectangular form, beside a small

The discrepancy between Magritte's meticulously painted briar pipe and his caption, "This is not a pipe," challenges the viewer's reliance on the conscious and the rational in the read-

14-25 RENÉ MAGRITTE, The Treachery (or Perfidy) of Images, 1928–1929. Oil on canvas, I' $11\frac{5}{8}$ " x 3' I". Los Angeles County Museum of Art, Los Angeles (purchased with funds provided by the Mr. and Mrs. William Preston Harrison Collection).

ing of visual art.

moved to Paris in 1927 and joined the intellectual circle of André moved to Paris in 1927 and joined the intellectual circle of André Breton. In 1929, Magritte published an important essay in the Surrealist journal La revolution surréaliste in which he discussed the discussed to objects, pictures of objects, and names of objects and pictures. The essay explains the intellectual basis for The Treachery (or Perfidy) of Images (Fig. 14-25), in which Magritte presented a meticulously rendered depiction of a briar pipe. The caption beneath the image, however, contradicts what seems obvious: "Ceci nèst pas une pipe" ("This is not a pipe"). The discrepancy between image and caption clearly challenges the assumptions underlying the reading of visual art. As is true of the other Surrealists' work, this painting wreaks visual art. As is true of the other Surrealists' work, this painting wreaks

MERET OPPENHEIM Sculpture especially appealed to the Surrealists because its concrete tangibility made their art all the more disquieting. Object (FIG. 14-26), also called Le Déjeuner en Fourrure

solid or in outline, with dramatic accents of white and vermilion. the artist freely reshaped on the canvas to create black silhouettes random doodles. The abstract curvilinear forms became motifs that works such as Painting (FIG. 14-27). He began Painting by making art, Miró devised a new painting method that enabled him to create poets in Paris introduced him to the use of chance in the creation of contained an element of fantasy and hallucination. After Surrealist as "the most Surrealist of us all." I'r From the beginning, Mirôs work movement or group, including the Surrealists, Breton identified him experience. Although Miró resisted formal association with any "accidents" to provoke reactions closely related to subconscious of art without conscious control-and various types of planned ish artist Joan Miró (1893-1983) used automatism—the creation control that they believed society had shaped too much. The Spanto free the creative process from reliance on the kind of conscious JOAN MIRÓ Like the Dadaists, the Surrealists used many methods much of Surrealist art. soft, tactile fur lining the concave form) that are also components of

incorporates a sensuality and eroticism (seen here in the seductively

factured object. Further, the sculpture captures the Surrealist flair for alchemical, seemingly magical or mystical, transformation. It

animated by the quirky combination of the animal fur with a manu-

ordering "un peu plus de fourrure" (a little more fur), and the sculpture had its genesis. Object takes on an anthropomorphic quality,

her tea grew cold, Oppenheim responded to Picasso's comment by

fur, Picasso noted that anything might be covered with fur. When

let that Oppenheim had made from a piece of brass covered with

inspired by a conversation with Picasso. After admiring a brace-

characterizing Surrealism. The artist presented a fur-lined teacup

captures the incongruity, humor, visual appeal, and, often, eroticism

(Luncheon in Fur), by Swiss artist Meret Oppenheim (1913-1985)

Miró described his creative process as a switching back and forth between unconscious and conscious image-making: "Rather than setting out to paint something, I begin painting and as I paint the picture begins to assert itself, or suggest itself under my brush. The form becomes a sign for a woman or a bird as I work.... The first

They suggest a host of amoebic organisms or constellations in outer space floating in an immaterial background space filled with soft

reds, blues, and greens.

14-26 Мевет Оррегинеїм, Оbject (Le Déjeuner en Fourture), 1936. Fur-covered cup $4\frac{3}{8}$ " diameter, saucer $9\frac{3}{8}$ " diameter, spoon 8" long. Museum of Modern Art, New York.

The Surrealists loved the concrete tangibility of sculpture, which made their art even more disquieting. Oppenheim's fur-covered manufactured object captures the Surrealist flair for magical transformation.

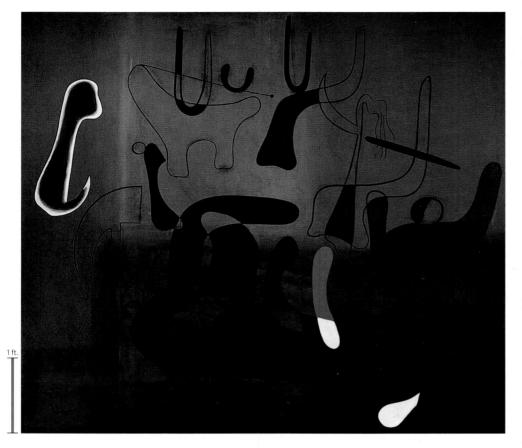

14-27 JOAN MIRÓ, *Painting*, 1933. 5' 8" × 6' 5". Museum of Modern Art, New York (Loula D. Lasker Bequest by exchange).

Miró promoted automatism, the creation of art without conscious control. He began this painting with random doodles and completed the composition with forms suggesting floating amoebic organisms.

stage is free, unconscious. . . . The second stage is carefully calculated." ¹⁸ Even the artist could not always explain the meanings of pictures such as *Painting*. They are, in the truest sense, spontaneous and intuitive expressions of the little-understood, submerged unconscious part of life.

WIFREDO LAM Loosely associated with the Surrealists was Wifredo Lam (1902-1982), an artist whose work is as distinctive as his background. Cuban by birth, Lam was the son of a Chinese immigrant father and a mother of Cuban-African descent. He studied painting in Havana and later in Madrid, where he fought alongside the Republicans in the Spanish Civil War. That endeared Lam to Picasso, whom he met in Paris in 1938. Picasso introduced Lam to Braque and Breton and many other avant-garde artists and critics, and Lam's mature work, although the distinctive by-product of his Caribbean-African heritage, shows the influence of both Cubism and Surrealism.

The Jungle (FIG. 14-28) is generally considered Lam's greatest work. The complex, crowded composition indeed suggests a dense jungle, populated by Surrealistic creatures whose fragmented forms recall Cubism. Inspired also by Santería, the Cuban religion that is a blend of African ritual and European Catholicism, The Jungle depicts four hybrid figures with long legs, prominent buttocks, and heads resembling African masks in a tropical jungle of sugarcane and tobacco plants. Two of Lam's composite figures have a horse's tail. The figure at the right holds a scissors—as if she, not the artist, is the one responsible for dismembering

14-28 WIFREDO LAM, *The Jungle*, 1943. Gouache on paper mounted on canvas, $7' \cdot 10\frac{1}{4}'' \times 7' \cdot 6\frac{1}{2}''$. Museum of Modern Art, New York (Inter-American Fund).

In Lam's tropical jungle stand four composite creatures with long legs, prominent buttocks, and faces resembling African masks. The painting draws on Cubism, Surrealism, and Cuban religious ritual.

Time spent in Paris before World War I introduced Mondrian to Cubism. However, as his attraction to contemporary theological writings grew, Mondrian sought to purge his art of every overt reference to individual objects in the external world. He formulated a conception of nonobjective design—"pure plastic art"—that he believed expressed universal reality:

Art is higher than reality and has no direct relation to reality.... To approach the spiritual in art, one will make as little use as possible of reality, because reality is opposed to the spiritual.... [W]e find ourselves in the presence of an abstract art. Art should be above reality, otherwise it would have no value for man. 20

To achieve "pure plastic art," or Neoplasticism, as Mondrian called it, he eventually limited his formal vocabulary to the three primary colors (red, blue, and yellow), the three primary values (black, white, and gray), and the two primary directions (horizontal and vertical). He believed that primary colors and values were construct a harmonious composition. Mondrian created numerous paintings locking color planes into a grid of intersecting vertical and horizontal lines, as in Composition with Red, Blue, and Yellow (Fig. 14-29). In each of these paintings, he altered the grid patterns and the size and placement of the color planes to create an internal cohesion and harmony. This did not mean inertia. Rather, Mondrian worked to maintain what he called a "dynamic equilibrium" in his paintings through the size and position of lines, shapes, and colors.

Sculpture

During the second quarter of the 20th century, European sculptors also explored avant-garde ideas in their work, especially abstraction.

the work, thereby inducing a feeling of flight. the gleaming reflection along the delicate curves right off the tip of viewer's eye to linger on the sculpture itself. Instead, the eye follows highly reflective surface of the polished bronze does not allow the tion of a bird about to soar in free flight through the heavens. The each end. Despite the abstraction, the sculpture retains the suggesand ended with a gently curving columnar form sharply tapered at with the image of a bird at rest with its wings folded at its sides, of the work is the final result of a long process. Brancusi started 14-30). Clearly not a literal depiction of a bird, the abstract form conveying the essence of his subjects is evident in Bird in Space (FIG. surface."21 Brancusi's ability to design rhythmic, elegant sculptures anyone to express anything essentially real by imitating its exterior the essence of things. Starting from this truth it is impossible for depicted. He asserted: "What is real is not the external form but surface appearances to capture the essence or spirit of the object CONSTANTIN BRANCUSI (1876-1957) sought to move beyond CONSTANTIN BRANCUSI In his sculptures, Romanian artist

The British sculptor HENRY MOORE (1898–1986; FIG. 14-30A (3) summed up Brancusi's contribution to the history of sculpture as follows: "Since the Gothic, European sculpture had become overgrown with moss, weeds—all sorts of surface excrescences which completely this overgrowth, and to make us once more shape-conscious. To do this he has had to concentrate on very simple direct shapes. . . . Abstract qualities of design are essential to the value of a work."

herself and her companions. In many ways, The Jungle is a bridge between Cubism, Surrealism, and the nonrepresentational canvases of the New York School Abstract Expressionists of the 1940s and 1950s (see pages 413–416).

De Stijl

The utopian spirit and ideals of the Suprematists (FIG. 14-17) in Russia were shared by a group of young Dutch artists. They formed a new movement in 1917 called De Stijl (The Style). The name reflected confidence that this style—the style—revealed the underlying eternal atructure of existence. Accordingly, De Stijl artists reduced their formal vocabulary to simple geometric elements.

PIET MONDRIAN The cofounders of De Stijl were the painters Piet Mondrian (Fig. 14-29) and Theo van Doesburg (1883–1931). Their goal, according to van Doesburg and architect Cor van Eesteren (1897–1988), was a total integration of art and life:

We must realize that life and art are no longer separate domains. That is why the "idea" of "art" as an illusion separate from real life must disappear. The word "Art" no longer means anything to us. In its place we demand the construction of our environment in accordance with creative laws based upon a fixed principle. These laws, following those of economics, mathematics, technique, sanitation, etc., are leading to a new, plastic unity.¹⁹

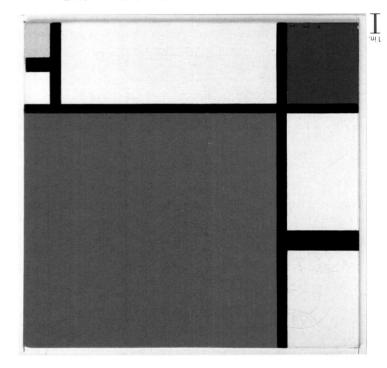

14-29 РІЕТ МОИВВІАУ, Сотроsition with Red, Blue, and Yellow, 1930. Oil on canvas, $1^{\circ} 6_{\overline{8}^{"}} \times 1^{\circ} 6_{\overline{8}^{"}}$. Kunsthaus, Zurich. © Mondrian/ Holtzman Trust c/o HCR International USA.

Mondrian's "pure plastic" paintings consist of primary colors locked into a grid of intersecting vertical and horizontal lines. By altering the grid patterns, he created a "dynamic equilibrium."

14-30 CONSTANTIN BRANCUSI, *Bird in Space*, 1924. Bronze, 4' $2\frac{5}{16}$ " high. Philadelphia Museum of Art, Philadelphia (Louise and Walter Arensberg Collection, 1950).

Although not a literal depiction of a bird, Brancusi's softly curving, light-reflecting abstract sculpture in polished bronze suggests a bird about to soar in free flight through the heavens.

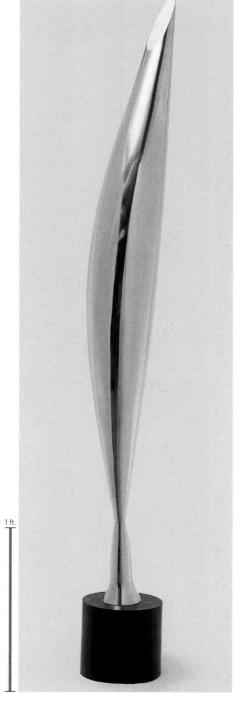

BARBARA HEPWORTH Another leading British artist of this era was BARBARA HEPWORTH (1903–1975), who developed her personal kind of essential sculptural form, combining pristine shape with a sense of organic vitality. She sought a sculptural idiom that would express her sense both of nature and the landscape and of the person who is in and observes nature. By 1929, Hepworth arrived at a breakthrough that evolved into an enduring and commanding element in her work from that point on. It represents her major contribution to the history of sculpture: the use of the hole, or void. In Hepworth's sculptures, holes are abstract elements. They do not represent anything specific, but they are as integral and important as the masses. *Oval Sculpture* (*No. 2*) is a plaster cast (FIG. 14-31) of an earlier wood sculpture that Hepworth carved in 1943. Pierced

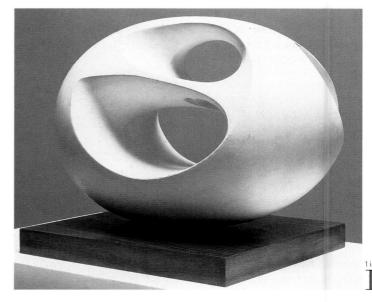

14-31 BARBARA HEPWORTH, Oval Sculpture (No. 2), 1943. Plaster cast, $11\frac{1}{4}$ " × 1' $4\frac{1}{4}$ " × 10". Tate, London.

Hepworth's major contribution to the history of sculpture was the introduction of the hole, or void, as an abstract element that is as integral and important to the sculpture as its mass.

in four places, the work is as much defined by the smooth, curving holes as by the volume of white plaster. Like the forms in all of Hepworth's mature works, those in *Oval Sculpture* are basic and universal, expressing a sense of timelessness.

UNITED STATES AND MEXICO, 1930 TO 1945

In the years leading up to and during World War II, many European artists emigrated to the United States. Their collective presence in America was critical for the development of American art in the decades following the 1913 Armory Show. Yet few of the leading American artists of this period pursued abstraction, either in painting or sculpture.

Sculpture and Photography

ALEXANDER CALDER One exception was Alexander Calder (1898–1976), who rose to international prominence because of his contributions to the development of abstract art. The son and grandson of sculptors, Calder initially studied mechanical engineering. Fascinated all his life by motion, he explored movement in relationship to three-dimensional form in much of his work. As a young artist in Paris in the late 1920s, Calder invented a circus full of wirebased miniature performers that mimicked the motion of their reallife counterparts. After a visit to Piet Mondrian's studio in the early 1930s, Calder set out to put the Dutch painter's brightly colored rectangular shapes (FIG. 14-29) into motion. (Marcel Duchamp, intrigued by Calder's early motorized and hand-cranked examples of moving abstract pieces, named them mobiles.) Calder soon used his engineering skills to fashion a series of balanced structures hanging from rods, wires, and colored, organically shaped plates. This new kind of sculpture, which combined nonobjective organic

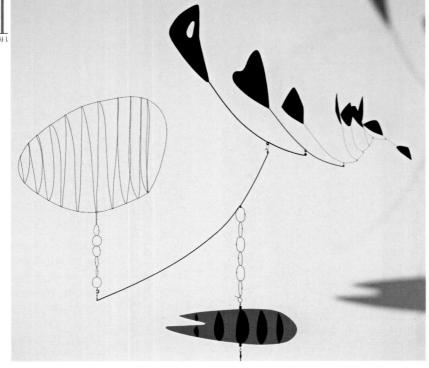

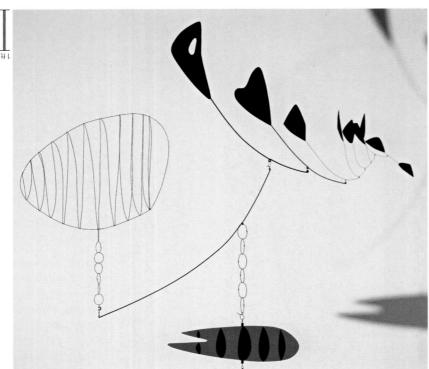

.msimenyb kind of sculpture—the mobile—that expressed reality's innate nonobjective organic forms and motion, Calder created a new Using his thorough knowledge of engineering to combine

dynamism of the natural world. forms and motion, succeeded in expressing the innate

bioforms. the shapes resemble cells, leaves, fins, wings, and other forms. Organically, the lines suggest nerve axons, and rigging, and the shapes derive from circles and ovoid organic. Geometrically, the lines suggest circuitry and viewers can read Calder's forms as either geometric or Joan Miro's Surrealist paintings (FIG. 14-27). Indeed, mobiles, but their organic shapes resemble those in work may have provided the initial inspiration for the create a constantly shifting dance in space. Mondrian's so that any air current would set the parts moving to (FIG. 14-32). The artist carefully planned each mobile An early Calder mobile is Lobster Trap and Fish Tail

people rushed food to Nipomo to feed the hungry workers. Lange's moving photograph appeared in a San Francisco newspaper, while turning their faces away from the camera. Within days after a baby on her lap. Two older children cling to their mother trustfully worry in the raised hand and careworn face of a mother, who holds ley (FIG. 14-33), in which she captured the mixture of strength and tures Lange made on this occasion was Migrant Mother, Nipomo Valstarving because the crops had frozen in the fields. Among the pic-Lange stopped at a camp in Nipomo and found the workers there assignment photographing migratory pea pickers in California, the deplorable living conditions of the rural poor. At the end of an THEA LANGE (1895-1965) in 1935 and dispatched her to document

Beginning in 1929, Bourke-White worked for Fortune, then for Life to furnish illustrations for the magazines in his publishing empire. was the first staff photographer that Henry Luce (1898–1967) hired her reputation as a photojournalist in Depression-era America. She otheа Lange, Мак
GARET Во
URKE-WHITE (1904–1971) also made MARGARET BOURKE-WHITE Almost 10 years younger than Dor-

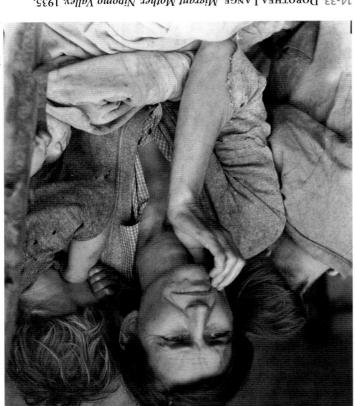

Oakland (gift of Paul S. Taylor). Gelatin silver print, I' I" × 9". Oakland Museum of California, 14-33 Dorother Lange, Migrant Mother, Vipomo Valley, 1935.

the woman's strength and worry. Lange made this unforgettable photograph of a mother in which she captured While documenting the lives of migratory farm workers during the Depression,

14-34 MARGARET BOURKE-WHITE, Fort Peck Dam, Montana, 1936. Gelatin silver print, 1' 1" \times 10 $\frac{1}{2}$ ". Metropolitan Museum of Art, New York (gift of Ford Motor Company and John C. Waddell, 1987).

Bourke-White's dramatic photograph of Fort Peck Dam graced the cover of the first issue of *Life* magazine and celebrated the achievements of American engineering during the depths of the Great Depression.

when Luce launched the famous newsweekly in 1936. Her most memorable photographs for Luce were not of people or events but of the triumphs of 20th-century engineering, which instilled pride in an American public severely lacking in confidence during the

Depression. For example, Bourke-White photographed the Chrysler Building (FIG. 14-41A 1) while it was under construction in New York, attracting media attention for her daring balancing act on steel girders high above the pavement. Her photograph Fort Peck Dam, Montana (FIG. 14-34) appeared on the cover of the first issue of Life (November 23, 1936). Fort Peck Dam was at the time the largest earth-filled dam in the world. Bourke-White photographed the still unfinished dam before the installation of the elevated highway at its summit. (The supports of that highway fortuitously conjure the image of a crenellated medieval fortress.) She chose a sharp angle from below to communicate the dam's soaring height, underscoring the immense scale by including two dwarfed figures of men in the foreground. The tight framing, which shuts out all of the landscape and much of the sky, transforms the dam into an almost abstract composition, a kind of still life, like Edward Weston's peppers (FIG. 14-21).

Painting

Although many European modernist artists emigrated to the United States during the 1930s and 1940s, the leading American painters of this period were figural artists with little interest in abstraction.

EDWARD HOPPER Trained as a commercial artist, EDWARD HOPPER (1882–1967) studied painting and printmaking in New York and then in Paris. When he returned to the United States, he concentrated on scenes of contemporary American life. His paintings depict buildings, streets, and landscapes that are curiously muted, still, and filled with empty spaces, evoking the national mindset during the Depression era. Hopper did not paint historically specific scenes. He took as his subject the more generalized theme of the overwhelming loneliness and echoing isolation of modern life in the United States. In his paintings, motion is stopped and time suspended.

From the darkened streets outside a restaurant in Hopper's *Nighthawks* (FIG. 14-35), the viewer glimpses the lighted interior through huge windows, which lend the inner space the paradoxical sense of being both a safe refuge and a vulnerable place for the three

14-35 EDWARD HOPPER, Nighthawks, 1942. Oil on canvas, 2' 6" × 4' 8 ³/₄". Art Institute of Chicago, Chicago (Friends of American Art Collection).

The seeming indifference of Hopper's characters to one another, and the echoing spaces that surround them, evoke the overwhelming loneliness and isolation of Depression-era life in the United States.

I was part of the migration, as was my family, my knew from his own experience. had left behind in the South, as the artist Jacob Lawrence were often as difficult and discriminatory as those they encountered both during their migration and in the North environment. But the conditions that African Americans opportunities and a more hospitable political and social years following World War I, seeking improved economic thousands of African Americans migrated north in the Disillusioned with their lives in the South, hundreds of Migration of the Negro Jacob Lawrence's

series began to take form in my mind.* the middle of the 1930s, and that's when the Migration ing.... I didn't realize what was happening until about tales about people "coming up," another family arrivmother, my sister, and my brother. . . . I grew up hearing

ART AND SOCIETY

educational value. He stated: cation, Lawrence argued that his proposal was of high Julius Rosenwald Fund. In his successful fellowship appli-Lawrence sought funding for his project from the

of this particular minority group, of which they know the whole of America might learn some of the history played in the History of the United States. In addition Negroes themselves a little of what part they have this effect, I feel that my project would lay before the mentally, economically and socially. Since it has had since this Migration has affected the whole of America It is important as a part of the evolution of America,

work in the North. Many of them left because of South-"They did not always leave because they were promised 60 panels, all with explanatory captions—for example, Migration on the Negro. The resulting series consists of tion on Various Parts of the North; and The Effects of the of the Migration on the South; The Effects of the Migration; Public Opinion Regarding the Migration; The Effects Spread of the Migration; The Efforts to Check the Migra-Causes of the Migration; Stimulation of the Migration; The can American migration northward in eight sections: His plan was to depict the history of the great Afri-

FIG. 14-36). much different from that which they had known in the South" (No. 49; (No. 8) and "They also found discrimination in the North although it was and therefore they were unable to make a living where they were" ern conditions, one of them being great floods that ruined the crops,

Tempera on Masonite, I' 6" x I'. Phillips Collection, Washington, D.C. 14-36 JACOB LAWRENCE, No. 49 from The Migration of the Negro, 1940-1941.

discrimination behind. rence's depiction of a segregated dining room underscored that the migrants had not left The 49th in a series of 60 paintings documenting African American life in the North, Law-

Phillips Collection, 1993), 20. Elizabeth Hutton Turner, ed., Jacob Lawrence: The Migration Series (Washington, D.C.: *Quoted in Henry Louis Gates Jr., "New Negroes, Migration, and Cultural Exchange," in

Los Angeles: University of California Press, 2009), 98. Quoted in Patricia Hills, Painting Harlem Modern: The Art of Jacob Lawrence (Berkeley and

simplified the shapes in a move toward abstraction. ers, but in keeping with more recent trends in painting, Hopper humans. Nighthawks recalls the work of 19th-century Realist paint-

spaces surrounding them evoke the pervasive loneliness of modern ence of Hopper's characters to one another as well as the echoing customers and the man behind the counter. The seeming indifferJACOB LAWRENCE African American artist JACOB LAWRENCE (1917–2000) moved to Harlem, New York, in 1927 while still a boy. There, he came under the spell of the African art and the African American history he found in lectures and exhibitions and in the special programs sponsored by the 135th Street branch of the New York Public Library. The everyday life of Harlem and African American history became the subjects of Lawrence's paintings. In 1941, he began a series titled *The Migration of the Negro*, in which he defined his vision of the continuing African American struggle against discrimination (see "Jacob Lawrence's *Migration of the Negro*," page 402).

Lawrence's *Migration* paintings provide numerous vignettes capturing the experiences of the African Americans who had moved to the North. Often, a sense of the bleakness and degradation of their new life dominates the images. In *No. 49* (FIG. 14-36), which tells of the unexpected and different kind of discrimination that African Americans encountered in the North, Lawrence depicted a blatantly segregated dining room with a barrier running down the room's center separating the whites on the left from the African Americans on the right. To ensure a continuity and visual integrity among all 60 paintings, Lawrence interpreted his themes systematically in rhythmic arrangements of bold, flat, and strongly colored shapes. His style drew equally from his interest in the push-pull effects of Cubist space and his memories of the patterns made by

the colored scatter rugs brightening the floors of his childhood homes. He unified the narrative with a consistent palette of bluish green, orange, yellow, and grayish brown throughout the entire series.

GRANT WOOD A very different picture of life in America appears in the paintings of Grant Wood (1891-1942), the leading figure in a Midwestern art movement known as Regionalism, which focused on American subjects, in opposition to the modernist abstraction of Europe and New York. The Regionalists chronicled rural life, which they believed was America's cultural backbone. Wood's paintings focus on the people of Iowa, where he was born and raised. The work that catapulted Wood to national prominence was American Gothic (FIG. 14-37). The artist depicted his dentist and his sister posing as a farmer and his spinster daughter standing in front of a neat house with a small lancet window, a motif associated with Gothic churches and religious piety. The man and woman wear traditional attire. He appears in worn overalls and she in an apron trimmed with rickrack. The dour expression on both faces gives the

14-37 Grant Wood, *American Gothic*, 1930. Oil on beaverboard, 2' $5\frac{7}{8}$ " \times 2' $\frac{7}{8}$ ". Art Institute of Chicago, Chicago (Friends of American Art Collection).

In reaction to modernist abstract painting, the Midwestern Regionalism movement focused on American subjects. Wood's painting of an lowa farmer and his daughter became an American icon.

painting a severe quality, which Wood enhanced with his meticulous brushwork. The public immediately embraced *American Gothic* as embodying qualities that represented the true spirit of America, and the painting became an American icon.

DIEGO RIVERA During the period between the two world wars, several Mexican painters achieved international renown for their work both in Mexico and the United States. The eldest was José CLEMENTE OROZCO (1883-1949; FIG. 14-37A (4)), but the most famous is DIEGO RIVERA (1886-1957). Orozco and Rivera were determined to base their art on the culture of their homeland. The movement that these artists formed was part of the idealistic rethinking of society that occurred in conjunction with the Mexican Revolution (1910–1920) and the lingering political turmoil of the 1920s. Among the projects these politically motivated artists undertook were vast mural cycles placed in public buildings to dramatize and validate the history of Mexico's native peoples. A staunch Marxist, Rivera strove to develop an art that served his people's needs. Toward that end, he sought to create a national Mexican style incorporating a popular, generally accessible aesthetic in keeping with the socialist spirit of the Mexican Revolution.

Perhaps Rivera's finest mural cycle is the one lining the staircase of the National Palace in Mexico City. In these images, painted

14-38 DIEGO RIVERA, Ancient Mexico, detail of History of Mexico, fresco in the Palacio Nacional, Mexico City, 1929-1935.

A staunch Marxist, Rivera painted vast mural cycles in public buildings to dramatize the history of his native land. This fresco depicts the conflicts between indigenous Mexicans and Spanish colonizers.

pain. Her life became a heroic and tumultuous battle for survival against illness and stormy personal relationships.

Typical of her long series of unflinching self-portraits is The Two Fridas (Fig. 14-39). The twin figures sit side by side on a low bench in a barren landscape under a stormy sky. The figures suggest different sides of the artist's personality, inextricably linked by the clasped hands and by the thin artery stretching between them, joining their exposed hearts. The artery ends on one side in surgical forceps and on the other in a miniature portrait of her husband as a child. Kahlo's deeply personal paintings touch sensual and psychochild. Kahlo's deeply personal paintings touch sensual and psychological memories in her audience.

To read Kahlo's paintings solely as autobiographical overlooks the powerful political dimension of her art. Kahlo was deeply nationalistic and committed to her Mexican heritage. Politically active, she joined the Communist Party in 1920 and participated in public political protests. The Two Fridas incorporates Kahlo's commentary on the struggle facing Mexicans in the early 20th century in defining their national cultural identity. The Frida on the right in defining their national cultural identity. The Frida on the right

between 1929 and 1935, he depicted scenes from Mexico's history, of which Ancient Mexico (FIG. 14-38) is one. This section of the mural represents the conflicts between the indigenous people and the Spanish colonizers. Rivers included portraits of important figures in Mexican history, especially those involved in the struggle for Mexican independence. Although the composition is complex, the simple monumental shapes and areas of bold color make the story easy to read.

PRIDA KAHLO Born to a Mexican mother and German father, the painter FRIDA KAHLO (1907–1954), who married Diego Rivera, used the details of her life as powerful symbols for the psychological pain of human existence. Art historians often consider Kahlo a Surrealist due to the psychic, autobiographical issues she dealt with in her art. Indeed, André Breton described her as a Naturalistic Surrealist. Sahlo herself, however, rejected any association with the Surrealists. She began painting seriously as a young student, during convalescence from an accident that tragically left her in constant convalescence from an accident that tragically left her in constant

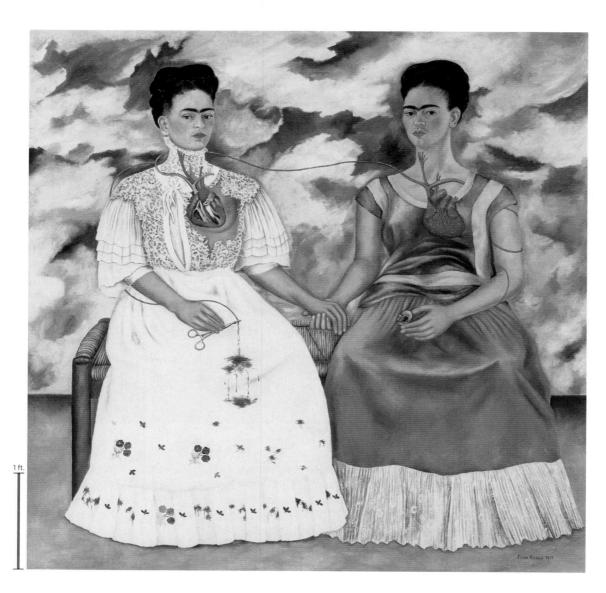

14-39 FRIDA KAHLO, The Two Fridas, 1939. Oil on canvas, 5' 7" × 5' 7". Museo de Arte Moderno, Mexico City.

Kahlo's deeply personal paintings touch sensual and psychological memories in her audience. Here, twin self-portraits linked by clasped hands and a common artery suggest two sides of her personality.

(representing indigenous culture) appears in a Tehuana dress, the traditional costume of Zapotec women from the Isthmus of Tehuantepec, whereas the Frida on the left (representing imperialist forces) wears a European-style white lace dress. The heart, depicted here in such dramatic fashion, was an important symbol in the art of the Aztecs, whom Mexican nationalists idealized as the last independent rulers of their land. Thus *The Two Fridas* represents both Kahlo's personal struggles and the struggles of her homeland.

ARCHITECTURE

The first half of the 20th century was a time of great innovation in architecture too. As in painting, sculpture, and photography, new ideas came from both sides of the Atlantic.

WALTER GROPIUS The De Stijl group developed an appealing simplified geometric style in architecture as well as painting, and promoted the notion that art should be thoroughly incorporated into living environments. In Germany, Walter Gropius (1883–1969) developed the concept of "total architecture" at a school called the *Bauhaus*. In 1919, he became the director of the Weimar School

of Arts and Crafts, founded in 1906. Under Gropius, the school assumed a new name—Das Staatliche Bauhaus (State School of Building). Gropius's goal was to train artists, architects, and designers to accept and anticipate 20th-century needs. He staunchly advocated the importance of strong basic design and craftsmanship as fundamental to good art and architecture, and promoted the unity of art, architecture, and design. Further, Gropius emphasized the need for thorough knowledge of machine-age technologies and materials. To encourage the elimination of the boundaries that traditionally separated art from architecture and art from craft, Gropius developed a curriculum for the Bauhaus that included courses in a wide range of artistic disciplines: weaving, pottery, bookbinding, carpentry, metalwork, stained glass, mural painting, stage design, advertising, and typography, in addition to architecture, painting, and sculpture. Ultimately, Gropius hoped to achieve a marriage between art and industry—a synthesis of design and production. Like the De Stijl movement, the Bauhaus philosophy had its roots in utopian principles. Gropius declared: "Let us collectively desire, conceive, and create the new building of the future, which will be everything in one structure: architecture and sculpture and painting, which, from the million hands of draftsmen, will one day

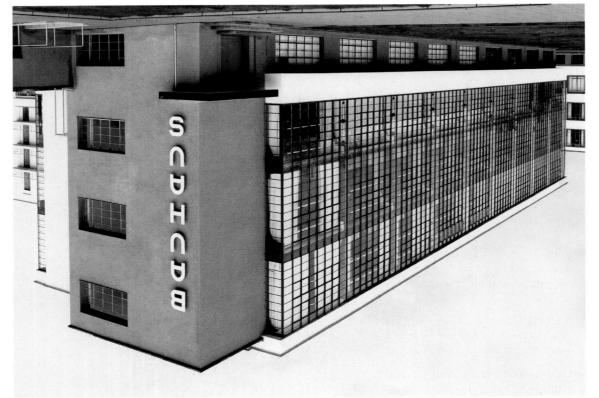

Shop Block (looking northeast), the Bauhaus, Dessau, Germany, 1925–1926.

Gropius constructed this Bauhaus constructed this

14-40 Магтев Своргиз,

Gropius constructed this Bauhaus building by sheathing a reinforced concrete skeleton in glass. The design followed his dictum that architecture should avoid "all romantic embellishment and whimsy."

layout of the Shop Block, which consisted of large areas of free-flowing undivided space. Gropius believed that this kind of spatial organization encouraged interaction and the sharing of ideas.

steel skyscrapers found in major cities throughout the world today. through the glass, prefigured the design of many of the glass-andillusion of movement created by reflection and by light changes seen turous. The weblike delicacy of the lines of the model, as well as the inset supports was, at the time, technically and aesthetically advenvertical supporting elements. The bold use of glass sheathing and horizontal patterning of the cantilevered floor planes and their thin toilets. Wholly transparent, the perimeter walls reveal the regular at the ends of the court, each containing elevators, stairways, and room, and a community center. Two cylindrical entrance shafts rise outward from a central court designed to hold a lobby, a porter's skyscraper building in 1921. Three irregularly shaped towers flow his aesthetic when he conceived the model (FIG. 14-41) for a glass and bones," the new Bauhaus director had already fully formed Taking as his motto "less is more" and calling his architecture "skin took over the directorship, moving the school to Berlin in 1932. haus, and Ludwig Mies van der Rohe (1886–1969) eventually LUDWIG MIES VAN DER ROHE In 1928, Gropius left the Bau-

END OF THE BAUHAUS One of the first actions that Adolf Hitler (1889–1945) took after coming to power was to close the Bauhaus in 1933. The Nazis suspected that the school housed a press that printed antigovernment brochures. During its 14-year existence, the Bauhaus graduated fewer than 500 students, yet it achieved legendary status. Its phenomenal influence extended beyond architecture, painting, and sculpture to interior design, graphic design, and advertising, Moreover, art schools everywhere began to structure advertising in line with the program that the Bauhaus pioneered.

rise towards heaven as the crystalline symbol of a new and coming faith."23 In its reference to a unity of workers, this statement also reveals the undercurrent of socialism in Germany at the time.

BAUHAUS IN DESSAU After encountering increasing hostility from a new government elected in 1924, the Bauhaus moved north to Dessau in early 1925. By this time, the Bauhaus program had matured. In a statement, Gropius listed the school's goals:

- A decidedly positive attitude to the living environment of
- vehicles and machines.

 The organic shaping of things in accordance with their own current laws, avoiding all romantic embellishment and
- whimsy.

 Restriction of basic forms and colors to what is typical and
- Restriction of basic forms and colors to what is typical and universally intelligible.
- Simplicity in complexity, economy in the use of space, materials, time, and money.²⁴

The building that Gropius designed for the Dessau Bauhaus was the school's architectural manifesto. The Dessau complex consisted of workshop and class areas, a dining room, a theater, a gymnasium, a wing with studio apartments, and an enclosed two-story bridge housing administrative offices. Of the major wings, the most dramatic was the Shop Block (Fig. 14-40). Three stories tall, the Shop Block housed a printing shop and dye works facility, in addition to other work areas. The builders constructed the skeleton of reinforced concrete but set these supports well back, sheathing the entire structure in glass, creating a streamlined and light effect. This design's simplicity followed Gropius's dictum that architecture should avoid "all romantic embellishment and whimsy." Further, he realized his principle of "economy in the use of space" in his interior realized his principle of "economy in the use of space" in his interior

14-41 LUDWIG MIES VAN DER ROHE, model for a glass skyscraper, Berlin, Germany, 1922 (no longer extant).

In this technically and aesthetically adventurous design, the architect whose motto was "less is more" proposed a transparent building that revealed its cantilevered floor planes and thin supports.

The numerous Bauhaus instructors who fled Nazi Germany spread the school's philosophy and aesthetic widely. Many, including Gropius and Mies van der Rohe, settled in the United States.

LE CORBUSIER The simple geometric aesthetic developed by Gropius and Mies van der Rohe became known as the *International Style* because of its widespread popularity, although a highly decorative style, *Art Deco*, also had many proponents, both in Europe and America—for example, William van Alen (1882–1954), who designed the Chrysler Building (Fig. 14-41A) in New York City. The first and purest champion of the International Style was the Swiss architect Charles-Edouard Jeanneret, who took the name Le Corbusier (1887–1965). An influential theorist (see page 385) as well as practitioner, Le Corbusier sought to design a functional living space, which he described as a "machine for living."

Le Corbusier's Villa Savoye (FIG. 14-42) at Poissy-sur-Seine near Paris is a cube of lightly enclosed and deeply penetrated space with only a partially confined ground floor (containing a three-car garage, bedrooms, a bathroom, and utility rooms). Much of the house's interior is open space, with thin columns supporting the main living floor and roof garden area. The major living rooms in the Villa Savoye are on the second floor, wrapping around an open central court. Strip windows running along the membranelike exterior walls provide illumination to the rooms as well as views out to nature. From the second-floor court, a ramp leads up to the roof-terrace and an interior garden protected by a curving windbreak along the north side. The building has no traditional facade. The ostensible approach to the house does not define an entrance. Visitors must walk around and through the house to comprehend its layout, which incorporates spiral staircases and several changes of

14-42 Le Corbusier, Villa Savoye (looking southeast), Poissysur-Seine, France, 1929.

Steel and ferroconcrete made it possible for Le Corbusier to invert the traditional practice of placing light architectural elements above heavy ones and to eliminate weight-bearing walls on the ground story.

Pennsylvania, 1936-1939. northeast), Bear Run, (Fallingwater; looking WRIGHT, Kaufmann House 14-43 FRANK LLOYD

natural environment. ture the expansiveness of the limits, that reach out and capunconfined by abrupt wall water has long, sweeping lines, over a waterfall, Wright's Falling-Perched on a rocky hillside

a space designed to fit the patron's life and enclosed and divided as key element of Wright's new architecture was space, not mass to create a stunning interweaving of interior and exterior space. The enlivens its shapes, as does Wright's use of full-length strip windows painted metal, and natural stones in the house's terraces and walls but concealed the entrance. The contrast in texture among concrete, eliminated a facade, extended the roofs far beyond the walls, and all

the subject of Chapter 15. emulated. This new preeminence of the United States in the arts is lead in establishing innovative styles that artists elsewhere quickly conflict, American painters, sculptors, and architects often took the World War II. However, in the decades following that new global ence in Europe was exceptional for any American artist before [Wright's] work invigorated a whole generation."25 Wright's influ-1940, Mies van der Rohe wrote that the "dynamic impulse from Frank Lloyd Wright achieved international tame. As early as

as a nonsymmetrical design interacting spatially with its natural have the right to move within a "free" space, which he envisioned tecture—that is, buildings designed to serve free individuals who livan (FIG. 13-22). Wright believed in "natural" or "organic" archi-Chicago, where he eventually joined the firm headed by Louis Sul-Wisconsin-born Frank Lloyd Wright (1867-1959) moved to FRANK LLOYD WRIGHT Perhaps America's greatest architect, stories appear to hover lightly on the slender column supports.

a skeleton of iron bars), makes the "load" of the Villa Savoye's upper sible by the use of steel and ferroconcrete (concrete strengthened by

of the Villa Savoye with masonry walls. This openness, made posand light ones below, and by refusing to enclose the ground story

inverted traditional design practice by placing heavy elements above

and outside space intermingle. In the Villa Savoye, Le Corbusier

direction. Spaces and masses interpenetrate so fluidly that inside

structure, materials, and site. surroundings. He sought to develop an organic unity of planning,

levels from a central core structure. Abandoning all symmetry, he the location, Wright designed a series of terraces that extend on three ence and power if they merely overlooked it. To take advantage of the Kaufmanns would become desensitized to the waterfall's presdecided to build it over the waterfall because he believed that than build the house overlooking or next to the waterfall, Wright and capture the expansiveness of the natural environment. Rather ing lines, unconfined by abrupt wall limits, that reach out toward over a small waterfall, the Kaufmann House has long, sweepstore magnate Edgar Kaufmann Sr. Perched on a rocky hillside retreat at Bear Run, Pennsylvania, for the Pittsburgh department named "Fallingwater" (FIG. 14-43), which he designed as a weekend Wright's universally acclaimed masterpiece is the house nick-

following additional subjects: buildings, Google EarthTM coordinates, and essays by the author on the Explore the era further in MindTap with videos of major artworks and

- André Derain, The Dance (FIG. 14-3A)
- ART AND SOCIETY: Science and Art in the Early 20th Century
- Arthur Dove, Nature Symbolized No. 2 (FIG. 14-17A) ■ ART AND SOCIETY: Primitivism and Colonialism
- ART AND SOCIETY: Art "Matronage" in the United States
- Henry Moore, Reclining Figure (FIG. 14-30A)
- (FIG. 14-37A) José Clemente Orozco, Epic of American Civilization: Hispano-America
- \blacksquare William van Alen, Chrysler Building, New York (FIG. 14-41A)

MODERNISM IN EUROPE AND AMERICA, 1900 TO 1945

Europe, 1900 to 1920

- In the early 1900s, avant-garde artists searched for new definitions of art in a changed world. The Fauves used bold colors as the primary means of conveying feeling. German Expressionist paintings feature clashing colors, disquieting figures, and perspective distortions.
- Picasso and Braque radically challenged prevailing artistic conventions with Cubism. The Cubists dissected forms and placed them in interaction with the space around them.
- The Futurists focused on motion in time and space to create paintings and sculptures capturing the dynamic quality of modern life. The Dadaists celebrated the spontaneous and intuitive, often incorporating found objects in their artworks.

Boccioni, Unique Forms of Continuity in Space, 1913

United States, 1900 to 1930

- The Armory Show of 1913 introduced European avant-garde art to American artists.
- The Harlem Renaissance brought African American artists, such as Douglas, to the forefront.
- Photography emerged as an important American art form in the work of Stieglitz, who promoted "straight photography," and Weston, who emphasized the careful arrangement of forms and patterns of light and dark.

Douglas, Noah's Ark, ca. 1927

Europe, 1920 to 1945

- World War I gave rise to the Neue Sachlichkeit movement in Germany. "New Objectivity" artists focused on depicting the horrors of war.
- The Surrealists investigated ways to express in art the world of dreams and the unconscious. Naturalistic Surrealists aimed for "concrete irrationality" in their naturalistic paintings of dreamlike scenes. Biomorphic Surrealists experimented with automatism and employed abstract imagery.
- Many European modernists pursued utopian ideals. The Suprematists developed an abstract style to express pure feeling. De Stijl artists employed simple geometric forms in their "pure plastic art." Brancusi and Hepworth also turned to abstraction in their sculptures.

Dalí, The Persistence of Memory, 1931

United States and Mexico, 1930 to 1945

- Although Calder created abstract works between the wars, other American artists favored figural art. Hopper explored the loneliness of life in the Depression era. Lawrence recorded the struggle of African Americans. Wood depicted life in rural lowa.
- Mexican artists Orozco and Rivera painted epic mural cycles of the history of Mexico. Kahlo's powerful paintings explore the human psyche.

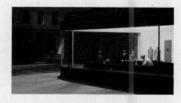

Hopper, Nighthawks, 1942

Architecture

- The Bauhaus in Germany promoted "total architecture"—the integration of all the arts in constructing modern living environments. In France, Le Corbusier used modern construction materials in his "machines for living"—simple houses with open plans and unadorned surfaces.
- The leading American architect of the first half of the 20th century was Wright. Fallingwater is a bold asymmetrical design integrating a private home with nature.

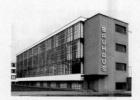

Gropius, Bauhaus, Dessau, 1925-1926

■ 15-1b Postmodernist architects frequently incorporate references to historical styles in their designs. In addition to motifs based on Roman buildings, Moore included modern versions of medieval flying buttresses.

Moore's circular postmodern Italian postmodern Italian plaza incorporates elements drawn from classical architecture, including a portico inspired by ancient Roman fora and an exedra loosely based exedra loosely based on a triumphal arch.

61-21 **₽**

CHARLES Moore, Piazza d'Italia (looking northeast), New Orleans, 1976-1980.

► 15-1c Many of Moore's historical motifs are rendered in high-tech materials unavailable to earlier architects—for example, stainless-steel columns and capitals and neon lighting for multicolored nightime illumination.

Modernism and Postmodernism in Europe and America, 1945 to 1980

AFTER MODERNISM: POSTMODERNIST ARCHITECTURE

One of the most significant developments in later-20th-century architecture was postmodernism. Postmodernist architects rejected the severity and simplicity of the modernist idiom pioneered by Gropius (FIG. 14-40), Mies van der Rohe (FIG. 14-41), Le Corbusier (FIG. 14-42), and their postwar successors. Instead, they celebrated complexity and incorporated historical references in their designs, often rendered in high-tech materials unavailable to earlier architects.

An outstanding example of a postmodernist design that creates a dialogue between the past and the present is Piazza d'Italia (Plaza of Italy; fig. 15-1) in New Orleans, designed by Charles Moore (1925-1993), dean of the Yale School of Architecture from 1965 to 1970. Erected in the late 1970s and restored after sustaining serious damage in the wake of Hurricane Katrina in 2005, Piazza d'Italia is dedicated to the city's Italian American community. Appropriately, Moore selected elements relating specifically to Italian history, all the way back to ancient Roman culture.

Piazza d'Italia is an open circular area partially formed by short segments of colonnades arranged in staggered concentric arcs, which direct the eye to the focal point of the composition—an exedra. This recessed area on a raised platform serves as a rostrum (speaker's platform) during the annual festivities of Saint Joseph's Day. Moore inlaid the piazza's pavement with a map of Italy centered on Sicily, from which the majority of the city's Italian families originated. From there, the map's Italian "boot" stretches to the steps, which correspond to the Alps, and ascends the rostrum.

The piazza's most immediate historical references are to the porticos of an ancient Roman forum (FIGS. 3-12 and 3-35) and to triumphal arches (FIG. 3-32), but the irregular placement of the concentrically arranged colonnade fragments inserts a note of instability into the design reminiscent of Mannerism (FIG. 9-26). Illusionistic devices, such as the continuation of the piazza's pavement design (apparently through a building and out into the street), are Baroque in character (FIG. 10-2). Moore incorporated all the classical orders-most with whimsical modifications, such as the stainless-steel columns and capitals, neon collars around the column necks, and neon lights framing various parts of the exedra and porticos for dramatic multicolored nighttime illumination. He even made references to medieval architecture by including modern versions of flying buttresses, and alternating white and graygreen stones in emulation of the revetment of medieval Italian buildings (FIGS. 7-37 and 7-38). This kind of eclecticism, especially rich in Piazza d'Italia, is a key ingredient of postmodernist architectural design.

YH9A9DOTOH9 QNA РАІИТІИБ, SCULPTURE,

35 million lives. dead, whereas World War II was a truly global catastrophe, claiming was largely a European conflict that left roughly 10 million people did so soon after the "war to end all wars." Further, World War I nearly impossible to do the same with World War II, coming as it page 386) had tried to find redemptive value in World War I, it was Although many people (for example, the Futurists in Italy; see in a pervasive sense of despair, disillusionment, and skepticism. bombing of Hiroshima and Nagasaki and of the Holocaust, resulted factors, coupled with the massive loss of life and the horrors of the economies, and governments in chaos throughout Europe. These The end of World War II in 1945 left devastated cities, ruptured

Postwar Expressionism in Europe

ized the work of many European sculptors and painters. the artist's state of mind and the larger cultural sensibility characterwar period. A brutality or roughness appropriately expressing both despair emerged frequently in European art of the immediate postwithout absolutes or traditional values. This spirit of pessimism and struggle in isolation with the anguish of making decisions in a world ing to Sartre, if God does not exist, then individuals must constantly (1905–1980) most clearly captured the existentialist spirit. Accordpromoted atheism. The writings of French author Jean-Paul Sartre the impossibility of achieving certitude. Many existentialists also tialism, a philosophy asserting the absurdity of human existence and The cynicism pervading Europe in the 1940s found voice in existen-

emerged in the aftermath of world war. cometti's evocative sculptures spoke to the pervasive despair that surrounding them, imparting a sense of isolation and fragility. Giathese thin and elongated figures seem swallowed up by the space veying the solidity and mass of conventional bronze sculpture, featureless figures with rough, agitated surfaces. Rather than conof the 1940s, such as Man Pointing No. 5 (FIG. 15-2), are thin, nearly solitary, and lost in the world's immensity. Giacometti's sculptures figures as the personification of existentialist humanity—alienated, phy. Indeed, Sartre, Giacometti's friend, saw the artist's sculptured tialist ideas in his art, his works capture the spirit of that philosospirit. Although Giacometti never claimed that he pursued existen-GIACOMETTI (1901–1966) perhaps best express the existentialist ALBERTO GIACOMETT! The sculptures of Swiss artist ALBERTO

II AAW GJROW 30 HTAMRSTAA 3HT

in Vietnam. bitter fighting in Southeast Asia, the United States suffered deteat a prolonged war with Algeria's Muslim natives. After 15 years of dead. Algeria expelled France in 1962 after the French waged Civil war also broke out in Indonesia, leaving more than 100,000 independence from colonial powers, civil wars devastated them. ria, Angola, Mozambique, Sudan, Congo, and Kwanda—won their Almost as soon as many African nations—Kenya, Uganda, Nige-United States intervened in disputes in Central and South America. ings in East Germany, Poland, Hungary, and Czechoslovakia. The United States and its allies. The Soviets brutally suppressed uprisinvaded South Korea in 1950 and fought a grim war with the war, Communists came to power in China in 1949. North Korea into two hostile nations, India and Pakistan. After a bloody civil century. In 1947, the British left India, dividing the subcontinent for further conflict and upheaval during the second half of the 20th World War II, with the global devastation it unleashed, set the stage

sity curricula as irrelevant. embraced alternative belief systems, and rejected Western univerof rock music. Young people "dropped out" of regulated society, lution, the widespread use and abuse of drugs, and the development social standards. The postwar youth era witnessed the sexual revomanners, habits, and morals deliberately subversive of mainstream mocked their elders' lifestyles and adopted unconventional dress, cies but often also of the society generating them. Young Americans culture," expressed in the radical rejection not only of national polirebellion of the young. A new system of values emerged—a "youth campuses, and for disengagement from the Vietnam War led to a civil rights for African Americans, for free speech on university cultural sphere. In the United States, for example, the struggles for The period from 1945 to 1980 also brought upheaval in the

mounted challenges to discriminatory policies and attitudes. ties for centuries. Gays and lesbians and various ethnic groups also perceived as having limited their political and economic opportunically began to challenge the male-dominated culture, which they fought discrimination and sought equal rights. Women systematipled with the rejection of racism and sexism. African Americans tion movement of the 1970s reflected this spirit of rebellion, cou-The civil rights movement of the 1960s and the women's libera-

pressing social and political issues of the day. Western society, producing compelling artworks addressing the participated in these challenges to the established institutions of found in the artworld. Painters, sculptors, and photographers fully The impact of these developments was immediate and pro-

MODERNISM AND POSTMODERNISM IN EUROPE AND AMERICA, 1945 TO 1980

- rials traditionally associated with women. by promoting women's themes and employing mate-■ Artists play a leading role in the feminist movement 0861-0/61
- buildings that often incorporate references to his-Postmodern architects erect complex and eclectic
- "art" by creating earthworks composed of natural ■ Environmental artists redefine what constitutes
- computers—as tools for creating art. Artists embrace new media—video recorders,
- of pigment on canvas. texture of action painting and celebrate the flatness ■ Post-Painterly Abstractionists reject the passion and
- Minimalists reduce sculpture to basic shapes and using only geometric forms. Op artists produce the illusion of motion and depth
- emphasize their works' "objecthood."
- commercial products. Pop artists find inspiration in popular culture and
- Superrealists strive for scrupulous fidelity to optical
- with temporal actions. Performance artists replace traditional artworks
- in the wake of World War II. sculptures the revulsion and cynicism that emerged European Expressionists capture in paintings and 0961-5761
- over subject matter. Expressionism, emphasizing form and raw energy New York School painters develop Abstract
- become familiar sights in cities throughout the Sleek, geometrically rigid modernist skyscrapers

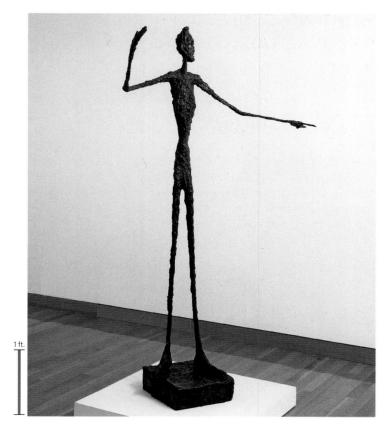

15-2 Alberto Giacometti, *Man Pointing No. 5*, 1947. Bronze, 5' 10" high. Des Moines Art Center, Des Moines (Nathan Emory Coffin Collection).

The writer Jean-Paul Sartre saw Giacometti's thin and virtually featureless sculpted figures as the personification of existentialist humanity—alienated, solitary, and lost in the world's immensity.

FRANCIS BACON Created in the year after World War II ended, Painting (FIG. 15-3) by British artist Francis Bacon (1910–1992) is a reflection of war's butchery and an indictment of humanity. Bacon presented a repulsive image of a powerful, stocky man with a gaping mouth and a vivid red stain on his upper lip, as if he were a carnivore devouring the raw meat sitting on the railing surrounding him. Bacon may have based his depiction of this central figure on news photos of similarly dressed European and American officials. The umbrella in particular recalls images of Neville Chamberlain (1869–1940), the wartime British prime minister who frequently appeared in photographs with an umbrella. The artist added to the gut-wrenching impact of the painting by depicting the flaved carcass hanging behind the central figure like a crucified human form. Painting is unmistakably "an attempt to remake the violence of reality itself," as Bacon often described his art based on what he referred to as "the brutality of fact."1

Abstract Expressionism

The devastation that World War II had inflicted across Europe resulted in an influx of artists escaping to the United States. In the 1950s, the center of the Western art world shifted from Paris to New

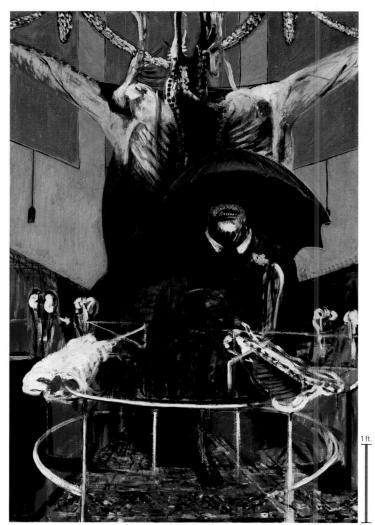

15-3 Francis Bacon, *Painting*, 1946. Oil and pastel on linen, 6' $5\frac{7}{8}$ " × 4' 4". Museum of Modern Art, New York.

Painted in the aftermath of World War II, this intentionally repulsive image of a powerful figure presiding over a slaughter is a reflection of war's butchery. It is Bacon's indictment of humanity.

York. It was there that the first major American avant-garde art movement—*Abstract Expressionism*—emerged. The most important forerunner of the Abstract Expressionists, however, was an Armenian.

ARSHILE GORKY Born a Christian in Islamic Turkish Armenia, Arshile Gorky (1904–1948) was four years old when his father escaped being drafted into the Turkish army by fleeing the country. His mother died of starvation in her 15-year-old son's arms in a refugee camp for victims of the Turkish campaign of genocide against the Christian minority. Penniless, Gorky managed in 1920 to make his way to America, settling in New York City four years later.

In a career lasting only two decades, Gorky contributed significantly to the artistic revolution born in New York. His work is the bridge between the Biomorphic Surrealism of Joan Miró (FIG. 14-27) and the totally abstract canvases of Jackson Pollock (FIG. 15-5).

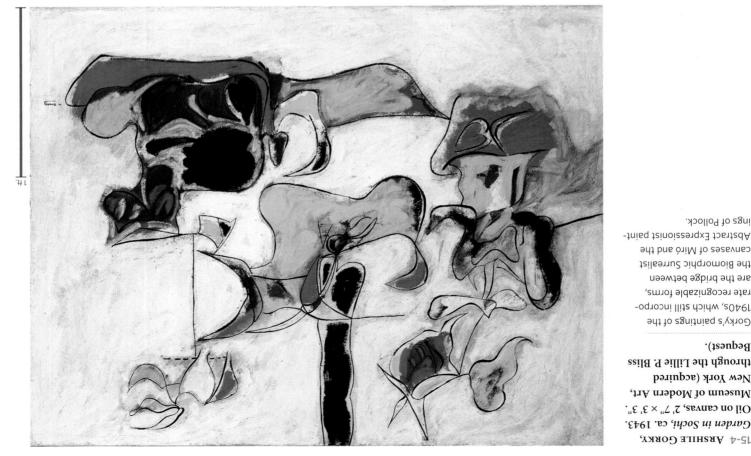

ings of Pollock. Abstract Expressionist paintcanvases of Miró and the the Biomorphic Surrealist are the bridge between rate recognizable forms, 1940s, which still incorpo-Gorky's paintings of the

through the Lillie P. Bliss New York (acquired Museum of Modern Art,

15-4 Авяніге Совку,

Bequest).

two oversized shoes-the Armenian slippers that Gorky's father at the center, a tree trunk with fluttering fabric. At the bottom are loose sketches representing, at the left, a bare-breasted woman, and, which initially appear to be purely abstract biomorphic shapes, are The brightly colored and thinly outlined forms in Garden in Sochi, den beneath a tree to which they tied torn strips of their clothing. granted if they rubbed their bare breasts against a rock in that gara modernist work of art must try, in principle, to avoid communica-Armenian village of Khorkom believed that their wishes would be the Garden of Wish Fulfillment in his birthplace. The women of the ture. Greenberg argued that a Black Sea resort, was inspired by Gorky's childhood memories of for example, flatness in painting and three-dimensionality in sculp-Garden in Sochi (FIG. 15-4), painted in 1943 and named after more explicit focus on the properties exclusive to each medium—

The Abstract Expressionist movement developed along two selves—that is, by becoming "abstract" or nonfigurative.2 achieve concreteness, "purity," by dealing solely with their respective means renouncing illusion and explicit subject matter. The arts are to essentially construed nature of its medium. Among other things, this tion with any order of experience not inherent in the most literally and

pigment. In contrast, the chromatic abstractionists focused on colabstractionists relied on the expressiveness of energetically applied lines—gestural abstraction and chromatic abstraction. The gestural

Pollock flung, poured, and dripped paint (not only traditional oil or's emotional resonance.

This working method earned Pollock the derisive nickname "Jack a section of canvas that he simply unrolled across his studio floor. paints but aluminum paints and household enamels as well) onto ers, drawing them into a lacy spider web. Using sticks or brushes, mural-sized fields of energetic skeins of pigment envelop viewconsist of rhythmic drips, splatters, and dribbles of paint. The ings, such as Number 1, 1950 (Lavender Mist; FIG. 15-5), which refined his technique and was producing large-scale abstract paintoped his signature style in the mid-1940s. By 1950, Pollock had gestural abstraction is Jackson Pollock (1912-1956), who devel-JACKSON POLLOCK The artist whose work best exemplifies

represented purity in art. He thought that artists should strive for a

ism. Greenberg championed abstraction because he believed that it

eral modernist tenets during this period as Greenbergian formal-

So dominant was Greenberg that scholars often refer to the gen-

ism and the exploration of the properties of each artistic medium.

parameters of modernism by advocating the rejection of illusion-

from the 1940s through the 1970s. Greenberg helped redefine the

ent Greenberg (see page 358), who wielded considerable influence

elements rather than its subject—was the American art critic Clem-

pion of this strict formalism—an emphasis on an artwork's visual

striking emotional chords in the viewer. The most important cham-

abstract but express the artist's state of mind, with the goal also of

Expressionism produced paintings that are, for the most part, suggests, the artists associated with the New York School of Abstract

Gorky's work disappeared in Abstract Expressionism. As the name

CLEMENT GREENBERG The few traces of representational art in

gave his son shortly before abandoning the family.

ARTISTS ON ART

Jackson Pollock on Action Painting

The kind of vigorous physical interaction between the painter and the canvas that Jackson Pollock championed led the critic Harold Rosenberg (1896-1989) to label Pollock's work (FIG. 15-5) action painting. In an influential 1952 article, Rosenberg described the attempts of Pollock and other Abstract Expressionists to get "in the painting":

At a certain moment the canvas began to appear to one American painter after another as an arena in which to act—rather than as a space in which to reproduce, redesign, analyze or "express" an object, actual or imagined. What was to go on the canvas was not a picture but an event. The painter no longer approached his easel with an image in his mind; he went up to it with material in

his hand to do something to that other piece of material in front of him. The image would be the result of this encounter.*

In an essay he published in 1947, Pollock explained the motivations for his action painting and described the tools he used and the way he produced his room-size canvases.

My painting does not come from the easel. I hardly ever stretch my canvas before painting. I prefer to tack the unstretched canvas to the hard wall or the floor. I need the resistance of a hard surface. On the floor I am more at ease. I feel nearer, more a part of the painting, since this way I can walk around it, work from the four sides and literally be in the painting. . . . I continue to get further away from the usual painter's tools such as easel, palette, brushes, etc. I prefer sticks, trowels, knives and dripping fluid paint or a heavy impasto with sand, broken glass and other foreign matter added. When I am in my painting, I'm not aware of what I'm

> doing....[T]he painting has a life of its own. I try to let it come through.... The source of my painting is the unconscious.

*Harold Rosenberg, "The American 1952): 22-29 †Quoted in Francis V. O'Connor, Jackson Pollock (New York: Museum of Modern

Action Painters," Art News 51 (December Art, 1967), 39-40.

15-5 JACKSON POLLOCK, Number 1, 1950 (Lavender Mist), 1950. Oil, enamel, and aluminum paint on canvas, 7' 3" × 9' 10". National Gallery of Art, Washington, D.C. (Ailsa Mellon Bruce Fund).

Pollock's "action paintings" emphasize the creative process. His muralsize canvases consist of rhythmic drips, splatters, and dribbles of paint that envelop viewers, drawing them into a lacy spider web.

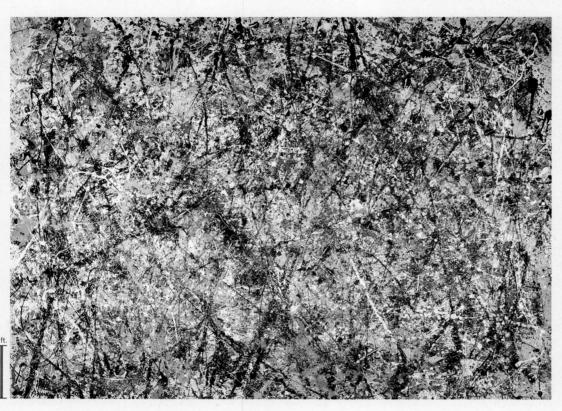

the Dripper." Responding to the image as it developed, he created art that was spontaneous yet choreographed. Pollock's painting technique highlights the most significant aspect of gestural abstraction—its emphasis on the creative process. Indeed, Pollock literally immersed himself in the painting during its creation (see "Jackson Pollock on Action Painting," above). Art historians have linked his ideas about improvisation in the creative process to his interest in what Swiss psychiatrist Carl Jung (1875-1961) called the collective unconscious. Pollock's reliance on improvisation and the subconscious has parallels in Surrealism and the work of Vassily Kandinsky (FIG. 14-5), whom critics described as an Abstract Expressionist as early as 1919.

LEE KRASNER A towering figure in 20th-century art, Pollock tragically died in a car accident at age 44, cutting short the development of his innovative artistic vision. Surviving him was his wife, LEE Krasner (1908-1984), whom art historians recognize as a major Abstract Expressionist painter, although overshadowed by Pollock during her lifetime. The Seasons (FIG. 15-5A 1) is one of her finest works.

WILLEM DE KOONING Despite the public's skepticism about Pollock's art, other artists enthusiastically pursued similar avenues of expression. Dutch-born WILLEM DE KOONING (1904–1997) also developed a gestural abstractionist style. Even his images rooted in figuration, such as

75-7 Макк Rothko, No. 14, 1960. Oil on canvas, 9° 6° × 8° 9° . San Francisco Museum of Modern Art, San Francisco (Helen Crocker Russell Fund Purchase).

works such as No. 14 (Fig. 15-7), Rothko created compelling visual experiences by confining his compositions to two or three large rectangles of pure color with hazy edges. The forms are shimmering veils of intensely luminous colors that appear to be suspended in front of sitions are visually captivating, Rothko intended them as more than decorative. He saw color as a doorway to another reality, and insisted that color could express "basic human emotions—tragedy, ecstasy, doom. . . The people who weep before my pictures are having the same religious experience I had when I painted them." Like the other same religious experience I had when I painted them." Like the other reliant on formal elements rather than on specific representational content to elicit emotional responses in viewers.

Post-Painterly Abstraction

Post-Painterly Abstraction, a term that Clement Greenberg coined, was another postwar American art movement. It developed out of Abstract Expressionism, but manifests a radically different sensibility. Whereas Abstract Expressionism conveys a feeling of intense passion, Post-Painterly Abstraction is characterized by detached rationality emphasizing tighter pictorial control. Greenberg saw this art as contrasting with "painterly" art, which emphasized loose, visible pigment application. Evidence of the artist's hand, so prominent in gestural abstraction, is conspicuously absent in Post-Painterly Abstraction. Greenberg championed this art form because it embodied his idea of purity in art.

15-6 Willem de Kooning, Woman I, 1950–1952. Oil on canvas, 6' 3 $_8^7$ \times 4' 10". Museum of Modern Art, New York.

Although rooted in figuration, including pictures of female models on advertising billboards, de Kooning's Woman I displays the energetic application of pigment typical of gestural abstraction.

Woman I (FIG. 15-6), display the sweeping gestural brushstrokes and energetic application of pigment typical of gestural abstraction. Out of the jumbled array of slashing lines and agitated patches of color appears a ferocious-looking woman with staring eyes and ponderous breasts. Her toothy smile, inspired by an ad for Camel cigarettes, seems to devolve into a grimace. Female models on advertising billboards partly inspired Woman I and de Kooning's other paintings of women, which he considered generic fertility goddesses or a satiric inversion of the traditional image of Venus, goddesse or a satiric inversion of the traditional image of Venus, goddesse or love.

Process was important to de Kooning, as it was for Pollock. Continually working on Woman I for almost two years, de Kooning painted an image and then scraped it away the next day and began anew. His wife, Elaine, also an accomplished painter, estimated that he painted approximately 200 scraped-away images of women on this canvas before settling on the final one.

MARK ROTHKO In contrast to the aggressively energetic images of the gestural abstractionists, the work of the chromatic abstractionists exudes a quieter aesthetic, exemplified by the work of Russianborn Mark Rothko (1903–1970). Rothko believed that references to anything specific in the physical world conflicted with the sublime idea of the universal, supernatural "spirit of myth," which he saw as the core of meaning in art. Rothko's paintings are compositionally simple, with color serving as the primary conveyor of meaning. In

FRANK STELLA Attempting to arrive at pure painting, the Post-Painterly Abstractionists distilled painting down to its essential elements, producing spare, elemental images. One variant of Post-Painterly Abstraction was *hard-edge painting*. Its leading exponent was Frank Stella (b. 1936). In works such as *Mas o Menos (More or Less*; Fig. 15-8), Stella eliminated many of the variables associated with painting. His simplified compositions of thin, evenly spaced pinstripes on colored grounds have no central focus, no painterly or expressive elements, only limited surface modulation, and no tactile quality. Stella's systematic method of painting illustrates Greenberg's insistence on purity in art. The artist's own famous comment on his work, "What you see is what you see," reinforces the notions that painters interested in producing advanced art must reduce their work to its essential elements and that the viewer must acknowledge that a painting is simply pigment on a flat surface.

HELEN FRANKENTHALER *Color-field painting*, another variant of Post-Painterly Abstraction, also emphasized painting's basic properties. However, rather than produce sharp, unmodulated shapes as the hard-edge artists had done, the color-field painters poured diluted paint onto unprimed canvas and allowed the pigments to soak in. No other painting method results in such literal flatness. The images created, such as *The Bay* (FIG. 15-9) by HELEN FRANKENTHALER (1928–2011), appear spontaneous and almost accidental (see "Helen Frankenthaler on Color-Field Painting," below).

15-8 Frank Stella, *Mas o Menos (More or Less)*, 1964. Metallic powder in acrylic emulsion on canvas, 9' $10" \times 13'$ $8\frac{1}{2}"$. Musée national d'art moderne, Centre Georges Pompidou, Paris (purchase 1983 with participation of Scaler Foundation).

In his hard-edge paintings, Stella tried to achieve purity using evenly spaced pinstripes on colored grounds. His canvases have no central focus, no painterly or expressive elements, and no tactile quality.

ARTISTS ON ART

Helen Frankenthaler on Color-Field Painting

In 1965, the art critic Henry Geldzahler (1935–1994) interviewed Helen Frankenthaler about her work as a color-field painter. In the following excerpt, Frankenthaler described her approach to placing color on canvas in works such as *The Bay* (Fig. 15-9), and compared her method with the way earlier modernist artists used color in their paintings.

I will sometimes start a picture feeling "What will happen if I work with three blues and another color, and maybe more or less of the other color than the combined blues?" And very often midway through the picture I have to change the basis of the experience. Or I add and add to the canvas. And if it's over-worked and beyond help I throw it away. I used to try to work from a given, made shape. But I'm less involved now with the shape as such. . . . When you first saw a Cubist or Impressionist picture there was a whole way of instructing the eye or the subconscious. Dabs of color had to stand for real things; it was an abstraction of a guitar or a hillside. The opposite is going on now. If you have bands of blue, green, and pink, the mind doesn't think sky, grass, and flesh. These are colors and the question is what are they doing with themselves and with each other. Sentiment and nuance are being squeezed out.*

Frankenthaler's "unsentimental" abstract canvases are very different from Matisse's emotive Fauve representations of recognizable figures, objects, and places, but her comments on a painter's struggle to find the right combination of colors without regard to colors in nature echo those of Matisse almost 60 years before (see "Henri Matisse on Color," page 379).

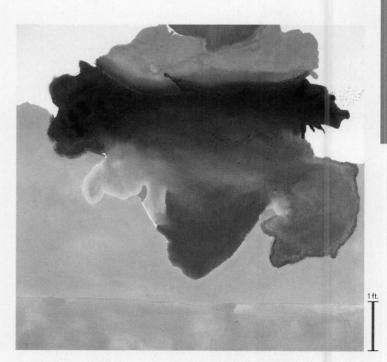

15-9 HELEN FRANKENTHALER, *The Bay*, 1963. Acrylic on canvas, $6' \, 8\frac{7}{8}" \times 6' \, 9\frac{7}{8}"$. Detroit Institute of Arts, Detroit.

Frankenthaler and other color-field painters poured paint onto plain canvas, allowing the pigments to soak into the fabric. Her works underscore that a painting is simply pigment on a flat surface.

^{*}Henry Geldzahler, "Interview with Helen Frankenthaler," Artforum 4, no. 2 (October 1965): 37-38.

understandably, chose to focus on three-dimensionality as the essential characteristic and inherent limitation of the sculptural medium.

DAVID SMITH Sculptor DAVID SMITH (1906–1965) produced metal sculptures that have affinities with the Abstract Expressionist movement in painting. In the 1960s, he created a series of large-scale works called Cubi that he intended to be seen in the open air (see "David Smith on Outdoor Sculpture" (a). Cubi XII (FIG. 15-11), a characteristic example, consists of simple geometric forms—cubes and rectangular bars. Made of stainless-steel sections piled on top of one another, often at unstable angles, and then welded together, the Oubi sculptures make a striking visual statement.

DONALD JUDD A predominantly sculptural movement that emerged in the 1960s among artists seeking Greenbergian purity of form was Minimalism. Minimalist artworks generally lack identifiable subjects, colors, surface textures, and narrative elements. By rejecting illusionism and reducing sculpture to basic geometric forms, Minimalists emphasized their art's "objecthood" and concrete tangibility. In so doing, they reduced experience to its most fundamental level. Two of the leading Minimalist sculptors were Isaam NoeucHI (1904–1988; FIG. 15-11A (4)) and Missouri native

15-71 DAVID SMITH, Cubi XII, 1963. Stainless steel, 9' $1\frac{8}{8}$ " high. Hirshhorn Museum and Sculpture Garden, Smithsonian Institution, Washington, D.C. (gift of the Joseph H. Hirshhorn Foundation, 1972). © Estate of David Smith/Licensed by VAGA, New York, NY.

David Smith designed his abstract metal sculptures of simple geometric forms to reflect the natural light and color of their outdoor settings, not the sterile illumination of a museum gallery.

15-10 Bridget Riley, Fission, 1963. Tempers on composition board, $2'11''\times 2'10''$. Museum of Modern Art, New York (gift of Philip Johnson).

Op Art paintings create the illusion of motion and depth using only geometric forms. The effect can be disorienting. The pattern of black dots in Riley's Fission appears to cave in at the center.

JyA qO

A major artistic movement of the 1960s was Op Art (short for Optical Art), in which painters sought to produce optical illusions of motion and depth using only geometric forms on flat surfaces.

painter can create the illusion of depth through perspective. the Op Art movement embraced the Renaissance notion that the not a representation of any person, object, or place. Nonetheless, painting is a two-dimensional surface covered with pigment and sickness. Thoroughly modernist is the Op artist's insistence that a sometimes disturbing, and some works can even induce motion viewer of Op Art paintings such as this one is disorienting and caves in at the center (hence the painting's title). The effect on the sizes and shapes, creating the illusion of a pulsating surface that ment. In Fission, Riley filled the canvas with black dots of varied of Modern Art bestowed an official stamp of approval on the moveclothing. In 1965, the exhibition The Responsive Eye at the Museum magazine. The publicity unleashed a craze for Op Art designs in attention after being featured in the December 1964 issue of Life paintings—for example, Fission (FIG. 15-10)—came to the public's her signature black-and-white Op Art style in the early 1960s. Her Art is the British painter BRIDGET RILEY (b. 1931), who developed BRIDGET RILEY The artist whose name is synonymous with Op

Abstraction in Sculpture

Painters were not the only artists interested in Clement Greenberg's formalist ideas. American sculptors also strove for purity in their medium. While painters worked to emphasize flatness, sculptors,

15-12 DONALD JUDD, Untitled, 1969. Brass and colored fluorescent Plexiglas on steel brackets, 10 units $6\frac{1}{8}$ " × 2' × 2' 3" each, with 6" intervals. Hirshhorn Museum and Sculpture Garden, Smithsonian Institution, Washington, D.C. (gift of Joseph H. Hirshhorn, 1972). © Donald Judd Estate/ Licensed by VAGA, New York, NY.

By rejecting illusionism and symbolism and reducing sculpture to basic geometric forms, Donald Judd and other Minimalist artists emphasized the "objecthood" and concrete tangibility of their works.

DONALD JUDD (1928–1994), who produced most of his major works in New York City. Judd's determination to arrive at a visual vocabulary devoid of deception or ambiguity propelled him away from representation and toward precise and simple sculpture. For Judd, a work's power derived from its character as a whole and from the specificity of its materials.

Untitled (FIG. 15-12) presents basic geometric boxes constructed of brass and red Plexiglas, undisguised by paint or other materials. The artist did not intend the work to be metaphorical or symbolic. It is a straightforward declaration of sculpture's objecthood. Judd used Plexiglas because its translucency enables the viewer access to the interior, thereby rendering the sculpture both open and enclosed. This aspect of the design reflects Judd's desire to banish ambiguity or falseness from his works.

LOUISE NEVELSON Although Minimalism was a dominant sculptural trend in the 1960s, many sculptors pursued other styles. Russian-born Louise Nevelson (1899-1988) created sculpture combining a sense of the architectural fragment with the power of Dada and Surrealist found objects to express her personal sense of life's underlying significance. Beginning in the late 1950s, Nevelson assembled sculptures of wood objects and forms. She enclosed small sculptural compositions in boxes of varied sizes, and joined the boxes to one another to form "walls." She then painted the forms in a single hue—usually black, white, or gold. This monochromatic color scheme unifies the diverse parts of pieces such as Tropical Garden II (FIG. 15-13) and creates a mysterious field of shapes and shadows. The structures suggest magical environments resembling the treasured secret hideaways dimly remembered from childhood. Yet the boxy frames and the precision of the manufactured found objects create a rough geometric structure that the eye roams over freely, lingering on some details. The effect is rather like viewing the side of an apartment building from a moving elevated train.

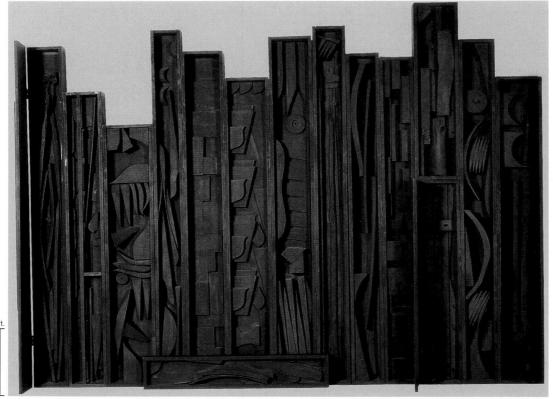

15-13 Louise Nevelson, Tropical Garden II, 1957–1959. Wood painted black, 5' $11\frac{1}{2}$ " × 10' $11\frac{3}{4}$ " × 1'. Musée national d'art moderne, Centre Georges Pompidou, Paris.

The monochromatic color scheme unifies the diverse sculpted forms and found objects in Nevelson's "walls" and creates a mysterious field of shapes and shadows suggesting magical environments.

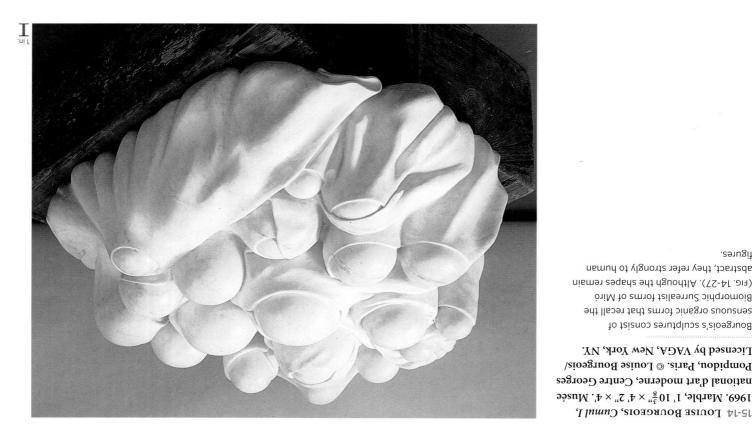

page 421).

abstract, they refer strongly to human (FIG. 14-27). Although the shapes remain Biomorphic Surrealist forms of Miró sensuous organic forms that recall the Bourgeois's sculptures consist of Licensed by VAGA, New York, NY.

15-14 Louise Bourgeois, Cumul I,

comic books, and movies (see "Pop Art and Consumer Culture," thetics and content of such facets of popular culture as advertising, thinking in art, in part by sharing their fascination with the aes-Contemporary Art in London in 1952. They sought to initiate fresh and writers who formed the Independent Group at the Institute of ans trace the roots of Pop Art to the young British artists, architects, born the art movement that came to be known as Pop. Art historicommunicative power of art to reach a wide audience. Thus was

ence fiction, and the mass media. Is Tomorrow, which included images from Hollywood cinema, scifor the poster and catalog of one section of an exhibition titled This whole world of visual communication. He created Just What Is It? elements of popular art and fine art, seeing both as belonging to the Duchamp's ideas (see page 388), Hamilton consistently combined that advertising shapes public attitudes. Long intrigued by Marcel man, exhibition designer, and painter, Hamilton studied the way which exemplifies British Pop Art. Trained as an engineering drafts-It That Makes Today's Homes So Different, So Appealing? (FIG. 15-15), RICHARD HAMILTON (1922-2011), made a small collage, Just What Is RICHARD HAMILTON In 1956, an Independent Group member,

development of American Pop Art was JASPER JOHNS (b. 1930), who production, and advertising. One of the artists pivotal to the early age to America's predominance in the realms of mass media, mass Hollywood, Detroit, and New York's Madison Avenue, paying hompendent Group members claimed that their inspiration came from provided a fertile environment for the movement. Indeed, Indepart because the more fully matured American consumer culture movement found its greatest success in the United States, in large JASPER JOHNS Although Pop Art originated in England, the

> forms and the soft folds swaddling them. increases the sensuous distinction between the group of swelling Cumul I, the alternating high gloss and matte finish of the marble each material's qualities to suit the expressiveness of the piece. In plastics, in addition to alabaster, marble, and bronze. She exploited variety of materials in her works, including wood, plaster, latex, and abstract, they refer strongly to human figures. Bourgeois used a wide lends a distinctive personality to each. Although the shapes remain holes. The units differ in size, and their position within the group with their heads protruding, within a collective cloak dotted with Cumul I (FIG. 15-14) is a collection of round-headed units huddled, work of French-American artist Louise Bourgeois (1911–2010). Biomorphic Surrealist forms of Joan Miró (FIG. 14-27) pervades the Nevelson's work, a sensuous organic quality recalling the evocative LOUISE BOURGEOIS In contrast to the architectural nature of

> male and female, active and passive."5 breasts like clouds—but often I merge the activity—phallic breasts, times I am totally concerned with female shapes—characters of "There has always been sexual suggestiveness in my work. Someand caves and holes." Sculptures such as Cumul I are openly sexual: a topographical point of view, as a land with mounds and valleys they are landscape also, since our body could be considered from relationships to landscape: "[My pieces] are anthropomorphic and Bourgeois connected her sculpture with the body's multiple

11A qoq

of the avant-garde had alienated the public, sought to harness the ists, however, observing that the insular and introspective attitude all adopted an artistic vocabulary of pure abstraction. Other arterly Abstractionists, Op Art painters, and Minimalist sculptors Despite their differences, the Abstract Expressionists, Post-Paint-

ART AND SOCIETY

Pop Art and Consumer Culture

Although the acceptance of pure abstraction as an artistic mode had gained significant momentum in the decades after the end of World War II, many artists, as well as the general public, reacted against pure formalism in painting and sculpture. In the 1950s and 1960s, the artists of the Pop Art movement reintroduced all the devices that the postwar abstractionists had purged from their artworks. Pop artists revived the tools traditionally used to convey meaning in art, such as signs, symbols, metaphors, allusions, illusions, and figural imagery. They not only embraced representation but also firmly grounded their art in the consumer culture and mass media of the postwar period, thereby making it much more accessible and understandable to the average person. Indeed, the name "Pop Art"—credited to the British art critic Lawrence Alloway (1926-1990)—is short for "popular art" and referred to the popular mass culture and familiar imagery of the contemporary urban environment, such as the collection of everyday objects, advertisements, and celebrity photographs featured in Richard Hamilton's

collage Just What Is It That Makes Today's Homes So Different, So Appealing? (Fig. 15-15).

The fantasy interior in Hamilton's collage reflects the values of mid-20th-century consumer culture through figures and objects cut from glossy magazines. *Just What Is It?* includes references to mass media (the television, the theater marquee outside the window, the newspaper), to advertising (Hoover vacuum cleaners, Ford cars, Armour hams, Tootsie Pops), and to popular culture (the "girlie magazine," the body builder Charles Atlas, romance comic books). Artworks of this sort stimulated viewers' wide-ranging speculation about society's values. This kind of intellectual toying with mass-media meaning and imagery typified Pop Art both in Europe and America.

Alloway eloquently described the intellectual basis of Pop Art in a 1958 essay:

The definition of culture is changing as the result of the pressure of the great audience . . . [I]t is no longer sufficient to define culture solely as something that a minority guards for the few and the future . . . Our definition of culture is being stretched beyond the fine art limits imposed on it by Renaissance theory, and refers

now, increasingly, to the whole complex of human activities. Within this definition, rejection of the mass produced arts is not, as critics think, a defense of culture but an attack on it.*

*Lawrence Alloway, "The Arts and the Mass Media," *Architectural Design* (February 1958): 34–35.

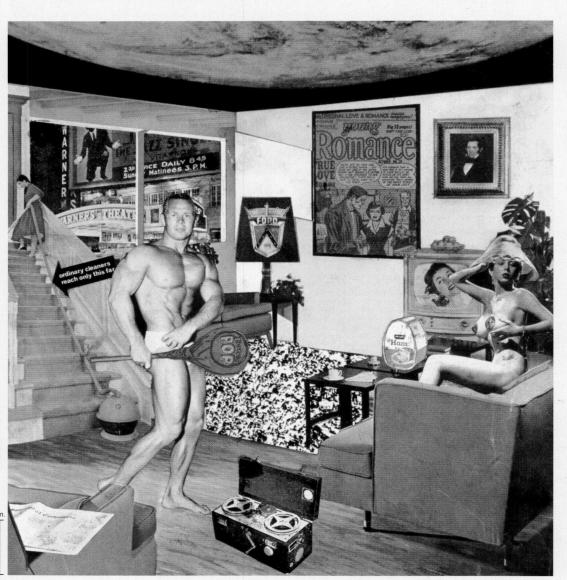

15-15 RICHARD HAMILTON, Just What Is It That Makes Today's Homes So Different, So Appealing? 1956. Collage, $10\frac{1}{4}$ " $\times 9\frac{3}{4}$ ". Kunsthalle Tübingen, Tübingen.

The fantasy interior in Hamilton's collage of figures and objects cut from glossy magazines reflects the values of modern consumer culture. Toying with mass-media imagery typifies British Pop Art.

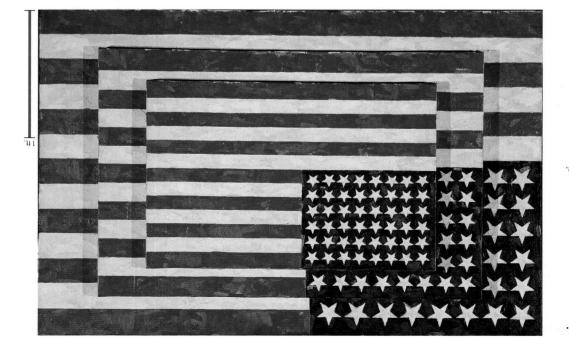

15-16 Jasper Johns, Three Flags, 1958. Encaustic on canvas, $2' \, 6 \frac{7}{8}'' \times 3' \, 9 \frac{1}{2}''$. Whitney Museum of American Art, New York (50th Anniversary Gift of the Gilman Foundation, the Lauder Foundation, and A. Alfred Taubman). © Jasper Johns/Licensed by VAGA, New York, NY.

American Pop artist Jasper Johns wanted to draw attention to common objects that people view frequently but rarely scrutinize. He made many paintings of targets, flags, numbers, and alphabets.

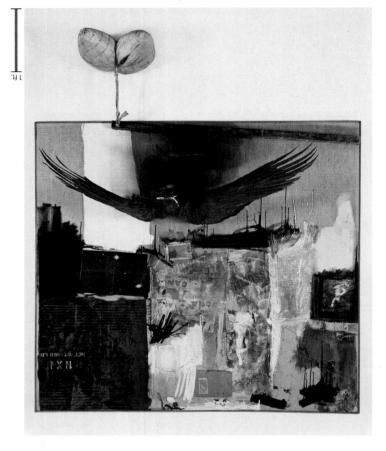

15-17 ROBERT RAUSCHENBERG, Canyon, 1959. Oil, pencil, paper, fabric, metal, cardboard box, printed paper, printed reproductions, photograph, wood, paint tube, and mirror on canvas, with oil on bald eagle, string, and pillow, 6' 9 $\frac{3}{4}$ " × 5' 10" × 2'. Sonnabend Collection, New York, © Estate of Robert Rauschenberg/Licensed by VAGA, New York, NY.

Rauschenberg's "combines" intersperse painted passages with sculptural elements. Canyon incorporates pigment on canvas with pieces of printed paper, photographs, a pillow, and a stuffed eagle.

looked at." To this end, he did several series of paintings of numbers, letters, flags, and maps of the United States.

In Three Flags (Fig. 15-16), Johns painted a trio of overlapping American banners of decreasing size, reversing traditional perspective. By reducing the American flag to a repetitive pattern, Johns tive. By reducing the American flag to a repetitive pattern, Johns

moved to New York City in 1952. Johns sought to draw attention to common objects in the world—what he called things "seen but not

American banners of decreasing size, reversing traditional perspective. By reducing the American flag to a repetitive pattern, Johns drained meaning from the patriotic emblem. This is not the flag of Abstract Expressionism is still apparent in Johns's choice of medium—encaustic, an ancient method of painting with liquid wax and dissolved pigment (FIG. 3-42), here mixed with newsprint. Thus the flags, painted on three overlapping canvases, have a pronounced surface texture, emphasizing that the viewer is looking at a handmade painting, not a machine-made fabric.

ROBERT RAUSCHENBERG A close friend of Johns's, ROBERT RAUSCHENBERG (1925–2008) began using mass-media images in his work in the 1950s. Rauschenberg set out to create works that would be open and indeterminate, and he began making multimeasges with sculptural elements. Some Rauschenberg combines seem to be sculptures with painting incorporated into certain sections. Others are paintings with three-dimensional objects attached to the surface.

Canyon (FIG. 15-17) is typical of his combines. Pieces of printed paper and photographs cover parts of the canvas. Much of the unevenly painted surface consists of pigment roughly applied in a manner reminiscent of de Kooning's work (FIG. 15-6). A stuffed bald eagle attached to the lower part of the combine spreads its wings as if lifting off in flight toward the viewer. Completing the combine, a pillow dangles from a string attached to a wood stick below the eagle. Rauschenberg tilted or turned some of the images sideways, and each overlays part of another image. The compositional confusion may resemble that of a Dada collage, but the combine's parts sion may resemble that of a Dada collage, but the combine's parts and each overlays part of another image. The compositional confusion may resemble that of a Dada collage, but the combine's parts and each overlays part of another image and defy a consistent reading, although objects seem unrelated and defy a consistent reading, although Rauschenberg chose all the elements of his combines with specific

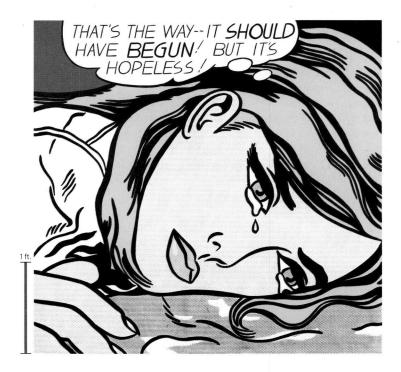

15-18 ROY LICHTENSTEIN, *Hopeless*, 1963. Oil and synthetic polymer paint on canvas, $3' 8'' \times 3' 8''$. Kunstmuseum Basel, Basel. © Estate of Roy Lichtenstein.

Comic books appealed to Lichtenstein because they were a mainstay of popular culture, meant to be read and discarded. The Pop artist immortalized their images on large canvases.

meanings in mind. For example, he based *Canyon* on a Rembrandt painting of Jupiter in the form of an eagle carrying the boy Ganymede heavenward. The photo in the combine is a reference to the Greek boy, and the hanging pillow is a visual pun on his buttocks.

ROY LICHTENSTEIN As the Pop Art movement matured, the images became more concrete and tightly controlled. In the late 1950s, Roy Lichtenstein (1923–1997), who was born in Manhattan not far from Madison Avenue, the center of the American advertising industry, turned his attention to commercial art and especially to the comic book as a mainstay of American popular culture (see "Roy Lichtenstein on Pop Art and Comic Books" 1). In paintings such as *Hopeless* (Fig. 15-18), Lichtenstein excerpted an image from a comic book, a form of entertainment meant to be read and discarded, and immortalized the image on a large canvas.

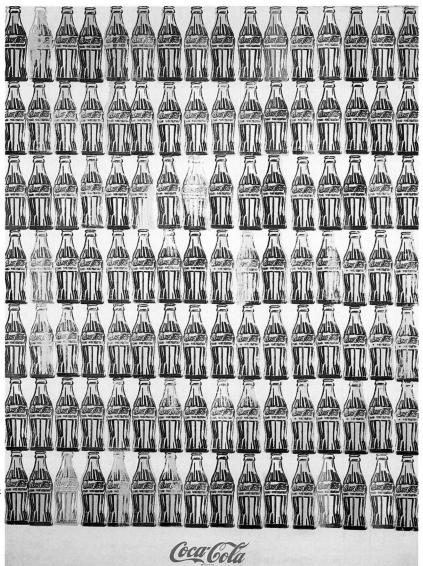

ANDY WARHOL The quintessential American Pop artist was ANDY WARHOL (1928–1987). An early successful career as a commercial artist and illustrator grounded Warhol in the sensibility and visual rhetoric of advertising and the mass media. This knowledge proved useful for his Pop artworks, which often depicted icons of mass-produced consumer culture, such as Coca Cola bottles (FIG. 15-19), and Hollywood celebrities, such as Marilyn Monroe (1926–1962; FIG. 15-19A ◀). Warhol favored reassuringly familiar objects and people. He explained his attraction to the omnipresent curved Coke bottle:

What's great about this country is that America started the tradition where the richest consumers buy essentially the same things as the poorest. You can be watching TV and see Coca-Cola, and you can know that the President drinks Coke, Liz Taylor drinks Coke, and just think, you can drink Coke, too. A Coke is a Coke and no amount of money can get you a better Coke.⁷

Like other Pop artists, Warhol used a visual vocabulary and a printing method that reinforced the image's connections to consumer culture. The *silk-screen printing* technique enabled Warhol to reproduce the image endlessly (although in *Green Coca Cola Bottles* he varied each bottle slightly). The repetition and redundancy of the Coke bottle reflect the saturation of this product in American society.

15-19 ANDY WARHOL, Green Coca-Cola Bottles, 1962. Oil on canvas, 6' $10\frac{1}{2}$ " \times 4' 9". Whitney Museum of American Art, New York.

Warhol was the quintessential American Pop artist. Here, he selected an icon of mass-produced consumer culture and then multiplied it, reflecting Coke's omnipresence in American society.

a tractor-earthmover for construction work but a military tank designed for destruction in warfare. Lipstick was to be a speaker's platform for protesters, and originally the lipstick tip was a drooping red vinyl balloon that the speaker had to inflate, underscoring the sexual innuendo. Vandalism and exposure to the elements (the original tractor was plywood) caused so much damage to Lipstick that it had to be removed. Oldenburg reconstructed it in metal and fiberglass.

Superrealism and Photography

Like the Pop artists, the artists associated with Superrealism sought a form of artistic communication that was more accessible to the public than the remote, unfamiliar visual language of the postwar abstractionists. The Superrealists expanded Pop's iconography in both painting and sculpture by making images in the late 1960s and 1970s involving acrupulous fidelity to optical fact. Because many Superrealists used photographs as sources for their imagery, art historians also refer to this movement as Photorealism.

AUDREY FLACK One of Superrealism's pioneers was AUDREY PLACK (b. 1931), who was intrigued by both the formal and technical qualities of photography. For paintings such as Marilyn (Fig. 15-21), Flack first projected a photograph onto the canvas. By next using an airbrush (a device originally designed as a photoretouching tool that sprays paint with compressed air), she could duplicate the smooth gradations of tone and color found in photographs. Most of her paintings are still lifes that present the viewer graphs. Most of her paintings are still lifes that present the viewer with a collection of familiar objects painted with great optical

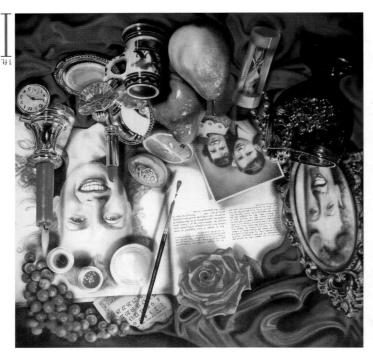

15-27 AUDREY FLACK, Marilyn, 1977. Oil over acrylic on canvas, 8' × 8'. University of Arizona Museum, Tucson (museum purchase with funds provided by the Edward J. Gallagher Jr. Memorial Fund).

Flack's pioneering Photorealist still lifes record objects with great optical fidelity. Marilyn alludes to Dutch vanitas paintings (Fig. 10-26) and incorporates multiple references to the transience of life.

Warhol's ascendance to the rank of celebrity artist underscored his remarkable and astute understanding of the dynamics and visual language of mass culture. He predicted that the age of mass media would enable everyone to become famous for 15 minutes. His own fame has lasted much longer.

clars olderburge In the 1960s, Clars Olderburge (b. 1929) also produced Pop artworks that incisively commented on American consumer culture, but his medium was sculpture. Born in Sweden, Olderburg graduated from Yale University in 1950. He is best known for his mammoth outdoor sculptures—for example, Lipstick (Ascending) on Caterpillar Tracks (Fig. 15-20), which, at the request he group of graduate students at the Yale School of Architecture, he created (in secret and without a fee) as a gift to his alma mater. He installed the 21-foot-tall sculpture on Ascension Day, May 15, 1969, on Beinecke Plaza across from the office of the university's president, the site of many raucous protests against the Vietnam War. Oldenburg's characteristic humor emerges unmistakably in the combination of phallic and militaristic imagery, especially in the double irony of the "phallus" being a woman's cosmetic item, and the Caterpillar-type endless-loop metal tracks suggesting not and the Caterpillar-type endless-loop metal tracks suggesting not

15-20 CLAES OLDENBURG, Lipstick (Ascending) on Caterpillar Tracks, 1969; reworked, 1974. Painted steel, aluminum, and fiberglass, 21' high. Morse College, Yale University, New Haven (gift of Colossal Keepsake Corporation).

Designed as a speaker's platform for antiwar protesters, Lipstick humorously combines phallic and militaristic imagery. Originally, the lipstick tip was soft red vinyl and had to be inflated.

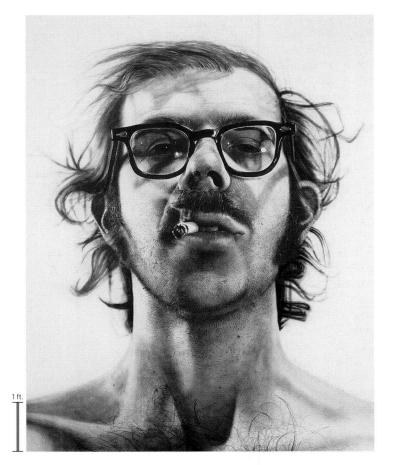

15-22 СНИСК СLOSE, Big Self-Portrait, 1967–1968. Acrylic on canvas, 8' 11" \times 6' 11". Walker Art Center, Minneapolis (Art Center Acquisition Fund, 1969).

Close's goal was to translate photographic information into painted information. In his portraits, he deliberately avoided creative compositions, flattering lighting effects, and revealing facial expressions.

fidelity. *Marilyn* is a still life incorporating photographs of the face of Hollywood actress Marilyn Monroe (1926–1962). It is a poignant commentary on Monroe's tragic life and differs markedly from Warhol's *Marilyn Diptych* (FIG. 15-19A), which celebrates celebrity and makes no allusion to the death of the glamorous star. Flack's still life includes multiple references to death and alludes to Dutch *vanitas* paintings (FIG. 10-26). The fresh fruit, hourglass, burning candle, watch, and calendar all refer to the passage of time and the transience of life.

CHUCK CLOSE Also usually considered a Superrealist is Seattleborn Chuck Close (b. 1940), best known for his large-scale portraits, such as *Big Self-Portrait* (Fig. 15-22). However, Close felt that his connection to the Photorealists was tenuous, because for him, realism was not an end in itself but rather the result of an intellectually rigorous, systematic approach to painting (see "Chuck Close on Photorealist Portrait Painting" (1).

LUCIAN FREUD Born in Berlin in 1922, LUCIAN FREUD (1922–2011) moved to London with his family in 1933 when Adolph Hitler became German chancellor. The grandson of Sigmund Freud, the painter is best known for his unflattering close-up views

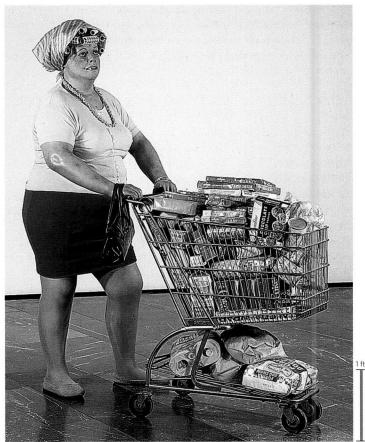

15-23 DUANE HANSON, Supermarket Shopper, 1970. Polyester resin and fiberglass polychromed in oil, with clothing, steel cart, and groceries, life-size. Nachfolgeinstitut, Neue Galerie, Sammlung Ludwig, Aachen. © Estate of Duane Hanson/Licensed by VAGA, New York, NY.

Hanson used molds from live models to create his Superrealist life-size painted plaster sculptures. His aim was to capture the emptiness and loneliness of average Americans in familiar settings.

of faces in which the sitter seems almost unaware of the painter's presence, and for his portrayals of female and male nudes in fore-shortened and often contorted poses—for example, *Naked Portrait* (FIG. 15-22A 1).

DUANE HANSON Not surprisingly, many sculptors also were Superrealists, including DUANE HANSON (1925–1996), who perfected a casting technique that enabled him to create life-size sculptures that many viewers mistake at first for real people. Hanson began by making plaster molds from live models and then filled the molds with polyester resin. After the resin hardened, he removed the outer molds and cleaned and painted the sculptures with an airbrush, and added wigs, clothes, and other accessories. These works, such as *Supermarket Shopper* (FIG. 15-23), depict stereotypical average Americans, striking chords with the public precisely because of their familiarity. Hanson explained:

The subject matter that I like best deals with the familiar lower and middle-class American types of today. To me, the resignation, emptiness and loneliness of their existence captures the true reality of life for these people. . . . I want to achieve a certain tough realism which speaks of the fascinating idiosyncrasies of our time.⁸

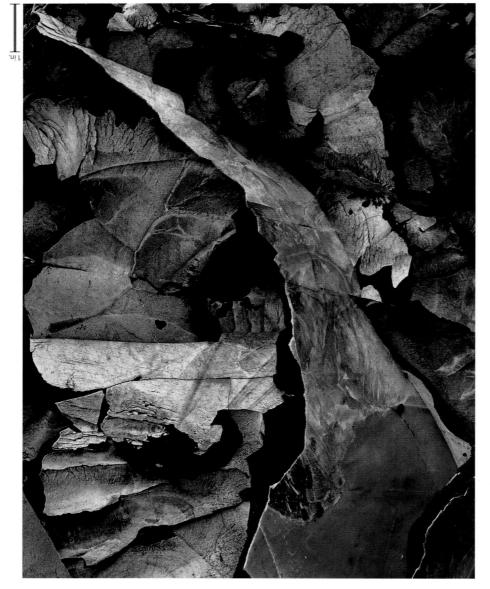

15-24 Minor White, Moencopi Strata, Capitol Reef, Utah, 1962. Gelatin silver print, $1^{1\frac{1}{8}} \times 9^{\frac{1}{4}}$. Museum of Modern Art, New York. © The Minor White Archive, Princeton University.

White's "straight photograph" of a natural rock formation is also an abstract composition of jagged shapes and contrasts of light and dark reminiscent of Abstract Expressionist paintings.

medium in the postwar period. profound influence on the development of the tography magazine of the time, White had a (1952-1975) of Aperture, the leading art pho-As one of the founders and the longtime editor nature becomes the springboard for meditation. ject as a detail of a landscape, but in his hands, copi Strata may recognize White's nominal subcontrasts of light and dark. Viewers of Moenan abstract composition of jagged shapes and Stieglitz and Weston (see page 392), it is also ple. A "straight photograph" in the tradition of rock formation in Utah is a characteristic examown work. His 1962 photograph (FIG. 15-24) of a sought to incorporate a mystical element in his dhism (see "Zen Buddhism," page 515), White greatly admired. Deeply influenced by Zen Bud-Alfred Stieglitz, whose photographs of clouds he War II, settled in New York City, where he met after serving in the United States Army in World Progress Administration (see page 400), and, 1976) became a photographer for the Works abstraction. In 1938, MINOR WHITE (1908their medium to pursue varied ends, including and places, photographers themselves used duce faithfully the appearance of people, objects, admired the ability of photography to repro-MINOR WHITE Although Superrealist artists

on The Dinner Party," page 427). She originally conceived the work as a feminist Last Supper for 13 "honored guests," as in the biblical account of Christ's passion, but at Chicago's table the guests are women instead of men. A witches' coven also comprises 13 women, and Chicago's Dinner Party additionally refers to witchcraft and the worship of the Mother Goddess. But because Chicago had uncovered so many worthy women in the course of her research, she trippled the number of guests and placed table settings for 39 women around a triangular table 48 feet long on each side. The triangular form refers to the ancient symbol for both woman and the Goddess. The notion of a dinner party also alludes to women's traditional role as homemakers.

CINDY SHERMAN The primary means of expression for CINDY SHERMAN (b. 1954) is photography. Sherman addresses in her work how Western artists have traditionally presented female beauty for the enjoyment of the "male gaze," a primary focus of contemporary feminist theory, which explores gender as a socially constructed concept. Beginning in 1977, she produced more than 80 black-and-white photographs called Untitled Film Stills. She got the idea for the serries after examining soft-core pornography magazines and noting serries after examining soft-core pornography magazines and noting

Feminist Art

With the renewed interest in representation that the Pop artists and Superrealists introduced in the 1960s and 1970s, painters and sculptors once again began to embrace the persuasive powers of art to communicate with a wide audience. In the 1970s, many artists began to investigate the social dynamics of power and privilege, especially in relation to gender, although racial, ethnic, and sexual orientation issues have also figured prominently in the art of recent decades (see Chapter 16).

feminist movement, which sought equal rights for women and feminist movement, which sought equal rights for women and focused attention on the subservient place of women in societies throughout history. Chicago native Judy Chicago native Judy Chicago native Judy Chicago native Judy 1970s, she began planmas a leader of that movement. In the early 1970s, she began planning an ambitious piece, The Dinner Party (Fig. 15-25), using craft techniques (such as china painting and needlework) traditionally practiced by women, to celebrate the achievements and contributions that women had made throughout history (see "Judy Chicago tions that women had made throughout history (see "Judy Chicago

ARTISTS ON ART

Judy Chicago on The Dinner Party

One of the acknowledged masterpieces of feminist art is Judy Chicago's *The Dinner Party* (FIG. 15-25), which required a team of nearly 400 to create and assemble. In 1979, Chicago published a book explaining the genesis and symbolism of the work.

[By 1974] I had discarded [my original] idea of painting a hundred abstract portraits on plates, each paying tribute to a different historic female figure. . . . In my research I realized over and over again that women's achievements had been left out of history. . . . My new idea was to try to symbolize this. . . . [I thought] about putting the plates on a table with silver, glasses, napkins, and tablecloths, and over the next year and a half the concept of The Dinner Party slowly evolved. I began to think about the piece as a reinterpretation of the Last Supper from the point of view of women, who, throughout history, had prepared the meals and set the table. In my "Last Supper," however, the women would be the honored guests. Their representation in the form of plates set on the table would express the way women had been confined, and the piece would thus reflect both women's achievements and their oppression. . . . My goal with The Dinner Party was . . . to forge a new kind of art expressing women's experience. . . . [It] seemed appropriate to relate our history through art, particularly through techniques traditionally associated with women—china-painting and needlework.*

The Dinner Party rests on a triangular white tile floor inscribed with the names of 999 additional women of achievement to signify that the accomplishments of the 39 honored guests rest on a foundation that other women had laid. Among those with place settings at the table are the Egyptian pharaoh Hatshepsut (Fig. 1-31), the Minoan snake goddess (Fig. 2-8), the Byzantine empress Theodora (Fig. 4-18), the medieval nun Hildegard of Bingen (Fig. 6-26), and the painters Artemisia Gentileschi (Fig. 10-10 and 10-10 A) and Georgia O'Keeffe (Fig. I-5). Other woman artists among the 999 names include Élisabeth-Louise Vigée-Lebrun (Fig. 11-7), Adélaïde Labille-Guiard (Fig. 11-7 A), Angelica Kauffman (Fig. 11-1), Mary Cassatt (Fig. 13-6), Berthe Morisot (Fig. 13-7), Käthe Kollwitz (Fig. 14-7), Barbara Hepworth (Fig. 14-31), Dorothea Lange (Fig. 14-33), and Louise Nevelson (Fig. 15-13).

Each woman's place has identical eating utensils and a goblet, but features a unique oversized porcelain plate and a long place mat or table runner covered with imagery reflecting significant facts about that woman's life and culture. The plates range from simple concave shapes with china-painted imagery to dishes whose sculptured three-dimensional designs almost seem to struggle to free themselves. The designs on each plate incorporate both butterfly and vulval motifs—the butterfly as the ancient symbol of liberation and the vulva as the symbol of female sexuality. Each table runner combines traditional needlework techniques, including needlepoint, embroidery, crochet, beading, patchwork, and appliqué.

The Dinner Party is more than the sum of its parts, however. Of monumental size, as so many great works of public art have been throughout the ages, Chicago's 1979 masterwork provides viewers with a powerful launching point for considering broad feminist concerns.

*Judy Chicago, "The Dinner Party": A Symbol of Our Heritage (Garden City, N.Y.: Anchor Press, 1979), 11-12.

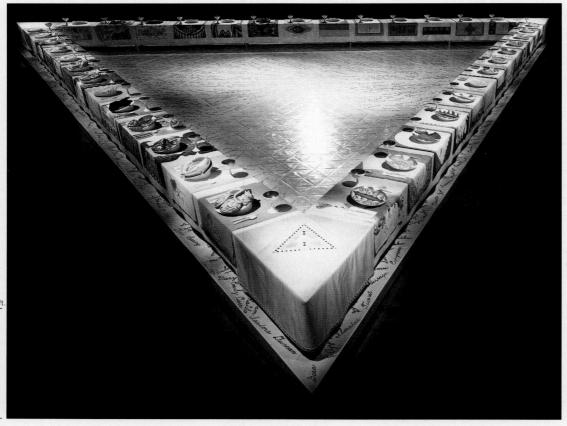

15-25 JUDY CHICAGO, *The Dinner Party*, 1979. Multimedia, including ceramics and stitchery, 48' × 48' × 48'. The Brooklyn Museum, Brooklyn.

Chicago's *Dinner Party* honors 39 women from antiquity to the 20th century. The triangular form and the materials—painted china and fabric—are traditionally associated with women.

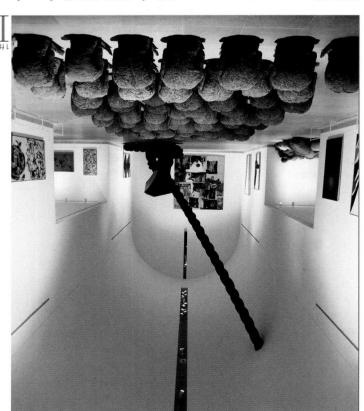

15-27 Magdalena Abakanowicz, 80 Backs, 1976–1980. Burlap and resin, each 2' 3° high. Museum of Modern Art, Dallas.

Polish fiber artist Abakanowicz explored the stoic, everyday toughness of the human spirit in this group of nearly identical sculptures that serve as symbols of distinctive individuals lost in the crowd.

stoic, everyday toughness of the human spirit. For Abakanowicz, fiber materials are deeply symbolic:

I see fiber as the basic element constructing the organic world on our planet, as the greatest mystery of our environment. It is from fiber that all living organisms are built—the tissues of plants and ourselves... Fabric is our covering and our attire. Made with our hands, it is a record of our souls.⁹

of fiber texture on each. material dried and because the artist imprinted a different pattern viduality because each assumed a slightly different posture as the from a single mold, the figures achieve a touching sense of indisuggests meditation, submission, and anticipation. Although made directly on the floor. The repeated pose of the figures in 80 Backs back, and arms of a figure of indeterminate sex and rests legless into a plaster mold. Every sculpture depicts the slumping shoulders, wicz made each piece by pressing layers of natural organic fibers impression is especially powerful in 80 Backs (FIG. 15-27). Abakanosociety, lost in the crowd yet retaining some distinctiveness. This each form for exhibition in groups as symbols for the individual in Best known for her works based on human forms, she multiplies disturbed by the dislocations of World War II and its aftermath. of her early life experiences as a member of an aristocratic family Abakanowicz's sculptures are to a great degree reflections

15-26 Cindy Sherman, Untitled Film Still #35, 1979. Gelatin silverprint, $10^n \times 8^n$. Private collection.

Sherman here assumed a role for one of a series of 80 photographs resembling film stills in which she addressed the way women have been presented in Western art for the enjoyment of the "male gaze."

the stereotypical ways that they depicted women. She decided to produce photographs showing herself designing, acting in, directing, and photographing the works. In so doing, Sherman took control of her own image and constructed her own identity, a primary feminist concern. In Untitled Film Still #35 (Fig. 15-26), for example, Sherman appears in costume and wig in a photograph that seems to be a film still. Most of the images in this series recall popular film genres but are sufficiently generic that the viewer cannot relate them to specific movies. Sherman often reveals the constructed nature of these images by holding in her hand the shutter release cable used to take the pictures. (The cord runs across the floor in #35.) Although the artist is still the object of the viewer's gaze in these photographs, the identity is one she alone chose to assume.

MAGDALENA ABAKANOWICZ Not strictly feminist in subject, but created using materials traditionally associated with women, are the sculptures of Polish fiber artist Magdalena Abakanowicz (b. 1930). A leader in the exploration of the expressive powers of weaving techniques in large-scale artworks, Abakanowicz gained fame with experimental freestanding figural works expressing the

ARCHITECTURE AND SITE-SPECIFIC ART

Some of the most innovative architects of the first half of the 20th century, most notably Frank Lloyd Wright (FIG. 14-43), Le Corbusier (FIG. 14-42), and Ludwig Mies van der Rohe (FIG. 14-41), concluded their long and productive careers in the postwar period. At the same time, younger architects rose to international prominence, some working in the modernist idiom, others taking architectural design in new, postmodern directions (see "After Modernism: Postmodernist Architecture," page 411).

Modernism

In parallel with the progressive postwar movement toward formal abstraction in painting and sculpture, modernist architects stressed formalist simplicity in buildings adhering to a rigid geometry as well as buildings featuring organic sculptural qualities.

FRANK LLOYD WRIGHT The last great building Frank Lloyd Wright designed was the Solomon R. Guggenheim Museum (FIG. 15-28) in New York City. Using reinforced concrete almost as a sculptor might use resilient clay, Wright, who often described his architecture as "organic," designed a structure inspired by the spiral of a snail's shell. The shape of the shell expands toward the top, and a winding interior ramp (FIG. 16-28) spirals to connect the gallery bays. A skylight strip embedded in the museum's outer wall provides illumination to the ramp, which visitors can stroll up or down, viewing the artworks displayed along the gently sloping pathway. Thick walls and the solid organic shape give the building, outside and inside, the sense of turning in on itself, and the long interior viewing area opening onto a 90-foot central well of space creates a sheltered environment, secure from the bustling city outside.

LE CORBUSIER Compared with his pristine geometric design for Villa Savoye (FIG. 14-42), the organic forms of Le Corbusier's Notre-Dame-du-Haut (FIG. 15-29) come as a startling surprise. Completed in 1955 at Ronchamp, France, the chapel attests to the boundless

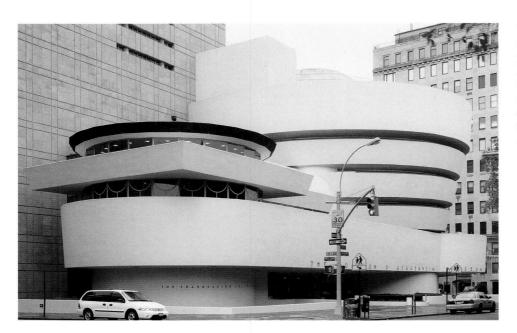

15-28 Frank Lloyd Wright, Solomon R. Guggenheim Museum (looking southeast), New York, 1943–1959.

Using reinforced concrete almost as a sculptor might use resilient clay, Wright designed a snail shell–shaped museum with a winding, gently inclined interior ramp (FIG. 16-28) for the display of artworks.

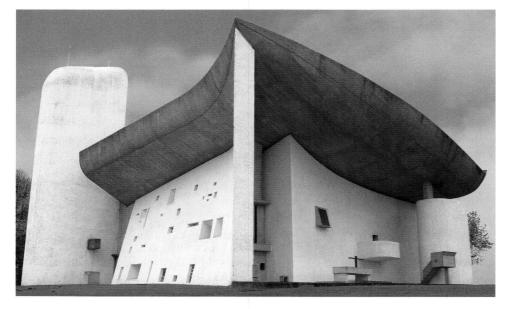

15-29 Le Corbusier, exterior of Notre-Dame-du-Haut (looking northwest), Ronchamp, France, 1950–1955.

The organic forms of Le Corbusier's mountaintop chapel present a fusion of architecture and sculpture. The architect based the shapes on praying hands, a dove's wings, and a ship's prow.

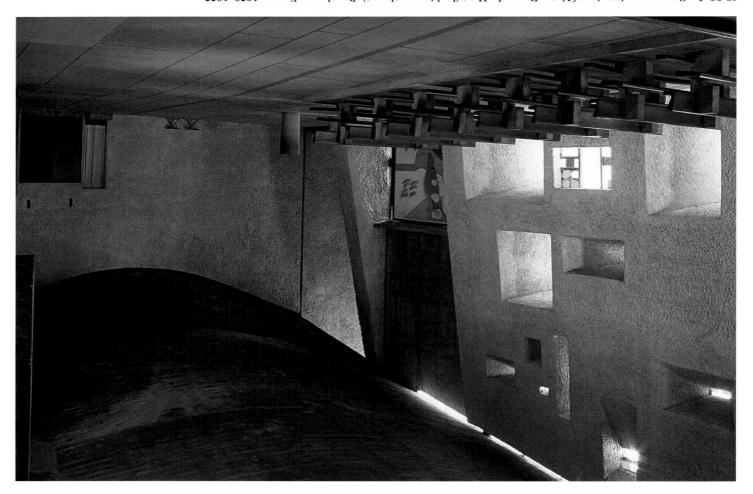

15-30 LE CORBUSIER, interior of Notre-Dame-du-Haut (looking southwest), Ronchamp, France, 1950-1955.

Constructed of concrete sprayed on a frame of steel and metal mesh, the heavy walls of the Ronchamp chapel enclose an intimate and mysteriously lit interior that has the aura of a sacred cave.

wings of a dove (representing both peace and the Holy Spirit), and with the prow of a ship (a reminder that the term for the central aisle in a traditional basilican church is nave—Latin for "ship"). The architect hoped that in the mystical interior he created and in the rolling hills around the church, worshipers would reflect on the sacred and the natural. No one who has visited Notre-Dame-dusacred and the natural is a pright sunlit day or in a thundering storm, has come away unmoved.

MIES VAN DER ROHE In contrast to the sculpturesque postwar idiom of Wright and Le Corbusier, other modernist architects created massive, sleek, and geometrically rigid buildings, following Bauhaus architect Ludwig Mies van der Rohe's contention that "less is more" (see page 406). Many of these more Minimalist designs are heroic presences in the urban landscape, effectively symbolizing the giant corporations that often were the skyscrapers' primary tenants. The purest example of these corporate towers is the rectilingent eart glass-and-bronze Seagram Building (FIG. 15-31) in Manhattan, ear glass-and-bronze Seagram Building (FIG. 15-31) in Manhattan,

The purest example of these corporate towers is the rectuinear glass-and-bronze Seagram Building (Fig. 15-31) in Manhattan, designed by Mies van der Rohe and American architect PHILIP JOHNSON (1906–2005). By the mid-1950s, the steel-and-glass skyscrapers pioneered by Louis Sullivan (Fig. 13-22) and carried further by Mies van der Rohe himself (Fig. 14-41) had become a familiar sight in cities throughout the world. Appealing in its structural logic and clarity, the style, easily imitated, quickly became the norm for postvar commercial high-rise buildings. The architects of the Seagram

creativity of this great architect. A fusion of architecture and sculpture, the small chapel occupies a pilgrimage site in the Vosges Mountains. The monumental impression of Notre-Dame-du-Haut seen from afar is deceptive. Although one massive exterior wall (Fig. 15-29, right) contains a pulpit resembling a balcony that faces a spacious outdoor area for large-scale open-air services on holy days, the interior (Fig. 15-30) holds at most 200 people. The intimate scale, stark and heavy walls, and mysterious illumination (jewel tones cast from the deeply recessed stained-glass windows) give this space an aura reminiscent of a sacred cave or a medieval monastery.

Notre-Dame-du-Haut's structure may look free-form to the untrained eye, but Le Corbusier, like the designers of late medieval cathedrals, based it on an underlying mathematical system. The church has a frame of steel and metal mesh, which the buildrior private chapel niches with colored walls and the roof, which Le Corbusier wished to have darken naturally with the passage of time. The roof appears to float freely above the worshipers in their pews (Fig. 15-30), intensifying the quality of mystery in the interior space. In reality, a series of nearly invisible blocks holds up the roof. The mystery of the roof's means of support recalls the reaction to The mystery of the roof's means of support recalls the reaction to Hagia Sophia's miraculously floating dome (Fig. 4-12) a millennium

Le Corbusier's preliminary sketches for the building indicate that he linked the design with the shape of praying hands, with the

and a half before in Byzantium.

15-31 Ludwig Mies van der Rohe and Philip Johnson, Seagram Building (looking northeast), New York, 1956–1958.

Massive, sleek, and geometrically rigid, this modernist skyscraper has a bronze and glass skin that masks its concrete-and-steel frame. The giant corporate tower appears to rise from the pavement on stilts.

Building deliberately designed it as a thin shaft, leaving the front quarter of its midtown site as an open pedestrian plaza. The tower appears to rise from the pavement on stilts. Glass walls even surround the recessed lobby. The building's recessed structural elements make it appear to have a glass skin, interrupted only by the thin strips of bronze anchoring the windows. The bronze strips and the amber glass windows give the tower a richness found in few of its neighbors.

Postmodernism

Within a few years of the completion of the Seagram Building (FIG. 15-31), some architects were already questioning the validity of the modernist approach to architectural design. Thus was born the diverse and complex style called postmodernism (see page 411). Among the first to explore this new direction in architecture were Jane Jacobs (1916–2006) and Robert Venturi (b. 1925). In their influential books The Death and Life of Great American Cities (Jacobs, 1961) and Complexity and Contradiction in Architecture (Venturi, 1966), Jacobs and Venturi argued that the uniformity and anonymity of modernist architecture (in particular, the corporate skyscrapers dominating many urban skylines) were unsuited to human social interaction and that diversity is the great advantage of urban life. Postmodern architects accepted, indeed embraced, the messy and chaotic nature of big-city life. When designing these varied buildings, many postmodern architects consciously selected past architectural elements or references and juxtaposed them with contemporary elements or fashioned them of high-tech materials, thereby creating a dialogue between past and present, as Charles Moore did in Piazza d'Italia (FIG. 15-1). Postmodern architecture incorporates references not only to traditional architecture but also to mass culture and popular imagery.

MICHAEL GRAVES The Portland Building (FIG. 15-32), designed by MICHAEL GRAVES (1934–2015), reasserts the wall's horizontality against the verticality of modernist skyscrapers. Graves favored

15-32 MICHAEL GRAVES, Portland Building (looking northeast), Portland, Oregon, 1980.

In this early example of postmodern architecture, Graves reasserted the horizontality and solidity of the wall. He drew attention to the mural surfaces through polychromy and ornamental motifs.

15-33 Richard Rogers and Renzo Plano, Centre Georges Pompidou (the "Beaudourg," looking northeast), Paris, France, 1977.

The architects fully exposed the anatomy of this six-level building, as in the century-earlier Crystal Palace (Fig. 12-24), and color-coded the internal parts according to function, as in a factory.

Paris from its terrace. down and inside the building), as well as dramatic panoramas of val facilities, movie theaters, rest areas, and restaurant (which looks science and music centers, conference rooms, research and archibuilding enjoying its art galleries, industrial design center, library, provide a festive environment for the crowds flowing through the opened. The flexible interior spaces and the colorful structural body theless, the Pompidou Center has been popular with visitors since it excessive maintenance to protect them from the elements. Nevertural supermarket" and point out that its exposed entrails require ing's industrial qualities disparagingly refer to the complex as a "culmuch as in a sophisticated factory. Critics who deplore the buildgreen for water, blue for air-conditioning, and yellow for electricity), corridors according to function (red for the movement of people, "metabolism" visible. They color-coded pipes, ducts, tubes, and updated version of the Crystal Palace (FIG. 12-24), and made its exposed the anatomy of this six-level building, which is a kind of

Environmental and Site-Specific Art

One of the most exciting developments in postwar art and architecture has been Environmental Art, sometimes called earthworks. Environmental Art stands at the intersection of architecture and sculpture. It emerged in the 1960s and includes a wide range of

guage of pop culture. postmodernist innovation that borrowed from the lively, garish lantory's verdict will be, the Portland Building is an early marker of the building as a courageous architectural adventure. Whatever hisclassical references as constituting a "symbolic temple" and praised an "oversized Christmas package," but others approvingly noted its denounced Graves's Portland Building as "an enlarged jukebox" and features, taken together, raised a storm of criticism. Various critics the ornamental wall, color painting, or symbolic references. These penthouse levels. The modernist purist surely would not welcome and painted surfaces further define the building's base, body, and painted keystone motif joins five upper levels on one facade pair, of stylized Baroque roundels tied by bands on the other pair. A huge capital-like large hoods on one pair of opposite facades and a frieze tying together seven stories open two paired facades. These support and carries a set-back penthouse crown. Narrow vertical windows composition (echoed in the windows), which rests on a wider base the square's solidity and stability, making it the main body of his

ROGERS AND PIANO During their short-lived partnership, British architect RICHARD ROGERS (b. 1933) and Italian architect RENZO PIANO (b. 1937) used motifs and techniques from ordinary industrial buildings in their design for the Georges Pompidou National Center of Art and Culture (FIG. 75-33) in Paris. The architects fully

artworks, most of which are *site-specific* (created for a unique location) and in the open air. Many artists associated with the movement also use natural or organic materials, including the land itself. It is no coincidence that this art form developed during a period of increased concern for the environment. The ecology movement of the 1960s and 1970s aimed to publicize and combat escalating pollution, depletion of natural resources, and the dangers of toxic waste. The problems of public aesthetics (for example, litter, urban sprawl, and compromised scenic areas) were also at issue. Widespread concern in the United States about the environment led to the passage of the National Environmental Policy Act in 1969 and the creation of the federal Environmental Protection Agency. Environmental artists use their art to call attention to the landscape and, in so doing, are an important part of this national dialogue.

As an innovative art form challenging traditional assumptions about art making, Environmental Art clearly has an avant-garde, progressive dimension. But as Pop artists did, Environmental artists insist on moving art out of the rarefied atmosphere of museums and galleries and into the public sphere. Most encourage spectator interaction with their works. Ironically, the remote locations of many earthworks have limited public access.

ROBERT SMITHSON One of the pioneering Environmental artists was ROBERT SMITHSON (1938-1973), who used industrial construction equipment to manipulate vast quantities of earth and rock on isolated sites. Smithson's best-known project is Spiral Jetty (FIG. 15-34), a mammoth 1,500-foot-long coil of black basalt, limestone rocks, and earth extending out into Utah's Great Salt Lake. As he was driving by the lake one day, Smithson came across some abandoned mining equipment, left there by a company that had tried and failed to extract oil from the site. Smithson saw this as a testament to the enduring power of nature and to the inability of humans to conquer it. He decided to create an artwork in the lake that ultimately became a mammoth coil curving out from the shoreline into the water. Smithson insisted on designing his work in response to the location itself. He wanted to avoid the arrogance of an artist merely imposing an unrelated concept on the site. The spiral idea grew from Smithson's first impression of the location. Then, while researching Great Salt Lake, Smithson discovered that the molecular structure of the salt crystals coating the rocks at the water's edge is spiral in form.

As I looked at the site, it reverberated out to the horizons only to suggest an immobile cyclone while flickering light made the entire

15-34 ROBERT SMITHSON, Spiral Jetty (looking northeast), Great Salt Lake, Utah, 1970. © Estate of Robert Smithson/Licensed by VAGA, New York, NY.

Smithson used industrial equipment to create Environmental artworks by manipulating earth and rock. Spiral Jetty is a mammoth coil of black basalt, limestone, and earth extending into Great Salt Lake.

15-35 Саколее Schneemann, Meat Joy (performance at Judson Church, New York City), 1964.

In her performances, Schneemann transformed the nature of Performance Art by introducing a feminist dimension through the use of her body (often nude) to challenge traditional gender roles.

Conceptual Art

The relentless challenges to artistic convention fundamental to the historical avant-garde reached a logical conclusion with Conceptual Art in the late 1960s. Conceptual artists maintain that the "artfulness" of art lies in the artist's idea, rather than in its final expression. These artists regard the idea, or concept, as the defining component of the artwork. Indeed, some Conceptual artists eliminate the object altogether.

JOSEPH KOSUTH Among the earliest proponents of Conceptual Art was Joseph KOSUTH (b. 1945), whose work operates at the intersection of language and vision, and deals with the relationship between the abstract and the concrete. For example, in One and Three Chairs (Fig. 15-36), Kosuth juxtaposed a real chair, a full-scale photograph of the same chair, and an enlarged reproduction of a dictionary definition of the word "chair." By so doing, the Conceptual artist asked viewers to ponder the notion of what constitutes "chairness."

landscape appear to quake. A dormant earthquake spread into the fluttering stillness, into a spinning sensation without movement. The site was a rotary that enclosed itself in an immense roundness. From that gyrating space emerged the possibility of the Spiral Jetty.¹⁰

PERFORMANCE AND CONCEPTUAL ART AND NEW MEDIA

Environmental art, although a singular artistic phenomenon, typifies postwar developments in the art world in redefining the nature of an "artwork" and expanding the range of works that artists and the general public consider "art." Some of the new types of artworks are the result of the invention of new media, such as computers and video cameras. But the new art forms also reflect avant-garde artists' continued questioning of the status quo.

Performance Art

One of the new artistic genres is Performance Art. Performance artists replace traditional stationary artworks with movements, gestures, and sounds performed before an audience, whose members sometimes participate in the performance. The informal and spontaneous events staged by early Performance artists anticipated the rebellion and youthful exuberance of the 1960s and at first pushed art outside the confines of mainstream art institutions—museums and galleries. Performance Art also served as an antidote to the pretentiousness of most traditional art objects and challenged art's function as a commodity.

Beginning in the later 1960s, however, museums commissioned artists to create and stage performances with increasing frequency, thereby neutralizing much of the subversiveness characteristic of this new art form.

CAROLEE SCHNEEMANN One of the pioneering Performance artists of the 1960s was Сакоlee Schweemann reflected on the nature of art production and contrasted her kinetic works with more traditional art forms.

Environments, happenings—concretions—are an extension of my painting-constructions which often have moving (motorized) sections. . . [But the] steady exploration and repeated viewing which the eye is required to make with my painting-constructions is reversed in the performance situation where the spectator is overwhelmed with changing recognitions, carried emotionally by a flux of evocative actions and led or held by the specified time sequence which marks the more passive than when confronting a . . . "still" work . . . With paintings, constructions and sculptures the viewers are able to carry out ings, constructions and sculptures the viewers are able to carry out repeated examinations of the work, to select and vary viewing positions (to walk with the eye), to touch surfaces and to freely indulge responses to areas of color and texture at their chosen speed."

Schneemann's self-described "kinetic theater" radically transformed the nature of Performance art by introducing a feminist dimension through the use of her body (often nude) to challenge gender atereotypes. In her 1964 performance, Meat Joy (FIG. 15-35), which was intended to be both erotic and repulsive, Schneemann cavorted with male performers and reveled in the taste, smell, and feel of raw sausages, chickens, and fish.

15-36 Јоѕерн Kosuth, One and Three Chairs, 1965. Wood folding chair, photographic copy of a chair, and photographic enlargement of a dictionary definition of "chair"; chair $2' 8\frac{3}{8}" \times 1' 2\frac{7}{8}" \times 1' 8\frac{7}{8}"$; photo panel $3' \times 2' \frac{1}{8}"$; text panel 2' \times 2' $\frac{1}{8}$ ". Museum of Modern Art, New York (Larry Aldrich Foundation Fund).

Conceptual artists regard the concept as an artwork's defining component. To portray "chairness," Kosuth juxtaposed a chair, a photograph of the chair, and a dictionary definition of "chair."

He explained:

Like everyone else I inherited the idea of art as a set of *formal* problems. . . . [T]he radical shift was in changing the idea of art itself. . . . It meant you could have an art work which was that *idea* of an art work, and its formal components weren't important. I felt I had found a way to make art without formal components being confused for an expressionist composition. The expression was in the idea, not the form—the forms were only a device in the service of the idea. 12

Conceptual artists such as Kosuth challenge the very premises of artistic production, pushing art's boundaries to a point where no concrete definition of "art" is possible.

New Media

During the 1960s and 1970s, in their attempt to find new avenues of artistic expression, many avant-garde artists eagerly embraced technologies previously unavailable. Among the most popular new media were video recording and computer graphics. Initially, only commercial television studios possessed video equipment, but in the 1960s, with the development of relatively inexpensive portable video recorders and of electronic devices allowing manipulation of recorded video material, artists began to explore in earnest the expressive possibilities of this new technology. In its basic form, video recording involves a special motion-picture camera that captures visible images and translates them into electronic data for display on a video monitor or television screen. Video pictures

resemble photographs in the amount of detail they contain, but a video image consists of a series of points of light on a grid. Viewers looking at television or video art are not aware of the monitor's surface. Instead, fulfilling the ideal of Renaissance artists, they concentrate on the image and look through the glass surface, as through a window, into the "space" beyond. Video images combine the optical realism of photography with the sense that the subjects move in real time in a deep space "inside" the monitor.

NAM JUNE PAIK When video introduced the possibility of manipulating subjects in real time, artists such as NAM JUNE PAIK (1932–2006) were eager to work with the medium. After studying music performance, art history, and Eastern philosophy in Korea and Japan, Paik worked with electronic music in Germany in the late 1950s. In 1965, after relocating to New York City, Paik acquired the first inexpensive video recorder (the Sony Porta-Pak). Experience acquired as artist-in-residence at television stations WGBH in Boston and WNET in New York enabled him to experiment with the most advanced broadcast video technology.

Paik collaborated with the gifted Japanese engineer-inventor Shuya Abe (b. 1932) in developing a video synthesizer. This instrument enables artists to manipulate and change electronic video information in various ways, causing images or parts of images to stretch, shrink, change color, or break up. With the synthesizer, artists can also layer images, inset one image into another, or merge images from various cameras with those from video recorders to make a single visual kaleidoscopic "time-collage." This kind of compositional freedom enabled Paik to combine his interests in

15-37 NAM JUNE
PAIK, video still
from Global Groove,
1973. 3" color videotape, sound, 30 minutes. Collection of
the artist.

Korean-born video artist Paik's best-known work is a cascade of fragmented sequences of performances and commercials intended as a sample of the rich worldwide television menu of the future.

AFTER 1980 The decades following the conclusion of World War II were unparalleled in the history of art for innovation in form and content and for the development of new media. Those exciting trends have continued unabated since 1980—and with an increasingly international dimension that will be explored in Chapter 16.

 \mathbb{A} Explore the era further in MindTap with videos of major artworks and buildings, Google Earth^m coordinates, and essays by the author on the following additional subjects:

■ Lee Krasner, The Seasons (Fig. 15-5A)
■ ARTISTS ON ART: David Smith on Outdoor Sculpture

Isamu Noguchi, Shodo Shima Stone Study (FIG. 15-11A)
 ■ ARTISTS ON ART: Roy Lichtenstein on Pop Art and Comic Books

• Andy Warhol, Marilyn Diptych (Fig. 15-19A)

■ ARTISTS ON ART: Chuck Close on Photorealist Portrait Painting

• Lucian Freud, Naked Portrait (FIG. 15-22A)

painting, music, Eastern philosophy, global politics for survival, humanized technology, and cybernetics. Paik called his video works "physical music" and said his musical background enabled him to understand time better than could video artists trained only in painting or sculpture.

Paik's best-known video work, Global Groove (FIG. 15-37), combines in quick succession fragmented sequences of female tap dancers, poet Allen Ginsberg (1926–1997) reading his work, a performance by cellist Charlotte Moorman (1933–1991) using a man's sion, Korean drummers, and a shot of the Living Theatre group performing a controversial piece called Paradise Now. The cascade of imagery in Global Groove gives viewers a glimpse of the rich worldwide television menu that Paik predicted would be available in the future—a prediction that has been fulfilled with the advent of affordable cable and satellite television service.

MODERNISM AND POSTMODERNISM IN EUROPE AND AMERICA, 1945 TO 1980

Painting, Sculpture, and Photography

- The art of the decades following World War II reflects cultural upheaval—the rejection of traditional values, the civil rights and feminist movements, and the new consumer society.
- The first major postwar avant-garde art movement was Abstract Expressionism, which championed an artwork's formal elements rather than its subject. Gestural abstractionists, such as Pollock and de Kooning, sought expressiveness through energetically applied pigment. Chromatic abstractionists, such as Rothko, struck emotional chords through large areas of pure color.
- Post-Painterly Abstraction promoted a cool rationality in contrast to Abstract Expressionism's passion. Both hard-edge painters, such as Stella, and color-field painters, such as Frankenthaler, pursued purity in art by emphasizing the flatness of pigment on canvas.
- Pop artists, such as Johns, Lichtenstein, and Warhol, turned away from abstraction to represent subjects grounded in popular culture—flags, comic strips, Coca-Cola bottles—sometimes employing commercial printing techniques.
- Riley and other Op artists sought to produce optical illusions of motion and depth using only geometric forms on two-dimensional surfaces.
- Superrealists, such as Flack, Close, and Hanson—kindred spirits to Pop artists in many ways—created paintings and sculptures featuring scrupulous fidelity to optical fact.
- The leading sculptural movement of this period was Minimalism. Judd created artworks consisting of simple unadorned geometric shapes to underscore the "objecthood" of his sculptures.
- Many artists pursued social agendas in their work. Postwar feminist artists include Chicago, whose *Dinner Party* honors women throughout history, and Sherman, who explored the "male gaze" in her photographs resembling film stills.

Frankenthaler, The Bay, 1963

Lichtenstein, Hopeless, 1963

Sherman, Untitled Film Still #35, 1979

Architecture and Site-Specific Art

- Some of the leading early-20th-century modernist architects remained active after 1945. Wright built the snail-shell Guggenheim Museum, Le Corbusier the sculpturesque Notre-Dame-du-Haut, and Mies van der Rohe the Minimalist Seagram skyscraper.
- In contrast to modernist architecture, postmodern architecture is complex and eclectic and often incorporates references to historical styles. Two pioneering postmodern projects are Graves's Portland Building and Moore's Piazza d'Italia.
- Site-specific art stands at the intersection of architecture and sculpture. Smithson's *Spiral Jetty* is a mammoth coil of natural materials in Utah's Great Salt Lake.

Moore, Piazza d'Italia, New Orleans, 1976-1980

Performance and Conceptual Art and New Media

- Among the most significant developments in the art world after World War II has been the expansion of the range of works considered "art."
- Performance artists, such as Schneemann, replace traditional stationary artworks with movements and sounds performed before an audience.
- Conceptual artists, such as Kosuth, believe that the "artfulness" of art is in the artist's idea, not the work resulting from the idea.
- Paik and others have embraced video recording technology to produce artworks combining images and sounds.

Schneemann, Meat Joy, 1964

■ **16-1b** Newspaper clippings chronicle the conquest of Native America by Europeans and include references to the problems facing those living on reservations today—poverty, alcoholism, and disease.

■ **16-1a** Smith's *Trade* celebrates her Native American identity. The cheap trinkets she offers in return for confiscated land include sports team memorabilis with offensive names, such as Braves and Redskins.

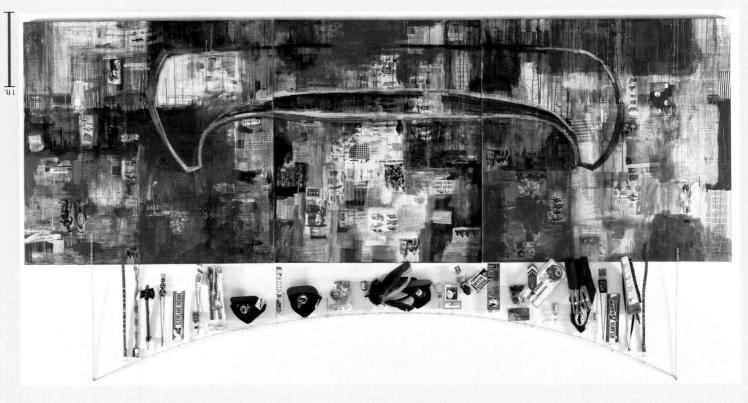

6-7 JAUNE QUICK-TO-SEE SMITH, Trade (Gifts for Trading Land with White People), 1992. Oil and mixed media on canvas, 5' × 14' 2". Chrysler Museum of Art, Norfolk.

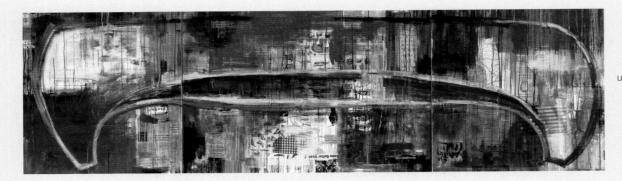

► 16-1c Overlapping the collage and the central motif of the canoe in Smith's anti-Columbus is dripping red paint, symbolic of the shedding of bolic of the shedding of Native American blood.

Contemporary Art Worldwide

ART AS SOCIOPOLITICAL MESSAGE

Although televisions, smartphones, and the Internet have brought people all over the world closer together than ever before, national, ethnic, religious, and racial conflicts are also an unfortunate and pervasive characteristic of contemporary life. Some of the most eloquent voices raised in protest about the major political and social issues of the day have been those of painters and sculptors, who can harness the power of art to amplify the power of the written and spoken word.

Jaune Quick-to-See Smith (b. 1940) is a Native American artist descended from the Shoshone, Salish, and Cree peoples. Raised on the Flatrock Reservation in Montana, she is steeped in the traditional culture of her ancestors, but she trained as an artist in the European American tradition at Framingham State University in Massachusetts and at the University of New Mexico. Smith's ethnic heritage has always informed her art, however, and her concern about the invisibility of Native American artists has led her to organize exhibitions of their art. Her self-identity has also been the central theme of her mature work as an artist.

In 1992, Smith created what many critics consider her masterpiece: *Trade* (FIG. 16-1), subtitled *Gifts* for *Trading Land with White People*. A complex multimedia work of imposing size, *Trade* is Smith's response to what she called "the Quincentenary Non-Celebration"—that is, white America's celebration of the 500th anniversary of Christopher Columbus's arrival in what Europeans called the New World. *Trade* incorporates collage elements and attached objects, reminiscent of a Rauschenberg combine (FIG. 15-17), with energetic brushwork recalling Willem de Kooning's Abstract Expressionist canvases (FIG. 15-6). Among the items in *Trade*'s collage are clippings from Native American newspapers featuring images chronicling the conquest of North America by Europeans and references to the problems facing those living on reservations today—poverty, alcoholism, and disease. The dripping red paint overlaying the collage with the central motif of the canoe is symbolic of the shedding of Native American blood.

Above the painting, as if hung from a clothesline, is an array of objects. These include Native American artifacts, such as beaded belts and feather headdresses; plastic tomahawks; "Indian princess" dolls; and contemporary sports memorabilia from teams with American Indian–derived names: the Cleveland Indians, Atlanta Braves, and Washington Redskins. The inclusion of these objects reminds viewers of the vocal opposition to the use of these and similar names for high school and college as well as professional sports teams. All the cheap artifacts together also have a deeper significance. As the title indicates and Smith explained: "Why won't you consider trading the land we handed over to you for these silly trinkets that so honor us? Sound like a bad deal? Well, that's the deal you gave us."

YADOT TAA

Santa Monica. paintstick on three canvas panels, $8' \times 6' \ 3''$. Broad Art Foundation, 16-2 JEAN-MICHEL BASQUIAT, Horn Players, 1983. Actylic and oil

rhythms of jazz and the excitement of New York. combined bold colors, fractured figures, and graffiti to capture the dynamic In this tribute to two legendary African American musicians, Basquiat

most histories of Western art until recently. often demeaning roles. Black artists have also been omitted from

to the streets. He first drew attention as an artist in 1980 when he against middle-class values, dropped out of school at 17, and took tant from Haiti and a black Puerto Rican mother, Basquiat rebelled BASQUIAT (1960-1988). Born in Brooklyn, the son of an accounexperiences of American men of African descent was JEAN-MICHEL JEAN-MICHEL BASQUIAT One artist whose work tocused on the

puter graphics, and video.

with the new media of digital photography, com-

work with age-old materials and also experiment

worldwide art scene as artists on all continents

coexist today in the increasingly interconnected

Modern, postmodern, and traditional art forms

art and architecture. useful way to approach the complex phenomenon of contemporary eral different media. Nevertheless, these six categories constitute a commentary and combine representation and abstraction and sev-Quick-to-See Smith's Trade (FIG. 16-1), can also be a work of social a painting that explores personal and group identity, such as Jaune fall into more than one of these categories, however. For example, and Site-Specific Art; and New Media. Most contemporary artworks Social Commentary; Representation and Abstraction; Architecture the following headings: Personal and Group Identity; Political and matically and stylistically and, to a lesser degree, by medium, under since 1980. Instead, this survey of contemporary art is organized theon the extraordinarily diverse range of works produced worldwide unwise to try to impose a strict chronological development scheme to be surveyed is increasing literally daily. It is both impractical and the past 35 to 40 years—is still unfolding, and the body of material present generation—that is, the history of the art and architecture of This is an "incomplete" chapter, because the story of the art of the

PERSONAL AND GROUP IDENTITY

instantly international in character. that, thanks to 21st-century technological breakthroughs, is now powers of art to communicate with a wide audience—an audience desire on the part of artists once again to embrace the persuasive pages 420-425), a rejection of modernist formalist doctrine and a sents, as did the earlier work of the Pop artists and Superrealists (see political issues. This focus on the content and meaning of art repreof the decades since 1980 in addressing contemporary social and tions, but her work parallels that of many other innovative artists can who has sought to bridge native and European artistic tradi-Trade is the unique product of Smith's heritage as a Native Ameri-

everybody keenly aware of her or his distinct national, ethnic, racial, The multicultural diversity of the world today has made almost

have made their personal and group identity the focus of their work. and religious identity. Not surprisingly, many contemporary artists

African American Art

produced by European and American artists except in marginal and people of African descent have rarely been the subject of artworks opment in the history of art because outside Africa, Africans and their art are African Americans. This is a very significant devel-Prominent among those for whom race has been a key element of

CONTEMPORARY ART WORLDWIDE

- Neshat, Bester, and Zhang. by, among others, Quick-to-See Smith, Sikander, sanes confiune to be broduced in great numbers Artworks addressing pressing political and social 0007-0661
- Murray) remain vital components of the contemporary Kiki Smith) as well as abstraction (Schnabel, Realistic figure painting and sculpture (Saville,
- Green architecture (Piano, Foster) emerge as major Deconstructivist (Gehry, Hadid) and Hi-Tech and

Mapplethorpe, and many others. prominently in the art of Basquiat, Ringgold, Kruger, ity; ethnic, religious, and national identity-figure Social and political issues—gender and sexual-0661-0861

lightning rods for debate over the public financing tions of the work of Mapplethorpe and Offli become Site-specific artworks by Lin and Serra and exhibi-

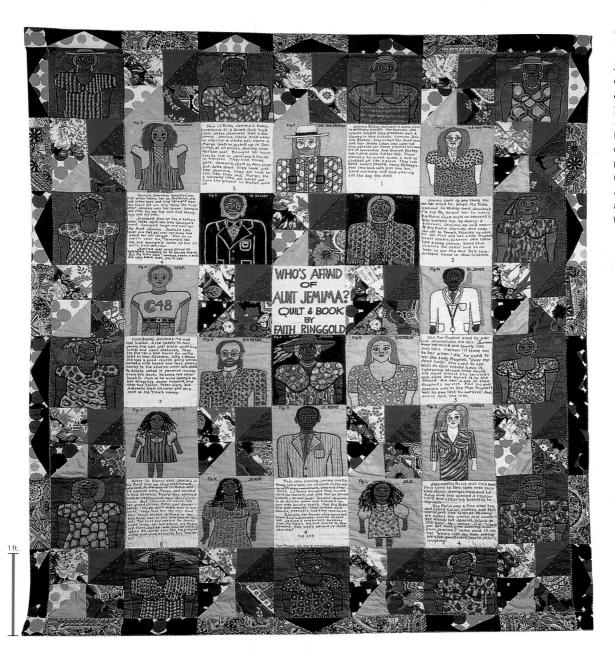

16-3 FAITH RINGGOLD, Who's Afraid of Aunt Jemima? 1983. Acrylic on canvas with fabric borders, quilted, 7' 6" × 6' 8". Private collection.

In this quilt, a medium associated with women, Ringgold presented a tribute to her mother that also addresses African American culture and the struggles of women to overcome oppression.

participated in a group show—the "Times Square Show"—in an abandoned 42nd Street building. Eight years later, after a meteoric rise to fame, he died of a heroin overdose at age 27. Basquiat was self-taught, both as an artist and about the history of art, but he was not a "primitive." His sophisticated style owes a debt to diverse sources, including the late paintings of Pablo Picasso, Abstract Expressionism, and urban graffiti. Many of Basquiat's paintings celebrate black heroes—for example, the legendary jazz musicians Charlie "Bird" Parker and Dizzy Gillespie, whom he memorialized in Horn Players (FIG. 16-2). The fractured figures, the bold colors against a black background, and the deliberately scrawled, crossedout, and misspelled graffiti ("ornithology"—the study of birds—is a pun on Parker's nickname and also the title of one of Parker's musical compositions) create a dynamic composition suggesting the rhythms of jazz music and the excitement of the streets of New York.

FAITH RINGGOLD One of the leading artists addressing issues associated with African American women is Harlem native FAITH

RINGGOLD (b. 1930). In the 1960s, Ringgold produced numerous works that provided incisive commentary on the realities of racial prejudice. She increasingly incorporated references to gender as well and, in the 1970s, turned to fabric as the predominant material in her art. Using fabric enabled Ringgold to make more pointed reference to the domestic sphere, traditionally associated with women, and to collaborate with her mother, Willi Posey, a fashion designer. After her mother's death, Ringgold created Who's Afraid of Aunt Jemima? (FIG. 16-3), a quilt composed of dyed, painted, and pieced fabric. A moving tribute to her mother, this "story quilt"-Ringgold's signature art form-merges the personal and the political. The quilt tells the witty story of the family of the stereotypical black "mammy" in the mind of the public, but here Aunt Jemima is a successful African American businesswoman. Ringgold narrates the story using black dialect interspersed with embroidered portraits and traditional patterned squares. Aunt Jemima, while resonating with autobiographical references, also speaks to the larger issues of the history of African American culture and the struggles of women to overcome oppression.

Gender and Sexuality

stani artist Shahzia Sikander. and Robert Mapplethorpe in America and the Pakia diverse group of artists, including Barbara Kruger homosexuality are the central themes explored by elements of their personal identity. Feminism and and nationalities with gender and sexuality as core eral concern among contemporary artists of all races can women artists is but one aspect of a more gen-The interest in feminist issues among African Ameri-

nalizing stereotypes and conditioned roles. language is one of the most powerful vehicles for internificant. Many cultural theorists have asserted that moving car). Kruger's use of text in her work is sigpainted on the pavement to be read by a driver in a intensifies the meaning (rather like a series of words a cumulative quality that delays understanding and single glance. Reading them is a staccato exercise, with of eight words. The words cannot be taken in with a head of a woman with a vertical row of text composed overlaid a photograph of a classically beautiful sculpted ded in commercial advertising. In Your Gaze, Kruger graph collages challenge the cultural attitudes embedthe media constantly reinforce. Her word-and-photothe myths—particularly those about women—that ers complacently absorb. Kruger wants to undermine the deceptiveness of the media messages that viewcal use of advertising imagery. She aimed to expose of advertising, Kruger's goal was to subvert the typishe chose the reassuringly familiar format and look and billboards use to sell consumer goods. Although ger incorporated the layout techniques that magazines (Your Gaze Hits the Side of My Face; FIG. 16-4), Kru-Mademoiselle magazine in the late 1960s. In Untitled media fascinate Kruger, who was the art director of The strategies and techniques of contemporary mass (b. 1945) examines similar issues in her photographs. notion of gender in their art. Barbara Krugera explored the "male gaze" and the culturally constructed ists, chief among them Cindy Sherman (FIG. 15-26), BARBARA KRUGER In the 1970s, some feminist art-

is as important an element of their personal identity as their gen-ROBERT MAPPLETHORPE For many artists, their homosexuality

daze

Boone Gallery, New York. graph, paper letters, red painted frame, 4' $7" \times 3' 5"$. © Barbara Kruger/Courtesy Mary

16-4 Ваяваяа Квибев, Untitled (Your Gaze Hits the Side of My Face), 1981. Photo-

gender. constructed this word-and-photograph collage to challenge culturally constructed notions of Kruger has explored the "male gaze" in her art. Using the layout techniques of mass media, she

of the 20th century.

homosexuals, minorities, and the disabled during the second half in American society and the struggle for equal rights for women, ists of the time, are inextricably bound up with the social upheavals plethorpe's photographs, like the work of other gay and lesbian arthair and makeup, confronting the viewer with a steady gaze. Mappresents Mapplethorpe as an androgynous young man with long in December 1988. The self-portrait reproduced here (FIG. 16-5) until he died only months after the show opened in Philadelphia changing appearance (from having contracted AIDS) almost up sexual men, a series of self-portraits documenting Mapplethorpe's graphs included, in addition to some very graphic images of homoof many of Mapplethorpe's images. The Perfect Moment phototional subject with roots in antiquity—but the openly gay character sculpture. What shocked the public was not nudity per se-a tradiestablish photography as an art form on a par with painting and innovative compositions of still lifes (FIG. 14-21) and nudes helped many ways, Mapplethorpe was the heir of Edward Weston, whose textures with rich tonal gradations of black, gray, and white. In photographic medium. His gelatin silver prints have glowing Never at issue was Mapplethorpe's technical mastery of the of Controversial Art," page 443). restrictions on government funding of the arts (see "Public Funding

expression for artists and prompted new legislation establishing

in nature. The show led to a landmark court case on freedom of

some depicting children, some homoerotic and sadomasochistic

tured an extensive series of photographs, including many nudes,

tion, funded in part by the National Endowment for the Arts, fea-

Mapplethorpe (1946-1989). His Perfect Moment traveling exhibi-

the U.S. Congress as well as among the public at large was ROBERT

ist who became the central figure in a heated debate in the halls of

der, ethnicity, or race-often more important. One brilliant gay art-

ART AND SOCIETY

Public Funding of Controversial Art

Although art can be beautiful and uplifting, throughout history art has also challenged and offended. Since the early 1980s, a number of heated controversies about art have surfaced in the United States. There have been many calls to remove "offensive" works from public view (see "Richard Serra's *Tilted Arc*," page 455) and, in reaction, accusations of censorship. The central questions in all cases have been whether there are limits to what art can appropriately be exhibited and whether governmental authorities have the right to monitor and pass judgment on creative endeavors. A related question is whether the acceptability of a work should be a criterion in determining the public funding of art.

Two exhibits in 1989 placed the National Endowment for the Arts (NEA), a U.S. government agency charged with distributing federal funds to support the arts, squarely in the middle of this debate. One of the exhibitions, devoted to recipients of the Awards for the Visual Arts (AVA), took place at the Southeastern Center for Contemporary Art in North Carolina. Among the award winners was Andres Serrano (b. 1950), whose *Piss Christ*, a photograph of a crucifix submerged in urine, sparked an uproar. Responding to this artwork, Donald Wildmon, an evangelical minister from Mississippi and head of the American Family Association, expressed outrage that this kind of work was in an

exhibition funded by the NEA and the Equitable Life Assurance Society (a sponsor of the AVA). He demanded that *Piss Christ* be removed and launched a letter-writing campaign that caused Equitable Life to cancel its sponsorship of the awards. To staunch conservatives, this exhibition, along with *Robert Mapplethorpe: The Perfect Moment*, which included erotic homosexual images of the artist (FIG. 16-5) and others, served as evidence of cultural depravity and immorality. These critics insisted that art of an offensive character should not receive public funding. As a result of media furor over *The Perfect Moment*, the director of the Corcoran Museum of Art canceled the scheduled exhibition of this traveling show. But Dennis Barrie, director of the Contemporary Arts Center in Cincinnati, did mount the show, resulting in his indictment on charges of obscenity, but a jury acquitted him six months later.

These controversies intensified public criticism of the NEA and its funding practices. The next year, the head of the NEA, John Frohnmayer, vetoed grants for four lesbian, gay, or feminist performance artists, who became known as the "NEA Four." Infuriated by what they perceived as overt censorship, the artists filed suit, eventually settling the case and winning reinstatement of their grants. Congress responded by dramatically reducing the NEA's budget, and the agency no longer awards grants or fellowships to individual artists.

Controversies have also erupted on the municipal level. In 1999, Rudolph Giuliani, then mayor of New York, joined the protest over the inclusion of several artworks in the exhibition *Sensation: Young British Artists from the Saatchi Collection* at the Brooklyn Museum. Chris

Ofili's *The Holy Virgin Mary* (FIG. 16-7) became the flashpoint for public furor. Denouncing the show as "sick stuff," the mayor threatened to cut off all city subsidies to the museum.

Art that seeks to unsettle and challenge is critical to the cultural, political, and psychological life of a society. The regularity with which unconventional art raises controversy suggests that it operates at the intersection of two competing principles: free speech and artistic expression on the one hand, and a reluctance to impose images on an audience that finds them repugnant or offensive on the other. What these controversies do demonstrate, beyond doubt, is the enduring power of art—and artists.

16-5 ROBERT MAPPLETHORPE, Self-Portrait, 1980. Gelatin silver print, $7\frac{3}{4}$ " × $7\frac{3}{4}$ ". Robert Mapplethorpe Foundation, New York.

Mapplethorpe's *Perfect Moment* show led to a landmark court case on freedom of expression for artists. In this self-portrait, an androgynous Mapplethorpe confronts the viewer with a steady gaze.

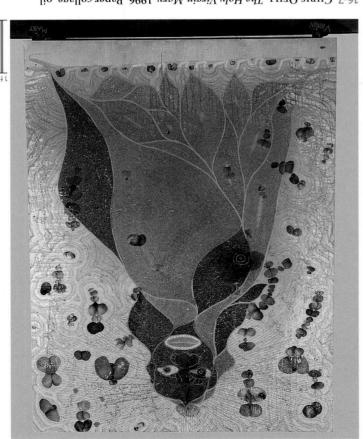

16-7 Сняіз Ояілі, Тhe Holy Virgin Mary, 1996. Рарет collage, oil paint, glitter, polyester resin, map pins, elephant dung on linen, γ' II" \times 5' II $\frac{5}{16}$ ". Museum of Old and New Art, Hobart.

Ofili, a British-born Catholic of Nigerian descent, represented the Virgin Mary with African elephant dung as a breast and with genitalia and buttocks surrounding her. The painting produced a public outcry.

Controversial Art," page 443). decided to merge the sacred and the vile (see "Public Funding of elicited strong reactions, as Ofili clearly intended it to do when he and see them in new ways. Not surprisingly, The Holy Virgin Mary the viewer to move beyond the cultural associations of the materials to incorporate Africa into his work in a literal way. Still, he wants two more serving as supports for the canvas. The dung enabled Offli the clumps of elephant dung—one forming the Virgin's breast, and paintings. Another reference to Ofili's African heritage surfaces in the artist, parallel the putti often surrounding Mary in Renaissance lia and buttocks cut out from pornographic magazines, which, to whose face is that of an African woman, are tiny images of genitaimages from ancient caves in Zimbabwe). Surrounding the Virgin, applied to the canvas in multiple layers of beadlike dots (inspired by indeterminate space. The artist employed brightly colored pigments sents the Virgin in simplified form, and she appears to float in an from conventional Renaissance representations. Offli's work pre-Mary (FIG. 16-7) depicts Mary in a manner that departs radically an artist with his racial and national background. His Holy Virgin Ofili has addressed is religion, as interpreted through the eyes of homeland figures prominently in his art. One of the major themes OFILI (b. 1968) is one of the leading European artists whose familial CHRIS OFILI A British-born Catholic of Nigerian descent, CHRIS

16-6 Shahzia Sikander, Perilous Order, 1994–1997. Vegetable color, dry pigment, watercolor, and tea on Wasli paper, $10\frac{1}{2}$ " \times 8". Whitney Museum of American Art, New York (purchase, with funds from the Drawing Committee).

Imbuing miniature painting with a contemporary message about hypocrisy and intolerance, Sikander portrayed a gay friend as a homosexual Mughal emperor who enforced Muslim orthodoxy.

and Hindu populations of Pakistan and India today. also incorporates a reference to the tensions between the Muslim behind the shadow of a veiled Hindu goddess. Perilous Order thus bleized background ringed by voluptuous nude Hindu nymphs and sexual. Sikander depicted him framed against a magnificent marstrict enforcer of Islamic orthodoxy although reputed to be a homoguise of the Mughal emperor Aurangzeb (r. 1658-1707), who was a ality, intolerance, and hypocrisy by portraying a gay friend in the meaning. In Perilous Order (FIG. 16-6), she addresses homosexupage 474), but imbued this traditional art form with contemporary the demanding South Asian/Persian art of miniature painting (see in her work. Sikander, who now lives in New York City, has revived Pakistani artist Shahzia SiкаиDев (b. 1969) brilliantly addresses women and homosexuals face especially difficult challenges, which has never been confined to the United States. In the Muslim world, SHAHZIA SIKANDER The struggle for recognition and equal rights

National Identity

As in the case of Shahzia Sikander, a person's birthplace is often a central component of personal identity, even if the artist has migrated to another country. National identity looms large in the work of many contemporary artists.

16-8 Shirin Neshat, Allegiance and Wakefulness, 1994. Offset print with ink calligraphy, 3' $5\frac{1}{4}$ " \times 2' 9". Israel Museum, Jerusalem (anonymous gift, New York, to American Friends of the Israel Museum).

Neshat's photographs address the repression of women in postrevolutionary Iran. She poses in traditional veiled garb but wields a rifle and displays militant Farsi poetry on her exposed body parts.

SHIRIN NESHAT Political and social oppression also plays a significant role in the art of Shirin Neshat (b. 1957), who grew up in a Westernized Iranian home and attended a Catholic boarding

school in Tehran before leaving her homeland for the United States. Neshat produces films, video, and photographs critical of the fundamentalist Islamic regime in Iran, especially its treatment of women (see "Shirin Neshat on Iran after the Revolution" (1)). She often poses for her photographs wearing a veil—which is for her a symbol both of ethnic pride and of the repression of Muslim women—and with her face and exposed parts of her body covered with Farsi (Persian) messages. Unlike the words in Kruger's photographs (FIG. 16-4), which evoke commercial typography, Neshat's handwritten additions to her photographs remind the viewer of the long tradition of calligraphy in Persian art (see page 151). A rifle also often figures prominently in Neshat's photographs as an emblem of militant feminism, a notion foreign to the Muslim faith. In Allegiance and Wakefulness (FIG. 16-8) from her Women of Allah series, Neshat omitted her face and most of her body, and focused on her feet covered with verses of militant Farsi poetry and on the barrel of a rifle she points menacingly toward the viewer.

POLITICAL AND SOCIAL COMMENTARY

Although almost all of the works discussed thus far are commentaries on contemporary society (seen through the lens of the artists' personal experiences), they do not incorporate references to specific events, nor do they address conditions affecting all people regardless of their race, national origin, gender, or sexual orientation—for example, homelessness, industrial pollution, and street violence. Other artists, including Canadian photographer EDWARD BURTYNSKY (b. 1955; FIG. 16-8A 🖪), have confronted precisely those aspects of late 20th- and early 21st-century life in their work.

MARTHA ROSLER Violence and armed combat are themes that have been explored by MARTHA ROSLER (b. 1943), who has produced a diverse body of artistic work, including photography, videos, and performance art. Throughout her career, Rosler has focused on social and political commentary, primarily issues concerning women, housing and homelessness, and war and its depiction in the media. *Gladiators* (FIG. 16-9) is one of the recent additions to Rosler's *Bringing the War Home: House Beautiful* photomontage series. Originally created between 1967 and 1972 as a critical com-

mentary on the Vietnam War, Rosler expanded *House Beautiful* in 2004 in reaction to the war in Iraq. Like the other photomontages in the series, *Gladiators* brings disturbing images of combat into the domestic sphere by inserting armed soldiers (modern "gladiators") into the tranquil living rooms of upscale houses, literally "bringing the war home" to those whose sons and daughters, unlike those of working-class families, rarely enlist in the armed forces and fight for their country.

16-9 MARTHA ROSLER, Gladiators, 2004, from Bringing the War Home: House Beautiful. Photomontage, 1' $8" \times 2'$. Mitchell-Innes & Nash Gallery, New York.

Rosler's House Beautiful photomontages disturbingly insert images of armed soldiers (modern "gladiators") into the tranquil living rooms of upscale houses, literally "bringing the war home."

military personnel. Critics have compared the painthumiliation and torture of Iraqi prisoners by American Botero's Abu Ghraib series is a condemnation of the Art Museum, Berkeley (gift of the artist).

2005. Oil on canvas, $4'9\frac{1}{2}" \times 5'9\frac{5}{8}"$. Berkeley 16-10 FERNANDO BOTERO, Abu Ghraib 46,

ings to scenes of martyrdom.

paintings are stripped of their clothes, blindgraphs from Abu Chraib, the men in Botero's domestic subjects. As in the published photothey differ markedly from his usually tranquil trademark larger-than-life inflated bodies, but Ghraib 46 (FIG. 16-10)—are peopled by Botero's prison. The paintings—for example, Abu of American military personnel at Abu Ghraib tion and torture of Iraqi prisoners at the hands news reports and photographs of the humiliain his 80s, Botero reacted with horror to the artist Fernando Botero (b. 1932). Still active series of paintings and drawings by Colombian the inhumane treatment of prisoners is the large outrage against war in general and specifically tionally wrenching recent artworks to express FERNANDO BOTERO Perhaps the most emo-

forever remain on display. ings and has donated them to museums on the condition that they vention. He has refused to profit from sales of the Abu Chraib painta broad condemnation of cruelty in violation of the Geneva Coninsisted that the paintings are not intended as anti-American but as to the passion of Christ and the martyrdom of saints. Botero has compared these graphic depictions of physical and mental torture ferocious dogs or forced to wear women's underwear. Critics have folded, bound, beaten, and bloodied, and are often threatened by

death. The red crosses on this vehicle's door and on Kruger's reflective if in a morgue, above the ambulance (to the left) also refers to Biko's mean "stop Kruget," or perhaps "stop apartheid." The tagged foot, as the inferno of burned townships. The stop sign (lower left) seems to Biko's head. The crosses stand out against a red background, recalling cated by the white graveyard crosses above a blue sea of skulls beside alizes both Biko and the many other antiapartheid activists, as indiraised in the classic worldwide protest gesture. This portrait memoribeneath Biko's portrait. Bester portrayed Biko with his chained fists ria in the yellow Land Rover ambulance seen left of center and again had him transported 1,100 kilometers (almost 700 miles) to Pretothe center, is near another of the police minister, James Kruger, who his picture with references to death and injustice. Biko's portrait, at in charge of him sparked protests around the world. Bester packed while he was in detention. The exoneration of the two white doctors African Black Consciousness Movement whom the authorities killed Biko (FIG. 16-17) is a tribute to the gentle and heroic leader of the South ment-sponsored racial separation). Bester's 1992 Homage to Steve South African artists who were vocal critics of apartheid (governnently in the paintings of Wille Bester (b. 1956), one of many WILLE BESTER Political oppression in South Africa figures promi-

ors dripped or painted on many parts of the canvas. Writing and Blood-red and ambulance-yellow are in fact unifying col-

dark glasses repeat, with sad irony, the graveyard crosses.

extent to which art can be invoked in the political process. critique of an oppressive sociopolitical system, and it exemplifies the signs, symbols, and pigment. Homage to Steve Biko is a powerful ture and dense in its collage combinations of objects, photographs, imposed by apartheid policies. The whole composition is rich in texto the social harmony and joy provided by music and to the control guitar (bottom center), another recurrent Bester symbol, refers both degraded lives of most South African people of color. The oilcan fragile, impermanent township dwellings—remind viewers of the metal, cans, and other discards—from which the poor construct under apartheid. Found objects-wire, sticks, cardboard, sheet the composition. Numbers refer to the dehumanized life of blacks ite Cubist motifs (FIGS. 14-8 and 14-9)—also appear throughout numbers, found fragments, and stenciled and painted signs—favor-

desirable male child. illustrated example, the yellow that draws attention to the highly Zhang's otherwise intentionally subdued palette, save for, in the (Fig. 14-39). The red bloodlines are the only touches of color in connecting the figures—a device used earlier by Frida Kahlo a girl. The Bloodline series takes its name from the faint red lines families to seek abortions, often in order to raise a boy instead of ried couples to having only a single child, a policy that has led many though recently eased, government policy of restricting most marthree-figure groups are also commentaries on the long-standing, of the Mao era in China. Ironically titled Big Family, these somber fathers, mothers, and children wearing the approved plain clothes are not really portraits. Instead, they depict generic, personality-less to 1976 under Mao Tse-tung (1893-1976), the Bloodline paintings of Chinese families popular during the Cultural Revolution of 1966 Family No. 2 (FIG. 16-12). Based on the black-and-white photographs Zhang is best known for his Bloodline portraits—for example, Big principal interest of Chinese painter Zhang Xiaogang (b. 1958). ZHANG XIAOGANG Political and social commentary is also the

16-11 WILLIE BESTER, Homage to Steve Biko, 1992. Mixed media, $3' 7\frac{5}{6}" \times 3' 7\frac{5}{6}"$. Collection of the artist.

Homage to Steve Biko is a tribute to a leader of the Black Consciousness Movement, which protested apartheid in South Africa. References to the injustice of Biko's death fill this complex painting.

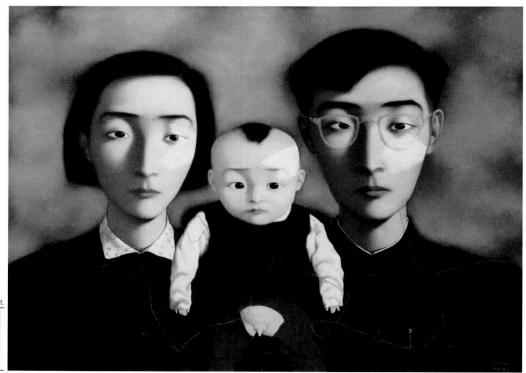

16-12 ZHANG XIAOGANG, *Bloodline:* Big Family No. 2, 1995. Oil on canvas, 5' $11'' \times 7'$ $6\frac{5}{8}''$. Private collection.

Ironically titled *Big Family* in reaction to the government's one-child policy, Zhang's generic, personality-less portraits intentionally recall black-and-white family photographs of the Mao era in China.

Book from the Sky to be read on many levels. the illegibility of the past. Indeed, Xu intended A porary political language and as a commentary on stinging critique of the meaninglessness of contemto tradition. Critics have interpreted it both as a carving. A Book from the Sky, however, is no hymn characters and extensive training in woodblock both an intimate knowledge of genuine Chinese invented by the artist. Producing them required in characters evocative of Chinese writing but an enormous number of woodblock-printed texts the University of Wisconsin. The work presents a room) called A Book from the Sky (FIG. 16-13), at assemblage that creates an artistic environment in ited his most famous work, a large installation (an during the Cultural Revolution. In 1987, Xu exhibforced to work in the countryside with peasants XU BING (b. 1955), a Chongqing native who was nese culture has been the hallmark of the work of XU BING A different kind of commentary on Chi-

Xu trained as a printmaker in Beijing. A Book from the Sky, with its invented Chinese woodblock characters, may be a stinging critique of the meaninglessness of contemporary

16-13 XU BING, A Book from the Sky, 1987. Installation of woodblock-printed books at the Elvehjem (now Chazen) Museum of Art, University of Wis-

political language.

consin, Madison, 1991.

REPRESENTATION AND ABSTRACTION

Despite the high visibility of contemporary artists whose work deals with the pressing social and political issues of the world, some critically acclaimed living artists have produced innovative modernist art during the postmodern era. Abstraction remains a valid and compelling approach to painting and sculpture in the 21st century, as does more traditional figural art.

Figural Painting and Sculpture

Recent decades have brought a revival of interest in figural art, both in painting and sculpture, a trend best exemplified in the earlier postwar period by Lucian Freud (FIG. I5-22A (3)), who remained an active and influential painter until his death in July 2011.

ing figure painter in the Freud mold of the younger generation of European and American artists. She is best known for her over-lifesize self-portraits in which she exaggerates the girth of her body and delights in depicting heavy folds of flesh with visible veins in minute detail and from a sharply foreshortened angle, which further distorts the body's proportions. Saville's nude self-portraits are a commentary on the contemporary obsession with the lithe bodies of fashion models. In Branded (Fig. 16-14), she highlights the dichotomy between the popular notion of a beautiful body and the imperfect bodies of most people by "branding" her body with words inscribed in her flesh—"delicate," "decorative," "petite." Art critic inscribed in her flesh—"delicate," "decorative," "petite." Art critic firentinist aesthetics of disgust.".

16-14 Jenny Saville, Branded, 1992. Oil on canvas, $7' \times 6'$. Saatchi Gallery, London.

Saville's unflattering foreshortened self-portrait "branded" with words such as "delicate" and "petite" underscores the dichotomy between the perfect bodies of fashion models and those of most people.

KIKI SMITH A distinctly unflattering approach to the representation of the human body is also the hallmark of the sculptures of Kiki Smith (b. 1954). In her work, Smith has explored the question of who controls the human body, an interest that grew out of her training as an emergency medical service technician. Smith, however, also wants to reveal the socially constructed nature of the body, and she encourages the viewer to consider how external forces shape people's perceptions of their bodies. In works such as *Untitled* (FIG. 16-15), the artist dramatically departed from conventional representations of the body, both in art and in the media. She suspended two life-size wax figures, one male and one female, both nude, from metal stands. Smith marked each of the sculptures with long white drips—body fluids running from the woman's breasts and down the man's leg. She commented:

Most of the functions of the body are hidden . . . from society. . . . [W]e separate our bodies from our lives. But, when people are dying, they are losing control of their bodies. That loss of function can seem

16-15 KIKI SMITH, *Untitled*, 1990. Beeswax and microcrystalline wax figures on metal stands, female figure installed height 6' $1\frac{1}{2}"$, male figure installed height 6' $4\frac{15}{16}"$. Whitney Museum of American Art, New York (purchased with funds from the Painting and Sculpture Committee).

Asking "Who controls the body?" Kiki Smith sculpted two life-size wax figures of a nude man and woman with body fluids running from the woman's breasts and down the man's leg.

humiliating and frightening. But, on the other hand, you can look at it as a kind of liberation of the body. It seems like a nice metaphor—a way to think about the social—that people lose control despite the many agendas of different ideologies in society, which are trying to control the body(ies) . . . medicine, religion, law, etc. Just thinking about control—who has control of the body? . . . Does the mind have control of the body? Does the social?³

JEFF KOONS The sculptures of JEFF KOONS (b. 1955) form a striking counterpoint to the figural art of Kiki Smith. Koons first became prominent in the art world for a series of works in the early 1980s involving the exhibition of everyday commercial products such as vacuum cleaners. Clearly following in the footsteps of Marcel Duchamp (FIG. 14-15), Koons made no attempt to manipulate or alter the machine-made objects. More recently, he turned to ceramic sculpture. In *Pink Panther* (FIG. 16-16), Koons intertwined a pin-up nude with a famous cartoon character. He reinforced the trite and kitschy nature of this imagery by titling the exhibition of which this sculpture was a part *The Banality Show*. Koons intends his work to

16-16 JEFF KOONS, *Pink Panther*, 1988. Porcelain, 3' 5" high. Museum of Contemporary Art, Chicago (Gerald S. Elliot Collection).

Koons creates sculptures highlighting everything he considers wrong with contemporary American consumer culture. In this work, he intertwined a centerfold nude and a cartoon character.

2007, the year after a major retrospective exhibition of her work was mounted at the Museum of Modern Art—a rare honor accorded to few women before her.

Can You Hear Me? (Fig. 16-17) is typical of Murray's innovative approach to abstract painting. It is an irregularly shaped composite of several small canvas-on-wood panels that bear comparison not only to Abstract Expressionist works but to the Biomorphic Surrealist paintings of Joan Miró (Fig. 14-27) and also to cartoon art. The central—although almost unnoticed at first—motif of Can You Hear Me? is a face with a smooth nout of which emerges a shape resembling an elonwide-open mouth out of which emerges a shape resembling an elongated comic-strip balloon (compare Fig. 15-18) but without words—the gated comic-strip balloon (compare Fig. 15-18) but without words—the reason the viewer cannot hear what the face is saying. Murray has acknowledged that Edvard Munch's Scream (Fig. 13-17) was the source of inspiration for her painting, but in Can You Hear Me? emotional frenzy is expressed by purely abstract means, most notably through the centribused force of the propeller-like shape of the painting itself.

PROBLEMS AND SOLUTIONS Rethinking the Shape of Painting

Since antiquity, rectangular frames for paintings have been the norm worldwide for wood panels, frescoed walls, oil paintings on canvas, manuscript illustrations, and silk scrolls alike. Even during the past century, when artists have rethought almost every traditional tenet of the art of painting, the vertically or horizontally oriented rectilinear painting surface has with few exceptions (for example, Fig. 15-8) reigned supreme, even among artists who have abandoned easel painting in favor of applying pigment to unstretched canvas spread out on the floor (Fig. 15-5). Recently, however, some artists have experimented not floor (Fig. 15-5) are geometric shapes but with highly irregular formats.

Chief among them is Elizabeth Murray. Born in Chicago, Murray moved to New York City in 1967 and painted there until her death in

16-17 ELIZABETH MURRAY, Can You Hear Me? 1984. Oil on canvas on wood, 8' 10" × 13' 3" × 1'. Dallas Museum of Art, Dallas (Foundation for the Arts Collection).

Elizabeth Murray's abstract compositions are of unusual format. She rejected the traditional rectillinear format for painting in favor of a multilayered composite of canvas-onwood panels.

wood, canvas, or silk from antiquity to the present day. A leading contemporary artist who experimented with alternate shapes was ELIZABETH MURRAY (1940–2007; see "Rethinking the Shape of Painting," above, and FIG. 16-17).

EL ANATSUI Probably the most unusual abstract artworks being created today are those of EL ANATSUI (b. 1944) of Ghana, who, unique among African artists, established his international reputation without moving his studio to Europe or America. Anatsui has spent his entire adult life in Nigeria and, even more remarkably, did not begin producing the art that has made him famous until his artistic genre that Anatsui invented, a kind of artwork that is so different from all others that art historians have yet to agree on a label for it. A cross between sculpture and textile design, Anatsui's "metal for it. A cross between sculpture and textile design, Anatsui's "metal

draw attention to everything that he believes is wrong with contemporary American society. His prominence in the art world is based on his acute understanding of the dynamics of consumer culture.

Abstract Painting and Sculpture

Today, many artists continue to explore abstraction as a compelling means of expression in pictorial art, among them Julian Schuabel (b. 1951; Fig. 16-16A (A) and Elizabeth Murray (Fig. 16-17) in the United States, Song Su-vam (b. 1938; Fig. 16-16B (A)) in Korea, and El Anatsui (Fig. 16-18) in Ghana.

ELIZABETH MURRAY One of the few things that paintings as diverse as those examined so far have in common is that they share the standard rectilinear format that has characterized paintings on

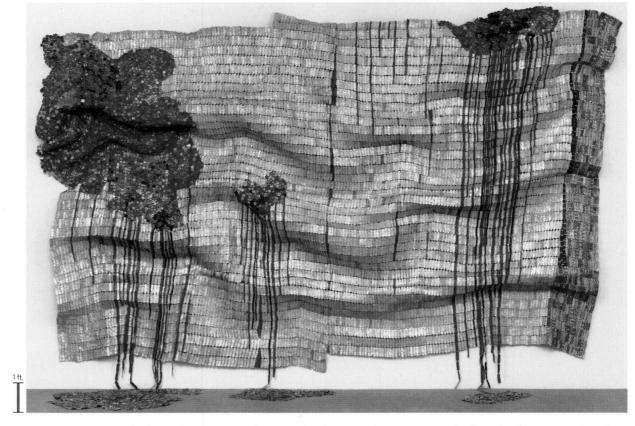

16-18 EL ANATSUI, *Bleeding Takari II*, 2007. Aluminum bottle tops and copper wire, 12' 11" × 18' 11". Museum of Modern Art, New York (gift of Donald L. Bryant Jr. and Jerry Speyer, 2008).

Anatsui's unique "metal hangings" are a cross between abstract sculptures and textiles. They are assemblages of thousands of crushed and pierced bottle caps and aluminum cans stitched together with copper wire.

hangings" (as they are often called) are labor-intensive constructions of crushed bottle caps and lids of aluminum cans pierced and stitched together using copper wire. The colors (primarily red, gold, and black) that Anatsui uses have close parallels in Asante *kente* cloth, and his works can be rolled and folded like fabric. When displayed on museum walls or hanging from a ceiling—or even draped on a building's facade—the metal sheets undulate with any breeze. Anatsui's artworks-in-motion deserve comparison with Alexander Calder's pioneering mobiles (FIG. 14-32). They are, however, thoroughly in tune with 21st-century concerns in being assembled (by a large team of assistants) almost entirely from recycled materials.

ARCHITECTURE AND SITE-SPECIFIC ART

The work of architects and Environmental artists today is as varied as that of contemporary painters and sculptors, but the common denominator in the diversity of contemporary architectural design and site-specific projects is the breaking down of national boundaries.

Architecture

In the late 20th and early 21st centuries, one of the by-products of the globalization of the world's economy has been that leading architects have received commissions to design buildings far from their home bases. In the rapidly developing emerging markets of Asia, the Middle East, Africa, Latin America, and elsewhere, virtually every architect with an international reputation can list on his or her résumé a recent building in a bustling new urban center.

DECONSTRUCTIVISM Perhaps the most radical development in architectural design during the closing decades of the 20th century was *Deconstructivism*. Deconstructivist architects attempt to disrupt the conventional categories of architecture and to rupture the viewer's expectations based on them. Disorder, dissonance, imbalance, asymmetry, irregularity, and confusion replace their opposites—order, harmony, balance, symmetry, regularity, and clarity. The seemingly haphazardly presented volumes, masses, planes, borders, lighting, locations, directions, and spatial relations, as well as the disguised structural facts of Deconstructivist design, challenge the viewer's assumptions about architectural form as it relates to function. According to Deconstructivist principles, the very absence of the stability of traditional categories of architecture in a structure announces a "deconstructed" building.

FRANK GEHRY One of the first practitioners of this audacious architectural mode was German architect GÜNTER BEHNISCH (1922–2010); FIG. 16-18A ☑). The architect most closely identified with Deconstructivist architecture, however, is Canadian Frank Gehry (b. 1929). Gehry works up his designs by constructing models and then cutting them up and arranging the parts until he has a satisfying composition. Among Gehry's most notable projects is

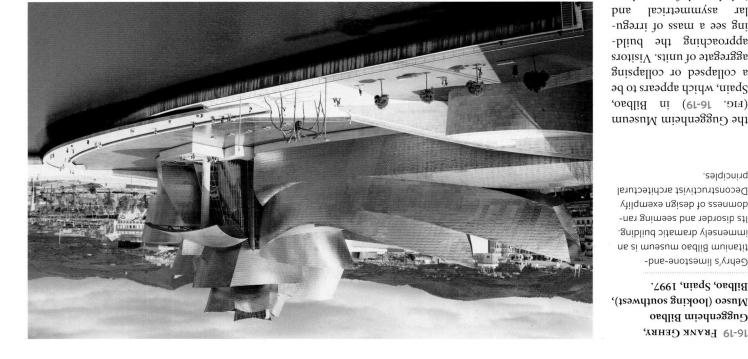

principles. Deconstructivist architectural domness of design exemplify Its disorder and seeming ranimmensely dramatic building. titanium Bilbao museum is an Gehry's limestone-and-

Bilbao, Spain, 1997.

Guggenheim Bilbao 16-19 FRANK GEHRY,

profiles change dramatiimbalanced forms whose lar asymmetrical and ing see a mass of irreguapproaching the buildaggregate of units. Visitors a collapsed or collapsing Spain, which appears to be (FIG. 16-19) in Bilbao, the Guggenheim Museum

FIG. 16-19A (1). as do the designs of London-based Iraqi ZAHA HADID (b. 1950; rium it prompts in viewers epitomize Deconstructivist principles, disorder, its deceptive randomness of design, and the disequilibheim Museum in Bilbao is a profoundly compelling structure. Its into one another, guided only by light and dark cues. The Guggenweightless screens, vaults, and volumes of the interior float and flow point for the three levels of galleries radiating from it. The seemingly walled atrium soars 165 feet above the ground, serving as the focal tops the museum. In the center of the building, an enormous glass-A group of organic forms that Gehry refers to as a "metallic flower" and highlights further the unique cluster effect of the many forms. titanium-clad exterior lends a space-age character to the structure cally with every shift of the viewer's position. The limestone- and

dispensing with all historical references. ture is distinct from other postmodern architectural movements in and exposing the structures' component parts. High-Tech architecincorporating the latest innovations in engineering and technology (FIG. 12-24) in London. High-Tech architects design buildings be traced to Joseph Paxton's mid-19th-century Crystal Palace of what critics call High-Tech architecture, the roots of which can several years later. Foster and Rogers are the leading proponents to London in 1962, although they established separate practices ture, and they opened a joint architectural firm when they returned met Richard Rogers (FIG. 15-33) at the Yale School of Architec-NORMAN FOSTER British architect Norman Foster (b. 1935)

At the base of the building is a plaza opening onto the neighboring he calls "villages," suspended from steel girders resembling bridges. HSBC tower into five horizontal units of six to nine floors each that nal working spaces on each cantilevered floor. Foster divided the ends of the building, a design that provides uninterrupted commuvators and other service elements located in giant piers at the short The 47-story skyscraper has an exposed steel skeleton with the elelion to build, exemplifies the High-Tech approach to architecture. Kong and Shanghai Bank Corporation (HSBC), which cost \$1 bil-Foster's design for the headquarters (FIG. 16-20) of the Hong

southwest), Hong Kong, China, 1979-1986. 16-20 Norman Foster, Hong Kong and Shanghai Bank (looking

computerized mirrors that reflect sunlight. uninterrupted working spaces. At the base is a 10-story atrium illuminated by Foster's High-Tech tower has an exposed steel skeleton featuring floors with

streets. Visitors ascend on escalators from the plaza to a spectacular 10-story, 170-foot-tall atrium bordered by balconies with additional workspaces. What Foster calls "sun scoops"—computerized mirrors on the south side of the building—track the movement of the sun across the Hong Kong sky and reflect the sunlight into the atrium and plaza, flooding the dramatic spaces with light at all hours of the day. Not surprisingly, the roof of this High-Tech skyscraper serves as a landing pad for corporate helicopters.

GREEN ARCHITECTURE The harnessing of solar energy as a power source is one of the key features of what critics commonly refer to as *Green architecture*—ecologically friendly buildings that use "clean energy" and sustain the natural environment. Green architecture is the most important trend in architectural design in the early 21st century. A pioneer in this field is Renzo Piano, the codesigner with

16-21 RENZO PIANO, Tjibaou Cultural Centre (looking southeast), Noumea, New Caledonia, 1998.

A pioneering example of Green architecture, Piano's complex of 10 bamboo units, based on traditional New Caledonian village huts, has adjustable skylights in the roofs for natural climate control.

Richard Rogers of the Pompidou Center (FIG. 15-33) in Paris. Piano won an international competition to design the Tjibaou Cultural Centre (FIG. 16-21) in Noumea. Rooted in the village architecture of the Kanak people of New Caledonia, the center consists of 10 beehive-shaped bam-

boo "huts" nestled in pine trees on a narrow island peninsula in the Pacific Ocean. Each unit has an adjustable skylight as a roof to provide natural—sustainable—climate control. The curved profile of the Tjibaou pavilions also helps the structures withstand the pressure of the hurricane-force winds common in the South Pacific.

Environmental and Site-Specific Art

When Robert Smithson created *Spiral Jetty* (FIG. 15-34) in Utah's Great Salt Lake in 1970, he was a trailblazer in the new genre of Environmental Art, or earthworks. In recent decades, earthworks and other site-specific artworks that bridge the gap between architecture and sculpture have become an established mode of artistic expression. As is true of all other media in the postmodern era, these artworks take a dazzling variety of forms.

CHRISTO AND JEANNE-CLAUDE The most famous Environmental artists of the past few decades are Christo (b. 1935) and Jeanne-Claude (1935–2009). In their works, the couple sought to intensify the viewer's awareness of the space and features of rural and urban sites. However, rather than physically alter the land itself, as Smithson often did, Christo and Jeanne-Claude prompted this awareness by temporarily modifying the landscape with cloth. Their projects required years of preparation and research, and scores of meetings with local authorities and interested groups of citizens. These temporary artworks were usually on view for only a few weeks.

Surrounded Islands (FIG. 16-22), created in Biscayne Bay in Miami, Florida, for two weeks in May 1983, typifies Christo and Jeanne-Claude's work. For this project, they surrounded 11 small

16-22 CHRISTO and JEANNE-CLAUDE, Surrounded Islands, Biscayne Bay, Miami, Florida, 1980–1983.

Christo and Jeanne-Claude created this Environmental artwork by surrounding 11 small islands with 6.5 million square feet of pink fabric. Characteristically, the work existed for only two weeks.

wounded soldier in her arms. Unveiled in 1993, the work occupies a site Glenna Goodacre (b. 1939) depicts three female figures, one cradling a women's service in the Vietnam War. The 7-foot-tall bronze statue by years later, a group of nurses won approval for a sculpture honoring formed, which stands approximately 120 feet from Lin's wall. Several by artist Frederick Hart (1943-1999) of three soldiers, armed and uniect, commissioned a larger-than-life-size realistic bronze sculpture the Commission of Fine Arts, the federal group overseeing the proj-

about 300 feet south of the Lin memorial.

cessfully encourages personal exploration. Minimalist simplicity. It does not dictate response and therefore succan be argued that much of this memorial's power derives from its lost in the Vietnam War or make rubbings from the incised names. It leave mementos at the foot of the wall in memory of loved ones they searching—viewers see themselves reflected among the names. Many the monument. The polished granite surface prompts individual soulerans Memorial, even those who know none of the soldiers named on Commonly, visitors react very emotionally to Lin's Vietnam Vet-

and Los Angeles: University of California Press, 1996), 525. Theories and Documents of Contemporary Art: A Sourcebook of Artists' Writings (Berkeley Excerpt from an unpublished 1995 lecture, quoted in Kristine Stiles and Peter Selz, *Elizabeth Hess, "A Tale of Two Memorials," Art in America 71, no. 4 (April 1983): 122.

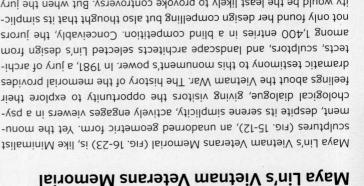

ART AND SOCIETY

erans. Lin herself, however, described the wall as follows: design as minimizing the Vietnam War and, by extension, Vietnam vetbracketing Lin's sunken wall, some people interpreted her Minimalist memorials (the Washington Monument and the Lincoln Memorial) monument. Because of the stark contrast between the massive white wide."* But the sharpest protests concerned the form and siting of the color of shame, sorrow and degradation in all races, all societies worldcame under attack. One veteran charged that black is "the universal made its selection public, heated debate ensued. Even the wall's color ity would be the least likely to provoke controversy. But when the jury not only found her design compelling but also thought that its simplicamong 1,400 entries in a blind competition. Conceivably, the jurors tects, sculptors, and landscape architects selected Lin's design from dramatic testimony to this monument's power. In 1981, a jury of archifeelings about the Vietnam War. The history of the memorial provides chological dialogue, giving visitors the opportunity to explore their ment, despite its serene simplicity, actively engages viewers in a psysculptures (Fig. 15-12), an unadorned geometric form. Yet the monu-

Because of the vocal opposition, a beyond the names.1 of the light and the quieter world ing an interface between the world ing the stone to pure surface, creatthe earth's surface—dematerializcutting open the earth and polishing but a work formed from the act of not an object inserted into the earth The Vietnam Veterans Memorial is

the memorial's completion. In 1983, compromise was necessary to ensure

Washington, D.C., 1981-1983. Veterans Memorial (looking north), 16-23 Maya Ying Liu, Vietnam

dialogue about the war. actively engage viewers in a psychological geometric form. Its inscribed polished walls to veterans of the Vietnam War is a simple Like Minimalist sculpture, Lin's memorial

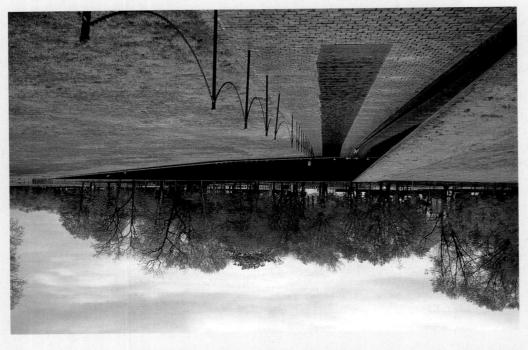

ness of descent as they walk along the wall toward the center. The Lin set the memorial into the landscape, enhancing visitors' awareend and gradually ascend to a height of 10 feet at the center of the V. two 246-foot-long wings of the wall begin at ground level at each a V-shaped wall constructed of polished black granite panels. The ture. Austere and simple, the Vietnam memorial takes the form of when she was a 21-year-old student at the Yale School of Architecwar memorial was designed in 1981 by Maya Ying Liu (b. 1959) sidered under the heading of site-specific art. The now-acclaimed Memorial (FIG. 16-23) in Washington, D.C., is perhaps best consculpture or as an architectural monument, the Vietnam Veterans MAYA YING LIN Often classified as either a work of Minimalist

tiny bit of land. the fabric "cocoons" to form magical floating "skirts" around each ors, the pink of the cloth, and the blue of the bay) and then unfurled the 11 islands (to assure maximum contrast between their dark col-Huge crowds watched as crews removed accumulated trash from lages, and models of works they created in the 1950s and 1960s. The artists raised the money by selling preparatory drawings, colforce, and obtain the \$3.2 million needed to complete the project. of preparation to obtain the required permits, assemble the labor floating fabric. This Environmental artwork required three years 6.5 million square feet of specially fabricated pink polypropylene artificial islands in the bay (created from a dredging project) with

ART AND SOCIETY

Richard Serra's Tilted Arc

When Richard Serra installed *Tilted Arc* (Fig. 16-24) in the plaza in front of the Javits Federal Building in New York City in 1981, much of the public immediately responded with hostile criticism. Prompting the chorus of complaints was the uncompromising presence of a Minimalist sculpture bisecting the plaza. Many argued that *Tilted Arc* was ugly, attracted graffiti, interfered with the view across the plaza, and prevented use of the plaza for performances or concerts. Because of the sustained barrage of protests and petitions demanding the removal of *Tilted Arc*, the General Services Administration, which had commissioned the sculpture, held a series of public hearings. Afterward, the agency decided to remove Serra's sculpture despite its prior approval of the artist's model. Understandably, this infuriated Serra, who had a legally binding contract acknowledging the site-specific nature of *Tilted Arc*. "To remove the work is to destroy the work," the artist stated.*

This episode raised intriguing issues about the nature of public art, including the public reception of experimental art, the artist's responsibilities and rights when executing public commissions, censorship in

the arts, and the purpose of public art. If an artwork is on display in a public space outside the relatively private confines of a museum or gallery, do different guidelines apply? As one participant in the *Tilted Arc* saga asked, "Should an artist have the right to impose his values and taste on a public that now rejects his taste and values?" Historically, one of the express functions of the artistic avant-garde was to challenge convention by rejecting tradition and disrupting the complacency of the viewer. Will placing experimental art in a public place always cause controversy? From Serra's statements, it is clear that he intended the sculpture to challenge the public.

Another issue that *Tilted Arc* presented involved the rights of the artist, who in this case accused the GSA of censorship. Serra filed a lawsuit against the federal government for infringement of his First Amendment rights and insisted that "the artist's work must be uncensored, respected, and tolerated, although deemed abhorrent, or perceived as challenging, or experienced as threatening." Did removal of the work constitute censorship? A U.S. district court held that it did not.

Ultimately, who should decide what artworks are appropriate for the public arena? One artist argued, "We cannot have public art by plebiscite [popular vote]." But to avoid recurrences of the *Tilted Arc* controversy, the GSA changed its procedures and now solicits input

from a wide range of civic and neighborhood groups before commissioning public artworks. Despite the removal of *Tilted Arc* (now languishing in storage), the sculpture maintains a powerful presence in all discussions of the aesthetics, politics, and dynamics of public art.

*Grace Glueck, "What Part Should the Public Play in Choosing Public Art?" New York Times, February 3, 1985, 27.

†Calvin Tomkins, "The Art World: Tilted Arc," New Yorker, May 20, 1985, 98.

†Ibid., 98–99.

†Ibid., 98.

16-24 RICHARD SERRA, *Tilted Arc*, as installed before its removal from Jacob K. Javits Federal Plaza (looking southwest), New York City, 1981.

Serra intended his Minimalist *Tilted Arc* to alter the character of an existing public space. He succeeded, but unleashed a storm of protest that caused the government to remove the work.

names of the Vietnam War's 57,939 American casualties (and those missing in action) incised on the wings (in the order of their deaths) contribute to the memorial's dramatic effect.

When Lin designed this pristinely simple monument, she gave a great deal of thought to the purpose of war memorials. She was determined to create a memorial that would

be honest about the reality of war and be for the people who gave their lives. . . . [I] didn't want a static object that people would just look at, but something they could relate to as on a journey, or passage, that would bring each to his own conclusions. . . . I wanted to work with the land and not dominate it. I had an impulse to cut open the earth . . . an initial violence that in time would heal. The grass would grow back, but the cut would remain.⁴

In light of the tragedy of the war, this unpretentious memorial's allusion to a wound and a "long-lasting scar" contributes to its visual and psychological impact (see "Maya Lin's Vietnam Veterans Memorial," page 454). In 2000, a long-lasting scar of a different kind—the Holocaust of World War II—was brilliantly memorialized by British sculptor RACHEL WHITEREAD (b. 1963) in the former Jewish Ghetto of Vienna (FIG. 16-23A 🕖).

RICHARD SERRA Also unleashing a heated public debate, but for different reasons and with a decidedly different outcome, was *Tilted Arc* (FIG. 16-24) by RICHARD SERRA (b. 1939), who as a young man worked in steel mills in California. In 1979, he received a commission from the U.S. General Services Administration (GSA) to install a 120-foot-long, 12-foot-high curved wall of Cor-Ten steel in the

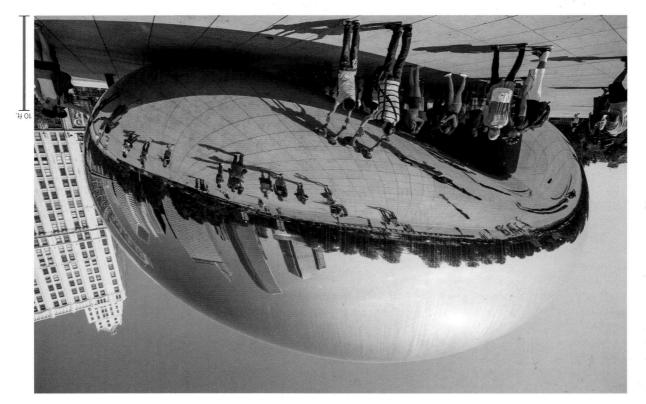

16-25 Аміян КлРООВ, Cloud Gate, 2004. Stainless steel, 33' × 66' × 42'. Millennium Park, Chicago.

Kapoor's enormous polished stainless steel sculpture has delighted visitors to Chicago's Millennium Park, who enjoy seeing distorted views of themselves and the city's skyline in Cloud Gate's curving mirrored surface.

NEW MEDIA

In addition to taking the ancient arts of painting, sculpture, and architecture in new directions, contemporary artists have continued to explore the expressive possibilities of the various new media developed in the postwar period, especially digital photography, computer graphics, and video.

ANDREAS GURSKY Since the mid-1990s, German photographer hardres GURSKY (b. 1955) has used computer and digital technology to produce gigantic color prints in which he combines and manipulates photographs taken with a wide-angle lens, usually from a high vantage point. The size of his photographs, sometimes almost a dozen feet wide, intentionally rivals 19th-century history paintings. But as was true of Gustave Courbet (FIGS. 12-13 and 12-14) in his day, Gursky's subjects come from everyday life. He records the mundane world of the modern global economy—vast industrial plants, major department stores, hotel lobbies, and stock and commodity exchanges—and, like Edward Burtynsky (FIG. 16-8Å ﴿), transforms the commonplace into striking, almost abstract compositions.

Gursky's enormous 1999 print (Fig. 16-26) documenting the frenzied activity on the main floor of the Chicago Board of Trade is a characteristic example of his work. He took a series of photographs from a gallery, creating a panoramic view of the traders in their brightly colored jackets. He then combined several digibilimages using commercial photo-editing software to produce a blurred tableau of bodies, desks, computer terminals, and strewn paper in which both mass and color are so evenly distributed as to negate the traditional Renaissance notion of perspective. In using the computer to modify the "objective truth" and spatial recession of "straight photography," Gursky blurs the distinction between painting and photography.

plaza in front of the Jacob K. Javits Federal Building in lower Manhattan. He completed the project in 1981. Serra wished Tilted Arc to "dislocate or alter the decorative function of the plaza and actively bring people into the sculpture's context." In pursuit of that goal. Serra situated the sculpture so that it bisected and consequently significantly altered the space of the open plaza and interrupted the traffic flow across the square. By creating such an intrusive presence in this large public space, Serra forced viewers to reconsider the plaza's physical space as a sculptural form—but only temporarily, because the public succeeded in having the sculpture removed (see because the public succeeded in having the sculpture removed (see Stichard Serra's Tilted Arc," page 455).

the pleasure of looking at the work. face, as Kapoor intended them to be, adding another dimension to people, buildings, and clouds are distorted by the Bean's curved surreflects clouds of similar bean shape. However, the reflections of skyline) in the mirrorlike surface. On many days, Cloud Gate also ing their reflection (with the backdrop of the panorama of Chicago's ages viewers to interact with it. Indeed, most people delight in see-Serra's Tilted Arc did in Manhattan, Kapoor's Cloud Gate encourits title Cloud Gate. Rather than disrupting activity in the park, as enough that people can walk under its swelling arched form, hence as the Bean, Kapoor's gigantic, gently curving sculpture is large Aussu Kapoor (b. 1954). Affectionately known to Chicagoans sculpture by the recently knighted Mumbai-born British sculptor a 33-foot-tall and 66-foot-long polished stainless steel abstract tion in 2004 in Chicago's Millennium Park of Cloud Gate (FIG. 16-25), ANISH KAPOOR The public reacted very differently to the installa-

Among the many other contemporary artists creating exciting site-specific artworks today is Korean Do-Ho Suh (b. 1962), whose installations—for example, *Bridging Home* (FIG. 16-25A A)—have been exhibited worldwide, underscoring the truly international nature of artistic production today.

16-26 Andreas Gursky, Chicago Board of Trade II, 1999. C-print, 6' $9\frac{1}{2}$ " × 11' $5\frac{5}{8}$ ". Matthew Marks Gallery, New York.

Gursky manipulates digital photographs to produce vast tableaus depicting places that are characteristic of the modern global economy. The size of his prints rivals that of 19th-century history paintings.

BILL VIOLA For much of his artistic career, BILL VIOLA (b. 1951) has also explored the capabilities of digitized imagery, producing many video installations and single-channel works. Often focusing on sensory perception, the pieces not only heighten viewer awareness of the senses but also suggest an exploration into the spiritual realm. Viola spent years seriously studying Buddhist, Christian, Sufi, and Zen mysticism. Because he fervently believes in art's transformative power and in a spiritual view of human nature, Viola designs works encouraging spectator introspection. His video projects have involved using techniques such as extreme slow motion, contrasts in scale, shifts in focus, mirrored reflections, staccato editing, and multiple or layered screens to achieve dramatic effects.

The power of Viola's work is evident in *The Crossing* (FIG. 16-27), an installation piece involving two color video channels projected on 16-foot-high screens. The artist either shows the two projections on the front and back of the same screen or on two separate screens in the same installation. In these two companion videos, shown simultaneously on the two screens, a man surrounded in darkness appears, moving closer until he fills the screen. On one screen, drops of water fall from above onto the man's head, while on the other screen, a small fire breaks out at the man's feet. Over the next few

16-27 BILL VIOLA, *The Crossing*, 1996. Video/sound installation with two channels of color video projection onto screens 16' high.

Viola's video projects use extreme slow motion, contrasts in scale, shifts in focus, mirrored reflections, and staccato editing to create dramatic sensory experiences rooted in tangible reality.

Barney's vast multimedia installations of drawings, Museum, New York, 2003. installation at the Solomon R. Guggenheim

16-28 MATTHEW BARNEY, Cremaster cycle,

boundaries among artistic media. ation at the opening of the 21st century of the traditional photographs, sculptures, and videos typify the relax-

MATTHEW BARNEY A major trend in the art experience very much rooted in tangible reality. dark space immerse viewers in a pure sensory tion's elemental nature and its presentation in a subsides and fades into darkness. This installapany these visual images. Eventually, everything a raging fire and a torrential downpour accomman on the other screen. The deafening roar of one screen (Fig. 16-27) and flames consume the until the man disappears in a torrent of water on minutes, the water and fire increase in intensity

lar contractions in response to external stimuli. to the cremaster muscle, which controls testicuthat Barney created. The title of the work refers lengthy narrative set in a self-enclosed universe (presented in videos), the Cremaster cycle is a sculptures, videos, films, and performances extravaganza involving drawings, photographs, many contemporary works. A multimedia in New York typifies the expansive scale of cycle (1994–2002) at the Guggenheim Museum installation (FIG. 16-28) of his epic Cremaster ists is Matthew Barney (b. 1967), whose 2003 new and traditional media. One of these artcomplex multimedia installations combining many contemporary artists are creating vast and boundaries between artistic media. In fact, world today is the relaxation of the traditional

in expansive and complicated ways. entire Cremaster project, in which he explores the notion of creation cess of sexual differentiation as the conceptual springboard for the Barney uses the development of this muscle in the embryonic pro-

force that competes with the immense scale and often frenzied pace ney's constructed world is disorienting and overwhelming and has a screens hanging in the Guggenheim's rotunda. Immersion in Bartogether conceptually by a five-channel video piece projected on century Budapest. In the installation, Barney tied the artworks Masonic rituals, a motorcycle race, and a lyric opera set in late-19thtion of the Chrysler Building (FIG. 14-41A A), Celtic mythology, the execution of convicted murderer Gary Gilmore, the construcrevue in Boise, Idaho (where Barney grew up), the life cycle of bees, and the artworks, makes reference to, among other things, a musical The cycle's narrative, revealed in the five feature-length films

what constitutes a "work of art." The universally expanding presence dominate. New technologies will undoubtedly continue to redefine tecture, it is certain that no single approach to or style of art will bring, but given the expansive scope of contemporary art and archi-WHAT NEXT? No one knows what the next years and decades will of contemporary life.

Explore the era further in MindTap with videos of major altworks and

has revealed, substantial progress has already been made in that

thereby creating a truly global artistic community. As this chapter

make art and information about art available to virtually everyone, what few conceptual and geographical boundaries remain, and

of computers, digital technology, and the Internet may well erode

- following additional subjects: buildings, Google Earth™ coordinates, and essays by the author on the
- Edward Burtynsky, Densified Scrap Metal #3A, Toronto, Ontario ■ ARTISTS ON ART: Shirin Neshat on Iran after the Revolution
- (A8-61,017)
- Julian Schnabel, The Walk Home (FIG. 16-16A)
- Song Su-nam, Summer Trees (FIG. 36-36B)

direction.

- Günter Behnisch, Hysolar Institute, Stuttgart (FIG. 16-18A)
- Emirates (FIG. 16-19A) Zaha Hadid, proposal for Signature Towers, Dubai, United Arab
- Rachel Whiteread, Holocaust Memorial, Vienna (FIG. 16-23A)
- Do-Ho Suh, Bridging Home (FIG. 16-25A)

CONTEMPORARY ART WORLDWIDE

Personal and Group Identity

The innumerable artworks created since 1980 worldwide are extraordinarily diverse in style, format, content, and technique, but can be classified under a few major themes, including personal and group identity. Many artists of African descent, including Jean-Michel Basquiat and Faith Ringgold, have produced important works addressing issues of concern to black Americans. Jaune Quick-to-See Smith has focused on her Native American heritage. Gender and sexuality are central themes in the work of Barbara Kruger, Robert Mapplethorpe, and Shahzia Sikander. National identity looms large in the art created by Shirin Neshat (Iran) and Chris Ofili (Nigeria).

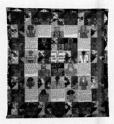

Ringgold, Who's Afraid of Aunt Jemima? 1983

Political and Social Commentary

- Rather than addressing the concerns of individuals and groups, other contemporary artists have treated political and economic issues that affect society at large.
- Edward Burtynsky's photographs of "manufactured landscapes" highlight the destructive effects of industrial pollution.
- The violence of contemporary life has been addressed by Martha Rosler (the effects of war on the home front) and Fernando Botero (torture at Abu Ghraib).
- Willie Bester has protested apartheid in South Africa, and Zhang Xiaogang has produced biting commentaries on the Cultural Revolution in China.
- Xu Bing is best known for his stinging critiques of the meaninglessness of contemporary political language.

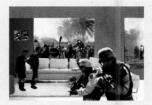

Rosler, Gladiators, 2004

Zhang, Big Family No. 2, 1995

Representation and Abstraction

- Among today's best-known figural painters and sculptors are Jenny Saville and Kiki Smith, who have revived the tradition of brutal realism.
- Leading abstract painters and sculptors include Julian Schnabel and Elizabeth Murray in the United States, Song Su-nam in Korea, and El Anatsui in Nigeria.

Anatsui, Bleeding Takari II, 2007

Architecture, Site-Specific Art, and New Media

- Contemporary architecture is as diverse as painting and sculpture. Among the major champions of Deconstructivism are Otto Behnisch, Frank Gehry, and Zaha Hadid. Leading Hi-Tech and Green architects include Norman Foster and Renzo Piano.
- The site-specific works of Maya Lin, Rachel Whiteread, Richard Serra, Anish Kapoor, and Do-Ho Suh bridge the gap between architecture and sculpture.
- Many contemporary artists have harnessed new technologies for their art: Andreas Gursky (digital photography), Bill Viola (video), and Matthew Barney (multimedia installations).

Piano, Tjibaou Cultural Centre, Noumea, 1998

► 17-1b The four foranse (gateways) to the Sanchi stupa feature reliefs depicting the story of the Buddha's life and tales of his past lives, when he accumulated sufficient merit to achieve enlightenment.

▲ 17-18 The Great Stupa at Sanchi is a 50-foot-tall earth-and-rubble domical mound containing relics of Shakyamuni. Worshipers walk around the stupa in a clockwise direction to venerate the Buddha.

shi. These goddesses personify fertility and vegetation and tie Buddhist iconography to earlier South Asian pictorial traditions.

third century BCE to first century CE.

▶ 17-1c Also carved on the east torana is a scantily clad, sensuous woman called a yak-

Great Stupa (looking west), Sanchi, India,

South and Southeast Asia

THE GREAT STUPA AT SANCHI

In 326 BCE, after conquering the Persian Empire, Alexander the Great (see page 72) reached the Indus River, but his troops refused to go forward. Reluctantly, the charismatic Greek king, probably the greatest general of the ancient world, abandoned his dream of conquering India and headed home. After Alexander's death three years later, his chief officers divided his empire among themselves. One of them, Seleucus Nicator (r. 321–281 BCE), reinvaded India, but Chandragupta Maurya (r. 323–298 BCE), founder of the Maurya dynasty, defeated him in 305 BCE and eventually consolidated almost all of present-day India under his domain.

India holds a special position in the history of civilization as the birthplace of two of the modern world's great religions, Buddhism and Hinduism, both of which are examined in this chapter. The person chiefly responsible for the spread of Buddhism was one of Chandragupta's successors, King Ashoka (r. 272–231 BCE), a Buddhist convert. Among the most important Buddhist sanctuaries founded during Ashoka's reign (see "Ashoka's Sponsorship of Buddhism" 🕖) was the monastery at Sanchi in central India. The site, which remained in use for more than a thousand years, boasts many structures, but the most impressive is the Great Stupa (FIGS. 17-1 and 17-4), a circular mound housing the Buddha's remains, or relics (see "The Stupa," page 465).

In its present form with its tall stone fence and four *toranas* ("gates"), the Sanchi *stupa* dates from about 50 BCE to 50 CE. The solid earth-and-rubble dome stands 50 feet high. In accordance with Buddhist ritual, to venerate the Buddha's relics, worshipers enter through one of the gateways to the stupa, walk on the lower circular path, then climb the stairs on the south side to *circumambulate* the sacred mound in a clockwise direction at the second level. Carved onto different parts of the Great Stupa are more than 600 brief inscriptions of donors to the project. Veneration of the Buddha was open to all, not just the monks. In fact, common laypeople, who hoped that their gifts would accrue merit for them for future rebirths (see "Buddhism," page 466), made most of the Sanchi dedications. More than a third of the donors who made the stupa's construction possible were women.

The reliefs on the stupa's four toranas depict episodes from the Buddha's life and tales of his past lives (*jatakas*). In Buddhist belief, everyone has had innumerable past lives, including the Buddha himself. Also carved on the east torana is a scantily clad, sensuous woman called a *yakshi*. These goddesses, worshiped throughout India, personify fertility and vegetation and tie Buddhist iconography to the pictorial tradition of earlier South Asian religions.

Indus Civilization

sewage. In Mohenjo-daro, hundreds of wells throughout the city one of the world's first sophisticated systems of water supply and and precisely laid kiln-baked bricks. The Indus cities also boasted to compass points and multistory houses built of carefully formed Harappa. Both were fully developed cities featuring streets oriented The most important excavated Indus sites are Mohenjo-daro and The Indus Civilization flourished from about 2600 to 1500 BCE.

Indus Civilization. Archaeologists have dubbed this early South Asian culture the they encountered a civilization already more than 2,000 years old. Thus, when Alexander the Great and his army reached India, into India as far south as Gujarat and east beyond Delhi (MAP 17-1). geographical area along the Indus River in Pakistan and extended In the third millennium BCE, a great civilization arose over a wide

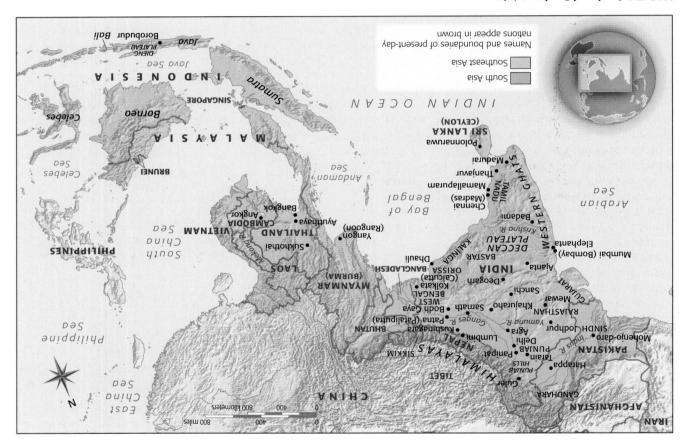

MAP 17-1 South and Southeast Asia.

wiesoporamia.

systems.

snpu

and 50 cE.

Sanchi between 50 BCE

Ashoka's Great Stupa at

dominate Southeast Asia. art and architecture sidbbud bns maidbbud gigantic gateways.

Hindu temples with

spling (98/L-679L)

The Nayak dynasty

architecture to northern

introduce Islamic art and

Delhi (1206-1526) and

Muslim Sultanate of

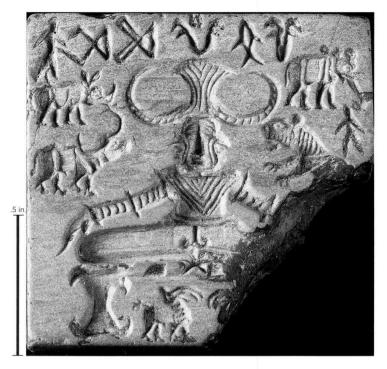

17-2 Seal with seated figure in yogic posture, from Mohenjo-daro, Pakistan, ca. 2300–1750 BCE. Steatite coated with alkali and baked, $1\frac{3}{8}$ " × $1\frac{3}{8}$ ". National Museum, New Delhi.

This seal depicting a (three-faced?) figure wearing a horned headdress and seated in a yogic posture indicates that this important Indian meditative practice began as early as the Indus Civilization.

provided fresh water to homes incorporating some of the oldest recorded private bathing areas and toilet facilities, with drainage into public sewers. The inhabitants of the Indus cities engaged in trade with cities as far away as modern Iraq, but in sharp contrast to the contemporaneous civilizations of Mesopotamia, Egypt, and the Mediterranean world, no excavated Indus building has yet been identified as a temple or a palace.

INDUS SEALS Surprisingly, archaeologists have discovered little art from the long-lived Indus Civilization, and all of the objects found are small. The most common are steatite seals with incised designs. They are similar in many ways to the seals found at contemporaneous sites in Mesopotamia. Most of the Indus examples have an animal or tiny narrative carved on the face, along with an as-yet-untranslated script. On the back, a boss (circular knob) with a hole enabled insertion of a string so that the owner could wear the seal or hang it on a wall. As in Mesopotamia, the Indus peoples sometimes used the seals to make impressions on clay, apparently for securing trade goods wrapped in textiles. The animals most frequently represented include the humped bull, elephant, rhinoceros, and tiger—always shown in strict profile (see "How to Represent an Animal," page 17). Some of the narrative seals indicate that the Indus peoples considered trees sacred, as both Buddhists and Hindus did later. Many scholars have suggested religious and ritual continuities between the Indus Civilization and later Indian culture.

One of the most elaborate seals (FIG. 17-2) depicts a male figure with a horned headdress and, perhaps, three faces, seated (with

erect penis) among the profile animals that regularly appear alone on other seals. The figure's position—folded legs with heels pressed together and arms resting on the knees—suggests a yogic posture. *Yoga* is a method for controlling the body and relaxing the mind used in later Indian religions to yoke, or unite, the practitioner to the divine. Although most scholars reject the identification of this figure as a prototype of the multiheaded Hindu god Shiva as Lord of Beasts (FIG. 17-10), the yogic posture proves that this important Indian meditative practice began as early as the Indus Civilization.

Vedic and Upanishadic Period

By 1700 BCE, the urban phase of the Indus Civilization had ended in most areas. Very little art survives from the next thousand years, but the religious foundations laid during this period helped define most later South Asian art.

VEDAS The basis for the new religious ideas were the oral hymns of the Aryans, a mobile herding people from Central Asia who occupied northwestern India in the second millennium BCE. The Aryans ("Noble Ones") spoke Sanskrit, the earliest language yet identified in South Asia. Around 1500 BCE, they composed the first of four Vedas. These Sanskrit compilations of religious learning (veda means "knowledge") included hymns intended for priests (called Brahmins) to chant or sing. The Arvan religion centered on sacrifice, the ritual enactment of often highly intricate and lengthy ceremonies in which the priests placed materials, such as milk and soma (an intoxicating drink), into a fire that took the sacrifices to the gods in the heavens. If the Brahmins performed these rituals accurately, the gods would fulfill the prayers of those who sponsored the sacrifices. These gods, primarily male, included Indra, Varuna, Surya, and Agni-gods associated, respectively, with rain, the ocean, the sun, and fire. The Aryans did not make images of these deities.

UPANISHADS The next phase of South Asian urban civilization developed east of the Indus heartland, in the Ganges River valley. Here, from 800 to 500 BCE, religious thinkers composed a variety of texts called *Upanishads*. Among the innovative ideas of the Upanishads were samsara, karma, and moksha (or nirvana). *Samsara* is the belief that individuals are born again after death in an almost endless round of rebirths. The type of rebirth can vary. One can be reborn as a human being, an animal, or even a god. An individual's past actions (*karma*), either good or bad, determine the nature of future rebirths. The ultimate goal of a person's religious life is to escape—*moksha* (liberation in Hinduism) or *nirvana* (cessation in Buddhism)—from the cycle of birth and death by merging the individual self into the vital force of the universe.

HINDUISM AND BUDDHISM Hinduism and Buddhism, the two major modern religions originating in Asia, developed in the late centuries BCE and the early centuries CE. Hinduism, the dominant religion in India today, discussed in more detail later, has its origins in Aryan religion. The founder of Buddhism was the Buddha, who advocated the path of *asceticism*, or self-discipline and self-denial, as the means to free oneself from attachments to people and possessions, thus ending rebirth (see page 466). Unlike their predecessors in South Asia, both Hindus and Buddhists use images of gods and holy persons in religious rituals. Buddhism has the older artistic tradition. The earliest Buddhist monuments date to the Maurya period.

Maurya Dynasty

the roads leading to Pataliputra. leading to monasteries at sites associated with the Buddha and on Buddhist architecture. The columns stood along pilgrimage routes verse"), a pre-Buddhist concept that became an important motif in connecting earth and sky, forming an axis mundi ("axis of the uniartworks in India. The pillars penetrated deep into the ground, lars reached 30 to 40 feet high and were the first large-scale stone lithic stone columns set up throughout his kingdom. Ashoka's pil-"Buddhism," page 466) and inscribed his laws on towering monoformulated a legal code based on the Buddha's Law (dharma; see beyond India (see "Ashoka's Sponsorship of Buddhism" (1). Ashoka Buddhism and spreading the Buddha's teaching throughout and (r. 272-231 BCE), who left his imprint on history by converting to liputra (modern Patna). The greatest Maurya ruler was Ashoka ritory corresponding roughly to India today. The capital was Pataover Seleucus in 305 BCE (see page 461) encompassed a vast ter-The dynasty that Chandragupta Maurya founded after his victory

worldwide announcement of the Buddha's message. the four lions facing the four quarters of the world may signify the a universal king imbued with divine authority. The open mouths of indicated Ashoka's stature as a chakravartin ("holder of the wheel"), The wheel (chakra) is a reference to the Wheel of the Law but also world. The lions once carried a large stone wheel on their backs. four wheels and four animals symbolizing the four quarters of the to the Buddha as "the lion") stand on a round abacus decorated with raphy is Buddhist. Two pairs of back-to-back lions (texts often refer tal owes much to ancient Mesopotamia and Persia, but its iconogset the Wheel of the Law into motion. Stylistically, the Sarnath capicomes from Sarnath, where the Buddha gave his first sermon and from a single block of stone. The finest (FIG. 17-3) is 7 feet high and Crowning Ashoka's pillars were elaborate capitals, also carved

Kushan Dynasty

Stupa (FIG. 17-1) is the largest.

caravan routes (see "Silk and the Silk Road" (1) bringing the luxuries rich on trade between China and the west along one of the main (r. 78-144 cE), whose capital was in Gandhara. The Kushans grew northern India. The most celebrated Kushan king was Kanishka vahanas, and, most important, the Kushans (r. ca. $50-320~{\rm CE}$) in passed to a succession of regional powers—the Shungas, Sataassassinated by one of his generals. Control of South Asia then The Maurya dynasty came to an abrupt end when its last ruler was

ot the Orient to the Roman Empire.

stupas (see "The Stupa," page 465), of which the aptly named Great including temples, viharas (celled structures where monks live), and period. It consists of many buildings constructed over the centuries, the great Buddhist monastery at Sanchi (see page 461) dates to this in South Asia was the patronage of Buddhism. In its present form, SANCHI The unifying characteristic of this age of regional dynasties

tion. The yakshi on the east torana (FIG. 17-5) reaches up to hold worshiped throughout India and personify fertility and vegetasensuous, nearly nude women called yakshis, goddesses who were ment—to indicate the Buddha's presence. The toranas also feature used symbols—for example, footprints or the seat of his enlightenappears in human form in the scenes. Instead, the Sanchi sculptors cial interest. They depict the Buddha's jatakas, but the Buddha never The reliefs on the four toranas (Fig. 17-1b) at Sanchi are of spe-

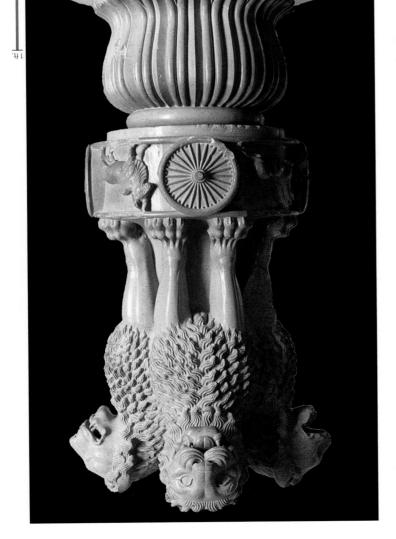

ca. 250 BCE. Polished sandstone, 7' high. Archaeological Museum, 17-3 Lion capital of the pillar set up by Ashoka at Sarnath, India,

supported the Wheel of the Law. those laws on pillars throughout his kingdom. The lions on this capital once Ashoka formulated a legal code based on the Buddha's teachings and inscribed

formulating Buddhist iconography. left). Thus South Asian artists adapted pan-Indian symbolism when representing the Buddha's mother, Maya, giving birth (FIG. 17-6, top pose, with its rich associations of procreation and abundance, for which causes the tree to flower. Buddhist artists later adopted this a mango tree branch while pressing her left foot against the trunk,

ship (see "Buddhism and Buddhist Iconography," page 466). Consequently, the Buddha's followers desired images of him to wormortal, the Buddha increasingly became regarded as a divinity. tion of the Buddha himself. Originally revered as an enlightened Buddhist iconography, but a major factor was the changing percep-Scholars still debate what brought about this momentous shift in is a statue of the meditating Buddha from Gandhara (FIG. 17-5A (A)). Buddha probably appeared in the first century CE. An early example GANDHARA The first anthropomorphic representations of the

ARCHITECTURAL BASICS

40 50 fee

The Stupa

An essential element of Buddhist sanctuaries is the *stupa* (FIG. 17-4), a large circular mound modeled on earlier South Asian burial mounds of a type familiar in many other ancient cultures (for example, FIGS. 2-11 and 3-5). The stupa was not a tomb, however, but a monument housing relics of the Buddha. When the Buddha died, his followers placed his cremated remains in eight reliquaries. Unlike their Western medieval equivalents, which were put on display in churches (see "Pilgrimages and the Veneration of Relics," page 170), the Buddha's relics were buried in solid earthen mounds (stupas) that could not be entered. In the mid-third century BCE, Ashoka opened the original eight stupas and

Chatras

Chatras

Chatras

Chatras

Chatras

Chatras

Chatras

Stupa dome

East torana

East torana

torana

Double

stairway

spread the Buddha's relics among thousands of stupas in all corners of his realm. Buddhists venerate the Buddha's remains by *circumambulation*, walking around the stupa in a clockwise direction. The circular movement, echoing the movement of the earth and the sun, brings the devotee into harmony with the cosmos.

Stupas come in many sizes. Some are handheld objects. The largest, such as the Great Stupa at Sanchi (Fig. 17-1), are three-dimensional mandalas, or sacred diagrams of the universe. The domed stupa itself represents the world mountain, with the cardinal points marked by toranas, or gateways. The harmika, positioned atop the stupa dome, is a stone fence that encloses a square area symbolizing the sacred domain of the gods. At the harmika's center, a yasti, or pole, corresponds to the axis of the universe, a motif already present in Ashoka's pillars (Fig. 17-3). Three chatras, or stone disks, assigned various meanings, crown the yasti. The

yasti rises from the mountain-dome and passes through the harmika, thus uniting this world with the heavenly paradise. A stone fence often encloses the entire structure, separating the sacred space containing the Buddha's relics from the profane world outside.

17-4 Diagram of the Great Stupa, Sanchi, India, third century BCE to first century CE.

Sanchi's Great Stupa is a mandala, a sacred diagram of the universe, with the cardinal points marked by toranas. At the mound's summit is a yasti, or pole, corresponding to the axis of the universe.

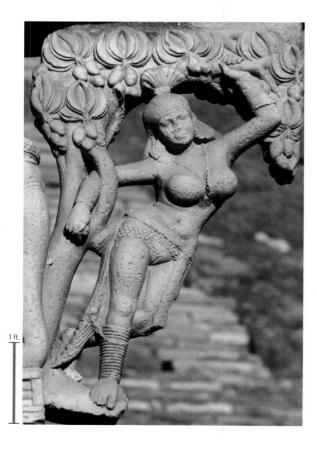

LIFE OF THE BUDDHA The Buddha (Enlightened One) was born around 563 BCE as Prince Siddhartha Gautama, the eldest son of the king of the Shakya clan. A prophecy foretold that he would grow up to be either a world conqueror or a great religious leader. His father preferred the secular role for young Siddhartha and groomed him for kingship by shielding the boy from the hardships of the world. When he was 29, however, the prince rode out of the palace, abandoned his wife and family, and encountered for himself the pain of old age, sickness, and death. Siddhartha responded to the suffering he witnessed by renouncing his opulent life and becoming a wandering ascetic searching for knowledge through meditation. Six years later, he achieved complete enlightenment, or buddhahood, while meditating beneath a pipal tree (the Bodhi tree) at Bodh Gaya ("place of enlightenment") in eastern India. Known from that day on as Shakyamuni ("wise man of the Shakya clan"), the Buddha preached his first sermon in the Deer Park at Sarnath. There he set in motion the Wheel (chakra) of the Law (dharma) and expounded the Four Noble Truths, the core insights of Buddhism: (1) life is suffering;

Stone fence

17-5 Yakshi, detail of the east torana (FIG. 17-1b) of the Great Stupa (FIG. 17-1), Sanchi, India, mid-first century BCE to early first century CE. Sandstone, 5' high.

Yakshis are nearly nude women who personify fertility and vegetation. The Sanchi yakshis make mango trees flower. Artists later used the motif for Queen Maya giving birth to the Buddha (FIG. 17-6).

Representations of the Buddha also feature a repertory of mudras, or hand gestures, conveying fixed meanings. These include the dhyana (meditation) mudra, with the right hand over the left, palms upward (FIG. 17-5A (A)); the bhumisparsha (earthtouching) mudra, right hand down reaching to the ground, calling the earth to witness the Buddha's enlightenment (FIG. 17-6, left center); the dharmachakra (Wheel of the Law, or teaching) mudra, a two-handed gesture with right thumb and index finger forming a circle (FIG. 17-7); and the abhaya (do not fear) mudra, right hand a circle (FIG. 17-7); and the abhaya (do not fear) mudra, right hand right).

Episodes from the Buddha's life are among the most popular subjects in all Buddhist artistic traditions. No single text provides the complete or authoritative narrative of the Buddha's life and death. Thus numerous versions and variations exist, allowing for a rich artistic repetrory. Four of the most important events are represented on the early frieze reproduced in Fig. 17-6.

Buddhism The earliest form of Buddhism is Theravada (Path of the Elders) Buddhism, practiced by the disciples of the historical Buddha (Shakyamuni; see page 465) after his death. The new religion developed and changed over time as the Buddha's teachings spread from India throughout Asia. The second major school of Buddhist thought, Mahayana (Great Path) Buddhism, emerged around the beginning of the first century ce. Mahayana Buddhists refer to Theravada Buddhism as Hinayana (Lesser Path) Buddhists dhism and believe in a larger goal than nirvana for an individual—thism and believe in a larger goal than nirvana for an individual—namely, buddhahood for all. Mahayana Buddhists also revere namely, buddhahood for all. Wahayana Buddhists also revere

RELIGION AND MYTHOLOGY

dhism and believe in a larger goal than nirvana for an individual—namely, buddhahood for all. Mahayana Buddhists also revere bodhisattvas (Buddhas-to-be), exemplars of compassion who restrain themselves at the threshold of nirvana to aid others in achieving buddhahood. Theravada Buddhism became the dominant sect in southern India, Sri Lanka, and mainland Southeast haia, whereas Mahayana Buddhism took root in northern India and spread to China, Korea, Japan, and Nepal.

A third important Buddhist sect, especially popular in East A third important Buddhist sect, especially popular in East

Asia, venerates the Amitabha Buddha (Amida in Japanese), the Buddha of Infinite Light and Life. The devotees of this Buddha hope to be reborn in the Pure Land Paradise of the West, where the Amitabha resides and can grant them salvation. In Pure Land teachings, people have no possibility of attaining enlightenment on their own but can achieve paradise by faith alone.

of the Buddha in human form show him as a robed monk. Artists

This Gandharan frieze is one of the earliest pictorial narrative cycles in which the Buddha appears in human form. It recounts the Buddha's life story from his birth at Lumbini to his death at Kushinagara.

77-6 The life and death of the Buddha, frieze from Gandhara, Pakistan, second century CE. Top: the Buddha's birth and enlightenment at Bodh Gaya, bottom: first sermon at Sarnath and death at Kushinagara. Schist, $2 \cdot 2 \cdot \frac{3}{8}$ " × 9' $6 \cdot \frac{1}{8}$ ". Freer Schist, of Art, Washington,

D'C'

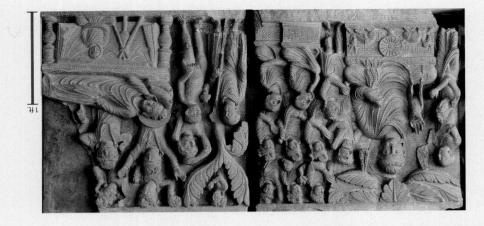

(2) the cause of suffering is desire; (3) one can overcome and extinguish desire; (4) the way to conquer desire and end suffering is to follow the Buddha's Eightfold Path of right understanding, right thought, right speech, right action, right livelihood, right effort, right mindfulness, and right concentration. The Buddha's path leads to nirvana, the cessation of the endless cycle of painful life, death, and rebirth. The Buddha continued to preach until his death at age 80.

One of the earliest pictorial narrative cycles of the Buddha's life is a stone frieze (FIG. 17-6) from Gandhara. Depicted, in chronological order from left to right, are the Buddha's birth at Lumbini, his enlightenment at Bodh Gaya, his first sermon at Sarnath, and his death at Kushinagara. At the left, Queen Maya gives birth to Prince

Siddhartha, who emerges from her right hip. Receiving him is the god Indra. Elegantly dressed ladies, one with a fan of peacock feathers, suggest the opulent court life the Buddha left behind. In the next scene, the Buddha sits beneath the Bodhi tree while the soldiers and demons of the evil Mara attempt to distract him from his quest for knowledge. They are unsuccessful, and the Buddha then preaches the Eightfold Path to nirvana in the Deer Park at Sarnath. The sculptor set the scene by placing two deer and the Wheel of the Law beneath the figure of the Buddha. In the final section of the frieze, the parinirvana, the Buddha lies dying among his devotees, some of whom wail in grief, while one monk, who realizes that the Buddha has been permanently released from suffering, remains tranquil in meditation.

Although the iconography of the frieze is Buddhist with roots in earlier South Asian art, Roman reliefs must have served as stylistic models for the Gandharan artist. For example, the distribution of standing and equestrian figures over the relief ground, with those behind the first row seemingly suspended in the air, is familiar in Roman art of the second and third centuries CE (FIG. 3-48). The figure of the Buddha on his deathbed has parallels in the reclining figures on the lids of Etruscan (FIG. 3-4) and Roman sarcophagi. The type of hierarchical composition in which a large central figure sits between balanced tiers of smaller onlookers is also common in Roman imperial art (FIG. 3-54).

The Gupta and Post-Gupta Periods

Around 320* a new empire arose in north-central India. The Gupta emperors (r. ca. 320–450) chose Pataliputra as their capital, deliberately associating themselves with the prestige of the former Maurya Empire. The heyday of this dynasty was under Chandragupta II (r. 375–415), whose very name recalled the first Maurya emperor.

SARNATH Under the Guptas, artists formulated what became the canonical image of the Buddha. A fifthcentury statue (FIG. 17-7) from Sarnath is a characteristic

*From this point on, all dates in this chapter are CE unless otherwise stated.

example. The Buddha wears a monastic robe covering both shoulders, as in earlier Gandharan examples (Fig. 17-5A), but it clings tightly to his body. The statue's smooth, unadorned surfaces conform to the Indian notion of perfect body form and emphasize the figure's spirituality. The Buddha's eyes are downcast in meditation, and he holds his hands in front of his body in the Wheelturning gesture, preaching his first sermon. Below the Buddha is a scene with the Wheel of the Law at the center between two deer symbolizing the Deer Park at Sarnath. Buddha images such as this one, which inject sensuality into the Roman-inspired Gandharan style, became so popular that temples housing Buddha statues largely superseded the stupa as the norm in Buddhist sacred architecture.

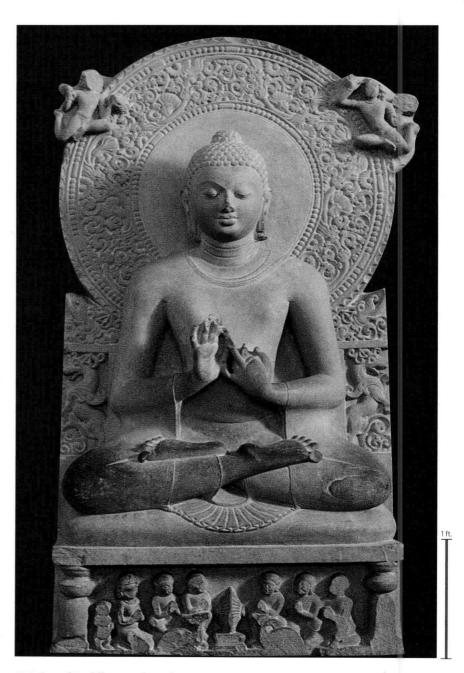

17-7 Seated Buddha preaching first sermon, from Sarnath, India, second half of fifth century. Tan sandstone, 5' 3" high. Archaeological Museum, Sarnath.

Gupta artists formulated the canonical image of the Buddha wearing a clinging monk's robe and featuring smooth, unadorned surfaces that conform to the Indian notion of perfect body form.

and multilimbed forms indicate that the subjects are not human but suprahuman gods with supernatural powers.

the cyclic pattern of death and rebirth (samsara). faces also symbolize, are part of Indian notions of time, matched by The cyclic destruction and creation of the universe, which the side opposing forces in check, and the central face expresses their balance. (Bhairava) represents Shiva's destructive side. Shiva holds these two female (Uma) indicates the creative aspect of Shiva. The fierce male man with a curling mustache who wears a cobra as an earring. The woman's, with framing hair curls. The left face is that of a grimacing two side faces differ significantly. The one on the viewer's right is a trast with the richness of the piled hair encrusted with jewels. The Shiva's quiet, balanced demeanor. The clean planes of the face congod has not emerged fully from the rock.) The central face expresses ent aspect of the deity. (A fourth, unseen at the back, is implied—the darkness. This image of Shiva has three faces, each showing a differthe depths of the cave as worshipers' eyes become accustomed to the the Great God or Lord of Lords. Mahadeva appears to emerge out of nearly 18-foot-high rock-cut image (FIG. 17-10) of Shiva as Mahadeva, within the temple, in a niche once closed off with wood doors, is a sixth century was under the control of the Kalachuri dynasty. Deep a cave temple on Elephanta, an island in Bombay's harbor that in the **ELEPHANTA** Another portrayal of Shiva as a suprahuman being is in

17-8 Bodhisattva Padmapani, detail of a wall painting in the antechamber of cave I, Ajanta, India, second half of fifth century.

In this early example of Indian painting in an Ajanta cave, the artist rendered the sensuous form of the richly attired bodhisattva with gentle gradations of color and delicate highlights and shadows.

rock-cut Buddha image in a cell at the back. ing the antechamber of the cave on their way to the bodhisattva gazes downward at worshipers enterered the placement of the painting in the cave. The in the face and neck. The artist also carefully considdelicate highlights and shadows, especially evident tly modeling the figure with gradations of color and sensuous form of the richly attired bodhisattva, genhis right hand. The painter rendered with finesse the stands holding his attribute, a blue lotus flower, in dark hair hanging down below a jeweled crown, he devotees, both princes and commoners. With long, seated bodhisattva Padmapani among a crowd of the restored mural paintings in cave I depicting the caves. Illustrated here (FIG. 17-8) is a detail of one of to the painted walls and ceilings in many of those 20 new caves to the site. Ajanta owes its fame today allied to the Guptas by marriage, added more than century, royal patrons of the local Vakataka dynasty, for centuries, but during the second half of the fifth had been the site of a small Buddhist monastery may be seen at Ajanta, northeast of Bombay. Ajanta V19gsmi shbbud to ytirsluqoq wan adl ATNALA

At Ajanta, as at many other sites in India, Buddhists and Hindus practiced their religions side by side. For example, the Hindu Vakataka king Harishena (r. 462–481) and members of his court were the

sponsors of new Hindu caves at Ajanta's Buddhist monastery, Buddhism and Hinduism are not monotheistic religions, unlike Judaism, Christianity, and Islam. Instead, Buddhists and Hindus approach the spiritual through many gods and varying paths, which permits mutually tolerated differences. In fact, in Hinduism, the Buddha is one of the 10 incarnations of Vishnu, one of the three principal Hindu deities (see "Hinduism and Hindu Iconography," page 469).

Badami relief, as figures with multiple body parts. Such composite sented Hindu deities as part human and part animal or, as in the Nandi, Shiva's bull mount, stands at the left. Artists often reprelower right, the elephant-headed Ganesha tentatively mimics Shiva. the hands hold objects, and others form prescribed mudras. At the mic dance, his 18 arms swinging rhythmically in an arc. Some of above the city. One relief (FIG. 17-9) shows Shiva dancing the costors carved a series of reliefs in the walls of halls cut into the cliff kings ruled from their capital at Badami. There, Chalukya sculprose to power. In the Deccan plateau of central India, the Chalukya brought down the Gupta Empire, and various regional dynasties monuments of South Asia. During the sixth century, the Huns stone sculpture and architecture began to rival the great Buddhist materials such as stone and brick. But in the Gupta period, Hindu because the Buddhists constructed their monasteries with durable BADAMI More early Buddhist than Hindu art has survived in India

RELIGION AND MYTHOLOGY Hinduism and Hindu Iconography

In contrast to Buddhism (and Christianity, Islam, and other religions), Hinduism recognizes no founder or great prophet. Hinduism also has no descriptive definition but means "the religion of the Indians." Both *India* and *Hindu* have a common root in the name of the Indus River. The practices and beliefs of Hindus vary tremendously, but the literary origins of Hinduism date to the Vedic period, and some aspects of Hindu practice apparently were already present in the Indus Civilization of the third millennium BCE. Ritual sacrifice by Brahmin priests is central to Hinduism, as it was for the Aryans. The goal of sacrifice is to please a deity in order to achieve liberation (moksha) from the endless cycle of birth, death, and rebirth (samsara) and become one with the universal spirit.

Not only is Hinduism a religion of many gods, but the Hindu deities have various natures and take many forms. This multiplicity suggests the all-pervasive nature of the Hindu gods. The three most important deities are the gods Shiva and Vishnu and the goddess Devi.

Shiva is the Destroyer, but, consistent with the multiplicity of Hindu belief, he is also a regenerative force. In the latter role, Shiva can be represented in the form of a linga (a phallus or cosmic pillar). When Shiva appears in human form in Hindu art, he frequently has multiple limbs and heads (Figs. 17-9, 17-10, and 17-16), signs of his suprahuman nature, and matted locks piled atop his head, crowned by a crescent moon. Sometimes he wears a serpent scarf and has a third eye on his forehead (the emblem of his all-seeing nature). Shiva rides the bull Nandi (Fig. 17-9) and often carries a *trident*, a three-pronged pitchfork.

- **Vishnu** is the Preserver of the Universe. Artists frequently portray him with four arms holding various attributes. He sometimes reclines on a serpent floating on the waters of the cosmic sea (Fig. 17-12). When the evil forces of the universe become too strong, he descends to earth to restore balance and assumes different forms (avatars, or incarnations), including a boar, fish, and tortoise, as well as **Krishna**, the divine lover (Fig. 17-21), and even the Buddha himself.
- Devi is the Great Goddess who takes many forms and has many names. Hindus worship her alone or as a consort of male gods (Parvati or Uma, wife of Shiva; Lakshmi, wife of Vishnu), as well as Radha, lover of Krishna (FIG. 17-21). She has both benign and horrific forms, and she creates as well as destroys. In one manifestation, she is Durga, a multiarmed goddess who often rides a lion (FIG. 17-8A ◀). Her son is the elephant-headed Ganesha (FIG. 17-9).

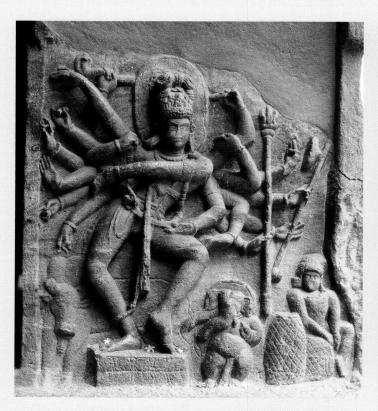

17-9 Dancing Shiva, rock-cut relief, cave 1, Badami, India, late sixth century.

Shiva here dances the cosmic dance and has 18 arms, some holding objects, others forming mudras. Hindu gods often have multiple limbs to indicate their suprahuman nature and divine powers.

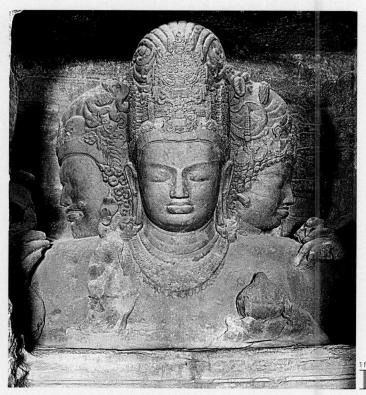

17-10 Shiva as Mahadeva, cave 1, Elephanta, India, ca. 550–575. Basalt, Shiva 17' 10" high.

This immense rock-cut image of Shiva as Mahadeva (Great God) emerges out of the depths of the Elephanta cave as worshipers' eyes adjust to the darkness. Shiva has both male and female faces.

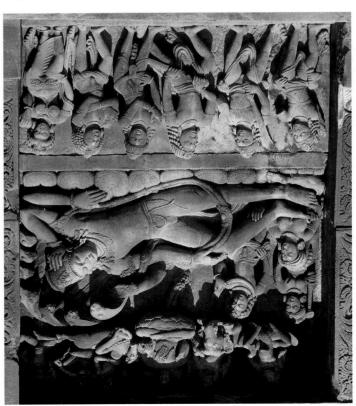

17-12 Vishnu Asleep on the Serpent Ananta, relief panel on the south facade of the Vishnu Temple (FIG. 17-11), Deogath, India, early sixth century.

Sculptors carved the reliefs of the Vishnu Temple at Deogarh in classic Gupta style. In the south panel, the four-armed Vishnu sleeps on the serpent Ananta as he dreams the universe into reality.

Medieval Period

During the 7th through the 12th centuries, regional dynasties ruled parts of India. Whereas Buddhism spread rapidly throughout eastern Asia, in medieval India it gradually declined, and the various local kings vied with one another to build glorious shrines to the Hindu gods.

THANIAVUR Under the Chola dynasty, whose territories extended into part of Sri Lanka and even Java, architects constructed temples of unprecedented size and grandeur in the southern Indian tradition (see "Hindu Temples," page 471). The Rajarajeshvara Temple (FIG. 17-13) at Thanjavur, dedicated in 1010 to Shiva as the Lord of Rajaraja, was the largest and tallest temple (210 feet high) in India at the time. The temple stands inside a walled precinct. It consists of a stairway leading to two flat-roofed mandapas, the larger one having 36 pillars, and to the garbha griha in the base of the enormous pyramidal arrs, and to the garbha griha in the base of the cholas' secular power as vimana, which is as much an emblem of the Cholas' secular power as of their devotion to Shiva. On the exterior walls of the lower stories are numerous reliefs in niches depicting the god in his various forms.

KHAJURAHO At the same time that the Cholas were building the Rajarajeshvara Temple at Thanjavur in the south, the Chandella dynasty was constructing northern-style temples at Khajuraho. The Vishvanatha Temple (Fig. 17-14) is one of more than 20 imposing temples at that site. Vishvanatha (Lord of the World) is another of the many names for Shiva. Dedicated in 1002, the structure has three towers over the mandapas, each rising higher than the preceding

77-71 Vishnu Temple (looking north), Deogarh, India, early sixth century.

One of the first masonry Hindu temples, the Vishnu Temple at Deogarh is a simple square building with a tower. Sculpted guardians protect its entrance. Narrative reliefs adorn the three other sides.

DEOGRRH The rock-cut Badami and Elephanta cave shrines are characteristic of early Hindu religious architecture, but temples constructed using quarried stone became more important as Hinduism evolved. The Vishnu Temple (Fig. 17-11) at Deogarh in north-central India, datable to the early sixth century, is among the first Hindu temples constructed with stone blocks. A simple square structure, it has an elaborately decorated doorway at the front and a relief in a niche on each of the other three sides. Sculpted guardians and mithunacte the doorway at Deogarh, because it is the transition point between the dangerous outside and the sacred interior. The temple culminates in a tall tower, originally at least 40 feet high.

The reliefs in the three niches depict important episodes in the saga of Vishnu. On the south (FIG. 17-12), Vishnu sleeps on the coils of the giant serpent Ananta, whose multiple heads form a kind of umbrella around the god's face. While Lakshmi massages her husband's legs (he has cramps as he gives birth), the four-armed Vishnu dreams the universe into reality. A lotus plant (said to have grown out of Vishnu dreams nu's navel) supports the four-headed Hindu god of creation, Brahma. Flanking him are other important Hindu divinities, including Shiva on his bull. Below are six figures. The four at the right are personifications of Vishnu's various powers. They will defeat the two armed demons at the left. The sculptor carved all the figures in the classic Gupta style, the left. The sculptor carved all the figures in the classic Gupta style,

with smooth bodies and clinging garments (compare Fig. 17-7).

ARCHITECTURAL BASICS

Hindu Temples

The Hindu temple is the home of the gods on earth and the place where they make themselves visible to humans. At the core of all Hindu temples is the *garbha griha* ("womb chamber"), which houses images or symbols of the deity—for example, Shiva's linga (see "Hinduism," page 469). Only Brahmin priests may enter this inner sanctuary to make offerings to the gods. Worshipers, however, may stand at the threshold and behold the deity, made present by its image. In the elaborate multiroomed temples of later Hindu architecture, the worshipers and priests progress through a series of ever more sacred spaces, usually on an east-west axis. Hindu priests and architects attached great importance to each temple's plan and sought to make it conform to the sacred geometric diagram (mandala) of the universe.

Architectural historians, following ancient Indian texts, divide Hindu temples into two major typological groups tied to geography.

- Northern temples (FIG. 17-14) The most important distinguishing feature of the northern style of temple is its beehivelike tower or *shikhara* ("mountain peak"), capped by an *amalaka*, a ribbed cushionlike form, derived from the shape of the amala fruit (believed to have medicinal powers). Amalakas appear on the corners of the lower levels of the shikhara too. Northern temples also have smaller towerlike roofs over the halls (*mandapas*) leading to the garbha griha.
- Southern temples (FIG. 17-13) Hindu temples of the southern type have flat roofs over their pillared mandapas, and shorter towered shrines, called *vimanas*, which lack the curved profile of their northern counterparts and resemble multilevel pyramids.

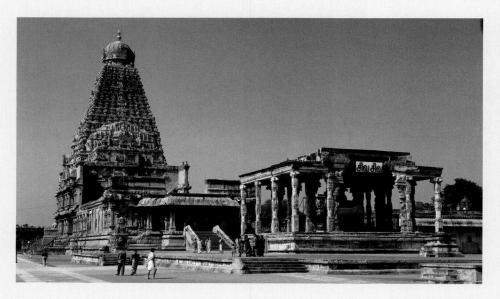

17-13 Rajarajeshvara Temple (looking southeast), Thanjavur, India, ca. 1010.

The Rajarajeshvara Temple at Thanjavur is an example of the southern type of Hindu temple. Two flat-roofed mandapas lead to the garbha griha in the base of its 210-foot-tall pyramidal vimana.

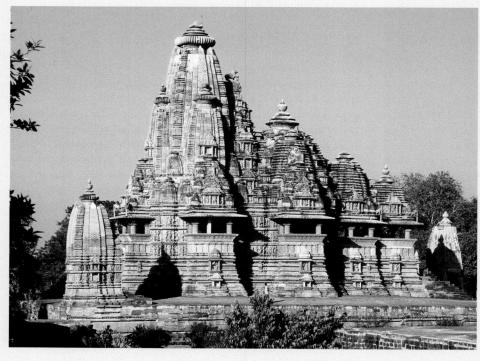

17-14 Vishvanatha Temple (looking north), Khajuraho, India, ca. 1000.

The Vishvanatha Temple is a northern Hindu temple type. It has four towers, each taller than the preceding one, symbolizing Shiva's mountain home. The largest tower is the beehive-shaped shikhara.

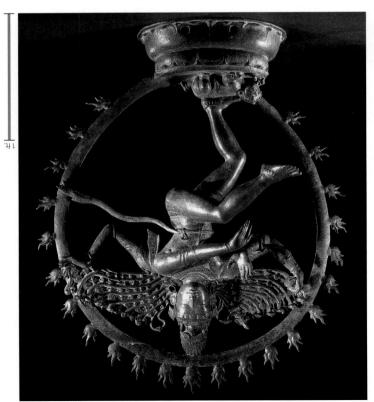

17-16 Shiva as Wataraja, from Tamil Wadu, India, ca. 1100. Bronze, 2' 111 $\frac{1}{4}$ " high. British Museum, London.

One of many portable images of the gods used in Hindu worship, this solid-bronze statuette of Shiva as Lord of the Dance depicts the god balancing on one leg atop a dwarf representing ignorance.

very long history, going back to the earliest architectural traditions, both Hindu and Buddhist (Fig. 17-5). As in the earlier examples, the erotic sculptures of Khajuraho suggest fertility and the propagation of life and serve as auspicious protectors of the sacred precinct.

and spreads like wings on both sides of his head. forward without fear. As Shiva spins, his matted hair comes loose right hand, raised in the abhaya mudra, tells worshipers to come where devotees can find refuge and enlightenment. The god's lower hand points to his upraised foot, indicating the foot as the place rhythm. The small fire represents destruction. Shiva's lower left and a flame (left hand). Shiva creates the universe to the drumbeat's him. These two upper hands also hold a small drum (right hand) of them touching the flaming nimbus ("light of glory") encircling the god stamps out as he dances. Shiva extends all four arms, two ancing on one leg atop Apasmara, the dwarf of ignorance, which today. Here, Shiva dances as Nataraja (Lord of the Dance) by balties created under the Chola kings and still used in Hindu rituals around 1000, it is one of many examples of moveable images of deithe Badami cave representing the god Shiva. Cast in solid bronze from Tamil Nadu and recalls the sixth-century relief (Fig. 17-9) in role in Hinduism. The statuette illustrated here (FIG. 17-16) comes SHIVA AS NATARAIA Portable objects also play an important

At times, worshipers insert poles into the holes on the base of the Shiva statuettes to carry them, but even when statuettes to Carry them, but even when statuette would not appear as it does in Fig. 17-16. Rather, when Hindus worship the Shiva Nataraja, they dress the image, cover it with jewels, and garland it with flowers. The only bronze part visible is the

one, leading to the tallest tower at the rear, in much the same way that the foothills of the Himalayas, Shiva's home, rise to meet their highest peak. The mountain symbolism applies to the interior of the Vishvanatha Temple as well. Under the tallest tower, the shikhara, is the garbha griha, the small and dark inner sanctuary chamber, as the Vishvanatha symbolize constructed mountains with caves, comparable to the cave temples at Elephanta and other Indian sites. In all cases, the deity reveals himself or herself within the cave and takes various forms in sculptures. The temple-mountains, however, are not intended to appear natural but rather are perfect mountains are not intended to appear natural but rather are perfect mountains designed using ideal mathematical proportions.

The reliefs of Thanjavur's Rajarajeshvara Temple are typical of southern temple decoration, which is generally limited to images of deities. The exterior walls of Khajuraho's Vishvanatha Temple are equally typical of northern temples in the profusion of sculptures (Fig. 17-15) depicting mortals as well as gods, especially pairs of men and women (mithunas) embracing or engaged in sexual intercourse in an extraordinary range of positions. The use of seminude yakshis and amorous couples as motifs on religious buildings in India has a and amorous couples as motifs on religious buildings in India has a

17-15 Mithuna reliefs, detail of the north side of the Vishvanatha Temple (Fig. 17-14), Khajuraho, India, ca. 1000.

Northern Hindu temples usually feature reliefs depicting deities and amorous couples (mithunas). The erotic sculptures suggest the propagation of life and serve as protectors of the sacred precinct.

face, marked with colored powders and scented pastes. Considered the embodiment of the deity, the image is not a symbol of the god but the god itself. All must treat the image as a living being. Worship of the deity involves caring for him as if he were an honored person. Bathed, clothed, given foods to eat, and taken for outings, the image also receives gifts—songs, lights (lit oil lamps), good smells (incense), and flowers, things the god can enjoy through the senses. The food given to the god is particularly important, because he eats the "essence," leaving the remainder for the worshiper. The food is then prasada (grace), sacred because it came in contact with the divine. In an especially religious household, the deity resides as an image and receives the food for each meal before the family eats. When the god resides in a temple, it is the duty of the priests to feed, clothe, and take care of him.

The Chola dynasty ended in the 13th century, a time of political, religious, and cultural change in South Asia. At this point, Buddhism survived in only some areas of India. It soon died out completely there, although the late form of northern Indian Buddhism continued in Tibet and Nepal. At the same time, Islam became a potent political force.

ISLAM Arab armies first appeared in South Asia—at Sindh (Pakistan)—in 712. With them came Islam, the new religion that had already spread with astonishing speed from the Arabian peninsula to Syria, Iraq, Iran, Egypt, North Africa, and even southern Spain (see page 143). At first, the Muslims established trading settlements in South Asia but did not press deeper into the subcontinent. But in 1192, at the Battle of Tarain in what is now Afghanistan, Muhammad of Ghor (d. 1206) defeated the armies of a confederation of independent states. His general, Qutb al-Din Aybak (d. 1210), established the sultanate of Delhi (1206–1526). The *sultan* passed power to his former slave and son-in-law, Iltutmish (r. 1211–1236), who extended Ghorid rule across northern India.

Mughal Empire

In 1526, a Muslim prince named Babur (1483–1530) defeated the last of the Ghorid sultans at the Battle of Panipat. Declaring himself the ruler of India, Babur established the *Mughal* Empire (1526–1857) at Delhi.

AKBAR THE GREAT The first great flowering of Mughal art and architecture occurred during the long reign of Babur's grandson, Akbar (r. 1556–1605), called the Great. Akbar enlarged the imperial painting workshop to about a hundred artists and kept them busy working on a series of ambitious projects. One of these was to illustrate the text of the biography he had commissioned Abul Fazl (1551-1602), a member of his court and a close friend, to write. One of the full-page illustrations (FIG. 17-17), or so-called miniatures (see "Indian Miniature Painting," page 474), in the emperor's personal copy of the Akbarnama (History of Akbar) was a collaborative effort between the painter Basawan, who designed and drew the composition, and Chatar Muni, who colored it. The painting depicts the episode of Akbar and Hawai, a wild elephant that the 19-year-old ruler had mounted and pitted against another ferocious elephant. When the second animal fled in

defeat, Hawai, still carrying Akbar, chased it to a pontoon bridge. The enormous weight of the elephants capsized the boats, but Akbar managed to bring Hawai under control and dismount safely. The young ruler viewed the episode as an allegory of his ability to govern—that is, to take charge of an unruly state.

For his pictorial record of that frightening day, Basawan chose the moment of maximum chaos and danger—when the elephants crossed the pontoon bridge, sending boatmen flying into the water. The composition is a bold one, with a very high horizon and two strong diagonal lines formed by the bridge and the shore. Together these devices tend to flatten out the vista, yet at the same time, Basawan created a sense of depth by diminishing the size of the figures in the background. He was also a master of vivid gestures and anecdotal detail. Note especially the

17-17 BASAWAN and CHATAR MUNI, Akbar and the Elephant Hawai, folio 22 from the Akbarnama (History of Akbar) by Abul Fazl, ca. 1590. Opaque watercolor on paper, 1' $1\frac{7}{8}$ " × $8\frac{3}{4}$ ". Victoria & Albert Museum, London.

The Mughal rulers of India were great patrons of miniature painting. This example, showing the young emperor Akbar bringing an elephant under control, is an allegory of Akbar's ability to rule.

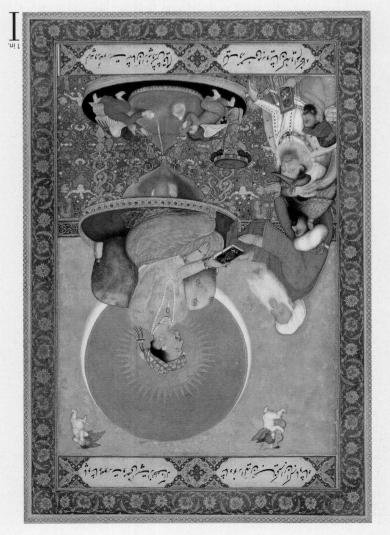

17-18 BICHITR, Jahangir Preferring a Sufi Shaykh to Kings, ca. 1615–1618. Opaque watercolor on paper, l' $6\frac{7}{8}$ " \times l' l". Freer Gallery of Art, Washington, D.C.

European influence on Mughal painting is evident in this allegorical portrait of the haloed emperor Jahangir on an hourglass throne, seated above time, favoring spiritual over worldly power.

MATERIALS AND TECHNIQUES Indian Miniature Painting

Although India had a tradition of mural painting going back to ancient times (FIG. 17-8), the most popular form of painting under the Mughal emperors (FIG. 17-17 and 17-18) and Rajput kings (FIG. 17-21) was miniatures isture painting. Art historians usually call these paintings miniatures because of their small size (about the size of a page in this book) compared with paintings on walls, wood panels, or canvas, but the original terminology derives from the red lead (miniatures designed them to be held in the hands, either as illustrations in books or as loose-leaf pages in albums. Owners did not place Indian miniatures in frames and only very rarely hung them on walls.

Indian artists used opaque watercolors and paper (occasionally cotton cloth) to produce their miniatures. The manufacturing and painting of miniatures was a complicated process and required years of training as an apprentice in a workshop. The painters' assistants created pigments by grinding natural materials—minerals such as malachite for green and lapis lazuli for blue; earth ochers for red and yellow; and metallic foil for gold, silver, and copper. They fashioned brushes and metallic foil for gold, silver, and copper. They fashioned brushes from bird quills and kitten or baby squirrel hairs. For minute details, the painters used brushes with a single hair.

The artist began the painting process by making a full-size sketch of the composition. The next step was to transfer the sketch onto paper by pouncing, or tracing, using thin, transparent gazelle skin placed on top of the drawing and pricking the contours of the design with a pin. Then, with the skin laid on a fresh sheet of fine paper, the painter forced also the same through the tiny holes, reproducing the outlines of the composition.

Painting proper started with the darkening of the outlines with black or reddish-brown ink. Painters of miniatures sat on the ground, resting their painting boards on one raised knee. Each pigment color was in a separate half seashell. The paintings usually required several layers of color, with gold always applied last. The final step was to burnish the painted surface. The artists accomplished this by placing the miniature, painted side down, on a hard, smooth surface and stroking the paper with polished agate or crystal.

bare-chested figure in the foreground clinging to the end of a boat; the figure near the lower right corner with outstretched arms sliding into the water as the bridge sinks; and the oarsman just beyond the bridge who strains to steady his vessel while his three passengers stand up or lean overboard in reaction to the surrounding commotion.

is significant in itself. Pre-Mughal art in India is virtually anonymous. In contrast, many of those whom the Mughal emperors employed signed their artworks. Another of these was Bichitz, an artist in the imperial workshop of Akbar's son and successor, Jahangir (r. 1605–1627). The Mughal dynasty presided over a cosmopolitan court with refined tastes. British ambassadors and merchants were frequent visitors, and Jahangir, like his father, acquired many European quent visitors, and Jahangir, like his father, acquired many European luxury goods, including globes, hourglasses, prints, and portraits.

The influence of European art on Mughal miniature painting under Jahangir is evident in Bichitr's allegorical portrait (FIG. 17-18)

of Jahangir seated on an hourglass throne. As the sands of time run out, two cupids (clothed, unlike their European models more closely copied at the top of the painting) inscribe the throne with the wish that Jahangir would live a thousand years. Bichitr portrayed his patron as an emperor above time and placed behind Jahangir's head a radiant halo combining a golden sun and a white crescent moon, indicating that Jahangir is the center of the universe and its light source. One of the inscriptions in the painting's borders gives the source. One of the inscriptions in the painting's borders gives the emperor's title as "Light of the Faith."

At the left are four figures. The lowest, both spatially and in the social hierarchy, is the Hindu painter Bichitr himself. He wears a red turban and holds a painting representing two horses and an elephant, costly gifts to him from Jahangir. In the painting-within-the-painting, the artist signed his name across the top of the footstool Jahangir uses to step up to his hourglass throne. Thus the ruler steps on Bichitr's name, further indicating the painter's inferior status.

Above Bichitr is a portrait in full European style of King James I of England (r. 1603-1625), copied from a painting by John de Critz (ca. 1552–1641) that was a gift the English ambassador to the Mughal court presented to Jahangir. Above the king is a Turkish sultan, a convincing portrayal but probably not a specific likeness. The highest member of the foursome is an elderly Muslim Sufi shaykh (mystic saint). Jahangir's father, Akbar, had gone to the mystic to pray for an heir. The current emperor, the answer to Akbar's prayers, presents the holy man with a sumptuous book as a gift. An inscription explains that "although to all appearances kings stand before him, Jahangir looks inwardly toward the Dervishes [Islamic ascetic holy men]" for guidance. Bichitr's allegorical painting portrays his emperor in both words and pictures as favoring spiritual over worldly power.

TAJ MAHAL Monumental tombs were not part of either the Hindu or Buddhist traditions, but had a long history in Islamic architecture. The Delhi sultans had erected tombs in India, but none could compare in grandeur to the fabled Taj Mahal (FIG. 17-19) at Agra. Shah Jahan (r. 1628–1658), Jahangir's son, built the immense mausoleum as a memorial to his favorite wife, whose official title was Mumtaz Mahal (1593–1631), or "Chosen of the Palace." Taj Mahal means "Crown Palace," and the mausoleum eventually became the ruler's tomb as well. It figures prominently in official histories of Shah Jahan's reign (see "Abd al-Hamid Lahori on the Taj Mahal" ◀).

The dome-on-cube shape of the central block has antecedents in earlier Islamic mausoleums and other Islamic buildings, but modifications and refinements in the design of the Agra tomb converted the earlier massive structures into an almost weightless vision of glistening white marble. The Agra mausoleum seems to float magically above the broad water channels and tree-lined reflecting pools punctuating the fountainfilled garden leading to it. Reinforcing the illusion of the marble tomb being suspended above water is the absence of any visible means of ascent to the upper platform. A stairway does exist, but the architect intentionally hid it from the view of anyone who approaches the memorial.

The Taj Mahal follows the traditional char-bagh ("four-plot") plan of Iranian garden pavilions, which symbolized the Koranic Garden of Paradise. Today, however, the mausoleum appears to stand at the northern end of the garden on the edge of the Yamuna River, rather than in the center of the formal garden, as it should in a char-bagh plan. Originally, the gardens extended to the other side of the river, and the Taj Mahal did, in fact, occupy a central position. The tomb itself is octagonal in plan and has typically Iranian arcuated niches (FIG. 5-12) on each side. The interplay of shadowy voids with light-reflecting marble walls that seem paper-thin creates an impression of translucency, further enhanced by the pietra dura inlay (FIG. 17-20) of precious and semiprecious stones in the masonry walls. The pointed arches lead the eye in

17-19 USTAD AHMAD LAHORI(?), Taj Mahal and gardens (looking north), Agra, India, 1632-1647.

The mausoleum for Shah Jahan's favorite wife seems to float magically over reflecting pools in a vast garden. The tomb may have been conceived as the throne of God perched above the gardens of Paradise.

17-20 Detail of the pietra dura stonework of the area above the central niche of the facade of the Taj Mahal (FIG. 17-19), Agra, India, 1632–1647.

Set into the light-reflecting marble walls of the Taj Mahal are inlaid precious and semiprecious stones. This pietra dura stonework enhances the impression that the huge structure is weightless.

brilliant fusion of Islamic and Hindu elements. equal to the height of the facade. The mausoleum is a unique and the minarets) is as wide as it is tall, and the height of its dome is all-encompassing system of proportions. The Taj Mahal (excluding balance between verticality and horizontality by strictly applying an (d. 1649), Shah Jahan's chief court architect—achieved this delicate the mausoleum. The designer—probably Usran AHMAD LAHORI triple-domed pavilions enhance and stabilize the soaring form of like a crown (taj). Four carefully related minarets and two flanking a sweeping upward movement toward the climactic dome, shaped

ern India (present-day Rajasthan) remained under the control of The Mughal emperors ruled vast territories, but much of northwest-Later Hindu Kingdoms

stubbornly resisted Mughal expansion, but even the Hindu Rajput (Sons of Kings) dynasties. These small kingdoms had

degree of independence but had to pay tribute to the king"), like the other Rajput rulers, maintained a Mewari forces in 1615, the Mewar maharana ("great the Mughal emperors. When Jahangir defeated the strongest of them—Mewar—eventually submitted to

paintings as the Mughal painter Bichitr did in his anonymity, never inserting self-portraits into their respects. Most Rajput artists, for example, worked in format and material, but it differs sharply in other Rajput painting resembles Mughal painting in Mughal treasury.

miniature (FIG. 17-18) of Jahangir on an hourglass

is one of the standard symbols used in Rajput and indicating the moment's electric passion. Lightning soon sky momentarily lights up with a lightning flash is night, the time of lovemaking, and the dark mondirectly into her face. Radha shyly averts her gaze. It Krishna gently touches Radha's breast while looking a lush garden of ripe mangoes and flowering shrubs. lovers sit naked on a bed beneath a jeweled pavilion in In the Krishna and Radha in a Pavilion miniature, the its coloration, lyricism, and sensuality are distinctive. Pahari painting owed much to Mughal drawing style, Govardhan Chand of Guler (r. 1741-1773). Although by an artist of the "Pahari School," probably for Raja (FIG. 17-21), a miniature painted in the Punjab Hills paintings, including Krishna and Radha in a Pavilion Jayadeva's poem was the source for hundreds of later model of the devotion, or bhakti, paid to Vishnu. Govinda (Song of the Cowherd). Their love was a related the story of Krishna and Radha in the Gita lover was Radha. The 12th-century poet Jayadeva sporting with beautiful herdswomen. His favorite lic existence tending his cows, playing the flute, and Vishnu. Krishna was a herdsman who spent an idyl-Krishna, the "Blue God," the most popular avatar of for Rajput paintings was the amorous adventures of KRISHNA AND RADHA One of the favorite subjects

Hindu temple complexes in India occurred under MADURAI Construction of some of the largest

Pahari miniatures to represent sexual excitement.

Pahari watercolor. Krishna's love was a model of the devotion paid to the Hindu god Vishnu. The love of Krishna, the "Blue God," for Radha is the subject of this colorful, lyrical, and sensual

figures. Reconsecration of the temple occurs at 12-year intervals, at

resenting the vast pantheon of Hindu deities and a host of attendant

consisting of row after row of brightly painted stucco sculptures repbarrel-vaulted roof with finials. The ornamentation is extremely rich,

tall. Rising in a series of tiers of diminishing size, they culminate in a and his consort Minakshi (the Fish-Eyed One), stand about 150 feet

to Shiva (under his local name, Sundareshvara, the Handsome One),

plexes. The tallest gopuras of the Great Temple at Madurai, dedicated

reached colossal size, dwarfing the temples at the heart of the com-

was taller than those of the previous circuit. The outermost towers

ras, always expanding outward from the center. Each set of gopuras

ers constructed walls to connect them and then built more gopu-

bottom with painted sculptures. After erecting the gopuras, the build-

their gateway towers called gopuras (FIG. 17-22), decorated from top to

two centuries. The most striking features of these huge complexes are

the Nayak dynasty (r. 1529-1736), which ruled southern India for

 $\prod_{\frac{1}{8}} \times 7 \frac{3}{4}$ ". National Museum, New Delhi. 17-27 Krishna and Radha in a Pavilion, ca. 1760. Opaque watercolor on paper,

which time the gopura sculptures receive a new coat of paint, which accounts for the vibrancy of their colors today.

The Mughal Empire came to an end in 1857, and for nearly a century thereafter, the British ruled India. Under the leadership of Mahatma Gandhi (1869–1948), India and Pakistan attained independence in 1947. Throughout the period of British sovereignty, local traditions mixed with imported European styles in both art and architecture. The rich and varied contemporary art of South Asia continues to draw upon these diverse traditions.

17-22 Outermost gopuras of the Great Temple (looking southeast), Madurai, India, completed 17th century.

The colossal gateway towers set up during the Nayak dynasty at the Great Temple at Madurai feature brightly painted stucco sculptures representing the vast pantheon of Hindu deities.

SOUTHEAST ASIA

Art historians once considered the art of Southeast Asia an extension of Indian civilization. Because of the Indian character of many Southeast Asian monuments, scholars hypothesized that Indian artists had constructed and decorated them and that Indians had colonized Southeast Asia. Today, researchers have concluded that the expansion of Indian culture to Southeast Asia during the first millennium CE was peaceful and nonimperialistic, a by-product of trade. Accompanying the trade goods from India were Sanskrit, Buddhism, and Hinduism—and Buddhist and Hindu art. But the Southeast Asian peoples soon modified the Indian models. Art historians now recognize Southeast Asian art and architecture as a distinctive and multifaceted tradition.

Sri Lanka

Sri Lanka (formerly Ceylon) is an island located at the very tip of the Indian subcontinent. Theravada Buddhism, the oldest form of Buddhism, stressing worship of the historical Buddha, arrived in Sri Lanka as

early as the third century BCE. From there it spread to other parts of Southeast Asia. With the demise of Buddhism in India in about the 13th century, Sri Lanka now has the longest-lived Buddhist tradition in the world.

GAL VIHARA One of the largest sculptures in Southeast Asia is the 46-foot-long recumbent Buddha (FIG. 17-23) carved out of a rocky outcropping at Gal Vihara. To the left of the Buddha, much smaller in scale, stands his cousin and chief disciple, Ananda, arms crossed,

17-23 Death of the Buddha (Parinirvana), Gal Vihara, near Polonnaruwa, Sri Lanka, 11th to 12th century. Granulite, Buddha 10' × 46'.

The sculptor of this colossal recumbent Sri Lankan Buddha emulated the classic Gupta style of a half millennium earlier in the figure's clinging robe, rounded face, and coiffure.

10

17-24 Aerial view of Borobudur, Java, Indonesia, ca. 800.

Borobudur is a gigantic, unique Buddhist monument. Built on nine terraces with more than 1,500 stupas and 1,500 statues and reliefs, it takes the form of a cosmic mountain, which worshipers circumambulate.

mourning the death of Shakyamuni. Although more than a half millennium later in date, the Sri Lankan representation of the Buddha's parintvana reveals its sculptures of India, with their clinging garments, rounded faces, and distinctive renditions of hair (compare FIG. 17-7).

marked independence from Indian models.

to the summit encounter more than 500 life-size Buddha images, at least 1,000 relief panels, and some 1,500 stupas of various sizes.

Scholars debate the intended meaning of Borobudur. Most think it is a constructed cosmic mountain, a three-dimensional mandala where worshipers pass through various realms on their way to ultimate enlightenment. As they circumambulate the structure, pillerims first see reliefs illustrating the karmic effects of different kinds of human behavior, then reliefs depicting episodes of the Buddha's earlier lives (jatakas), and, farther up, events from the life of Shakyamuni. On the circular terraces near the summit, each stupa is hollow and houses a statue of the seated Buddha, who has achieved spiritual and houses a statue of the seated Buddha, who has achieved spiritual

canic stone. Visitors ascending the massive structure on their way view of Angkor Wat (looking northeast), Ang-

SVEL

Angkor Wat, built by Suryavarman II to associate the Khmer king with the god Vishnu, has ive towers symbolizing the five peaks of Mount Meru, the sacred mountain at the center of the

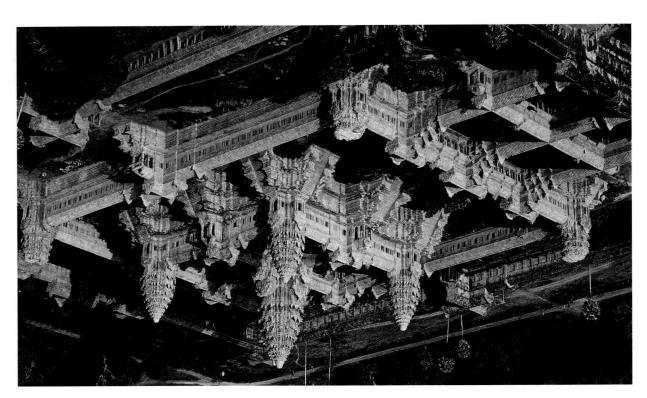

dinal points, Borobudur contains literally millions of blocks of vol-

hill on nine terraces accessed by four stairways aligned with the car-

17-24) is a Buddhist monument of colossal size, measuring about 400 feet per side at the base and about 98 feet tall. Built over a small

BOROBUDUR Unique in both form and meaning, Borobudur (FIG.

island of Java, part of the modern nation of Indonesia, exhibit a

In contrast to the Buddhist monuments of Sri Lanka, those on the

enlightenment and preaches using the Wheel-turning mudra. At the very top is the largest, sealed stupa. It may once have contained another Buddha image, but the builders may also have left it empty to symbolize the formlessness of true enlightenment.

Although scholars have interpreted the iconographic program in different ways, all agree on two essential points: that Borobudur is dependent on Indian art, literature, and religion, and that nothing comparable exists in India itself. Borobudur's sophistication, complexity, and originality underline how completely the Javanese, and Southeast Asians in general, had absorbed, rethought, and reformulated Indian religion and art by 800.

Cambodia

In 802, at about the same time that the Javanese built Borobudur, the Khmer king Jayavarman II (r. 802–850) founded the Angkor dynasty, which ruled Cambodia for the next 400 years and sponsored the construction of hundreds of monuments, including gigantic Buddhist monasteries (*wats*).

ANGKOR WAT Founded by Indravarman (r. 877–889), Angkor is an engineering marvel, a vast complex of temples and palaces within a rectangular grid of canals and reservoirs fed by local rivers. Each of the Khmer kings built a temple mountain at Angkor and installed his personal god—Shiva, Vishnu, or the Buddha—on top and gave the god part of his own royal name, implying that the king was a manifestation of the deity. When the king died, the Khmer believed that the god reabsorbed him because he had been the earthly portion of the deity during his lifetime, so they worshiped the king's image as the god. This concept of kingship approaches deification of the ruler, familiar in many other societies, such as ancient Egypt (see page 30).

Two of the Khmer kings' monuments—Angkor Wat (FIG. 17-25) and Angkor Thom (FIG. 17-25A 1)—never fail to impress. Angkor Wat, built by Suryavarman II (r. 1113-1150), is the largest of the many Khmer temple complexes. It rises from a huge rectangle of land delineated by a moat measuring about 5,000 by 4,000 feet. Like the other Khmer temples, its purpose was to associate the king with his personal god, in this case Vishnu. The centerpiece of the complex is a tall stepped tower surrounded by four smaller towers connected by covered galleries. The five towers symbolize the five peaks of Mount Meru, the sacred mountain at the center of the universe. Two more circuit walls with galleries, towers, and gates enclose the central block. Thus, as worshipers progress inward through the complex, the towers rise ever higher, paralleling the towers of Khajuraho's Vishvanatha Temple (FIG. 17-14) but in a more complex sequence and on a much grander scale. Throughout Angkor Wat, stone reliefs glorify both Vishnu in his various avatars and Suryavarman II.

Thailand

Southeast Asians practiced both Buddhism and Hinduism, but by the 13th century, in contrast to developments in India, Hinduism was in decline and Buddhism dominated much of the mainland. Historians date the beginning of the Sukhothai kingdom in Thailand to 1292, the year King Ramkhamhaeng (r. 1279–1299) set up a four-sided stele bearing the first inscription written in the Thai language. Sukhothai's political dominance proved to be short-lived, however. Ayuthaya, a city founded in central Thailand in 1350, quickly became the more powerful kingdom and warred sporadically with other states in Southeast Asia until the mid-18th century.

Scholars nonetheless regard the Sukhothai period as the golden age of Thai art. In the inscription on his stele, Ramkhamhaeng (Rama the Strong) described Sukhothai as a city of monasteries and many images of the Buddha.

WALKING BUDDHA Sukhothai's crowning artistic achievement was the development of a type of walking-Buddha statue (FIG. 17-26) displaying a distinctively Thai approach to body form. The bronze Buddha has broad shoulders and a narrow waist and wears a clinging monk's robe. He strides forward, his right heel off the ground and his left arm raised with the hand held in the do-not-fear mudra

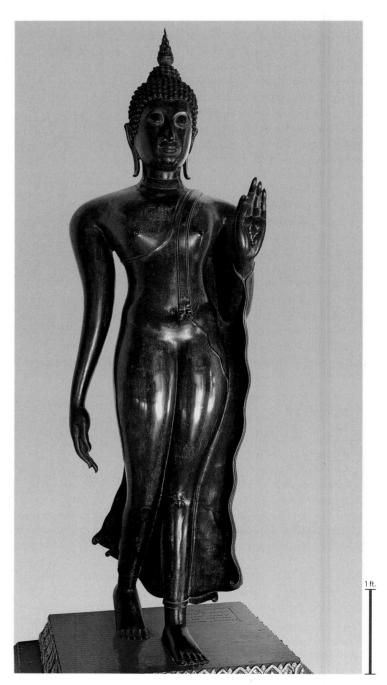

17-26 Walking Buddha, from Sukhothai, Thailand, 14th century. Bronze, 7' $2\frac{1}{2}$ " high. Wat Bechamabopit, Bangkok.

Walking-Buddha statues are unique to Thailand and display a distinctive approach to human anatomy. The Buddha's body is soft and elastic, and the right arm hangs loosely, like an elephant trunk.

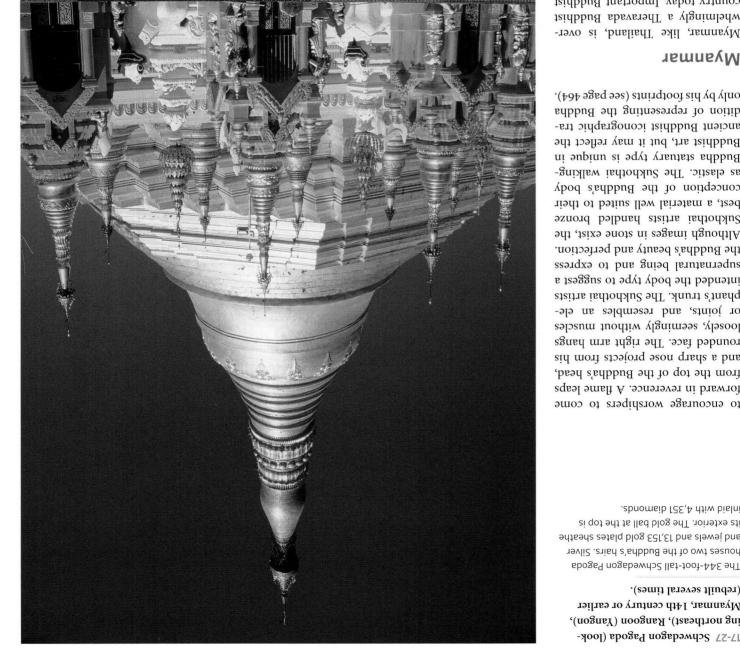

(rebuilt several times). Myanmar, 14th century or earlier ing northeast), Rangoon (Yangon), 17-27 Schwedagon Pagoda (look-

.ebnomeib [25,4 AJiw bielni its exterior. The gold ball at the top is and jewels and 13,153 gold plates sheathe houses two of the Buddha's hairs. Silver The 344-foot-tall Schwedagon Pagoda

only by his footprints (see page 464). dition of representing the Buddha ancient Buddhist iconographic tra-Buddhist art, but it may reflect the Buddha statuary type is unique in as elastic. The Sukhothai walkingconception of the Buddha's body best, a material well suited to their Sukhothai artists handled bronze Although images in stone exist, the the Buddha's beauty and perfection. supernatural being and to express intended the body type to suggest a phant's trunk. The Sukhothai artists or joints, and resembles an eleloosely, seemingly without muscles rounded face. The right arm hangs and a sharp nose projects from his from the top of the Buddha's head, forward in reverence. A flame leaps

Myanmar

the countryside. monasteries and monuments dot country today. Important Buddhist whelmingly a Theravada Buddhist Myanmar, like Thailand, is over-

tion of secular art (see Chapters 18 and 19). sive surviving Buddhist monuments as well as a distinguished tradiarchitects, sculptors, and painters created some of the most impresonly to Southeast Asia but also to China, Korea, and Japan, where Buddhism and Buddhist art gradually spread from India not

following additional subjects: buildings, Google EarthTM coordinates, and essays by the author on the Explore the era further in MindTap with videos of major artworks and

■ Meditating Buddha, from Gandhara (FIG. 17-5A) ■ MATERIALS AND TECHNIQUES: Silk and the Silk Road ■ THE PATRON'S VOICE: Ashoka's Sponsorship of Buddhism

■ WRITTEN SOURCES: Abd al-Hamid Lahori on the Taj Mahal ■ Durga Slaying the Buffalo Demon Mahisha (FIG. 17-8A)

Bayon, Angkor Thom (FIG. 17-25A)

enlightenment. dha from the laypeople of Myanmar to earn merit on their path to of which weighs 76 carats. This great wealth was a gift to the Budumbrella crowned with a gold ball inlaid with 4,351 diamonds, one gold, each about a foot square. At the very top is a seven-tiered stands 344 feet high. Covering its upper part are 13,153 plates of silver, and jewels encrusting its surface. The Schwedagon Pagoda several times, this highly revered stupa is famous for the gold, merchants who received them from the Buddha himself. Rebuilt dha's hairs, traditionally said to have been brought to Myanmar by a word for "stupa.") The Rangoon pagoda houses some of the Bud-Pagoda (FIG. 17-27). (Pagoda derives from the Portuguese version of centerpiece one of the largest stupas in the world, the Schwedagon buildings, including shrines filled with Buddha images, has as its SCHWEDAGON PAGODA In Rangoon, an enormous complex of

SOUTH AND SOUTHEAST ASIA

Indus Civilization and Maurya Dynasty

- The Indus Civilization (ca. 2600–1500 BCE) was one of the world's earliest civilizations. Indus cities had streets oriented to the compass points and sophisticated water-supply and sewage systems, but little Indus art survives, most of it seals with incised designs and small-scale sculptures.
- The greatest ruler of the Maurya dynasty (323–185 BCE) was Ashoka (r. 272–231 BCE), who converted to Buddhism and spread the Buddha's teaching throughout South Asia. Ashoka built the original Great Stupa at Sanchi. His pillars with lion capitals are the first monumental stone artworks in India.

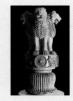

Lion capital of Ashoka, Sarnath, ca. 250 BCE

Kushan, Gupta, and Post-Gupta Periods

- The first representations of the Buddha in human form date to the Kushan Empire (mid-first century to 320 ce). Gandharan Buddhist art owes a strong stylistic debt to Greco-Roman art. By the second century ce, the iconography of the life of the Buddha was well established.
- Gupta sculptors formulated the canonical Buddha image in the fifth century, combining Gandharan iconography with a soft, full-bodied figure in clinging garments. The Gupta-period Buddhist caves of Ajanta are the best surviving examples of early mural painting in India.
- The oldest Hindu large-scale stone temples and sculptures—at Badami, Elephanta, Deogarh, and elsewhere—date to the fifth and sixth centuries.

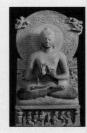

Seated Buddha, Sarnath, second half of fifth century CE

Medieval Period

Various dynasties ruled South Asia from the 7th to the 12th century, and distinctive regional styles emerged in Hindu religious architecture. Northern temples, such as the Vishvanatha Temple at Khajuraho, have a series of small towers leading to a tall beehive-shaped tower, or shikhara, over the sacred garbha griha. Southern temples, such as the Rajarajeshvara Temple at Thanjavur, have flat-roofed pillared halls (mandapas) leading to a pyramidal tower (vimana).

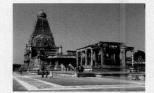

Rajarajeshvara Temple, Thanjavur, ca. 1010

Mughal Empire

- The first great flowering of art and architecture in the Mughal Empire (1526–1857) occurred under Akbar the Great (r. 1556–1605), whose imperial painting workshop produced magnificent miniatures. Shah Jahan (r. 1628–1658) built the Taj Mahal as a memorial to his favorite wife.
- While the Mughal emperors ruled from their capital at Delhi, Hindu Rajput kings ruled much of north-western India. The coloration and sensuality of Rajput painting distinguish it from the contemporaneous Mughal style.
- Between 1529 and 1736, the Hindu Nayak dynasty controlled southern India and built immense temple complexes with towers (gopuras) featuring painted stucco sculptures of Hindu deities.

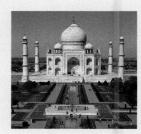

Taj Mahal, Agra, 1632-1647

Southeast Asia

- Southeast Asian art and architecture—for example, at Gal Vihara—reflect Indian prototypes, but many local styles developed.
- Borobudur has no parallel in India. The Khmer kings built vast Buddhist temple complexes at Angkor. The Sukhothai walking-Buddha statuary type displays a unique approach to body form. The Schwedagon Pagoda in Rangoon, one of the world's largest stupas, is encrusted with gold, silver, and jewels.

Parinirvana, Gal Vihara, 11th to 12th century

▲ 18-1b The Hall of Supreme Harmony is the climax of the Forbidden City's long north-south axis. It is the largest wood building in China and has 72 gigantic columns carved from Sichuan trees.

▲ 18-1a The southern entrance to the Beijing palace complex was the Moon Gate. Only the emperor could walk through the central portal. Those of decreasing rank used the lateral passageways.

China, Ming dynasty, 15th century and later.

Aerial view (looking north) of the Forbidden City, Beijing,

► 18-1c Inside the Hall of Supreme Harmony is the emperor's opulently appointed throne room. Here, the Ming Son of Heaven, elevated on a stepped platform, received important visitors.

1-81

China and Korea

THE FORBIDDEN CITY

Since ancient times, emperors and regional kings ruled the vast territory of present-day China. In 1368, Zhu Yuanzhong led a popular uprising that drove the last Mongol emperor from Beijing. Zhu then founded the native Chinese Ming dynasty (r. 1368–1644) and assumed the official name of the Hongwu (Abundantly Martial) emperor (r. 1368–1398). He built his capital at Nanjing (Southern Capital), but the third Ming ruler, the Yongle (Perpetual Happiness) emperor (r. 1403–1424), moved the imperial seat back to Beijing (Northern Capital).

The Ming builders laid out Beijing as three nested walled cities. The outer perimeter wall was 15 miles long and enclosed the walled Imperial City, with a perimeter of 6 miles surrounded by a 50-yard-wide moat, and, within the city, the vast imperial palace compound (FIG. 18-1), which, with the Great Wall, is the enduring emblem of China. The name "Forbidden City" dates to 1576 and aptly describes the highly restricted access to the inner compound, where the Ming emperor, the Son of Heaven, resided. The layout of the Forbidden City provided the perfect setting for the elaborate ritual of the imperial court. For example, the entrance gateway to the complex, the Noon Gate, has five portals. Only the emperor could walk through the central doorway. The two entrances to its left and right were reserved for the imperial family and high officials. Others had to use the outermost passageways. Entrance to the Forbidden City proper was through the nearly 40-yard-tall triple-passageway Meridian Gate. Only the emperor and his retinue and foreign ambassadors who had been granted an official audience could pass through the Meridian Gate.

Within the Forbidden City, more gates and a series of courtyards, gardens, temples, and other buildings led eventually to the Hall of Supreme Harmony, in which the emperor, seated on his dragon throne on a high stepped platform, received important visitors. The hall is the largest wood building in China. For its columns, the Ming builders had to transport gigantic tree trunks from Sichuan Province down the Yangtze River. Perched on an immense platform above marble staircases, the Hall of Supreme Harmony was the climax of a long north-south axis. The fill for the platform consists of the soil and rocks that the Ming engineers collected from the excavation of the great moat around the imperial complex.

Beyond that grand reception hall is the even more restricted Inner Court and the Palace of Heavenly Purity—the private living quarters of the emperor and his extended family of wives, concubines, and children. At the northern end of the central axis of the Forbidden City is the Gate of Divine Prowess, through which the palace servants gained access to the complex.

CHINA

has made possible a shared Chinese literary, philosophic, and reli-

the Xia (ca. 2000–1600 BCE), long thought to have been mythical. have begun to confirm the existence of China's earliest royal dynasty. tion of the potter's wheel in the fourth millennium BCE. Archaeologists China, produced fine decorated ceramic bowls even before the invenshao Culture, which arose along the Yellow River in northeastern Mastery of the art of pottery soon followed. The potters of the Yangvillage life as far back as the seventh or early sixth millennium BCE. history. Discoveries in recent years have provided evidence of settled China traces its beginnings to long before the dawn of recorded

employs characters (signs recording meaning rather than sounds), understand one another. The written language, however, which language varies so much that speakers of different dialects do not world's largest population and is ethnically diverse. The spoken cally to about twice the area of the United States. China boasts the have varied over the millennia, and at times it has grown geographitains, and fertile farmlands. Its political and cultural boundaries (MAP 18-1) comprises sandy plains, mighty rivers, towering moun-Vast and varied both topographically and climatically, China

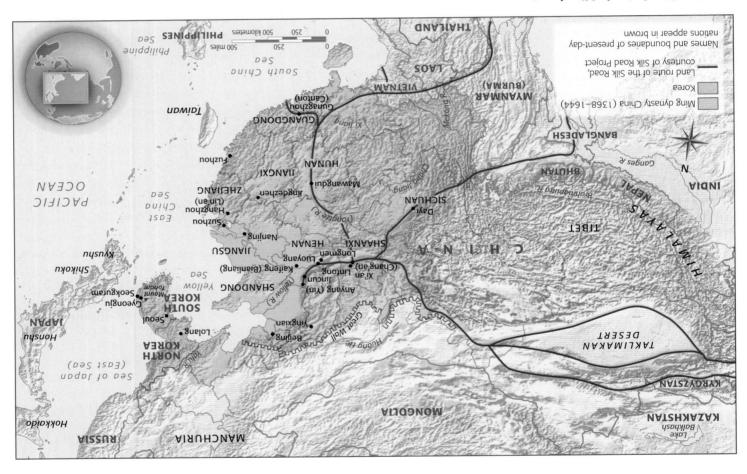

MAP 18-1 China during the Ming dynasty.

1600-206 BCE

Ming to People's Republic 0861-8981

- vated scenic gardens at Suzhou. Landscape architects design uncultithe Forbidden City in Beijing. Ming (1368-1644) emperors build
- Korea erects Namdaemun gate. The Joseon dynasty (1392-1910) in
- Manchus rule China as the Qing
- art of the People's Republic (1911-). Marxist themes dominate the official dynasty (1644-1911).

Song to Yuan 8981-406

society.

most technologically advanced Song (907-1279) China is the world's

- the Song emperors. Landscape painting flourishes under
- the world's tallest wood building at The Liao dynasty (907-1125) builds
- Mongols establish the Yuan dynasty
- lain pottery with cobalt-blue under-The Jingdezhen kilns produce porce-(1279-1368).

glaze decoration.

gneT bns neH 206 BCE-907 CE

■ Xie He formulates "six canons" of feature interlocking clusters of wood Han (206 BCE-220 CE) buildings

- The Tang dynasty (618-906) is the Chinese painting in the early sixth
- most magnificent city in the world. Chang'an, the Tang capital, is the golden age of Chinese painting on silk
 - Shang (1600-1050 BCE) artists per-Shang to Qin
- in fashioning luxurious objects in Zhou (1050-256 BCE) artists excel variety of vessel shapes in bronze. fect the technique of casting a wide

CHINA AND KOREA

guarded by 8,000 terracotta soldiers. builds an immense burial mound The First Emperor of Qin (227-210 BCE) bronze, lacquer, and jade.

Shang and Zhou Dynasties

The first great well-documented Chinese dynasty is the Shang (ca. 1600-1050 BCE), whose kings ruled from a series of royal capitals in the Yellow River valley. In 1928, excavations at Anyang (ancient Yin) brought to light the last Shang capital. There, archaeologists found a large number of objects inscribed in the earliest form of the Chinese language. These fragmentary records and the other finds at Anyang reveal a warlike, highly stratified society living within cities ringed by walls of pounded earth. The excavated tomb furnishings include weapons and a great wealth of objects in jade, ivory, lacquer (sap-coated wood), and bronze. Not only the kings received lavish burials. The tomb of Fu Hao, the wife of Wu Ding (r. ca. 1215– 1190 BCE), for example, contained more than a thousand bronze and jade objects and an ivory beaker inlaid with turquoise.

SHANG BRONZES Shang artists perfected the casting of elaborate bronze vessels. Used in sacrifices to ancestors and in funerary ceremonies, Shang bronzes held wine, water, grain, or meat for sacrificial rites. Each vessel's shape matched its intended purpose. The guang illustrated here (FIG. 18-2) is a libation vessel shaped like a covered gravy boat, characteristically densely decorated with abstract and animal motifs. The multiple designs and their fields of background spirals integrate so closely with the form of the guang that they are not merely an external embellishment but an integral part of the sculptural whole. Some motifs on the guang's side may represent the eyes of a tiger and the horns of a ram. A horned animal forms the

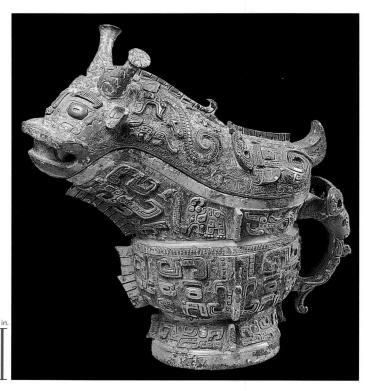

18-2 Guang, probably from Anyang, China, Shang dynasty, 12th or 11th century BCE. Bronze, $6\frac{1}{2}$ high. Asian Art Museum of San Francisco, San Francisco (Avery Brundage Collection).

Shang artists perfected casting elaborate bronze vessels covered with animal motifs. The animal forms, real and imaginary, on this libation guang are probably connected with the world of spirits.

front of the lid, and at the rear is a horned head with a bird's beak. Another horned head appears on the handle. Fish, birds, elephants, rabbits, and more abstract composite creatures swarm over the surface against a background of spirals. The fabulous animal forms, real and imaginary, are unlikely to have been purely decorative. They are probably inhabitants of the world of spirits addressed in the rituals.

ZHOU DYNASTY Around 1050 BCE, the Zhou, former vassals of the Shang, captured Anyang and overthrew their Shang overlords. The Zhou dynasty (ca. 1050-256 BCE) proved to be the longest lasting in China's history—so long that historians divide the Zhou era into two periods: Western Zhou (ca. 1050-771 BCE) and Eastern Zhou (770-256 BCE). The dividing event is the transfer of the Zhou capital from Chang'an (present-day Xi'an) in the west to Luoyang in the east. Under the Zhou, the development of markets and the introduction of bronze coinage brought heightened prosperity and a taste for lavish products, such as bi disks carved from jade (see "Chinese Jade" and FIG. 18-2A (1) and bronzes inlaid with gold and silver. The closing centuries of Zhou rule include a long period of warfare among competing states (Warring States Period, ca. 475-221 BCE). This period of political and social turmoil was also a time of intellectual upheaval, when conflicting schools of philosophy, including Legalism, Daoism, and Confucianism, emerged (see "Daoism and Confucianism," page 488).

Qin Dynasty

The ruler of the state of Qin (from which the modern name China derives) brought the Warring States Period to an end by conquering all rival states, including the Zhou. Known to history by his title, Qin Shi Huangdi (First Emperor of Qin, r. 221-210 BCE), he controlled an area equal to about half of present-day China. During his reign, Shi Huangdi linked the fortifications along the northern border of his realm to form the famous Great Wall (MAP 18-1), which defended China against the fierce nomadic peoples of the north, especially the Huns. By sometimes brutal methods, the First Emperor consolidated his power and then established a centralized bureaucracy with standardized written language, weights and measures, and coinage. He also repressed all schools of thought other than Legalism, which espoused absolute obedience to the state's authority and advocated strict laws and punishments. Chinese historians have condemned the First Emperor, but the bureaucratic system he put in place long outlasted his reign. Its success was due in large part to Shi Huangdi's decision to replace the feudal lords with talented salaried administrators and to reward merit rather than favor high birth.

Shi Huangdi is best known today for the spectacular discovery of his grandiose tomb at Lintong (see "The First Emperor's Army in the Afterlife," page 486, and FIG. 18-3).

Han Dynasty

Soon after the First Emperor's death, the people who had suffered under his reign revolted, assassinated his corrupt and incompetent son, and founded the Han dynasty in 206 BCE. The Han ruled China for four centuries, integrating many of the Qin reforms in a more liberal governing policy. They also extended China's southern and western boundaries, penetrating far into Central Asia (present-day Xinjiang). Han merchants even traded indirectly with distant Rome via the so-called Silk Road (see "Silk and the Silk Road" 1.

army served as the First Emperor's bodyguard deployed in perpetuity

outside his tomb.

individuality. The result of these efforts was a brilliant balance of uniformity and added further variations to the appearance of the terracotta army. to differentiate the figures even more. The Qin painters undoubtedly modeling of the cast body parts before firing enabled the sculptors slightly, sometimes markedly, from statue to statue. Additional hand ment folds, equipment, coiffures, and facial features vary, sometimes ferent combinations. Consequently, the stances, arm positions, garfor different parts of the statues, but assembled the parts in many difstrict formation. In fact, they did employ the same molds repeatedly and over again to produce thousands of identical soldiers standing in First Emperor's artisans could have opted to use the same molds over sculptors and painters, as well as a large number of huge kilns. The shop. Manufacturing this army of statues required a veritable army of but also to a high degree of organization in the Qin imperial workassemblage testifies not only to the power and wealth of Shi Huangdi alry, chariots, archers, lancers, and hand-to-hand fighters. The huge Today, the Lintong army consists of about 2,000 statues of cav-

The First Emperor's Army in the Afterlife **ART AND SOCIETY**

chariots, which probably numbered 8,000 or more. The terracotta figures (Fig. 18-3) of soldiers and horses, as well as bronze horses and covery of pits around the tomb containing life-size painted terracotta palaces, but scholars did not take his account seriously until the disoccupied in life. The historian Sima Qian (136-85 BCE) described both funerary palace designed to match the fabulous palace the emperor ologists believe that it contains a vast treasure-filled underground The First Emperor's tomb remains unexcavated, but Chinese archaeambitious undertaking, he conscripted more than 700,000 laborers. Huangdi began construction of his home in the eternal afterlife. For this other powerful monarchs throughout history, during his lifetime Shi burial mound of Qin Shi Huangdi, China's "First Emperor." Like many Chinese excavators soon concluded that they belonged to the immense tong in Shaanxi Province discovered some broken terracotta statues. came to light in 1974 when farmers digging a well in a village near Lin-One of the greatest archaeological discoveries ever made anywhere

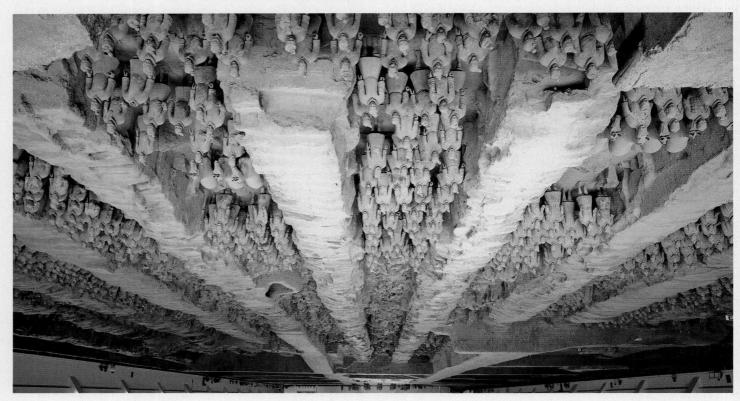

Painted terracotta, average figure 5' $10\frac{7}{8}"$ high. 18-3 Army of the First Emperor of Qin in pits next to his burial mound, Lintong, China, Qin dynasty, ca. 210 BCE.

common molds, every figure has an individualized appearance. The First Emperor was buried beneath an immense mound guarded by thousands of life-size terracotta soldiers. Although produced from

immortal beings appear between and below two orbs—the red sun and At the bottom is the Underworld. In the heavenly realm, dragons and resents Heaven. Most of the vertical section below is the human realm. the marquise's coffin. The area within the cross at the top of the T repthe discovery of a painted T-shaped silk banner (FIG. 18-4) draped over innermost of four nested sarcophagi. Most remarkable, however, was

utensils, rich textiles, and an astonishingly well-preserved corpse in the noblewoman into the afterlife. Among the finds were decorated lacquer of goods for use during burial ceremonies and for accompanying the the marquise of Dai at Mawangdui. The tomb contained a rich array Han art occurred in 1972, when archaeologists excavated the tomb of MARQUISE OF DAI One of the most important discoveries of

18-4 Funeral banner, from tomb 1 (tomb of the marquise of Dai), Mawangdui, China, Han dynasty, ca. 168 BCE. Painted silk, 6' $8\frac{3}{4}$ " × 3' $\frac{1}{4}$ ". Hunan Provincial Museum, Changsha.

Archaeologists found this T-shaped silk banner draped over the coffin of the Marquise of Dai, who is shown awaiting her ascent to immortality in Heaven, the realm of the red sun and silvery moon.

18-5 Flying horse, from the tomb of Governor-General Zhang, Wuwei, China, Han dynasty, late second century CE. Bronze, 1' $1\frac{1}{2}$ " high. Gansu Provincial Museum, Lanzhou.

Found in a late Han dynasty tomb, this cast-bronze galloping, flying horse has one hoof on a swallow with spread wings, suggesting the deceased's heavenward journey to the afterlife.

its symbol, the raven, on the right, and the silvery moon and its symbol, the toad, on the left. Below, the standing figure on the first white platform near the center of the vertical section is probably the marquise of Dai herself—one of the first portraits in Chinese art. The woman awaits her ascent to Heaven, where she can attain immortality. The artist depicted her funeral nearer the bottom. Between these two sections are two intertwining dragons. Their tails reach down to the Underworld and their heads point to Heaven, unifying the entire composition.

WUWEI FLYING HORSE Another Han tomb of special interest is that of Governor-General Zhang, discovered in 1969 at Wuwei. The tomb contained almost 100 cast-bronze sculptures of horses, chariots, and soldiers—a miniature version of the life-size army (Fig. 18-3) guarding the tomb of the First Emperor of Qin. The figurine illustrated here (Fig. 18-5) represents a distinctive breed of horse from Turkestan. It differs from all the others in Zhang's tomb because it is not prancing or standing still but galloping, or, more accurately, flying because one hoof rests on a swallow with spread wings. The sculptor posed the horse with its head tilted to one side but presented the animal's body in a pure profile. The Wuwei horse has an elegant silhouette, with its legs spread widely and its tail lifted behind it like a fifth leg, balancing the curved neck and the rear left leg. Zhang's airborne horse suggests that the journey from his tomb will take him heavenward to an immortal afterlife.

Period of Disunity

For three and a half centuries, from 220 to 589,* civil strife divided China into competing states. The history of this so-called Period of Disunity is extremely complex, but one development deserves

^{*}From this point on, all dates in this chapter are CE unless otherwise stated.

Confucius sought. Although originally a junzi had to be of noble birth, in Confucian thought anyone can become a junzi by cultivating the virtues that Confucius espoused, especially empathy for suffering, pursuit of morality and justice, respect for ancient ceremonies, and adherence to traditional social relationships, such as those between parent and child, elder and younger sibling, husband and wife, and ruler and subject.

Confucius's disciple Mencius (or Mengzi, 371?-289? BCE) developed his master's ideas further, stressing that the deference to age and rank at the heart of the Confucian social order brings a reciprocal responsibility. For example, a king's legitimacy depends on the goodwill of his people. A ruler should share his joys with his subjects and will know that his laws are unjust if they bring suffering to the people.

Confucius spent much of his adult life trying to find rulers willing to apply his teachings, but he died in disappointment. However, he and Mencius profoundly influenced Chinese thought and social practice. Chinese traditions of venerating deceased ancestors and outstanding leaders encouraged the development of Confucianism as a religion as well as a philosophic tradition. Eventually, Emperor Wu (r. 140–87 BCE) of the Han dynasty established Confucianism as the state's official doctrine. Thereafter, it became the primary subject of the civil service exams required for admission into and advancement within government service.

Confucian and Daoist are broad, imprecise terms often used to distinguish aspects of Chinese culture stressing social responsibility and order (Confucian—for example, Fies. 18-6 and 18-9) from those emphasizing cultivation of individuals, often in reclusion (Daoist—for example, Fies. 18-10 and 18-14). But both philosophies share the idea that anyone can cultivate wisdom or ability, regardless of birth.

bulence led to social unrest.

Daoism and Confucianism are both philosophies and religions native to China. Both schools of thought attracted wide followings during the fifth to third centuries BCE (Warring States Period), when political tur-

Daoism emerged out of the metaphysical teachings attributed to Laozi (604?–531? BCE) and Zhuangzi (370?–301? BCE). It takes its name from Laozi's treatise Daodejing (The Way and Its Power). Daoist philosophy stresses an intuitive awareness, nurtured by harmonious contact with nature, and shuns everything artificial. Daoists seek to follow the universal path, or principle, called the Dao, whose features cannot be described but only suggested through analogies. For example, the Dao is said to be like water, always yielding but eventually wearing away the hard stone that does not yield. For Daoists, strength comes from flexibility and inaction. Historically, Daoist principles encouraged from society in favor of personal cultivation in nature.

Confucius (Kong Fuzi, or Master Kong, 551-479 BCE) was born in the state of Lu (roughly Shandong Province) to an aristocratic family that had fallen on hard times. From an early age, he showed a strong interest in the rites and ceremonies that helped unite people into an orderly society. As he grew older, he developed a deep concern for the suffering caused by the civil conflict of his day. Thus he adopted a philosophy that he hoped would lead to order and stability. The junzi ("superior person" or "gentleman") who possesses ren ("humanheartedness") and Ii ("etiquette") personified the ideal social order that

18-6 Attributed to Gu KAIZHI, Lady Feng and the Bear, detail of Admonitions of the Instructress to the Court Ladies, Period of Disunity, late fourth century. Handurity, late fourth century. Handscroll, ink and colors on silk; full scroll $11^{1/4} \frac{1}{2}^{-1}$ long, detail $9\frac{3}{4}^{-1}$ high. British Museum, London.

Lady Feng's act of heroism to save the life of her emperor was a perfect model of Confucian behavior. In this early Chinese representation of the episode, the painter set the figures against a blank background.

the north. But Buddhism's promise of hope beyond the troubles of this world earned it an ever broader audience during the upheavals of the Period of Disunity. In addition, the fully developed Buddhist system of thought attracted many intellectuals. Although Buddhism never fully displaced Daoism and Confucianism, it did prosper throughout China for centuries and had a profound influence on the further development of the religious forms of those two native traditions.

special mention—the occupation of northern China by peoples who were not ethnically Han Chinese and who spoke non-Chinese languages.

It was in the northern states, connected to India by the Silk Road (see "Silk and the Silk Road" (), that Buddhism first took root in China during the Han dynasty. Certain practices shared with Daoism (see "Daoism and Confucianism," above), such as withdrawal from ordinary society, helped Buddhism gain an initial foothold in

GU KAIZHI Secular arts also flourished in the Period of Disunity, as rulers sought artists to lend prestige to their courts. The most famous early Chinese painter with whom extant works can be associated is Gu Kaizhi (ca. 344–406). Gu was a friend of important members of the Eastern Jin dynasty (317–420) and won renown as a calligrapher, a painter of court portraits, and a pioneer of landscape painting. A *handscroll* (see "Chinese Painting Materials and Formats," page 491) attributed to Gu in the 11th century is not by his hand, but it exemplifies the key elements of his art. Called *Admonitions of the Instructress to the Court Ladies*, the horizontal scroll contains painted scenes and accompanying explanatory text.

Like all Chinese handscrolls, this one was unrolled and read from right to left, with only a small section exposed for viewing at one time. The section illustrated here (FIG. 18-6) records a virtuous act of heroism—Lady Feng saving her emperor's life by placing herself between him and an attacking bear, a perfect model of Confucian behavior. As in many early Chinese paintings, the artist set the figures against a blank background with only a minimal setting for the scene, although in other works, Gu provided landscape settings for his narratives. The figures' poses and fluttering drapery ribbons convey a clear quality of animation in concert with the individualized facial expressions. (The Han emperor is fearful. Lady Feng is remarkably calm.) This style accords well with painting ideals expressed in texts of the time, when representing inner vitality and spirit took precedence over reproducing surface appearances (see "Xie He's Six Canons" (4).

Tang Dynasty

The emperors of the short-lived Sui dynasty (r. 581–618) succeeded in reuniting China and prepared the way for the brilliant Tang dynasty (r. 618–906). Under the Tang emperors, China entered a period of unequaled magnificence. Chinese armies marched across Central Asia, prompting an influx of foreign peoples, wealth, and ideas into China. Traders, missionaries, and other travelers journeyed to the cosmopolitan Tang capital at Chang'an, and the Chinese, in turn, ventured westward. Chang'an, laid out on a grid

scheme, occupied more than 30 square miles. It was the greatest city in the world during the seventh and eighth centuries.

LONGMEN CAVES The Tang emperors were lavish art patrons. One of the most spectacular Tang commissions was the group of sculptures (FIG. 18-7) carved into the face of a cliff in the Longmen Caves complex near Luoyang. The central figure of the Buddha is 44 feet tall—seated. An inscription records that the project was completed in 676 when Gaozong (r. 649–683) was emperor and that in 672, the empress Wu Zetian underwrote a substantial portion of the considerable cost with her private funds. Wu Zetian was an exceptional woman by any standard, and when Gaozong died in 683, she declared herself emperor and ruled until 705, when she was forced to abdicate at age 82.

Wu Zetian's Buddha is the Vairocana Buddha, or the Mahayana Cosmic Buddha, the Buddha of Boundless Space and Time (see "Buddhism," page 466). Flanking him are two of his monks, attendant bodhisattvas, and guardian figures—all smaller than the Buddha but still of colossal size. The sculptors represented the Buddha in serene majesty. An almost geometric regularity of contour and smoothness of planes emphasize the volume of the massive figure. The folds of the Buddha's robes fall in a few concentric arcs. The artists suppressed surface detail in the interest of monumental simplicity and dignity.

DUNHUANG GROTTOES The westward expansion of the Tang Empire increased the importance of Dunhuang, the westernmost gateway to China on the Silk Road. Dunhuang long had been a wealthy, cosmopolitan trade center, a Buddhist pilgrimage destination, and home to thriving communities of Buddhist monks and nuns of varied ethnicity, as well as to adherents of other religions. In the course of several centuries beginning in the Period of Disunity—when work also began at the Longmen Caves—the Chinese cut hundreds of sanctuaries into the soft rock of the cliffs near Dunhuang and decorated them with painted murals. Known today as the Mogao Grottoes and in antiquity as the Caves of a Thousand Buddhas, the Dunhuang cave temples are especially important

18-7 Vairocana Buddha, disciples, and bodhisattvas, Fengxian Temple, Longmen Caves, Luoyang, China, Tang dynasty, completed 676. Buddha 44' high.

Empress Wu Zetian sponsored these colossal rock-cut sculptures. The Tang artists represented the Mahayana Cosmic Buddha in serene majesty, suppressing surface detail in favor of monumental simplicity.

18-8 Paradise of Amitabha, cave 172, Dunhuang, China, Tang dynasty, mid-eighth century. Wall painting, 10' high.

This richly detailed, brilliantly colored mural aided worshipers at Dunhuang to visualize the wonders of the Pure Land Paradise promised to those who had faith in Amitabha, the Buddha of the West.

in East Asia as compassionate beings ready to achieve buddhahood but dedicated to humanity's salvation. Some received direct worship and became the main subjects of sculpture and painting.

his attendants, two of whom carry the ceremonial fans that signify sents Emperor Xuan of the Chen dynasty (557-589) seated among semblance of volume and presence. The detail in FIG. 18-9 repre-Simple shading in the faces and the robes gives the figures an added tive to his attendants immediately establishes his superior stature. stands or sits in an undefined space. The emperor's great size relawith the Confucian ideal of learning from the past. Each emperor torical figures as exemplars of moral and political virtue, in keeping the Han to the Sui dynasties. Its purpose was to portray these hiscelebrated painter. This handscroll depicts 13 Chinese rulers from was prime minister under the Tang emperor Gaozong as well as a Born into an aristocratic family and the son of a famous artist, Yan drawing and colored washes long attributed to YAN LIBEN (d. 673). painting. The Thirteen Emperors (FIG. 18-9) is a masterpiece of line regard the early Tang dynasty as the golden age of Chinese figure page 491). Although few examples exist today, many art historians of scroll painting (see "Chinese Painting Materials and Formats," YAN LIBEN The Tang emperors also fostered a brilliant tradition

because in 845 the emperor Wuzong instituted a major persecution, destroying 4,600 Buddhist temples and 40,000 shrines and forcing the return of 260,500 monks and nuns to lay life. Wuzong's policies did not affect Dunhuang, then under Tibetan rule, so the site preserves much of the type of art lost elsewhere.

them a celestial dance takes place. Bodhisattvas had strong appeal bodhisattvas and lesser divine attendants surround him. Before buildings characteristic of the Tang era. The Buddha's principal sits in the center of a raised platform against a backdrop of ornate by visualizing the wonders of the Pure Land Paradise. Amitabha dynasty, such as this one, greatly aided worshipers in gaining faith brilliantly colored pictures steeped in the opulence of the Tang through faith in Amitabha's promise of salvation. Richly detailed, could obtain rebirth in a realm free from spiritual corruption simply own power because of the waning of the Buddha's law. Instead, they individuals had no hope of attaining enlightenment through their flourish during the Tang dynasty. Pure Land teachings asserted that popular imagination in the Period of Disunity and continued to those centered on Amitabha, Buddha of the West, had captured the together in a powerful image. Buddhist Pure Land sects, especially how the splendor of the Tang era and religious teachings could come Paradise of Amitabha (FIG. 18-8), in Dunhuang cave 172, shows

MATERIALS AND TECHNIQUES Chinese Painting Materials and Formats

Mural paintings in caves (FIG. 18-8) were popular in China, as they were in South Asia (FIG. 17-8), but Chinese artists also employed several other materials and formats for their paintings. The basic requirements for paintings not on walls were the same as for writing—a round tapered brush, soot-based ink, and either silk or paper. The Chinese were masters of the brush. For contours and interior details, they sometimes used modulated lines that elastically thicken and thin to convey depth and mass. In other works, scroll painters used *iron-wire lines* (thin, unmodulated lines with a suggestion of tensile strength) to define the figures. Chinese artists also used richly colored minerals as pigments, finely ground and suspended in a gluey medium, and watery

washes of mineral and vegetable dyes. The formats of Chinese paintings on silk or paper tend to be personal and intimate, and they are usually best viewed by only one or two people at a time. The most common types are listed here.

- Hanging scrolls (FIGS. 18-10, 18-15, and 18-19) Chinese painters often mounted pictures on, or painted directly on, unrolled vertical scrolls for display on walls.
- Handscrolls (FIGS. 18-6, 18-9, and 18-11) Artists also frequently attached paintings to, or painted on, long, narrow scrolls that the viewer unrolled horizontally, section by section from right to left.
- Album leaves (FIGS. 18-14 and 18-20) Many Chinese artists painted small panels on paper leaves, which collectors placed in albums.

18-9 Attributed to YAN LIBEN, Emperor Xuan and Attendants, detail of The Thirteen Emperors, Tang dynasty, ca. 650. Handscroll, ink and colors on silk; full scroll 17' 5" long, detail 1' 8 ½ high. Museum of Fine Arts, Boston.

This handscroll portrays 13 Chinese rulers as Confucian exemplars of moral and political virtue. Yan Liben, a celebrated Tang painter, was a master of line drawing and colored washes.

his rank. Xuan stands out from the others also because of his dark robes. His majestic serenity contrasts with his attendants' animated poses, which vary sharply from figure to figure, lending vitality to the composition.

Song Dynasty

The last century of Tang rule brought many popular uprisings and the empire's gradual disintegration. After an interim of internal strife known as the Five Dynasties period (907–960), General Zhao Kuangyin succeeded in consolidating the country once again. He established himself as the first emperor (r. 960–976) of the Song dynasty (960–1279), which ruled China from a capital in the north

at Bianliang (present-day Kaifeng) during the Northern Song period (960–1127). The Song emperors curtailed many of the hereditary privileges of the elite class. They also made political appointments on the basis of scores on civil service examinations, and education became a more important prerequisite for Song officials than high birth. The three centuries of Song rule, including the Southern Song period (1127–1279) when the capital was at Lin'an (present-day Hangzhou) in southern China, were also a time of extraordinary technological innovation. Under the Song emperors, the Chinese invented the magnetic compass for sea navigation, printing with moveable clay type, paper money, and gunpowder. Song China was the most technologically advanced society in the world in the early second millennium.

18-10 Fan Kuan, Travelers among Mountains and Streams, Northern Song period, early 11th century. Hanging scroll, ink and colors on silk, $6' ? \frac{1}{4}" \times 3" 4 \frac{1}{4}"$. National Palace Museum, Taibei.

Fan Kuan, a Daoist recluse, spent long days in the mountains studying the effects of light on rock formations and trees. He was one of the first masters of recording light, shade, distance, and texture.

distance, and texture. first masters of the recording of light, shade, leading Chinese painters of the day as the forms. Song critics lauded Fan and other effect of sunlight and moonlight on natural configurations of rocks and trees and the spent long days in the mountains studying ter teacher than were other artists, and he liang. He believed that nature was a betwho shunned the cosmopolitan life of Bian-(see "Daoism and Confucianism," page 488) KUAN (ca. 960-1030) was a Daoist recluse masters worked for the imperial court, FAN Although many of the great Northern Song major subject during the Period of Disunity. scape painting, which first emerged as a Song era is the golden age of Chinese land-FAN KUAN For many art historians, the

strokes the Chinese call "raindrop strokes." small, pale brush marks, the kind of texture mountain, for example, Fan Kuan employed sense of tactile surfaces. For the face of the help model massive forms and convey a brushstroke. Numerous "texture strokes" cate details and on the character of each on the larger composition but also on intriscape fully, observers must focus not only mountains. To appreciate the painted landeyes on a vicarious journey through the The shifting perspectives direct viewers' the top (the shrubbery on the highest cliff). the foreground), and others obliquely from ground (for example, the great boulder in ders. Fan showed some elements from level continues in all directions beyond its bortain nature's grandeur, and the landscape 7-foot-long silk hanging scroll cannot conreduced to minute proportions. The nearly in the lower right corner), which the artist animal figures (for example, the mule train natural forms dwarf the few human and ing from the distance. The overwhelming cal landscape of massive mountains ris-Streams (FIG. 18-10), Fan painted a verti-In Travelers among Mountains and

HUIZONG A century after Fan painted in the mountains of Shanxi, HUIZONG (1082–1135; r. 1101–1126) assumed the Song throne at Bianliang. Less interested in

MATERIALS AND TECHNIQUES

Calligraphy and Inscriptions on Chinese Paintings

Many Chinese paintings (FIGS. 18-6, 18-9, 18-11, 18-14, 18-15, 18-19, and 18-20) bear inscriptions, texts written on the same surface as the picture, or *colophons*, texts written on attached pieces of paper or silk. Throughout Chinese history, calligraphy and painting have been closely connected. Even the primary implements and materials for writing and drawing are the same—a brush, ink, and paper or silk (see "Chinese Painting Materials," page 491). Chinese calligraphy depends for its effects on the controlled vitality of individual brushstrokes and on the dynamic relationships of strokes within a character and among the characters themselves. Training in calligraphy was a fundamental part of the education and self-cultivation of Chinese scholars and officials. Many stylistic variations exist in Chinese calligraphy. At the most formal extreme, each character consists of distinct straight and

angular strokes and is separate from the next character. At the other extreme, the characters flow together as cursive abbreviations with many rounded forms.

A long tradition in China links pictures and poetry. Famous poems frequently provided subjects for paintings, and poets composed poems inspired by paintings. Either practice might prompt inscriptions on artworks.

Some inscriptions address the painting's subject. Others praise the painting's quality or the character of the painter. Some inscriptions explain the circumstances of the work. Later admirers and owners of paintings frequently inscribed their own appreciative words.

Painters, inscribers, and even owners usually also added *seal* impressions in red ink (Figs. 18-14, 18-15, 18-19, and 18-20) to identify themselves. With all these textual additions, some paintings that have passed through many collections may seem cluttered to Western viewers. However, the historical importance given to these inscriptions and to the works' ownership history has been and remains a critical aspect of painting appreciation in China.

18-11 Attributed to Huizong, Auspicious Cranes, Northern Song period, 1112. Section of a handscroll, ink and colors on silk, $1' \, 8 \, \frac{1}{8}" \times 4' \, 6 \, \frac{3}{8}"$. Liaoning Provincial Museum, Shenyang.

Huizong added to the painting on this handscroll a lengthy explanatory text and a poem he composed to underscore that the white cranes that appeared at his palace in 1112 were an auspicious sign.

governing than in the arts, he brought the country to near bank-ruptcy and lost much of the Song's territory to the armies of the Tartar Jin dynasty (1115–1234), which captured the Song capital in 1126 and took Huizong as a prisoner. He died in Jin hands nine years later. An accomplished poet, calligrapher, and painter, Huizong reorganized the imperial painting academy and required the study of poetry and calligraphy as part of the official training of court painters. Prominent inscriptions are frequent elements of Chinese paintings (see "Calligraphy and Inscriptions on Chinese Paintings," above).

A short handscroll (FIG. 18-11) usually attributed to Huizong is more likely the work of court painters under his direction, but it displays the emperor's style as both calligrapher and painter. Huizong's characters represent one of many styles of Chinese calligraphy. They consist of thin strokes, and each character is meticulously aligned with its neighbors to form neat vertical rows. The painting depicts cranes flying over the roofs of Bianliang. It is a masterful combination of elegant composition and realistic observation. The painter carefully recorded the black and red feathers of the white cranes and depicted the birds from a variety of viewpoints to suggest that they

ARCHITECTURAL BASICS Chinese Wood Construction

Although the basic unit of Chinese architecture, the rectangular hall with columns supporting a roof, was common in many ancient civilizations, Chinese buildings have two major distinguishing features: the curving silhouettes of their roofs and their method of construction. The Chinese, like other ancient peoples, used wood to construct their Restliest buildings. Although those structures do not survive, scholars believe that many of the features giving East Asian architecture its specific character may date to the Zhou dynasty.

The typical Chinese hall has a pitched roof with projecting eaves. Timber columns, lintels, and brackets provide the support. The walls have no weight-bearing function but serve only as screens separating inside from outside and room from room. The colors of Chinese buildings, predominantly red, black, yellow, and white, are also distinctive. Chinese wood architecture is customarily multicolored throughout, save for certain parts left in natural color, such as railings made of white marble. The builders usually painted the screen walls and the columns red. Chinese designers often chose dazzling combinations of colors and elaborate patterns for the beams, brackets, eaves, rafters, and ceilings. Artists painted or lacquered the surfaces to protect the timber from rot and wood parasites, as well as to produce an arresting sesthetic effect.

The drawing reproduced here (Fig. 18-12) shows the basic construction method of Chinese architecture, with the major components

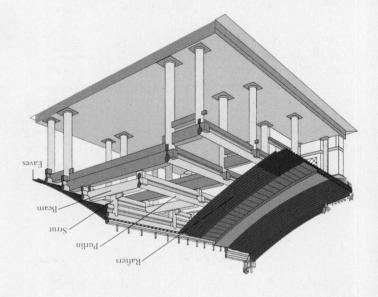

38-32 Chinese raised-beam construction (after L. Liu).

Chinese walls have no weight-bearing function. They serve only as screens separating inside from outside and room from room. Curved rafters and eaves are distinctive features of Chinese architecture.

Remarkably, the highly skilled Chinese workers fit the parts together ules, allowing for standardization of parts and thus rapid construction. The proportions of the structural elements could be fixed into modbay could be no wider or longer than the length of a single tree trunk. extend the building's length to any dimension desired, although each 18-13). Multiplication of the bays (spaces between the columns) could eaves, another typical feature of Chinese architecture (FIGS. 18-1 and of brackets were capable of supporting roofs with broad overhanging tually became the norm throughout East Asia. The interlocking clusters and the variously placed purlins can create curved profiles, which evenrooflines, the varying lengths of the Chinese structures' cross beams trussed timber roof common in the West, which produce flat sloping ing the roof's sloping rafters. Unlike the rigid elements of the triangular and eventually the purlins running the length of the building and carrybeams supported vertical struts, which in turn supported higher beams umns, decreasing the length of the beams as the structure rose. The of a Chinese building labeled. The builders laid beams between col-

without using any adhesive substance, such as mortar or glue.

18-13 Foguang Si Pagoda, Yingxian, China, Liao dynasty, 1056.

The tallest wood building in the world is this Buddhist pagoda at Yingxian. The nine-story tower shows the Chinese wood beam-and-bracket construction system at its most ingenious.

FOGUANG SI PAGODA For two centuries during the Northern Song period, the Liao dynasty (907–1125) ruled part of northern ern China. In 1056, the Liao rulers built the tallest wood building ever constructed (see "Chinese Wood Construction," above, and ever constructed (see "Chinese Wood Construction," above, and ever ronstructed (see "Chinese Wood Fig. 18-12)—the Foguang Si Pagoda (Fig. 18-13) at Yingxian. The pagoda, or tower—the building type most often associated with

were circling around the roof. Huizong did not, however, choose this subject because of his interest in the anatomy and flight patterns of birds. The painting was a propaganda piece commemorating the appearance of 20 white cranes at the palace gates during a festival in 1112. The Chinese interpreted the cranes as an auspicious sign, proof that Heaven had blessed Huizong's rule.

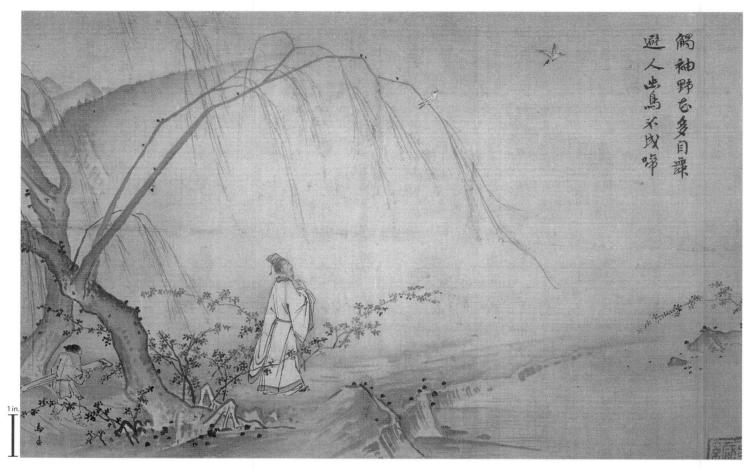

18-14 MA YUAN, On a Mountain Path in Spring, Southern Song period, early 13th century. Album leaf, ink and colors on silk, $10\frac{3}{4}$ " × 1' 5". National Palace Museum, Taibei.

In contrast to Fan (FIG. 18-10), Ma reduced the landscape on this silk album leaf to a few elements and confined them to one part of the page. A solitary robed figure gazes into the infinite distance.

Buddhism in China and other parts of East Asia—is the most eye-catching feature of a Buddhist temple complex. It somewhat resembles the tall towers of Indian temples (see "Hindu Temples," page 471) and their distant ancestor, the Buddhist stupa (see "The Stupa," page 465). As did stupas, many early pagodas housed relics and provided a focus for devotion to the Buddha. Later pagodas served other functions, such as housing sacred images and texts.

The octagonal pagoda at Yingxian is 216 feet tall. Sixty giant, four-tiered bracket clusters carry the floor beams and projecting eaves of the five main stories. They rest on two concentric rings of columns at each level. Alternating main stories and windowless mezzanines with cantilevered balconies, set back farther on each story as the tower rises, form a combined elevation of nine stories. Along with the open veranda on the ground level and the soaring pinnacle, the balconies visually lighten the building's mass.

MA YUAN Gaozong (r. 1127–1162), Huizong's sixth son, fled Bianling after his father's capture, established a new Southern Song capital at Lin'an, and resumed court sponsorship of the arts. During the reign of Ningzong (r. 1194–1224), both the emperor and empress, Yang, frequently added brief poems to the paintings created under their direction. Some painters belonged to families that had worked for the Song emperors for several generations. The most famous was the Ma family. MA YUAN (ca. 1160–1225) painted *On a Mountain*

Path in Spring (FIG. 18-14), a silk album leaf, for Ningzong in the early 13th century. In his composition, in striking contrast to Fan's much larger *Travelers among Mountains and Streams* (FIG. 18-10), Ma reduced the landscape to a few elements and confined the natural setting to the foreground and left side of the page. A large, solitary figure gazes out into the infinite distance. Framing him are the carefully placed diagonals of willow branches. Near the upper right corner, a bird flies toward the couplet Ningzong added in ink:

Brushed by his sleeves, wild flowers dance in the wind; Fleeing from him, hidden birds cut short their songs.

Some scholars have suggested that the author of the two-line poem was Empress Yang, but the inscription is in Ningzong's hand. In any case, landscape paintings such as this one are perfect embodiments of the Chinese ideals of peace and unity with nature.

Yuan Dynasty

The 13th century was a time of profound political upheaval in Asia. During the opening decade, the Islamic armies of Muhammad of Ghor wrested power from India's Hindu kings and established a Muslim sultanate at Delhi (see page 473). Then, in 1210, the Mongols, led by Genghis Khan (1167–1230), invaded China from Central

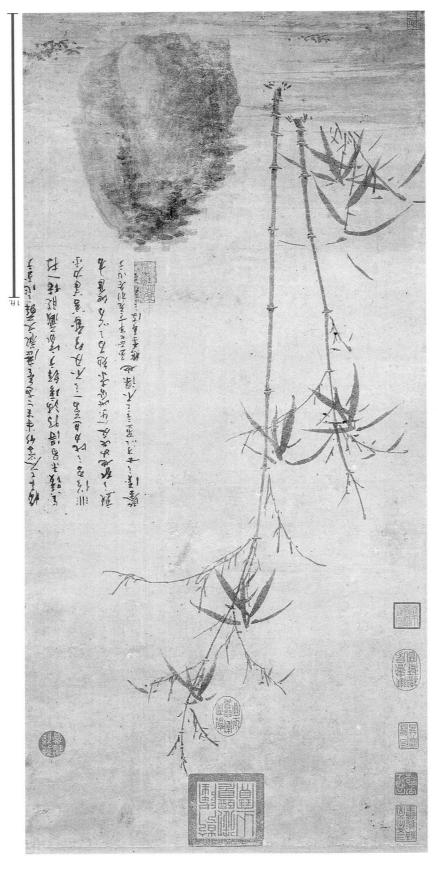

18-15 Wu Zhen, Stalks of Bamboo by a Rock, Yuan dynasty, 1347. Hanging scroll, ink on paper, 2' $\Pi 1_2^{1}$ " $\times 1'$ 4 $\frac{5}{8}$ ". National Palace Museum, Taibei.

Wu Zhen was one of the leading Yuan literati (scholar-artists). The bamboo plants in this hanging scroll are perfect complements to the prominently featured black Chinese calligraphic characters.

Asia. By 1215 they had destroyed the Jin dynasty's capital at Beijing and taken control of northern China. Two decades later, the Mongols attacked the Song dynasty in southern China, but it was not until 1279 that the last Song emperor fell at the hands of Genghis Khan's grandson, Kublai Khan (1215–1294), who proclaimed himself emperor (r. 1279–1294) of the new Yuan dynasty.

During the relatively brief tenure of the Yuan (r. 1279–1368), trade between Europe and Asia increased dramatically. It was no coincidence that Marco Polo (1254–1324), the most famous early European visitor to China, arrived during the reign of Kublai Khan. Part fact and part fable, Marco Polo's chronicle of his travels to and within China was the only eyewitness description of East Asia available in Europe for several centuries. The Venetian's account makes clear that he profoundly admired Yuan China. He paraceled not only at Kublai Khan's opulent lifestyle and palaces but also at the volume of commercial traffic on the Pangrees but also at the volume of commercial traffic on the palaces but also at the volume of commercial traffic on the palaces but also at the volume of commercial traffic on the postal system; and the hygiene of the Chinese postal system; and the chinese postal system; and the chinese postal system; and the chinese or the chinese postal system; and the chinese or the

nologically more advanced than late medieval Europe.

nostalgia for the past. Literati art is usually personal in nature and often shows ing, and other arts as a sign of social status and refined taste. Chinese culture, they cultivated poetry, calligraphy, paintsocial peers. Highly educated and steeped in traditional families who painted primarily for a small audience of their dynasty. The literati were men and women from prominent the literati, or scholar-artists, who emerged during the Song the luxurious milieu of the Yuan emperors. He was among (1280-1354), for example, chose to live as a hermit, far from whom they considered barbarian usurpers. Wu Zhen refused to collaborate with their new foreign overlords, In addition, many Chinese loyal to the former emperors former Southern Song subjects into their administration. art and culture, but they were very selective in admitting WU ZHEN The Mongols were great admirers of Chinese

Bamboo was a popular subject of literati painters because the plant was a symbol of the ideal Chinese Bentleman, who bends in adversity but does not break, and because depicting bamboo branches and leaves approximated the cherished art of calligraphy. In Stalks of Bamboo by a Rock (Fig. 18-15), Wu clearly differentiated the individual bamboo plants and reveled in the abstract patterns formed by the stalks and leaves. The bamboo plants are perfect complements to the calligraphic beauty of the Chinese black characters and red seals so prominently featured on this hanging scroll (see "Calligraphy and Inscriptions," page 493). Both the bamboo and the inscriptions gave the artist the Both the bamboo and the inscriptions gave the artist the poportunity to display his proficiency with the brush.

JINGDEZHEN PORCELAIN By the Yuan period, Chinese potters had extended their mastery to fully developed porcelains, a technically demanding medium (see "Chinese Porcelains," page 497). Two tall temple vases, known as the David Vases (Fig. 18-16) after the collector who acquired them, are the best surviving examples from the Jingdezhen

MATERIALS AND TECHNIQUES

Chinese Porcelain

No other Chinese art form has achieved such worldwide admiration, inspired such imitation, or penetrated so deeply into everyday life as porcelain (FIG. 18-16). Long imported by China's Asian neighbors as luxury goods and treasures, Chinese porcelains later captured great attention in the West, where potters did not succeed in mastering the production process until the early 18th century.

Porcelain objects are fired in a kiln at an extremely high temperature (well over 2,000° Fahrenheit) until the clay fully fuses into a dense, hard substance resembling stone or glass. Unlike traditional

pottery wares, however, ceramists create porcelain from a fine white clay called kaolin mixed with ground petuntse (a type of feldspar). True porcelain is translucent and rings when struck.

Chinese ceramists often decorate porcelains with colored designs or pictures, working with finely ground minerals suspended in water and a binding agent (such as glue). The minerals change color dramatically in the kiln. The painters apply some mineral colors to the clay surface before the main firing and then apply a clear glaze over them. This underglaze decoration fully bonds to the piece in the kiln, but because the raw materials must withstand intense heat, Yuan dynasty potters could fire only a few colors. The most stable and widely used coloring agents for porcelains are cobalt compounds, which emerge from the kiln as an intense blue (Fig. 18-16).

18-16 David Vases, Yuan dynasty, 1351. Pair of white porcelain vases with cobalt-blue underglaze, each 2' 1" tall. British Museum, London (Sir Percival David Foundation of Chinese Art).

The David Vases are early examples of porcelain with cobalt-blue underglaze decoration. Dragons and phoenixes are the major painted motifs. They may be auspicious symbols of male and female energy, respectively.

kilns, which during the Ming dynasty became the official source of porcelains for the court. The pair can be dated exactly by the inscription citing the emperor's regnal year, equivalent to 1351 in the Western calendar. The inscription also says that the vases, together with an incense burner, composed an altar set donated to a Buddhist temple as a prayer for peace, protection, and prosperity for the donor's family. The *David Vases* are among the earliest dated examples of fine porcelain with cobalt-blue *underglaze* decoration. The painted decoration consists of bands of floral motifs between broader zones containing

auspicious symbols, including phoenixes in the lower part of the neck and dragons (compare FIG. 18-4) on the main body of the vessel, both among clouds. These motifs may suggest the donor's high status or invoke prosperity blessings. Because of their vast power and associations with nobility and prosperity, the dragon and phoenix also symbolize the emperor and empress, respectively, and often appear on objects made for the imperial household. The dragon also may represent *yang*, the Chinese principle of active masculine energy, while the phoenix may represent *yin*, the principle of passive feminine energy.

PROBLEMS AND SOLUTIONS Planning an Unplanned Garden

pavilions rise on pillars above the water, and stone bridges, paths, and causeways encourage wandering through ever-changing vistas of trees, flowers, rocks, and their reflections in the ponds. The typical design is a sequence of carefully contrived visual surprises, the polar opposite of the predictable formality of Ming palace architecture (FIG. 18-1).

A favorite garden element, fantastic rockwork, is a prominent feature of Liu Yuan (Lingering Garden; Fie. 18-18) in Suzhou. Workmen dredged the stones from nearby Lake Tai, and then sculptors shaped them to create an even more natural look. The one at the center of Fie. 18-18, called the Guanyun (Cloud Crowned) Peak, is about 20 feet all and weighs approximately 5 tons. The Ming gardens of Suzhou were the pleasure retreats of high officials and the landed gentry, sanctuaries where the wealthy could commune with nature in all its reptractive forms and as an ever-changing and boundless presence. Chinese poets never cease to sing of the restorative effect of gardens on mind and spirit.

The Ming gardens at Suzhou are among the most precious examples of landscape architecture anywhere in the world. Several have been meticulously restored, and in each one, the designers grappled with the problem of how to design a garden that appears not to have been designed—that is, a planned garden that seems unplanned, like nature itself. Laying out a Ming garden was not a matter of cultivating plants in rows or of laying out terraces, flower beds, and avenues in geometric fashion, as was the case in many other cultures (compare, for example, the 17th-century French gardens at Versailles, Fie. 10-31). Instead, Ming gardens, such as the huge (almost 54,000-square-foot) Wangshi Yuan (Garden of the Master of the Fishing Nets; Fie. 18-17), are often scenic arrangements of natural and artificial elements intended to reproduce the irregularities of uncultivated nature. Verandas and to reproduce the irregularities of uncultivated nature. Verandas and

18-18 Guanyun (Cloud Crowned) Peak, rock formation in the Liu Yuan (Lingering Garden), Suzhou, China, Ming dynasty, 16th century and later.

A favorite element of Chinese gardens was fantastic rockwork. For the Lingering Garden, workmen dredged the stones from a nearby lake, and sculptors shaped them to produce an even more natural look.

18-17 Wangshi Yuan (Garden of the Master of the Fishing Nets), Suzhou, China, Ming dynasty, 16th century and later.

Ming gardens are arrangements of natural and artificial elements intended to reproduce the irregularities of nature. This approach to design is the opposite of the formality and axiality of the Ming palace (Fig. 18-1).

18-19 DONG QICHANG, *Dwelling in the Qingbian Mountains*, Ming dynasty, 1617. Hanging scroll, ink on paper, 7' $3\frac{1}{2}$ " × 2' $2\frac{1}{2}$ ". Cleveland Museum of Art, Cleveland (Leonard C. Hanna Jr. bequest).

Dong Qichang, the "first modernist painter," conceived his landscapes as shaded masses of rocks alternating with blank bands, flattening the composition and creating expressive, abstract patterns.

Ming Dynasty

The Ming emperors who succeeded the Yuan as rulers of China were, like many other powerful dynasts throughout history, great builders. Their grandest project was the Forbidden City (FIG. 18-1), the imperial palace complex in Beijing discussed briefly in the introduction to this chapter. Strictly organized along a north-south axis as a series of courtyards alternating with traditional wood buildings featuring curved rooflines, the Forbidden City featured at its heart the Hall of Supreme Harmony (FIG. 18-1b) in which the Son of Heaven received official visitors seated on his throne atop a flight of steps (FIG. 18-1c). The hall's columns, walls, and ceiling are richly decorated with gold lacquer and imperial dragon motifs. Lacquered wood furniture was much admired in China, and the Ming emperors owned countless examples produced by a large workshop in Beijing known today as the Orchard Factory (FIG. 18-16A 1). The Forbidden City housed a huge support staff for the emperor and his family as well as the artists of the imperial painting workshop. One of the leading painters in the employ of the Ming emperors was Shang XI (active ca. 1425-1440; FIG. 18-16B (4).

SUZHOU GARDENS In the Forbidden City, everything, even the gardens, is tightly organized, reflecting the order that the Son of Heaven brings to the world. There can hardly be a greater contrast than that between the formality and rigid axiality of the Forbidden City and the seemingly unplanned Ming-era pleasure gardens at Suzhou (see "Planning an Unplanned Garden," page 498).

DONG QICHANG The Ming emperors maintained an official workshop of painters in the Forbidden City itself, but the venerable tradition of literati painting also flourished. One of the most intriguing and influential literati of the late Ming dynasty was Dong Qichang (1555–1636), a wealthy landowner and high official who was a poet, calligrapher, and painter. He also amassed a vast collection of Chinese art and achieved great fame as an art critic. In Dong's view, most Chinese landscape painters could be classified as belonging to either the Northern School of precise, academic painting or the Southern School of more subjective, freer painting. "Northern" and "Southern" were not geographic but stylistic labels. Dong chose these names for the two schools because he determined that their characteristic styles had parallels in the northern and southern schools of Chan Buddhism. Northern Chan Buddhists were "gradualists" and believed that enlightenment could be achieved only after long training. The Southern Chan Buddhists believed that enlightenment could come suddenly. Dong's Northern School therefore comprised professional, highly trained court painters, whose role was to promote Ming ideology. The leading painters of the Southern School were the literati, whose freer and more expressive style Dong judged to be far superior.

Dong's own work—for example, *Dwelling in the Qingbian Mountains* (FIG. 18-19)—belongs to the Southern School that he

berseverance. steep mountain expresses loneliness and this album leaf, the solitary rider scaling a Shitao experimented with unusual composi-

Smithsonian Institution, Washington, $I' \frac{1}{4}" \times 8 \frac{7}{8}"$. Arthur M. Sackler Gallery, Album leaf, ink and colors on paper, Riding the Clouds, Qing dynasty, 1707.

tions and extreme effects of massed ink. In

mordial line" as the root of all phenomena and representation. adopted name), called for use of the "single brushstroke" or "primost notably his Sayings on Painting from Monk Bitter Gourd (his and he was orphaned as an infant.) Shitao's theoretical writings, ecution as a Ming loyalist. (Most of his family had been murdered, a Chan Buddhist monk at age 20, which protected him from pros-1642-1707), a descendant of the Ming imperial family who became new directions. Perhaps the most innovative was SHITAO (DAOJI, SHITAO Other Qing painters, however, took landscape painting in

much depict the landscape's appearance as animate it, applying ink artist's distinctive style. Unlike traditional literati, Shitao did not so and large blank areas are characteristic features of this pioneering scape and the massing of thick ink alternating with sinuous lines perseverance. The sharp angle that Shitao used to record the landamid low-hanging clouds expresses the themes of loneliness and in Nanjing. Here, the solitary rider scaling a steep mountain path his personal feelings, some happy, some sad, about his reclusive life during the last year of his life. Each of the paintings encapsulates Painting Formats," page 491) in a series of 12 that Shitao produced Riding the Clouds (FIG. 18-20) is one album leaf (see "Chinese

with unprecedented expressive force.

painting (FIG. 13-15). shadowing developments in 19th-century European landscape critics have called Dong Qichang the first modernist painter, foreposition and creating highly expressive and abstract patterns. Some masses of rocks alternate with flat, blank bands, flattening the comespecially in his treatment of the towering mountains, where shaded ist's debt to earlier literati painters. But Dong was also an innovator, poration of a long inscription at the top, immediately reveal the artadmired so much. The scroll's subject and style, as well as the incor-

Qing Dynasty

and cultivated knowledge of China's arts, including traditional liteing all of China. The Manchus adapted themselves to Chinese life (Lasting Prosperity) emperor (r. 1662-1722), succeeded in pacify-China remained rebellious until the second Qing ruler, the Kangxi chus quickly restored effective imperial rule in the north. Southern century and establish the Qing dynasty (r. 1644-1911). The Maninvaders, the Manchus of Manchuria, to overrun China in the 17th The Ming bureaucracy's internal decay enabled another group of

005

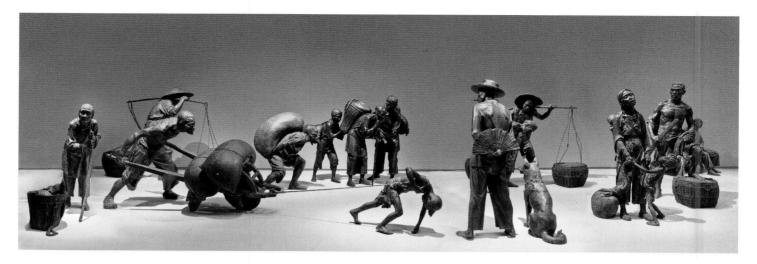

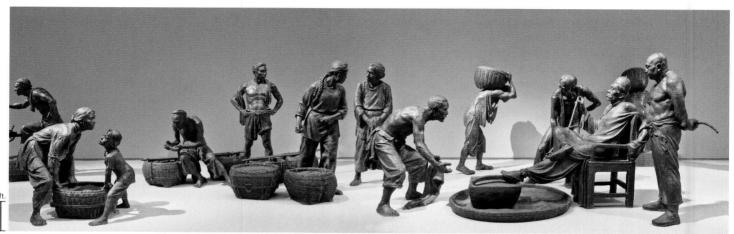

18-21 YE YUSHAN and others, *Rent Collection Courtyard* (two details of a larger tableau), Dayi, China, 1965. Clay, 100 yards long with life-size figures.

In this propagandistic tableau incorporating 114 figures, sculptors depicted the exploitation of peasants by their merciless landlords during the grim times before the Communist takeover of China.

People's Republic

The overthrow of the Qing dynasty and establishment of the Republic of China under the Nationalist Party in 1912 did not bring an end to the traditional themes and modes of Chinese art. But the triumph of Marxism in 1949, when the Communists took control of China and founded the People's Republic, inspired a social realism that broke drastically with the past. The intended purpose of Communist state-sponsored art was to promote Marxist ideas and official government propaganda.

YE YUSHAN In *Rent Collection Courtyard* (FIG. 18-21), a 1965 tableau 100 yards long and incorporating 114 life-size figures, YE YUSHAN (b. 1935) and a team of sculptors employed by the Communist government in Dayi depicted the grim times before the People's Republic. Peasants, worn and bent by toil, bring their taxes (in produce) to the courtyard of their merciless, plundering landlord. (The group was first displayed in the actual courtyard of the former home of the pre-Communist rural landlord Liu Wencai.) The message is clear—this kind of exploitation must not happen again, and the Communists will ensure that it does not. Initially, the authorities did not reveal the artists' names. The anonymity of those who

depicted the event was significant and consistent with the Communist ethic. By withholding the identities of the artists, the state underscored that collective action, not individual initiative, was the best means to transform society for the better.

KOREA

Korea is a peninsula that shares borders with China and Russia and faces the islands of Japan (MAPS 18-1 and 19-1). Korea's pivotal location is a key factor in understanding the relationship of its art to that of China and the influence of Korean art on Japanese art.

Three Kingdoms Period

About 100 BCE, during the Han dynasty, the Chinese established outposts in Korea. The most important was Lolang, which became a prosperous commercial center. By the middle of the century, however, three native kingdoms—Goguryeo, Baekje, and Silla—controlled most of the Korean peninsula and reigned for more than seven centuries until Silla completed its conquest of its neighbors in 668 CE.

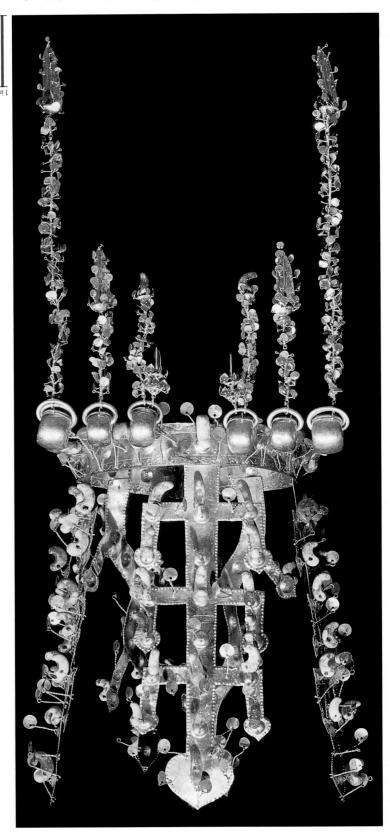

18-22 Crown, from the north mound of the Cheonmachong tomb (tomb 98), Hwangnam-dong, near Gyeongju, Korea, Three Kingdoms Period, fifth to sixth century. Gold and jade, $10\frac{3}{4}$ high. Gyeongju National Museum, Gyeongju.

This gold-and-jade crown from a Silla tomb attests to the wealth of that kingdom and the skill of its artists. The uprights may be stylized tree and antler forms symbolizing life and supernatural power.

During this era, known as the Three Kingdoms period (ca. 57 BCE-668 CE), Korea remained in continuous contact with both China and Japan. Buddhism came to Korea from China in the fourth century CE. The Koreans in turn transmitted it from the peninsula to Japan in the sixth century.

gold may have come to Korea from northeast China. Chinese counterpart, although the technique of working sheet life and supernatural power. The Cheonmachong crown has no uprights as stylized tree and antler forms believed to symbolize jade further embellishing the crown. Archaeologists interpret the and wires secure the whole, as do the comma-shaped pieces of cut from sheet gold and embossed along the edges. Gold rivets uprights—as well as the myriad spangles adorning them, were Silla artists. The crown's major elements—the band and the sixth century, also attests to the high quality of artisanship among tomb at Hwangnam-dong, near Gyeongju, dated to the fifth or crown (FIG. 18-22) from the Cheonmachong (Heavenly Horse) city's ancient name—Kumsong (City of Gold). The gold-and-jade ers. Finds in the region of Gyeongju, the Silla capital, justify the tacular artifacts representative of the wealth and power of its rul-SILLA CROWN Tombs of the Silla kingdom have yielded spec-

mobgniX slli2 bailinU

Aided by China's emperor, the Silla kingdom conquered the Goguryeo and Baekje kingdoms and unified Korea in 668. The era of the Unified Silla Kingdom (668–935) is roughly contemporaneous with the Tang dynasty's brilliant culture in China, and many consider the era to be Korea's golden age.

SEOKGURAM The Silla rulers embraced Buddhism both as a source of religious enlightenment and as a protective force. They considered the magnificent Buddhist temples they constructed in and around their capital of Gyeongju to be supernatural defenses as and around their capital of Gyeongju to be supernatural defenses against external threats as well as places of worship. Unfortunately, none of these temples survived Korea's turbulent history. However, at Seokguram, near the summit of Mount Toham, northeast of the city, a splendid granite Buddhist monument helps fill the gap. Kim Tae-song, a member of the royal family who served as prime minister, initiated construction of the temple in 742 to honor his parents in his previous life. Certainly, the intimate scale of Seokguram and the quality of its reliefs and free-standing figures suggest that it was a private chapel for royalty. The main rotunda (circular area under a dome; FIG. 18-23)

(FIG. 17-6, top right). Although remote in time and place from the it to witness the realization of his enlightenment at Bodh Gaya the image represents the Buddha as he touched the earth to call ber and faces the entrance. Carved from a single block of granite, Shakyamuni, the historical Buddha, which dominates the cham-All these figures face inward toward the 11-foot-tall statue of contain miniature statues of seated bodhisattvas and believers. and guardians line the lower zone of the wall. Above, 10 niches instead of mortar. Sculpted images of bodhisattvas, lohans, of various shapes and sizes, attaching them with stone rivets tion. Instead, workers assembled hundreds of granite pieces ture were not cut from the rock in the process of excava-Dunhuang (FIG. 18-8), the interior wall surfaces and sculpthe Chinese Buddhist caves at Longmen (FIG. 18-7) and the Seokguram project required substantial resources. Unlike measures about 21 feet in diameter. Despite its modest size,

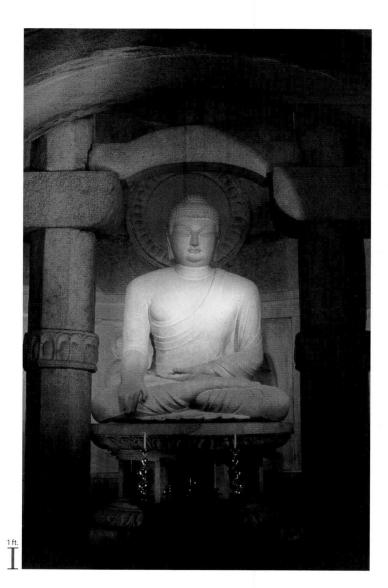

18-23 Shakyamuni Buddha, in the rotunda of the cave temple, Seokguram, Korea, Unified Silla Kingdom, 751-774. Granite, 11' high.

Unlike rock-cut Chinese Buddhist shrines, this Korean cave temple was constructed of granite blocks. Dominating the rotunda is a huge statue depicting the Buddha at the moment of his enlightenment.

Sarnath Buddha (FIG. 17-7) in India, this majestic image remains faithful to its iconographic prototype. However, no close precedents exist for the figure's distinctly broad-shouldered dignity combined with harmonious proportions. Art historians consider this Korean statue one of the finest images of the Buddha in East Asia.

Joseon Dynasty

At the time the Yuan overthrew the Song dynasty in China, the Goryeo dynasty (r. 918–1392), which had ruled Korea since the downfall of China's Tang dynasty, was still in power. The Goryeo kings outlasted the Yuan as well. Toward the end of the Goryeo dynasty, however, the Ming emperors attempted to take control of northeastern Korea. General Yi Seong-gye (1335–1408) repelled them and founded the last Korean dynasty, the Joseon, in 1392. The long rule of the Joseon kings ended only in 1910, when Japan annexed Korea.

NAMDAEMUN, SEOUL Public building projects helped give the new Korean state an image of dignity and power. One impressive early monument, built for the new Joseon capital of Seoul, is the city's south gate, or Namdaemun (FIG. 18-24). It combines the imposing strength of its stone foundations with the sophistication of its intricately bracketed wood superstructure. In East Asia, elaborate gateways, often in a processional series, are a standard element in city designs, as well as royal and sacred compounds, all usually surrounded by walls, as at Beijing's Forbidden City (FIG. 18-1). These gateways served as magnificent symbols of the ruler's authority, as did the triumphal arches of imperial Rome (FIGS. 3-32 and 3-53).

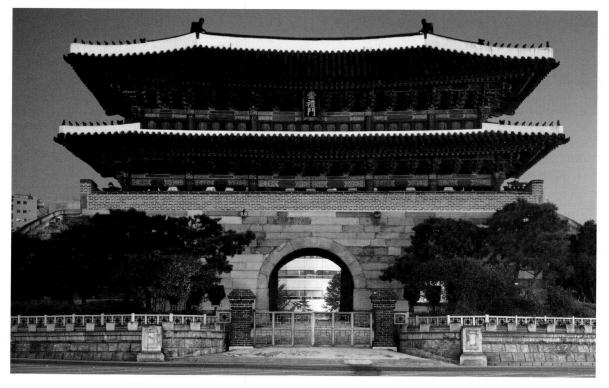

18-24 Namdaemun (looking southwest), Seoul, South Korea, Joseon dynasty, first built in 1398.

The new Joseon dynasty constructed the south gate to their new capital of Seoul as a symbol of their authority. Namdaemun combines stone foundations with Chinese-style bracketed wood construction.

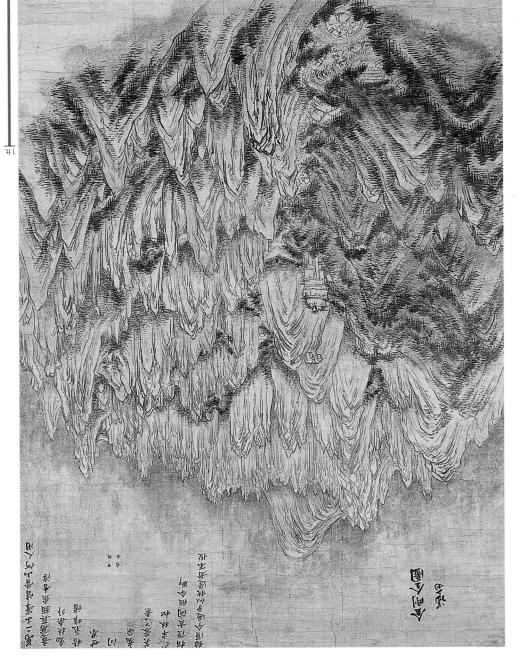

18-25 Jeong Seon, Geumgangsan Mountains, Joseon dynasty, 1734. Hanging scroll, ink and colors on paper, $4'3\frac{1}{2}"\times 1'11\frac{1}{4}"$. Hoam Art Museum, Kyunggi-Do.

In a variation on Chinese literati painting, Jeong used sharp, dark brushstrokes to represent the bright crystalline appearance and spiky forms of the towering Diamond Mountains in North & Korea.

tains and to emphasize their spiky forms. bright crystalline appearance of the mounliterati favored, he was able to represent the the fibrous brushstrokes that most Chinese painting. Using sharper, darker versions of an approach known in Korea as "true view" South Korea, Jeong evoked a specific scene, peak in North Korea near the border with a view of the 1,638-meter-high mountain gangsan (Diamond) Mountains (FIG. 18-25), of the mountainous landscape. In Geumdistinctive vision to the traditional theme Southern School painting who brought a (1676-1759), a great admirer of Chinese most renowned painters was Jeong Seon Ming and Qing China. One of Korea's the same wide range of subjects seen in in many different modes and treated Joseon dynasty, Korean painters worked JEONG SEON Over the long course of the

Modern Korea

After its annexation in 1910, Korea remained part of Japan until 1945, when the Western Allies and the Soviet Union took control of the peninsula nation at the end of World War II. Korea was divided end of World War II.

into the Democratic People's Republic of Korea (North Korea) and the Republic of Korea (South Korea) in 1948. South Korea soon emerged as a fully industrialized nation, and its artists have had a wide exposure to art styles from around the globe. While some Korean and Chinese artists continue to work in a traditional East Asian manner, others—for example, Song Su-nam (FIG. 16-16B A) and Do-Ho Suh (FIG. 16-25A A)—have embraced developments in Europe and America. Contemporary East Asian art is examined in Chapter 16.

 \mathbb{A} Explore the era further in MindTap with videos of major artworks and buildings, Google Earth^m coordinates, and essays by the author on the following additional subjects:

- MATERIALS AND TECHNIQUES: Chinese Jade
- Eastern Zhou bi disk (FIG. 18-2A)
- MATERIALS AND TECHNIQUES: Silk and the Silk Road
- PATISTS ON ART: Xie He's Six Canons
- Ming lacquered table with drawers (FIG. 18-16A)
- Shang Xi, Guan Yu Captures General Pang De (FIG. 18-16B)

CHINA AND KOREA

Shang to Qin Dynasties

The Shang (ca. 1600–1050 BCE) is the earliest well-documented Chinese dynasty. The Shang kings ruled the Yellow River valley. Shang bronze-workers were among the best in the ancient world. The Zhou dynasty (ca. 1050–256 BCE) was the longest in China's history. During the last centuries of Zhou rule, Daoism and Confucianism gained wide followings in China. Shi Huangdi founded the short-lived Qin dynasty (221–206 BCE) after defeating the Zhou and other rival states. A terracotta army of at least 8,000 soldiers guarded the First Emperor's burial mound at Lintong.

Army of Shi Huangdi, Lintong, ca. 210 BCE

Han to Tang Dynasties

The Han dynasty (206 BCE-220 CE) extended China's boundaries. Han tombs have yielded rich finds, including painted silks and bronze figurines. Civil strife divided China into competing states during the Period of Disunity (220-581 CE). China enjoyed unequaled prosperity and power under the Tang emperors (618-907), whose capital at Chang'an became the most cosmopolitan city in the world. The Tang dynasty was the golden age of Chinese figure painting. Yan Liben's *Thirteen Emperors* handscroll illustrates historical figures as exemplars of Confucian ideals. The Dunhuang mural paintings provide evidence of the magnificence of Tang Buddhist art.

Flying horse of Governor-General Zhang, late second century CE

Song and Yuan Dynasties

Song China (Northern Song, 960-1127, capital at Bianliang; Southern Song, 1127-1279, capital at Lin'an) was the most technologically advanced society in the world in the early second millennium. The Song era also marked the height of Chinese landscape painting. Among the leading artists were Fan Kuan and Ma Yuan. The Mongols invaded northern China in 1210 and defeated the last Song emperor in 1279 to establish the Yuan dynasty (1279-1368). Yuan China was richer and technologically more advanced than Europe. The Jingdezhen kilns gained renown for porcelain pottery with cobalt-blue underglaze decoration.

Ma Yuan, On a Mountain Path in Spring, early 13th century

Ming Dynasty to 1980

The Ming dynasty (1368-1644) constructed a vast new imperial palace compound, the Forbidden City, at its capital of Beijing. Surrounded by a moat and featuring an axial plan, it was the ideal setting for court ritual. At the opposite architectural pole are the gardens of Suzhou, which reproduce the irregularities of uncultivated nature. Under the Qing dynasty (1644-1911), traditional painting styles remained fashionable, but some Qing painters, such as Shitao, experimented with extreme effects of massed ink and free brushwork patterns. The overthrow of the Qing dynasty did not bring a dramatic change in Chinese art, but when the Communists gained control in 1949, state art focused on promoting Marxist ideals in vast propaganda pieces, such as Rent Collection Courtyard.

Hall of Supreme Harmony, Forbidden City, Beijing, 15th century and later

Korea

The art of Korea is closely related to both Chinese and Japanese art. The first golden age of Korean art and architecture was under the Unified Silla Kingdom (668–935), when a magnificent Buddhist complex was constructed at Seokguram. The last Korean dynasty was the Joseon (1392–1910), which established its capital at Seoul and erected impressive public monuments, such as the Namdaemun gate, to serve as symbols of imperial authority.

Shakyamuni Buddha, Seokguram, 751-774

■ 19-1b The maid attending her mistress turns her head toward a chiming clock.

Harunobu based his print on a Chinese series featuring temple bells, but substituted a lapanese clock for the Chinese bells.

▲ 19-1c Harunobu's prints focus on the daily lives of Japanese women, a subject he pioneered. Erotic themes are quite common in ukiyo-e. Here, a beautiful woman dries herself on her veranda after bathing.

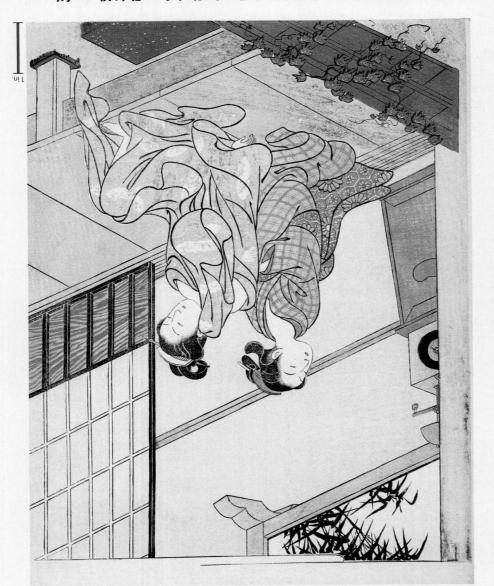

Suzukı Навимови, Evening Bell at the Clock, from Eight Views of the Parlor, Edo period, 1765. Woodblock print, 11 $\frac{1}{4}$ " \times 8 $\frac{1}{2}$ ". Art Institute of Chicago, Chicago (Clarence Buckingham Collection).

Japan

THE FLOATING WORLD OF EDO

In 1185, the Japanese emperor in Kyoto appointed the first *shogun* (head of the military government) in Kamakura. In theory, the shogun managed the country on the emperor's behalf, but in reality the emperor lost most of his governing authority. The Japanese *shogunate* was a political and economic arrangement in which feudal lords called *daimyo* (Japanese, "great names"), the leaders of powerful warrior bands composed of *samurai* (Japanese, "guards"), pledged allegiance to the shogun but retained ownership of and control over their own domains. In 1615, the shogun set up his headquarters in Edo (modern Tokyo), initiating the Edo period (1615–1868) of Japanese history and art.

The ensuing rapid urbanization of Edo led to an increase in the pursuit of sensual pleasure and entertainment in the city's brash popular theaters and brothels of its Yoshiwara district, which the prosperous merchant class and samurai frequented. Those of lesser means could partake in these pleasures and amusements vicariously. Rapid developments in the printing industry led to the availability of inexpensive pictures (see "Japanese Woodblock Prints," page 522), and these *ukiyo-e* ("pictures of the floating world") conveyed the city's delights for a fraction of the cost of direct participation.

One of the most admired ukiyo-e printmakers was Suzuki Harunobu (ca. 1725–1770), who played a key role in developing polychrome prints. Called *nishiki-e* ("brocade pictures") because of their texture and brilliant color, these prints, in contrast to most Edo prints, employed the highest-quality paper and costly pigments.

The sophistication of Harunobu's work is evident in *Evening Bell at the Clock* (FIG. 19-1), from a series called *Eight Views of the Parlor*, which drew on a Chinese series, *Eight Views of the Xiao and Xiang Rivers*. In the Chinese model, each image focuses on a particular time of day or year. In Harunobu's adaptation, beautiful young women and the activities occupying their daily lives became the subject of each picture. These themes were new to the ukiyo-e repertoire, but after Harunobu introduced them, they became common. In *Evening Bell at the Clock*, two young women seen from the typically Japanese elevated viewpoint sit on a veranda. One is drying herself after a bath. The viewer gets a privileged glimpse of a private moment. (Erotic themes, including explicit depictions of lovemaking, are quite common in ukiyo-e.) The bather's companion—her maid—turns to face the chiming clock. Here, the artist playfully transformed the great temple bell ringing over the waters in the Chinese series into a modern Japanese clock. In Harunobu's nishiki-e prints, the flatness of the depicted objects and the rich color recall the traditions of court painting, but in a much more affordable medium. This was especially true of the more ordinary prints sold in small shops and on the street, which went for the price of a bowl of noodles.

MAP 19-1 Japan.

Kotun

the power and wealth of those buried beneath them. in other ancient cultures, these gigantic tombs served to proclaim appear in the third century. (Ko means "old"; fun means "tomb.") As the enormous earthen burial mounds, or tumuli, that had begun to Historians named the succeeding Kofun period (ca. 300-552)* after

*From the point on, all dates in this chapter are CE unless otherwise noted.

producing culture antedates the birth of the Bud-

prising number of them inhabited. Yet Japanese

and Kyushu—and hundreds of smaller ones, a sur-

four main islands-Hokkaido, Honshu, Shikoku,

The Japanese archipelago (MAP 19-1) consists of

JAPAN BEFORE BUDDHISM

lower and Yayoi dha by roughly 10,000 years. among them. However, the earliest Japanese artresponsiveness to imported ideas—Buddhism civilizations, but rather has long demonstrated culture does not share the isolation of some island

any other area of the world. before 10,000 BCE-older than the ceramics in dated some pottery fragments found in Japan to ticed agriculture. In fact, archaeologists have tive ceramic technology, even before they pracsettled lives enabled them to develop a distincnomadic, the Jomon inhabited villages. Their ers, but unlike most similar societies, which were vessels. The Jomon people were hunter-gathernese potters of this era used to decorate ceramic markings") and refers to the technique that Japaits name from the Japanese word jomon ("cord The Jomon period (ca. 10,500-300 BCE) takes

ernmost of the main Japanese islands. Increased Yayoi (ca. 300 BCE-330 CE) in Kyushu, the south-The Jomon culture gradually gave way to the

interaction with both China and Korea and

Yayoi period, the Japanese also developed bronze-casting and loom social and economic foundations for this development. During the highly stratified social structure. Wet-rice agriculture provided the noted that Japan had walled towns, many small kingdoms, and a ceived need for defense. In the third century CE, Chinese visitors ants built fortifications and moats around them, indicating a pertransformations. Japanese villages grew in size, and their inhabitimmigration from Korea brought dramatic social and technological

Meiji and Showa 0861-8981

as a Living National official recognition Hamada Shoji receives Ceramic master Olympics in Tokyo. diums for the 1964 the modernist sta-Kenzo Tange designs

Edo 8981-5191

Edo's "floating world" seusnal pleasures of buurs gebicring rue Japanese woodblock cuoor painting to the Kano alternative style of emerges as the major The Rinpa School domestic architecture. standard for Japanese Villa at Kyoto sets the The Katsura Imperial

reach a wide audience.

Мотоуата SL9L-EZSL

plify the aesthetic Zuino ceramics exemfoster humility. designs teahouses that tea ceremony and master of the Japanese the most renowned Sen no Rikyu becomes ish use of gold leat. screens featuring lavwith painted folding tial fortress-castles decorate their palasungous asaueder

principles of wabi and

Muromachi Kamakura and EZSL-5811

lenoiten eseneget leut School becomes a virprominence. The Kano of sasin msidbbud na2 period (1333-15/3), During the Muromachi ock-crystal eyes. portraits in wood with tors create realistic (1185-1332). Sculpzemakura period shoguns during the yields power to The Japanese emperor

painting academy.

Asuka, Nara, Heian S8LL-Z99

Esoteric Buddhism (Kyoto) in 794, and moves to Heiankyo The imperial capital 'sjapou follows Chinese temple architecture tsidbbu8 (487-244) During the Nara period (225-645). the Asuka period In 552, initiating Japan from Korea m Buddhism arrives in

period (794-1185). during the Heian

takes hold in Japan

on top of them. (haniwa) around and cylindrical clay figures wonuqs aug blace keyhole-shaped burial construct monumental pottery and bronzes. artisans produce fine (300 BCE-320 CE) 300 BCE) and Yayoi

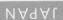

-005,01) nomol Jomon, Yayoi, Kofun 10,500 BCE-552 CE

Kofun (300-552) elite

19-2 Aerial view of the tomb of Emperor Nintoku (looking northeast), Sakai, Osaka Prefecture, Japan, Kofun period, late fourth to early fifth century.

The largest Kofun tumulus, attributed to Emperor Nintoku, has a keyhole shape and three surrounding moats. About 20,000 clay haniwa originally stood on the gigantic earthen mound.

TOMB OF NINTOKU The largest tumulus in Japan, at Sakai, is usually identified as the tomb of Emperor Nintoku, although some scholars think that the tumulus postdates his death in 399. The central mound, which takes the standard Kofun "keyhole" form, is 1,574 feet long and rises to a height of 114 feet. Surrounded by three moats, the entire site covers 458 acres (FIG. 19-2). Kofun tumuli usually had a stone-walled burial chamber near the summit of the mound. Inside were the deceased's coffin and numerous objects to take into the afterlife. The objects buried with exalted individuals such as Emperor Nintoku included imperial regalia, swords, and bronze mirrors. The mirrors were imports from China, but the form of the Kofun keyhole tombs and many of the other burial goods—for example, comma-shaped jewels—suggest even closer connections with Korea (compare FIG. 18-22).

HANIWA The Japanese also placed unglazed ceramic sculptures called haniwa on and around Kofun tumuli. These sculptures, usually several feet in height, as is the warrior shown here (FIG. 19-3), are distinctly Japanese. Compared with the Chinese terracotta soldiers and horses (FIG. 18-3) buried with the First Emperor of Qin, these statues appear deceptively whimsical as variations on a cylindrical theme (hani means "clay"; wa means "circle"). Yet haniwa sculptors skillfully adapted the basic clay cylinder into a host of forms, from abstract shapes to objects, animals, and human figures. These artists altered the shapes of the cylinders, emblazoned them with applied ornaments, excised or built up forms, and then painted the haniwa. The variety of figure types suggests that the haniwa did not function as military guards but rather represented the realm that the deceased ruled during life. The Japanese set the statues both in curving rows around the tumulus and in groups around a haniwa house placed directly over the deceased's burial chamber. The arrangement may mimic a funeral procession in honor of the dead.

19-3 Haniwa warrior figure, from Gunma Prefecture, Japan, late Kofun period, fifth to mid-sixth century. Lowfired clay, 4' $3\frac{1}{4}$ " high. Tokyo National Museum, Tokyo.

During the Kofun period, the Japanese set up cylindrical clay statues (haniwa) of humans, animals, and objects on burial tumuli. They may represent the realm that the deceased ruled when alive.

Presumably, the number of sculptures reflected the stature of the dead person. Emperor Nintoku's tumulus had about 20,000 haniwa placed around the mound.

BUDDHIST JAPAN

In 552, according to traditional interpretation, King Syong Myong of Baekje, one of Korea's Three Kingdoms (see page 501), sent Emperor Kimmei (r. 539–571) a gilded-bronze statue of the Buddha along with *sutras* (Buddhist scriptures) translated into Chinese, at the time the written language of eastern Asia. This event marked the beginning of the Asuka period (552–645), during which the ruling elite embraced major elements of continental culture that had been gradually filtering into Japan. These cultural components, which ultimately became firmly established in Japan, included Chinese writing, Confucianism, and Buddhism. Older beliefs and practices (those that came to be known as Shinto—Way of the Gods; see "Shinto" (**J*) continued to have significance, especially as agricultural rituals and imperial court rites. As time passed, Shinto deities even gained new identities as local manifestations of Buddhist deities. Shinto continues to play a role in modern Japanese thought, and its

19-4 Tori, Shaka triad, kondo, Horyuji, Ikaruga, Nara Prefecture, Japan, Asuka period, 623. Bronze, central figure 2' 10" high.

Tori's Shaka triad (the historical Buddha and two bodhisattvas) is among the earliest Japanese Buddhist sculptures. The elongated heads and elegant swirling drapery reflect Chinese models.

HORYUII KONDO Tori created his *Shaka triad* for Horyuji, an Asuka Buddhist temple complex that Prince Shotulu founded near the estate at Ikaruga, outside Nara. Fire destroyed the temple, but the priests rescued Tori's statue and reinstalled it around 680 in the kondo, or Golden Hall, of the successor Nara-era complex (FIG. 19-5).

main shrine (Fig. 19-3A (A)), at Ise, is meticulously maintained and rebuilt every 20 years.

In 645, a series of reforms led to the establishment of a centralized government in place of the individual clans that controlled Japan's different regions. This shift marked the beginning of the Nara period (645–784), when the Japanese court, ruling from a series of capitals south of present-day Kyoto, increasingly adopted the forms and rites of the Chinese court. In 710, the Japanese finally established what they intended as a permanent capital at Heijo (present-day Nara). City planners laid out the new capital on a symmetrical grid closely modeled on the plan of the Chinese capital of Chang'an.

Asuka and Nara

In the arts associated with Buddhist practices, Japan followed Korean and Chinese prototypes very closely, especially during the Asuka and Nara periods. In fact, early Buddhist architecture in Japan adhered so closely to mainland standards (although generally with a considerable time lag) that surviving Japanese temples have helped greatly in the reconstruction of what was almost completely lost in China and Korea.

ment contrast with the serenity of his pose and expression. defying, waterfall-like swirls. The vibrant patterns of Shaka's garfeatured clongated heads and elegant drapery folds forming gravityof the early to mid-sixth century in China and Korea, a style that dant of a Chinese immigrant. Tori's Buddha triad reflects the style Busshi (busshi means "maker of Buddhist images"), was a descensmall figures of other Buddhas. The sculptor, Tori, known as Tori is a flaming mandorla (a lotus-petal-shaped nimbus) incorporating "Buddhism and Buddhist Iconography," page 466). Behind Shaka his right hand raised in the abhaya mudra (fear-not gesture; see Japanese name for Shakyamuni, the historical Buddha), seated with for rebirth in Paradise. The central figure in the triad is Shaka (the the triad to the prince's well-being in his next life and to his hoped-Shotuku, fell ill in 621. When Shotuku died, the empress dedicated missioned the work as a votive offering when her nephew, Prince bodhisattvas; FIG. 19-4) dated 623. Empress Suiko (r. 593-628) comdhist sculpture is a bronze Buddha triad (Buddha flanked by two TORI BUSSHI Among the earliest extant examples of Japanese Bud-

19-5 Aerial view of the Horyuji temple complex (looking northwest), Ikaruga, Nara Prefecture, Japan, Nara period, ca. 680.

The main components of a Japanese Buddhist temple complex were the kondo (Golden Hall), which housed statues of the Buddha and bodhisattvas, and the podhisattvas, and the relics of the Buddha.

The kondo, like the later and more grandiose Daibutsuden kondo (FIG. 19-5A 1) at Todaiji, was the main hall for worship and housed statues of the Buddha and the bodhisattvas that the temple honored. Although periodically repaired and somewhat altered, the Horyuji kondo retains its graceful but sturdy forms beneath the modifications. The main pillars (not visible in FIG. 19-5 due to the addition of a porch in the eighth century) decrease in diameter from bottom to top. The tapering provides an effective transition between the more delicate brackets above and the columns' stout forms. Also somewhat masked by the later porch is the harmonious reduction in scale from the lower to the upper roof. Following Chinese models, the builders used ceramic tiles as roofing material and adopted the distinctive curved roofline of Chinese architecture (see "Chinese Wood Construction," page 494). Among the other buildings at the site is a five-story, 122-foot-tall pagoda that serves as a reliquary.

Heian

In 784, possibly to escape the power of the Buddhist priests in Nara, the imperial house moved its capital north, eventually relocating in 794 to what became its home until modern times. Originally called Heiankyo (Capital of Peace and Tranquility), its name today is Kyoto. The Heian period (794-1185) of Japanese art takes its name from the new capital. Early in the period, Japan maintained fairly

close ties with China, but from the middle of the ninth century on, relations between Japan and China deteriorated so rapidly that by the end of that century, court-sponsored contacts had ceased. Japanese culture became much more self-directed than it had been in the preceding few centuries.

ESOTERIC BUDDHISM Among the major developments during the early Heian period was the introduction of Esoteric Buddhism to Japan from China. The name reflects the secret transmission of its teachings. Two Esoteric sects made their appearance: Tendai in 805 and Shingon in 806. The teachings of Tendai were based on the Lotus Sutra, one of the Buddhist scriptural narratives. The sources for Shingon (True Word) teachings were two other sutras-the Mahavairocana and the Vajrasekhara. Both Tendai and Shingon Buddhists believe that all individuals possess Buddha nature and can achieve enlightenment through meditation rituals and careful living. To aid focus during meditation, Shingon disciples use special hand gestures (mudras) and recite particular words or syllables (mantras in Sanskrit, shingon in Japanese). Shingon became the primary form of Buddhism in Japan through the mid-10th century.

TAIZOKAI MANDARA Because of the emphasis on ritual and meditation in Shingon, the arts flourished during the early Heian period. Both paintings and sculptures provided followers with visualizations

of specific Buddhist deities and enabled them to contemplate the transcendental concepts central to the religion. Of particular importance in Shingon meditation was the mandara (mandala in Sanskrit), a diagram of the cosmic universe. The most famous Japanese mandaras are the Womb World (Taizokai) and the Diamond World (Kongokai). Together they formed a complementary pair on the wall of a Shingon kondo. The central motif in the Womb World is the lotus of compassion. (In the Diamond World, it is the diamond scepter of wisdom.) The Womb World is composed of 12 zones, each representing one of the various dimensions of Buddha nature (for example, universal knowledge, wisdom, achievement, and purity). The mandara illustrated here (FIG. 19-6)—at Kyoogokokuji (Toji), the Shingon teaching center established at Kyoto in 823—is among the oldest and best preserved. Many of the figures hold lightning bolts, symbolizing the power

of the mind to destroy human passion. 19-6 Taizokai (Womb World) mandara, Kyoogokokuji (Toji), Kyoto, Japan, Heian period, ca. 850-900. Hanging scroll, colors on silk, $6' \times 5' \frac{5}{8}$ ".

The Womb World mandara is a diagram of the cosmic universe, composed of 12 zones representing the dimensions of Buddha nature. Mandaras played a central role in Esoteric Buddhist meditation.

19-7 Phoenix Hall (looking west), Byodoin, Uji, Kyoto Prefecture, Japan, Heian period, 1053.

The Phoenix Hall's elaborate winged form evokes images of Amida's palace in the Western Pure Land. Situated on a pond, the temple suggests the floating weightlessness of celestial architecture.

The oldest extant examples of illustrated copies are fragments from a deluxe set of early-12th-century handscrolls produced by five teams, each consisting of a nobleman talented in calligraphy, a chief painter who drew the compositions in ink, and assistants who added the colors. The script is primarily hiragana, a sound-based cursive writing system developed in Japan from Chinese characters. Hiragana originally served the needs of women (who were not taught In the Genji handscrolls, pictures alternate with text, as in Gu Kairlithe Genji handscrolls, pictures alternate with text, as in Gu Kairlithe Genji handscrolls, pictures alternate with text, as in Gu Kairlithe Genji handscrolls, pictures alternate with text, as on the focuses on emotionally charged moments in personal relationships, focuses on emotionally charged moments in personal relationships, rather than on lessons in exemplary behavior.

("Japan") (Yamato means and general flatness—typical of yamato-e, or "native-style painting." bright mineral pigments, lack of emphasis on strong brushwork, several formal features of the Genji illustrations—native subjects, ing directly at exalted persons. Later Japanese critics considered lack of individualization may reflect societal restrictions on lookhorizontal line, or dash, for each eye and a hook for the nose. This the artist simplified and generalized the aristocratic faces, using a figures appear constructed of stiff layers of contrasting fabrics, and architectural ornamentation create an aura of luxury. The human ing's two-dimensional character. Rich patterns in the textiles and where the action takes place. Flat fields of color emphasize the paintomitted roofs and ceilings to provide a view of the interior spaces strong diagonal lines suggest three-dimensional space. The painter the fading of life and love. A radically upturned ground plane and in the garden identifies the season as autumn, a time associated with greatest love, Murasaki, near the time of her death. The bush-clover In the scene illustrated here (FIG. 19-8), Genji meets with his

from the marriage of daughters to the imperial line. empresses. The authority of the Fujiwara family derived primarily alighted on lands properly ruled. Phoenixes are also associated with the ridgepole ends. In eastern Asia, people believed that these birds its overall birdlike shape and from two bronze phoenixes decorating lessness of celestial architecture. The building's name derives from on a pond, the Phoenix Hall builders suggested the floating weightpillars on the exterior, elevating the wings, and situating the whole tecture reflects the design of Chinese palaces. By placing only light as depicted in East Asian paintings (FIG. 18-8) in which the archiwinged form evokes images of the Buddha's palace in his Pure Land, south of Kyoto. Dedicated in 1053, the Phoenix Hall's elaborate memory of his father on the grounds of his family's summer villa for three emperors between 1016 and 1068, built the temple in complex at Uji. Fujiwara Yorimichi (990-1074), the powerful regent Phoenix Hall (Fig. 19-7) of the Byodoin, a Heian Buddhist temple surviving monument in Japan related to Pure Land beliefs is the of Buddhism to all classes of Japanese society. The most important Pure Land Buddhism—universal salvation—facilitated the spread among the Japanese aristocracy. Eventually, the simple message of to save the faithful through rebirth in his realm gained prominence belief in the vow of Amida, the Buddha of the Western Pure Land, PHOENIX HALL, UII During the middle and later Heian period,

TALE OF GENJI Japan's most admired literary classic is Tale of Genji. written around 1000 by Murasaki Shikubu (usually referred to as Lady Murasaki; ca. 978–ca. 1025), a lady-in-waiting at the court (see "Woman Writers and Calligraphers at the Heian Imperial Court" (). Recounting the lives and loves of Prince Genji and his descendants. Tale of Genji provides readers with a view of Heian court culture.

19-8 Genji Visits Murasaki, from the Minori chapter, Tale of Genji, Heian period, first half of 12th century. Handscroll, ink and colors on paper, $8\frac{5}{8}$ high. Goto Art Museum, Tokyo.

In this handscroll of Lady Murasaki's *Tale of Genji*, the upturned ground and diagonal lines suggest three-dimensional space. Flat color fields emphasize the painting's two-dimensionality.

JAPAN UNDER THE SHOGUNS

A series of civil wars in the late 12th century brought an end to imperial power. In 1185, the Japanese emperor in Kyoto appointed Minamoto Yoritomo (1147–1199) the first shogun at Kamakura in eastern Japan. Although the imperial family theoretically remained the source of political authority, real power was in the hands of the shogun and his daimyo and samurai (see page 507).

Kamakura

During the Kamakura shogunate (1185–1332), more frequent and positive contact with China brought with it an appreciation for more recent cultural developments there, ranging from new architectural styles to Chan (in Japan, *Zen*) Buddhism.

SHUNJOBO CHOGEN Rebuilding in Nara after the destruction that the civil wars inflicted presented an early opportunity for architectural experimentation. A leading figure in planning and directing the reconstruction efforts was the Shingon priest Shunjobo Chogen (1121–1206), who sources say made three trips to China between 1166 and 1176. After learning about contemporary Chinese architecture, he oversaw the rebuilding of the Todaiji Buddhist complex (FIG. 19-5A 🗐), among other projects.

Chogen's portrait statue (FIG. 19-9) is one of the most striking examples of the high level of naturalism prevalent in the early Kamakura period. It features finely painted details and a powerful rendering of the signs of aging, including sunken cheeks and eye sockets, lined face and neck, and slumping posture. Details such as the nervous handling of the prayer beads capture the personality as well as the appearance of the priest. The statue is the work of the Kei

19-9 Portrait statue of the priest Shunjobo Chogen, Todaiji, Nara, Japan, Kamakura period, ca. 1206. Painted cypress wood, 2' $8\frac{3}{8}$ " high.

Kamakura artists' interest in naturalism is evident in this moving portrait of a seated priest. The statue is noteworthy for its finely painted details and powerful rendering of personality and old age.

staccato brushwork and the vivid flashes of color that beautifully capture the drama of the event.

Muromachi

In 1336, after years of upheaval and conflict, Ashikaga Takauji (1305–1358) succeeded in establishing domination of his clan over all of Japan and became the new imperially recognized shogun. The civil war leading to the rise of the Ashikaga clan marked the beginning of the Muromachi period (1333–1573), named after the district in Kyoto in which the Ashikaga shogunate maintained its headquarters.

with Zen Buddhism. nese art, literature, and learning, which the Japanese imported along but also as centers of secular culture, where people could study Chi-Land sects. Zen temples functioned not only as religious institutions accepted other Buddhist teachings, especially the ideas of the Pure ers studied at and supported Zen temples. Zen Buddhists generally monks and highly placed warriors. Aristocrats, merchants, and othwarrior elite. Zen, however, was not exclusively the religion of Zen edge and refinement, thereby legitimizing the elevated status of the with Chinese Chan culture carried implications of superior knowlhigh value on loyalty, courage, and self-control. Further, familiarity for the upper echelons of samurai, whose behavioral codes placed sonal responsibility. For this reason, Zen held a special attraction Buddha of the West, Zen emphasized rigorous discipline and perdhism, which stressed reliance on the saving power of Amida, the dhism," page 515) rose to prominence. Unlike Pure Land Bud-During the Muromachi period, Zen Buddhism (see "Zen Bud-

School of sculptors, known for their expert craftsmanship and use of inlaid rock crystal for the eyes, a technique unique to Japan. One of the Kei School's leading masters—Unkei—carved a huge statue of Agyo (FIG. 19-9A (1)) for Todaiji.

The Kei School, which traced its lineage to Jocho, a master sculptor of the mid-11th century, typified traditional Japanese artistic practice. Indeed, until recently, hierarchically organized male workshops produced most Japanese art. Membership in these workshops was often based on familial relationships. Dominating apprentices were relatives. Outsiders of considerable skill sometimes joined workshops, often through marriage or adoption. The eldest son usually inherited the master's position, after rigorous training in the necessary skills from a very young age. Therefore, one meaning of the term art school in Japan is a network of workshops training in their origins back to the same master, a kind of artistic clan.

in the Kamakura period. Events of the Heiji Period is a 13th-century masterpiece of historical-narrative painting. The scroll depicts civilmasterpiece of historical-narrative painting. The section reproduced war battles at the end of the Heian period. The section reproduced during which the retired emperor Goshirakawa (r. 1155–1158) was taken prisoner and his palace burned. Swirling flames and billowing clouds of smoke dominate the composition. Below, soldiers on horseback and on foot do battle. As in other Heian and Kamakura scrolls, the buildings in the Heiji handscroll are represented from scrolls, the buildings in the Heiji handscroll are represented from shove at a sharp angle. Especially noteworthy here are the painter's

19-10 Night Attack on the Sanjo Palace, from Events of the Heiji Period, Kamakura period, 13th century. Handscroll, ink and colors on paper, full scroll 22' 10" long, detail 1' 4 1 1 1 high. Museum of Fine Arts, Boston (Fenollosa-Weld Collection).

This Kamakura scroll is an example of Japanese historical narrative painting. Staccato brushwork and vivid flashes of color capture the drama of the night attack and burning of Emperor Goshirakawa's palace.

RELIGION AND MYTHOLOGY Zen Buddhism

Zen (Chan in Chinese), as a fully developed Buddhist tradition, began filtering into Japan in the 12th century and had its most pervasive impact on Japanese culture starting in the 14th century during the Muromachi period. As in other forms of Buddhism, Zen followers hoped to achieve enlightenment. Zen teachings assert that everyone has the potential for enlightenment, but worldly knowledge and mundane thought patterns are barriers to achieving it. Thus followers must succeed in breaking through the boundaries of everyday perception and logic. This is most often accomplished through meditation. Indeed, the word zen means "meditation."

Some Zen schools stress meditation as a long-term practice eventually leading to enlightenment, whereas others stress the benefits of sudden shocks to the worldly mind. One of these shocks is the subject of Kano Motonobu's Zen Patriarch Xiangyen Zhixian Sweeping with a Broom (FIG. 19-13), in which the shattering of a fallen roof tile opens the monk's mind.

The guidance of an enlightened Zen teacher is essential to arriving at enlightenment. Years of strict training involving manual labor under the tutelage of this master, coupled with meditation, provide

the foundation for a receptive mind. According to Zen beliefs, by cultivating discipline and intense concentration, Buddhists can transcend their ego and release themselves from the shackles of the mundane world. Although Zen is not primarily devotional, followers do pray to specific deities. In general, Zen teachings view mental calm, lack of fear, and spontaneity as signs of a person's advancement on the path to enlightenment.

Zen training for monks takes place at temples, some of which have gardens designed in accord with Zen principles, such as Kyoto's Ryoanji dry-landscape garden (FIG. 19-11). Zen temples also sometimes served as centers of Chinese learning and conducted funeral rites. These temples even embraced many traditional Buddhist observances, such as devotional rituals before images, which had little to do with meditation per se.

As Zen teachings spread, they reverberated throughout Japanese culture. Lay followers as well as Zen monks painted pictures and produced other artworks that appear to reach toward Zen ideals through their subjects and means of expression. Other cultural practices reflected the widespread appeal of Zen Buddhism. For example, the tea ceremony (see "The Japanese Tea Ceremony," page 518) offered a temporary respite from everyday concerns, especially when the ceremony took place in a quiet setting with a meditative atmosphere, such as the Taian teahouse (FIG. 19-15).

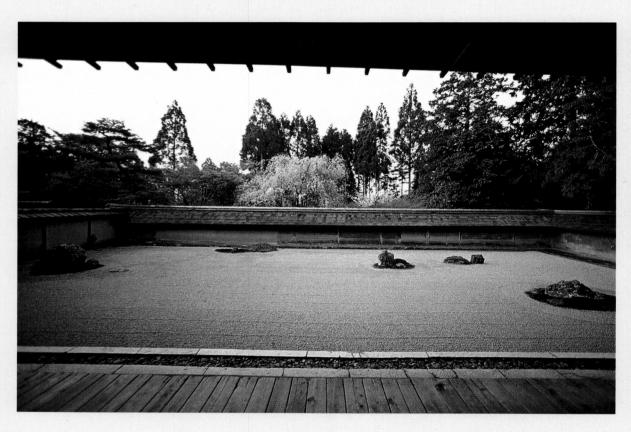

19-11 Karesansui (dry-landscape) garden, Ryoanji, Kyoto, Japan, Muromachi period, ca. 1488.

Perfectly suited for meditation by Zen Buddhist monks, the karesansui garden of the Peaceful Dragon Temple features artfully placed, irregularly shaped rocks in a bed of raked white gravel.

KARESANSUI GARDENS Gardens played a major role in Zen Buddhist monasteries, providing the monks with an austere and serene place where they could walk and meditate, far removed from the noise and distractions of daily life. But some gardens were meant solely to be viewed, not entered—for example, the *karesansui* (Japanese,

"dry-landscape") rock garden (FIG. 19-11) of Ryoanji (Temple of the Peaceful Dragon) in northwestern Kyoto. The land belonged to the Muromachi shogun Hosokawa Katsumoto (1430–1473), who left his estate to the Rinzai Zen sect, which erected the temple on the site around 1488. The Ryoanji karesansui garden probably dates to that

around the stones. The unknown designer intended the monks to view the garden from a stationary position, but from any vantage point it is possible to see only 14 rocks at one time—symbolizing the sense of incompleteness a monk experiences before achieving enlightenment. Although the arrangement of rocks and raked is an abstract composition, striking in its severity and emptiness especially in contrast to the dense and colorful foliage that forms a backdrop to the enclosed garden, many observers have variously compared the Ryoanji garden to islands in a calm lake, to mountain peaks projecting through the clouds, or to a cherry tree with branches. The purpose of the garden, however, is to inspire meditation and to direct the attention of the monks inward, not to the natural world.

SESSHU TOYO Muromachi painting displays great variety in both style and subject matter. Among the most celebrated Muromachi artists was the Zen priest Sesshu Toyo (1420–1506), one of the few Japanese painters who traveled to China and studied contemporaneous Ming painting. His most dramatic works are in the splashed-ink (haboku) style, a technique with Chinese roots. The painter of

19-13 Kano Motonobu, Zen Patriarch Xiangyen Zhixian Sweeping with a Broom, from Daitokuji, Kyoto, Japan, Muromachi period, ca. 1513. Hanging scroll, ink and color on paper, $S^1 \setminus \frac{3}{8}^n \times 2^v \cdot 10^{\frac{3}{4}^n}$. Tokyo National Museum, Tokyo.

The Kano School and splashed-ink painting represent opposite poles of Muromachi style. In this scroll depicting a Zen patriarch experiencing enlight-enment, bold outlines define the forms.

time as well, although many scholars believe that its present form is the result of a later remodeling. Unlike expansive Zen gardens, the Ryoanji karesansui measures only about 30 by 10 yards and is surrounded by low walls. Situated adjacent to the abbot's quarters, the garden is continuously tended by the monks, who rake it daily and remove any weeds that may have emerged. The karesansui consists of 15 artfully placed, irregularly shaped rocks of varying sizes set in a bed of white gravel with green moss growing on and sizes set in a bed of white gravel with green moss growing on and

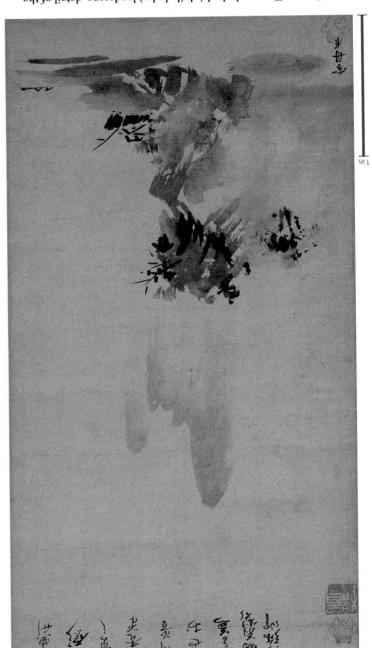

19-12 Sesshu Toyo, splashed-ink (haboku) landscape, detail of the lower part of a hanging scroll, Muromachi period, 1495. Ink on paper, full scroll 4' $10\frac{1}{4}$ " × $1'\frac{2}{8}$ ", detail $4\frac{1}{2}$ " high. Tokyo National Museum, Tokyo.

In this haboku landscape, the artist applied primarily broad, rapid strokes, sometimes dripping the ink on the paper. The result hovers at the edge of legibility, without dissolving into abstraction.

a haboku picture pauses to visualize the image, loads the brush with ink, and then applies primarily broad, rapid strokes, sometimes even dripping the ink onto the paper. The result often hovers at the edge of legibility, without dissolving into sheer abstraction. This balance between spontaneity and a thorough knowledge of the painting tradition gives the pictures their artistic strength. In the haboku landscape illustrated here (FIG. 19-12), images of mountains, trees, and buildings emerge from the ink-washed surface. Two figures appear in a boat (to the lower right), and the two swift strokes nearby represent the pole and banner of a wine shop.

KANO MOTONOBU Representing the opposite pole of Muromachi painting style is the Kano School, which by the 17th century had become virtually a national painting academy. KANO MOTONOBU (1476-1559) was the most prominent Muromachi Kano painter. Zen Patriarch Xiangyen Zhixian Sweeping with a Broom (FIG. 19-13) is one of six panels that he designed as fusuma (sliding door paintings) for the abbot's room in the Zen temple complex of Daitokugi in Kyoto. The illustrated panel, which was later refashioned as a hanging scroll, depicts Xiangyen (d. 898) at the moment he achieved enlightenment. As the patriarch sweeps the ground near his rustic retreat, a roof tile falls at his feet and shatters. Xiangyen's Zen training is so deep that the resonant sound propels him into an awakening. In contrast to Muromachi splashed-ink painting, Kano's work displays exacting precision in applying ink in bold outlines. Thick clouds obscure the mountainous setting and focus the viewer's attention on the sharp, angular rocks, bamboo branches, and modest hut framing the patriarch. Lightly applied colors also draw attention to Xiangyen, whom Kano showed as having dropped his broom with his right hand as he recoils in astonishment.

Momoyama

In 1573, Oda Nobunaga (1534-1582) overthrew the Ashigara shogunate in Kyoto, but was later killed by one of his generals. Toyotomi Hidevoshi (1536-1598) then took control of the government until his death in 1598. In the ensuing power struggle, Tokugawa Ieyasu (1542-1616) emerged victorious, and the emperor granted him the title of shogun in 1603. Ievasu continued to face challenges, but by 1615 he had eliminated his last rival, initiating a new era in Japan's long history, the Edo period (see page 519). During the brief intervening Momoyama period (1573-1615), the successive warlords constructed huge fortified castles to serve as their palatial residences. An especially impressive example is the White Heron Castle (FIG. 19-13A 1) at Himeji. These castles were so numerous and so symptomatic of the turbulent times that historians have named the era after one of Hideyoshi's castles-Momoyama (Peach Blossom Hill). Each warlord commissioned lavish decorations for the interior of his castle, including fusuma and byobu (folding screens) in ink, color, and gold leaf.

KANO EITOKU The grandson of Kano Motonobu, Kano EITOKU (1543–1590), was the leading Momoyama painter of murals and screens and received numerous commissions to provide paintings for the warlords' castles. So extensive were these commissions that Eitoku adopted a painting system developed by his grandfather, which depended on a team of specialized painters to assist him. Unfortunately, little of Eitoku's elaborate work remains because of the subsequent destruction of the Momoyama shoguns' ostentatious castles. One extant six-panel screen (FIG. 19-14) features two ancient Chinese mythological beasts, a lion and a lioness—appropriate

19-14 KANO EITOKU, *Chinese Lions*, Momoyama period, late 16th century. Six-panel screen, ink, colors, and gold leaf on paper, 7' 4" × 14' 10". Museum of the Imperial Collections, Tokyo.

Chinese lions were fitting imagery for the castle of a Momoyama warlord because they exemplified power and bravery. Eitoku's huge screen features boldly outlined forms on a gold ground.

as an excuse to display treasured collections of Chinese objects, espe-

Initially, the Japanese held tea ceremonies in a room or section cially porcelains, lacquers, and paintings.

bamboo implements and occasionally even ceramic vessels. gardens), as well as the design of tea utensils. They often make simple teahouses and tearooms within larger structures (including interiors and ceremony and acquire students. Tea masters even influence the design of master tea-ceremony practitioners (tea masters) advise patrons on the edged as having superior aesthetic sensibilities, individuals recognized as decoration, which changes according to occasion and season. Acknowlas water jars (FIG. 19-16) and tea bowls; and determining the tearoom's responsibilities include serving the guests; selecting special utensils, such sequence of rituals in which both host and guests participate. The host's ing teahouses (FIG. 19-15) became common. The ceremony involves a of a house. As the popularity of tea ceremonies increased, freestand-

chi period, grand tea ceremonies in warrior residences served primarily and, by the late 16th century, wealthy merchants. Until the late Muromaand spirit. The practices spread to other social groups, especially samurai as a symbolic withdrawal from the ordinary world to cultivate the mind period. Simple forms of the tea ceremony started in Japan in Zen temples to a much higher degree of sophistication, peaking in the Momoyama nese ritual of serving tea, although based on Chinese practice, developed Eichu brought tea to Japan from China. Eventually, however, the Japabegan in China. It was not until the ninth century that a monk named serving, and drinking of powdered green tea. The fundamental practices The Japanese tea ceremony (chanoyu) involves the ritual preparation,

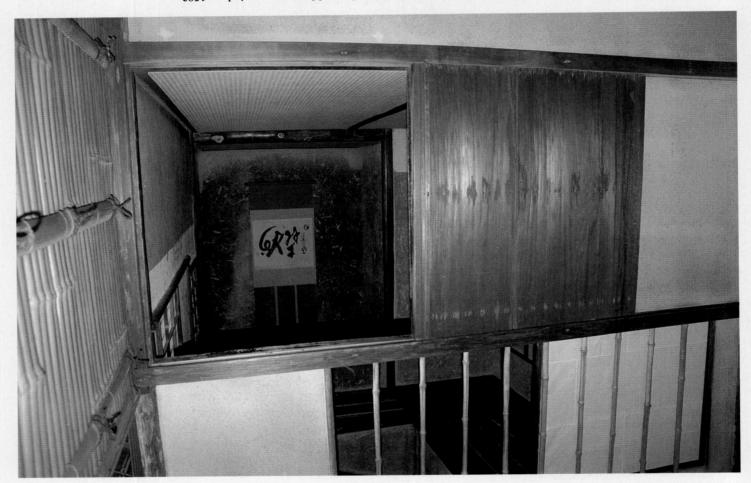

19-15 SEN NO RIKYU, interior of the Taian teahouse, Myokian Temple, Kyoto, Japan, Momoyama period, ca. 1582.

who must crawl through a small door to enter. The dimness and tiny size of the Taian tearoom and its alcove produce a cavelike feel and encourage intimacy among the host and guests,

cultural realm. For example, on returning from a major military tively new to political or economic power to assert authority in the and ideological implications and provided a means for those rela-Tea Ceremony," above), which eventually came to carry political in the Momoyama period was the tea ceremony (see "The Japanese SEN NO RIKYU A favorite exercise of cultivation and refinement

scale—it is more than 7 feet tall and nearly 15 feet long. gold clouds. The dramatic effect of this work derives in part from its lines, stride forward in a schematic landscape of brown rocks and fully muscled bodies, defined and flattened by heavy black contour power and bravery. In Kano's painting, the colorful beasts' powermotifs for a warlord's castle because lions were associated with campaign, Toyotomi Hideyoshi held an immense tea ceremony lasting 10 days and open to everyone in Kyoto. The ceremony's political connotations became so important that warlords granted or refused their vassals the right to host tea rituals.

The most venerated tea master of the Momoyama period was Sen no Rikyu (1522–1591), who was instrumental in establishing the rituals and aesthetics of the tea ceremony—for example, the manner of entry into a teahouse (crawling on one's hands and knees). Rikyu believed that crawling fostered humility and created the impression, however unrealistic, that there was no rank in a teahouse. Rikyu was the designer of the first Japanese teahouse, or *chashitsu*, built as an independent structure as opposed to being part of a house. The Taian teahouse (Fig. 19-15) at the Myokian temple in Kyoto, also attributed to Rikyu, is the oldest in Japan. The interior displays two standard features of late Muromachi residential architecture—very thick, rigid straw mats called *tatami* (a Heian innovation) and an alcove called a *tokonoma*. The tatami accommodated the traditional Japanese customs of not wearing shoes indoors and of sitting on the floor. Scrolls of painting or calligraphy and other prized objects were displayed in the tokonoma.

The Taian tearoom has unusually dark walls, with earthen plaster covering even some of the square corner posts. The room's dimness and tiny size (about 6 feet square, the size of two tatami mats) produce a cavelike feel and encourage intimacy among the tea host and guests. The guests enter from the garden outside by crawling through a small sliding door. The means of entrance emphasizes a guest's passage into a ceremonial space set apart from the ordinary world.

SHINO CERAMICS Sen no Rikyu also was influential in determining the aesthetics of tea-ceremony utensils. In his view, value and refinement lay in character and ability and not in bloodline or rank, and he therefore encouraged the use of tea items whose value was their inherent beauty rather than their monetary worth. Even before Rikyu, in the late 15th century, admiration of the technical brilliance

of Chinese objects had begun to give way to greater appreciation of the virtues of rustic wares. This new aesthetic of refined rusticity, or *wabi*, was consistent with Zen concepts. Wabi suggests austerity and simplicity. Related to wabi and also important as a philosophical and aesthetic principle was *sabi*—the value found in the old and weathered, suggesting the tranquility reached in old age.

Wabi and sabi aesthetics underlie the ceramic vessels produced for the tea ceremony, such as the Shino water jar named *Kogan* (FIG. 19-16). The name, which means "ancient stream bank," comes from the painted design—marsh grass—on the jar's surface as well as from its coarse texture and rough form. The term *Shino* generally refers to ceramic wares produced during the late 16th and early 17th centuries in kilns in Mino. The Kogan illustrated here has surface cracks, an irregular rim, and sagging contours (all intentional) to suggest the accidental and natural, qualities essential to the values of wabi and sabi.

Edo

When Tokugawa Ieyasu consolidated his power in 1615, he abandoned Kyoto, the official capital, and set up his headquarters in Edo (see page 507). The new regime instituted many policies designed to severely limit the pace of social and cultural change in Japan. Fearing the kind of colonization that had occurred in New Spain (see pages 538 and 541), the Tokugawa rulers banned Christianity and expelled all Western foreigners except the Dutch. The Tokugawa were also concerned about destabilization of the social order, and instituted Confucian ideas of social stratification and civic responsibility as public policy. They also tried to control the social influence of urban merchants, some of whom had accumulated wealth far outstripping that of most warrior leaders. However, the population's great expansion in urban centers, the spread of literacy in the cities and beyond, and a growing thirst for knowledge and diversion made for a very lively popular culture not easily subject to tight control.

19-16 Kogan (tea-ceremony water jar), Momoyama period, late 16th century. Shino glazed stoneware with underglaze iron slip decoration, $7\frac{3}{4}$ " high. Cleveland Museum of Art, Cleveland (John L. Severance Fund).

The vessels used in the Japanese tea ceremony reflect the concepts of wabi, the aesthetic of refined rusticity, and sabi, the value found in weathered objects, suggesting the tranquility of old age.

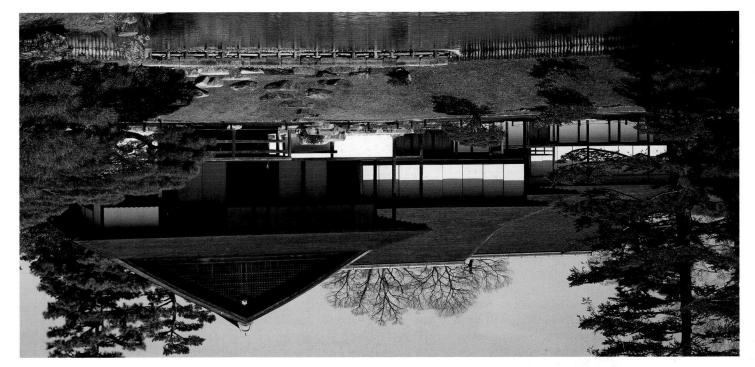

19-17 East facade of the Katsura Imperial Villa, Kyoto, Japan, Edo period, 1620-1663.

The Katsura Imperial Villa became the standard for Japanese residential architecture. The design relies on subtleties of proportion, color, and texture instead of ornamentation for its aesthetic appeal.

The Rinpa School did not have a similar continuity of lineage and training through father and son, master and pupil. Instead, over time, Rinpa aesthetics and principles attracted a variety of individuals as practitioners and champions. Stylistically, Rinpa works feature vivid color and extensive use of gold and silver and often incorporate decorative patterns. Rinpa takes its name from the last syllable in the name of Ogata Koria (1658–1716; Fig. I-10) and pa ("school").

sprinkling of gold dust in wet lacquer. box's brilliant gold surface. The gold decoration comes from careful ics, especially the juxtaposition of the bridge's dark metal and the matic contrasts of form, texture, and color typifying kinpa aesthetevoking reflection on life's insecurities. The box also shows the drathe poem, which describes the experience of crossing a bridge as the water, boats, and bridge are a few Japanese characters from a band across the lid's convex surface. The raised metallic lines on planks of a temporary bridge. The bridge itself, a lead overlay, forms scene of small boats lined up side by side in the water to support the bridge at Sano, north of Edo. The lid presents a subtle, gold-on-gold exhibits motifs drawn from a 10th-century poem about the boat between the two arts. Koetsu's Boat Bridge writing box (FIG. 19-18) and craft decoration to develop a style that collapsed boundaries lacquered wood objects, drawing on ancient traditions of painting calligrapher who also produced ceramics for the tea ceremony and smiths in the ancient capital of Kyoto. Koetsu was a greatly admired KOETSU (1558-1637), the heir of an important family of sword-HONAMI KOETSU One of the earliest Rinpa masters was Honami

UKIYO-E Although the Tokugawa shogunate tried to hold in check the pursuit of sensual pleasure and entertainment in the rapidly

the primary ideals of Japanese residential architecture. to achieve a harmonious integration of building and garden—one of haps most important, the residents can open the doors to the outside sliding doors between them can create broad rectangular spaces. Perand textures. The rooms are not large, but parting or removing the burnished all surfaces to bring out the natural beauty of their grains villa's lines, planes, and volumes. Artisans painstakingly rubbed and wood, tile, plaster) and subdued colors and tonal values enrich the subtleties of proportion, color, and texture. A variety of textures (stone, forms plays no role in the Katsura villa's appeal, which relies instead on lords, ornamentation that advertises wealth and disguises structural courtly gracefulness as well. Unlike the castles of the Momoyama war-(FIG. 19-15). However, the villa's designers incorporated elements of borrowed many features from earlier teahouses, such as Rikyu's Taian Imperial Villa (FIG. 19-17), on the Katsura River southwest of Kyoto, Japanese architecture. Completed by his son in 1663, the Katsura est country retreat into a villa that became the standard for domestic ture. In 1620, Prince Toshihito (1579-1629) began to develop a modbut the court continued to wield influence in matters of taste and culpower remained as it had been for centuries, symbolic and ceremonial, KATSURA IMPERIAL VILLA In the Edo period, the imperial court's

RINPA In painting, the Kano School enjoyed official governmental sponsorship during the Edo period, and its workshops provided paintings to the Tokugawa shoguns and their major vassals. By the mid-18th century, Kano masters also served as the primary painting teachers for nearly everyone aspiring to a career in the field. Even so, individualist painters and other schools emerged and flourished, working in quite distinct styles.

The earliest major alternative school to emerge in the Edo period, Rinpa, was quite different in nature from the Kano School.

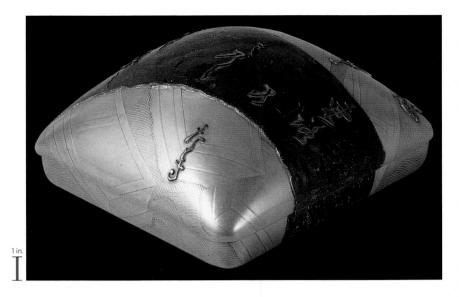

growing cities of Osaka, Kyoto, and Edo, their efforts were largely in vain. The best-known products of this urban counterculture are the *ukiyo-e* woodblock prints (see "The Floating World of Edo," page 507, and "Japanese Woodblock Prints," page 522) that depict the theater

19-18 Honami Koetsu, *Boat Bridge*, writing box, Edo period, early 17th century. Lacquered wood with sprinkled gold and lead overlay, $9\frac{1}{2}$ " \times 9" \times $4\frac{3}{8}$ ". Tokyo National Museum, Tokyo.

Koetsu's writing box is an early work of the Rinpa School, which drew on ancient traditions of painting and craft decoration to develop a style that collapsed boundaries between the two arts.

and brothels of Edo-era Japan as well as beautiful young women in domestic settings (FIG. 19-1) and landscapes (FIGS. 19-19 and 19-20).

KATSUSHIKA HOKUSAI Landscape painting—long revered as a major genre of Chinese and Korean art—emerged in the 18th century in Japan as an immensely

popular subject with the proliferation of inexpensive multicolor woodblock prints. One of the foremost Japanese landscape artists was Katsushika Hokusai (1760–1849). In *The Great Wave off Kanagawa* (Fig. 19-19), from *Thirty-six Views of Mount Fuji*, the

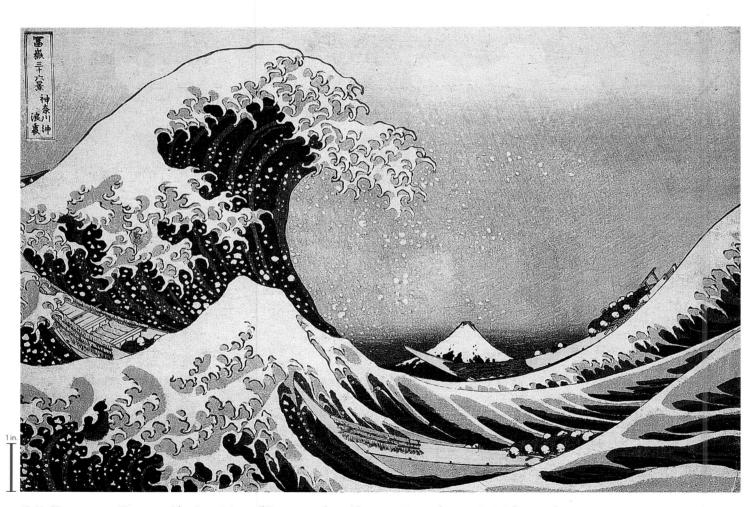

19-19 Катѕиѕніка Нокиѕаї, *The Great Wave off Kanagawa*, from *Thirty-six Views of Mount Fuji*, Edo period, ca. 1826–1833. Woodblock print, ink and colors on paper, $9\frac{7}{8}$ " × 1' $2\frac{3}{4}$ ". Museum of Fine Arts, Boston (Bigelow Collection).

Adopting the low horizon line of Western painting, master woodblock printmaker Hokusai used the flat and powerful graphic forms of Japanese art to depict the threatening wave in the foreground.

Be anyer how programmy

19-20 Ando Hiroshige, Plum Estate, Kameido, from One Hundred Famous Views of Edo, Edo period, 1857. Woodblock print, ink and colors on paper, Views of Edo, Edo period, 1857. Woodblock print, ink and colors on paper,

Hiroshige's multicolor woodblock print shows only a partial view of the Kameido Sleeping Dragon Plum, whose branches spread out in abstract patterns resembling the beloved Japanese art of calligraphy.

fading, especially when exposed to strong light. In the early 19th century, more permanent European synthetic dyes began to enter Japan. The first, Prussian blue, appears in Hokusai's The Great Wave off Kanagawa (Fig. 19-19).

with the low horizon typical of Western painting, Hokusai placed in the foreground the wave's more traditionally flat and powerful graphic forms, mainly curved triangles.

ANDO HIROSHIGE The leading landscape printmaker of the midleth century was ANDO HIROSHIGE (1797–1858). Plum Estate, Kameido (FIG. 19-20), dated "11th Month, 1857," comes from his

MATERIALS AND TECHNIQUES Japanese Woodblock Prints

During the Edo period, woodblock prints with ukiyo-e themes became enormously popular. People with very modest incomes could collect these inexpensive prints in albums or paste them on walls. Ukiyo-e artists were generally painters who did not themselves manufacture the prints that made them famous. As the designers, they sold drawings to publishers, who in turn oversaw their printing. The publishers also played a role or adapting ukiyo-e prints by commissioning specific designs or adapting them before printing. Consequently, the names of both designer and publisher appeared on the final prints. Unactornated the prints, the block carvers and prints. Unactornated in nearly all cases, however, were the individuals who made the prints, the block carvers and printers. Using skills honed since childhood, they worked with both speed and skills honed since childhood, they worked with both speed and skills honed since childhood, they worked with both speed and affordable.

the last block. alignment errors with a final printing of the black outlines from and a straight ridge on one side. The printers could cover small printing guides in their blocks—an L-shaped ridge in one corner critical to prevent overlapping of colors, so the carvers included sheet of paper. Perfect alignment of the paper in each step was Then another printer would print a different color on the same and rubbed the back of the paper with a smooth flat object. ment to a block's raised surface, laid a sheet of paper on it, blocks. To print a color, a printer applied the appropriate pignary prints sometimes required up to 20 colors and thus 20 left in relief only the areas to be printed in that color. Even ordiblocks, one for each color used. On each color block, the carver These master prints became the guides for carving the other the block with black ink and printed several initial outline prints. print remained raised in relief. The master printer then coated the forms and other elements that would be black in the final the cutting of the block. After the carving, only the outlines of tly scraping the thin paper revealed the reversed image to guide painted designs face down on a wood block. Wetting and genmat is a result of the printing process. A master carver pasted outlines separating distinct color areas (FIG. 19-1). This for-Japanese prints during the Edo period tend to have black

The materials used in printing varied over time, but by the mid-18th century had reached a high level of standardization. The blocks were planks of fine-grained hardwood, usually cherry. The best paper came from the white layer beneath the

bark of mulberry trees because its long fibers helped the paper stand up to repeated rubbing on the blocks. The printers used a few mineral pigments but favored inexpensive dyes made from plants for most colors. As a result, the colors of ukiyo-e prints are highly susceptible to

huge foreground wave dwarfs the artist's representation of the distant mountain. This contrast and the whitecaps' ominous fingers magnify the wave's threatening aspect. The men in the boats bend low to dig their oars against the rough sea and drive their long vessels past the danger. Although Hokusai's print draws on Western techniques and incorporates the distinctive European color called Prussian blue, it also engages the Japanese pictorial tradition. Against a background

One Hundred Famous Views of Edo series. The "famous views" are not monuments and buildings but places of leisure and natural beauty where the Japanese sought to escape from the noise and pressures of city life. Many of the sites are Shinto shrines and Buddhist temples. Others, including the plum orchard of Kameido, were favorite spots to visit at particular times of the year, when their natural beauty was at its peak. The main attraction of the Kameido estate was the Sleeping Dragon Plum, the most famous tree in Edo, celebrated for its large white blossoms and aromatic fragrance. Hiroshige's print shows only a partial view of the venerable tree, with its branches spreading out to touch all sides of the print and forming a bold abstract pattern resembling the beloved art of calligraphy. The pattern of the tree's limbs so dominates the print that the viewer hardly notices the crowd of onlookers behind a fence in the background. The unnatural coloration of the red sky enhances the abstract effect, flattening the pictorial space in a manner completely foreign to the Western notion of perspective. It was precisely this quality that fascinated 19th-century European painters who were trying to break free of the Renaissance ideals perpetuated by the official painting academies (see pages 362 and 366).

MODERN JAPAN

The Edo period and the rule of the shoguns ended in 1868, when rebellious samurai from provinces far removed from Edo toppled the Tokugawa. Facilitating this revolution was the shogunate's inability to handle increasing pressure from Western nations for Japan to open its doors to the outside world. Although the rebellion restored direct sovereignty to the imperial throne, real power rested with the emperor's cabinet. As a symbol of imperial authority, however, the official name of this new period was Meiji (Enlightened Rule; 1868–1912), after the emperor's chosen regnal name.

During the Showa period (1926–1989), Japan became increasingly prominent on the world stage in economics, politics, and culture, and played a leading role in World War II. The most tragic consequences of that conflict for Japan were the widespread devastation and loss of life resulting from the atomic bombings of Hiroshima and Nagasaki in 1945. During the succeeding occupation period, the United States imposed new democratic institutions on Japan, with the emperor serving as a ceremonial head of state. Japan's economy rebounded with remarkable speed, and during the past several decades, Japanese artists have also made a mark in the international art world.

KENZO TANGE In the postwar period, Japanese architecture, especially public and commercial building, underwent rapid transformation along Western lines. In fact, architecture may be the most influential Japanese art form on the world stage today. One of the most daringly experimental architects was Kenzo Tange (1913–2005). In his design of the stadiums (FIG. 19-21) for the 1964 Olympics, he employed a cable suspension system that enabled him to shape steel and concrete into remarkably graceful structures. His

19-21 Kenzo Tange, aerial view of the national indoor Olympic stadiums (looking northeast), Tokyo, Japan, Showa period, 1961–1964.

Tange was one of the most daring architects of postwar Japan. His Olympic stadiums employ a cable suspension system that enabled him to shape steel and concrete into remarkably graceful structures.

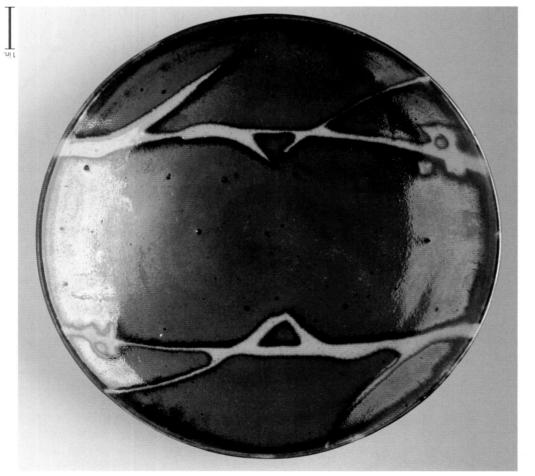

Shows period, 1958. Stoneware with porcelain enamel glaze, $10^{\frac{3}{4}}$ " diameter. Private collection.

19-22 HAMADA SHOJI, large plate,

A leading figure in the modern folk art movement in Japan, Hamada Shoji gained international fame. His unsigned stoneware features casual slip designs and a coarser, darker texture than porcelain.

Hamada's artistic influence extended beyond the production of pots. He traveled to England in 1920 and, along with English potter Bernard Leach (1887–1978), established a community of ceramists committed to the mingei aesthetic. Together, Hamada and Leach now, the "Hamada-Leach aesthetic" is part of potters' education worldwide, underscoring the productive exchange of artistic ideas between wide, underscoring the productive exchange of artistic ideas between Asia and the West today—discussed more fully in Chapter 16.

attention to both the sculptural qualities of each building's raw concrete form and the fluidity of its spaces allied him with architects worldwide who carried on the legacy of the late style of Le Corbusier (Figs. 15-29 and 15-30) in France.

AHMADA SHOJI Another modern Japanese art form that has ancient roots in Japan. A formative figure in Japan's folk art movement, the philosopher Yanagi Soetsu (1889–1961), promoted an ideal of beauty inspired by the tea ceremony. He argued that true beauty could be achieved only in functional objects made of natural materials by anonymous craftspeople, such as the Shino water jar (Fig. 19-16). Among the ceramists who produced this type of folk pottery, known as mingei, was Hamada Shoji (1894–1978). Although Hamada espoused Yanagi's selfless ideals, he still gained international fame and in 1955 received official recognition in Japan as a Living National Treasure. Works such as his plate (Fig. 19-22) with casual slip designs are unsigned, but connoisseurs easily recognize them as his. This kind of pottery is coarser, darker, and heavier than porcelain and lacks the latter's fine decoration. To those who appreciporcelain and lacks the latter's fine decoration. To those who appreciporcelain and lacks the latter's fine decoration. To those who appreciporcelain and lacks the latter's fine decoration. To those who appreciporcelain and lacks the latter's fine decoration. To those who appreciporcelain and lacks the latter's fine decoration. To those who appreciporcelain and lacks the latter's fine decoration. To those who appreciporcelain and lacks the latter's fine decoration. To those who appreciporate and the latter's fine decoration in Japan.

ate simpler, earthier beauty, however, this dish holds great attraction.

 $[\]mathbb{A}$ Explore the era further in MindTap with videos of major artworks and buildings, Google Earth^m coordinates, and essays by the author on the following additional subjects:

[■] RELIGION AND MYTHOLOGY: Shinto

Honden of the Ise Jingu, Ise (FIG. 19-3A)
 Daibutsuden, Todaiji, Nara (FIG. 19-5A)

 $[\]blacksquare$ WRITTEN SOURCES: Woman Writers and Calligraphers at the Heian

Imperial Court = Unkei, Agyo, Todaiji, Nara (FIG. 19-9A)

[■] White Heron Castle, Himeji (FIG. 19-13A)

JAPAN

Japan before Buddhism

- The Jomon (ca. 10,500–300 BCE) is Japan's earliest distinct culture. It takes its name from the applied clay cordlike coil decoration of Jomon pottery. The succeeding Yayoi culture (ca. 300 BCE–300 CE) developed bronze-casting and loom weaving.
- During the Kofun (Old Tomb) period (ca. 300-552 cE), the Japanese erected great earthen keyhole-shaped burial mounds and placed clay cylindrical figures (haniwa) on top of them.

Haniwa warrior, fifth to mid-sixth century

Buddhist Japan

- Buddhism came to Japan from Korea in 552, and the first Japanese Buddhist artworks, such as Tori's Shaka triad at Horyuji, date to the Asuka period (552–645).
- During the Nara period (645-784), Buddhist architecture followed Chinese models in construction technique and curved roofline.
- In 794, the imperial house moved its capital to Kyoto, initiating the Heian period (794–1185). The Phoenix Hall at Uji evokes images of the celestial architecture of the Buddha's Pure Land of the West. Heian scrolls feature elevated viewpoints suggesting three-dimensional space and flat colors emphasizing the painting's two-dimensional character.

Tori, Shaka triad, Horyuji, 623

Japan under the Shoguns

- In 1185, power shifted from the emperor to the Kamakura shogunate (1185–1332). Kamakura painting is diverse in both subject and style and includes historical narratives and Buddhist imagery. Kamakura wood statuary is noteworthy for its realism and the use of rock crystal for eyes.
- During the Muromachi period (1333-1573), Zen Buddhism rose to prominence in Japan. Zen temples often featured gardens of the karesansui (dry-landscape) type, which facilitated meditation.
- The Momoyama period (1573–1615) was a brief interlude between two long-lasting shogunates, but it was then that the tea ceremony became an important social ritual. Sen no Rikyu designed the first teahouse built as an independent structure. The favored tea utensils were rustic Shino wares.
- The Edo period (1615-1868) began when Tokugawa leyasu moved his headquarters from Kyoto to Edo (Tokyo). Edo woodblock prints feature scenes from the "floating world" of the new urban pleasure quarters and landscapes.

Sen no Rikyu, Taian teahouse, Kyoto, ca. 1582

Hiroshige, Plum Estate, Kameido, 1857

Modern Japan

The Tokugawa shogunate toppled in 1868, opening the modern era of Japanese history. In the post-World War II period, Japanese modernist architects achieved international reputations, but rustic pottery also earned worldwide recognition.

Shoji, large plate, 1958

as bloodlettings. state ceremonies, such figured prominently in Maya rulers' spouses them is his wife. The Chan Muwan. Among stand to either side of Bonampak ruling class clad members of the ▶ 20-1b Other richly

headdress, stands at the jaguar pelt and elaborate Chan Muwan, wearing a ■ ZO-1a The Maya lord

for mercy. appears to beg the ruler crouching captive who a pyramid and faces a top of what is probably

Haven. of Natural History, New scale. Yale Peabody Museum Heather Hurst at one-half Mural, 17' × 15'; copy by Mexico, Maya, ca. 790 ce. of Structure 1, Bonampak, Lord Chan Muwan, room 2 Presentation of captives to

1-02

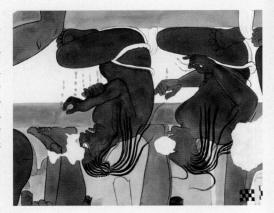

appeased the Maya gods. The slaughter of captives from their mutilated hands. template the blood dripping them kneel and dumbly conawaiting death. Some of steps are naked captives ■ 20-1c On the pyramid's

Native Americas and Oceania

WAR AND HUMAN SACRIFICE IN ANCIENT MEXICO

When, in the 15th century, Europeans discovered what for them was a "New World," they encountered native civilizations that had flourished for more than 2,000 years and boasted a sophisticated knowledge of agriculture, astronomy, mathematics, and the arts. The most famous of the indigenous peoples of the Western Hemisphere before 1300 were the Maya, renowned for their towering temple-pyramids and masterful sculptures and paintings depicting their gods, rulers, and rituals.

Although now heavily damaged, the Maya mural paintings of Bonampak (Painted Walls) in south-eastern Mexico are among the finest ever found. The illustrated example (FIG. 20-1; an expert copy) shows Maya captives and their victors on a terraced platform. Circumstantial details abound in what appears to have the accuracy of an eyewitness report of a state ceremony. Public bloodletting was an integral part of Maya ritual. The ruler, his consort, and certain members of the nobility drew blood from their own bodies and sought union with the supernatural world (compare FIG. 20-7). The slaughter of captives taken in war was a standard component of this ceremony. Indeed, the Maya and other ancient American peoples undertook warfare largely to provide victims for sacrifice. The torture and eventual execution of prisoners served both to nourish the gods and to strike fear into enemies and the general populace.

This Bonampak mural depicts the presentation of prisoners to Lord Chan Muwan. Using a combination of mineral and organic pigments mixed with water, crushed limestone, and vegetable gums, the Maya painter arranged the figures on several levels that probably represent a pyramid's steps. At the top, against a blue background, is a file of gorgeously dressed nobles wearing animal headgear. Conspicuous among them on the right are retainers clad in jaguar pelts and jaguar headdresses. Also present is Chan Muwan's wife (third from right). The ruler himself, in jaguar jerkin and high-backed sandals, stands at the center, facing a crouching victim who appears to beg for mercy. Naked captives, anticipating death, crowd the middle level. One of them, already dead, sprawls at the ruler's feet. Others dumbly contemplate the blood dripping from their mutilated hands. The lower zone, cut through by a doorway, shows clusters of attendants who are doubtless of inferior rank to the lords of the upper zone. The regal bearing of the Maya victors contrasts vividly with the supple imploring attitudes and gestures of the hapless victims.

The Bonampak murals are the most famous Maya wall paintings, but not the oldest. In 2001 at San Bartolo in northeastern Guatemala, American archaeologists discovered the earliest examples yet found. They date to around 100 BCE, almost a millennium before the Bonampak murals. Indeed, San Bartolo and other sites are gradually rewriting the history of art in the Western Hemisphere.

NATIVE AMERICAS

classic, from 900 to the Spanish conquest of the Aztecs in 1521. 2000 BCE to about 300 CE; Classic, from about 300 to 900; and Post-Historians divide that history into three epochs: Preclassic, from much of the art and architectural history of ancient Mesoamerica. ies, archaeologists and art historians have been able to reconstruct of other sites. But despite the ruined state of the pre-Hispanic citand the encroachment of tropical forests—caused the abandonment of non-Christian shrines and "idols." The forces of nature—erosion

Names and boundaries of present-day səlim 00p ◆ Archeological site EL SALVADOR HONDUKAS CUATEMALA Copan PACIFIC OCEAN SAGAIHO ADAXAO Bonampak Yaxchilán BELIZE CUERRERO TABASCO La Venta oloned ned CAMPECHE (Tenochtitlán) COLIMA YUCATÁN pulls DOSITAL · Chichén Itzá NATADUY **TINAYAN** Gulf of Mexico STATE

nword ni resqqe snouen

MAP 20-1 Mesoamerica.

0051-006

these Stone Age hunter-gatherer nomads had settled in villages and have reached the Western Hemisphere via boat. By 8000 to 2000 BCE, Asia and North America at the Bering Strait. Some migrants may cans probably crossed the now-submerged land bridge connecting tain. Sometime no later than 30,000 to 10,000 BCE, these first Ameri-The origins of the indigenous peoples of the Americas are still uncer-

tion treats the art of the indigenous inhabitants America, and North America. The second secof the native peoples of Mesoamerica, South ines in turn the greatest artistic achievements alwork. The first section of this chapter exammastered the arts of weaving, pottery, and metand reliefs, painted extensive mural cycles, and ering temples, carved large-scale stone statues irrigation and drainage systems. They built towconstruction of cities, roads and bridges, and America), ancient Americans excelled in the and had no pack animals but the llama (in South tools, did not use the wheel (except for toys), cal achievement. Although most relied on stone high level of social complexity and technologiries CE, several population groups had reached a learned to fish and farm, and by the early centu-

Mesoamerica

of the South Pacific (Oceania).

can cities in their zeal to obliterate all traces destroyed most of the once-glorious Ameri-Cortés (1485-1547). The European armies the conquest of the Aztec Empire by Hernán of Christopher Columbus (1451-1506) and civilizations that flourished before the arrival homeland of several of the great pre-Columbian El Salvador (MAP 20-1). Mesoamerica was the mala, Belize, Honduras, and the Pacific coast of comprising part of present-day Mexico, Guate-The term Mesoamerica describes the region

NATIVE AMERICAS AND OCEANIA

səsnoy s,uəm jeunumos cloaks, and construct of bark, weave feather ornaments and sheets ties, paint wood prow of ancestors and delscniptures and masks Australian artists carve sian, Polynesian, and Melanesian, Microneon-black glazed pottery. ceramists develop blackthe elite, and Southwest robes and regalia for artists fashion elaborate figurines, Great Plains Hopi produce katsina transformation masks, **СМАКМАКА** МАКМ САГУЕ In North America, 0861-0081

Temple of the Sun in Andes and build the miles of roads in the Inka construct 20,000 sacred precinct. statues and reliefs in the and place monumental Mayor at lenochtitian Aztecs build the Templo 7891-0081

0081-7891

Nui (Easter Island). colossal moai on Rapa Oceanic sculptors erect Picchu. Cuzco and Machu

mounds, is the largest 1500) Cahokia, with 120 Mississippian (ca. 800-EZ1 Mesoamerica at Chichén the largest ball court in pyramid-temple and construct the Castillo 900-1521) Maya ■ The Postclassic (ca.

bns O2ff neewted ober build Cliff Palace in Colo-■ The Ancestral Puebloans city in North America.

miles of earth drawings 600 cE) create 800 The Nasca (ca. 200 BCE-Mesoamerica. sic (ca. 300-900 cE) and ball courts in Clasremple-pyramids, plazas, vast complexes of The Maya construct

around 500 cE. Preclassic (ca. 400 ser up colossal ruler 400 BCE) of Mesoamerica The Olmec (ca. 900ca. 1500 BCE. animal stone figurines, -namud stizoqmoo Oceanic artists carve 1200 BCE-300 CE 006-008

Peru produces extraordi-BCE-ZOO CE) culture in ■ The Paracas (ca. 400 of leotihuacan. construct the pyramids BCE-300 CE) pnilders

BCE) build mounds in The Adena (ca. 500-1 nary textiles.

OLMEC Archaeologists often refer to the Preclassic Olmec culture of the present-day states of Veracruz and Tabasco as the "mother culture" of Mesoamerica because many distinctive Mesoamerican religious, social, and artistic traditions can be traced to it. Settling in the tropical lowlands of the Gulf of Mexico, the Olmec peoples cultivated a terrain of rain forest and sandy lowland. Here, between approximately 1500 and 400 BCE, social organization assumed the form that later Mesoamerican cultures developed. The mass of the population—food-producing farmers scattered in hinterland villages—provided the sustenance and labor that maintained a hereditary caste of rulers, hierarchies of priests, functionaries, and artisans. At regular intervals, the whole community convened for ritual observances at religious-civic centers such as La Venta.

LA VENTA At La Venta, stone fences enclosed two great courtyards. At one end of the larger area was a pyramidal earthen mound almost 100 feet high and adorned with colored clays. Its form may have mimicked a mountain, held sacred by Mesoamerican peoples as both a life-giving source of water and a feared destructive force. The La Venta layout is an early form of the temple-pyramid-plaza complex aligned on a north-south axis that characterized later Mesoamerican ceremonial center design.

Four colossal basalt heads (FIG. 20-2), weighing about 10 tons each and standing between 6 and 10 feet high, face out from the plaza. Archaeologists have discovered more than a dozen similar heads at San Lorenzo and Tres Zapotes. Almost as much of an achievement as the carving of these huge heads with stone tools was their transportation across the 60 miles of swampland from the nearest known basalt source, the Tuxtla Mountains. Although the identities of the colossi are uncertain, their individualized features

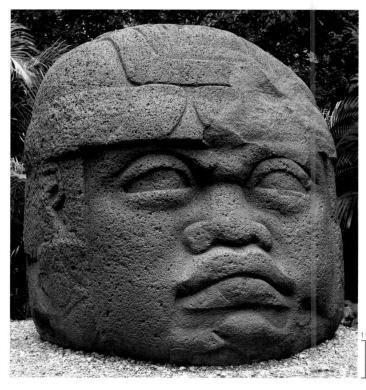

20-2 Colossal head, La Venta, Mexico, Olmec, 900–400 BCE. Basalt, 9' 4" high. Museo-Parque La Venta, Villahermosa.

The identities of the Olmec colossi are uncertain, but their individualized features and distinctive headgear as well as later Maya practice suggest that these heads portray rulers rather than deities.

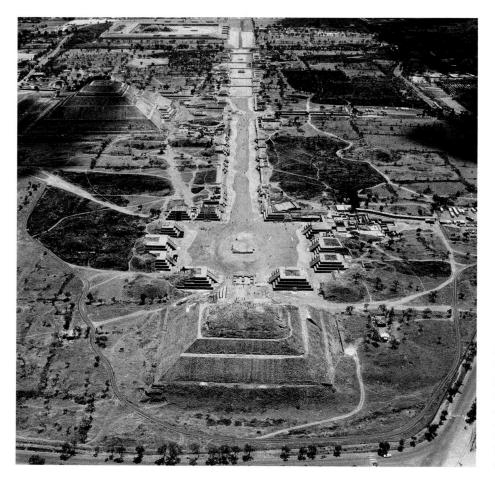

and distinctive headgear and ear ornaments, as well as the later Maya practice of carving monumental ruler portraits, suggest that the Olmec heads portray rulers rather than gods. The sheer size of the heads and their intensity of expression evoke great power, whether mortal or divine.

TEOTIHUACÁN No Olmec site can compare in size, grandeur, or complexity with the late Preclassic site of Teotihuacán (FIG. 20-3), northeast of Mexico City, a densely populated metropolis that fulfilled a central civic, economic, and religious role for the region and indeed for much of Mesoamerica. The city covers 9 square miles, laid out in a

20-3 Aerial view of the northern section of Teotihuacán (looking south), Mexico, with the Pyramid of the Moon in the foreground and the Pyramid of the Sun at the top left, ca. 50–250 CE.

At its peak around 600 cE, Teotihuacán was the world's sixth-largest city. It featured a grid plan, a 2-mile-long main avenue, and monumental pyramids echoing the shapes of nearby mountains.

Mesoamerican sites. Rubble-filled and faced with the local volcanic stone, the pyramids consist of stacked square platforms diminishing in perimeter from the base to the top. Ramped stairways once led to crowning temples constructed of perishable materials such as wood and thatch.

The Teotihuacános built the Pyramid of the Sun over a cave that may have marked a sacred spring. Excavators found the skeletons of children buried at the four corners of each of the pyramid's tiers. The Aztec sacrificed children to bring rainfall, and Teotihuacán art abounds with references to water, so the Teotihuacános may have shared the Aztec preoccupation with rain and agricultural fertility. The city's inhabitants enlarged the Pyramid of the Moon at least five times in Teotihuacán's early history. The structure may have been positioned to mimic the shape of Cerro Gordo, the volcanic mountain behind it.

painted stucco once covered Teotihuacán's buildings and streets. Elaborate murals also decorated the walls of the rooms of its elite residential compounds. The Teotihuacáno artists applied pigments to a smooth lime-plaster surface coated with clay, and then polished the surface to a high sheen. Although some preserved murals have a restricted palette of varying tones of red, creating subtle contrasts a restricted palette of varying tones of red, creating subtle contrasts between figure and ground, most employ vivid hues arranged in flat, carefully outlined patterns.

grid pattern with the axes oriented by sophisticated surveying. Its major monuments date between 50 and 250 ce. At its peak, around 600 ce, Teotihuacán may have had a population of 125,000 to 200,000, making it the sixth-largest city in the world at that time. Hundreds of years later, the Aztecs gave Teotihuacán its current name, which means "the place of the gods." Because the city's hieroflyphs remain largely undeciphered, the names of many major necessarily relate to the original names. North-south and east-west axes, each two miles in length, divide the grid plan into quarters. The main north-south axis (FIG. 20-3), the Avenue of the Dead, is axes, each two miles in length, divide the grid plan into quarters. If the Surrounding buildings and landscape.

temple platforms popularly called pyramids, as in Egypt, but there is no connection between these two ancient cultures. The Pyramid of the Sun (Fig. 20-3, top left), facing west on the east side of the Avenue of the Dead, dates to the first century CE. The city's centerpiece, it rises to a height of more than 200 feet. The Pyramid of the Moon (Fig. 20-3, foreground) dates at least a century later, around 150 to 250 CE. The shapes of the pyramids echo the surrounding mountains. Their imposing mass and scale surpass those of all other

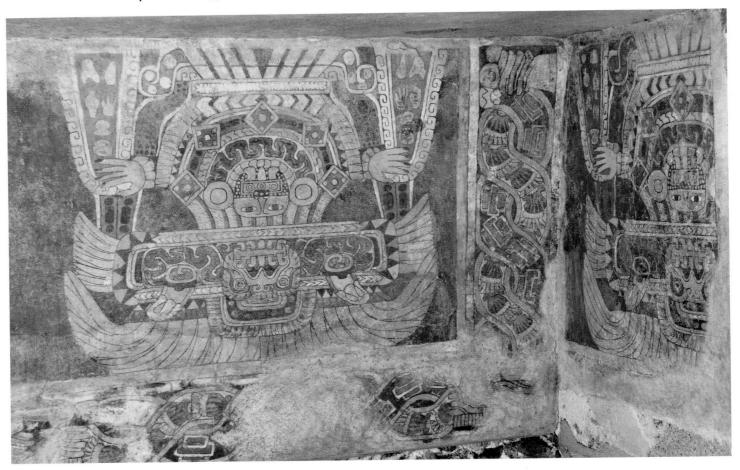

20-4 Goddess, wall painting from the Tetitla apartment complex at Teotihuacán, Mexico, 650-750 CE. Pigments over clay and plaster.

Elaborate mural paintings adorned Teotihuacán's elite residential compound. This example may depict the city's principal deity, a goddess wearing a jade mask and a large feathered headdress.

The mural illustrated here (FIG. 20-4) depicts an earth or nature goddess. Some scholars think she was the city's principal deity. Always shown frontally with her face covered by a jade mask, she is dwarfed by her large feathered headdress and reduced to a bust placed on a stylized pyramid. She stretches her hands out to provide liquid streams filled with bounty. The stylized human hearts flanking the frontal bird mask in the Teotihuacáno goddess's headdress reflect the ancient Mesoamerican belief that human sacrifice is essential to agricultural renewal.

MAYA As was true of Teotihuacán, the foundations of Maya civilization date to the Preclassic period, perhaps 600 BCE or even earlier. At that time, the Maya, who occupied the moist lowland areas of Belize, southern Mexico, Guatemala, and Honduras, seem to have abandoned their early, somewhat egalitarian pattern of village life and adopted a hierarchical autocratic society. This system evolved into the typical Classic Maya city-state governed by hereditary rulers and ranked nobility. How and why this happened are still unknown, but the Classic Maya culture endured for 600 years.

Although the causes of the beginning and end of Classic Maya civilization are obscure, researchers now know a great deal about Maya history, religion, ceremonies, conventions, and patterns of daily life through scientific excavations and progress made in decoding Mayan script. The deciphered inscriptions prove that the Maya depicted their rulers (rather than gods or anonymous priests) in their art and noted their kings' achievements in their texts. It is also now clear that the Maya possessed a highly developed knowledge of mathematical calculation and the ability to observe and record the movements of the sun, the moon, and several planets. Their calendar, although radically different in form from that used today, was just as precise and efficient. It enabled the Maya to establish the genealogical lines of their rulers and to create the only systematic written history in ancient America.

ARCHITECTURE AND RITUAL Vast complexes of terraced temple-pyramids, palaces, plazas, and residences of the governing elite dotted the Classic Maya area. Unlike Teotihuacán, no single Maya site ever achieved dominance as the center of power. Each city's architecture and art advertised the power of its rulers, who routinely appropriated cosmic symbolism and stressed their descent from gods to reinforce their claims to legitimate rule.

The Maya erected their most sacred and majestic buildings in enclosed, centrally located precincts within their cities. There, the Maya rulers staged dramatic rituals within spacious sculpture-filled plazas. In both life and art—for example, the Bonampak murals (FIG. 20-1)—the Maya elite wore extravagant, vividly colorful cotton textiles, feathers, jaguar skins, and jade, all emblematic of their rank and wealth. On the different levels of the painted and polished temple platforms, the ruling classes performed the rites in clouds of incense to the music of maracas, flutes, and drums. The Maya thus transformed the architectural complex at each city's center into a theater of religion and statecraft.

COPÁN Because Copán, on the western border of Honduras, has more hieroglyphic inscriptions and well-preserved carved monuments than any other site in the Americas, it was one of the first Maya sites excavated. It also has proved one of the richest in the trove of architecture, sculpture, and artifacts recovered. In Copán's Great Plaza, the Maya set up tall stone stelae featuring sculpted portraits of their rulers and inscriptions recording their names, dates of reign, and notable achievements. Stele D (Fig. 20-5), set up in 736 CE,

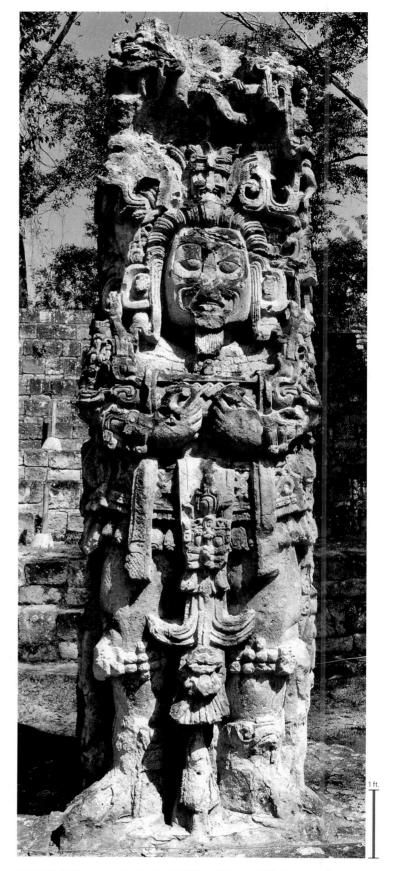

20-5 Stele D portraying Ruler 13 (Waxaklajuun-Ub'aah-K'awiil), Great Plaza, Copán, Honduras, Maya, 736 CE. Stone, 11' 9" high.

This 12-foot stele portrays one of Copán's most important rulers as an overlife-size figure wearing an elaborate headdress and holding a double-headed serpent bar, symbol of his sacred authority.

adjacent to the important civic structures of Mesoamerican cities, such ing the game with portable markers and sticks. Most ball courts were a ball court there, but mural paintings at the site illustrate people play-Teotihuacán (FIG. 20-3) is an exception. Excavators have not yet found

as palaces and temple-pyramids, as at Copán.

rubber ball (FIG. 20-6A ▲). padded their knees and arms against the blows of the fast-moving solid legs. They wore thick leather belts, and sometimes even helmets, and touch the ball with their hands but used their heads, elbows, hips, and against the walls and into the end zones. As in soccer, players could not Alternatively, players may have scored goals by bouncing the ball players aimed to get the ball through a ring in order to score a point. ground, but many courts lack this feature, so it is uncertain whether the Some have stone rings set high up on their walls at right angles to the Chichén Itzá—is nearly 500 feet long. Copán's is about 93 feet long. Mesoamerican ball courts vary widely in size. The largest known-at goals. Unlike a modern soccer field with its standard dimensions, itself, not even how many players were on the field or how they scored Historians know surprisingly little about the rules of the ball game

then forced to participate in a game they were predestined to lose. minated in human sacrifice, probably of captives taken in battle and the walls of some ball courts make clear that the game sometimes culthe court imitating the sun's daily passage through the sky. Reliefs on have represented a celestial body such as the sun, its movements over game did not serve solely for entertainment. The ball, for example, may Although widely enjoyed as a competitive spectator sport, the ball

The Mesoamerican Ball Game **ART AND SOCIETY**

never seen before. tition, and the ball itself, made of rubber, a substance the Spaniards had athletes' great skill, the heavy wagering that accompanied the compe-Europe to demonstrate the novel sport. Their chronicles remark on the the 16th-century Spanish conquerors took Aztec ball players back to After witnessing the native ball game of Mexico soon after their arrival,

even rubber balls at Olmec sites. archaeologists have found remnants of sunken earthen ball courts and region they inhabited. Not only do ball players appear in Olmec art, but the Aztec language-means "rubber people," after the latex-growing ently avid players. Their very name—a modern invention in Nahuatl, ago, the date of the earliest known ball court. The Olmec were apparinto the southwestern United States, beginning at least 3,400 years Native Americans played the game throughout Mesoamerica and

courts even though only a small portion of the site has been excavated. ies. At Cantona, for example, archaeologists have uncovered 22 ball court. These structures were common features of Mesoamerican cit-(FIG. 20-6). At other sites, temples stood at either end of the ball were wide enough to support small structures on top, as at Copán flanked by two parallel sloping or straight walls. Sometimes the walls can cultures into a plastered masonry surface, I- or T-shaped in plan, The Olmec earthen playing field evolved in other Mesoameri-

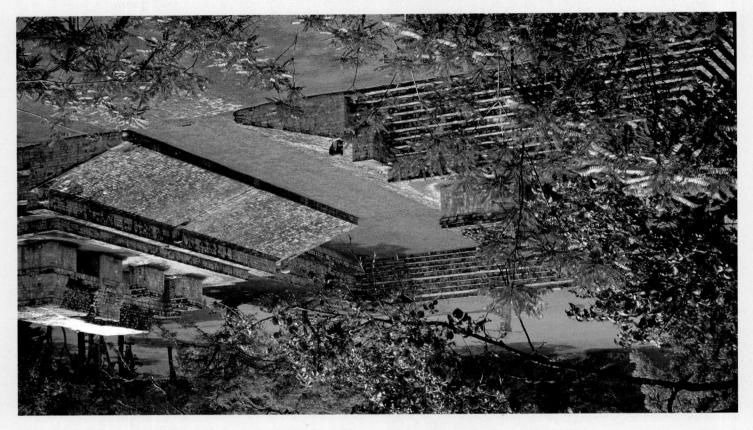

20-6 Ball court (looking northeast), Middle Plaza, Copán, Honduras, Maya, 738 CE.

sometimes ended in the sacrifice of captives taken in battle. Ball courts were common in Mesoamerican cities. Copán's is 93 feet long. The rules of the ball game itself are unknown, but games

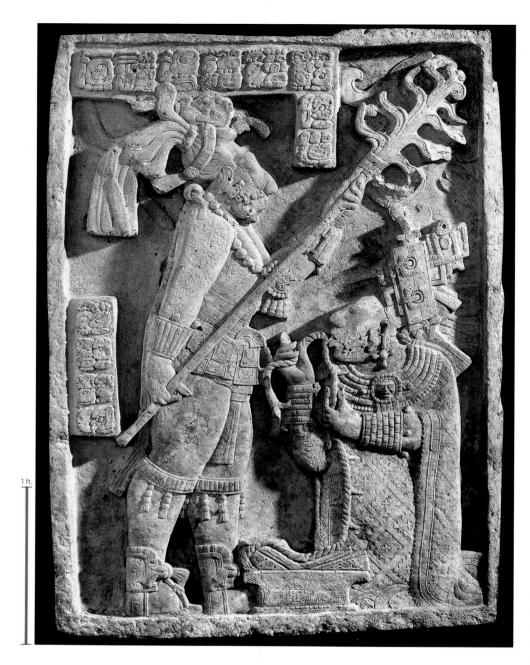

20-7 Shield Jaguar and Lady Xoc, Lintel 24 of Temple 23, Yaxchilán, Mexico, Maya, ca. 725 CE. Limestone, $3'7" \times 2'6\frac{1}{2}"$. British Museum, London.

The carved lintels of this eighth-century temple document the central role that elite women played in Maya society. Lady Xoc pierces her tongue in a bloodletting ritual intended to induce a visionary state.

YAXCHILÁN Elite women played an important role in Maya society, and some surviving artworks, such as the painted reliefs on the lintels of Temple 23 at Yaxchilán, document their high status. Lintel 24 (FIG. 20-7) depicts Itzamna B'ahlam II (r. 681-742 CE), known as Shield Jaguar, and his principal wife, Lady Xoc, who is magnificently outfitted in an elaborate woven garment, headdress, and jewels. With a barbed cord she pierces her tongue in a bloodletting ceremony that, according to accompanying inscriptions, celebrated the birth of a son to one of the ruler's other wives as well as an alignment between the planets Saturn and Jupiter. The celebration must have taken place in a dark chamber or at night because Shield Jaguar provides illumination with a blazing torch. These ceremonies induced an altered state of consciousness in order to connect the bloodletter with the supernatural world. (Lintel 25 depicts Lady Xoc and her vision of an ancestor emerging from the mouth of a serpent.)

represents Waxaklajuun-Ub'aah-K'awiil (r. 695-738), the 13th in the Copán dynastic sequence of 16 rulers. During his long reign, the city may have reached its greatest physical extent and range of political influence. On Stele D, Ruler 13, as scholars call him, wears an elaborate headdress and ornamented kilt and sandals. He holds across his chest a double-headed serpent bar, symbol of his sacred authority. His features are distinctly Maya, although highly idealized. The Maya elite usually required sculptors and painters to depict them as ever-youthful. The dense, deeply carved ornamental details framing the face and figure in florid profusion stand almost clear of the block and wrap around the sides of the stele. The high relief, originally painted, gives the impression of an over-life-size freestanding statue, although an incised hieroglyphic text is on the flat back of the stele. Ruler 13 erected many stelae and buildings at Copán, including one of Mesoamerica's best-preserved (and carefully restored) ball courts (FIG. 20-6; see "The Mesoamerican Ball Game," page 532), but suffered a humiliating death when the king of neighboring Quiriguá captured and beheaded him.

CHICHÉN ITZÁ Throughout Mesoamerica, the Classic period ended at different times with the disintegration of the great civilizations. Teotihuacán's political and cultural empire, for example, began to wane around 600, when fire destroyed the city center. Within a century, Teotihuacán was deserted. Around 900, the Maya abandoned many of their sites to the jungle, leaving a few northern Maya cities to flourish for another century or two during the Postclassic period before they, too, became depopulated. The war and confusion that followed the collapse of the Classic civilizations fractured the great states into small, local political entities isolated in fortified sites. In central Mexico, the Toltec and the later Aztec peoples, both ambitious migrants from the north, forged empires by force of arms, while the militant city-state of Chichén Itzá dominated Yucatán, a flat, low limestone peninsula covered with scrub vegetation. During the Classic period, Mayan-speaking peoples sparsely inhabited this northern region. For reasons scholars still debate, when the southern Maya abandoned their Classic sites after 900, the northern Maya continued to build many new temples in this area.

structure's silhouette and the angle of the sun, the shadow takes the shape of the serpent-god slithering along the pyramid's face as the sun moves across the sky. The Castillo thus refers in its form to the sun in Heaven, the Underworld, and the feathered serpent.

Solar as well as Underworld imagery is a common feature of Mesoamerican architecture. At El Tajín, for example, the Pyramid of the Niches (not illustrated) has a total of 365 niches on its four sides.

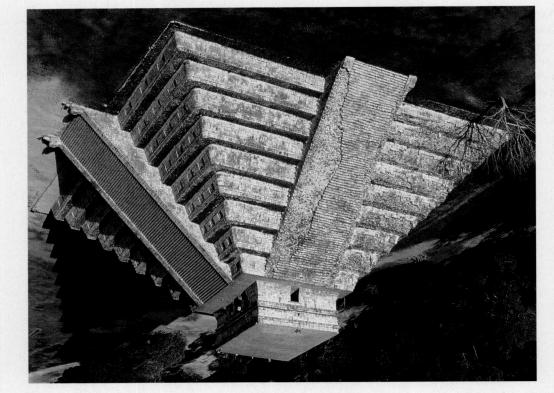

20-8 Aerial view of the Castillo (looking southwest), Chichén Itzá, Maya, Mexico, ca. 800-900 CE. A temple to Kukulcán sits atop this pyramid featuring a total of 365 stairs on its four sides. At the winter and

summer equinoxes, the sun casts a shadow in the shape of a serpent along the northern staircase.

.gnissimg.

PROBLEMS AND SOLUTIONS

The Underworld, the Sun, and

Mesoamerican Pyramid Design

The Maya believed that Heaven and earth consisted of 13 layers, with the lowest. Below, the Underworld, or Xibalba (the Place of

Fear), had nine levels, ruled by gods of the dead who subjected humans to various fortures. Most Maya resided in Xibalba forever after they died. However, when divine Maya rulers died, they would descend to the bottom of the Underworld and then rise to of the Underworld and then rise to Heaven.

staircase of the Castillo. Because of the sun casts a shadow along the northern the winter and summer equinoxes, the the number of days in a solar year. At sides 91 steps each for a total of 365, tillo has 92 steps and the other three serpent god. The north side of the Cas-Teotihuacáno and Aztec feathered-Maya equivalent of Quetzalcoatl, the a temple dedicated to Kukulcán, the oriented to the four cardinal points, is solar year. Atop the pyramid, which is the Castillo, however, is also tied to the nine Underworld layers. The form of the nine stepped stories symbolize the nine levels. No one doubts that (FIG. 20-8) at Chichén Itzá, have Maya pyramids, including the Castillo design of their pyramid-temples. Many references to Maya cosmology in the liant but simple way to incorporate Maya architects found a bril-

CASTILLO Dominating the main northern plaza of Chichén Itzá today is the 98-foot-high pyramid (Fig. 20-8) that the Spaniards nicknamed the Castillo (Castle), an extraordinary structure that incorporates in its form references to both the Underworld and the Sun above). In 1937, excavations within the Castillo revealed an earlier nine-level pyramid inside the later and larger structure. In the earlier pyramid, archaeologists found a chamber with a throne in the form of a red jaguar and a stone figure of the chacmool (Mayan, "red jaguar paw") type depicting a fallen warrior. Chacmools (for example, per 20-9, found on the so-called Platform of the Eagles near the Castillo) recline on their backs and have receptacles on their chests to teceive ritual offerings, probably of sacrificial victims. The distinctive forms of Mesoamerican chacmools made a deep impression on some forms of Mesoamerican chacmools made a deep impression on some forms of Mesoamerican chacmools made a deep impression on some forms of Mesoamerican chacmools made a deep impression on some forms of Mesoamerican chacmools made a deep impression on some forms of Mesoamerican chacmeols made a deep impression on some 20th-century sculptors (compare Fig. 14-30A).

TOLIEC The name Toltec ("makers of things") refers to a powerful northern Mesoamerican population group whose arrival in central Mexico coincided with the fall of the Classic civilizations, although they may have not been the cause. In any case, the Toltecs occupied

Tula, north of Mexico City, from about 900 to 1200, the early part of the Postclassic period. Master artisans as well as feared warriors, the Toltecs constructed imposing temples and set up monumental statues. Most impressive are the four colossal atlantids (male statuecolumns; Pie. 20-10) built up of four stacked stone drums each that stand atop Pyramid B at Tula. Whether the atlantids portray rulers in military dress or anonymous armed warriors is uncertain, but their function is clear. These images of brutal authority stand eternally at attention, warding off all hostile forces. They wear feathered headdresses and, as breastplates, stylized butterflies, heraldic ered headdresses and, as breastplates, stylized butterflies, heraldic symbols of the Toltecs. In one hand they clutch a bundle of darta and in the other an atlath (spear-thrower), typical weapons of highland in the other an atlath (spear-thrower), typical weapons of highland in the other an atlath (spear-thrower), typical weapons of highland in the other an atlath (spear-thrower), typical weapons of high-

By 1180, the last Toltec ruler abandoned Tula, and most of his people followed. Some years later, the city was catastrophically destroyed, its ceremonial buildings burned to their foundations, its walls torn down, and the straggling remainder of its population scattered. The exact reasons for the Toltecs' departure and for their city's destruction are unfortunately unknown.

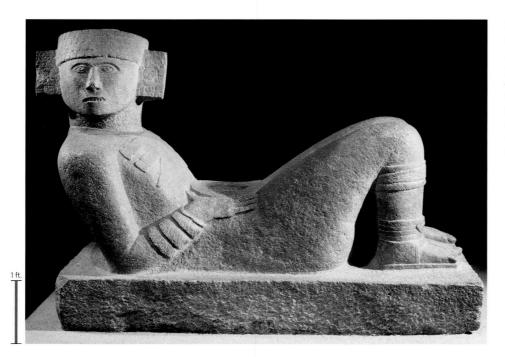

20-9 Chacmool, from the Platform of the Eagles, Chichén Itzá, Mexico, Maya, ca. 800–900 CE. Stone, $4' 10\frac{1}{2}"$ high. Museo Nacional de Antropología, Mexico City.

Chacmools represent fallen warriors reclining on their backs holding receptacles for sacrificial offerings. Excavators discovered one in the throne chamber inside an earlier pyramid within the Castillo (Fig. 20-8).

AZTEC The fall of the Toltecs brought a century of anarchy to the Valley of Mexico, the vast highland valley 7,000 feet above sea level now home to sprawling Mexico City. Waves of northern invaders established warring city-states and wrought destruction in the valley. The last and greatest of these conquerors were the Aztecs, who called themselves Mexica and claimed descent from the Toltecs. Fulfilling a legendary prophecy that they would build a city where they saw an eagle perched on a cactus with a serpent in its mouth (FIG. 20-10A ③), they settled on an island in Lake Texcoco. Their settlement grew into the magnificent city of Tenochtitlán, which had a population of more than 150,000 at its peak in the 16th century.

Recognized by those they subdued as fierce in war and cruel in peace, the Aztecs radically changed the social and political situation in Mexico. Subservient groups not only had to submit to Aztec military power but also had to provide victims to be sacrificed to Huitzilopochtli, the hummingbird god of war, and to other Aztec deities (see "Aztec Religion," page 537). As did other Mesoamerican peoples before them, the Mexica practiced bloodletting and human sacrifice to please the gods and sustain the great cycles of the universe. The Aztecs, however, engaged in human sacrifice on a greater scale than any of their predecessors, even waging wars expressly to obtain captives for future sacrifice.

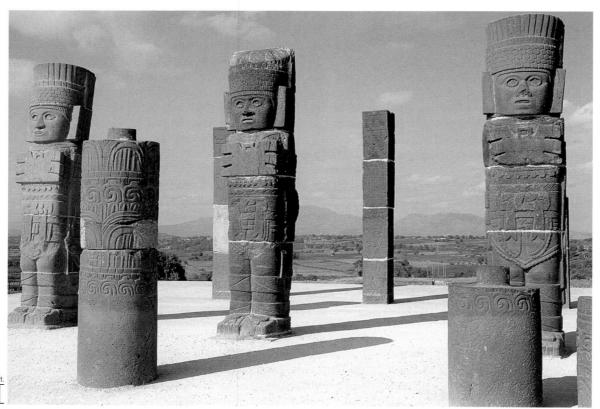

20-10 Colossal atlantids, Pyramid B, Tula, Mexico, Toltec, ca. 900–1180 CE. Stone, each 16' high.

Little is known about the Toltecs, but they left behind these colossal stone statue-columns atop a pyramid-temple at Tula. The atlantids portray warriors or rulers armed with darts and spear-throwers.

1 f

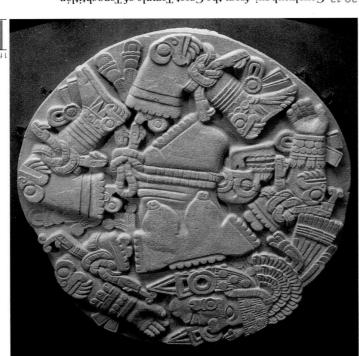

20-72 Coyolxauhqui, from the Great Temple of Tenochtitlán, Mexico City, Aztec, ca. 1469. Stone, diameter 10' 10". Museo del Templo Mayor, Mexico City.

The sacrificed foes' bodies that the Aztecs hurled down the Great Temple's stairs landed on this disk, which depicts the segmented body of the moon goddess Coyolxauhqui, Huitzilopochtli's sister.

god Tlaloc. Two great staircases originally swept upward from the plaza level to the two sanctuaries at the summit. The Hueteocalli is a remarkable example of superimposition, a common trait in Meso-american architecture, already noted in the Castillo (Fig. 20-8) at Chichén Itzá. The excavated structure, composed of seven shells, indicates how earlier walls nested within the later ones. (Today, only two of the inner structures remain. The Spaniards destroyed the later ones in the 16th century.) The sacred precinct also contained the temples of other deities, a ball court, a skull rack for the exhibition of the heads of victims killed in sacrificial rites (Fig. 20-10A, top right A), and a school for the children of the nobility.

ried a contemporary political message. The Aztecs sacrificed their mented body of Coyolxauhqui. The mythological theme also car-Temple.) The relief presents the image of the murdered and segnever saw it because it lay within the outermost shell of the Great of Huitzilopochtli's earlier temples on the site. (Cortés and his army that the Aztecs placed at the foot of the staircase leading up to one The mythical event is the subject of a huge stone disk (FIG. 20-12) Coatepec Mountain near Tula (represented by the pyramid itself). bered the body of his sister, the moon goddess Coyolxauhqui, at Huitzilopochtli killed or chased away his brothers and dismemthe sun's battle with the forces of darkness, the stars and moon. sun at dawn, a role that Huitzilopochtli sometimes assumed, and gion," page 537, and FIG. 20-13). The myth signifies the birth of the who had plotted to kill their mother, Coatlicue (see "Aztec Relicommemorated the god's victory over his sister and 400 brothers, COYOLXAUHQUI The Temple of Huitzilopochtli at Tenochtitlán

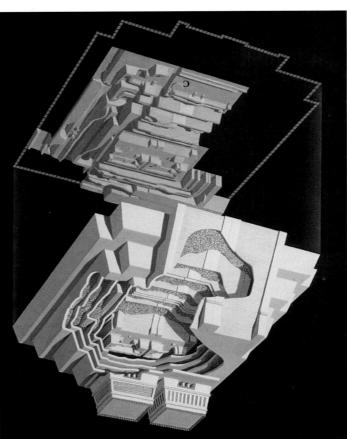

 $20\mbox{-}11$ Reconstruction drawing with cutaway view of various rebuildings of the Great Temple, Tenochtitlân, Mexico City, Mexico, Aztec, ca. $1400\mbox{-}1500$. C = Coyolxauhqui disk (Fig. 20-12).

The Great Temple in the Aztec capital encases successive earlier atructures. The latest temple honored the gods Huitzilopochtli and Tlaloc, whose sanctuaries were at the top of a stepped pyramid.

never beheld before."1 and so full of people, and so well regulated and arranged, they had ple, and all over Italy, and in Rome, said that so large a marketplace among us who had been in many parts of the world, in Constantinofirst entered Tenochtitlan on August 13, 1521: "Some of the soldiers Díaz del Castillo (1492-1581), who accompanied Cortés when he boasted a vast and bustling marketplace. In the words of Bernal vision. Crowded with buildings, plazas, and courtyards, the city also Venice when they saw the city rising from its canals like a radiant via canals and other waterways. Many of the Spaniards thought of island location required conducting communication and transport doned, had become a pilgrimage site for the Aztecs. Tenochtitlán's wards, reminiscent of Teotihuacán (FIG. 20-3), which, long abantitlán on a grid plan dividing the city into quarters (FIG. 20--10A) and directly beneath the center of Mexico City. The Mexica laid out Tenoch-TENOCHTITLAN The ruins of the Aztec capital, Tenochtitlan, lie

HUETEOCALLI In the 1970s, Mexican archaeologists identified the exact location of many of the most important structures within Tenochtitlán's sacred precinct. The principal building was the Hueteocalli—the Templo Mayor, or Great Temple (FIG. 20-11), a temple pyramid honoring the Aztec god Huitzilopochtli and the local rain

RELIGION AND MYTHOLOGY Aztec Religion

The Aztecs saw their world as a flat disk resting on the back of a monstrous earth deity. Tenochtitlán, their capital, was at its center. Hueteocalli, the Great Temple (FIG. 20-11), at the heart of the city, represented the Hill of Coatepec, the Serpent Mountain, and formed the axis passing up to the heavens and down through the Underworld—a concept with parallels in other cultures (see, for example, "The Stupa," page 465). Each of the four cardinal points had its own god, color, tree, and calendar symbol. The sky consisted of 13 layers, whereas the Underworld had 9.

Because the Aztecs often adopted the gods of conquered peoples, their pantheon was complex and varied. When the Aztecs arrived in the Valley of Mexico, their own chief god, *Huitzilopochtli* (Hummingbird of the South), a war and sun/fire deity, joined such well-established Mesoamerican gods as the rain and fertility god *Tlaloc* and the feathered serpent *Quetzalcoatl*, who was a benevolent god of life, wind, learning, and culture. Huitzilopochtli was the son of *Coatlicue* (She of the Serpent Skirt; Fig. 20-13). Coatlicue was also the mother of *Coyolxauhqui* (She of the Golden Bells; Fig. 20-12) and 400 sons, the *Centzon Huitznahua* (Four Hundred Southerners), who, jealous that their mother was pregnant with Huitzilopochtli, banded together to murder her. At the moment of her death, she gave birth to Huitzilopochtli, who slaughtered Coyolxauhqui and most of her brothers, then cut his sister's body into pieces and threw it down Coatepec Mountain.

Most Aztec ceremonies involved colorfully attired dancers and actors, and musicians playing conch-shell trumpets, drums, rattles, rasps, bells, and whistles. Almost every Aztec festival also included human sacrifice. To Tlaloc, the priests offered small children because their tears brought the rains. Distinctive hairstyles, clothing, and black body paint identified the priests. Women served as priestesses, particularly in temples dedicated to various earth mother cults. When Cortés and his men encountered a group of foul-smelling priests with uncut fingernails, long hair matted with blood, and ears covered in cuts, they recoiled in shock, not realizing that the priests were performing rites in honor of the deities they served, including piercing their skin with cactus spines to draw blood. These men were the opposite of the "barbarians" that the European conquerors considered them to be. They were, in fact, the most highly educated Aztecs. The religious practices that horrified the Spaniards, however, were not unique to the Aztecs but were deeply rooted in earlier Mesoamerican society.

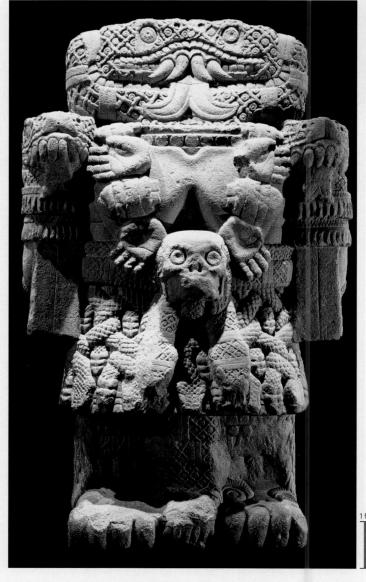

20-13 Coatlicue, from Tenochtitlán, Mexico City, Aztec, ca. 1487–1520. Andesite, 11' 6" high. Museo Nacional de Antropología, Mexico City.

This colossal statue may have stood near the Great Temple. The beheaded goddess wears a necklace of human hands and hearts. Entwined snakes form her skirt. All her attributes symbolize sacrificial death.

conquered enemies at the top of the Great Temple and then hurled their bodies down the temple stairs to land on this stone. The victors thus forced their foes to reenact the horrible fate of the dismembered goddess. The unforgettable image of the fragmented goddess proclaimed the power of the Mexica over their enemies and the inevitable fate that must befall their foes when defeated. Marvelously composed in low, almost flat, relief, the horrific representation has a kind of dreadful beauty. Within the circular space, the design's carefully balanced and richly detailed components have a slow turning rhythm reminiscent of a revolving galaxy.

COATLICUE The Aztecs also produced freestanding statues. Perhaps the most impressive is the colossal image (FIG. 20-13) of the

beheaded Coatlicue. The main forms are in high relief, the details executed either in low relief or by incising. The overall aspect is of an enormous blocky mass, its ponderous weight looming over awestruck viewers. From the beheaded goddess's neck writhe two serpents whose heads meet to form a tusked mask. Coatlicue wears a necklace of severed human hands and excised human hearts. The pendant of the necklace is a skull. Entwined snakes form her skirt. From between her legs emerges another serpent, symbolic perhaps of both menstruation and the male member. Like most Aztec deities, Coatlicue has both masculine and feminine traits. Her hands and feet have great claws. All her attributes symbolize sacrificial death. Yet, in Aztec thought, this mother of the gods combined savagery and tenderness, for out of destruction arose new life.

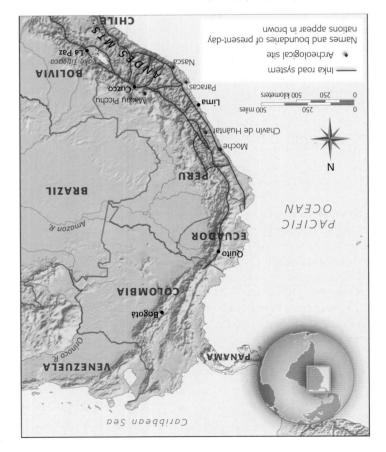

MAP 20-2 Andean South America.

as well as the Inka Empire that the Europeans encountered and defeated in the 16th century.

PARACAS The Paracas culture occupied a desert peninsula and a nearby river valley on the south coast of Peru. Outstanding among the Paracas arts are the textiles used to wrap the bodies of the dead in

the Spanish king's new domains, due in part to a host of new discentury of turmoil and an enormous population decline throughout sanctuary to exorcise its evil. The ensuing clash of cultures led to a put a high cross above the pyramid and a statue of the Virgin in the blood. Denouncing Huitzilopochtli as a devil, Cortés proposed to in horror, recoiling in disgust at the huge statues clotted with dried entourage into Huitzilopochtli's temple, the Spaniards started back when Emperor Moctezuma II (r. 1502-1521) brought Cortes and his and its grandees resplendent in exotic bird feathers. But in 1519, and spacious gardens, its sparkling waterways, its teeming markets, They admired its splendid buildings ablaze with color, its luxuriant city of Tenochtitlán with what they regarded as its hideous cults. Europeans found it impossible to reconcile the beauty of the great zealous friars destroyed countless "idols" and illustrated books. The took Aztec gold artifacts back to Spain and melted them down, and not survive the Spanish conquest and its aftermath. The conquerors CORTÉS AND MOCTEZUMA Unfortunately, most Aztec art did

South America

As in Mesoamerica, until their defeat by Spanish armies, the indigenous peoples of Andean South America (MAP 20-2) erected towering monuments and produced sophisticated paintings, sculptures, ceramics, and textiles. Although less well studied than the ancient Mesoamerican cultures, the South American civilizations are older, and in some ways they surpassed the accomplishments of their northern counterparts. Andean peoples, for example, mastered northern counterparts. Andean peoples, for example, mastered and in some ways they surpassed the accomplishments of their northern counterparts. Andean peoples, for example, mastered metalworking much earlier, and their monumental architecture predates the Olmec pyramids by more than a millennium.

eases for which the Native Americans had no immunity.

The Central Andean region of South America lies between Ecuador and northern Chile. The Pacific Ocean constitutes its western border. Andean civilizations flourished both in the highlands and on the coast. The most important are the Chavin culture (ca. 800–200 BCE; FIG. 20-13A A), roughly contemporaneous with the Olmec civilization in Mexico, and the later Paracas (ca. 400 BCE–200 CE), Nasca (ca. 200 BCE–600 CE), and Moche (ca. 1–700 CE) cultures,

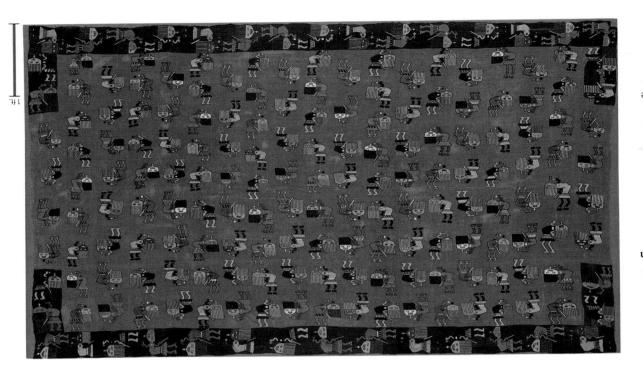

funerary mantle, from the southern coast of Peru, Paracas, first century CE. Plain-weave camelid fiber with stem-stitch end wool, $4^{\circ} 7 \frac{7}{8}^{\circ} \times 7 \cdot 10 \frac{7}{8}^{\circ}$. Museum of Fine Arts, Boston (William A. Paine Pund).

20-14 Embroidered

Paracas weavers created elaborate mantles to wrap around the bodies of the dead. The flying or floating figure repeated endlessly on this mantle is probably the deceased or a relibrous practitioner.

ART AND SOCIETY

Nasca Lines

Some 800 miles of lines drawn in complex networks on the dry surface of the Nasca Plain have long attracted world attention because of their colossal size, which defies human perception from the ground. Preserved today are about three dozen images of birds, fish, and plants, including a hummingbird (FIG. 20-15) several hundred feet long. The Nasca artists also drew geometric forms, such as trapezoids, spirals, and straight lines running for miles.

The Nasca produced these "Nasca Lines," as art historians have dubbed their immense earth drawings, by selectively removing the dark top layer of stones to expose the light clay and calcite below. Artisans created the lines quite easily from available materials and using rudimentary geometry. Small groups of workers have made modern reproductions of them with relative ease. The lines seem to be paths laid out using simple stone-and-string methods. Some lead in traceable directions across the deserts of the Nasca River drainage. Others have many shrinelike nodes punctuating the lines, like the knots on a cord. Some lines converge at central places usually situated close to water sources and seem to be associated with water supply and irrigation. They may have marked pilgrimage routes for those who journeyed to local or regional shrines on foot.

Altogether, the vast arrangement of the Nasca Lines is a system—not a meaningless maze but a traversable map that plotted the whole terrain of Nasca material and spiritual concerns. Remarkably, until quite recently, the peoples of highland Bolivia made and used similar ritual pathways in association with shrines, demonstrating the tenacity of indigenous Andean belief systems.

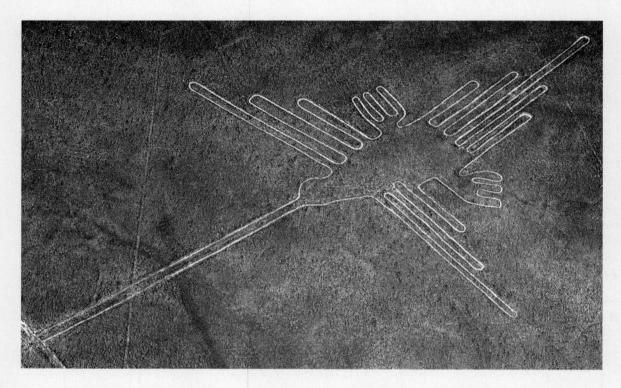

20-15 Hummingbird, Nasca Plain, Peru, Nasca, ca. 500 CE. Dark layer of pebbles scraped aside to reveal lighter clay and calcite beneath.

The earth drawings known as Nasca Lines represent birds, fish, plants, and geometric forms. They may have marked pilgrimage routes leading to religious shrines, but their function is uncertain.

multiple layers. Most are of woven cotton with designs embroidered onto the fabric in alpaca or vicuña wool imported from the highlands. The weavers, probably exclusively women, used more than 150 vivid colors, and sometimes sewed rare tropical bird feathers and small plaques of gold and silver onto cloth destined for the nobility. Feline, bird, and serpent motifs appear on many of the textiles, but the human figure, real or mythological, predominates. Humans dressed up as or changing into animals are common motifs on the grave mantles, consistent with the Andean transformation theme seen earlier on the Raimondi Stele (FIG. 20-13A 1). On one wellpreserved mantle (FIG. 20-14), a figure with prominent eyes appears scores of times. The flowing hair and the slow kicking motion of the legs suggest that the figure is flying or floating while carrying batons and fans or, according to some scholars, knives and hallucinogenic mushrooms. On other mantles, the figures carry the skulls or severed heads of enemies. Art historians have interpreted the flying figures either as Paracas religious practitioners dancing or flying during an

ecstatic trance or as images of the deceased. Despite endless repetitions of the figure, variations of detail occur throughout each textile, notably in the figures' positions and in subtle color changes.

NASCA The Nasca culture takes its name from the Nasca River valley south of Paracas. It is most famous today for its gigantic earth drawings (see "Nasca Lines," above). The early centuries of the Nasca civilization ran concurrently with the closing centuries of the Paracas culture, and, with the exception of the Nasca Lines, Nasca style emulated Paracas style.

MOCHE The Moche occupied a series of river valleys on the north coast of Peru around the same time that the Nasca flourished to the south. The Moche left behind an extraordinary variety of painted vessels illustrating architecture, metallurgy, weaving, the brewing of maize beer, human deformities and diseases, and even sexual acts. Predominantly flat-bottomed stirrup-spouted jars, Moche vessels

accumulate enormous wealth and to amass the fabled troves of gold and silver that the Spaniards coveted. An empire as vast and rich as the Inka's required skillful organizational and administrative control. The Inka had rare talent for both. They divided their Andean empire, which they called Tawantinsuyu (Land of the Four Quarters), into sections and subsections (provinces and communities) whose boundaries all converged on, or radiated from, the capital city of Cuzco.

The engineering prowess of the Inka matched their talent for governing. They overcame the difficult problems of agriculture in a mountainous region with expert terracing and irrigation, and knitted their extensive territories with networks of highways and bridges, upgrading or constructing more than 20,000 miles of roads. Instead of using wheeled vehicles and horses, the Inka efficiently moved goods on their highways by llama herds. They also established a swift communication system of relay runners who carried is a wift communication system of relay runners who carried for a paved flat surface, the Inka built stone steps, and their rope bridges crossed canyons high over impassable rivers. They placed small settlements along the roads no more than a day apart, where travelers could rest and obtain supplies for the journey.

The Inka never developed a writing system, but they maintained highly accurate accounts using a device known as the khipu, which enabled them to record calendar and astronomical information, census and tribute totals, and inventories. For example, the Spaniards noted admiringly that Inka officials always knew exactly how much maize or cloth was in any storeroom in their empire. Not a book or a tablet, the khipu consisted of a main fiber cord and other knotted threads hanging perpendicularly off it. The color and position of each threads hanging perpendicularly off it. The color and signified numbers and categories of things, whether people, llamas, or crops. Studies of khipus have demonstrated that the Inka used the decimal system, were familiar with the concept of zero, and could record numbers up to five digits.

MACHU PICCHU The Inka were gifted architects, and their masons were masters of shaping and fitting stone. As a militant people, they selected breathtaking, naturally fortified sites and further strengthened them by building various defensive structures. Inka settlement planning reveals an instinctive grasp of the harmonious relationship of architecture to site.

ing of important astronomical events. framed spectacular views of sacred peaks and facilitated the recordplaza. The Inka carefully sited buildings so that windows and doors of Huayna Picchu, the great hill just beyond Machu Picchu's main spill down the mountainsides and extend even up to the very peak cut large stones to echo the shape of the mountain beyond. Terraces mountain ranges surrounding the site on all sides. The Inka even scape is so complete that the buildings seem a natural part of the Inka settlement. The accommodation of its architecture to the land-Picchu is of great archaeological importance as a rare undisturbed (its resident population was a little more than a thousand), Machu Though relatively small and insignificant compared to its neighbors century Inka ruler, probably the emperor Pachacuti (r. 1438–1472). of the region's other sites, was the estate of a powerful mid-15th-Machu Picchu is about 50 miles north of Cuzco and, like some world until its rediscovery in 1911. In the very heart of the Andes, some 1,600 feet below, the site remained unknown to the outside 9,000 feet above sea level. Invisible from the Urubamba River Valley (FIG. 20-17), which perches on a ridge between two jagged peaks One of the world's most awe-inspiring sights is Machu Picchu

The realistic face is particularly striking. This one in the shape of a head may depict a warrior, ruler, or royal retainer. The Moche culture produced an extraordinary variety of painted vessels. Museo Arqueológico Rafael Larco Herrera, Lima. of Peru, Moche, fifth to sixth century CE. Painted clay, $I^{-\frac{1}{2}}$ high. 20-16 Vessel in the shape of a portrait head, from the northern coast

are generally decorated with a two-color slip. Although the Moche made early vessels by hand without the aid of a potter's wheel, they fashioned later ones in two-piece molds. Thus numerous near-duplicates survive. The portrait vessel illustrated here (Fig. 20-16) is an elaborate example of a common Moche type. It may depict the face of a warrior, a ruler, or even a royal retainer whose image may have been buried with many other pots to accompany his dead master into the afterlife. The realistic rendering of the physiognomy is particularly striking.

selves in the Cuzco Valley of Peru around 1000.* In the 15th century, however, they rapidly extended their power until their empire atretched from modern Quito, Ecuador, to central Chile. At the time of the Spanish conquest, the Inka Empire, although barely a century old, was the largest in the world with a population of some 12 million. Expertise in mining and metalwork enabled the Inka to

*From this point on, all dates in this chapter are CE unless otherwise noted.

CUZCO Spanish troops largely destroyed the Inka capital at Cuzco, but some 16th-century accounts describe the city's plan as having the shape of a puma—a symbol of Inka royal power—with a great shrine-fortress on a hill above the city representing its head and the

20-17 Machu Picchu (looking northwest), Peru, Inka, 15th century.

Machu Picchu was probably the estate of the Inka emperor Pachacuti. Large upright stones echo the contours of sacred peaks. Precisely placed windows and doors facilitated astronomical observations.

southeastern convergence of two rivers forming its tail. A great plaza, still the hub of the modern city, is nestled below the animal's stomach.

One Inka building at Cuzco that survives in small part is the Temple of the Sun (FIG. 20-18), built of stone blocks fit together without mortar. Cuzco masons expertly laid the stones with perfectly joined faces, even in curved walls. Remarkably, the Inka produced the close joints of their masonry by abrasion alone. Known to the Spanish as Coricancha (Golden Enclosure), the Temple of the Sun was the most magnificent of all Inka shrines. The 16th-century Spanish chroniclers wrote in awe of Coricancha's splendor, its interior veneered with sheets of gold, silver, and emeralds and housing life-size statues of silver and gold. Dedicated to the worship of several Inka deities, including the creator god Viracocha and the gods of the sun, moon, stars, and the elements, the temple was the center point of a network of radiating sight lines leading to some 350 shrines, which had both calendar and astronomical significance.

PIZARRO AND ATAWALPA Smallpox spreading south from Spanish-occupied Mesoamerica killed the last Inka emperor and his heir and unleashed a civil war. In 1532, Francisco Pizarro (1471–1541)

ambushed the would-be emperor Atawalpa on his way to be crowned at Cuzco after vanquishing his rival half-brother. Although Atawalpa paid a huge ransom of gold and silver, the Spaniards killed him and took control of his vast domain, only a decade after Cortés had

defeated the Aztecs in Mexico. Following the murder of Atawalpa, the Spaniards erected the church of Santo Domingo, in an imported European style, on what remained of the Inka Temple of the Sun at Cuzco. A curved section of Inka wall serves to this day as the foundation for the church's apse (FIG. 20-18). The two contrasting structures remain standing one atop the other. Santo Domingo is an enduring symbol of the Spanish conquest of the Americas.

20-18 Remains of the Temple of the Sun (surmounted by the church of Santo Domingo; looking north), Cuzco, Peru, Inka, 15th century.

Perfectly constructed ashlar masonry walls are all that remain of the Temple of the Sun, the most important shrine in the Inka capital. Gold, silver, and emeralds covered the temple's interior walls.

1000 kilometers Gulf of Mexico WEXICO nations appear in brown Names and boundaries of present-day MOODLANDS --- Native American culture area SOUTHWEST SOUTHEAST ADENA Ancient or modern peoples HOPI ZUNI CHOCO CONYON Archeological site OSUOJEPO NO POLICE OSUO NO POLICE O NO POLICE O NO POLICE O NO POLICE O POL OCEAN CALIFORNIA DITNAJTA GREAT CARA SIVIES ADENA **UNITED** MOODLANDS NORTHEAST NAGNAM OCEAN PLATEAU PACIFIC TEAOS NOBIHMES CANADA KWAKWAKA WAKW SUBARCTIC

MAP 20-3 Native American sites in the United States and southern Canada.

each stage were timber structures that the Mississippians eventually destroyed in preparation for the building of a new layer.

SERPENT MOUND The Mississippians also constructed effigy mounds (mounds built in the form of animals or birds). One of the largest and best preserved is Serpent Mound, a twisting earthwork on a bluff overlooking a creek in Ohio. It measures nearly a quar-

ter mile from its open jaw (Fig. 20-20, top right), which seems to clasp an oval-shaped mound in its mouth, to its tightly coiled tail (far left). Both its date and meaning are controversial.

For a long time after the first excavations in the 1880s, archaeologists attributed construction of Serpent Mound to the Adena culture. Radiocarbon dates taken from the mound, however, indicate that the Mississippians built it much later. Unlike most other Woodlands mounds, Serpent Mound contained no evidence of burials or temples, but it may have had religious but it may have had religious

20-19 Pipe, from a mound in Ohio, Adena, ca. 500-1 BCE. Stone, 8" high. Ohio Historical Society, Columbus.

Smoking was an important ritual in ancient Morth America, and the Adena often placed pipes in graves for men to use in the afterlife.

This one resembles some Mesomerican sculptures in form and costume.

North America

In many parts of the United States and Canada, archaeologists have identified indigenous cultures dating back as far as 12,000 years ago. Most of the surviving art objects, however, come from the past 2,000 years. Scholars divide the vast and varied territory of North America (MAP 20-3) into cultural regions based on the relative homogeneity of language and social and artistic patterns. Lifestyles varied widely over the continent, ranging from small bands of migratory hunters to settled—at times even urban—agriculturalists. Thus native art in the United States and Canada is more diverse than in Mesoamerica and Andean South America. Four major regions are of special interest: the Eastern Woodlands, the American Southwest, the Northwest Coast (Washington and British Columbia), and the Great Plains.

ADENA Archaeologists have found remains of the Woodlands Adena culture of Ohio at about 500 sites. The Adena buried their elite in great earthen mounds and often placed ceremonial pipes in the graves. Smoking was an important social and religious ritual in many Mative American cultures, and pipes were treasured status symbols shown here (FIG. 20-19), carved between 500 BCE and the Adena pipe amount takes the shape of a standing man. The figure has naturallennium, takes the shape of a standing man. The figure has naturalistic joint articulations and musculature, a lively flexed-leg pose, and an alert facial expression—all combining to suggest movement. In form and costume (for example, the prominent ear spools), the figure resembles some Mesoamerican sculptures.

MISSISSIPIAN The Adena were the first great mound builders of North America, but the Mississippian culture, which emerged around 800 cE and eventually encompassed much of the eastern United States, surpassed all earlier Woodlands groups in the size and complexity of their communities. One Mississippian mound site, Cahokia in southern Illinois, was the largest city in North America in the early second millennium, with a population of at least 15,000. Another 10,000 people probably lived in the countryside surrounding the great civic and religious center. Cahokia boasted arounding the great civic and religious center. Cahokia boasted arounding the great civic and religious center. Cahokia boasted aroundounds. The grandest, 100 feet tall and built in stages between about 900 and 1200, was Monk's Mound. Aligned with the position of the sun at the equinoxes, it may have served as an astronomical observatory as well as the site of agricultural ceremonies. Topping observatory as well as the site of agricultural ceremonies. Topping

20-20 Serpent Mound, Ohio, Mississippian, ca. 1070. 1,200' long, 20' wide, 5' high.

The Mississippians constructed effigy mounds in the form of animals and birds. This mound seems to depict a serpent. Some scholars, however, think it replicates the path of Halley's Comet in 1066.

"enemy ancestors"), which emerged around 200 but did not reach its peak until about 1000. The many ruined *pueblos* (Spanish, "urban settlements") scattered throughout the Southwest reveal the Ancestral Puebloans' masterful construction skills. In Chaco Canyon, New Mexico, for example, they built a great semicircle of 800 rooms reaching to five stepped-back sto-

ries, the largest of several similar sites in and around the canyon. Chaco Canyon was the center of a wide trade network extending as far as Mexico.

CLIFF PALACE Sometime in the late 12th century, a drought occurred, and the Ancestral Puebloans largely abandoned their open canyon-floor dwelling sites to move farther north to the steep-sided canyons and lusher environment of Mesa Verde in southwestern Colorado. Cliff Palace (FIG. 20-21) is wedged into a sheltered ledge above a valley floor. It contains about 200 rectangular rooms (mostly communal dwellings) of carefully laid stone and timber, once plastered inside and out with *adobe* (sun-dried mud brick). The location for Cliff Palace was not accidental. The Ancestral Puebloans designed it to take advantage of the sun to heat the pueblo in winter and the sheltering ledge to shade it during the hot summer months.

significance. The Mississippians associated serpents with the earth and the fertility of crops, and the serpent is an important motif in Mississippian art. Nonetheless, some researchers have proposed another possible meaning for the shape of Serpent Mound. The date suggested for it is 1070, not long after the brightest appearance in recorded history of Halley's Comet in 1066. Could Serpent Mound have been built in response to this important astronomical event? The serpentine form of the mound may replicate the comet streaking across the night sky. Whatever its meaning, an earthwork as large and elaborate as Serpent Mound could only have been built by a large labor force under the firm direction of a powerful elite eager to leave its mark on the landscape forever.

SOUTHWEST The dominant culture of the American Southwest during the centuries preceding the arrival of Europeans was the Ancestral Puebloan, formerly known as the Anasazi (Navajo,

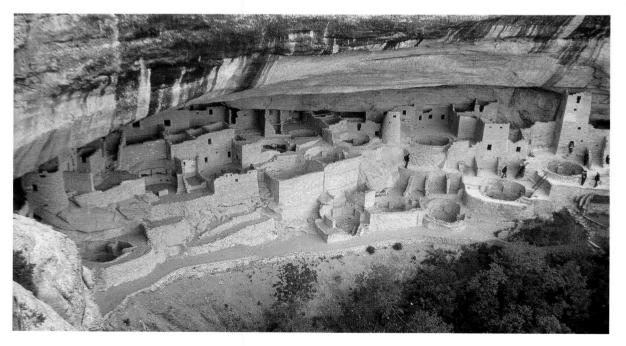

20-21 Cliff Palace, Mesa Verde National Park, Colorado, Ancestral Puebloan, ca. 1150-1300.

Cliff Palace, wedged into a sheltered ledge to heat the pueblo in winter and shade it during the hot summer months, contains about 200 stone-and-timber rooms plastered inside and out with adobe.

20-22 Detail of a kiva mural from Kuaua Pueblo (Coronado State Monument), New Mexico, Ancestral Puebloan, late 15th to early 16th century. Interior of the kiva, 18' × 18'. Museum of New Mexico, Santa Fe.

The kiva, or male council house, was the spiritual center of Puebloan life. Kivas were decorated with agricultural fertility. This one depicts a light-fertility, This one depicts a light-ling man, fish, birds, and seeds.

20-23 OTTO PENTEWA, katsina figurine, Mew Oraibi, Arizona, Hopi, carved before and feathers, I' high. Arizona State Museum, University of Arizona, Tucson.

Katsinas are benevolent spirits living in mountains and water sources. This Hopi katsina represents a rain-bringing deity wearing a mask with geometric patterns symbolic of water and agricultural fertility.

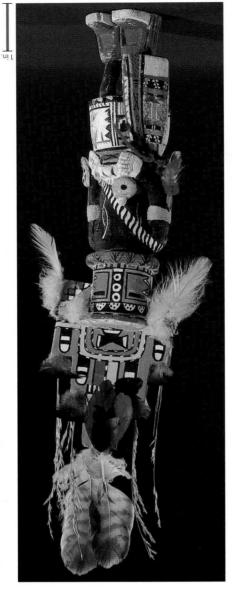

KUAUA PUEBLO Scattered in the foreground of FIG. 20-21 are about 25 large circular semisubterranean atructures, called kivas. The Ancestral Puebloans entered the kivas using a ladder extending through a hole in the (now-lost) flat roof. These rooms were the spiritual centers of native Southwest life, male council houses where the elders stored ritual regalia and where private rituals and preparations for public ceremonies took place—and still do.

Between 1300 and 1500, the Ancestral Puebloans decorated their kivas with elaborate mural paintings representing deities associated with agricultural fertility. According to their descendants, the present-day Hopi and Zuni, the detail of the Kuaua Pueblo mural shown here (FIG. 20-22) depicts a "lightning man" on the left side. Fish and eagle images (associated with rain) appear on the right mouth. All these figures are associated with the fertility of the earth and the life-giving properties of the seasonal rains, a constant preoccupation of Southwest farmers. The painter depicted the figures with great economy, using thick black lines, dots, and a restricted with great economy, using thick black lines, dots, and a restricted the figures with great economy, using thick black lines, dots, and a restricted with great economy as a meutral ground makes an immediate lightning man seen against a neutral ground makes an immediate visual impact.

nial period). However, the cult is probably very ancient. from carved saints that the Spaniards introduced during the colosina figurines have been lost in time (they even may have developed feathers to carry the Hopis' airborne prayers. The origins of the kat-Topping the mask is a stepped shape signifying thunderclouds and in geometric patterns symbolic of water and agricultural tertility. (d. 1963), represents a rain-bringing deity who wears a mask painted illustrated Hopi katsina (FIG. 20-23), fashioned by Otto Pentewa give them miniature representations of the masked dancers. The ing. To educate young girls in ritual lore, the Hopi traditionally during yearly festivals dedicated to rain, fertility, and good huntrary Pueblo groups, masked dancers ritually impersonate katsinas sources. Humans join their world after death. Among contempoing ancestors and natural elements living in mountains and water figurine. Katsinas are benevolent supernatural spirits personify-HOPI KATSINAS Another Southwestern art form is the katsina

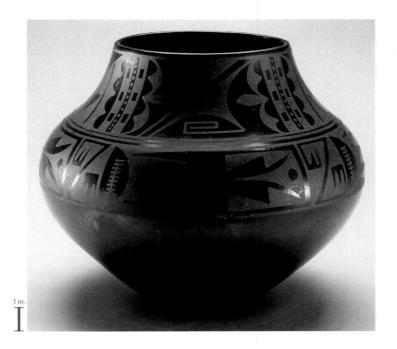

20-24 María Montoya Martínez, jar, San Ildefonso Pueblo, New Mexico, ca. 1939. Blackware, $11\frac{1}{8}$ " × 1' 1". National Museum of Women in the Arts, Washington, D.C. (gift of Wallace and Wilhelmina Hollachy).

María Montoya Martínez revived old techniques to produce pottery of striking shapes, proportions, and textures. Her black-on-black vessels feature matte designs on highly polished surfaces.

PUEBLO POTTERY The Southwest has also provided the finest examples of North American pottery. Originally producing utilitarian forms, Southwest potters worked without the potter's wheel and instead coiled shapes of clay that they then covered with slip, polished, and fired. Decorative motifs, often abstract and conventionalized, dealt largely with forces of nature—clouds, wind, and rain. In the early decades of the 20th century, San Ildefonso Pueblo potter María Montoya Martínez (1887–1980) revived old techniques to produce forms of striking shape, proportion, and texture. Her black-on-black pieces (FIG. 20-24) feature matte designs on highly polished surfaces specially fired in an oxygen-poor atmosphere.

NORTHWEST COAST The Native Americans of the coasts and islands of northern Washington State and the province of British Columbia in Canada have long enjoyed a rich and reliable environment. They fished, hunted sea mammals and game, gathered edible plants, and made their homes, utensils, and ritual objects from the region's great cedar forests.

KWAKWAKA'WAKW Among the numerous groups who settled the Northwest Coast are the Kwakwaka'wakw of southern British Columbia. Kwakwaka'wakw religious specialists wore masks in their healing rituals and in dramatic public performances during the winter ceremonial season. The animals and mythological creatures represented in masks and a host of other carvings derive from the Northwest Coast's rich oral tradition and celebrate the mythological origins and inherited privileges of high-ranking families. The artist who made the Kwakwaka'wakw mask illustrated here (FIG. 20-25) meant it to be seen in flickering firelight, and ingeniously constructed it to open and close rapidly when the wearer manipulated hidden strings. He could thus magically transform himself from human to eagle and back again as he danced. The transformation theme, in myriad forms, is a central aspect of the art and religion of the Americas. The Kwakwaka'wakw mask's human aspect also owes its dramatic character to the exaggeration and distortion of facial parts—such as the hooked beaklike

20-25 Eagle transformation mask, closed (top) and open (bottom) views, Alert Bay, Canada, Kwakwaka'wakw, late 19th century. Wood, feathers, and string, 1' 10" \times 11". American Museum of Natural History, New York.

The wearer of this Kwakwaka'wakw mask could open and close it rapidly by manipulating hidden strings, magically transforming himself from human to eagle and back again as he danced.

over his left shoulder, for example, is an abstract rendering of an eagle-feather war bonnet.

Whether secular and decorative or spiritual and highly symbolic, the diverse styles and forms of Native American art in the United States and Canada have traditionally reflected the indigenous peoples' reliance on and reverence toward the environment they considered it their privilege to inhabit. Today, some Native American artists work in media and styles indistinguishable from those of other contemporary artists worldwide, but in the work of others—for example, Jaune Quick-to-See Smith (Fig. 16-1)—of others—for example, Jaune Quick-to-See Smith (Fig. 16-1)—the Native American experience remains central to their artistic

OCEANIA

identity.

When people think of the South Pacific (MAP 20-4), images of balmy tropical islands usually come to mind. But the islands of the Pacific Ocean encompass a wide range of habitats. Environments range from the arid deserts of the Australian outback to the Marshall rainforests of inland New Guinea and the coral atolls of the Marshall Islands. The region is not only geographically varied but also politically, linguistically, culturally, and artistically diverse.

In 1831, the French explorer Jules Sebastien César Dumont d'Urville (1790–1842) proposed dividing the Pacific islands into major regions based on general geographical, racial, and linguistic distinctions. Despite its limitations, his division of Oceania into the areas of Melanesia ("many islands"), Micronesia ("small islands"), and Polynesia ("many islands") continues in use today. Melanesia includes the islands of New Guinea, New Ireland, New Britain, New includes the islands of New Guinea, Micronesia consists primarily of Wet Caroline, Mariana, Gilbert, and Marshall Islands in the western Pacific. Polynesia covers much of the eastern Pacific and consists of a triangular area defined by the Hawaiian Islands in the western a triangular area defined by the Hawaiian Islands in the north, Rapa Nui (Easter Island) in the east, and Aotearoa (New Zealand) in the southwest.

Although documentary evidence is lacking about Oceanic cultures before the arrival of seafaring Europeans in the early 16th century, archaeologists have determined that humans have inhabited the islands for tens of thousands of years. The archaeological evidence indicates that different parts of the Pacific experienced distinct migratory waves beginning in the Old Stone Age, but habitation of the most far-flung islands—Hawaii, New Zealand, and Easter Island—began no later than 500 to 1000 ce. Because of the expansive chronological span of these migrations, Pacific cultures expansive chronological span of these migrations, pacific cultures a language unrelated to any of those of New Guinea, whose languages tall into a distinct but diverse group. In contrast, most of the rest of the Pacific Islanders speak languages tall into a distinct but diverse group. In contrast, most of the rest of the Pacific Islanders speak languages derived from the Austronesian language family.

These island groups came to Western attention as a result of the extensive exploration and colonization that began in the 16th century and reached its peak in the 19th century. Much of the history of Oceania in the 20th century revolved around indigenous peoples struggles for independence from colonial powers. Yet colonialism also facilitated an exchange of ideas—not solely the transfer of Western cultural values and technology to the Pacific. Oceanic art, for example, had a strong influence on many Western artists, especially the late-19th-century French painter Paul Gauguin (Fig. 13-14). The "primitive" art of Oceania also inspired many early-20th-century artists (see "Primitivism and Colonialism" (*).

nose and flat flating nostrils—and to the deeply undercut curvilinear depressions, which form strong shadows. In contrast to the carved human face, but painted in the same colors, is the two-dimensional abstract image of the eagle painted on the inside of the outer mask.

intelligible to other Native Americans. The concentric circle design story—a composite artistic statement in several media immediately tions and military accomplishments. These items represent his life claw necklace, and feather decorations, all symbolic of his affiliaincludes the Hidatsa warrior's pipe, painted buffalo-hide robe, bearration of Pehriska-Ruhpa (Two Ravens). The portrait (FIG. 20-26) BODMER (1809-1893) of Switzerland portrayed the personal decocostumes as anthropological curiosities. In 1833, for example, KARL American and European artists, who recorded Native American can sometimes be found in the paintings and drawings of visiting and various containers. Transient but important Plains art forms and other portable objects, such as shields, clubs, pipes, tomahawks, pouches, horse trappings, tipis, buffalo-skin robes (FIG. 20-25A A), focused their aesthetic attention largely on their leather garments, flourished on the Great Plains for a short time. Great Plains artists the horse to North America, a new mobile Native American culture enous communities on the East Coast and the Europeans introduced GREAT PLAINS After colonial governments disrupted settled indig-

20-26 Karl Bodner, Hidatsa Warrior Pehriska-Ruhpa (Two Ravens), 1833. Engraving by Paul Legrand after the original watercolor in the Joslyn Art Museum, Omaha, $1^{1}3\frac{7}{8}^{n}\times11\frac{1}{2}^{n}$. Engraving: Buffalo Bill Historical Center, Cody.

The personal regalia of a Hidataa warrior included his pipe, painted buffalohide robe, bear-claw necklace, and feather decorations, all symbols of his affiliations and military accomplishments.

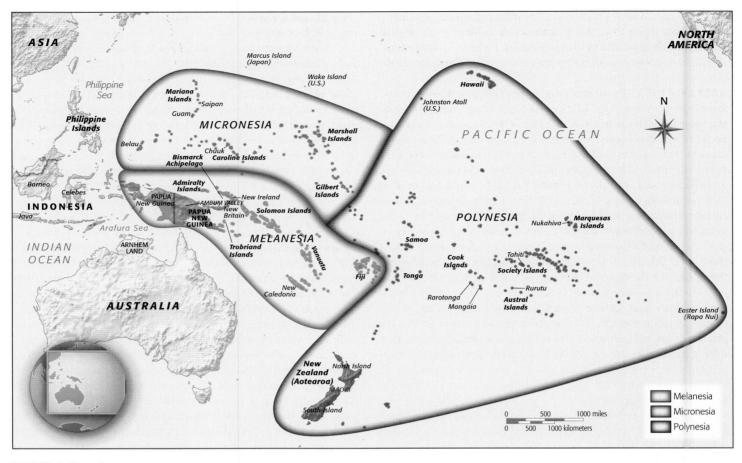

MAP 20-4 Oceania.

The discussion in this chapter focuses on Oceanic art from the European discovery of the islands in the 16th century until 1980, although the earliest preserved sculptures—for example, the *Ambum Stone* (FIG. 20-26A 1) from Papua New Guinea—date to around 1500 BCE.

Before 1800

RAPA NUI Some of the earliest datable artworks in Oceania are also the largest. This is especially true of the colossal sculptures, called *moai* (FIG. 20-27), of Rapa Nui (Easter Island) in Polynesia,

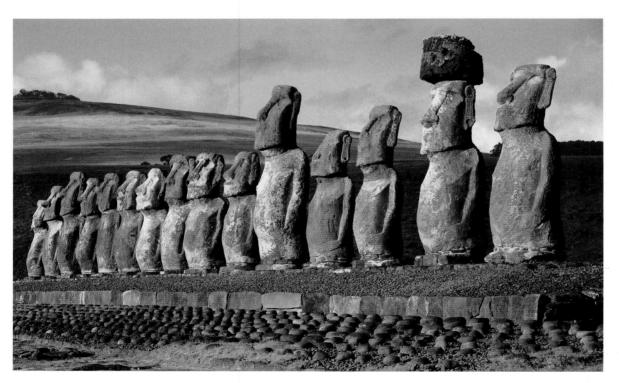

20-27 Row of moai on a stone platform, Ahu Tongariki, Rapa Nui (Easter Island), Polynesia, ca. 1200–1500. Volcanic tuff and red scoria.

The moai of Rapa Nui are monoliths as much as 50 feet tall. Most scholars believe that they portray ancestral chiefs. They stand on platforms marking burials or sites for religious ceremonies.

19th century, relates to the sea (FIG. 20-27A (A)). reason, much of the artistic imagery of Micronesia, especially in the ing, and long-distance travel in large oceangoing vessels. For this Micronesian cultures focuses on seafaring activities—fishing, trad-

eventually conferred statehood on the island group in 1959. trol. The United States annexed Hawaii as a territory in 1898 and not endure, however, and Hawaii soon came under American conas Kamehameha I (r. 1810-1819). The kingdom he established did established himself as the first king of the Hawaiian islands, ruling major islands of the Hawaiian archipelago in 1795, and 15 years later evolved into kingdoms. In Hawaii, Chief Kamehameha unified the HAWAII By the 1800s, some hierarchical Polynesian societies had

Lawrence Kearny of the U.S. frigate Constellation in 1843 in gratitude King Kamehameha III (r. 1824-1854), who gave it to Commodore ated the fabric lining. The cloak in FIG. 20-28 originally belonged to they worked, believing that the power of the sacred chants permephysical protection. The artists who fashioned the cloaks chanted as wearers, but their dense fiber base and feather matting also provided Not only did these cloaks confer the protection of the gods on their nesians associated the plaited fiber base for the feathers with deities. extraordinary. The cloak also linked its owner to the gods. The Polyfeathers, the resources and labor required to produce a cloak were feathers, and because a full-length cloak could require up to 500,000 mamo birds. Some of these birds yield only six or seven suitable yellow feathers from the 'i 'iwi, 'apapane, 'o 'o, and (now extinct) The materials were exceedingly precious, particularly the red and rank. Every aspect of the ahu 'ula reflected the status of its wearer. century example shown here (FIG. 20-28) belonged to men of high For example, elegant feather cloaks (ahu ula) such as the early-19thof Hawaiian society, were a prominent part of artistic production. Chiefs regalia, which visualized and reinforced the hierarchy

rulers, the political system before European contact allowed for the Islands in Polynesia trace their right to rule by descent from earlier MARQUESAN TATTOOS Although the chiefs of the Marquesas

for Kearny's assistance during a temporary occupation of Hawaii.

The statues thus mediate between chiefs and gods, and between the Islanders believed had the ability to accommodate spirits or gods. ever, are not individual portraits but generic images that the Easter and that the sculptures depict ancestral chiefs. The moai, howscholars believe that lineage chiefs or their sons erected the moai knot or hat—atop their heads. Although debate continues, many scoria (a local volcanic stone) cylinders that serve as a sort of topelongated earlobes. A number of the moai have pukno-small red strong jaws, straight noses with carefully articulated nostrils, and blocky figures with fairly planar facial features—large staring eyes, sites used for religious ceremonies. Most of the moai consist of huge, silent sentinels on stone platforms (ahu) marking burial or sacred are as much as 50 feet tall and weigh up to 100 tons. They stand as nizations headed by chiefs and ritual specialists. The Rapa Nui moai creation. Most Polynesian societies possess elaborate political orga-Indeed, rulers often trace their genealogies directly to the gods of typically are highly stratified, with power determined by heredity. one of the last areas in the world to be settled. Polynesian societies

tures, 90 men two months to transport it from the quarry to the ahu have taken 30 men one year to carve one of these colossal sculpments of this Polynesian culture. According to one scholar, it would their production and placement serve as testaments to the achievethem vertically. Given the extraordinary size of these monoliths, ter Islanders dragged the moai to the ahu sites and then positioned tures are red scoria, basalt, or trachyte. After quarrying, the Easand came from the same quarry at Rano Raraku. Some of the sculperected on some 250 ahu. Most of the stones are soft volcanic tuff Archaeological surveys have documented nearly 1,000 moai natural and cosmic worlds.

it vertically on the platform. site (often several miles away), and 90 men three months to position

19th Century

nesia, home to about 200,000 people today. Life in virtually all over nearly three million square miles of ocean make up Micro-MICRONESIA Some 2,500 islands, most of them tiny, scattered

tection. Each cloak required wearer with the gods' proone, which belonged to King Costly Hawaiian feather Honolulu. Bishop Pauahi Museum,

fiber netting, 4' $8\frac{1}{3}$ " × 8'. 1824-1843. Feathers and Hawaii, Polynesia, ca. Kamehameha III, from 20-28 Feather cloak of

the feathers of thousands of Kamehameha III, provided the cloaks ('ahu 'ula) such as this

ART AND SOCIETY

Tattoo in Polynesia

Body decoration was an important means of representing cultural and personal identity in Oceanic societies. In addition to clothing and ornaments, body adornment most often took the form of tattoo. Although tattooing was a common practice in Micronesia, it was more widespread in Polynesia. Indeed, the English term tattoo is Polynesian in origin, related to the Tahitian, Samoan, and Tongan word *tatau* or *tatu*. In New Zealand, the markings are called *moko*. Within Polynesian cultures, tattoo reached its peak in the highly stratified societies of New Zealand, the Marquesas Islands, Tahiti, Tonga, Samoa, and Hawaii. Both sexes displayed tattoos. In general, men had more tattoos than women, and the location of tattoos on the body differed. For instance, in New Zealand, the face and buttocks were the primary areas of male tattoo, whereas tattoos appeared on the lips and chin of women.

Historically, tattooing served a variety of functions in Polynesia beyond personal beautification. It indicated status, because the quantity and quality of tattoos often reflected rank. In the Marquesas Islands, for example, tattoos completely covered the bodies of men of high status (Fig. 20-29). Certain patterns could be applied only to ranking individuals, but commoners also had tattoos, generally on a less extensive scale than elite individuals. For identification purposes, slaves had tattoos on their foreheads in Hawaii and on their backs in New Zealand. According to some accounts, victors placed tattoos on defeated warriors. In Polynesia, tattoos often identified clan or familial connections. Tattoos could also serve a protective function by in essence wrapping the body in a spiritual armor. On occasion, tattoos marked significant events. In Hawaii, for example, a tattooed tongue was a sign of grief. The pain that the tattooed person endured was a sign of respect for the deceased.

Priests who were specially trained in the art form usually applied the tattoos. Rituals, chants, or ceremonies often accompanied the procedure, which took place in a special structure. Tattooing involves the introduction of black, carbon-based pigment under the skin with the use of a bird-bone tattooing comb or chisel and a mallet. In New Zealand, a distinctive technique emerged for tattooing the face. In a manner similar to Maori woodcarving, a serrated chisel created a groove in the skin to receive pigment, thereby producing a colored line.

Polynesian tattoo designs were predominantly geometric, and affinities with other forms of Polynesian art are evident. For example, the curvilinear patterns found on decorated wall panels (poupou) in Maori meeting houses (FIG. 20-30) resemble and make reference to the patterns that predominate in Maori facial moko. Depending on their specific purpose, many tattoos could be "read" or deciphered. For facial tattoos, the Maori generally divided the face into four major, symmetrical zones: the left and right forehead down to the eyes, the left lower face, and the right lower face. The right-hand side conveyed

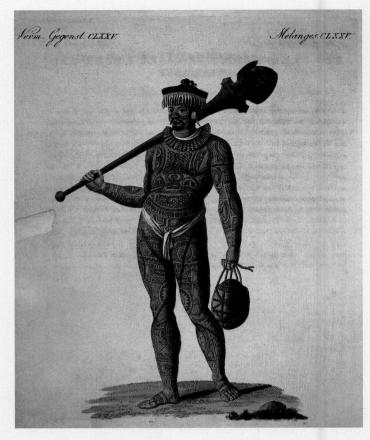

20-29 Tattooed warrior with war club, Nukahiva, Marquesas Islands, Polynesia, early 19th century. Color engraving in Carl Bertuch, *Bilderbuch für Kinder* (Weimar, 1813).

In Polynesia, with its hierarchical social structure, noblemen and warriors accumulated tattoo patterns to enhance their status and beauty. Tattoos wrapped a warrior's body in spiritual armor.

information on the father's rank, tribal affiliations, and social position, whereas the left-hand side provided information about the mother's family. Smaller secondary facial zones provided information about the tattooed individual's profession and position in society. Te Pehi Kupe (FIG. I-17) was the chief of the Ngati Toa tribe in the early 19th century. The upward and downward *koru* (unrolled spirals) in the middle of his forehead connote his descent from two paramount tribes. The small design in the center of his forehead documents the extent of his domain—north, south, east, and west. The five double koru in front of his left ear indicate that the supreme chief (the highest rank in Maori society) was part of his matrilineal line. The designs on his lower jaw and the anchor-shaped koru nearby reveal that Te Pehi Kupe was not only a master carver but descended from master carvers as well.

acquisition of power by force. As a result, warfare was widespread through the late 19th century. Marquesan warriors covered their bodies with *tattoos*, which formed a kind of spiritual armor. Body decoration in general is among the most pervasive art forms found throughout Oceania. Polynesians developed the painful but prestigious art of tattoo more fully than many other Oceanic peoples (see "Tattoo in Polynesia," above), although tattooing also occurred in

various parts of Micronesia. In Polynesia, with its hierarchical social structure, nobles and warriors in particular accumulated various tattoo patterns over the years to enhance their status, *mana* (spiritual power), and personal beauty.

An 1813 engraving (FIG. 20-29) depicts a Marquesan warrior from Nukahiva Island covered with elaborate tattoo patterns. The warrior holds a large wood war club over his right shoulder and

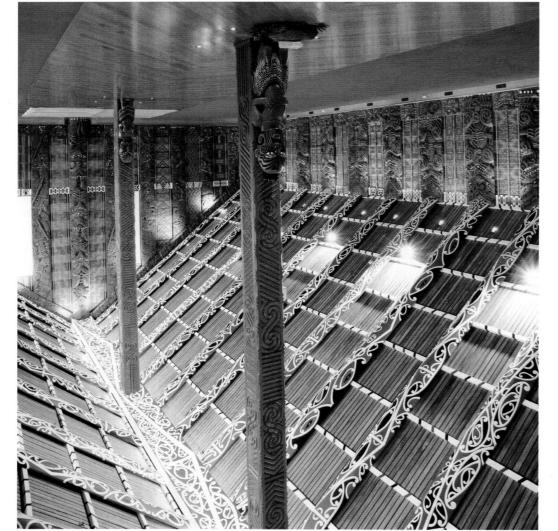

20-30 Wepina Apavui, interior of Mataatua meeting house, Whaka-tane, New Zealand, Polynesia, 1871–1875.

Maori meeting houses feature elaborate decoration. In this late-19th-century example, Wepiha Apanui carved figures of ancestors along the interior walls. The patterns on their bodies may be tattoos.

poupou are the work of female fabric artists, but because women could not enter the meeting house, they installed the panels from the outside.

Begun in 1871, construction and decoration of the Mataatua meeting house took four years to complete. The lead sculptor was Wepine Apanul. The poupou along the walls depict specific ancestors, each of which appears frontally with hands across the stomach. The elaborate curvilinear patterns covering the entire poupou may represent tattoos. Decoration covers virtually every surface of the meeting house. In the spaces between the poupou are tukutuku. Above, intricate painted shapes cover the rafters. In the center of the meeting house are pou tokomanawa of ancestors supporting the building's ridgepoles. The presence of all of these ancestral images and the energy of the persistent patterning create a charged space for the initiation of collective action.

20th Century

Among the most interesting artworks produced in Oceania are the deity images with multiple figures attached to their bodies that are characteristic of Rurutu in the Austral Islands as well as Rarotonga and Mangaia in the Cook Islands of Polynesia. These carvings probably represented clan and district ancestors, honored for their protective and procreative powers.

carries a decorated water gourd in his left hand. The various tattoo patterns marking his entire body seem to subdivide his body parts into zones on both sides of a line down the center. Some tattoos accentuate joint areas, whereas others separate muscle masses into horizontal and vertical geometric shapes. The warrior also covered his face, hands, and feet with tattoos.

meeting house. The tukutuku (stitched lattice panels) between the erally support the symbolic spine of the ancestral body that is the (pou tokomanawa) comparable to classical caryatids (Fig. 2-42) litanother, their bodies decorated with tattoos. Freestanding figures tors standing in frontal positions, sometimes stacked one above rafters his ribs. Along the walls, relief panels (poupou) depict ancesrepresenting his outstretched arms, the ridgepole his spine, and the rior barge boards (the angled boards outlining the house gables) ancestor or of the ultimate ancestor, the sky father, with the extetors. The very structure of the building symbolized the body of an community to assemble in the benevolent presence of their ances-The Maori meeting house was a place for the male members of the such as the Mataatua meeting house at Whakatane (FIG. 20-30). as is evident in the form and decoration of Maori meeting houses, ies. Ancestors and lineage traditionally played an important role, land) share many cultural practices with other Polynesian societ-MAORI MEETING HOUSES The Maori of Aotearoa (New Zea20-31 Staff god (Tangaroa?), from Rarotonga, Cook Islands, Polynesia, ca. 1900. Wood, 2' 4½" high. Cambridge University Museum of Archaeology and Anthropology, Cambridge.

The "body" of the Polynesian god Tangaroa consists of seven figures that probably represent generations of his human offspring. Several of the figures have erect penises, a reference to procreation.

RAROTONGA The wood sculptures representing Rarotonga gods are distinctive in style and format. Called staff gods or district gods, some examples are more than 20 feet tall. The staff god illustrated here (FIG. 20-31) is one of the smaller but best-preserved examples. It may represent the Polynesian creator god Tangaroa. His head, with its enormous eyes, is about a third of the height of the sculpture. The "body" of the god resembles a spinal column and consists of seven figures with alternating frontal and profile heads. They probably represent the successive generations of humans whom Tangaroa created. The imagery suggests that these humans come from the body of the god. Several of the figures have erect penises, an unmistakable reference to sexual reproduction and the continuation of the race for many generations to come.

AUSTRALIAN DREAMINGS Over the past 40,000 years, the Aboriginal peoples of Australia spread out over the entire continent and adapted to a variety of ecological conditions, ranging from those of tropical and subtropical areas in the north to desert regions in the continent's interior and more temperate locales

in the south. The Aboriginal perception of the world centers on a concept known as the Dreamings—ancestral beings whose spirits pervade the present. The Aborigines call the spiritual domain that the Dreamings occupy Dreamtime, which is both a physical space within which the ancestral beings moved in creating the landscape

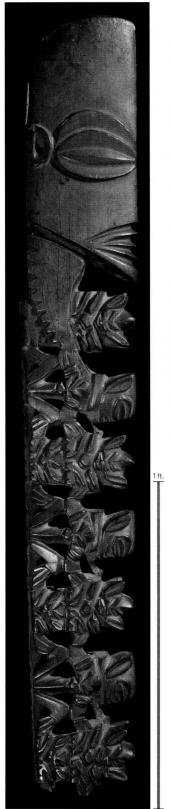

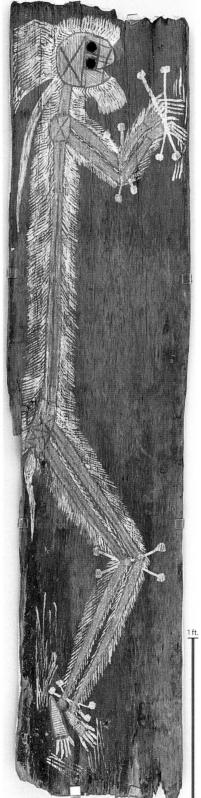

20-32 Male ancestor figure, from East Alligator Rivers, Northern Territory, Australia, 1913. Ocher on bark, 4' $10\frac{5}{8}$ " × 1' 1". Museum Victoria, Melbourne.

Aboriginal painters frequently depicted Dreamings, ancestral beings whose spirits pervade the present, using the X-ray style that shows both the figure's internal organs and its external appearance.

and a psychic space providing Aborigines with cultural, religious, and moral direction.

Because of the importance of Dreamings to all aspects of Aboriginal life, native Australian art symbolically links Aborigines with these ancestral spirits. Most Aboriginal art is relatively small and portable. As hunters and gatherers in difficult terrain, the Aborigines were generally nomadic peoples, rendering large-scale impractical. Consequently, lightweight bark painting became a mainstay of Aboriginal art. Dreamings were common subjects. Traditionally, because knowledge of Dreamings was sacred and restricted, an Aborigine could depict only a Dreaming with which the artist had a connection. Thus specific Aboriginal lineages, clans, or regional groups "owned" individual designs, and it is often difficult for outsiders to interpret the representations.

The bark painting illustrated here (FIG. 20-32) depicts a Dreaming known as Auuenau and comes from the Northern Territory. The artist represented the elongated figure in a style known as "X-ray," which Aboriginal painters used to depict both animal and human forms. In this style, the artist simultaneously depicts the subject's

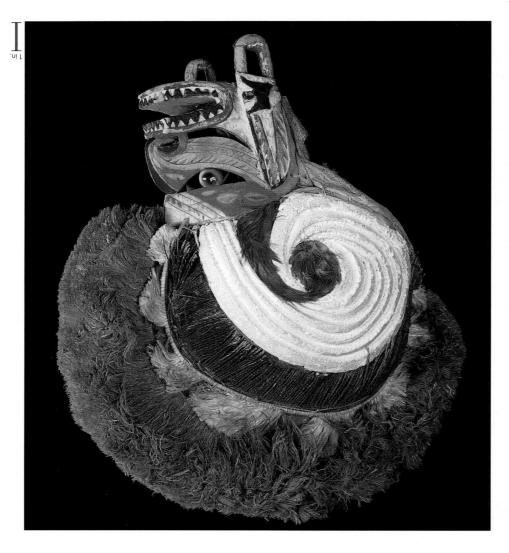

Although, until modern times, there was no contact between the art-producing cultures of Oceania and Africa, certain traditions, especially mask-making and body decoration, figure prominently in both. The final chapter of Art through the Ages examines the art and architecture of Africa, the world's largest continent.

20-33 Tatanua mask, from New Ireland, Papua New Guinea, Melanesia, 20th century. Wood, fiber, shell, lime, and feathers, $1^{'}$ 5 $\frac{1}{2}^{"}$ high. Otago Museum, Dunedin.

In New Ireland, malanggan rites facilitate the transition of the soul from this world to the land of the dead. Dancers wearing tatanua masks representing the deceased play a key role in these ceremonies.

internal organs and exterior appearance. The painting possesses a fluid and dynamic quality, with the X-ray-like figure clearly defined against a solid background.

MALANGGAN MASKS In New Ireland (Melanesian Papua New Guinea), a central feature of native Oceanic society is malanggan, a term that refers both to the feativals held in honor of the deceased and to the carvings and objects produced for these feativals. Malangan rites are part of an ancestor cult and are critical in facilitating the transition of the soul from the world of the living to the realm of from the world of the living to the realm of

the dead and the rechanneling of energy from the deceased into the community of the living. In addition to the religious function of malanggan, the extended ceremonies also promote social solidarity and stimulate the economy through the investment necessary to mount impressive festivities. To educate the younger generation about these practices, malanggan also includes the initiation of young men.

Of the many types of objects created for the malanggan, perhaps the most striking are tatanua masks (FIG. 20-33). Tatanua represent the spirits of specific deceased people. The materials used to make New Ireland tatanua masks are primarily soft wood, vegetable fiber, and rattan. The crested hair, made of fiber, duplicates a makers insert sea-snail shells. Traditionally, artists paint the masks black, white, yellow, and red—colors that the people of New Ireland associate with warfare, magic spells, and violence. Although some masks are display pieces, dancers wear most of them. Rather than destroying their ritual masks after the conclusion of the ceremonies, as some other cultures do, the New Irelanders store them for future use, hence the preservation of many examples today.

 \mathbb{R} Explore the era further in MindTap with videos of major artworks and buildings, Google Earth^m coordinates, and essays by the author on the following additional subjects:

- Maya ball player, Jaina Island (FIG. 20-6A)
- Founding of Tenochtitlán, Codex Mendoza (FIG. 20-10A)
- Raimondi Stele, Chavín de Huántar (FIG. 20-13A)
- Mandan buffalo-hide robe (Fig. 20-25A)
- ART AND SOCIETY: Primitivism and Colonialism
- Ambum Stone, Papua New Guinea (FIG. 20-26A)
- Chuuk canoe prow ornament (FIG. 20-27A)

NATIVE AMERICAS AND OCEANIA

Mesoamerica

- The Olmec (ca. 1200–400 BCE)—the "mother culture" of Mesoamerica—built pyramids and ball courts and carved colossal basalt portraits of their rulers during the Preclassic period.
- Teotihuacán in the Valley of Mexico was a huge metropolis that covered 9 square miles and was laid out on a strict grid plan. Its major pyramids (stepped temple platforms) and plazas date to the late Preclassic period, ca. 50–250 ce. The shapes of the pyramids echo the surrounding mountains.
- During the Classic period (ca. 300-900), the Maya built temple-pyramids, plazas, and ball courts and decorated them with sculptures and paintings glorifying their rulers and gods. Among the major Maya sites explored by archaeologists are Copán (Honduras), Bonampak, Yaxchilán, and Chichén Itzá (Mexico).
- Tenochtitlán, the capital of the Aztec Empire, was a magnificent island city laid out on a grid plan. Statues and reliefs depicting major Aztec deities such as Coyolxauhqui and Coatlicue adorned the main religious complex, the Templo Mayor.

Colossal head, La Venta, Olmec, ca. 900-400 BCE

Castillo, Chichén Itzá, Maya, ca. 800-900 ce

South America

- The Paracas (ca. 400 BCE-200 CE) and Moche (ca. 1-700 CE) cultures of Peru produced extraordinary textiles and distinctive painted ceramics.
- The Nasca (ca. 200 BCE-600 CE) are famous for their immense earth drawings, known as Nasca Lines, which may have marked pilgrimage routes.
- In the 15th century, the Inka ruled a vast Andean empire. Machu Picchu, constructed on a terraced hillside with spectacular views of sacred peaks, is the best-preserved site.

Portrait vessel, Moche, fifth to sixth century CE

North America

- The peoples of the Mississippian culture (ca. 800–1500 cE) were great mound builders. Cahokia encompassed about 120 mounds and was the largest city in North America during the early second millennium.
- In the American Southwest, the Ancestral Puebloans constructed urban settlements (pueblos) and decorated their council houses (kivas) with mural paintings.
- On the Northwest Coast, masks played an important role in religious rituals. Some examples enabled the wearer to transform himself from human to animal and back again.

Cliff Palace, Ancestral Puebloan, ca. 1150-1300 cE

Oceania

- The oldest large-scale Oceanic artworks are the moai of Rapa Nui (Easter Island).
- Body adornment was an important Oceanic art form. Hawaiian artists produced elite regalia using feathers; tattoos distinguished rank and provided warriors with spiritual armor in Polynesia; in New Ireland, malanggan masks represented the spirits of the dead.
- Meeting houses played an important role in Oceanic life. Those of the Maori of Aotearoa (New Zealand) are notable for their elaborate ornamentation featuring carved relief panels depicting ancestors.
- The Aboriginal art of Australia focuses on ancestral spirits called Dreamings, whom artists represented in an X-ray style showing the internal organs.

Tattooed warrior, Marquesas Islands, early 19th century

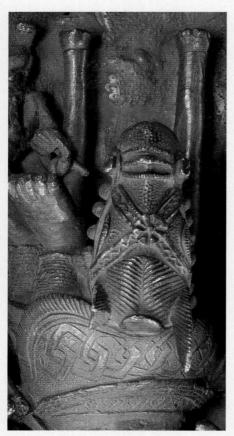

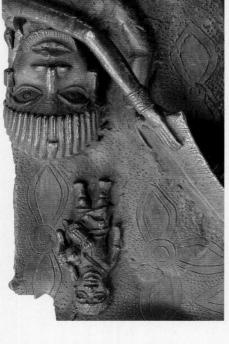

underscoring his elevated status. largest hold shields over the king's head, their importance in Benin society. The two dants whose size varies greatly according to ▲ 21-1c Flanking the king are several atten-

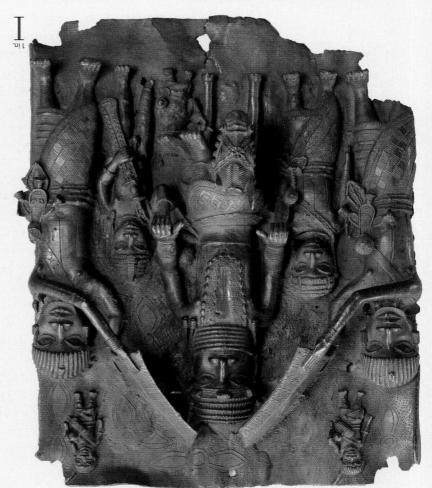

Memorial Collection, gift of Nelson A. Rockefeller). Museum of Art, New York (Michael C. Rockefeller ca. 1550–1680. Brass, 1' $\sqrt{\frac{1}{2}}$ " × 1' $4\frac{1}{2}$ ". Metropolitan King on horseback with attendants, from Benin, Nigeria,

Africa

THE ROYAL ARTS OF BENIN

African art is as diverse as the continent is vast, and the variety of African artworks makes the study of African art especially fascinating. Africa also boasts some of the most ancient artworks ever found anywhere. Unfortunately, most African paintings and sculptures created before 1800 are hard to date and sometimes difficult to interpret. The art of the Benin kingdom, just west of the lower reaches of the Niger River in what is today Nigeria (not to be confused with the modern Republic of Benin; see MAP 21-1), is exceptional. The kingdom, most likely established in the 13th century, reached the peak of its wealth and power in the 16th century. As is true of many areas of Africa, Benin kingship was hereditary and considered sacred, and the purpose of the finest preserved Benin artworks was to honor the ruling *oba*, his family, and his ancestors. Unlike in most other African cultural and linguistic groups, the names and dates of many of the Benin kings have been recorded, and numerous extant artworks can even be confidently associated with specific rulers.

The 16th- or 17th-century brass plaque illustrated here (FIG. 21-1), which portrays the oba on horseback flanked by attendants, underscores the centrality of the sacred king in Benin culture. About a foot-and-a-half tall and almost as wide, the relief is one of scores of extant plaques that probably adorned the wood pillars of the main rooms of the Benin royal residence. This plaque characteristically features a symmetrical, hierarchical composition centered on the king, who wears an elaborate headdress, multistrand coral necklace, and coral and agate bracelets and anklets-emblems of his high office. The artist represented the king as a larger-than-life figure who, contrary to nature, dwarfs the horse he rides. (Horses have been a symbol of power and wealth in many societies worldwide from prehistory to the present.) The king also is disproportionately large compared to his most important attendants. The two largest hold shields over the king's head, which further underscores the oba's elevated status. Several other figures, including two who seem to float in midair, are of smaller size and therefore less important at the Benin court. One tiny figure next to the horse is almost hidden from view beneath the king's feet. The sculptor not only varied the size of each figure in the relief according to his relative importance in Benin society but also enlarged all the heads for emphasis. As in many other cultures, the Benin people considered the head the seat of a person's will and power. Benin men celebrate a festival of the head called Igue, and one of the king's praise names is "great head."

The glorification of the royal family, especially the king, is a persistent theme in African art (see "Art and Leadership in Africa," page 559), but by no means the only one, as the sculptures and paintings examined in this chapter clearly demonstrate.

centralized state under a king. smaller groups, whereas larger populations sometimes formed a ing bands, to 20 million or more. Councils of elders often governed cally have ranged in size from a few hundred, in hunting and gatherinhabited the African continent. These population groups historithan 2,000 distinct ethnic, cultural, and linguistic groups long have lush valleys support agriculture and large settled populations. More Africa (MAP 21-1) is a vast continent of more than 50 nations com-

AFRICAN PEOPLES AND ART FORMS

three great rivers—the Niger, the Congo, and the Nile—and their northern and southern regions, high mountains rise in the east, and tinct topographical and ecological zones. Parched deserts occupy prising more than one-fifth of the world's land mass and many dis-

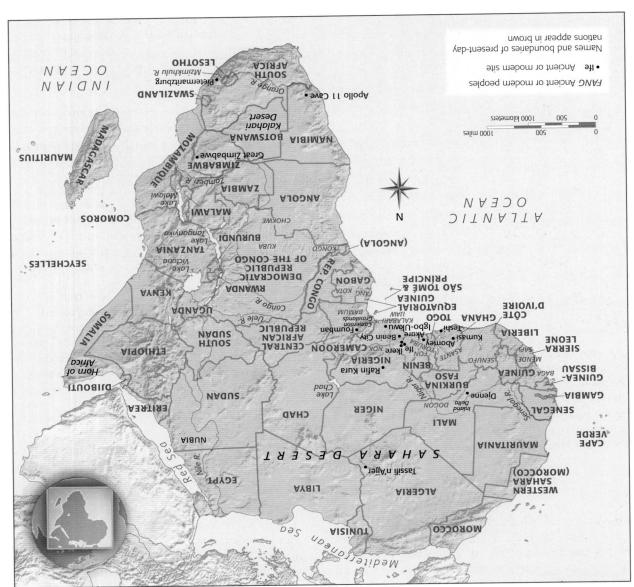

MAP 21-1 Africa.

ADIMA

- Osei Bonsu and Olowe of kingdom. societies, such as the Benin flourish in highly stratified Royal arts continue to 0861-0061
- be danced at masquerades. broduce elaborate masks to African peoples continue to Ise achieve wide renown as
- of Bamum king Ngansu and Royal arts include the throne ancestors. rial screens to venerate guardian figures and memoartists produce reliquary weil insdaled bna stoX = 0061-0081

Fon king Glele's bocio of the

god Gu.

- European patrons. between African artists and est evidence of interaction Sapi saltcellars are the earliglorifying the royal family. ivories and cast bronzes ■ Benin sculptors produce 0081-0051
- tification walls and towers, Great Zimbabwe erects foradobe mosque, 13th century. Djenne builders construct an bronze-casting, 9th century. the lost-wax method of Igbo Ukwu sculptors perfect 0051-0

14th century.

- **5000 BCE**. art between 6000 and many examples of rock Neolithic artists produce ca. 23,000 BCE. the earliest artworks, Namibia create some of Paleolithic painters in 25,000-0 BCE
- the first African sculptures 200 BCE-500 CE) broduces The Mok culture (ca.

in the round.

Despite this great variety, African peoples have long shared many core beliefs and practices, including honoring ancestors, worshiping nature deities, and elevating rulers to sacred status. These beliefs have given rise to many richly expressive art traditions, which, given Africa's size and the diversity of its ethnic groups, vary enormously in subject, materials, and function. The most ancient artworks are rock engravings and paintings depicting animals and rituals, but by the first millennium BCE, Africans produced figural sculptures in terracotta, wood, and metal for display in shrines to legendary ancestors or to nature deities held responsible for the health of crops and the well-being of the people. The regalia, art, and architecture of kings and their courts, as elsewhere in the world, celebrate the wealth and power of the rulers themselves (see "The Royal Arts of Benin," page 555). Many African peoples have lavished artistic energy on the decoration of their bodies to express their identity and status, and many communities mount richly layered festivals, including masquerades, to celebrate harvests and the New Year and to commemorate the deaths of leaders.

PREHISTORY AND EARLY CULTURES

Thousands of rock engravings and paintings found at hundreds of sites across the continent constitute the earliest known African art. Some painted animals from the Apollo 11 Cave (FIG. 1-3A 🗷)

in Namibia date to perhaps as long as 25,000 years ago, older than all but the earliest Paleolithic art of Europe (see page 16). Because humankind apparently originated in Africa, archaeologists may yet discover the world's earliest art there as well.

The greatest concentrations of rock art are in the Sahara Desert to the north, the Horn of Africa in the east, and the Kalahari Desert to the south, as well as in caves and on rock outcroppings in southern Africa. Accurately naturalistic renderings as well as stylized images on rock surfaces show animals and humans in many different positions and activities, singly or in groups, stationary or in motion. Most of these works date to within the past 4,000 to 6,000 years, but some may have been created as early as 8000 BCE. They provide a rich record of the environment, human activities, and animal species in prehistoric times.

TASSILI N'AJJER A 7,000-year-old painting (FIG. 21-2) from Tassili n'Ajjer in southeastern Algeria in the central Sahara is one of the earliest and finest surviving examples of rock art. In striking contrast to today, in the Neolithic age, the Sahara had ample water, rich soil, foliage, and large populations of humans and animals. In the illustrated rock painting, a woman seems to be running, although the artist's intention may have been to show her dancing. In any case, the animation is convincing and the degree of detail significant. The dotted marks on her shoulders, legs, and torso probably indicate that she is wearing body paint applied for a ritual. Her face, however, is featureless, a common trait in the earliest art of Europe (FIG. 1-2) as well as Africa. The white parallel patterns attached to her arms and waist probably represent flowing raffia decorations and a raffia skirt. Horns are also part of her ceremonial attire, shown, as typically in prehistoric art, in composite view—that is, seen from the front even though on a profile head. If the woman is dancing and wearing a headdress, this is evidence that the important African ritual of masquerade is very ancient (see "African Masquerades," page 568). Notably, the artist painted this detailed image over a field of much smaller painted human beings, an example of why it is often so difficult to date and interpret art on rock surfaces, as subsequent superimpositions are frequent. Nonetheless, scholars have been able to establish a rough chronology for African rock art, an art form that continues to the present day.

Although the precise meaning of most African rock art also remains uncertain, a considerable literature exists describing, analyzing, and interpreting the varied human and animal activities shown, as well as the evidently symbolic, more abstract patterns. The human and humanlike figures may include representations of supernatural beings as well as mortals. Some scholars have, in fact, interpreted the woman from Tassili n'Ajjer as a horned deity rather than a human wearing ceremonial headgear.

NOK Outside Egypt and neighboring Nubia (MAP 1-3), the earliest African sculptures in the round have been found at several sites in central Nigeria that archaeologists collectively call the Nok culture. Scholars disagree on whether the Nok sites were unified politically or socially. Hundreds of Nok-style human and animal heads, body parts, and figures have been found accidentally during tin-mining operations, but not in their original context. Most date between

21-2 Running woman, rock painting, Tassili n'Ajjer, Algeria, ca. 6000-4000 BCE.

Prehistoric rock paintings are difficult to date and interpret. This Algerian example represents a woman with a painted body wearing a raffia skirt and horned headgear, apparently in a ritual context.

11TH TO 18TH CENTURIES

Although kings ruled some African population groups from an early date, the best evidence for royal arts in Africa comes from the several centuries between about 1000 and the beginning of European colonization in the 19th century.* During this period, Africans also constructed major houses of worship for the religions of Christianity and Islam, both of which originated in the Middle East but quickly gained adherents south of the Sahara.

jewelry (see "Art and Leadership in Africa," page 559). reproducing the details of the crown, heavily beaded costume, and great care to indicate the man's status as a sacred ruler by precisely head in Ife statuary and African art in general. The artist also took developed at least 800 years ago, accounting for the emphasis on the wisdom, destiny, and the essence of being, and these ideas probably pared to their bodies. For modern Yoruba, the head is the locus of heads of the rulers, for example, are disproportionately large com-The naturalism does not extend to body proportions, however. The of the naturalistic recording of facial features and fleshy anatomy. similar representations of Ife rulers are exceptional in Africa because zinc-brass alloy, datable to the 11th or 12th century. This and many impressive examples is a statuette (FIG. 21-4) of an Ite king cast in a ists often portrayed their sacred kings in sculpture. One of the most ("ruler" or "king") of Ife and the ancestor of all Yoruba kings. Ife artearth and its peoples. Tradition also names Oduduwa the first oni tion, the place where the gods Oduduwa and Obatala created the Igbo Ukwu in southwestern Nigeria, the cradle of Yoruba civiliza-IFE Africans have long considered Ife, about 200 miles west of

clay on the exterior that occurs during an annual festival. as perches for workers undertaking the essential recoating of sacred beams further enliven the walls, but also serve a practical function resembling engaged columns. The many rows of protruding wood dle East and features soaring adobe towers and vertical buttresses Mosque," page 147). The facade, however, is unlike any in the Midemulating the plan of many of the oldest mosques known (see "The 1830. The mosque has a large courtyard and a roofed prayer hall, structed in 1906-1907 after a fire destroyed the earlier building in Great Mosque (FIG. 21-5), first built in the 13th century and reconof adobe (sun-dried mud-brick) architecture in the world, the city's flooding season. Djenne boasts one of the most ambitious examples present-day Mali, had been built on high ground left dry during the opotamia (see page 22). By about 800, a walled town, Djenne in can continent a kind of "fertile crescent" analogous to ancient Mes-DIENNE The inland floodplain of the Niger River was for the Afri-

Djenne is also noteworthy for the extensive series of terracotta sculptures (for example, FIG. 21-5A \blacksquare) found in the region, most dating to between 1100 and 1500.

GREAT ZIMBABWE The most famous southern African site of this period is a complex of stone ruins at the large southeastern political center called Great Zimbabwe. First occupied in the 11th century, the site features walled enclosures and towers dating from about the late 13th to the middle of the 15th centuries. At that time, Great Zimbabwe had a wide trade network. Finds of beads and pottery from Mesopotamia and China, along with copper, gold, and ivory objects, underscore that Great Zimbabwe was a prosperous trade center well before Europeans began their coastal voyaging in the center well before Europeans began their coastal voyaging in the

*From this point on, all dates in this chapter are CE unless otherwise stated.

late 15th century.

21-3 Nok head, from Rafin Kura, Nigeria, ca. 500 bce–200 ce. Terracotta, 1' 2 $\frac{3}{16}$ high. National Museum, Lagos.

The earliest African sculptures in the round come from Migeria. The Mok culture produced expressive terracotta heads with large eyes, mouths, and ears. Piercing equalized the heat during the firing process.

been women, Nok women may have sculpted these heads as well. ceramists and clay sculptors across the continent have traditionally gender of the Nok artists is also unknown, but because the primary the person portrayed held an elevated position in Nok society. The of the Rafin Kura figure may be a bead necklace, an indication that the Nok terracottas is unclear, but the broken tube around the neck the head after removing the sculpture from the kiln. The function of engraved details suggest that the sculptor carved some features of during the firing process. The incised grooves in the hair and other as air vents, helping to equalize the heating of the hollow clay head mouth, and ear holes are characteristic of Nok sculpture and served lips, and a coiffure divided into tuffed sections. The pierced pupils, an expressive face with large triangular eyes, flaring nostrils, parted tionately large compared with the bodies. The head shown here has African artworks—for example, FIG. 21-1—the heads are disproporfashioned standing, seated, and kneeling figures. As in most later Preserved fragments of other statues indicate that the Nok sculptors found at Rafin Kura, is a fragment of what was originally a full figure. 500 BCE and 200 CE. A representative terracotta head (FIG. 21-3),

By the 9th or 10th century, African sculptors had also mastered bronze-casting, as seen in the many examples unearthed at Igbo-Ukwu in the lower Niger area—including a remarkable fly whisk (FIG. 21-3A (A)) representing an equestrian figure.

CHAPTER 21 Africa

ART AND SOCIETY

Art and Leadership in Africa

The relationships between leaders and art forms are strong, complex, and universal in Africa. Political, spiritual, and social leaders—kings, chiefs, titled people, and religious specialists—have the power and wealth to obtain the services of the best artists and acquire the most expensive materials to adorn themselves, furnish their homes and palaces, and make visible the cultural and religious organizations they lead. Leaders also possess the power to dispense artworks and the right to own and display them.

Several formal or structural principles characterize leaders' arts and thus set them off from the popular arts of ordinary Africans. Leaders' arts-for example, the lavish and layered regalia of chiefs and kings (FIGS. 21-1 and 21-4)—tend to be durable and fashioned of costly materials, such as ivory, beads, copper alloys, and other metals. Some of the objects made specifically for African leaders, such as thrones and footstools (FIG. 21-10), ornate clothing (FIG. 21-21), and special weaponry, draw attention to their superior status. Handheld objects for example, staffs (Figs. 21-13 and 21-15), spears, knives (Fig. 21-15), scepters, pipes, and fly whisks (FIG. 21-3A 1)—extend a leader's reach and magnify his or her gestures. Other objects associated with leaders, such as fans, shields (FIG. 21-1), and umbrellas, protect the leaders both physically and spiritually. Sometimes the regalia and implements of an important person are so heavy that they render the leader virtually immobile (FIG. 21-21), suggesting that the temporary holder of an office is less significant than the eternal office itself. In African art, leaders are also commonly portrayed as larger-than-life figures flanked by diminutive attendants (FIGS. 21-1 and 21-15) or mounted on undersized horses (FIG. 21-1). Often, the leaders, both male and female, have facial scars (FIGS. 21-3A) and 21-7; compare FIG. 21-20A), indicating their elevated status in society.

Although leaders' arts are easy to recognize in centralized, hierarchical societies, such as the Benin (Figs. I-13, 21-1, 21-7, and 21-16) and Bamum (Fig. 21-10) kingdoms, leaders among less centralized peoples have been no less conversant with the power of art to move people and effect change. For example, African leaders often oversee religious

21-4 Ife king, from Ita Yemoo, Nigeria, 11th to 12th centuries. Zinc-brass, 1' 6½" high. Museum of Ife Antiquities, Ife.

This figure with an overly large head has a naturalistically modeled torso and facial features approaching portraiture. The crown, heavily beaded costume, and jewelry indicate that he is a king.

rituals in which they may be less visible than the forms used in those rituals: shrines, altars, festivals, and rites of passage such as funerals. The arts that leaders control thus help create pageantry, mystery, and spectacle (see "African Masquerades," page 568), enriching and changing the lives of the people.

21-5 Aerial view of the Great Mosque (looking northwest), Djenne, Mali, constructed in the 13th century, razed in 1830, and rebuilt in 1906–1907.

The Great Mosque at Djenne resembles Middle Eastern mosques in plan (large courtyard in front of a roofed prayer hall), but the construction materials—adobe and wood—are distinctly African.

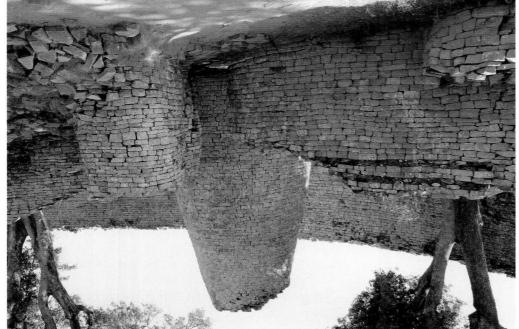

Africa had a trade network that extended The Great Zimbabwe Empire in southern Zimbabwe, 14th century. (looking north), Great Zimbabwe,

21-6 Walls and tower, Great Enclosure

the royal residence. to 32 feet high and conical towers enclosed to Mesopotamia and China. Stone walls up

in metals, cloth, and other goods-with Olokun, the deity they ships from across the sea, their powerful weapons, and their wealth Benin people probably associated the Portuguese—with their large lower part of the carving. In the late 15th and 16th centuries, the and creativity. Another series of Portuguese heads also adorns the tionships with the Portuguese and to Olokun, god of the sea, wealth, bolic references respectively to Benin's trade and diplomatic relacrown are alternating bearded Portuguese heads and mudfish, symis remarkable for its sensitive naturalism. On the Queen Mother's mother's face an integral part of his own identity. The life-size head

(FIG. 21-7A (A). especially noteworthy for their wood statuettes of seated kings traits before 1800, the Kuba (Democratic Republic of Congo) are Among the other African peoples that produced royal por-

deemed responsible for abundance and prosperity.

hybrid art form. Characterized by refined detail and careful finish, African trade with Europe. The Sapi export ivories are a fascinating days and was one of the coveted exports in early West and Central lars from elephant tusk ivory, which was plentiful in those early the European elite. Sapi sculptors meticulously carved the saltceltive. Costly saltcellars were prestige items that graced the tables of able commodity, used both as a flavoring and as a food preservawell as boxes, hunting horns, and knife handles. Salt was a valuforks, and elaborate containers usually referred to as saltcellars, as to Europe. The Portuguese commissions included delicate spoons, for Portuguese explorers and traders, who took the objects back lectively called the Sapi, created art not only for themselves but also of Africa in present-day Sierra Leone, whom the Portuguese col-SAPI Between 1490 and 1540, some peoples on the Atlantic coast

another seated figure about to lose his head. On the ground before shield in one hand holds an ax (restored) in the other hand over the source of the artist's assigned name. A kneeling figure with a EXECUTION. The saltcellar, which depicts an execution scene, is (FIG. 21-8), almost 17 inches high, to the Master of the Symbolic Art historians have attributed the saltcellar shown here they are the earliest examples of African tourist art.

> people in times of need. erosity, as the ruler received tribute in grain and dispensed it to the suggests a granary. Grain bins were symbols of royal power and gentheir precise significance is unknown. The form of the large tower symbolically as masculine (large) and feminine (small) forms, but towerlike stone structures, which archaeologists have interpreted Enclosure (FIG. 21-6) houses one large and several small conical, are 32 feet tall and 17 feet thick in the lowest courses. The Great for their size and the excellence of their stonework. Some sections not survived, the walls of the enclosures remain. They are unusual plex reserved for royalty. Although the habitations themselves have area, with most of the commoners living outside the enclosed compower, as many as 18,000 people may have lived in the surrounding nial gatherings (the royal hill complex). At the peak of the empire's the ruler, his wives, and nobles, including an open court for ceremo-Great Zimbabwe was a royal residence with special areas for

> "Art and Leadership," page 559). pense art objects as royal favors to title holders and other chiefs (see wrought iron. The hereditary oba and his court still use and disproduced sophisticated artworks in ivory, wood, ceramic, and copper-alloy sculptures (FIGS. I-13 and 21-1), Benin artists have tinues to live, has been partially rebuilt. In addition to finely cast thrives today, however, and the palace, where the Benin king con-British burned and sacked the Benin palace and city. Benin City kingdom's slow decline thereafter culminated in 1897, when the its greatest power and geographical extent in the 16th century. The century was the grandson of a Yoruba king of Ife. Benin reached BENIN According to oral tradition, the first Benin king in the 13th

> palace. Esigie probably wore the pendant at his waist, making his for her the title of Queen Mother (iyoba) and built her a separate Portuguese. Idia had helped her son in warfare, and Esigie created great prosperity and expanded through a flourishing trade with the Esigie (r. ca. 1504-1550), under whom the Benin kingdom enjoyed is an ivory pendant (FIG. 27-7) portraying Idia, the mother of Oba QUEEN MOTHER IDIA One of the masterworks of Benin sculpture

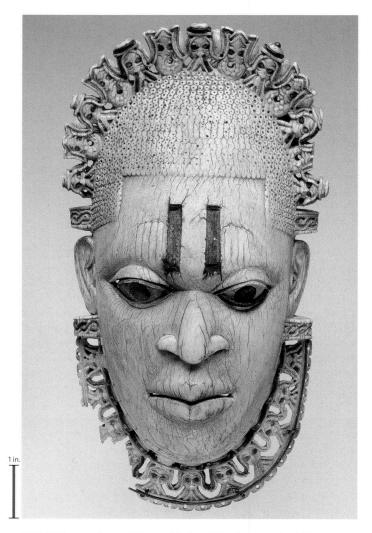

21-7 Waist pendant of Queen Mother Idia, from Benin, Nigeria, ca. 1520. Ivory and iron, $9\frac{3}{8}$ " high. Metropolitan Museum of Art, New York (Michael C. Rockefeller Memorial Collection, gift of Nelson A. Rockefeller, 1972).

This life-size ivory head portraying Queen Mother Idia was worn by her son, Oba Esigie, on his waist. Above Idia's head are Portuguese heads and mudfish, symbols of trade and of the sea god Olokun.

the executioner, six severed heads grimly testify to the executioner's power. A double zigzag line separates the lid of the globular container from the rest of the vessel. This vessel rests in turn on a circular platform held up by slender rods adorned with crocodile images. Two male and two female figures sit between these rods, grasping them. The men wear European-style pants and have long, straight hair. The women wear skirts, and the elaborate raised patterns on their upper chests surely represent decorative scars. The European components of this saltcellar are the overall design of a spherical container on a pedestal and some of the geometric patterning on the base and the sphere, as well as certain elements of dress, such as the shirts and hats. Distinctly African are the style of the human heads and figures and their proportions, the latter skewed to emphasize the head. It is unknown whether it was the African carver or the European patron who specified the subject matter and the configurations of various parts, but the Sapi works testify to a fruitful artistic interaction between Africans and Europeans during the early 16th century.

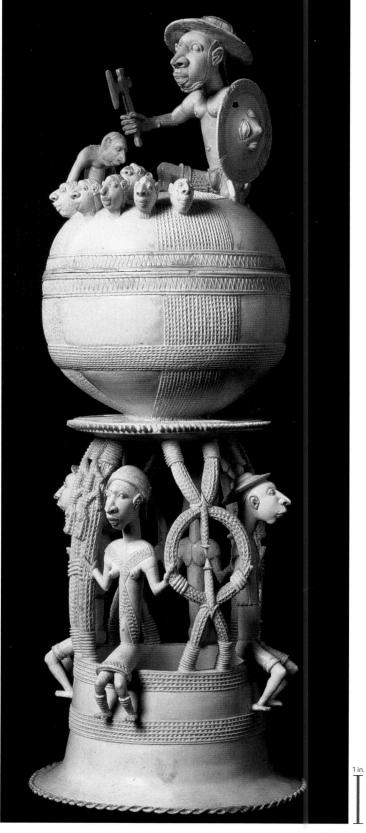

21-8 MASTER OF THE SYMBOLIC EXECUTION, Sapi-Portuguese saltcellar, from Sierra Leone, ca. 1490–1540. Ivory, 1' $4\frac{7}{8}$ " high. Museo Nazionale Preistorico e Etnografico Luigi Pigorini, Rome.

The Sapi exported saltcellars combining African and Portuguese traits. This one represents an execution scene with an African-featured man wearing European pants seated among severed heads.

19TH CENTURY

ries than for the period before 1800. meaning of African art objects produced during the past two centulocal people) have provided much more detail on the function and Archaeology and field research in Africa (mainly interviews with

The Kota believed that the gleaming surfaces repelled evil. The abstract body with strips and sheets of polished copper and brass. a wood head. The Kota sculptors covered both the head and the severely stylized bodies in the form of an open diamond below reliquaries with guardian figures called mbulu ngulu, which have for use in ancestor worship (reliquaries). The Kota crowned their (relics) of the deceased and deposited them in special containers Kota and Fang traditionally collected the cranial and other bones the area just south of the equator in Cameroon and Gabon. Both the tors are the Kota (Fig. 21-9) and Fang (Fig. 21-9A (1), who occupy KOTA Among the many African peoples who venerate their ances-

admitted to his palace. colors of his seat, advertising his wealth and power to all who were (compare FIG. 21-21), his rich garments complemented the bright decorate the rectangular footstool. When the king sat on this throne of the king's bodyguards wielding European rifles. Dancing figures is a woman carrying a serving bowl in her hands. Below are two

his service. One, a man, holds the royal drinking horn. The other

Above are the figures of two of the king's retainers, perpetually at

Intertwining blue and black serpents decorate the cylindrical seat.

throne (FIG. 21-10) of King Msangu (r. 1865–1872 and 1885–1887).

and cowrie shells. One of the masterpieces of Bamum art is the

richly colored textiles and luminous materials, such as glass beads

destruction in 1910. The royal arts of Bamum make extensive use of

lived in a palace compound at the capital city of Foumban until its

dom of Bamum in present-day Cameroon, a long line of kings

major genre of 19th-century African art production. In the king-

BAMUM As in earlier times, art crafted to honor royalty was a

brass basins obtained in trade with Europe. The Kota inserted the

these images is reworked sheet brass (or copper wire) taken from

textured elegance to the shiny forms. The copper alloy on most of

beside the face. Geometric ridges, borders, and subdivisions add a

simplified heads have hairstyles flattened out laterally above and

lower portion of the image into the box of ancestral relics.

Museum für Völkerkunde, Staatliche Museen zu Berlin, Berlin. ca. 1870. Wood, textile, glass beads, and cowrie shells, 5' 9" high. 21-10 Throne and footstool of Bamum king Neangu, from Cameroon,

Musée Barbier-Mueller, Geneva. 19th or early 20th century. Wood, copper, iron, and brass, 1' 9 16" high. 21-9 Kota reliquary guardian figure (mbulu ngulu), from Gabon,

believe that gleaming surfaces repel evil. diamond. Polished copper and brass sheets cover the wood forms. The Kota Kota guardian figures have large heads and bodies in the form of an open **FON** The founding of the Fon kingdom in the present-day Republic of Benin dates to around 1600. Under King Guezo (r. 1818-1858), the Fon became a regional power with an economy based on trade in palm oil. After his first military victory, Guezo's son Glele (r. 1858-1889) commissioned a prisoner of war, AKATI AKPELE KENDO, to make a life-size iron statue (FIG. 21-11) of a warrior, probably Gu, the Fon god of war, for a battle shrine in Glele's palace at Ahomey. This bocio, or empowerment figure, was the centerpiece of a circle of iron swords and other weapons set vertically into the ground. The warrior strides forward with swords in both hands, ready to do battle. He wears a crown of miniature weapons and tools on his head. The form of the crown echoes the circle of swords around the statue. The Fon believed that the bocio protected their king, and they transported it to the battlefield whenever they set out to fight an enemy force. King Glele's iron warrior is remarkable for its size and for the fact that not only is the patron's name known but so, too, is the artist's name—a rare instance in Africa before the 20th century (see "African Artists," page 567).

KONGO The Congo River formed the principal transportation route for the peoples of Central Africa during the 19th century. Some of the most distinctive African artworks of that period come

21-11 AKATI AKPELE KENDO, Fon warrior figure (Gu?), from the palace of King Glele, Abomey, Republic of Benin, 1858–1859. Iron, 5' 5" high. Musée du quai Branly, Paris (on loan to the Musée du Louvre, Paris).

This bocio, or empowerment figure, probably representing the war god Gu, was the centerpiece of a circle of iron swords. The Fon believed that it protected their king, and they set it up on the battlefield.

from Kongo—for example, the large standing statue (FIG. 21-12) shown here. It represents a man bristling with nails and blades—a Kongo *nkisi n'kondi* (power figure). These figures, consecrated by priests using precise ritual formulas, embodied spirits believed to heal and give life, or sometimes to inflict harm, disease, or even death.

Each statue had its specific role, just as it wore particular medicines—here protruding from the abdomen, which features a large cowrie shell. The Kongo also activated every image differently. Owners appealed to a figure's forces every time they inserted a nail or blade, as if to prod the spirit to do its work. People invoked other spirits by repeating certain chants, by rubbing the images, or by applying special powders. The roles of power figures varied enormously, from curing minor ailments to stimulating crop growth, from punishing thieves to weakening enemies. Very large Kongo figures, such as this one, had exceptional ascribed powers and aided entire communities. Although benevolent for their owners, the figures stood at the boundary between life and death, and most villagers held them in awe. Compared with the sculptures of most other African peoples, this Kongo figure is relatively naturalistic, although the carver simplified the facial features and magnified the size of the head for emphasis.

21-12 Kongo power figure (nkisi n'kondi), from Shiloango River area, Democratic Republic of Congo, ca. 1875–1900. Wood, nails, blades, medicinal materials, and cowrie shell, 3' 10 \(\frac{3}{4}''\) high. Detroit Institute of Arts, Detroit.

Only priests using ritual formulas could consecrate Kongo power figures, which embody spirits that can heal or inflict harm. The statue has simplified anatomical forms and an oversized head.

D21-14 Dogon seated couple, from Mali, ca. 1800–1850. Wood, 2' 4" high. Metropolitan Museum of Art, New York (gift of Lester Wunderman).

This Dogon carving of a linked man and woman documents gender roles in traditional African society. The protective man wears a quiver on his back. The nurturing woman carries a child on hers.

Docon The Dogon live south of the inland delta region of the great Niger River in what is today Mali. One of the most common themes in Dogon art—and in African art in general—is the human couple. A characteristic Dogon example is the statue of a linked man and woman illustrated here (Fig. 21-14). It dates to the early 19th century and may have served as a portable shrine or altar, although contextual information is lacking. Interpretations vary, but the image vivial information is lacking. Interpretations vary, but the image vivial information is lacking. Interpretations vary, but the image vivial information is lacking. Interpretations vary, but the image vivial information is lacking. Interpretations vary, but the image vivial information is lacking. The woman carries a child on here. Thus the man assumes a protective role as hunter or warrior, the woman a nurturing role. The slightly larger man reaches behind his mate's neck and touches her breast, as if to protect her. His left his mate's neck and touches her breast, as if to protect her. His left

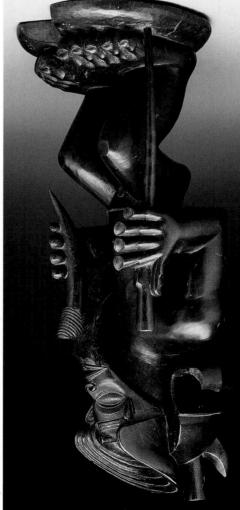

The Chokwe claim descent from the legendary hunter Chibinda llunga, portrayed in art as a muscular man with a chiet's headdress, oversized hands and feet, and a beard of human hair.

figure of Chibinda Ilunga, binda Ilunga, from Angola or Democratic Republic of Congo, late 19th to 20th century. Wood and human hair, I' 4" high. Kimbell Art Museum, Fort

chokwe The Chokwe occupy the area of west-central Africa corresponding to parts of northeastern Angola and southwestern Democratic Republic of Congo. Local legend claims that the Chokwe are the descendants of the widely traveled Chibinda Ilunga, who won fame as a hunter. He married a princess named Lueji, who was a hereditary ruler of one of the kingdoms of the Lunda Empire, an important regional power during the 16th through 19th centuries. Lueji gave Chibinda a sacred bracelet, the basis and symbol of her rule, which established his authority. He taught the Lunda to be great hunters, enriched the kingdom, and extended its territory. The great hunters, enriched the kingdom, and extended its territory. The expansion, became skilled elephant hunters and ivory traders. They eventually revolted against the Lunda kings and brought about the eventually revolted against the Lunda kings and brought about the contually revolted Empire in the mid-19th century.

The Chokwe figures Dibinda Ilunga as founder, hunter, and civilizing hero, and he figures prominently in their royal arts. The statue illustrated here (Fig. 21-13) is one of the finest examples. It shows the legendary hunter-king wearing a chief's barkcloth-andrattan headdress and holding a staff in his right hand and, in his left hand, a medicine horn containing powerful substances to aid hunters. The sculptor portrayed Chibinda with a muscular body and oversized arms and feet to underscore the hunter's manual dexterity and ability to undertake long journeys. A rare feature of this and and ability to undertake long journeys. A rare feature of this and other Chokwe figures is the use of human hair for Chibinda's beard other Chokwe figures is the use of human hair for Chibinda's beard.

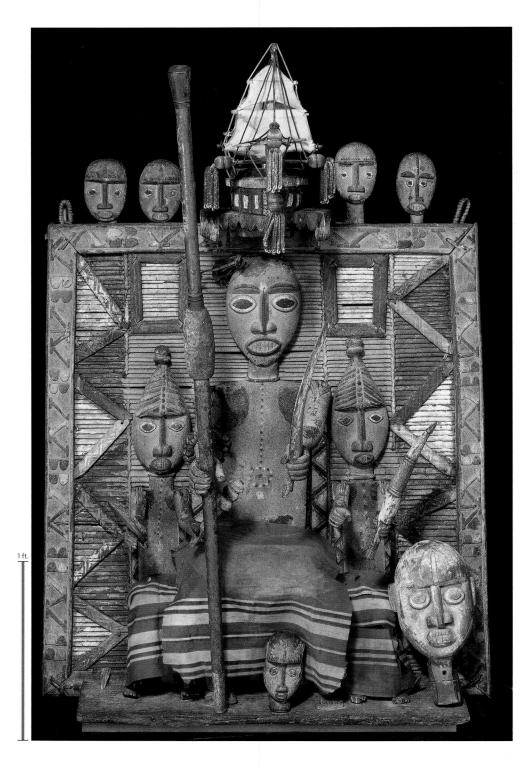

hand points to his genitalia. Four stylized figures support the stool on which they sit. They are probably either spirits or ancestors, but the identity of the larger figures is uncertain.

The strong stylization of Dogon sculptures contrasts sharply with the organic, relatively realistic treatment of the human body in Kongo and Chokwe art (FIGS. 21-12 and 21-13). The artist who carved the Dogon couple based the forms more on the idea or concept of the human body than on observation of individual heads, torsos, and limbs. The linked body parts are tubes and columns articulated inorganically. The carver reinforced the almost abstract geometry of the overall composition by incising rectilinear and diagonal patterns on the surfaces. The Dogon artist also understood the importance of

21-15 Kalabari Ijaw ancestral screen (nduen fobara), from Nigeria, late 19th century. Wood, fiber, and cloth, $3' 9 \frac{1}{2}"$ high. British Museum, London.

Kalabari Ijaw ancestral screens are memorials to the chiefs of trading companies. The deceased, the central figure with a headdress in the form of a 19th-century European sailing ship, is also the largest.

space, and charged the voids, as well as the sculptural forms, with rhythm and tension.

KALABARI IJAW The Kalabari Ijaw peoples have hunted and fished in the eastern delta of the Niger River in present-day Nigeria for several centuries. As in so many other African cultures, Kalabari artists and patrons have lavished attention on memorials to ancestors. Their shrines take a unique form, however, because a cornerstone of their economy has long been trade, and trading organizations known locally as "canoe houses" play a central role in Kalabari society. Kalabari ancestor shrines are screens of wood, fiber, textiles, and other materials. An especially elaborate example (FIG. 21-15) is the almost 4-foot-tall nduen fobara ("foreheads of the deceased") honoring a chief of a trading company. The chief's family usually commissioned these memorial screens on the one-year anniversary of his death. Displayed in the house in which the chief lived, the screen represents the deceased himself at the center. In this case, the chief holds a long silver-tipped staff in his right hand and a curved knife in his left hand. His chest is bare, but covering the lower part of his body is a richly colored fabric, an emblem of his elevated stature in Kalabari society. His impressive headdress is in the form of a 19thcentury European sailing ship, a reference to the chief's successful trading business, and another indication of the important role that costume plays in Africa. Flank-

ing the chief are his attendants, smaller in size as is appropriate for their lower rank. The heads of his slaves are at the top of the screen, and those of his conquered rivals are at the bottom. The hierarchical composition and the stylized rendition of human anatomy and facial features are common in African art, but the richness and complexity of this shrine are exceptional.

Unusual, too, is the way the sculptor created the shrine by assembling it from separately carved sections and then painting it. Most African sculptors fashioned their works from a single block of wood. The carpentry technique employed for the Kalabari screens may be the result of sustained contact with European traders and firsthand knowledge of European woodworking techniques.

Art, Washington, D.C. National Museum of African alloy, wood, and ivory. Photo: graphed in 1970. Clay, copper in Benin City, Nigeria, photoof King Eweka II, in the palace 21-76 Benin royal ancestral altar

lective strength of his ancestors. Benin king annually invokes the colsacrificing animals at this altar, the materials, objects, and symbols. By ancestors is an assemblage of This shrine to the heads of royal

shown 10" high. Collection of the Paramount Chief of Offinso, Asante. of food, from Ghana, mid-20th century. Wood and gold leaf, section

21-17 OSEI BONSU, Asante linguist's staff of two men sitting at a table

a metaphor for the office of the king. speak for the Asante king. At the top are two men sitting at a table of food— Bonsu carved this gold-covered wood linguist's staff for someone who could

20TH CENTURY

16-11, and 16-18). international in both content and style (for example, FIGS. 16-7, works depicting age-old African themes to modern works that are The art of Africa during the past 100 years ranges from traditional

and the pyramidal copper-alloy bells serve the important function of the back refer to generations of dynastic ancestors. The rattle-staffs resent male physical power. The carved wood rattle-staffs standing at goodness (probably of royal ancestors), and the tusks themselves repages in Benin history. Their bleached white color signifies purity and carvings atop the heads commemorate important events and personthe shrine and thus the king and kingdom. The elephant-tusk relief red and signaling danger, repel evil forces that might adversely affect rial, the enduring nature of kingship. Their glistening surfaces, seen as both the kings themselves and, through the durability of their matein relief. Behind are wood staffs and metal bells. The heads represent plus copper-alloy heads, each fitted on top with an ivory tusk carved flanked by smaller members of his entourage (compare FIG. 21-1), symbols: a central copper-alloy altarpiece depicting a sacred king riverbank clay, it is an assemblage of varied materials, objects, and tory, it is similar to centuries-earlier versions. With a base of sacred one 20th-century altar (FIG. 21-16) remains. According to oral hisstill I7 shrines to ancestors in the Benin royal palace. Today, only BENIN In 1897, when the British sacked Benin City, there were

visually and ritually to the imaging of royal power, as well as to its objects, symbols, colors, and materials of this shrine contribute both by invoking the collective strength of his ancestors. Thus the varied this site, the living king annually purifies his own head (and being) tral altar multiply these qualities. By means of animal sacrifices at divine guidance for the kingdom. The several heads in the ances-The Benin king's head stands for wisdom, good judgment, and

calling royal ancestral spirits to rituals performed at the altar.

history, renewal, and perpetuation.

ART AND SOCIETY

African Artists and Apprentices

Like European art before the Renaissance, most African art is anonymous, primarily because early researchers rarely asked for artists' names. Nonetheless, connoisseurs can recognize many individual hands or styles even when an artist's name has not been recorded. And, as art historians regularly do with unsigned European artworks, they will assign names to the artists who produced them—for example, the Master of the Symbolic Execution (FIG. 21-8), an anonymous 16th-century sculptor from Sierra Leone.

During the past century, art historians and anthropologists have been systematically noting the names and life histories of specific individual artists, many of whom have strong regional reputations. One of the earliest recorded names is that of the mid-19th-century Fon sculptor and metalsmith Akati Akpele Kendo (FIG. 21-11). Two 20th-century artists, renowned even beyond their homelands, were Osei Bonsu (FIG. 21-17), based in the Asante capital of Kumasi, and the Yoruba sculptor called Olowe of Ise (FIG. 21-18) because he came from the town of Ise. Both artists were master carvers, producing sculptures for kings and commoners alike.

Like other great artists throughout history, both Bonsu and Olowe had apprentices to assist them for several years while learning their master's trade. Although there are various kinds of apprenticeship in Africa, novices typically lived with their masters and were household servants as well as assistant carvers. They helped fell trees, carry logs, and rough out basic shapes, which the master later transformed into finished work.

African sculptors typically worked on commission. Sometimes, as in Bonsu's case, patrons traveled to the home of the artist. But other times, Bonsu moved to the home of a patron for weeks or months while working on a commission. Masters, and in some instances also apprentices, lived and ate in the patron's compound. Olowe, for example, resided with different kings for many months at a time while he carved doors (FIG. 21-18), veranda posts, and other works for royal families.

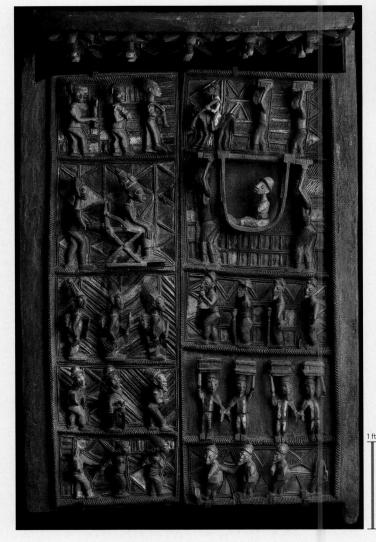

21-18 OLOWE OF ISE, doors from the shrine of the Yoruba king's head in the royal palace, Ikere, Nigeria, 1910–1914. Painted wood, 6' high. British Museum, London.

Olowe's painted high-relief doors to the shrine of the king's head depict the 1897 visit of the British provincial commissioner to the Ikere palace. The enthroned Yoruba king is the largest figure.

OSEI BONSU Traditionally, Africans have tended not to exalt artistic individuality as much as Westerners have, but some 20th-century African artists achieved enviable reputations (see "African Artists and Apprentices," above). One of these was OSEI BONSU (1900–1976), a master carver based in the Asante capital, Kumasi, in present-day Ghana. A more naturalistic rendering of the face and crosshatched eyebrows are distinctive features of Bonsu's personal style. The gold-covered wood sculpture illustrated here (FIG. 21-17) is a characteristic example of his work. It is a *linguist's staff*, so named because its carrier often speaks for a king or chief. This one depicts two men sitting at a table of food and reflects an Asante proverb: "Food is for its rightful owner, not for the one who happens to be hungry." Food is a metaphor for the office that the king or chief rightfully holds. The "hungry" man lusts for the office.

The linguist, who is an important counselor and adviser to the king, might carry this staff to a meeting at which a rival contests the king's title to the stool (his throne, the office). Many hundreds of Asante sculptures have proverbs or other sayings associated with them, which has created a rich verbal tradition related to Asante visual arts.

OLOWE OF ISE The leading Yoruba sculptor of the early 20th century was Olowe of Ise (ca. 1873–1938). Kings throughout Yorubaland (southern Nigeria and southern Benin) commissioned Olowe to carve reliefs, masks, bowls, veranda posts, and other works. The *ogaga* (king) of Ikere, for example, employed Olowe for four years starting in 1910, during which he resided at Ikere and produced the magnificent carved and painted doors (FIG. 21-18) of the shrine of the king's head in his palace in northeastern Yorubaland. Departing

ART AND SOCIETY African Masquerades

otherworldly behavior that is usually both stimulating and instructive. Masquerades, in fact, vary in function or effect along a continuum from weak spirit power and atrong entertainment value to those rarely seen but possessing vast executive powers backed by powerful shrines. Most operate between these extremes, crystallizing varieties of human and animal behavior—caricatured, ordinary, comic, bizarre, serious, or threatening. Such actions inform and affect audience members because of their dramatic staging. It is the purpose of most masqueraecase of their dramatic staging. It is the purpose of most masqueraecase of their dramatic staging. It is the purpose of most masqueraecase of their dramatic staging. It is the purpose of most masqueraecase of their dramatic staging.

Thus masks and masquerades are mediators—between men and women, youths and elders, initiated and uninitiated, powers of nature and those of human agency, and even life and death. For many groups in West and Central Africa, masking plays (or once played) an active role in the socialization process, especially for men, who control most masks. Maskers carry boys (and, more rarely, girls) away from their mothers to bush initiation camps, put them through ordeals and schooling, and welcome them back to society as men months or even schooling, and welcome them back to society as men months or even

A second major role is in aiding the transformation of important deceased persons into productive ancestors who, in their new roles, can bring benefits to the living community. Because most masking cultures are agricultural, it is not surprising that Africans often invoke masquerades to increase the productivity of the fields, to stimulate the growth of crops, and later to celebrate the harvest.

The srt of masquerade has long been a quintessential African expressive form, laden with meaning and of the highest importance culturally. This is true today, but was even more so in colonial times and earlier, when African masking societies boasted extensive regulatory and judicial powers. In stateless societies, such as those of the Senuto (Fig. 27-79) and Mende (Fig. 27-20), masks sometimes became so influential that they had their own priests and served as power sources or as oracles. Societies empowered maskers to levy fines and to apprehend witches (usually defined as socially destructive people) and criminals, and to judge and punish them. Normally, however—especially today—masks are less threatening and more secular and educational and serve as diversions from the humdrum of daily life. Masked dancers usually embody ancestors, seen as briefly returning to the human realm; variendody ancestors, seen as briefly returning to the human realm; variends our nature spirits called on for their special powers; or, in the case of the Baga, the Mother of Fertility (Fig. 27-20A A).

The mask, a costume ensemble's focal point, combines with held objects, music, and dance gestures to invoke a specific named character, almost always considered a spirit. A few masked spirits appear by themselves, but more often several characters come out together or in turn. Maskers enact a broad range of human, animal, and fantastic

years later.

21-19 Senufo masqueraders, Côte d'Ivoire, photographed ca. 1980-1990.

Senufo masqueraders are always men. Their masks often represent composite creatures incarnating both ancestors and bush powers. They fight malevolent spirits with their aggressively powerful forms.

than the British emissary) and his principal wife receive him. The other panels on each door depict the entourage of the two protagonists, including, at the left, the king's bodyguards and other wives, and, on the right door, shackled slaves carrying chests. Characteristically for Olowe, the relief is so high that some of the figures project as much as 6 inches from the surface, which has a vividly colored

from convention, Olowe made the two doors of unequal width to accommodate a rare historical narrative in 10 panels in five registers. The reliefs recount the 1897 visit of the representative of the British Empire, Major W. R. Reeve-Tucker, the first traveling commissioner of Ondo province. Litter-bearers carry Reeve-Tucker into the palace compound, where the enthroned king (who is far larger

patterned background. Olowe also carved the veranda posts of the courtyard in front of the shrine.

SENUFO The Senufo of the western Sudan region in what is now northern Côte d'Ivoire number more than a million today and produce many different art forms. Perhaps the most interesting are the masks used in the important communal rite of the masquerade (see "African Masquerades," page 568). Senufo men dance many masks, mostly in the context of Poro, the primary men's association for socialization and initiation—a protracted process taking nearly 20 years to complete. Maskers also perform at funerals and other public spectacles. Large Senufo masks (for example, FIG. 21-19) are composite creatures, combining characteristics of antelope, crocodile, warthog, hyena, and human: sweeping horns, a head, and an open-jawed snout with sharp teeth. These masks incarnate both ancestors and bush powers that combat witchcraft and sorcery, malevolent spirits, and the wandering dead. They are protectors who fight evil with their aggressively powerful forms and their medicines. At funerals, Senufo maskers attend the corpse and help expel the deceased from the village. This is the deceased individual's final transition, a rite of passage parallel to that undergone by all men during their years of Poro socialization. When an important person dies, the masquerades, music, dancing, costuming, and feasting together constitute a festive and complex work of art that transcends any one mask or character.

MENDE The Mende have long been farmers whose homeland is the Atlantic coast of Africa in Sierra Leone. Although men own and perform most masks in Africa, in Mende society, women control and dance Sande society masks, while men perform the Poro society masks. The Sande society controls the initiation, education, and acculturation of Mende girls. The glistening black surface of Mende Sowie masks (FIG. 21-20) evokes female ancestral spirits newly emergent from their underwater homes (also symbolized by the turtle on top). The mask and its parts refer to ideals of female beauty, morality, and behavior. A high, broad forehead signifies wisdom and success. The neck ridges have multiple meanings. They are signs of beauty, good health, and prosperity and also reference the ripples in the water from which the water spirits emerge. Intricately woven or plaited hair is the essence of harmony and order found in ideal households. A small closed mouth and downcast eyes indicate the silent, serious demeanor expected of recent initiates. Sande women wear these helmet masks on top of their heads as headdresses, with black raffia and cloth costumes to hide the wearers' identity during public performances. Elaborate coiffures, shiny black color, dainty triangular-shaped faces with slit eyes, rolls around the neck, and actual and carved versions of amulets and various emblems on the top commonly characterize Sowie masks. These symbolize the adult women's roles as wives, mothers, providers for the family, and keepers of medicines for use within the Sande association and the society at large.

Also celebrating the importance of women in African society are the *d'mba* masks (FIG. 21-20A 🗹) of the Baga of Guinea.

KUBA Throughout history, African costumes have been laden with meaning and have projected messages that all members of the society could read. A photograph (FIG. 21-21) taken in 1970 shows the Kuba king Kot a-Mbweeky III (r. 1969–) seated in state before his court, bedecked in a dazzling multimedia costume with many symbolic elements. The king commissioned the costume that he wears.

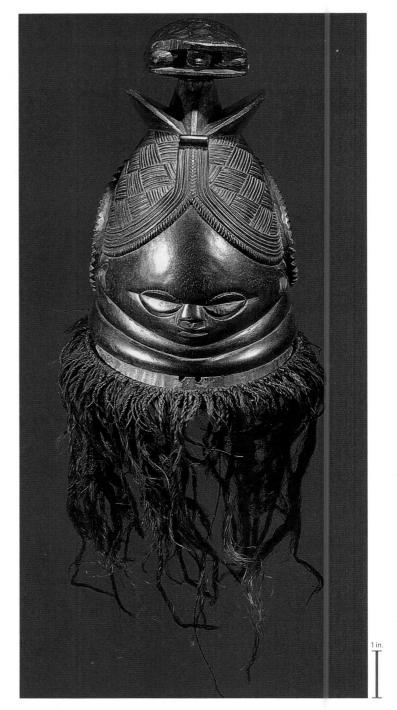

21-20 Mende female mask, from Sierra Leone, mid- to late 20th century. Painted wood, 1' $2\frac{1}{2}$ " high. Fowler Museum of Cultural History, University of California, Los Angeles (gift of the Wellcome Trust).

This Mende mask refers to ideals of female beauty, morality, and behavior. The large forehead signifies wisdom, the neck design beauty and health, and the plaited hair the order of ideal households.

Eagle feathers, leopard skin, cowrie shells, imported beads, raffia, and other materials combine to overload and expand the image of the man, making him larger than life and truly a work of art. He holds not one but two weapons, symbolic of his military might and underscoring his wealth, dignity, and grandeur. The man, with his regalia, embodies the office of sacred kingship. He is a superior

Mushenge, Democratic Republic of and filmmaker Eliot Elisofon in 1970, during a display for photographer 21-21 Kuba King Kot a-Mbweeky III

wealth, dignity, and military might. than life. His costume underscores his als combine to make the Kuba king larger imported beads, raffia, and other materi-Eagle feathers, leopard skin, cowrie shells,

vast continent itself and continues to evolve. uphold traditional art forms. African art remains as varied as the in villages especially, and some people adhere to spiritual beliefs that Traditional values, although under pressure, hold considerable force

of the opulent style of Kuba court arts. the abundance and redundancy of rich materials, are characteristic geometric patterns on the king's costume and nearby objects, and drums, with a treasure basket of sacred relics by his left foot. The being, in fact and figuratively, raised upon a dais, flanked by ornate

following additional subjects: buildings, Google Earth™ coordinates, and essays by the author on the Explore the era further in MindTap with videos of major artworks and

- Fly-whisk hilt, from Igbo Ukwu (Fig. 21-3A)
- Terracotta archer, from Djenne (FIG. 21-5A)
- Ndop of Shyaam aMbul aNgoong (FIG. 27-7A)
- Fang bieri guardian figure (FIG. 21-9A)

Baga d'mba mask (FIG. 21-20A)

of urbanism, most African people still live in rural communities. sale as tourist arts. Nonetheless, despite the growing importance or as incarnations of ancestors or spirits are now made mostly for nent, traditional figures and masks earlier commissioned for shrines tional prominence (see Chapter 16). Also, in many areas of the contiartists have trained or worked abroad and have achieved internasecularization in all the arts of Africa. Many contemporary African Western education, and market economies have led to increasing cially in recent decades, the encroachments of Christianity, Islam, AFRICAN ART TODAY During the past two centuries and espe-

AFRICA

Prehistory and Early Cultures

- Humankind apparently originated in Africa, and some of the oldest known artworks come from Namibia. Rock paintings dated ca. 6000-4000 BCE have been found at Tassili n'Ajjer in Algeria.
- The Nok culture of central Nigeria produced the oldest African sculptures in the round between 500 BCE and 200 CE. The earliest examples of African bronze-casting using the lost-wax method are the 9th- or 10th-century CE sculptures found at Igbo Ukwu (Nigeria).

Running woman, Tassili n'Ajjer, ca. 6000-4000 BCE

11th to 18th Centuries

- Ife (Nigeria) sculptors portrayed their kings in an unusually naturalistic style during the 11th and 12th centuries, but the figures' heads are disproportionately large in comparison to their bodies, as in most African artworks.
- African builders erected Islamic and Christian shrines emulating foreign models, but employed African construction materials and methods—for example, the adobe Great Mosque at Djenne (Mali).
- Great Zimbabwe conducted prosperous trade with Mesopotamia and China long before the first contact with Europeans. Impressive stone walls and towers enclosed the royal palace complex.
- The Benin kingdom in the Lower Niger region, established in the 13th century, reached its peak in the 16th century. Benin sculptors excelled in ivory carving and bronze-casting, producing artworks glorifying the royal family.
- An early example of the interaction between African artists and European patrons is the series of Sapi ivory saltcellars from Sierra Leone datable between 1490 and 1540.

Great Mosque, Djenne, 13th century

Queen Mother Idia, Benin, ca. 1520

19th Century

- Most of the traditional forms of African art continued into the 19th century. Among these are sculptures and shrines connected with the veneration of ancestors, such as the Kalabari Ijaw screens honoring deceased chiefs. Especially impressive examples of African woodcarving are the Kongo nkisi n'kondi (power figures) bristling with nails and blades and the Dogon sculptures of linked men and women.
- The royal arts also flourished in the 19th century. One of the earliest African artists whose name survives is Akati Akpele Kendo, who worked for the Fon king Glele around 1858.

Kongo nkisi n'kondi, ca. 1875-1900

20th Century

- As they did in the 19th century, traditional arts flourished in 20th-century Africa, but the names of many more individual 20th-century artists are known. Two of the most famous are the Asante sculptor Osei Bonsu and the Yoruba sculptor Olowe of Ise.
- The fashioning of masks for festive performances remains important in many parts of Africa today. Senufo masqueraders are almost always men, even when the masks they dance are female, but in Mende society, women are maskers too.

Senufo masqueraders, ca. 1980-1990

Notes

INTRODUCTION

- Quoted in George Heard Hamilton, Painting and Sculpture in Europe, 1880–1940, 6th ed. (New Haven, Conn.: Yale University Press, 1993), 345.
- 2. Quoted in *Josef Albers: Homage to the Square* (New York: Museum of Modern Art, 1964), n.p.

CHAPTER 1

 The chronology adopted in this chapter is that of John Baines and Jaromír Malék, Atlas of Ancient Egypt (Oxford: Oxford University Press, 1980), 36–37. The division of kingdoms is that of, among others, Mark Lehner, The Complete Pyramids (New York: Thames & Hudson, 1997), 89, and David P. Silverman, ed., Ancient Egypt (New York: Oxford University Press, 1997), 20–39.

CHAPTER 2

- 1. Pliny, Natural History, 36.20.
- 2. Lucian, Amores, 13-14; Imagines, 6.
- 3. Pliny, 35.110.

CHAPTER 3

- 1. Livy, History of Rome, 25.40.1-3.
- 2. Pliny the Elder, Natural History, 35.133.
- 3. Bernard Berenson, *The Arch of Constantine: or, The Decline of Form* (London: Chapman & Hall, 1954).

CHAPTER 4

- Procopius, *De aedificiis*, 1.1.23ff. Translated by Cyril Mango, *The Art of the Byzantine Empire*, 312–1453: Sources and Documents (reprint of 1972 ed., Toronto: University of Toronto Press, 1986), 74.
- Paulus Silentiarius, Descriptio Sanctae Sophiae, 489, 668. Translated by Mango, 83, 86.
- 3. Procopius, 1.1.23ff. Translated by Mango, 75.
- Libri Carolini, 4.2. Translated by Herbert L. Kessler, Spiritual Seeing: Picturing God's Invisibility in Medieval Art (Philadelphia: University of Pennsylvania Press, 2000), 119.

CHAPTER 6

- 1. Translated by Giovanna De Appolonia, Boston University.
- Beowulf, 3162–3164. Translated by Kevin Crossley-Holland (New York: Farrar, Straus & Giroux, 1968), 119.
- Translated by Charles P. Parkhurst Jr., in Elizabeth G. Holt, A Documentary History of Art, 2d ed. (Princeton, N.J.: Princeton University Press, 1981), 1:18.

CHAPTER 7

 Paul Frankl, The Gothic: Literary Sources and Interpretation through Eight Centuries (Princeton, N.J.: Princeton University Press, 1960), 55.

CHAPTER 8

- Giorgio Vasari, "Life of Lorenzo Ghiberti." Translated by Gaston du C. de Vere, ed., Giorgio Vasari, Lives of the Painters, Sculptors and Architects (New York: Knopf, 1996), 1:304.
- Quoted in H. W. Janson, The Sculpture of Donatello (Princeton, N.J.: Princeton University Press, 1965), 154.
- 3. Vasari, "Life of Masaccio." Translated by Gaston du C. de Vere, 1:318.

CHAPTER 9

- 1. Leonardo da Vinci to Ludovico Sforza, ca. 1480–1481. Elizabeth Gilmore Holt, ed., *A Documentary History of Art* (Princeton: Princeton University Press, 1981), 1:274–275.
- Quoted in James M. Saslow, The Poetry of Michelangelo: An Annotated Translation (New Haven, Conn.: Yale University Press, 1991), 407.
- 3. Giorgio Vasari, *Lives of the Painters, Sculptors and Architects.* Translated by Gaston du C. de Vere (New York: Knopf, 1996), 2:736.
- 4. Quoted in A. Richard Turner, Renaissance Florence: The Invention of a New Art (New York: Abrams, 1997), 163.
- 5. Quoted in Bruce Boucher, *Andrea Palladio: The Architect in His Time* (New York: Abbeville Press, 1998), 229.
- 6. Quoted in Robert J. Clements, *Michelangelo's Theory of Art* (New York: New York University Press, 1961), 320.
- Giorgio Vasari: The Lives of the Artists. Translated by Julia Conaway Bondanella and Peter Bondanella (New York: Oxford University Press, 1991), 489
- 8. Translated by Erwin Panofsky, in Wolfgang Stechow, *Northern Renaissance Art 1400–1600: Sources and Documents* (Evanston, Ill.: Northwestern University Press, 1989), 123.

CHAPTER 10

- Filippo Baldinucci, Vita del Cavaliere Giovanni Lorenzo Bernini (1681).
 Translated by Robert Enggass, in Robert Enggass and Jonathan Brown, Italian and Spanish Art 1600–1750: Sources and Documents (Evanston, Ill.: Northwestern University Press, 1992), 116.
- 2. Translated by Kristin Lohse Belkin, Rubens (London: Phaidon, 1998), 47.
- 3. Albert Blankert, *Johannes Vermeer van Delft 1632–1675* (Utrecht: Spectrum, 1975), 133, no. 51. Translated by Bob Haak, *The Golden Age: Dutch Painters of the Seventeenth Century* (New York: Abrams, 1984), 450.

CHAPTER 11

- 1. Translated by Robert Goldwater and Marco Treves , eds., *Artists on Art*, 3d ed. (New York: Pantheon Books, 1958), 157.
- 2. Quoted in Thomas A. Bailey, *The American Pageant: A History of the Republic*, 2d ed. (Boston: Heath, 1961), 280.
- 3. Translated by Elfriede Heyer and Roger C. Norton in Charles Harrison, Paul Wood, and Jason Gaiger, eds., *Art in Theory 1648–1815: An Anthology of Changing Ideas* (Oxford: Blackwell, 2000), 453.

CHAPTER 12

- 1. Helmut Bösch-Supan, *Caspar David Friedrich* (New York: Braziller, 1974), 7–8
- Quoted in Charles Harrison, Paul Wood, and Jason Gaiger, eds., Art in Theory 1815–1900: An Anthology of Changing Ideas (Oxford: Blackwell, 1998), 119.
- 3. Quoted in Harrison, Wood, and Gaiger, 518.
- 4. Quoted in Lloyd Goodrich, *Thomas Eakins, His Life and Work* (New York: Whitney Museum of American Art, 1933), 51–52.
- Quoted in Nicholas Pevsner, An Outline of European Architecture (Baltimore: Penguin, 1960), 627.
- Quoted in Naomi Rosenblum, A World History of Photography, 4th ed. (New York: Abbeville Press, 2007), 69.
- 7. Quoted in Kenneth MacGowan, Behind the Screen (New York: Delta, 1965), 49.

CHAPTER 13

- 18. Quoted in William S. Rubin, Miró in the Collection of the Museum of Mod-17. Quoted in Hunter, Jacobus, and Wheeler, 179.
- 19. Quoted in Kenneth Frampton, Modern Architecture: A Critical History, ern Art (New York: Museum of Modern Art, 1973), 32.
- 4th ed. (New York: Thames & Hudson, 2007), 147.
- 20. Quoted in Michel Seuphor, Piet Mondrian: Life and Work (New York:
- 22. Quoted in Herbert, 173-179. 21. Quoted in Hamilton, 426. Abrams, 1956), 117.
- 1933 (New York: Museum of Modern Art, 2009), 64. 23. Translated by Charles Haxthausen, in Barry Bergdoll, ed., Bauhaus 1919-
- Sobriety, 1917-1933 (New York: Da Capo Press, 1978), 119. 24. Quoted in John Willett, Art and Politics in the Weimar Period: The New
- seum of Modern Art, 1954), 200-201. 25. Quoted in Philip Johnson, Mies van der Rohe, rev. ed. (New York: Mu-

CHAPTER 15

- Francis Bacon, 3d ed. (London: Thames & Hudson, 1987), 182. son, 1985), 8; and David Sylvester, The Brutality of Fact: Interviews with I. Dawn Ades and Andrew Forge, Francis Bacon (London: Thames & Hud-
- 3. Quoted in Selden Rodman, Conversations with Artists (New York: Devin-2. Clement Greenberg, "Modernist Painting," Art & Literature 4 (Spring
- 4. Quoted in Deborah Wye, Louise Bourgeois (New York: Museum of Mod-Adair, 1957), 93-94.
- ern Art, 1982), 22.
- 6. Quoted in Richard Francis, Jasper Johns (New York: Abbeville Press, 5. Ibid., 25.
- 7. Andy Wathol, The Philosophy of Andy Wathol (New York: Harcourt Brace .12 (4891
- Orbis, 1980), 130. 8. Quoted in Christine Lindey, Superrealist Painting and Sculpture (London: Jovanovich, 1975), 100.
- ville, 1982), 94. 9. Quoted in Mary Jane Jacob, Magdalena Abakanowicz (New York: Abbe-
- 11. Quoted in Bruce McPherson, ed., More Than Meat Joy: Complete Perfor-New York University Press, 1975), 111. 10. Quoted in Nancy Holt, ed., The Writings of Robert Smithson (New York:

mance Works and Selected Writings (New Paltz, N.Y.: Documentext,

words: Discourse on the 60s and 70s (Ann Arbor, Mich.: UMI Research 12. Quoted in "Joseph Kosuth: Art as Idea as Idea," in Jeanne Siegel, ed., Art-75 (6461

CHAPTER 16

Press, 1985), 221, 225.

- on File, 1994), 115. 1. Quoted in Arlene Hirschfelder, Artists and Craftspeople (New York: Facts
- 3. Quoted in Donald Hall, Corporal Politics (Cambridge: MIT List Visual Hypatia 18, no. 4 (2003): 23-41. 2. Michelle Meagher, "Jenny Saville and a Feminist Aesthetics of Disgust,"
- 4. Quoted in "Vietnam Memorial: America Remembers," National Geo-Arts Center, 1993), 46.
- .001, 1985, 100. 5. Quoted in Calvin Tomkins, "The Art World: Tilted Arc," New Yorker, May graphic 167, no. 5 (May 1985): 557.

by A. P. Maudslay (New York: Farrar, Straus & Giroux, 1956), 218-219. I. Bernal Díaz del Castillo, The Discovery and Conquest of Mexico, translated CHAPTER 20

- Baudelaire, 2d ed. (New York: Phaidon, 1995), 12. Jonathan Mayne, The Painter of Modern Life and Other Essays by Charles 1. Charles Baudelaire, Le peintre de la vie moderne (1863). Translated by
- .461-661 : (3061 gning2) 2. Clement Greenberg, "Modernist Painting," Art and Literature, no. 4
- ford: Blackwell, 1998), 595. Gaiger, Art in Theory 1815-1900: An Anthology of Changing Ideas (Ox-3. Translated by Carola Hicks, in Charles Harrison, Paul Wood, and Jason
- ments (Englewood Cliffs, N.J.: Prentice Hall, 1965), 184. 4. Quoted in John McCoubrey, American Art 1700-1960: Sources and Docu-
- Bonger and V. W. van Gogh, eds., The Complete Letters of Vincent van 5. Vincent van Gogh to Theo van Gogh, September 1888, in J. van Gogh-
- Van Gogh: A Self-Portrait. Letters Revealing His Life as a Painter (New 6. Vincent van Gogh to Theo van Gogh, July 16, 1888, in W. H. Auden, ed., Gogh (Greenwich, Conn.: New York Graphic Society, 1979), 3:534.
- Gauguin by Himself (Boston: Little, Brown, 1993), 270-271. 7. Letter to Charles Morice, March 1898. Translated by Belinda Thompson, York: Dutton, 1963), 299.
- ed., Conversations with Cezanne (Berkeley: University of California Press, 8. Reported by Joachim Gasquet (1873-1921). Quoted in Michael Doran,
- 9. Quoted in Petra ten-Doesschate Chu, Nineteenth-Century European Art, 771 (0007
- 1939), 203. 10. Quoted in V. Frisch and J. T. Shipley, Auguste Rodin (New York: Stokes, 3d ed. (Upper Saddle River, N.J.: Pearson, 2011), 515.

CHAPTER 14

- (New York: Museum of Modern Art, 1976), 29. 1. Quoted in John Elderfield, The "Wild Beasts": Fauvism and Its Affinities
- Marc as German Expressionism (New York: Harper & Row, 1979), 57. 2. Quoted in Frederick S. Levine, The Apocalyptic Vision: The Art of Franz
- rev. 3d. ed. (Upper Saddle Hill, N.).: Prentice Hall, 2004), 121. 3. Quoted in Sam Hunter, John Jacobus, and Daniel Wheeler, Modern Art,
- 4. Quoted in George Heard Hamilton, Painting and Sculpture in Europe,
- 5. Ibid., 238. 1880-1940, 6th ed. (New Haven: Yale University Press, 1993), 246.
- 112-113. 6. Quoted in Edward Fry, ed., Cubism (London: Thames & Hudson, 1966),
- (Oxford: Blackwell, 2003), 649. Wood, eds., Art in Theory 1900-2000: An Anthology of Changing Ideas 7. Pablo Picasso, "Statement to Simone Téry," in Charles Harrison and Paul
- Harper & Row, 1971), 311. 8. Quoted in Roland Penrose, Picasso: His Life and Work, rev. ed. (New York:
- (Berkeley and Los Angeles: University of California Press, 1968), 286. B. Chipp, Theories of Modern Art: A Source Book by Artists and Critics (Le Figaro, February 20, 1909). Translated by Joshua C. Taylor, in Herschel 9. Filippo Tommaso Marinetti, The Foundation and Manifesto of Futurism
- .72 (1961 10. Hans Richter, Dada: Art and Anti-Art (London: Thames & Hudson,
- 12. Charles C. Eldredge, "The Arrival of European Modernism," Art in Amer-Art, 2nd ed. (Mineola, N.Y.: Dover, 2000), 117. 11. Translated by Howard Dearstyne, in Robert L. Herbert, Modern Artists on
- 13. Dorothy Norman, Alfred Stieglitz: An American Seer (Millerton, N.Y.: ica 61 (July-August 1973): 35.
- 14. Ibid., 161. Aperture, 1973), 9-10.
- 15. Quoted in Hamilton, 392.
- York: Museum of Modern Art, 1968), 64. 16. Quoted in William S. Rubin, Dada, Surrealism, and Their Heritage (New

Glossary

a secco-Italian, "dry." See fresco.

abacus—The uppermost portion of the *capital* of a *column*, usually a thin slab.

abbess—See abbey.

abbey—A religious community under the direction of an abbot (for monks) or an abbess (for nuns).

abbot—See abbey.

abhaya—See mudra.

abrasion—The rubbing or grinding of stone or another material to produce a smooth finish.

abstract—Nonrepresentational; forms and colors arranged without reference to the depiction of an object.

Abstract Expressionism—The first major American avant-garde movement, Abstract Expressionism emerged in New York City in the 1940s. The artists produced *abstract* paintings that expressed their state of mind and that they hoped would strike emotional chords in viewers. The movement developed along two lines: *gestural abstraction* and *chromatic abstraction*.

acropolis—Greek, "high city." In ancient Greece, usually the site of the city's most important temple(s).

action painting—Also called *gestural abstraction*. The kind of *Abstract Expressionism* practiced by Jackson Pollock, in which the emphasis was on the creation process, the artist's gesture in making art. Pollock poured liquid paint in linear webs on his canvases, which he laid out on the floor, thereby physically surrounding himself in the painting during its creation.

ad catacumbas—Latin, "in the hollows." See catacombs.

additive light—Natural light, or sunlight, the sum of all the wavelengths of the visible *spectrum*. See also *subtractive light*.

additive sculpture—A kind of sculpture *technique* in which materials (for example, clay) are built up or "added" to create form.

adobe—The clay used to make a kind of sun-dried mud brick of the same name; a building made of such brick.

aerial perspective—See perspective.

agone-Italian, "foot race."

agora—An open square or space used for public meetings or business in ancient Greek cities.

ahu—A stone platform on which the *moai* of Easter Island stand. Ahu marked burial sites or served ceremonial purposes.

'ahu 'ula—A Hawaiian feather cloak.

aisle—The portion of a *basilica* flanking the *nave* and separated from it by a row of *columns* or *piers*.

ala (pl. **alae**)—One of a pair of rectangular recesses at the back of the *atrium* of a Roman *domus*.

album leaf—A painting on a single sheet of paper for a collection stored in an album.

alchemy—The study of seemingly magical changes, especially chemical changes.

altar frontal—A decorative panel on the front of a *church* altar.

altarpiece—A panel, painted or sculpted, situated above and behind an altar. See also *retable*.

alternate-support system—In *church* architecture, the use of alternating wall supports in the *nave*, usually *piers* and *columns* or *compound piers* of alternating form.

amalaka—In Hindu temple design, the large, flat disk with ribbed edges surmounting the beehive-shaped tower (*shikara*).

Amazonomachy—In Greek mythology, the battle between the Greeks and Amazons.

ambulatory—A covered walkway, outdoors (as in a church cloister) or indoors; especially the passageway around the apse and the choir of a church.

amphiprostyle—A *classical* temple *plan* in which the *columns* are placed across both the front and back but not along the sides.

amphitheater—Greek, "double theater." A Roman building type resembling two Greek theaters put together. The Roman amphitheater featured a continuous elliptical cavea around a central arena.

amphora—An ancient Greek two-handled jar used for general storage purposes, usually to hold wine or oil.

amulet—An object worn to ward off evil or to aid the wearer.

Analytic Cubism—The first phase of *Cubism*, developed jointly by Pablo Picasso and Georges Braque, in which the artists analyzed form from every possible vantage point to combine the various views into one pictorial whole.

anamorphic image—A distorted image that must be viewed by some special means (such as a mirror) to be recognized.

ancien régime—French, "old order." The term used to describe the political, social, and religious order in France before the Revolution at the end of the 18th century.

antae—The molded projecting ends of the walls forming the pronaos or opisthodomos of an ancient Greek temple.

apadana—The great audience hall in ancient Persian palaces. **aphros**—Greek, "foam."

apostle—Greek, "messenger." One of the 12 disciples of Jesus.

apotheosis—Elevated to the rank of gods, or the ascent to Heaven.

apoxyomenos—Greek, "athlete scraping oil from his body."

apse—A recess, usually semicircular, in the wall of a building, commonly found at the east end of a *church*.

apsidal—Rounded; apse-shaped.

aqueduct—A channel for carrying water, often elevated on *arches*.

arcade—A series of *arches* supported by *piers* or *columns*.

arch—A curved structural member that spans an opening and is generally composed of wedge-shaped blocks (voussoirs) that transmit the downward pressure laterally. See also thrust.

Archaic—The artistic style of 600–480 BCE in Greece, characterized in part by the use of the *composite view* for painted and *relief* figures and of Egyptian stances for *statues*.

Archaic smile—The smile that appears on all *Archaic* Greek *statues* from about 570 to 480 BCE. The smile is the Archaic sculptor's way of indicating that the person portrayed is alive.

architrave—The *lintel* or lowest division of the *entablature*; also called the epistyle.

archivolt—The continuous molding framing an *arch*. In *Romanesque* and *Gothic* architecture, one of the series of concentric bands framing the *tympanum*.

arcuated—Arch-shaped.

arena—In a Roman *amphitheater*, the central area where bloody *gladiator* combats and other boisterous events took place.

the art of **burgher**—A middle-class citizen. elaborate **burgomeister**—Chief magistrate (mayor) of a Flemish city.

buon fresco—See fresco.

on each side by a bodhisattva.

realine.

brocade—The weaving together of threads of different colors.

Buddha triad—A three-figure group with a central Buddha flanked

23 inches. Dreviary—A Christian religious book of selected daily prayers and

boss—A circular knob.

braccia—Italian, "arm," A unit of measurement; I braccia equals

taining prayers to be read at specified times of the day.

not to achieve enlightenment in order to help save humanity. **Book of Hours**—A Christian religious book for private devotion con-

tion to a wall surface. **bocio**—A Fon (Republic of Benin) empowerment figure. **bodhisattva**—In Buddhist thought, a potential Buddha who chooses

with linear details incised through the silhouettes.

blind arcade—An arcade having no true openings, applied as decora-

dark figures against a light background of natural, reddish clay, with figures against a light background of natural, reddish clay,

tral axis.

Biomorphic Surrealism—See Surrealism.

black-figure painting—In early Greek pottery, the silhouetting of dark figures painting a light pockground of natural reddish clay.

Cameroon. bilateral symmetry—Having the same forms on either side of a cen-

bieri—The wood *reliquary* guardian figures of the Fang in Gabon and Cameroon.

carvings.

pipliophile—Lover of books.

bi—In ancient China, jade disks carved as ritual objects for burial with the dead. They were often decorated with piercings that extended entirely through the object, as well as with surface

all tasks and activities of life to the service of one god. **bhumisparsha**—See *mudra*.

bestiary—A collection of illustrations of real and imaginary animals. **bhakti**—In Buddhist thought, the adoration of a personalized deity (bodhisattva) as a means of achieving unity with it; love felt by the devotee for the deity. In Hinduism, the devout, selfless direction of

placement and size of colored dots.

benedictional—A Christian religious book containing bishops' blessings.

ben-ben—A pyramidal stone; an emblem of the Egyptian god Re. benday dots—Named after the newspaper printer Benjamin Day, the benday dot system involves the modulation of colors through the

with a view of a landscape or seascape.

superstructure of a building; a timber lintel.

belvedere—Italian, "beautiful view." A building or other structure

of a church; also, the passageway in an arcuated gate.

beam—A horizontal structural member that carries the load of the

architecture, and design. $\mathbf{bay} - \mathsf{The} \text{ space between two } \text{ columns, or one unit in the } \mathsf{nave} \text{ arcade}$

one end and with an apse at the other.

Bauhaus—A school of architecture in Germany in the 1920s under the aegis of Walter Gropius, who emphasized the unity of art,

basilica (adj. basilican)—In Roman architecture, a public building for legal and other civic proceedings, rectangular in plan, with an entrance usually on a long side. In Christian architecture, a church somewhat resembling the Roman basilica, usually entered from

base—In ancient Greek architecture, the molded projecting lowest part of *lonic* and *Corinthian columns*. (*Dovic* columns do not have bases.)

barrel vault—See vault.

barroco—Portuguese, "irregularly shaped pearl." See Baroque.

base—In ancient Greek architecture, the molded projecting lowest

Greece. The term derives from barroco.

ornamentation in contrast to the simplicity and orderly rationality of Renaissance art, and is most appropriately applied to Italian art. Lowercase baroque describes similar stylistic features found in the art of other periods—for example, the Hellenistic period in ancient

Maori meetinghouse. Baroque/baroque—The traditional blanket designation for European art from 1600 to 1750. Uppercase Baroque refers to the art of this period, which features dramatic theatricality and elaborate

Darge Doards—The angled boards that outline the exterior gables of a

within a church for baptismal rites.

convert becomes a member of the Christian community. **baptistery**—In Christian architecture, the building used for *baptism*, usually situated next to a *church*. Also, the designated area or hall

to support a sword.

baptism—The Christian bathing ceremony in which an infant or a

baldacco—Italian, "silk from Baghdad." See *baldacchino*. **baldric**—A sashlike belt worn over one shoulder and across the chest

baldacchino—A canopy on columns, frequently built over an altar. The term derives from baldacco.

planted deep in the ground, connecting earth and sky.

axial plan—See plan. axis of the world." In South Asia, a tall pillar

an incarnation of a god.

established convention in their work. Also used as an adjective:

avatar—A manifestation of a deity incarnated in some visible form in

which the deity performs a sacred function on earth. In Hinduism,

20th-century artists who emphasized innovation and challenged established convention in their work. Also used as an adjective.

created. **avant-garde**—French, "advance guard" (in a platoon). Late-19th- and 20th-century artists who emphasized innovation and challenged

about."

automatism—In painting, the process of yielding oneself to instinctive motions of the hands after establishing a set of conditions (such as size of paper or medium) within which a work is to be

augustus—Latin, "majestic" or "exalted." autem generatio—Latin, "now this is how the birth of Christ came

attribution—Assignment of a work to a maker or makers.

example, an object held, an associated animal, or a mark on the body. (v.) To make an attribution.

adveduct.

attribute—(n.) The distinctive identifying aspect of a person—for

front of and attached to a Christian basilica.

attic—The uppermost story of a building, triumphal arch, city gate, or

Mexico.

atmospheric perspective—See perspective.

atrium (pl. atria)—The central reception room of a Roman domus that is partly open to the sky. Also, the open, colonnaded court in

See also caryatid.

atlatl—Spear-thrower, the typical weapon of the Toltecs of ancient

used in construction, fitted together without mortar.

adantid—A male figure that functions as a supporting column or pier.

asceticism—Self-discipline and self-denial. ashlar masonry—Carefully cut and regularly shaped blocks of stone

ascetic—One who follows a path of self-denial.

art movement whose proponents tried to synthesize all the arts in an effort to create art based on natural forms that could be mass produced by technologies of the industrial age. The movement had other names in other countries: Jugendstil in Austria and Germany, Modernismo in Spain, and Stile Floreale in Italy.

either machined or handcrafted. Characterized by streamlined, elongated, and symmetrical design.

Art Nouveau—French, "new art." A late-19th- and early-20th-century

Art Deco—Descended from Art Nouveau, this movement of the 1920s and 1930s sought to upgrade industrial design as a "fine art" and to work new materials into decorative patterns that could be airbor materials into decorative patterns that could be solved to be added to b

applied to the wall. arringatore—Italian, "orator."

clay form.

arriccio—In fresco painting, the first layer of rough lime plaster

armature—The crossed, or diagonal, arches that form the skeletal framework of a Gothic rib vault. In sculpture, the framework for a

burin—A pointed tool used for *engraving* or *incising*.

bust—A freestanding sculpture of the head, shoulders, and chest of a person.

buttress—An exterior masonry structure that opposes the lateral *thrust* of an *arch* or a *vault*. A pier buttress is a solid mass of masonry. A flying buttress consists typically of an inclined member carried on an arch or a series of arches and a solid buttress to which it transmits lateral thrust.

byobu—Japanese painted folding screens.

Byzantine—The art, territory, history, and culture of the Eastern Christian Empire and its capital of Constantinople (ancient Byzantium).

caduceus—In ancient Greek mythology, a serpent-entwined herald's rod (Latin, caduceus), the attribute of Hermes (Roman Mercury), the messenger of the gods.

caementa—Latin, "small stones." A key ingredient of Roman *concrete*. **caldarium**—The hot-bath section of a Roman bathing establishment. **caliph(s)**—Islamic rulers, regarded as successors of Muhammad.

calligraphy—Greek, "beautiful writing." Handwriting or penmanship, especially elegant writing as a decorative art.

calotype—From the Greek *kalos*, "beautiful." A photographic process in which a positive image is made by shining light through a negative image onto a sheet of sensitized paper.

came—A lead strip in a *stained-glass* window that joins separate pieces of colored glass.

camera lucida—Latin, "lighted room." A device in which a small lens projects the image of an object downward onto a sheet of paper.

camera obscura—Latin, "dark room." An ancestor of the modern camera in which a tiny pinhole, acting as a lens, projects an image on a screen, the wall of a room, or the ground-glass wall of a box; used by artists in the 17th, 18th, and early 19th centuries as an aid in drawing from nature.

campanile—A bell tower of a *church*, usually, but not always, freestanding.

canon—A rule (for example, of proportion). The ancient Greeks considered beauty to be a matter of "correct" proportion and sought a canon of proportion, for the human figure and for buildings. The fifth-century BCE sculptor Polykleitos wrote the *Canon*, a treatise incorporating his formula for the perfectly proportioned *statue*. Also, a *church* official who preaches, teaches, administers sacraments, and tends to pilgrims and the sick.

canon table—A concordance, or matching, of the corresponding passages of the four *Gospels* as compiled by Eusebius of Caesarea in the fourth century.

capital—The uppermost member of a *column*, serving as a transition from the *shaft* to the *lintel*. In *classical* architecture, the form of the capital varies with the *order*.

Capitolium—An ancient Roman temple dedicated to the gods Jupiter, Juno, and Minerva.

capriccio—Italian, "originality." One of several terms used in Italian Renaissance literature to praise the originality and talent of artists.caput mundi—Latin, "head (capital) of the world."

Carolingian—Pertaining to the empire of Charlemagne (Latin, "Carolus Magnus") and his successors.

carpet page—In early medieval manuscripts, a decorative page resembling a textile.

cartoon—In painting, a full-size preliminary drawing from which a painting is made.

carving—A sculptural technique in which the artist cuts away material (for example, from a stone block) in order to create a statue or a relief.

caryatid—A female figure that functions as a supporting column. See also atlantid.

castellum—See westwork.

casting—A sculptural *technique* in which the artist pours liquid metal, plaster, clay, or another material into a *mold*. When the material dries, the sculptor removes the cast piece from the mold.

catacombs—Subterranean networks of rock-cut galleries and chambers designed as cemeteries for the burial of the dead.

cathedra—Latin, "seat." See cathedral.

cathedral—A bishop's *church*. The word derives from *cathedra*, referring to the bishop's chair.

causeway—A raised roadway.

cavea—Latin, "hollow place or cavity." The seating area in ancient Greek and Roman theaters and *amphitheaters*.

cella—The chamber at the center of an ancient temple; in a *classical* temple, the room (Greek, *naos*) in which the *cult statue* usually stood.

centaur—In ancient Greek mythology, a creature with the front or top half of a human and the back or bottom half of a horse.

centauromachy—In ancient Greek mythology, a battle between the Greeks and *centaurs*.

central plan—See plan.

chacmool—A Mesoamerican statuary type depicting a fallen warrior on his back with a receptacle on his chest for sacrificial offerings.

chakra—The Buddha's wheel, set in motion at Sarnath.

chakravartin—In South Asia, the ideal king, the Universal Lord who ruled through goodness.

Chan—See Zen.

chancel arch—The arch separating the chancel (the *apse* or *choir*) or the *transept* from the *nave* of a basilica or *church*.

chanoyu—Japanese, "tea ceremony."

chaplet—A metal pin used in hollow-casting to connect the *invest-ment* with the clay core.

chapter house—The meeting hall in a monastery.

characters—In Chinese writing, signs that record spoken words.

char-bagh—The "four-plot" plan of Iranian gardens.

chartreuse—A Carthusian monastery.

chashitsu-Japanese, "teahouse."

château (pl. châteaux)—French, "castle." A luxurious country residence for French royalty, developed from medieval castles.

chatra—See yasti.

chiaroscuro—In drawing or painting, the treatment and use of light and dark, especially the gradations of light that produce the effect of modeling.

chigi—Decorative extensions of the *rafters* at each end of the roof of a Japanese shrine.

chisel—A tool with a straight blade at one end for cutting and shaping stone or wood.

chiton—A Greek tunic, the essential (and often only) garment of both men and women, the other being the *himation*, or mantle.

choir—The space reserved for the clergy and singers in the *church*, usually east of the *transept* but, in some instances, extending into the *nave*.

Christ—Savior. From Latin Christus and Greek Christos, "the anointed one."

Christogram—The monogram comprising the three initial letters (chi-rho-iota) of Christ's name in Greek.

Christophoros—Greek, "he who carries Christ"—that is, Saint Christopher.

chromatic abstraction—A kind of *Abstract Expressionism* that focuses on the emotional resonance of color, as exemplified by the work of Barnett Newman and Mark Rothko.

chronology—In art history, the dating of art objects and buildings. **chryselephantine**—Fashioned of gold and ivory.

church—Christian house of worship.

Cinquecento—Italian, "500"—that is, the 16th century (the 1500s) in Italy.

circumambulation—In Buddhist worship, walking around the stupa in a clockwise direction, a process intended to bring the worshiper into harmony with the cosmos.

circus—An ancient Roman chariot racecourse.

cire perdue—See lost-wax process.

shown frontally; also called twisted perspective. figure is shown in profile and another part of the same figure is

composite view—A convention of representation in which part of a

compose—See composition.

of the three primary colors is a mixture of the other two. that together embrace the entire spectrum. The complement of one

complementary colors—Those pairs of colors, such as red and green, elements.

gave to his assemblages of painted passages and sculptural combines-The name that American artist Robert Rauschenberg

shaft, and a capital. in cross-section and consisting of a base (sometimes omitted), a

column—A vertical, weight-carrying architectural member, circular pilasters are two or more stories tall. Also called a giant order.

colossal order—An architectural design in which the columns or

tion based on preliminary drawing.

in contrast, largely emphasized disegno—careful design preparaimportant element of the creative process. Central Italian artists,

Venetian artists who emphasized the application of paint as an application of paint. Characteristic of the work of 16th-century colorito-Italian, "colored" or "painted." A term used to describe the

Frankenthaler and Morris Louis. ments soak into the fabric, as exemplified by the work of Helen pouring diluted paint onto unprimed canvas and letting these pigwhich artists sought to reduce painting to its physical essence by

color-field painting—A variant of Post-Painterly Abstraction in and complementary colors.

brightness or dullness. See also primary colors, secondary colors, darkness. The intensity, or saturation, of a color is its purity, its color—The value, or tonality, of a color is the degree of its lightness or

on attached pieces of paper or silk. tion about a book's manufacture. In Chinese painting, written texts

colophon—An inscription, usually on the last page, giving informacolonnette—A thin column.

colonnade—A series or row of columns, usually spanned by lintels.

coller—French, "to stick."

tions, photographs, and cloth.

materials, such as newspaper, wallpaper, printed text and illustra-

collage—A composition made by combining on a flat surface various coffer—A sunken panel, often ornamental, in a vault or a ceiling. dion-like pleats.

deerskin coated with fine white plaster and folded into accorpainted and inscribed book on long sheets of bark paper or book. The codex superseded the rotulus. In Mesoamerica, a bound together at one side; the predecessor of the modern

codex (pl. codices)—Separate pages of vellum or parchment cluster pier—See compound pier.

ambulatories along its sides.

cloister—A monastery courtyard, usually with covered walks or also, decorative brickwork in later Byzantine architecture.

cloisonné—A decorative metalwork technique employing cloisons;

resemble sparkling jewels.

precious stones, pieces of colored glass, or glass paste fired to metal strip soldered edge-up to a metal base to hold enamel, semicloison—French, "partition." A cell made of metal wire or a narrow

ceiling or the vaults.

windows that form the nave's uppermost level below the timber tian. In Roman basilicas and medieval churches, clerestories are the roofs of the other parts. The oldest known clerestories are Egypclerestory—The fenestrated part of a building that rises above the

Greco-Roman art and culture. 480 and 323 BCE. Lowercase classical refers more generally to

Classical/classical—The art and culture of ancient Greece between city-state—An independent, self-governing city.

bodies, used for women's toiletry articles. bronze with cast handles and feet, often with elaborately engraved cista (pl. cistae)—An Etruscan cylindrical container made of sheet

Christian catacomb that served as a mortuary chapel.

onto the atrium of a Roman domus. Also, a chamber in an Early cubiculum (pl. cubicula)—A small cubicle or bedroom that opened turing the Holy Land from the Muslims.

Crusades—In medieval Europe, armed pilgrimages aimed at recap-

cruciform—Cross-shaped.

crucifix—A freestanding sculptural representation of Christ on the crossing tower—The tower over the crossing of a church.

of the nave and the transept.

crossing—The space in a cruciform church formed by the intersection

cross vault—See vault.

notched tops of walls, as in battlements.

crenellation—Alternating solid merlons and open crenels in the course—In masonry construction, a horizontal row of stone blocks.

on the head.

corona civica—Latin, "civic crown." A Roman honorary wreath worn ing the pediment; also, any crowning projection.

cornice—The projecting, crowning member of the entablature fram-

capital is a substitute for the standard capital used in the Ionic thian order, in strict terms no such order exists. The Corinthian this capital is often cited as the distinguishing feature of the Corinflowers grow, wrapped around a bell-shaped echinus. Although

sists of a double row of acanthus leaves from which tendrils and Corinthian capital—A more ornate form than Dovic or Ionic; it con-

cessive circles of horizontal courses, cantilevered inward to form a

corbeled dome—A dome formed by the piling of stone blocks in sucreystone.

zontal courses, cantilevered inward until the blocks meet at a corbeled arch—An arch formed by the piling of stone blocks in horimeeting at the topmost course, create a corbeled arch.

each course projects beyond the one beneath it. Two such walls, ment in the superstructure. Also, courses of stone or brick in which

corbel—A projecting wall member used as a support for some ele-

to one foot, creating tension on one side and relaxation on the "weight shift" because the weight of the body tends to be thrown positioning of the body about its central axis. Sometimes called legs one way, shoulders and chest another), creating a counterpart is turned in opposition to another part (usually hips and contrapposto—The disposition of the human figure in which one

contour line—In art, a continuous line defining the outer shape of an consuls—In the Roman Republic, the two chief magistrates.

than another. More generally, an expert on artistic style. connoisseur—An expert in attributing artworks to one artist rather

Also called the great mosque or Friday mosque. modate the entire Muslim population for the Friday noon prayer.

congregational mosque—A city's main mosque, designed to accomcondottiere (pl. condottieri)—An Italian mercenary general.

and small stones. ing of various proportions of lime mortar, volcanic sand, water, concrete—A building material invented by the Romans and consistcomposite view.

or object appears in space and light at a specific moment. See also distinguishing properties of a person or object, not the way a figure conceptual representation—The representation of the fundamental

ist's idea rather than its final expression. 1960s whose premise was that the "artfulness" of art lay in the art-Conceptual Art—An American avant-garde art movement of the

responds, especially characteristic of Gothic architecture. compound pier—A pier with a group, or cluster, of attached shafts, or

work, either by placing shapes on a flat surface or arranging forms composition—The way in which an artist organizes forms in an artCubism—An early-20th-century art movement that rejected *naturalistic* depictions, preferring *compositions* of shapes and *forms* abstracted from the conventionally perceived world. See also *Analytic Cubism* and *Synthetic Cubism*.

cuirass—A military leather breastplate.

cult statue—The *statue* of the deity that stood in the *cella* of an ancient temple.

cuneiform—Latin, "wedge-shaped." A system of writing used in ancient Mesopotamia, in which wedge-shaped characters were produced by pressing a *stylus* into a soft clay tablet, which was then baked or otherwise allowed to harden.

cura animarum—Latin, "care of souls," the duty of a Catholic priest.
cutaway—An architectural drawing that combines an exterior view with an interior view of part of a building.

Cycladic—The prehistoric art of the Aegean Islands around Delos, excluding Crete.

Cyclopean masonry—A method of stone construction, named after the mythical *Cyclopes*, using massive, irregular blocks without mortar, characteristic of the Bronze Age fortifications of Tiryns and other *Mycenaean* sites.

Cyclops (pl. Cyclopes)—A mythical Greek one-eyed giant.

Dada—An early-20th-century art movement prompted by a revulsion against the horror of World War I. Dada embraced political anarchy, the irrational, and the intuitive. A disdain for convention, often enlivened by humor or whimsy, is characteristic of the art the Dadaists produced.

Daedalic—The Greek *Orientalizing* sculptural style of the seventh century BCE named after the legendary artist Daedalus.

daguerreotype—A photograph made by an early method on a plate of chemically treated metal; developed by Louis J. M. Daguerre.

daimyo—Local lords who controlled small regions and owed obeisance to the *shogun* in the Japanese *shogunate* system.

damnatio memoriae—The Roman decree condemning those who ran afoul of the Senate. Those who suffered damnatio memoriae had their memorials demolished and their names erased from public inscriptions.

De Stijl—Dutch, "the style." An early-20th-century art movement (and magazine), founded by Piet Mondrian and Theo van Doesburg, whose members promoted utopian ideals and developed a simplified geometric style.

Deconstructivism—A late-20th-century architectural *style*. Deconstructivist architects attempt to disorient the observer by disrupting the conventional categories of architecture. The haphazard presentation of *masses*, *planes*, lighting, and so forth challenges the viewer's assumptions about *form* as it relates to function.

Deësis—Greek, "supplication." An image of Christ flanked by the figures of the Virgin Mary and John the Baptist, who intercede on behalf of humankind.

demos—Greek, "the people," from which the word *democracy* derives.
 Der Blaue Reiter—German, "the blue rider." An early-20th-century *German Expressionist* art movement founded by Vassily Kandinsky and Franz Marc. The artists selected the whimsical name because of their mutual interest in the color blue and horses.

Dervish—A Muslim ascetic holy man.

dharma—In Buddhism, moral law based on the Buddha's teaching. **dharmachakra**—See *mudra*.

dhyana—See mudra.

di sotto in sù—Italian, "from below upward." A perspective view seen from below.

diagonal rib—See rib.

dictator—In the Roman Republic, the supreme magistrate with extraordinary powers, appointed during a crisis for a specified period. Julius Caesar eventually became dictator perpetuo, or "dictator for life."

Die Brücke—German, "the bridge." An early-20th-century *German Expressionist* art movement under the leadership of Ernst Ludwig Kirchner. The group thought of itself as the bridge between the old age and the new.

diptych—A two-paneled painting or *altarpiece*; also, an ancient Roman, Early Christian, or Byzantine hinged writing tablet, often of ivory and carved on the external sides.

disegno—Italian, "drawing" and "design." *Renaissance* artists considered drawing to be the external physical manifestation (*disegno esterno*) of an internal intellectual idea of design (*disegno interno*).

diskobolos-Greek, "discus thrower."

disputatio—Latin, "logical argument." The philosophical methodology used in Scholasticism.

divine right—The belief in a king's absolute power as God's will.

d'mba—A Baga mask of the Mother of Fertility in the form of the head and breasts of a woman, worn over the shoulders and with a raffia skirt concealing the dancer's identity.

documentary evidence—In art history, the examination of written sources in order to determine the date of an artwork, the circumstances of its creation, or the identity of the artist(s) who made it.

doge-Italian (Venetian dialect), "duke."

dome—A hemispherical *vault*; theoretically, an *arch* rotated on its vertical axis. In *Mycenaean* architecture, domes are beehive-shaped.

domus—A Roman private house.

donor portrait—A portrait of the individual(s) who commissioned (donated) a religious work (for example, an *altarpiece*) as evidence of devotion.

Doric—One of the two systems (or *orders*) invented in ancient Greece for articulating the three units of the *elevation* of a *classical* building—the platform, the *colonnade*, and the superstructure (*entablature*). The Doric order is characterized by, among other features, *capitals* with funnel-shaped *echinuses*, *columns* without *bases*, and a *frieze* of *triglyphs* and *metopes*. See also *Ionic*.

dormer—A projecting gable-capped window.

doryphoros-Greek, "spear bearer."

dressed masonry—Stone blocks shaped to the exact dimensions required, with smooth faces for a perfect fit.

drum—One of the stacked cylindrical stones that form the *shaft* of a *column*. Also, the cylindrical wall that supports a *dome*.

duomo-Italian, "cathedral."

earthworks—See Environmental Art.

eaves—The lower part of a roof that overhangs the wall.

echinus—The convex element of a capital directly below the abacus.
edition—A set of impressions taken from a single incised metal plate or carved woodblock.

effigy mounds—Ceremonial mounds built in the shape of animals or birds by native North American peoples.

elevation—In architecture, a head-on view of an external or internal wall, showing its features and often other elements that would be visible beyond or before the wall.

embroidery—The *technique* of sewing threads onto a finished ground to form contrasting designs. Stem stitching employs short overlapping strands of thread to form jagged lines. Laid-and-couched work creates solid blocks of color.

emir—A Muslim ruler.

empiricism—The search for knowledge based on observation and direct experience.

en plein air—See plein air.

enamel—A decorative coating, usually colored, fused onto the surface of metal, glass, or ceramics.

encaustic—A painting *technique* in which pigment is mixed with melted wax and applied to the surface while the mixture is hot.

engaged column—A half-round column attached to a wall. See also pilaster.

engraving—The process of *incising* a design in hard material, often a metal plate (usually copper); also, the *print* or impression made from such a plate.

Enlightenment—The 18th-century Western philosophy based on empirical evidence. The Enlightenment was a new way of thinking critically about the world and about humankind, independently of religion, myth, or tradition.

became an international currency for trade.

florin-The denomination of gold coin of Renaissance Florence that fleur-de-lis—A three-petaled iris flower; the royal flower of France. ored glass to another to produce a greater range of colors.

flashing—In making stained-glass windows, fusing one layer of colflagellate-To whip.

appearance of costly marble panels.

aim of the artist was to imitate, using painted stucco relief, the First Style mural—The earliest style of Roman mural painting. The finial—A crowning ornament.

findspot—Place where an artifact was found; provenance. about an uncertain future.

World War I, when decadence and indulgence masked anxiety tural history from the end of the 19th century until just before fin-de-siècle—French, "end of the century." A period in Western culgarments.

fibula (pl. fibulae)-A decorative pin, usually used to fasten depicting the outdoor amusements of French upper-class society. fête galante—French, "amorous festival." A type of Rococo painting

called reinforced concrete. ferroconcrete—Concrete strengthened by a skeleton of iron bars; also fenestrated—Having windows.

the cultured hostesses of Rococo salons.

femme savante—French, "learned woman." The term used to describe for pictorial coherence and the primary conveyor of meaning.

For the Fauves, color became the formal element most responsible Fauvism—An early-20th-century art movement led by Henri Matisse.

Fauves-French, "wild beasts." See Fauvism. the atrium.

fauces-Latin, "jaws." In a Roman domus, the narrow foyer leading to in ancient Rome.

fasces—A bundle of rods with an ax attached, an emblem of authority Renaissance literature to praise the originality and talent of artists. fantasia—Italian, "imagination." One of several terms used in Italian fan vault—See vault.

faience—A low-fired opaque glasslike silicate.

they are emphasized architecturally.

facade—Usually, the front of a building; also, the other sides when describing the empirical world.

dimension. Expressionism contrasts with art focused on visually unique inner or personal vision and that often has an emotional Expressionism—Twentieth-century art that is the result of the artist's tence and the improbability of achieving certitude.

existentialism—A philosophy asserting the absurdity of human exisexemplum virtutis—Latin, "example or model of virtue."

exedra—Recessed area, usually semicircular.

the New Testament Gospels.

evangelist—One of the four authors (Matthew, Mark, Luke, John) of eunuch—A castrated male.

which believers hold to be either Christ himself or symbolic of Eucharist-In Christianity, the partaking of the bread and wine, the plate is immersed after incising. See also drypoint, intaglio.

exposed are then etched (slightly eaten away) by the acid in which of wax or varnish on a metal plate. The parts of the plate left etching—A kind of engraving in which the design is incised in a layer

hand of the artist. Sometimes referred to as earthworks. the environment, calling attention both to the land itself and to the manent or impermanent, these works transform some section of artists construct monuments of great scale and minimal form. Per-1960s. Often using the land itself as their material, Environmental

Environmental Art-An American art form that emerged in the column.

entasis—The convex profile (an apparent swelling) in the shaft of a tuəmibəq.

roof. The entablature has three parts: architrave, frieze, and entablature—The part of a building above the columns and below the

southern Indian temple compounds.

gopuras—The massive, ornamented entrance gateway towers of applied to surfaces.

gold leaf—Gold beaten into tissue-paper-thin sheets that then can be after a harvest.

gleaning—The collection by peasants of wheat scraps left in the field glazing—The application of successive layers of glaze in oil painting. glazier—A glassworker.

applied over a color to alter it slightly.

matte. In oil painting, a thin, transparent, or semitransparent layer surface; it may be colored, transparent, or opaque, and glossy or

glaze—A vitreous coating applied to pottery to seal and decorate the who competed in an amphitheater.

gladiator—An ancient Roman professional fighter, usually a slave, fresco painter expects to complete in one session.

giornata (pl. giornate)—Italian, "day." The section of plaster that a and giants.

gigantomachy—In ancient Greek mythology, the battle between gods giant order—See colossal order.

lock. See also Abstract Expressionism.

the subject of art. Its most renowned proponent was Jackson Polabstract painting in which the gesture, or act of painting, is seen as

gestural abstraction-Also known as action painting. A kind of for paintings on wood panels.

gesso-Plaster mixed with a binding material, used as the base coat sionist movement.

German Expressionism—An early-20th-century regional Expres-

schematic figures.

turies BCE, characterized by abstract geometric ornament and Geometric—The style of Greek art during the ninth and eighth cencally depicts scenes from everyday life.

genre—A style or category of art; also, a kind of painting that realistithe holy inner sanctum often housing the god's image or symbol.

garbha griha—Hindi, "womb chamber:" In Hindu temples, the cella, dynamism of modern technology.

oned war as a cleansing agent and that celebrated the speed and Futurism—An early-20th-century Italian art movement that champi-

fusuma—Japanese painted sliding-door panels.

furta sacra—Latin, "holy theft."

establishment. frigidarium-The cold-bath section of a Roman bathing cornice; also, any sculptured or painted band. See register.

frieze-The part of the entablature between the architrave and the

Friday mosque—See congregational mosque.

fresco secco—See fresco.

freshly laid lime plaster. Also, a painting executed in either method. ments are mixed with water and become chemically bound to the secco) or wet (true, or buon, fresco). In the latter method, the pig-

fresco-Painting on lime plaster, either dry (dry fresco, or fresco freestanding sculpture—See sculpture in the round.

vistas of the Fourth Style are irrational fantasies.

marks a return to architectural illusionism, but the architectural Fourth Style mural—In Roman mural painting, the Fourth Style forum (pl. fora)—The public square of an ancient Roman city.

formal analysis—The visual analysis of artistic form.

dimensions (such as a statue).

sions (for example, a figure painted on a surface) or in three form—In art, an object's shape and structure, either in two dimenback in space at an angle to the perpendicular plane of sight.

sent in art the apparent visual contraction of an object that extends foreshortening (adj. foreshortened)—The use of perspective to repre-.ofil gni

fons vitae-Latin, "fountain of life." A symbolic fountain of everlastfolio-A page of a manuscript or book.

flying buttress—See buttress.

section and used principally on columns and pilasters. flute or fluting—Vertical channeling, roughly semicircular in crossgorgon—In ancient Greek mythology, a hideous female demon with snake hair. Medusa, the most famous gorgon, was capable of turning anyone who gazed at her into stone.

Gospels—The four New Testament books that relate the life and teachings of Jesus.

Gothic—Originally a derogatory term named after the Goths, used to describe the history, culture, and art of western Europe in the 12th to 14th centuries. Typically divided into periods designated Early (1140–1194), High (1194–1300), and Late (1300–1500).

Grand Manner portraiture—A type of 18th-century portrait painting designed to communicate a person's grace and class through certain standardized conventions, such as the large scale of the figure relative to the canvas, the controlled pose, the *landscape* setting, and the low *horizon line*.

graver—An *engraving* tool. See also *burin*.

great mosque—See congregational mosque.

Greek cross—A cross with four arms of equal length.

green architecture—Ecologically friendly architectural design using clean energy to sustain the natural environment.

grisaille—A *monochrome* painting done mainly in neutral grays to simulate sculpture.

groin—The edge formed by the intersection of two barrel *vaults*. **groin vault**—See *vault*.

ground line—In paintings and *reliefs*, a painted or carved baseline on which figures appear to stand.

guang—An ancient Chinese covered vessel, often in animal form, holding wine, water, grain, or meat for sacrificial rites.

guild—An association of merchants, craftspersons, or scholars in medieval and *Renaissance* Europe.

haboku—In Japanese art, a loose and rapidly executed painting style in which the ink seems to have been applied by flinging or splashing it onto the paper.

Hadith—The words and exemplary deeds of the Prophet Muhammad. **haiku**—A 17-syllable Japanese poetic form.

halo—An aureole appearing around the head of a holy figure to signify divinity. See also *nimbus*.

handscroll—In Asian art, a horizontal painted scroll that is unrolled right to left, section by section, and often used to present illustrated religious texts or *landscapes*.

hanging scroll—In Asian art, a vertical scroll hung on a wall with pictures mounted or painted directly on it.

haniwa—Sculpted fired pottery cylinders, modeled in human, animal, or other forms and placed on Japanese tumuli of the Kofun period.

hard-edge painting—A variant of *Post-Painterly Abstraction* that rigidly excluded all reference to gesture and incorporated smooth knife-edge geometric forms to express the notion that painting should be reduced to its visual components.

harmika—In Buddhist architecture, a stone fence or railing that encloses an area surmounting the *dome* of a *stupa* that represents one of the Buddhist heavens; from the center arises the *yasti*.

hatching—A series of closely spaced drawn or *engraved* parallel *lines*. Cross-hatching employs sets of lines placed at right angles.

hay wain—A hay-filled wagon.

Hellas—The ancient name of Greece.

Hellenes (adj. **Hellenic**)—The name the ancient Greeks called themselves as the people of *Hellas*.

Hellenistic—The term given to the art and culture of the roughly three centuries between the death of Alexander the Great in 323 BCE and the death of Queen Cleopatra in 30 BCE, when Egypt became a Roman province.

henge—An arrangement of *megalithic* stones in a circle, often surrounded by a ditch.

Hiberno-Saxon—An art *style* that flourished in the *monasteries* of the British Isles in the early Middle Ages. Also called Insular.

hierarchy of scale—An artistic convention in which greater size indicates greater importance.

hieroglyph—A *symbol* or picture used to confer meaning in *hieroglyphic* writing.

high relief—See relief.

High-Tech—A contemporary architectural *style* calling for buildings that incorporate the latest innovations in engineering and technology and expose the structures' component parts.

Hijra—The flight of Muhammad from Mecca to Medina in 622, the year from which Islam dates its beginnings.

himation—An ancient Greek mantle worn by men and women over the *chiton* and draped in various ways.

hiragana—A phonetic cursive script developed in Japan from Chinese *characters*; it came to be the primary script for Japanese court poetry.

historiated—Ornamented with representations, such as plants, animals, or human figures, that have a narrative—as distinct from a purely decorative—function.

historiated capital—A capital with a carved figural ornament.

honden—Main hall of a Shinto sanctuary.

horizon line—See perspective.

hôtel-French, "town house."

hubris—Greek, "arrogant pride."

hue—The name of a color. See also primary colors, secondary colors, and complementary colors.

humanism—In the Renaissance, an emphasis on education and on expanding knowledge (especially of classical antiquity), the exploration of individual potential and a desire to excel, and a commitment to civic responsibility and moral duty.

hydria—An ancient Greek three-handled water pitcher.

hypostyle hall—A hall with a roof supported by *columns*.

icon—A portrait or image; especially in *Byzantine churches*, a panel with a painting of sacred personages that are objects of veneration. In the visual arts, a painting, a piece of sculpture, or even a building regarded as an object of veneration.

iconoclasm—The destruction of religious or sacred images. In Byzantium, the period from 726 to 843 when there was an imperial ban on such images. The destroyers of images were known as iconoclasts. Those who opposed such a ban were known as iconophiles.

iconoclast—See iconoclasm.

iconography—Greek, the "writing of images." The term refers both to the content, or subject, of an artwork and to the study of content in art. It also includes the study of the symbolic, often religious, meaning of objects, persons, or events depicted in works of art.

iconophile—See iconoclasm.

illuminated manuscript—A luxurious handmade book with painted illustrations and decorations.

illusionism (adj. **illusionistic**)—The representation of the three-dimensional world on a two-dimensional surface in a manner that creates the illusion that the person, object, or place represented is three-dimensional. See also *perspective*.

imagines—In ancient Rome, wax portraits of ancestors displayed in the *atrium* of a *domus*.

imam—In Islam, the leader of collective worship.

imperator—Latin, "commander in chief," from which the word emperor derives.

impluvium—In a Roman *domus*, the basin located in the *atrium* that collected rainwater.

impost block—The uppermost block of a wall or *pier* beneath the *springing* of an *arch*.

Impressionism—A late-19th-century art movement that sought to capture a fleeting moment, thereby conveying the elusiveness and impermanence of images and conditions.

in antis—In ancient Greek architecture, the area between the *antae*. **incise**—To cut into a surface with a sharp instrument, especially to

decorate metal and pottery.

incrustation—Wall decoration consisting of bright panels of different colors.

indulgence—A religious pardon for a sin committed.

581

ing in mountains and water sources.

sina doll represents benevolent supernatural spirits (katsinas) liv-

katholikon—The main church in a Greek Orthodox monastery. katsina—An art form of Native Americans of the Southwest, the kat-

person's life, which determine his or her fate.

karesansui—A Japanese dry-landscape (rock) garden. **karma**—In Vedic religions (see Veda), the ethical consequences of a

(mountains, waterfalls) and in charismatic people.

bolic center of the Islamic world. **kami**—Shinto deities or spirits, believed in Japan to exist in nature

ka—In ancient Egypt, the immortal human life force. **Kaaba**—Arabic, "cube." A small cubical building in Mecca, the sym-

model of Confucian behavior.

Jugendstil—See Art Nouveau.
junzi—Chinese, "superior person" or "gentleman." A person who is a

journaux—French, "newspapers."

jouir—French, "to enjoy:"

jouer—French, "to play.",

nique characterized by ropelike markings.

jomon—Japanese, "cord markings." A type of Japanese ceramic tech-

to make the pieces lighter.

jataka—Tales of the past lives of the Buddha. See also sutra.
joined-wood technique—A Japanese sculptural technique in which a statue is assembled from multiple wood blocks, each hollowed out

Japonisme emerged in the second half of the 19th century.

jambs—In architecture, the side posts of a doorway.

Japonisme—The French fascination with all things Japanese.

Jamb of a Gothic church portal.

iyoba—Benin queen mother. jamb statue—A statue, usually attached to a column, set against the

onto a courtyard.

gesting tensile strength.

iwan—In Islamic architecture, a vaulted rectangular recess opening

lonic—One of the two systems (or orders) invented in ancient Greece for articulating the three units of the elevation of a classical building: the platform, the colonnade, and the superstructure (entablature). The lonic order is characterized by, among other features, volutes, capitals, columns with bases, and an uninterrupted frieze. **iron-wire lines**—In ancient Chinese painting, thin brush lines sugiton-wire lines—In ancient Chinese painting, thin brush lines sugiton-wire

exterior of the wax model. Invented in ancient Greece Ionic—One of the two systems (or orders) invented in ancient Greece

applied to the wall; the painting layer.

In hollow-casting, the first end talent of artists.

Renaissance literature to praise the originality and talent of artists.

In hollow-casting, the final clay mold applied to the

look of modern office buildings and skyscrapers. intonaco—In fresco painting, the last layer of smooth lime plaster

with Le Corbusier, whose elegance of design came to influence the

themes involving splendid processions of knights and ladies. International style—A style of 20th-century architecture associated

begun by Simone Martini, who fused the French Gothic manner with Sienese art. This style appealed to the aristocracy because of its brilliant color, lavish costumes, intricate ornamentation, and

work to identify the artist who created it.

International Gothic—A style of 14th- and 15th-century painting

internal evidence—In art history, the examination of what an artwork represents (people, clothing, hairstyles, and so on) in order to determine its date. Also, the examination of the style of an art-

intercolumniation—See interaxial.

this the reverse of the woodcut technique.

room or gallery.

intaglio—A graphic technique in which the design is incised, or scratched, on a metal plate, either manually (engraving) or chemically (etching). The incised lines of the design take the ink, making

artists.

installation—An artwork that creates an artistic environment in a

ingegno—Italian, "innate talent." One of several terms used in Italian Renaissance literature to praise the originality and talent of

lithography—A printmaking *technique* in which the artist uses an oilbased crayon to draw directly on a stone plate and then wipes water onto the stone. When ink is rolled onto the plate, it adheres only to the drawing. The print produced by this method is a lithograph.

landed gentry.

 $\begin{tabular}{lintel} A horizontal $beam$ used to span an opening. \\ \end{tabular}$ In China, talented amateur painters and scholars from the

speak for a king or chief.

lithograph—See lithography.

lingai—In Hindu art, the depiction of Shiva as a phallus or cosmic pillar. linguist's staff—In Africa, a staff carried by a person authorized to

drawing on or chiseling into a plane. linear perspective—See perspective.

libation—The pouring of liquid as part of a religious ritual. **line**—The extension of a point along a path, made concrete in art by

ii—Chinese, "etiquette."

were often placed in Greek graves as offerings to the deceased.

religious services, including the Mass, throughout the year. **lekythos** (pl. **lekythoi**)—A flask containing perfumed oil; lekythoi

colored glass pieces using lead cames.

lectionary—A book containing passages from the Gospels, arranged in the sequence that they are to be read during the celebration of

lateral section—See section.

leading—In the manufacture of stained-glass windows, the joining of

Empire.

content. Late Antique—The non-naturalistic artistic style of the Late Roman

pointed arch. Institute showing natural scenety, without narrative landscape—A picture showing natural scenety, without narrative

bull or lion.

lancet—In Gothic architecture, a tall narrow window ending in a

shanas include the urna and ushnisha.

lamassu—Assyrian guardian in the form of a man-headed winged

ness and has a lustrous surface.

lakshana—One of the distinguishing marks of the Buddha. The lak-

lacquer—A varnishlike substance made from the sap of the Asiatic sumac tree, used to decorate wood and other organic materials. Often colored with mineral pigments, lacquer cures to great hard-

Named after the city of Kufa. labyrinth—Maze. The English word derives from the mazelike plan of the Minoan palace at Knossos.

water.

Kufic—An early form of Arabic script, characterized by angularity, with the uprights forming almost right angles with the baseline.

a young man. krater—An ancient Greek wide-mouthed bowl for mixing wine and

in their tattoos. kouroi)—Greek, "young man." An Archaic Greek statue of

a young woman.

koru—An unrolled spiral design used by the Maori of New Zealand

into verses. korai)—Greek, "young woman." An Archaic Greek statue of

nese Buddhist temple complex. The kondo contained *statues* of the Buddha and the *bodhisattvas* to whom the temple was dedicated. **Koran**—Islam's sacred book, composed of *surahs* (chapters) divided

Kogan—The name of a distinctive type of Shino water jar. kondo—Japanese, "golden hall." The main hall for worship in a Japa-

kofun—Japanese, "old tomb."

and ceremonial center of Pueblo Indian life.

kinetic sculpture—Sculpture with parts that move. **kiva**—A square or circular underground structure that is the spiritual

keystone—See voussoir.

toga-like robes.

nese shrine to hold the thatched roof in place.

kente—Brightly colored patterned cloth woven by Asante men on horizontal looms in long, narrow strips sewn together to form

katsuogi — Wood logs placed at right angles to the ridgepole of a Japa-

liturgy (adj. liturgical)—The official ritual of public worship.

local color—An object's true *color* in white light.

loggia—A gallery with an open arcade or a colonnade on one or both sides.

lohan—A Buddhist holy person who has achieved enlightenment and *nirvana* by suppression of all desire for earthly things.

longitudinal plan—See plan.

longitudinal section—See section.

lost-wax process—A bronze-*casting* method in which a figure is modeled in wax and covered with clay; the whole is fired, melting away the wax (French, *cire perdue*) and hardening the clay, which then becomes a *mold* for molten metal. Also called the cire perdue process.

low relief—See relief.

lunette—A semicircular area (with the flat side down) in a wall over a door, niche, or window; also, a painting or *relief* with a semicircular frame.

lux nova—Latin, "new light." Abbot Suger's term for the light that enters a *Gothic church* through *stained-glass* windows.

magus (pl. magi)—One of the three wise men from the East who presented gifts to the infant Jesus.

malanggan—Festivals held in honor of the deceased in New Ireland (Papua New Guinea). Also, the carvings and objects produced for these festivals.

malwiya—Arabic, "snail shell."

mana—In Polynesia, spiritual power.

mandala—Sanskrit term for the sacred diagram of the universe; Japanese, mandara.

mandapa—Pillared hall of a Hindu temple.

mandara—See mandala.

mandorla—An almond-shaped *nimbus* surrounding the figure of Christ or other sacred figure. In Buddhist Japan, a lotus-petal-shaped nimbus.

maniera—Italian, "style" or "manner." See Mannerism.

maniera greca—Italian, "Greek manner." The Italo-*Byzantine* painting *style* of the 13th century.

Mannerism—A *style* of later *Renaissance* art that emphasized "artifice," often involving contrived imagery not derived directly from nature. Such artworks showed a self-conscious stylization involving complexity, caprice, fantasy, and polish. Mannerist architecture tended to flout the *classical* rules of order, stability, and symmetry, sometimes to the point of parody.

mantra—Sanskrit term for the ritual words or syllables recited in Shingon Buddhism.

manu scriptus-Latin, "manuscript."

manuscript—A handwritten book; see manu scriptus.

maqsura—In some *mosques*, a screened area in front of the *mihrab* reserved for a ruler.

margrave—Military governor of the Holy Roman Empire.

martyr—A person who chooses to die rather than deny his or her religious belief. See also saint.

martyrium (pl. martyria)—A shrine to a Christian martyr.

mass—The bulk, density, and weight of matter in space.

Mass—The Catholic and Orthodox ritual in which believers understand that Christ's redeeming sacrifice on the cross is repeated when the priest consecrates the bread and wine in the *Eucharist*.

mastaba—Arabic, "bench." An ancient Egyptian rectangular brick or stone structure with sloping sides erected over a subterranean tomb chamber connected with the outside by a shaft.

matte—In painting, pottery, and photography, a dull finish.

maulstick—A stick used to steady the hand while painting.

mausoleum (pl. mausolea)—A monumental tomb. The name derives from the mid-fourth-century BCE tomb of Mausolos at Halikarnassos, one of the Seven Wonders of the ancient world.

mbulu ngulu—The wood-and-metal *reliquary* guardian figures of the Kota of Gabon.

meander—An ornament, usually in bands but also covering broad surfaces, consisting of interlocking geometric motifs. An ornamental pattern of contiguous straight lines joined usually at right angles.

medium (pl. **media**)—The material (for example, marble, bronze, clay, *fresco*) in which an artist works; also, in painting, the vehicle (usually liquid) that carries the pigment.

megalith (adj. **megalithic**)—Greek, "great stone." A large, roughly hewn stone used in the construction of monumental prehistoric structures.

memento mori—Latin, "reminder of death." In painting, a reminder of human mortality, usually represented by a skull.

Mesoamerica—The region that comprises Mexico, Guatemala, Belize, Honduras, and the Pacific coast of El Salvador.

Mesolithic—The "middle" Stone Age, between the *Paleolithic* and the *Neolithic* ages.

Messiah—The savior of the Jews prophesied in Hebrew scripture. Christians believe that Jesus of Nazareth was the Messiah.

metope—The square panel between the *triglyphs* in a *Doric frieze*, often sculpted in *relief*.

mezquita—Spanish, "mosque."

mihrab—A semicircular niche set into the qibla wall of a mosque.

mina—A unit of ancient Mesopotamian currency.

minaret—A distinctive feature of *mosque* architecture, a tower from which the faithful are called to worship.

minbar—In a mosque, the pulpit on which the imam stands.

mingei—A type of modern Japanese folk pottery.

miniatures—Small individual Indian paintings intended to be held in the hand and viewed by one or two individuals at one time.

Minimalism—A predominantly sculptural American trend of the 1960s characterized by works featuring a severe reduction of *form*, often to single, homogeneous units.

Minoan—The prehistoric art of Crete, named after the legendary King Minos of Knossos.

Minotaur—The mythical beast, half man and half bull, that inhabited the *labyrinth* of the *Minoan* palace at Knossos.

Miraj—The ascension of the Prophet Muhammad to Heaven.

mithuna—In South Asian art, a male-female couple embracing or engaged in sexual intercourse.

moai—Large, blocky figural stone sculptures found on Rapa Nui (Easter Island) in Polynesia.

mobile—A kind of sculpture, invented by Alexander Calder, combining nonobjective organic forms and motion in balanced structures hanging from rods, wires, and colored, organically shaped plates.

modernism—A movement in Western art that developed in the second half of the 19th century and sought to capture the images and sensibilities of the age. Modernist art goes beyond simply dealing with the present and involves the artist's critical examination of the premises of art itself.

Modernismo—See Art Nouveau.

module (adj. **modular**)—A basic unit of which the dimensions of the major parts of a work are multiples. The principle is used in sculpture and other art forms, but it is most often employed in architecture, where the module may be the dimensions of an important part of a building, such as the diameter of a *column*.

moko—The form of tattooing practiced by the Maori of New Zealand. **moksha**—See *nirvana*.

mold—A hollow form for casting.

monastery—A group of buildings in which monks live together, set apart from the secular community of a town.

monasticism—The religious practice in which monks live together in a *monastery* set apart from the secular community of a town.

monochrome (adj. monochromatic)—One color.

monolith (adj. monolithic)—A stone *column shaft* that is all in one piece (not composed of *drums*); a large, single block or piece of stone used in *megalithic* structures. Also, a colossal *statue* carved from a single piece of stone.

ancient Greece and Rome.

Neo-Expressionism—An art movement that emerged in the 1970s and that reflects artists' interest in the expressive capability of art, seen earlier in German Expressionism and Abstract Expressionism.

with the uraeus cobra of kingship on the front.

Neoclassicism—A style of art and architecture that emerged in the late 18th century as part of a general revival of interest in classical cultures. Neoclassical artists adopted themes and styles from

cemetery.

nemes—In ancient Egypt, the linen headdress worn by the pharaoh,

of a deceased chief of a trading house. necropolis—Greek, "city of the dead." A large burial area or

ndop—A portrait figure of a seated Kuba king. nduen fobara—A Kalabari IJaw (Nigeria) ancestral screen in honor

by piers or columns separating the nave from the aisles.

demarcated from aisles by piers or columns.

nave arcade—In basilien architecture, the series of arches supported

Naturalistic Surrealism—See Surrealism.
nave—The central area of an ancient Roman basilica or of a church,

was at the core of the classical tradition.

natatio—The swimming pool in a Roman bathing establishment. naturalism (adj. naturalistic)—The style of painted or sculpted representation based on close observation of the natural world that

naos—See cella.

narthex—A porch or vestibule of a church, generally colonnaded or arcaded and preceding the nave.

named after the citadel of Mycenae. **mystery play**—A dramatic enactment of the holy mysteries of the Christian faith, performed at *church* portals and in city squares.

Muslim—A believer in Islam. Mycenaean—The prehistoric art of the Late Helladic period in Greece,

mural—A wall painting.

tite-like forms break a structure's solidity.

mummy—An embalmed Egyptian corpse; see mummification. muqarnas—Stucco decorations of Islamic buildings in which stalac-

immortal ka.

one window from another. $\frac{1}{2}$ mummification—A technique used by ancient Egyptians to preserve human bodies so that they may serve as the eternal home of the

Muhaqqaq—A cursive style of Islamic calligraphy. mullion—A vertical member that divides a window or that separates

India, 1526–1857.

palm outward, is a gesture of protection or blessing. Mughal—"Descended from the Mongols." The Muslim rulers of

mudra—In Buddhist and Hindu iconography, a stylized and symbolic hand gesture. The dhyana (meditation) mudra consists of the right hand over the left, palms upward, in the lap. In the bhumisparsha (earth-touching) mudra, the right hand reaches down to the ground, calling the earth to witness the Buddha's enlightenment. The dharmachakra (Wheel of the Law, or teaching) mudra is a two-handed gesture with right thumb and index finger forming a circle. The abhaya (do not fear) mudra, with the right hand up,

moschophoros—Greek, "calf bearer."

mosque—The Islamic building for collective worship. From the Arabic word masjid, meaning a "place for bowing down."

floors; also, the technique of making such works. **mosaic tilework**—An Islamic decorative technique in which large ceramic panels are fired, cut into smaller pieces, and set in plaster.

worship of a deceased pharaoh.

mosaic—Patterns or pictures made by embedding small pieces (tesserae) of stone or glass in cement on surfaces such as walls and

mortise-and-tenon system—See tenon.
mortuary temple—In Egyptian architecture, a temple erected for the

their moral significance.

monotheism—The worship of one all-powerful god.
moralized Bible—A heavily illustrated Bible, each page pairing paintings of Old and New Testament episodes with explanations of

ment in 19th-century European painting.

performance took place.

order—In classical architecture, a style represented by a characteristic design of the columns and entablature. See also superimposed orders.

Orientalism—The fascination on the part of Westerners with Oriental cultures, especially characteristic of the Romanticism move-

oratory—The church of a Christian monastery.

orchestra—Greek, "dancing place." In ancient Greek theaters, the circular piece of earth with a hard and level surface on which the

ancient gesture of prayer.

Gothic art and architecture. Also called opus francigenum.

orant—In Early Christian art, a figure with both arms raised in the

Gothic France; opere francigeno (adj.), "in the French manner." opus modernum—Latin, "modern work." The late medieval term for

seen from a fixed viewpoint.

opus francigenum—Latin, "French work." Architecture in the style of

a temple, set against the blank back wall of the cella. optical mixture—The visual effect of juxtaposed complementary colors. optical representation—The representation of people and objects

opere francigeno—See opus francigenum.

opisthodomos—In ancient Greek architecture, a porch at the rear of

metric forms on two-dimensional surfaces.

oni—An African ruler.

Op Art—An artistic movement of the 1960s in which painters sought to produce optical illusions of motion and depth using only geo-

now the standard medium for painting on canvas.

Ogoga—A Yoruba king.

oil painting—A painting technique using oil-based pigments that rose to prominence in northern Europe in the 15th century and is

Gothic, arch.

at a point.

ogive (adj. ogival)—The diagonal rib of a Gothic vault; a pointed, or

odalisque—A woman in a Turkish harem.

ogee arch—An arch composed of two double-curving lines meeting

Also, a small round window in a Gothic cathedral.

symbolic of the Egyptian sun god Re. oculis)—Latin, "eye." The round central opening of a dome.

oba—An African sacred king.

obelisk—A tall four-sided monolithic pillar with a pyramidal top—

and woods.

nyim—A Kuba king. nythology, female divinities of springs, caves, nymphs—In classical mythology, female divinities of springs, caves,

cut prints valued for their sumptuous colors.

nkisi n'kondi—A power figure carved by the Kongo people of the Democratic Republic of Congo. Such images embodied spirits be lieved to heal and give life or to be capable of inflicting harm or death.

supreme spirit. Also called moksha. nishiki-e—Japanese, "brocade pictures." Japanese polychrome wood-

nio—A Japanese guardian figure.
nirvana—In Buddhism and Hinduism, a blissful state brought about
by absorption of the individual soul or consciousness into the

ure to signify divinity.

enects.

nimbus—A halo or aureole appearing around the head of a holy fig-

nepotism—The appointment of relatives to important positions.

Neue Sachlichkeit—German, "new objectivity." An art movement that grew directly out of the World War I experiences of a group of German artists who sought to show the horrors of the war and its

teachings of Christianity.

vidual using an abstract formal vocabulary.

Neo-Platonism—An ancient school of philosophy based on the ideas of Plato, revived during the Renaissance and modified by the

Neolithic—The "new" Stone Age. Neoplasticism—The Dutch artist Piet Mondrian's theory of "pure plastic art," an ideal balance between the universal and the indi-

in the 19th century.

Neo-Gothic—The revival of the Gothic style in architecture, especially

orrery—A mechanical model of the solar system demonstrate the planets revolve around the sun.

orthogonal—A line imagined to be behind and perpendicular to the picture *plane*; the orthogonals in a painting appear to recede toward a *vanishing point* on the horizon.

Ottonian (adj.)—Pertaining to the empire of Otto I and his successors.

pa—Japanese, "school."

pagoda—An East Asian tower, usually associated with a Buddhist temple, having a multiplicity of winged *eaves*; thought to be derived from the Indian *stupa*.

palaestra—An ancient Greek and Roman exercise area, usually framed by a colonnade. In Greece, the palaestra was an independent building; in Rome, palaestras were also frequently incorporated into a bathing complex.

palazzo pubblico—Italian, "public palace." City hall.

Paleolithic—The "old" Stone Age, during which humankind produced the first sculptures and paintings.

palette—A thin board with a thumb hole at one end on which an artist lays and mixes *colors*; any surface so used. Also, the colors or kinds of colors characteristically used by an artist. In ancient Egypt, a slate slab used for preparing makeup.

palette knife—A flat tool used to scrape paint off the *palette*. Artists sometimes also use the palette knife in place of a brush to apply paint directly to the canvas.

palmette—A classical decorative motif in the form of stylized palm leaves.

Pantokrator—Greek, "ruler of all." Christ as ruler and judge.

papyrus—A plant native to Egypt and adjacent lands used to make paperlike writing material; also, the material or any writing on it.

parade helmet—A masklike helmet worn by Roman soldiers on special ceremonial occasions.

parallel hatching—See hatching.

parapet—A low, protective wall along the edge of a balcony, roof, or bastion.

parchment—Lambskin prepared as a surface for painting or writing. parinirvana—Image of the reclining Buddha, a position often interpreted as representing his death.

parthenos—Greek, "virgin." The epithet of Athena, the virgin goddess.

passio-Latin, "suffering."

Passover—The annual feast celebrating the release of the Jews from bondage to the *pharaohs* of Egypt.

paten—A large shallow bowl or plate for the bread used in the Eucharist.

patrician—A Roman freeborn landowner.

patron—The person or entity that pays an artist to produce individual artworks or employs an artist on a continuing basis.

pebble mosaic—A *mosaic* made of irregularly shaped stones of various *colors*.

pediment—In *classical* architecture, the triangular space (gable) at the end of a building, formed by the ends of the sloping roof above the *colonnade*; also, an ornamental feature having this shape.

pendant—The large hanging terminal element of a *Gothic* fan *vault*.
pendentive—A concave, triangular section of a hemisphere, four of which provide the transition from a square area to the circular base of a covering *dome*. Although pendentives appear to be hanging (pendant) from the dome, they in fact support it.

Pentateuch—The first five books of the Old Testament.

peplos (pl. **peploi**)—A simple, long, belted garment of wool worn by women in ancient Greece.

Performance Art—An American *avant-garde* art trend of the 1960s that made time an integral element of art. It produced works in which movements, gestures, and sounds of persons communicating with an audience replace physical objects. Documentary photographs are generally the only evidence remaining after these events. See also *Happenings*.

arou

Perpendicus guished by the

personal style—See

personification—An ab.

perspective—A method of

dimensional world on a two-dative, the most common type, all parative, the most common type, all parative on one, two, or three vanishing points eye level of the viewer (the horizon line of the objects are rendered smaller the farther from intended to seem. Atmospheric, or aerial, perspective sion of distance by the greater diminution of *color* intensity, color toward an almost neutral blue, and the blurring of conthe intended distance between eye and object increases.

pharaoh (adj. pharaonic)—An ancient Egyptian king.

philosophe—French, "thinker, philosopher." The term applied to French intellectuals of the *Enlightenment*.

Phoibos—Greek, "radiant." The epithet of the Greek god Apollo.

photomontage—A *composition* made by pasting together pictures or parts of pictures, especially photographs. See also *collage*.

Photorealism—See Superrealism.

physical evidence—In art history, the examination of the materials used to produce an artwork in order to determine its date.

pictograph—A picture, usually stylized, that represents an idea; also, writing using such means; also, painting on rock. See also hieroglyphic.

pier—A vertical, freestanding masonry support.

Pietà—A painted or sculpted representation of the Virgin Mary mourning over the body of the dead Christ.

pietra dura—Stonework inlaid with precious and semiprecious stones.

pilaster—A flat, rectangular, vertical member projecting from a wall of which it forms a part. It usually has a base and a capital and is often fluted.

pillar—Usually a weight-carrying member, such as a *pier* or a *column*; sometimes an isolated, freestanding structure used for commemorative purposes.

pinnacle—In *Gothic churches*, a sharply pointed ornament capping the *piers* or flying *buttresses*; also used on *church facades*.

pittura—Italian, "painting.

Pittura Metafisica—Italian, "metaphysical painting." An early-20thcentury Italian art movement led by Giorgio de Chirico, whose work conveys an eerie mood and visionary quality.

plan—The horizontal arrangement of the parts of a building or of the buildings and streets of a city or town, or a drawing or diagram showing such an arrangement. In an axial plan, the parts of a building are organized longitudinally, or along a given axis; in a central plan, the parts of the structure are of equal or almost equal dimensions around the center.

plane—A flat surface.

plate tracery—See tracery.

poesia—A term describing "poetic" art, notably Venetian *Renaissance* painting, which emphasizes the lyrical and sensual.

pointed arch—A narrow *arch* of pointed profile, in contrast to a semicircular arch.

pointillism—A system of painting devised by the 19th-century French painter Georges Seurat. The artist separates color into its component parts and then applies the component colors to the canvas in tiny dots (points). The image becomes comprehensible only from a distance, when the viewer's eyes optically blend the pigment dots.

Regionalists include Grant Wood and Thomas Hart Benton. trayed American rural life in a clearly readable, Realist style. Major Regionalism—A 20th-century American art movement that porregional style—See style. refectory—The dining hall of a Christian monastery. reverse of black-figure painting. figures against a black background, with painted linear details; the red-figure painting—In later Greek pottery, the silhouetting of red recto—The front side of a manuscript *Jolio*. inappropriate for depiction) in a relatively naturalistic mode. day life (especially subjects that previously had been considered tury France. Realist artists represented the subject matter of every-Realism (adj. Realist)—A movement that emerged in mid-19th-cenroyal court of Louis IX at Paris. the second half of the 13th century and associated with the French Rayonnant—The "radiant" style of Gothic architecture, dominant in raking cornice—The cornice on the sloping sides of a pediment. ridgepole of a root to its edge. rafters—The sloping supporting timber planks that run from the relics that opened directly onto the ambulatory and the transept. radiating chapels—In medieval churches, chapels for the display of in Italy. Quattrocento—Italian, "400"—that is, the 15th century (the 1400s) cloverleaf. quatrefoil—A shape or plan in which the parts assume the form of a the surface of a shallow, curved vault.

quadro riportato—A ceiling design in which painted scenes are arranged in panels that resemble framed pictures transferred to

quadrant arch—An arch whose curve extends for one-quarter of a

pyxis (pl. pyxides)—A cylindrical container with a hemispherical lidqibla—The direction (toward Mecca) that Muslims face when

pylon—The wide entrance gateway of an Egyptian temple, character-

poles, resting on the main rafters and giving support to the second-

"machine aesthetic" and sought purity of form in the clean func-

purlins—Horizontal beams in a roof structure, parallel to the ridge-

Purism—An early-20th-century art movement that embraced the

pulpit—A raised platform in a church or mosque on which a priest or

pukao—A small red scoria cylinder serving as a topknot or hat on

the cella to give the appearance of a peripteral colonnade.

yueblo—A communal multistoried dwelling made of stone or adobe brick by the Native Americans of the Southwest. Uppercase Pueblo

adoperipteral—In Roman architecture, a pseudoperipteral temple has a series of engaged columns all around the sides and back of

am—The part of a theatrical stage in front of the curtain.

→ A classical temple plan in which the columns are only in

-The relationship in size of the parts of persons, build-

e space, or porch, in front of the cella, or naos, of an

work on paper, usually produced in multiple

first citizen." The title Augustus and his successors peror used to distinguish themselves from Hellenis-

circle's circumterence.

ized by its sloping walls.

Easter Island moai.

ary rafters.

putto (pl. putti)—A cherubic young boy.

tional lines of industrial machinery.

punchwork—Tooled decorative work in gold leaf.

er—A book containing the Psalms.

ireek temple.

ing how

nance—Origin or source; findspot.

it of the cella and not on the sides or back.

objects, often based on a module.

imam stands while leading the religious service.

refers to various groups that occupied such dwellings.

register—One of a series of superimposed bands or *friezes* in a pictorial narrative, or the particular levels on which motifs are placed.

relics—The body parts, clothing, or objects associated with a holy figure, such as the Buddha or Christ or a Christian *saint*. Also, in Africa, the bones of ancestors.

relief—In sculpture, figures projecting from a background of which they are part. The degree of relief is designated high, low (bas), or sunken. In the last, the artist cuts the design into the surface so that the highest projecting parts of the image are no higher than the surface itself. See also *repoussé*.

relief sculpture—See relief.

relieving triangle—In *Mycenaean* architecture, the triangular opening above the *lintel* that serves to lighten the weight to be carried by the lintel itself.

reliquary—A container for holding relics.

ren—Chinese, "human-heartedness." The quality that the ideal Confucian *junzi* possesses.

Renaissance—French, "rebirth." The term used to describe the history, culture, and art of 14th- through 16th-century western Europe during which artists consciously revived the *classical* style.

renovatio—Latin, "renewal." During the *Carolingian* period, Charlemagne sought to revive the culture of ancient Rome (*renovatio imperii Romani*).

renovatio imperii Romani-See renovatio.

repoussé—Formed in *relief* by beating a metal plate from the back, leaving the impression on the face. The metal sheet is hammered into a hollow *mold* of wood or some other pliable material and finished with a *graver*. See also *relief*.

respond—An engaged *column*, *pilaster*, or similar element that either projects from a *compound pier* or some other supporting device or is bonded to a wall and carries one end of an *arch*.

retable—An architectural screen or wall above and behind an altar, usually containing painting, sculpture, or other decorations. See also *altarpiece*.

reverentissimo—Latin, "most revered."

revetment—In architecture, a wall covering or facing.

rib—A relatively slender, molded masonry *arch* that projects from a surface. In *Gothic* architecture, the ribs form the framework of the *vaulting*. A diagonal rib is one of the ribs that form the X of a *groin vault*. A transverse rib crosses the *nave* or *aisle* at a 90-degree angle.

rib vault—A vault in which the diagonal and transverse ribs compose a structural skeleton that partially supports the masonry web between them.

ridgepole—The *beam* running the length of a building below the peak of the gabled roof.

rocaille—See Rococo.

Rococo—A style, primarily of interior design, that appeared in France around 1700. Rococo interiors featured lavish decoration, including small sculptures, ornamental mirrors, easel paintings, *tapestries*, *reliefs*, wall paintings, and elegant furniture. The term *Rococo* derived from the French word *rocaille* (pebble) and referred to the small stones and shells used to decorate grotto interiors.

Romanesque—"Roman-like." A term used to describe the history, culture, and art of medieval western Europe from ca. 1050 to ca. 1200.

Romanticism—A Western cultural phenomenon, beginning around 1750 and ending about 1850, that gave precedence to feeling and imagination over reason and thought. More narrowly, the art movement that flourished from about 1800 to 1840.

rose window—A circular stained-glass window.

rostrum—A speaker's platform.

rotulus (pl. **rotuli**)—The manuscript scroll used by Egyptians, Greeks, Etruscans, and Romans; predecessor of the *codex*.

rotunda—The circular area under a *dome*; also, a domed round building.

roundel—See tondo.

Rubéniste—A member of the French Royal Academy of Painting and Sculpture during the early 18th century who followed Peter Paul Rubens in insisting that *color* was the most important element of painting. See also *Poussiniste*.

rustication (adj. **rusticated**)—To give a rustic appearance by roughening the surfaces and beveling the edges of stone blocks to emphasize the joints between them. Rustication is a *technique* employed in ancient Roman architecture and was also popular during the *Renaissance*, especially for stone *courses* at the ground-floor level.

sabi—Japanese; the value found in the old and weathered, suggesting the tranquility reached in old age.

sacramentary—A Christian religious book incorporating the prayers that priests recite during *Mass*.

saint—From the Latin word sanctus, meaning "made holy by God." Applied to persons who suffered and died for their Christian faith or who merited reverence for their Christian devotion while alive. In the Roman Catholic Church, a worthy deceased Catholic who is canonized by the pope.

saltcellar—A salt dispenser.

samsara—In Hindu belief, the rebirth of the soul into a succession of lives.

samurai—Medieval Japanese warriors.

sarcophagus (pl. sarcophagi)—Greek, "consumer of flesh." A coffin, usually of stone.

saturation—See color.

satyr—A Greek mythological follower of Dionysos having a man's upper body, a goat's hindquarters and horns, and a horse's ears and tail.

scarification—Decorative markings on the human body made by cutting or piercing the flesh to create scars.

Scholasticism—The *Gothic* school of philosophy in which scholars applied Aristotle's system of rational inquiry to the interpretation of religious belief.

school—A chronological and stylistic classification of works of art with a stipulation of place.

scriptorium (pl. scriptoria)—The writing studio of a monastery.

sculpture in the round—Freestanding figures, *carved* or *modeled* in three dimensions.

seal—In Asian painting, a stamp affixed to a painting to identify the artist, the calligrapher, or the owner. See also *cylinder seals*.

Second Style mural—The *style* of Roman *mural* painting in which the aim was to dissolve the confining walls of a room and replace them with the illusion of a three-dimensional world constructed in the artist's imagination.

secondary colors—Orange, green, and purple, obtained by mixing pairs of *primary colors* (red, yellow, blue).

section—In architecture, a diagram or representation of a part of a structure or building along an imaginary *plane* that passes through it vertically. Drawings showing a theoretical slice across a structure's width are lateral sections. Those cutting through a building's length are longitudinal sections. See also *elevation* and *cutaway*.

sedes sapientiae—Latin, "throne of wisdom." A *Romanesque* sculptural type depicting the Virgin Mary with the Christ Child in her lap.

senate—Latin senatus, "council of elders." The Senate was the main legislative body in Roman constitutional government.

serdab—A small concealed chamber in an Egyptian *mastaba* for the *statue* of the deceased.

sexpartite vault—See vault.

sfumato—Italian, "smoky." A smokelike haziness that subtly softens outlines in painting; particularly applied to the paintings of Leonardo da Vinci and Correggio.

shaft—The tall, cylindrical part of a *column* between the *capital* and the *base*

Shaka triad—See Buddha triad.

shaykh—An Islamic mystic saint.

885

bodies after exercising.

strigil—A tool ancient Greek athletes used to scrape oil from their still life—A picture depicting an arrangement of inanimate objects.

Stile Floreale—See Art Nouveau.

memorate historical events.

stele (pl. stelae)—A carved stone slab used to mark graves or to comstatue—A three-dimensional sculpture.

stanza (pl. stanze)—Italian, "room."

.swobniw

stained glass—In Gothic architecture, the colored glass used for for footraces and other athletic contests.

stadium—An ancient Roman long and narrow theater-like structure lintels, corbels, or arches.

to a polygonal or circular base for a dome. It may be composed of squinch—An architectural device used as a transition from a square transverse rib.

block. In Gothic vaulting, the lowest stone of a diagonal or springing—The lowest stone of an arch, resting on the impost

splashed-ink painting—See haboku.

head of a human.

sphinx—A mythical Egyptian beast with the body of a lion and the spectrum—The range or band of visible colors in natural light.

framing columns and entablature.

enclosing right angle. The area between the arch proper and the texes; also, the space enclosed by the curve of an arch and an adjacent arches and a horizontal member connecting their verspandrel—The roughly triangular space enclosed by the curves of

painting and sculpture. building encloses and the illusionistic representation of space in

space—In art history, both the actual area that an object occupies or a solidus (pl. solidi)—A Byzantine gold coin.

slip—A mixture of fine clay and water used in ceramic decoration. tive painting.

skenographia—Greek, "scene painting"; the Greek term for perspecskene—Greek, "stage." The stage of a classical theater.

mental Art. site-specific art—Art created for a specific location. See also Environa cartoon to the arriccio before the artist paints the plaster.

sinopia—A burnt-orange pigment used in fresco painting to transfer and the latter even lighter. See also successive contrasts.

green next to light green, making the former appear even darker affecting the eye's reception of each, as when a painter places dark simultaneous contrasts—The phenomenon of juxtaposed colors point it maintained.

15th centuries because of the fine it produced and the sharp silverpoint—A stylus made of silver, used in drawing in the 14th and

silk or a similar tightly woven porous fabric stretched tight on a

ates a sharp-edged image by pressing ink through a design on silk-screen printing—An industrial printing technique that creantine imperial palace in Constantinople.

silentiary—An usher responsible for maintaining silence in the Byz-Renaissance Florence.

signoria—Italian, "lordship." The governing body of medieval and

sibyl—A Greco-Roman mythological prophetess. 19th centuries.

shogunate—The Japanese military government of the 12th through who managed the country on behalf of a figurehead emperor.

shogun—In 12th- through 19th-century Japan, a military governor early 17th centuries in kilns in Mino.

Shino—Japanese ceramic wares produced during the late 16th and or syllables recited in Buddhist rituals.

10th century. Lowercase shingon is the Japanese term for the words Shingon—The primary form of Buddhism in Japan through the midtemple.

shikara—The beehive-shaped tower of a northern-style Hindu **shekel**—A unit of ancient Mesopotamian currency.

woven directly into the fabric.

packed densely over the vertical threads so that the designs are tapestry—A weaving technique in which the horizontal threads are taj-Arabic and Persian, "crown."

tablinum—The study or office in a Roman domus.

by a barrel vault.

taberna—In Roman architecture, a single-room shop usually covered and abstraction.

engage the viewer with pictorial issues, such as figuration, realism, paper or other materials to represent parts of a subject, in order to

drawings were constructed from objects and shapes cut from Synthetic Cubism—A later phase of Cubism, in which paintings and that fact.

formed the facts of nature into a symbol of the inner experience of the artist was not an imitator of nature but a creator who trans-

Symbolism—A late-19th-century movement based on the idea that an idea. symbol—An image that stands for another image or encapsulates

ing the Buddha. A scriptural account of the Buddha. See also jataka. sutra—In Buddhism, an account of a sermon by or a dialogue involvnightmare image.

Dali, presented recognizable scenes transformed into a dream or abstract compositions. Naturalistic Surrealists, notably Salvador Biomorphic Surrealists, such as Joan Miró, produced largely ways to express in art the world of dreams and the unconscious. improvisational nature of its predecessor into its exploration of the Surrealism—A successor to Dada, Surrealism incorporated the

surah—A chapter of the Koran, divided into verses.

forms in art—shapes not related to objects in the visible world. which attaches to no object and thus calls for new, nonobjective vey his belief that the supreme reality in the world is pure feeling, Suprematism-A type of art formulated by Kazimir Malevich to con-

Photorealists because many used photographs as sources for their fidelity to optical fact. The Superrealist painters were also called 1970s that emphasized producing artworks based on scrupulous Superrealism—A painting and sculpture movement of the 1960s and

the nesting of a series of buildings inside each other. new structure on top of, and incorporating, an earlier structure; superimposition—In Mesoamerican architecture, the erection of a

and descriptions of his deeds. Sunnah—The collection of the Prophet Muhammad's moral sayings sultan—A Muslim ruler.

the complementary color (red). See also simultaneous contrasts. then shifts to a white area, the fatigued eye momentarily perceives When a person looks intently at a color (green, for example) and successive contrasts—The phenomenon of colored afterimages. rials are taken away from the original mass; carving.

subtractive sculpture—A kind of sculpture technique in which matepigments and objects. See also additive light.

subtractive light—The painter's light in art; the light reflected from ancient writing instrument used to inscribe clay or wax tablets.

stylus—A needlelike tool used in engraving and incising, also, an temple, which supports the columns.

stylobate—The uppermost course of the platform of a classical Greek artwork in order to determine its date or the identity of the artist. stylistic evidence—In art history, the examination of the style of an manner.

geographical area. Personal style is an individual artist's unique style of a specific time. Regional style is the style of a particular style—A distinctive artistic manner. Period style is the characteristic

stupa—A large, mound-shaped Buddhist shrine. walls. Also used as a sculptural medium.

stucco—A type of plaster used as a coating on exterior and interior arm or leg in a statue.

in a building. Also, a short section of marble used to support an strut—A timber plank or other structural member used as a support **tatami**—The traditional woven straw mat used for floor covering in Japanese architecture.

tatanua—In New Ireland (Papua New Guinea), the spirits of the dead.

tatau—See tattoo.

tattoo—A permanent design on the skin produced using indelible dyes. The term derives from the Tahitian, Samoan, and Tongan word *tatau* or *tatu*.

tatu—See tattoo.

technique—The processes artists employ to create *form*, as well as the distinctive, personal ways in which they handle their materials and tools.

tempera—A *technique* of painting using pigment mixed with egg yolk, glue, or casein; also, the *medium* itself.

templon—The columnar screen separating the sanctuary from the main body of a *Byzantine church*.

tenebrism—Painting in the "shadowy manner," using violent contrasts of light and dark, as in the work of Caravaggio. The term derives from *tenebroso*.

tenebroso—Italian, "shadowy." See tenebrism.

tepidarium—The warm-bath section of a Roman bathing establishment.

terminus ante quem-Latin, "point [date] before which."

terminus post quem—Latin, "point [date] after which."

terracotta—Hard-baked clay, used for sculpture and as a building material. It may be *glazed* or painted.

terribilità—Italian, "the sublime shadowed by the fearful." A term used to describe Michelangelo Buonarroti.

tessera (pl. **tesserae**)—Greek, "cube." A tiny stone or piece of glass cut to the desired shape and size for use in forming a *mosaic*.

tetrarch—One of four corulers.

tetrarchy—Greek, "rule by four." A type of Roman government established in the late third century CE by Diocletian in an attempt to foster order by sharing power with potential rivals.

texture—The quality of a surface (rough, smooth, hard, soft, shiny, dull) as revealed by light. In represented texture, a painter depicts an object as having a certain texture even though the pigment is the real texture.

theatron—Greek, "place for seeing." In ancient Greek theaters, the slope overlooking the *orchestra* on which the spectators sat.

Theotokos—Greek, "she who bore God." The Virgin Mary, the mother of Jesus.

Third Style mural—In Roman *mural* painting, the *style* in which delicate linear fantasies were sketched on predominantly *monochromatic* backgrounds.

tholos (pl. **tholoi**)—A temple with a circular plan. Also, the burial chamber of a *tholos tomb*.

tholos tomb—In *Mycenaean* architecture, a beehive-shaped tomb with a circular plan.

thrust—The outward force exerted by an *arch* or a *vault* that must be counterbalanced by a *buttress*.

tipi—A Native American tent dwelling.

toga—The garment worn by an ancient Roman male citizen.

tokonoma—A shallow alcove in a Japanese room, which is used for decoration, such as a painting or stylized flower arrangement.

tonality—See color.

tondo (pl. tondi)—A circular painting or relief sculpture.

Torah—The Hebrew religious scroll containing the *Pentateuch*.

torana—Gateway in the stone fence around a *stupa*, located at the cardinal points of the compass.

torii—Wood gates to a Shinto shrine.

torque—The distinctive necklace worn by the Gauls.

tracery—Ornamental stonework for holding *stained glass* in place, characteristic of *Gothic cathedrals*. In plate tracery, the glass fills only the "punched holes" in the heavy ornamental stonework. In bar tracery, the stained-glass windows fill almost the entire opening, and the stonework is unobtrusive.

transept—The part of a *church* with an axis that crosses the *nave* at a right angle.

transverse arch—An *arch* separating one *vaulted bay* from the next. **transverse rib**—See *rib*.

treasury—In ancient Greece, a small building set up for the safe storage of *votive offerings*.

Trecento—Italian, "300"—that is, the 14th century (the 1300s) in Italy

trefoil—A cloverlike ornament or symbol with stylized leaves in groups of three.

trefoil arch—A triple-lobed arch.

tria-Greek, "three."

tribune—In *church* architecture, a gallery over the inner *aisle* flanking the *nave*.

triclinium (pl. **triclinia**)—The dining room of a Roman *domus*.

trident—The three-pronged pitchfork associated with the ancient Greek sea god Poseidon (Roman Neptune).

triforium—In a *Gothic cathedral*, the *blind arcaded* gallery below the *clerestory*; occasionally, the *arcades* are filled with *stained glass*.

triglyph—A triple projecting, grooved member of a *Doric frieze* that alternates with *metopes*.

trilithon—A pair of *monoliths* topped with a *lintel*; found in *megalithic* structures.

Trinity—In Christianity, God the Father, his son Jesus Christ, and the Holy Spirit.

triptych—A three-paneled painting, ivory plaque, or *altarpiece*. Also, a small, portable shrine with hinged wings used for private devotion.

triumphal arch—In Roman architecture, a freestanding *arch* commemorating an important event, such as a military victory or the opening of a new road.

trompe l'oeil—French, "fools the eye." A form of *illusionistic* painting that aims to deceive viewers into believing that they are seeing real objects rather than a representation of those objects.

trumeau—In *church* architecture, the *pillar* or center post supporting the *lintel* in the middle of the doorway.

tubicen-Latin, "trumpet player."

tukutuku—A stitched lattice panel found in a Maori (New Zealand) meetinghouse.

tumulus (pl. **tumuli**)—Latin, "burial mound." In Etruscan architecture, tumuli cover one or more subterranean multichambered tombs cut out of the local tufa (limestone). Tumuli are also characteristic of the Japanese Kofun period of the third and fourth centuries CE.

tunnel vault—See vault.

turris—See westwork.

Tuscan column—The standard type of Etruscan *column*. It resembles ancient Greek *Doric* columns but is made of wood, is un*fluted*, and has a *base*. Also a popular motif in *Renaissance* and *Baroque* architecture.

twisted perspective—See composite view.

tympanum (pl. **tympana**)—The space enclosed by a *lintel* and an *arch* over a doorway.

ukiyo-e—Japanese, "pictures of the floating world." During the Edo period, *woodcut prints* depicting brothels, popular entertainment, and beautiful women.

underglaze—In *porcelain* decoration, the *technique* of applying mineral *colors* to the surface before the main firing, followed by an application of clear *glaze*. See also *overglaze*.

Upanishads—South Asian religious texts of ca. 800–500 BCE that introduced the concepts of *samsara*, *karma*, and *moksha*.

uraeus—An Egyptian cobra; one of the emblems of *pharaonic* kingship.

urna—A whorl of hair, represented as a dot, between the brows; one of the *lakshanas* of the Buddha.

ushabti—In ancient Egypt, a figurine placed in a tomb to act as a servant to the deceased in the afterlife.

web—The masonry blocks that fill the area between the ribs of a groin wat—A Buddhist monastery in Cambodia. ushnisha—A knot of hair on the top of the head; one of the lakshanas

valley temple—The temple closest to the Nile River, associated with of the Buddha.

value—See color.

each of the Old Kingdom pyramids at Gizeh in ancient Egypt.

vanitas—Latin, "vanity." A term describing paintings (particularly vanishing point—See perspective.

westwork—The facade and towers at the western end (Westwerk) of a Westwerk—German, "western entrance structure." parts of a statue made by casting.

white-ground painting—An ancient Greek vase-painting technique oblong space. A quadrant vault is a half-barrel vault. A groin (or photographic plate is exposed, developed, and fixed while wet. an uninterrupted series of arches, one behind the other, over an wet-plate photography—An early photographic process in which the nel) vault, semicylindrical in cross-section, is in effect a deep arch or "fortress") or turris ("tower"). arch principle, or a concrete roof of the same shape. A barrel (or tundocuments, the westwork is called a castellum (Latin, "castle" or vault (adj. vaulted)—A masonry roof or ceiling constructed on the medieval church, principally in Germany. In contemporaneous 17th-century Dutch still lifes) that include references to death.

vaulting web—See web. tecture, in which radiating ribs form a fanlike pattern. vault is a vault characteristic of English Perpendicular Gothic archi-

vault is one whose ribs divide the vault into six compartments. A fan

arches under the intersections of the vaulting sections. A sexpartite

sect at right angles. In a ribbed vault, there is a framework of ribs or

cross) vault is formed at the point at which two barrel vaults inter-

rolled down from the top of the cavea to shield spectators from sun veduta (pl. vedute)—Italian, "scenic view." South Asian compilations of religious learning.

or rain. velarium—In a Roman amphitheater, the cloth awning that could be

Veda—Sanskrit, "knowledge." One of four second-millennium BCE

venationes-Ancient Roman wild animal hunts staged in an vellum—Calfskin prepared as a surface for writing or painting.

veristic—True to natural appearance; super-realistic. amphitheater.

vik—Old Norse, "cove." vihara—A Buddhist monastery, often cut into a hill. verso—The back side of a manuscript Jolio.

of the southern style. vimana—A pyramidal tower over the garbha griha of a Hindu temple

vita contemplativa—Latin, "contemplative life." The secluded spirivita—Italian, "life." Also, the title of a biography.

volute—A spiral, scroll-like form characteristic of the ancient Greek tual life of monks and nuns.

votive offering—A gift of gratitude to a deity. lonic capital.

true arch. The central voussoir, which sets the arch, is called the voussoir—A wedge-shaped stone block used in the construction of a

Vulgate—Common tongue; spoken medieval Latin. keystone.

wabi—A 16th-century Japanese art style characterized by refined rus-

ticity and an appreciation of simplicity and austerity.

19th century to project sequences of still photographic images; a zoopraxiscope—A device invented by Eadweard Muybridge in the for a temple.

ziggurat—In ancient Mesopotamian architecture, a tiered platform

Zen—A Japanese Buddhist sect and its doctrine, emphasizing enlight-

enment through intuition and introspection rather than the study

in later Indian religions to yoke, or unite, the practitioner to the

dome of the stupa and its harmika and symbolizes the axis of the

energy, which permeates the universe in varying proportions with

style that often involved colorful, decorative representations of

and vegetation. Yakshas, the male equivalent of yakshis, are often

Hindu divinities. Yakshis are goddesses associated with fertility

design raised; also, the printed impression made with such a

intended to print are cut away to a slight depth, leaving the

over which black glaze was used to outline figures, and diluted

in which the pot was first covered with a slip of very fine white clay,

weld—To join metal parts by heating, as in assembling the separate

woodcut—A wood block on the surface of which those parts not

brown, purple, red, and white were used to color them.

yaksha (m.), yakshi (f.)—Lesser local male and female Buddhist and

yasti—In Buddhist architecture, the mast or pole that arises from the

yang—In Chinese cosmology, the principle of active masculine

yamato-e-Also known as native-style painting, a purely Japanese

yoga—A method for controlling the body and relaxing the mind used

universe; it is adorned with a series of chatras (stone disks).

yin, the principle of passive feminine energy.

represented as fleshy but powerful males.

Xibalba—The Maya Underworld; "the place of fear."

of scripture. In Chinese, Chan.

yin—See yang.

yosegi—Japanese joined-wood technique.

Japanese narratives or landscapes.

vault. Also called vaulting web.

predecessor of the modern motion-picture projector.

Bibliography

This list of books is very selective, but comprehensive enough to satisfy the reading interests of the beginning art history student and general reader. The resources listed range from works that are valuable primarily for their reproductions to those that are scholarly surveys of schools and periods or monographs on individual artists. The emphasis is on recent in-print books and on books likely to be found in college and municipal libraries. No entries for periodical articles appear, but the bibliography begins with a list of some the major journals that publish art historical scholarship in English.

Selected Periodicals

African Arts American Art American Indian Art American Journal of Archaeology Antiquity Archaeology Archives of American Art Archives of Asian Art Ars Orientalis Art Bulletin Art History Art in America Art Journal Artforum International Artnews Burlington Magazine Gesta History of Photography Journal of Egyptian Archaeology Journal of Roman Archaeology Journal of the Society of Architectural Historians Journal of the Warburg and Courtauld Institutes Latin American Antiquity October Oxford Art Journal Women's Art Journal

General Studies

- Baxandall, Michael. *Patterns of Intention: On the Historical Explanation of Pictures*. New Haven, Conn.: Yale University Press, 1985.
- Bosträm, Antonia. *The Encyclopedia of Sculpture*. 3 vols. London: Rout-ledge, 2003.
- Broude, Norma, and Mary D. Garrard, eds. *The Expanding Discourse: Feminism and Art History.* New York: HarperCollins, 1992.
- Bryson, Norman, Michael Ann Holly, and Keith Moxey. Visual Theory: Painting and Interpretation. New York: Cambridge University Press, 1991.
- Burden, Ernst. Illustrated Dictionary of Architecture. 2d ed. New York: McGraw-Hill, 2002.
- Büttner, Nils. Landscape Painting: A History. New York: Abbeville, 2006. Carrier, David. A World Art History and Its Objects. University Park: Penn-
- Carrier, David. A World Art History and Its Objects. University Park: Penn sylvania State University Press, 2009.
- Chadwick, Whitney. Women, Art, and Society. 5th ed. New York: Thames & Hudson, 2012.
- Cheetham, Mark A., Michael Ann Holly, and Keith Moxey, eds. The Subjects of Art History: Historical Objects in Contemporary Perspective. New York: Cambridge University Press, 1998.

- Chilvers, Ian, and Harold Osborne, eds. *The Oxford Dictionary of Art.* 3d ed. New York: Oxford University Press, 2004.
- Crouch, Dora P., and June G. Johnson. *Traditions in Architecture: Africa, America, Asia, and Oceania*. New York: Oxford University Press, 2000.
- Curl, James Stevens. Oxford Dictionary of Architecture and Landscape Architecture. 2d ed. New York: Oxford University Press, 2006.
- Davis, Whitney. A General Theory of Visual Culture. Princeton, N.J.: Princeton University Press, 2011.
- Encyclopedia of World Art. 17 vols. New York: McGraw-Hill, 1959-1987.
- Evers, Bernd, and Christof Thoenes. Architectural Theory from the Renaissance to the Present. Cologne: Taschen, 2011.
- Fine, Sylvia Honig. Women and Art: A History of Women Painters and Sculptors from the Renaissance to the 20th Century. Montclair: Alanheld & Schram, 1978.
- Fleming, John, Hugh Honour, and Nikolaus Pevsner. *The Penguin Dictionary* of Architecture and Landscape Architecture. 5th ed. New York: Penguin, 2000
- Freedberg, David. The Power of Images: Studies in the History and Theory of Response. Chicago: University of Chicago Press, 1989.
- Gaze, Delia, ed. Dictionary of Women Artists. 2 vols. London: Routledge, 1997.
 Hall, James. Illustrated Dictionary of Subjects and Symbols in Eastern and Western Art. 2d ed. Boulder, Colo.: Westview, 2008.
- Harris, Anne Sutherland, and Linda Nochlin. *Women Artists:* 1550–1950. Los Angeles: Los Angeles County Museum of Art, 1977.
- Ingersoll, Richard, and Spiro Kostof. World Architecture: A Cross-Cultural History. New York: Oxford University Press, 2012.
- Kemp, Martin. The Science of Art: Optical Themes in Western Art from Brunelleschi to Seurat. New Haven, Conn.: Yale University Press, 1990.
- Kultermann, Udo. The History of Art History. New York: Abaris, 1993.
- Lucie-Smith, Edward. *The Thames & Hudson Dictionary of Art Terms*. 2d ed. New York: Thames & Hudson, 2004.
- Moffett, Marian, Michael Fazio, and Lawrence Wadehouse. A World History of Architecture. Boston: McGraw-Hill, 2004.
- Nelson, Robert S., and Richard Shiff, eds. *Critical Terms for Art History*. Chicago: University of Chicago Press, 1996.
- Pazanelli, Roberta, ed. *The Color of Life: Polychromy in Sculpture from Antiq*uity to the Present. Los Angeles: J. Paul Getty Museum, 2008.
- Penny, Nicholas. The Materials of Sculpture. New Haven, Conn.: Yale University Press, 1993.
- Pevsner, Nikolaus. A History of Building Types. London: Thames & Hudson, 1987. Reprint of 1979 ed.
- ——. An Outline of European Architecture. 8th ed. Baltimore: Penguin, 1974.Pierce, James Smith. From Abacus to Zeus: A Handbook of Art History. 7th ed.Upper Saddle River, N.J.: Pearson Prentice Hall, 2003.
- Placzek, Adolf K., ed. Macmillan Encyclopedia of Architects. 4 vols. New York: Macmillan, 1982.
- Podro, Michael. The Critical Historians of Art. New Haven, Conn.: Yale University Press, 1982.
- Pollock, Griselda. Vision and Difference: Femininity, Feminism and Histories of
- Art. London: Routledge, 1988.
 Preziosi, Donald, ed. The Art of Art History: A Critical Anthology. New York:
 Oxford University Press, 1998.
- Reid, Jane D. *The Oxford Guide to Classical Mythology in the Arts 1300–1990s.* 2 vols. New York: Oxford University Press, 1993.
- Roth, Leland M. Understanding Architecture: Its Elements, History, and Meaning. 2d ed. Boulder, Colo.: Westview, 2006.
- Schama, Simon. The Power of Art. New York: Ecco, 2006.
- Slatkin, Wendy. Women Artists in History: From Antiquity to the 20th Century. 4th ed. Upper Saddle River, N.J.: Prentice Hall, 2000.
- Steer, John, and Antony White. Atlas of Western Art History: Artists, Sites and Monuments from Ancient Greece to the Modern Age. New York: Facts on File, 1994.

University Press, 2008.

Foster, Benjamin R., and Karen Polinger Foster. Civilizations of Ancient Iraq.

Frankfort, Henri. The Art and Architecture of the Ancient Orient. 5th ed. New Princeton, N.J.: Princeton University Press, 2009.

Haven, Conn.: Yale University Press, 1996.

Meyers, Eric M., ed. The Oxford Encyclopedia of Archaeology in the Near East.

Moortgat, Anton. The Art of Ancient Mesopotamia. New York: Phaidon, 1969. 5 vols. New York: Oxford University Press, 1997.

Parrot, André. The Arts of Assyria. New York: Golden Press, 1961.

Sumer: The Dawn of Art. New York: Golden Press, 1961.

Castleden, Rodney. Mycenaeans. London: Routledge, 2005.

Wilkinson, Toby. The Egyptian World. London: Routledge, 2009.

Weeks, Kent R., ed. Valley of the Kings. Vercelli: White Star, 2001.

Dead. Cambridge, Mass.: Harvard University Press, 2010.

Betancourt, Philip P. Introduction to Aegean Art. New York: Institute for

Taylor, John H. Journey through the Afterlife: The Ancient Egyptian Book of the

Snape, Steven. Ancient Egyptian Tombs: The Culture of Life and Death. Oxford:

Smith, William Stevenson, and William Kelly Simpson. The Art and

Silverman, David P., ed. Ancient Egypt. New York: Oxford University Press,

Shaw, Ian, and Paul Nicholson. The Dictionary of Ancient Egypt. London: Brit-

Shafer, Byron E., ed. Temples of Ancient Egypt. Ithaca, N.Y.: Cornell University

Schulz, Regina, and Matthias Seidel, eds. Egypt: The World of the Pharachs.

Robins, Gay. The Art of Ancient Egypt. Rev. ed. Cambridge, Mass.: Harvard

Redford, Donald B., ed. The Oxford Encyclopedia of Ancient Egypt. 3 vols. New

O'Neill, John P. Egyptian Art in the Age of the Pyramids. New York: Abrams,

Lehner, Mark. The Complete Pyramids: Solving the Ancient Mysteries. New

Kemp, Barry J. Ancient Egypt: Anatomy of a Civilization. 2d ed. New York:

Ikram, Salima, and Aidan Dodson. The Mummy in Ancient Egypt: Equipping

Dodson, Aidam, and Salima Ikram. The Tomb in Ancient Egypt. New York:

Davis, Whitney. The Canonical Tradition in Ancient Egyptian Art. New York:

Bard, Kathryn A. An Introduction to the Archaeology of Ancient Egypt. Oxford:

Baines, John, and Jarom'r Málek. Atlas of Ancient Egypt. New York: Facts on

Arnold, Dorothea. When the Pyramids Were Built: Egyptian Art of the Old

Arnold, Dieter. Building in Egypt: Pharaonic Stone Masonry. New York: Oxford

Strommenger, Eva, and Max Hirmer. 5,000 Years of the Art of Mesopotamia.

Sasson, Jack M., ed. Civilizations of the Ancient Near East. 4 vols. New York:

Roaf, Michael. Cultural Atlas of Mesopotamia and the Ancient Near East. New

Mesopotamia. Cambridge, Mass.: Harvard University Press, 1991. Reade, Julian E. Assyrian Sculpture. Cambridge, Mass.: Harvard University

ed. Encyclopedia of the Archaeology of Ancient Egypt. London: Rout-

Málek, Jaromír. Egypt: 4,000 Years of Art. New York: Phaidon, 2003.

the Dead for Eternity. New York: Thames & Hudson, 1998.

Architecture of Ancient Egypt. Rev. ed. New Haven, Conn.: Yale University

Aegean Prehistory, 2007.

Wiley-Blackwell, 2011.

ish Museum, 1995.

Cologne: Känemann, 1999.

York: Oxford University Press, 2001.

York: Thames & Hudson, 1997.

Thames & Hudson, 2008.

Cambridge University Press, 1989.

Kingdom. New York: Rizzoli, 1999.

University Press, 1991.

New York: Abrams, 1964.

York: Facts on File, 1990.

Scribner, 1995.

Routledge, 2006.

ledge, 1999.

File, 1980.

FRYPt

Blackwell, 2007.

Egyptian Art. London: Phaidon, 1999.

University Press, 2008.

Prehistoric Aegean

Ancient Greece

Press, 1998.

Press, 1997.

'666I

CHAPTER 2

Finkel, Irving L., and Michael J. Seymour, eds. Babylon. New York: Oxford

sia. Berkeley: University of California Press, 2005.

Curtis, John E., and Nigel Tallis. Forgotten Empire: The World of Ancient Per-Abbeville, 2007.

Curatola, Giovanni, ed. The Art and Architecture of Mesopotamia. New York: Crawford, Harriet, ed. The Sumerian World. London: Routledge, 2013. nia Press, 1995.

Collins, Paul. Assyrian Palace Sculptures. Austin: University of Texas Press,

Philadelphia: University of Pennsylvania Press, 2003.

Collon, Dominique. Ancient Near Eastern Art. Berkeley: University of Califor-

Bahrani, Zainab. The Graven Image: Representation in Babylonia and Assyria.

and Los Angeles: University of California Press, 2007.

Ascalone, Enrico. Mesopotamia: Assyrians, Sumerians, Babylonians. Berkeley

Amiet, Pierre. Art of the Ancient Near East. New York: Abrams, 1980.

Allen, Lindsay. The Persian Empire. Chicago: University of Chicago Press,

Ancient Near East

Хотк: Аbrams, 2003.

White, Randall. Prehistoric Art: The Symbolic Journey of Humankind. New

Press, 1998. Scarre, Chris. Exploring Prehistoric Europe. New York: Oxford University

Press, 2005.

Guthrie, R. Dale. The Nature of Paleolithic Art. Chicago: University of Chicago

Oxford University Press, 1994.

Cunliffe, Barry, ed. The Oxford Illustrated Prehistory of Europe. New York: Clottes, Jean. Cave Art. London: Phaidon, 2008.

versity of California Press, 1997.

Bahn, Paul G., and Jean Vertut. Journey through the Ice Age. Berkeley: Uni-

Frances Lincoln, 2007.

-. Cave Art: A Guide to the Decorated Ice Age Caves of Europe. London: Cambridge University Press, 1998.

Bahn, Paul G. The Cambridge Illustrated History of Prehistoric Art. New York:

Aujoulat, Norbert. Lascaux: Movement, Space, and Time. New York: Abrams,

Prehistory

Prehistory and the First Civilizations

CHAPTER 1

York: Cambridge University Press, 2003.

Trigger, Bruce. Understanding Early Civilizations: A Comparative Study. New tices. London: Thames & Hudson, 1991.

Renfrew, Colin, and Paul G. Bahn. Archaeology: Theories, Methods, and Prac-

the Classical World. New York: Oxford University Press, 2008. Oleson, John Peter, ed. The Oxford Handbook of Engineering and Technology in

of the Greeks and Romans. Los Angeles: J. Paul Getty Museum, 2010. Malacrino, Carmelo. Constructing the Ancient World: Architectural Techniques

Guide to Terms, Styles, and Techniques. Los Angeles: J. Paul Getty Museum, Grossman, Janet Burnett. Looking at Greek and Roman Sculpture in Stone: A

Near East and Egypt, Greece, and Rome. 2d ed. London: Routledge, 2011. Gates, Charles. Ancient Cities: The Archaeology of Urban Life in the Ancient Architectural Press, 2005.

Chitham, Robert. The Classical Orders of Architecture. 2d ed. Boston:

Press, 1997. , ed. The Oxford History of Classical Art. New York: Oxford University

Boardman, John. The World of Ancient Art. London: Thames & Hudson,

Ancient Art, General

Wittkower, Rudolf. Sculpture Processes and Principles. New York: Harper & Row, West, Shearer. Portraiture. New York: Oxford University Press, 2004.

King, 2011. Watkin, David. A History of Western Architecture. 5th ed. London: Laurence versity Press, 2003.

Turner, Jane, ed. The Dictionary of Art. 34 vols. New ed. New York: Oxford Uni-Post-Modernism. 2d ed. Upper Saddle River, N.J.: Prentice Hall, 2003.

Trachtenberg, Marvin, and Isabelle Hyman. Architecture: From Prehistory to Thames & Hudson, 1999.

Sutton, Ian. Western Architecture: From Ancient Greece to the Present. New York: London: Studio, 1986.

Stratton, Arthur. The Orders of Architecture: Greek, Roman and Renaissance.

- Cline, Eric H., ed. *The Oxford Handbook of the Bronze Age Aegean*. New York: Oxford University Press, 2010.
- Cullen, Tracey, ed. Aegean Prehistory: A Review. Boston: Archaeological Institute of America, 2001.
- Dickinson, Oliver P.T.K. *The Aegean Bronze Age*. New York: Cambridge University Press, 1994.
- Doumas, Christos. *The Wall-Paintings of Thera*. Athens: Thera Foundation, 1992.
- Fitton, J. Lesley. *Cycladic Art.* 2d ed. Cambridge, Mass.: Harvard University Press, 1999.
- . The Discovery of the Greek Bronze Age. London: British Museum, 1995. Forsyth, Phyllis Young. Thera in the Bronze Age. New York: Peter Lang, 1997
- Graham, James W. The Palaces of Crete. Princeton, N.J.: Princeton University Press, 1987.
- Hood, Sinclair. The Arts in Prehistoric Greece. New Haven, Conn.: Yale University Press, 1992.
- Immerwahr, Sarah A. *Aegean Painting in the Bronze Age.* University Park: Pennsylvania State University Press, 1990.
- McEnroe, John. Architecture of Minoan Crete: Constructing Identity in the Aegean Bronze Age. Austin: University of Texas Press, 2010.
- Preziosi, Donald, and Louise A. Hitchcock. Aegean Art and Architecture. New York: Oxford University Press, 1999.
- Schofield, Louise. The Mycenaeans. London: British Museum, 2007.
- Shelmerdine, Cynthia W., ed. *The Cambridge Companion to the Aegean Bronze Age.* New York: Cambridge University Press, 2008.
- Warren, Peter. The Aegean Civilizations: The Making of the Past. New York: Peter Bedrick, 1989.

Greece

- Boardman, John. Athenian Black Figure Vases. Rev. ed. New York: Thames & Hudson, 1985.
- —. Athenian Red Figure Vases: The Archaic Period. New York: Thames & Hudson, 1988.
- ——. Athenian Red Figure Vases: The Classical Period. New York: Thames & Hudson, 1989.
- . Greek Sculpture: The Archaic Period. Rev. ed. New York: Thames & Hudson, 1985.
- Greek Sculpture: The Late Classical Period and Sculpture in Colonies and Overseas. New York: Thames & Hudson, 1995.
- Camp, John M. *The Archaeology of Athens*. New Haven, Conn.: Yale University Press, 2001.
- Clark, Andrew J., Maya Elston, and Mary Louise Hart. Understanding Greek Vases: A Guide to Terms, Styles, and Techniques. Los Angeles: J. Paul Getty Museum. 2002.
- Coldstream, J. Nicholas. *Geometric Greece:* 900–700 BC. 2d ed. London: Routledge, 2003.
- Fullerton, Mark D. Greek Art. New York: Cambridge University Press, 2000.
 Gunter, Ann C. Greek Art and the Orient. New York: Cambridge University Press, 2009.
- Haynes, Denys E. L. *The Technique of Greek Bronze Statuary*. Mainz: von Zabern, 1992.
- Hurwit, Jeffrey M. The Art and Culture of Early Greece, 1100–480 B.C. Ithaca, N.Y.: Cornell University Press, 1985.
- The Athenian Acropolis: History, Mythology, and Archaeology from the Neolithic Era to the Present. New York: Cambridge University Press, 1999.
- Jenkins, Ian. Greek Architecture and Its Sculpture. Cambridge, Mass.: Harvard University Press, 2006.
- Junker, Klaus. Interpreting the Images of Greek Myths: An Introduction. New York: Cambridge University Press, 2012.Keesling, Catherine M. The Votive Statues of the Athenian Acropolis. New York:
- Cambridge University Press, 2008. Lawrence, Arnold W., and R. A. Tomlinson. *Greek Architecture*. Rev. ed. New
- Haven, Conn.: Yale University Press, 1996. Mattusch, Carol C. Classical Bronzes: The Art and Craft of Greek and Roman
- Statuary. Ithaca, N.Y.: Cornell University Press, 1996.
- Mee, Christopher. *Greek Archaeology.* Hoboken, N.J.: Wiley-Blackwell, 2011. Mee, Christopher, and Tony Spawforth. *Greece: An Oxford Archaeological Guide.* New York: Oxford University Press, 2001.
- Morris, Sarah P. *Daidalos and the Origins of Greek Art*. Princeton, N.J.: Princeton University Press, 1992.
- Neer, Richard T. *The Emergence of the Classical Style in Greek Sculpture.* Chicago: University of Chicago Press, 2010.

- Greek Art and Archaeology: A New History, c. 2500–c. 150 BCE. New York: Thames & Hudson, 2011.
- Osborne, Robin. Archaic and Classical Greek Art. New York: Oxford University Press, 1998.
- Palagia, Ólga, ed. Greek Sculpture. Functions, Materials, and Techniques in the Archaic and Classical Periods. New York: Cambridge University Press, 2006.
- Pedley, John Griffiths. *Greek Art and Archaeology.* 5th ed. Upper Saddle River, N.J.: Prentice Hall, 2007.
- Pollitt, Jerome J. Art in the Hellenistic Age. New York: Cambridge University Press, 2011.
- . The Art of Ancient Greece: Sources and Documents. 2d ed. New York: Cambridge University Press, 1990.
- Rhodes, Robin F. Architecture and Meaning on the Athenian Acropolis. New York: Cambridge University Press, 1995.
- Ridgway, Brunilde S. *The Archaic Style in Greek Sculpture*. 2d ed. Chicago: Ares, 1993.
- Fourth-Century Styles in Greek Sculpture. Madison: University of Wisconsin Press, 1997.
- ——. Hellenistic Sculpture I: The Styles of ca. 331–200 B.C. Madison: University of Wisconsin Press, 1990.
- ——. Prayers in Stone: Greek Architectural Sculpture. Berkeley: University of
- California Press, 1999.

 Robertson, Martin, A History of Greek Art, Rev. ed. 2 vols. New York: Cam-
- Robertson, Martin. *A History of Greek Art.* Rev. ed. 2 vols. New York: Cambridge University Press, 1986.
- Smith, R.R.R. Hellenistic Sculpture. New York: Thames & Hudson, 1991.
- Spawforth, Tony. The Complete Greek Temples. London: Thames & Hudson, 2006.
- Spivey, Nigel. Greek Art. London: Phaidon, 1997.
- Stansbury-O'Donnell, Mark D. *Looking at Greek Art.* New York: Cambridge University Press, 2011.
- ——. Pictorial Narrative in Ancient Greek Art. New York: Cambridge University Press, 1999.
- Stewart, Andrew. Classical Greece and the Birth of Western Art. New York: Cambridge University Press, 2008.
- ——. Greek Sculpture: An Exploration. 2 vols. New Haven, Conn.: Yale University Press, 1990.

CHAPTER 3

The Roman Empire

Etruria

- Barker, Graeme, and Tom Rasmussen. *The Etruscans*. Oxford: Blackwell, 1998. Bonfante, Larissa, ed. *Etruscan Life and Afterlife: A Handbook of Etruscan Studies*. Detroit: Wayne State University Press, 1986.
- Brendel, Otto J. *Etruscan Art.* 2d ed. New Haven, Conn.: Yale University Press, 1995.
- Haynes, Sybille. Etruscan Civilization: A Cultural History. Los Angeles: J. Paul Getty Museum, 2000.
- Spivey, Nigel. Etruscan Art. New York: Thames & Hudson, 1997.
- Sprenger, Maja, Gilda Bartoloni, and Max Hirmer. *The Etruscans: Their History, Art, and Architecture*. New York: Abrams, 1983.
- Steingräber, Stephan. *Abundance of Life: Etruscan Wall Painting.* Los Angeles: J. Paul Getty Museum, 2006.
- Torelli, Mario, ed. The Etruscans. New York: Rizzoli, 2001.
- Turfa, Jean Macintosh, ed. The Etruscan World. London: Routledge, 2013.

Rome

- Anderson, James C., Jr. Roman Architecture and Society. Baltimore: Johns Hopkins University Press, 1997.
- Barton, Ian M., ed. Roman Domestic Buildings. Exeter: University of Exeter Press, 1996.
- . Roman Public Buildings. 2d ed. Exeter: University of Exeter Press, 1995. Claridge, Amanda. Rome: An Oxford Archaeological Guide. 2d ed. New York: Oxford University Press, 2010.
- Clarke, John R. *The Houses of Roman Italy, 100 B.C.-A.D. 250.* Berkeley and Los Angeles: University of California Press, 1991.
- Coarelli, Filippo. *Rome and Environs: An Archaeological Guide.* Berkeley and Los Angeles: University of California Press, 2007.
- D'Ambra, Eve. Roman Art. New York: Cambridge University Press, 1998.
- Dobbins, John J., and Pedar W. Foss, eds. *The World of Pompeii*. London: Routledge, 2007.

- Elsner, Jás. Art and the Roman Viewer: The Transformation of Art from the bridge University Press, 2010.
- Grabar, André. The Beginnings of Christian Art, 200-395. London: Thames &
- .7961, nosbuH
- . Christian Iconography. Princeton, N.J.: Princeton University Press,

The Golden Age of Justinian: From the Death of Theodosius to the Rise of

Carpets. New York: Prestel, 2010.

burgh: Edinburgh University Press, 1994.

ing. 2d ed. New York: Thames & Hudson, 1984.

Islamic Arts. London: Phaidon, 1997.

Conn.: Yale University Press, 2007.

Cambridge University Press, 1994.

Princeton University Press, 1990.

Princeton, N.J.: Princeton University Press, 1999.

Kleinbauer, W. Eugene. Hagia Sophia. London: Scala, 2004.

Islam. New York: Odyssey Press, 1967.

University Press, 2000.

Abrams, 1998.

ledge, 2000.

York: Abrams, 1997.

Känemann, 2000.

University Press, 1987.

versity Press, 2001.

7661 'uos

'8007

The Islamic World

CHAPTER 5

Mozzati, Luca. Islamic Art: Architecture, Painting, Calligraphy, Ceramics, Glass,

Irwin, Robert. The Alhambra. Cambridge, Mass.: Harvard University Press, -. Islamic Art and Architecture. New York: Thames & Hudson, 1999.

Hillenbrand, Robert. Islamic Architecture: Form, Function, Meaning. Edin-

Hattstein, Markus, and Peter Delius, eds. Islam: Art and Architecture. Cologne:

Grube, Ernst J. Architecture of the Islamic World: Its History and Social Mean-. Islamic Visual Culture, 1100-1800. New York: Ashgate, 2006.

Grabar, Oleg. The Formation of Islamic Art. Rev. ed. New Haven, Conn.: Yale

Frishman, Martin, and Hasan-Uddin Khan. The Mosque: History, Archi-

Brend, Barbara. Islamic Art. Cambridge, Mass.: Harvard University Press,

Bloom, Jonathan, and Sheila S. Blair. The Grove Encyclopedia of Islamic Art

Blair, Sheila S., and Jonathan Bloom. The Art and Architecture of Islam 1250-

Blair, Sheila S. Islamic Calligraphy. Edinburgh: Edinburgh University Press,

Baker, Patricia L. Islam and the Religious Arts. London: Continuum, 2004.

World, A.D. 400-900. Berkeley: University of California Press, 1997.

Webster, Leslie, and Michelle Brown, eds. The Transformation of the Roman

Spier, Jeffrey, ed. Picturing the Bible: The Earliest Christian Art. New Haven,

Rodley, Lyn. Byzantine Art and Architecture: An Introduction. New York:

Pelikan, Jaroslav. Imago Dei: The Byzantine Apologia for Icons. Princeton, N.J.:

Ousterhout, Robert. Master Builders of Byzantium. Princeton, N.J.: Princeton

Mathews, Thomas F. Byzantium: From Antiquity to the Renaissance. New York:

ments. Toronto: University of Toronto Press, 1986. Reprint of 1972 ed. Mango, Cyril. Art of the Byzantine Empire, 312-1453: Sources and Docu-

Lowden, John. Early Christian and Byzantine Art. London: Phaidon, 1997.

Krautheimer, Richard, and Slobodan Curĉić. Early Christian and Byzantine

Koch, Guntram. Early Christian Art and Architecture. London: SCM Press,

Jensen, Robin Margaret. Understanding Early Christian Art. New York: Rout-

Architecture. 4th ed. New Haven, Conn.: Yale University Press, 1986.

. Byzantine Architecture. New York: Electa/Rizzoli, 1985.

. The Clash of Gods: A Reinterpretation of Early Christian Art. Rev. ed.

Poeschke, Joachim. Italian Mosaics, 300-1300. New York: Abbeville, 2010.

and Architecture. New York: Oxford University Press, 2009.

1800. New Haven, Conn.: Yale University Press, 1994.

tectural Development and Regional Diversity. New York: Thames & Hud-

and Architecture of Islam, 650-1250. Rev. ed. New Haven, Conn.: Yale Uni-Ettinghausen, Richard, Oleg Grabar, and Marilyn Jenkins-Madina. The Art

Islamic Art in Context: Art, Architecture, and the Literary World. New

- sity Press, 2004. Freely, John. Byzantine Monuments of Istanbul. New York: Cambridge Univer-
- Press, 1998.
- . Imperial Rome and Christian Triumph. New York: Oxford University Pagan World to Christianity. New York: Cambridge University Press, 1995.
- Deliyannis, Deborah Mauskopf. Ravenna in Late Antiquity. New York: Cam-
- Dyson, Stephen L. Rome: A Living Portrait of an Ancient City. Baltimore: Johns
- Hannestad, Niels. Roman Art and Imperial Policy. Aarhus: Aarhus University Hopkins University Press, 2010.
- Press, 1986.
- Press, 1992. Kleiner, Diana E. E. Roman Sculpture. New Haven, Conn.: Yale University
- sworth, 2010. Kleiner, Fred S. A History of Roman Art. Enhanced ed. Belmont, Calif.: Wad-
- Kraus, Theodor. Pompeii and Herculaneum: The Living Cities of the Dead. New
- York: Abrams, 1975.
- Lancaster, Lynne. Concrete Vaulted Construction in Imperial Rome. New York:
- Cambridge University Press, 2006.
- MacDonald, William L. The Architecture of the Roman Empire I: An Introduc-Ling, Roger. Roman Painting. New York: Cambridge University Press, 1991.
- tory Study. Rev. ed. New Haven, Conn.: Yale University Press, 1982.
- the Bay of Naples. New York: Thames & Hudson, 2008. Mattusch, Carol C., ed. Pompeii and the Roman Villa: Art and Culture around
- J. Paul Getty Museum, 2004. Mazzoleni, Donatella. Domus: Wall Painting in the Roman House. Los Angeles:
- Potter, T. W. Roman Italy. Berkeley and Los Angeles: University of California Rev. ed. New York: Cambridge University Press, 1983. Pollitt, Jerome J. The Art of Rome, 753 B.C.-A.D. 337: Sources and Documents.
- Richardson, Lawrence, Jr. A New Topographical Dictionary of Ancient Rome. Press, 1990.
- -. Pompeii: An Architectural History. Baltimore: Johns Hopkins Uni-Baltimore: Johns Hopkins University Press, 1992.
- versity Press, 2008. Stewart, Peter. The Social History of Roman Art. New York: Cambridge University Press, 1988.
- .2003. Taylor, Rabun. Roman Builders. New York: Cambridge University Press,
- Thames & Hudson, 1971. Toynbee, Jocelyn M. C. Death and Burial in the Roman World. London:
- Princeton, N.J.: Princeton University Press, 1994. Wallace-Hadrill, Andrew. Houses and Society in Pompeii and Herculaneum.
- Ward-Perkins, John B. Roman Imperial Architecture. 2d ed. New Haven,
- Conn.: Yale University Press, 1981.
- Wilson-Jones, Mark. Principles of Roman Architecture. New Haven, Conn.:
- Yale University Press, 2000.
- Zanker, Paul. The Power of Images in the Age of Augustus. Ann Arbor: Uni-
- versity of Michigan Press, 1988.
- -. Roman Art. Los Angeles: J. Paul Getty Museum, 2010.

Medieval Art, General

- New Haven, Conn.: Yale University Press, 1992. Alexander, Jonathan J. G. Medieval Illuminators and Their Methods of Work.
- 1500. New York: Oxford University Press, 1998. Calkins, Robert G. Medieval Architecture in Western Europe: From A.D. 300 to
- Coldstream, Nicola. Medieval Architecture. New York: Oxford University
- Cross, Frank L., and Elizabeth A. Livingstone, eds. The Oxford Dictionary of Press, 2002.
- the Christian Church. 3d ed. New York: Oxford University Press, 1997.
- Phaidon, 1986. De Hamel, Christopher. A History of Illuminated Manuscripts. Oxford:
- Hourihane, Colum, ed. The Grove Encyclopedia of Medieval Art and Architec-
- ture. New York: Oxford University Press, 2012.
- Kessler, Herbert L. Seeing Medieval Art. Toronto: Broadview Press, 2004.
- Murray, Peter, and Linda Murray. The Oxford Companion to Christian Art and
- Ross, Leslie. Medieval Art: A Topical Dictionary. Westport, Conn.: Green-Architecture. New York: Oxford University Press, 1996.
- Snyder, James, Henry Luttikhuizen, and Dorothy Verkerk. Art of the Middle Sekules, Veronica. Medieval Art. New York: Oxford University Press, 2001. .0661 ,boow
- Ages. 2d ed. Upper Saddle River, N.J.: Prentice Hall, 2006.
- Stokstad, Marilyn. Medieval Art. 2d ed. Boulder, Colo.: Westview, 2004.

Early Christianity and Byzantium CHAPTER 4

- Cioffarelli, Ada. Guide to the Catacombs of Rome and Its Surroundings. Rome:
- Cormack, Robin. Byzantine Art. New York: Oxford University Press, 2000. Bonsignori, 2000.
- -. Icons. Cambridge, Mass.: Harvard University Press, 2007.
- Cormack, Robin, and Maria Vassiliki. Byzantium, 330-1453. London: Royal
- Academy of Arts, 2008.

Ruggles, D. Fairchild, ed. Islamic Art & Visual Culture: An Anthology of Sources. Malden, Mass.: Wiley-Blackwell, 2011.

Schimmel, Annemarie. Calligraphy and Islamic Culture. New York: New York University Press, 1984.

Tadgell, Christopher. Four Caliphates: The Formation and Development of the Islamic Tradition. London: Ellipsis, 1998.

CHAPTER 6

Early Medieval and Romanesque Europe

Ashley, Kathleen, and Marilyn Deegan. Being a Pilgrim: Art and Ritual on the Medieval Routes to Santiago. Burlington, Vt.: Lund Humphries, 2009.

Bagnoli, Martina, Holger A. Kleiner, C. Griffith Mann, and James Robinson, eds. Treasures of Heaven: Saints, Relics, and Devotion in Medieval Europe. New Haven, Conn.: Yale University Press, 2010.

Cahn, Walter. Romanesque Manuscripts: The Twelfth Century. 2 vols. London: Miller, 1998.

Conant, Kenneth J. Carolingian and Romanesque Architecture, 800–1200. 4th ed. New Haven, Conn.: Yale University Press, 1992.

Davis-Weyer, Caecilia. *Early Medieval Art*, 300–1150: Sources and Documents. Toronto: University of Toronto Press, 1986. Reprint of 1971 ed.

Diebold, William J. Word and Image: An Introduction to Early Medieval Art. Boulder, Colo.: Westview Press, 2000.

Dodwell, Charles R. *The Pictorial Arts of the West, 800–1200.* New Haven, Conn.: Yale University Press, 1993.

Fernie, Eric. Romanesque Architecture. New Haven, Conn.: Yale University Press. 2014.

Harbison, Peter. *The Golden Age of Irish Art: The Medieval Achievement* 600–1200. New York: Thames & Hudson, 1999.

Hearn, Millard F. Romanesque Sculpture: The Revival of Monumental Stone Sculpture in the Eleventh and Twelfth Centuries. Ithaca, N.Y.: Cornell University Press, 1981.

Henderson, George. From Durrow to Kells: The Insular Gospel-Books, 650–800. London: Thames & Hudson, 1987.

Hubert, Jean, Jean Porcher, and Wolfgang Fritz Volbach. *The Carolingian Renaissance*. New York: Braziller, 1970.

Lasko, Peter. Ars Sacra, 800–1200. 2d ed. New Haven, Conn.: Yale University Press, 1994.

McClendon, Charles. *The Origins of Medieval Architecture: Building in Europe,* A.D. 600–900. New Haven, Conn.: Yale University Press, 2005.

Meehan, Bernard. The Book of Kells. London: Tate, 2002.

Minne-Sève, Viviane, and Hervé Kergall. Romanesque and Gothic France: Architecture and Sculpture. New York: Abrams, 2000.

Nees, Lawrence J. Early Medieval Art. New York: Oxford University Press, 2002.

Petzold, Andreas. Romanesque Art. New York: Abrams, 1995.

Stalley, Roger. Early Medieval Architecture. New York: Oxford University Press, 1999.

Toman, Rolf, ed. Romanesque: Architecture, Sculpture, Painting. Cologne: Känemann, 1997.

Webster, Leslie. Anglo-Saxon Art. Ithaca: Cornell University Press, 2012.

CHAPTER 7

Gothic and Late Medieval Europe

Bony, Jean. French Gothic Architecture of the Twelfth and Thirteenth Centuries. Berkeley: University of California Press, 1983.

Branner, Robert. *Manuscript Painting in Paris during the Reign of St. Louis.* Berkeley: University of California Press, 1977.

— St. Louis and the Court Style in Gothic Architecture. London: Zwemmer, 1965.

Camille, Michael. Gothic Art: Glorious Visions. New York: Abrams, 1996.

Cole, Bruce. Sienese Painting: From Its Origins to the Fifteenth Century. New York: HarperCollins, 1987.

Courtenay, Lynn T., ed. The Engineering of Medieval Cathedrals. Alder-shot: Scolar, 1997.

Derbes, Anne, and Mark Sandona, eds. *The Cambridge Companion to Giotto*. New York: Cambridge University Press, 2004.

Erlande-Brandenburg, Alain. *The Cathedral: The Social and Architectural Dynamics of Construction.* New York: Cambridge University Press, 1994.

Flores d'Arcais, Francesca. *Giotto*. 2d ed. New York: Abbeville, 2012.

Frankl, Paul, and Paul Crossley. *Gothic Architecture*. New Haven, Conn.: Yale University Press, 2000.

Frisch, Teresa G. Gothic Art 1140–c. 1450: Sources and Documents. Toronto: University of Toronto Press, 1987. Reprint of 1971 ed.

Grodecki, Louis. Gothic Architecture. New York: Electa/Rizzoli, 1985.

Grodecki, Louis, and Catherine Brisac. *Gothic Stained Glass*, 1200–1300. Ithaca, N.Y.: Cornell University Press, 1985.

Maginnis, Hayden B. J. *The World of the Early Sienese Painter.* University Park: Pennsylvania State University Press, 2001.

Minne-Sève, Viviane, and Hervé Kergall. Romanesque and Gothic France: Architecture and Sculpture. New York: Abrams, 2000.

Moskowitz, Anita Fiderer. *Italian Gothic Sculpture: c. 1250–c. 1400.* New York: Cambridge University Press, 2001.

Murray, Stephen. Notre Dame, Cathedral of Amiens: The Power of Change in Gothic. New York: Cambridge University Press, 1996.

Norman, Diana, ed. Siena, Florence, and Padua: Art, Society, and Religion 1280–1400. New Haven, Conn.: Yale University Press, 1995.

Panofsky, Erwin. Abbot Suger on the Abbey Church of Saint-Denis and Its Art Treasures. 2d ed. Princeton: Princeton University Press, 1979.

Poeschke, Joachim. *Italian Frescoes: The Age of Giotto, 1280–1400.* New York: Abbeville, 2005.

Raguin, Virginia Chieffo. Stained Glass from its Origins to the Present. New York: Abrams, 2003.

Rudolph, Conrad. Artistic Change at St-Denis: Abbot Suger's Program and the Early Twelfth-Century Controversy over Art. Princeton, N.J.: Princeton University Press, 1990.

Sauerländer, Willibald, and Max Hirmer. Gothic Sculpture in France, 1140–1270. New York: Abrams, 1973.

Stubblebine, James H. *Duccio di Buoninsegna and His School.* Princeton, N.J.: Princeton University Press, 1979.

Toman, Rolf, ed. *The Art of Gothic: Architecture, Sculpture, Painting.* Cologne: Känemann, 1999.

White, John. Art and Architecture in Italy: 1250–1400. 3d ed. New Haven, Conn.: Yale University Press, 1993.

Williamson, Paul. *Gothic Sculpture*, 1140–1300. New Haven, Conn.: Yale University Press, 1995.

Wilson, Christopher. The Gothic Cathedral: The Architecture of the Great Church, 1130–1530. London: Thames & Hudson, 1990.

Renaissance Art, General

Ames-Lewis, Francis, ed. *Florence*. (*Artistic Centers of the Italian Renaissance*.) New York: Cambridge University Press, 2011.

Anderson, Christy. Renaissance Architecture. New York: Oxford University Press, 2013.

Andrés, Glenn M., John M. Hunisak, and Richard Turner. *The Art of Florence*. 2 vols. New York: Abbeville Press, 1988.

Campbell, Gordon, ed. The Grove Encyclopedia of Northern Renaissance Art. New York: Oxford University Press, 2009.

Campbell, Stephen J., and Michael W. Cole. *Italian Renaissance Art*. New York: Thames & Hudson, 2011.

Christian, Kathleen, and David J. Drogin, eds. *Patronage and Italian Renaissance Sculpture*. Burlington, Vt.: Ashgate, 2010.

Cole, Bruce. Italian Art, 1250–1550: The Relation of Renaissance Art to Life and Society. New York: Harper & Row, 1987.

— . The Renaissance Artist at Work: From Pisano to Titian. New York: HarperCollins, 1983.

Freedman, Luba. *The Revival of the Olympian Gods in Renaissance Art.* New York: Cambridge University Press, 2003.

Frommel, Christoph Luitpold. *The Architecture of the Italian Renaissance*. London: Thames & Hudson, 2007.

Hall, Marcia B, ed. Rome. (Artistic Centers of the Italian Renaissance.) New York: Cambridge University Press, 2005.

Hartt, Frederick, and David G. Wilkins. *History of Italian Renaissance Art.* 7th ed. Upper Saddle River, N.J.: Prentice Hall, 2010.

Humfrey, Peter, ed. Venice and the Veneto. (Artistic Centers of the Italian Renaissance.) New York: Cambridge University Press, 2008.

Levey, Michael. Florence: A Portrait. Cambridge, Mass.: Harvard University Press, 1998.

Paoletti, John T., and Gary M. Radke. Art, Power, and Patronage in Renaissance Italy. Upper Saddle River, N.J.: Prentice Hall, 2005.

Partridge, Loren. Art of Renaissance Florence, 1400–1600. Berkeley and Los

Angeles: University of California Press, 2009.
Richardson, Carol M., Kim W. Woods, and Michael W. Franklin. *Renaissance*

Art Reconsidered: An Anthology of Primary Sources. Oxford: Blackwell, 2007. Romanelli, Giandomencio, ed., Venice: Art & Architecture. Cologne: Könemann, 2005.

Rosenberg, Charles M., ed. The Court Cities of Northern Italy: Milan, Parma, Piacenza, Mantua, Ferrara, Bologna, Urbino, Pesaro, and Rimini. (Artistic Centers of the Italian Renaissance.) New York: Cambridge University Press, 2010

York: Abrams, 1997.

University Press, 1999.

University Press, 1992.

versity Press, 2005.

sance. New York: Abrams, 1993.

Press, 1997.

White, John. The Birth and Rebirth of Pictorial Space. 3d ed. Boston: Faber &

Welch, Evelyn. Art and Society in Italy 1350-1500. Oxford: Oxford University

Faber, 1987.

Cologne: Taschen, 2007.

Flammarion, 2003.

versity Press, 2005.

University Press, 1995.

Yale University Press, 1995.

& Hudson, 2013.

Chicago Press, 2004.

versity Press, 1995.

Yale University Press, 1993.

Conn.: Yale University Press, 2001.

Press, 1990.

view, 2000.

Press, 2006.

Hudson, 2012.

CHAPTER 9

Zöllner, Frank. Leonardo da Vinci: The Complete Paintings and Drawings.

Zerner, Henri. Renaissance Art in France: The Invention of Classicism. Paris:

Wallace, William. Michelangelo: The Artist, the Man, and His Times. New York:

Tronzo, William, ed. St. Peter's in the Vatican. New York: Cambridge Uni-

Summers, David. Michelangelo and the Language of Art. Princeton, U.J.:

Stechow, Wolfgang. Northern Renaissance Art, 1400–1600: Sources and Docu-

Rubin, Patricia Lee. Giorgio Vasari: Art and History. New Haven, Conn.: Yale

Rowe, Colin, and Leon Satkowski. Italian Architecture of the 16th Century.

Marías, Fernando. El Greco: Life and Work—A New History. London: Thames

Lotz, Wolfgang. Architecture in Italy, 1500-1600. 2d ed. New Haven, Conn.:

Landau, David, and Peter Parshall. The Renaissance Print: 1470-1550. New

Koerner, Joseph Leo. The Reformation of the Image. Chicago: University of

Kliemann, Julian-Matthias, and Michael Rohlmann. Italian Frescoes: High

Huse, Norbert, and Wolfgang Wolters. The Art of Renaissance Venice:

Humfry, Peter. Painting in Renaissance Venice. New Haven, Conn.: Yale Uni-

Hall, Marcia B. After Raphael: Painting in Central Italy in the Sixteenth Cen-

Goffen, Rona. Renaissance Rivals. Michelangelo, Leonardo, Raphael, Titian.

Freedberg, Sydney J. Painting in Italy: 1500-1600. 3d ed. New Haven, Conn.:

Franklin, David. Painting in Renaissance Florence, 1500-1550. New Haven,

Ekserdjian, David. Parmigianino. New Haven, Conn.: Yale University Press,

Cole, Bruce. Titian and Venetian Painting, 1450-1590. Boulder, Colo.: West-

Brown, Patricia Fortini. Art and Life in Renaissance Venice. New York: Abrams,

Blunt, Anthony. Art and Architecture in France, 1500-1700. Rev. ed. New

Bazzotti, Ugo. Palazzo Tè: Giulio Romanos Masterwork. London: Thames &

Bartrum, Giulia, ed. Albrecht Dürer and His Legacy: The Graphic Work of a

Renaissance Artist. Princeton, N.J.: Princeton University Press, 2003.

the Renaissance of Venetian Painting. New Haven, Conn.: Yale University Brown, David Alan, and Sylvia Ferino-Pagden. Bellini, Giorgione, Titian and

Architecture, Sculpture, and Painting. Chicago: University of Chicago

Renaissance and Mannerism, 1510-1600. New York: Abbeville, 2004.

Partridge, Loren. The Art of Renaissance Rome. New York: Abrams, 1996.

an Age of Uncertainty. Princeton, N.J.: Princeton University Press,

. German Sculpture of the Later Renaissance, c. 1520-1580: Art in

Wolf, Norbert. Albrecht Dürer. New York: Prestel, 2010.

Talvacchia, Bette. Raphael. London: Phaidon, 2007.

ments. Upper Saddle River, N.J.: Prentice Hall, 1966.

Smith, Jeffrey Chipps. Dürer. London: Phaidon: 2012.

New York: Princeton Architectural Press, 2002.

Haven, Conn.: Yale University Press, 1994.

-. Titian. London: Phaidon, 2007.

tury. New York: Cambridge University Press, 1999.

New Haven, Conn.: Yale University Press, 2002.

Dal Pozzolo, Enrico. Giorgione. Milan: Motta, 2010.

Brock, Maurice. Bronzino. Paris: Flammarion, 2002.

Haven, Conn.: Yale University Press, 1999.

High Renaissance and Mannerism in Europe

Pieter Bruegel. New York: Abbeville, 2011.

Silver, Larry. Hieronymous Bosch. New York: Abbeville, 2006.

Shearman, John K. G. Mannerism. Baltimore: Penguin, 1978.

Cambridge University Press, 2009.

Princeton University Press, 1981.

Smith, Jettrey Chipps. The Northern Renaissance. New York: Phaidon,

Snyder, James, Larry Silver, and Henry Luttikhuizen. Northern Renaissance

chester: Manchester University Press, 1993. Thomson, David. Renaissance Architecture: Critics, Patrons, and Luxury. Man-

Woods, Kim W. Making Renaissance Art. New Haven, Conn.: Yale University Identity. Manchester: Manchester University Press, 1997.

Press, 2007.

.7002 Viewing Renaissance Art. New Haven, Conn.: Yale University Press,

The Early Renaissance in Europe

Baxandall, Michael. Painting and Experience in Fifteenth Century Italy: A

Cole, Alison. Virtue and Magnificence: Art of the Italian Renaissance Courts. National Gallery of Art, 2004.

Cole, Bruce. Masaccio and the Art of Early Renaissance Florence. Blooming-

the Eve of the Scientific Revolution. Ithaca, N.Y.: Cornell University Press, Edgerton, Samuel Y., Jr. The Heritage of Giotto's Geometry: Art and Science on ton: Indiana University Press, 1980.

Gilbert, Creighton, ed. Italian Art 1400-1500: Sources and Documents. Evan-

sance. Cambridge, Mass.: Harvard University Press, 2002.

Harbison, Craig. The Mirror of the Artist: Northern Renaissance Art in Its His-

Sixteenth Century. Baltimore: Johns Hopkins University Press, 1994.

Rogier van der Weyden. Ostfildern: Hatje Cantz, 2009.

Artist in the Italian Renaissance. London: Penguin, 1992.

Oeuvre. New Haven, Conn.: Yale University Press, 2000.

Netherlandish Painting. New York: Harper & Row, 1984.

Parkstone, 2006. Manca, Joseph. Andrea Mantegna and the Italian Renaissance. New York:

versity of Texas Press, 1991.

1400-1500. New Haven, Conn.: Yale University Press, 1986.

Nash, Susie. Northern Renaissance Art. New York: Oxford University Press,

Turner, A. Richard. Renaissance Florence: The Invention of a New Art. New

Tavernor, Robert. On Alberti and the Art of Building. New Haven, Conn.: Yale

Seymour, Charles. Sculpture in Italy: 1400-1500. New Haven, Conn.: Yale

Poeschke, Joachim. Donatello and His World: Sculpture of the Italian Renais-

Parshall, Peter, and Rainer Schoch. Origins of European Printmaking: Fif-

Pächt, Otto. Early Netherlandish Painting from Rogier van der Weyden to

Olson, Roberta J. M. Italian Renaissance Sculpture. London: Thames & Hud-

teenth-Century Woodcuts and Their Public. New Haven, Conn.: Yale Uni-

Smith, Jeffrey Chipps. The Northern Renaissance. New York: Phaidon, 2004.

Tomlinson, Amanda. Van Eyck. London: Chaucer, 2007.

Gerard David. New York: Harvey Miller, 1997.

Müller, Theodor. Sculpture in the Netherlands, Germany, France and Spain:

Morand, Kathleen. Claus Sluter: Artist at the Court of Burgundy. Austin: Uni-Michels, Alfred. Hans Memling. London: Parkstone, 2008.

Lane, Barbara G. The Altar and the Altarpiece: Sacramental Themes in Early

Kent, Dale. Cosimo de' Medici and the Florentine Renaissance: The Patron's

Kempers, Bram. Painting, Power, and Patronage: The Rise of the Professional

Kemperdick, Stephan, and Jochen Sander, eds. The Master of Flémalle and

Hollingsworth, Mary. Patronage in Renaissance Italy: From 1400 to the Early

Conn.: Yale University Press, 1996.

Heydenreich, Ludwig H. Architecture in Italy, 1400-1500. 2d ed. New Haven,

torical Context. New York: Abrams, 1995.

Grafton, Antonhy. Leon Battista Alberti: Master Builder of the Italian Renais-

ston, Ill.: Northwestern University Press, 1992.

New York: Abrams, 1995.

Chapuis, Julien, ed. Tilman Riemenschneider, c. 1460-1531. Washington, D.C.: National Gallery Publications, 1998.

Campbell, Lorne. The Fifteenth Century Netherlandish Schools. London:

University Press, 1988. Primer in the Social History of Pictorial Style. 2d ed. New York: Oxford

Ahl, Diane Cole. Fra Angelico. New York: Phaidon, 2008.

CHAPTER 8

Tingali, Paola. Women in Italian Renaissance Art: Gender, Representation,

Saddle River, N.J.: Prentice Hall, 2005. Art: Painting Sculpture, the Graphic Arts from 1350 to 1575. 2d ed. Upper

Baroque Europe

Alpers, Svetlana. *The Art of Describing: Dutch Art in the Seventeenth Century.* Chicago: University of Chicago Press, 1984.

Bailey, Gauvin Alexander. Baroque & Rococo. London: Phaidon, 2012.

Bajou, Valérie. Versailles. New York: Abrams, 2012.

Belkin, Kristin Lohse. Rubens. London: Phaidon, 1998.

Bissel, R. Ward. Artemisia Gentileschi and the Authority of Art. University Park: Pennsylvania State University Press, 1999.

Blunt, Anthony. Art and Architecture in France, 1500–1700. Rev. ed. New Haven, Conn.: Yale University Press, 1999.

Brown, Jonathan. *The Golden Age of Painting in Spain*. New Haven, Conn.: Yale University Press, 1991.

Carr, Dawson W., ed. Velázquez. London: National Gallery, 2006.

Enggass, Robert, and Jonathan Brown. Italy and Spain, 1600–1750: Sources and Documents. Upper Saddle River, N.J.: Prentice Hall, 1970. Franits, Wayne. Dutch Seventeenth-Century Genre Painting: Its Stylistic and Thematic Evolution. New Haven, Conn.: Yale University Press, 2008.

Haak, Bob. The Golden Age: Dutch Painters of the Seventeenth Century. New York: Abrams, 1984.

Harris, Ann Sutherland. Seventeenth-Century Art & Architecture. 2d ed. Upper Saddle River, N.J.: Prentice Hall, 2008.

Harrison, Charles, Paul Wood, and Jason Gaiger, eds. Art in Theory 1648–1815: An Anthology of Changing Ideas. Oxford: Blackwell, 2000.

Held, Julius, and Donald Posner. 17th and 18th Century Art: Baroque Painting, Sculpture, Architecture. New York: Abrams, 1971.

Keazor, Henry. Nicholas Poussin, 1594-1665. Cologne: Taschen, 2007.

Lagerläf, Margaretha R. *Ideal Landscape: Annibale Carracci, Nicolas Poussin and Claude Lorrain.* New Haven, Conn.: Yale University Press, 1990.

Lemerle, Frédérique, and Yves Pauwels. *Baroque Architecture*, 1600–1750. Paris: Flammarion, 2008.

Liedtke, Walter. Vermeer: The Complete Paintings. Antwerp: Ludion, 2008. Mérot, Alain. French Painting in the Seventeenth Century. New Haven, Conn.:

Yale University Press, 1995. Norberg-Schulz, Christian. *Baroque Architecture*. New York: Rizzoli, 1986. North, Michael. *Art and Commerce in the Dutch Golden Age*. New Haven,

Conn.: Yale University Press, 1997. Puglisi, Catherine. *Caravaggio*. London: Phaidon, 2000.

Rosenberg, Jakob, Seymour Slive, and E. H. ter Kuile. *Dutch Art and Architecture*, 1600–1800. New Haven, Conn.: Yale University Press, 1979.

Schama, Simon. *The Embarrassment of Riches: An Interpretation of Dutch Culture in the Golden Age.* Berkeley: University of California Press, 1988.

Slive, Seymour. Frans Hals. New York: Phaidon, 2014.

Strinati, Claudio, and Jordana Pomeroy. Italian Women Artists from Renaissance to Baroque. Milan: Skira, 2007.

Toman, Rolf. Baroque: Architecture, Sculpture, Painting. Cologne: Känemann, 1998.

Varriano, John. *Italian Baroque and Rococo Architecture*. New York: Oxford University Press, 1986.

Vlieghe, Hans. *Flemish Art and Architecture*, 1585–1700. New Haven, Conn.: Yale University Press, 1998.

Westermann, Mariët. Rembrandt. London: Phaidon, 2000.

——. A Worldly Art: The Dutch Republic 1585–1718. New Haven, Conn.: Yale University Press, 1996.

Wittkower, Rudolf. Art and Architecture in Italy 1600–1750. 3 vols. 6th ed., revised by Joseph Connors and Jennifer Montagu. New Haven, Conn.: Yale University Press, 1999.

CHAPTER 11

Rococo to Neoclassicism in Europe and America

Boime, Albert. Art in the Age of Revolution, 1750–1800. Chicago: University of Chicago Press, 1987.

Craske, Matthew. Art in Europe, 1700–1830: A History of the Visual Arts in an Era of Unprecedented Urban Economic Growth. New York: Oxford University Press, 1997.

Gaunt, W. The Great Century of British Painting: Hogarth to Turner. New York: Phaidon, 1971.

Goodman, Elise, ed. Art and Culture in the Eighteenth Century: New Dimensions and Multiple Perspectives. Newark: University of Delaware Press, 2001.

Herrmann, Luke. British Landscape Painting of the Eighteenth Century. New York: Oxford University Press, 1974.

Irwin, David. Neoclassicism. London: Phaidon, 1997.

Jarrassé, Dominique. 18th-Century French Painting. Paris: Terrail, 1999.

Lee, Simon. David. London: Phaidon, 1999.

Plax, Julie-Ann. Watteau and the Cultural Politics of Eighteenth-Century France. New York: Cambridge University Press, 2000.

Roworth, Wendy Wassyng. Angelica Kauffman: A Continental Artist in Georgian England. London: Reaktion, 1992.

Sheriff, Mary D. The Exceptional Woman: Elisabeth Vigée-Lebrun and the Cultural Politics of Art. Chicago: University of Chicago Press, 1996.

Waterhouse, Ellis Kirkham. *Painting in Britain: 1530–1790.* 4th ed. New Haven, Conn.: Yale University Press, 1979.

19th and 20th Centuries, General

Arnason, H. H., and Elizabeth C. Mansfield. *History of Modern Art: Painting, Sculpture, Architecture, Photography.* 6th ed. Upper Saddle River, N.J.: Prentice Hall, 2009.

Ashton, Dore. Twentieth-Century Artists on Art. New York: Pantheon Books, 1985.

Butler, Cornelia, and Alexandra Schwartz, eds. *Modern Women: Women Artists at the Museum of Modern Art.* New York: Museum of Modern Art, 2010.

Chipp, Herschel B. *Theories of Modern Art*. Berkeley: University of California Press, 1968.

Chu, Petra ten-Doesschate. *Nineteenth-Century European Art.* 3d ed. Upper Saddle River, N.J.: Prentice Hall, 2011.

Colquhoun, Alan. Modern Architecture. New York: Oxford University Press, 2002.

Craven, Wayne. American Art: History and Culture. Rev. ed. New York: McGraw-Hill, 2002.

Doss, Erika. Twentieth-Century American Art. New York: Oxford University Press, 2002.

Eisenman, Stephen F., ed. *Nineteenth Century Art: A Critical History.* 4th ed. New York: Thames & Hudson, 2011.

Foster, Hal, Rosalind Krauss, Yve-Alain Bois, and Benjamin H. D. Buchloh. *Art since 1900: Modernism, Antimodernism, Postmodernism.* 2d ed. New York: Thames & Hudson, 2011.

Frampton, Kenneth. *Modern Architecture: A Critical History.* 4th ed. New York: Thames & Hudson, 2007.

Hamilton, George H. *Painting and Sculpture in Europe, 1880–1940.* 6th ed. New Haven, Conn.: Yale University Press, 1993.

Harrison, Charles, and Paul Wood. Art in Theory 1900–2000: An Anthology of Changing Ideas. Oxford: Blackwell, 2003.

Herbert, Robert L., ed. *Modern Artists on Art.* Upper Saddle River, N.J.: Prentice Hall, 1971.

Hertz, Richard, and Norman M. Klein, eds. *Twentieth-Century Art Theory: Urbanism, Politics, and Mass Culture.* Englewood Cliffs: Prentice-Hall, 1990.

Heyer, Paul. Architects on Architecture: New Directions in America. New York: Van Nostrand Reinhold, 1993.

Hills, Patricia. Modern Art in the USA: Issues and Controversies of the 20th Century. Upper Saddle River, N.J.: Prentice Hall, 2000.

Hunter, Sam, John Jacobus, and Daniel Wheeler. Modern Art: Painting, Sculpture, Architecture, Photography. Rev. 3d ed. Upper Saddle River, N.J.: Prentice Hall, 2004.

Lewis, Samella S. *African American Art and Artists*. Rev. ed. Berkeley and Los Angeles: University of California Press, 1994.

Marien, Mary Warner. *Photography: A Cultural History.* 3d ed. Upper Saddle River, N.J.: Prentice Hall, 2011.

Pohl, Frances K. *Framing America: A Social History of American Art.* 3d ed. New York: Thames & Hudson, 2012.

Rosenblum, Naomi. A World History of Photography. 4th ed. New York: Abbeville, 2007.

Rosenblum, Robert, and Horst W. Janson. 19th-Century Art. Rev. ed. Upper Saddle River, N.J.: Prentice Hall, 2005.

Upton, Dell. Architecture in the United States. Oxford: Oxford University Press, 1998.

CHAPTER 12

Romanticism, Realism, and Photography, 1800 to 1870

Amic, Sylvain, et al. Gustave Courbet. Ostfildern: Hatje Cantz, 2008.

Athanassaglou-Kallmyer, Nina. *Théodore Géricault*. London: Phaidon, 2008. Bergdoll, Barry. *European Architecture 1750–1890*. New York: Oxford University Press, 2000.

Boime, Albert. The Academy and French Painting in the 19th Century. London: Phaidon, 1971.

6007 Bergdoll, Barry. Bauhaus 1919-1933. New York: Museum of Modern Art,

ists from 1792 to the Present. New York: Pantheon Books, 1993.

Thomson, Belinda, ed. Gauguin: Maker of Myth. London: Tate, 2010.

Sund, Judy. Van Gogh. London: Phaidon, 2002.

Rachman, Carla. Monet. London: Phaidon, 1997.

Rubin, James H. Impressionism. London: Phaidon, 1999.

Rey, Jean-Dominique. Berthe Morisot. Paris: Flammarion, 2011.

lowers. Princeton, N.J.: Princeton University Press, 1984. Clark, T. J. The Painting of Modern Life: Paris in the Art of Manet and His Fol-

Bryson, Norman. Tradition and Desire: From David to Delacroix: New York:

Bordes, Philippe. Jacques-Louis David: Empire to Exile. New Haven, Conn.:

Brown, David Blayney. Romanticism. London: Phaidon, 2001.

Cambridge University Press, 1984.

Yale University Press, 2007.

Eitner, Lorenz. Neoclassicism and Romanticism, 1750-1850: An Anthology of

Sources and Documents. New York: Harper & Row, 1989.

cago: University of Chicago Press, 1996. Fried, Michael. Manet's Modernism, or, The Face of Painting in the 1860s. Chi-

Holt, Elizabeth Gilmore, ed. From the Classicists to the Impressionists: A Docu-Hofmann, Werner. Goya. New York: Thames & Hudson, 2003. Grave, Johannes. Caspar David Friedrich. New York: Prestel, 2012.

City, N.J.: Anchor Books/Doubleday, 1966. mentary History of Art and Architecture in the Vineteenth Century. Garden

Krell, Alain. Manet and the Painters of Contemporary Life. London: Thames &

Kroeber, Karl. British Romantic Art. Berkeley: University of California Press,

Arts, 2013. Lampert, Catherine, ed. Daumier: Visions of Paris. London: Royal Academy of

Middleton, Robin. Architecture of the Nineteenth Century. London: Phaidon, Licht, Fred. Goya. New York: Abbeville, 2001. Le Men, Ségolène. Courbet. New York: Abbeville, 2008.

uments. Upper Saddle River, N.J.: Prentice Hall, 1966. Nochlin, Linda. Realism and Tradition in Art, 1848-1900: Sources and Doc-

Porterfield, Todd. The Allure of Empire: Art in the Service of French Imperial-Haven, Conn.: Yale University Press, 1988. Novotny, Fritz. Painting and Sculpture in Europe, 1780-1880. 3d ed. New

Porterfield, Todd, and Susan L. Siegfried. Staging Empire: Napoleon, Ingres, and ism 1798-1836. Princeton, N.J.: Princeton University Press, 1998.

David. University Park, Pa.: Pennsylvania State University Press, 2006.

2010. Rubin, James Henry. Manet: Initial M, Hand and Eye. Paris: Flammarion,

Painting, Drawings, 1750-1848. Cologne: Känemann, 2006. Toman, Rolf, ed. Neoclassicism and Romanticism: Architecture, Sculpture, Shelton, Andrew Carrington. Ingres. London: Phaidon, 2008.

York: Prestel, 2010.

Distel, Anne. Renoir. New York: Abbeville, 2010. Nationaux, 2010.

Escritt, Stephen. Art Nouveau. London: Phaidon, 2000.

Haven, Conn.: Yale University Press, 1988.

Masson, Raphaël, and Véronique Mattiussi. Rodin. Paris: Flammarion, 2004. Art Nouveau. Paris: Flammarion, 2007.

and Documents. Upper Saddle River, N.J.: Prentice Hall, 1966.

Nochlin, Linda. Impressionism and Post-Impressionism, 1874-1904: Sources

French Art: From Romanticism to Impressionism, Post-Impressionism, and

Loyette, Henri, Sebastien Allard, and Laurence Des Cars. Vineteenth Century Lewis, Mary Tompkins. Cézanne. London: Phaidon, 2000.

Herbert, Robert L. Impressionism: Art, Leisure, and Parisian Society. New

Cogeval, Guy, ed. Claude Monet, 1840-1926. Paris: Réunion des Musées Broude, Norma. Impressionism: A Feminist Reading. New York: Rizzoli, 1991.

Breuer, Karin. Japanesque: The Japanese Print in the Era of Impressionism. New

Impressionism, Post-Impressionism, and Symbolism, 1870 to 1900 CHAPTER 13

Boston: New York Graphic Society, 1980. -, ed. Pablo Picasso: A Retrospective. New York: Museum of Modern Art; Rubin, William S. Dada and Surrealist Art. New York: Abrams, 1968.

of Dissent. New Haven, Conn.: Yale University Press, 2005.

Collins, Bradford R. Pop Art. London: Phaidon, 2012. Celant, Germano, ed. Louise Nevelson. Turin: Skira, 2012.

scape. New York: Abbeville Press, 1984.

Mass.: MIT Press, 2007.

fornia Press, 2012.

CHAPTER 15

sity Press, 1978.

the Wars. Milan: Skira, 2006.

University Press, 2009.

Garde Movements. Milan: Skira, 2006.

Crow, Thomas. The Rise of the Sixties: American and European Art in the Era

Causey, Andrew. Sculpture since 1945. New York: Oxford University Press,

Butler, Cornelia H., ed. WACK! Art and the Feminist Revolution. Cambridge,

Beardsley, Richard. Earthworks and Beyond: Contemporary Art in the Land-

Ashton, Dore. American Art since 1945. New York: Oxford University Press,

Archer, Michael. Art since 1960. New ed. New York: Thames & Hudson,

Anreus, Alejandro, Robin Adèle Greeley, and Leonard Folgarait, eds. Mexican

Anfam, David. Abstract Expressionism. New York: Thames & Hudson, 1990.

Tisdall, Caroline, and Angelo Bozzolla. Futurism. New York: Oxford Univer-

Terraroli, Valerio, ed. Art of the Twentieth Century, 1900-1919: The Avant-

Taylor, Michael R., ed. Arshile Gorky: A Retrospective. New Haven, Conn.: Yale

Modern. 2 vols. New York: Museum of Modern Art, 1984.

-. Art of the Twentieth Century, 1920-1945: The Artistic Culture between

ed. "Primitivism" in 20th-Century Art: Affinity of the Tribal and the

Modernism and Postmodernism in Europe and America, 1945 to 1980

Muralism: A Critical History. Berkeley and Los Angeles: University of Cali-

can Movement of the 1970s, History and Impact. New York: Abrams, 1994. Broude, Norma, and Mary D. Garrard. The Power of Feminist Art: The Ameri-

Rhodes, Colin. Primitivism and Modern Art. New York: Thames & Hudson,

mism. Princeton, N.J.: Princeton University Press, 2009.

Poggi, Christine. Inventing Futurism: The Art and Politics of Artificial Opti-Boston: Hall, 1981.

Motherwell, Robert, ed. The Dada Painters and Poets: An Anthology. 2d ed. Conn.: Yale University Press, 1991.

Lloyd, Jill. German Expressionism: Primitivism and Modernity. New Haven,

Historical Society, 2013. Armory Show at 100: Modernism and Revolution. New York: New York Kushner, Marilyn Satin, Kimberly Orcutt, and Casey Nelson Blake, eds. The

querque: University of New Mexico Press, 1989.

Hurlburt, Laurance P. The Mexican Muralists in the United States. Albu-Conn.: Yale University Press, 1992. Herbert, James D. Fauve Painting: The Making of Cultural Politics. New Haven,

versity Press, 1993. Abstraction: The Early Twentieth Century. New Haven, Conn.: Yale Uni-

Harrison, Charles, Francis Frascina, and Gil Perry. Primitivism, Cubism, Gale, Matthew. Dada and Surrealism. London: Phaidon, 1997.

Paris. Washington, D.C.: National Gallery, 2008.

Dietrich, Dorothea, ed. Dada: Zurich, Berlin, Hannover, Cologne, New York, of Modern Art, 2013.

Dickerman, Leah, ed. Inventing Abstraction, 1910-1925. New York: Museum York: Harper & Row, 1981.

Davidson, Abraham A. Early American Modernist Painting, 1910-1935. New 1938. New York: Museum of Modern Art, 2013.

D'Alessandro, Stephanie, ed. Magritte: The Mystery of the Ordinary, 1926-Prentice Hall, 1996. Curtis, William J. R. Modern Architecture since 1900. Upper Saddle River, N.J.:

Curtis, Penelope. Sculpture 1900-1945. New York: Oxford University Press,

Cox, Neil. Cubism. London: Phaidon: 2000. lery, 2011.

Cowling, Elizabeth, ed. Picasso: Challenging the Past. London: National Galeton University Press, 2013.

Clark, T.J. Picasso and Truth: From Cubism to Guernica. Princeton, N.J.: Princ-Breton, André. Surrealism and Painting. New York: Harper & Row, 1972.

Life & Culture. New York: Vendome, 2010. Bouvet, Vincent, and Gérard Durozoi. Paris between the Wars 1919-1939: Art,

& Hudson, 2001. Antliff, Mark, and Patricia Leighten. Cubism and Culture. New York: Thames Modernism in Europe and America, 1900 to 1945 CHAPTER 14

Smith, Paul. Impressionism: Beneath the Surface. New York: Abrams, 1995.

Pfeiffer, Ingrid, et al. Women Impressionists. Ostfildern: Hatje Cantz, 2008.

Bearden, Romare, and Harry Henderson. A History of African-American Art-

Fineberg, Jonathan. *Art since 1940: Strategies of Being.* 3d ed. Upper Saddle River, N.J.: Prentice Hall, 2010.

Foster, Hal. The First Pop Age: Painting and Subjectivity in the Art of Hamilton, Lichtenstein, Warhol, Richter, and Ruscha. Princeton, N.J.: Princeton University Press, 2011.

Godfrey, Tony. Conceptual Art. London: Phaidon, 1998.

Goodman, Cynthia. Digital Visions: Computers and Art. New York: Abrams, 1987.

Grundberg, Andy. Photography and Art: Interactions since 1945. New York: Abbeville, 1987.

Hopkins, David. *After Modern Art, 1945–2000.* New York: Oxford University Press, 2000.

Jacobus, John. Twentieth-Century Architecture: The Middle Years, 1940–1964. New York: Praeger, 1966.

Jencks, Charles. *The Language of Post-Modern Architecture*. 6th ed. New York: Rizzoli, 1991.

—. What Is Post-Modernism? 3d rev. ed. London: Academy Editions, 1989.Joselit, David. American Art since 1945. New York: Thames & Hudson, 2003.Lovejoy, Margot. Postmodern Currents: Art and Artists in the Age of the Electronic Media. Ann Arbor, Mich.: UMI Research Press, 1989.

Lucie-Smith, Edward. *Movements in Art since 1945*. New ed. New York: Thames & Hudson, 2001.

Mamiya, Christin J. *Pop Art and Consumer Culture: American Super Market.*Austin: University of Texas Press, 1992.

Rondeau, James, and Sheena Wagstaff, eds. *Roy Lichtenstein: A Retrospective*. Chicago: Art Institute of Chicago, 2012.

Rosen, Randy, and Catherine C. Brawer, eds. Making Their Mark: Women Artists Move into the Mainstream, 1970–1985. New York: Abbeville, 1989.

Rush, Michael. New Media in Art. 2d ed., New York: Thames & Hudson,

Sackler, Elizabeth A., ed. Judy Chicago. New York: Watson-Guptill, 2002.

Shapiro, David, and Cecile Shapiro. Abstract Expressionism: A Critical Record. New York: Cambridge University Press, 1990.

Siegel, Katy. Since '45: America and the Making of Contemporary Art. London: Reaktion, 2011.

, ed. Abstract Expressionism. New York: Phaidon, 2011.

Stiles, Kristine, and Peter Selz. *Theories and Documents of Contemporary Art:*A Sourcebook of Artists' Writings. Berkeley and Los Angeles: University of California Press, 1996.

Taylor, Brendon. *Contemporary Art: Art since 1970.* Upper Saddle River, N.J.: Prentice Hall, 2005.

Terraroli, Valerio, ed. Art of the Twentieth Century, 1946–1968: The Birth of Contemporary Art. Milan: Skira, 2007.

Theriault, Kim S. *Rethinking Arshile Gorky*. University Park: Pennsylvania State University Press, 2009.

Varnedoe, Kirk. Pictures of Nothing: Abstract Art since Pollock. Princeton, N.J.: Princeton University Press, 2006.

Waldman, Diane. Collage, Assemblage, and the Found Object. New York: Abrams, 1992.

Wheeler, Daniel. Art since Mid-Century: 1945 to the Present. Upper Saddle River, N.J.: Prentice Hall, 1991.

Wood, Paul. Modernism in Dispute: Art since the Forties. New Haven, Conn.: Yale University Press, 1993.

CHAPTER 16

Contemporary Art Worldwide

Andrews, Julia F., and Kuiyi Shen. *The Art of Modern China*. Berkeley and Los Angeles: University of California Press, 2012.

Anfam, David, ed. Anish Kapoor. New York: Phaidon, 2009.

Chilwers, Ian, and John Glaves-Smith. Oxford Dictionary of Modern and Contemporary Art. 2d ed. New York: Oxford University Press, 2009.

Danto, Arthur C., and Marina Abramovic. Shirin Neshat. New York: Rizzoli, 2010.

Enwezor, Okwui, and Chika Okeke-Agulu. Contemporary African Art since 1980. Bologna: Damiani, 2009.

Heartney, Eleanor. Art & Today. New York: Phaidon, 2008.

Heartney, Eleanor, Helaine Posner, Nancy Princenthal, and Sue Scott. After the Revolution: Women Who Transformed Contemporary Art. New York: Prestel, 2007.

Jencks, Charles. The New Paradigm in Architecture: The Language of Post-Modernism. New Haven, Conn.: Yale University Press, 2002.

Joselit, David. *After Art.* Princeton, N.J.: Princeton University Press, 2013. Moszynska, Anna. *Sculpture Now.* New York: Thames & Hudson, 2013.

Mullins, Charlotte. *Painting People: Figure Painting Today.* New York: Thames & Hudson, 2008.

O'Brien, Elaine, Everlyn Nicodemus, Melissa Chiu, Benjamin Genocchio, Mary K. Coffey, and Roberto Tejada, eds. *Modern Art in Africa, Asia, and Latin America: An Introduction to Global Modernisms*. Malden, Mass.: Wiley-Blackwell, 2013.

Paul, Christiane. Digital Art. 2d ed. New York: Thames & Hudson, 2008.

Perry, Gill, and Paul Wood. *Themes in Contemporary Art.* New Haven, Conn.: Yale University Press, 2004.

Risatti, Howard, ed. *Postmodern Perspectives: Issues in Contemporary Art.* Upper Saddle River, N.J.: Prentice Hall, 1990.

Sandler, Irving. *Art of the Postmodern Era*. New York: HarperCollins, 1996. Smith, Terry. *Contemporary Art: World Currents*. Upper Saddle River, N.J.: Prentice Hall, 2011.

——. What Is Contemporary Art? Chicago: University of Chicago Press, 2009.

Sollins, Susan, ed. Art:21 (Art in the Twenty-first Century). 5 vols. New York: Abrams, 2001–2009.

Stiles, Kristine, and Peter Selz. *Theories and Documents of Contemporary Art:* A Sourcebook of Artists' Writings. 2d ed. Berkeley and Los Angeles: University of California Press, 2012.

Storr, Robert. *Elizabeth Murray*. New York: Museum of Modern Art, 2005. Vogel, Susan Mullin. *El Anatsui: Art and Life*. New York: Prestel, 2012. Wands, Bruce. *Art of the Digital Age*. New York: Thames & Hudson, 2007. Wines, James. *Green Architecture*. Cologne: Taschen, 2008.

Asian Art, General

Béguin, Giles. Buddhist Art: An Historical and Cultural Journey. Bangkok: River Books, 2009.

Fisher, Robert E. Buddhist Art and Architecture. New York: Thames & Hudson, 1993.

Leidy, Denise Patry. The Art of Buddhism: An Introduction to Its History and Meaning. Boston: Shambhala, 2008.

McArthur, Meher. *The Arts of Asia: Materials, Techniques, Styles.* New York: Thames & Hudson, 2005.

CHAPTER 17

South and Southeast Asia

Asher, Catherine B. Architecture of Mughal India. New York: Cambridge University Press, 1992.

Beach, Milo Cleveland. *Mughal and Rajput Painting*. New York: Cambridge University Press, 1992.

Beach, Milo Cleveland, Eberhard Fischer, and B.N. Goswamy, eds. *Masters of Indian Painting*, 1100–1900. 2 vols. Zurich: Artibus Asiae, 2011.

Blurton, T. Richard. Hindu Art. Cambridge, Mass.: Harvard University Press, 1993. Chakraverty, Anjan. Indian Miniature Painting. New Delhi: Roli & Janssen, 2005.

Chaturachinda, Gwyneth, Sunanda Krishnamurty, and Pauline W. Tabtiang. *Dictionary of South and Southeast Asian Art.* Chiang Mai, Thailand: Silkworm Books, 2000.

Dehejia, Vidya. Indian Art. London: Phaidon, 1997.

Dehejia, Vidya. Unseen Presence: The Buddha and Sanchi. Mumbai: Marg, 1996

Girard-Geslan, Maud, ed. Art of Southeast Asia. New York: Abrams, 1998.

Hardy, Adam. The Temple Architecture of India. Chichester: Wiley, 2007.

Harle, James C. *The Art and Architecture of the Indian Subcontinent.* 2d ed. New Haven, Conn.: Yale University Press, 1994.

Huntington, Susan L., and John C. Huntington. The Art of Ancient India: Bud-dhist, Hindu, Jain. New York: Weatherhill, 1985.

Jacques, Claude. The Khmer Empire: Cities and Sanctuaries from the 5th to the 13th Century. Bangkok: River Books, 2007.

Kerlogue, Fiona. Arts of Southeast Asia. New York: Thames & Hudson, 2004.Koch, Ebba. The Complete Taj Mahal and the Riverfront Gardens of Agra. London: Thames & Hudson, 2006.

Kramrisch, Stella. *The Hindu Temple*. New Delhi: Motilal Banarsidass, 1991. McIntosh, Jane R. *A Peaceful Realm: The Rise and Fall of the Indus Civilization*. Boulder, Colo.: Westview Press, 2002.

Michell, George. Hindu Art and Architecture. New York: Thames & Hudson,

— The Hindu Temple: An Introduction to Its Meaning and Forms. Chicago: University of Chicago Press, 1988.

Mitter, Partha. Indian Art. New York: Oxford University Press, 2001.

Rawson, Phillip. The Art of Southeast Asia. New York: Thames & Hudson,

Schimmel, Annemarie. The Empire of the Great Mughals: History, Art, and Culture. London: Reaktion, 2006.

Saleppiernskonsenne und annatum sautum a.
Art. NiewiYende Abrains, 1990ang, c.
Art. NiewiYende Abrains, 1990ang, c.
Starrecka, Dorota'red, Madri Art and Cult.
Thermas, Nicholas, Oceanic Art. London
Thermas, Nicholas, Oceanic Art. London
Thermas, Nicholas, Oceanic Art. London

Credits

The authors and publisher are grateful to the proprietors and custodians of various works of art for photographs of these works and permission to reproduce them in this book. Sources not included in the captions are listed here.

NOTE: All references in the following credits are to figure numbers unless otherwise indicated.

Introduction—I-1 (all): National Gallery, London/Art Resource, NY; I-2: Hirshhorn Museum and Culture Garden, Smithsonian Institution, Washington, DC, Joseph H. Hirshhorn Purchase Fund, 1992 © City and county of Denver, courtesy the Clyfford Still Museum. Photo: akg images; I-3: Interior view of the choir, begun after 1284 (photo), French School, (13th century)/Beauvais Cathedral, Beauvais, France/© Paul Maeyaert/The Bridgeman Art Library; I-4: akg-images/Rabatti-Domingie; I-5: National Gallery of Art, Alfred Stieglitz Collection, Bequest of Georgia O'Keeffe 1987.58.3; I-6: Art © Estate of Ben Shahn/Licensed by VAGA, New York, NY. Photo: Whitney Museum of American Art, New York (gift of Edith and Milton Lowenthal in memory of Juliana Force); I-7: The Metropolitan Museum of Art/Art Resource, NY; I-8: Courtesy Saskia Ltd., © Dr. Ron Wiedenhoeft; I-9: © 2011 The Josef and Anni Albers Foundation/ Artists Rights Society (ARS), New York. Photo: © Whitney Museum of American Art; I-10: Photograph © 2011 Museum of Fine Arts, Boston. 11.4584; I-11: bpk, Berlin/Staatsgemaeldesammlungen, Munich, Germany/Art Resource, NY; I-12: Jürgen Liepe, Berlin; I-13: The Trustees of the British Museum/Art Resource, NY; I-14: Nimatallah/Art Resource, NY; I-15: Scala/Art Resource, NY; 1-16: Cengage Learning; I-17 left: Portrait of Te Pehi Kupe wearing European clothes, c. 1826 (w/c), Sylvester, John (fl. 1826)/© National Library of Australia, Canberra, Australia/The Bridgeman Art Library; I-17 right: Public Domain.

Chapter 1—1-1 (all): Erich Lessing/Art Resource, NY; 1-2: Erich Lessing/Art Resource, NY; 1-3: Jean Vertut; 1-4: Jean Vertut; 1-5: Jean Vertut; 1-6: Jean Vertut; 1-7s: Gianni Dagli Orti/Fine Art/Corbis; 1-8: Erich Lessing/Art Resource, NY; 1-9: F1 ONLINE/SuperStock; 1-10: Richard Ashworth/Robert Harding; 1-11: Silvio Fiore/SuperStock; 1-12: Erich Lessing/Art Resource, NY; 1-13: The Trustees of the British Museum/Art Resource, NY; 1-14: @ The Trustees of The British Museum/Art Resource, NY; 1-15: Iraq Museum/akg-images; 1-16: RMN-Grand Palais/Art Resource, NY; 1-17: Rmn-Grand Palais/Art Resource, NY; 1-18: © The Bridgeman Art Library Ltd./Alamy; 1-19: The Trustees of The British Museum/ Art Resource, NY; 1-20: Bildarchiv Preussischer Kulturbesitz/Art Resource, NY; 1-21: The Art Archive/Alfredo Dagli Orti/Picture Desk; 1-22: Werner Forman/ Art Resource, NY; 1-23: Werner Forman/Art Resource, NY; 1-24: Cengage Learning; 1-25: akg-images; 1-26: Courtesy of the Semitic Museum, Harvard University; 1-27: © Jon Arnold Images Ltd/Alamy; 1-28: Araldo de Luca; 1-29: Photograph © 2011 Museum of Fine Arts, Boston. 11.1738; 1-30: Jean Vertut; 1-31: De Agostini/SuperStock; 1-32: akg-images/Robert O'Dea; 1-33: Yann Arthus-Bertrand/Corbis; 1-35: Araldo de Luca; 1-36: Sean Gallup/Getty Images; 1-37: Egyptian Museum and Papyrus Collection Berlin; 1-38: Robert Harding World Imagery/Getty Images.

Chapter 2—2-1: Carolyn Clarke/Alamy; 2-1a: © Fred S. Kleiner 2012; 2-1b: A Centaur triumphing over a Lapith, metope XXVIII from the south side of the Parthenon, 447-432 BC (marble), Greek, (5th century BC)/British Museum, London, UK/The Bridgeman Art Library; 2-1c: Royal Ontario Museum; 2-2: Erich Lessing/Art Resource, NY; 2-3: John Burge; 2-4: Roger Wood/Fine Art/Corbis; 2-5: The Art Archive/Heraklion Museum/Gianni Dagli Orti/Picture Desk; 2-6: Nimatallah/Art Resource, NY; 2-7: Scala/Art Resource, NY; 2-8: The Art Archive/ Heraklion Museum/Gianni Dagli Orti/Picture Desk; 2-9: STUDIO KONTOS/ PHOTOSTOCK; 2-10: © Bildarchiv Monheim GmbH/Alamy; 2-11: © Fred S. Kleiner 2012; 2-12: © Vanni Archive/CORBIS; 2-13: Joe Vogan/SuperStock; 2-14: The Metropolitan Museum of Art/Art Resource, NY; 2-15: RMN-Grand Palais/ Art Resource, NY; 2-16: The Metropolitan Museum of Art/Art Resource, NY; 2-17: Gianni Dagli Orti/Fine Art/Corbis; 2-18: Nimatallah/Art Resource, NY; 2-19: Cengage Learning, 2014; 2-20: John Burge/Cengage Learning; 2-21: © 2008 Fred S. Kleiner; 2-22: Cengage Learning; 2-23: Vanni/Art Resource, NY; 2-24: Scala/Art Resource, NY; 2-25: Bridgeman-Giraudon/Art Resource, NY; 2-26: Courtesy Saskia Ltd., © Dr. Ron Wiedenhoeft; 2-27: Courtesy Saskia Ltd., © Dr. Ron Wiedenhoeft and Cengage Learning; 2-28: Gianni Dagli Orti/Fine Art/ Corbis; 2-29: Saskia Ltd., © Dr. Ron Wiedenhoeft; 2-30: SASKIA Ltd. Cultural

Documentation. © Dr. Ron Wiedenhoeft; 2-31: Marie Mauzy/Art Resource, NY; 2-32: Scala/Art Resource, NY; 2-33: Cengage Learning, 2014; 2-34: Erich Lessing/ Art Resource, NY; 2-35: Scala/Ministero per i Beni e le Attività culturali/Art Resource, NY; 2-36: Cengage Learning; 2-37: Cengage Learning, 2014; 2-38: A Centaur triumphing over a Lapith, metope XXVIII from the south side of the Parthenon, 447-432 BC (marble), Greek, (5th century BC)/British Museum, London, UK/The Bridgeman Art Library; 2-39: STUDIO KONTOS/PHOTOSTOCK; 2-40: R Sheridan/Ancient Art & Architecture Collection Ltd.; 2-41: © Ancient Art and Architecture Collection Ltd. (bottom) STUDIO KONTOS/PHOTO-STOCK (middle) © Chao-Yang Chan/Alamy (top); 2-42: © Fred S. Kleiner 2012; 2-43: © Fred S. Kleiner 2012; 2-44: Marie Mauzy/Art Resource, NY; 2-45: Nimatallah/Art Resource, NY; 2-46: Scala/Art Resource, NY; 2-47: Scala/Art Resource, NY; 2-48: Statue of Hermes and the Infant Dionysus, c. 330 BC (parian marble), Praxiteles (c. 400-c. 330 BC)/Archaeological Museum, Olympia, Archaia, Greece/ The Bridgeman Art Library; 2-49: Canali Photobank; 2-50: Canali Photobank; 2-51: © Duby Tal/Albatross/Alamy; 2-52: Antikensammlung, Staatliche Museen, Berlin, Germany/Jürgen Liepe/Art Resource, NY; 2-53: bpk, Berlin/Antikensammlung, Staatliche Museen, Berlin, Germany/Johannes Laurentius/Art Resource, NY; 2-54: Dying Gaul/Fine Art/Corbis; 2-55: The Victory of Samothrace (Parian marble) (see also 92583 & 94601-03 & 154093), Greek, (2nd century BC)/Louvre, Paris, France/Giraudon/The Bridgeman Art Library; 2-56: RMN-Grand Palais/ Art Resource, NY; 2-57: Saskia Ltd.; 2-58: © The Metropolitan Museum of Art/ Art Resource, NY; 2-59: Araldo de Luca/Fine Art Premium/Corbis.

Chapter 3—3-1: Scala/Art Resource, NY; 3-1a: © Fred S. Kleiner 2010; 3-1b: Scala/Ârt Resource, NY; 3-1c: © Fred S. Kleiner 2010; 3-2: Model of an Etruscan temple, reconstruction, 4th-5th century BC (plastic)/Institute of Etruscology, University of Rome, Italy/The Bridgeman Art Library; 3-3: Araldo de Luca/Corbis Art/Corbis; 3-5: © 2006 Fred S. Kleiner; 3-6: Leemage/Getty Images; 3-8: Scala/ Art Resource, NY; 3-7: Charles Bowman/Getty Images; 3-9: Charles & Josette Lenars/Encyclopedia/Corbis; 3-10: © Fred S. Kleiner 2013; 3-12: Alinari/Art Resource, NY; 3-13: @ Guido Alberto Rossi/AGE Fotostock; 3-14: Erich Lessing/Art Resource, NY; 3-15: John Burge; 3-16: John Burge/Cengage Learning; 3-17: Copyright: Photo Henri Stierlin, Geneve; 3-18: Wayne Howes/Photographer's Direct; 3-19: Scala/Art Resource, NY; 3-20 left: © The Metropolitan Museum of Art/Art Resource, NY; 3-20 right: The Metropolitan Museum of Art/Art Resource, NY; 3-21: Luciano Romano; 3-22: © The Metropolitan Museum of Art/ Art Resource, NY; 3-23: Canali Photobank; 3-24: Canali Photobank; 3-25: Scala/ Art Resource, NY; 3-26: Ny Carlsberg Glyptotek; 3-27: Brenda Kean/Alamy; 3-28: SASKIA Ltd. Cultural Documentation; 3-29: © Jonathan Poore/Cengage Learning; 3-30: © Jonathan Poore/Cengage Learning; 3-31: Araldo de Luca/ Corbis art/Corbis; 3-32: © Jonathan Poore/Cengage Learning; 3-33: © Jonathan Poore/Cengage Learning; 3-34: © Jonathan Poore/Cengage Learning; 3-35: John Burge and James Packer/Cengage Learning; 3-36: © Jonathan Poore/Cengage Learning; 3-37: © Fred S. Kleiner 2011; 3-38: © Jonathan Poore/Cengage Learning; 3-39: John Burge/Cengage Learning; 3-40: Copyright: Photo Henri Stierlin, Geneve; 3-41: © 2006 Fred S. Kleiner; 3-42: The Trustees of The British Museum; 3-43: Bildarchiv Preussischer Kulturbesitz/Art Resource, NY; 3-44: Bildarchiv Preussischer Kulturbesitz/Art Resource, NY; 3-45: Cengage Learning; 3-46: Scala/ Art Resource, NY; 3-47: Araldo de Luca; 3-48: Araldo de Luca/CORBIS; 3-49: Scala/Art Resource, NY; 3-50: © Fred S. Kleiner 2010; 3-51: © Jonathan Poore/ Cengage Learning; 3-52: John Burge/Cengage Learning, Originally published in A History of Roman Art by © Fred S. Kleiner (Belmont, Calif.: Thomson Wadsworth, 2007); 3-53: © Jonathan Poore/Cengage Learning; 3-54: © Jonathan Poore/Cengage Learning.

Chapter 4—4-1 (all): Scala/Art Resource, NY; 4-2: foto Pontificia Commissione per l'Archeologia Sacra; 4-3: John Burge/Cengage Learning; 4-4: Cengage Learning; 4-5: © Jonathan Poore/Cengage Learning; 4-6: Cengage Learning; 4-7: Scala/Art Resource, NY; 4-8: Scala/Art Resource, NY; 4-9: Images & Stories/Alamy; 4-10: John Burge/Cengage Learning; 4-11: John Burge/Cengage Learning; 4-11: John Burge/Cengage Learning; 4-12: david pearson/Alamy; 4-13: Cengage Learning; 4-14: Archivio e Studio Folco Quilici; 4-15: Cengage Learning; 4-16: Canali Photobank, Italy; 4-17: Canali Photobank, Italy; 4-18: Canali Photobank, Italy; 4-19: Österreichische Nationalbibliothek, Vienna, Bildarchiv, folio 7 recto of the Vienna Genesis; 4-20: Ronald Sheraton/Ancient Art and Architecture Collection Ltd.; 4-21: © Fred S. Kleiner 2012; 4-22: Vanni/Art Resource, NY; 4-23: STUDIO KONTOS/PHOTOSTOCK; 4-24: Alinari/Art Resource, NY; 4-25: Réunion des Musées Nationaux/Art Resource, NY; 4-26: © Josephine Powell; 4-27: Snark/Art Resource, NY; 4-28: Scala/Art Resource, NY.

loseph Martin; 10-3: Alinari Archives/Corbis; 10-4: Scala/Art Resource, NY; Chapter 10—10-1 (all): Jonathan Poore/Cengage Learning: 10-2: akg-images/ Robert Harding/Getty Images; 9-40: Scala/Art Resource, NY. Resource, NY; 9-38: Kunsthistorisches Museum, Vienna; 9-39: Adam Woolfitt/ ler; 9-37: bpk, Berlin/Gemaeldegalerie, Staatliche Museen/Joerg P. Anders/Art sity Art Collection; 9-36: Oeffentliche Kunstsammlung Basel, photo Martin Büh-Art Library; 9-34: RMM-Grand Palais/Art Resource, NY; 9-35: Uppsala Univerpanel), Bosch, Hieronymus (c. 1450-1516)/Prado, Madrid, Spain/The Bridgeman Poore/Cengage Learning; 9-33: The Garden of Earthly Delights, c. 1500 (oil on Resource, NY; 9-31: Heritage Image Partnership Ltd/Alamy; 9-32: © Jonathan ages, London/Art Resource, NY; 9-30: Bildarchiv Preussischer Kulturbesitz/Art 9-28: Photograph © 2011 Museum of Fine Arts, Boston. 68.187; 9-29: V&A Im-SuperStock/SuperStock; 9-27: O. Zimmermann/Musée d'Unterlinden, Colmar; source, NY; 9-24: Scala/Art Resource, NY; 9-25: © 2006 Fred S. Kleiner; 9-26: e le Attività culturali/Art Resource, NY; 9-23: National Gallery, London/Art Re-Art Resource, NY; 9-21: Scala/Art Resource, NY; 9-22: Scala/Ministero per i Beni Scala/Art Resource, NY; 9-20: Scala/Ministero per i Beni e le Attività culturali/ Arte, Venice/Art Resource, NY; 9-18: Erich Lessing/Art Resource, NY; 9-19: ing; 9-15 right: Cengage Learning; 9-16: Marka/SuperStock; 9-17: Cameraphoto ing; 9-14: Tips Images/SuperStock; 9-15 left: © Jonathan Poore/Cengage Learnmages/Electa, 9-12: © Jonathan Poore/Cengage Learning, 9-13: Cengage Learn-Photo Vatican Museums; 9-10: © BracchiettiZigrosi/Vatican Museums; 9-11: akgums; 9-7: Araldo de Luca/CORBIS; 9-8: Arte & Immagini srl/CORBIS; 9-9: 9-5: Erich Lessing/Art Resource, NY, 9-6:

M. Sarri 1983/Photo Vatican Muse-NY, 9-3: Alinari/Art Resource, NY, 9-4: RMN-Grand Palais/Art Resource, NY,

© Philadelphia Museum of Art, E1950-2-1; 10-30: © RMN-Grand Palais/Art Libbey, 1956.57; 10-28: Erich Lessing/Art Resource, NY; 10-29: Photo copyright Purchased with funds from the Libbey Endowment, Gift of Edward Drummond Resource, NY; 10-26: akg-images; 10-27: The Toledo Museum of Art, OH. shuis, The Hague; 10-24: National Gallery of Art; 10-25: Erich Lessing/Art tional; 10-22: The Pierpont Morgan Library/Art Resource, NY; 10-23: Maurit-10-21: © English Heritage Photo Library/The Bridgeman Art Library Internamuseum, Amsterdam, The Netherlands/Artothek/The Bridgeman Art Library; c. 1642 (oil on canvas), Rembrandt Harmenszoon van Rijn (1606-69)/Rijksage fotostock/Alamy; 10-19: National Gallery of Art; 10-20: The Nightwatch, Lessing/Art Resource, NY; 10-17: RMN-Grand Palais/Art Resource, NY; 10-18: ing/Art Resource, NY; 10-15: IRPA-KIK, Brussels, www.kikirpa.be; 10-16: Erich Art/Art Resource, NY; 10-13: Erich Lessing/Art Resource, NY; 10-14: Erich Less-© Jonathan Poore/Cengage Learning; 10-12: Wadsworth Atheneum Museum of NY; 10-9: Scala/Art Resource, NY; 10-10: Alinari/Art Resource, NY; 10-11: Learning; 10-7: © Jonathan Poore/Cengage Learning; 10-8: Scala/Art Resource, 10-5: akg-images/Pirozzi; 10-5: Araldo de Luca; 10-6: © Jonathan Poore/Cengage

Pompeo Girolamo (1708-87)/Louvre, Paris, France/Giraudon/The Bridgeman John Crowle (1738-1811) of Crowle Park, c. 1761-62 (oil on canvas), Batoni, Arts, Boston, 30.781; II-I2: Scala/Art Resource, NY; II-I3: Portrait of Charles 11-10: National Gallery of Canada; 11-11: Photograph © 2011 Museum of Fine Resource, NY; 11-9: National Gallery, London, UK/The Bridgeman Art Library; man-Giraudon/Art Resource, NY; II-6: Réunion des Musées Vationaux/Art Wallace Collection, London, UK/The Bridgeman Art Library; II-5: Bridge-Arts; II-2: Bildarchiv Monheim/akg-images; II-3: Scala/Art Resource, NY; II-4: Chapter II—II-I (all): Photo: Katherine Wetzel © Virginia Museum of Fine Corbis; 10-33: Angelo Hornak/Corbis. Resource, NY, 10-31: © Yann Arthus-Bertrand/Altitude; 10-32: Massimo Listri/

Chapter 12-12-1 (all): Erich Lessing/Art Resource, NY; 12-2: Scala/Ministero Photo © The Library of Virginia. Crichton/Encyclopedia/Corbis; II-18: Thomas Jefferson Foundation; II-19: Scala/Art Resource, NY; 11-16: © Jonathan Poore/Cengage Learning; 11-17: Eric Art Library; II-14: Réunion des Musées Nationaux/Art Resource, Inc.; II-15: Resource, NY; II-7: Summerfield Press, Ltd.; II-8: National Gallery, London//Art

12-26: Nadar/Bettmann/Corbis; 12-27: New York Public Library/Art Resource, man Art Library; 12-25: Louis Daguerre/Time & Life Pictures/Getty Images; Achille-Louis (1806–77)/Private Collection/The Stapleton Collection/The Bridge-Terra/Corbis, 12-24: Crystal Palace, Sydenham, c. 1862 (colour litho), Martinet, don/Art Resource, NY; 12-22: Andrew Aitchison/Alamy; 12-23: Roger Antrobus/ NY, 12-20: The Granger Collection, NYC. All rights reserved; 12-21: Tate, Lon-Scala/Art Resource, NY; 12-19: The Philadelphia Museum of Art/Art Resource, Art Gallery/Art Resource, NY; 12-17: Erich Lessing/Art Resource, NY; 12-18: source, NY, 12-15: RMN-Grand Palais/Art Resource, NY, 12-16: Yale University mlungen Dresden/The Bridgeman Art Library; 12-14: Erich Lessing/Art Re-(1819–77)/Galerie Neue Meister, Dresden, Germany/© Staatliche Kunstsam-Stone Breakers, 1849 (oil on canvas) (destroyed in 1945), Courbet, Gustave 99.22; 12-12: The Metropolitan Museum of Art/Art Resource, NY; 12-13: The chiv Preussischer Kulturbesitz/Art Resource, NY; 12-10: National Gallery, London/Art Resource, NY; 12-11: Photography © 2011 Museum of Fine Arts, Boston, (1774–1840), Der Wanderer über dem Nebelmeer, ca. 1817. Oil on canvas. Bildar-12-8: RMM-Grand Palais/Art Resource, NY; 12-9: Friedrich, Caspar David del Prado Madrid/Gianni Dagli Orti; 12-7: RMN-Grand Palais/Art Resource, NY; Metropolitan Museum of Art/Art Resource, NY; 12-6: The Art Archive/Museo Resource, NY; 12-4: Réunion des Musées Nationaux/Art Resource, NY; 12-5: The per i Beni e le Attività culturali/Art Resource, NY; 12-3: RMN-Grand Palais/Art

Manet, Edouard (1832-83)/© Samuel Courtauld Trust, The Courtauld Gallery, Chapter 13-13-1 (all): A Bar at the Folies-Bergere, 1881-82 (oil on canvas), NY; 12-28: Courtesy George Eastman House.

> Gayumars (2005.1.165 M200) © Aga Khan Trust for Culture Geneva. 5-15: Victoria & Albert Museum, London/Art Resource, NY; 5-16: The Court of atty Library, Dublin; 5-14: Réunion des Musées Nationaux/Art Resource, NY; politan Museum of Art/Art Resource, NY; 5-13: The Trustees of the Chester Be-Getty Images; 5-11: Copyright: Photo Henri Stierlin, Geneve; 5-12: @ The Metroing Picture Library; 5-9: Mauritius/SuperStock; 5-10: Toyohiro Yamada/Taxi/ Henri Stierlin, Geneve; 5-7: © Bednorz-Images; 5-8: Adam Woolnt/Robert Hard-Srl a socio unico/Alamy; 5-5 right: Cengage Learning; 5-6: Copyright: Photo Richard T. Nowitz/CORBIS; 5-5 left: Guido Alberto Rossi/Tips Images/Tips Italia 5-2: Hanan Isachar/SuperStock; 5-3: Erich Lessing/Art Resource, NY; 5-4: © 5-1b: @ Bednorz-Images; 5-1c: Adam Woolfit/Robert Harding Picture Library; Chapter 5-5-1: Album/Oronoz/Album/SuperStock; 5-1a: © BednorzImages;

College, Cambridge, 6-34: The Bridgeman Art Library; 6-35: By special permis-6-32: Cengage Learning, 2016; 6-33: The Master and Fellows of Corpus Christi Learning; 6-30 right: Cengage Learning, 2016; 6-31: Angelo Hornak/Corbis, 6-29: © Jonathan Poore/Cengage Learning; 6-30 left: © Jonathan Poore/Cengage gard; 6-27: Canali Photobank, Italy; 6-28: © Jonathan Poore/Cengage Learning; Art Resource, NY; 6-25: Erich Lessing/Art Resource, NY; 6-26: Abtei St. Hilde-© Jonathan Poore/Cengage Learning; 6-24: © The Metropolitan Museum of Art/ John Burge/Cengage Learning; 6-22: © Jonathan Poore/Cengage Learning; 6-23: 6-19: © Jonathan Poore/Cengage Learning; 6-20: © Fred S. Kleiner 2010; 6-21: Dagli Orti/Picture Desk; 6-17: Jean Dieuzaide; 6-18: Cengage Learning, 2016; Köln, rba_c000008; 6-16: The Art Archive/Abbaye de Saint Foy Conques/Cianni 2016; 6-14: Dom-Museum, Hildesheim; 6-15: Photo: @ Rheinisches Bildarchiv Poore/Cengage Learning; 6-12: © Bednorz-Images; 6-13: Cengage Learning, Learning; 6-9: Cengage Learning, 2016; 6-10: akg-images; 6-11: © Jonathan front cover. The Pierpont Morgan Library, New York, NY, USA. Photo Credit: The Pierpont Morgan Library/Art Resource, NY, 6-8: © Jonathan Poore/Cengage School of Charles the Bald, France. Ca. 880 CE. Repousse gold and jewels. M.I., © Gianni Dagli Orti/Corbis; 6-7: Front cover of the Lindau Gospels. Court NY; 6-4: Album/Art Resource, NY; 6-5: Kunsthistorisches Museums, Wien; 6-6: ees of the British Museum/Art Resource, NY; 6-3: Erich Lessing/Art Resource, Chapter 6—6-1 (all): © Jonathan Poore/Cengage Learning; 6-2: © The Trust-

sion of the City of Bayeux; 6-36: By special permission of the City of Bayeux.

7-37: © Jonathan Poore/Cengage Learning, 7-38: Alinati/Art Resource, NY, 7-39: Scala/Art Resource, NY; 7-35: Canali Photobank; 7-36: Scala/Art Resource, NY; Resource, NY; 7-32: Scala/Art Resource, NY; 7-33: Scala/Art Resource, NY; 7-34: Resource, NY, 7-30: Summerfield Press/Corbis Art/Corbis; 7-31: Scala/Art Cengage Learning; 7-29: Scala/Ministero per i Beni e le Attività culturali/Art Learning; 7-27: Erich Lessing/Art Resource, NY; 7-28: © Jonathan Poore/ 7-25: © Jonathan Poore/Cengage Learning; 7-26: © Jonathan Poore/Cengage 7-23: Werner Forman/Corbis Art/Corbis; 7-24: Erich Lessing/Art Resource, NY; 7-21: Edmund Nagele PCL/SuperStock, 7-22: Sites & Photos/Art Resource, NY; tionalbibliothek, Vienna; 7-20: Réunion des Musées Nationaux/Art Resource, NY; 7-18: The Pierpont Morgan Library/Art Resource, NY, 7-19: Österreichische Naing; 7-16: Bridgeman-Giraudon/Art Resource, NY; 7-17: © Bednorz-Images; Learning; 7-14: Cengage Learning, 2016; 7-15: © Jonathan Poore/Cengage Learn-France/Peter Willi/The Bridgeman Art Library; 7-13: @ Jonathan Poore/Cengage the west door of the south portal, c. 1220 (stone)/Chartres Cathedral, Chartres, athan Poore/Cengage Learning, 7-12: Four martyr saints, column figures from Paul Maeyaert/The Bridgeman Art Library; 7-10: Cengage Learning; 7-11: © Jon-(photo), French School, (12th century)/Chartres Cathedral, Chartres, France/⊚ 7-6: © Jonathan Poore/Cengage Learning; 7-7: © Jonathan Poore/Cengage Learning; 7-8: John Burge/Cengage Learning; 7-9: View of the nave, begun 1194 2016; 7-4: Cengage Learning, 2016; 7-5: © Jonathan Poore/Cengage Learning; Learning; 7-2: © Jonathan Poore/Cengage Learning; 7-3: Cengage Learning, Chapter 7—7-1: Bertl123/Shutterstock.com; 7-1a-c: @ Jonathan Poore/Cengage

8-39: Scala/Art Resource, NY; 8-40: Erich Lessing/Art Resource, NY. Art Resource, NY; 8-37: Canali Photobank, Italy; 8-38: Scala/Art Resource, NY; Scala/Ministero per i Beni e le Attività culturali/Art Resource, NY; 8-36: Alinari/ 8-33: © Jonathan Poore/Cengage Learning; 8-34: Scala/Art Resource, Inc.; 8-35: © Jonathan Poore/Cengage Learning; 8-32: © Jonathan Poore/Cengage Learning; (1377-1446)/San Lorenzo, Florence, Italy/The Bridgeman Art Library; 8-31: Learning; 8-30: View of the Nave, 1425-46 (photo), Brunelleschi, Filippo Metropolitan Museum of Art/Art Resource, NY; 8-29: © Jonathan Poore/Cengage Art Resource, NY; 8-27: Summerfield Press Ltd.; 8-28: Image copyright © The Italy; 8-24: Scala/Art Resource, NY; 8-25: Canali Photobank, Italy; 8-26: Scala/ Resource, NY; 8-22: Erich Lessing/Art Resource, NY; 8-23: Canali Photobank, 2013 Fred S. Kleiner; 8-20: Erich Lessing/Art Resource, NY, 8-21: Scala/Art © Jonathan Poore/Cengage Learning, 8-18: Erich Lessing/Art Resource; 8-19: 8-15: Scala/Art Resource, NY; 8-16: © Jonathan Poore/Cengage Learning; 8-17: NY; 8-13: Erich Lessing/Art Resource, NY; 8-14: Erich Lessing/Art Resource, NY; atliche Museen/Art Resource, NY, 8-11: AKG Images; 8-12: Scala/Art Resource, Condé/Grand Palais/Art Resource, NY; 8-10: bpk, Berlin/Gemaeldegalerie, Sta-8-7: Erich Lessing/Art Resource, NY; 8-8: Scala/Art Resource, NY; 8-9: Musée NY; 8-5: Erich Lessing/Art Resource, NY; 8-6: Erich Lessing/Art Resource, NY; politan Museum of Art. Image source: Art Resource, NY, 8-4: Scala/Art Resource, 93.153; 8-2: Erich Lessing/Art Resource, NY; 8-3: Image copyright © The Metro-Chapter 8-8-1 (all): Photograph © 2011 Museum of Fine Arts, Boston. © Fred S. Kleiner, 2012.

Art Library International; 9-1c: akg-images/Electa; 9-2: Erich Lessing/Art Resource, ums; 9-1b: Vatican Museums and Galleries, Vatican City, Italy/The Bridgeman Chapter 9—9-1: Canali Photobank; 9-1a: © Bracchietti-Zigrosi/Vatican Muse-

London, UK/The Bridgeman Art Library; 13-2: Erich Lessing/Art Resource, NY; 13-3: Erich Lessing/Art Resource, NY; 13-4: RMN-Grand Palais/Art Resource, NY; 13-5: © Culture and Sport Glasgow (Museums); 13-6: Photography © The Art Institute of Chicago, 1910.2; 13-7: Summer's Day, 1879 (oil on canvas), Morisot, Berthe (1841-95)/National Gallery, London, UK/The Bridgeman Art Library; 13-8: Nocturne in Black and Gold, the Falling Rocket, 1875 (oil on panel), Whistler, James Abbott McNeill (1834-1903)/Detroit Institute of Arts, USA/Gift of Dexter M. Ferry Jr./The Bridgeman Art Library; 13-9: Photography © The Art Institute of Chicago, 1928.610; 13-10: Helen Birch Bartlett Memorial Collection, 1926.224, The Art Institute of Chicago. Photography © The Art Institute of Chicago; 13-11: Yale University Art Gallery/Art Resource, NY; 13-12: Digital Image © The Museum of Modern Art/Licensed by SCALA/Art Resource, NY; 13-13: National Galleries of Scotland, Dist./RMN-Grand Palais/Art Resource, NY; 13-14: Photograph © 2011 Museum of Fine Arts, Boston, 36.270; 13-15: Photograph © Philadelphia Museum of Art, E1936-1-1; 13-16: Digital Image © The Museum of Modern Art/Licensed by SCALA/Art Resource, NY; 13-17: © 2011 The Munch Museum/The Munch-Ellingsen Group/Artists Rights Society (ARS), NY. Photo: © Erich Lessing/Art Resource, NY; 13-18: Erich Lessing/Art Resource, NY; 13-19: The Gates of Hell, 1880-90 (bronze), Rodin, Auguste (1840-1917)/Musee Rodin, Paris, France/Peter Willi/The Bridgeman Art Library; 13-20: SOFAM; 13-21: © Jonathan Poore/Cengage Learning; 13-22: Hedrich Blessing Collection/Archive

Photos/Chicago History Museum/Getty Images. Chapter 14-14-1 (all): © 2014 Estate of Pablo Picasso/Artists Rights Society (ARS), New York, Digital Image © The Museum of Modern Art/Licensed by SCALA/Art Resource; 14-2: © 2011 Succession H. Matisse, Paris/Artists Rights Society (ARS), NY. Photo © San Francisco Museum of Modern Art; 14-3: © 2011 Succession H. Matisse, Paris/Artists Rights Society (ARS); 14-4: Digital Image © The Museum of Modern Art/Licensed by SCALA/Art Resource, NY; 14-5: © 2011 Artists Rights Society (ARS), New York/ADAGP, Paris. Photo: © Solomon R. Guggenheim Museum; 14-6: Oeffentliche Kunstsammlung Basel, photo Martin Bühler; 14-7: © 2011 Artist's Rights Society (ARS), New York/VG Bild-Kunst, Bonn. Photo: © Erich Lessing/Art Resource, NY; 14-8: © 2011 Artists Rights Society (ARS), NY/ADAGP, Paris. Photo: © Bridgeman-Giraudon/Art Resource, NY; 14-9: © 2011 Estate of Pablo Picasso. Licensed by Artist's Rights Society (ARS), NY. Photo: © Réunion des Musées Nationaux/Art Resource, NY; 14-10: © 2011 Estate of Pablo Picasso/Artists Rights Society (ARS), NY. Photo: © Erich Lessing/Art Resource, NY; 14-11: © 2011 Artists Rights Society (ARS), New York/ADAGP, Paris. Photo: © The Philadelphia Museum of Art/Art Resource, NY; 14-12: © 2011 Artist's Rights Society (ARS), NY. © DACS/The Bridgeman Art Library; 14-13: Digital Image © The Museum of Modern Art/Licensed by SCALA/Art Resource, NY; 14-14: © 2011 Artists Rights Society (ARS), NY Photo Credit: Digital Image © The Museum of Modern Art/Licensed by SCALA/Art Resource, NY; 14-15: © 2011 Artists Rights Society (ARS), New York/ADAGP, Paris/Succession Marcel Duchamp. Photo: © Philadelphia Museum of Art, 1998-74-1; 14-16: © 2014 Artists Rights Society (ARS), New York/VG Bild-Kunst, Bonn. Digital image: bpk, Berlin/Nationalgalerie, Staatliche Museen, Berlin, Germany/Jörg P. Anders/Art Resource, NY; 14-17: Digital Image © The Museum of Modern Art/Licensed by SCALA/Art Resource, NY; 14-18: Photo © Philadelphia Museum of Art, 1950-134-59, © 2008 Artists Rights Society (ARS), New York/ADAGP, Paris/Succession Marcel Duchamp; 14-19: Fisk University Galleries, University of Tennessee, Nashville; 14-20: Digital Image © The Museum of Modern Art/Licensed by SCALA/Art Resource, NY; 14-21: Photograph by Edward Weston. Collection Center for Creative Photography ©1981 Arizona Board of Regents; 14-22: © 2011 Artists Rights Society (ARS), NY/VG Bild-Kunst, Bonn. Photo © Erich Lessing/Art Resource, NY; 14-23: © 2011 Estate of Giorgio de Chirico, Licensed by Artist's Rights Society (ARS), NY. Photo: © The Museum of Modern Art/Licensed by SCALA/Art Resource, NY; 14-24: © 2012 Salvador Dali, GalaSalvador Dali Foundation/Artists Rights Society (ARS), NY. Digital Image © The Museum of Modern Art/Licensed by Scala/Art Resource, NY, 162.1934; 14-25: Digital Image © 2009 Museum Associates/LACMA/Art Resource, NY; 14-26: © 2011 Artist's Right's Society (ARS), NY/ProLitteris, Zürich. Digital Image © The Museum of Modern Art/Licensed by SCALA/Art Resource, NY; 14-27: © 2011 Successió Miró/Artists Rights Society (ARS), NY/ADAGP, Paris. Digital Image @ The Museum of Modern Art/Licensed by Scala/Art Resource, NY, 229.1937; 14-28: © 2011 Artists Rights Society (ARS), New York Photo: Digital Image © The Museum of Modern Art/Licensed by SCALA/Art Resource, NY; 14-29: © 2011 Mondrian/Holtzman Trust c/o HCR International, VA, USA; 14-30: © 2012 Artists Rights Society (ARS), NY/ADAGP, Paris. © Philadelphia Museum of Art/Corbis, 1950-134-14, 15; 14-31: @ Bowness, Hepworth Estate. Photo © Tate, London/Art Resource, NY; 14-32: © 2011 Estate of Alexander Calder/Artists Rights Society (ARS), NY. Digital Image © The Museum of Modern Art/Licensed by Scala/Art Resource, NY, 590.1939 a-d; 14-33: Courtesy The Dorothea Lange Collection, The Oakland Museum of California; 14-34: Margaret Bourke-White/Time & Life Pictures/Getty Images; 14-35: Photography © The Art Institute of Chicago, 1942.51, Estate of Edward Hopper © The Whitney Museum of American Art; 14-36: © 2011 The Jacob and Gwendolyn Lawrence Foundation, Seattle/Artists Rights Society (ARS), NY. Photo: The Phillips Collection, Washington, DC; 14-37: Art © Figge Art Museum, successors to the Estate of Nan Wood Graham/Licensed by VAGA, New York, NY Photography © The Art Institute of Chicago,1930.934; 14-38: © 2011 Banco de México Trust. Licensed by Artist's Rights Society (ARS), NY. Dirk Bakker, photographer for the Detroit Institute of Arts/The Bridgeman Art Library; 14-39: © 2011 Banco de México Trust. Licensed by Artists Rights Society (ARS), NY. Photo © Schalkwijk/Art Resource,

NY; **14-40:** © Jonathan Poore/Cengage Learning; **14-41:** © 2011 Artists Rights Society (ARS), NY/VG Bild-Kunst, Bonn. Digital Image © The Museum of Modern Art/Licensed by Scala/Art Resource, NY; **14-42:** © Jonathan Poore/Cengage Learning; **14-43:** Peter Cook/VIEW View Pictures/Newscom.

Chapter 15—15-1 (all): © Fred S. Kleiner; 15-2: © 2011 Artists Rights Society (ARS), NY/ADAGP, Paris. Photo: © Des Moines Art Center; 15-3: © The Estate of Francis Bacon. All rights reserved/DACS, London/ARS, NY 2014. Digital Image © Museum of Modern Art/Licensed by Scala/Art Resource, NY, 229.1948; 15-4: © 2014 The Arshile Gorky Foundation/The Artists Rights Society (ARS), New York. Photograph: © The Museum of Modern Art/Licensed by SCALA/Art Resource, NY; 15-5: © 2011 The Pollock-Krasner Foundation/Artists Rights Society (ARS), NY. Photo © National Gallery of Art, 1976.37.1; 15-6: © 2011 The Willem de Kooning Foundation/Artists Rights Society (ARS), NY. Digital Image © The Museum of Modern Art/Licensed by Scala/Art Resource, NY, 478.1953; 15-7: © 2011 Kate Rothko Prizel & Christopher Rothko. Licensed by Artists Rights Society (ARS), NY. Photo: © San Francisco Museum of Modern Art; 15-8: © 2011 Frank Stella/Artists Rights Society (ARS), NY. Photo © CNAC/MNAM/Dist. Réunion des Musées Nationaux/Art Resource, NY; 15-9: Helen Frankenthaler, The Bay, 1963 (acrylic on canvas), 205.1 × 207.7 cm, Detroit Institute of Arts, USA/© DACS/Founders Society Purchase, Dr. & Mrs. Hilbert H. DeLawter Fund/ The Bridgeman Art Library International. Art © 2011 Helen Frankenthaler/Artists Rights Society (ARS), New York; 15-10: The Museum of Modern Art/Licensed by SCALA/Art Resource, NY. @ Bridget Riley 2014. All rights reserved, courtesy Karsten Schubert, London; 15-11: Hirshhorn Museum and Sculpture Garden, Smithsonian Institution, Photo: Lee Stalsworth, Art: Estate of David Smith/Licensed by VAGA, New York, NY; 15-12: Art © Judd Foundation/Licensed by VAGA, NY Hirshhorn Museum and Sculpture Garden, Smithsonian Institution, photo Lee Stalsworth, 72.154; 15-13: © 2012 Estate of Louise Nevelson/Artists Rights Society (ARS), NY. Photo © CNAC/MNAM/Dist. Réunion des Musées Nationaux/Art Resource, NY; 15-14: Art © Louise Bourgeois Trust/Licensed by VAGA, New York, NY Photo © CNAC/MNAM/Dist. Réunion des Musées Nationaux/Art Resource, NY; 15-15: © 2011 Artists Rights Society (ARS), NY/DACS, London. Photo © The Bridgeman Art Library; 15-16: Art © Jasper Johns/Licensed by VAGA, New York, NY Photo: Whitney Museum of American Art, New York, USA/© DACS/The Bridgeman Art Library; 15-17: Art © Estate of Robert Rauschenberg/Licensed by VAGA, New York, NY. Digital Image © The Museum of Modern Art/Licensed by SCALA/Art Resource, NY; 15-18: © Estate of Roy Lichtenstein; 15-19: © The Whitney Museum of American Art, New York, Photograph by Geoffrey Clements, © 2012 The Andy Warhol Foundation for the Visual Arts, Inc./Artists Rights Society (ARS), New York; 15-20: Art © Copyright 1969 Claes Oldenburg. Photo: © 2009 Fred S. Kleiner; 15-21: © Audrey Flack Collection of The University of Arizona Museum of Art & Archive of Visual Arts, Tucson Museum Purchase with Funds Provided By the Edward J. Gallagher, Jr. Memorial Fund; 15-22: Close, Chuck Big Self Portrait 1967-68, acrylic on canvas. Collection Walker Art Center Minneapolis. Art Center Acquisition Fund, 1969; 15-23: Art © Estate of Duane Hanson/Licensed by VAGA, New York, NY Photo by Anne Gold; 15-24: Reproduced with permission of the Minor White Archive, Princeton University Art Museum. © Trustees of Princeton University. Digital Image © The Museum of Modern Art/Licensed by SCALA/Art Resource, NY; 15-25: © 2011 Judy Chicago. Licensed by Artists Rights Society (ARS), NY. Photo: © The Brooklyn Museum; 15-26: Cindy Sherman, courtesy the artist and Metro Pictures; 15-27: Magdalena Abakanowicz, courtesy Marlborough Gallery, NY; 15-28: © Jonathan Poore/Cengage Learning; 15-29: © 2012 Artists Rights Society (ARS), New York/ADAGP, Paris/F.L.C./Photo by Jonathan Poore/Cengage Learning; 15-30: © 2012 Artists Rights Society (ARS), New York/ADAGP, Paris/F.L.C. Photo: © Francis G. Mayer/CORBIS; 15-31: © Jonathan Poore/Cengage Learning; 15-32: dk/Alamy; 15-33: © Jonathan Poore/Cengage Learning; 15-34: Art © Estate of Robert Smithson/Licensed by VAGA, New York, NY//Photo © George Steinmetz/Corbis; 15-35: © 2011 Carolee Schneemann/Artists Rights Society (ARS), NY. Photo @ Al Geise, Courtesy PPOW Gallery; 15-36: Digital Image © The Museum of Modern Art/Licensed by SCALA/Art Resource, NY; 15-37: Courtesy Nam June Paik Studios, Inc.

Chapter 16—16-1 (all): Courtesy artist Jaune Quick-to-See Smith (Salish member of the Confederated Salish and Kootenai Nation, MT, and The Accola Griefen Gallery, New York). Digital Photo: Chrysler Museum of Art; 16-2: The Broad Art Foundation, Santa Monica Photography credit: Douglas M. Parker Studio, Los Angeles; 16-3: © 1983 Faith Ringgold; 16-4: Copyright: Barbara Kruger. Courtesy: Mary Boone Gallery, New York; 16-5: Self-Portrait, 1980 © Copyright The Robert Mapplethorpe Foundation. Courtesy Art + Commerce; 16-6: © Shahzia Sikander. Photograph: Sheldan C. Collins, courtesy Whitney Museum of American Art; 16-7: © Chris Ofili, courtesy Chris Ofili-Afroco and Victoria Miro Gallery, photo by Stephen White; 16-8: Allegiance with Wakefulness, 1994 (offset print), Neshat, Shirin (b. 1957)/84 × 105 cm/The Israel Museum, Jerusalem, Israel/Anonymous gift, New York/to American Friends of the Israel Museum/The Bridgeman Art Library; 16-9: Photograph by Martha Rosler, Represented by Mitchell-Innes & Nash, NYC; 16-10: Marlborough Gallery in NY; 16-11: Willie Bester; 16-12: Bloodline: Big Family, No. 2, 1995 (oil on canvas), Zhang Xiaogang (b. 1958)/Private Collection/Photo © Christie's Images/The Bridgeman Art Library; 16-13: Copyright © Xu Bing, courtesy Chazen Museum of Art (formerly Elvehjem Museum of Art), University of Wisconsin; 16-14: © Jenny Saville. Courtesy Gagosian Gallery; 16-15: Photo @ Whitney Museum of American Art, © Kiki Smith; 16-16: Museum of Contemporary Art, Chicago © Jeff Koons; 16-17: Dallas Museum of Art, Dallas; 16-18: Digital Image © The Museum of

Iyn Museum; 19-21: AP Photo/Kyodo News; 19-22: © DEA PICTURE LIBRARY. Museum 30.1478.30 Gift of Anna Petris. Museum photograph © 2006 The Brook-Photograph © 2011 Museum of Fine Arts, Boston. 11.17652; 19-20: Brooklyn Library; 19-18: TMM Image Archives, Source: http://TMMArchives.jp/; 19-19: Library at The Cleveland Museum of Art; 19-17: Lebrecht Music and Arts Photo fice. Haga Library/Lebrecht Music and Arts Photo Library; 19-16: The AMICA Photo Research Laboratory/Corbis; 19-15: Photograph by Oyamazaki Town Of-19-13: TVM Image Archives, Source: http://TVMArchives.jp/; 19-14: Sakamoto

Chapter 21—21-1 (all): © The Metropolitan Museum of Art/Art Resource, Victoria; 20-33: Copyright © Otago Museum, Dunedin, New Zealand, D45.179. chaeology & Anthropology, E 1895.158; 20-32: Reproduced courtesy Museum of 20-31: Reproduced by permission of the University of Cambridge Museum of Ar-Pauahi Bishop Museum, Honolulu; 20-29: akg-images; 20-30: The Ngati Awa; West/21.69.37; 20-27: Stephen Tapply/Alamy; 20-28: Photo by Seth Joel, Bernice Peck/Buffalo Bill Center of the West, Cody, Wyoming/Buffalo Bill Center of the Museum of Natural History, Library; 20-26: The Art Archive/Gift of Clara S. American Museum of Natural History, Library; 20-25: Image # 4480, American 20-24: Photo © National Museum of Women in the Arts; 20-25: Image # 4481, ages; 20-23: Arizona State Museum, University of Arizona, photo W. McLennan; Mark Newman/Media Bakery; 20-22: Ira Block/National Geographic/Getty Im-Corbis; 20-19: Ohio Historical Society; 20-20: Tony Linck/SuperStock; 20-21: Agostini Picture Library/Getty Images; 20-18: Michael Freeman/Encyclopedia/ 31.501; 20-15: SGM/Stock Connection; 20-16: Nathan Benn/CORBIS; 20-17: De Orti/Fine Art/Corbis; 20-14: Photograph © 2011 Museum of Fine Arts, Boston. graphic Society; 20-12: Gianni Dagli Orti/Fine Art/Corbis, 20-13: Gianni Dagli than Blair/CORBIS; 20-11: Adapted from an image by Ned Seidler/National Geo-20-8: Yann Arthus-Bertrand/CORBIS; 20-9: Scala/Art Resource, NY; 20-10: Jona-Westmorland/Getty Images; 20-7: The British Museum/HIP/The Image Works; Maschmeyer/age fotostock; 20-5: Sean Sprague/The Image Works; 20-6: Stuart Oronoz/Album/SuperStock; 20-3: Georg Gerster/Science Source; 20-4: Richard copyright Bonampak Documentation Project, Yale University; 20-2: Album/ Chapter 20-20-1 (all): Reconstruction by Heather Hurst and Leonard Ashby.

21-21: Photograph by Eliot Elisofon, 1971, EEPA EECL 2139, Eliot Elisofon Phomentary Value/Corbis; 21-20: Fowler Museum at UCLA, photo: Don Cole; 21-18: © Trustees of the British Museum, London; 21-19: Fulvio Roiter/Docutional Museum of African Art, Smithsonian Institution; 21-17: Herbert M. Cole; Trustees of the British Museum/Art Resource, NY; 21-16: Photo by Eliot Elisofon, 1970, Image no. EEPA EECL 7590. Eliot Elisofon Photographic Archives, Na-NY; 21-14: © The Metropolitan Museum of Art/Art Resource, NY; 21-15: The African Art/The Bridgeman Art Library; 21-13: Werner Forman/Art Resource, Institute of Arts, USA/Founders Society Purchase/Eleanor Clay Ford Fund for n'kondi) Yombe, Congo (mixed media), African School, (19th Century)/Detroit 21-11: Musée du Quai Branly/Scala/Art Resource, NY; 21-12: Nail figure (nkisi Barbier-Mueller; 21-10: Bildarchiv Preussischer Kulturbesitz/Art Resource, NY; Nazionale Preistorico e Etnografico Luigi Pigorini, Rome; 21-9: abm-Archives copyright © The Metropolitan Museum of Art/Art Resource, NY; 21-8: Museo 21-6: I Vanderharst/Robert Harding World Imagery/Getty Images; 21-7: Image Dirk Bakker/The Bridgeman Art Library; 21-5: Yann Arthus-Bertrand/Corbis; NY; 21-2: Jean-Dominique Lajoux; 21-3: Scala/Art Resource, NY; 21-4: Figure of an Oni, Ife (zire brass), c. 14th c., Yoruba Culture/Private Collection/Photo ©

tographic Archives, National Museum of African Art, Smithsonian Institution.

Magers Berlin London; 16-27: Bill Viola, photo: Kira Perov; 16-28: Photograph Rights Society (ARS), New York/VG Bild-Kunst, Bonn. Photo, Courtesy Sprüth nie; 16-25: © Richard T. Nowitz/Corbis; 16-26: © 2011 Andreas Gursky/Artists Artists Rights Society (ARS), NY. Photo © Burt Roberts, courtesy of Harriet Se-Christo; 16-23: Kokyat Choong/The Image Works; 16-24: © 2011 Richard Serra/ Gollings/Arcaid/Architecture (RM)/Corbis; 16-22: Wolfgang Volz @ 1983 Image Works; 16-20: Martin Jones/Ecoscene/Encyclopedia/Corbis; 16-21: John Modern Art/Licensed by SCALA/Art Resource, NY; 16-19: 2006 © Joe Sohm/The

Phototravel/Corbis; 17-1b: Tim Makins/Getty Images; 17-1c: Robert Harding Chapter 17-17-17 Yogesh S. More/age fotostock/SuperStock; 17-1a: Atlantide by David Heald @ The Solomon R. Guggenheim Foundation, NY.

seum, New Delhi; 17-22: FIONLINE/SuperStock; 17-23: age fotostock/Getty Im-Documentary Value/Corbis; 17-20: Charles O. Cecil/Alamy; 17-21: National Muian Institution, Washington, DC, Purchase, F1942.15a; 17-19: Kevin R. Morris/ V&A Images, London/Art Resource, NY; I7-18: Freer Gallery of Art, Smithson-Jones/Alamy; 17-15: akg-images; 17-16: Erich Lessing/Art Resource, NY; 17-17: 17-12: Saskia Ltd.; 17-13;: V. Muthuraman/Getty Images; 17-14: © David Keith I7-9: © Dinodia/AGE Fotostock.com; I7-10: © Luca Tettoni; I7-11: Saskia Ltd.; I7-7: Benoy K. Behl; I7-8: Photo © Luca Tettoni/The Bridgeman Art Library; Gallery of Art, Smithsonian Institution, Washington, DC. Purchase, F1949.9a-d; Library; I7-3: Benoy K. Behl; I7-4: John Burge; I7-5: akg-images; I7-6: Freer 2300-1750 BC/National Museum of India, New Delhi, India/The Bridgeman Art World Imagery/Getty Images; 17-2: Steatite Pasupati seal, Mohenjodaro,

18-1b: Best View Stock/Getty Images, 18-1c: Vidler Steve/Prisma Bildagentur Chapter 18—18-1: Photos12.com; 18-1a: Best View Stock/Photolibrary; bis; 17-26: Stuart Westmorland; 17-27: Ladislav Janicek/Flame/Corbis. ages; I7-24: Charles & Josette Lenars/CORBIS; I7-25: © Christophe Loviny/Cor-

ture Library/Art Resource, NY; 18-23: Chad Ehlers/Alamy; 18-24: Yoshio Tomii/ Norbert Miguletz. Exhibited at Schirn Kunsthalle, Frankfurt; 18-22: © DeA Picums of Asian Art. Giff of Arthur M. Sackler \$1987.204.10; 18-21: Photograph by of Art, Cleveland; 18-20: Freer and Sackler Galleries of Art: Smithsonian's Muse-Snell/Alamy; 18-18: Best View Stock/Alamy; 18-19: Image © Cleveland Museum Republic of China; 18-16: © The Trustees of the British Museum; 18-17: Michael tional Palace Museum; 18-15: Collection of the National Palace Museum, Taiwan, Learning; 18-13: © Yan Yan/Xinhua Press/Corbis; 18-14: Collection of the Na-Picture Desk; 18-11: Cultural Relics Publishing House, Beijing; 18-12: Cengage of Fine Arts, Boston; 18-10: The Art Archive/National Palace Museum Taiwan/ 18-8: Cultural Relics Publishing House, Beijing, 18-9: Photograph © 2011 Museum British Museum/Art Resource, NY; 18-7: TAO Images Limited/Getty Images; chase, Nelson Trust, 33-521. Photo: Robert Newcombe, 18-6: The Trustees of the CORBIS; 18-5: The Nelson-Atkins Museum of Art, Kansas City, Missouri. Pur-Collection; 18-3: Chu Yong/Getty Images; 18-4: © Asian Art & Archaeology, Inc./ AG/Alamy; 18-2: Asian Art Museum of San Francisco, The Avery Brundage

Value/Corbis; 19-12: TVM Image Archives, Source: http://TVMArchives.jp/; © 2011 Museum of Fine Arts, Boston; 19-11: Michael S. Yamashita/Documentary 19-8: The Gotoh Art Museum, Tokyo; 19-9: Todaiji, Nara; 19-10: Photograph amana images inc./Alamy; 19-6: Kyoogokokuji (Toji), Kyoto; 19-7: © B.S.P.I./Corbis; seum. Image © TMM Image Archives; 19-4: Iberfoto/The Image Works; 19-5: cago; 19-2: Georg Gerster/Photo Researchers, Inc.; 19-3: Toyko National Mu-Chapter 19-19-1 (all): 1925.2043, Photography @ The Art Institute of Chi-

SuperStock; 18-25: Leeum, Samsung Museum of Art.

909

NOTE: Italic page numbers indicate illustrations.

Numbers

18th century European and American art: Enlightenment and Industrial Revolution, 313, 314, 316-323; Grand Tour, 321-322; Neoclassic art and architecture, 313, 323-328; Rococo art and architecture, 314-316, 329 18th century Oceanic art, 547-548 19th century African art, 562-565, 571 19th century Oceanic art, 548–550 20th century Africa art, 566-570, 571 20th century Oceanic art, 550-552 80 Backs (Abakanowicz), 428, 428 1948-C (Still), 2

Aachen, Germany: Coronation Gospels (Gospel Book of Charlemagne), 162, 162; Palatine Chapel of Charlemagne, 163-164, 164, 166

Abakanowicz, Magdalena, 80 Backs, 428, 428

Abbasids (caliphs of Iraq), 144, 148-149, 151

Abd al-Malik (Umayyad caliph), 144, 146 Abd al-Rahman I (Umayyad emir), 143,

Abduction of the Sabine Women (Giambologna) (sculpture), 271, 271

Abe, Shuya, 435 Abraham's sacrifice of Isaac, east portal doors, Baptistery of San Giovanni (Ghiberti), 229-233, 230, 231

Abraham's sacrifice of Isaac, Rome (relief on sarcophagus), 116, 117 Abstract Expressionism, 2, 340, 412, 413-416, 418-420, 422, 437, 439,

441, 450 abstract painting, 5. See also specific works of art for examples

abstract sculpture, 378 Abu Ghraib 46 (Botero), 446, 446 Abu Simbel, Egypt, facade of the temple

of Ramses II, 38, 38 Abul Fazl, 473

Achaemenes (king of Persia), 28 Achaemenid art, 16, 16, 28-30, 29, 43 Achilles and Ajax playing dice game, black-figure amphora, Vulci, Italy (Exekias), 59-60, 59

Achilles Painter: depiction of Achilles, 5: warrior taking leave of his wife, Eretria (vase painting), 72, 72

Acropolis, Athens, Greece: Athena Parthenos, Athens, Greece (Phidias). 44, 45, 66, 67, 76; Erechtheion, 70, 70; Kritos Boy, Acropolis, Athens, Greece, 63, 63; Nike adjusting her sandal, parapet of Temple of Athena Nike, 71, 71; Parthenon (Iktinos and Kallikrates), 44, 45, 66–69, 66, 67, 68, 69, 73, 76; Peplos Kore (statue), 56, 56; restored view of (John Burge), 66; Temple of Athena Nike, 70-72, 70, 71

Adad (Mesopotamian deity), 28, 29 Adam and Eve: in early Christian art, 116, 117, 119; in early Renaissance art, 216, 217, 222, 222; in High Renaissance/Mannerist art, 250, 251, 257-260, 259, 260; in Ottonian art. 169, 169

Adam and Eve in the garden, Rome (relief on sarcophagus), 116, 117

additive light, 7 additive sculpture, 11

Adena art, 528, 542, 542

Admonitions of the Instructress to the Court Ladies (Gu Kaizhi), 488, 489,

Adoian, Vosdanik Manoog. See Gorky, Arshile

Adoration of the Magi, Santa Trinità, Florence (Gentile da Fabriano), 120, 234-235, 235

Adoration of the Shepherds, Portinari Altarpiece, Sant'Egidio, Florence (Hugo van der Goes), 120, 224, 225

Aegean art (prehistoric): Cycladic period, 46, 47-48, 48, 81; Minoan, 48-51; Mycenaean, 51-53

Aegina, Greece, Temple of Aphaia, 61-62, 61, 62

Aeneas (Roman deity), 47, 98-99 Aeneid (Vergil), 80, 99

aerial perspective. See atmospheric perspective

Aertsen, Pieter, Butcher's Stall, 279, 279, 283, 283

Aeschylus, 63, 75

African American art, 390, 402-403, 409, 412, 440-441, 558-561. See also specific African Americans

African art: 11th to 18th centuries, 571; 19th century, 562–565, 571; 20th century, 566–570, 571; apprentices, 567; Asante, *566*, 567, 571; background, 556–557, 558; Bamum, 562, 562, 571; Benin kingdom, 10, 554, 555, 556, 560, 561, 566, 566, 571; Chokwe, 564, 564, 571; contemporary, 446, 450-451, 459, 570; Djenne, 556, 558, 559, 559, 571; Dogon, 564-565, 564, 571; Fon, 563, 571; Great Zimbabwe, 556, 558, 560, 560, 571; Ife, 558, 559, 559, 571; Igbo Ukwu, 556, 571; Kalabari Ijaw, 565, 565, 571; Kongo, 563, 563, 571; Kota, 556, 562, 562, 571; Kuba, 560, 569-570, 571; leaders' arts, 559, 559; location of, 556map; Mende, 569, 569, 571; Nok, 556, 557-558, 571; prehistoric, 556, 557; Sapi, 556, 560-561, 561, 571; Senufo masqueraders, 568, 568, 569, 571; Western fascination with (primitivism), 383; Yoruba, 567-569, 571

African masquerades, 557, 568, 568, 569, 571, 571

age of art, 2-3 Agni (Aryan deity), 463

Agra, India, Taj Mahal (Ustad Ahmad Lohori?), 462, 475-476, 475

Agrippa of Nettesheim, Heinrich Cornelius, De occulta philosophia, 275 Ahmose I (pharaoh of Egypt), 36

Ain Ghazal, Jordan, human figure (sculpture), 21, 21

Ajanta, India, cave paintings, 468, 468, 481

Akbar and the Elephant Hawai, Akbarnama (Basawan and Chatar Muni), 473-474, 473

Akbar the Great (Mughal emperor), 473, 475, 481

Akbarnama (History of Akbar) (Abul Fazl), 473-474, 473

Akhenaton, Aton, Karnak (sculpture), 40, 40 Akkad, 16

Akkadian art, 25-26, 25, 26, 27, 27, 43 Akrotiri (Cyclades), landscape with

swallows (Spring Fresco), 49-50, 50 Alaric (Visigoth king), 124, 141 Albers, Josef, Homage to the Square, 7, 7

Alberti, Leon Battista: demands for churches, 262; On the Art of Building, 218, 232, 246, 249; On Painting, 218, 231; Sant'Andrea, Mantua, Italy, 218, 246, 246, 249, 249, 263, 264; style of, 213; West facade, Santa Maria Novella, Florence, 264

album leaves, 491, 495, 495, 500, 500 Alcuin of York, 162 Alexander VI (Pope), 255, 263

Alexander VII (Pope), 287, 295 Alexander Mosaic (Battle of Issus)

(Philoxenos of Eretria), 74-75, 75 Alexander of Antioch-on-the-Meander, Aphrodite (Venus de Milo) (sculpture), 78-79, 78

Alexander the Great: conquest of Egypt, 42, 72, 76; conquest of Mesopotamia, 76; conquest of Persia, 28, 29, 30, 72, 74, 461; Greece and, 74–75; India and, 72, 461, 462; portrait of, 74; razing of Persepolis, 29

Algeria, running woman, Tassili n'Ajjer (rock painting), 557-558, 571, 571

Alhambra, Granada, Spain: Court of the Lions, Palace of the Lions, 149-150, 149, 155; Muqarnas dome, Hall of the Abencerrajes, Palace of the Lions, 149, 149, 155, 155; palaces in, 144

Allegiance and Wakefulness, Women of Allah series (Neshat), 445, 445

Allegory of the Art of Painting (Vermeer), 304-305, 305 Alloway, Lawrence, 421

Altar of Zeus, Pergamom, Turkey, 76-77, 76, 77

Altar to the Hand, Benin (cast bronze), 10, 10, 560

Aman-Re (Egyptian deity), 38-39 Amarna, Egypt, bust of Nefertiti (Thutmose), 40-41, 41

Amazonomachy, 67 Ambum Stone, Papua New Guinea, 547 Amen-Re temple, Karnak, Egypt,

38-40, 39American art and architecture: 18th century, 320-321, 326-328, 328,

329; Art Nouveau, 373; contemporary, 439, 440-443, 446, 449-450, 453-456, 457-458; Impressionism, 362-363; Realism, 347-348; Romanticism, 341, 355; Sullivan's architecture, 374. See also Native American art

American Gothic (Wood), 403, 403 American Revolution, 313, 314, 316, 329 Amida (Amitabha Buddha), 466. See also Pure Land Buddhism

Amiens Cathedral, Amiens, France (Robert de Lauzarches, Thomas and Renaud de Cormont), 196, 197

Amitabha Buddha, 466. See also Pure Land Buddhism

Amor. See Eros (Amor, Cupid) (Greek/ Roman deity)

amphitheater, Pompeii, Italy, 91, 91, 93, 101

Amsterdam, Netherlands: The Company of Captain Frans Banning Cocq (Night Watch), Musketeers Hall, 301-302, 301; economic prosperity of. 300

Analytic Cubism, 383-384, 385, 390

anamorphic images, 276

Anasazi art, 543-545 Anatsui, El: Bleeding Takari II, 450-451, 451, 459; style of, 459

Anavysos, Greece: Kouros? (sculpture), 55, 55; Krioisos (sculpture), 55-56, 55

Ancestral Puebloan art and architecture, 528, 543-545, 553

ancestral screen (nduen fobara), Kalabari Ijaw, Nigeria, 565, 565

Ancient Mexico, History of Mexico, Palacio Nacional, Mexico City (Rivera), 403-404, 404

Andean South American art. See South American art and architecture

Angelic Concert, Isenheim Altarpiece, Hospital of Saint Anthony (Grünewald), 272

Angkor Thom, 479 Angkor Wat, Angkor, Cambodia, 478, 479, 481

Anglo-Saxons: cloisonné ornamentation, 159, 159; illuminated manuscripts, 158-161; small utilitarian items, 158

Annunciation, Ghent Altarpiece, Saint Bavo Cathedral, Ghent (Hubert and Jan van Eyck), 221, 221

Annunciation, Isenheim Altarpiece, Hospital of Saint Anthony (Grünewald), 272

Annunciation, Maestà altarpiece, Siena Cathedral, Siena, Italy, 210, 210 Annunciation, Mérode Altarpiece

(Campin), 220, 221 Annunciation, Reims Cathedral, Reims, France, 196, 197, 198

Annunciation, San Marco, Florence (Fra Angelico) (fresco), 237, 237

Annunciation altarpiece, Saint Ansanus, Siena, Cathedral, Siena, Italy (Simone Martini and Lippo Memmi), 210-211, 211

Annunciation and Visitation, Reims Cathedral (sculpture), 196, 197, 198 Annunciation to Mary, Saint Michaels, Hildesheim, Germany (Bernward), 120, 168, 168

401 '06

179' 177' 104

Constantinople, Turkey, 126-128,

Anthemius of Tralles, Hagia Sophia,

Liberty, New York, 373 Bartholdi, Frédéric Auguste, Statue of London, 348, 349 Barry, Charles, Houses of Parliament, architecture barroco. See Baroque art and Barrie, Dennis, 443 411; Spanish, 295-298, 311 287; Piazza d'Italia, New Orleans, 287-295, 311; origin of the term, , 285, 9, 306-309, 311; Italian, 285, Flemish, 9, 298-300, 311; French, 300-306, 311; English, 310, 311; Baroque art and architecture: Dutch, 458; multimedia installations, 459 Barney, Matthew: Cremaster cycle, 458, Barbizon School, 343-344 (sculpture), 79, 79 Barberini Faun (sleeping satyr), Rome 855,755 A Bar at the Folies-Bergère (Manet), 356, 202,206 baptistery pulpit, Pisa (Nicola Pisano), Paradise (Ghiberti), 229-233, 231, competition, 229-230, 230; Gates of Baptistery of San Giovanni, Florence: 211,78,88,78-88 Banditaccia necropolis, Cerveteri, Italy, Bamum art, 562, 562, 571 (Léger), 385 Ballet Mécanique (Mechanical Ballet) a Leash, 386, 386 Balla, Giacomo, Dynamism of a Dog on ball court, Copán, Honduras, 532, 532 Baldinucci, Filippo, 289 587, 289 baldacchino, Saint Peter's (Bernini), 287, relief), 468, 469, 469, 481 Badami, India, dancing Shiva (rock-cut Bacon, Francis, Painting, 413, 413 (Creek/Roman deity) Bacchus. See Dionysos (Bacchus) Neo-Babylonian art (Tower of Babel), 23, 28. See also (Babylon ziggurat), 23, 28; ziggurat mythology, 28; Tower of Babel restoration, 28; religion and 26-27, 26; Neo-Babylonian 28, 29; law stele of Hammurabi, Hammurabi's law, 16; Ishtar Gate, law stele of Hammurabi, 26-27, 26; 43; Hammurabi and Shamash on tation with foreshortening, 27, Babylonian history and art: experimen-Babur (Mughal emperor), 473 Babel, Tower of (Babylon ziggurat), 23, 535-537, 538, 553 Aztec culture and art, 405, 530, 533, structure for examples axial plan, 38-39, 93, See also specific

Avenue of the Dead, Teotihuacán, 529,

American art; Modernism in

avant-garde artists, 378, 390, 392, 397,

Auvergne, France, Virgin and Child

(Dreaming), 551-552, 551

Auuenau, Northern Territory, Australia

Autun, France: Last Judgment, tympa-

409, 413, 420, 433, 435, 437. See

(Morgan Madonna), 174, 175, 176

174, 175, 175; shrine to Saint Laza-

num of Saint-Lazare (Gislebertus),

culture, 371; Klimt, 358, 371-372,

Austria: Art Nouveau, 373; fin-de-siècle

Australian dreamings, 551-552, 551, 553

Auspicious Cranes (Huizhong), 493-494,

Australian art, 453, 546, 551-552

Austral Islands, 550-551

Modernism in Europe and America

Europe and America (1900-1945);

also late 20th century European and

(0861-5461)

071 ,sur

Italy (sculpture), 88, 88 Aule Metele (Arringatore), Cortona, (marble bust), 6, 6 Augustus wearing the corona civica 511 '86-76 '06 Augustus (Roman emperor), 6, 6, 13, 76, Augustine, Saint, 119 art, 6 Augustan/Julio-Claudian period Roman attribution, 5-6 attributes, 5 ture), 55, 55, 383 Attica, Greece, New York Kouros (sculp-Aton (Egyptian deity), 40 Attalos I, king of Pergamon, 76–77 səjduvxə also specific works of art for atmospheric perspective, 232, 236. See Atlantids, 534, 535 89 ,83 ,(non Aphrodite? pediment of Parthethree goddesses (Hestia, Dione, and Nike (Kallikrates), 70-72, 70, 71; of Acropolis, 66; Temple of Athena (Mnesikles), 66, 66; restored view (480 BCE), 66, 67, 68, 70; Propylaia (sculpture), 56, 56; Persian sack 67, 68, 69, 73, 76; Peplos Kore and Kallikrates), 44, 45, 66-69, 66, non, 68-69, 69; Parthenon (Iktinos Festival procession frieze, Parthe-Athena Nike, 71, 71; Parthenaic ing her sandal, parapet of Temple of Boy (sculpture), 63, 63; Nike adjustpediment of Parthenon, 68; Kritos 71-72, 71; Helios and his horses, grave stele, Dipylon cemetery, Dipylon cemetery, 54, 54; Hegeso's 70, 70; geometric krater, from Parthenon, 67-68, 67; Erechtheion, machy, metope of south frieze of dias), 44, 45, 66, 67, 76; Centauro-Athens, Greece: Athena Parthenos (Phi-92 '29 '99 '51 Athena Parthenos, Athens (Phidias), 44, Pergamon Turkey, 76-77, 77 tomachy frieze of Altar of Zeus, Athena battling Alkyoneos, gigandeity), 44, 45, 47, 62, 66, 67, 68, 70, Athena (Minerva) (Greek/Roman Athanadoros, Laocoon and his son (sculpture), 80, 80, 271 Atawalpa (Inka emperor), 541 Atar of Zeus, Pergamon, Turkey, 76-77, 364, 365 At the Moulin Rouge (Toulouse-Lautrec), Asuka period, Japan, 508, 509-511, 525 28; royal citadel of Sargon II, 27, 27 enemies (relief sculpture), 27-28, Assyrian art: Assyrian archers pursuing Iraq (painted relief), 27-28, 28 Assyrian archers pursuing enemies, Kalhu, 292 '297 Gloriosa dei Frari, Venice (Titian), Assumption of the Virgin, Santa Maria Altarpiece (Riemenschneider), Assumption of the Virgin, Creglingen deity), 47, 76 Asklepios (Aesculapius) (Greek/ Roman Ashurnasirpal II (king of Assyria), 28 Ashurbanipal (king of Assyria), 336 184 '594 Ashoka (Maurya king), 461, 462, 464, Ashikaga Takauji, 514 Ashigara shogunate, 514, 517 Asceticism, 463 Asante art, 567, 571 Aryans, 463, 469 69 'LT Artemis (Diana) (Greek/Roman deity), Antwerp, Netherlands: Butcher's Stall Artaxerxes I (Sasanian king), 30 Antoninus Pius (emperor of Rome), 83,

586, 287, 288, 289 289; piazza, Saint Peter's, Rome, Four Rivers, Rome, 284, 285, 287, 290, 290, 311, 311; Fountain of the Santa Maria della Vittoria, Rome, of Saint Teresa, Cornaro chapel, Borghese, Rome, 289, 289; Ecstasy Peter's, 287, 287, 289; David, Villa Bernini, Gianlorenzo: baldacchino, Saint Bernard of Clairvaux, 173-174, 176-177 212,891 Reims, France, 186, 187, 196, 197, Bernard de Soissons, Reims Cathedral, (Mies van der Rohe), 406, 407

Berlin, Germany, glass skyscraper model Berbers, 149

Beowulf, 159 mother Idia, 560, 561, 571, 571

556; waist pendant of a queen

Benin City, 566, 566; sculptors of,

554, 555; location of, 557map; royal

with attendants (bronze sculpture)

obo) (cast bronze), 10, 10, 560; his-

ancestral altar of King Eweka II,

tory of, 555; king on horseback

Benin, Nigeria: Altar to the Hand (ikeg-

Benedictine monastic community, Saint Gall, Switzerland, 164–166, 165

Benedict of Nursia (Saint Benedict), 165

Beijing, China, Forbidden City, 482, 483, 483, 484, 499, 505, 505

Bellori, Giovanni Pietro, 293, 323 Bellori, Giovanni Pietro, 293, 323 Benedict of Murcia (Salut Benedict)

Belgium: Art Nouveau, 373; Mosan

Beckmann, Max, Night, 393-394, 394

Beauvais Cathedral, Beauvais, France, 3,

Beaubourg (Centre Georges Pompidou),

Kaufmann House (Fallingwater)

Westminster Abbey, Bayeux Tapes-try, Bayeux Cathedral, 183–184, 183

Bayeux, France, 183-184, 183

184, 184; funeral procession to

eux Tapestry, Bayeux Cathedral,

Bayeux, France: Battle of Hastings, Bay-

The Bay (Frankenthaler), 417, 417, 437,

Madrid, Spain, 281-282, 281

Bauhaus buildings (Gropius), 405-406,

visi Battle Sarcophagus), 110, 111

peii, Italy, (Philoxenos of Eretria),

eux Cathedral, Bayeux, France, 184,

tro (Piero della Francesca), 245, 245

battle of Romans and barbarians (Ludo-

Battle of Issus, House of the Faun, Pom-

Battle of Hastings, Bayeux Tapestry, Bay-

Battista Sforza and Federico da Montefel-

Batoni, Pompeo: Charles John Crowle,

Baths of Caracalla, Rome, 109, 109

Basquiat, Jean-Michel: Horn Players,

Basilica Ulpia, Forum of Trajan, Rome,

Basilica Nova, Rome, 113-114, 113, 246,

"Basilica" (Temple of Hera), Paestum,

Hawai, Akbarnama, 473-474, 473

Basil I (Byzantine emperor), 135

Basawan, Akbar and the Elephant

Baths of Diocletian, frigidarium, Rome,

440-441, 440; issues addressed by,

323, 323, 329; portraiture of, 329

Bautista de Toledo, Juan, El Escorial,

Bauhaus, 378, 405-406, 409

240-241, 241

52 '52-72

601 '601

103, 103, 167

basilica, Pompeii, Italy, 91, 91

Italy, 57, 58, 58

Baudelaire, Charles, 357, 358, 372

Battle of Ten Nudes (Pollaiuolo),

90t

Bayeux Tapestry, Bayeux Cathedral,

604, 804, 408, 408, 409)

Bear Run, Pennsylvania (U.S.A.),

Paris (Rogers and Piano), 432, 432

Behnisch, Günter, 451, 459

3, 12, 12

Benedictine order, 133, 164-166, 173

Art Nouveau, 358, 373, 373 EI, to inioq 2-6; terminology of, 6-12; view-

art historians: intersection with other

fields, 12-13; questions asked by,

Bernward (bishop of Hildesheim), bronze doors of Saint Michaels, Hildesheim, Germany, 167-168,

Bester, Willie: Homage to Steve Biko, 446, 447; issues addressed by, 440, 459

Bhairava (Hindu deity), 469

Bible: codification of, 119; Gospels, 160, 160, 162-163, 162, 163; moralized Bibles, 199-200, 199, 200, 215, 215; translation into vernacular, 272. See also Christianity; illuminated manuscripts; Jesus, life of; New Testament themes; Old Testament themes

Bichitr, Jahangir Preferring a Sufi Shaykh to Kings, 474–475, 474 Big Family No. 2 (Zhang), 446, 447

Big Self-Portrait (Close), 425, 425 Bihzad: illustration of books, 155; Seduction of Yusuf, Bustan, 154

Bilbao, Spain, Guggenheim Bilbao Museo (Gehry), 451-452, 452 Biomorphic Surrealism, 394, 409, 414,

420, 450 Bird in Space (Brancusi), 398, 399 Birth of Venus (Botticelli), 240, 240, 249,

black-figure painting, 59-60, 59 Blanche of Castile, Louis IX, a monk, and a scribe, moralized Bible, Paris, 199, 199

Der Blaue Reiter (The Blue Rider artist group), 378, 380-381

Bleeding Takari II (Anatsui), 450-451, 451, 459

Bloodline portraits (Zhang), 446 Blouet, Guillaume-Abel, Temple of Aphaia restored view, 61

Boat Bridge (writing box) (Honami Koetsu), 520, 521

Boccioni, Umberto, Unique Forms of Continuity in Space, 386, 387, 409, 409

Bodhisattvas Padmapani, Ajanta (cave

painting), 468, 468 Bodmer, Karl, *Hidatsa Warrior Pehriska*-Ruhpa (Two Ravens), 545, 545, 546, 546

Boffrand, Germain, Salon de la Princesse, Hôtel de Soubise, Paris, 314-315, 314

Bonampak, Mexico, presentation of captives to Lord Chan Muwan (mural), 526, 527, 531

Bonsu, Osei: fame of, 556; two men sitting at a table of food (Asante linguist's staff) (sculpture), 566, 567; use of apprentices, 567

A Book from the Sky (Xu), 448, 448 Book of Kells, Iona, Scotland, 160-161, 161

books: Byzantine, 132-133, 133, 139, 139; Carolingian, 162-163, 162, 163; French late medieval/early Renaissance, 225-226, 225; Gothic, 199-200; Hiberno-Saxon, 159-161, 160, 161; Islamic, 151-154, 154, 155; Japanese, 512; Romanesque, 176-177, 176, 177. See also Bible; illuminated manuscripts

Borghese, Cardinal Scipione, 289 Borgia, Cesare, 255

Borluut, Isabel, 221

Borobudur, Java, Indonesia, 478-479, 478, 481

Borromini, Francesco: influence of, 310; San Carlo alle Quattro Fontane, Rome, 286, 290-291, 291, 311; Sant'Agnese in Agone, Rome, 284

Bosch, Hieronymus, Garden of Earthly Delights, 278, 278, 280

Boscoreale, Italy, wall painting in cubiculum M of Villa of Publius Fannius Synistor (Second Style wall painting), 95-96, 95

Boscotrecase, Italy, Villa of Agrippa Postumus (Third Style wall painting),

Botero, Fernando: Abu Ghraib 46, 446, 446; issues addressed by, 459

Botticelli, Sandro: Birth of Venus, 240, 240, 249, 249; Primavera, 239, 239; style of, 218, 249

Bourbon dynasty, 286

Bourgeois, Louise, Cumul I, 420, 420 Bourke-White, Margaret: documentary photography of, 378, 400-401; Fort

Peck Dam, Montana, 400-401, 401 Boyle, Richard, Chiswick House, near

London, 326, 327 Brady, Mathew B., 353

Brahmins, 463, 469, 471 Brahms, Johannes, 335

Bramante, Donato d'Angelo: architecture of, 252, 261-263, 272; plan for Saint Peter's, Rome, 263; Tempietto, Rome, 262, 262, 283, 283

Brancusi, Constantin: abstract sculpture of, 378; Bird in Space (sculpture), 398, 399, 409

Branded (Saville), 448, 448

Braque, Georges: Cubism of, 378, 383, 409; exposure at Armory Show, 391; Lam's relationship with, 397; The Portuguese, 383-384, 383

brawl in the Pompeii amphitheater, wall painting from House I, Pompeii, Italy, 91

Breakfast Scene, Marriage à la Mode (Hogarth), 319, 319

Breton, André: First Surrealist Manifesto. 394, 395; on Kahlo, 404; Lam's relationship with, 397; on Miró, 396 Bridging Home (Do-Ho), 456

Brighton, England, Royal Pavilion (Nash), 348, 349, 350

Bringing the War Home: House Beautiful (Rosler), 445, 445, 459

British Royal Academy of Arts, 313, 320 bronze altar, Benin, Nigeria, 10, 10 bronze casting, 11, 64. See also specific sculpture for examples

Bronzino (Agnolo di Cosimo): architecture of, 252; Venus, Cupid, Folly, and Time, 270, 270

Die Brücke (The Bridge artist group), 378, 380

Bruegel the Elder, Pieter: Hunters in the Snow, 281, 281; Netherlandish Proverbs, 280-281, 280

Bruges, Belgium: hall of cloth guild, 198, 198; prosperity of, 219

Brunelleschi, Filippo: Duomo, Florence, 263; Ospedale degli Innocenti (Foundling Hospital), Florence, 218, 241-242, 241; Pazzi Chapel, Santa Croce, Florence, 242-243, 242, 243; perspective, 218, 232, 238, 241, 249; Sacrifice of Isaac, 229-230, 230; San Lorenzo, Florence, 242, 242, 246, 249

Brussels, Belgium, Van Eetvelde house (Horta), 373, 373

bubonic plague (Black Death), 218, 333 Buddha (Enlightened One): Death of the Buddha (Parnirvana), Gal Viahra, 477-478, 477; first sculptures of, 462, 464, 466, 466, 481; life of, 460, 461, 465, 467; preaching his first sermon, 467, 467. See also Amitabha Buddha; Shakyamuni Buddha; Vairocana Buddha

Buddha triad, Horyuji temple, Ikaruga, Japan (Tori Busshi), 510, 510

Buddhism: Ashoka's conversion to, 461, 462, 464, 481; birthplace of, 461, 463; Chan/Zen, 513, 514, 515, 517, 518, 525; in China, 488, 489-490, 499; Esoteric, 511; Great Stupa, Sanchi, India, 460, 461, 462, 464, 465, 465; iconography of, 466, 466, 467; in Japan, 502, 508, 509–510, 511, 512, 513, 525; in Korea, 502; life of Buddha, 460, 461, 466, 477; medieval decline of in India, 470; Pure Land, 490, 512, 514, 525; in Southeast Asia, 478-479; spread of,

470, 477; stupas, 461, 464, 465, 467, 478-479, 480, 481; Theravada, 466 Buddhist art: Chinese, 488-491, 494-495; Japanese, 510, 514-519, 525; Korean, 502-503, 503; South Asian, 460, 461, 464-469; Southeast Asian, 477-480

bull-leaping, palace, Knossos palace, Greece (fresco), 49, 49

buon fresco painting, 208. See also

fresco painting Buonarroti, Michelangelo. See Michelangelo Buonarroti

Burghers of Calais (Rodin), 372 Burgundy, France, Renaissance art in, 219, 219, 249

Burial at Ornans (Courbet), 343, 343 Burial of Count Orgaz (El Greco), 282, 282

Burials. See funerary customs

Burke, Edmund: concept of the sublime, 340; A Philosophical Enquiry into the Origins of Our Ideas of the Sublime and Beautiful, 335

Burmese art (Myanmar art), 480-481 Burtynsky, Edward, 445, 456, 459 Bury Bible, Bury Saint Edmunds abbey,

England (Master Hugo), 181-182, 182

Bury Saint Edmunds, England, Bury Bible (Master Hugo), 181-182, 182 bust of Augustus wearing the corona

civica (sculpture), 6, 6 bust of Caracalla, 108, 108 Bustan (Bihzad), 154

busts, 12. See also specific bust Butcher's Stall (Aertsen), 279, 279, 283, 283

Byron, Lord, 335, 336

Byzantine history, art, and architecture: after 1204, 140, 141; architecture, 118, 126-131, 135-136, 135, 141; capture of Ravenna, 129; Carolingian monarchs and, 135; Crusades and, 140, 141; at death of Justinian, 118map; Early period, 124-135, 141; fall of Constantinople to Ottoman Turks, 118, 125, 140, 144; iconoclasm, 118, 134-135; icons, 134, 134, 136-137, 136, 140, 140; illuminated manuscripts, 132-133, 133, 139-140, 139, 140, 141; Islam and, 135, 144, 146; ivory triptychs, 118, 138, 138, 141; Macedonian dynasty, 135; Middle Byzantine period, 135-140, 141; mosaics, 136-137, 136, 137; Ottoman Turks and, 118, 125, 126, 140, 141; recapture of Constantinople after Crusader sack, 118

Caen, France, Saint-Étienne, 179-180, 179, 180, 185, 185

Cahokia, Illinois (U.S.A.), Monk's Mound, 528, 542, 553

Calder, Alexander: abstract works of, 378, 409; kinetic sculpture of, 386; Lobster Trap and Fish Tail, 399-400, 400

Caliari, Paolo. See Veronese, Paolo (Paolo Caliari)

calligraphy: Chinese, 493, 496, 499-500, 499; in contemporary social and political art, 445, 445; feminist art, 445, 445; Islamic (Kufic), 144, 149, 150, 151-152, 151, 152, 154, 445, 445; Japanese, 512

Calling of Saint Matthew (Caravaggio), 293, 293, 311, 311

calotypes, 351, 352 Calvin, John, 272 Calvinism, 272, 300, 306 Cambodian art, 478, 481 camera, invention of, 351, 355 camera lucida, 351 camera obscura, 286, 304-305, 351, 352 Camera Picta (Room of the Newly-

weds), Palazzo Ducale, Mantua (Mantegna), 246-247, 247

Camera Work (journal), 393 Cameroon, throne and footstool of King Nsangu, Bamum, 562, 562

Campbell, Colin, 326 Campin, Robert (Master of Flémalle): Mérode Altarpiece, 220, 221, 222, 223, 249; oil painting and, 218, 220-221

Campus Martius (Field of Mars), Rome, 83

Canaletto, Antonio: paintings of views of Venice, 314, 329; Riva degli Schiavoni, Venice, 321-322, 322

Canon (Polykleitos of Argos), 65 canons: defined, 10; of Lysippos's statues, 74; of Polykleitos, 46, 65-67, 73, 81; for relief sculpture of Egypt, 36

Canova, Antonio: Pauline Borghese as Venus, 333, 333, 334; style of, 332,

Canyon (Rauschenberg), 422-423, 422 Capitalism, 218-219 Capitolium, Pompeii, 88, 91, 91 Cappella Scrovegni (Arena Chapel),

Padua (Giotto di Bondone), 207-209, 207, 208 Los Caprichos (The Caprices) (Goya),

335, 335 caput mundi. See Rome, Italy

Caracalla (Roman emperor), 90, 108-110, 108

Caracalla, portrait bust (sculpture), 108-109, 108

Caravaggio (Michelangelo Merisi): Calling of Saint Matthew, 293, 293, 311, 311; Conversion of Saint Paul, 293; influence of, 298, 299; tenebrism of, 286, 293, 294, 297

Carolingian art and architecture: Benedictine monastic community, Saint Gall, Switzerland, 164-166, 165; Coronation Gospels (Gospel Book of Charlemagne), Aachen, Germany, 162, 162; Ebbo Gospels, abbey of Saint Peter, Hautvillers, France, 162, 163; Lindau Gospels, Saint Gall, Switzerland, 163, 163; monarchs and, 135; Palatine Chapel of Charlemagne, Aachen, Germany, 163-164, 164, 166; westwork of abbey church, Corvey, Germany, 158, 166, 166

carpet from funerary mosque of Shaykh Safi al-Din, Ardabil, Iran (Maqsud of Kashan), 152-153, 153

carpet pages, 159-160, 160 Carracci, Agostino, 292

Carracci, Annibale: influence of, 298; Loves of the Gods, Palazzo Farnese, Rome, 292, 292

Carracci, Ludovico, 292 Carthusian order, 219

carving, 11 Cassatt, Mary: *The Child's Bath*, 362–363, 362; exposure to

Modernists art, 390 Castagno, Andrea del, Last Supper, Sant'Apollonia, Florence,

238, 238 Castillo, Chichén Itzá, Mexico, 528, 534, 534, 553, 553

casting, 11. See also bronze casting Catacomb of Saints Peter and Marcelli-

nus, Rome, 119, 119 catacombs, 118-119

Çatal Höyük (Anatolia), deer hunt mural (cave painting), 20-21, 20

Cathedral complex, Pisa, Italy, 178,

Catholic Church: Counter-Reformation, 252, 260, 265, 272, 287, 288, 290, 295, 311; patronage of High Renaissance art, 258; Reformation and, 272; Spanish defense of, 281; Thirty Years' War (1618-1648), 286. See also Christianity; monasteries; monastic orders; monasticism; papacy; Vatican Palace, Rome; specific cathedral or church; specific pope

ticello (Jefferson), 327–328, 327, 329; University of Virginia, 327 140, 141, 149, 173, 188; early consumer culture, 421, 437 1.89 Coatlicue, Tenochtitlán (sculpture), 537, 287, 288, 290, 295, 311; Crusades, Crusader sack, 118 Charles X (king of France), 338 Charlottesville, Virginia (U.S.A.): Mon-Coatlicue (Aztec deity), 537 ter-Reformation, 252, 260, 265, 272, ture), 112, 112; recapture after 115, 118, 120, 141, 202, 245; Coun-Cluniac order, 157 portraits of four tetrarchs (sculp-Charles VII (king of France), 226 169; Constantine and, 112-114, 324, 354, (100qsX) (.A.S.U) sionillI 126-128, 126, 127, 141, 141, 196; Charles VI (king of France), 223 Cloud Gate, Millennium Park, Chicago, churches in Romanesque Europe, Tralles and Isidorus of Miletus), 867 '187 128-129, 134; Chinese ban, 519; 505 ,86₽ Holy Wisdom) (Anhemius of Charles V (Holy Roman Emperor), 277, Isles, 159; in Byzantium, 125-126, ing Garden), Suzhou, China, 498, 141; Hagia Sophia (Church of the dictine rule, 165, 173; in British Cloud Crowned Peak, Liu Yuan (Linger-141; founding of, 84, 112, 115, 118, Charles John Crowle (Batoni), 323, 323, Christianity: in Africa, 558, 570; Benestyle of, 437 141; fall to Ottoman Turks, 118, Charles IV (king of Spain), 335 Close, Chuck: Big Self-Portrait, 425, 425; 311, 333 Crusader sack of (1204), 118, 126, Charles II (king of England), 310 Print) (Rembrandt), 302-303, 302, Constantinople, Istanbul, Turkey: cloisonné ornamentation, 158, 159, 185 567 '008-667 ing the Children (Hundred-Guilder Satyr Carousing, 314 Roman Empire), 125 Charles I at the Hunt (Van Dyck), Christ with the Sick around Him, Receiv-Constantine XI (emperor of Eastern Clodion (Claude Michel), Nymph and 008-667 138, 138, 140 Cliff Palace, Mesa Verde National Park, Colorado, 528, 543, 543, 553 113, 113; rule of, 90 Charles I (king of England), 298, baville Triptych) (ivory carving), Basilica Nova, Rome (sculpture), aged by, 205; rule of, 161-162, 185 Christ enthroned with saints, (Har-Cleopatra (queen of Egypt), 30, 76, 115 ple, 84, 112-114, 118; portrait of, 163-164, 164; renovatio encour-(Perugino), 120, 244-245, 244, 249 Clement VII (Pope), 218 202, 245; founding of Constantinotine Chapel, Aachen, Germany, dom to Saint Peter, Sistine Chapel Clement V (Pope), 218 Aachen, Germany, 162, 162; Palaanity and, 112-114, 118, 120, 141, Christ Delivering the Keys of the King-70£, 80£-30£, 70£-30£, stra Constantine (Roman emperor): Christi-(Gospel Book of Charlemagne), 141, 651, 751-851 9; Landscape with Cattle and Peasscapes, 341 burial of, 166; Coronation Gospels Dormition, Daphni (mosaic), kation of the Queen of Sheba, xx, 7, 339, 339, 344; transcendental land-Charlemagne (Holy Roman Emperor): Christ as Pantokrator, Church of the Claude Lorrain (Claude Gellée): Embar-Constable, John, 355; The Hay Wain, 19 '59-19 174' 174 71-72; vase painting, 72 Charioteer of Delphi, Delphi, Greece, Confucius (Kong Fuzi), 488 Galla Placidia, Ravenna, Italy, 123, 62-63; sculpture, 63-66, 67-69, Confucianism, 485, 488, 505, 509, 519 318, 318; style of, 314, 329 Christ as Good Shepherd, Mausoleum of ture, 66-72; historical events, Chardin, Jean-Baptiste-Siméon: Grace, sky), 380 Classical period of Greek art: architec-Concerning the Spiritual in Art (Kandinand William Vertue), 202, 215 Saints Peter and Marcellinus, Rome, architecture, 528, 533, 534 Conceptual Art, 434-435, 437 minster Abbey, London (Robert Christ as Good Shepherd, Catacomb of Classic period of Mesoamerican art and Comte, Auguste, 341 emperor), 461, 464 Changan, China, 484, 489, 505 chapel of Henry VII fan vaults, West-Chopin, Frédéric, 335 Christ. See Jesus, life of Clarkson, Thomas, 340 898, 398, (Mondrian), 398, 398 Vanitas Still Life, 305-306, 306, 352 Composition with Red, Blue, and Yellow £12-473 Claesz, Pieter: still life paintings of, 311; səldmaxə rol tra Chandragupta Maurya (Mauryan Chola dynasty (South Asia), 470, Civil War (U.S.A.), 353, 353 composition, 6. See also specific works of Chandragupta II (Gupta king), 467 Chokwe art, 564, 564, 571 civil rights movement, 412 tecture (Venturi), 431 Chandella dynasty (South Asia), 470-472 and Kent), 326, 327, 328 The City (Leger), 385, 385 Complexity and Contradictions in Archi-Chiswick House, near London (Boyle 218, 525 941 '441-941 complementary colors, 7 Chan Buddhism, 513, 514, 515, 517, de Chirico, Giorgio, The Song of Love, 394-395, 394 fighting a dragon, Moralia in Job, 301-302, 301 bord, 277, 277 Citeaux, France, Initial R with knight Hall, Amsterdam (Rembrandt), Chambord, France, Château de Chamcitadel of Tiryns, Greece, 51-52, 51, 53 Scotland, 161, 161 Cocq (Night Watch), Musketeers Chi-rho-iota page, Book of Kells, Iona, Chalukya dynasty (South Asia), 468 The Company of Captain Frans Banning (Khorsabad), 27, 27 Chinese Lions (Eitoku), 517-518, 517 543 citadel of Sargon II, Dur Sharrukin Engels), 358 Chaco Canyon, New Mexico (U.S.A.), Cistercian order, 165, 173, 176-177 dynasty, 484, 485, 505 Communist Manifesto (Marx and chen Itzá (sculpture), 534, 535 dynasty, 484, 495-499, 505; Zhou 302, 556, 558, 571 Communism, 358, 412, 501 chacmool, Platform of the Eagles, Chi-494; Xia dynasty, 484; Yuan cire perdue (lost wax) method, 64, 64, communal men's houses, 528 275,358,370,375 circles of confusion, 305 505; wood construction, 494-495, Commodus (Roman emperor), 90, 108 Sainte-Victoire, 369, 369, 370; style Angels and Prophets, Santa Trinità, Florence, 206, 206; style of, 215 505; Tang dynasty, 484, 489-491, Commentarii (Ghiberti), 188 Cézanne, Paul: influence of, 383; Mont 505; Song dynasty, 484, 491-495, Combines, 422 necropolis, Cerveteri, Italy, 86, 86 500, 505; Shang dynasty, 484, 485, Cimabue: Madonna Enthroned with 103, 104, 104, 115, 133 Cerveteri sarcophagus, Baditaccia 485, 486, 505; Qing dynasty, 484, Rome (Apollodorus of Damascus), 487-488, 492, 505; Qin dynasty, krater (Euphronios), 60, 60 church portals, Romanesque, 173-174, Column of Trajan, Forum of Trajan, wrestling Antaios, red-figure calyx 501, 505; Period of Disunity, Jem, 146, 170 Columba, Saint, 159 84, 86-87, 86, 87, 115; Heraldes People's Republic of China, 484, Church of the Holy Sepulcher, Jerusa-Colossus of Nero, 89, 101 Cerveteri, Italy: Banditaccia necropolis, 484, 484map, 499-500, 503, 503; Greece, 128, 136, 136, 141 Rome, 113, 113 Roman deity) 494-495; Ming dynasty, 482, 483, Church of the Dormition, Daphni, Colossus of Constantine, Basilica Nova, Ceres. See Demeter (Ceres) (Greek/ 485-487, 505; Liao dynasty, 484, Germany, 201 also vase painting porary, 446, 448; Han dynasty, 484, Church of Saint Peter, Wimpfen-im-Tal, Rome, 84, 89, 100-101, 100, 115, 239-540, 540, 545, 545, 553. See Communist takeover, 412; contem-Colosseum (Flavian Amphitheater), 50, 51; Native American, 528, Chinese history, art, and architecture: Church of Jesus, Rome (Vignola), 264, Aton, Karnak, Egypt, 40, 40 524, 524, 525, 525; Minoan, 50-51, Alen), 401, 407 The Child's Bath (Cassatt), 362-363, 362 colossal statue of Akenaton, temple 72; Japanese, 214, 508, 519, 519, Church), Florence, 207, 207 Chrysler Building, New York (van ture), 529, 529 Greek, 54, 54, 59-61, 59, 60, 61, 72, Chiesa di Ognissanti (All-Saints Chrysaor (Medusa's child), 58-59 colossal head, Olmec, La Venta (sculpceramics: Chinese, 467, 496-497, 497; 234, 535, 553 chromatic abstraction, 414, 416, 437 ture), 534, 535 ceramic tile work, 151, 155 Chichén Itzá, Mexico, 532, 533-534, color-field painting, 417, 437 colossal atlantids, Tula, Mexico (sculp-423-424, 453 ceramic sculpture, 243 LST '95V Вау, Міаті, Florida, 1980-1983, Chicago Board of Trade II (Gursky), Christo, Surrounded Islands, Biscayne color theory, 7 Centzon Huitznahua (Aztec deities), 457, 427, 437 Madonna, or Virgin Chicago, Judy, The Dinner Party, 426, color. See specific works of art for colors Annunciation, Christ, Crucifixion, Paris (Rogers and Piano), 432, 432, (Kapoor), 456, 456 hiw gninnigod egnibaod bna colonialism. See imperialism Centre Georges Pompidou (Beaubourg), 375; Cloud Gate, Millennium Park of Verdun), 202, 203, 215 sance; specific cathedral or church səլdшvxə Center (Sullivan), 374, 374, 375, Reformation; reliquaries; Renais-Shrine of the Three Kings (Nicholas Acropolis, Athens, Greece, 67, 67 central-plan building, 129–132, 129, 130. See also specific structure for Chicago, Illinois (U.S.A.): Sullivan ment themes; papacy; Protestant Cologne): Gero crucifix, 169, 169; ture), 564, 564 Jesus); medieval art; New Testa-Cologne Cathedral (Gerhard of Chibinda Ilunga figure, Chokwe (sculp-Jesus, life of; Mary (mother of of Chance (Arp), 388, 388 Centauromachy, metope of Parthenon, Cheonmachong tomb, Hwangnamdong, Korea, 502–503, 502 Collage Arranged According to the Laws architecture; Catholic Church; Cenni di Pepo. See Cimabue also Byzantine history, art, and 454-455, 439 Chavin culture, 538 D'Audoubert, 17, 17 110-111, 112, 115, 128, 141. See collage, 384-385, 388-390, 421, India, 468, 469; two bison, Le Tuc Château de Chambord, 277, 277 Europe, 169-184; in Rome, 108, Coleridge, Samuel Taylor, 335 489; Shiva as Mahadeva, Elephanta, Hawai, Akbarnama, 473-474, 473 scapes, 332 283, 286, 287; in Romanesque 468, 469; Longmen Caves, Luoyang, Chatar Muni, Akbar and the Elephant estant Reformation, 260, 272, 277, cave sculptures: Dancing Shiva, Badami, 341, 341, 355; transcendental land-219, 219, 249 relics, 158map, 169-170, 202; Protsachusetts, after a Thunderstorm), Merle, France, 18, 18 France (Drouet de Dammartin), Colbert, Jean-Baptiste, 308 Cole, Thomas: The Oxbow (View from Mount Holyoke, Northampton, Masof followers, 110, 118; pilgrims and and negative hand imprints, Pech-Chartreuse de Champmol, Dijon, 164-166, 172-173, 176; persecution bison, 19-20, 19; spotted horses 561 '561-161 ica, 538; monasticism, 133, 159, wounded man, and disemboweled stained-glass windows, 188, 41-42, 41 Cohen, Judy. See Chicago, Judy 272; Islam and, 145; in Mesoamerpurpose of, 18; rhinoceros, south transept sculpture, 196, 196; oclasm, 118, 134-135, 134, 174, 18, 19; painting techniques, 17; Portal, 188, 189-191, 191, 215; coffin of Tutankamen, Thebes, Egypt, 118-119, 183-184; icons and iconcave painting: Ajanta, India, 465, 468, 481; Çatal Höyük, 20, 20; Hall of the Bulls, 19, 19; Lascaux, 18–20, reconstruction after 1194 fire, 192–196, 194, 195, 196, 215; Royal lists, 5; funerary customs, 110-111, 11-47'41 coffin, tomb of Tutankhamen, Thebes, Edict of Milan, 109; four evange-

codex/codices, defined, 132

medieval period, 157, 159-169;

Chartres Cathedral, Chartres, France:

contemporary art: abstraction, 448-451, 459; African, 444, 446, 459, 570; African American, 440-441, 459; architecture and site-specific art, 451-453, 459; Chinese, 447-448, 459; Deconstructivism, 440, 451-453, 459; Environmental and Site-specific, 453-456, 459; feminist, 441-442, 459; figural painting and sculpture, 448-450, 459; gay/ lesbian artists, 442-444, 459; Middle Eastern, 444, 445, 459; national identity represented in, 446, 459; Native American, 439, 440, 459; new media, 456-458; as sociopolitical message, 439, 459; South American, 446, 459; South Asian, 444, 459

Conversion of Saint Paul (Caravaggio),

Cook Islands, staff god (Tangaroa?), Rarotonga, 550–551, *551*

Copán, Honduras: ball court, 532, 532; Stele D, Waxaklajuun-Ub'aah-K'awiil, 531, 531, 533

Copley, John Singleton, Paul Revere, 320-321, 321

Córdoba, Spain, Great Mosque (Cathedral of Saint Mary), 142, 143, 144, 148-149, 148, 149, 155, 155

Corfu, Greece, west pediment of Temple of Artemis, 58-59, 59

Cornaro, Federico, 290

Cornaro chapel, Santa Maria della Vittoria, Rome (Bernini), 290, 290 Corneille, Pierre, 325

Cornelia Presenting Her Children as Her Treasures (Mother of the Gracchi) (Kauffmann), 312, 313

Coronation Gospels (Gospel Book of Charlemagne), Aachen, Germany, 162, 162

Cortés, Hernán, 528, 536-537, 538, 541 Cortona, Italy, Aule Metele (Arringatore) (sculpture), 88, 88

Corvey, Germany, westwork of abbey church, 158, 166, 166, 185, 185

Cosimo, Angolo di. See Bronzino (Agnolo di Cosimo)

Côte d'Ivoire, Senfu masqueraders, 568, 568, 569

Council of Trent (1545-1563), 252 Counter-Reformation, 252, 260, 265, 272, 287, 288, 290, 295, 311

Courbet, Gustave: Burial at Ornans, 343, 343; influence of, 456; Modernist view point, 360; photography and, 351, 353; on Realism, 342; The Stone Breakers, 342, 343; on subjects of art, 332, 355

Court of Gayumars. Shahnama of Shah Tahmasp, Tavriz, Iran (Sultan-Muhammad), 154, 154

Coyolxauhqui, Great Temple of Tenochtitlán (relief sculpture), 536-537,

Creation of Adam, Sistine Chapel ceiling, Vatican, Rome (Michelangelo), 250, 251, 260, 260, 293

Creation of Eve on bronze doors of Saint Michaels, Hildesheim, Germany (Bernward), 168, 168

Creglingen Altarpiece (Riemenschneider), 227, 227

Cremaster cycle (Barney), 458, 458 Crete: Knossos palace (model), 48-49, 48; Lady of Auxerre (statue), 54, 55, 56; octopus flask, 50, 50

The Crossing (Viola), 457-458, 457 crown, Cheonmachong tomb, Hwangnam-dong, Korea, 502, 502

Crucifixion, Church of the Dormition, Daphni, Greece (mosaic), 121, 136-137, 136

Crucifixion, doors of Saint Michaels, Hildesheim, Germany (Bernward), 121, 168, 168

Crucifixion, Isenheim Altarpiece, Hospital of Saint Anthony, Isenheim,

Germany (Grünewald), 272-273,

Crucifixion, Lindau Gospel, Saint Gall, Switzerland, 163, 163

Crucifixion, Saint Mark's Venice, 137-138

Crusades, 140, 141, 149, 173, 188 Crystal Palace, London (Paxton), 350-351, 350, 355, 355, 452

Cubi XII (Smith), 418, 418

Cubism: Analytic Cubism, 383-384, 385, 390; fundamentals of, 409; influence on Modernist art, 391, 397-398; Mondrian's exposure to, 398; Noah's Ark (Douglas), 390, 392; Picasso and, 385; Synthetic Cubism, 384-386, 390, 392

Cumul I (Bourgeois), 420, 420 Cupid. See Eros (Amor, Cupid) (Greek/ Roman deity)

Cut with the Kitchen Knife Dada through the Last Weimar Beer Belly Cultural Epoch of Germany (Höch), 389-390, 389

cutaway (views), 12

Cuzco, Peru: as capital of Inkas, 540; Temple of the Sun and church of Santo Domingo, 541, 541

Cycladic art, 47-48, 81, 81 Cyclopian masonry, 51 Cyrus of Persia, 28

da Vinci, Leonardo. See Leonardo da Vinci

Dada: Arp, 388; collages, 388-390, 422; Duchamp, 388; exploration of role of chance, 378; Höch, 388-390; incorporation of found objects, 388, 409, 419; response to Enlightenment, 386-388; Surrealism and, 394, 395

Daedalus (legendary Greek artist), 55 Daguerre, Louis-Jacques-Mandé: invention of camera and photographic process, 332, 351-352, 355; Still Life in Studio, 351, 351

daguerreotypes, 351-352, 351 Dalí, Salvador, The Persistence of Memory, 395-396, 395, 409

dancing Shiva, Badami, India (rock-cut relief), 468, 469, 469, 481 Dante Alighieri: Divine Comedy, 199;

Inferno, 372 Daoism, 485, 488, 505

Daphni, Greece, Church of the Dormition, 128, 136, 136, 141

Darius I (king of Persia), 28-29 Darius III (king of Persia), 28, 74-75

Dark Ages of Greece, 53 Darwin, Charles, 358

dating (of art), 2-3 Daumier, Honoré: reception of photography, 351, 353; Rue Transnonain, 344, 345, 355

David, Jacques-Louis: Death of Marat, 325-326, 325; Delacroix's view of, 337; as First Painter of France, 332, 333, 355; on Greek style and public art, 314, 323, 324, 325, 329; Oath of the Horatii, 324-325, 324, 329, 329, 334

David, Palazzo della Signoria, Florence (Michelangelo), 258, 259, 289, 292

David, Palazzo Medici, Florence (Donatello), 233, 233, 234, 249, 258, 266, 289

David, Villa Borghese, Rome (Bernini), 289, 289

David Composing the Psalms, Paris Psalter, 139-140, 139

David Vases, Yuan dynasty, 496-497, 497 Davies, Arthur B., 391

Dayi, China, Rent Collection Courtyard (Ye Yushan) (sculpture), 501, 501 De imitatione statuarum (On the Imita-

tion of Statues) (Rubens), 298 de Kooning, Willem: gestural abstract art of, 437; influence of, 422, 439; Woman 1, 415-416, 416

De Stijl (The Style), 378, 398, 405-406, 409

The Death and Life of Great American Cities (Jacobs), 431

death mask of Tutankhamen, Thebes, Egypt, 42, 42, 53

Death of General Wolfe (West), 320, 321, 329

Death of Marat (David), 325-326 Death of Sardanapalus (Delacroix), 325, 336-338, 337, 355, 372

Death of the Buddha (Parinirvana), Gal Vihara, Sri Lanka (sculpture), 477-478, 477, 481

Death of the Virgin, Strasbourg Cathedral, Strasbourg, France, 202-203,

Deconstructivism, 440, 451-453, 459 deer hunt mural, Çatal Höyük (wall painting), 20, 20

Degas, Edgar: Cassatt and, 363; influence of, 364; influences on, 354; The Rehearsal, 361-362, 362, 367, 375,

Deir el-Bahri, Egypt, Hatshepsut mortuary temple, 37-38, 37, 39

Deities. See religion and mythology; and specific deity

deity images, 550-551, 551. See also Greek history, art, and architecture; Roman Empire history, art, architecture; specific deity

Le Déjeuner sur l'Herbe (Luncheon on the Grass) (Manet), 344-346, 345, 358, 383

Delacroix, Eugène: Death of Sardanapa*lus*, 336–338, 337, 355, 372; interest in photography, 351, 353; *Liberty* Leading the People, 338, 338; Nadar portrait of, 352, 353; on Neoclassic style, 332, 337

Delft, Dutch Republic, 301 Delhi sultanate, 143, 462, 473, 481, 495 Delian League, 66

della Robbia family, 243 Delphi, Greece, Charioteer of Delphi from Sanctuary of Apollo, 64-65, 64

Demeter (Ceres) (Greek/Roman deity), Democratic Republic of Congo: Kongo power figure (sculpture), 563, 563,

571, 571; Kuba King Kot a-Mbweeky III (photograph), 569-570, 570

Les Demoiselles d'Avignon (Picasso), 376, 377, 383

Denis (Dionysius), Saint, 189 Deogarh, India, Vishnu Temple, 470, 470 Deposition (Rogier van der Weyden), 121, 224, 224 Derain, André, 391

Descartes, René, 316

Dessau, Germany, Bauhaus buildings (Gropius), 405-406, 406, 409

Devi (Hindu deity), 469 dharma (Buddhist law), 464, 465, 467 Diana. See Artemis (Diana) (Greek/

Roman deity) Dickens, Charles, 344

Diderot, Denis, 316

Dietrich II of Wettin, Naumburg Cathedral, Naumburg, Germany, 204-205, 204

Dijon, France, Chartreuse de Champmol (Drouet de Dammartin), 219, 219, 249

The Dinner Party (Chicago), 426, 427,

Dinteville, Jean de, 276 Diocletian (Roman emperor), 84, 90, 112, 115, 118

Diogenes, 256

Dione (Greek deity), 47, 68, 68 Dionysiac mystery frieze, Villa of the Mysteries, Pompeii, Italy (Second Style wall painting), 94-95, 94

Dionysius (Denis), Saint, 189 Dionysos (Bacchus) (Greek/Roman deity), 47, 68, 68, 94

Diptych of Martin van Nieuwenhove and His Wife (Memling), 223

Diskobolos (Disc Thrower), Rome (Myron), 63-64, 63, 289

distribution of largesse, Arch of Constantine, Rome (relief sculpture), 114, 114

Divine Comedy (Dante), 199 Djenne, Mali: Great Mosque, 556, 558, 559, 571; sculptures, 558

Djoser's pyramid, Saqqara, Egypt (Imhotep), 32-33, 33, 34, 43

doctrine of perfectibility of humankind, 316

doctrine of progress, 316 documentary evidence, 2 documentary photography, 353-354,

378, 400-401, 409 Doesburg, Theo van, 398

Doge's Palace, Venice, Italy, 213-214,

Dogon art, 564-565, 564, 571 Do-Ho Suh: Bridging Home, 456; sitespecific art of, 459, 504

Dome of the Rock, Jerusalem, 144, 145, 146, 146, 151, 155, 155

Domenico Contarini (doge of Venice), 137

Dominican order, 237 Domitian (Roman emperor), 90, 100,

101, 103 Donatello (Donato de Niccolo Bardi): David, Medici palace, Florence, 233-234, 233, 249, 289; Gattamelata, 234, 234, 249, 249; Saint Mark, Or San Michele, 233, 233, 249; stat-

uary of, 218 Dong Qichang, Dwelling in the Qingbian Mountains, 499, 499

donor portraits, 204-205, 221, 223, 223 The Door to Salvation, Saint-Pierre,

Moissac, France, 157, 173-174 Doric architecture, 57. See also specific structure for examples

Doric temple design, 56, 57, 57, 58-59, 58, 59, 61–62, 66–67, 66

Doric temple of Artemis (Corfu, Greece), 58-59, 59

Doryphoros (Spear Bearer), Delphi, Greece (Polykleitos of Argos), 65-66, 65, 74, 196

Douglas, Aaron: African American art of, 378, 409; Noah's Ark, 390, 392, 392, 409

Dove, Arthur, 390

drama, 63, 75, 81, 209

Duccio di Buoninsegna: style of, 188; Virgin and Child Enthroned with Saints, Maestà altarpiece, Siena Cathedral, Siena, Italy, 209-210, 209, 239

Duchamp, Marcel: exposure at Armory Show, 391; Fountain, 388, 388; influence of, 420, 449; influences on, 354; naming of Calder's work, 399; Nude Descending a Staircase, No. 2, 390, 391

Dumont d' Urville, Jules Sebastien César, 546

Dunhuang Grottoes (Mogao Grottoes), China, 489-490, 490, 505

Duomo, Florence, Italy (Brunelleschi), 263

Dur Sharrukin, Khorsabad, Iraq, lamassu (man-headed winged bull), citadel of Sargon II (sculpture),

Durandus (abbot of Saint-Pierre), 173 Durandus, William (bishop of Mende),

Dürer, Albrecht: Fall of Man (Adam and Eve), 274, 274, 283, 283; fame of, 252; Four Apostles, 275-276, 275; The Four Horsemen of the Apocalypse, 5, 5, 7, 10; Melencolia I, 274–275, 275; printmaking income, 303

Durga (Hindu deity), 469 Durham Cathedral, Durham, England, 180-181, 181, 192

611

71-72; vase painting, 72 Encyclopédie (Diderot), 316 art: architecture, 44, 44, 45, 66–71; sculpture, 11, 44, 44, 63–66, 67–69, cific works of art for examples encaustic painting, 56, 108. See also speempiricism, 316, 341-342 Early/High Classical period of Greek Romanticism (1800 to 1840) 16t '16t-06t Pre-Raphaelite art; Realism; Thirteen Emperors (Yan Liben), early 19th century art. See Photography; Emperor Xuan and Attendants, The princely courts, 244-248, 249 culture, 538-539, 538 peian/Vesuvius area, 90-96; embroidered funerary mantle, Paracas Or San Michele, 219-224; Pom-(Claude Lorrain), xx, 7, 9 Mexican interwar Modernist, 403; Embarkation of the Queen of Sheba 229-248, 249; locations of, 218map; embalming, 32 Roman Empire, 226-229, 249; Italy, plans (architectural) France, 224-226, 225, 249; Holy elevations (architectural), 12. See also 218-219, 229; Florence, 229-244; 118,892 ders, 217, 249; destabilizing events, Elevation of the Cross (Rubens), 298-299, 246-248, 262; Burgundy and Flanelevation (architectural), 12 early Renaissance art: architecture, (statue), 54-55, 54, 56 tiago de Compostela, 158map Eleutherna, Greece, Lady of Auxerre Etruscan art: Apollo of Veii, 85, 85, 86; 166-169; pilgrimage routes to Santure), 468, 469, 469 Étienne de Bage (Cluniac bishop), 174 158-159, 185; Ottonian, 157, Shiva as Mahadeva (cave sculp-Merovingian and Anglo-Saxon, Elephanta, India: cave paintings, 468; Étienne Chevalier and Saint Stephen, Hiberno-Saxon, 159-160, 185; gnidətə Charlemagne's rule, 161-162; Eleanor of Aquitaine (queen of France), etching, 228, 302. See also specific tecture: Carolingian, 161-166, 185; non, Acropolis, Athens, Greece), 69 70£, 70£, (nissuoq) early Medieval European art and archielders and maidens (east frieze, Parthe-Et in Arcadia Ego (Even in Arcadia) 001 '86-46 El Tajín, Mexico, 534 Esoteric Buddhism, 511 98; Pont-du-Gard, 100; rulers, 90, style of, 252, 283 Esigie (Benin king), 560 Greek Classical revival, 115; Livia, Burial of Count Orgaz, 282, 282; two worshipers, 23, 23 100-101; Flavian portraiture, 101; El Greco (Doménikos Theotokópoulos): El Escorial, Madrid, Spain (Herrera and Baustista de Toledo), 281–282, 281 Amphitheater), Rome, Italy, deity), 47, 240, 270 civil war, 96-97; Colosseum (Flavian Eros (Amor, Cupid) (Greek/Roman dral, Naumburg, Germany (Naumburg, Master), 204–205, 204 the corona civica (sculpture), 6; 101-103; bust of Augustus wearing Peace), 98-99; Arch of Titus, Ekkehard and Uta, Naumburg Cathe-Eretria, Greece, warrior taking leave of Augustae (Altar of Augustan 409 Erechtheus (king of Athens), 70 Eight Views of the Xiao and Xiang Rivers, Early Empire Roman art: Ara Pacis Erechtheion, Athens, 66, 70, 70 Rome, 116, 117, 119 Harunobu), 506, 507 Trajan, Rome, 103, 103 sarcophagus of Junius Bassus, Eight Views of the Parlor series (Suzuki equestrian statue of Trajan, Forum of nian art and, 169; painting, 119; 918 818 Rome, 107, 107 themes in, 116, 117, 119, 119; Otto-Eiffel Tower, Paris (Eiffel), 358, 373-374, equestrian statue of Marcus Aurelius, Paris, 358, 373-374, 373, 375 mosaics, 123-125; Old Testament 120-121; location of, 118map; Eiffel, Alexandre-Gustave, Eiffel Tower, equestrian statue of Erasmo da Narni, Islamic art and, 146; life of Jesus, Fichu, 518 Ukwu (sculpture), 558, 559 tian history, art, and architecture 163; catacombs, 118-119, 141; equestrian figure on fly-whisk hilt, Igbo conquest of, 30, 97. See also Egyp-141; Carolingian art influenced by, 18'44'44-94 Early Christian art: architecture, 120-123, ogy, 30-32, 35, 38, 40, 42; Roman Epigonos (?), dying Gaul sculpture, and America (1900-1945) 30-33, 30, 43; religion and mytholican art. See Modernism in Europe Epidauros, Greece, theater of Epidauros tic and early dynastic periods, 9, early 20th century European and Amer-Kingdom, 16, 33-36, 43; predynas-Environmental Protection Agency, 433 Romanticism, 334-341 144; New Kingdom, 16, 36, 43; Old 654 '954-654 ism, 332, 341-348, 355, 360, 372; Environmental Art, 412, 432-434, 437, 30map; Mamluk patronage of arts, 355; Pre-Raphaelite, 347-348; Real-51, 53, 55, 56, 63, 81; location, 587 '587 '697 phy, 351-354, 351, 352, 353, 354, influence on Aegean and Greek art, Napoleonic era, 332-334; photogra-Entombment of Christ, Santa Felicità, decline of, 42; fall to Persians, 28; 350, 355; locations of, 332map; Egyptian history, art, and architecture: Enrico Scrovegni, 207 ican art: architecture, 348-351, 349, egg tempera. See tempera painting Romanticism, 355 early 19th century European and Amer-321–323; Industrial Revolution and, 316–317, 329, 341; and effigy mounds, 542 347; style of, 355 (Lorenzetti), 211-212, 211 Eakins, Thomas: The Gross Clinic, 346, Palazzo Pubblico, Siena, Italy 313, 314, 317-318; Grand Tour, Кwаkwakw, wakw, 545, 545 and in the Country, Sala della Pace, of, 386-387; French Revolution, eagle transformation mask, Effects of Good Government in the City 313, 316-323, 329; Dadaists view 182-183, 182 181-881 (bnsl and American art influenced by, Trinity College, Cambridge, Enlightenment: 18th century European Edward the Confessor (king of Eng-Eadwine the Scribe, Eadwine Psalter, woodblock prints, 508, 522 128, 228, 229, 241 ers, 507, 519; ukiyo-e, 520-521; 187-183, 182 in early Renaissance period, 218, bridge (Eadwine the Scribe), Harunobu, 506, 507; Tokugawa rulengraving: of Dürer, 274-275, 274, 275; Eadwine Psalter, Trinity College, Cam-Rinpa School, 8, 9, 508, 520; Suzuki also London, England sai, 521-522; Ogata Korin, 8, 9; Kyoto, 508, 520; Katsushika Hokuart, 339-341, 339, 340, 355; Salis-508, 520; Katsura Imperial Villa, 386, 386 religion in, 310; Romanticism in Dynamism of a Dog on a Leash (Balla), 520; initiation of, 517; Kano School, ist art and architecture, 349, 350; Edo period Japanese art: Ando Hiroshige, 522-523, Honami Koetsu, pediment, Aegina (sculpture), 62, Northumbria, 160, 160, 185; Predying warrior, Temple of Aphaia west Edict of Milan, 109 201-202, 201; Lindisfarne Gospels, pediment, Aegina (sculpture), 62, 62 182-183, 182; Gothic period, 116,116,092 dying warrior, Temple of Aphaia, east Ecstasy of Saint Teresa (Bernini), 290, wine Psalter (Eadwine the Scribe), ture), 77-78, 77, 81, 81 Durham, 180-181, 181, 192; Ead-Italy, 129-132, 129, 130, 131, 132 dying Gaul statue (Epigonos) (sculp-Ecclesius, Bishop, San Vitale, Ravenna, 181-182, 182; Durham Cathedral, (Dong Qichang), 499, 499 villers, France, 162, 163 Edmunds abbey (Master Hugo), Dwelling in the Qingbian Mountains 311; Bury Bible, Bury Saint Ebbo Gospels, abbey of Saint Peter, Haut-Dutch school, 6 Baroque art and architecture, 310, meer, 286, 304-305, 304, 305, 311 Eastern Roman Empire. See Byzantine 351, 352, 355; Art Nouveau, 373; Ruisdael, 303-304, 303, 311; Ver-355; 19th century photography, Rijn, 301-303, 301, 302, 303, 311; Easter Island sculptures, 528, 547-548,

ancestor figure, 551-552, 551

earthworks, 432-434, 453-455. See also

Engels, Friedrich, 344, 358

East Alligator Rivers, Australia, male

Environmental Art

Leyster, 301, 301; Rembrandt van

Frans Hals, 300, 300, 301, 311;

Dutch Republic: Baroque art, 300–306, 311; 300, 311; Claesz, 305–306, 311;

Fang, 562 891 '891 Euclid, 256

06 - 68

96'112 84, 86-87, 86; veristic portraits, 84, House, Herculaneum, Italy, 94, 94, accia necropolis, Cerveteri, Italy, characteristics of, 84; Samnite Cerveteri, Italy, 87; tumuli, Bandit-First Style Roman wall painting: Reliefs, Banditaccia necropolis, First Emperor of Qin, 484, 485 Tarquinia, Italy, 87, 87; Tomb of the fin-de-siècle, 371, 372 Leopards, Monterozzi necropolis, film. See motion pictures 85, 88, 91, 91, 115, 115; Tomb of the 84 '84-44 figurine of a woman, Syros, Greece, Rome, 88, 91, 91; temples, 84, 85, (Capitolium), Capitoline Hill, £95 '£95 figure of Chibinda Ilunga (Chokwe), Italy, 85, 86; Temple of Jupiter Baditaccia necropolis, Cerveteri, Ficino, Marsilio, 275 Fertile Crescent, 15, 22-30 cophagus with reclining couple, Second style wall painting, 84; sarfeminist movement, 412, 437 Feminist Art Program, 426 veteri sarcophagus, 86, 86; First and compared to tombs, 118-119; Cer-445, 443, 459 Italy (sculpture), 88, 88; Catacombs feminist art, 426-428, 434, 437, 441-Aule Metele (Arringatore), Cortona, female mask, Mende, 569, 569 542 '542 Federico da Montefeltro, Resurrection, Melun Diptych (Fouquet), 226, 226 Hawaii, 528, 548, 548 feather cloak of Kamehameha III, Fauvism, 378-379, 409 Fate of the Animals (Marc), 382, 382 Farnese, Cardinal Odoardo, 292 Farnese, Alessandro, 264 structure for examples fan vaults, 202, 202. See also specific Eshnunna, Tell Asmar, Iraq, statuettes of and Streams, 492, 492, 505 Fan Kuan, Travelers among Mountains Run (Wright), 408, 409, 409 lekythos (Achilles Painter), 72, 72 Fallingwater (Kaufmann House), Bear his wife, Athenian white-ground and Gold) (Whistler), 364, 364 The Falling Rocket (Nocturne in Black 721, 260 Vatican, Rome (Michelangelo), 250, Fall of Man, ceiling of Sistine Chapel, 274, 274, 283, 283 Fall of Man (Adam and Eve) (Dürer), Piazza del Santo, Padua, Italy, 234 Hildesheim, Germany (Bernward), Fall of Adam and Eve, Saint Michaels, sionism; Postwar Expressionism 412-416. See also Abstract Expres-(Polykleitos the Younger), 75-76, 75 Expressionism, 364, 378, 380-382, existentialism, 412 game, black-figure amphora, 59-60, Exekias, Achilles and Ajax playing dice evolutionary theory, 358 Florence (Pontormo), 121, 268-269, Events of the Heiji Period (handscroll), the Parlor (Suzuki Harunobu), 506, Evening Bell at the Clock, Eight Views of Eve. See Adam and Eve 18 '18 '19 '19-09 Athenian red-figure amphora, content, 241; three revelers on shortening and use of narrative Euthymides: experimentation with fore-398; sculpture, 398–399; Surrealism, 370, 394–399, 419 European interwar Modernism: De Stijl, cific kingdom or nation bury Cathedral, 201-202, 201. See and America (1945-1980); and spe-(1900-1945); Modernism in Europe ernism in Europe and America tecture in, 405-408. See also Mod-Raphaelite art, 347-348, 348; Real-War II, 332map, 412; prewar archisionism in, 412-413; post-World Pop Art in, 420; Postwar Expresernism in, 376-390, 393-399, 409; end of World War I, 380map; Mod-286map; around 1870, 358map; at Europe: in 17th century, 286-287, Euripides, 45, 63, 75, 81 Cerveteri (red-figure calyx krater), Euphronios, Herakles wrestling Antaios Eugenius III (Pope), 177 tecture, 348-351, 349, 350, 355, 325, 352, 353 Eugène Delacroix (Nadar) (photograph), 326, 327, 329; 19th century architure, 317, 317, 319-321, 319, 320, England: 18th century art and architec-Eucharist (Mass), 121, 128, 131, 132

Etruscan temple model, 85

First Surrealist Manifesto (Breton), 394,

Fission (Riley), 418, 418 Flack, Audrey: *Marilyn*, 424–425, 424; style of, 437

Flagellation of Jesus, 121 Flamininus (Roman general), 80 Flanders: Baroque art, 286, 298-300, 298, 299, 311; Renaissance art, 217, 218, 220-224, 249; stock exchange, 218-219

Flavian Amphitheater. See Colosseum (Flavian Amphitheater), Rome Flavian woman, Rome (sculpture), 101,

Florence, Italy: Abduction of the Sabine Women, Piazza della Signoria (Giambologna) (sculpture), 271, 271; Baptistery of San Giovanni (Ghiberti), 229-233, 230, 231, 232, 372; David, Medici palace (Donatello), 233-234, 233, 249, 258; David, Palazzo della Signoria (Michelangelo), 258, 259; Duomo (Brunelleschi), 263; in early Renaissance period, 229-244; Entombment of Christ, Santa Felicità (Pontormo), 269-270, 269, 283, 283; expulsion of Medici, 218, 244, 257, 258; Madonna Enthroned (Ognissanti Madonna), Chiesa di Ognissanti (Giotto di Bondone), 206-207, 207, 209, 239; Madonna Enthroned with Angels and Prophets, Santa Trinità (Cimabue), 206, 206; Michelangelo Buonarroti, 257-258; Or San Michele, 219, 233, 233; Ospedale degli Innocenti (Foundling Hospital) (Brunelleschi), 241-242, 241; Palazzo Medici-Riccardi (Michelozzo di Bartolommeo), 243; Palazzo Rucellai (Alberti and Rosselino). 243-244, 243; Pazzi Chapel, Santa Croce (Brunelleschi), 242-243, 242, 243; San Lorenzo (Brunelleschi), 242, 242, 246, 249; San Marco, 237, 237; Santa Croce, 3, 3, 242-243, 242, 243; Santa Maria del Carmine, 235-236, 235, 236; Santa Maria del Fiore (Arnolfo di Cambio), 212–213, *213*; Santa Maria Novella, 236–237, *237*, 249, 264; Santa Trinità, 234-235, 235; Sant'Apollonia, 238, 238;

Sant'Egidio, 224, 225 Flower Still Life (Ruysch), 306, 306 flying buttress, 12, 187, 192, 193, 193, 200, 215

flying horse, tomb of Governor-General Zhang, Wuwei, China (sculpture), 487, 487, 505, 505

Foguang Si Pagoda, Yingxian, China, 494-495, 494

Fon art, 563, 571

Fon warrior figure, palace of King Glele, Abomey, Republic of Benin (Kendo), 563, 563

Forbidden City, Beijing, China, 482, 483, 484, 499, 505, 505

Foreshortened Christ (Lamentation over the Dead Christ) (Mantegna), 248,

foreshortening, 9. See also specific works of art for examples

Forever Free (Lewis) (sculpture), 347, 347 form, 6

formal analysis terminology, 6-12 formalism, 414, 418, 421, 429

Fort Peck Dam, Montana (Bourke-White), 401, 401

Fortune magazine, 400-401 Forum, Pompeii, Italy, 90-91, 91 Forum of Trajan, Rome (Apollodorus of Damascus), 103-104, 103, 104, 115

Foster, Norman: architectural style of, 440, 459; Hong Kong and Shanghai Bank, Hong Kong, 452-453, 452 Fountain (Duchamp), 388, 388

Fountain of the Four Rivers, Rome (Bernini), 284, 285, 287, 289 Fouquet, Jean, Melun Diptych, 226, 226 Four Apostles (Dürer), 275-276, 275 The Four Horsemen of the Apocalypse (Dürer), 5, 5, 7, 10

Four Noble Truths, 465-466 Fourth Style Roman wall painting: defined, 84; Ixion room, triclinium P of the House of the Vettii,

Pompeii, Italy, 96, 97; preservation of, 115

Fra Angelico, Annunciation, San Marco, Florence (fresco), 237, 237

Fragonard, Jean-Honoré: style of, 329; The Swing, 316, 316

France: 18th century art and architecture, 318, 318, 323-326, 324, 325, 326, 329; 19th century photography, 351-353, 351, 352, 355; 1789 revolution, 189, 190-191, 313, 314, 316, 317, 323, 325-326, 332; 1848 revolution, 343, 344; Art Nouveau, 373; art under Napoleon, 332-334, 333, 334; Baroque art and architecture, 306-309, 311; Cubism and Purism in, 383-385; early Renaissance art, 224–226, 225, 226, 249; Fauvism in, 378-379; funeral procession to Westminster Abbey, Bayeux Tapestry, Bayeux Cathedral, 183-184; Gothic architecture, 186, 188-198, 189, 191, 192, 193, 194, 197, 198, 215; Gothic sculpture, 186, 191, 196, 197, 215, 215; Impressionist art, 356, 357, 359, 360-363, 360, 361, 362, 363; interwar architecture, 407-408, 409; invention of, 331; late 19th century sculpture, 372-373, 372; Mannerist architecture, 277; maps, 218map, 358map; Neoclassic art and architecture, 323-326, 324, 325, 333; Notre-Dame, 192, 192; photography, 351-352; Post-Impressionist art, 364-370, 365, 367, 368, 369; Realism, 341-347, 355; Rococo art, 314; Romanticism in art, 330, 334-335, 336-338, 337, 338, 355;

Symbolism, 370, 370 Francis I (king of France), 255, 270, 277 Franciscan order, 242-243 Frankenstein (Shelley), 335

Frankenthaler, Helen: The Bay, 417, 417, 437, 437; on color-field painting, 417

Franklin, Benjamin, 316, 328 Franks, 144, 161. See also Carolingian

art and architecture Frederick II (Holy Roman Emperor),

freestanding sculpture, 12. See also spe-

cific statue for examples The French Ambassadors (Holbein the

Younger), 276, 276

French Baroque art and architecture: Lorrain, 306-308; Louis XIV and, 308; Poussin, 306, 307, 307; Versailles, 308-309

French Gothic art and architecture: architecture, 3-4, 12, 186, 187, 189-198, 189; sculpture, 189-191, 196, 200-201; stained-glass windows, 194-195, 198

French Revolution (1789): destruction of Chartres Cathedral, 189, 190-191; Napoleon Bonaparte's rise to power, 332; Neoclassic art and, 325-326; overthrow of monarchy, 314, 329; painter-ideologist of, 313, 323; philosophes' role in, 316; Rousseau's role in, 317

French Revolution (1848), 343, 344 French Romanesque art: architecture, 170-174; illuminated manuscripts, 176-177, 176, 177

fresco painting, 49, 208. See also specific works of art for examples fresco secco painting, 49, 208

Freud, Lucian, Naked Portrait, 425 Freud, Sigmund, 370, 387-388 Friday Mosque, Isfahan, Iran, 150, 151 Friedrich, Caspar David: transcendental landscapes, 332, 338, 355; Wanderer above a Sea of Mist, 338, 339

Frohnmayer, John, 443 Fujiwara Yorimichi (Chinese regent),

512 funeral banner, tomb of the marquise of Dai, Mawangdui, China, 486-487,

funeral procession to Westminster Abbey, Bayeux Tapestry, Bayeux Cathedral, Bayeux, France, 183-184, 183

funerary complex of Djoser, 43 funerary customs: African, 565, 568, 569; Andean South American, 538-540; Chinese, 486-487; early Christian, 110-111, 118-119, 183-184; early medieval pre-Christian, 159; Egyptian, 31-35, 36, 37–38, 41–42, 43; Etruscan, 86–87; Greek, 53, 54, 71, 72, 86; Japanese, 508-509; Mesopotamian, 24-25; Native North American, 542; Oceanic, 552; Roman, 86, 110, 111, 116, 117

funerary mask, Grave Circle A of royal shaft graves, Mycenae, Greece, 53, 53

Futurism, 386, 387, 390, 395, 409, 412 Futurist Painting: Technical Manifesto (Balla and Boccioni), 387

Gabon, Kota reliquary guardian figure (mbulu ngulu) (sculpture), 562, 562 Gaius Gracchus (Roman leader), 313 Gal Vihara, Sri Lanka, Death of the Buddha (Parnirvana) (sculpture),

477-478, 477, 481, 481 Galerie des Glaces, palace of Versailles (Hardouin-Mansart and Le Brun),

308-309, 309, 311, 314 Galla Placidia's mausoleum, Ravenna, Italy, 123, 124, 124

Gandhara, Pakistan: frieze of life of Buddha, 466, 466, 467, 481; meditating Buddha (sculpture), 464

Gandhi, Mahatma, 477 Ganesha (Hindu deity), 469 Gaozong (Chinese emperor), 489 Garden in Sochi (Gorky), 413-414, 414 Garden of Earthly Delights (Bosch), 278

Garden of the Master of the Fishing Nets (Wangshi Yuan), Suzhou, China, 498, 498, 505

gardens: Egyptian, 37-38; Guanyun (Cloud Crowned) Peak, Liu Yuan (Lingering Garden), Suzhou, China, 498, 498; karesansui (dry landscape) garden, Ryoanji, Kyoto, Japan, 515-516, 515; Suzhou, China, 484, 505; Versailles palace gardens (Le Nôtre), 309, 309; Wangshi Yuan (Garden of the Master of the Fishing Nets), Suzhou, China, 498, 498

gardenscape, Villa of Livia, Primaporta, Italy (Second Style wall painting), 95-96, 95

Gardner, Alexander, albumen print of A Harvest of Death, Gettysburg, Pennsylvania, July 1863 (O'Sullivan), 353, 353

Gate of All Lands, 29 The Gates of Hell (Rodin), 358, 372-373, 375, 375

Gates of Paradise, Baptistery of San Giovanni, Florence (Ghiberti), 218, 230-233, 231, 372

Gattamelata, Piazza del Santo (sculpture) (Donatello), 219, 234, 234, 249

Gaucher de Reims, Reims Cathedral, Reims, France, 186, 187, 196, 197, 198, 213, 215

Gaudi, Antonio, 373

Gauguin, Paul: influence of, 378; influences on, 546; style of, 375; Vision after the Sermon (Jacob Wrestling with the Angel), 367-368, 368; Where Do We Come From? What Are We? Where Are We Going? 368, 369-370, 375

Gautama, Siddhartha. See Shakyamuni Buddha

gay/lesbian artists, 441, 442-444. See also specific artists

Gayumars (king of Iran), 154 Gehry, Frank: architectural style of, 440, 459; Guggenheim Bilbao Museo,

Bilbao, Spain, 451-452, 452 Geldzahler, Henry, 417

Gellée, Claude. See Claude Lorrain General Services Administration, 455 Genghis Khan, 495-496

Genji Visits Murasaki, Tale of Genji (handscroll) (Mursaki Shikubu), 512, 513

genre subjects, 5

Gentile da Fabriano, Adoration of the Magi, Santa Trinità, Florence, 234-235, 235

Gentileschi, Artemisia: Judith Slaying Holofernes, 294, 294; letters of, 294; style of, 286

geometric krater, Dipylon cemetery, Athens, Greece, 54, 54

Geometric period Greek art, 54-55 George III (king of England), 320

George IV (king of England), 348 George Washington (Houdon) (sculpture), 328, 328

Géricault, Théodore: Raft of the Medusa, 330, 331, 338, 340; Romanticism and, 336

German Expressionism, 378, 380-382,

Germany: Art Nouveau (Jugendstil), 373; Bauhaus in, 405–407, 406, 407, 409, 409; church of Saint Peter, Wimpfen-im-Tal, 201; Expressionism in, 380-382; Late Gothic style, 218; moveable type invented in, 218, 249; Neue Sachlichkeit painters, 378, 393-394, 409; Romanticism in art, 338, 339, 355; westwork of abbey church, Corvey, 158, 166, 166, 185, 185; World War I, 393

Gero, Archbishop, Gero Crucifix, Cologne Cathedral, Germany, 169,

Gero Crucifix, Cologne Cathedral, Germany (Archbishop Gero), 158, 169,

gestural abstraction, 414-416, 437 Geumgangsan (Diamond) Mountains (Jeong Seon), 504, 504

Ghana, two men sitting at table of food (linguist's staff) (Bonsu), 566, 567

Ghent Altarpiece, Saint Bavo Cathedral, Ghent, Belgium (Hubert and Jan van Eyck), 221-222, 221, 249

Gherardini, Lisa di Antonio Maria, 255 Ghiberti, Lorenzo: Commentarii, 188; Gates of Paradise, Baptistery of San Giovanni, Florence, 218, 230-233, 231, 372; Sacrifice of Isaac, 229-230, 230

Giacometti, Alberto, Man Pointing No. 5, 412, 413

Giacomo della Porta: dome of Saint Peter's, Rome, 263, 264; facade of Il Gesù, 264, 264

Giambologna. See Giovanni da Bologna gigantomachy, 59, 67, 76-77, 73

Giorgione da Castelfranco: style of, 252; The Tempest, 266-267, 266

Giotto di Bondone: Florentine Duomo's campanile, 213; Lamentation, Arena Chapel, Padua, Italy, 208-209, 208, 215, 215; Last Judgment, Arena Chapel, Padua, Italy, 208; Madonna Enthroned (Ognissanti Madonna), Chiesa di Ognissanti, Florence,

Italy, 206-207, 207, 209, 239;

Giotto di Bondone (continued)

Radha in a Pavilion? 476, 476

Govardhan Chand of Guler, Krishna and

cific buildings for examples Neoclassicism and Romanticism, hard-edge painting, 416-417, 437 Gothic rib vault, 190, 191. See also spe-222, 565, 566, 568; in Chinese art, Gros, Antoine-Jean: as bridge between 138, 140 hierarchy of scale: in African art, 554, Gothic Revival, 326, 348 Bauhaus, Dessau, 406, 406, 409 with saints) (ivory carving), 138, Narmer, 30-31, 31 212,891,891-491 405-406, 407, 411; Shop Block, Harbaville Triptych (Christ enthroned Hierakonpolis, Egypt, palette of King 188; stained-glass windows, Gropius, Walter: Bauhaus architecture, Harappa, Pakistan, 462 Ravens) (Bodmer), 546, 546 202-206; spread of Gothic style, 9/1,771-371,301 ket Shopper, 425, 425 painting of, 206–212, 215; sculpture of, 189–191, 196, 198, 200–201, Hidatsa Warrior Pehriska-Ruhpa (Two Gregory the Great (Pope), Moralia in Hanson, Duane: style of, 437; Supermar-Illumination, 177 Post-Painterly Abstraction, 416, 417 (sculpture), 509, 509, 525, 525 period, 188, 202; locations, 188map; land, 159-160, 160; manuscript 418; on Modernism, 358, 360; on haniwa warrior, Gunma Pretecture farne Gospels, Northumbria, Eng-Italy, 205-214, 215; Late Gothic Greenberg, Clement: on formalism, 414, 211, 511, 515-516, 516, 516, 517 minated manuscripts, 199-200; Scotland? 160-161, 161; Lindishanging scrolls, 491, 496, 499-500, 499, 453-454, 423 Hiberno-Saxon art: Book of Kells, Iona, Roman Empire, 202-205, 215; illu-Green Coca-Cola Bottles (Warhol), handscrolls, 489, 490-491, 493, 512 Gothic period, 188, 192-196; Holy Green architecture, 440, 453 Han dynasty, China, 484, 485-487, 505 201–202, 215; France, 189–201, 215; fresco painting, 211–212; High Hestia (Vesta) (Greek/Roman deity), 47, Athens, Greece (relief), 44, 45 97 '17-97 Greeks battling centaurs, Parthenon, of Hammurabi, Babylon, Iraq, Early Gothic period, 188; England, Hesire, relief from his tomb at Saqqara, Hammurabi and Shamash on law stele See also Athens, Greece and production, 199, 200, 215, Spain, 281-282, 289 Western thought influenced by, 46. So Appealing? 420, 421 Herrera, Juan de, El Escorial, Madrid, Italy, 212-214; book illumination of, 88, 115; tomb construction, 86; Makes Today's Homes So Different, architecture of Holy Roman Empire, 202–205; architecture of Herodotus, 63, 81 Hamilton, Richard, Just What Is It That 26-59, 60, 67-79; Roman conquest (Praxiteles?), 73-74, 73 gion and mythology, 45, 46-47, 48, Hamada-Leach aesthetic, 524 Temple of Hera, Olympia, Greece France, 3-4, 12, 187, 188-199, 215; 47-51, 81; regions of, 46map; reliperiod, 524, 524, 525 Hermes and the infant Dionysos statue, 201-202, 215; architecture of 76-77, 81; prehistoric Aegean art, Hermes (Mercury) (Greek/Roman deity), 47, 73–74, 240 Hamada Shoji, large plate, Showa Gothic Europe: architecture of England, 124; Persia and, 45, 46, 72, 74, 75, Goryeo dynasty, Korea, 503 Gospels, 160, 160, 162–163, 162, 163 300, 300, 311; group portraits, 286, 81; location of, 46map; mosaics, (Greek/Roman hero) 81; Late Classical period, 46, 72-76, Hals, Frans: Archers of Saint Hadrian, Hercules. See Herakles (Hercules) £4, 61, 61-81, (gni of, 88; Hellenistic period, 46, 76-80, ence of, 413; Garden in Sochi, 414, metric period, 54, 81; Golden Age 96, 97. See also Pompeii/Vesuvius Hall of the Bulls, Lascaux (cave paint-Gorky, Arshile: background and influ-Etruscan art influenced by, 88; Geo-Stags (Fourth Style wall painting), 120-121, 150 ence on, 46-47, 53, 55, 56, 63, 81; still life with peaches, House of the Lions, Alhambra, Granada, Spain, Memorial, Washington, D.C. (Lin), Hall of the Abencerrajes, Palace of the 45, 46, 62-72, 81; Egyptian influpainting in Samnite House, 94, 94, Goodacre, Glenna, Vietnam Veterans High Classical period, 11, 11, 44, Herculaneum, Italy: First Style wall 505 '505 611 '611 81; Dark Ages of, 53-54; Early/ City, Beijing, China, 482, 483, 499, 100 (soluo) and Marcellinus, Rome (fresco), 54-62, 81; Classical age, 62-72, 62, calyx krater, Cerveteri, Italy (Euph-Hall of Supreme Harmony, Forbidden orants, Catacomb of Saints Peter (ancient): Archaic period, 46, Herakles wrestling Antaios, red-figure Good Shepherd, story of Jonah, and hall of cloth guild, Bruges, Belgium, 198, Greek history, art, and architecture hero), 60, 60, 68, 68 218, 246-248, 249 263, 290 143, 149 Herakles (Hercules) (Greek/Roman Gonzaga, Ludovico (duke of Mantua), Greek cross, 118, 136, 137, 141, 236, Heraclius (emperor of Byzantium), 135 Al-Hakam II (Umayyad caliph), 142, 145 '095 '095 land, 164-166, 165 96 '58 '85-75 Gonzaga, Federigo (duke of Mantua), Great Zimbabwe, Zimbabwe, 556, 558, tic community, Saint Gall, Switzer-Hera (Juno) (Greek/Roman deity), 47, Gogh, Vincent van. See van Gogh, Vincent Hokusai), 521-522, 521 Basel), plan for Benedictine monas-668 '668 Goethe, Johann Wolfgang von, 338 Views of Mount Fuji (Katsushika Haito (abbot of Reichenau and bishop of of, 378, 409; Oval Sculpture (No. 2), piece, Santegidio, Florence, 224, 225 The Great Wave off Kanagawa, Thirty-six Hepworth, Barbara: abstract sculpture Goes, Hugo van der, Portinari Altar-Great Wall of China, 485 118, 126-128, 126, 127, 141, 141, deity), 47 dess or specific region or religion 236, 537 Hephaistos (Vulcan) (Greek/Roman of Tralles and Isidorus of Miletus), mythology; and specific god or god-Great Temple, Tenochtitlan, 536-537, dom), Constantinople (Anthemius Henry VIII (king of England), 276 gods/goddesses. See religion and Hagia Sophia (Church of the Holy Wis-Verse (Johnson), 392 901 '201-901 Great Temple, Madurai, India, 476-477, hemispherical dome with oculus, 92, 92, God's Trombone: Seven Negro Sermons in 187 '597 '597 '497 '791 and his sons (sculpture), 80, 80, goddess, Tetitla apartment complex, Teotihuacán (mural), 530–531, 530 087 '087 Great Stupa, Sanchi, India, 460, 461, Hagesandros (Greek sculptor), Laocoon van Hemessen, Caterina, Self-Portrait, Great Sphinx, Gizeh, Egypt, 33, 34, 35 Saint Anthony, Isenheim, 272, 273 18 '08-94 Bible, Paris, 199-200, 200 Hagenauer, Nikolaus, shrine, Hospital of Great Schism, 218 Hellenistic period of Greek art, 46, God as Creator of the World, moralized thenon, Acropolis, Athens, 68, 68 Göbekli Tepe, Turkey, 20 Jetty (Smithson), 433-434, 433, 437, Hadrian (Roman emperor), 84, 90, 105, Helios and his horses, pediment of Par-Great Salt Lake, Utah (U.S.A.), Spiral Hadid, Zaha, 440, 459 Sant'Ignazio, Rome, 286, 294-295, 89 '89 55, 38, 43 Helios (Sol) (Greek/Roman deity), 47, Hades (Pluto) (Greek/Roman deity), 47 Glorification of Saint Ignatius (Pozzo), Great Pyramids of Gizeh, 33-35, 33, 34, Habsburg-Valois Wars, 277 Heliopolis, Egypt, 34 Global Groove (Paik), 435-436, 436 Great Plaza, Copán, Honduras, 531 Habsburg dynasty, 286, 295-296, 298 Heian period, Japan, 508, 511-512, 525 The Gleaners (Millet), 343-344, 344 Athens, 71-72, 71 oyo), 516-517, 516 Rohe), 406, 407 Great Plains Native American art, 528, haboku landscape (hanging scroll) (Ses-Hegeso's grave stele, Dipylon cemetery, glass skyscraper model (Mies van der Haarlem, Dutch Republic, 301 Gladiators (Rosler), 445, 445, 459 Great Mosque, Samarra, Iraq, 147-148, head reliquary statue of Saint Alexander, Khafre, 34 SSI '/#I '/#I-9#I (sculpture), 36, 36; pyramid of Great Mosque, Kairouan, Tunisia, Gutenberg, Johannes, 218, 227, 229 head of warrior, sea off Riace (sculpture), enthroned (sculpture), 35, 35, 43; Menkaure and Khamerernebty(?) Great Mosque, Djenne (Mali), 558, 559 (sculpture), 90, 90, 115 251,251,149, 148, 155, 155, 155 Trade II, 456, 457; photography of, head of an elderly patrician, Osimo, Italy Great Sphinx, 34, 35; Khafre Mary), Córdoba, Spain, 142, 144, Gursky, Andreas: Chicago Board of ture), 25, 25 Pyramids, 33-35, 34, 38, 43; Great Mosque, (Cathedral of Saint head of Akkadian ruler, Nineveh (sculp-(Mies van der Rohe), 406; Great Great Iconoclasm (1566), 272 Gupta period art (South Asia), 462, 467, The Hay Wain (Constable), 339, 344 Gizeh, Egypt: glass skyscraper model Great Enclosure, Great Zimbabwe, Zim-babwe, 560, 560 rior (sculpture), 509, 509, 525, 525 701,801-701,(gni Italy, 271-272, 271; style of, 252 Gunma Prefecture, Japan, haniwa warpriest of Serapis (encaustic paint-Giulio Romano: Palazzo del Tè, Mantua, Spain (Gehry), 440, 451–452, 452 guilds, 188, 217, 229, 233 Great Depression, 400-401 Hawara, Egypt, mummy portrait of Giuliano da Maiano, 242 Portland, 431-432, 431, 437 III, 548, 548; tattooing, 549 (Jayadeva poem), 476 Giuliani, Rudolph, 443 Graves, Michael, Portland Building, Guggenheim Bilbao Museo, Bilbao, Hawaii: feather cloak of Kamehameha Guezo (Fon king), 563 graves. See funerary customs of Saint Peter, 162, 163 Gita Govinda (Song of the Cowherd) Мусепае, Greece, 53, 53 Guernica (Picasso), 384, 385 Hautvillers, France, Ebbo Gospels, abbey 175, 175; style of, 182, 185 Grave Circle A of royal shaft graves, Bahri, Egypt, 37-38, 37, 39, 43 Guérin, Pierre-Narcisse, 331 of Saint-Lazare, Autun, France, 174, Grande Odalisque (Ingres), 334, 334 Hatshepsut mortuary temple, Deir el-China, 498, 498, 505 Gislebertus: Last Judgment, tympanum Grand Tour, 321-322, 329 A Harvest of Death, Gettysburg, 1863 (O'Sullivan) (photograph), 355, 355 Yuan (Lingering Garden), Suzhou, Giraldus Cambrensis, 161 Grand Manner portraiture, 314, 320, 320 Guanyun (Cloud Crowned) Peak, Liu 271, 271; style of, 252, 334 guang, Anyang (bronze vessel), 485, 485 Harunobu. See Suzuki Harunobu Abduction of the Sabine Women, Alhambra, 149-150, 149, 150, 155, Hart, Frederick, 454 the Court Ladies, 488, 489, 512 Giovanni da Bologna (Jean de Boulogne): Grace (Chardin), 318, 318 Granada, Spain, Palace of the Lions, Admonitions of the Instructress to Harold, earl of Wessex, 183 van Eyck), 223, 223, 278, 297 Gu Kaizhi, Lady Feng and the Bear, Los Caprichos, 335, 335, 355, 355; Third of May, 1808, 336, 336, 344 Giovanni Arnolfini and His Wife (Jan piece, Hospital of Saint Anthony, Isenheim, Germany, 272-273, 273 harmonious numerical ratios, 44, 45, 65, 517 '207-907 Harlem Renaissance, 390-391, 409 236; naturalistic approach of, 188, Sleep of Reason Produces Monsters, Grünewald, Matthias, Isenheim Altar-Harishena (Vakataka king), 468 Masaccio's figures compared to, Goya Lucentes, Francisco José de: The The Gross Clinic (Eakins), 346, 347 Versailles, 308-309, 309, 314

at Jaffa, 333-334, 333, 355, 355

332; Napoleon at the Plague House

Glaces (Hall of Mirrors), palace of

Hardouin-Mansart, Jules, Galerie des

490–491; in Egyptian art, 9, 10, 31, 36; in Greek art, 59; in Mesopotamian art, *14*, 15, 24, 26; in South Asian art, 470; in Southeast Asian art, 477

hieroglyphics: Egyptian, 31, 31; Mesoamerican, 530

Hieron of Gela, 64

High Empire Roman art, 84, 90, 103–108

High Renaissance/Mannerist art and architecture: architecture, 261–265, 283; Bramante, 261–262, 272, 283; Dürer's study of, 274; Dutch, 277–281; France, 277; Giorgione, 266–267, 283; Holy Roman Empire, 272–275; Italy, 252–268, 283; Leonardo da Vinci, 252–255, 268, 274, 277, 283; location of, 252*map*; Michelangelo Buonarroti, 250, 251, 257–261, 270, 283; Raphael (Raffaello Santi), 255–256, 268, 283, 306; Spain, 281–282; Titian (Tiziano Vecelli), 267–268, 270, 283, 298

high-relief sculpture, 12. See also specific relief sculpture for examples

High-Tech architecture, 440, 452–453, 459. *See also* skyscrapers

Hildegard of Bingen, Scivias (Know the Ways of God), 177, 177

Hildegard receives her visions, folio of Rupertsberger *Scivias* (Hildegard of Bingen), 177, 177

Hildesheim, Germany, Saint Michaels (Bernward), 166–168, 167, 168, 173, 185

Himeji, Japan, White Heron castle, 517 Hindu art: dancing Shiva, Badami, India (rock-cut relief), 468, 469, 469; of later kingdoms, 476–477; Rajput painters, 462; temples, 462; Vishnu Temple, Deogarh, India, 470, 470

Hinduism: birthplace of, 461; gods/goddesses of, 468, 469; iconography of, 469, 469; practice of yoga, 463; in Southeast Asia, 478–479; temples of, 470–472, 470, 471, 472. See also Hindu art

Hiroshige Ando, Plum Estate, Kameido, One Hundred Famous Views of Edo (woodblock print), 522–523, 522, 525, 525

History of Ancient Art (Wincklemann), 323

History of Mexico, Palacio Nacional, Mexico City (Rivera), 403–404, 404 History of the Abolition of the Slave Trade (Clarkson), 340

Hitler, Adolf, 406

Höch, Hannah: Cut with the Kitchen Knife Dada through the Last Weimar Beer Belly Cultural Epoch of Germany, 389–390, 389; photomontage of, 388–390

Hogarth, William, The Tête à Tête, Marriage à la Mode, 319, 319

Holbein the Younger, Hans: in England, 319; *The French Ambassadors*, 276, 276

Holland: Art Nouveau, 373; Rembrandt van Rijn, 286

hollow-casting bronze statues, 64, 64. See also specific bronze sculpture for examples

Holocaust Memorial, Vienna (Whiteread), 455

Holy Roman Empire: Carolingian dynasty, 135, 161–162, 163–164; Cologne Cathedral, 215; early Renaissance art, 226–229, 227, 228, 249; Mannerist art, 272–276, 273, 274, 275; map, 218map; Naumburg Cathedral, Naumburg, Germany, 204–205, 204, 215; Ottonian dynasty, 166–169; Protestantism, 272; Reformation and art of, 272; Röttgen Pietä, Rhineland, Germany, 204, 205; Salian dynasty, 177; Sant'Ambrogio, Milan, Italy,

178–179, 178; Scivias (Know the Ways of God) (Hildegard of Bingen), 177, 177; Shrine of the Three Kings, Cologne Cathedral, Cologne, Germany (Nicholas of Verdun), 202, 203; Strasbourg Cathedral, Strasbourg, France, 202–203, 203

Holy Trinity, Santa Maria Novella, Florence (Masaccio) (fresco), 236, 237, 249

The Holy Virgin Mary (Ofili), 443, 444, 444

Homage to Steve Biko (Bester), 446, 447 Homage to the Square: "Ascending" (Albers), 7, 7

Homer, 47, 51, 52, 53, 54, 80 Homer, Winslow: style of, 347, 355; *Vet*-

eran in a New Field, 353 homosexuality, 79, 412, 442–444, 459 Honami Koetsu, Boat Bridge (writing

Honami Koetsu, *Boat Bridge* (writing box), 521, *521* Honduras: Copán ball court, 532, *532*;

Stele D, Waxaklajuun-Ub'aah-K'awiil, Copán, 531, 531, 533 Hong Kong and Shanghai Bank, Hong

Kong (Foster), 452–453, 452 Hongwu (Chinese emperor), 483 Honorius (emperor of Western Roman

Empire), 123, 124, 141 Hopeless (Lichtenstein), 423, 423, 437,

Hopi art, 528, 545, 545

Hopper, Edward: Nighthawks, 401–402, 401, 409; subject matter of art, 409 Horn Players (Basquiat), 440–441, 440 Horse Galloping (Muybridge), 354, 354 horsemen (south frieze, Parthenon,

Acropolis, Athens, Greece), 69 Horta, Victor, Van Eetvelde house, Brussels, 373, 373

Horus (Egyptian deity), 31, 32, 35 Horyuji temple, Nara Prefecture, Ikariga, Japan, 510, 510, 525, 525

Hosios Loukas (Saint Luke), Greece, Katholikon church, 135–136, *135*, 141

Hosokawa Katsumoto, 515–516 Hospital of Saint Anthony, Isenheim, 272–273, 273

Hôtel de Soubise, Paris, 314–315, 314 Houdon, Jean-Antoine, George Washington, 328, 328

House of Vettii, Pompeii, Italy, 93–94, 93 houses, of Roman Empire, 93–96, 93, 94, 95, 96

Houses of Parliament (Barry and Pugin), 348, 349

Hudson River School, 341 hues, 7

Hugh of Saint-Victor, 195

Huitzilopochtli (Aztec deity), 536, 537, 538

Huizong (Chinese emperor): Auspicious Cranes, 493–494, 493; patronage of, 492–493

human figure, Ain Ghazal, Jordan (sculpture), 21, 21

humanism, 205, 229, 230, 237, 244, 256 hummingbird, Nasca Plain, 539, 539 Hundred Years' War (1337-1453), 218, 219, 226

Hundred-Guilder Print (Christ with the Sick around Him, Receiving the Children) (Rembrandt), 302–303, 303, 311, 334

Hunters in the Snow (Bruegel the Elder), 281, 281, 283

Husayn Mayqara (Tamurid sultan), 153 Hwangnam-dong, Korea, Cheonmachong tomb, 502, 502 Hyksos, 43

hypostyle halls, 38–40, 39, 146, 148, 148, 151, 155

I quattro libri dell'architettura (Palladio), 265, 327 Ibn Zamrak, 150 icon painting, Mount Sinai, 118 iconoclasm, 118, 134–135, 272 iconography, 5, 466, 469

icons: Byzantine, 134, 134, 140, 140; Christ as Pantokrator, Church of Dormition, Daphni, Greece (mosaic), 136–137, 136; Virgin (Theotokos) and Child between Saints Theodore and George, Monastery of Saint Catherine, Mount Sinai, Egypt, 134, 134, 141; Vladimir Virgin (painting), 140, 140

mir Virgin (painting), 140, 140 Ife (Nigeria), king, Ita Yemoo (sculpture), 559, 559

Ife art, 558, 559, 559, 571

Ife king, Ita Yemoo, Nigeria (sculpture), 559, 559

Igbo Ukwu, Nigeria: bronze casting, 556, 559, 571; equestrian figure on fly-whisk hilt (sculpture), 558, 559 Ignatius of Loyola, Saint, 265, 290, 296,

304 Ikaruga, Japan, Shaka triad, Horyuji temple (Tori Busshi) (sculpture),

510–511, 510
Ikere, Nigeria, doors, shrine of the Yoruba king's head, royal palace,
(Olowe of Ise) (relief sculpture),
567–569, 567

Iktinos (Greek architect), Parthenon, 44, 45, 66–72

Il Gesù, Rome (Vignola): architecture of, 264–265, 264; Triumph in the Name of Jesus (Gaulli), 294

Iliad (Homer), 47. See also Homer
illuminated manuscripts: Anglo-Saxon, 158–161; Byzantine, 132–133, 133, 139–140, 139, 140, 141; Carolingian, 162–163, 162, 163; early Renaissance, 218, 224–225, 225-226, 225, 249; Gothic European, 199, 199, 200, 215, 215; Hiberno-Saxon, 159–161, 160, 161; in High Gothic period, 188; Islamic, 144, 153–154, 154; Romanesque, 176–177, 176, 177, 181–183, 182. See also books; Gospels

illusionistic space, 7, 9 Iltutmish (Muslim sultan), 473 Imhotep (Egyptian architect): mortuary precinct of Djoser, Saqqara, Egypt,

Saqqara, Egypt, 32–33, 33, 43 imperialism: in Africa, 558; in Americas, 314, 320, 329, 404, 412, 528, 538, 541; European expansion, 286–287; Grand Tour and, 321, 322; Indian independence, 477; in Oceania, 546; Romanticism and, 348. See

43; stepped pyramid of Djoser,

also colonialism Impression: Sunrise (Monet), 359, 359,

Impressionism: Analytic Cubism influenced by, 380–382; Cassatt, 362–363, 362; Degas, 361–362, 362; development of, 344; en plein air painting, 359; Fauvism influenced by, 378; location of, 358map; Manet, 356, 357; Monet, 359, 360–361, 360; Morisot, 362–363, 363; origin of the term, 375; painting light and color, 359; Post-Impressionist art influenced by, 364; Renoir, 361, 361; Rodin influenced by, 372; Whistler, 363–364, 364

Improvisation 28 (Kandinsky), 380–381, 381

In Praise of Scribes (Johannes Trithemius), 199

Inanna (Ishtar) (Mesopotamian deity), 15, 28

Independent Group, 420

India: Alexander the Great and, 72, 461, 462; independence, 412; Indus Civilization art, 462–463, 462map, 481. See also Buddhism; Hindu art

Indra (Aryan deity), 463 Indravarman (Khmer king), 479 Indus Civilization art, 462–463, 462*map*, 481. *See also* Buddhism; Hindu art Indus seals, 463, 463
Industrial Revolution: 18th century
European and American art and,
314; effects on European life, 332,
339, 348; Enlightenment and, 313,
316–317, 329, 341; German Expressionism and, 380; Napoleonic era
art, 314; Neo-Gothic architecture

and, 348; Romantic art affected by,

339; spread and expansion of, 358 Inghelbrecht, Peter, 221 Ingres, Jean-Auguste-Dominique, 332, 336; *Grande Odalisque*, 334, 334;

photography and, 351 Initial R with knight fighting a dragon, *Moralia in Job*, Citeaux, France, 176–177, 176

Inka art and architecture, 528, 538, 540–541, *541*, 553

Innocent X (Pope), 285, 287, 289 Insular art. *See* Hiberno-Saxon art intaglio technique, 228, 249 internal evidence, 2

International Gothic style, 210–211, 234–235, 235

International Style (Modernist architecture), 407–408

The Interpretation of Dreams (Freud), 370, 388

Introduction to the Three Arts of Design (Vasari), 188

Iona, Scotland, Book of Kells, 160–161,

Ionic temple design, 57, 57, 67, 70, 70, 89. See also specific structure for examples

Ireland, illuminated manuscripts, 158 Irene (empress of Byzantium), 135 Isaac and His Sons, Gates of Paradise, Baptistery of San Giovanni, Flor-

ence (Ghiberti), 231–233, 231, 232 Isenheim Altarpiece, Hospital of Saint Anthony, Isenheim, Germany (Grünewald), 272–273, 273

Isfahan, Iran: Friday Mosque, *150*, 151; Madrasa Imami, 151, *151*

Ishtar (Inanna) (Mesopotamian deity), 15, 28

Ishtar Gate, Babylon, 28, 29
Isidorus of Miletus, Hagia Sophia
(Church of the Holy Wisdom),
Constantinople, Turkey, 126–128,
126, 127, 164

Islam: Abbasids, 144, 148–149, 151, 155; in Africa, 558, 570; in Asia, 154; conquest of Byzantium, 135, 140, 144; conquest of Persia, 30, 135; Crusades against, 140, 141, 149, 173, 188; Delhi sultanate, 143, 462, 473, 481, 495; homosexuality and, 444; Nasrids, 144, 149, 155; oppression of women, 445; rise and spread of, 143, 144, 144map; Safavids, 144, 154, 155; in South Asian, 473; tenets of, 145; Timurids, 144, 153–154, 155; Umayyads, 144, 148–149, 155. See also Crusades; Islamic art; Koran; Ottoman Turks

Islamic art and architecture: and 19th century English architecture, 348–349; architecture, 142, 143, 144, 146–151, 475–476; ardabil carpets, 152–153, 155; contemporary, 444, 445; early Christian influence on, 147; ivory carvings, 152, 155; Korans, 151–152, 155; Korans, 151–152, 155; kocations of, 144map; mosaics and tilework, 142, 146, 149, 150, 151; Roman influence of, 147; sculpture, 148–149; secular books, 154; Taj Mahal, Agra, 475–476, 475; Timurid secular books, 154, 155

Istanbul. See Constantinople, Turkey Ita Yemoo, Nigeria, king, Ife (sculpture), 559, 559

Italian Baroque art: architecture, 284, 285, 287–288; painting, 292–294; sculpture, 289, 290–291

249; Baptistery of San Giovanni

architecture, 241-243, 246-247,

Italian early Renaissance art, 218map;

Jefferson, Thomas: Monticello, 327, 327,

Jeanneret, Charles-Edouard. See Le Cor-

busier (Charles-Edourd Jeanneret)

1980-1983, 453-454, 453 Fridas, 404-405, 405 (Praxiteles), 73, 73, 81, 240 Biscayne Bay, Miami, Florida, 215, 513 Kahlo, Frida: influence of, 446; The Two Knidos, Greece, Aphrodite of Knidos Lady Mursaki, Tale of Genji (handscroll), Jeanne-Claude, Surrounded Islands, Kaaba, 145 fin-de-siècle culture, 358, 371 France, 186, 187, 196, 197, 198, 215 (Gu Kaizhi), 488, 489, 512 Kiss, 371-372, 371; reflection of Jean Le Loup, Reims Cathedral, Reims, the Instructress to the Court Ladies Klimt, Gustav, 371-372, 371; The Lady Feng and the Bear, Admonitions of France, 186, 187, 196, 197, 198, 215 Italy (mosaic), 131-132, 131 kiva mural, Kuaua Pueblo, 544, 544 Labille-Guiard, Adelaïde, 318 Bologna Jean d'Orbais, Reims Cathedral, Reims, attendants, San Vitale, Ravenna, The Kiss (Klimt), 371-372, 371 (sculpture), 529, 529 Justinian, Bishop Maximianus, and 186,088 La Venta, Mexico, colossal head, Olmec Jean de Boulogne. See Giovanni da 126-128, 126, 127, 141 Armory Show, 391; Street, Dresden, Jean (duke of Berry), 218, 225-226 dom), Constantinople, Turkey, 118, Kirchner, Ernst Ludwig: exposure at Jayavarman II (Khmer king), 479 Sophia (Church of the Holy Wis-099 '999 (Toji), (hanging scroll), 511 Cowherd), 476 Justinian (Byzantine emperor), Hagia Benin (bronze sculpture), 554, 554, Jayadeva, Gita Govinda (Song of the World) mandara, Kyoogokokuji (Hamilton), 421 king on horseback with attendants, 518, 525, 525; Taizokai (Womb Javan art, 478-479 Homes So Different, So Appealing? Taian teahouse, Myokian temple, Kyoto (Sen no Rikyu), 508, 518–519, Kimmei (Japanese emperor), 509 king, Ita Yemoo, Ile (sculpture), 559, Just What Is It That Makes Today's Javan, Indonesia, Borobudur, 478-479, Roman deity) Katsura Imperial Villa, 520, 520; Japanese tea ceremony, 515, 518-519 Jupiter. See Zeus (Jupiter) (Greek/ Khufu (king of Egypt), 33–34 Kim Tae-song, 502–503 garden, Ryoanji, 515-516, 515, 525; period, 508, 523; Yayoi period, 508 deity) Kyoto, Japan: karesansui (dry landscape) by, 362; under shoguns, 513; Showa Juno. See Hera (Juno) (Greek/Roman Кһтег аті, 481 scroll), 511, 511 Post-Impressionist art influenced khipu, 540 Taizokai (Womb World) (hanging Junius Bassus sarcophagus, 116, 117, Muromachi period, 514-517, 525; Khamerernebty (queen of Egypt), 36 Kyoogokokuji (Toji), Kyoto, Japan, Momoyama period, 517-519, 525; The Jungle (Lam), 397-398 470-472, 471, 472, 481 258' 242-246' 242 Jung, Carl, 415 modern period, 523-524; Khajuraho, India, Vishvanatha Temple, Kwakwaka'wakw, transformation masks, 508map; Meiji period, 508, 523-524; 762-263, 296 ture), 35, 35, 43, 43 Kushans (Kushan king), 464 Kofun period, 508-509, 525; maps, Julius II (Pope), 250, 251, 255, 256, 258, Khafre (king of Egypt), 34–35 Khafre enthroned, Gizeh, Egypt (sculp-Kushan dynasty, 462, 464, 481 Kamakura period, 513-514, 525; Julius Caesar (Roman emperor), 90 Kuhn, Walt, 391 and Yayoi periods, 508, 525; stadiums, Tokyo, 523-524, 524 767 'F67 125, 155 period, 508, 511-512, 525; Jomon Judith Slaying Holofernes (Gentileschi), Kenzo Tange, national indoor Olympic Kufic calligraphy, 144, 150, 151-152, enced by, 358, 362, 364, 368; Heian 614,614-814 Kublai Khan (Chinese emperor), 496 London, 326, 327 519-523, 525; European art influ-Judd, Donald: style of, 437; Untitled, display (photograph), 569-570, 570 Kent, William, Chiswick House, near Edo period, 8, 9, 506, 507, 508, 517, Joseon dynasty, Korea, 484, 503-504, 505 563, 563 Kuba king Kot a-Mbweeky III during a Nara periods, 508, 509-511, 525; warrior figure (Gu?) (sculpture), Kuba art, 569-570, 570, 571 Japanese art and architecture: Asuka and Peter and Marcellinus, Rome, 119, Kendo, Akati Akpele: fame of, 567; 045 '095 Kings (Bichitr), 474-475, 474 Jonah, ceiling of Catacomb of Saints Kekrops (king of Athens), 70 Kuba (Democratic Republic of Congo), Jahangir Preferring a Sufi Shaykh to Jomon period of Japanese art, 508, 525 Kei School of sculptors, 513-514 Kuaua Pueblo, New Mexico, 544, 544 York, 430-431, 431 Keats, John, 335 Jahangir (Mughal emperor), 474-475, Johnson, Philip, Seagram Building, New Kearny, Lawrence, 548 Gaze Hits the Side of My Face), 442, 524 '924-524 '794 Johnson, James Weldon, 392 Run (Wright), 408, 408, 409 459; style of, 440; Untitled (Your Jahan (Shah), Taj Mahal, Agra, India, Three Flags, 420, 422, 422 Kruger, Barbara: issues addressed by, Kaufmann House (Fallingwater), Bear American Cities, 431 Johns, Jasper: style of painting, 437; Kroisos, Anavysos, Greece (sculpture), 55–56, 55 style of, 323, 329 Jacobs, Jane, The Death and Life of Great John the Evangelist, Saint, 221 (Mother of the Gracchi), 312, 313; 768 '9 John the Baptist, Saint, 121, 221 ing Her Children as Her Treasures (sculpture), 63, 63 Jack-in-the-Pulpit No. 4 (O'Keefe), 4, 4, Johannes Trithemius, 199 Kritos Boy, Acropolis, Athens, Greece Kauffmann, Angelica: Cornelia Present-Jocho (Japanese sculptor), 514 Mount Fuji, 521-522, 521 ardhan Chand ?), 476, 476 Jingdezhen porcelain, 496-497, 497 Kanagawa, Thirty-six Views of Krishna and Radha in a Pavilion (Gov-Style wall painting), 96, 97 Jin dynasty, China, 493, 496 Katsushika Hokusai, The Great Waves off Krasner, Lee, The Seasons, 415 the Vettii, Pompeii, Italy (Fourth Testament themes (statue), 55–56, 55, 383 Ixion room, triclinium P of the House of Jewish subjects in Christian art. See Old Katsura Imperial Villa, Kyoto, Japan, Kouros, Attica, Anavysos, Greece 125, 153, 155 (relief on sarcophagus), 116, 117 (Pentewa), 528, 544, 544 ngulu), Gabon (sculpture), 562, 562 Islamic, 152, 153; Pyxis of al-Mughira, Medina al-Zahra, Spain, Jesus Christ with Peter and Paul, Rome Kota reliquary guardian figure (mbulu katsina figurine, New Oraibi, Arizona 711, 811, (sug (Saint Luke), Greece, 135-136, 135 Kota art, 556, 562, 562, 571 (Harbaville Triptych), 138, 138, 140; donkey, Rome (relief on sarcopha-Katholikon church, Hosios Loukas 025 '025-695 141; Christ enthroned with saints, Jesus Christ entering Jerusalem on a temple of Amen-Re, 38-40, 39 ivory carvings: Byzantine triptychs, 118, Kot a-Mbweeky III (Kuba king), or specific event in His life 40; Amen-Re temple, 38-39, 39; architecture; specific Italian city 434-435, 435; style of, 437 beginning with Christ or Crucifixion Karnak, Egypt: Akhenaton statue, 40, Kosuth, Joseph: One and Three Chairs, See also Roman Empire history, art, Virgin and Child; and headings God) (Hildegard of Bingen), 177. Korin. See Ogata Korin 175-176, 175, 176. See also Pictàs; karesansui (dry landscape) garden, Ryo-anji, Kyoto, Japan, 515–516, 515, Korean War, 412 244-248; Scivias (Know the Ways of art, 120-121; in Romanesque art, Kingdom, 502-503, 505 map, 229map; princely courts of, Mannerism, 268–272; life events in art of, 459 period, 501-502; Unified Silla and, 177-179; Mannerism, 268-272; Park, Chicago, 456, 456; site-specific tion of, 484map; Three Kingdoms 252map, 283; Holy Roman Empire Kapoor, Anish: Cloud Gate, Millennium dynasty, 484, 503-504, 505; loca-210; High Renaissance/Mannerist High Renaissance period, 252-268, Goryeo dynasty, 503; Joseon Grand Tours in, 321-322, 329; Gothic art, 204, 205, 207-210, 207, Kano School of Japanese painting, 517, Korean art: contemporary, 459, 504; 207, 208, 209, 210, 211, 212, 213; ni ;842, 244-245, 244, 248, 248; in Broom, 516, 517 241, lo 387; Gothic period, 205-214, 206, sance art, 221, 224, 224, 235-236, n nitw gridsowe anixid novganis Islamic architecture, 151; writing 229-248, 249; Futurism in, 386, Kano Motonobu, Zen Patriarch 163, 163, 169, 169; in Early Renais-155, 155; verses as decoration of 179; early Renaissance period, 125, 125, 169; in early medieval art, Koran: paintings in, 144, 151-152, 152, 295, 311; Cathedral complex, Pisa, 119, 119, 120, 123, 123-124, 124, Kano Eitoku, Chinese Lions, 517-518, 288, 289, 290, 291, 311; Baroque painting, 291–295, 292, 293, 294, 644 '054-644 Early Christian art, 116, 116, 117, Kanishka (Kushan king), 464 Koons, Jeff, Pink Panther (sculpture), ni; 134, 134, 136, 136, 140, 169; in Kangxi (Chinese emperor), 500 145 '145 '895 and sculpture, 284, 287-291, 287, 298, 311; in Byzantine art, 130-132, Republic of Congo (sculpture), 563, 381; influence of, 415 reale), 373; Baroque architecture Jesus, life of: in Baroque art, 298-299, of, 378; Improvisation 28, 380-381, Shiloano River area, Democratic 323, 329; Art Nouveau (Stile Flo-567-767 Kongo power figure (nkisis n'kondi), Armory Show, 391; Expressionism Italy: 18th century art, 322-323, 322, Jesuit order (Society of Jesus), 264, 265, Kongo art, 563, 563, 571 tual in Art, 380; exposure at ture, 205-206. See also Renaissance 105, 146 Kong Fuzi (Confucius), 488 Kandinsky, Vassily: Concerning the Spiri-210, 211; painting, 206-212; sculpin, 144, 145; Roman sack of (70), Kamehameha (Hawiian chief), 548 115-015 155; Muslim capture and building 3-4, 212-214; International Style, Kamakura period, Japan, 513-514, 525 kondo, Horyuji temple, Ikaruga, Japan, Italian late medieval art: architecture, Rock, 144, 145, 146, 146, 151, 155, Parthenon (Iktinos and Kallikrates) Child, 382, 382 Italian Futurists, 378, 386 Sepulchre, 146, 170; Dome of the Nike, 66, 70-71, 70, 71. See also Kollwitz, Käthe, Woman with Dead Jerusalem, Israel: Church of the Holy 234, 233, 234, 249; Urbino, 245 Kallikrates, Greece, Temple of Athena 615 '615 Mountains, 504, 504 courts, 244-248; sculpture, 233-Kogan (Shino tea-ceremony water jar), Jeong Seon, Geumgangsan (Diamond) 244-245, 247-248, 249; princely Kofun period, Japan, 508-509, 525 enemies (relief sculpture), 27-28, sity of Virginia, 327 248; Milan, 248; painting, 235-240, Kalhu (Iraq), Assyrian archers pursuing 18 '18 '15 '61 '81 Florence, 229-244; Mantua, 246-Kalabari Ijaw art, 556, 565, 565, 571 Richmond, Virginia, 327; Univer-Knossos palace, Crete, Greece, 48-51, celli, 239-240; engraving, 240-241; 314, 316, 326-327; State House, 551 '241 '241-941 15,12-02 competition, 229-230, 230; Botti-Kairouan, Tunisia, Great Mosque, 329; Neoclassicism promoted by,

87 '87-17

pursuing enemies (relief sculpture),

Kahlu (Nimrud), Iraq, Assyrian archers

Snake Goddess, palace of Knossos,

palace, 48-49, 48, 49, 51, 81, 81;

Knossos (Crete), Greece: bull-leaping, palace of Knossos (fresco), 49, 49;

Lady of Auxerre, Crete, Greece (sculpture), 54, 55, 56 Lagraulas, Jean de Bilhères, 258 Lahori, Usatad Ahmad, Taj Mahal, Agra,

India, 462, 475-476, 475

Lakshmi (Hindu deity), 469 Lam, Wifredo, The Jungle, 397-398 lamassu (man-headed winged bull), citadel of Sargon II, Dur Sharrukin (Khorsabad) (sculpture), 27, 27,

Lamentation, Arena Chapel (Cappela Scrovegni), Padua, Italy (Giotto di Bondone), 208-209, 208, 215, 215 Lamentation, Isenheim Altarpiece, Hos-

pital of Saint Anthony (Grünewald), 272-273, 273 Lamentation, Saint Pantaleimon, Nerezi,

Macedonia, 121, 138-139, 139 Lamentation over the Dead Christ (Foreshortened Christ) (Mantegna), 248,

248 landscape, 5, 8. See also specific landscape Landscape with Cattle and Peasants (Claude Lorrain), 306-308, 307

landscape with swallows (Spring Fresco), Akrotiri, 49-50, 50

Lange, Dorothea: documentary photography of, 378; Migrant Mother, Nipomo Valley, 400, 400

Laocoön and his sons (Athanadoros, Hagesandros, and Polydoros of Rhodes) (sculpture), 80, 80, 271 Laozi, 488

large plate, Showa period (Hamada), 524, 524, 525, 525

Las Meninas (The Maids of Honor) (Velázquez), 297-298, 297, 311

Lascaux, France: Hall of the Bulls cave painting, 18-19, 19; rhinoceros, wounded man, and disemboweled bison (cave painting), 19-20, 19

Last Judgment, Arena Chapel (Cappella Scrovegni), Padua, Italy (Giotto di

Bondone), 208 Last Judgment, Saint-Lazare, Autun, France (Gislebertus), 174, 175, 175

Last Judgment, Sistine Chapel ceiling (Michelangelo), 250, 251, 261, 261, 334, 372

Last Supper (Tintoretto), 270-271, 270 Last Supper, Santa Maria delle Grazie, Milan, Italy (Leonardo da Vinci), 254–255, 254, 256, 270–271

Last Supper, Sant'Apollonia, Florence (Andrea del Castagno), 238, 238

late 19th century European and American art: architecture, 373-374, 375; Art Nouveau, 373; fin-de-siècle, 371; Impressionism, 344, 357, 359-364, 375; locations of, 358*map*; Modernism, 358, 360; Post-Impressionism, 364-370, 375; sculpture, 372; Symbolism, 370-372, 375

late 20th century European and American art: Abstract Expressionism, 2, 413–416, 418, 437; abstract sculpture, 418–420, 437; after 1980, 436; Conceptual Art, 434-435, 437; Environmental and Site-Specific Art, 432–434, 437; Expressionism, 412–416, 437; feminist art, 426– 428, 437; Modernist architecture, 429-430, 437; new media, 435-436, 437; Op Art, 7, 417, 418, 437; Performance Art, 434, 437; Pop Art, 420-424, 437; Postmodernism, 410, 411, 431-434, 437; Post-Painterly Abstraction, 415-417, 437; sculpture, 412, 418-420, 424, 437; Superrealism and photography, 424-426, 437. See also Modernism in Europe and America (1945-1980)

Late Classical period of Greek art, 46, 72-76, 81

Late Empire Roman art, 90, 108-114 Late Gothic period, 188, 218 La Venta, Mexico, colossal head, Olmec

(sculpture), 529

law stele of Hammurabi, Babylon, Iraq, 26 - 27, 26

Lawrence, Jacob: The Migration of the Negro series, 402-403, 402; subject matter of art, 378, 409

Le Brun, Charles, Galerie des Glaces (Hall of Mirrors), palace of Versailles, 308-309, 309

Le Corbusier (Charles-Edourd Jeanneret): architecture of, 409, 411, 429; influence of, 524; Notre-Dame-du-Haut, Ronchamp, France, 429-430, 429, 430, 437; Purism founded by, 385; Villa Savoye, Poissy-sur-Seine, 407-408, 407

Le Déjeuner en Fourrure (Luncheon in Fur) (Oppenheim), 396, 396

Le Nôtre, André, park, palace of Versailles, 309, 309

Le Tuc D'Audoubert, France, two bison reliefs, 17

Leach, Bernard, 524 Legalism, 485

Léger, Fernand: Ballet Mécanique (Mechanical Ballet), 385; The City, 385, 385

Legrand, Paul, Hidatsa Warrior Pehriska-Ruhpa (Two Ravens) (Bodmer) (engraving), 545

Leibniz, Gottfried Wilhelm von, 316 Lemoyne, Jean-Baptiste, sculptures, Salon De La Princesse, Hôtel de Soubise, Paris, 314-315, 314

Leo III (Byzantine emperor), 13, 118, 126, 135, 141

Leo III (Pope), 161 Leo X (Pope), 272

Leonardo da Vinci: architecture and sculpture of, 255; Francis I's invitation, 277; Last Supper, Santa Maria delle Grazie, Milan, Italy, 254-255, 254, 256, 270-271; Madonna of the Rocks, 232, 253, 253, 255; in Milan, 248; Mona Lisa, 255, 255; scientific investigations, 252-253; style of, 268, 302; treatises of, 274

Leto/Latona (Greek deity), 47 Le Tuc D'Audoubert, France, two bison reliefs, 17

Lewis, Edmonia, Forever Free, 347, 347 Leyster, Judith, Self-Portrait, 301, 301 Liao dynasty, China, 484, 494-495 Liberty Leading the People (Delacroix), 338, 338

Lichtenstein, Roy: Hopeless, 423, 423, 437, 437; style of painting, 437 Licinius, 112

life and death of Buddha, Gandhara, Pakistan (frieze), 466, 466, 467,

Life magazine, 400-401, 418 Life of Jesus, Maestà atlarpiece, Siena Cathedral, Siena, Italy (Duccio),

Limbourg brothers (Pol, Herman, Jean): illusionistic capabilities of manuscript illumination of, 218, 224-225, 249; Les Très Riches Heures du Duc de Berry (Very Sumptuous Hours of the Duke of Berry), 225-226, 225, 249

Lin, Maya Ying, Vietnam Veterans Memorial, Washington, D.C., 440, 454-455, 454, 459

Lincoln, Abraham, 347 Lindau Gospels, Saint Gall, Switzerland, 163, 163

Lindisfarne Gospels, Northumbria, England, 160, 160, 185 line, 7

linear perspective, 232, 241, 249. See also perspective; specific works of art for examples

Lingering Garden, Suzhou, China, 498, 498, 505

linguist's staff, Ghana (Bonsu), 566, 567 Lintong, China, Army of the First Emperor of Qin, 485, 486, 486, 505, lion capital of the pillar set up by Ashoka, Sarnath, India (sculpture), 464, 464, 481, 481

Lion Gate, Mycenae, Greece, 52, 52 Lion Hunt (Rubens), 8, 9, 298

lions of trumeau of Saint-Pierre, Moissac, France, 156, 174

Lippi, Fra Filippo, Madonna and Child with Angels, 238-239, 238, 255

Lipstick (Ascending) on Caterpillar Tracks (Oldenburg), 424, 424 Liszt, Franz, 335

literati painting, 499–500, 499, 500 lithograph of the Crystal Palace (Martinet), 350

lithography, 344, 345, 355. See also specific lithographs

Yuan (Lingering Garden), Suzhou, China, 498, 498

Lives of the Most Eminent Painters, Sculptors, and Architects (Vasari), 252 Livia (empress of Rome), 98, 98

Lobster Trap and Fish Tail (Calder), 399-400, 400

Locke, John, 316

London, England: 18th century architecture, 326, 327; Chapel of Henry VII, Westminster Abbey (Robert and William Vertue), 202, 202, 215; Crystal Palace (Paxton), 350-351, 350, 351, 355, 452; Houses of Parliament (Barry and Pugin), 348, 349; Saint Paul's Cathedral (Wren), 286, 310, 310, 326

longitudinal plan, 122, 122 longitudinal sections, 12 Longmen Caves, Luoyang, China, 489, 489 Lord Heathfield (Reynolds), 320, 320

Lorenzetti, Ambrogio: Effects of Good Government in the City and in the Country, Sala della Pace, Palazzo Pubblico, Siena, Italy, 211-212, 211; Peaceful Country, walls of Sala della Pace, Palazzo Pubblico, Siena, Italy, 212

Lorenzo the Magnificent, 233, 240, 244 Lorrain, Claude. See Claude Lorrain Louis VI (king of France), 189, 192 Louis VII (king of France), 189 Louis IX (king of France), 198, 199, 199 Louis XIV (king of France), 286, 308-309, 308, 314

Louis XIV (Rigaud), 308, 308 Louis XV (king of France), 318 Loves of the Gods, Palazzo Farnese, Rome (Carracci), 292, 292

low relief sculpture, 12. See also specific relief sculpture for examples Luce, Henry, 400-401

Lucius Verus (emperor of Rome), 83, 90,

Ludovisi Battle Sarcophagus (battle of Romans and barbarians), Rome, 110, 111

Luna. See Selene (Luna) (Greek/Roman deity)

Luther, Martin, 272, 275

Luxembourg Palace, Paris, Arrival of Marie de' Medici at Marseilles (Rubens), 299

Luxor, Egypt. See Thebes, Egypt luxury arts: early Medieval European, 158-159; Gothic, 199-201; Islamic, 151-154. See also ceramics; illuminated manuscripts

Lysippos of Sikyon, Apoxyomenos (Scraper), 74, 74

Ma Yuan, On a Mountain Path in Spring, 495, 495, 505 Macedonian dynasty, 135 Macedonian Renaissance, 139 Machu Picchu, Peru, 528, 540, 541 Maderno, Carlo, east facade, Saint Peter's, Rome, 288, 288, 291

Madonna and Child, Isenheim Altarpiece, Hospital of Saint Anthony (Grünewald), 272

Madonna and Child with Angels (Lippi), 144, 238-239, 238

Madonna Enthroned (Ognissanti Madonna), Chiesa di Ognissanti, Florence (Giotto di Bondone), 206-207, 207, 209, 239

Madonna Enthroned with Angels and Prophets, Santa Trinità, Florence (Cimabue), 206, 206

Madonna in the Meadow (Raphael), 256, 256, 283, 283

Madonna of the Rocks (Leonardo da Vinci), 253, 253, 255

Madonna with the Long Neck, Santa Maria dei Servi, Parma, Italy (Parmigianino), 269-280, 269

Madrasa Imami, Isfahan, Iran, 151, 151 Madrid, Spain, El Escorial (Herrera and Baustista de Toledo), 281-282, 281

Madurai, India, Great Temple, 476-477, 477

Maestà altarpiece, Siena Cathedral, Siena, Italy (Duccio di Buoninsegna), 209-210, 209, 210, 239

Magritte, René, The Treachery (or Perfidy) of Images, 396, 396 Mahatma Gandhi, 477

Mahayana Buddhism, 466 Maitani, Lorenzo, Orvieto Cathedral, Orvieto, Italy, 212, 212

malanggan mask, New Ireland, Papua New Guinea, 552, 552

male ancestor figure, East Alligator Rivers, Northern Territory, Australia, 551-552, 551

Malevich, Kazimir, Suprematist Composition: Airplane Flying, 390, 390

Mali, Dogon seated couple (sculpture), 564-565, 564

Malik Shah I (Muslim caliph), 151 Malouel, Jean, Well of Moses, Chartreuse de Champmol, Dijon, France, 219, 219

Malwiya Minaret, Great Mosque, Samarra, Iraq, 147-148 Mamluks, 144

Man Pointing No. 5 (Giacometti), 412, 413

mandara (mandalas), defined, 511, 511 Manet, Édouard: A Bar at the Folies-Bergère, 356, 357, 358; Le Déjeuner sur l'Herbe (Luncheon on the Grass), 344-346, 345, 358, 383; Morisot and, 363; Olympia, 346-347, 346, 355; reception of his works, 332; reception of photography, 353; style of, 355

Mangaia, Cook Islands, 550-551 maniera greca painting, 206-207, 206, 215

Mannerist art and architecture: Bronzino (Agnolo di Cosimo), 270, 270; France, 277, 277; Giambologna, 252, 271, 271; Giulio Romano, 271-272, 271; Holy Roman Empire, 272-276; Netherlands, 277-281; Parmigianino, 252, 269-270, 269, 283; Piazza d'Italia, New Orleans, 411; Pontormo, 252, 268-269, 269, 283; Romano, 252, 271-272, 271, 283; Spain, 281-282, 281, 282; Tintoretto, 252, 270-271, 270

Mantegna, Andrea: Camera degli Sposi (Room of the Newlyweds), Palazzo Ducale, Mantua, Italy, 246-248, 247, 260; Foreshortened Christ (Lamentation over the Dead Christ), 248, 248

Mantua, Italy: Palazzo del Tè (Giulio Romano), 271-272, 271; Palazzo Ducale (Mantegna), 246-248, 247, 260; Sant'Andrea (Alberti), 246, 246, 249, 249, 264

manuscript illumination. See illuminated manuscripts

Maori art: Mataatua meeting house, Whakatane, New Zealand (Apanui), 549, 550, 550, 553; tattoos, 13, 13, 549

preoccupying, 369; Impression: Monet, Claude: atmospheric conditions ence of, 399-400 Blue, and Yellow, 398, 398; influ-Mondrian, Piet: Composition with Red, 176. See also monasteries; monastic monasticism, 133, 159, 165, 172-173, 567-767 can, 242-243; Jesuit, 264, 265, 173-174; Dominican, 237; Francis-181-182; Cluniac, 157, 158, Cistercian, 165, 173, 176-177, 164-166, 173; Carthusian, 219; monastic orders: Benedictine, 133, 219. See also specific monasteries 164-166, 165, 169-170, 176, 219, Christian, 133, 135, 159, 161, monasteries: Buddhist, 468, 515-516; 557 Mona Lisa (Leonardo da Vinci), 255, Momoyama period, Japan, 517-519, 525 II 'splom Romanesque capitals in cloister of Saint-Pierre, 172–173 156, 157, 174, 174, 185, 185; Moissac, France: portal of Saint-Pierre, in yogic posture, 463, 463 of, 462-463; seal with seated figure Mohenjo-daro, Pakistan: development (White), 426, 426 Moencopi Strata, Capitol Reef, Utah modules, 9-10 Rome, 288 Moderno, facade of Old Saint Peter's, 424-426, 437 ism, 412, 437; Superrealism, 412, 415-417, 437; Postwar Expression-Painterly Abstraction, 412, Pop Art, 412, 420-424, 437; Post-437; performance arts, 412, 437; 437, 454-455; Op Art, 412, 417, 426-428, 437; Minimalism, 412, 429-433, 437; feminist art, architecture and site-specific art, sculpture, 418-420, 424, 437; ism, 422, 437, 450; abstract (1945-1980): Abstract Expression-Modernism in Europe and America 450, 450 398, 409; Surrealism, 394–398, 409, ture, 398-399; Suprematism, 390, ism, 385; Regionalism, 403; sculp-376, 377, 383–385, 396, 397; Pur-Sachlichkeit, 393-394, 409; Picasso, Mexican art, 403-405; Neue Expressionism, 378, 380-382, 409; 387, 390, 395, 409, 412; German vism, 378-379, 409; Futurism, 386, De Stijl, 398, 405-406, 409; Fau-386-390, 394, 395, 409, 419, 422; 383-385, 390, 392, 409, 446; Dada, architecture, 405-408, 409; Cubism, :4vm08£, e04-37£, (2491-0091) Modernism in Europe and America msilodmyz sionism; Post-Impressionism; 4-5; Chinese, 500. See also Impres-Modernism: in 19th century, 344–346, 345, 358, 357, 358, 360, American, Amen-Re, Karnak, Egypt, 39 model of hypostyle hall, temple of (Mies van der Rohe), 406, 407 model for a glass skyscraper, Berlin Moctezuma II (Aztec emperor), 538 Moche culture, 538, 539-540 mobiles, 399-400 Rapa Nui, 547-548, 547 moai on stone platform, Ahu Tongariki, collage 427; Picasso, 384-385. See also European and American art, 426, 444, 450-451; late 20th century mixed media: contemporary, 438, 439,

627 '627-827

Money-Changer and His Wife (Massys),

363; Saint-Lazare Train Station,

Sunrise, 359, 359, 360; influence of,

360-361, 360; style of, 375

Khajuraho, India, 472, 472 Mithuna reliefs, Vishcanatha Temple, Mithridates VI (king of Pontus), 80 Mithras (Persian deity), 110 Mississippian culture, 528, 542-543, 553 Painting, 396-397, 397 Miró, Joan: influence of, 400, 413, 420; (mosaic), 123, 125, 125 Sant'Apollinare, Ravenna, Italy Miracle of the Loaves and Fishes, Minoan art, 48-51, 48 954-454 ,784, 412, 412, 419, 437, miniatures: contemporary, 444, 444; of India, 462, 473, 474, 481 505, 502, 002-994, 4pm484 Ming dynasty, China, 482, 483, 484, Roman deity) Minerva. See Athena (Minerva) (Greek/ EIS Minamoto Yoritomo (Japanese shogun), 343-344, 344 Millet, Jean-François, The Gleaners, Millais, John Everett, Ophelia, 347-348, 871, 971-871, oigordmA'ins2 ardo da Vinci), 253, 253; 253; Madonna of the Rocks (Leon-256, 270; Leonardo da Vinci, 248, (Leonardo da Vinci), 254-255, 254, per, Santa Maria delle Grazie Milan, Italy: Bramante in, 261; Last Sup-ISI 'ISI Mihrab, Madras Imami, Isfahan, Iran, rence), 402-403, 402 The Migration of the Negro series (Law-00+ '00t Migrant Mother, Nipomo Valley (Lange), Wright's architecture, 408 New York, 430-431, 431, 437; on Berlin, 406, 407; Seagram Building, 411; model for a glass skyscraper, of, 429; Bauhaus architecture, 407, Mies van der Rohe, Ludwig: architecture Middle Stone Age, 20 Middle Plaza, Copán, Honduras, 532, Persian history and art Middle Eastern art, 445, 459. See also Micronesia, 528, 546, 548, 549 Medici-Riccardi, Florence, 218, 243 Michelozzo di Bartolommeo, Palazzo 261; unfinished captive (sculpture), Rome, 250, 251, 258-261, 259, 260, Sistine Chapel ceiling, Vatican, sculpture and painting of, 252, 283; Santa Maria degli Angeli, 109, 109; 762-263, 262, 263, 264, 288, 289; 257, 325, 334; Saint Peter's, Rome, Sistine Chapel altar wall, 250, 251, 261, 261, 334, 372; Pieta, 257-258, Julius II and, 296; Last Judgment, 251, 260; influence of, 270, 298; Man, Sistine Chapel ceiling, 250, 293; David, Palzzo dell Signoria, Florence, 258, 259, 289, 292; Fall of Chapel ceiling, 250, 251, 260, 260, jects, 296; Creation of Adam, Sistine Michelangelo Buonarroti: choice of sub-Michel) Michel, Claude. See Clodion (Claude emperor), 118, 140 Michael VIII Palaeologus (Byzantine Spain, 142, 143, 144, 148-149, 148, Mezquita (Great Mosque), Córdoba, 504 '404' 404-604 Mexico City, Mexico, Palacio Nacional, 553; Toltec culture, 533, 534-535, 537, 553; Teotihuacán, 529-531, 553; Tenochtitlán, 536-537, 536, 531-533, 553; Olmec culture, 529, Mayan culture, 526, 527, 528, Modernism in, 403-405, 409; 528, 536-537, 536, 537; interwar

553; Great Temple, Tenochtitlan,

553; Chichén Itzá, 533-534, 553,

553; Castillo pyramid-temple, 528, Mexico: Aztec culture, 533, 535-537, Mexican Revolution (1910-1920), 403 Mexica. See Aztec culture and art Metaphysical Painting, 394-395 12, 22-25, 43 South Asian art, 462; Sumerian, 14, mythology, 21, 23-25, 28; and Sumerian, 26, 43; religion and 22map; Neo-Babylonian, 28; Neo-Babylonian, 24, 26-27; location, 25-26, 27, 43; Assyrian, 27-28; aemenid Persia, 28-30; Akkadian, Mesopotamian history and art: Ach-Mesolithic Age, 20 Toltec, 533, 534, 535, 553 529, 532, 553; periods of, 528; Teo-tihuacán, 528, 529–531, 533, 553; 531-533, 534, 534, 535, 553; Olmec, tion, 528map; Maya, 526, 527, Aztec, 405, 533, 535-538, 553; loca-Mesoamerican art and architecture (U.S.A.), Cliff Palace, 528, 543, 543, Mesa Verde National Park, Colorado 129, 159, 159 from ship burial, Sutton Hoo, Eng-128, 159, 185; fibulae, 158; purse Merovingians: cloisonné ornamentation, 220-221, 220, 222, 223, 249 Mérode Altarpiece (Master of Flémalle), (Michelangelo Merisi) Merisi, Michelangelo. See Caravaggio Roman deity) Mercury, See Hermes (Mercury) (Greek) mercantilism, 286 Mentuhotep II (king of Egypt), 36 Menrva (Etruscan deity), 85 Gizeh, Egypt (sculpture), 36, 36 Menkaure and Khamerernebty (?), Menkaure (king of Egypt), 34, 36 (Velázquez), 286 Las Meninas (The Maids of Honor) Menes (king of Egypt), 30 Mende art, 569, 571 Mencius (Mengzi), 488 Siena, Italy, 210-211, 211 Saint Ansanus, Siena Cathedral, Memmi, Lippo, Annunciation altarpiece, portraiture established by, 249 Nieuwenhove and His Wife, 223; Memling, Hans: Diptych of Martin van Melun Diptych (Fouquet), 226, 226 Melos, Greece, Venus de Milo, 78-79, 78 Melencolia I (Dürer), 274-275, 275 Melanesian art, 528, 546, 552, 552 Meiji period, Japan, 508, 523-524 Saint Anthony (Grünewald), 272, Isenheim Altarpiece, Hospital of Meeting of Saints Anthony and Paul, ∠-9 'muipəm ture), 464 meditating Buddha, Gandhara (sculp-123' 122 al-Mughira (ivory carving), 152, Abd-al-Raham III, 152; Pyxis of Medina al-Zahra, Spain: palace of Medina, 145 medieval sultanate, 462 esdue Europe Italian late medieval art; Romantecture; Gothic art and architecture; medieval European art and archimedieval art, 335, 348. See also early 229, 233, 238, 239, 240, 242 papacy and, 272; patronage of, 218, (Michelozzo di Bartolommeo), 243; 257, 258; Palazzo Medici-Riccardi Medici family: expulsion of, 218, 244, Medici, Marie de, 298, 299 Magnificent), 233, 240 Medici, Lorenzo di Pierfrancesci de' (the Medici, Giovanni di Bicci de, 233, 242 Medici, Cosimo I de, 233, 270 Mecca, 145 Meat Joy (Schneemann), 434, 434, 437, issues addressed by, 459; The Perfect Mapplethorpe, Robert: influence of, 440;

Meagher, Michelle, 448

258, 531-533, 534, 534, 553 Mayan art and architecture, 526, 527, Maximianus, Bishop, 118 18t 18t-98t tomb of the marquise of Dai, Mawangdui, China, funeral banner, Italy, 123, 124, 124 Maurya dynasty, 461, 462, 464, 481 Mausoleum of Galla Placidia, Ravenna, Woman with the Hat, 378-379, 378 Room (Harmony in Red), 379, 379, exposure at Armory Show, 391; Red description of Braque's work, 383; Matisse, Henri: on color, 378-379, 417; material, 6-7 New Zealand (Apanui), 550, 550 Mataatua meeting house, Whakatane, guese saltcellar, 560-561, 561 bution of works of, 567; Sapi-Portu-Master of the Symbolic Execution: attri-(Master of Flémalle) Master of Flémalle. See Campin, Robert Edmunds abbey, England, 181-182, Master Hugo, Bury Bible, Burry Saint mastaba of Ti, Saqqara, Egypt, 36, 37 mastaba, 31-33, 32, 33, 36, 37, 43 His Wife, 278-279, 279 Massys, Quinten, Money-Changer and masquerades, African, 568, 568, 569 masks of ancestors, 528 Florence (fresco), 235-236, 235 Money, Santa Maria del Carmine, (fresco), 236, 237, 249; Tribute Santa Maria Novella, Florence Mone Cassai), 218; Holy Trinity, Masaccio (Tommaso di ser Giovanni di Mas o Menos (More or Less) (Stella), 417, Mary Magdalene, 121, 202-203, 208 Μαδοπης οτ Μιτβίπ ings beginning with Annunciation, 138, 140, 140. See also Pietàs; head-197, 200-201; in scenes in interior role in Gothic Europe, 190, 196, 202-203, 203; in life of Jesus, 120; Cathedral, Strasbourg, France, Virgin, tympanum at Strasbourg Mary (mother of Jesus): Death of the Marxism, 358, 500 Marx, Karl, 344, 358 piece, Saint Ansanus, Siena, Cathedral, Siena, Italy, 210–211, 211 Martini, Simone, Annunciation altarfonso Pueblo, New Mexico, 545, 545 Martinez, Maria Montoya, jar, San Ildethe Crystal Palace, 350 Martinet, Achille-Louis, lithograph of Martin V (Pope), 218 deity) Mars. See Ares (Mars) (Greek/Roman Marriage à la Mode (Hogarth), 319, 319 Marquesan tattoos, 13, 13, 548-550, 549 of Damascus), 104-105, 105, 115 Markets of Trajan, Rome (Apollodorus Mark Antony (Roman consul), 76, 90, Marinetti, Filippo Tommaso, 386, 387 Marilyn Diptych (Warhol), 425 Marilyn (Flack), 424-425, 424 Marduk (Mesopotamian deity), 28 801 '201 '201 '06 Marcus Aurelius (Roman emperor), 83, Marco Polo, 496 Marcellus (Roman consul), 90 ers group, 380 381-382; founding of The Blue Rid-382; focus on color and feelings, Marc, Franz: Fate of the Animals, 382, Marat, Jean-Paul, 325 Ardabil, Iran, 152-153, 153 ary mosque of Shaykh Safi al-Din, Maqsud of Kashan, carpet from funer-EFF 'EFF

Moment, 442, 443; Self-Portrait,

Mongols, 484, 495-496 Monk's Mound, Cahokia, Illinois, 528, 542, 553 Mont Sainte-Victoire (Cézanne), 369, 369, 370 Montegna, 218 Monterozzi necropolis, Tarquinia, Italy, 87, 87, 115 Monticello (Jefferson), 327-328, 327, 329 Moore, Charles, Piazza d'Italia, New Orleans, 410, 411, 431, 437, 437 Moore, Henry, 398 Moorish art. See Islamic art Moralia in Job, initial R with knight fighting a dragon, Citeaux, France (Gregory the Great), 176-177, 176 moralized Bibles, 199, 199, 200, 215, 215 Morgan Bible, 199, 199 Morgan Madonna, Auvergne, France, 174, 176, 176 Morisot, Berthe, Summer's Day, 362-363, 363 mortuary temple of Hatshepsut, Deir el-Bahri, Egypt, 37-38, 37, 39, 43 mortuary temple of Khafre, Gizeh, Egypt (model), 33, 35 mosaics: Byzantine, 130-132, 131, 132, 136-137, 136; early Christian, 121, 123-125; Islamic, 142, 146, 149, 149, 151; materials and techniques for Greek pebble mosaics, 124; Roman, 74-75, 75 Mosan artisans, Shrine of the Three Kings, Cologne Cathedral, Cologne, Germany, 202, 203 Moses Expounding the Law, Bury Bible, Bury Saint Edmunds abbey, England (Master Hugo), 182, 182 motion pictures, 354, 386. See also video Le Moulin de la Galette (Renoir), 361, 361, 364 Mount Sinai monastery, Egypt, 141; Saint Catherine's monastery, 133; Virgin (Theotokos) and Child between Saints Theodore and George, Monastery of Saint Catherine (icon), 134, 134, 141 mudras, 466 Mughal Empire art, 462, 473-477, 481 Muhammad, 143, 144, 145, 146 Muhammad of Ghor, 473, 495 multimedia installations, 458, 459 mummification, 32, 41-42, 107-108 mummy portrait of a priest of Serapis, Hawara (encaustic painting), 107-108, 107 Munch, Edvard, The Scream, 370-371, 371, 380, 450 Muqarnas dome, Hall of the Abencerrajes, Palace of the Lions, Granada, Spain, 149, 149 mural painting: Mesoamerican, 526, 527, 530–531, 530; Minoan, 49–50; of Native North Americans, 544, 544; of Orozco and Rivera, 378, 403-404. See also cave painting; wall painting Murasaki Shikubu, Genji Visits Murasaki, Tale of Genji (handscroll), 512, Murder of Cain, doors of Saint Michaels, Hildesheim, Germany (Bernward), 168, 168 Muromachi period, Japan, 514-517, 525 Murray, Elizabeth: Can You Hear Me? 450, 450; style of, 440, 459 music, 335 Muslim sultanate, 462 Muslims. See Islam; Islamic art al-Mutawakkil (Abbasid caliph), 148 Muybridge, Eadweard, Horse Galloping (Calotype print), 354, 354 Myanmar art (Burmese art), 480-481 Mycenae citadel, 51 Mycenean art: funerary mask, Grave

Circle A of royal shaft graves, 53,

53; Lion Gate, 52, 52; royal shaft

of Atreus, 52-53, 52, 53, 86

graves, 53; Tiryns, 51, 53; Treasury

Myokian temple, Kyoto, Japan (Sen no Rikyu), 508, 518-519, 518 Myron, Diskobolos (Discus Thrower). 63-64, 63, 289 mystery plays, 209 mythology. See religion and mythology; and specific mythological deity Nadar (Gaspar-Félix Tournachon): Eugène Delacroix, 352, 352, 353; style of, 355 nail figure (nkisi n'kondi), Kongo (sculpture), 563, 563, 571 Naked Portrait (Freud), 425 Namdaemun, Seoul, Korea, 503, 503, Namibia, Apollo 11 Cave, 556, 557 Napoleon at the Plague House at Jaffa (Gros), 333–334, 333, 355, 355 Napoleon Bonaparte, 328, 332, 333, 355 Napoleonic era art, 332-334, 333, 334, Nara, Japan, Shunjobo Chogen portrait statue, Todaiji, 513-514, 513 Nara period Japanese art, 508, 510-511, Nara Prefecture, Horyuji temple, Ikariga, Japan, 510-511, 510 Naram-Sin victory stele, Susa, 25-26, 26 Narmer (king of Egypt), 30-31 Nasca culture, 528, 538, 553 Nasca Lines, 539, 539, 553 Nasca Plain, Peru, hummingbird (Nasca Lines), 539, 539 Nash, John, Royal Pavilion, Brighton, 348, 349, 350 Nasrids, 144, 149, 155 National Endowment for the Arts (NEA) (U.S.A.), 442, 443 National Environmental Policy Act (1969), 433national identity in contemporary art, 440, 444-445, 459 Native American art: contemporary, 438, 439, 440, 459, 546, 550-552; Great Plains, 546, 553; maps, 528map, 538map, 542map; Meso-america, *526*, 527, 528–538, 553; Northwest Coast, 545-546, 553; South American, 538-541, 553; Southwest, 543-545, 553; Woodlands, 542-543, 553 nativity, 120, 234-235, 235 Natoire, Joseph, paintings in Salon De La Princesse, Hôtel de Soubise, 314-315, 314 Naturalistic Surrealism, 394, 404, 409 Naukratis, Greece, 56 Naumburg Cathedral (Naumburg Master), 204-205, 204, 215 Naumburg Master, Ellehard and Uta, Naumburg Cathedral, Naumburg, Germany, 204-205, 204 Nayak dynasty, 462, 476, 481 Nefertiti, bust of, Amarna, Egypt (Thutmose) (sculpture), 40-41, 41 Neo-Babylonian art, 28, 29, 43 Neoclassicism, 313, 314, 323-328, 329, 331, 332 Neo-Gothic architecture, 348, 355. See also Gothic Revival Neolithic Age: African art, 556, 557; Çatal Höyük wall painting, 20–21, 20; Cycladic culture during, 47; human figure, Ain Ghazal, Jordan (sculpture), 21, 21; sculpture and painting of, 43; Stonehenge, England, 21–22, 21; White Temple, Uruk, Iraq, 22 Neoplasticism, 398 Neo-Platonism, 239, 240 Neo-Sumerian art, 26, 43 Neptune. See Poseidon (Neptune) (Greek/Roman deity) Nerezi, Macedonia, Lamentation, Saint Pantaleimon, 121, 138-139, 139 Neshat, Shirin: Allegiance and Wakeful-

ness, Women of Allah series, 445,

445; issues addressed by, 459; political and social issues presented by, 440 Netherlandish Proverbs (Bruegel the Elder), 280-281, 280 Netherlands: Aertsen, 279, 279, 283, 283; Bruegel the Elder, 280-281, 280, 281, 283; division of, 298; Dürer, 5, 5, 7, 10, 274-276, 274, 275, 283; economic and religious activity, 277, 278-279; Great Iconoclasm (1566), 272; Mannerist art, 277-281, 283; moralizing religious messages in painting, 252 Neue Sachlichkeit (New Objectivity) painters, 378, 393-394, 409 Nevelson, Louise, Tropical Garden II, 419, 419 New Guinea, 546 New Ireland, Papua New Guinea, Malanggan mask, 552, 552 New Kingdom period of Egyptian art, 36-42, 43new media, 435-436, 440, 456-458, 459 New Mexico (USA): jar (Martínez), 545, 545; Kuaua Pueblo, 544 New Orleans, Louisiana (USA), Piazza d'Italia (Moore), 410, 411, 431, 437, New Saint Peter's. See Saint Peter's, Rome New Stone Age, 20-22 New Testament themes: Calling of Saint Matthew (Caravaggio), 293, 293, 311, *311*; *Elevation of the Cross* (Rubens), 298–299, 298, 311. *See* also Jesus, life of; Mary (mother of Jesus); headings beginning with Annunciation, Christ, Madonna or Virgin or specific New Testament event New York Kouros (sculpture), 55, 55 New York, New York (U.S.A.): Armory Show, 390, 391, 409; Chrysler Building (van Alen), 401, 407; School of Abstract Expressionism, 398, 412, 414; Seagram Building (Mies van der Rohe and Johnson), 430-431, 431, 437; Solomon R. Guggenheim Museum (Wright), 429, 429, 437; Statue of Liberty (Bartholdi), 373; Tilted Arc, Jacob K. Javits Federal Plaza (Serra), 455-456, 455 New York School of Abstract Expressionists, 398, 412, 414 New Zealand art: Mataatua meeting house (Apanui), 550, 551; tattoos, 13, 13, 549 Newton, Isaac, 316 Ngansu (Bamum king), 556 Nicholas of Verdun, Shrine of the Three Kings, Cologne Cathedral, Cologne, Germany, 202, 203 Nicola Pisano (Nicola of Pisa), pulpit of the baptistery, Pisa, Italy, 205, 206, 215, 215 Niépce, Joseph Nicéphore, 352 Nietzsche, Friedrich, 395 Nigeria: ancestral screen (nduen fobara), Kalabari Ijaw, 565, 565; doors from shrine of the Yoruba king's head, royal palace, Ikere (Olowe of Ise), 567-569, 567; Ife king, from Ita Yemoo (sculpture), 559, 559; Igbo Ukwu fly-whisk, 558; Nok head, Rafin Kura (sculpture), 557-558, 558 Night (Beckmann), 393-394, 394 Night Attack on the Sanjo Palace, Events of the Heiji Period (handscroll), 514, Night Café (van Gogh), 366-367, 366, Night Watch (The Company of Captain Frans Banning Cocq) (Rembrandt), 301-302, 301

Nighthawks (Hopper), 401-402, 401

Nike adjusting her sandal, Temple of Athena Nike parapet (Kallikrates) (relief sculpture), 71, 71 Nike alighting on a warship (Nike of Samothrace) (sculpture), 78, 78, 386 Nimes, France, Pont-du-Gard, 100, 100 Ninety-five Thesis (Luther), 272 Nineveh, Iraq, head of an Akkadian ruler (sculpture), 25, 25 nirvana, 463, 467 nishiki-e prints, 507 No. 14 (Rothko), 416, 416 No. 49, The Migration of the Negro series (Lawrence), 402-403, 402 Noah's Ark (Douglas), 390, 392, 392, 409 Nocturne in Black and Gold (The Falling Rocket) (Whistler), 364, 364 Noguchi, Isamu, 418 Nok culture, 556, 557-558, 559, 571 Nok head, Rafin Kura, Nigeria (sculpture), 557-558, 558 Noli Me Tangere on bronze doors of Saint Michaels, Hildesheim, Germany (Bernward), 121, 168, 168 Noon Gate, Forbidden City, Beijing, China, 482, 483 Normandy: Battle of Hastings, Bayeux Tapestry, Bayeux Cathedral, Bayeux, France, 184, 184; Bury Bible, Bury Saint Edmunds abbey (Master Hugo), 181-182, 182; Durham Cathedral, Durham, England, 180-181, 181; Eadwine Psalter (Eadwine the Scribe), 182-183, 182: funeral procession to Westminster Abbey, Bayeux Tapestry, Bayeux Cathedral, Bayeux, France, 183-184, 183; Saint-Étienne, Caen, 179-180, 179, 180 North American Native art: Adena, 542; Great Plains, 546, 553; Mississippian, 542-543, 553; Northwest Coast, 545-546, 553; regions of, 542map; Southwest, 543-545, 553 North Korea, 412 Northern School of Chinese painting, Northumbria, England: illuminated manuscripts, 158; Lindisfarne Gospels, 160, 160, 185 Northwest Coast Native American art, 545-546, 553 Norway, Symbolism, 370–371, 371 "Notes of a Painter" (Matisse), 380–382 Notre Dame Cathedral, Chartres. See Chartres Cathedral, Chartres, France Notre-Dame, Paris, 192, 192 Notre-Dame-du-Haut, Ronchamp, France (Le Corbusier), 429–430, 429, 430, 437 Noumea, New Caledonia, Tjibaou Cultural Centre (Piano), 453, 453, 459, 459 Nubia, 557-558 Nude Descending a Staircase, No. 2 (Duchamp), 390, 391 nude woman (Venus of Willendorf), Austria, 16-17, 16, 21 Number 1, 1950 (Lavender Mist) (Pollock), 414-415, 415 Nymph and Satyr Carousing (Clodion), 314 Nyx (Greek deity), 68 Oath of the Horatii (David), 324-325, 325, 329, 334 Obatala (Ife deity), 558 Object (Le Déjeuner en Fourrure) (Luncheon in Fur) (Oppenheim), 396, De occulta philosophia (Agrippa of Nettesheim), 275, 547map Oceanic art: Australian dreamings, 551-552, *551*, 553; Hawaiian feather cloaks, 548, 548; malanggan masks,

552, 552, 553; Maori meeting

houses, 550, 550, 553; Marquesan

tattoos, 13, 13, 548-550, 549, 553;

wall paintings; specific artist, time yamato-e, 512. See also cave painttrompe l'oeil, 247-248; true view, (China), 499, 504; tenebrism, 293; 17-19, 20-21; Southern School 220; plein air, 359; prehistoric, miniatures, 474; oil vs. tempera, тапіета greca, 206-207, 206, 215; 520; literati, 499-500, 499, 500; edge, 416-417, 437; Japanese, 516, 208, 208; fresco secco, 49; hard-437; encaustic, 56, 108; fresco, 49, painting techniques: color-field, 417, Painting (Miró), 396-397, 397 Painting (Bacon), 413, 413 period, style, or work of art ing; oil painting; tempera painting; painting. See cave painting; mural paint-The Painter of Modern Life (Baudelaire), and family, 108, 108 painted portrait of Septimius Severus 436; video recordings of, 437 Paik, Nam June: Global Groove, 435-436, Pavilion, 476, 476 Pahari School, Krishna and Radha in a 564-464 'seposed ica"), 56, 57, 58, 58 Paestum, Italy, Temple of Hera ("Basil-(Donatello), 234, 234 Piazza del Santo (statue) 207-209, 207, 208; Gattamelata, painting (Giotto di Bondone), Padua, Italy: Arena Chapel interior Packer, James E., 103 Pachacuti (Inka emperor), 540 Ozymandias (Shelley), 335 a Thunderstorm) (Cole), 341, 341 Northampton, Massachusetts, after The Oxbow (View from Mount Holyoke, 668 Oval Sculpture (No. 2) (Hepworth), 399, many, 166-169, 167, 168 Saint Michaels, Hildesheim, Ger-(Archbishop Gero), 158, 169, 169, fix, Cologne Cathedral, Germany 158, 167-168, 168, 173; Gero Cruci-Hildesheim, Germany (Bernward), bronze doors, Saint Michaels, Ottonian art: architecture of, 158; Ottoman Turks, conquest of Byzantium, 118, 125, 140, 144 Civil War, 332 July 1863, 353, 353; photographs of Death, Gettysburg, Pennsylvania, O'Sullivan, Timothy: A Harvest of Ostrogoths, 123, 129, 130 218, 241-242, 241 Hospital), Florence (Brunelleschi), Ospedale degli Innocenti (Foundling Osiris (Egyptian deity), 38, 42 (sculpture), 90, 90 Osimo, Italy, head of an elderly patrician Orzoco, José Clemente, 378, 403 (Lorenzo Maitani), 212, 212 painting and, 520; Waves at Matsu-Orvieto Cathedral, Orvieto, Italy Ogata Korin: Rinpa School of Japanese Orozco, José Clemente, 378, 409 Orientalism, 334 səjduvxə Ofili, Chris: The Holy Virgin Mary, 443, 57. See also specific structure for orders (of Greek temple architecture), Order of Mercy, Seville, Spain, 296 Or San Michele, Florence, 233, 233 Europe: architecture of 187, 193, 193, 201. See also Gothic opus modernum style architecture, 186, 968 '968 en Fourrure) (Luncheon in Fur), Oppenheim, Meret, Object (Le Déjeuner regions of, 546; Western fascination Ophelia (Millais), 347-348, 348 547, 553; Rarotonga gods, 551, 551; Op Art, 7, 412, 418, 437 225, 525

series (Hiroshige), 522-523, 522,

One Hundred Famous Views of Edo

səlduvxə

period, style of art, or work of art for

Raphael, 255, 256 244-245, 244, 249; influence on to Saint Peter, Sistine Chapel, 218, Delivering the Keys of the Kingdom Perugino (Pietro Vannucci), 255; Christ Moche, 539-540, 540, 553 sel in the shape of a portrait head, Temple of the Sun, Cuzco, 528; vesart, 528; Paracas cultural art, 528; Machu Picchu, 528, 540, 541; Nasca 539, 539; Inka culture, 540-541; bird (Nasca Lines), Nasca Plain, Peru: Cuzco, 540, 541, 541; hummingworks of art for examples 249. See also foreshortening; specific defined, 7, 9; linear, 232, 238, 241, perspective: atmospheric, 232, 236; personification, 5 personal style, 3-4 persistence of vision, 354 60£ '56£ '96£-56£ The Persistence of Memory (Dali), Persepolis, 29-30 Persians and Medes, processional frieze, Uruk, 22 28-30, 29, 43; White Temple, location, 22map; Persepolis, 16, 74, 75, 76-77, 81; Islam and, 30; 45, 46, 62-63, 66, 67, 68, 70-71, 72, Persia, 28-30; Greece and, 30, 44, Persian history and art: Achaemenid Persepolis, Iran, 28-30, 29, 43, 43 Perry, Lilla Cabot, 359 Perpendicular style, 202, 202, 215 period style, 3 Period of Disunity, China, 487-489, 505 Perilous Order (Sikander), 444, 444 Pericles, 46, 63, 66, 67, 81 14 '94 Pergamon, Turkey, Altar of Zeus, 76-77, Pergamene frieze, 76-77, 77 Performance Art, 434 445, 443 The Perfect Moment (Mapplethorpe), Pepper No. 30 (Weston), 393, 393 (sculpture), 56, 56 Peplos Kore, Acropolis, Athens, Greece People's Republic of China, 484, 501, Pentewa, Otto, katsina figure, 544, 544 Peloponnesian War, 72-73 Pech-Merle, France, cave paintings, 18, pebble mosaics, 124 garden, Kyoto, Japan, 515-516, Peaceful Dragon Temple, karesansui (Lorenzetti), 212 Pace, Palazzo Pubblico, Siena, Italy Peaceful Country, walls of Sala della (Brunelleshci), 242-243, 242, 243 Pazzi Chapel, Santa Croce, Florence cated glass-and-iron, 332, 350-351, 320-321, 350, 355, 452; pretabri-Paxton, Joseph: Crystal Palace, London, \$33, 333, 334 Pauline Borghese as Venus (Canova), Paul Revere (Copley), 320–321, 321 Paul V (Pope), 287, 289 Paul III (Pope), 250, 260-261, 265 səidunxə artist, region, or time period for patronage/patrons, 6. See also specific Pastoral Symphony (Titian), 266, 267 Shahn), 4, 4, 5 The Passion of Sacco and Vanzetti Pascal, Blaise, 316 Parvati (Uma) (Hindu deity), 469 plan of, 66 reliefs, 67, 67, 76; pediments, 68, 68; frieze, 68-69, 69, 73, 99; metope (Phidias), 44, 45, 66, 67, 76; Ionic 45, 66-67, 66; Athena Parthenos

and Kallikrates): architecture of, 44,

Long Neck, Santa Maria dei Servi,

influence of, 334; Madonna with the

Parthenon, Acropolis, Athens (Iktinos

Parma, Italy, 269

Maria Mazzola), 252, 269–270, 283; ing, mural painting; vase painting; Parmigianino (Girolamo Francesco eianino), 269-270, 269 504; veduta painting, 321-322, 322; Neck, Santa Maria dei Servi (Parmi-Parma, Italy, Madonna with the Long Paris Psalter, 139-140, 139, 141 dows, Sainte-Chapelle, 198, 198 314-315, 314; stained-glass win-(Boffran, Natoire, Lemoyne), La Princesse, Hôtel de Soubise Saint-Chapelle, 198, 198; Salon De flot), 326, 326, 329; Rococo art, 314; theon (Sainte-Geneviève) (Sout-314; Notre-Dame, 192, 192; Panera, 189; Hôtel de Soubise, 314-315, ized Bible, 199-200, 200; Gothic God as Creator of the World, moral-Tower (Eiffel), 358, 373-374, 373; vase painting; wall paintings; specific and Piano), 432, 432, 453; Eiffel Pompidou (Beaubourg) (Rogers 199-200, 199, 215; Centre Georges illumination and production, moralized Bible, 199, 199; book tile, Louis IX, a monk, and a scribe, (Rubens), 299, 299; Blanche of Casat Marseilles, Luxembourg Palace Paris, France: Arrival of Marie de' Medici toes, China (wall painting), 490, 490 Paradise of Amitabha, Dunhuang Grot-538, 553 Paracas culture and art, 528, 538-539, Malanggan mask, 552, 552 Papua New Guinea: Ambum Stone, 547; Catholic Church; specific popes support of Crusades, 173. See also patronage of Mannerist art, 272; 722' 726' 728' 760' 761-763' of High Renaissance art, 245, 251, 287, 288, 289, 292, 297; patronage Baroque art and architecture, 285, Great Schism, 218; patronage of papacy: challenge of Reformers, 272; 115, 115, 252, 263, 265 Pantheon, Rome, 105-107, 105, 106, (Soufflot), 326, 326, 329 Panthéon (Sainte-Geneviève), Paris 66 '69 '69-89 Parthenon, Acropolis, Athens, Panathenaic Festival procession frieze, Rotonda, near Vicenza, 265, 265, survey of ancient temples, 262; Villa books, 265; influence of, 310, 326; tecture, 265, 327; illustration of architect, 252; Four Books of Archi-Palladio, Andrea: as chief Venetian palette of King Narmer, Hierakonpolis, Egypt, 30–31, 31, 43 Le Tuc d; Audoubert, France, 17, 17 43; two bison, reliefs in the cave at Willendorf), 16-17, 16; subjects of, of, Ismap; nude woman (Venus of habitation of Greece, 47; location ings, 17-20, 18, 19, 43, 50; human Paleolithic Art: African, 556; cave paintand Rosselino), 243-244, 243 Palazzo Rucellai, Florence, Italy (Alberti Palazzo Pubblico (Siena), 188 (Michelozzo di Bartolommeo), 243 Palazzo Medici-Riccardi, Florence Palazzo Farnese, Rome, 292, 292 746-248, 247, 260 Palazzo Ducale, Mantua (Mantegna), Romano), 271-272, 271 Palazzo del Tè, Mantua, Italy (Giulio Palazzo Comunale, Borgo San Sepolero, Aachen, Germany, 163-164, 164, Palatine Chapel of Charlemagne, Palaikastro, Crete, octopus flask, 50, 50 tot Palacio Nacional, Mexico City, 403-404, Spi, 139, 149, 150, 155, 155 Palace of the Lions, Alhambra, Granada, 64 '84 '64-84 palace (Minoan), Knossos, Greece,

ludex 079 434-435, 435 One and Three Chairs (Kosuth), Natural Selection (Darwin), 358 On the Origin of Species by Means of 737, 246, 249 On the Art of Building (Alberti), 218, On Painting (Alberti), 218, 231 also Vitruvius (Roman architect) On Architecture (Vitruvius), 265. See Yuan), 495, 495 on a Mountain Path in Spring (Ma Tange), 523-524, 524 Olympic stadiums, Tokyo, Japan (Kenzo Olympic Games, 54, 55, 81, 124 Hera, 57, 58, 58 (Praxiteles), 73-74, 73; Temple of Dionysos statue, Temple of Hera Olympia, Greece: Hermes and the infant Olympia (Manet), 346-347, 346, 355, apprentices, 567 267-569, 567; fame of, 556; use of Ikere, Nigeria (relief sculpture), Yoruba king's head, royal palace, Olowe of Ise: doors from shrine of the Olmec culture, 528, 529, 532, 553 on Caterpillar Tracks, 424, 424 Oldenburg, Claes, Lipstick (Ascending) in Old Testament deginning with David; specific event 181-182, 182. See also headings Romanesque art, 174, 174, sionist art, 367-368, 368; in art, 167-168, 168; in Post Impresart, 250, 251, 258–261, 259, 260, 261, 274, 283, 283, in Ottonian 251; in Italian High Renaissance 190-191; in High Renaissance, 250, 222, 229-233; in Gothic art, 117, 119, 119, in early Renaissance art, 216, 217, 219, 219, 221–222, 133, 133; in early Christian art, 116, Old Testament themes: in Byzantine art, (relief sculpture), 174, 174 Isaiah?), Saint-Pierre, Moissac Old Testament prophet (Jeremiah or tres, France, 190-191, 191 Portal, Chartres Cathedral, Char-Old Testament kings and queen, Royal 257-258, 257, 258, 325, 334 Old Stone Age, 16-20 Old Tectament Pierce (Michelangelo), 120-122, 122, 141, piazza (Bernini), 288; Pietá chino, 287; facade (Moderno), 288; Old Saint Peter's, Vatican City: baldac-Old market woman (sculpture), 79-80, 79 11, 36, 37 hunt, relief painting in mastaba of (sculpture), 36; style of sculpture, 43; Ti watching a hippopotamus kaure and Khamerernebty(?) enthroned statue, 35, 35; Men-Great Sphinx, 34, 35; Khafre Gizeh Pyramids, 33-35, 33, 34, 43; Old Kingdom period of Egyptian art: 76£ '5' 4' 0N O'Keefe, Georgia, Jack-in-the-Pulpit works of art for examples

oil painting, 217, 220. See also specific

444, 444; influence of, 440; issues

6 '8 'puilys

Odyssey (Homer), 80

addressed by, 459

Odoacer (king of Italy), 123 Oduduwa (Ife deity), 558

Odo (Bishop of Bayeux), 183

Oda Nobunaga (shogun), 517

octopus flask (Palaikastro, Crete,

Octavian (emperor of Rome), 96-98

with (primitivism), 383, 546

Island) sculptures, 528, 547-548,

Micronesia, 558; Rapa Nui (Easter

Greece), 50, 50

Oceanic art (continued)

Peter, Saint, 119, 119, 120, 244-245, 275 Pink Panther (sculpture) (Koons), pharaohs. See specific pharaoh 449-450, 449 Phidias: Athena Parthenos, 44, 45, 81; pipe from mound in Ohio, Adena, 542, direction of rebuilding of Parthe-Pisa, Italy: baptistery pulpit (Nicola Pisano), 205, 206, 215, 215 Pisa non, 66-71 Philip II (king of Macedonia), 72, 74 Philip II (king of Spain), 277, 281-282, Cathedral, 178, 179 298 Pisa Cathedral, 178, 179 Philip III (king of Spain), 295-296 Pisano, Nicola, baptistery pulpi, Pisa, Philip IV (king of Spain), 295-296, 298 Italy, 205, 206, 215, 215 Philip the Bold (duke of Burgundy), Piss Christ (Serrano), 443 218, 219, 249 Pittura Metafisica, 394 Philip the Good (duke of Burgundy), Pius II (Pope), 246 219, 221 Pizarro, Francisco, 541 Philip von Heinsberg, 202 plague (Black Death), 218, 333 A Philosopher Giving a Lecture at the plan (architectural), 12, 57; axial, 38-39, Orrery (Wright of Derby), 317, 317 93, 93; central-plan building, 129-Philosopher Sarcophagus, 110, 111 132, 129, 130; defined, 12; Greek philosophes, 316 temples, 57; longitudinal, 122, 122. A Philosophical Enquiry into the Origins See also specific structure fo of Our Ideas of the Sublime and examples Beautiful (Burke), 335 plane, 7 Philosophy (School of Athens), Vatican Platform of the Eagles, Chichén Itza, Palace, Rome (Raphael), 256, 257, Mexico, 534, 535 275 Plato, 256, 257. See also Neo-Platonism Philoxenos of Eretria, Battle of Issus plein air painting, 359 (Alexander Mosaic), 74-75, 75 Pliny the Elder, 65, 73, 75, 77, 80, 108, Phoenix Hall, Byodoin, Uji, Kyoto Prefecture, Japan, 512, 512, 525 Plum Estate, Kameido, One Hundred photography: camera lucida, 351; cam-Famous Views of Edo series (Hiroera obscura, 286, 304-305, 351, shige), 522-523, 525, 525 352; contemporary, 442, 445, Pluto. See Hades (Pluto) (Greek/Roman 456-458, 459; daguerreotypes, god) 351-352, 351; in Depression-era pointillism, 358, 364, 375 Poissy-sur-Seine (France) Villa Savoye America, 400-401, 409; early 19th century European and American, (Le Corbusier), 407-408, 407 351-354, 351, 352, 353, 354, 355; Poliziano, Angelo, 240 and Impressionism, 362; invention Pollaiuolo, Antonio del, Battle of Ten of camera and photographic pro-Nudes, 240-241, 241 cess, 332, 351; late 20th century Pollock, Jackson: gestural abstract art of, European and American, 424-426, 413, 437; Number 1, 1950 (Lavender 437; Post-Impressionist art influ-Mist), 414-415, 415 enced by, 364; Realism and, 351; Polydoros of Rhodes, Laocoön and his Stieglitz and Weston and, 392-393, sons (sculpture), 80, 80, 27 409; Superrealism and, 424-426 Polykleitos of Argos: Canon, 46, 65, 66, photomontage, 388-390, 389 73, 81; Doryphoros (Spear Bearer), 65–66, 65, 74, 196 Photorealism, 424-426. See also Superrealism Polykleitos the Younger, Theater of Epi-dauros, 75–76, *75* Photo-Secession group, 393 physical evidence, 2 Polynesian art, 528, 546, 547-55 Piano, Renzo: architectural style of, 440; Pompeii/Vesuvius area art: amphithe-Centre Georges Pompidou (Beauater, 91, 91, 93, 101; Battle of Issus (Philoxenos of Eretria), 74-75, 75; bourg), Paris, 432, 432, 453; Green architecture of, 453; Tjibaou Culbrawl in the Pompeii amphitheater, tural Centre, Noumea, New Calewall painting from House I, 91; donia, 453, 453, 459, 459 Dionysiac mystery frieze, Villa of piazza, Saint Peter's, Rome (Bernini), the Mysteries (Second Style wall 286, 287, 288, 289 painting), 94-95, 94; Doryphoros Piazza della Signoria, Florence, Abduc-(Spear Bearer) (Polykleitos) 65-66, tion of the Sabine Women (Giambo-65; Forum, 90-91, 91; history of, logna) (sculpture), 271, 271 90, 115; House of Vettii, 93-94, 93; Piazza d'Italia, New Orleans (Moore), and Italian early Renaissance art, 410, 411, 431, 437, 437 248; Ixion room, triclinium P of the Piazza Nova, Rome, Fountain of the House of the Vettii (Fourth Style Four Rivers (Bernini), 284, 285, wall painting), 96, 97 Pont-du-Gard, Nimes, France (aque-Picasso, Pablo: comment to Oppenheim, duct), 100, 100 396; Cubism of, 378, 383, 409; Les Pontormo, Jacopo da: Entombment of Demoiselles d'Avignon, 376, 377, Christ, 121, 268-269, 269; Manner-383; exposure at Armory Show, ist style of, 252 391; Guernica, 384, 385; influence Pop Art, 412, 420-424, 437, 440 of, 377, 441; Lam's relationship porcelain, 484, 496-497, 497 with, 397; Still Life with Chair-Portinari Altarpiece, Sant'Egidio, Flor-Caning, 384-385, 384 ence (van der Goes), 224, 225 Piero della Francesca: Battista Sforza Portland Building, Portland, Oregon and Federico da Montefeltro, 245, (Graves), 431-432, 431, 437 245; at court of Gonzaga, 249; Resportrait bust of Flavian woman, Rome urrection, Borgo San Sepolcro, 245 (sculpture), 101, 101 Pietà, Old Saint Peter's, Vatican City portrait bust of Livia, Arsinoe, Egypt (Michelangelo), 257-258, 258, 325, (sculpture), 98, 98 portrait bust of Trajan Decius, 110, 110 Pieter Bruegel the Elder, 252 portrait of an Akkadian king, Nineveh pilgrimage and pilgrimage sites: Byzan-tine era, 133; Chinese, 489; early (sculpture), 25, 25 portrait of Augustus as imperator, Pri-Christian era, 121; Gothic era, 188; maporta, Italy (sculpture), 98, 98 Mesoamerican, 536, 539, 553; Portrait of Te Pehi Kupe (Sylvester), 13,

Romanesque era, 158map, 169-170,

Pilgrimage to Cythera (Watteau), 314, 315

portrait statue of the priest Shunjobo

Chogen, 513-514, 513

171, 173, 174, 185

portraits of four tetrarchs, Constantinople, Turkey (sculpture), 112, 112 portraiture: comparison of styles, 13, 13; donor portraits, 204-205, 221, 223, 223; popularization of, 249; veristic portraits, 84, 89-90, 90. See also specific portrait for examples The Portuguese (Braque), 383-384, 383 Portunus (Roman deity), 88 Poseidon (Neptune) (Greek/Roman deity), 47, 68, 69, 70 Poseidon, Apollo, Artemis. Aphrodite, and Eros (east frieze, Parthenon, Acropolis, Athens, Greece), 69, 70 Posey, Willi, 441 positivism, 341-342 Post-classic period of Mesoamerican art and architecture, 528, 533-538 post-Gupta period of South Asian art, 462, 468, 470, 481 Post-Impressionism: Cézanne, 369, 369, 370, 375; Environmental Art, 412; Gauguin, 367-370, 368, 375; Seurat, 364, 365, 375; technological tools, 412; Toulouse-Lautrec, 364, 375; van Gogh, 366, 367, 375 Postmodernism (1945-1980): architecture, 431, 437; Graves, 431-432, 437; High-Tech architecture, 452; Modernist art and, 448; Moore, Charles, 410, 411, 412, 437; Rogers and Piano, 432. See also contemporary art; Environmental Art; sitespecific Art Post-Painterly Abstraction: David Smith, 418; Frankenthaler, 417-418, 437; Judd, 418; Stella, 417, 437; Still, 1, 2; style of, 412, 437 Postwar Expressionism, 412-413 pottery. See ceramics Poussin, Nicolas: Cézanne's art and, 369, 369; Et in Arcadia Ego (Even in Arcadia), 306, 307, 307; notes for a Treatise on Painting, 307, 315, 320; style of, 286 Poussinistes, 315, 336 Pozzo, Fra Andrea, Glorification of Saint Ignatius, Sant'Ignazio, Rome, 286, Praxiteles: Aphrodite of Knidos, 73, 81, 81, 240; Hermes and the infant Dionysos, Temple of Hera (sculpture)? 73-74, 73, 79; view of painted statuary, 108 Preclassic Mesoamerican art and architecture: colossal head, La Venta, Mexico, 529; Mayan art and architecture, 531, 534; mural painting, 530-531; Olmec civilization, 530; pyramids of Teotihuacán, 528, 529-530 pre-Columbian civilizations, 528. See also Mesoamerican art and architecture; Native American art; South American art and architecture Predynastic period Egyptian art: palette of King Narmer, 30–31, 43; pyramids, 31–33, 43 prefabricated architecture, 350-351, 350 prehistoric art: Aegean, 47-53; African, 557-558, 571; Egyptian, 30-33; map, 16map; Neolithic, 22-23, 43, 47, 557; Paleolithic, 16–20, 43, 47, 50, 557 Pre-Raphaelite art, 347-348, 348 Pre-Raphaelite Brotherhood, 347-348 presentation of captives to Lord Chan Muwan, Bonampak, Mexico (mural), 526, 527, 531, 553 presentation of offerings to Inanna (Warka Vase), Uruk, 14, 15, 23, 43 priest of Serapis, mummy portrait, Hawara, Egypt, 107-108, 107 Primaporta, Italy: gardenscape from Villa of Livia (Second Style wall painting), 95-96, 95; portrait of Augustus as imperator (sculpture), 98, 98 primary colors, 7

Primavera (Spring) (Botticelli), 239, 239 Primitivism, 383, 546 printing press, 227, 229, 249 printmaking: Baroque, 302; Japanese influence on German Impressionists, 358, 362, 363, 364, 366, 368, 375; lithography, 344, 345, 355; nishiki-e prints, 507; Pop Art, 423, 437; Realist, 344, 345; Renaissance, 5, 227, 228, 228, 241, 241; silkscreen printing, 423; ukiyo-e woodblock prints, 506, 507, 520-523, 521, 522; from woodcuts, 218, 227-229, 249; woodcuts, engraving, and etching, 5, 227-229, 249 procession of imperial family, Ara Pacis Augustae, Rome (relief sculpture), 99, 99 proportion, 9-10. See also hierarchy of scale; specific works of art for examples Propylaia, Athens, 66, 66 Protestant Reformation, 260, 272, 277, 283, 286, 287 provenance, 3 pueblos, 543-544, 543, 553, 553 Pugin, Augustus Welby Northmore, Houses of Parliament, London, 348, pulpit, baptistery, Pisa, Italy (Nicola Pisano), 205 pulpit of the baptistery, Pisa, Italy (Nicola Pisano), 206, 215, 215 Pure Land Buddhism, 466, 490, 512, 514, 525 Purism, 385 purse from ship burial, Sutton Hoo, England, 159, 159 pylon temple, 38-39, 39 pyramid of Khafre, Gizeh, Egypt, 33-34, 34, 35 pyramid of Menkaure, Gizeh, Egypt (model), 33 Pyramid of Niches, 534 Pyramid of the Moon, Teotihuacán, 529, 530 Pyramid of the Sun, Teotihuacán, 529, 530 Pythagoras of Samos, 45, 65, 256 Pyxis of al-Mughira, Medina al-Zahra, Spain (ivory carving), 152, 153, 155 Qin dynasty, China, 485, 486, 505 Qin Shi Huangdi (emperor of China), 485 Qing dynasty, China, 484, 500, 505 Queen Mother Idia, 560, 561 Quetzalcoatl (Aztec deity), 536, 537 Qutb al-Din Aybak (sultan of Delhi), 473 Radha (Hindu deity), 469 Raedwald (king of East Anglia), 159 Rafin Kura, Nigeria, Nok head (sculpture), 557-558, 558 Raft of the Medusa (Géricault), 330, 331, 338, 340 Raimondi Stele, 539 Rajarajeshvara Temple, Thanjavur, India, 470, 471, 471, 481, 481 Rajput painting, 462, 476, 476, 481 Ramkhamhaeng (king of Thailand), 479 Ramses II (pharaoh of Egypt), 38, 43 Rangoon (Yangon), Myanmar, Schwedagon Pagoda, 480, 480, 481 Rapa Nui (Easter Island) sculptures, 528, 547–548, 547, 553 Raphael (Raffaello Santi): influence of, 306, 334; Madonna in the Meadow, 256, 256, 283, 283; School of Athens (Philosophy), Vatican Palace, Rome, 256, 257; style of, 252, 255-256, 268; Theology, 256 Rarotonga, Cook Islands, staff god (Tangaroa?), 551, 551 Rauschenberg, Robert: Canyon, 422-423,

422; influence of, 439

(Ye Yushan and others), 501, 501

Mausoleum of Galla Placidia

Ravenna, Italy: Christ as Good Shepherd,

palace of King Glele, Abomey

Republic of Benin, Fon warrior figure,

Junius Bassus, 116, 117, 119; lenistic period Greek art and, 80; 533, 233, 249 sion of Etruscan kings, 88; extent of, 83, 84map; fall of, 124–125; Hel-Rent Collection Courtyard, Dayi, China Saint Mark, Or San Michele (Donatello), ceiling), 286, 295; sarcophagus of mini), 285; Sant'Ignazio (Pozzo's van der Weyden), 216, 217 Galette, 361, 361, 364; style of, 361, 84; Etruscan art and, 85-88; expul-290; Sant'Agnese in Agone (Borro-Saint Luke Drawing the Virgin (Rogiet Renoir, Pierre-Auguste: Le Moulin de la 102, 115, 411; establishment of, 83, postela, Spain, 157, 185 Maria della Vittoria (Bernini), 290, Amiens, France, 196, 197 (Michelangelo), 109, 109; Santa 44, 90, 96-103, 98, 99, 100, 101, Saint James, tomb of, Santiago de Com-Renaud de Cormont, Amiens Cathedral, Egypt, 30, 42; Early Empire period, 146; Santa Maria degli Angeli 166, 165; westwork of basilicas, 185 Renaissance/Mannerist art construction, 92, 92; conquest of 311; Santa Costanza, 122-123, 123, dictine monastic community, 164also early Renaissance art; High of, 112-114, 117, 118, 124; concrete 163, 163; plan for rebuilding Bene-(Borromini), 286, 290-291, 291, istics of, 205; Macedonian, 139. See Empire, 161-162; Christianization San Carlo alle Quattro Fontane Saint Gall, Switzerland: Lindau Gospels, Renaissance art: birth of, 139; characterinfluenced by, 164; Carolingian Sinai, Egypt, 133 263, 286, 288, 288, 289, 291, 310; Clouds (Shitao), 500, 500 Michelangelo), 170, 262-263, 262, 84-85; Carolingian architecture Saint Catherine's monastery, Mount Reminiscences of Nanjing: Riding the Empire and, 135; Caput Mundi, Paul's, 170; Saint Peter's (Bramante/ 777-177 116, 286, 311 Julio-Claudian period, 6; Byzantine (Hubert and Jan van Eyck), woman (sculpture), 101, 101; Saint eagle carrying a boy, 423; Self-Por-trait, ca. 1659-1660, 302, 302; style art as political tool, 83; Augustan/ Saint Bavo Cathedral, Ghent, Belgium 265, 327; portrait bust of Flavian Roman Empire history, art, architecture: (Schongauer), 228, 228, 229 106-107, 106, 115, 115, 252, 263, dam, 301-302, 301; painting of 453; influence of, 452 Farnese, 292, 292; Pantheon, 105, Saint Anthony Tormented by Demons tain Frans Banning Cocq (Night Watch), Musketeers Hall, Amsterpidou (Beaubourg), Paris, 432, 432, Isenheim, Germany, 272-273, 273 258, 287, 288, 325, 334; Palazzo Rogers, Richard: Centre Georges Pom-Saint Peter's, 120-122, 122, 257-258, piece, Hospital of Saint Anthony, 303, 311, 334; The Company of Cap-(sculpture), 358, 372, 372, 375, 375 model of (4th century), 89; Old Saint Anthony Abbot, Isenheim Altar-(Hundred-Guilder Print), 302-303, Rodin, Auguste, The Gates of Hell Damascus), 104-105, 105, 115; around Him, Receiving the Children Safi al-Din (Shaykh of Iran), 152-153 716,215,314 Markets of Trajan (Apollodorus of Safavids, 144, 151, 154 Rembrandt van Rijn: Christ with the Sick Paris (Boffran, Natoire, Lemoyne), visi Battle Sarcophagus, 110, 111; Junius Bassus, Rome, 116, 117, 119 0/ILa Princesse, Hôtel de Soubise, (Vignola), 264, 264, 265, 294; Ludosacrifice of Isaac, from sarcophagus of Faith), Conques, France, 169-170, 316; Pilgrimage to Cythera (Watteau), 315, 315, 329, 329; Salon De Tour in, 322-323, 322, 323; Il Gesù reliquary statue of Sainte-Foy (Saint Sacrifice of Isaac (Chiberti), 229-230, nini), 284, 285, 287, 289; Grand ngulu), Kota, Gabon, 556, 562, 562 Rococo art: The Swing (Fragonard), 316, Four Rivers, Piazza Navona (Ber-229-230 reliquary guardian figure (mbulu Sacrifice of Isaac (Brunelleschi), 103-104, 103, 104; Fountain of the 200, 202, 203 rock painting, African, 557-558, 557, (Apollodorus of Damascus), reliquaries, 169, 170, 170, 174, 200-201, (usngo) Aurelius, 107, 107; Forum of Trajan u0181121 10 Robusti, Jacopo. See Tintoretto (Jacopo 63; equestrian statue of Marcus Dragon), Kyoto, Japan, 515–516, 515, 525 Hinduism; and specific god, region, dral, Amiens, France, 196, 197 (Discus Thrower) (Myron), 63-64, Robert de Lauzarches, Amiens Cathe-Confucianism; funerary customs; 104, 115, 133; copy of Diskobolos Ryoanji (Temple of the Peaceful See also Buddhism; Christianity; Riviève, Georges, 361 lodorus of Damascus), 103, 104, 908 cycles of, 378, 409 105-106, 108, 110, 112, 117, 124. Trajan, Forum of Trajan (Apol-Ruysch, Rachel, Flower Still Life, 306, Mexico City, 403-404, 404; mural Empire, 47, 83, 91, 94, 96, 102, sus of Nero, 89, 101; Column of Ruskin, John, 348, 364 History of Mexico, Palacio Nacional, Polynesians, 548, 549; of Roman tine, Basilica Nova, 113, 113; Colos-Rurutu, Austral Islands, 550-551 Rivera, Diego: Ancient Mexico detail of Americans, 542-543, 544, 545; of 100, 115, 244; Colossus of Constan-(rock painting), 557, 557, 571 Riva degli Schiavoni, Venice (Canaletto), 321–322, 322, 329 534, 535, 537; of Native North vian Amphitheater), 89, 100-101, running woman, Tassili n'Ajjer, Algeria Mesoamericans, 527, 529, 530-531, cellinus, 119, 119; Colosseum (Fla-Overveen, 303-304, 303 ment and, 316; of Maori, 550; of Rinpa School of Japanese painting, 520 Catacomb of Saints Peter and Mar-View of Haarlem from the Dunes at Aborigines, 551-552; Enlighten-Aunt Jemima? 441, 441, 459 pus Martius (Field of Mars), 83; Ruisdael, Jacob van: landscapes of, 311; Americans, 541; of Australian 459; style of, 440; Who's Afraid of cesi (Caravaggio), 293, 293; Cam-Rue Transnonain (Daumier), 344, 345 56-59, 60, 67-79; of Andean South Ringgold, Faith: issues addressed by, Saint Matthew, San Luigi dei Fran-Hunt, 8, 9, 298; style of, 286 754 Bainting ancient Greece, 45, 46-47, 48, Diocletian, 109, 109; Calling of land, 319; influence of, 315; Lion 10 :695 :895 :695 :795 :685 :885 Riley, Bridget: Fission, 418, 418; style of scalla, plan of, 109, 109; Baths of Cross, 298-299, 298, 311; in Engreligion and mythology: of Africa, 557, Rigaud, Hyacinthe, Louis XIV, 308, 308 Trajan, 103, 103, 167; Baths of Carcation of, 298; Elevation of the also reliquaries 817,10 246, 256; Basilica Ulpia in Forum of Medici at Marseilles, 299, 299; edu-169-170, 171, 172, 174, 185. See many, 227, 227, 229; wood retables 79, 79; Basilica Nova, 113-114, 113, Rubens, Peter Paul: Arrival of Marie de of the Virgin (Creglingen Altarpiece), Herrgottskirche, Creglingen, Gerera, 190, 202; Romanesque era, Rubénistes, 315, 336 101-103, 101, 102; Barberini Faun, 465; early Christian, 121; Gothic royal shaft graves, Mycenae, Greece, 53 114, 115, 115, 245; Arch of Titus, relics: African, 562, 570; Buddhist, 461, Riemenschneider, Tilman: Assumption 115, 131; Arch of Constantine, 114, Chartres, France, 190-191, 191, 215 212, 196, 197, 198, 213, 215 Richter, Hans, 388 of Augustan Peace), 98-99, 99, 103, Royal Portal of Chartres Cathedral, Reims, Bernard de Soissons), 186, House, 327 Rome, Italy: Ara Pacis Augustae (Altar 946,350 d'Orbais, Jean Le Loup, Gaucher de Richmond, Virginia (U.S.A.), State 334-335; Turner, 340-341, 340 Royal Pavilion, Brighton (Nash), 348, Reims Cathedral, Reims, France (Jean cific structure for examples classicism vs., 336; Rousseau and, Benin City, 566, 566 rib vaulting, 189, 190, 190. See also speings, 338-341, 339, 340, 341; Neoroyal ancestral altar of King Eweka II, (sculpture), 11, 11 The Rehearsal (Degas), 362, 362, 367, impact on, 339; landscape paintture (France), 308, 315, 318 Regionalism, 378, 403 Riace, Italy, head of a warrior in sea near 336, 344; Industrial Revolution's Royal Academy of Painting and Sculpsəldmaxə rol borrəq bna (cave painting), 19-20, 19 331, 336, 340; Goya, 335-336, 335, regional style, 3. See also specific region Friedrich, 338, 339; Géricault, 330, boweled bison, Lascaux, France Royal Academy of Arts (England), 313, (Winckelmann), 323 rhinoceros, wounded man, and disemcroix, 332, 336-338, 337, 338, 372; 329, 334-335, 338 Works in Painting and Sculpture Rousseau, Jean-Jacque, 317-318, 320, 341; Constable, 339, 334; Dela-Reflections on the Imitation of Greek Rhineland, Germany, Röttgen Pietá, 204, Romanticism (1800-1840): Cole, 341, 370; style of, 375 red-figure painting, 60-61, 60 soldings for examples Rousseau, Henri: Sleeping Gypsy, 370, 6/8 6/8 traiture, 314, 320; Lord Heathfield, Romanesque vault, 190, 191. See also Red Room (Harmony in Red) (Matisse), Reynolds, Joshua: Grand Manner por Röttgen Pieta, Rhineland, Germany, 204, 172, 174, 185 manuscript), 133, 133 and relics, 158map, 169-170, 171, 437; No. 14, 416, 416 Genesis, Vienna, Italy (illuminated Revolution, 403. See also Industrial and English, 179-184; pilgrimages Rothko, Mark: chromatic abstract art of, Rebecca and Eliezer at the Well, Vienna 325-326, 332, 343, 344; Mexican Rossellino, Bernardo, 243 177-179; Italian, 178-179; Norman photography and, 351; Rodin, 372 190-191, 313, 314, 316, 317, 323, 445, 459; issues addressed by, 459 176; Holy Roman Empire and Italy, 314, 316, 329; in France, 189, Millais, 347-348; Millet, 343-344; War Home: House Beautiful, 445, ture, 172-188; France, 170-177 211-212, 211; Manet, 332, 344-347; revolutions: American Revolution, 313, Rosler, Martha: Gladiators, Bringing the Romanesque European art and architec-357; Lewis, 347; of Loenzetti, Pierre, Moissac, France, 172-173 Rosenberg, Harold, 415 La revolution surréaliste (journal), 395, gence of, 332; Impressionist art vs., Romanesque capitals, cloister of Saint-Daumier, 344; Eakins, 347; emer-Roman houses, 93-96 851-751 Cathedral, Chartres, France, 195, Pet, 332, 342-343, 351, 355; Resurrection, Saint Mark's, Venice, Roman historical reliefs, 83 rose window and lancets, Chartres Realism: architecture, 348-351; Cour-Cathedral, Siena, Italy, 210, 210 Road, 485 Re (Egyptian deity), 32, 33, 34 Resurrection, Maestà altarpiece, Siena (70), 102, 144, 155; trade along Silk (Le Corbusier), 429-430, 429, 430, Rayonnant style, 198 Grünewald), 272 Ronchamp, France, Notre-Dame-du-Haut 88-96, 115, 411; sack of Jerusalem 173' 172' 172 pital of Saint Anthony 117, 124; Republican period, 84, Romulus (founder of Rome), 84-85, 90 141, 141; Sant'Apollinare Nuovo, Resurrection, Isenheim Altarpiece, Hos-Chapel; Vatican Palace, Rome 94, 96, 102, 105-106, 108, 110, 112, Ravenna, Italy, 123–124, 125; San Vitale, 129–132, 129, 130, 131, 132, gion and mythology of, 47, 83, 91, della Francesca), 245 of (410), 124, 141. See also Sistine Resurrection, Borgo San Sepolero (Piero peian/Vesuvius area, 90-96; reli-Virilis), 88-89, 89; Visigoths' sack Loaves and Fishes, Sant'Apollinare, Portunus, Rome, 88-89, 89 New Persian Empire and, 30; Pomof Portunus (Temple of Fortuna Lombards, 137; Miracle of the 84, 90, 108-114, 411; monarchy, 90; Republican art: rulers, 90; Temple of Capitoline Hill, 88, 91, 91; Temple (mosaic), 123, 124, 124; fall to (Kendo), 563, 563 Temple of Jupiter (Capitolium), ence of, 84; Late Imperial period,

High Empire period, 84, 90, 103–108, 115; houses, 93–96; influ-

(Bramante), 262, 262, 283, 283;

Tempietto, San Pietro in Montorio

Saint Mark's, Venice, Italy, 137-138, 137 Saint Matthew folio of Coronation Gospels, Aachen, Germany, 162, 162 Saint Matthew folio of Ebbo Gospels,

Hautvillers, France, 162, 163

Saint Michaels, Hildesheim, Germany (Bernward), 158, 166-167, 167, 168, 185

Saint Pantaleimon, Nerezi, Macedonia, 121, 138-139, 139

Saint Paul's Cathedral, London (Wren), 170, 286, 310, 310

Saint Peter's, Rome (Bramante/Michelangelo): baldacchino (Bernini), 287, 287, 289; dome (Giacomo della Porta), 263, 263, 264; east facade (Maderno), 288, 289, 291; influence of, 310; Julius II's rebuilding plans, 262-263; piazza (Bernini), 286, 288, 289; Pietà (Michelangelo), 257-258, 258, 325, 334; pilgrimages to, 170; plans for (Bramante), 263; plans for (Michelangelo), 262-263, 262. See also Old Saint Peter's, Rome

Saint Sebastian, Isenheim Altarpiece, Hospital of Saint Anthony (Grünewald), 272-273, 273 Saint Serapion (Zurbarán), 296, 296

Saint Theodore, south transept, Chartres Cathedral, Chartres, France (relief sculpture), 196, 196

Saint Walburga, Antwerp, Elevation of the Cross (Rubens), 298-299, 298

Saint'Apollinare Nuovo, Ravenna, Italy, 123-124, 125

Saint-Denis, France: royal abbey church (Suger), 188, 189, 189, 202, 215; Virgin of Jeanne d'Evreux, abbey church, Saint-Denis, France (statuette), 200-201, 200

Sainte-Chapelle, Paris, 198, 198 Sainte-Foy (Saint Faith), reliquary statue, Conques, France, 169

Sainte-Geneviève (Panthéon), Paris (Soufflot), 326, 326, 329

Saint-Étienne, Caen, France, 179-180, 179, 180, 185, 185

Saint-Lazare (Saint Lazarus), Autun, France, 174, 175

Saint-Lazare Train Station (Monet), 360-361, 360 Saint-Pierre, Moissac, France, 156, 157,

172-174, 173, 174

Saint-Sernin, Toulouse, France, 170-172, 171, 179

Sakai, Japan, tomb of Emperor Nintoku, 509, 509

Salians, 177

Salisbury Cathedral, Salisbury, England, 201-202, 201, 215, 215

Salon de la Princesse, Hôtel de Soubise, Paris (Boffrand, Natoire, and Lemoyne), 314-315, 314

Samarra, Iraq, Great Mosque, 147-148, 148

Samnite House, Herculaneum, Italy, 94, 94, 115

Samnites, 90 Samoa, 549

Samothrace, Greece, Nike of Samothrace, 78, 78, 386

San Bartolo, Guatemala, 527

San Carlo alle Quattro Fontane, Rome (Borromini), 286, 290-291, 291,

San Giorgio Maggiore, Venice, Italy, Last Supper (Tintoretto), 252, 270-271,

San Giovanni, baptistery of, Florence, 229-233, 230, 231, 232, 372

San Ildefonso Pueblo, New Mexico, jar (Martinez), 545, 545

San Lorenzo, Florence (Brunelleschi), 242, 242, 246, 249

San Luigi dei Francesi, Rome, Calling of Saint Matthew (Caravaggio), 293, 293 San Marco, Florence, 237, 237

San Pietro in Montorio, Rome (Bramante), 262, 262, 283, 283

San Vitale, Ravenna, Italy, 118, 129-132, 129, 130, 131, 132, 141

San'Andrea, Mantua, Italy (Alberti), 218, 246, 246, 249, 249

Sanchi, India, Great Stupa, 460, 461, 462, 464, 465, 465, 481

Santa Costanza, Rome, 122-123, 123, Santa Croce, Florence: interior, 3, 3;

Pazzi Chapel (Brunelleschi), 242-243, 242, 243

Santa Cruz de la Serós, Spain, 157 Santa Felicità, Florence, Entombment of Christ (Pontormo), 269-270, 270, 283, 283

Santa Maria degli Angeli, Rome

(Michelangelo), 109, *109* Santa Maria del Carmine, Florence, 235-236, 235

Santa Maria del Fiore (Saint Mary of the Flower), Florence (Arnolfo di Cambio), 212-213, 213

Santa Maria della Vittoria, Rome, Ecstasy of Saint Teresa (Bernini), 290, 290

Santa Maria delle Grazie, Milan, Italy, Last Supper (Leonardo da Vinci), 254-255, 254, 256, 270-271

Santa Maria Gloriosa dei Frari, Venice, Assumption of the Virgin (Titian), 267, 267

Santa Maria Novella, Florence: Holv Trinity (Masaccio) (fresco), 236, 237, 249; West facade (Alberti), 264

Santa Sabrina, Rome, 121–122 Santa Tomé, Toledo, Spain, Burial of Count Orgaz (El Greco), 282, 282 Santa Trinità, Florence, 206, 206,

234-235, 235 Sant'Agnese in Agone, Rome (Borromini), 285

Sant'Ambrogio, Milan, Italy, 178-179, 178

Sant'Andrea, Mantua, Italy (Alberti), 246, 246, 247, 249, 249, 263, 264 Sant'Apollinare Nuovo, Ravenna, Italy,

123, 125, 125 Sant'Apollonia, Florence, 238, 238

Sant'Egidio, Florence, 224, 225 Santi, Giovanni, 255

Santi, Raffaello. See Raphael (Raffaello Santi) Santiago de Compostela, Spain, tomb of

Saint James, 157, 170, 185 Sant'Ignazio, Rome, 286, 294-295, 295 Santo Domingo church, Cuzco, Peru, 541, 541

Sapi art, 556, 560-561, 561, 571

Sapi-Portuguese saltcellar, Sierra Leone (Master of the Symbolic Execution), 560-561, 561

Saqqara, Egypt: Hesire, relief from his tomb, 9, 9; stepped pyramid of Djoser (Imhotep), 32-33, 33, 43; Ti watching hippopotamus hunt, mastaba of Ti, 36, 37

sarcophagus, battle of Romans and barbarians (Ludovisi Battle Sarcophagus), Rome, 110, 111

sarcophagus of Junius Bassus, Rome, 116, 117, 119

sarcophagus with reclining couple, Baditaccia necropolis, Cerveteri, Italy, 86, 86

Sardanapalus (Byron), 335, 336 Sargon II (king of Assyria), 27 Sargon of Akkad, 25

Sarnath, India: lion capital of the pillar set up by Ashoka (sculpture), 464, 464, 481, 481; seated Buddha preaching first sermon (sculpture), 467, 467, 481, 481

Sartre, Jean-Paul, 412 Sasan (Sasanian king), 30 Sasanians, 30, 134-135 saturation, 7

Saville, Jenny: Branded, 448, 448; style of, 440, 459

Savonarola, Girolamo, 218, 244

Sayings on Painting from Monk Bitter Gourd (Shitao), 500

scale, 10

Schnabel, Julian, 440, 450, 459 Schneemann, Carolee, Meat Joy, 434, 434, 437, 437

Schongauer, Martin: Saint Anthony Tormented by Demons, 228, 228, 229; style of, 218, 249

School of Athens (Philosophy), Vatican City (Raphael), 256, 257, 275

schools of art, 6. See also specific school of art

Schubert, Franz, 335

Schwedagon Pagoda, Rangoon (Yangon), Myanmar, 480, 480, 481

Scivias (Know the Ways of God) (Hildegard of Bingen), 177, 177

The Scream (Munch), 370-371, 371, 380,

Scrovegni, Enrico, 207

Scrynmakers, Margarete, 221

sculpture, types of, 12. See also specific period or work of art for examples

sculpture techniques: additive and subtractive, 11; bronze casting, 11, 64; cire perdue (lost wax) method, 64, 64, 305, 556, 558, 571

Seagram Building, New York (Mies van der Rohe and Johnson), 430-431, 431, 437

seal with seated figure in yogic posture, Mohenjo-daro, Pakistan, 462, 463

seated Buddha preaching first sermon, Sarnath (sculpture), 467, 467, 481,

seated couple, Dogon, Mali (sculpture), 564-565, 564

Second Coming of Christ, tympanum of Saint-Pierre, Moissac, France, 156, 174, 185, 185

Second Style Roman wall painting: characteristics of, 84; from cubiculum M of Villa of Publius Fannius Synistor, Boscoreale, Italy, 95, 95; Dionysiac mystery frieze, Villa of the Mysteries, Pompeii, Italy, 94-95, 94; Gardenscape from Villa of Livia, Primaporta, Italy, 95-96, 95; illusionism of, 115; Mantegna's trompe l'oeil, 247

secondary colors, 7 sections (architectural), 12

Selene (Luna) (Greek/Roman deity), 47,68

Seleucus Nicator, 461, 464 Self-Portrait (Leyster), 301, 301 Self-Portrait (Mapplethorpe), 442-443,

Self-Portrait (Te Pehi Kupe), 13, 13 Self-Portrait (van Hemessen), 280, 280 Self-Portrait (Vigée-Lebrun), 318, 318 Self-Portrait, ca. 1659-1660 (Rembrandt),

302, 302 Selve, Georges de, 276

Sen no Rikyu, Taian teahouse, Myokian temple, Kyoto, Japan, 508, 518-519, 518, 525, 525

Senefelder, Alois, 345

Sensation: Young British Artists from the Saatchi Collection, 443

Senufo art, 568-569

Senufo masqueraders, Côte d'Ivoire, 568, 568, 569, 571, 571

Seokguram cave temple, Korea, 502-503, 503, 505

Seoul, South Korea, Namdaemun, 503, 503, 505 Septimius Severus and his family (tona

portrait), Egypt, 108, 108 Septimus Severus (Roman emperor), 108 Serapis (Egyptian deity), 108

Serpent Mound, Ohio, Mississippian, 542-543, 543

Serra, Richard: political and social issues presented by, 440; site-specific art of, 459; Tilted Arc, Jacob K. Javits Federal Plaza, New York City, 443, 455-456, 455

Serrano, Andres, Piss Christ, 443 Sesshu Toyo, splashed-ink (haboku) landscape (hanging scroll), 516-517, 516

Seurat, Georges: style of, 358, 364, 369, 375; A Sunday on La Grande Jatte,

364-365, 365 Severans, 84, 108-109, 108, 115

Sforza, Battista, 245, 245 Sforza, Francesco, 255

Sforza, Ludovico, 253, 254 Shahn, Ben, The Passion of Sacco and Vanzetti, 4, 4, 5

Shahnama (Book of Kings) of Shah Tahmasp, Tabriz, Iran (Sultan-Muhammad), 154, 154

Shaka triad, kondo, Horyuji temple, Ikariga, Japan (Tori Busshi), 510, 510, 525, 525

Shakyamuni Buddha: in Japanese art, 510, 510; in Korean art, 502-503, 503, 505, 505; origin of, 466; in South East Asian art, 478

Shakyamuni Buddha, Seokguram, Korea (sculpture), 502-503, 503, 505, 505 Shamash (Mesopotamian deity), 26-27

Shang dynasty Chinese art, 484, 485,

Shang Xi, 499 Shapur I (Sasanian king), 30 Shelley, Mary Wollstonecraft, 335

Shelley, Percy Bysshe, 335 Sherman, Cindy: study of male gaze, 437, 442; Untitled Film Stills series, 426, 428, 428, 437, 437

Shi Huangdi (emperor of China), 484, 505

Shield Jaguar and Lady Xoc, Yaxchilán (relief sculpture), 533, 533 Shingon Buddhism, 511 Shino ceramics, 508, 519, 519 Shitao (Daoji), 505; Reminiscences of Nanjing: Riding the Clouds, 500, 500; Sayings on Painting from Monk

Bitter Gourd, 500 Shiva as Mahadeva, Elephanta, India (cave sculpture), 468, 469, 469

Shiva as Nataraja, Tamil Nadu, India (statuette), 472-473, 472 shogunate/shoguns, 507, 508, 513-519

Shop Block, Bauhaus, Dessau (Gropius), 406, 406, 409 Shotuku (Japanese prince), 510

Showa period, Japan, 508, 523 shrine of the king's head, royal palace, Ikere (Olowe of Ise), 567-569, 567

Shrine of the Three Kings, Cologne Cathedral, Cologne, Germany (Nicholas of Verdun), 202, 203

Shunjobo Chogen, 513-514 Siddhartha Gautama (Buddha), 465 Siena, Italy: Annunciation altarpiece, Saint Ansanus altar, Siena Cathedral (Martini and Memmi), 210-211, 211; Effects of Good Government in the City and in the Country, Sala della Pace, Palazzo Pubblico (Lorenzetti), 211-212, 211; Maestà altarpiece, Siena Cathedral (Duccio di Buoninsegna),

Pubblico, 188 Siena Cathedral, Siena, Italy: Annunciation altarpiece, altar of Saint Ansanus (Martini and Memmi), 210-211, 211; Maestà altarpiece (Duccio di Buoninsegna), 209-210,

209-210, 209, 210, 239; Palazzo

209, 210, 239 Sierra Leone: Mende female mask, 569, 569; Sapi-Portuguese saltcellar (Master of the Symbolic Execution), 560-561, 561

Sikander, Shahzia: issues addressed by, 440, 442, 459; Perilous Order, 444, 444

Silk Road, 485, 487map, 488, 489 Silla crown, Cheonmachong tomb, Hwangnam-dong, Korea, 502, 502 Silla kingdom, Korea, 502-503

623

184 647-874 subject matter of art, 5 181, 481 nist art, 428; Islamic, 152-153, 153; Lanka, 477-478, 481; Thailand, stylistic evidence, 2, 2-3 contemporary use of, 441; in femi-Lahori ?), 143, 462, 474-476, 475, 462map; Myanmar, 480, 481; Sri style, 3-4 Taj Mahal, Agra, India (Ustad Ahamd contemporary art, 453-454; 481; Java, 478-479; location of, Strozzi family, 234-235 (hanging scroll), 511, 511 538-539, §38; Chinese, 487; Southeast Asian art: Cambodia, 478, Street, Dresden (Kirchner), 380, 381, 381 ogokokuji (Toji), Kyoto, Japan textiles: Andean South American, South Korea, 412 France, 202-203, 203 Taizokai (Womb World) mandara, Kyo-Tetitla apartment complex, 530-531, 530 463. See also Buddhism; Hinduism Strasbourg Cathedral, Strasbourg, (Hogarth), 319, 319 463; Vedic and Upanishadic period, Strasbourg, France, 202-203, 203 (Sen no Rikyu), 518-519, 518, 525, The Tete à Tete, Marriage à la Mode rise of Buddhism and Hinduism, tympanum, Strasbourg Cathedral, Taian teahouse, Myokian temple, Kyoto 474; Mughal Empire, 462, 476, 481; 481; Nayak dynasty, 462, 476, 481; terminus post quem, defined, 2 Strasbourg, France, Death of the Virgin, Tahmasp (Shah of Iran), 152-153, 154 terminus ante quem, defined, 2 story quilts, 441 Tahiti, 549 terminology of artists, 6-12 470-473, 481; miniatures, 473-474, Stonehenge, England, 21-22, 21 Muhammad), 154, 154 urban planning for, 529-530, 553 The Stone Breakers (Courbet), 342, 343 dynasty, 464, 481; medieval period, ama of Shah Tahmasp (Sultan-536; pyramids, 528; role of, 529; location of, 462map; Maurya Age; Paleolithic art Tabriz, Iran, Court of Gayumars, Shahn-530-531, 532; as pilgrimage site, Stone Age, 16, 16map. See also Neolithic 473; Kushan dynasty, 462, 464, 481; integration of, 533; mural painting, Stags, Herculaneum, Italy (Fourth Style wall painting), 96, 97 Indus seals, 463, 463; Islam and, Teotihuacán, Mexico: deity of, 534; dis-470, 481; Indus civilization, 462-463; Arts, and Crafts (Diderot), 316 Post-Gupta period, 462, 467-468, 536; urban planning for, 553 still life with peaches, House of the Systematic Dictionary of the Sciences, 536-537, 536; Great Temple, 536, chi, 460, 461; Gupta and \$86,285-485 84,84-74 Coyolxauhqui (relief sculpture), temporary, 444; Great Stupa, San-Still Life with Chair-Caning (Picasso), Syros, Greece, figurine of a woman, ture), 537, 537; Cortés and, 538; South Asian art and architecture: con-Syong Myong (Backje king), 509 Tenochtitlán, Mexico: Coatlicue (sculp-Atawalpa, 541 Still Life in Studio (Daguerre), 351-352, Synthetic Cubism, 384-385, 390, 392 tenebroso. See tenebrism still life, 5. See also specific still life 528, 538-539; Pizarro and səlduvxə 10f tenebrism, 293, 294 Still, Clyfford, 1948-C, 1, 2 Nasca art, 539, 553; Paracas art, symbols, 5. See also specific works of art Tendai Buddhism, 511 tography of, 409; The Steerage, 392–393, 392 540-541; Moche art, 539-540; 371; Rodin, 375; Rousseau, 370, 375 978 '96 '58 '49 538map; Machu Picchu, 528, 371-372, 371; Munch, 370-371, Ten Books on Architecture (Vitruvius), Stieglitz, Alfred: influence of, 426; pho-Inka art, 528, 540-541, 553; location, Symbolism: fin-de-siècle, 371; Klimt, Stewart, Andrew, 66 South American art and architecture: Kupe, 13, 13 Altarpiece (Grünewald), 272-273, Sainte-Geneviève, Paris, 326 Egypt (Imhotep), 32-33, 33 Sylvester, John Henry, Portrait of Te Pehi Temptation of Saint Anthony, Isenheim Soufflot, Jacques-Germain, Panthéon, stepped pyramid of Djoser, Saqqara, The Swing (Fragonard), 316, 316 temple vases, Yuan dynasty, 496-497, 497 Sophocles, 63, 75, 81 series, 506, 507 150 145 '145 Song Su-nam, 450, 459, 504 Clock, Eight Views of the Parlor Less), 417, 417; style of painting, Temple of the Sun, Cuzco, Peru, 528, Stella, Frank: Mas o Menos (More or 76E Suzuki Harunobu, Evening Bell at the Egypt, 38, 38 The Song of Love (de Chirico), 394-395, the Fishing Nets), 498, 505 Iraq, 26-27, 26, 27 Temple of Ramses II, Abu Simbel, Song dynasty, China, 484, 491-495, 505 stele with the laws of Hammurabi, Susa, Temple of Portunus, Rome, 88-89, 89 shi Yuan (Garden of the Master of ing Garden), 498, 498, 505; Wangstele of Naram-Sin, 26 34,35 429, 437; Cremaster cycle (Barney), Copán, Honduras, 531, 531, 533 Crowned) Peak, Liu Yuan (Lingertemple of Khafre, Gizeh, Egypt (model), York (Wright): architecture of, 429, Stele D, (Waxaklajuun-Ub'aahK'awiil), Suzhou, China: Guanyun (Cloud 16 '16 Solomon R. Guggenheim Museum, New The Steerage (Stieglitz), 392-393, 392 158, 158 line Hill, Rome (Vulca of Veii), 88, Sol. See Helios (Sol) (Greek/Roman deity) Sutton Hoo ship burial, Suffolk, England, Temple of Jupiter (Capitolium), Capitoorder (Society of Jesus) murabi, 26–27, 26, 27; victory stele of Naram-Sin, 25–26, 26 statuettes of two worshipers, Eshnunna, Society of Jesus (Jesuit order). See Jesuit statues, 12. See also specific statue Temple of Hera, Paestum, Italy, 57, 58, socialism, 344, 358 Susa, Iran: stele with the laws of Ham-Greece, 66, 70-71, 70, 71 Social Contract (Rousseau), 334 Statue of Liberty, New York (Bartholdi), Suryavarman II (Khmer king), 479 Temple of Athena Vike, Kallikrates, Starry Night (van Gogh), 367, 367 (sculpture), 50-51, 51 Surya (Aryan deity), 463 65 '65-85 Snake Goddess, Knossos, Crete, Greece nature) Vatican Palace, Rome, 256 and Jeanne-Claude), 453-454, 453 Temple of Artemis, Cortu, Greece, Lake, Utah, 433-434, 433, 437, 453 Stanza della Segnatura, (Room of the Sig-Miami, Florida, 1980-1983 (Christo (Guillaume-Abel Blouet), 61 Smithson, Robert, Spiral Jetty, Great Salt Stanford, Leland, 354 Surrounded Islands, Biscayne Bay, 61-62, 61; restored view of facade Untitled, 449, 449 The Standard of Ur, 24-25, 24 unconscious, 378 internal elevation and plan ot, Smith, Kiki: sculptures of, 440, 459; 964 '964 dying warriors (sculptures), 62, 62; Oppenheim, 396; representation of Trade (Gifts for Trading Land with White People), 438, 439, 440 Stalks of Bamboo by a Rock (Wu Zhen), 396-397; Murray's art and, 450; Temple of Aphaia, Aegina, Greece: du-Haut, Ronchamp, France, 430 Lam, 397; Magritte, 396; Miró, 6£ '01-88 addressed by, 459; style of, 546; 196, 198, 198, 215; in Notre-Dametemple of Amen-Re, Karnak, Egypt, of, 419; influences on, 278, 370; Smith, Jaune Quick-to-See: issues '561 '561-461 '681 '681 '281 '981 de Chirico, 394-395; found objects plans, 12; in Gothic Cathedrals, 3, 814 Manifesto, 395, 409; Dali, 395-396; Rome (Bramante), 262, 262, 283, Smith, David, Cubi XII (sculpture), 418, stained-glass windows: in architectural The Tempest (Giorgione), 266–267, 266 Tempietto, San Pietro in Montorio, Surrealism: Breton's First Surrealist 519, 249, 249 nard de Soissons), 186, 187 Suprematist Composition: Airplane Flying (Malevich), 390, 390 Champmol, Dijon, France, 219, Le Loup, Gaucher de Reims, Berples; specific works of art for examples 218; Well of Moses, Chartreuse de Suprematism, 390, 409 Reims, France (Jean d'Orbais, Jean painting; specific painting for exam-Sluter, Claus: statue of Philip the Bald, Supermarket Shopper (Hanson), 425, 425 Superrealism, 412, 424–426, 437, 440 stained glass windows, Reims Cathedral, tempera painting, 220. See also mural sleeping satyr (Barberini Faun) (sculp-ture), 79, 79 Islands, 551, 551 sənbiuu2ə1 staff god (Tangaroa?), Rarotonga, Cook niques; printmaking; sculpture 364-365, 365 Sleeping Gypsy (Rousseau), 370, 370 Sri Lankan art, 477-478, 481 A Sunday on La Grande Jatte (Seurat), technique, 6-7. See also painting tech-Los Caprichos (Goya), 335, 335, 355 Akrotiri, Thera, Greece, 49-50, 50 (Boccioni), 387 Summer's Day (Morisot), 362-363, 363 The Sleep of Reason Produces Monsters, Spring Fresco (landscape with swallows), Technical Manifesto of Futurist Sculpture 23, 23, 26, 43 81,81,(gni Slavery, 47, 337, 338, 340-341, 340, 347 tea ceremony, Japan, 515, 518 Temple, 22-23, 22; ziggurat at Ur, Coming On) (Turner), 340-341, 341 imprints, Pech-Merle (cave paint-6₽2 , to soot Standard of Ur, 24-25, 24; White spotted horses and negative hand board the Dead and Dying, Typhoon 23; religion and mythology of, 15; Te Pehi Kupe: Self-Portrait, 13, 13; tat-The Slave Ship (Slavers Throwing Over-Inanna (Warka Vase), Uruk, 14, 15, (relief panel), 102-103, 102 (Sesshu Toyo), 516–517, 516 Spoils of Jerusalem, Arch of Titus, Rome 430-431, 437, 452-453 22map; presentation of offerings to tattoos as art, 13, 13, 548-550, 549, 553, skyscrapers, 358, 406-407, 407, 412, statuettes, 23-24, 23; location, Sixtus V (Pope), 287, 288 Sumerian history and art: Eshnunna splashed-ink landscape (hanging scroll) hiva, Marquesas Islands, 549-550, Sixtus IV (Pope), 244 Wright and, 408 tattooed warrior with war club, Nuka-Building), Chicago, 374, 375; 375; skyscrapers, 358, 374, 375, 430; 685 '6St '9St-ISt Spiritual Exercises (Ignatius of Loyola), Guinea, 552, 552 site-specific art, 432-434, 437, 440, (Smithson), 433-434, 433, 437, 453 Tatanua mask, New Ireland, Papua New ceiling (Michelangelo), 259, 259 Spiral Jetty, Great Salt Lake, Utah (rock painting), 557, 571, 571 (formerly the Carson, Pirie, Scott Separation of Light from Darkness, 335, 336 Tassili n'Ajjer, Algeria, running woman, Sullivan, Louis Henry: Sullivan Center gelo), 250, 251, 261, 261, 334, 372; Romanticism in art, 335-336, Sulla (Roman consul and dictator), 80, 90 Tarquinius Superbus (king of Rome), 90 Judgment, altar wall (Michelan-Sukhothai kingdom, 479 283; Mannerist art, 281-282; (Michelangelo), 250, 251, 260; Last nikos Theotokópoulos), 282, 282, (sculpture), 479-480, 479, 481 Monterozzi necropolis, 84, 87, 87, angelo), 259; Fall of Man, ceiling Habsburgs, 281; El Greco (Domé-Sukhothai, Thailand, Walking Buddha Tarquinia, Italy, Tomb of the Leopards, 260; Drunkenness of Noah (Michel-311; dominance of under Tang dynasty, China, 484, 489-491, 505 Suiko (Japanese empress), 510 ceiling (Michelangelo), 250, 251, Baroque art, 295-298, 296, 297, (statuette), 472-473, 472 189, 189, 202, 215 Spain: Art Nouveau (Modernismo), 373; 244-245, 244; Creation of Adam, church, Saint-Denis, France, 188, Tamil Nadu, India, Shiva as Nataraja Kingdom to Saint Peter (Perugino), space, 7, 9 Tamerlane (Muslim caliph), 153-154 nova), 195; Saint-Denis royal abbey Christ Delivering the Keys of the 243-545, 553 from stained-glass windows (lux 215,513 (Michelangelo), 251, 258-261, 293; Southwest Native American art, Suger (Abbot of Saint-Denis): on light Tale of Genji (Murasaki Shikubu), 512, Sistine Chapel, Vatican, Rome: ceiling

subtractive sculpture, 11

subtractive light, 7

352, 355

Talbot, William Henry Fox, 332, 351,

₹05 '66¥

Southern School of Chinese painting,

Sima Qian, 486

Japanese, 511; Norman Romanesque, 183-184, 183, 184; Romanesque, 183-184, 183; South American, 528. See also Ardabil carpets

texture, 7

Thai art, 478-479

Thanjavur, India, Rajarajeshvara Temple, 470, 471-472, 471, 472, 481, 481 theater at Epidauros, Greece (Polykleitos the Younger), 75–76, 75

Thebes, Egypt: death mask of Tutankhamen, 42, 42, 53; innermost coffin, tomb of Tutankhamen, 41-42, 41

Theodora (Byzantine empress, wife of Theophilos), 118, 132, 132, 135 Theodora and attendants, San Vitale,

Ravenna, Italy (mosaic), 132, 132 Theodoric (king of the Ostrogoths), 123, 129

Theodoros of Phokaia, 76 Theodosius I (emperor of Rome), 141

Theophilus, 195 Theotokos. See Mary (mother of Jesus); and headings beginning with Annunciation, Madonna, or Virgin

Thera, (Cyclades), Greece, landscape with swallows (Spring Fresco), 49-50, 50

Theravada Buddhism, 466, 477, 480 Theseus (king of Athens), 48, 67 The Thinker, Gates of Hell (Rodin) (sculpture), 372, 372

Third Dynasty of Ur, 26, 43 Third of May, 1808 (Goya), 336, 336, 344

Third Style Roman wall painting: characteristics of, 84; preservation of, 115; Villa of Agrippa Postumus, Boscotrecase, Italy, 96, 96

The Thirteen Emperors (Yan Liben), 490-491, 491, 505

Thirty Years' War (1618-1648), 286, 295 Thirty-six Views of Mount Fuji series (Katshushika Hokusai), 521-522, 521

tholos at Delphi (Theodoros of Phokaia), 76

tholos tombs, 52-53, 52, 53, 76, 86 Thomas de Cormont, Amiens Cathedral, Amiens, France, 196, 197

Three Flags (Johns), 420, 422, 422 three goddesses (Hestia, Dione, and Aphrodite? east pediment of Parthenon), Acropolis, Athens, Greece, 68, 68

Three Kingdoms period, Korea, 501-502

three revelers, Vulci, Italy (Euthymides) (Athenian red-figure amphora), 60-61, 61, 81, 81

The Three Shades, Gates of Hell (Rodin) (sculpture), 372, 372

throne and footstool of King Nsangu, Bamum, 556, 562, 562

Thutmose (Egyptian sculptor), bust of

Nefertiti, 40-41, 41 Thutmose III (pharaoh of Egypt), 37 Ti watching hippopotamus hunt, mas-

taba of Ti, Saqqara, Egypt (relief sculpture), 36, 37 Tiberius (Roman leader), 313 tilework, 151, 151. See also mosaics

Tilted Arc, Jacob K. Javits Federal Plaza, New York City (Serra), 443, 455-456, 455

Timur. See Tamerlane (Muslim caliph) Timurid court: Bustan (Bihzad) (secular book), 154; manuscript painting, 144; Timurid dynasty, 153-154 Tinia (Etruscan deity), 85

Tintoretto (Jacopo Robusti): Last Supper, 252, 270-271, 270, 282; style of, 252

Tiryns, Greece, citadel, 51-52, 51, 53 Titian (Tiziano Vecelli): Assumption of the Virgin, 267, 267; influence of, 298; Pastoral Symphony, 266, 267; students of, 270, 282; Venus of Urbino, 268, 268

Titus (Roman emperor), 90, 100, 101-102, 146

Tjibaou Cultural Centre, Noumea, New Caledonia (Piano), 453, 453, 459,

Tlaloc (Aztec deity), 537

Todaiji, Nara, Japan, portrait statue of the priest Shunjobo Chogen, 513-514, 513

Tokugawa Ieyasu (shogun), 517, 519, 525 Tokugawa shogunate. See Edo period

Tokyo, Japan, Olympic stadiums (Kenzo Tange), 523, 523

Toledo, Spain, Burial of Count Orgaz, Santa Tomé (El Greco), 282, 282 Toltec culture and art, 533, 534-535, 535, 553

tomb of Emperor Nintoku, Sakai, Japan, 509, 509

tomb of Khufu, Gizeh, Egypt, 34–35 tomb of Saint James, Santiago de Compostela, Spain, 157, 170

Tomb of the Leopards, Monterozzi necropolis, Tarquinia, Italy, 87, 87 tomb of the marquise of Dai, Mawangdui, China, 486-487

Tomb of the Reliefs, Banditaccia necropolis, Cerveteri, Italy, 87, 87

tomb of Ti, Saqqara, Egypt, 36, 37 tonality, 7 Tongan, 549

Tori Busshi, Shaka triad, Horyuji temple (sculpture), 510-511, 510, 525, 525 Toulouse, France, Saint-Sernin, 170-172, 171, 179

Toulouse-Lautrec, Henri de, At the Moulin Rouge, 364, 365

Tournachon, Gaspar-Félix. See Nadar (Gaspar-Félix Tournachon)

Tower of Babel (Babylon ziggurat), 23,

Toyotomi Hideyoshi (shogun), 517, 519 Trade (Gifts for Trading Land with White People) (Smith), 438, 439, 440

Trajan (emperor of Rome), 83, 84, 90, 103, 115

Trajan Decius (Roman emperor), 90, 110, 110, 118

Trajan's Column. See Column of Trajan, Rome

transcendental landscapes, 355 Transfiguration of Christ, 120 transformation masks, 528

Trastevere, Rome, copy of Apoxyomenos (Scraper) (Lysippos), 74, 74 Travelers among Mountains and Streams

(Fan Kuan), 492, 492, 495 The Treachery (or Perfidy) of Images

(Magritte), 396, 396 Treasury of Atreus, Mycenae, Greece, 52-53, 52, 53, 86

Treasury Relief Art Project (USA), 400 Les Très Riches Heures du Duc de Berry (Very Sumptuous Hours of the Duke of Berry) (Limbourg brothers), 225-226, 225, 249, 249

Tribute Money, Santa Maria del Carmine, Florence (Masaccio) (fresco), 235-236, 235

triglyphs, 57 Trinity College, Cambridge, England, *Eadwine Psalter* (Eadwine the Scribe), 182-183, 182

Trithemius, Johannes, In Praise of Scribes, 199-200

Triumph in the Name of Jesus, Il Gesù, Rome (Gaulli), 294

Triumph of Titus, Arch of Titus, Rome Italy (relief panel), 102, 103 trompe l'oeil, 247-248

Tropical Garden II (Nevelson), 419, 419 true view painting, 504

Tula, Mexico, colossal atlantids (sculpture), 534, 535

tumuli, Banditaccia necropolis, Cerveteri, Italy, 86-87, 86, 115 Turner, Joseph Mallord William: The Slave Ship (Slavers Throwing

Overboard the Dead and Dying, Typhoon Coming On), 340-341, 341; transcendental landscapes, 332, 355

Tutankhamen (pharaoh of Egypt), 41-42

twisted perspective, 19 two bison relief, Le Tuc D'Audoubert, France, 17, 17

The Two Fridas (Kahlo), 404-405, 405 two men sitting at a table of food (linguist's staff), Ghana, (Bonsu), 566, 567

Uji, Japan, Phoenix Hall of the Byodoin, 512, 512, 525

ukiyo-e woodblock prints, 506, 507, 520-523, 521, 522 Uma (Parvati) (Hindu deity), 469 Umayyad dynasty, 144, 148-149, 155 undraped architecture, 350-351, 350 unfinished captive statue (Michelangelo), 11, 11

Uni (Etruscan deity), 85 Unified Silla Kingdom, Korea, 502-503,

Unique Forms of Continuity in Space (Boccioni), 386, 387, 409, 409

United States: 19th century documentary photography, 353–354, 353, 354; Abstract Expressionism in, 413; Armory Show, New York, 378; Great Depression in, 400; Harlem Renaissance, 390-391, 409; Modernist art (1930-1945), 399-403, 408; Pop Art in, 420-421; post-World War II events, 412; prewar architecture in, 408. See also 18th century European and American art; Modernism in Europe and America (1900-1945); Modernism in Europe and America (1945-1980); Washington, D. C.; specific state

University of Virginia, Charlottesville (Jefferson), 327 Untitled (Judd), 418-419, 419 Untitled (sculpture) (Smith), 449, 449 Untitled (Your Gaze Hits the Side of My Face) (Kruger), 442, 442

Untitled Film Stills series (Sherman), 426, 428, 428, 437, 437 Upanishadic period of Indus civiliza-

tion, 463 Ur (Tell Muqayyar), Iraq: The Standard

of Ur, 24-25, 24; ziggurat, 23, 23 Urban VI (Pope), 218 Urban VIII (Pope), 285, 287, 289 Urbino, Italy: Battista Sforza and Fed-

erico da Montefeltro (Piero della Francesca), 245, 245; princely courts, 249

Uruk, Iraq: Warka Vase (presentation of offerings to Inanna), 14, 15, 23, 43; White Temple, 22-23, 22

Ustad Ahmad Lahori, Taj Mahal, Agra, India, 481, 481

Vairocana Buddha, disciples, and bodhisattvas, Longmen Caves, Luovang, China (sculpture), 489, 489 valley temple of Khafre, Gizeh, Egypt

(model), 33, 35 van Alen, William, Chrysler Building,

New York, 401, 407 Van Dyck, Anthony: Charles I at the Hunt, 299-300, 299; in England,

Van Eetvelde house, Brussels (Horta), 373, 383, 383

van Eyck, Hubert, Ghent Altarpiece, 221-222, 221

van Eyck, Jan: Ghent Altarpiece, 221-222, 221, 249; Giovanni Arnolfini and His Wife, 223, 223, 278, 297; oil painting and, 218

van Gogh, Vincent: exploration of color, 358; influence of, 374, 378; Night

Café, 366-367, 366, 375, 375; Starry Night, 367, 367

Vanitas Still Life (Claesz), 305-306, 305, 352

Vannucci, Pietro. See Perugino (Pietro Vannucci)

Varuna (Aryan deity), 463

Vasari, Giorgio: focus on biography, 323; introduction of term "Gothic," 188, 205; Introduction to the Three Arts of Design, 188; on Leonardo da Vinci, 255; Lives of the Most Eminent Painters, Sculptors, and Architects, 252; on Michelangelo, 257, 258; view of Giorgione, 266, 267; view of Giotto, 206

vase painting: ancient Greek geometric krater, 54, 54; black-figure painting, 59-60, 59; Chinese, 497, 497; Minoan, 50-51, 50; red-figure painting, 60, 60; white-ground painting, 72, 72. See also specific vase

Vatican City: Fountain of the Four Rivers (Bernini), 284, 285; Old Saint Peter's, 120-122, 122, 257-258, 258, 287, 288, 325, 334; Saint Peter's (Bramante/Michelangelo), 170, 262-263, 262, 263, 288, 288, 289, 291; Sistine Chapel, 334; Sistine Chapel ceiling (Michelangelo), 244-245, 244, 250, 251, 258-261, 259, 260, 261, 372. See also papacy; Vatican Palace, Rome; specific pope

Vatican Palace, Rome: Law (Justice) (Raphael), 256; Poetry (Raphael), 256; School of Athens (Philosophy) (Raphael), 256, 257, 275; Stanza della Segnatura (Room of the Signature), 256; Theology (Raphael), 256

Vauxcelles, Louis, 378, 383 Vecelli, Tiziano. See Titian (Tiziano Vecelli)

Vedas, 463

Vedic period of South Asian art, 463, 469 Veduta painting, 321-322, 322 Veii, Italy, Apulu (Apollo of Veii), Por-

tonaccio temple, (statue), 85, 85, 86 Velázquez, Diego: Las Meninas (The Maids of Honor), 286, 297–298, 311; style of, 302; Water Carrier of Seville, 296–297, 296

Venice, Italy: Doge's Palace, 213-214, 214; High Renaissance painting, 266-268, 266, 267, 268; independence, 137; Last Supper, San Giorgio Maggiore (Tintoretto), 252, 270-271, 270, 282; Saint Mark's, 137–138, *137*

La Venta, Mexico, colossal head, Olmec (sculpture), 529

Venturi, Robert, Complexity and Contradiction in Architecture, 431 Venus. See Aphrodite (Venus) (Greek/ Roman deity)

Venus, Cupid, Folly, and Time (Bronzino), 270

Venus de Milo, Melos, Greece (Alexandros of Antioch-on-the-Meander), 78-79, 78

Venus of Urbino (Titian), 268, 268 Venus of Willendorf, Willendorf, Austria, 16-17, 16, 21

Verism, 89-90

veristic portraits, 84, 89-90, 90 Vermeer, Jan: Allegory of the Art of Painting, 304-305, 305; use of camera obscura, 286, 304; Woman Holding a Balance, 304, 304, 311, 311

vernacular literature, 205

Versailles, palace of: Galerie des Glaces (Hall of Mirrors) (Hardouin-Mansart and Le Brun), 286, 308-309, 309, 311, 314; park (Le Nôtre), 309,

Vertue, Robert and William, Chapel of Henry VII, Westminster Abbey, 202, 202

200-201, 200

quet), 226, 226

99, 99, 1igaiV

592, 265

924, to sosbiv

Villani, Giovanni, 212

76 'S6-76

29, 29, (gni

687 '687

Vietnam War, 412

Vikings, 179

96, 96, (gnitnisq

Portrait, 318, 318

(Sippar), 25-26, 26

Vicenza, Italy, Villa Rotonda (Palladio),

Vézelay, France, Mission of the Apostles,

Vesuvius, Mount, 90, 115. See also Pom-

Vesta. See Hestia (Vesta) (Greek/Roman

vessel in the shape of a portrait head, Moche, Peru, 539-540, 540, 553

Vespasian (Roman emperor), 89, 90,

Veteran in a New Field (Homer), 353

peii/Vesuvius area art

326, 328

deity)

101-001

Vesari, Giorgio, 236

967 '967 '987 717 '607 Zurbarán, Francisco de, Saint Serapion, World War I, 382, 386-390, 393-394, zoopraxiscope, 354 004 (.A.2.U) Zola, Émile, 344 Works Progress Administration (WPA) Wordsworth, William, 335 095 '095 Zimbabwe, Great Zimbabwe, 556, 558, 245-543, 553 ziggurat, Ur, 23, 23, 26, 43 Woodlands Native American art, ziggurat, Babylon, 23, 28 227-229, 249 Apocalypse, 5, 5; printing from, 218, Zhuangzi, 488 Zhu Yuanzhong (Chinese emperor), 483 229; The Four Horsemen of the woodcuts: Buxheim Saint Christopher, Zhou dynasty, China, 484, 485, 505 270-275, 521, 522, 525, 525 161 Zhao Kuangyin (Chinese emperor), woodblock prints, 362, 506, 507, 508, Athens, Greece), 68, 70 by, 440 political and social issues presented wood statue of Athena (Acropolis, Bloodline portraits, 446, 447, 459; wood prow ornaments, 528 403; subject matter of art, 409 Zhang Xiaogang: Big Family No. 2, Wood, Grant: American Gothic, 403, 1. St Zeus (Jupiter) (Greek/Roman deity), Woman with the Hat (Matisse), 378-379 815 Zen/Chan Buddhism, 513, 514, 515, Woman with Dead Child (Kollwitz), 382, (hanging scroll), 516, 517 304, 304, 311 Woman Holding a Balance (Vermeer), (udonotoM) moord a stiw gai Zen Patriarch Xiangyen Zhixian Sweepwoman from Syros figurine (Greece), Woman I (de Kooning), 415-416, 416 Winckelmann, Johann Joachim, 323 Yuan dynasty, China, 484, 495-499, 505 youth culture, 412 Wimpfen-im-Tal, Germany, 201 Yoruba art, 567-569, 567, 571 Conqueror), 179, 180, 183-184 William of Normandy (William the Yongle (Chinese emperor), 483 (Venus of Willendorf), 16-17, 16, 21 yoga, 463 Yingxian, China, Foguang Si Pagoda, 494-495, 494 Willendorf (Austria), nude woman Wildmon, Donald, 443 Yi Seong-gye, 503 654 '144 '144 Who's Afraid of Aunt Jemima? (Ringgold), 105,102 Vienna, 455; site-specific art of, 459 Ye Yushan, Rent Collection Courtyard, Whiteread, Rachel: Holocaust Memorial, Yayoi period, Japan, 508, 525 white-ground painting, 72, 72 White Temple (Uruk, Iraq), 22-23, 22 Lady Xoc (relief sculpture), 533, White Heron castle, Himeji, Japan, 517 Yaxchilán, Mexico, Shield Jaguar and Reef, Utah, 426, 426 Myanmar Yangon. See Rangoon (Yangon), White, Minor, Moencopi Strata, Capitol Yang (Chinese empress), 495 Rocket), 364, 364; style of, 363-364 Yanagi Soetsu, 524 turne in Black and Gold (The Falling sure to Modernist art, 390; Noc-505 '164' '164-064 Whistler, James Abbott McNeill: expo-Yan Liben, The Thirteen Emperors, (Gauguin), 368, 369-370, 375 yamato-e painting, 512 We? Where Are We Going? Where Do We Come From? What Are yakshi (Buddhist deity), 460, 461, 462, meeting house (Apanui), 550, 551 Whakatane, New Zealand, Mataatua issues addressed by, 459 223-224 painting, 218; portraiture of, 249; Saint Luke Drawing the Virgin, 216, 217; style of, 220, 269; subjects of, Xu Bing: A Book from the Sky, 448, 448; Xie He, 484 Xia dynasty, China, 484 224, 224; popularization of oil Xerxes (king of Persia), 28-29, 63 Weyden, Rogier van der: Deposition, wet-plate photography, 351, 352 many, 158, 166, 166, 185, 185 Wuzong (Chinese emperor), 490 westwork of abbey church, Corvey, Gerture), 487, 487, 505, 505 Governor-General Zhang (sculp-Westphalia, Treaty of, 286 Wuwei, China, flying horse, tomb of per No. 30, 393, 393; style of, 409 Weston, Edward: influence of, 426; Pep-964 '964 William Vertue), 202, 202, 215 Wu Zhen, Stalks of Bamboo by a Rock, Henry VII, fan vaults (Robert and Wu Zetian (Chinese empress), 489 Westminster Abbey, London, Chapel of writing, 512. See also calligraphy Western Roman Empire, 124 317; style of, 314, 329 Giving a Lecture at the Orrery, 317, 320, 321, 329; style of, 329 West, Benjamin: Death of General Wolfe, Wright of Derby, Joseph: A Philosopher Well of Moses, Chartreuse de Champmol (Sluter), 219, 219, 249, 249 New York, 429, 429, 437 mon R. Guggenheim Museum, Copán, Honduras, 531, 531, 533 Wedgwood, Josiah, 317 ter), Bear Run, 408, 408, 409; Solo-429; Kaufmann House (Fallingwa-Waxaklajuun-Ubaah-K'awiil, Stele D, Wright, Frank Lloyd: architecture of, Waves at Matsushima (Korin), 8, 9 Cathedral, London, 286, 310, 315, 329 Watteau, Antoine: fête galante, 314, 315, 329, Pilgrimage to Cythera, 315, Wren, Christopher, Saint Paul's World War II, 412-413, 523, 525

967 '267-967 Water Carrier of Seville (Velázquez), Saint-Denis, France (statuette), Virgin of Jeanne d'Evreux, abbey church, 624,454,455,454,(niJ) Virgin), Vladimir, Russia (icon), 140 454; Vietnam Veterans Memorial Virgin of Compassion icon (Vladimir nam Veterans Memorial (Hart), Virgin Mary. See Mary (mother of Jesus) Memorial (Goodacre), 454; Viet-Washington, D. C.: Vietnam Veterans Virgin and Child, Melun Diptych (Fou-Jekythos), 72, 72 segna), 209-210, 209 Greece (white-ground Athenian Siena, Italy (Duccio di Buoninwarrior taking leave of his wife, Eretria, Maestà altarpiece, Siena Cathedral, 263, 563 Auvergne, France, 174, 175, 176 Virgin and Child Enthroned with Saints, warrior figure (Gu?) (Kendo) (sculpture), Inanna), Uruk, 14, 15, 23, 43 Virgin and Child (Morgan Madonna), Warka Vase (presentation of offerings to Sinai, Egypt (icon), 134, 134, 141 425; style of painting, 437 astery of Saint Catherine, Mount 423-424, 423; Marilyn Diptych, Warhol, Andy: Green Coca-Cola Bottles, Saints Theodore and George, Mon-Virgin (Theotokos) and Child between the Fishing Nets), Suzhou, 498, 498, Wangshi Yuan (Garden of the Master of Viola, Bill: The Crossing, 457-458, 457; 68E '8EE painting; mural painting Wanderer above a Sea of Mist (Friedrich), Vincenza, Italy, Villa Rotonda (Palladio), 96, 96. See also cave painting; tresco 50\$, 40\$−40\$, 40₹ Third Style Roman wall painting, Villa Savoye, Poissy-sur-Seine (Le Cor-94-96, 95, 247; technique, 20-21; Style Roman wall painting, 84, ladio), 265, 265, 326, 328 Villa Rotonda, near Vicenza, Italy (Pal-Roman still life, 96, 97; Second 526, 527; in Neolithic Age, 20; Villa of the Mysteries, Pompeii, Italy, 96, 97; Greek fresco, 49; Mayan, Fourth Style Roman wall painting, reale, Italy (Second Style wall paint-Roman wall painting, 94, 94; Villa of Publius Fannius Synistor, Bosc-Etruscans, 87, 115; First Style Style wall painting), 95-96, 95 deer hunt (Çatal Höyük), 20, 20; of wall paintings: Byzantine, 138-139, 139; Villa of Livia, Primaporta, Italy (Second (sculpture), 479-480, 479, 481 Walking Buddha, Sukhothai, Thailand trecase, Italy (Third Style wall Benin, 560, 561 Villa of Agrippa Postumus, Boscowaist pendant of a queen mother Idia, Villa Borghese, Rome, David (Bernini), viharas (monasteries), 464 Vyd, Jodocus, 221 La Madeleine, 332; style of, 333 18 '18 '19 Vignon, Pierre-Alexandre Barthélémy: amphora (Euthymides), 60-61, Vignola, Giacomo da, 264-265 revelers on Athenian red-figure (Exekias), 59-60, 59; three Vigée-Lebrun, Élisabeth Louise, Selfdice game, black-figure amphora Overveen (Ruisdael), 303-304, 303 Vulci, Italy: Achilles and Ajax playing View of Haarlem from the Dunes at (Greek/Roman deity) Vulcan. See Hephaistos (Vulcan) ton, D.C. (Lin), 454-455, 454, 459 (Vulca of Veii), 88, 91, 91 Vietnam Veterans Memorial, Washing-Maximus, Capitoline Hill, Rome ton, D.C. (Hart), 454 Vulca of Veii, Temple of Jupiter Optimus Vietnam Veterans Memorial, Washington, D.C. (Goodacre), 454 Voltaire (François Marie Arouet), 316, Vietnam Veterans Memorial, Washing-041 '041 nated manuscript), 133, 133 Vladimir Virgin, Vladimir, Russia (icon), Vienna Genesis, Vienna, Austria (illumi-Vitruvius Britannicus (Campbell), 326 (illuminated manuscript), 133, 133 on Architecture, 67, 85, 96, 265, (Whiteread), 455; Vienna Genesis Vitruvius (Roman architect), Ten Books Vienna, Austria: Holocaust Memorial De vita triplici (Ficino), 275 video, 435-436, 457-458, 459 507 '861 '761 victory stele of Naram-Sin, Susa, Iran France (jamb sculpture), 120, 196, Visitation, Reims Cathedral, Reims,

898 '898-798

Visigoths, 141, 148

with the Angel) (Gauguin),

470-472, 471, 472, 481

sculpture), 470, 470

Vision after the Sermon (Jacob Wrestling

Vishvanatha Temple, Khajuraho, India,

Vishnu Temple, Deogarh, India, 470, 470

Vishnu Temple, Deogarh (relief

Vishnu (Hindu deity), 468, 469, 470, 470

Virgin of Paris, Notre-Dame Cathedral,

Vishnu Asleep on the Serpent Ananta,

Paris (sculpture), 200-201

Carrier and the control of the style of the control of the control

etmi Asa

		•